Theatre Censorship in
Honecker's Germany

German Linguistic and Cultural Studies

Editor: Peter Rolf Lutzeier

Volume 23

PETER LANG

Oxford• Bern • Berlin • Bruxelles • Frankfurt am Main • New York • Wien

Barrie Baker

Theatre Censorship in Honecker's Germany

From Volker Braun to Samuel Beckett

PETER LANG

Oxford· Bern · Berlin · Bruxelles · Frankfurt am Main · New York · Wien

Bibliographic information published by Die Deutsche Bibliothek
Die Deutsche Bibliothek lists this publication in the Deutsche Nationalbibliografie;
detailed bibliographic data is available on the
Internet at ‹http://dnb.ddb.de›.

British Library and Library of Congress Cataloguing-in-Publication Data:
A catalogue record for this book is available from *The British Library*, Great Britain,
and from *The Library of Congress*, USA

ISSN 1422-1454
ISBN 978-3-03911-086-5

© Peter Lang AG, International Academic Publishers, Bern 2007
Hochfeldstrasse 32, Postfach 746, CH-3000 Bern 9, Switzerland
info@peterlang.com, www.peterlang.com, www.peterlang.net

Printed in Germany

—

The worst tyranny
would be a tyranny
of concealed rules

—

Karl Marx

Contents

Preface

My interest in the theatre of the German Democratic Republic was kindled by studies of Theatre as History in the German-speaking countries and in Politics and Society in the GDR undertaken at University College London. I decided to explore related themes in a Ph.D. dissertation at the University of Reading, seat of the Centre for East German Studies and the International Samuel Beckett Foundation. I started with the idea of advancing knowledge of the Honecker era (1971–1989) but came to the view I had the exceptional opportunity, by concentrating on the late 1980s, to interview the makers of history for that period while they still lived and to search not only the public archives but to explore any material held in some of those theatres that had fortuitously retained reports and other papers about performances and controversial productions of those years. In achieving these objectives I was struck by the extent to which the cultural policy and development of the 1980s had been pre-determined by events following on from Honecker's advent to power. Hence, re-inforced by my experience during the case studies, I returned to the project for a comprehensive study of the state's relationship to the theatre as now presented.

This volume provides for the first time in the English-speaking world and in the German sphere a full account of state supervision of the theatre of the German Democratic Republic in the Honecker era (1971–1989) with special emphasis on the formal controls and other pressures on the performing art in the 1980s. It seeks out the reasons for the existence of such controls and the ideological and theoretical basis for the regime's attitude to the theatre and the effect on the theatrical profession of the resultant 'Kulturpolitik'. In doing so it offers new insights into the drama production of the republic, for instance, into the question whether the theatre as an institution gave loyal support to the regime or whether it formed an element of the opposition.

9

A prime instrument of the controls was censorship, considered here in its broadest sense, including not only formal procedures but also social conditioning, and the influence of the political and mass organisations and drama criticism in the media. This was burdensome for GDR drama to an extent that has not been realised before now. The various ways in which the theatrical profession was coerced have not been appreciated and, given the total effect on lives and careers as well as on professional practice, they deserve attention and, wherever possible, an evaluation of their efficacy and impact. The exercise thereby exposes underlying factors, such as the oddities of administration that are of interest not only because they show the inner workings of cultural policy but because they help explain the special character of drama in the GDR. Not least of the means of state surveillance was the ever increasing secret police activity in the cultural sphere, the widespread use of informers and the mounting of covert operations against writers, dramaturges, directors and intendants.

The study is founded on concrete examples of the application and effect of pressures on members of the theatrical profession. Projects in Berlin and Dresden illustrate in detail and with geographical diversity aspects of the controls, such as the formal and non-formal channels for obtaining permission, the exercise of power to keep works from the stage, and the penalties for those who did not conform.

Volker Braun was a prominent, albeit problematic, Party member but enjoyed an international reputation as a poet and dramatist. Thus he could rely on this reputation to afford him access to powerful figures in the higher echelons of the regime. He was very much a product of the GDR, his upbringing and early career being within its borders. He endured considerable censorship and retained a personal vision of socialism in the face of calls for orthodoxy. His difficulties and successes show what could be achieved by a dramatist of his background. The GDR did not only censor its own population. The state was at the frontline of resistance to foreign 'decadent' art exemplified by the plays of Samuel Beckett, a poet too, as was Volker Braun, but the theatre world had its own concerns, ideas and movements that could not be ignored. This is illustrated by an appraisal of the assimilation into the repertoire of the classics of Russian and German drama, and into the emergence of contemporary work in the

GDR itself. This is underpinned by a specific case study of Beckett's *Waiting for Godot* depicting the gradual change of attitude towards this 'decadent' play from rejection to acceptance by the political establishment over the lifetime of the GDR.

It will be seen that the main concern of the present work is the interface between control and creativity. This has led to explorations of the relationships between the principles and practice of censorship and surveillance: the theory and method of drama: and with the mechanisms by which such conflicts were handled. Attention has been expresssly focused on areas of dispute between 'art and authority', since these areas bring immediately and clearly into view the specific problems experienced in theatrical life in the GDR and identify the attitudes of the various participants. The emergence and deployment of the controls imposed upon drama not only affected the work directly, but equally determined the very atmosphere in which GDR dramatists wrote and performed their work, and strove to have it appreciated.

The result is a journey from policy to practice in which censorship and politics go hand in hand with social and cultural currents and influences peculiar to the GDR. This has enabled a wide-ranging view of the special cultural niche that theatre occupies. Moreover, the universal sweep of theatrical tradition and progress is demonstrated to have suffused the repertoire. It has become apparent from the twin perspectives that the mix of politics and drama in the GDR not only constitutes a rare phenomenon rewarding the effort of discovery, but that the analysis undertaken here provides a foundation to assist future appreciation of the drama itself and to the search for further insights into problems attending state intervention in such creative enterprise.

Acknowledgements

I have received generous help during the work on which this book is based, both in Germany and in the UK. I thank especially Dr Peter Ullrich and Frau Henriette Kuzior of the Academy of Arts in Berlin for their invariable patience and courtesy in answering my enquiries. I am also indebted to present and former theatre ensemble members, Manfred Möckel at the Maxim Gorki Theater Berlin, Michael Philipps at the Hans Otto Theater Potsdam, Karla Kochta at the Staatschauspiel Dresden, Wolfgang Engel at the Stadtschauspiel Leipzig and Alexander Weigel at the Deutsches Theater, for useful conversations. Comments made by Frau Marschall-Reiser of the Bundesarchiv, by Wolfgang Schuch of Henschel Schauspiel Verlag and by Professor Frank Hörnigk at the Humboldt University, and by Dr Detlef Gwosc were most helpful. I am grateful to Frau Beate Vajen at the Stasi Archives in Berlin for her diligence and kindness and to Frau Waltraut Kegel and Frau Sandra Kaesche for very valuable practical assistance. Constant encouragement has come from my wife, Irmingard, sons Frederick, Nicholas and Christopher and from colleagues Angela Brock and Ann Charlotte Montenbruck. Special appreciation is accorded Professor John Sandford and Mr Graham Jackman of the University of Reading for their longstanding interest and support. Finally, I would like to express my gratitude for financial aid from that university towards my travels in Germany.

Glossary

All translations are the product of my own effort. I have sought to mirror official and political speech. In other cases I try to match vivid expression with bold prose. To further assist readers for whom English is the more convenient language some of the more common acronyms used in the GDR are clarified below.

Abt Abteilung; a section or department in a state ministry

AdK Stiftung Archiv der Akademie der Künste; Archive of the
 Academy of Arts in Berlin

BL Bezirksleitung; the leadership or managers of the 13
 administrative areas of the GDR

BStU Bundesbeauftragte für die Unterlagen des Staatssicher-
 heitsdienstes der ehemaligen Deutschen Demokratischen
 Republik; Commissioner for the Records of the Security
 Service of the former German Democratic Republic

CDU Christlich-Demokratische Union; Christian Democratic
 Union

DBD Demokratische Bauernpartei Deutschlands; German
 Democratic Farmers' Party

DDR Deutsche Demokratische Republik; German Democratic
 Republic

FDGB Freier Deutscher Gewerkschaftsbund; Free German
 Trade Union Federation

FDJ Freie Deutsche Jugend; Free German Youth Organisation

FRG Federal Republic of Germany

GDR	German Democratic Republic
HA	Hauptabteilung; main department
IM	Inoffizieller Mitarbeiter; secret police informer
IMS	Inoffizieller Mitarbeiter in Schlüsselposition; informer in a key position
LDPD	Liberal-Demokratische Partei Deutschlands; German Democratic Liberal Party
MfK	Ministerium für Kultur; Ministry of Culture
MfS	Ministerium für Staatssicherheit; Ministry of State Security
NDPD	Nationaldemokratische Partei Deutschlands; German National Democratic Party
OV	Operativer Vorgang; secret police operation
Politbüro	East German Cabinet
SAPMO	Stiftung Archiv der Parteien und Massenorganisationen der ehemaligen Deutschen Demokratischen Republik; Archive of the Political Parties and Mass Organisations of the former German Democratic Republic
SED	Sozialistische Einheitspartei Deutschlands; Socialist UnityParty, the leading political party in the GDR
Stasi	Ministerium für Staatssicherheit; Ministry of State Security or secret police
VEB	Volkseigener Betrieb; state-owned concern or factory
ZK	Zentralkomitee; Central Committee, the executive organ of the Politbüro

Chapter One
'Kulturpolitik'

This chapter provides an overview of the cultural climate of the Honecker era (1971–1989) including the theoretical and practical aspects of policy. First, however, one ought to be clear why the GDR regime sought so actively to influence that climate. Filling the theatres with socialist-minded people and letting them get on with their work was an option that could have been taken. Also, Honecker might have closed the theatres on the same grounds as Cromwell closed the English theatres, namely that there had been in living memory quite enough drama in real life.

The Marxist-Leninist view was that bourgeois culture (to which the theatre was integral) consists of ever-prevalent false ideas created by the powerful to manipulate the powerless. It was therefore imperative to stop the flow of these ideas, or any trace of them, within the existing society and embed socialist ideology and culture. All this fitted in with the class struggle to ensure the ascendancy of the workers and the socialisation of the population. GDR citizens could not be relied upon to fend off the challenge.The socialist ideological counterview had to be formulated and promulgated by the state. The theatre was a means to this end.

A position about cultural matters, resting on theory, had already been taken by the SED in 1965 before Honecker came to power in Kultur in unsrer Zeit. It comprised four elements strung together in a mutually re-inforcing chain of cause and effect (artistic expression was, as seen below, part of one of these elements, namely the forming of social consciousness):

• the process of perfecting man's existence through changing the world.

• the consequent ideological reflection of the process.

17

- the expression of that ideological reflection indifferent forms of socialconsciousness (especially art).

- the impact of this social consciousness upon the perfecting of the process.

In the Honecker era, though, the special quality claimed for culture as ennobling and improving mankind was overlaid by a more utilitarian view, espoused at the SED VIII Parteitag in 1971, namely that culture was a collective material and intellectual force through which man could better control his destiny:

> We view socialist culture as a totality of the material conditions of existence, activities, practical ways of life and behaving, of artistic achievements, discovery, ideas and ideals through which men – as conscious shapers of their own history and future – first become capable of that 'free universal development' of which Lenin spoke. (Koch 1983: 9)

In the cultural sphere, and in the context of international co-operation, the acceptance and incorporation of the cultural and artistic achievements of the Soviet Union into the cultural life of the GDR were rated as important ideological tasks. Ideology, however, was not thought of as the sole determinant of culture:

> They extend – indeed, like culture – beyond ideological matters. They touch upon many emotions, moods, practical experiences, customs, habits, spontaneity, the numerous and richly differentiated cultural needs, the working out, acquisition and recognition of a whole system of new values appropriate to the advanced socialist society. (Rüß 1976: 595)

Under Honecker this more differentiated approach to culture with emphasis returning to the divergent qualities of the individual made for livelier and more problematic characters on stage (Hasche 1994: 175). The GDR's vision differed from the Soviet model in placing emphasis on the individual as separate from, but not incompatible with, the collective consciousness. Authors became more interested and involved with the situation of the individual either in relation to society, or existentially. GDR politicians placed emphasis on meeting more of the needs of the individual as a consumer. GDR drama was to

change both itself, and audiences through portraying characters corresponding to the unique 'socialist personality'.

The social emphasis exhibited in the cultural sphere occurred within and beyond the frontiers of the GDR. There continued to be a mix of indigenous and Soviet drama as part of a variegated pattern of culture intended to foster co–operation among all countries in the Soviet bloc, and in support of an ideological homogeneity. The gulf between the ideal communist state and current conditions was a recurrent theme of GDR drama. At the same time there emerged a greater willingness, appropriate in an advanced socialist society, to thrash out the problems through dialectical discussion. That required an involvement of the individual and more personal commitment to taking responsibility for change.

The repertoire was selected from new drama about the present day, and German or international classics either in their traditional form or in versions that increased their appeal to East German audiences. Especially prominent, for a variety of reasons, were the works of Soviet authors. Everyone could feel comfortable with works that had already reached the stage in the Soviet Union, relying on the assumption that they had passed the tests of Marxism-Leninism by the time they came to the GDR. Cultural officials and theatre professionals could steer such works more confidently through the approval procedures. Moreover, these works enabled the airing of topics, such as corruption in officialdom, which, if they had been drawn solely from the GDR, would have encountered not only hostility but formal disapproval. A successful example was Victor Rosow's *Das Nest des Auerhahns,* where the author himself helped German colleagues to stage his play (Albiro 2001: 269).

The idea of progress towards perfection, as apparent in the fundamental ideological criteria listed above, became a theme of GDR drama. Typical were plays in which a person ill at ease in their relationship to the SED or to the GDR, develops in the course of trial and experience into a well adjusted socialist helping to fulfil the norms of production in industry or agriculture, for instance the work of the playwright, Helmut Baierl whose *Frau Flinz* concerns a woman resembling Brecht's character Mother Courage who rises to a responsible position in the Party. (Emmerich 1996: 156). Also, plays that

19

showed a society en route to Utopia kept alive a belief in the distant ideal. The introduction by Honecker of the concept of 'real existing Socialism' lauding the attainments of the GDR required celebratory theatre. Most favoured were endings to plays that held out hope for the future. These expectations were not always fulfilled, but they lay at the heart of reproaches towards works that contained expressions of dissatisfaction with, or pessimism about life in the GDR. The plays were regarded by SED officials as insufficiently 'parteilich'. On similar grounds, there was no room for the genre of tragedy because, ideologically, socialism could not contemplate man's existence in the hands of fate or of God; tragedy was brought into the world by man who could also rid the world of it (Schumacher 1989: 21).

Honecker sought to lay down guidelines that would clarify the role and freedom of the artist and writer. In December 1971 he included the subsequently much quoted remark in a speech to the 4th Plenum of the Central Committee of the Socialist Unity Party:

> If you start from the solid base of socialism, there can, in my opinion, be no taboos in the field of art and literature. That applies to style as well as creative content – in short: those questions of what one regards as artistic excellence. (Emmerich 1996: 247)

This signified a shift to a more liberal attitude, but the speech taken as a whole made it clear that a commitment to and understanding of socialism were prerequisites for all artistic endeavour in the GDR.

The SED was in theory as much in control of cultural policy as before. However, the writers and artists had glimpsed new possibilities and, as Andrea Jäger observes: 'Die Maßstäbe des Erlaubten allerdings hatten sich geändert' (A. Jäger 1995: 74). She makes the point that literature was relieved of the task of evoking social consciousness in the population. It was now to support the regime through embellishing its achievements. Also, any contradiction in socialism related to class difference or unsocialistic consciousness could and should, as stated by Hager, be discussed, but only to the extent that it 'nicht mehr mit dem Willen auf praktische Umsetzung und schon gar nicht auf politischen Konsequenzen beharrte' (ibid.: 81).

During the next five years works that had previously failed to be published or performed now appeared. For example, in 1972 Volker Braun's *Die Kipper*, published in 1966, finally reached the stage; from 1972 Plenzdorf's *Die neuen Leiden des jungen W.* was performed with great success at 14 theatres.

However, 1976 saw Reiner Kunze forced out of the writers' union over the appearance of *Die wunderbaren Jahre* in the FRG and Wolf Biermann deprived of citizenship and the right to live in the GDR while on tour in Cologne. Protest at this persecution included an open letter by eleven well-known authors and a sculptor that was only publishable in the FRG. The reaction from the regime was a purge of those who protested or associated themselves with the protest.

The exodus of dissidents led to a thinning of the ranks of outstanding writers and artists. There was neither a wish to give to enemies the gratification of seeing the best of the remaining talent leave the GDR, nor to have new works by internationally-known authors first published in West Germany. That demanded restraint as to how prominent authors were treated. Weber indicates that in the 1980s the SED itself was 'ailing', the distance between the official version of history and actual events was more clearly perceived; members of the FDJ began to criticise the style of propaganda. Nonetheless, the regime sped on with the purge it had begun. In Halle the only remaining theatre intendant who was not a party member was dismissed for supporting the protesters (Schulze-Reimpell 1992:42). At the Deutsches Theater, the director Adolf Dresen surrendered his membership of the SED and in 1977 went to work at the Burgtheater in Vienna.

For dramatists the period 1977 to 1985 was one of difficulty due to the uncertain direction of cultural affairs in the GDR and the increasing encroachment on their freedom of access to theatre audiences. From 1978 permission from the Minister for Culture had to be obtained for first performances of new works. This, coming on top of the difficulties experienced in dealing with local SED functionaries, was much complained about, especially since ministers and senior officials had long advocated that there should be more contemporary drama on the GDR stage. The response was to reinforce the restriction by ordering the editor of *Theater der Zeit* not to publish the text of

plays whose first performance had not been authorised (Lennartz 1988: 13) and was symptomatic of the inherent distrust of intellectuals in the theatre, and in other creative arts, manifested by successive GDR regimes. The theatre was singled out for special attention.

From 1985 there was a new external influence on cultural policy, namely the reforming policies of 'glasnost' and 'perestroika' pursued by the Soviet leader, Gorbachov, and the effect of these on governments and intellectuals in the Soviet bloc. The GDR regime was resistant to change, partly because the leadership held rigidly to time-honoured views and disregarded facts that did not fit in with these views, but partly because the policies, if applied in the GDR, were especially likely to reveal a great deal to the detriment of the leaders. This anxiety is described in Peter Hutchinson's biography of Stefan Heym:

> The new frankness towards the past was the most embarrassing, for it brought an obligation to confront the earlier years of their own country in a comparably open manner. [...] Soviet intellectuals had given expression to many frustrations – the mistakes, indeed crimes of the past; the suppression of these; the ruthlessness of Stalinism; and the corruption which had obtained only a few years previously under Brezhnev. In the GDR, so many of its members had been in post at the very foundation of the republic, and had implemented Stalinist policies for most of their lives. There had been only two leaders and personally selected associates in 40 years. The responsibility for mistakes was therefore very tightly held. (Hutchinson 1992: 217–218)

Kurt Hager was dismissive of the Gorbachev reforms as a 'change of wallpaper' that the GDR had no need to imitate. His statements demanded adherence to the existing order. In 1985 he criticised young authors for their pessimistic outlook and appealed for writing that showed a hero making history and which emphasised optimism (Jäger 1993a : 235). Speaking to cultural officials in December 1986, the Minister for Culture, Hans Joachim Hoffmann referred to the question raised from time to time whether the policy should be changed in the light of contemporary circumstances:

> We can answer that with clarity and certainty. We hold unerringly fast to the programme of the SED and to the GDR's constitutional orientation towards the development of socialist national culture in the GDR. In this orientation there

has been, and remains no need – and the 11th Parteitag throughout its entire course made this abundantly clear – to alter a single word. (*Sonntag* 52/86)

However, the system of controls showed signs of breaking down. Heiner Müller's manuscript for *Wolokolamsker Chaussee III* went the rounds of the Berlin Magistrat, District Council and Politbüro and was returned to the Volksbühne Theater 'ohne eine Stellungnahme' (Hasche 1994: 187). The knowledge that relaxation of supervision of the arts in the Soviet Union was proceeding apace could not have helped:

> Not least, the staffing changes in the management of the relevant association made it clear, that in art also, a new era had begun. Keen champions of artistic freedom superseded the old guard. (Hildemeier 1998: 1029)

At the 1987 Writers' Union congress de Bruyn, the novelist, and Hein, a playwright who had long been a critic of the structure and organisation of the GDR theatre, argued strongly for the abolition of censorship. Hein made a series of points. He stated that though censorship had had a role in the decade after World War II to establish order out of chaos and to help correct historical misrepresentation, it had outlived its purpose. It could delay literature but not prevent it, so it served no useful function.

It had the opposite effect to that intended since the object censored became a political matter: it had the appearance of being an idea of the publishers to promote the book. Censorship was inhuman, damaging to the author, the reader, the publisher, and to the person who implemented it; the GDR had over the previous ten years lost irreplaceable writers whose work was missed and whose views were of value. Its existence was hostile to the people who were well able to form their own judgement; the idea that an official knew best was pure arrogance. Censorship was unlawful and unconstitutional. It demeaned the reputation of the GDR (X. Schriftstellerkongress der DDR. Protokoll Arbeitsgruppen, Berlin und Weimar 1988, 228 ff.). Hein was not free to say, as he implied, that censorship should have ended when Stalin died. His polemic was directed at the system but also at the profession. He insisted that censorship should vanish and not be replaced. He was certainly not in favour of proposals put

forward by colleagues for a more open and accountable system of censoring the theatre while other arts were looking for progress towards abolition (Hein 1990: 119).

From then forward, to November 1989 and the collapse of the GDR, the policy of SED and official intervention in the writing and production of drama was pursued, tempered by the wish to avoid an open breach with theatre professionals that might lead to an accentuation of political tensions and to unwelcome publicity.

Such shifts contributed to a weakening of control and a more assertive stance by writers and artists, despite sporadic attempts among SED hard-liners to regain command of the situation, such as the ban imposed on the distribution of copies of *Theater 1988* to prevent further dissemination of the Minister's views. In 1989, plays overtly or covertly critical of GDR society and its leadership, such as Braun's *Die Übergangsgesellschaft*, were performed. On the opposite side, and serving as an indication of the thorough conditioning of many GDR authors, not all playwrights were in favour of abandoning the official system. Thus, while some authors supported Hein in his arguments for abolition of censorship, others spoke for the retention of helpful controls, even those like Rudi Strahl who had had two of his plays, *Flüster-Party* in 1978 and *Das Blaue vom Himmel* in 1984 attacked and/or removed from the repertoire (Jäger 1993a: 250).

These events at the end of the 1980s are the last travails of the deficient cultural governance to be found in Honecker's GDR. Theorists were at work to variegate the ideological base and ministers exhorted artists, writers and intellectuals to discover new depths within the socialist ethos. What was lacking, however, was the formulation and promulgation of a rational policy that could withstand debate and provide constructive guidelines for cultural functionaries and those engaged in the creative process. On the contrary, the image that emerges is of a continual tug-of-war between the two. When playwrights, and other writers, produced works of originality, they encountered delay and obstruction. As we see, the response to pressure for relaxations in policy was often a sleight of hand resulting in a neutral effect or a tightening of, rather than a relief from, restriction. In 1975 the responsibility for excluding plays from a theatre's repertoire was transferred from the MfK to intendants, and as

24

mentioned above, from 1978 *Theater der Zeit* was prevented from publishing plays whose first performance had not yet been approved. With the arrival of Gorbachev at the helm in the Soviet Union and the making of cultural agreements with West Germany in the second half of the 1980s, a clamour for the lifting of restrictions arose. Even then that call was more often heard than acted upon, and progress came about by default rather than by any initiative of the GDR regime.

Many plays of the 1970s and 1980s are about the situation of individuals, about their behaviour in relation to society, and what they may expect from society. From *Die neuen Leiden des jungen W.* to *Die Übergangsgesellschaft*, the concerns are less about what people are to do for a common cause, and more about the opportunities, or lack of opportunities that society offers them for self-fulfilment. 'Kulturpolitik' alone had not engineered this, but had rather trailed along confusedly, moving from the dogma of *Kultur in unsrer Zeit* to Hoffmann's late liberal apostasy in *Theater 1988*.

Chapter Two
Theatre Practice and State Control

East Berlin was an important hub of theatrical life, as can be seen by the presence of four major ensembles, the Deutsches Theater, the Berliner Ensemble, the Volksbühne and the Maxim Gorki Theater. However, there were 39 professional theatres in the other large and small towns of the GDR. Nine of these were classified as being devoted to drama whereas the others were 'Mehrspartentheater', which signified that other activity also took place, e.g. music and ballet. The coverage was impressive, and it was not uncommon to find 'Mehrspartentheater' in towns with as few as 20,000 inhabitants (Irmer 2003: 8).

From 1951 all theatres, cabaret and music ensembles were classified according to the quality of the art they produced and according to the cultural importance assigned to their work. Roughly speaking, this meant that institutions such as the Deutsches Nationaltheater in Weimar, where there was a strong cultural focus arising from the connection to the classic plays of Goethe and Schiller, and where productions attained high standards and required corresponding resources to maintain them, received the highest classification 'A'. A theatre well known for its artistic achievements such as the Hans Otto Theater in Potsdam ranked as category 'B'. Theatres of more modest aspirations which were significant in a local context, such as the Theater der Bergarbeiter in Senftenberg, were given the classification 'C'. A snapshot in time of the classifications of all types of theatres throughout the country is contained in a list in a ministerial brief in 1987, as enclosed in a letter I received from Dr Peter Ullrich of the Academy of Arts. There was no small élite at the top of a pyramid since, of the 56 actually named, 19 were 'A' class, 13 in 'B' and 24 in 'C'. According to Dr Ullrich, when the classification system was decided no provision for future modification was made, the result being that it was extremely difficult to change a classification.

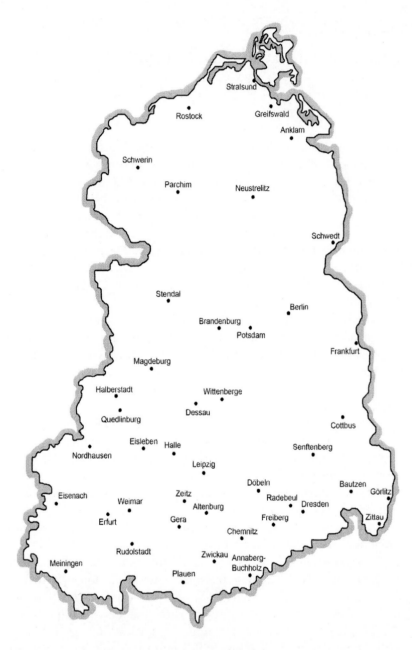

Towns in the GDR supporting Theatre and Cabaret

In conversation with me, he has mentioned that, for example, Schwedt became a larger town because of the development of an oil industry there but was never able to have its theatre upgraded. Over time, this inflexibility of the classification system proved to be a constraint on re-organising the theatre structure in the GDR. Where the quality of performance rose or fell substantially, or where cultural conditions and ambitions changed, perhaps partly through population growth or decline, the classification originally awarded might well become out of kilter with the actual situation on the ground. Thus, it is only with substantial reservation that the classification system can be used as a gauge of the artistic standards achieved by each theatre over the whole period of the existence of the GDR.

Whilst the classifications may have been founded on artistic and cultural criteria, the system was used thereafter on a regular basis as a framework within which to allocate money and resources. Michael Philipps of the Hans Otto Theater has remarked, in speaking of the management of theatres in the larger cities and towns, that political importance and demography were also significant factors:

It was more a question of housekeeping and a matter of artistic, political importance and the size of the town taken together. Leipzig and Dresden had three, four times more inhabitants, and they were in a different league. Sometimes, it had nothing to do with artistic coherence, sometimes there was better drama in the smaller theatres. It does not automatically make sense, it depended on the size, the budget and the status, and was purely organisational. (Interview Baker/Philipps on 1 April 2003)

One variation within the classification was the special status awarded to the prominent theatres of Berlin, like the Berliner Ensemble, who were designated as having 'S' status. This distanced these theatres in Berlin further from the best of GDR theatre elsewhere in the country and so skewed the structure and organisation in favour of the capital of the GDR. In 1985 the Generalintendant in Dresden, Dr Seeger, put forward proposals for reform. The idea was to classify the players rather than the playing fields. This was given short shrift by the head of the cultural department of the Central Committee of the SED on the grounds that:

It could deal with the different remunerations of the workers at the different theatres. This arose from the classification of the theatres according to their capabilities and workload which had already in 1951 been the object of the pay and salary agreement at the time. The 1972 overall accord built on that and now laid down a classification of theatres into three ranking groups – A, B and C – and established for each of them separate levels of pay basic and average earnings]. (SED ZK IV 32/9.06/68)

Ursula Ragwitz also stated that, as was the case all over the world, the theatres of the capital city had a special responsibility for national development of the theatre and its validity internationally. These theatres were duty bound to use their rich artistic potential, and their funds, for the purpose of setting exemplary standards of artistic achievement. That being so the Berlin theatres had to employ the best actors, singers, dancers, directors, conductors etc. in their ensembles and to remunerate them accordingly. In her view, 'a levelling of the remuneration of artists between the Berlin theatres and other big theatres in the republic was not desired' (ibid.).

The pay of theatre staff was ineluctably linked to the classification of their theatre and not to how well work was done, so that once employed in a particular ensemble, there were hardly any incentives to rise above the average attainment. An attempt to overcome the problem was made in 1987 when the 'collective framework agreement' introduced performance-related payments for achievement, for coping with emergency situations, and in the form of permanent additions to basic pay (Hasche 1994: 198).

The headquarters of the SED, the ministries and the Stasi were in Berlin, but they not only had oversight of the institutions of drama there, but through regional and local organisations, operated in the other cities and towns where, indeed, most of the theatre activity in the GDR took place. The diagram on page 31 shows these three strands of authority and also indicates their relationship one to another. For instance, the political organs, the Central Committee and the Politbüro, were superior to all other bodies: the SED–District Councils were the highest-ranking regional bodies. In the ensembles, the political interest was represented by a 'Grundorganisation' of SED members under the aegis of a local Party Secretary. The MfK assisted by an advisory committee and the professional association generally

carried out its functions in relation to the theatres by means of cultural officials working at district or local level and was responsible for the bulk of day-to-day business. The MfS had representation at the highest levels of the GDR, and was very large on account of its wide remit for national security. The Stasi spied on the ensembles through informers, Inoffizielle Mitarbeiter (often members of the ensembles), and these were controlled by local Stasi units. Additionally, it was not unusual for Stasi officers to have regular meetings with intendants. (There are a few other, special, working relationships not illustrated in the diagram and these are described separately in detail in the chapters where issues relating specifically to them are discussed.)

Organisation Chart (after Schroeder 1998: 422)

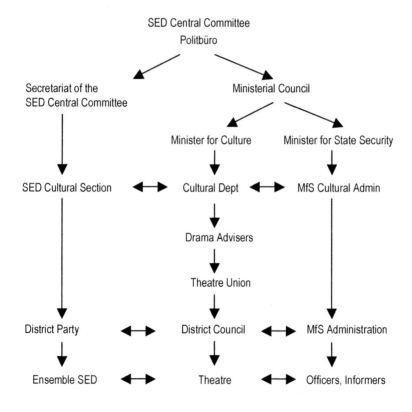

The provincial ensembles existed to meet the needs and preferences of their own communities but they also operated in a symbiotic relationship with Berlin. The municipal theatres tried out new plays or new productions for which the ideas were first mooted in Berlin, and gradually over time, perhaps years, the plays would either fail or become accepted repertoire and appear on a Berlin stage (Riewoldt 1983: 134). Conversely, very successful productions that were first staged in Berlin were taken on tour in other towns or the local ensembles would put on their own productions. These theatres served also as venues for works which, whether experimental or not, were unsuitable for the cosmopolitan and politically sensitive capital, i.e. the seat of central government and of the SED, in close proximity to West Berlin and under the eyes of Soviet bloc diplomats and of embassy representatives from all over the world. Such works sometimes provided opportunities for theatre professionals in the provinces. This is not to say that these plays were invariably welcomed there. A conference in Berlin in September 1978 recorded the complaint of chief dramaturges in the provincial theatres who were obliged to take charge of suspect plays emanating from Prenzlauer Berg in Berlin (SED ZK IV B2/9.06/67).

To some extent, the relationship of the theatres to Berlin was always bound to be unequal, not simply because the Berlin establishments brought in high income and justifiably attracted greater investment than the other theatres, but because East Berlin was a national showpiece and it was from there that the most important media, television and the national newspapers, were managed. Honecker himself took a close and frequent interest in the detailed editing of *Neues Deutschland*. For their part the provincial dramatists were not content to receive only regional recognition: a positive review in *Neues Deutschland* was the ultimate accolade. When the intendant of the Stadtschauspielhaus in Leipzig, Karl Kayser, was worried by the lack of publicity and discussion of the work of his theatre in the newspaper he complained in very strong terms to Ursula Ragwitz, head of the cultural department of the secretariat of the Central Committee of the SED (SAPMO-BArch, DY 30/ vorl. SED 32803).

One difficulty in Berlin was the greater extent of political intrigue in the direction, and style of management of the Berlin theatres.

For example, at the Deutsches Theater in 1969, at the behest of the SED District Council in Berlin under Konrad Naumann, a new Intendant, Anselm Perten, was appointed. His reorganisation abolished the previous team structure and centred power in himself (Weigel 1999: 264); his plans were politically oriented and lacked a coherent artistic strategy. There ensued two years of turmoil in which the ensemble resisted the efforts of the Intendant and during which he became paranoid and called on the Stasi to assist him. The theatre's productions were troubled and did not enjoy much success. Honecker replaced Ulbricht and embarked upon new cultural policies. Anselm Perten was dismissed and replaced by Gerhard Wolfram from the Halle Theater – against the wishes of Naumann. Berlin became the nexus of a struggle between the old guard and the new following the VIII Parteitag in which the Intendant throughout his term of office was the 'Gegenstand der Machtkämpfe zwischen dogmatischen und liberalen Kräften in der SED' (Weigel 1999: 268). Wolfram had enjoyed a good relationship with the local SED leadership in his previous post, where he evolved a pragmatic contemporary drama that made his reputation. He was not able to transfer that to the Deutsches Theater, and was indeed advised against doing so by the Minister for Culture, Hans-Joachim Hoffmann.

There were other special features in Berlin. The personnel were better paid than elsewhere and, in career terms, Berlin was the place to be as you rose in the profession. Members of the Berlin ensembles did not have much motivation to move away from Berlin and most stayed, which had the effect of producing ensembles of ageing professionals (SAPMO-BArch, SED ZK IV B 2/9 06/68) whom no one could dismiss, with consequences for the roles that could be played, or even for the choice of plays for the theatre repertoires. The difficulty could be got round by employing guest actors and directors, though this could divert talent away from the provincial theatre.

There was also a sense in which Berlin was the pinnacle of provincialism when viewed from a West European perspective, the GDR being seen as a walled-in country of inward-looking people for whom East Berlin was the ultimate and only centre to which all else graduated. This perspective was rather one-sided since it disregards the exchange of theatre experience within the Soviet bloc and other

international contacts resulting from guest performances by GDR ensembles. But there is no doubt that the absence of opportunities for ambitious individuals to travel freely for professional development and better-paid employment in Western Europe was bemoaned in theatrical circles in East Berlin and felt to be detrimental:

> Whoever had arrived at the Berliner Ensemble or Deutsches Theater had reached and fulfilled their dreams at the same moment and it dealt a blow to their ceativity. He who cannot dream of change, of fleeing from the everyday to Vienna, Munich, Zurich or even Paris, or at least of earning more, then he is somehow, artistically-speaking, short of petrol in the tank. (Merschmeier 1991: 3)

This commentator goes on to attribute to this circumstance the great amount of intrigue and factionalism in the GDR theatre world, leading in turn to laxness, slowness and sentimentality (ibid.: 4).

Because their theatre productions did not have to contend with the sensibilities ever present in the main Berlin theatres – the Deutsches Theater, Berliner Ensemble and the Volksbühne, for example, were for this reason directly answerable to the Minister für Kultur – the towns in the provinces enjoyed some degree of latitude in the content of their programmes. The ensembles themselves were not however exempt from the universal obligation to put their planned programmes and the proposals for individual productions to, and to gain the approval of, officials of the municipal administrations as well as to those of the SED at local and district levels. These bodies had a voice in the appointment of Intendants. The municipal authorities were expected to take a significant interest in various aspects of the local cultural scene. This is shown in paragraph 34 of a codification of laws proposed in the Politbüro in 1985 regarding the duties of local bodies in the GDR:

> In mutual trust they develop co-operation with writers, artists and creators of culture, liaise with them in the formation of a cultural life in the region and encourage the young talent. They provide favourable conditions for the artists and plan and support the production of new socialist-realist works of art. (SAPMO-BArch, J4 2/2 – 2109)

Municipal authorities employed staff and also had charge of the theatre buildings and their maintenance. The discharge of this latter

responsibility was of continual concern and commentators, in the main, take the view that provincial theatres suffered from a poor infrastructure. The following extract from a speech at a theatre congress on 5 June 1980 is illustrative:

> There are nevertheless problems in the small and medium-sized theatres of our republic which we must accept require a great deal of attention. Also, the technical state of some of these theatres, especially the remote theatres, is worrying. At several post-election meetings of our district groups it was said that we lost audiences because the accompanying cultural facilities for visitors by way of services for the public provided by the state and social organs, namely the auditorium and the catering, fell below the minimum of what the audience expected. (Heinz 1980: 955)

This element in the cultural life of the GDR as a whole was recognised at the highest level, and referred to in a speech by Erich Honecker at the IX. Parteitag, cited by Heinz:

> Quite rightly, many people see a yardstick for the cultural level of society in the outward appearance of the public services from the state and the social organs, in catering, in trade, and in tourism. (ibid.)

Foreigners visiting the GDR also observed this state of affairs. The Germanist Anthony Meech, who travelled around the country viewing productions, noted that a 'reaction of a visiting theatre practitioner [...] would probably be amazement at the rudimentary level of, above all, the lighting provision in most East German theatres' (Meech 1988: 112).

Whilst Berlin was the main showcase to the world for the GDR theatre, practical experimental activity and the attention to the developmental aspects of theatre work took place, by and large, outside Berlin. In the late 70s and in the 80s two provincial theatres, the Staatsschauspiel Dresden and the Mecklenburgisches Staatstheater in Schwerin were pre-eminent. There, directors could over years and in relative calm test and refine their own conceptions of theatre (Schulze Reimpell 1992: 40).

Both theatres made guest appearances in cultural exchanges with West Germany, in Düsseldorf, Duisburg, Cologne und Hamburg. These were such outstanding performances of the finest critical drama

that the impression was given that overall in East Germany the aesthetic quality was markedly superior to West Germany (ibid.). There was no one blueprint for such excellence. Ensembles in East Germany took longer over preparation as a rule, which allowed more time for perfecting performances. This one factor could not account for the outstanding productions applauded by West Germans. It had more to do with the calibre of leadership, with individual initiative in favourable circumstances. The ensembles from Schwerin and Dresden, for instance, may have excelled with equal brilliance but the persons who led them and the nature of their local background were quite dissimilar. The former chief editor of *Theater der Zeit* describes the difference between the two theatres as being determined by the leading figures in the ensembles:

> In the 1980s, especially after Alexander Langhoff's departure, Schwerin was considered the most important theatre town of the GDR. Next to Dresden. Schroth in Schwerin, Gerhard Wolfram in Dresden. (Linzer 2001: 207)

The local population's attitude towards the arts, and the human geography, were also significant since Schwerin was a former capital of a small Duchy in a rural area with few inhabitants whilst Dresden was a large city with good communication links and enjoyed international esteem:

> It was very different in the poor and remote duchy of Schwerin where life went on largely in a more bourgeois manner. In Dresden you could do anything as long as it was art. (ibid.: 208)

In the 80s Schwerin was a literary and theatrical venue, especially for younger intellectuals. The FDJ's poetry seminar was a regular event. The 'Day of the Soviet Book' and the 'Children and Youth Book Colloquium' were instituted, as well as a biennial training workshop for promising young theatre professionals (Akademie der Gesellschaftswissenschaften 1989: Liste 1984–85). Notable in the repertoire of the Mecklenburgisches Staatstheater were the festivals directed by Christoph Schroth in the late 70s and early 80s, which helped to earn the theatre a reputation that went beyond its own region. Also, the Staatstheater often put on plays that explored the question of

individuality in the context of the supposed unity of the individual and society, though these were not directed polemically against the GDR. However, the theatre had not by then become so successful, as it later became, that it was beyond the reach of the SED District Council, who attempted to hinder their work, as illustrated by the following attempt to nullify the efforts of the ensemble at the last moment.

For that reason the distrust on the part of the district leadership could be extremely dangerous, especially the leadership in Schwerin, they were considered rather stupid and dogmatic. At one of the 'Discovery' plays they had wanted to ban a text by Paul Gratiek. Fritz Wunderlich, who as intendant was a member of the district management, was just able to prevent it. Schroth only knew about it after the premiere. (ibid.: 196)

On another occasion in 1979 the district council referred a text of *Faust* Part 1 and Part 2 to the Institut for Social Sciences in Berlin for ideological comment. There the text fell into the hands of an expert on Goethe who recognised its quality. It was not rejected as the council may have hoped, but officially approved (ibid.).

In Dresden the Sächsisches Staatsschauspiel had a freer hand. Historically there was a great tradition in the arts stretching back into the eighteenth century, when the Dukes of Saxony were also the Kings of Poland. The city had also for centuries enjoyed international renown, not least for the grandeur and elegance of its Baroque architecture, the reconstruction of which after wartime bombing was a priority. The completion of the renovation of the Semper Opera House in 1985 was of especial significance as was also the re-opening of the Staatsschauspielhaus in Dresden which coincided with Gerhard Wolfram's tenure as Intendant. He was resolved to make the standing of theatre in Dresden at least as high as that of the music and opera. In the Honecker era the Staatskapelle and the Philharmonie were of world repute, and guest appearances were made in Paris and Leningrad. The talents of young musicians were fostered, as was contemporary music, in specially staged events like a children's musical theatre and a festival for young artistic talent in 1987 (Akademie für Gesellschaftswissenschaften: Liste 1982 u.1987).

Emmerich observes that directors whose productions were curtailed or banned in Berlin found opportunities for innovative work in

the smallest of the towns of the GDR such as Anklam, Rudolstadt or Schwedt. Such involuntary decentralisation improved the quality of drama available to audiences in the provinces (Emmerich 1996: 350). Sometimes the innovative directors selected their own teams of professionals and introduced new works and new methods to small town theatres. Hans-Dieter Meves, who had been an adviser in the MfK and then active in both the Volksbühne and the Deutsches Theater, took up his first post as Intendant in Magdeburg, where he assembled young talent from the Ernst-Busch-Schule in Berlin. His productions included plays such as Müller's *Weiberkomödie*, Braun's *Kipper* (known as the play which described the GDR as boring), Büchner's *Dantons Tod* and *Das Schwitzbad* by Majakovsky. The latter, a satire on Soviet bureaucracy, had been banned after a few performances when it had been played in Berlin. His plan to tell of the reign of terror following the Russian Revolution through staging Müller's *Mauser* during a week of Soviet drama did not win the acceptance of the district council, of which he was a member and he resigned. His dramaturge at the time, Heiner Maaß, who was also the Parteisekretär, resigned too but opted to work on the conveyor belt at the heavy industry factory in Magdeburg and was later rehabilitated (Linzer 2001: 161–164).

It happened also that the theatres of towns outside Berlin originated new drama that was later taken up by theatre management in the metropolis. In Schwedt, the writer Gerhard Winterlich wrote *Horizont* and was ready to stage it in the amateur workers' theatre of the oil refinery, Erdölverarbeitungskombinat Schwedt, when Hans-Peter Minetti arranged for Benno Besson and others from the Deutsches Theater to produce it in Schwedt. The plot revolves round the holiday taken by workers when the wife of its manager proposes a play in which they all switch the roles that they had in normal life. The problems of the refinery are then aired in front of an audience of workers from the real refinery (Stuber 1998: 224). This apposition of the theatrical and the real was a huge success. When the piece was produced later by professionals at the Deutsches Theater, it was less successful because, in the process of making it into an aesthetically rewarding, and professional production in the new setting, the immediacy and local resonance of the amateur production was lost.

A function fulfilled in the provincial theatre far from the centre of power was the performing of foreign plays and musicals originating in the West to check whether they could be released generally in the GDR. The theatres in Leipzig and Rostock were so used:

> The most important stage in the district was the Volkstheater in Rostock, which under its intendant Hans-Anselm Perten fostered a cosmopolitan programme and brought in most of the first productions of works by authors from the West. (DDR Handbuch 1985: 1356)

Another instance was the initiative in Rudolstadt, a small town between Jena and Saalfeld, by the young director, Klaus Fiedler who took on a whole group of actors graduating from the training school in Rostock. It was usual for new actors to start in a little theatre, gain experience and move on after two or three year to another town or to try their luck in Berlin. The main acting schools were those in Berlin, Leipzig and Babelsberg, all of which ranked above the Rostock establishment. It was an idealistic venture whereby the ensemble lived and worked together and aimed to engender enthusiasm for critical drama in a deeply conservative community. The programme was a mixture of Shakespearan theatre, and popular or fashionable plays, alongside contemporary drama of a more critical kind, such as Gelman's *Protokoll einer Sitzung* about a worker being rewarded for what turned out to be sabotage. These contemporary plays tended to point up the difference between official propaganda and real life in the GDR. Hungarian and Polish plays of an avantgarde character were also performed. Despite support from the MfK the director had a hard time justifying the programme and the Intendant, who sheltered the group, came under criticism from higher authority. After two years the position could no longer be held and the programme was abandoned (ibid.: 171–175).

The 'Berliner Zentrale' was a useful term for the centre of power, a centre that was full of prejudice against any other part of the GDR. Honecker, personally, had no scruples about denuding the provinces of resources in order to bolster Berlin. Speaking of expensive building plans for Marzahn in 1975 in East Berlin, he stated:

Also, the statistical record must be aware that the capital of the GDR, and not Rostock, has to be named first in the statistics. The administration must make sure of this. There will be no discussion whatsoever of the transfer of building capacity from other districts to Berlin. That is decided and settled. Berlin remains Berlin! I would like to make this clear once and for all in the Politbüro. There will be no argument over Berlin! (Bouvier 2002: 192)

In Halle, the birthplace of Handel and now the capital of Sachsen-Anhalt, the Landestheater, a venue for theatre, opera and ballet, was an 'A' class theatre. It was a deprived area in the GDR, the region being notable for the production of lignite and for being one of the main centres of the chemical industry. Environmental damage through pollution was considerable. Halle had a population of around a quarter of a million and was the sixth largest town in the GDR. The theatre director during the 80s, Peter Sodann, remarked:

Halle is the dirtiest, most desolate, dilapidated and run down town in the republic. What Hitler's war did not destroy, the building industry has, in a second war, on its conscience. (Müller: 1990: 28)

The theatre enjoyed much success in the period 1966–1973, when Gerhard Wolfram was the Intendant. He and his team had been influenced by the campaign to bring workers and writers closer, along the lines initiated at a special conference in 1959 in the neighbouring town of Bitterfeld. They produced 'sozialistisches Volkstheater' tailored to the working class in evening entertainments known as 'Anregungen'. These consisted of songs, clowning and scenes in which the majority of the material derived from the chemical industry region itself and had been specifically written for these evenings (Stuber 1998: 218). Apart from this, new productions included first performances of Hermann Kant's *Die Aula* and Ulrich Plenzdorf's *Neue Leiden des jungen W*. A fallow period followed Wolfram's departure to Berlin, including the dismissal of the Intendant for being one of the protesters at the treatment of Wolf Biermann in 1976 (Schulze-Rempell 1992: 42), but its fortunes revived with the appointment of Peter Sodann in 1981. He had been imprisoned by the regime in the 1960s, but recalling his experiences in Halle in an interview with *Theater Heute* in 1990, he said that he personally had had no

problems with censorship. It was his supporters in the theatre who were persecuted and locked up. He and his troupe were not allowed to travel to the West, unlike colleagues in nearby Leipzig. The work of these colleagues, he claimed, was inferior and they were paid 2500 marks in contrast to the 1700 earned in Halle (Müller 1990: 28–29). This better pay was a temptation for the actors in Halle. However, the audience support in Halle was high, 100-mark donations were sometimes pressed into the Intendant's hand and some plays were booked out for years ahead. By 1989 the theatre was attracting 15,000 more visitors per year than the music section, who took most of the state subvention, but the extra earned did not benefit the theatre but was diverted to the administration:

> In theory we made a profit since our visitor target was set at 196,000 but 214,000 attended, which makes a surplus of 70,000 Marks of which according to the rules half must be returned to us. The reason why that is not the case is the central authority in Berlin: we are on the index! And without good connections to the ministry nothing can happen in the GDR: Christopher Schroth the theatre director in Schwerin was constantly in and out of Kurt Hager's office. (ibid.)

It was, according to Sodann, not only a question of animosity towards Halle, but also a general, vexing problem of communication and lack of mutual appreciation between Berlin and most of the country that was evident in the GDR and continued after the fall of the Wall in Berlin in 1989:

> Of course the wall to West Germany has now fallen, but there is still a second wall standing: that between Berlin and the republic. In Berlin's Academy of the Arts they know absolutely nothing about what is happening in the republic. Moreover, the central press in Berlin is only interested in Berlin, the rest does not count except, perhaps, with the exceptions of Dresden with its long tradition in the arts and Leipzig with its trade fairs. (ibid.)

Despite, or even on account of, the lack of interest in Berlin and because of regional pride, nowhere in the GDR was the theatre more popular than in Halle. Performances were always booked out for long periods. The audience in the 400-seat theatre constructed in a former Wilhelmine ballroom consisted mainly of people under the age of

thirty. The visitor statistics show that Halle held its own in comparison with all the other principal theatres of the GDR. In principle, the importance of theatre ensembles being well integrated into local and regional life had been recognised officially, at least from the late 1970s. For example, in 1977 a consultation document by the MfK and the theatre association declared that no theatre could exist without close ties to the region in which it operated, to the people of the region, to the state bodies and the social organisations. It argued that cultural and political and artistic effectiveness depended very much on how the theatre succeeded in being a partner in the development of the region, on how it adjusted to the region's intellectual and material values in doing its work. These values were important for the character and image of the theatre, which was dependent on the support, guidance and assistance of its social partners. The roots of theatrical work in each audience area, and the role of town theatres was specifically mentioned:

> It is an important task to establish the principle of co-operation in the work of all state organizations in charge of theatres and in whose areas the theatres operate, and for these bodies to break out of the limits of territorial planning [...] in each territory theatre is indispensable [...] Questions about the profile of individual ensembles were in recent years more expressly posed in the context of their special contribution towards the development of of the theatre and against the background of the particular locality. (Holàn 1978: 573)

Recognition of the inter-relationship of territory and theatrical work as ingredients of a unique contribution to the art of drama in the GDR was but one step on the way to co-operative work between state and theatre. A year later the theatre association wrote to the SED's cultural department, who were preparing a report to the Politbüro, recommending that attention be drawn to the need to clear up confusion about the position of contemporary drama in the presentation of societal conflicts, a confusion prevalent among local tiers of the SED. (It was policy to encourage new GDR drama as representative of the cultural progress that might be expected in a sovereign socialist country. In 1978 preparations were in hand to celebrate 30 years of the existence of the GDR, celebrations in which the GDR theatre would

participate.) Dr. Klaus Pfützner of the association described the situation thus:

> The main question [...] is the never ending clarification of criteria for socialist-realist contemporary drama. [...] Politically-aware theatre artists believe these plays to be their constructive contribution to the strengthening of our society. It is here that there are recurring differences of opinion among colleagues in the political leadership, especially in the regions, over the right and duty of the theatre to take a stand on important social problems and to point these out in a constructive and party manner, even where a solution is not at once apparent. (SAPMO-BArch, SED ZK DY 30/IV B2/9.06/70)

The difference in the viewpoints of local Party organisations, or even disagreements within them, meant that theatres were forever embattled in ideological arguments. Dr Pfützner believed this could be overcome where there was genuine commitment:

> This clarification process is enormously influenced in a productive manner where the party leaderships and the state organs and social partners actively recognize their social responsibility for the theatre, encourage its work, involve themselves with it continuously and openly, giving the theatre staff a sense of usefulness, and making palpably clear their worth in society. (ibid.)

The role of theatre in relation to its local partner bodies was further emphasised in relation to drama as a deserved cultural benefit provided via their communities to the most productive workers in the GDR. In praising small theatres such as Anklam, Senftenberg and Rudolstadt, it was asserted that:

> They fulfill their vital cultural and political mission, playing to men and women who produce a huge share of our national income – in brown coal production, in agriculture, in industry – in extraordinarily difficult circumstances. (Heinz 1980: 955)

Both the bodies commissioning the Holàn report, the MfK and the theatre association, were interested in harmony between the local theatre and the local SED party activists and the provincial authorities. Sometimes, this was lacking. There were fluctuations in these relationships over time. In the early 80s the controls at the local level became more meticulous. The possibility of performing contemporary

43

drama of a critical nature from the Soviet Union lessened. A panoply of tricks, arguments, interpretations and networking was required to convince these local monitors not to censor new texts and productions. Because local officials were relatively tolerant in Karl-Marx-Stadt, the town theatre became a focus for critical drama, especially Soviet contemporary drama. (Albiro 2001: 269). The play *Das Nest des Auerhahns* by the Soviet writer Victor Rosov was smuggled out of the USSR and secretly translated into German. The plot concerns a corrupt and corrupting bureaucrat and the devastating effect his behaviour has on his family, an explosive issue in the GDR. It was known that a performance would give rise to objections, especially from the 'Zentrale' in Berlin. The theatre association was holding a conference in Berlin on the theme of youth in the theatre; it was known that Rosov would be invited, that he wanted to speak out in support of a performance in Karl-Marx-Stadt. However, because protocol required that he be asked to speak by a member of the audience, the Intendant, Albiro Hartwig, arranged for a young female representative of Henschel Verlag who was giving a paper on Rosow's work with young people in the Moscow theatre to ask permission for him to comment. This was applauded by both the SED and the government officials, whereupon Rosov gave a speech, after which he mentioned his delight that the Karl-Marx-Stadt theatre would put on his play and congratulated the Berlin officials responsible for this decision which was such a real proof of German–Soviet friendship. Amid the ensuing applause, there were some troubled brows among the functionaries present, but the news in the announcement could not be denied without causing a huge fuss; the play was performed twelve months later and was a great triumph (ibid.).

Similar dexterity in seizing an opportunity was shown in the late 1980s in Dresden when the Intendant at the Sächsisches Schauspiel, Gerhard Wolfram, capitalised on the success arising from a much praised production of *Die Nibelungen*, which had also inspired a demand for performances in the FRG. Against the initial advice of the MfK the production toured in 1986 in the FRG to great acclaim. The subsequent congratulations by the Minister for Culture were turned to good account through a visit to Berlin by the Intendant, who secured the personal agreement of Kurt Hager to put *Waiting for Godot* on in

Dresden. The moment was opportune. The GDR had just reached cultural accords with the FRG, and was anxious to demonstrate a mature attitude in cultural matters and that it was by no means an intolerant state. For the theatrical professionals involved, assent to a performance was the ultimate proof that the GDR theatre had re-entered the formerly rejected world of modernism. The assent was not won without argument. The matter went as far as the Central Committee der SED, where Harry Tisch, the veteran FDGB leader, waving a copy of a highly critical appraisal of the play in 1956, demanded to know whether they were surrendering all their principles in order to let this decadent piece be performed (Bechert 1997: 316–317). The permission unleasheded no unbridled freedom:

> Aside from the auto-mechanism of self censorship, it was sufficient to dismiss the submitted drama conception on grounds of possible 'subversive dangerous moments', or on the other hand, it was never out of the question that a permission to perform could at any time be withdrawn. One had always to take the controls into account. (ibid.)

One vital link, which ensured that there was no local ban imposed on the play, was the relationship between the theatre management and the regional SED leader Hans Modrow He supported both the intendant, Gerhard Wolfram and, in a private capacity, the work of Wolfgang Engel who was not an SED member. Unusually, it was the official cultural adviser who generally took a hard line against the theatre in Dresden, but he could be and was overridden by Modrow. There existed here a combination of pro-active theatre professionals of high standing who went to enormous lengths to stage outstanding drama and a sympathetic political force at the provincial level, which together reinforced the special geo-political situation of Dresden within the GDR, and helped to maintain its international standing.

According to Wolfgang Engel, the director of *Waiting for Godot* in Dresden, a hindrance to modern international drama being played more often in the theatres of the GDR was the purchase of performing rights. Money for this was often insufficient from the allocation held by any one theatre, and especially where there was also an opera group or an orchestra to share the funding, as in the 'Spartentheater'. But one advantage was that once a purchase had been made, inter-

nationally known works required no 'Abnahme', i.e. no official jury before the premiere.

It would be a mistake to suppose that all theatres far from Berlin were full of liberal-minded SED members. In Leipzig the management led by Karl Kayser, a member of the Central Committee, was considered to be hard-line. A controversial Soviet play, whose title translated into German as *Diktatur des Wissens*, required the insistence of Mikhail Gorbachov in pursuance of 'perestroika' to overcome political and theatrical objections before it could be performed in Moscow. It generated much excitement and the public fought to obtain tickets. The main character challenged a communist apologist about acts of Stalinist terror in the Spanish Civil War. Senior members of the GDR leadership were honoured veterans of this conflict. Between the first performance in Moscow and the staging in Leipzig there was an interval of over eighteen months, when it was included in a programme to celebrate the seventieth anniversary of the 1917 October Revolution. Michael Patterson observed that 'despite these efforts to emasculate the piece, it touched a nerve in the East German public and raised questions that had for too long remained unasked' (Patterson 1995: 260).

Censorship

Works of drama in the GDR were published as well as being performed, so the screening procedures in regard to works of literature generally are relevant to a study of controls over the GDR theatre. A review appertaining to both published literature and drama is provided below and is elaborated in a specialised and detailed survey and analysis of the control procedures relating to circulation of drama texts within the profession and to the rehearsal and performance of plays.

Officially no system of censorship, as understood historically, was imposed on the arts. The arts were seen as participatory in the development of socialism, in which role they are supported by organs such as the Ministry for Culture. Given that works of art appropriate

to a socialist society were deemed to be created by citizens who were imbued with socialist values, the avoidance of creative expression that might be inappropriate to such a society was evidently unproblematic. Thus, theoretically at least, censorship was obviated through a combination of internalised self-restraint and social consciousness on the part of the individual, and a benevolent attitude on the part of the state. Jäger mentions the desire for such a symbiosis. In the GDR the censorship measures were camouflaged under the consensus to affirm all things socialist in a discussion amongst participants. Everyone liked to talk of the harmony between the inner and the external mission (Jäger 1993a: 26). No code of censorship, as such, was ever promulgated, and a definition of the term is absent from the GDR reference books *Kleines Politisches Wörterbuch* and *Kultur-Politisches Wörterbuch*. The nearest to a definition is to be found in *Wörterbuch der Literaturwisssenschaft:*

> In the conditions of socialist society by which the editing and distribution of newspapers and publications were fundamentally based on democratic centralism and regulated on the full responsibility of the producers [authors, publishers, editors etc], publications that endangered peace, international understanding, the dignity of man and social progress were excluded. (Träger 1986: 582)

In practice there existed numerous inhibiting factors, hurdles and controls which together constituted a sophisticated and formidable means of supervision of the arts in general, of literature and theatre, of the written and spoken word. Care was taken by the managers of the controls not to refer to these as censorship. Sometimes, those involved would go to enormous lengths to disassociate themselves from any actions that might be so construed.

As background to the categorisation below, the perception of SED leadership in the matter of censorship is relevant in that the SED seldom admitted that censorship existed. They believed that their entire policy of manipulation of the arts and practitioners of the arts was essential to the creation and maintenance of a socialist state. In this context, censorship, in the narrow sense in which it was conceived in the previous hundred years, was an outmoded blunt instrument. In nineteenth-century Prussia, for example, censorship was a police

function carried out under legal regulation by a known official whose activity was publicly noticeable through blanked out passages in the published texts. Editors of newspapers could be penalised if they published unauthorised material, but a court could be asked to undertake a judicial review. Karl Marx fell foul of the Prussian censor as he edited the *Rheinische Zeitung* from 1842 to 1849, when more and more restrictions were being placed on the freedom of the press. Censorship, Marx argued, was logically absurd in that it made mere officeholders, untrained in philosophy, literature or science, the supreme arbiters over their intellectual superiors, the writers and thinkers. He concluded succinctly: 'The real radical cure for censorship is its abolition, for it is a bad institution' (Padover 1979: 261).

The non-existence of such pedestrian policing was held up as a virtue of socialism in the Honecker era. In an interview after the collapse of the GDR, Honecker stated that as far as the press was concerned there had been no censorship:

> We had no censorship. Censorship means that the proofs have to be submitted and are then scrutinised. From this point of view, we had, in contrast to other socialist countries, no censorship. [...] We relied on the force of conscience. (Jäger 1993b: 18)

He also distanced himself from any form of literary censorship. If, he surmised, there had been anything of the sort, it would have emanated from the power exercised by the MfK:

> As far as the matter of book publishers is concerned, that they had to so act towards authority was probably due to the power of the Ministry of Culture who exercised that control. I did not care about that. I allowed Stefan Heym to be published without question. (ibid.19)

In the interview Honecker pinpointed two of the dominant factors in the art of writing in the GDR, i.e. the self-restraint practised by authors, and the bureaucratic supervision.

Some GDR writers have remarked on their own experiences of self-censorship, either before they wrote, as they wrote or after their work was finished. Two statements by Christa Wolf are illustrative:

The mechanism of self-censorship, from which censorship follows, is more dangerous than the latter. It internalises demands that can prevent the creation of literature, envelop many an author in an unfruitful and hopeless struggle with commandments that cancel each other out: that, for example, he should write in a realist manner and avoid conflicts: that he should write the truth, but not believe what he sees, because it may not be typical. An author who does not stay highly conscious of this process and maintain his own strict control will give up and weaken and begin to sweep away the objections. (Kaufmann 1974: 102)

> While I am writing I'm sometimes aware of some inner resistance that maybe you could call an inner censor. This inner resistance can refer to all kinds of things, not only conflicts with society, but maybe some sexual questions. I have noticed for myself that I cannot break down this resistance unless I'm completely ready to do so. (Wolf 1993: 373)

In the second interview, recorded in English, Wolf mentions that each of her books overcome more of the taboos that she herself experiences. In her opinion the role of literature is to widen the limits of taboo. She adds that she has never been in a country where there are no taboos at all. Christa Wolf knew other traditions and other countries, but by the 1980s a generation of writers, poets and dramatists who knew no home but the GDR was coming into prominence. Their mind set was unique to the new state:

> For the political socialisation of an entire generation had given rise to such a powerful feeling of belonging, that many people stood back in fear of the radical and the definitive 'No'. (Jäger 1993b: 24)

The imperative of being published influenced new authors in particular. So the temptation to reject thoughts and wording that might cause problems with those controlling publication was strong. Jäger cites the experience of Günter de Bruyn, whose first novel *Der Hohlweg,* constructed according to the cliches of the socialist realist novel of pesonal dvelopment, was awarded the respected Heinrich Mann prize. (Jäger 1993b: 28). In de Bruyn's case, the experience was regretted and strengthened his determination, shown in his later writing, to resist the self-censorship of prior accommodation to the expectations of the literary monitors (ibid.: 31). Others, mindful of such dangers, sought to preserve their original impulses. Erich Loest

circulated his drafts to friends and acquaintances, while Erwin Strittmatter stowed his manuscripts away and assumed posthumous publication (ibid.: 31–35).

Self-restraint extended also to the spoken word, to the presentation of the message of the text on stage. Gestures, significant pauses, intonation of voice and the stage management all contributed to the production of a play. The style of a director, who had to manage all these elements, was important. The successful directors were those who, whether from trait of personality, or deliberately, or both, were sensitive to the parameters of acceptability in the GDR. In this respect those who had from childhood known no other culture than GDR culture had some advantage. An example from the theatre is the difference between the difficulties in the GDR career of Wolfgang Langhoff, a well known director in the Germany of the 1930s and former inmate of a Nazi concentration camp, who was in 1946 recruited to run the Deutsches Theater, and who was already politically out of favour by the 1950s (Leinemann 1999: 116), and the successful, if not untroubled, GDR career of his son, Thomas. Leinemann describes Thomas Langhoff's attitude to censorship:

> His biographer Ingeborg Pietsch recalls, however, that censorship never bothered him. He did not need to exercise control over himself, whether he was going too far or not. He could rely upon his antennae. His sense of the 'right tone' is highly developed. Langhoff: 'It is an art of accommodation, an opportunism which is inherent in one, but which one does not consciously register'. (ibid.: 124)

Honecker was correct in saying that there was no censorship in terms of galley proofs being submitted for censorship. The laws that governed the censorship suffered by Marx and his contemporaries under Prussian rule applied at the point of publication. In the GDR, long before proofs of novels, plays or poems were printed, much action had already been taken in regard to manuscripts to ensure that the content was acceptable to the publishers and the MfK. Such action flowed from the implementation of a politically inspired policy towards the arts. The instrument at the centre of government was the Ministry of Culture.

The actions or inaction of the ministry could have intentional or unintentional effect on the rate of publication of authors' manuscripts, e.g. shortages of paper delaying publication or resulting in absurdly small editions. Sheer delay was very much a problem since, although topicality is not a measure of literary quality, relevance to contemporary society was a feature of much work whose impact was weakened by appearing many years after it was written. Now and again the reverse was true. That such delay became an accepted fact of life in the GDR did not make it less of a serious hindrance.

The MfK both sponsored and awarded prizes and scholarships to encourage talent in literature and drama. There is evidence that the ministry supported writers who did not publish or accepted limited circulation, or who did not complain at the slowness of the process. Arranging for favourable reviews of new work to be given created a taste for it among potential purchasers. Following appearance in print, availability could be manipulated through lists of recommended books and the selective stocking of public libraries (Czechowski 1995: 78–79).

For authors in general, that part of the MfK most relevant to their work was the department in charge of publishing under the direction of a deputy Minister for Culture. The Hauptverwaltung Verlage und Buchhandel (HV) had responsibilities over the whole field of publishing, i.e. to license publishers, provide guidance, to ensure purposeful distribution of work, to direct the thematic, yearly and long-term planning by the publishers, to co-ordinate and monitor the fulfilment of the plans; to approve manuscripts, to authorise print runs and permit publication; to control book publication and distribution (Sauerland 1990: 130). Whilst its activities resulted in censorship, it was much more than a censor. It was not exactly a secret organisation, but knowledge of the workings of its various sections remains limited, and as far as the relationship with GDR theatre is concerned, the relevant records remain fragmented and uncatalogued. (Bundesarchiv letter DDR-1-00/A-Baker dated 3.November 2000).

Regarding the supervision of the publication plans, the publishing sector was no different from any other sector in the GDR. It was part of the centralised economy (Westgate 2002: 65). However, it was at the annual planning stage that political and cultural policy,

censorship and economic considerations converged. The plans of each publisher were scrutinised by the HV and altered, if necessary, and the approved versions were collated to form a complete plan for the whole of the GDR. Using this, the scarce paper supplies were allocated, marketing and sales co-ordinated and revenue estimated. In this process particular titles could be identified for special support on political grounds (ibid.). Other titles considered less socially useful, would be published in smaller editions without publicity. Given that all titles would have successfully passed through all screening procedures, the control here was one related to pecking order and specific to titles. Planning publications so far in advance carried the risk that, by the time of the eventual publication and distribution, the political and cultural atmosphere had changed. For instance, the purge of intellectuals and a revision of acceptable norms in GDR writing following the exiling of Wolf Biermann in 1976 could not have been foreseen.

A more obvious lever of control lay in the permission to print in the gift of the HV without which no publication in the GDR was possible. As described below, before this question of permission could be considered by the HV each title had to be justified by a certification of fitness for publication from the head of the publishing house supported by an in-house assessment, compiled by the publisher's readers. The HV used advice from anonymous literary experts to assist in decision-making (Westgate 2002: 67). That advice was critical to the taking of decisions. The preferred method was a review providing a vivid description of the problems the text presented, expressing reservations but then showing a quite different way in which the text could be read. The appraisals likely to be successful were those in which the receptiveness of the audience and the attitude of readers were analysed and clarified, and which addressed the question of the insights that the author's presentation of his work would stimulate in the reader. The most welcome observations were those where the official in the HV knew that the commentator was also the person who would review the book on its publication. Many of the reviews in this period of the GDR cannot be taken at face value. It is essential to know what line of criticism was being officially encouraged. Experience taught officials to judge when, and from

whom to seek views, and from whom not to seek any (Mittenzwei 2002: 267–8).

Nor did the people involved in seeking and providing opinions always stay on the same side of the fence. In regard to the HV, Mittenzwei mentions that the literary intelligentsia also occupied official positions; they did not only suffer censorship, they exercised it on behalf of the state (ibid: 265). The work done by an author and a censor were certainly different but authors and censors were not normally in opposition to one another, they were interchangeable. Officials of the HV became editors, publishers, even writers. Publishers' readers switched to the HV. The constant change in these links meant that censors could count on a wide and informed system for gathering observations. The observations so obtained were the basis for giving or withholding permission. They came from many different sources, authors, academics, editors and ministry officials. Thus, we find that Heiner Müller wrote a comprehensive, rigorous but highly philosophical assessment of a controversial volume of poetry by Günter Kunert (ibid.).

A form of relationship united the censors and the censored, whatever the differences of attitude and opinion. This was exemplified at the opening of a literary café in 1991 in the building on the Dorotheenstrasse in Berlin which had previously housed the HV, when there arose a discussion on censorship among the intellectuals present, who included the former Minister Höpcke and two of his former assistants and a number of GDR writers, notably Christoph Hein and Klaus Schlesinger. Scherpe describes how they reminisced:

> They started to wallow a little in shared memories, friend and foe separated politically and emotionally but, nevertheless, intimate and bound together. Ministers and authors were on close terms, not at one with one another but dependent on one another. (Scherpe 2002: 310)

After an hour and a half one of the Western journalists declared that there was something obscene about the discussion and walked out. Scherpe shares the view that the intellectual opposition stabilised the Honecker regime even while it criticised it. In a system in which all, outwardly, had to agree, there was more than a touch of collegiality:

It was an intimacy in a curious way imbued with fear, hate and protest. Within the system it was always potentially possible that the roles of victim and perpetrator would be exchanged, would have to be exchanged, if one was appointed the Party Secretary of the other or, in principle, it was conceivable that one would have to report on, spy on or censor the other. (ibid.: 311)

The publishing houses were in the charge of SED appointees, whose duties included submitting programmes of intended publications to the MfK for confirmation, attesting the suitability of each manuscript submitted and managing the readers. These were the key staff who examined the manuscripts submitted by or on behalf of authors and recommended changes that would make these ideologically sound. The responsibility for considering such recommendations rested with the author. Alterations to the text were not made by readers, but were to be agreed by the author. The author knew that he had to negotiate a mutually acceptable version if his work were to be published. Manfred Jäger notes that this complicity was a special feature of the GDR:

> In earlier times censorship was carried out more absolutely over the heads of the authors but in the GDR the assent of those concerned was desired. Thus, to that extent, censorship as a rule respected the copyright of the author. That meant the the author himself always had to agree the excisions, the omissions and the alterations. He was involved in the process of permission, and so, became a partner in the mutilation of the text. (Jäger 1993a: 26)

Just as authors became complicit, so, too, when censors proposed alterations they became involved in the fate of the work and would bear part of the responsibility for that agreement. If the author refused assent the censor assumed no responsibility. The censor's attitude to a particular work was crucial since the censor had the option to make proposals that were either clearly unacceptable to the author or were negotiable. The need to co-operate to enable progress to be made towards approval of publication may account for the views held by those responsible for censorship matters that they had a positive function and were instrumental in helping authors to reach the public and also for the apparent ease with which authors and censors could exchange places, as mentioned previously.

A report in 1974 prepared for the ministry in reference to the work of readers and recognition of their place in society underscored

their importance, placed emphasis on their responsibility (the emphasising being a duty of the publishers) and the need for them to develop their own opinions (fashioned within the collective of the publishing house). Upon their expert judgement depended the reputation and position of the publishers, the cultural and scientific policies, and in the final analysis those of the Party and the state. The order in which the required expertise was listed put extensive knowledge of Marxist-Leninist teachings and SED decisions and of the development of socialist society well in front of expert knowledge of philosophy, aesthetics, literary theory and literary history (SAPMO-BArch, DR1 (MfK) 1699, 1–28, p.1).

It is sometimes postulated that the existence of censorship was in itself a spur to creativity, that writers were obliged to use all available methods, such as satire, irony, metaphor and rhetoric to get round the censor (Zipser 1995: 35); that, far from its being a betrayal of artistic integrity, literary works were improved through discussions with the readers (ibid.: 328). True though this may be, those implementing SED policy, like the readers, were able to pitch collective will against the individual opinion of the writer. They, indeed, were able to pose as benevolent advisers to writers, protecting them against the consequences likely to arise if their work were to be published without alteration, and simultaneously they represented the wider, weightier and wiser view of the SED in its leading role in the GDR (ibid.: 266). Then the political socialisation of an entire generation had produced such a powerful feeling of belonging that many shrank in fear from a radical and definite rejection (Jäger 1993b: 24).

After a reader and the author had agreed on a version of the work to be published this version was considered by an editorial committee. An editor-in-chief, an SED appointee, would be brought in if there were any unresolved disputes (Zipser 1990: 111–112). The publisher's commentary would be sent to the ministry. Like the onus placed on the author for self-censorship, the burden of evaluating the request for permission to publish was normally borne by the publishers themselves, before the novel or play manuscript was submitted to the MfK. Opinions from external experts might also be sought to assist the evaluation if there remained uncertainty after the particular section of

the MfK had carried out their own review and consultation (Westgate 2002: 66).

Manuscripts of new plays were dealt with by Henschel Schauspiel Verlag, which was less the publisher that this title implies, but more of a 'Bühnenvertrieb', an agency for publication and performing rights enjoying a monopoly over drama, defined as 'Sprechtheater'. To reflect this and to distinguish the concern from mainstream publishers, and from a similar Henschel agency for musical rights with which it had been combined, the title was changed in 1975 to henschel SCHAUSPIEL (Misterek 2002: 70). Working in co-operation with authors, the readers in this publishing agency produced supporting material for a theatre project in a report referred to as the 'Übernahmebegründungen'. Such in-house appraisals submitted to the ministry were accompanied by the observations of external assessors and the procedures were not in principle very different from those described in detail above in respect of book publishing, apart from the use of a standard form, the 'TAK-Bogen'.

If henschel SCHAUSPIEL secured the approval of the MfK, then copies of the approved version of a play would be circulated on loan to theatre managements to gauge interest and test the demand; publication of new work in *Theater der Zeit* before or after the premiere was normal. At the instance of the highest levels of the SED hierarchy, who now and then overrode all previous approvals, there were occasions when a play was ripped out from a printed journal before distribution, as happened with Rainer Kerndl's *Der Georgsberg*, or when a play appeared in the journal but was never publicly performed, as in the case of Rudi Strahl's *Das Blaue vom Himmel*. From 1974 *Theater der Zeit* was banned from publishing texts for which no premiere had been approved (Lennartz 1988: 13).

However, it was fundamentally always easier to obtain MfK permission for a theatre text to be issued rather than for a book to be published (Misterek 2002: 505). There were reasons for this. The quantity of paper used was far less than for a book, and only 200–300 copies would be needed, so the resource implications were relatively insignificant. (As a result, the quality of the paper, and its adequacy for use at readings and rehearsals was a matter of concern to theatre professionals.) A limited circulation also diminished the possibility of

reaching the wider public that read books; this fact made those approving the text feel safer and also afforded room for a little more flexibility in what might be allowed by way of content. Another reason was that the henschel SCHAUSPIEL was unique in being privately owned by the SED itself, who derived income, i.e. foreign currency, from the transactions in intellectual property rights when plays were performed abroad. The criteria of the Bühnenvertrieb for proposing, and of the ministry for permitting, a play was not solely the quality of the piece as a drama. In the late 70s and 80s it was the 'Valuta' earned that took precedence over cultural aims, and the agency income proved crucial to the achievement of plan objectives (ibid.: 65–66).

The situation of henschel SCHAUSPIEL was unsatisfactory from the viewpoint of the ministry since the SED ownership gave the agency a certain independence from the officials, whose attempts to end the monopoly of the SED were without success.

Authors and theatre managers were discontented at having no real alternative to henschel SCHAUSPIEL. Christoph Hein referred to this predicament in his speech at the tenth writers' congress in 1988:

> The dramatists can only pray that in this one theatre agency virtuous and reasonable people will go on working and will also be ready to work for them. The dramatists can only work and pray, they have no alternative, because, as is well known, there can be no argument with a monopoly. [...] Where there is already only one agency for stage works, then it is conceivable that one day there will be only one agency for prose, poetry, essays and children's books. This possibility should not only frighten us authors. Arno Schmidt tells us that in every village there should be at least two cuisines; when there is only one cook the food soon tastes horrid. I rather think that none of us is so fortunate not to have experienced this type of cuisine. (Hein 1988: 232–233)

Looking at henschel SCHAUSPIEL as a control mechanism, the production of copies of plays was limited by the capacity of this one agency (it did not possess an automated copier until 1986). That capacity dictated the choice of new drama that the theatres in the GDR could be informed about and present to their audiences. Again, because of the resultant limited choice offered, a high degree of variety in the repertoire was not achievable. It was not, according to

Anthony Meech, a British commentator who attended performances in the GDR, unusual for the same play to be performed in several towns simultaneously (Meech 1988: 111). henschel SCHAUSPIEL could operate to prevent further work of a playwright being published but it was an institution subject to both the severe and lenient phases of cultural policy, and its decisions on new drama had more to do with what was desirable at a specific point in time regarding the promotion of single texts.

When dramatists sought to publish abroad, they were allowed to do so only if it was arranged through a GDR publishing house. The GDR publishers had in turn to arrange for the copyright office, the Büro für Urheberrechte (BfU), to negotiate the contract with the foreign publishers. If they found no publisher, or no theatre to perform their work in the GDR, dramatists did on occasion publish and premiere abroad without permission. In 1979 the regime introduced financial penalties and possible imprisonment for such offences (Zipser 1991: 114). It was not difficult to make the accusation that in publishing abroad an author was being greedy, especially for highly valued Deutschmarks. The BfU itself accepted payments in Deutschmarks but paid authors in East German marks on a disadvantageous one for one basis. The legal penalties did not stop publication abroad, nor did they impinge on work in preparation.

In the theatre ensemble the responsibility for what was performed rested with the intendant, i.e. the general administrative and artistic director, who was in overall charge. Only with his agreement would the performance of a play be suspended. However, the intendant, unlike other staff, had no security of employment and could be instantly dismissed and replaced. Nearly all intendants were SED members or members of one of the other associated political parties. Since 1975 intendants had been made fully responsible for the ideological content of the theatre repertoire. This appeared to be a liberalising measure, which, for instance, enabled Plenzdorf's *Die neuen Leiden des jungen W.*, and Hein's *Die wahre Geschichte des Ah Q*, to reach the public stage, though the latter production was soon followed by the resignation of the intendant at the Deutsches Theater. The formal delegation to the intendant introduced a tension between the intendant and his dramaturge, whose job was to select and adapt

58

plays for production. The two colleagues, who were once at one in arguing the case for new drama, now argued from different perspectives (ibid.).

The procedures for introducing other genres of new plays to the stage and for their production were different from those for literature such as novels or poetry, where the single creator sought to interest the reading public in the GDR, who would, for the most part, read the work in private. Theatre was basically local and a public enjoyment specific to audiences, which were at any one time no more than the capacity of the auditorium. Theatre productions were collective enterprises undertaken by employees of the local public authority. There was, therefore, logic in the activities of the theatre, and other performing arts in the GDR, being subject to controls of an additional and different nature to general literature. Thus, the admission and timing of the introduction of a new play into the repertoire, the editing of the text during preparation for the stage, the choice of director and actors, the place and frequency of performance, the composition of the target audience, all become matters upon which officialdom or the SED might have an opinion which could not be ignored.

An example of especial relevance to the theatre is the censorship of what was seen as well as what was heard on the stage. Certain images were taboo, such as the Berlin Wall, the Politbüro, Inter-shops and Soviet troops. The production of Rudi Strahl's *Das Blaue vom Himmel* at the Volksbühne in Berlin was cancelled after the Defence Ministry objected to actors having to wear army uniform. Uniforms borrowed from the police for the performance of *Revisor oder Katze aus dem Sack* in Bautzen had to be handed back. Portrayal of the GDR and Soviet leaders was not allowed, though that of minor functionaries could be. In Hammel's comedy *Die Preussen kommen* a scene where the portraits of Marx and Engels fell off the wall caused concern and these were replaced by a lift conveying the figures upwards to heaven. In a performance of Georg Seidel's *Jochen Schanotta* the depiction of a country all wrapped round in wire so that it would not fall apart was changed to show a few traffic cones instead. The presentation of a picture of the ruined Garnisonkirche in Potsdam to the government inspector by the town councillors in *Revisor oder Katze aus dem Sack* had to be replaced by another less controversial one. It was in the

Garnisonkirche that Hitler and Hindenburg sealed their accord in 1933; the SED decided to blow up the church so the use of the picture on stage was seen as a protest against this action. The repertoire of the GDR theatre also contained classic plays where directors were tempted to hint at newly found relevance to the present-day GDR. Thomas Langhoff's production of Shakespeare's *A Midsummer Night's Dream* was able to show the character Wall in a new light

The SED took a public stance by which they called for more contemporary drama to be performed, but, in fact, obtaining permission to perform new East German drama was fraught with difficulty. Such inconsistency was the crux of a commentary by Knut Lennartz in *Deutschland Archiv* in regard to an article in *Theater der Zeit* by Klaus Höpcke, in which the minister had spoken out on behalf of contemporary drama: 'As it should be up-to-date, the repertoire of a theatre only earns recognition when, in full measure and in suitable strength, the present finds its expression' (Lennartz 1988: 12). Lennartz records strong support for this position but asserts that cultural authorities locally read new works as if they were instructions on how to bring down the socialist order, and the ministry all too often refused permission for performances, even for work by prominent dramatists, e.g. Heiner Müller's *Germania, Tod in Berlin*, and popular playwrights, e.g. Rudi Strahl's *Das Blaue vom Himmel*. The list of unperformed plays grew longer each year. Lothar Trolle who, at 44, had written plays for 20 years and had had only two or three one-acters performed in the GDR, joked that whoever was unpublished and unperformed enjoyed eternal youth (ibid.).

Published plays could indeed languish unperformed for many years, as for instance, did Hein's *Lassalle*, which took nearly ten years to receive consent for a performance, and whose premiere took place hardly noticed in a small theatre in Erfurt in 1987 (ibid.). There were many other cases of undue delay (Emmerich 1996: 349). Uncertainty about the outcome of the processes was dispiriting for the author, and also damaging to the works themselves when these depended on contemporary resonance for their impact. Because the phenomenon was so widespread, involving respected playwrights such as Hacks, Müller, Braun and Hein, and promising newcomers like Brasch and Schütz, the entire practice of delay in this sphere merits a place

as a strategy of control. The delays were described by one critic, euphemistically, as functioning as 'ripening process' (ibid.). Even one of those affected, Volker Braun, appeared reluctant, at least in a published interview, to criticise long delays in the appearance of his plays.

The theatre professionals resented the 1978 regulation that required the signature of the Minister for Culture to be obtained before new work was premiered, or new productions were staged. At the 1985 theatre congress, Hartwig Albiro, chairman of the drama section of the theatre association, complained not about the existence of the various controls, but that these were ineffective. The procedures were wasteful and irrelevant:

> A lot of time and effort is used up in reaching decisions whether or not to perform contemporary drama. That makes the work pedestrian and laborious. Anyway, one can only decide once a performance has an audience – it does not work through prior readings, through rehearsals, and only to a small degree with conceptual presentations. (*Theater der Zeit* 4/85)

Höpcke accepted that more might be done to publicise unperformed texts but he turned his fire on local attitudes, such as that of 'upturned noses' (ibid.): when a play was successful in one district, opinion in another would attribute its attraction to ideological ambiguity. The MfK's record in facing down despotic behaviour locally was, according to Lennartz, less than good. He cites the case of Ulrich Plenzdorf, who left the SED after the Biermann affair, and who was never again able to have a play performed in his home town of Potsdam, even though his work was successful throughout the rest of the GDR (Lennartz 1988: 14).

Certainly, Höpcke was a key figure and known informally as 'book minister' who often worked direct to Kurt Hager, the ideological expert of the Politbüro: he also had charge of culture. Some intendants such as Gerhard Wolfram and Albert Hetterle, and individual writers like Volker Braun, cultivated their personal relationship with the most senior figures, e.g. Kurt Hager and Hans Joachim Hoffmann, and used their credit to obtain favours as opportunities presented themselves. For instance, Hetterle, intendant at the Maxim Gorki Theater, who had for five years not dared to stage

Gelman's *Wir die Endesunterzeichnenden* seized the chance to ask for permission to perform the play on the occasion of being called to the ministers's office to discuss with him and Gelman the hospitality programme for Gelman's visit to the DDR. The permission was subject to the condition that Hetterle or his representative supervised every performance. The rehearsals were, as was usual, observed by cultural officials and culminated in the 'Abnahme', the final rehearsal at which a jury of cultural officials and SED representatives decided whether the play was fit to be performed for the GDR public. Hetterle advised his actors not to shout too much and not to be too direct, and to make everything appear harmless. They would give a more ebullient performance after the first night. (Irmer 2003: 29-30). It was at the level of the Secretariat of the Central Committee of the SED, and above, where decisions on the most politically sensitive cases were taken. Typical was the steering of Volker Braun's *Die Nibelungen* away from the Berliner Ensemble to a theatre in Weimar (Lennartz 1988: 14).

Other direct influences on creative work by the GDR leaders, political parties, mass organisations, professional bodies, security organs and the media, or a particular classification of that work under their auspices, could affect an individual's reputation to the extent of hindering all further output. The position might be recoverable but the effect on the writer or director might be long-term and remain harmful to professional standing.

Individuals who had taken the political decision to join the SED enjoyed special status in society and in any theatre in which they were active. They were, conversely, subject to SED rules and could be called to account for their actions, reprimanded or expelled. Being disciplined by the Party was bad for one's livelihood or career and might entail working in future in areas that were less political, and with a lower public profile, or even accepting redirection into other employment. An innovation of the Honecker era arising from the 1977 VIII Parteitag, was the extension of the basic unit of the SED organisation into teaching, training and cultural bodies (DDR Handbuch 1979: 496–497). Most theatres formed such a unit, a Grundorganisation, comprising those staff who were SED members and who kept an eye on ideological standards in the ensemble. It had this

internal function but could also be called upon by the local SED Party Secretary to assist him where there was evidence of public or Party disquiet over political content in the programme. A Grundorganisation might find it difficult to work with certain playwrights or directors and thereby blight their careers. The leading activists in this body could be very influential (Hörnigk 1991: 28).

The proportion of SED members to the total workforce in an ensemble was usually quite small. For example, SED membership records from 1976 to 1979 for the theatres of the Karl-Marx-Stadt district, taken from an internal Party report, reveal an average of less than 10%:

	Staff	SED 1976	SED 1979	Percentage
Karl-Marx-Stadt	615	52	45	7.3
Zwickau	304	25	32	10.5
Planen	239	27	28	11.7
Frieburg	163	7	13	8.0
Annaberg	111	21	16	14.4
District average				9.4

Last intake of candidates, KMS 1971, Z 1978, P 1977, F 1978, A 1975
(SED ZK DY 30/IV B 219.06/67)

The leadership of the Grundorganisation would contain people in senior positions in the ensemble, but not necessarily all of them. The report above goes on to criticise such non-members as being neglectful of their responsibilities to inculcate a broader world view on the part of the ensembles. Apparently, they tended to seek artistic rather than political satisfaction:

> The majority had become accustomed to the status of non-member artists because that was how they found recognition and kept themselves largely free of the detail of political tasks. Similarly, this was true of a whole line of talented, and therefore successful, actors, singers, musicians and dancers. (ibid.)

The deduction might be made that there were two groups in each theatre, those who put SED allegiance high in their priorities, and those who put career or artistic development before involvement in

political matters. While broadly accurate, this view is somewhat simplistic in that even the most single-minded professional had to have regard to what was politically acceptable. This might be a relatively comfortable, even imperceptible, accommodation for persons born and educated in the GDR who would have been entirely moulded by their upbringing in the socialist state. Others, older, who had had wider experience or had been motivated or shaped by other forces, could find the adaptation to political doctrine harder. In order to pursue theatrical ends, the intendants, for instance, moved in political circles to persuade SED leaders of their proposals for future programmes. Conversely, intendants who were SED members, or members of other political parties, were regarded as part of the power structure, and had the clout that came with that position, and could count on a degree of political support. They sometimes served on the very bodies that scrutinised theatre plans, such as the SED District Council. Intendants who were not Party members were clearly more vulnerable to criticism founded on political attitude.

One test of who actually exercises the control function in or over any group is to ascertain who takes command in an emergency. In the context of a GDR theatre, the cultural department of the municipal authority, representatives of the SED, the Ministry for Culture, and the central organisation of the theatrical profession were all candidates for the post of troubleshooter. A practical illustration is afforded in the case of the Theater Zeitz in Halle district, about which complaints reached the cultural section of the SED in 1974, in a letter purporting to have been composed by theatre staff. The letter reported a disastrous state of affairs concerning a lack of democracy in the ensemble, incompetence and irregularities. Accused were the local cultural official, described as incapable of the necessary leadership and control as well as being totally unqualified, and the intendant, who was alleged to be behind the times culturally, to behave with arrogance, and was said, among a long list of complaints about his conduct, to have embezzled funds, been guilty of nepotism, and to have insulted and assaulted the staff (SAPMO-BArch, SED ZK DY30/B2/9.06/68). The regional SED was charged to lead an investigation involving all other relevant local bodies. This they duly carried out and their findings were that the SED Grundorganisation

was too weak, there was too little ideological debate and a lack of influence on politico-cultural and artistic matters, there was too high a proportion of older members and not enough with the right expertise. The work of the intendant on the musical side and his work as director and actor adversely affected his role as leader. Shortcomings in his professional training undermined his position. He needed to improve his management skills and to correlate the theatre's activity to local needs in liaison with the large factories in the area. The management style of the municipal cultural department also needed to change. Comprehensive guidance had now been given (ibid.). On the one hand, no part of the report refers to the alleged misbehaviour of the intendant in regard to the staff, on the other hand, the signatures to the letter of petition were never linked to members of the ensemble. The emphasis in the report on political control, i.e. SED leadership, is unmistakable.

Ultimate sanctions were available to the GDR leadership. These effectively prevented further work being published or performed in the GDR and included campaigns of calumny, denunciation, or being classed as 'likely to flee the republic'. These measures were coupled with punishments of loss of career prospects or a ban on carrying on one's trade or profession.

The regime wanted to be rid of dissidents on the assumption that the GDR would be easier to govern if the dissidents were out of the way. Expatriation, as in the unique case of Wolf Biermann, was in line with this policy. From 1978, with greater sophistication, the regime developed a system of issuing visas for three to ten years for individuals to go abroad but to retain citizenship of the GDR (Zipser 1990: 114).

Theatre ensembles made guest appearances in other countries in cultural exchange, a privilege that could be withdrawn for the whole group or for individuals. Lack of freedom to travel was a perennial topic of complaint in the population as a whole, so the theatre groups were in a comparatively enviable position.

There was also the question of wilful machinations by the GDR leadership, when behind the scenes Honecker or other members of the Politbüro acted to discredit those who had fallen from favour. Intrigue against opponents was rife among leading figures of the SED. For

65

the working professional in the theatre, compliance with the rules governing forms of expression did not endow inalienable rights to publish or perform which could protect them from the whim of those in powerful positions. As mentioned in the chapter on 'Kulturpolitik', over time the rules were relaxed or reinforced as the leadership changed tack. Normal expectations might be overturned, vigilance heightened or relaxed.

GDR theatre staff had their own central professional organisation, the theatre association, Der Verband der Theaterschaffenden (VT), which was a forum for debating the ideological and aesthetic development of socialist theatre and an association to promote the interests of members, e.g. in matters of remuneration and conditions of employment. A third function was to systematically foster new talent, especially young talent (Hasche 1994: 193). In the wake of controversy in 1965 over Peter Hack's play *Die Sorgen und die Macht* the organisation had been founded as an umbrella body for actors and singers, cabarettists, puppeteers, theatre experts and theatre critics. According to Linzer, its main purpose was control of the profession:

> The main idea was to create a theatre police whose task would be to control and tame theatre professionals politically and to prevent in the future the occurrence of surprises in the form of performances such as *Die Sorgen und Die Macht*. (Linzer 2001: 138)

This proved in part to be the case, but the existence of the VT nevertheless provided other, new, opportunities. The VT had offices, money and some of the staff strove to have open, critical discussions and to help to bring to notice authors, such as Heiner Müller and Lothar Trolle, whose work was difficult to stage, e.g. by readings at the 'Leipziger-Werkstatt-Tage' (ibid.: 139). Informal seminars in Potsdam were arranged for theatre managers to learn about the latest research findings, and efforts were made to introduce schoolchildren to the play *Was heisst'n hier Liebe*, though the Minister of Education, Margot Honecker, vetoed this as pornography (ibid.).

Some dramatists were also members of the writers' organisation, the Schriftstellerverband. This and the VT were managed by Party stalwarts. They kept firmly to the SED line, at least, until the latter

years of the 1980s. A record of work or behaviour that did not fit the SED mould could result in members being subject to persuasion to conform or to disciplinary proceedings, or to expulsion. Freedom to write or perform was not necessarily formally withdrawn, but, in effect, publication or performance in the GDR and in the whole of communist-dominated Eastern Europe and the USSR became well nigh impossible:

> Then aside from favourable tax treatment, support and insurance contributions or preferential treatment over travel applications – especially to the East – independent work was only allowed via a state-sponsored association (Huberth 2003: 82)

A leading figure in the VT was the well-known actor Hans-Peter Minetti, who became its vice-president in 1980 and president in 1984, continuing until 1989. The theatrical profession, he recalls, was disappointed that the VT had not been set up in the form they wished; it was an advisory body linked to the Ministry of Culture and lacked executive authority. Minetti claims that he was the author of proposals for reform in the profession and that despite opposition from the Minister and the head of the cultural section of the secretariat of the Central Committee, he won the approval of Kurt Hager and the Politbüro for more scope for experimental work, more freedom for independent groups, agreement to the abolition of the hierarchical classification of theatres into A, B and C and to a policy of more openness and honesty between the ministry and the VT. Also achieved was a general increase in levels of remuneration. Regarding the slow bureaucratic procedures for approval of performances, the ministry was now put under an obligation to decide applications within three months. This target was not always met and, in fact, sometimes the processing took two or three times as long, but it was a considerable improvement (Minetti 1997: 290–293).

The VT leadership acted as an intermediary between the GDR cultural arbiters and individual members. For, example, when the 1982 premiere of Heiner Müller's *Macbeth* was severely criticised at a FDJ conference in Leipzig, Minetti was sent by Kurt Hager to assure Müller that this was not the official view and that provided Müller was careful in his public comment all would be well. Müller asked for

certain favours to enable members of his family to travel, which Minetti promised to deliver (ibid.: 282–286). Another illustration of the mentoring function adopted by senior members of the association and of the way in which the complexity of the relationships between an author and a theatre performing his play, and between the theatre and the political leadership, was handled, is found in remarks about the author Volker Braun in a letter of 24 January 1979 from Manfred Wekwerth to Kurt Hager:

> Volker Braun attends the rehearsal and is working very well, since he – which is rare among present day writers – is ready to learn by it. Of course, there is now and then some argument with him, for our authors have not become easier to deal with. There, Volker Braun is an exception, in that you can in every instance reach agreement on the fundamental political position. I have made an agreement with him that we discuss publishing and interviews with one another. He is actually holding to this. Unhappily, there is some backsliding which is traceable, on the one hand, to his naivety, the constant pressure upon us from not very sensible people, but also in a small way to, on his part, misunderstood popularity. So I had a chat with him to clear the air about his publishing in France, a matter he had not discussed with me. I hope he realized that, in terms of our friendship, this had been a mistake. At any rate, that is how he sees it. (SAPMO BArch, DY30 IV B2/2 024 86)

Evaluation of the VT after the collapse of the GDR showed there were mixed views about how competent it had been. In 1989 Minetti had not been seen as a man under whom the profession could unite. It was considered, in retrospect, that the VT had not sufficiently challenged SED orthodoxy and had been used against members as an instrument of SED power, its efforts amounting to an amelioration of official decisions affecting individual members in tentative fashion and through informal channels (Hasche 1994: 194–195). This ties in with a similar, earlier, judgement by Ernest Schumacher at the special conference of the VT in 1990, though he had then gone further and demanded that an apology be made to the members who had been victimised (Schumacher 1990: 30–31). As mentioned in chapter four, Peter Sodann believed that the organising committee members who represented theatres in Berlin, Dresden and Leipzig had used the VT as the means to feather their own nests.

In one sense the theatre was a workplace like any other. The managers were not only managers, but also formed the leadership of the union in the local factory and operated according to rules intended to ensure that the various objectives of artistic, cultural, political and economic achievement were met; that ideological and career development went hand in hand; that communal activity and individual initiatives were fostered, and staff working and living conditions were improved; and that relevant specialist and Party literature and materials, together with SED and government decisions, were properly heeded in the work of the theatre (Hasche 1994: 201). These local union leaders came under the authority of the Gewerkschaft Kunst, a member union of the FDGB. As far as it involved a representative function for theatre workers and assisted theatre studies and events, the work of the Gewerkschaft Kunst overlapped that of the VT. The relationship between the two bodies was regulated by their respective committees. The Gewerkschaft Kunst concentrated on new drama and musicals, on ensemble development and training, and on practical liaison under the auspices of the FDGB (ibid.: 206).

The FDGB was one mass organisation that had a direct and continuing influence on the GDR theatre. Its policies carried forward locally among the constituent unions were designed to make theatre-going a regular habit for all. To that end they supported the theatres in practical ways. They organised residential studies, ran excursions and were active in the support services, such as ensuring that catering was on hand. Reciprocally, benefits, such as preferential bookings and daytime performances for shift workers, were expected from this patronage:

> The unions demand a flexible subscription entitlement and appropriate ticket sales, corresponding to the current working and living conditions, and which assure the working collective, particularly the young brigade, of being able to take advantage of the best the theatre has to offer, and the shift workers of the possibility of regular visits to the theatre. (Lübbe 1984: 675).

Theatres in the GDR enjoyed high attendances not only because they were the only places where serious problems had an airing, not simply because of the generally high artistic standard, but also because of socially organised theatre visits by industrial organisations (Emmerich

1996: 507). This theatrical interest was present also in factories, workplaces and youth clubs where there were numerous amateur theatre and cabaret groups. The newspapers of the mass organisations carried reviews by their own theatre critics.

Conferences of these bodies were used as platforms by ministers or SED leaders to promote the socialist vision of the arts in society. Their speeches sometimes contained open or veiled references to the type of work that was not desired. Occasionally, attacks were made on particular playwrights or productions, as for instance, the FDJ reaction to the 1982 premiere of Müller's *Macbeth*. Iconoclastic criticism directed at well-known writers was one way in which rising stars in the political hierarchy brought themselves to notice and proved their own ideological soundness.

Attracting the attention of the secret police, the Stasi, could put enormous pressure on persons in the creative sphere. Theatres always had someone who was spying on behalf of the Stasi, perhaps working as an informer, an Inoffizieller Mitarbeiter (IM) under the distant supervision of a Stasi officer. To be effective an IM had to be at an influential, if not the most senior, level, occasionally it was the intendant himself, more usually a colleague with important responsibilities. Among the rest of the staff that person might be well known or suspected as an informer. Reports and material in use by directors and dramaturges would be leaked to the Stasi. Their unit monitoring literature and the arts was well staffed, and in the Honecker years, the organisation was given more support for covert operations by the GDR leadership. The Stasi had at their disposal many ways of destabilising relationships and destroying careers. In the main the surveillance did not result in inability of dramatists to function, but it did inhibit full creative expression.

Reviews of performances by drama critics, particularly by those working in the mass media, touched upon the reputation of the theatre professionals, influenced whether further performances would take place, determined sometimes whether a play or a production should be modified, had a bearing on whether the public were encouraged to attend, and to some extent, conditioned them as to what they might expect, by helping to shape the perception of what they saw and heard on the stage. These published reviews also formed a written record of

70

the reception of the performance, and in many cases might be the only lasting trace of the event. Their tenor indicated the current thinking of the regime in cultural terms.

It is in this latter manifestation that the critics' views can be seen as a control or censoring method in drama. The observations were not made, in the main, on aesthetic grounds alone and were the outcome of guidance by superiors and of direction in centralised policy about the angle from which criticism should and should not come and at whom it should be aimed. Editors of newspapers were regularly briefed by the Propaganda and Agitation section of the central SED.

Rainer Kerndl was for more than 20 years the chief drama critic of *Neues Deutschland*. Recalling his experience in this post, he mentions that controversial views did exist among the newspaper staff, and that he himself had been able to express such views. He had all the same, to act with circumspection in the knowledge that his drama criticism carried weight precisely because it appeared in this newspaper:

> The theatrical reviews, simply because they appeared in ND, were accepted by all sorts of people as the supreme judgement of the prevailing cultural policy: as if they were written by some anonymous department of the highest authority. That they were not, nor did I wish them to be so. (Kerndl 1993: 14)

He states, on the one hand, that: 'In order not to create trouble, I held back on many things I actually wished to say (thus arose a form of censorship that one imposed on oneself)' (ibid.). On the other, he remembers that censorship directives from the editorial office were given, though he, he says, never succumbed to pressure to alter his articles:

> Of course, it happened that some of my articles did not appear in the newspaper I did not comply with the alterations desired by the editor, which were required by 'higher interests', in this case I preferred that someone else wrote the review. That was not wanted either and so we reached the situation where for one or the other premieres nothing appeared at all. The special GDR understanding was that all those interested then knew: Kerndl has a different view from 'those above' and they have not allowed it […]. (ibid.)

Theatre critics like Kerndl did not limit themselves to being commentators on individual performances. They engaged in the debate about the merits of contemporary drama and criticised those in the profession who appeared to be working against the interests of the regime. For example, Kerndl wrote an article in *Theater der Zeit* complaining, among other matters, about an informal categorisation of playwrights into hypocrites who wrote 'Parteiliteratur' and others who wrote actual and truthful drama. He defended the former, authors motivated by a readiness to identify with the Party and with society in their literary work for the theatre (*Theater der Zeit*, 1978, Heft 5, 52–54). He criticised the Potsdam director Uta Birnbaum for giving an interview to *Theater Heute* in Basel and for speaking of this unflattering dichotomy. The GDR authorities were especially sensitive to unfavourable comment in the western press. When Kerndl later lost his job, he assigned the blame to such reporting abroad in connection with his play *Der Georgsberg*.

Within the GDR certain types of comment on the work of dramatists were especially damaging: being labelled as 'friendly to the class enemy' because a favourable impression of the West was given, or a dismal one of the GDR; or being ideologically out of line, or showing dissatisfaction with the progress towards socialism, thus engendering the serious charge of 'counter-revolutionary' attitude or behaviour. When work was so labelled there would usually be a substantial period before trust was restored in the work of the persons concerned.

Journalists who were also art critics had an unenviable position. They were answerable not to the Ministry for Culture but through their editors to the Department of Agitation and Propaganda. Their self-censorship was reinforced by their choice of employment. The views they aired publicly were not supposed to reveal any direct censorship they were under. They were expected to criticise along Party lines and thereby to inflict fear of imminent or future censorship on the work of those who provided the substance from which they created their own reviews.

Der Georgsberg had been written by the chief drama critic of *Neues Deutschland*, Rainer Kerndl, who was reasonably well known as a writer of plays, some of which had had successful runs, and it

might be assumed that his latest play would have had sympathetic reviews. In the event, the reaction to the play as serious drama was, to say the least, muted. The topics were mentioned but, with one exception, no comment was made on how these were developed on stage. The lack of a review in *Neues Deutschland* was considered to guarantee larger audiences since the piece would be presumed to be controversial. In the Western press there was much more forthright discussion of the themes, ostensibly causing Kerndl's dismissal. In regard to *Godot* there was an outpouring of press reviews that were thoughtful but essentially self-congratulatory. Performance having been approved by the Politbüro, the press critics praised the production and the director's novel interpretation of Beckett's work. *Die Übergangsgesellschaft*, also complex, was seen to show many of the faults in contemporary society but also how new impulses might be released within people to enable them to develop and change society.

Emmerich explains the special relevance of censorship to the theatre on the grounds that the theatre deals with radicality, boldness, spectacle, and with controversy in the context of the collective receptivity of an audience. It was understandable that the GDR public showed interest in it, and that it attracted more censorship and control than any other literary form. This was especially true for the 1970s and 1980s when performances were delayed or banned, and playwrights and directors harassed and disciplined (Emmerich 1996: 347–348). Because other media did not adequately inform or offer debate, the theatre became a substitute forum, though one where the struggle for expression was hard fought. The expectations to satisfy the censors – whether in the formal procedures or via the non-formal mechanisms – to develop their own sense of theatre, and to cultivate their audiences, all bore heavily on the theatre professionals. The numerous agencies involved made censorship measures cumbersome; objections and caution would usually prevail over risk-taking. Although there could be differences of opinion within the organisations and in their hierarchies that the dramatists exploited, it required exceptional perseverance, and active patronage from individual officials and politicians, to steer through to the stage and to the GDR public any dramatic work that was remotely controversial.

Surveillance

Interlaced with all such activity was a gradual and deepening involvement in the realm of culture by the security services. The secret police organisation in the GDR was the Ministerium für Staatssicherheit (MfS), commonly known as the Stasi. By the time Honecker came to power in 1971 it had been in operation for 22 years. From then on its methods underwent a process of refinement, coupled with an emphasis on measures to forestall or hinder expressions of dissent. The size of the Stasi in relation to the population was unprecedented: never in the recent past had so great a number of secret police been deployed to keep citizens under observation. Estimates of the actual number vary in the statistics concerning the Stasi. An assessment by Anthony Glees puts the figure at more than 90,000 official personnel in 1989. This is said to represent a ratio of one Stasi officer to every 70 persons in the GDR, and compares to a 1938 figure of one Gestapo officer to 4,800 inhabitants in the Third Reich, and to one KGB officer to 595 Soviet citizens in the 1980s (Glees 2003: 2–3).

The organisational structure of the Stasi corresponded approximately to the political and administrative structure of the GDR and the aim was not to leave any group of the population out of the surveillance network. To this end the Stasi established 14 administrative districts and 217 local units. Taking into account units under the direct control by the MfS as well as all the regional and local units, there were by 1989 around 680 units with specific objectives. Much of the expansion took place under Honecker: from 1971 to 1982 personnel increased by 50 per cent (Schwan 1997: 144) and over the longer term of 1972 to 1989 the Stasi doubled in size (Glees 2003: 3).

The degree of surveillance is even more remarkable when account is taken of the multitude of helpers the Stasi recruited to assist them as Inoffizielle Mitarbeiter (IM). The American journalist and writer John Koehler, who in 1991 arranged an interview with Joachim Gauck, the official then in charge of the Stasi archives, calculates that, taking all the types of informers into account, it would not have been unreasonable to assume that at least one Stasi informer was present in any dinner party of ten or twelve (Koehler 1999: 8–9).

Glees estimated their number in 1989 at between 150,000 and 170,000 (Glees 2003: 2–3). In its role as an early warning system for the regime in regard to changes of public attitude that might de-stabilise the GDR, the Stasi monitored the use of telephone and postal services and accessed the databases of the state authorities, banks and hospitals. It also initiated, maintained and extended a network of informers categorised according to their usefulness, and according to their status and role in GDR society. However, measures that went beyond observation and the collection of information were usually backed up by at least verbal instruction from the SED leadership. Also, the prescribed area of official competence, as explained by the deputy head of *Abteilung 7* below, constituted a limitation on the power of the Stasi, as indeed did the labyrinthine complexity of bureaucratic structures in the GDR. Westgate underlines this:

> However, as it was not the task of the MfS to be an incognito ersatz government, its influence on decisions made in other Ministries, including the MfK and its sub-department the HV Verlage, was by no means absolute and its involvement depended on a number of variables. In the literary field, the apparatus of control was extensive and multi-layered, and the MfS was not the all-dominant player. (Westgate 2002: 69)

Like most population databases, the Stasi's own records required to be maintained with updated information, and were additionally extended in the light of new directions in SED policy, fresh objectives for MfS operations or changes in the perception of the security risks. The Stasi therefore needed a continual inward flow of information. There was no prospect that evidence of thoughts or actions harmful or potentially harmful to the GDR state would be volunteered by the persons under suspicion, which meant that the information-gathering was organised through the use of people close to the suspects, those who could be persuaded to report on their workmates or colleagues, neighbours or family members. Socially, these informers had to be protected from exposure to the subjects of their attention; their surveillance of others was conducted secretly.

It was essential that informers had motivation. The Stasi preferred those with political conviction who accepted the need for a

secret police and 'its operational logic of denunciation'. Others acted out of desire for material gain, career advancement, and the conferment of privileges and honours not available to ordinary citizens. For example, IM enjoyed access to the services of the Stasi's own bank and through their controlling Stasi officer could obtain credit up to 10,000 Marks. They were also eligible for extras such as loyalty bonuses after 5 years service (Schell 1991: 94). The IM were not in general on the regular payroll: in 1989 there were only 3,300 salaried 'hauptamtliche IM' (Schwan 1997: 157).

Some recruits were attracted by a sense of adventure, or by an idealistic and often short-lived notion of combating the threat of fascist imperialism. Many were coerced into co-operation through threats and blackmail. Before a potential informant was contacted a secret investigation of all aspects of the life of the individual, from political reliability through to health and personal relationships, would be undertaken in the course of an assessment termed the 'IM-Vorlauf'. Those supplying the information were not made aware of the use to which it would be put and were unaware, too, of who else had been requested to provide facts. If all was satisfactory, the next stage was a personal approach, the 'Kontaktgespräch', leading to recruitment, and usually to the allocation of a 'Deckname' and the signing of a pledge of duty and confidentiality known as the 'Verpflichtung' (Westgate 2002: 71).

> The supervision of IM was an important function of the Stasi controllers. They were required to draw up a structured and realisable programme of activity for the individual IM, the 'Auftrag', a contract to obtain certain information and evidence secretly, as well as for participation in measures to forestall harm to the GDR. This could be communicated verbally or in writing (Sukcut 1996: 179-180).

Once someone became an IM there was no easy way to stop apart from obvious disqualifications such as ill health, or being found to be untrustworthy (Suckut 1996: 181–182), since if you wanted to stop this it was in itself suspicious. Revealing yourself to those you kept an eye on was an effective method but still brought Stasi disapproval, coupled with the subject's odium and socially the lack of trust associated with having been an informer. On the face of it, the best

way out was to achieve promotion in the SED hierarchy whereby you could no longer act for the MfS as an IM, though, even then, you might want to do what you could, and might be re-classified under a different Stasi denomination. Even if that did not happen, you would be expected to co-operate:

> If the IM was promoted, the procedure was terminated and the filed closed. As the SED gave the MfS its orders, no highly placed SED official was used and controlled as an informer. But continuing the trusted and reliable collaboration was, without outward sign of duty, a matter of honour. (Walther 1993: 86)

At the highest level in the GDR, the Stasi was represented at Politbüro meetings by Erich Mielke, where Kurt Hager, an expert on ideological matters, held the portfolio for the arts. It was in the Politbüro and in the Cultural Department of the Central Committee of the SED that major decisions in the cultural sphere were made. The Ministry of Culture had charge of the secondary tasks of organising and co-ordinating (Walther 1996: 822), and within it at least one of the deputy ministers concerned with all forms of publishing worked frequently and co-operatively with the Stasi. An outward sign of the worth accorded to the links between the Stasi and the ministry occurred in 1975 when in celebration of 25 years of their existence the Stasi awarded honours to, among others, the Minister for Culture, Hans Joachim Hoffmann, to Kurt Löffler, State Secretary, and to Deputy Minister Klaus Höpcke (ibid.: 822–823).

Given the superior position of the SED, and from the above example, also the patronage of the Ministry of Culture, the influence of the ministry in the hierarchy of the GDR power structure may appear relatively subordinate, but there is no doubt that it had a very wide range of activity: it advised on, and took part in, the formulation of policy; the formal control of the arts was largely effected through the procedures it instituted; and it handled the bulk of the day-to-day issues. Since the MfS had a mission which seems to 'second guess' the function of the Ministry of Culture, and even to usurp the authority of the SED as the protector of ideological purity, some clarification of the MfS's role in cultural matters is given below.

The line taken by the MfS was essentially that it kept watch, made reports, considered the grounds for legal action and carried out

measures decided by the SED or the state authorities. An exposition of the Stasi's position by the deputy head of *Abteilung 7* in 1975 is cited by Matthias Braun in his contribution to Alexander Weigel's history of the *Deutsches Theater*. Oberstleutnant Karl Brosche acknowledged that both cultural policy and the detail of its implementation were the preserve of the SED and the Ministry of Culture; the MfS had not to agree or decide anything. The duty of the MfS was simply to report the results of their observation of the behaviour of artists and writers; this information was for reference in the course of work done by the MfK and for decisions by the SED. Only rarely would a view be volunteered (Weigel 1996: 258).

Sometimes, information was offered by the Ministry of Culture to the MfS which led to the MfS commenting or saying whether or not they agreed: for instance, when modification to the procedure for authors to obtain consent to publish was proposed the Ministry of Culture consulted with and awaited the view of the MfS before proceeding. In relation to the SED, who were very much exercised by the political exigencies of the day, the MfS could and did under Mielke's guidance take a longer view by tracking individuals over many years and accumulating impressive hoards of data in the interests of national security. Its senior management was also among the more important SED members and the Minister for State Security was an active and senior member of the Politbüro. The Stasi were often close and proactive partners with other state and SED agencies. Less than omnipotent, the Stasi nevertheless had a presence in practically all walks of life in the GDR. From the time Honecker came to power and Mielke became a 'Kandidat' member of the Politbüro, in 1971, more use was made of the MfS to try to resolve problems that should have been dealt with by the SED or the state organs. The extra work necessitated extra staff. In Berlin, for instance, there was a 20 per cent increase in MfS personnel (Schwan 1997: 152–153).

Whilst the high proportion of secret police in relation to the population, the existence of a specialist department of the Stasi for cultural matters and the network of IM and collaborators in key positions in the SED and the state apparatus combined to exercise considerable influence, the Stasi began to falter in its efforts to gain the comprehensive covert control of the lives of citizens active in the

arts. The mistrust of intellectuals and high culture grew from the mid-1970s onwards when the expectations of the SED for unquestioning loyalty due to relaxation in cultural policy at the start of the Honecker regime were disappointed, and the arts community continued to test the boundaries of what was possible. From around the time of the Biermann affair, a more thorough surveillance was deemed imperative, a task to which HA/XX/7, as then organised, proved unequal. The Stasi responded to the new frictions by expanding its institutional and social penetration. Among a catalogue of around sixty state and state-supported bodies in the media and the arts that the Stasi were directly monitoring in the early 1980s as 'Objekte' there were, for instance, several organisations whose concerns affected people who worked in the theatre, for instance:

> Internationales Theaterinstitut DDR-Zentrum, Berlin
> Verband der Theaterschaffenden der DDR, Berlin
> Büro für Urheberrechte, Berlin
> Direktion für Theater und Orchester, Berlin
> Gewerkschaft Kunst (Zentralvorstand), Berlin
> Akademie der Künste der DDR.

The MfS increased the staff employed in HA/XX/7, whose numbers rose from 27 in 1980 to 40 in 1989 (ibid: 179), and it drew in some of its other departments to assist and formed new departments and units dealing ad hoc with specific problems which were not necessarily linked to HA/XX/7. For example, there were task forces concentrating on the book fairs in Frankfurt am Main, in Moscow and in Leipzig. A specially well-staffed and well-equipped team, active against underground literature, had been active against Wolf Biermann and his circle of friends and acquaintances from late 1975. Later, writers, playwrights and poets seeking reforms, such as Stefan Heym, Rolf Schneider, Ulrich Plenzdorf or Günter Kunert, were singled out for attention by units formed specifically to upset their lives (Walther 1993: 80–81).

The MfS organisations in the provinces were also galvanised into increased watchfulness through instructions issued by HA/XX/7 to the MfS district and local offices. In Neubrandenburg, for instance, guidance in a strategy document concerning security and treatment of

selected spheres of operation and of persons engaged in culture and the arts was prepared in 1981 and codenamed 'Cobra'. It shows how fully professional and amateur theatres, cultural groups and artists and anyone with connections to the FRG were kept under secret observation. Suspicious tendencies were noted, such as withdrawal from work in the community, efforts to evade the influence of the SED, establishing second homes in the remote countryside where information could be exchanged freely, politics discussed and poetry evenings held. The MfS and its helpers were to repress negative ideas and behaviour by all means at their disposal. The MfS sought to combat the revisionist, opportunistic and pacifist thought and behaviour among artists by inserting informers in theatres and other groups, by intercepting mail and telephone conversations, through secret house searches, handwriting analysis, bank account investigations and the blocking of all career moves (Gill 1991: 162). The many 'IM-Vorläufe' later discovered to have been instigated leads Joachim Walther to suspect that there could have been but a few writers who were not approached by the MfS (Walther 1996: 716). In all, there appear to have been nearly 500 IM active in the literary field in the 1970s and 1980s (ibid.: 559).

Massive as this state apparatus eventually became, it originally had nothing to do with cultural activity as such. At its establishment in 1950 the Stasi was concerned with national security, e.g. guarding factories and railways against possible sabotage. The Soviet military administration had encouraged post-war cultural revival and the intervention of the secret police in cultural matters first occurred in the wake of the second Parteikongreß in 1952 when a campaign against 'formalism' was instituted and the Stasi was assigned its first objective in the arts. In 1954 another main section, Hauptabteilung V, was set up to cover education, science and culture and in fulfilling this remit it had a presence in all the fifteen administrative and SED districts into which the GDR had been divided in 1952 (Gill 1993: 53–55).

At the national level the writers' union was one of the organisations penetrated. By 1958 Haupabteilung V had not penetrated the Ministry of Culture (Westgate 2002: 69–70) though this was to change after an investigation into the causes of the Hungarian uprising of

1956, for which event the attitudes taken by Eastern Bloc intellectuals were held partly responsible. Erich Mielke's promotion to Minister for State Security in 1957 was followed by show trials in the GDR, such as that of Walter Janka, director of the Aufbau Verlag.

The construction of the Berlin Wall in 1961 virtually halted the exodus of disgruntled citizens and secured the border. One result was increased watchfulness by the Stasi on the 'enemy within' (ibid.), to which end they set up a new department of the MfS, Hauptverwaltung XX, with several sub-departments to combat attacks on the cultural policies of the GDR. The unrest of the Prague Spring in 1968 led to the founding of Abteilung 7 dedicated to the control of the arts in the GDR and the firm implementation of SED cultural policies. Within Abteilung 7, one group monitored the Ministry for Culture, and another was given charge of the whole area of literature, the arts and publishing. Theatres in the provinces now came within its remit and Abteilung 7 was represented at both district and local levels (Walther 1993: 83). Furthermore, there were continual efforts to undermine dramatists in exile through Stasi propaganda in other countries, e.g. feeding disinformation to professional critics in the arts establishment of the FRG to discredit exiles. This was a special feature of the Honecker regime. In the last twenty years before the collapse of the GDR the Stasi had also set up in West Germany a powerful network which proved efficient enough to achieve all its top secret aims: the destruction of the personalities of former GDR artists and authors and condemnation of critical artists and authors from within the ranks of the exiles. (Deinert 1995: 89)

In 1985 a new department, HA/XX/9, originating from these operations above, was brought into being to enforce Mielke's instruction (Dienstanweisung Nr. 2/85) dedicated to pre-emptive prevention, discovery and combat of underground political activity. It further strengthened the campaign against the intellectual and artistic opposition and their foreign contacts. Meantime the potential victims were no longer seen simply to be undermining cultural policies, serious as that was, but were now perceived to be opponents of socialism (Walther 1993: 80). Mielke would have been aware that by this time the SED leadership were no longer driving forward the official cultural policy with any sustained or consistent vigour.

However, the regime was paranoid over any type of opposition so they were keen for the Stasi to succeed. As indicated by David Childs, the leadership became ever more reliant on the Stasi:

> The MfS was, if anything, even more necessary to the maintenance of the SED's power in the 1970s and 1980s than it was in the 1950s and 1960s. The expansion of the MfS under Honecker was a reflection of the leadership's feelings of insecurity. (Childs 1996: 175)

The increase in the size of the Stasi in the Honecker years, not least in the cultural sphere, lends support to the argument that changing political conditions were met with more covert operations against intellectuals, writers and others, who in their turn had the insight to see that new responses were required. What was increasingly missing was any attempt by the GDR leadership itself to acknowledge criticism and to re-think policies.

The Stasi had at its disposal a large range of laws and regulations that they could invoke to prosecute dissidents, or anyone who deviated or showed any tendency to burst the bounds of cultural or political conformity. These legal instruments of power had been used unsparingly in Ulbricht's time. Artists and writers had served prison sentences. That background and history, and the knowledge among the cultural community in the Honecker era that their own activity or attitude could be criminalised at any point constituted a cogent reason for being circumspect in speech and writing. The clearly defined set of laws which the MfS had available were widely drawn and provided for almost seamless transgression against the socialist legal system, so that for every need in every case a suitable paragraph existed that could have served to institute a prosecution, but for the fact that political expediency, especially in the 1980s, necessitated a reliance on threats. (Walther 1996: 365)

Besides crimes traditionally associated with espionage such as passing on secrets, unlawful visits abroad, sabotage and bribery, terrorism and the carrying of weapons, there were a number of offences so vague that they could embrace a variety of situations, and some others relating to communication of information that could easily be deployed against authors or anyone handling or distributing written material. An example of the first kind from paragraph 106

of the *Strafgesetzbuch* was inflammatory anti-regime propaganda, 'staatsfeindliche Hetze', carrying a penalty of from one to ten years imprisonment. This was the most common of the vague all-purpose laws invoked to threaten anyone in the cultural sphere concerned with writing or the performing arts. It was the ground on which operations against Ulrich Plenzdorf were justified. An example of the second type of offence, punishable by fines or up to five years' imprisonment, was unlawful contact, 'ungesetzliche Verbindungsaufnahme' under paragraph 219, section 2 of the punishment law. This section related to people sending information abroad harmful to the GDR, in particular anyone who handed over or caused to be handed over texts, manuscripts or other material damaging to the interests of the GDR to organizations, institutions or persons abroad in circumvention of the regulations (Gesetzbuch der DDR, Paragraph 219, Absatz 2.) Thus, manuscripts not accepted by publishers in the GDR might be sent to foreign publishers to test the market, in the FRG for instance, and, depending on the content of the play, poem or novel, the writer could be liable to prosecution.

As far as the arts were concerned, the practice in the Honecker era was to make sure that the laws and penalties were well known, but to avoid formal legal proceedings, especially against authors of any stature. Such proceedings would undermine the image of an enlightened GDR worthy of respect for its human rights record and of international recognition of its sovereignty. The potential for different interpretations of a work of art did in any case complicate a purely legal approach. Mielke appreciated that strict application of the law and its enforcement would not in itself ensure the success of GDR cultural aims. It was, he considered, better to detect and thwart dissidents by means of covert operations. The tactic he adopted is revealed in his speech to the 1972 Stasi conference in which he referred to the special nature of work involving artists and writers in which resort to the law should not be immediate, though, of course, the evidence that might be needed should be collected. The aim should be rather to discredit such persons. However, the implemenation, the operational treatment of such persons and groups must, he insisted, from the very beginning be more srongly focused to undermine them, to destroy their credibility, to isolate, to create mistrust, to remove the basis of

their effectiveness. Success in this way was politically more valuable than arrest and conviction. The principle to follow was that in most cases it was more purposeful and useful to MfS objectives to deploy a variety of means. (Walther 1993: 85–86)

Informers, for example, progressing well in their careers, such as senior theatre directors or important officials and ministers, were carefully classified according to their type of usefulness to the Stasi. Among these were Hermann Kant (IM 1963–1976), Manfred Wekwerth (IM 1955-1989) and Klaus Höpcke (IM 1973–1989). Some became 'Kontaktpersonen', who by virtue of the position they held were deemed to be persons on whom the Stasi could rely (it follows that the Stasi welcomed the advancement of collaborators and that they would favour the candidacy of successors who were also ready to co-operate). For instance, the Stasi had working for them the MfK official in charge of literary censorship for the whole of the GDR:

> The MfS was integrated into the apparatus of control and censorship of literature, and the head of the HV Verlage, as an official *Kontaktperson* of the MfS, functioned as a central intermediary between the MfS, the publishing house, the HV, the MfK and the ZK der SED. The MfS could at any time directly influence the fate of any given manuscript. (Westgate 2002: 72)

The Stasi was more interested in the human aspects than the literary output. Its attention, and that of the IM, was directed more to the question of how the writer was behaving and whether legal action was warranted. Of the three senior figures mentioned above, Manfred Wekwerth had served the Stasi the longest. He was recruited in 1955 and since he and his wife were prepared to let their flat be used for secret rendezvous he was classed as an IM/KW, in possession of a 'konspirative Wohnung'. As his career as a director progressed and he received visits from assistants and actors this use became improbable. He was re-designated as an IM/GI 'Geheimer Informator' but by 1969 he was a busy chief director and was re-classified GMS 'Gesellschaft-licher Mitarbeiter für Sicherheit'. GMS 'Manfred' supplied information on people who wrote for or worked in the theatre, such as Volker Braun and Heiner Müller, and about institutional problems in the Berliner Ensemble (with which he had been associated ever since he was an assistant to Brecht in 1951 and where he was the intendant

from 1977–1991), in the Academy of Arts (whose President he was from 1982–1990) and also in the theatre academy in Berlin. From 1986 to1989 he was a member of the Central Committee of the SED. Wekwerth was praised by Stasi Hauptmann Muck, BV Berlin, Abteilung XX/7, in a report on 12 January 1983:

> GMS 'Manfred' is honest, reliable, as well as being involved in the following action in regard to H. Müller and V. Braun. Through stabilizing measures taken by the Party after the Cultural Conference of the FDJ to deal with the turbulence and problems over Müller and Braun, it has been possible to influence both Müller, through Comrade Professor Minetti, and Braun, through Comrade Professor Wekwerth, positively in terms of cultural policy. (Walther 1996: 624)

There are indications that Wekwerth was active not only in ensuring the smooth working of the cultural policy, but on behalf of his spymasters intervened in particular drama productions. In 1989 a final report evaluated the co-operation in the following terms:

> In the framework of his professional work there has been co-operation with the GMS over many years, with breaks. In recent years through this co-operation and his opportunity to guide leading artists – particularly dramatists – influence has been exercised to bind them to the GDR. Through him, pressure has been brought to bear in connection with problematic productions, so that the work with the artists has been endowed with such a character that operational concerns have been satisfied, and at the same time no damage to the GDR has been sustained. (ibid.: 624–625)

Early in 1989 Wekwerth ended his association with the Stasi and became involved in a large demonstration by theatre staff in Berlin protesting at police brutality and arrests at an earlier demonstration. In the context of negotiations with the police, the Berlin SED district leadership, cultural officials and representatives from the Central Committee, and with the Stasi, for permission to hold the planned demonstration in November, he declared that he would take part with, or without, permission (Süß 1999: 394).

The screen writer and dramatist, Ulrich Plenzdorf, had a brief spell as an IMK/DA 'Inoffizieller Mitarbeiter zur Sicherung der Konspiration und des Verbindungswesens' from 1971 to 1973 when he was induced to help the Stasi department HA/III which listened in to telephone calls and intercepted mail, by the use of his postal

address for their conspiratorial purposes and was given the cover name 'Ewald Richards'. He failed to deal with letters and was turned over to HA/XX/7 where he fell into disfavour after the publication of the play *Die neuen Leiden des jungen W.* in the literary journal *Sinn und Form* and was categorised as unreliable by the Stasi department in 1973 (Walther 1996: 625). They opened a new file, 'OV Dramatiker' in 1974, the year when he supported Stefan Heym's plea for an end to censorship, and Höpcke reported to the Stasi his concerns at Plenzdorf's involvement in the incident, which occurred at a meeting of the Berlin branch of the Deutscher Schriftstellerverband. Plenzdorf ran into more trouble as a co-initiator of a venture to set up an independent publishing house to publish an anthology, an enterprise the Stasi tried to infiltrate in a separate operation 'OV Selbstverlag'. He supported the protests when Biermann was deprived of his citizenship in 1976. He was kept under observation by informers. A rival writer and official of the writers' union, and fanatical IM, Günter Görlich, conspired with the head of the SED in Berlin, Konrad Naumann, to discredit Plenzdorf. (Görlich was honoured for his work and ended his Stasi IM career in selection as candidate member of the Central Committee (ibid.: 649).) In 1984 the Stasi reviewed Plenzdorf's case in the light of the dedicated observation by numerous IM who had kept watch on him. The controlling Stasi officer concluded that, thanks largely to the efforts of the IM in carrying through the Stasi strategy, the desired result had been achieved:

> As a result of the political operational arrangement on the basis of deputy Minister Lieutenant-General Mittig's confirmed working idea, the activities of Plenzdorf and his potential impact and effectiveness against the socialist state and the social order in the GDR were considerably limited and then brought to an end. (ibid.: 358–359)

Walther comments that in the 1980s the MfS no longer succeeded in changing the opinions of authors like Plenzdorf, nor to influence what they wrote. The MfS were content that the authors behaved with moderation and that they refrained from direct political activity (ibid.). Plenzdorf's play *Freiheitsberaubung* was banned in 1987 so this finding by the Stasi did not serve to guarantee him much freedom of

expression (Emmerich 1996: 350). However, a performance did take place in 1988.

Another instance concerns the play *Revisor* oder *Katze aus dem Sack* performed at the Hans Otto Theater in Potsdam in 1989. Michael Philipps, an experienced dramaturge, was instrumental in having this play accepted into the repertoire initially and worked on a version adapted to the local circumstances with the director, Wilfred Mattukat, and under the general supervision of the intendant, Gero Hammer.

The Stasi surveillance of Philipps is linked not only to the play, but also to the prevailing circumstances at the Hans Otto Theater in 1987 and 1988. The following Stasi appraisal reveals the niche occupied by the Hans Otto Theater in the structure of the GDR theatre and also indicates what the Stasi thought was going wrong there and how they organised themselves to deal with the situation.

The theatre employed 300 main staff, and in addition about 40 ancillary staff and self-employed workers. It drew its audiences from a large area of the Potsdam Bezirk and in accordance with the legacy of Hans Otto, the famous actor killed by the Nazis, it delivered a range of dramatic work ranging from contemporary socialist to anti-imperialist drama. It hosted a bi-annual festival of new drama. The total annual audience was around 200,000. Many in the profession regarded a position at the Hans Otto Theater as a step to an appointment in a theatre in Berlin.

The Stasi team concerned with the Hans Otto Theater ensemble consisted of four officers and six IM, though the latter were not the only sources of information available and other spies were activated as deemed necessary. The work was distributed among the spies and officers who were assigned to areas requiring investigation, as follows:

1 IMB	Major Münn	Leitung/Technischer Bereich
1 IMS	OSL Kühn	Theaterleitung
1 IMK	Hptm Schulze	Theaterleitung
1 IM	Hptm Tuda	Regie/Schauspiel
1 IMS	Hptm Tuda	Dramaturgie
1 IMS/Vorlauf	Hptm Tuda	Theatervorstand/Technik

(BStU, BVfS Potsdam Kdm Pdm. 458/124)

The team had identified the trouble spot to be in the departments of the directors of plays and the dramaturges. The designated area of concentration concerned seven directors and their assistants, ten dramaturges and assistant dramaturges, and eight members of the artistic management.

In Stasi eyes, the trouble had built up over time through external and internal factors:

> The Hans Otto Theater [has] for many years been the target of external enemy forces
>
> [The theatre reveals] a concentration of negative theatre staff, especially of employees who have not succeeded on the stages of Berlin.
>
> [The theatre] attempts to install negative enemy forces and to stage plays containing statements foreign to socialism [Plenzdorf, Seidel, Braun, Drewniok etc.] (ibid.: 458/151)

The bad influences were seen in the attempts of Western publishers, such as the Gustav Fischer Verlag, Stuttgart, and of individual staff members, to try to stage Western drama at the Hans Otto Theater, in the training of a Dutch director in 1985, and in the activity of accredited representatives of the Western mass media in promoting plays from the GDR in the West.

Attitudes among staff, which the Stasi considered to have been inspired from the West, included the view that it was not objective reality that should be presented, but exaggerations whereby the problems of an advanced socialist society are negatively politicised. Another was the refusal to allow state and social organisations to influence the theatre programming on the grounds that only the professionals in art and culture were qualified to judge these matters. Also prevalent was the notion that there were two cultural policies in the GDR, one for other theatres, where, up to a point, politically negative plays could be performed, and another in Potsdam where permission was withheld in a unique absolutist fiefdom (ibid.: 458/152). Lack of theatrical success was attributed to inhibitions and constraint on the artistic output. The Stasi believed that the staff chose plays with a view to successful productions and less from politico-social considerations. They were also alleged to foster the idea that there was a polarisation in the GDR in which the leadership had lost

touch with the masses and were untouchable in the exercise of their rights and privileges. Conversely, the staff was charged with producing work that could only be appreciated by the elite few.
The appraisal goes on to cite instances:

– the dramaturges use the two-yearly workshops to promote unsuitable plays – about the outsiders of society – or to make people think that the problems of the GDR can never be solved

– an actor infiltrated by the enemy has been allowed to put on plays with a negative message, and has contacts in the West, through whom the GDR receives bad publicity

– in a youth club a dramaturge has organised non-political plays about peace

– technical workers are evading political control

– some of the directing staff consider themselves to be professional, not political, leaders. (ibid.: 458/154)

The report concludes that the intendant has insufficient drive, the Grundorganisation has members who are indifferent to the perceived problems, the youth section does no work, the district leaders' time is taken up with trade union aims, and the staff is too much involved in the recruitment of newcomers (ibid.).

The action decided upon was put into the hands of Hauptmann Tuda, who was to take measures to keep negative works out of the theatre workshop and to assign a further IMS to the project, and to analyse the results. An assessment on 15 August 1988 gives the impression that the ensemble members who were targeted suffered setbacks but were going their own way. There were voices calling for control and censorship to be abolished and Georg Seidel had criticised officials during a recent visit. The ensemble members had improved their contacts with the West where there was now a nucleus of ex-ensemble members or former associates. A group of directors showed interest in productions of speculative and alternative character. Uncritical interpretations of 'glasnost' und 'perestroika' were being

imported from the West. For the repertoire up to 1989 the directors and dramaturges had put together a programme of critical contemporary drama, and the banned theatre youth group had disappeared but a new group under the title 'Spielgruppe Potsdam' was gaining support from West Berlin.

The Stasi team claimed success in firming up the timetable for planning the repertoire so that changes could not be introduced at a later stage. The two dramaturges had been criticised for proposing plays of a non-socialist character. At the annual Youth Theatre workshop, the main focus had been kept on plays already in the repertoire, the programme had been shortened and the young people were allowed little time in which to view the alternative drama on offer. The Stasi seem to have been able to influence recruitment of new technical staff (ibid.: 458/314).

It is in the light of the above struggle between the local Stasi and a core of the staff responsible for bringing plays to the stage that Philipp's case must be viewed. His was one of several cases being handled by the Stasi controlling officers and the IM of the Potsdam district. In addition to his duties at the Hans Otto Theater, Philipps was artistic director of the nearby Arbeitertheater Teltow, an amateur club of some renown located close to the border with West Berlin. Since 1982 he had tried to have *Revisor oder Katze aus dem Sack* performed at this theatre, but according to the Stasi file, this had been prevented by progressive forces active there (BStU. 000268/9 Kreisdienststelle Potsdam 30 May1989). Eventually he persuaded Mattukat at the Hans Otto Theater and, with other support in the ensemble, he managed to have *Revisor oder Katze aus dem Sack* included in the forward planning. The author, Jürgen Groß, was commissioned by the Hans Otto Theater and the Sächsisches Staatsschauspiel in Dresden to re-work the 1981 version. The new version was offered to the Dresden theatre but the offer was declined in the light of opposition from the senior local cultural official.

The first performance took place at the Deutsch-Sorbisches Volkstheater in Bautzen, where it attracted praise and blame but was saved from being banned, because, according to the Stasi, Modrow objected. The production was allowed to continue for a while and then fade from the repertoire.

90

The Stasi's report (ibid.), compiled by Hauptmann Tuda of the Kreisdienststelle Potsdam on 30 May 1989, referred to the accusation that Philipps had peppered the text with allusions to the lives and characteristics of public officials in Potsdam:

> At the Potsdam final rehearsal Philipps managed to make additions to produce definite connections to the town and its officials. According to a source, Philipps had fully succeeded in his efforts. (ibid.)

Misgivings arose among the officials attending the Potsdam premiere. One left during the intermission, another stayed, gave only polite applause, and remarked that he would never have thought that there could ever be another play like *Wolokamsker Chaussee* (a controversial piece by Heiner Müller) (ibid.). A bigger team attended the second performance. In turn, they alerted the First Secretary of the district who came to the third performance on 24 May 1989. He launched into a tirade of criticism and at a later SED meeting it was decided that immediate steps be taken to instigate a campaign against the ensemble including the actors in specific roles who portrayed the venality of various public officials in the play (BStU. 000268 Kreisdienststelle Potsdam 30 May 1989). In an evaluation of reactions and opinions of theatre staff emanating from the Stasi Kreisdienststelle Potsdam on 7 June 1989, from which an extract is given below, it is clear that Philipps was being watched and was alleged to be intriguing against the SED Party Secretary of the Hans Otto Theater.

The allegations were threefold:

> Michael Philipps positioned himself in the audience during the performance, observed attentively the officials present who were alluded to in the play, and enjoyed himself 'maliciously' at their reaction to the acting.
>
> Ph. was especially gratified at the reaction of Party Secretary, comrade Markowski, over the mention of his twenty-five years in the army causing problems in civil life.
>
> Ph. spread the word at the HOT that comrade Markowski was demanding the withdrawal of *Revisor oder Katze aus dem Sack* because the play contained a derogatory remark about him. (BStU 000275 Kreisdienststelle Potsdam 7 June 1989)

The Stasi had been interested in Philipps well before the play was performed. In 1986 'Operative Vorgänge' 'Duett' were started against him and his superior, the chief dramaturge Irmgard Mickisch. The Stasi suspected them of undermining the socialist order through their choice of plays for the theatre season, and by reason of Philipp's treatment of the texts. They deployed various IM to gather information and to hinder them. Mickisch had been the SED-Parteisekretär of the Hans Otto Theater and was herself an IM under the codenames 'Mai' and 'Maria Zimmer'. Neither was aware that they were being spied upon. Mickisch was assigned to clarify Philipp's family circumstances and to observe his wife and to assess her influence on Philipps, and also to ascertain his motives for working at the Teltow theatre (Schriel 1998: 319). Interviewed at the Hans Otto Theater in 2003, Philipps commented:

> Mickisch was a special case. Up to 1984 she had been with the Stasi and had then resigned and not made herself available any more. She was therefore outside the circle, and whoever had given up their work became suspect in the eyes of the Stasi; that was a problem and she was afterwards seemingly shut out of the party management because she had not taken her function of control as chief dramaturge sufficiently seriously. However, I did not hear that from the Stasi. I first knew about it from my file. (Interview Baker/Philipps 1 April 2003)

After *Revisor oder Katze aus dem Sack* was seen by the First Secretary, the Stasi recorded that he instructed that disciplinary proceedings be taken against her and her Party card be withdrawn, if necessary (BstU 000268–9 Kreisdienststelle Potsdam 30 May 1989). Philipps was the dramaturge directly responsible for *Revisor oder Katze aus dem Sack*. He was not a member of the SED. In the above interview, when asked whether he had been a member of any political party, he gave the following reasons:

> No, everybody was in the FDJ, but I was never a Party member. That was not looked upon with favour, that one had a prior commitment; politically, though, they gave up on me early on. I considered what to say if they asked why I was not a member, at the time the wall had been built and the events of spring 1968 had occurred and I had always said: 'well you people would have in me a very poor propagandist, if I am not in agreement with something I cannot represent

it' They only wanted people that would make propaganda and with me that would in no way have happened. (Interview Baker/Philipps, 1 April 2003)

Philipps had come under suspicion on account of being an inhabitant of the GDR in close touch with a foreigner. He had known his Dutch friend, Adrianus Schriel, who had stayed with him at his home, since 1981. They had met when they were both visiting students at the Berliner Ensemble. Schriel was sponsored by the International Theatre Institute, which worked under the direction of Manfred Wekwerth and took part in the Berliner Ensemble's production of the *Dreigroschenoper*.

Philipps later introduced Schriel to the ensemble at the Hans Otto Theater. On the instructions of the Stasi, IMS 'Ernst' was to find out about Schriel's intentions and ties to theatre professionals in the GDR, and also to explore whether it was possible to prevent him from guesting as a director. Schriel did obtain a contract and directed Arthur Miller's *Death of a Salesman* at the Hans Otto Theater in 1988. Philipps stated in my interview with him that he found out in the end that at the same time as this was happening pressure had been put on the intendant not to cultivate the contacts between Philipps and Schriel (unbeknown to Philipps, the intendant, Gero Hammer was himself classed by the Stasi as an IM):

> But parallel to that I discovered from the files that of course there had been surveillance, I was already under observation and Mr Schiel was also. It was Hammer, I found out afterwards, who proposed that the contact be no longer maintained and it somehow ran into the sand. He found no more to do here, no production. (ibid)

Schriel was not only a West European but had studied in the U.S.A., so the Stasi's suspicions about the danger of the relationship with Philipps were easy to arouse. They were annoyed that, because of the friendship, news about *Revisor oder Katze aus dem Sack* being removed from the repertoire was likely to reach the West:

> Moreover, it is possible that through Ph. persons from the West could be informed of the ban. The Dutch guest director of the HOT, Schriel, Adrian, knows about the circumstances of the ban. (BStU 00057 Kreisdienststelle Potsdam 21 June 1989)

The Stasi investigated Philipps because of his interest in Georg Seidel's drama *Jochen Schanotta* about disaffected youth who could find no role in the GDR. He tried to stage the world premiere at the Hans Otto Theater, but his request to the MfK was rejected. The first perfomance took place at the Berliner Ensemble in 1985, and he chose the piece for the 1988 season of the Arbeitertheater Teltow. This theatre was financially supported by the electronics conglomerate VEB Geräte und Reglerwerke Teltow, and had won prizes in national competitions and several of its actors turned professional. Work behind the scenes by GMS 'Dieter' to dilute the provocative message of this play was carried out before the premiere. GMS 'Dieter' was Dieter Pacziepny, a leading member of the theatre who was also the Potsdam cultural officer. According to Philipps, it was this position that carried with it an obligation to co-operate with the Stasi:

> I knew him well because he acted with me in the worker's theatre. Dieter and I were friends and I always had the impression that that he held a rather protective hand over the theatre, he was actually really reasonable and liberal-minded. Of course, by reason of his job he was automatically a social member of the Stasi, GMS it was called, just like the intendant. Because of the nature of their position, they were obliged to pass on certain information. (Interview Baker/Philipps I April 2003)

Philipps proved not to be fully co-operative in the efforts to dilute *Jochen Schanotta*. He succeeded in keeping in the play a passage in which the youth, Schanotta, tells his girlfriend that the country was all wrapped around in wire so that it would not fall apart (ibid.). At a subsequent performance in Kleinmachnow to assess the play's suitability for entry to the national competition FDGB delegates refused to include it, on artistic grounds, whereupon a row broke out between the theatre representatives, supported by some functionaries, and this delegation. The discussion was recorded by GMS 'Dieter Salow'. At a later meeting the FDGB were persuaded to withdraw their objection. The author, Georg Seidel, who sat through one of the rehearsals, commented that he could not identify with the play because there had been so many cuts (ibid.).

There was no reason for the Stasi to object in principle to Philipps' participation in amateur theatre. Amateur theatre and

amateur cabaret in the GDR had a strong following. In 1975 it was reckoned that there were more than a thousand such ensembles putting on hundreds of shows every year (*Theater der Zeit* 1/75: 7). The entertainment served as an introduction to drama and comedy for youth and as a self-help leisure pursuit for workers supported by the FDJ and the FDGB. It was not at all uncommon for professionals and full-time technical workers to be engaged in amateur theatre, where their advice and help would be highly valued and where they might have possibilities for expression, self-development or experiment that were not currently available to them in their professional life. Amateur theatre and cabaret provided a forum for new talents. Some actors would graduate to the profession; occasionally shows would transfer wholesale to the professional stage. In parts of the country where there was no professional theatre, the amateur groups aspired to fill the gap. In other instances there was co-ordination of regional repertoires between professionals and amateurs. This is not to say that there were no differences in outlook or in conception of the entertainment to be offered. The Stasi had their informers everywhere and amateur groups were kept under observation, and could be investigated by the Stasi through their IM.

The secret observations in the Philipps' case above already show how well the Stasi had positioned themselves in the Potsdam and Teltow theatre circles through their informants. Much of the information they collected, which appeared to show the results of this infiltration, consisted effectively of accounts of SED and state cultural officials carrying out duties expected of them. The Stasi reports in the case of Philipps give the impression, partly because they repeat so much information from others about official actions, that they were simply chroniclers. Where precise effects are claimed in relation to Philipps' activities, there is only vagueness about the actual process that led to these. The sources and forces at work are kept secret and the descriptions are cryptic. This appearance may have been exactly what the Stasi wanted to achieve. It is a common practice in intelligence agencies, whose information may be passed to other government organs, to protect the identity of the members of the intelligence service who provided the information or took action based on the information. Because of such secrecy, the total effectiveness of the

Stasi may never be susceptible to precise measurement: did the clandestine nature of the job mask passivity, or action, by the officers and operatives? Whether the SED officials conducted themselves punctiliously out of political conviction, or because of the Stasi presence, it is impossible to divine from the reports of the secret police on Michael Philipps.

The case of Gero Hammer, the intendant at the Hans Otto Theater; demonstrates the thin line between doing one's duty and doing duty for the security service. The Stasi had frequent contact with the intendant through meetings in the theatre and in the intendant's flat, and many of the conversations were tape-recorded over nearly twelve years. In 1994, Gero Hammer wrote two letters disputing the evidence of this association that had emerged during investigation of the Stasi files. He, for the most part, accepted that meetings had taken place on the dates alleged, though there were inaccuracies, some meetings were said to have taken place at times when, as his diaries record, he was not present, and the information said to have been taped was, he wrote, invented. His case did not rest on these discrepancies, serious as they were, but on the belief that in his official position he had a duty to provide information to state authorities (as he was sure his predecessor had done). The MfS was such an authority.. At no time did he consider himself to be in the service of the MfS; he had never considered himself to be a collaborator. He was unaware that he was secretly designated 'GMS', 'IMV 'or 'IMS'.

Hammer asked that his letters be placed with the Stasi files and this was duly arranged. Referring in the second letter, of 3 July 1994, to the way he was asked about political matters and their effect on the theatre ensemble, he complained that his own views did not receive attention, and they were sometimes omitted from the transcription of the recordings by the MfS. He mentioned particularly that the indignation he registered at the actions of the First Secretary and his staff over *Revisor oder die Katze aus dem Sack* had been ignored (BStU, AIM 248/80 T.II/1).

One playwright whose development the Stasi sought to influence was Volker Braun. In 1975 the Stasi acquired a copy of the text of the play *Guevara oder der Sonnenstaat,* on which a view was taken by

96

Oberstleutnant Kühn of the Stasi. He characterises the piece as one in which Braun philosophises over the process of a revolution. Guevara is a freedom fighter keen to achieve revolution but with little interest in the responsibilities and day-to-day problems that a revolution forces upon the revolutionaries. Kühn noted that the last part resembled Samuel Beckett's *Endspiel* and considered this to be a bending of the knee to contemporary bourgeois notions of drama. Overall, he concludes that Braun's play would enrich the GDR's theatre life, as well as providing a counterpoint to Peter Hack's ambiguous interpretations of the classics.

Volker Braun had for a long time been investigated as the subject of 'Operativ-Vorlauf' 'Erbe' set in train by the Stasi, who tried to place informers close to him to gain his trust and report on his political views. Kühn reasoned that through the play being performed Braun would expose his views to public scrutiny. The production of the play would place him in a position where he could be observed and influenced positively by IM, whose influence might help to detach Braun from friends like Wolf Biermann, and be carried over to any new writing by Braun. One IM might be able to accompany Braun on a trip he planned to make to Cuba. A mention that the Cubans might not like the play, or the whole theme of it, is crossed out in Kühn's note. A fellow officer he consulted, Oberstleutnant Hähnel, agreed. If staged in the capital, he thought that *Guevara oder der Sonnenstaat* could become a magnet for the forces of the sectarian left. He proposed Dresden where Braun was born and which was a city of culture on a par with Berlin. Hähnel then spoke to Dr Kiesig, the head of the cultural department of the SED District Council, with whom it was agreed that, in view of the bans on Braun's earlier plays such as *Tinka* and *Lenins Tod* that had caused him to harden his attitude to the SED, allowing his new work to be performed might assist in bringing him back into the fold. Dr Kiesig noted the MfS grounds for preferring Dresden but he said the Ministry of Culture favoured the Deutsches Theater, where the management was already in touch with Braun. In respect of the content of *Guevara oder der Sonnenstaat*, Hähnel also commented that the Stasi was not in a position to judge which alterations to the play had to be taken to make it fit for the stage (BStU.AOP 15582/83 1).

Stasi plans instructing IM to achieve the aims described above were approved by Oberstleutnant Häbler, head of Abteilung XX. An IMF 'Sumatic' was charged with having the play open in Dresden where the intendant might need a recommendation from higher authority before entertaining the idea. IMF 'Sumatic' should also travel to Cuba with Braun. IMV 'Romeo' was to assist IMF 'Sumatic'. IMV 'Carcinus', an actor liked by Biermann, was to persuade Biermann to propose him for the principal role. GMS 'Hölderlin' was to report on any rehearsals at the Deutsches Theater. IM 'Sumatic', 'Romeo' and 'St. Just' were all enjoined to seize opportunities to be in close contact with Braun for the elucidation of his opinions on literary and political matters. In the event, the play was given a performance early in 1976 by students in Leipzig, where Braun had himself been a student. At an SED meeting in April of that year the decision to have the official premiere at the Deutsches Theater was announced by the intendant.

The meeting was also informed that the Ministry of Culture would consult the Cuban embassy. The Stasi file states that the Cubans were less concerned about what was in the text than with the very idea that any play about Guevara should appear on the GDR stage. As mentioned above, Oberstleutnant Kühn's concern about Cuban reaction was crossed out in his memorandum of 22 May 1975. A note by IM 'Sumatic' on 18 July 1975 had advised that care be taken not to warn the Cubans or the Bunke family too early. The files do not indicate that the Stasi officers marshalling IM produced any specific plans to subvert the production of Braun's play at the last moment, though it is clear that they knew that the Cubans were very likely to react unfavourably. If IM 'Sumatic' knew that information was to be planted on comrade Nadja Bunke, whose daughter had been Guevara's lover, then it is more than probable that his controlling Stasi officer was also aware. Whatever the involvement of the Stasi, comrade Nadja Bunke, the mother, arrived at the *Deutsches Theater* on 14 March 1977 and lodged a strong protest.

The rehearsals planned for 29 and 31 March were abandoned on 22 March and the decision not to proceed further in Berlin, or in Dresden, was taken at a Berlin SED meeting on the grounds that the Cubans were unhappy. Some adaptations had been made to

98

accommodate the objections of the Cubans but these were deemed inadequate. Braun, in his turn, sent a letter of protest to Erich Honecker to which the response was a meeting between Kurt Hager and Volker Braun at which it was agreed that rehearsals could continue. Arrangements were made for a performance to be video-taped but the review did not result in the premiere being allowed. At a question and answer session at a poetry reading in Greifswald soon afterwards, Braun is said, in a Stasi report, to have defended the play by claiming that it was never his intention to point out Guevara's mistakes but to show the problems in the world which were bound to cause Guevara to fail.

The machinations of the Stasi above reveal the resources that they could muster to spy on one author and, generally, the accounts of Stasi activity in this chapter show the numerous ways in which theatre professionals were involved, from Plenzdorf's inveiglement to Wekwerth's constant engagement, from the intensive operations against Philipps to the information provided by Hammer as a matter of duty. Also, in my view, enough material has been assembled to prove that the Stasi did not stand by to await instructions from the SED: they developed agendas of their own, even to the extent of planning where a play should be performed. The ultimate decisions in important cases might be taken by the SED but that left plenty of room for Stasi initiatives. In that regard, I would point out that much of the record here is from what the Stasi chose to record. Other data, not at the time of writing in the public domain, is being collected by the Archive of Suppressed Literature in the GDR, and preliminary indications from this are that the Stasi were themselves suppressing manuscripts, and severely punishing unpublished authors, and not simply relying on threats. Joachim Walther wrote in June 2005:

> At any rate we have discovered an eclectic collection of dramatic texts and authors which were 'neutralised' right at the beginning, before they could fall under the mill of the censor. The most shocking example is the sentence to six years' imprisonment in regard to a 58-page drama with the title *Hundert Prozent* [it is about the manipulation of elections in the GDR]. (Email 3 June 2005 Walther/Baker)

The emergence of more evidence from the Stasi sources is to be expected over coming years as more research is done and more of the many papers shredded in the closing phase of the GDR are reassembled. Even then the record will remain fragmentary. This is already a noticeable aspect of the studies undertaken where, despite searches by myself and officials, little or no trace in the archives has been found of Stasi activity in respect of the case studies relating to *Die Übergangsgesellschaft* or *Waiting for Godot*, though reconstructions of Stasi involvement with *Revisor oder Katze aus dem Sack* and with *Die Ritter der Tafelrunde* have proved possible.

As to the overall impact of the Stasi on the theatre in the 1980s, the organization had greatly extended itself by then and could easily intrude everywhere in the theatre. However, there are indications that it was not necessarily more influential (except in the general repressive atmosphere of the early 1980s), and its expansion was not the answer to the pull of political and economic forces in that period that eventually brought down the GDR, nor to the cultural movements and innovation that gained momentum. The targeting of persons was well planned, but there were blunders, and plans that came to nothing, such as are mentioned in the case study connected with *Die Ritter der Tafelrunde*. Noteworthy for the 1980s, in the sampling possible in the course of this research, is that frank and varied comment by Stasi officers on whether or not productions of plays should be allowed, has been found, which is gratifying, since the executive operations and observations are usually cloaked in jargon, and field reports are often deliberately vague, presumably to protect the sources from being discovered. Heiner Müller, who was not afraid to engage with the Stasi, once remarked that the Stasi was the only body in the GDR that knew what was really happening. That, of course, was their job, and it can be said that as regards the gathering of intelligence, they had no rival.

Chapter Three
Directions in Drama

The development of drama can, but does not necessarily, coincide with political change. It may not occur in, or correspond to, periods of ascendancy of political leaders, i.e. that of an Ulbricht or a Honecker. Changes in theatrical style or method that came about in the 1970s and 1980s often had their origins in trends starting in the 1960s and 1950s, or earlier. Nonetheless, as is the case with most public spheres in the GDR, it is hard to find areas where political forces are never manifest. So developments that might appear purely internal to the world of theatre remained at risk of intervention by political functionaries and by mass organisations with specific agendas in regard to the arts, e.g. the FDJ, or simply through an alteration in the general political climate. New drama was especially vulnerable. Now and then, works considered theatrically and ideologically too radical in their time would occasionally acquire an unforeseen resonance in a later period, and/or their eventual production after delay might coincide with a more relaxed political atmosphere. An example is *Die Übergangs-gesellschaft*, finished in 1982 when cultural policy was repressive, but performed in 1988 in the post-Glasnost era This chapter supplements the politically aspected chapters by placing emphasis on developments in theatrical theory and practice. Linked to it is the case study of *Waiting for Godot* in Chapter Five providing evidence of the total change of attitude over the lifetime of the GDR towards an important play representative of modern European drama.

According to Wolfgang Emmerich, GDR writing as a whole did acquire a distinctive character during the late 1960s and the 1970s, but in this period was the subject of centrifugal forces, politically, aesthetically and territorially, which militate against the construction of a plausible categorisation. He observes that the GDR's fluctuating measures and decisions in the cultural sphere can only tentatively be regarded as the guide to the history of literature. It is the works

of literature that are paramount. In so far as these are the outcome of the experiences of the authors, an understanding of the general economic, social and cultural development of the GDR is pertinent. Such an understanding shows that the authoritarian, fossilized 'realer Sozialismus' was more and more confronted with structural dilemmas, which, in the end, could no longer be resolved. In its own way literature stood witness to those circumstances (Emmerich 1996: 240).

These factors are examined in Petra Stuber's *Spielräume und Grenzen*, where a digression from socialist realism is traced back to the building of the Berlin Wall in 1961. This, Stuber states, was the last chance for the GDR to survive and also the beginning of the end for the GDR. The GDR state became more confident and sovereign. Reforms of economic planning, of the judicial system, and in cultural organisation were introduced. Included in the reforms was the creation of large concerns known as *Kombinate,* which were freer of central political control, and also the introduction of better financial incentives for workers. 1961 had been the year when the cosmonaut Gagarin flew round the earth, heralding a new era in technology and communication, which suggested that systems like the physical wall were becoming outmoded. The regime, wedded to this means of control of the population, was paranoid about transgression of the borders, be it by people or through the media or the arts. Before long the SED re-asserted its control and began to renege on reform. For instance, the *Theaterkombinat* comprising the Volksbühne and two other Berlin theatres set up in 1963 was abolished in 1965. In 1966 a professional body, Der Verband der Theaterschaffenden der DDR, was established as a new control. The leadership felt confident enough to invite Western journalists into the GDR but were dismayed over reports, such as those in the West German journal *Theater Heute* (*Theater Heute* 1/1966), recording both the plurality of development coming from the younger generation of directors, and the similarities with theatre concepts in the West. A GDR riposte re-affirming the existence of a uniform cultural policy was made through the columns of *Theater der Zeit* (*Theater der Zeit* 5/1966) (Stuber 1998: 211–216).

That idea of uniformity was nevertheless weakened by an increasing artificiality in theatre presentation, by a more robust and detached treatment of historical models of drama, and by the in-

effectiveness of a representative and national conception of theatre (Stuber 1998: 216). In other words, the invariable use of positive GDR role models, and the notion that there was only one, right, way of doing things, began to wane. Some dramatists believed that any turmoil within the GDR would disappear as a result of the Berlin Wall having been built, and that freedom within the borders would exist (ibid.: 207). It would provide the opportunity, as envisaged by Heiner Müller, to deal with everything realistically and critically (Müller 1994: 487). In the event, the SED accused some of the more innovative theatre professionals, like Müller, of playing into the hands of the West, and works such as Müller's *Der Bau* fell victim to censorship (Stuber 1998:207).

There was development that was not, in socialist terms, discordant, for instance, 'Spektakel' or 'Theaterfeste', which were clearly themed events where performances of plays and other entertainments were designed to engage closely with the theatre audiences. The 1974 Volksbühne 'Zeitstücke' consisted mainly of the work of young GDR authors. Youth was also accented in Schwerin in 'Jugend-entdeckungen' in 1977, Brecht was the mainspring of 'Brecht-Entdeckungen' in 1978, and 'DDR-Entdeckungen' took place in 1979. In 1977 Rudolstadt staged 'Spektakel 77' in which the work of different contemporary GDR and foreign writers was celebrated. Typically, plays were interspersed with shorter pieces and revues, and there were evenings of song and dance, discussions were held and the audience dined together in the intervals. The theatre aspired to be at once the centre of the arts and the centre of communication (ibid.: 227–228). Days during which Shakespeare's oeuvre or the drama of Ancient Greece were presented enabled a new understanding to be drawn from seeing such groups of plays together. Also, the reinterpretation of the plays themselves provided contemporary relevance (Meech 1988: 113–114).

Benno Besson and his team brought to the Volksbühne Theatre in Berlin a style that sought closer contact with the audience and advocated the abolition of the so-called 'Vierte Wand' and of the separation between theatre and reality. Stuber points out that the origins were varied and included the tradition of wandering market players, the Commedia dell'Arte, the avantgarde methods of Meyer-

hold, Brecht's Lehrstücke and the Bitterfelder Weg of the 1950s. During renovation, the theatre interior itself was substantially altered:

> Among other things, the government box was taken down, stalls and circle were so linked together to produce a steep sloping auditorium and the 'brown salon' became a public cafeteria open all day. (Stuber 1998: 223)

The theatre was a model for a new society free of barriers. The separation of art and reality, of artists and their public, of actors and roles, of professionals and amateurs, and of intellectuals and workers was called into question (ibid.). This 'Volksbühnekonzept' relativised text, dramatic structure and ideological message, but was adopted into the GDR canon. It was the hinge between the theatre of the fifties and sixties and its development in the seventies and eighties, and remained the inspiration for many later productions (ibid.: 227).

In a survey of the condition of GDR literature between 1971 and 1979 Wolfgang Emmerich notes a widespread withdrawal from unconditional acceptance of 'real existing Socialism'. In literature, hopes for a utopian socialism were accompanied by an ever more critical attitude of the existing system and greater use of the language forms of Europpean modernism (Emmerich 1996: 239). Literary expression became increasingly subversive in form, if not in content. Most of the authors combined this subversion of the regime with loyalty to socialism. Unlike in other countries of the Soviet bloc, dissident writing in the GDR stayed on the outer edge of the literary scene (ibid.). Dissidence, whether for reasons of artistic expression and/or out of political conviction, had an outlet denied to other countries of similar status, because the persons concerned could have their work in its original form published or performed for other audiences who were not too far away, or could, as opportunity arose, move to the FRG:

> Those writers who stayed and worked within certain limits [including a degree of self-censorship] had not in the event ever mounted any effective challenge to a repressive state; and the stability of the East German regime had been aided by the ease with which it could export overly critical voices to a common language community, with automatic rights of citizenship, in the West – in a way that Czechoslovakia, Poland or Hungary could not. (Fulbrook 1992: 68–69)

Conversely, the proximity to the FRG, the reception of television and radio broadcasts and the setting up of intra-German cultural exchange agreements in the Honecker era contributed to the influence of theatrical experience and experiment in the FRG on dramatists in the GDR.

A number of theatre professionals were impressed by developments in the theatre within countries other than the FRG. For instance, Soviet playwrights like Rosov and Gelman showed a degree of social criticism in their work that went beyond that normally tolerated in the GDR (Zipser 1995: 117). Productions of their plays such as *Das Nest des Auerhahns* and *Protokoll einer Sitzung* enabled the theatre ensembles of the GDR who chose to do so, to address issues robustly and to build up an exciting repertoire to offer to their audiences. Styles of performance elsewhere were also acknowledged as an influence on GDR dramatists, as for instance, the following statement about new stagecraft and dramatic work in West Germany by the director, Frank Castorf:

> There are many sources of inspiration. I live in the GDR and know very little of what happens elswhere. The work of Pina Bausch or the stagecraft of Stein and Zadek produced great innovations, and, of course, I have myself been influenced by personal experience, such as Karge/Langhoff's *Räubern*. (Kreuzer 1998: 494)

In her detailed study Petra Stuber reaches the conclusion that the theatre as an art form in the GDR re-invigorated itself through a fresh appraisal of the avantgarde and in disengagement from politics (Stuber 1998: 241).

The aims of socialist theatre are an indispensable background to an understanding of its development. In the early 1970s the new Honecker regime specified the criteria against which GDR theatre activity would be judged: it would have to meet the mature, cultural, and present and future needs of the workers and make a unique contribution to the formation of the socialist character. As Hoffmann pointed out in a memorandum to Hager in 1973 this was to be achieved in the following way:

> That requires a repertoire that equally develops the contemporary creativeness of the GDR, the art of the Soviet Union and of other socialist countries, as well

as the humanistic heritage of world culture and learns from its variety, namely, how a socialist culture of theatre is formed and how the distinct direction of the theatre as an art of high social effectiveness and intensity over the long term is elaborated and gradually developed. (SAPMO B Archiv DY 30/IV B2/9.06/66)

The existence of notions of theatre other than those already seen as orthodox in socialist terms was a concern to the SED political establishment. Honecker's speech in December 1971 appearing to herald a more liberal approach to the arts was based on the premise that one started out from the solid basis of socialism Depending on the particular political climate and the vigour with which policy in the executive organs was carried out during any one period in the history of the GDR, the resistance by the establishment to new ideas in the arts could be strong or weak. Of course, within the theatre there were fluctuations in the overall professional climate, and among members at different levels of the institution.

Drama was a public and transient event occurring at regular intervals of time. The only other institution that could compare with the theatre was the Christian church in the GDR. The church, like the regime, wanted adherence to one belief that would justify its existence and set a pattern of behaviour that was right for everyone. The theatre, unburdened by the drive to find workable solutions, could afford to seek its core in the drama on stage, i.e. engage in a deconstruction of situations, to explore the contradictory elements, and to allow questions posed to remain without an answer at the end of the play. The church was unwilling to acknowledge the state as superior and to abandon its spiritual sphere, and the theatre not opposed to socialism, but unwilling to surrender control over its art. Despite these reservations, a *modus vivendi* was required. Just as the church had pastors at the grass roots who resisted socialism and sought social change and, at the same time, had leaders who made great efforts to reach an accommodation with the regime, so, too, the theatre supported controversial writing and drama productions, but had more than a sprinkling of members among intendants and internationally known authors and directors who sought favour with the regime. For the regime it was an advantage to know that politically awkward people working in the church and theatre were embedded in organisations in which they

exerted authority to guide careers and impose censorship. Secret observation of the church and the cultural sphere were assigned together in Department XX of the Stasi. This may have had some prescience in that the church and the theatres were both venues for public discussions during the revolutionary months of 1989:

> Not without reason was the theatre, apart from the church, the only institution which provided citizens with a forum for discussion in the run up to the peaceful revolution of 1989. Exemplary in this respect was the Staatsschauspiel Dresden. (*Die Deutsche Bühne* 1993: 14)

Institutionally, the Party continued to allow to exist within it a core of opinion, which held only to what had been the line of the SED or its Soviet equivalent before Honecker came to power. For instance, modernist works by dramatists such as Samuel Beckett were criticised as representative of late bourgeois decadence in the period immediately following World War II (Emmerich 1996: 81). This opinion remained influential and, thus, progressive shifts in the official attitude to the arts turned out to be less substantial than they had at first seemed. Changes introduced into the procedures under which the performing arts operated, such as the devolution from the MfK to theatre intendants in 1975 of any decision whether to ban unsatisfactory or controversial works, were often mere variations of the method of supervision. Other controls were often in the hands of functionaries who were generally neither well positioned to evaluate novel artistic interpretations nor sufficiently self-assured to become advocates for these within the cultural establishment. The special dilemma they faced in making judgements is exemplified in the following glimpse of a censor's concerns:

> Above all, he must possess a sense for the mood of the members of the Central Committee of the SED in order to be sure that he did not permit anything that would snub them or could cause a scandal. For cases he decided the censor could not align himself with any fixed, written guidelines. Rather, he was dependent on his experience, his feel for the situation and his intuition. Moreover, there was an understandable need not to put oneself in the firing line and jeopardize one's own existence. (Zipser 1995: 19)

Perception of what was performable on the stage, at least as envisaged by authors and theatre directors, was not a constant and the boundaries of the permissible were continually being tested:

> In contrast, for instance, with the Soviet Union, it was not possible in the GDR to make any precise criticism of society, the censor decided for overwhelmingly general, in principle and symbolically presented criticism. This ambiguous front-line, with its inexact criteria, could be pushed back and forth. Despite the watchfulness of the publishers [secretly and via the Party and leaders and superiors] they sought constantly to expand their room for manoeuvre. (Zipser 1995: 117)

Statements by Honecker and ministers and senior officials that appeared to support a flourishing of the performing arts were not necessarily followed by consistent detailed advice on how this desirable aim could be attained, save for a reiteration of the need for correct ideological orientation. For the GDR theatre, Kurt Hager, for instance, briefly laid down guidelines for its content in 1972:

> In our cultural policy, therefore, we are concerned with satisfying different cultural and artistic needs. So, for example, we require in the theatre the classic productions from *Hamlet* to *Faust*, the works of the great socialist dramatists from Gorki to Brecht, the contemporary socialist play. In a basic sense that applies to all the arts. (Hager 1982: 15)

On the one hand, the consequent lack of reliable criteria was hazardous for the officials who had to decide what could be performed. Thus, works initially encouraged at an official level might turn out to be offensive when viewed in different political and cultural circumstances later when they were ready for publication. On the other hand, the aesthetic vacuum in which censorship was exercised left room for arguments in favour of the writing and performance of new drama, e.g. for plays dealing with contemporary issues, in terms that were an artistic articulation of social and political dilemmas that were real and often unacknowledged, e.g. Kerndl's *Der Georgsberg*. Some professional critics, Martin Linzer for one, were concerned that the traditional ways of understanding the theatre were now hopelessly outmoded and that the lack of new yardsticks was a hindrance to an appreciation of the avantgarde. He acknowledged a risk involved in drawing on international experience to set new criteria: 'In addition we are affected by international ideas and often dubious 'models', it

is not always easy to decide in cases where the aesthetic stimulus smuggles ideological contraband' (Linzer 1981: 4). But the search to identify and underpin the authentic avantgarde remained important:

> My concerns are with other manifestations, with the fact that we do not yet always succeed in sorting out the wheat from the chaff, in recognizing authentic attempts of the avant-garde and supporting them; thus to patiently explain such experiments so as to enlist the understanding of the public, to protect the work from frivolous attacks. (ibid.)

The above is a generalised image of the situation in the GDR theatre in the Honecker era, during which the theatre explored the social and personal issues arising from the declared existence of a state of socialism rather than (as previously) those issues relating to the basic political impetus necessary for the initial formation of a socialist state. The GDR theatre also maintained a strong link with theatre culture in its broadest sense, and in doing so was cognisant of, or took on board, certain artistic currents of the post-1945 European and Soviet theatre. One development was a noticeable shift away from works and productions fashioned to suit the GDR's political agenda, and towards more enjoyment of the theatre for its unique qualities:

> In the 1970s and the 1980s the theatre in the GDR manifested ever more clearly its own internal and self-referencing structure of productions, a reaction owing less to cultural and political events and more to arguments about theatrical aesthetics. (Stuber 1998: 222)

For a relatively new state, the sources of drama are threefold: the drama of the state that has been superseded, the drama of other states, empires or civilisations who exert an external influence, or the creation of new drama. For the GDR these sources were in the main the classics of German drama, Russian and new Soviet plays, and the attempts by GDR playwrights to stage works of contemporary relevance. This section explores the roots of GDR drama, whether from tradition or the present, from indigenous or foreign sources. A newly created socialist state that despised bourgeois values and rejected inspiration from Germany's recent past, as well as being a Soviet satellite, would appear to have few roots. However, it will be shown that this was far from the case and that fruitful sources deriving from old

and new drama were found. Regarding the old drama, it is apparent that the survival of theatre with an appeal to the society in which it is performed depends to a large extent on the relationship that the output of the theatre forms with the experiences and hopes of the audiences. The presentation of drama as it may have been performed in earlier times is of interest to connoisseurs of the drama but has limited appeal to the majority of the public who visit theatres. The attempt at re-enactment is in itself informed by knowledge acquired since the original piece was put on the stage, so only an approximation to the first presentation can be guaranteed.

For all these reasons, drama of any tradition tends to be re-interpreted according to the era, and to the individual phase of an era, in which it is performed. It is possible to discern a difference of approach by dramatists in the Ulbricht and Honecker eras of the GDR, and also within each of these periods. Theatre development was influenced by both the cultural policies decided politically and changes occurring within the art form itself. For the drama of former times to flourish, some degree of re-interpretation for the present day is both inevitable and indispensable. The re-interpretation may or may not have political implications but to the extent that dramatists are the product of the society in which they live, which was precisely the situation among dramatists who had grown up in the GDR, any political input to the re-interpretation will derive from the experience of their own time.

Presentation of the classical drama of ancient Greece and Rome and the classics of modern world drama evolved in Ulbricht's time and continued throughout the Honecker era. Hasche suggests that in the 70s the emphasis was on the great works of antiquity that were, for censorship reasons, an easier alternative to contemporary drama, and which, through their interpretation on the stage, were shown to be relevant to the present-day GDR. Similar considerations regarding interpretation applied to the classics of German drama that were favoured in the 80s. Hasche, citing Reichel, asserts that in this decade these German works were viewed as assisting in the political aim of fostering a socialist national identity (Hasche 1994: 180). This periodisation has validity in general terms; examples of German classic drama are to be found in the 70s and to a lesser extent instances of the classical drama are to be found in the 80s.

That the humanistic tradition (for example, in the German context Lessing's *Nathan der Weise*) provided material for the practice of the art of theatre in socialism had been acknowledged and assimilated as part of the GDR canon from the founding years of the state (Stuber 1998: 229). Acceptance or the appropriation of the classics of humanism was re-iterated from time to time:

> In the early years of the GDR the classical and the classic – as always and everywhere – were self-chosen examples. It was their function to provide the GDR with historical continuity and authority and was intended thereby to help create political stability. (Stuber 1998: 233)

One reason why this appropriation took place with ease is that some of the best-known classics of German literature and theatre were inspired by the age of the Enlightenment during the eighteenth century, or were written or performed in the nineteenth century when the principle of the nation state of the German people was at its zenith. The resort to reason to elucidate all the problems of mankind, which the Enlightenment embodied, was construed as a forerunner to socialist realism, this new philosophy that would now transform into practice the humanistic ideals inherent in the earlier politico-cultural change in Europe. Because some of the nineteenth-century literature had associations with emergent nationalism, such literary works also provided a model for the arts in the GDR, in support of the new republic. The third Parteitag of the SED in 1950 called for the creation of a new democratic culture that built on the great German heritage of culture embracing humanism and democracy (Lauter 1951: 8).

In the 1950s and the 1960s the GDR had laid claim (as against any claims that might have been made by the FRG) to be the rightful inheritor of the traditional masterpieces of German literature – notably, the works of Goethe and Schiller. It was a selective process to extract material that accorded with the tenets of Marxism and Leninism. Walter Ulbricht declared in 1962:

> [...] that in the GDR the classic design would be 'developed' and explained, that the workers in the GDR would now write the third part of Goethe's *Faust*. According to Ulbricht, Goethe could not write this third part during his lifetime 'because the time was not yet ripe'. Only now, after more than a hundred years,

did the workers in the GDR begin to 'to write this third part of Faust through their work and through their struggle for peace and socialism'. (Stuber 1998: 229–230)

Whenever classic dramatic works were accepted into the canon of the GDR, the expectation was to use them as exemplary pieces. In the late 1960s new dramatists took a fresh look at these classics and enacted radical re-interpretations of the texts, presented them iconoclastically, and often emphasised the hitherto unsung sinister aspects and the pessimism in them. This display of negativity did not mesh well with sustaining a belief in the eventual inevitable triumph of a utopian communism. In 1968 an earthy and humorous version of *Faust* by Adolf Dresen and Wolfgang Heinz at the Deutsches Theater provoked debate at the highest levels in the regime. The SED castigated it as sacriligious because in its disrespectful and vulgar way it was an offence to the work of mankind (ibid.). Following a specially con-vened theatre congress and excision of the Walpurgis dream scene, the play started a popular run of five years at various theatres of the GDR. Significantly, the irreverent interpretation placed theatrical considera-tions above politically desirable outcomes, and was allowed into the public domain. Another production, of Schiller's *Die Räuber* in 1971 at the Volksbühne, directed by Manfred Karge and Matthias Langhoff, to a large extent reversed the importance of roles within the play through placing emphasis on the part played by the choir. In the mid-1970s and from then through to the end of the GDR other German classics were innovatively re-interpreted, as were classics of the Russian drama (ibid.).

It is a special quality of the performing arts that they are suited to engendering a new contemporary relevance in works of the past. The writings of Tolstoy, Dickens or Fontane, or the plays of Nestroy, are rooted in the social and political mores of the nineteenth century and the individual reader comprehends them in those terms. Drama or dramatisation brings fresh impulse from today's society, created by teams of people such as dramaturges, directors, stage and costume designers and actors. From the point of view of locating in classical drama a resemblance to current concerns, the contribution of actors, in particular, is acknowledged by Christoph Hein:

A completely current problem can be dealt with under the guise of Hamlet, for the connection with the present is formed by the actor, who is my contemporary. This is hardly possible, for example, in fiction and poetry, or in prose, since there the historical phenomenon is in the inner experience. (Irmer 2003: 304–305)

Dramatists derived inspiration from the past. In Marxist-Leninist terms, this was expressed in an article in *Sinn und Form* in 1973 about Plenzdorf's *Die neuen Leiden des jungen W.*:

That is the *sine non qua* of a dialectic theory of tradition: it understands tradition as a product of history that enters living literary creation, and as a productive moment of contemporary culture which roots itself in history. (Weimann 1973: 237)

The development of GDR drama can only be adequately understood when the influence of Russian and Soviet history and theatre is acknowledged. The Bolsheviks inherited a renaissance in the Russian theatre that began near the end of the nineteenth century. With their support and nationalisation of the theatres in 1917, it flourished as never before. 'The result in the first decade or so after 1917 was a flowering of theatrical art of a brilliance scarcely equalled in the history of any country' (Glenny 1977: 271). Glenny also points out that as a mass medium the Soviet theatre was better than the press because it was comprehensible to the not inconsiderable section of the population that was illiterate.

Actors were on the highest ration scale, had security and generous fixed salaries. Most theatre tickets were given away – an encouragement to the working class and the peasantry who poured into the theatres for the first time (ibid.). Whilst this idyll ended when Lenin launched the New Economic Policy in 1921 (ibid.), and the Soviet drama was severely repressed under Stalin, the avantgarde work of directors such as Vsevolod Meyerhold and the writer, Vladimir Mayakovsky, was never forgotten and was rediscovered by the German experimental dramatists of the Honecker era.

The administrative authorities in the Soviet zone of Germany after the Second World War stimulated the rebirth of cultural life in their zone through such acts as enabling the founding of professional

cabaret like the Distel ensemble in East Berlin, and did so partly to compete with the Western powers occupying the other zones, but principally in order to shape opinion and society as an essential element of their overall strategy towards Germany (Henckmann 1990: 60). The importance of culture as an arm of this strategy was maintained by the Soviets throughout the existence of the satellite state. From the end of hostilities Soviet culture had a definite profile in the Soviet zone and later in the GDR, though it was far from being the only external influence in the post-war years, when, for instance, the plays of Irish writers – Shaw, O'Casey and Behan, to name a few – were performed. At the Deutsches Theater, the intendant, Thomas Langhoff, preferred classical humanism, but after an article in *Neues Deutschland* in 1949 reproached him for having no Soviet plays in the repertoire, he was, under protest, obliged to conform (Stuber 1998: 40-41). The emphasis on Soviet culture was increased by the holding of a conference in Berlin in 1951 under the title 'Die Sowjetunion, das große Vorbild für die Entwicklung einer fortschrittlichen Kultur' and with the later much quoted slogan 'Aus den Erfahrungen der Sowjetunion lernen, heißt siegen lernen' (Henckmann 1990: 69). The Maxim Gorki Theatre specialising in Russian and Soviet drama was founded in 1952. From 1953 onwards the GDR journal *Kunst und Literatur* carried translations of Soviet experts' views on aesthetics in the realms of literature, art, music, theatre and film. Largely, the Soviet views were in the style of a debate rather than a strong single line of argument and the outcome was that these views were not weighty enough to overcome the awareness that the Germans had about their own culture, so little of Soviet theory percolated. Goethe and Herder were the great German theorists (ibid.: 70–71). The GDR cultural establishment was both the willing heir to the German classics of humanism, as described above, and the forced recipient of Soviet and Russian culture. The two were not incompatible. The Soviet empire was multinational. The Russian revolutionaries considered that the traditions of each nation should be encouraged with no conflict, and wanted to band these traditions together in a culture of socialist internationalism to set against Western cosmopolitanism, formalism, modernism and other manifestations of decadence (ibid.).

This link between national culture and the cultures of other nations in the Soviet bloc remained a centrepiece of socialist rhetoric. The Leipzig teacher and writer, Wolfgang Kröplin, wrote in reference to the period 1971 to 1984 that a socialist national culture proves itself all the richer and maturer the more it is capable of taking to itself the best of other cultures in order at the same time to add new quality to the development of socialist world culture (Kröplin 1984: 78). Such co-operation with other countries had been affirmed as a main principle at the eighth Parteitag. A research group at the Hans Otto Theater drama school in Leipzig examining the interaction of theatre cultures in socialist countries put forward the proposition that such interaction fell into three phases: that from 1945 to 1950 when Soviet drama had the lead, the second from 1955 to the end of the 60s when national drama came to the fore, and thirdly from the beginning of the 70s to the 80s when Soviet and national elements of the first two phases fused into better quality and organisation in both spheres through exchange of experience (ibid.: 80). The research group found that the balance between national and Soviet works then began to tilt in favour of the Soviet drama, augmented by plays from other socialist countries, mainly from Poland, and to a lesser extent from Romania and other countries of the Soviet bloc. German plays accounted for 33% of the GDR repertoire in 1969/70, falling to 24% in 1973/74 whereas the share of Soviet drama rose from 12% in 1970/71 to 22% in 1972/73 (ibid.: 81). This share remained substantial through changes in the nature of GDR theatre, which was characterised by interest in social problems peculiar to the advanced socialist society in the period from the mid-70s into the 1980s. In a retrospective and reflective survey of GDR drama the theatre historian, Peter Reichel, noted:

> The understanding of the function of literature, including that of drama, had considerably changed since the 1970s [...] the key term of 'Selbstverstän-digung' says something about the altered ways of communicating, it stems from a mature quality of producing and receiving subjectivity [...]. The entire artistic process is affected, such as the ease of the appropriation from the Soviet drama: a repertoire containing Rosow's Nest des Auerhahns [...] Gelmans Rück-koppelung would not have been possible a good ten years before. That it is so today is explained by literature and art turning to an internal socialist argument.

This, in turn, has originally to do with our whole social development, indeed, with the entry of the GDR into the phase of advanced socialism. (Reichel 1990: 24–25)

Irana Rusta, who examined Soviet 'Produktionsstücke' performed in the GDR during the 70s, considered that an aquaintance with Soviet drama was a prerequisite for research into the GDR drama. To a great extent Soviet drama determined the profile of the theatre of the GDR. In that decade over 200 Russian or Soviet plays were performed: at the Maxim Gorki Theater in Berlin every fourth play there since 1952 had been Russian or Soviet, as was practically every eighth performance in the theatres of the GDR as a whole (Rusta 1980: 8). The Henschel Verlag doubled its offerings of Russian and Soviet publications. Exchange visits between GDR and Soviet theatre ensembles increased and Soviet writers read their works publicly in the GDR (ibid.: 22–23).

The high proportion of Soviet or Russian drama stems from the defeat of Nazi Germany by Stalin's armies and the subsequent occupation of the eastern area of Germany and Berlin, during which the arts and drama were fostered; from the condition of the GDR later as a satellite state of the Soviet Union, which for most of the existence of the new state stationed around 300,000 troops in the country; and from acceptance in the GDR of the quality and relevance of the drama of the Soviet Union. The Soviets had developed their socialist theatre for more than thirty years before the GDR was founded. It had reached a maturity marked by the robust representation on the stage of the issues arising from the formation and progress of a socialist society, as illustrated by the plays by Rosov and Gelman mentioned above. Criticism of society was allowed, in contrast to the situation in the GDR. Members of the theatrical profession looked to the Russian classics of the nineteenth century and to twentieth-century drama in the Soviet Union for inspiration. Because the political and social problems dealt with in the latter corresponded to those being experienced in the socialist GDR, unlike in most Western drama, the audiences, too, were readily receptive to the Soviet experience:

The reason for the great impact of Soviet plays on German audiences resided in the similar structure of society, in comparable problems in substantially the

same ideology, and the mutual interests of the Soviet and the German public. (Runge 1981: 48)

Events such as a festival of international socialist drama held from 1972 onwards provided an annual showcase for Soviet drama and that of other countries in the Soviet sphere of influence. Audiences were appreciative. The GDR student of the social function of theatre, cited above, commented:

> The effect nationally of this international socialist drama on us, the acceptance by our public, originated in the first place from the socialist social and ideological explosiveness of the plays, from the imparted ability to transfer the problems handled to our own conditions [...] after many of the performances the spectators immediately discussed and argued amongst themselves about these problems based in reality [...] [it] manifested a specific possibility of direct social activation through the art of the theatre. (ibid.: 46)

Soviet plays did not always escape GDR censorship. In the 70s 'glasnost' tendencies were already apparent in the work of some young dramatists (Irmer 2003: 29). One of these, Alexander Gelman, wrote *Wir, die Endesunterzeichnenden,* about a Communist Party cover-up of poor management of a building project. It had to wait ten years until permission was given by the Ministry of Culture for a performance, with altered text, at the Maxim Gorki Theatre in Berlin in 1985 (Lennartz 1988: 12). The intendant considered the new drama in the 'glasnost' era of the Soviet Union to be a completely new drama dealing only with current social issues (Irmer 2003: 31).

Contemporary critical drama was not the only type of drama in which the Soviet Union provided a template for the GDR theatre professionals. The classics of pre-revolutionary Russia, e.g. plays by Gogol and Chekhov, were well respected. 'Official Soviet high culture under Brezhnev was something of a conservative, middlebrow version of what Soviet leaders imagined to be the bourgeois high culture of pre-revolutionary Russia' (Tomson 2003: 100). In the GDR the reworking or adaptation of these classics to fit a GDR context sometimes resulted in the creation of new works, e.g. *Revisor oder Katze aus dem Sack* by Groß and *Die Übergangsgesellschaft* by Braun. In a society in which much was copied from the USSR it is no surprise that the same occurred in the field of drama. Both Gogol's *The*

117

Government Inspector and Chekhov's *Three Sisters* were frequently performed. The two plays derived from these were not purely imitative, and Braun's play was by no means a pastiche.

The sources above allowed the GDR to tap into a heritage of drama, nationally and internationally. They were in themselves, in the mode and setting of their origin, insufficient to provide the GDR drama with a distinctive lustre deriving from the GDR's own identity as a German socialist state, a state whose leaders yearned for internationally recognised sovereignty and prestige. Reliance on German classics, and on the Russian and Soviet repertoire did not, on the whole, help to form the image of a unique progressive state drama. They did contribute stage material suitable for moulding the socialist personality, but they fell short of being a reflection of the achievements of the GDR or of all the special problems that the new state was encountering. There was a strong desire on the part of the leadership and the cultural functionaries to see more drama originate within the GDR. For the theatre professionals, too, a repertoire that was not refreshed by new work was unsatisfactory. The creation of such drama was a more difficult objective than one might expect and the difficulty arose from a combination of factors that included the GDR regime's notion of contemporary drama and the innate nature of the genre.

The message contained in Honecker's speech to the eighth SED Parteitag about the freedom and diversity possible within the socialist framework for the arts was carried over into GDR theatre as a requirement for a creative quest for new possibilities in the drama, for a wider and more varied repertoire and means of presentation, so as to better satisfy the real needs of the audiences. Uncertainty over how this remit was to be fulfilled led to the development of conflicting ideas on how to achieve the aims. Some theatres envisaged a greater emphasis on providing entertainment as opposed to imparting political doctrine, others saw the opportunity to improve the effectiveness of drama through the performance of more provocative works. This state of affairs was examined in an internal position paper of the cultural department, of the SED in 1974, which was concerned with problems in the development of contemporary socialist drama (SAPMO-BArch, DY 30/IV B2/9.06/66). The genre was superficially attractive because material about the present day was at hand. Turning this material into

drama of acceptable quality was quite another matter. Conflict and contrast are the very stuff of drama, but the SED wanted only resolvable conflict to be shown, i.e. dramatic effect which flowed from non-antagonistic problems but which allowed the theatre art to flourish (ibid.: I.3). A cardinal problem identified in the report was uncertainty about the degree of 'sharpness' in staging conflict or contradiction.

New drama drawn from the present day had to compete with what tradition could offer. Human conflicts and problems had been the stuff of drama of the past, which had sometimes been created by playwrights of genius. A special feature of the performing arts was that a new production and fresh performance of a classic would potentially endow the content with extra contemporary relevance. Similar considerations applied to mythical or historical material which had not been interpreted in dramatic form and was now viewed in the light of later experience or research and with modern insight. Christoph Hein, when asked why he liked to work with old material, explained that playwrights from antiquity onwards, even Shakespeare, had frequently chosen to set their plays in the past:

> To bring one of today's problems to the stage, I can really just play *Hamlet*. That is one of the great possibilities that drama and film have. Through that, and by means of a production, a translation takes place, I can tell the story with precision. I do not need any new material. That is, of course, tragic for contemporary authors, they are not, or only rarely, used. (Hammer 1992: 229)

In Hein's case, he had become adept at writing plays set in periods whose problems or upheavals were pertinent to the political situation in the GDR but could be written about without patent allusion to what was currently happening in the GDR. There is a particular twist in *Die Ritter der Tafelrunde* concerning the legendary court of King Arthur. The best-known stories about the court are those describing the valour and chivalry of the knights. His choice of the court in ultimate decline only heightens the contrast with its former glory. Audiences could hardly fail to reflect on the loss of former ideals demonstrated in the play and relate that to the GDR of the 1980s.

The SED report above was ambivalent regarding the wish for plays of contemporary resonance in the sense that topicality on the stage was regarded as having certain drawbacks. From the standpoint

of creating well-thought-out drama a certain distance from the present was usually beneficial. This had implications for the quality of work in the GDR theatre, and a delay might also be convenient on political grounds: 'Contemporary drama being one of the most difficult genres of literature obviously requires longer and more effort, until social changes find their resonance in artistic creation' (ibid.: 3). Contemporary work could and did fail for both artistic and political reasons. The latter could be cloaked in the former. Equally, judgements based on both criteria could be justified, as seems to have been the case for Kerndl's *Der Georgsberg*. Kerndl addressed taboo economic and political issues quite directly, but the play was also faulted for the quality of the drama.

Conditions in the GDR theatre, by way of management, organisation and liaison, also affected the fate of contemporary drama. Agreed criteria to which cultural officials and publishers of drama could work were lacking, there were no concepts or working practices around which co-operation with the artists' associations could take place. There was too much compartmentalism among the supervisory bodies. In the SED report (SAPMO- BArch, DY 30/IV B2/9. 06/66) it was urged that all theatres take their responsibility for contemporary drama more seriously, especially in discovering new authors, staging their plays and following that up with further support after the works had been performed, in order that the plays were taken up by other theatres. This problem had been identified a couple of years earlier by Rainer Kerndl, the chief drama critic of *Neues Deutschland* and himself a writer of plays. He recalled plays that had received only one performance: 'And if I think of it, I think of the self-opinionated and superficial way these plays were prepared for performance and then consigned to the fate of a nine-day wonder'. (Kreuzer 1998: 269)

He was concerned that productions which enjoyed critical acclaim failed to reach a wider public and wondered whether new plays were only of interest when a theatre could stage the first performance (ibid.: 270). To overcome the difficulties, the SED report mooted the idea that some theatres should take on the task of specialising in performing new work.

The situation of playwrights in relation to the ensembles and in the manner of their remuneration caused problems in the development

120

of contemporary GDR drama. The dramaturges, actors and directors were state employees who were paid regardless of the public reception of their productions. The writers were commissioned for specific plays and remunerated under a system of royalties related to performances of their works. The playwright was thus the only person who depended on the size of audiences for an income. Better conditions were to be obtained by writing for film and television (ibid.).

Ten years after the SED report was made, the problems with contemporary drama proved to be far from over. A press notice about developments in the theatre prepared for issue by the Foreign Ministry in 1984 noted:

> A special importance attaches to contemporary work. Here the effort is made, on the foundation of socialist realism, to perform more and new plays addressed to the workers and which leave behind an effect of help to them. In this way a greater variety of content and form should be attained and narrowmindedness overcome. Despite a string of positive results, the development in this sphere overall is still unsatisfactory. (SAPMO-BArch, DY 30/ vorl.SED 32803)

The press notice appears to have been too forthcoming about the deficiency and to have been the subject of second thoughts. The file copy indicates that it was withdrawn.

In writing for the theatre, the dramatist faced the triple jeopardy of the text having to be approved before rehearsal and again after rehearsal, as well as the possibility that the play would be banned after the initial or first few public performances. His experience of the hindrances caused Christoph Hein to condemn the whole procedure. Some writers, like Volker Braun, whose works took years to reach their public, patiently pushed forward with other projects in the meantime. A few writers, like the drama critic Rainer Kerndl had other paid occupations.

Lacking the legitimacy of classic tradition or an imprimatur as a product of the USSR, GDR contemporary drama was quite vulnerable to adverse comment from all quarters. In the SED particularly there was a measure of distrust. Criticism was easily sparked, and the criticism came both from genuine conviction that there was something wrong with the work being staged, or was intended as spiteful and mischievous, or from a mixture of these sentiments. It was sometimes

expressed openly in reviews, as for *Die Übergangsgesellschaft*, in publicised statements by local SED functionaries as with *Revisor oder Katze aus dem Sack*, or in secret behind the scenes as occurred with *Die Ritter der Tafelrunde*, or anonymously in Berlin as happened to *Der Georgsberg*. Individual members were also watchful and zealous – one example is set out below:

> A discussion with comrade Karl-Heinz Hafranke [Cultural Department of the Central Committee] revealed a convergence of our views. There is in fact a sort of fashion trend in our contemporary drama, with exaggerated exhibition of misbehaviour, conflicts and other negative manifestations [including many murders and suicides] supposedly educational and seeking to influence our socialist society by artistic means. That passes for an intended 'connection with life'. They rely partly on Maxim Gorki who accorded art the right to show the extremes of the good and the bad. However, nowadays only the bad is found on the stage, so the real picture of socialism in the GDR is distorted. (SAPMO-BArch, DY30/IV B.2/9.06/66)

Seen from the point of view of the management of GDR theatres, the problems besetting contemporary drama were to a substantial extent caused by the failure of society to give the writers of plays and members of the ensembles the support required to enable them to be successful. This difficult situation persisted into the 1980s. During a national conference in 1980, the Generalintendant of the Städtisches Theater Leipzig, Karl Kayser, took the opportunity to point out that the responsibility for ensuring the success of contemporary drama did not belong exclusively to theatres. Such drama was needed to help build up politically engaged ensembles and avoid an impoverished and dull repertoire. Contemporary drama needed audiences, but the support they gave was not synonymous with the support from socialist society. A genuine need for such works had to be fostered by the GDR theatre and its social partners. For instance, plays that dealt with social problems normally not discussed in public became, by default, vehicles for the ventilation of dissent by their audiences. This led to political sensitivity over negative images of reality making theatres unsure of their ground. A more robust attitude toward public reaction was required as well as effort to promote the plays. In Kayser's opinion, consistency of cultural and political policy was vital, contemporary drama should not be performed in one town when it was not

permitted in another. He asked that comrades should not heed rumours while a play was in the preparation stage for production, nor judge it until the final rehearsal. He said that the tolerance shown to contemporary art should be extended to the theatre (*Material zum Theater* Nr. 140/1980).

His remarks were particularly significant since the Leipzig theatre, along with that in Rostock, was where contemporary foreign drama was tried out to see whether it was suitable for general performance in the GDR. A consequence of this task was that the two theatres sought out drama that they wished to screen. Both sought to perform work by Samuel Beckett but their requests to stage *Waiting for Godot* were turned down by the Ministry of Culture. Nevertheless, knowledge of and interest in Beckett's work was widespread among theatre folk in the GDR, and the imitations and adaptations of it show that, by the 1980s, such avantgarde drama was appreciated by leading socialist intellectuals, and performances became a matter of cultural prestige. There had, in fact, always been a place in the GDR repertoire for certain modern foreign drama, such as American, British and Irish plays about social conditions, through which audiences were treated to a display of the shortcomings of capitalism. As GDR theatre professionals divested themselves of strict adherence to socialist realism they began to become involved in experimental drama, drama that was tolerated so long as it happened in obscure corners of the country.

The trend towards a higher regard for the theatre's unique qualities increased. The art of the theatre, and also its position vis-à-vis other art forms became a focus for discussion.

The conventional line, i.e. there is an inherent meaning in the text, that directors and actors are subservient to this meaning, or to the intentions of an author, if he states them, partly yielded to other views. Certainly, it did so in respect of any idea that the status of a text was higher than that of a performance. In comparative aesthetics the opinion was taken that a dramatic text was not a finished product such as a poem or a novel, but one phase in a transformation, consisting of several other phases. The verbalization of a dramatists's idea begins through dialogues and stage directions, in turn interpreted by a director who develops a concept for performance. The concept is transformed into a concrete mise en scene during rehearsals with

actors and the final stage is reached when the actors present their work to spectators during a performance. In this process the creative activities of the author and of the performing artists are to be considered of the same value; they need each other to realize the performance for which the text is written, to transform the words on paper into an audio-visual event on the stage.

It is argued, therefore, that dramatic art as a process of changes differs in this respect from all other arts. Changes in an architect's creation may forever violate his building, the same applies to a picture, or a novel. The changes that are made to transform a dramatic text into a performance are of a temporary nature, lasting only as long as the series of performances are played. They leave the text on which they are based uninjured, ready to be performed again in other, and again, different vesions (Buning 1992:149).

In a GDR dissertation about the press and the theatre, the distinctive nature of 'Theaterkunst' is formulated. Not only is the art of the theatre different from literature, but it is also an art that binds other art forms together:

> Contemporary drama as one of the most difficult genres of literature clearly required longer time and greater effort until the social changes found their expression in created art. Moreover, theatre art is a 'synthesising art' because within it, next to the acting, sister arts are involved [in form of drama, scenery, costume, music, dance, pantomime], involved in the achievement of the unified art of theatre. Its specific material is not the word [as in drama], the art of the theatre must deploy all the resources at its command, word, gestures, facial expression, musical tone, spatial design, light, elements of acoustics etc., in order to produce the unified work of art in a stage production of form and content. (Frotscher 1979: 17)

Drama has employed only one structural material, namely language, whereas 'Theaterkunst' makes use of the material of several arts according to need and herein lies the potential and the responsibility, especially the task of the director, to create a synthesis of the sister arts when developing the production of a play. The stuff of 'Theaterkunst' is man himself, who through his senses and artistic abilities by means of voice, mime and gesture and the assistance of the sister arts, brings the whole into a theatrical presentation. 'Theaterkunst' expresses itself principally through living images from historical or

124

invented happenings among people. It achieves visualisation by means of characters, played by persons who have an effect upon others, and the characters are shown to achieve impact only in relationship to other characters. These particular relationships, conveyed by the players, at the same time reflect social relationships (ibid.: 18–19).

The role of the director in theatre development was certainly significant in the GDR. Mention has been made of the work of Benno Besson at the *Volksbühne* in crossing the divide between stage and audience, and Christopher Schroth was responsible for the series of 'Spektakel' days in Schwerin. Directors were instrumental in the changes that ensued as commitment to the SED orthodoxy among theatre professionals waned during the late 1970s and in the 1980s, and more experimental theatre was undertaken, much of it by a younger generation of directors, such as Jo Fabian and Frank Castorf, who formed and led new ensembles in small provincial town theatres, or by established intendants or directors who, like Gerhard Wolfram and Wolfgang Engel, had sufficient standing and the political acumen to persuade the authorities to allow works of the avantgarde into the repertoire. Engel directed the first GDR performance of Beckett's *Waiting for Godot* in Dresden in 1987 after Wolfram had obtained the personal assent of Kurt Hager (Interview, Baker/Engel 5 December 2002).

Aspects of the work done by Fabian and Castorf illustrate the late advent of avantgarde theatre concepts in the GDR, typical by reason of the specificity and autonomy of the drama and by the way it overcomes and dissolves the limits of reality. In his productions of the latter part of the 1980s Fabian exhibited extreme artificiality and aesthetic stylisation. His work centred on variations of myths that were far removed from reality, he explored fundamental relationships between movement and space, the transforming effects of light and shadow, or the tension between music and silence. He tried to show the immaterial world and experimented with the techniques that placed beginnings and endings, space and time in paradoxical apposition. He was radically innovative and his work had little to do with everyday life:

Fabian protested against reason and understanding, showed the tension between technology and nature with film sequences of the one, and lively animals for the other. He broke the texts – which were mostly his own – into pieces, he cited texts and images from other contexts, let speech run backwards and in foreign tongues. With acerbic exactitude he constructed for GDR audiences of the time a still relatively unusual, self-referencing system of imagery. (Stuber 1998: 242)

Frank Castorf was also interested in the theatre freeing itself from old forms but his productions were not confined to aesthetic development and included the chaos of the everyday. They drew upon both the social and theatrical experience of the GDR and on current political situations. He took account of the qualities of his actors and their capacity for improvisation. He constantly altered scenes. His work had connection to reality at the same time as he sought to infringe and violate the time-honoured constraints of the art (ibid.: 243–244). He was eclectic:

Castorf did not tie himself to any single artistic concept, but staged and mixed together the different historical theatrical models. He viewed his theatrical work as being in the tradition of Brecht, and of Stanislavski. He concerned himself with Einstein's theory of montage, with Russian formalism, as much as with German expressionism or Dadaism, with Beckett or Pina Busch. (ibid.: 243)

It is hard to know how Castorf was able to make progress with putting his ideas into practice on the stage when they were so clearly radical. Hasche records that Castorf did experience disagreements with theatre management in the early 1980s, becoming unwanted in Brandenburg and taking up the post of Oberspielleiter in Anklam where he was able to work with the ensemble without restriction. Supervision of the theatre in Anklam was in effect in the hands of the SED district council for the Neubrandenburg area. These local politicians and functionaries did not register any views concerning the quality of Castorf 's work:

The authorities fought shy of delivering a considered view. Directorial conceptions were not required, still less examined. Furthermore, the stages, without being out of the way, were not mentioned by the local or regional press. (Hasche 1994: 192)

This is one case showing that the absorption of avantgarde practices into GDR theatre occurred at the same time as uncertainty in cultural policy during the 80s, the uncertainty resulting in either obstinacy or hesitancy among local decision-makers. Avantgarde work in the 70s and early 80s by directors who had defected to the FRG was seen by their peers in the GDR as important and interesting, but through the achievements of its own directors the GDR had, by the end of the 1980s, assimilated the previously excluded twentieth-century theatrical developments and was now part of an increasingly unified culture in which the differences in national theatre history were left behind. Art and politics were also converging, as illustrated by the Dresden production of *Waiting for Godot* in 1987 approved on grounds of cultural prestige for the GDR. It is hard, however, to escape the irony that what was being celebrated was a product of the immediate post-World War II existential drama, whereas the avantgarde in the GDR of the 1980s was struggling as a fringe activity in small theatres in the provinces.

Chapter Four
Only one Stone in the Mosaic:
Die Übergangsgesellschaft

The last decade of the GDR witnessed a spate of works reaching the stage whose theme was the problems and conflicts of contemporary society. Some of this was in the familiar form of 'Produktionsstücke', i.e. plays built around the organisation of labour, but new drama following on from Plenzdorf's *Die neuen Leiden des jungen W.*, written by a new generation of playwrights, took a moral stance towards the everyday difficulties of life for the young in a society where a strong contrast existed between Marxist rhetoric and prevalent careerism and consumerism (Emmerich 1996: 352–353). Whilst bourgeois attitudes were seen to be outdated, new social behaviour was often based on ruthless self-interest. New plays by authors such as Jürgen Groß, Ulrich Plenzdorf and Rainer Kerndl eschewed affirmative realism and examined balefully or satirically everyday concerns. However, Emmerich considers these works to be rather intimate, narrowly conceived sketches of a small country when ranked against Braun's more radical achievement:

> How much more moving reflection and distress on the part of the spectator was possible if the prevailing conception of the GDR was historically broken and made quite aesthetically unfamiliar, is shown in Volker Braun's *Die Übergangsgesellschaft*. (Emmerich 1996: 353)

The interest in Braun's *Die Übergangsgesellschaft* lies to a large extent in the circumstance that this was a politically sensitive work which attracted criticism but which nevertheless escaped censorship by state organs and was not banned following its premiere in the GDR. Volker Braun had experienced difficulties with the authorities prior to the production of *Hinze und Kunze* in 1973 in Karl-Marx-Stadt, and had also suffered a ban on *Guevara oder Der Sonnenstaat* in 1975. In reply to a question during an interview asking how far a

developed social system could tolerate censorship, he said that he agreed with the view that in politics, for reasons of humanity, it was necessary to compromise, but, he argued, it was impossible to do this with literature. (He would have been aware of Christoph Hein's speech demanding abolition of censorship). Nonetheless, Braun argued that an understanding of what society expected was required:

> What is required is the development of a general understanding as to what society itself expects of literature. I know from the view of the responsible minister how to alter the usual procedures so that the publishers do not need to submit the manscript and the observations, but only a justified application to publish. (Braun 1998: 564)

The author was really part of the GDR cultural establishment. He was close to Klaus Höpcke, the minister with most responsibility for censoring, and who almost lost his job through his support for *Hinze und Kunze.* (Wichner 1993:12). Because Braun enjoyed the confidence of senior figures in the GDR and was sensitive to their concerns, he felt he could circumvent the usual procedure by writing material that would not suffer interference and which would be judged fit to print. If that did not prove to be the case and the permission to publish was withheld, he had a publisher waiting in West Germany. It was also possible to find directors in the FRG to perform the plays. Braun's strategy was a factor, but not the only one, that contributed to the successful staging of *Die Übergangsgesellschaft.*

This was written over the period 1980–1982, after Braun had seen Thomas Langhoff direct Anton Chekhov's *Three Sisters* in 1979. *Die Übergangsgesellschaft* is a transposition of Chekhov's characters to a transitional phase of 'Übergang' in the GDR somewhere between the 'real existing socialism' of the Honecker era and the attained Utopia of the ideal communist state. The play reflects a mood in the early eighties when the hopes for a fresh start to creating a successful socialist society, which had been aroused by Honecker's advent to power, proved to have been misplaced, and disillusion had set in. As Emmerich comments:

> Certainly, no other GDR play has, in the form of literary parody, under the cloak of historical reminiscence, so vividly illuminated the transitional society

130

of the GDR as having arrived in the cul-de-sac of permanent stagnation (Emmerich 1996: 240)

Braun was attracted by the problematic family constellation in *Three Sisters* and became interested in how they might act in a modern setting (Kranz 1998: 554). He transplants and transfigures the characters of the Chekhov play into the GDR. Irina, a telephonist has her birthday at home with her sisters Olga, a teacher, and Mascha, who works as an historian. They had lived in Moscow 11 years previously where their father was in exile from the Nazi regime and later became a senior official in the GDR. The sisters appear at first as lifeless forms wrapped in gauze and come to life as citizens of the GDR of the 1980s. Irina's uncle Wilhelm, a former fighter for republican Spain, gives her a present of a globe that she fails to appreciate because she has no freedom to travel abroad. Her brother Walther comes to stay, bringing his actress wife Mette. Mascha is unhappily married to Dr Bobanz, a theorist of capitalism. Paul Anton, a friend and an intellectual, is a prospective buyer of the family's suburban villa. Mette inspires a game in which each of them imagines they have an aeroplane that will take them to wherever they would like to be. The ensuing expression of longings and illusions, from travel to self-discovery, contrasts strongly with the reality of their lives. Wilhelm brings them back to earth; he reflects bitterly on the ideals that are fading, and on the point of dying declares that the revolution can never succeed as a dictatorship (Braun 1988: 17). As they leave the villa, it goes up in flames, perhaps indicating a break with the past, and possibly new hope for the future.

Braun and his director for the play, Thomas Langhoff, were interviewed about the play in 1990 by Dieter Kranz (Kranz 1990: 554–562) when Braun admitted that one reason for his interest in writing a play of this title was that Chekhov's characters in the *Three Sisters* invested their hope in the future and did nothing to realise those hopes in their own lifetime, whereas, now, people were not content with the feeling that the better world might somehow come about. According to Braun that indulgence had been replaced by a more realistic attitude, basically that if things do not happen now then we have no way to experience them (ibid.: 555). In this sense there

had been a transition to a new way of thinking, sociologically and historically. Langhoff confirmed that a rejection of quiescence when confronting the future was reflected in the acting: 'The despair, comparable to that in Beckett's *Waiting for Godot,* found in this Chekhovian use of the term "Moscow" is no longer there, but exactly the opposite' (ibid.: 559).

Braun went on to speak of other transitions found in *Die Über-gangsgesellschaft,* namely:

> The transitions of attitudes which one, as if by habit, admires and which, per-haps, when more closely examined, change into another position. The whole piece shows these transitions. (ibid.)

He states that in the play these questionings of attitude introduce the persons concerned to new spiritual or moral landscapes and lead to the changing over from one partner to another. The emphasis is on the playing out of the relationships between individuals who, it is envisaged, will realise that the way to face the future is through changing attitudes. Another aspect of 'Übergänge' that interests Braun is a transition from one view to another among members of the audi-ence, the change in the attitude of the audience occurring during such an evening. (ibid.: 556). It is significant that Braun deals principally with these transitions in their historical, literary and the social dimen-sions. The political aspect is touched upon only briefly:

> Well, perhaps in the last instance the title bears such meaning. It would be neither a good nor a rewarding title, if it only attached to such a political term. (ibid.:555)

It is understandable that Volker Braun, who had been a Party member, would not wish to say anything politically provocative about *Die Übergangsgesellschaft.* However, the title could be, and surely was construed as a description of the GDR. In 1981 Honecker had an-nounced that in the 1980s the GDR would create the advanced socialist society and the conditions for a gradual transition into com-munism. (Weber 1999: 318). This promise of advance in socialism and a slow step towards Communism suited a regime that clung to power and was not hurrying on to the Marxist-Leninist goal of a

132

classless society in which the Party and the state organs would become superfluous. Indeed, a growing social and economic inequality was already evident and the leading role of the SED was set to grow rather than diminish (ibid.). The transitional condition of the GDR could therefore be criticised by those loyal to Communist ideals. *Die Übergangsgesellschaft* showed the need to break old habits and think anew if society and the lot of the individual were to improve; and it was not the only work of its kind.

Braun was one of the GDR writers kept under watch by a cluster of Stasi informers who got wind of the piece in 1983. A report was made that showed how close they were to him and his work:

> In his latest draft *Die Übergangsgesellschaft* or *Die Schwester* he writes regarding his own position as an author: literature has only one sense, to strip away that which the ideologues have fabricated. As long as their school of thinking rejoices, literature must stand its ground on behalf of that fine consciousness that has cost us so much. I would prefer to create a man from clay, but according to whose image? I am a demolition worker, war to the palaces! (BStU MfS HAXX ZMA 20015)

Hauptmann Muck of Hauptabteilung XX noted that the intendant at the Deutsches Theater did not think the play suitable for performance at his theatre, nor was his opposite number at the Berliner Ensemble any more confident about putting it on there. Manfred Wekwerth did, however, set up a working group to render the play performable in the GDR (ibid.). That task proved interminable, so the first performance took place instead in West Germany, in Bremen, in 1987 (Hensel 1991: 84). No theatre to perform the work could be found in the GDR until Langhoff revived his production of *Three Sisters* in Berlin in 1988 when his ensemble, by dint of playing the Russian characters that Braun had adopted, was well suited to perform *Die Übergangsgesellschaft*. In proposing it for performance at the Maxim Gorki Theater in March 1987, the intendant pointed out that while both *Three Sisters* and this work had the search for the meaning of life as a theme, Braun's characters are involved in the existential contradictions and conflicts of their time as well as being similar to the dramatis personae in the Chekhov play. Braun allows the sisters to experience the future in which they are different but the same.

Chekhov's tragicomedy becomes a comedy of the present day. The comedy lies in the somewhat inconsequential behaviour of the individuals, who are to show the way forward to a new pattern of life. They are a group of disappointed idealists of different sensibilities through which the author expresses the complications and problems of society and emphasises the links of the present to the past and to the future. The flight of fancy they act out on the stage brings the characters out of depression; it makes them realise that fantasy and curiosity are legitimate too, and asserts their completeness as thinking, active and emotional beings (ibid.: 5). The burning down of the house in the final scene marks a new beginning and an end to self-destructive 'Weltschmerz':

> As in Chekhov, so with Braun, in the polarity of the questions the characters continually pose, in their radical and painful honesty, in the tracking of the characters' lifetime set between reality and the ideal, lies hidden the positive answer about the meaning of life, that in our era has received so much new hope. (ibid.: 5)

The submission of the text, and the reasons for its inclusion in the plans of the Maxim Gorki Theater were, among other procedural matters, the subject of an interview with the intendant, Albert Hetterle, and the dramaturge Lilo Millis, which was conducted by Erika Stephan in 1991. *Die Übergangsgesellschaft* was even then in the repertoire. The interviewees explained that since the 1970s new plays had to be approved by the Ministry of Culture in addition to receiving the consent of the Berlin Magistrat. In seeking these approvals they said they sought to work through an informal network of cultural officials in both organisations who were known to be sympathetic to their type of critical contemporary drama:

> We never took the precise bureaucratic path, by observing the regular procedure, but sought out allies who understood contemporary literature and drama, and the workings of the theatre. (Stephan 1991: 2)

In this case the most important local discussions were with the cultural department of the district council (ibid.: 4). The rehearsals, particularly the last, were usually attended by the intendant and the dramaturge, and the author and the director were not asked to join the

discussions. The required approval was not put in writing since written answers were no longer important when there was verbal agreement and the understanding continued throughout the rehearsals (ibid.: 4). However, the ministry's agreement to the premiere was transmitted in a letter sent to the intendant by the Berlin Magistrat on 16 November 1987.

The intendant remembered two of the specific objections raised during the discussions. Wilhelm's political leaning seemed to be anarchistic, to which the reply was made that it was better to portray a resolute communist anarchist rather than a weak character as an anarchist. The house going up in flames seemed the opposite of a happy end, but nevertheless the intendant recalls that officials eventually accepted that the desired optimism was to be detected in the light in the eyes of Irina at the start of her new future (Stephan 1991: 2).

The intendant was in a unique position to judge the audience reaction at the premiere on 30 March 1988 as in addition to his usual responsibilities he was on stage playing the role of Wilhelm. He noticed, he recalls, suppressive tendencies at work:

> The reactions there below were nearly all subdued, only rarely a burst of liberating laughter that was swallowed as soon as it began. How would the neighbour react? Most people knew one another. It is very difficult to describe, such a depression, such a weird tension, while some reacted in a strained and indignant way, the others who had a normal reaction at once suppressed their impulse – after all, it could have consequences. (ibid.: 4–5)

At the close, a whole line of invited guests rose up and went out banging doors on their way to the exit. Subsequent performances were better received and the ensemble was able to take the production on tour to West Germany. In the following year or so theatres in Dresden, Leipzig, Weimar and Cottbus brought *Die Übergangsgesellschaft* to audiences in the provinces. In Cottbus SED functionaries made difficulties and the theatre ensemble there were obliged to revise their programme pamphlet and to do without posters.

Another troublesome incident had occurred after about ten performances at the Maxim Gorki Theater when a letter of complaint was sent to Erich Honecker by a biologist. The letter was passed down the line to the desk of the dramaturge who then invited the

complainant for a discussion at which the biologist elaborated on her views about the lack of a positive perspective and the unjustified criticism of the state. There was no meeting of minds and the play continued its run (ibid.: 5–6). The fate of the play was not beyond doubt. Intrigue and disparagement needed to be countered with resolute defence. Hans-Peter Minetti, now an eminence grise of the theatrical profession, records the threat in his memoirs: 'There was no shortage of controversial statements, and to that extent, there were sufficient grounds for those who wanted to ban further performances of the play' (Minetti 1997: 307). By the end of 1988 *Die Übergangsgesellschaft* was in peril of a ban. To avert this Minetti used his authority as member of the Central Committee and chairman of the theatre association to mount a defence of the play at the seventh Plenartag. The situation was critical since such a ban would set in motion the collapse of other drama productions. Before delivering his speech he consulted Albert Hetterle the intendant who had acted the role of Wilhelm, the veteran, outspoken communist and mouthpiece for some of Braun's more controversial aphorisms. Minetti praised Honecker's anti-fascist past, his conduct during imprisonment in Schergen where, in the tradition of Thälmann, the prisoners argued their point of view with their jailers. He emphasised the importance of the capacity to convince others through political discussion (Minetti 1997: 311). If ideology was inward-looking it would lose its attraction for young people, if problems were not detected neither could they be solved nor become the driving force of social development. Theatre was exactly about the working out of conflict through which audiences encountered views contrary to their own. He then referred to the character of Wilhelm Höchst for whom he expressed admiration. By inference *Die Übergangsgesellschaft* was also laudable. Minetti's speech, which dealt with other thorny issues, did not receive huge applause but most of it was later published in *Neues Deutschland*.

According to Thomas Langhoff, who directed *Die Übergangsgesellschaft* and who had discussed it with Kurt Hager (Braun 1988: 563), there was indeed a campaign against the play, but it was his view that the risks of it being taken off were exaggerated:

After the premiere there emerged an incredible chain of intrigue against this production. One must see it as a positive and new element in the GDR that these attempts to ban it were shot down. The production was never in imminent peril, and that is a novelty, and I am glad. (Michael 1989: 167)

Generally the GDR press acknowledged that transposing Chekhov to the present day was ingenious, and many of the observations were about the differences between his work and Braun's new play. Braun's text was considered rather high-flown and controversial, but the importance the author attached to the development of individuals for progress in society was recognised. Most critics referred to the novel device of the flight of fancy, the 'Flug'. There was praise for the cast, especially Albert Hetterle as Wilhelm, and for the director. The substance of the play and Braun's supposed message were the subject of mixed views but there was no disagreement about the huge applause at the end of the first performance. The critics' perceptions of the message from Braun about a society in transition, an 'Übergangsgesellschaft', and how they come to identify Uncle Wilhelm as the key character of the play, are examined further below.

The message about society is the object of comment in three respects: the nature of the characters and the 'GDR' society in which they find themselves; the 'Flug', especially its after-effect, as an agency of transformation from frustration to fulfilment; and the lack of compromise in Braun's views. An article in *Neue Zeit* on 4 April 1988 asks whether the characters, who are shown to be feeling that they are not getting all that they could from life and have become disillusioned, resigned, also sceptical and sometimes outright cynical, reflect the outlook of people, particularly intellectuals in the GDR discontented with themselves and with their surroundings, but incapable of changing anything. If so, are the causes personal or societal, or a combination of both? His linking of the characters to the condition of GDR society is not followed by the theatre critic of the *Sächsisches Tageblatt* on 8 April, who mentions that Braun opens the play with Chekhov's question: why are we when we have scarcely started life bored, grey, uninteresting, lazy, indifferent, useless and unhappy? He also reminds the newspaper's readers that it is a theatrical experience, not reality that is being discussed. The idea that theatre is a replication

of actual events on a stage was common among GDR commentators, but understandable in the light of the cult of 'socialist realism' and the political and social functions allocated to the theatre in the GDR. In a play that presents a depressing state of affairs in the GDR, commentators of that country's intellectual class might well consider the play's representation as indicative of their own and their readers' participation in contemporary society. Writing in *Theater der Zeit*, the drama critic, Ingeborg Pietsch, is in no doubt of the connection:

> In *Die Übergangsgesellschaft* uncompromising, merciless, hard facts are faced, lies and cover-ups are unmasked, and careerism, opportunism and hypocrisy in our society are exposed to the critical reason of the public. (Pietsch 1988: 57–58)

Regarding the 'Flug', the scene where some of the characters are encouraged to imagine themselves transported by aeroplane to a part of the world where all their unspoken wishes are fulfilled, the GDR radio commentator, Wolfgang Stein, sees this as producing disappointment. Only Mascha becomes to some degree idealistic, Irina confesses that she does not know the meaning of love and becomes capable of arson, Olga takes off her clothes, betrays her past and reveals to all her stunted, egoistic vision of happiness:

> This critical point, by which one was at first taken by surprise, I regard as an intellectual construct that is inadequately motivated. All the louder then is the whining, certainly among all the participants, as disillusion sets in after the supposed flight. (*Kulturpolitik Radio DDR*, Berlin, 31 March 1988)

The *Sächsisches Tageblatt* states that all three sisters acquire a sense of what life could be like, and, it is to be hoped, will better face the future (*Sächsisches Tageblatt,* 8 April 1988). Ingeborg Pietsch takes the view that the fictive flight released irritations, desires and hopes and revealed hidden depths; people changed their attitudes to themselves and to others. (Pietsch: 57–58). In *Neues Deutschland* it is thought that Braun's artifice is short on fantasy, frantically wound up, and in the end a disappointing, austere, psychodramatic look in the mirror (*Neues Deutschland* 8 April 1988). In the GDR where socialist realism was raised to dogma, a scene like that of the 'Flug', being a working out of frustrations in fantasy, was vulnerable to criticism. The

attack in *Neues Deutschland* should be understood in this context. It is perhaps a measure of Braun's own down-to-earth approach that the results of the experiment are shown to be on the whole disappointing; that there are a few positive outcomes, though the purpose of learning from one another may be considered to have been served. He shows that there can be at least some benefit in attempting to express suppressed feeling and ambition, for Mascha and Irina at least, but the 'Flug' is by no means a panacea. It is just one effort to overcome stagnation and galvanise the characters. In this respect it is effective as a dramatic device. The line taken in *Neues Deutschland* that Braun simply engages in unrewarding self-reflection misses the point.

The newspaper and journal articles feature arguments about Braun's supposed concerns: How can a society in transition be a society that stagnates? How can one that stagnates achieve transition to another condition? : How should an individual live his or her life? Wolfgang Stein regards *Die Übergangsgesellschaft* as a provocation to debate:

> Braun wants to provoke – and he succeeds. From the alarm over human relationships in our society, that we so often and lightly designate self-development, to the rejection of human inadequacy, that is in all completely imaginable, and to the rejection of where the reality he illustrates may lead. (*Kulturpolitik Radio DDR*, Berlin, 31 March 1988)

National Zeitung accuses Braun of being unlike Chekhov and looking only at the present-day:

> Brown, however, directs his gaze not on the fight, in which the reality of the future succeeds against all the persistent survivals, but exclusively toward this. Does he consider it insurmountable? Does he regard therefore regard the position of the isolated critical individual as the only possible one? (*National Zeitung*, 5 April 1988)

The theatre critic of *Neues Deutschland*, Gerhard Ebert, makes clear that he does not share Braun's views, but he applauds Braun in seeking to show that new societal relationships do not automatically lead to the fulfilment of all dreams and yearnings and that individuals must remain actively involved with the revolutionary process, must stride relentlessly forward beyond their own limits if they wish to

change the world. The review ends on a sourer note, observing that the satirical comedy was certainly remarkable, but it represented only one stone in the GDR's socialist drama (*Neues Deutschland* 8 April 1988). Wholehearted support for Braun and a positive interpretation of *Die Übergangsgesellschaft* is found in *Der Morgen*, where Christoph Funke describes how Braun defends the ideas of hope, expectation and utopia and demands that nothing, not even pain, should hold people back from achieving their desires. He continues:

> In artistic discourse with figures shaped by world literature Braun examines the submissiveness of a social state and the danger of persistent habituation, looks for the possibilities of letting rip, of the surprise deed, and defends the ensuing fantastical first and second thoughts. (*Der Morgen*, 6 April 1988)

However, amidst more praise for Braun in the article, Funke feels obliged to acknowledge that other views may exist:

> If experiences other than those of Volker Braun, if the living record and achievements refute his dramatic text, then I plead for such contrary views to be set out openly and constructively. (ibid.)

As some commentators mentioned, the characters in the play hardly have any ideals at all. An exception is the figure of Wilhelm Höchst, uncle to the sisters, pensioner, onetime anarchist and a member of the old guard of communists who fought in the Spanish Civil War on the side of the republic. *Neue Zeit,* above, comments that Wilhelm represents the ideal by which others are measured. The *Sächsisches Tageblatt* records that he is the bearer of hope, the one who knows the answer to the question: How should one live? He is the first to speak from the stage and the critic opens his article with an appraisal of his role. Wilhelm is given the best lines. He finds reciprocated love with the young actress Mette. In *Der Morgen*, the reviewer has special praise for Albert Hetterle's portrayal of Wilhelm; he categorises the performance as an exciting centrepiece of the play, albeit scenically on the edge. Conversely, this character is presumably a veteran who has a hand in creating the society in which the other, dissatisfied, characters are living. Gerhard Ebert of *Neues Deutschland* regards Wilhelm as Braun's 'prophet' and a man who seeks a full life and lives it. He is

now at the point of passing on the testimony of his time to the new generation:

> Reflecting upon the struggle of his class, upon the victorious nature of the revolution, over victims, over mistakes, over his basically modest place in this struggle, he stays loyal – and there, with Braun in contrast to Chekov dream and reality touch each other – to the picture of a free personality fighting for the better world. (*Neues Deutschland,* 8 April 1988)

Again, in the article in *Theater der Zeit,* Wilhelm is designated the central figure, he points to the task remaining and emphasises the need for people to free themselves. Also from his mouth the audience hears Braun's aphorism, 'literature that only records, and ideology that is a pretence, are both far from the truth; they do not have life'. For all that, the old survivor does not last the course. Thereby arises an open question, posed by Wolfgang Stein of *Radio DDR* in the commentary he gave on the 'Kulturpolitik' programme (see above): 'he is treated like a fossil from long ago and dies unnoticed. Who will pass on his legacy?' Wilhelm represents the passing of old ideals. The action of the play lies in the transition between their loss and the hoped-for, but not guaranteed, discovery and/or rediscovery of ideals by which to live.

The discussion of Braun's *Die Übergangsgesellschaft* in the media appears quite measured and sympathetic in tone, there is but little hint of the uproar that the play's castigation of the GDR must have aroused among the Party faithful, and, generally, the comment responds to the message that everyone has it in them to change for the better, if only the mechanism can be found. It is his choice of mechanism, the 'Flug' on which the fire of the critics is brought to bear, and that criticism, apart from the insight shown by Ingeborg Pietsch, overlooks the stinging comment on the GDR that Braun imparts by using, in translation, Chekhov's opening words from *Three Sisters* to describe the vacuity of the lives of the characters. The play emphasises this in the characters, for instance, in Mascha the poor-sighted historian who cannot see things as they really are, in Dr Bobanz who sees capitalism as the only salvation, and in Paul the intellectual concerned to pull off a property deal. The GDR represented on the stage is seen to be producing people with qualities

that are the opposite of the kind of socialist personality that it requires. The absurdity of these characters is not explored in the press, but must surely have been hugely entertaining for the audience. Braun's figures become even more ludicrous when their fantasies are given free rein in the 'Flug'. However, the dramatic focus finally skips forward onto whether they are capable of change, rather than dwelling on how they came to be as they are. The play offers more than one level of interpretation, which, in effect, allowed the media to review it in conventional terms, the audience to enjoy it as they wished, and the author to avoid a ban.

One other instrumental feature was the role of Wilhelm mentioned above. This veteran is highly praised by the commentators. He can be seen both as a homage to the image the senior GDR politicians had about themelves (the local paper actually describes him as the bearer of hope), or as Braun's ideal revolutionary who draws a judicious balance between the claims of literature and the demands of ideology that, by implication, the present incumbents of power fail to do. Whichever is the case, Wilhelm on stage was a salute to the old communists and could expect a good press, and therefore prove helpful to the survival of the play, as Minetti demonstrated.

As to the question of how the play reached the GDR stage in 1988 without falling victim to censorship, it should be recalled that hindrance if not actual censorship through delay in having a first performance, and lack of a venue for a GDR premiere had occurred. Factors in favour of *Die Übergangsgesellschaft* were that it was derived from Chekhov's classic and the East German regime respected Russian literature: many works of Russian and Soviet dramatists were regularly performed As Hilton observes, the regime had aspirations to the high ground of theatrical culture and Braun in his concerns with the classic tradition of Weimar, for instance his attempt to complete Schiller's *Demetrius*, had contributed to the attainment of this cultural appropriation (Hilton 1988: 126–127). The fait accompli of the performance of *Die Übergangsgesellschaft* in West Germany also undermined any notion of keeping knowledge of the play away from potential GDR audiences.

The press in the GDR approved of the play, albeit with definite reservations. The media in the FRG did not refrain from linking the

play to the political condition of the GDR. However, this did not result in a ban on the East German production being imposed after it had been performed in the GDR, as had happened in the recent past.

Getting the play performed required action from a network of sympathisers within the Ministry of Culture and the Berlin Magistrat, and permissions were by word of mouth, save for the Minister's signature. There was clearly disquiet in SED circles but they lost the initiative. Action at critical moments by theatre leaders was a remarkably important factor. Opportunities, such as anniversaries or festivals, were taken to introduce new works. In circumstances where there seemed to be potential for strife, prominent personalities would use their influence to promote the work in question or ask for special favours. For instance, in 1987 Gerhard Wolfram cut through all the red tape by going straight to Kurt Hager to seek permission to put *Waiting for Godot* on in Dresden.

It was also both subtle and opportune for the theatre association to launch, at a conference in Honecker's presence, an oblique defence of *Die Übergangsgesellschaft* through Minetti's inclusion in his speech of praise for the character Wilhelm. Of course, it was an advantage, too, that Braun, the author, was by no means a nonentity:

> According to Nakonz, the official of the FRG representative office in the GDR, Braun was regarded as the Solzhenitsyn of the GDR. He was also called the present and active 'Biermann' and therefore courted by people from the West. (BStU MfS HAXX ZMA 20015)

In Braun's plays we find the recurring theme of the difference between the ideals and practice of socialism that was anathema to the promoters of GDR cultural identity. However, he was an SED member. He moved comfortably in ministerial circles, sought and accepted official guidance and refrained from critical comment in public. Other well known authors who chose to stay in the GDR were rather different. Heiner Müller, a controversial figure within and outside the theatrical profession who endured official obstruction and was reviled by some critics, adopted a stance towards the political and cultural establishment that was pragmatic and without scruple. He engaged with the authorities and the Stasi to gain what advantages he

could. Christoph Hein suffered sabotage of performances of his plays but enjoyed a rise in his reputation through his novels. He used the authority he gained to campaign ever more vigorously for an end to censorship and for plurality in the opportunities for publishing of works of drama and literature.

Whilst the official line was to regard 'glasnost' and 'perestroika' as irrelevant to the GDR, these ideas, now Soviet policy, were hard to ignore, and were not ignored by the authors above. The MfK approved Braun's play just when, in the Soviet Union, the old guard of cultural officials were being replaced. Reservations about it in the GDR press and the political capital made out of the play by the Western media failed to trigger curbs on further performances. In all, there were more than a few reasons for the successful mounting of the production at the Maxim Gorki Theater, last and not least a loss of confidence and division of opinion among policy-makers in Berlin during the debilitated 'Kulturpolitik' of the late 1980s.

Chapter Five
'There is no way in which we can relate to this play': *Waiting for Godot*

Here is shown how art influenced politics, how one play scorned by the GDR was eventually accepted and performed, and how, in effect, the GDR became in the end integrated into the modern theatrical movement in Europe.

Directed by Wolfgang Engel in Dresden, *Warten auf Godot* was first performed in the GDR in 1987. That event is important as the juncture at which this work, for long regarded by Marxists as a notorious example of Western decadence in the theatre, was formally accepted into the GDR repertoire. The work in its original French entitled *En attendant Godot*, known to Germans as *Warten auf Godot* and to English audiences by the title *Waiting for Godot*, will in this Chapter for ease of reference be termed *Godot*.

The first part of the study introduces *Godot* as a clear example of the acceptance of avant-garde drama by the regime, and posits the Dresden production of *Godot* as a culmination of the course of the development of modern theatre in the GDR. To show the processes at work an historical review of the fortunes of *Godot* in the German-speaking world is presented, drawing on observations by politicians and theatre critics, and by individual playwrights and directors.

In detail the review shows some of the German influences upon the author, Samuel Beckett, and indicates his interest in German culture and theatre. Specifically it demonstrates his personal involvement with certain productions in Germany and the general impact of *Godot* on theatrical method, both of which affected German drama, and in particular GDR dramatists, such as Heiner Müller, Volker Braun and Christoph Hein.

The second part of the case study is devoted to a detailed account of exactly how the 1987 premiere in the GDR came about, the form that the production took, and the nature of the critics' reception of the piece.

Born in 1906 at Foxrock near Dublin, Beckett was a lecturer in French at Trinity College Dublin from 1932 to 1933, when he resigned and left Ireland. There followed a difficult period when 'he led a rather rootless life, marked at regular intervals by tragedy and instability' (Pattie 2000: 20); he travelled around Europe and then settled in Paris in 1937 and was active in the Resistance in France during the Second World War. He wrote *En attendant Godot* in French in the late 1940s; he translated it into English and Elmar Tophoven undertook the translation from French into German. Eventually *Godot* was translated into another eighteen other languages.

In 1953 there were premieres of the play in Paris and London (Fletcher 2003: xiii), and in West Berlin (Roßmann 1987: 1302). Beckett himself directed a production at the Schiller Theater in West Berlin in 1975 (Fletcher 2003:144); the first performance in the German Democratic Republic took place in 1987 in Dresden. Beckett was awarded the Nobel Prize for Literature in 1969. The playwright's rise to prominence came with the writing and staging of *Godot* soon after the founding of the GDR and he lived to witness the fall of the Berlin Wall and the collapse of the GDR in November 1989; he died in December of that year (Cronin 1996: 590–592).

Innumerable critical studies attest to the importance of Beckett's work for the development of present-day drama; *Godot* was the first of his plays to become widely known to international audiences. Peter Hall, who directed the London premiere, commented on the fiftieth anniversary of this occasion:

> *Godot* returned theatre to its metaphorical roots. It challenged and defeated a century of literal naturalism where a room was only considered a room if it was presented in full detail, with the fourth wall removed. *Godot* provided an empty stage, a tree and two figures who waited and survived. You imagined the rest. The stage was an image of life passing – in hope, despair, companionship and loneliness. To our times, the images on the cinema screen are real, though they are only made of flickering light. Since *Godot*, the stage is the place of fantasy. Film is simile, lifelike; theatre is metaphor, about life itself. (*The Guardian*, 4 January 2003)

At the time, behind the Iron Curtain, the piece was viewed quite differently, and doubt was expressed on whether it was worth

performing. In reviewing a production in West Berlin, the East German drama critic, Lily Leder, wrote:

> Here the really crucial question is whether the production of this play is still justified in front of people, who must struggle daily for their existence? From our viewpoint a decisive 'no' would be the answer. There is no way in which we can relate to this play, and, moreover, we look no longer seek to do so. (Leder 1954: 42)

Beckett wrote in English and in French, the languages, respectively, of the Protestant tradition in Ireland and of his chosen country of residence. For the purpose of this study it should be recorded that he had more than a superficial acquaintance with Germany and German culture. When he was in a relationship with his first cousin, Peggy Sinclair, whom he met in 1928, he used to visit her at the parental home in Kassel. He was in Germany again in 1936 and 1937, when he travelled extensively and where he took a deeper interest in German art and culture (Büttner 1988: 282–289). One of the paintings that deeply affected him was Caspar David Friedrich's *Two Men Looking at the Moon*, which seems to have inspired the image at the centre of *Godot* (Pattie 2000: 24 and Knowlson 2006: 222). It is rumoured that in 1937 Beckett met in Dresden a relative of Turgenev who went by the name of Pozzo, which is the name of one of the characters in *Godot* (Bechert 1996: 311).

At about that time the author had misgivings about continuing to write in English and these were explained in a letter written in German to Axel Kaun in 1937, a letter which was published in 1983 as 'The German Letter of 1937' (Devenney 2001:159). Beckett was able to understand nuances of translation, which was useful when he was involved in main productions of his work, such as when he directed at the Schiller Theater in Berlin, or in examining proposals for productions of *Godot* in countries where German was the language of the drama. Hans Mayer vouches for him: 'Beckett was at ease in admitting that he knew Brecht's plays, he had an extraordinary gift for languages, he spoke excellent German and Italian: he was very well read' (Mayer 1995: 559). *The Cambridge Companion to Beckett* informs us that 'He firmly deleted the word "Wir" from the German translation of the title "Wir warten auf Godot" so that audiences

would not focus on the individuality [...] but would think about how all existence is waiting' (Pilling 1994: 71). Fletcher's account of the 1975 production in Berlin, based partly on the two manuscript production books held in the International Beckett Foundation Archive at Reading University, states 'he amended and corrected the German text quite extensively, making it more colloquial and according greater emphasis to the network of motif words' (Fletcher 2003: 131). Beckett's close involvement with major productions in Germany began in 1963 when he assisted with the production of *Play* in 1963 and continued into the 1980s when the director, Walter Asmus, became his assistant (Pilling 1994: xx).

Such activity did not pass unnoticed among the theatre community in the GDR, whose ensembles made guest appearances in the FRG, and more than a few of whose directors from time to time worked in West Germany; some emigrated there, and GDR playwrights were also aware of Beckett's work. In the 1970s in Rostock and in Leipzig the theatre managements sought permission for performances of *Godot,* but were denied this by the Ministry of Culture (Bechert 1996: 311). These two theatres were used to try out foreign drama to sanitise it or halt it before it went anywhere else in the GDR. In the early 1980s the *Staatsschauspielhaus* in Dresden also began to express interest (Bechert 1996: 311). By the mid-1980s the prospect of a first performance in Rostock appeared closer, at least in the opinion of Andreas Roßmann, a commentator writing in *Deutschland Archiv,* who pointed out that *Godot* had long been a modern classic, and had been performed in other socialist countries, especially in Poland. In the GDR Beckett's works were already well-known among members of the theatrical profession:

> But even if they are officially taboo in the GDR, for the theatre people there they are – unofficially – obligatory reading and quite familiar association material. The texts go from hand to hand. Productions, among them Beckett's own, are well-known from the West's television, also, on the stage they were already much alluded to and quoted from. (Roßman 1985: 803–804)

Whereas enthusiasm for Beckett among many in the GDR theatre ran high, the outward acceptance of Beckett and of *Godot* by communist

intellectuals, with notable exceptions like Brecht, occurred more gradually and was more complex.

The play premiered in 1953 at the Babylon theatre in Paris. Such performances in the early fifties had been a feature of new drama on the periphery, unveiling in small auditoria the experimental art of the left bank (Satgé 1999: 16). It was very much in contrast to the contemporary movement in France dominated by the idea of a 'National Popular Theatre' associated with Jean Vilar and the concepts of celebration and universality, and embracing the classic authors such as Shakespeare, Corneille and Molière: Vilar's project was presented as a civic enterprise of cultural democracy (ibid.:17). Soon after *Godot* was performed, the Berliner Ensemble, East Germany's pioneering ensemble, came to Paris in 1954 with Brecht's 'epic theatre', whose drama *Mutter Courage* also sought to reveal universal realities and to influence public attitudes in the wider community. The dramas of Brecht and Beckett were both in the ascendant at the same time. Jean-Paul Sartre, the leading French intellectual, and a communist, thought that *Godot* was the best play of the last 30 years, but he observed that all Godot's themes were bourgeois, concerned with loneliness, despair, communal space and with lack of communication. (ibid : 20).

Brecht also, was greatly impressed. Towards the end of his life Brecht twice took an interest in *Godot* which had been published by Suhrkamp since 1953. His project for a counter play never saw the light of day but there remain a few notes sketching out the characters: Vladimir an intellectual, Estragon a worker (which led Brecht to invert some of their repartee), Pozzo as an aristocrat, von Pozzo, and landowner, and Lucky a madman or policeman; later, a proposal to stage the play in which film projections of the revolution in the Third World were to contrast the inaction of the two protagonists. (ibid. : 33) To Hanns Eisler's musical accompaniment there would be a play of shared scenes in which Estragon and Vladimir waited in vain for Godot against a background of film about revolutionary movements in the world, in the Soviet Union, China, and in Asia and Africa. (Sandberg 1985: 41)

In a lecture in Berlin in 1995, Hans Mayer pointed out the impossibility of the task, giving his view that Brecht had attempted to turn the abstract figures of Vladimir and Estragon into real people

149

with jobs and homes in a definite society. Brecht had to abandon it because one cannot change a play by Beckett into one by Brecht. (Mayer 1995: 579) Mayer went on to review the classifications of 'dekadent' and 'progressiv', terms that were part of the Stalinist aesthetic that had been applied to the works of Brecht and Beckett, and which had resulted in the verdict that Brecht was more or less progressive and Beckett was the most absurd decadence (ibid.:573). He attributed that outcome to the Stalinist desire for purity and for everyone to march in the same step, as well as the notion of art as the realistic reflection of life. The problem was that 'decadence' became a weapon in the hand of whoever claimed to be progressive (ibid.: 579). Mayer was of the opinion that neither of these slogan words fitted either playwright: 'they are incorruptible, truthful authors, whose hard life was spent, indeed, used up, in transforming all anxieties about the economic position into forward thinking, hope, and action'. (ibid.)

This absolution came from an apostate GDR luminary in 1995, but, in the period to which Mayer referred, the 1950s, there seemed faint prospect of Beckett's drama being accepted into the GDR theatre repertoire. David Caute, in his study of the struggle for cultural supremacy during the Cold War, mentions particular concerns that Marxists had in regard to *Godot*, i.e. the steadily worsening situation depicted, the charge that the work fitted the category of the general anti-humanist decadence of modernism, the lack of decorum and the absence of any historical and consequential scientific philosophy (Caute 2003: 341). The premiere of *Fin de Jeu* (*Endgame* or *Endspiel*) in Paris in 1957 appeared to be a sequel to *Godot*. It confirmed and strengthened the attitude taken by GDR critics:

> The piece is just as lacking in action as *En attendant Godot*. If one waited there in vain for Godot, then it now becomes clear: Godot did not come, he will never come. There is only one who comes: death. There is here no longer any sort of communication between human beings; everyone lives, or better, dies for himself alone. (Heidicke 1957: 25)

Whilst progressive French communists in Paris might be interested in Beckett's work as a counteracting force to bourgeois influences in the theatre, and might view the dramas as a picture of human despair induced by capitalism, in the GDR the really worst feature was taken

to be the complete lack of a point of view. Heidicke observes of Beckett's refusal to philosophise about the meaning of his work, that if one comes and describes in a play that thinking is an absurd process, then such a play is not only decadent, it is dangerous (ibid.: 26). It was alleged that Beckett's intention in putting such work on the stage was to cause sensation and that the plays would have grievous effects on the audiences, for with this kind of theatre one could make suicides and madmen out of normal people (Etto 1958: 31).

In contrast, performances of plays in the GDR by the nineteenth-century Russian writer Chekhov were common: the *Three Sisters*, for instance, ran for almost ten years in Berlin (see case study of Braun's *Die Übergangsgesellschaft*), and seemed to raise no problems, despite the fact that aspects of that drama were similar to Beckett's:

> Both dramatists excel in laying bare both the nature of life without real hope of improvement, or change, and the subterfuges we adopt to conceal from ourselves the worst facts about our condition, in dialogue that modulates with striking rapidity from the sublime to the ridiculous, speech without consequence reflecting action without conclusion. (Fletcher 1972: 58)

Up to the mid-1960s the GDR critics remained firm in their beliefs. In the view of Werner Mittenzwei, the struggle between late bourgeois modernity and realism was epitomised by Beckett and Brecht:

> Beckett – Brecht: it is hardly possible to think of a sharper antithesis in modern literature. Beckett who with monomaniac resolve depicts the alienation of man as his eternal condition, and Brecht whose philosophy is for change in social conditions and for the potential mastery of man's destiny. (Riewoldt 1978: 129)

The Marxist theorist, Theodor Adorno, an admirer since the 1950s, regarded Beckett as the one truly outstanding literary figure to emerge after the Second World War and his own work *Aesthetische Theorie,* uncompleted on his death in 1969, was to have been dedicated to Beckett (Lunn 1984: 273).

The 1960s also saw the growth of independence from Moscow's line in some of the European communist parties, notably in Italy. For instance, a conference to consider revising attitudes to Kafka took place in Lidice in 1963, though the Soviets did not attend and the head

of the East German delegation, Anna Seghers, made no public state-
ment (Kröhnke 1994: 34). Doubts about the wisdom of denigrating all
of the modernist works of drama and literature appeared:

> Kafka came back on the Marxist agenda, though not without fierce polemics,
> Georg Lukács, the Hungarian doyen of Marxist critics, continued to dismiss
> Beckett as plain negative. At a Prague literary conference in the spring of 1964
> the heterodox Austrian Marxist Ernst Fischer came to the defence of Beckett, a
> moralist whose 'absolute negation' in, for example, *Endgame* was 'explosive'.
> (Caute 2003: 343)

In 1965 Ernst Fischer launched an international debate in the Italian
communist weekly *Rinascita* with his essay 'Marxismus und Ideo-
logie' (Gauß 1984: 252). By then, even in communist Poland a per-
formance of *Godot* had been allowed (Bechert 1996: 20).

In the early seventies Honecker in some ways liberalised the
guidelines for artistic expression, but there was no concession in the
GDR to the type of contemporary works thought to be exemplified
by Beckett and other writers. In his contribution to the discussion
on cultural matters debated at the eighth Parteitag in June 1971,
Alexander Abusch asked pointedly:

> What, for example, has the socialist-humanist way of life and culture for which
> we strove have in common with the negation of the humanist traditions together
> with the inhuman excesses of the late capitalistic philistinism and the Ameri-
> canised style of life still practiced in West Germany? And, indeed, where is
> there is yet an affinity between the stammering in words, tones, and colours,
> which on the part of some artists in capitalistic countries, at least, is the
> expression of intellectual pointlessness and our striving for mastery, for higher
> perfection of the realistic and socialist form? (Ruess 1976: 145)

Despite this high-minded reminder of the superiority of the GDR
conception of culture, the theatrical profession, and even those in-
volved in other arts were aware of Beckett's reputation and some of
them knew about the plays, especially *Godot*. In Ulbricht's time the
play was parodied as 'Wir gähnen auf Wardot' (we are yawning at
Wardot) on West German television, whose broadcasts were access-
ible to many East Germans. In Honecker's GDR references to, and
imitations of, as well as serious adaptations of scenes from *Godot*
within new dramatic writing, were not uncommon. Examples appear

in Heiner Müller's *Nachtstück*, Christoph Hein's *Ah Q* and in Volker Braun's *Guevara oder der Sonnenstaat*. Braun tried his hand at a socialist adaptation in *Simplex Deutsch*.

Although in Braun's *Die Übergangsgesellschaft* it is possible to conjecture about some influence from Beckett and *Godot*, that influence is more obvious in other works by Braun, notably in the play *Simplex Deutsch* (1980). To understand how Braun might be susceptible to such influence, it is helpful to consider Braun's position in the drama of the 1970s and 1980s. During the 1970s the unconditional acceptance of an individual's sacrifice of their personal aspirations during the transition to a socialist society came under scrutiny in the GDR drama, as in society itself, and the balance between that sacrifice for the common good and for future generations and the burden and suffering endured in the present by the individual became the subject of debate:

> But in the seventies ever more substantial shortcomings come to light, and new, pressing questions are posed. What had remained unrealized, what had one jettisoned? At whose cost were these conflicts carried out (*Guevara oder der Sonnenstaat, Großer Frieden*): The question about the victims suddenly gained significance. (Bechert 1996: 252)

Braun was interested in particular in the difference between socialism in theory and socialism in practice. Beckett's concern with a condition in which individuals continually deliberated painfully over an event expected to happen, but which did not occur, resonated with the difficulties experienced within a community trying to develop a socialist society in the dawning realisation that that ideal was far from being achieved. Braun's investigation of the contrast between the way socialism was working, or not working, and what socialism offered theoretically, had some parallel with the changes of mood from stagnation and hope, and back again, as depicted in *Godot*.

Braun's *Simplex Deutsch* is a play with experimental content: 'Braun brought a lot of different scenes together, which despite, or exactly because of their diversity, enabled a new, more compact observation of social problems' (Bechert 1996: 257). It includes a scene 'Auftritt Godot'. The stage instruction indicates that Godot comes but W and E who have waited for him since the premiere are

153

not interested and are no longer waiting. E shits on the stage. (ibid.: 259). The scene not only parodies *Godot*: it departs radically from the original in that the characters cease waiting and Godot appears. A parody is presented to the GDR audience before the real play is ever performed, but given the regime's animosity to the latter, a parody belittling the original was less likely to stir objections from any quarter: even less from a proletariat that had little or no knowledge of *Godot* and no access to the work. Among the variations on Beckett's *Godot* in this parody, two illustrate the treatment that Braun gave to the original. Refusing to wait any longer, the two 'hippies', E and W, who might or might not be Estragon and Wladimir, become activists. The refusal to wait for Godot represents action, resistance and rebellion observes Bechert, who notes a connection made by Braun in the scene 'Auftritt Godot' in *Simplex Deutsch* to the actual political student protests across Europe in 1968, which reference, he believes, had to be made specific to May of that year to avoid any insinuation that Braun was criticising the Warsaw Pact intervention to prevent further liberalisation in Czechoslovakia in August of that year (ibid.: 269). Below are translated extracts from *Godot* and *Simplex Deutsch* illustrating the first variation:

> V. We have to come back tomorrow
> E. What for?
> V. To wait for Godot
> E. Ah! *Silence*. He didn't come?
> V. No.
> E. And now it's too late.
> V. Yes, and now it's night.
> E. And if we dropped him? *Pause*. If we dropped him?
> V. He'd punish us. *Silence. He looks at the tree*. Everything's dead but the tree.

(*Warten auf Godot*, p.229, lines 17–28, German translation by Elmar Tophoven, 1971, Frankfurt/Main.)

> B. *agitated*. I invented you. In the Babylon Theatre
> W. Not us
> E. We got away from him.
> W. Freaked out
> E. In the Odeon, 1968, in May.

154

W. Waited too long, sir
E. Changing times, eh?

(*Simplex Deutsch*, Zweiter Teil: Hans im Glück, Auftritt Godot, *Theater der Zeit*, H. 7, 1980)

In the second departure, the general enigma arising from the original play about who Godot might be is parodied by Braun via the plural identities of his own character Godot who removes a mask from his face and declares: 'Look, here is the real Godot! Your saviour! The resurrection. I summon Jesus, Che Guevara, Jimi Hendrix, and Buddha and so on. As you like. The symbols of the time' (ibid.). Braun re-fabricates *Godot*. He achieves a new balance of ambiguity and definition among the characters. The audience can be sure that the two vagrants are 'hippies' of the 1970s, but not whether they are really Estragon and Wladimir. Godot is now upon the stage, which is new and certain. However, he could be anybody, until at the end he is revealed to be Beckett. Whereas in Beckett's final scene Vladimir and Estragon register their anxiety about being punished by Godot if they stop waiting, Braun shows how strong his own characters become when they cease to expect anything from Godot and how Godot, in whatever form, is thereby humiliated.

The references in *Simplex Deutsch* to the 'hippies' of the 1970s and to the events of 1968 show the way Braun links his drama to historical fact, and imply that the passivity, passive resistance or resistance in the population that those social and political phenomena represent cannot be ignored. The notions of history as a force in the present, and of social consciousness, are, of course, key elements in the official understanding of socialism.

In Dresden and in the GDR cultural sphere in 1987 a number of circumstances came together to create a special opportunity for a high-quality production of a play by Beckett. Since 1983, when the Staats-schauspiel managed organisationally to separate itself from the opera and music departments which subsequently moved into the renovated Semper building, Gerhard Wolfram, the first intendant of the now independent ensemble, had been working assiduously to put on modern plays and to gain an audience for 'engaged' drama, especially among young people (Bechert 1996: 312). He was a member of the

155

SED and spent much time and energy in getting his ideas accepted by his Party comrades:

> He understood how to present his conceptions of an active theatre to Party and national institutionsin a credible and persuasive manner. It was to this special capacity for integrity that the Dresdner Schauspiel owed its recent ascent to being one of the best loved theatres of the GDR whose intendant confidently announced: 'Surely no other theatre of this size [...] can show the same quality as Dresden'. Not even Berlin. (ibid.: 312–313)

Wolfram had a talented team that included the director, Wolfgang Engel, whose productions were often concerned with dramatic situations in which hope was a key element, but that hope could not be realised by the stage characters. To a certain extent an existentialist work, such as a Beckett play, suited his directorial style. Engel had also great success with a production of Hebbel's *Die Nibelungen,* which toured West Germany in 1986. This resounding success was helpful to the Staatsschauspiel, reflected well upon the judgement of the Dresden Party Secretary, Hans Modrow, who was known to be keenly interested in the arts (ibid.: 316), and was a matter of prestige for the regime.

Gerhard Wolfram decided that the moment had come to exploit the high standing in which the theatre now found itself. His colleague, Wolfgang Engel, recalls the situation:

> The Central Committee congratulated us. Afterwards Hager had sent a telegram saying we had been the best ambassadors for socialism in the West. We declared that we must capitalise on this success. (Interview Baker/Engel, 5 December 2002)

Wolfram visited Kurt Hager in Berlin and persuaded him to support a proposal for a performance of *Godot* in Dresden. This request was not decided upon by Hager himself but was deemed to be a sufficiently important matter to go before a meeting of the Central Committee of the SED. Approval was not a foregone conclusion: objections were raised, especially by Harry Tisch, the trade union chief, who is reputed to have run around brandishing a 1956 guide to the theatre and to have enquired whether they were giving up all their principles and allowing

this decadent play to be performed? (Engel 1991: 46). In the end approval was forthcoming and, as Bechert points out:

> The permission gained signified no great freedom. Apart from the mechanism of self-censorship, the submitted conception of the drama could be brushed aside because of 'subversive moments of danger' and also it was never out of the question that the permission granted could at any time be withdrawn. One had, therefore, to reckon with control measures. (Bechert 1996: 316–317)

Engel was sanguine concerning the attitude of the Central Committee: 'This was a world class play. That it could not be performed was a prime instance of intolerance in the GDR. They wanted to extricate themselves from this position' (Interview Baker/Engel, 5 December 2002). His own sense of what would be acceptable was very good and he relied on it, rather than seeking to engage too much with authority over questions of the style of direction in his productions. The Dresden theatre had attained a high reputation that helped to deflect possible intervention in its affairs. In response to the question whether an 'Abnahme', a visiting jury of officials to vet the final rehearsal, had been required for *Godot,* he replied:

> I would never have allowed it here, that someone came and held a jury. That did not happen. That had, as so often, to do with civil courage, whether you had it, or not. (Interview Baker/Engel, 5 December 2002)

His directorial ambitions and intentions did have a considerable impact on the way in which *Godot* was produced in Dresden. Engel wanted an all-female cast, previously rejected by Beckett on the grounds that the character Vladimir exhibited problems with his prostrate gland (Fletcher 2003: 205), and proposed to set the play in a circus arena. Beckett's representatives rejected the first proposal and Beckett's aversion to theatre in the round was also clear. Engel, none the less went ahead with the circus idea, an idea that chimed well with the vogue for open theatre that unified stage and auditorium, actors and audience. His adaptation included elements that served both to avoid reviving the ideological controversy that the piece had aroused in the past, and to deflect attention away from its observed pessimistic philosophic message. A consequential benefit was that he thus

reduced the risk of presenting any material that might incite requests for cuts in the play.

Previous productions of *Godot* in the German-speaking world had emphasised the bleakness of the piece. An aura of gloomy existentialism clung to the play. Engel strove to strip this away. By placing the drama in a circus-like setting, the expectations of an audience were changed. The circus is a series of unrelated acts of virtuosity involving tricks and clowns viewable on all sides. Instead of Beckett's ageing Vladimir and Estragon and any associated assumptions about their past or about a collective history, which their age would suggest, these parts are played by clowning young GDR actors, who interpret the ordeal of waiting and questioning as an active search for self-identity. A number of the props used in *Godot* as objects of sinister provenance acquire a new resonance when used in Engel's circus ring:

> The few requisites lost their direct threatening dimension in the circus atmosphere. The rope, the whip, the harness, also the vaguely indicated tree that turns green in Act 2, are all accessories to the circus to which one no longer pays special attention. (ibid.)

The device of the tree with one leaf appears to be borrowed from *Simplex Deutsch.*

Engel introduces GDR place names, e.g. Erzgebirge-Scherzgebirge to replace the names Breisgau-Scheißgau used in the German version translated from French by Elmar Tophoven. A wish to travel is limited to the direction of the Spreewald, and the inability to find an exit (ibid.) is also comic in the circus ring and carries no philosophical message, though in the light of actual restriction on travel abroad by GDR citizens the message is probably ironic. Other 'GDRisms' are the use of Saxon dialect and a topical utterance 'Warten auf Gorba...' which would certainly be noted by GDR audiences. Engel's variations also assist in presenting *Godot* as an entertainment for the young audiences he sought and won in Dresden.

An unusual prelude to the first performance was the publication of an article in the *Sächsisches Tageblatt* on 4 March 1987, by the stage designer of the Dresden production, Frank Hänig. He provides a simple introduction to the play and, as might be expected, concen-

trates his comments on the scenic and spatial effects. He describes the playing of games to pass the time while the two tramps, in hope and fear, wait for Godot to arrive. They are at first divided by a red curtain as they wait in the circus arena under a roof of yellow sail that also extends over the audience. There is no rake of the seating, no box-like frame of a stage and no barriers between stage and auditorium, but a unity of space with direct contact between players and audience. Bright light causing sharp shadows is used, 'nichts wird verschleiert, alles ist hell, sandig, klar, scharf umrissen'; the characters are paired in costumes contrastingly dark or light in colour, too small or too large in size. The article is uncritical and is clearly intended to attract visitors to the theatre.

Unlike the limited publicity forced on the theatre management when they put on *Die Ritter der Tafelrunde,* there was no difficulty in giving advance notice of *Godot*'s GDR premiere on 7 March 1987. More tickets than seats were sold:

> The theatre in Dresden held an audience of 900 and 1500 wanted admission and we could not start the performance. The intendant sent the fire brigade away and let everyone in. The spectators for the premiere, the season ticket holders, began to clap, the performance should have begun at 7.30 p.m. and it was already 8.0 p.m., and as people kept arriving still no start could be made. [...] then someone on the edge of the crowd shouted, 'you have waited 25 years for this play, and now you can bear to wait another ten minutes! (Interview Baker/Engel, 5 December 2002)

The audience consisted mainly of men and women under thirty, the reception was rapturous, and came, no doubt, from delight at the arrival of the play in the GDR and more particularly in Dresden, as well as for its own sake. A post-performance discussion with the public also took place. *Godot* was welcomed by the theatre critics who, with one or two exceptions, were also generous in their praise, and conscious of the importance of the event in terms of a normalisation of theatrical experience in the GDR. They exuded a certain satisfaction that the GDR had found a new, and, in their view, legitimate way to present Beckett's work.

The critics concentrated on three main areas:

- the novelty of the production staged with clowns in a circus arena

- the possible message from Beckett's play for a GDR audience

- how it was now right for *Godot* to appear on the GDR stage.

The article by the stage designer, noted above, prepared the public for what they would see on the stage, namely a circus ring in which clowns would perform. Theatre critics also saw the clowning as the special feature of the Dresden production, and practically all commented on this element in the performance. Dieter Kranz in his article in *Tribüne* claims that Beckett himself wanted the audience to laugh during performances of *Godot*:

> If their production of Godot, turned consistently on playful clowning, director Wolfgang Engel and his set designer, Frank Hänig, could nevertheless call on the authority of the author. Beckett had specifically required *Waiting for Godot* to be so staged as to give the audience cause for laughter. That was definitely the case in Dresden. (*Tribüne*, 16 March 1987)

Lothar Ehrlich, writing in the *Sächsische Zeitung*, claimed that Beckett had intended to wrap the theme of the play in comicality, both to make the theme palatable and to help establish objective appreciation by the audience:

> Beckett, as it were, administered his bitter pills in sweetened form. An admirer of Valentin, Chaplin and their like, he made the clown the carrier of the action, building in absolutely regular clown numbers such as the changing of the hats. Also, the comedy in its various forms from sly joke to pure nonsense made the otherwise unbearable enjoyable. (*Sächsische Zeitung*, 10 March 1987)

His point about the creation of distance is echoed in Christoph Trilse's review in the Berlin newspaper *Neue Zeit* where Trilse refers to the distance created within the play itself in Engel's production, as when the outburst between Lucky and Pozzo is witnessed by Vladimir and Estragon:

They watched in a detached manner, or better, with indifferent satisfaction Lucky's outburst and the barbaric teasing of Pozzo, which concluded in a faschist act of torture. They observe as if watching a circus turn. (*Neue Zeit*, 18 March 1987)

Ehrlich also mentions three aspects of the actors' performance where the similarities with the circus are emphasised:

Pozzo appears as a trainer, who parades the passive and doglike Lucky like an animal trainer. Vladimir and Estragon come as clowns in costumes too tight or too loose and wearing bowler hats.. He employs a young troop and allows them, through all the circus gestures, to show the human types or their remains, that is to say, husks. (ibid.)

In the review carried by the *Nationalzeitung*, also based in Berlin, Horst Heizenröther praises the clowning:

Those in Dresden not directly affected were, nevertheless, left with a bitter taste on the tongue. However, in the main, the audience enjoyed the entertainment with the emphasis on clowning in the thinking of the characters, their brilliant trenchant reaction like clowns, like the silly Augustus, and the witty puns and the mental agility. (*Nationalzeitung*, 24 March 1987)

But he also applauds the way in which the director avoids the clichés of the circus tradition and shows how clowning is integrally a part of human behaviour: 'it is admirable how Wolfgang Engel dispenses with the hackneyed tricks of the simple circus clowns and reveals the abstruse expression of clownishness in human behaviour'. (ibid.)

The *Sächsische Neueste Nachrichten*, through its theatre critic, E. Ulischberger, takes the view that the director discloses the substance of the play via a mask of nonsense:

He sets on grotesque and clownish elements, which unlock the sense in nonsense. Also, he stresses lightheartedness in handling the language, very exactly and carefully in the manner of an intense pantomime presentation. (*Sächsische Neueste Nachrichten*, 14 March 1987)

Neues Deutschland's theatre critic, Gerhart Ebert, commented on the conversion of the characters Estragon and Vladimir from philosophers to clowns, picking up on the distancing effect so experienced, and

went on to indicate how the choice of young actors, as opposed to old, contributed to changing the spirit of hopelessness in the play into one of hope:

> Now, in Engel's production, these two are not cast down, resigned seventy year-olds proselytizing nihilism, who have already spent a long sad life waiting in vain for the mysteriously absent but never appearing Godot. They are two young, quite mobile vagrants, obviously unemployed, but still unbroken, still full hope. They drive out boredom not apocalyptically, but in an urgent, active, and restless 'economic mood'. According to such a notion Godot becomes a kind boss, who might fix them up with a job. Their behaviour is profoundly, tragi-comical and naïve. (*Neues Deutschland,* 7 May 1987)

Youth is accented not purely in the acting the parts on the stage in Engel's production. *Eulenspiegel* observes, for instance, that through grotesque, funny, sad fooling around, and by using everyday gestures, the young actors successfully communicate with the vocabulary of young people in the GDR of the late 1980s. (*Eulenspiegel* 1987: 15/6)

In the reviews above none of the GDR critics mentioned that setting *Godot* in a circus ring was an old idea mooted by Beckett's French director, Roger Blin around the time of the play's first performance in Paris. Beckett, we are told, was by no means convinced (Bechert 1996: 318–319).

Critical interest was shown in the parable of Vladimir and Estragon's unending wait for change in their situation. Their wait is punctuated by thoughts of hope and salvation and these stifle any action they think to take to extricate themselves from their predicament. A *Sächsische Zeitung* article quotes in translation the English director Peter Brook's comment that the ultimate negation of hope contained in *Godot* is built upon a yearning : the merciless 'no' is forged out of the yearning to say 'yes'. From the GDR perspective the play, whilst not polemical, destroys for all time the notion that capitalism is the best and most human of systems, but Beckett's personal concern for humanity is evident in *Godot*'s thought-provoking scenario: 'The radical, compassionateless display of paralysing, inhuman attitudes in unbearable situations proves the great human concern of this bourgeois poet'. The pointless and passive waiting of the two main characters and the disgusting subservience of

Lucky can, it seems, lead spectators to question their own behaviour, surroundings and quality of life (ibid.).

Other journals, such as *Tribüne*, write that the play provides an example of survival and hope in difficult circumstances. Whether there really is any hope remains unanswered. According to the *Sächsische Neueste Nachrichten*, in Engel's production hope is questionable, everyone must learn for themselves how to deal with it. (*Sächsische Neueste Nachrichten*, 12 March 1987). Here may be intended a reference to *Das Prinzip Hoffnung*, by the influential philosopher Ernst Bloch, who was compelled to vacate his chair at the Karl-Marx-Universität in Leipzig in 1957 after his mode of thought was categorised as 'unmarxist' (Bögeholz 1999: 219), but continued his work in Tübingen. He was concerned with the paradox of hope and fulfilment, with the phenomena of anticipation and reality. In his ideas about human nature he believed that man was not shaped by his environment alone, but also through the exercise of free will and impulse, and genetically.

Sonntag offers a Marxist response to *Godot*, i.e. illusory hopes are eliminated through eliminating their cause: the demand to abandon illusion over one's circumstances is the spur to be rid of the circumstances that require an illusion *(Sonntag* 19 March 1987). *Eulenspiegel*'s reviewer contends that the accent on wit in Engel's production makes it impossible for the play to address some of the serious questions. There is, though, at least one signal of hope:

> However: the bundle of steel wire representing the tree under which Vladimir and Estrago meet grows a green leaf in the second act. That was the boldest incorporation of the principle of hope that I ever saw. (*Eulenspiegel*, Issue No. 15: June 1987)

The idea that inanimate barbed wire, so often used to keep people from going anywhere, like the Berlin Wall, could produce biological life in the form of a green leaf is both absurd and a fantasy, but would appeal to many citizens in the GDR waiting for their hopes, including the right to travel, or to depart the GDR, to be realised. In *Der Morgen* the critic considers that *Godot* encompasses a huge breadth of human experience, from hope to fear, from love to hate, from sympathy to cruelty, and from life to death. Whatever the desperate condition of

Estragon and Vladimir, there lives in their sadness, melancholy and resignation also wisdom, confidence and a creative urge (*Der Morgen,* 12 March 1987).

The long wait, since 1953, for the arrival of *Godot* in the GDR is noted in every one of the theatre reviews cited above. They also all take a positive view of Engel's production. *Neue Zeit* and *Sonntag* acknowledge that the play has long been regarded as a masterpiece of world drama. *Sächsische Neueste Nachrichten* observes:

> Meantime the discussion about the author has moved from the polemic into the academic. *Waiting for Godot* has become an extraordinary international theatrical success. The author won the Nobel Prize for Literature [1969]. (*Sächsiche Neueste Nachrichten,* 14 March 1987)

Godot is seen to be a 'prototype' (*Tribüne* 16 March 1987) of the 'theatre of the absurd', the product of specific conditions existing in the aftermath of the Second World War:

> It is common knowledge that the bourgeois dramatists Beckett, Adamov, Ionesco and Genet founded, more or less independently from one another, what since then is called the theatre of the 'absurd' and which was subject to various interpretations. In the final analysis these writers reflected in their work the post-war period in Western Europe, especially the fears and psychoses of those who had recently suffered under capitalistic alienation. (*Neues Deutschland,* 7 May 1987)

Reviewers make it clear that in capitalist societies the quality of life is inferior to that in the GDR. The difference between capitalist society and the GDR allows the GDR to take a detached view and the Dresden production owes its success partly to this capacity. The *Nationalzeitung*'s critic believes that *Godot* was relevant to the economic situation in the West:

> I imagine a performance, and one only possible in his Western world, that could only be construed as a gibe at the unemployed. (*Nationalzeitung,* 24 March 1987)

As mentioned, an image of Estragon and Vladimir as unemployed appears in the review in *Neues Deutschland.*

Neue Zeit takes the view that *Godot* is difficult to perform, that models of performance in the USA and in Western Europe have influenced how the roles of characters are played. A tradition of negative interpretations has developed:

> Manifold instances of mystical gibberish, dark Beckett, solemn affectation, sacred acts of pessimism, mostly by means of spurious theatrical modes and methods such as psychology and cathartic drama that have led to the urge for identifcation. (*Neue Zeit*, 18 March 1987)

These interpretations have for so long made it hard to accept *Godot* on the GDR stage, since Beckett's rejection of his bourgeois and capitalistic roots have been assumed mistakenly as a rejection of human life. Precise acquaintance and a reading of the subtleties, as well as a command of an appropriate style of acting for the comic grotesque and the parabolic have been lacking (ibid.). This seems to amount to a contention that the play itself had never been the main problem, but only a stumbling failure of insight into its quality – which is remedied by Engel and his team. *Tribüne* shares the view that the capitalist theatre interpreted *Godot* as a desolate, depressing and pessimistic tale of doom (*Tribüne*, 16 March 1987). Marxist literature experts now took a more differentiated line on Beckett. Theatre itself had also developed methods to turn apparently abstract, difficult texts into understandable visualisation, whereby it relied on a mature sense of history and a sophisticated appreciation on the part of the audience (ibid.). *Neues Deutschland* maintained that when socialist theatre turned to Beckett, it had to speak with its own voice, and in this respect Engel's production was worthy of discussion (*Neues Deutschland*, 7 May 1987).

The reviews cited here are generally positive and contrast sharply with the negative attitude towards *Godot* taken by leading critics in the 1950s and 1960s, also referred to earlier. The part played by theatre critics in determining how particular plays or productions were regarded, and the questions about their integrity and independence, are touched upon in the chapter in relation to censorship and controls. A few of the well known theatre critics who came into dispute with their editors are reported as declining to alter their draft articles, or to have passed the reviewing on to other colleagues. This was feasible for

critics eminent enough to have obtained a position in the offices of *Theater der Zeit* or of *Neues Deutschland*, where many persons of high professional standing were employed, but such a choice would have been less available to an arts critic on the premises of newspapers serving only small towns or scattered rural communities.

Some playwrights in the GDR had already engaged with Beckett's work. As mentioned above, Brecht was one. *Sonntag* refers also to Brecht, Hammel, Braun, Wendt and Drewniok. The *Sächsische Zeitung* observes that Beckett brings the behaviour of man and his world to a high level of abstraction. Without illusions and relentless in his denial, but unpolemical, he endows his writing with poetic power. Beckett said of *Endspiel* (and the newspaper considers all his plays to be about doom transliterated into the absurd), there is no puzzle and there is no solution. He presents a parable about which the spectator may think, may agree or disagree (*Sächsiche Zeitung*, 10 March 1987). This parable is, explains the critic writing in the *Sächsische Neueste Nachrichten*, of relevance to the present day. Just as when the Second World War destroyed traditional values and a new form of expression to reflect man's existence in an absurd universe was required, Beckett discovered the speech and images for this in his writing and in his work as a dramatist. The critic considers, similarly to his colleague on *Der Morgen*, that the world is again, in 1987, under threat and Beckett's concerns remain relevant to us all:

> They have lost nothing of their driving insistence or their universal allegorical power. Yet again this world becomes fragile through the terrible threat to each and every existence. That poses new challenging questions, self-reflection and reflections on ambition and on hope. (*Sächsische Neueste Nachrichten*, 14 March 1987)

This case study substantially complements Chapter Three in which questions related to the selective adoption of drama from humanism of the nineteenth century, the influence of Russian and Soviet drama and the problems of contemporary plays by GDR authors were addressed. Certain of the trends identified in that chapter are relevant to the study of the journey of *Godot* from abhorred decadence to enjoyable entertainment in the GDR and, as mentioned there, the theatre professionals in the GDR did try continually to stretch the boundaries

of permitted theatrical development. These attempts were opportunistic, and success varied according to the cultural and political situation, but where new ideas and methods crept into practice they often survived later periods of repression, on the principle that once Pandora's box was opened it was difficult to close it.

For example, the importation of the concept of the open stage with maximum communication with the audience in a shared space in the late 1970s gained acceptance with the theatre-going public, as witnessed by the experiments at the Volksbühne and in the 'Spektakel' and 'Theaterfeste'. Wolfgang Emmerich refers to the language of modernism taking root in the GDR. Innovations in technique, such as background film montage, became more and more part of the normal options for theatre work. The selective approach to drama of historical humanism conceivably assisted the acceptance of later, more modern works, such as *Godot*, which were achieving paramount status within the contemporary international repertoire and did not exactly fit the socialist canon but were deemed to exhibit important human concerns. So, as mentioned in the press coverage above, the GDR theatre had undergone considerable change since the 1950s, i.e. from when *Godot* was anathema.

Directors in the theatre of the GDR, some of whom worked for periods abroad, helped create knowledge of and openness towards the reception of avant-garde drama from the West. Associated with the changing methods of directors was the notion of 'Theaterkunst' concerned with emphasis on visualisation on the stage. The GDR emerged in the 1980s with its own avant-garde directors, including Frank Castorf and Jo Fabian, and other well-established directors like Wolfgang Engel were also in the forefront of innovation. Engel's audience of mostly young people were inherently receptive to the idea of action as opposed to inaction, and therefore to a represention of the waiting in *Godot* as an active experience. The entry of Estragon and Vladimir struggling with their lines as they rose out of a tangled red curtain stammering 'Warten auf Gott...auf Godot...auf Gorba....' provided the Dresden audience with an experience that was both highly theatrical and acutely polititical.

The change in attitude to Godot over 34 years, now chronicled, is understandable within the framework of innovation in European

drama since 1945. The GDR theatre tried to be part of that development, though the directors and other creative members of the ensembles inevitably worked within their own socialist ethos and within the parameters of the socialist system. They explored the opportunities that opened up to enable them to be enterprising in their choice of repertoire. The fact remained that the political atmosphere at any time was crucial, e.g. the intensity of the promotion of cultural links with West Germany. The favourable reception to the long awaited *Godot* in 1987 had much to do with the internal political climate. Newly emergent social and environmental movements in the GDR saw the reforms of Gorbachev in the USSR and the advocacy of 'perestroika' and 'glasnost' as an opportunity to achieve political and social change in the GDR.

As to the control mechanisms deployed to keep *Godot* out of the GDR, these were the province of the ideologues and theorists who sought by propagation of their views to uphold socialist realism in preference to modernism or post-modernism. Visits abroad by the GDR ensembles had shown the rest of Europe and other countries overseas what excellence could be attained in socialist realism. The seminal works of Beckett were prevented from reaching the stage until the very last years of the republic. The influence of Beckett's plays on the thinking and attitude of serious players in the theatrical profession was, nevertheless, far-reaching and, as detailed in the study, led to plenty of not uncritical imitation and experimentation. Other socialist countries allowed performances of Beckett, which, in the end, helped to make the GDR look like a backwater of world theatre at a time when the regime set value on maximising cultural prestige. It is arguable that the acceptance of Beckett's *Godot* was a final consequence of the gradual implantation of the West European experience of modern theatre into the drama of the GDR just as, economically speaking, the FRG's drip-feed of financial support for the GDR economy throughout the 1980s culminated, during political upheaval a few years later, in the adoption of the Deutschmark as the currency of East as well as West Germany.

Chapter Six
Apparatus of Control

One aim in the selection of the case studies is the representation of the situation in Berlin as well as the conditions outside the capital. Dresden is a centre of high culture of equal quality. Each is in a different district of the GDR and together they form a microcosm of the overall position of Berlin and the provinces and their relationship to one another that is more generally analysed in Chapter Two. The case studies contain fuller detail of the practice of drama, the effectiveness of the controls on the performing arts and the tensions arising from their application in each location. They indicate, for instance, the depth of the rivalry between Dresden and Berlin, a rivalry that is part of the wider regional canvas in which Leipzig and Dresden are seen to be resentful of Berlin's appropriation of the title of capital city. The studies reveal that whilst the resentment was present, it was accompanied in the theatrical profession and among writers by attraction to Berlin's special status in the struggles of the Cold War, its unique metropolitan ethos, and the opportunities there for better-paid work and for advancing or crowning careers. That said, as the GDR leadership isolated itself from the population and failed to heed cries for change, the feelings towards Berlin became ever more heated. Ken Smith, in his book, *Berlin: Coming in from the Cold*, perceives a vengeful spirit at work in the regions of the GDR that made them eager to bring about the downfall of the SED in the city from which it governed the republic:

> East Berlin was the GDR's showcase; [...] the capital, a little freer, a little better fed and watered, to which labour and materials had long been diverted at the expense of other cities in the GDR. Resentment for this in other Eastern cities, Leipzig especially, accounts in part for the greater determination of the protesters there. (Smith 1990: 70)

Theatres in the larger provincial cities dispensed with certain stages in the approval process: e.g. in Dresden external judgement was not invited on whether a particular production of a play would be suitable for the public. The existence of fairly standard control mechanisms might have been expected to result in a tendency to performance of a similar type of drama all over the GDR. In so far as taboos on subject matter continued to be observed, there was almost wholly effective universal prohibition. However, it is far from the case that the blanket control caused theatre activity in the provinces to be either homogeneous or a carbon copy of the drama that was performed in Berlin. The authorities' direction of potentially controversial productions away from Berlin helped to create variety in the provincial theatre, and some playwrights like Christoph Hein, and directors like Frank Castorf, found easier outlets for their talents there.

General regulation took no account of municipal pride, local affiliations or regional characteristics. Nor could its centralised implementation do anything but accentuate an alienation of the cities and towns outside Berlin from the seat of central power that Berlin had become. Historically and territorially, places such as Dresden and Schwerin were quite distinct from the former Prussian capital. As belief in communism waned in the GDR as it failed economically, so too was there a retreat from an identification with the state to the rediscovery and re-invigoration of a regional heritage, such as plays in Plattdeutsch in the Rostock area. Inspiration for repertoires in the theatres also stemmed from the contemporary character of the area served by a theatre, as is seen with the relationship between the theatre and the modern chemical industry in Halle.

Plurality of any kind was not easily tolerated in the centralised state. Plurality represented by different practices in diverse geographical areas weakened the idea of an all-powerful monolithic state. Diversity in the cultural sphere led to an attrition of that power and transferred some of it to the regions of the GDR since local circumstances, or claims to special status and traditional international connections, i.e. in Dresden or Leipzig, could be invoked to justify variations on a national pattern. There were signs of disenchantment with the ability of the SED and the Ministry of Culture operating out of Berlin to understand and have sympathy with directors working in

provincial theatre. Among the complaints made are that their productions were not given their due in the national media, that they may as well have been situated in Siberia for all that Berlin had any respect for them (Interview Baker/Engel, 5 December 2002); indeed, it has been alleged, retrospectively, that the lack of communication and of mutual appreciation between Berlin and the provinces was a problem and continued to be so even after the re-unification of Germany. Peter Sodann likens this to the existence of a second wall still in place between Berlin and the 'Republik' after the fall of the Berlin Wall *Theater Heute* 3/90: 29). In the GDR the Berlin authorities working together had their own agenda to compete culturally with West Berlin, which ambition justified drawing off resources from all over the GDR even though this left provincial theatres with an inferior infrastructure. From Berlin's viewpoint, the territory in the rest of the GDR was peopled with theatre professionals that had yet to make it to Berlin or had been cast out from the capital. In the provincial theatres the feelings of alienation never led to any organised, independent, stance to assert, for instance, a claim to parity with Berlin.

The theatre was, however, a conduit for ideas from outside the GDR, such as freedom of expression and the rights of the individual; in the new state much of the repertoire was still being taken from international drama, from external sources not controlled by the regime. Also, ideas that had long existed before the founding of the GDR were to be found in the heritage of the theatre. The theatre therefore had a potential to present GDR citizens with ideas and human values that they would not find in the modern mass media of film, television and newspapers, all of which were put to use as vehicles for propaganda.

The press reported positive achievements and not those problems whose discussion could reveal that the GDR was not functioning well. Along with television, the press came under the supervision of the Department of Agitation and Propaganda and editors would not allow debate in the newspaper columns that amounted to denigration of the GDR. Professional writers as opposed to journalists were freer to write as they wished but unlike these reporters of the regime's successes could not be sure that their work would be published, still less performed. As Jürgen Groß's theatre director Habberle complains in

171

Revisor oder Katze aus dem Sack, he has to employ writers who write as if for newspapers, but cannot perform the work of authors who do not write like journalists.

The procedures enumerated in Chapter Two indicate that writers had a series of obstacles to negotiate before they received the permission of the Ministry of Culture. Although texts of plays might be more readily approved for circulation than the publication of prose and novels, playwrights could not see their work come to fruition until a piece was performed in public. The requirement to satisfy local authorities was also more onerous. Indeed, it is clear that the performance of new drama entailed greater and more multifarious controls than the publication of new writing but, unlike the press, it was able, within strict limits, to explore conflict and contradiction in the political and social spheres.

There was a clear difference between writing simply to be read, and producing drama. The theatre was a collective, state-run undertaking requiring many diverse talents, and involved organisations and social partners from whom the audiences were drawn. It was, moreover, a forum for intellectuals and required from the authorities more vigilance and surveillance than did individual authors who were the sole source of the novel or the poem, and who stood alone before the censors. Other matters such as the programme notes, forms of publicity, scenery and acting, reception by theatre audiences had to be watched. All this demanded a commensurate effort by the monitoring officials, and yet more demanding when local decisions to allow ensembles to perform or not perform were required in scores of theatres where a whole repertoire of plays was put on in each season. The local bodies engaged in all this were products of their environment and representative of their communities, as well as being answerable to the state and SED hierarchies, thus they had their particular agendas which may not have been the same as those of theatre managements. The task of overseeing GDR theatre was certainly labour-intensive. The huge manpower involved in watching over the theatre is remarkable, especially in connection with new drama requiring theatre managements to present and justify the new work, the vetting of the plays by publishers and officials, and the scrutiny of text and participation by local cultural officers in juries at

172

final rehearsals. Politically, too, there was much activity, as shown by interventions of the First Secretaries of the SED in Dresden and Potsdam, through the instances of Party disciplinary proceedings, and campaigns organised by the SED. In the professional sphere we see the advisory team from the Ministry of Culture despatched to sort out problems in Dresden, and the action of members of the professional associations to criticise or support the author of *Die Übergangs-gesellschaft*. By no means least, in terms of personnel, was the Stasi, which formed units dedicated to undermining the lives of playwrights like Ulrich Plenzdorf and Volker Braun and assigned groups of officers with duties related to separate theatre departments within the ensembles, as in the spying on the dramaturges before and during the production of *Revisor oder Katze aus dem Sack*. This is without counting the placing of informers. Reviewers in the press, plus, of course, the audiences, swelled the number of people keeping the theatre under purposeful observation.

When theatre and state interests clashed and the Party intervened they did not concern themselves overmuch with the standard of the drama: they concentrated on how the image of the Party might be affected and in so far as any justification was put forward it was based on political considerations. The SED ousted all the intendants that did not belong to the Party, or to a 'bloc' Party, as well as ensuring that SED members occupied the important positions in the publishing world. The publishing agency that dealt with all theatre matters had been acquired by the SED, who made it into a lucrative monopoly. The GDR's chief political ideologue and SED member was also responsible for cultural policy and, under the Politbüro, had the last word on what was permissible in the theatre. The theatrical pro-fession's central body was set up as a means of control over its members. The SED mobilised locally to monitor and steer what went on in individual theatres through committees in the local SED organs and within the theatres. The Party took the line that no censorship was being practised, when in fact it was, and observed taboos and areas of state secrecy, all of which hindered meaningful exploration of contemporary issues on stage.

There was hardly an equal partnership between the performing arts and the state because the theatre had always to propose and the

state to dispose. The authorities were gatekeepers to the permissions required and their decision was final. Nevertheless, the ensembles retained the initiative and no evidence has been adduced of active intervention by the authorities to insist on the performance of specific plays or programmes against the wishes of the theatre professionals. Success in negotiating the procedures and finding the route towards publication of a new play or new production came from adopting a variety of means. Some writers, like the popular playwright, Rudi Strahl, and some directors, such as Wolfgang Engel who directed the innovative production of *Godot*, had a fine sense for what would be acceptable and through self-censorship reached a position where they were confident and others trusted them. The written justifications for performance or production submitted to the authorities usually contained a balance of theatrical reasons and political grounds, the latter to satisfy the SED cultural functionaries rather than in expression of the views of the theatre management. The development of a reputation and of trust between author and theatre were clearly important as a basis of theatre projects and beneficial to both parties. The effective approach was to seek out theatre managements, officials and patrons who would be receptive to the new work so that the application for approval was steered along the right channels, or at least avoided known bottlenecks. A certain amount of intrigue was necessary, as were also efforts to indicate how plays should or should not be interpreted by audiences or critics, thus forestalling other less favourable immediate reactions.

The case studies illuminate factors, such as the nature and derivation of a play, the validity of approval received to its staging, the timing and location of a production and the role of leading personalities that facilitated access to the GDR stage. The play that derived from Russian drama, *Die Übergangsgesellschaft* gained from its association with *Three Sisters*, frequently seen in the GDR and performed there by Soviet ensembles. However, the same cannot be said of the Hans Otto Theater's production of *Revisor oder Katze aus dem Sack*, where the link to Gogol in the end counted for very little. Possessing ministerial approval was insufficient to guarantee a run beyond the first few performances: The ministry's approval was ignored in the case of *Der Georgsberg*, and it did not put *Die Über-*

gangsgesellschaft beyond challenge, it was not weighty enough to save *Revisor oder Katze aus dem Sack*, and only the consent of the Central Committee sufficed for *Godot*. More complex plays fared better than plain comedies, *Der Georgsberg* and *Revisor oder Katze aus dem Sack* were pretty well one-dimensional compared to *Die Übergangsgesellschaft* which could, and was, interpreted on more than one level, and was promoted on the level that caused least political fuss. Of course, timing was also one factor: Kerndl's *Der Georgsberg* was staged during a repressive political climate, whereas *Die Übergangsgesellschaft* and *Godot* were in tune with some of the trends of the late 1980s. As the Hans Otto Theater discovered, location was important, they happened to be in a district headed by a Party hard-liner, whereas the Dresden ensemble had the protection of Hans Modrow. It is noticeable that the plays that succeeded were the three that had a highly-placed patron, like Minetti, Modrow, or Hager. Patrons were needed, but crucial to success was the driving force provided by the intendants and directors of considerable calibre, by Langhoff, Wolfram and Engel. Much more than was previously known or suspected in a socialist society used to collective decision-making, it was the energetic activity of individuals in key positions who brought drama, especially new drama, to the point of performance. The Ministry's administrative work and Party deliberations did not really animate that process, it was achieved by forceful personalities who were not only proficient in the theatrical sphere but who also developed skills of persuasion and an ability to cut through the labyrinth of controls. This should not be overlooked during the consideration below of the organizations and structures affecting the theatre.

Formal connections between the various parties involved in supervising the theatrical life of the GDR have been shown in Chapter Two. Flowing from the Politbüro there were three strands of governance that impacted upon the theatre: i.e. the SED political structure, the official organisations headed up by ministers, and the state security service. In the actual theatre these strands manifested themselves in the local organisations of Party members, the theatre management under the intendant, and the presence of Stasi informers. Steering works through these bodies was a complicated and tortuous process,

but did allow some scope for advocates of new drama to exploit differences in attitude among them.

When a GDR author became aware that his play might reach the stage he would usually review its form and content and sometimes revise the text before presenting it to the theatre. It usually fell to the dramaturge to consider its suitability and alterations might be made then, and the director would probably also have views. A text would be forwarded to the ministry for approval via local cultural officials who had the opportunity to comment and would point out any passages they found objectionable. The author was bound to take these seriously. The ministry might also demand changes. The jury of officials at the final rehearsal might ask for certain sections to be reconsidered. Right up to performance the text could be in a state of flux; and the plays concerned in the case studies in Chapters Four and Five were no exception. The fact was that no amount of juggling with the wording of a play could guarantee its acceptance. Even the absence of objections to it could not be relied upon as firm encouragement. Objections were raised to *Die Übergangsgesellschaft* but the theatre managed to satisfy the officials. The passages in it translated directly from the Russian of Chekhov were, in any case, unlikely to be challenged in the satellite state. By contrast, *Godot* was the subject of minor but significant changes to suit the style of the successful Dresden production, and these were, in the main, theatrically inspired. Overall, the illustrations reveal that uncertainty prevailed through to the initial run of performances. Indeed, when the same play was performed in another theatre or another town, it might yet again be altered.

The text was not the only component of a theatre production. Stage management was important and would be inspected by officials during later rehearsals. Props and scenery had to be chosen with care. As listed earlier, there were a number of items that could never be shown on the stage. Even permissions to perform in public could be hedged with restrictions on the props to be used, or requiring the piece to be performed at a particular theatre, in a smaller theatre or not at all, say, during anniversary celebrations of the GDR. Sometimes, innocuous items appeared on the stage but had certain meaning for the audience, for example, when King Arthur wore lederhosen and

176

sported rimless spectacles in Hein's *Die Ritter der Tafelrunde*, it was presumably intended to denote a modern German context.

The themes addressed in each play played a part in the consideration it was given. If they were close to the taboo themes that are listed in the literature review they were immediately suspect; if they were concerned with matters that were not on the list, but were, notwithstanding, regarded as state secrets, that was also troublesome. In practice, the themes that proved particularly controversial were those that touched upon the current activities of the regime. Broader themes touching upon the nexus of continuity and change in society were susceptible to different interpretations by the regime and by the general theatre audience. These had an easier passage, providing they had, in the eyes of officials and politicians, some praiseworthy aspects, e.g. leaders showing wisdom that outweighed or balanced other, critical, features. Wilhelm in *Die Übergangsgesellschaft* is one example.

Surmounting the procedural obstacles to drama and persuading authority clearly took up a tremendous amount of time and energy, although in a state where hardly any public activity could take place without an official affiliation or sanction, the theatre was hardly an exception. Unlike theatre professionals in the capitalistic West, directors, dramaturges, writers and actors had secure employment and less constraint on time to develop and revise their work. The bureaucratic processes were burdensome but unavoidable in a centralist state. Also, repressive as these measures were, especially when seen from a position outside the GDR, it should be recalled that there were equal, if vastly different, difficulties in obtaining performances of political theatre in Britain in the 1970s and 1980s. Also in comparison with the previous Nazi regime in Germany, and even the Ulbricht era in the GDR, the operation of official screening of new work was relatively subtle.

There were a vast number of 'run of the mill' applications for approvals that were settled between theatre representatives and cultural officers, so the procedures were generally effective, however, when dealing with exceptionally controversial situations, the parties resorted to other lines of communication and to higher levels in the organisational structure and, indeed, to individuals who had attained

key positions of power or influence, in order to resolve disputes. Party Secretaries for the districts had a great deal of power. Jahn in Potsdam acted with zeal to halt performances of *Der Revisor oder Katze aus dem Sack* at the Hans Otto Theater, and the local SED mounted a clever campaign against the ensemble which, having received the approval of the MfK, had reason to feel justified in performing the play. Modrow, in Dresden, was instrumental in the dealings with Berlin to avert a ban on *Die Ritter der Tafelrunde.* Party Secretaries had regular meetings with Honecker and direct access to him and could complain to Honecker about the conduct of the MfK. Officials and members of the district leadership were not always of the same opinion as the Party Secretaries, as is borne out in both these cases which reveal that neither the SED structure nor the administrative organisation was monolithic. Officials' approvals for new drama were not necessarily the last word when it came to putting on a play in a specific theatre. Sending a group of expert advisers to represent the Minister sometimes tilted the balance in favour of the ensemble. In all but the most controversial cases, adjustments to text were negotiated between the theatre and the cultural officers. The intendant was the final arbiter of what could take place in his theatre. There are no instances of intendants ignoring protests from every quarter and going ahead with productions and performances but they were often men of courage.

Evidence that it was the state representatives who had the final say is to be found. A decision to cause a play or programme to be abandoned was never reviewed or subject to arbitration. Compliance with the usual procedures in no way guaranteed a safe passage later on which suggests that the concept of acquiring unassailable rights through compliance with the procedural rules did not exist. Also, no person in the cultural field, however well established in their position, was immune from sudden disfavour. Such action as the dismissal of the drama critic Rainer Kerndl shocked the theatre world of the GDR. It affirmed the supremacy of the SED which was unchallenged by any collective resistance from the writers' union, although within this association of writers there was much sympathy for Kerndl on account of the way he had been treated. It is neither hard, nor altogether surprising, to find that certain SED leaders had acquired a Stalinistic taste for exercising power unbridled by bureaucratic deliberation or concern

for individuals. Jahn, the Potsdam SED Secretary, also took matters into his own hands to bring about a ban on further performances of *Revisor oder Katze aus dem Sack,* though this was done more openly than with Kerndl's play. However, these cases raise a query as to why each play proceeded to performance before the work was suppressed. The explanation may be that since the playwrights' new dramas were looked on favourably by the department, local cultural officers were not inclined to raise immediately the substantial objections to the works that would cause the intendant to cancel performances whereas the existence or imminence of a ministerial approval carried less weight with SED functionaries. Regarding *Die Ritter der Tafelrunde* a team of eminent theatre professionals considered that a performance should be allowed but it was fortunate, too, that the District SED Secretary for Dresden came to the same opinion and that the fierce opposition of the local cultural official was ignored.

The bureaucracy of procedures rested on acceptance of the right of authority to interfere, but this was fortified by an underlying assumption, widely held, that all that could be expressed would not be expressed, especially on the public stage. Authors and ensemble members were very conscious of this form of self-restraint which Honecker, in retrospect, described as the force of conscience. In parenthesis, mention is made here of the taboo on referring to censorship. This was yet another difficulty for dramatists. The mechanisms of control and guidance were rendered more coercive because they could be presented as helpful and protective. However, by the mid-1980s the veil was wearing thin and Hein was able to criticise the whole system by name in his speech in 1987. The denial of any imposed censorship has not hindered the treatment of censorship in this publication; it has been subsumed into investigation of the general sphere of supervision by the state, the latter a function that was clearly acknowledged.

If self-censorship is seen in a sequential process, then it occurs after social and personal indoctrination and before external censorship expressly imposed. It was manifest in a personal subconsciously induced discipline among theatre professionals that sprang, most certainly for the younger element, from an upbringing in the GDR that implanted values through the systems of school and higher education

and the officially-backed youth movement, the FDJ. By the time individuals began writing for publication or became involved professionally in drama productions they had knowledge and experience of what was required of the citizen in the GDR. The official line was anyone could write without fear of censorship because censorship did not exist in the GDR. It was not needed because of the writer's or director's innate sense of what was fit to be written or acted in the GDR. In the GDR a situation arose whereby writers conditioned to the various taboos, worked, accompanied by an invisible presence that checked their thoughts before they had finished thinking them. In the theatrical context, the working out of the relationship between self-censorship and participation in the theatre had different outcomes. The urge to write, imbued with the desire to acquire and reveal insights into the human condition, to arrive at a 'truth' that is to be differentiated from an accumulation of facts, leads the writer to confront his shadow of self-censorship. He can let it be his guide, in which case he may never attain an artistic ideal, or he can convince himself that it does not exist and be a hypocrite, claiming that whatever he says or writes is the artistic 'truth'. He bears the imprint of his time and society rather than making his mark.

A third way is to confront self-censorship and decide consciously to resist it in order to preserve authenticity of the art. Writers, and writers for the theatre, who have the most seminal creative role, e.g. Christa Wolf and Christoph Hein, make resistance to, and overcoming, self-censorship a fundament of their work. Directors in the GDR based their contribution to drama on scripts provided by playwrights. The directors had an attenuated responsibility for this material, and for dramatic purposes were ready to edit it to produce a performable play. In the interlocution between author and audience, directors such as Thomas Langhoff and Wolfgang Engel used their 'antennae' to fashion the drama to suit conditions in the GDR.

Self-censorship by the authors themselves was clearly not trusted as a means of rendering censorship superfluous, otherwise the plethora of procedures would not have been instituted. However, that consciousness of areas that could not be written about constituted a shadow over authors, and other creative people: it formed in them a watchful 'super-ego' in Freudian terms, and is a special mark of GDR

literature and drama. The distinction drawn above between writer and director derives from their different functions. However, in either of the functions it is clear that individuals reacted differently: some, like Volker Braun, moved with ease within this duality of substance and shadow. He sought official guidance and clarification from the SED establishment. Others, like de Bruyn and Hein, though continuing to experience the presence of inner restraints, found the means to circumvent them or turn them to positive use in their work. A connection between inculcated and imposed censorship is detectable since the self-censorship can operate in harmony and in parallel with the threatened or imposed variety. Efforts to reject self-censorship indicate a desire and will for free expression that is inconsistent with full acceptance of formal mechanisms of coercion.

Conversely, any failure to stop the external mechanisms from affecting writing, can, in the view of Christoph Hein, lead to problems of literary self-censorship for an author:

> He will practice self censorship and will betray the text, or write against the censorship and then also commit a betrayal of the text, since its truth is involuntarily, and possibly unknowingly, polemically altered. (Hein 1990: 109)

It was not only writers and dramatists who had the shadow of self-censorship at their back, but publishers and cultural officials who, as they did their duty in relation to the work done by others, were not only imbued by this innate sense of restraint but expected it to be reflected in all creative endeavour in the GDR. In the end, the finished piece was the product of struggle or acquiescence with that force as well as the result of personal creativity.

In his history of GDR literature Wolfgang Emmerich traces the ideological arguments about particular dramas that took place in the specialist journals such as *Sinn und Form*. Here was the forum for the experts in expensive journals of small circulation. They enjoyed more freedom for the exchange of opposing views than existed in any other publications. Also, they were more ready to act as a testbed for new work: for instance, Plenzdorf's *Die neuen Leiden des jungen W.* first appeared in *Sinn und Form*, probably the only place where it could be accepted. Volker Braun was informed that one of his plays might be allowed to appear in the journal, but nowhere else.

Emmerich did not deal with the theatre criticism appearing in the local and national press, and in organs of the mass organisations. In this criticism – somewhat less esoteric – there is a relatively instantaneous reaction to performances that inform the readers what they may expect. Interpretations are offered, varying according to the press critic, and the viewpoint of his editor, and additionally reflecting the political background of the moment. Taken together and analysed, they provide insight into the range of critics' opinions within the audience radius of the theatre, and even beyond.

The reviews cited in the theatre case studies not only help to show the interpretation put upon the plays publicly, they further inform and illuminate the function of criticism as a means of control. They also yield extra material on which an appraisal may be made of the quality of the work of theatre critics employed in newspapers and magazines.

The critics provided the theatre-going public with information, performed a useful publicity function for the ensembles, helped establish the reputation of ensemble members and served to place the performances on record, a record which now provides often the only archival information about a first performance. In regard to their professional criticism they were hampered by being a part of the propagandist media and therefore could not fully debate the drama they saw. On stage this might well be more radical than they dared report. Notwithstanding this predicament, the case studies show the variety of viewpoints within drama criticism that could be expressed without deviating from the Party line. The GDR critics were habitually circumspect, a tendency that seems to have been noted by the SED. In 1977 the Politbüro specifically called upon art and literature critics to make up their minds as to which works contributed to the establishment of socialist conviction and behaviour, and to the imprinting of communist ideals, and which did not. The tendency to caution continued, however, even in the last years of the GDR, though there was usually more outspoken enthusiasm for a production by critics in the town where the theatre operated than in the regional or national press, and some serious and lively discussion of issues took place in the columns of the professional journals (scope for critical

discussion appeared to be in inverse proportion to the size of the audience).

It is clear that the SED politicians could always bring theatre in the GDR to a halt in any particular instance. Support by way of infrastructure and finance was provided by the regime but momentum in theatre activity came from individual intendants, dramaturges and directors, from the writers of plays. Leading personalities in the theatre were successful in persuading those in the SED responsible for cultural matters to allow the staging of avant-garde drama, or were able to defend debateable choices already made. Nor can it be said that the SED actually achieved the sort of reputation for GDR theatre they would have wished. The playwrights best known beyond the borders of the GDR, such as Müller, Braun and Hein, were committed socialists but hardly ever at one with the SED establishment. They earned their reputations in the face of official criticism and obstruction.

Despite having controls and surveillance imposed upon them, the playwrights above, and many others, together with the managements of the theatres, do not emerge simply as helpless victims of a system, but as dramatists and socialists working to fulfil their vision of how drama should help to shape and reflect the society in which they lived. A question sometimes posed is whether by their existence and activity they were principally a support of a cultural nature for the policies of the GDR regime or whether, through their handling of themes which, directly or indirectly, highlighted inconsistencies and contradictions in the GDR brand of socialism, they ventilated concerns that the regime wanted to be hidden and thereby undermined the aims of their political masters. Both propositions may be true, and not necessarily incompatible, but it is more realistic to ask, at least initially, whether, between these extremes, the dramatists exhibited independence of mind or action. A small sample of behaviour patterns is provided in the thesis in reference to the writers Volker Braun, Heiner Müller and Christoph Hein, each of whom had their own individual conceptions of drama and their own method of coping with the demands deriving from the SED's cultural aspirations. Each could have emigrated from the GDR at some challengingly difficult point in their careers but each chose to stay in the GDR.

It was possible to avoid being cowed into a submissive role, although GDR dramatists had inevitably to deal with state representatives who had the power to negate their work and it is not surprising that an element of negotiation was required to achieve publication or performance of a play. The patience and perseverance of the playwrights and directors is remarkable. Nevertheless, it is hard to escape the conclusion that in their behaviour the dramatists who remained in the GDR were, all in all, voluntarily or involuntarily, singly or collectively, entangled in and supportive of the regime and were involved in and responsible for the continuance of the socialist-oriented cultural life in the GDR. This support was paramount but they did also enrich the cultural sphere through openness to theatrical developments and through contacts in international exchange visits and guest appearances, especially with the FRG. It is also true that at the collapse of the GDR members of the theatrical profession were prominent among the huge demonstrations of popular discontent and are accorded credit for stepping forward during that perilous situation. Their legacy of drama, drawn on in this thesis, affords a unique insight into the repressive tendencies of a totalitarian state and into the cultural complexities of the GDR.

Authors, dramaturges and directors were all important figures, especially in creative terms. However if it were asked who the key players were in GDR theatre, then the intendants or general managers would have a strong claim. Mention has already been made of the efforts to do their best for their ensembles of several of the intendants responsible for theatre productions examined in the case studies. The majority of intendants had at some time been directors or dramaturges, so they were truly men of the theatre. In Honecker's time, by the late 1970s, they were all Party members. They were positioned at the interface between theatre and the political establishment and needed to be expert in managing the theatre and obtaining support from local cultural officials and local politicians. Under Honecker, they not only steered the proposed drama programmes to approval: their job became harder since they were delegated the responsibility for keeping in or removing items from the approved repertoire.

Action to censor creative work was not acknowledged to be a feature of the GDR and a similar fiction was maintained in relation to

the Stasi, who on their own account, took action against GDR citizens under suspicion. Stasi officers denied having and acting upon their own agenda and said they took orders from the SED or the state administration. They kept watch on the population and rendered reports for information. There is plenty of evidence in the case studies and in chapter four to show that the MfS formulated and implemented measures that were their own invention.

Reasons why the Stasi should be pro-active in the Honecker era are to be found in their record, in their failure as the intelligence arm of the GDR to forewarn the regime of the uprising of 1953. It was the recurring nightmare of successive Ministers of State Security that the same could happen again. It was why the Stasi stepped up from intelligence gathering to adopting the role of 'thought police'. The shift in that direction was accelerated by the regime having been taken unawares by the vehement reaction to their depriving Wolf Biermann of his citizenship. The Stasi were very closely involved in spying upon him in the months beforehand.

To find out what people were thinking necessitated getting closer to individuals and deploying informers who got to know their subjects very well and secured their subject's trust. Physical observation remained a very useful tool for the Stasi, but, in order to spot unorthodox thinking and other potential oppositional tendencies, spies in the more intimate circle of friends and family were more effective. These operations were more demanding and required astute management of the informers. There was in fact a huge expansion in Stasi numbers and in the recruitment of spies for the cultural areas of GDR life, since it was among the intelligentsia and creators of art that ideas were the common currency.

It has become a commonplace to say that under Honecker the Stasi acted more subtly than it had under Ulbricht and the impression is given that it was somehow more benevolent and less to be feared. Of course, the Stasi of the 1970s and the 1980s was able to point to Ulbricht's drastic measures and to rely on the threat rather than the actuality of those being re-activated. However, the new methods were more invasive of privacy, created greater distrust among all citizens of the republic and implicated a significant fraction of the population in informing on one another. It is arguable that the total effect was to

185

augment state control. The consequent loss of integrity in public and private life had an insidious impact on the morale of GDR communities. Stopping undesirable tendencies before anything happened was more difficult than apprehending wrongdoers, but it also made the Stasi inclined to magnify signs of deviance and to take clumsy or disproportionate preventive action. This was compounded by the general paranoia of the regime, i.e. by its inability to take any criticism lightly. Also, because, overall, change in policy was so strongly rejected by the leadership, the easier path was taken, of dealing with the prospective reformers in their personal and professional sphere, a task for which the Stasi was well qualified.

The Stasi performed these tasks in secret so there was no need for the GDR leaders to acknowledge accountability. Moreover, even though the Stasi law school in Potsdam devised more and more laws and regulations, a preference not to rule by law enforcement but through arbitrary power was evident. No legal battles were to be fought, no further emigration of disgruntled citizens was wanted but, rather international renown for the sovereign state, some of which sprang from the excellence of high culture to be found in the GDR. Prize-winning playwrights and outstanding directors were a distinction that added lustre to the GDR. However, this did not, by any means, exempt them from the attentions of the Stasi. The very people who had talent, and were favoured, nurtured and mentored by the cultural establishment, were being spied upon and having reports written about them This ambivalent attitude produces the curious spectacle of well-known authors mixing well with the senior echelons of the Party, while the Stasi dug away at their careers and reputation.

The Stasi were in some ways as involved in the theatre as the SED. They conducted appraisals of the state of the theatre in their district organisations, they regularly sent representatives to performances and had been known to disrupt these, Stasi officers reported on what they had seen and provided theatre criticism that was frank, if politically one-sided. They were in a position to know more about what was going on because the SED hierarchy would be fed information from Party members that put the best gloss on situations, and any information received by the SED from the Stasi on the basis of secret surveillance would also be filtered. Here, mention should be made of

the personal dedication of the minister, Erich Mielke, in charge of the Stasi from 1957 until 1989, who on all sides saw intellectuals as potential or actual enemies within the state and took extensive measures to keep them under observation. Compared to the theatre, the Stasi was a massive and powerful organisation. They definitely achieved success behind the scenes in stopping or hindering the careers of individuals in the theatre and appear to have taken the head count as a measure of their success. The Stasi were everywhere, though that did not mean they were all-powerful. Even among the case studies in which the Stasi figure, not everything went their way. Their officers and informers were deeply involved with the staff of the Hans Otto Theater in Potsdam but *Revisor oder Katze aus dem Sack* was, nevertheless, produced and performed.

The depth, nature and impact of the direct state control and surveillance of the theatre has been revealed. Extra interest arises from the discovery of unpublished documents that enable more to be known about the condition of the GDR theatre under Honecker, and the way that the state and Party carried out their policies. The picture is not one of order and compliance but of an uneasy relationship between politics and this particular performing art. The authorities were interested in stage presentation that exemplified socialist achievement and exhibited happiness or hope. They had little understanding of, or sympathy for, anything else. The ensembles' concern lay with the articulation of conflict and contradiction as the stuff of drama, where the outcome might be harmony but could as well be unresolved ambiguity or social criticism. They did not wish their work to be understood as propaganda, i.e. based solely on a desire for political conformity. Theatre criticism ranged between these extremes, from interpreting drama in Marxist-Leninist terms, generally supporting the theatrical aspirations of the productions, providing the public with some notion of what they could expect to find in a performance, to a modest measure of analysis that stayed within the bounds of orthodox opinion. There were a few exceptions, critics who were more expert than the rest, were more profound in their views and who went out of their way to encourage new talent.

Uneasy, and occasionally troublesome, as this relationship was between state and theatre, it is not clear that the theatre in the GDR in

the Honecker period fits Hammertaler's description of it as a socialist opposition to the regime, nor that his essay, as he asserts, proves this to be the case. There is a cogent case for the view that the theatre was a force that assisted in the legitimisation of the regime. Theatre was a long-established institution in Germany that embraced bourgeois values and was at the core of cultural life in cities and towns. In reviving the institution the socialist authorities had upheld a German tradition as well as giving theatre a new function. The latter was not as new as it might seem since more than a few of the theatres in East Germany had been founded by royalty and nobility as supportive adjuncts to their court life and, in the comparatively recent past, had been adopted to serve the aims of the National Socialists for twelve years. The theatre had, by Honecker's time, been imbued with socialist values but not completely overtaken by them because drama was linked to non-socialist tradition and had an international, not to say, universal, dimension of its own. The prestige it earned accrued to the benefit of the GDR's cultural image; the inherited and re-invigorated institution that had helped to consolidate the new German state continued to be a stable pillar. None of the established GDR ensembles ever sought to become independent of state support, nor did an alternative drama take hold as in neighbouring countries of the Soviet Bloc, i.e. in Poland and Czechoslovakia.

Even developments within the theatre during the Honecker era that might be termed oppositional are marginal to the major trend in the repertoire. Clearly some Soviet and Russian drama provided a cover for the expression of radical views about socialist society, some theatrical technique could be ascribed to Soviet experimentation of the 1920s, and re-working of the classics for a GDR setting also allowed an outlet for unorthodox opinion. However, the filling of up to a quarter of the GDR repertoire with Soviet or Russian plays could but remind the population of where the ultimate power over their lives resided, and to affirm that they were integrated into the Soviet bloc, and that they were subject, as they were in 1953 uprising, to the might of a superior power. The regime derived stability from this. The appropriation of classics of German drama did result in re-evaluative productions that brought out traits in them that were anti-socialist, and innovative productions in the German-speaking world encouraged

theatrical innovation in the GDR. Against this, the overall legitimising of the GDR's claim on this inheritance, together with the associated glory from excellent ensemble work, helped to polish the GDR's cultural image.

As to contemporary drama in the GDR, this was very much desired by the regime to accentuate the unique identity and achievement of the socialist republic. Paradoxically, playwrights experienced huge difficulties in having their plays performed at all, or for more than a few times. At the local level particularly, only lip-service was paid to the idea, and somewhere along the line, there would be a Party activist to take exception. Jürgen Groß's *Revisor oder Katze aus dem Sack* met this fate. Rainer Kerndl launched his career from the position of drama critic on *Neues Deutschland* which gave him some advantage, though ultimately his all-too-contemporary play, *Der Georgsberg*, was not only banned, but never published. Where the spirit of 'glasnost' was abroad, as it was for the productions of *Die Übergangsgesellschaft* and *Die Ritter der Tafelrunde*, it contributed to their salvation.

High quality and provocative new drama was a small fraction of the entire output. The larger proportion consisted of quite diverse works. Shakespeare, Russian and Soviet drama, European classics, and entertaining and undemanding German plays, old and new. In practice, the needs of the populace for amusement, as well as ideological or moral enlightenment, were catered for. The drama written by the authors considered in this volume enjoyed moderate ratings in the mid-1980s (*Wer Spielt Was* 1985-1987). Braun's *Die Übergangsgesellschaft* was the fourth most performed play and Hein's *Die Ritter der Tafelrunde* came 22nd on the list in 1988, but this was reversed by 1990 when Hein rose to fourth place and Braun sank to 18th (*Wer Spielt Was* 1988–1990).

If, in the light of the above factors, opposition did not stem from the institution as a whole, then possibly it is to be found in the activity of the theatrical profession, or among some of its members. However, the studies undertaken demonstrate to what extent self-censorship and imposed constraints combined to form behaviour patterns that seldom led to outright opposition to SED governance. Dramatists were by no means unanimous in rejecting the formal censorship. When criticism

was offered at all, it was often in terms of seeking greater efficiency, abolishing pointless procedures, achieving fairer conditions of employment and remuneration, easing of restrictions, and eliciting more transparency in policy and decisions (Hein 1990: 119). Only rarely, and then largely in the Gorbachev years, was censorship openly challenged. But greater artistic freedom was sought as a means of producing better theatre. Professionals working in the GDR had decided to keep their roots there and had little interest in uprooting these or abandoning the institution in which they survived, or thrived. The most critical of comment that came to public notice was from a handful of dramatists whose high reputation in their craft also afforded them a little latitude of opinion in the public domain. The proposition that theatre folk generally were an oppositional force within the state seems overstated, even though examples of individuals and ensembles very active in the closing struggles of the GDR may be cited. These should not in any sense be decried, they add a heroic note to the finish of theatre in the GDR, but if account is taken of the way the theatre existed over the nineteen years of the Honecker regime, the term 'opposition', even 'socialist opposition', does not aptly fit the theatrical profession in this particular period.

If the theatre was not an active opposition that did not mean that there failed to be a strong political dimension to its activity, which is what Petra Stuber implies, when she argues that it is necessary to view the GDR theatre differently from the middle of the 1960s onwards, and that the ensuing drama of the 1970s and of the 1980s tended to ignore 'Kulturpolitik' and concern itself instead with aesthetic argument:

> If the dominance of politics over the theatre disappears and the theatre is no longer deemed a clear political or ideological instrument, then the analogy between politics and theatre history ends. (Stuber 1998: 222)

For the reason above, she contends that theatrical history should recognise the increasing independence of the theatre and concentrate on the various models of theatre and theatre productions in this later period of the GDR. Certainly innovation and variety in theatrical conceptions was evident: e.g. seeking an open forum between players and

spectators, producing programmes that were a comparison of different plays in a single day, and drawing ideas from hitherto neglected forms of traditional and previously spurned avantgarde drama. The new forms were seen by some of their practitioners as harbingers of social change. Stuber cites this as the crucial point of departure from politics in the theatre and the start of a process whereby counter-models to the earlier style of theatre were increasing accepted, until theatre, released from political, ideological and moral considerations, lost its 'Spezifik' and its identity. In fact, the dramatists continued to have strong political agendas, but agendas of their own making. Looking, for instance, at the plays written by East German authors and performed in the GDR, it is clear that they all carry a political message, either on specific themes such as the GDR citizen and democracy, openness in decision-making, and intrigue by officials, or, on the challenge of political reverses and on the purpose of society. Indeed, in the second half of the 1980s, the opportunity to stage drama that bore directly on the political situation of the GDR was by no means ignored. The controversy so caused roused the authorities into last-ditch efforts to stem the tide.

It is gratifying to be able to demonstrate that determination and persistence in the face of bureaucratic authority that had no liking for the theatre – Wilhelm Pieck, the first President of the GDR, had a great love of the theatre, but Honecker had no enthusiasm for it – succeeded in creating drama and theatrical experiences of the highest quality. Emmerich makes clear that this was so, especially in the case of *Die Übergangsgesellschaft* (Emmerich 1996: 240). He does not inquire into, or bring together, the sanctions threatened or carried out against the many people engaged in the theatre. I seek to cover this aspect in that I have categorised the controls to show how the lives and careers of any non-conforming persons were affected. The results demonstrate that the informal, or rather non-formal, means of influence over the theatrical profession and its work are far more significant than the procedural. A prime example is the ban on further performances of *Der Georgsberg* that overruled approvals to performance obtained from the Ministry of Culture, the local SED and the Berlin Magistrat, and, furthermore, led to the author of the play being dismissed from his job as drama critic. Maximum damage was

191

done to his career and maximum disruption and waste of resources occurred at the theatre. The secret and arbitrary decisions were, seemingly, a punishment for breaking a taboo on public discussion of economic policy. Only a step down from the severity of this centrally-directed political act, in that it did not ruin a career, was the treatment meted out to the Hans Otto Theater for their performance, after receiving permission from the ministry and the local officials, of the satire *Revisor oder Katze aus dem Sack*. The First Secretary for Potsdam, aided by the Stasi, launched an unprecedented slanderous campaign against the intendant and other members of the ensemble. This Potsdam incident represented the last throes of the local Honecker hard-liners, thus while the play was removed from the theatre programme, the ensemble survived and members stayed in their posts. Other East German plays of the late 1980s such as *Die Ritter der Tafelrunde* and *Die Übergangsgesellschaft*, did not succumb to either the formal or non-formal measures activated against them, though in the former case disciplinary proceedings were a hindrance and a formal inspection by the ministry's advisers imposed strict conditions for the performance. In the event, informal discussions between provincial and national politicians saved *Die Ritter der Tafelrunde* from a ban, and its success with the public ensured a long run. Both playwrights had had previous bad experiences of censorship, but with these plays Hein and Braun and the theatres emerged with enhanced reputations. There was no GDR author for *Godot*, and its fate depended on the actions of the intendant and the director at the Dresdner Staatsschauspiel. Their unusual appeal direct to Politbüro member, Kurt Hager, to lift the longstanding embargo on the play, redounded to their credit.

Also relevant to how those working in the theatre were seriously or lightly affected by controls were external factors that were, for the most part, on the side of creators of drama in the 1980s, notably the new cultural accords with West Germany and radical political change in the USSR. It may never be known, however, how many paths during this period continued to be blocked, how many aspirations were denied among non-conforming members of the profession. From simply reading the Stasi files that remain available, there is no doubt that many people were victimised. Despite a degree of sub-

versive activity against the procedures, laws, conventions and other, sinister, pressures examined and analysed above, these were, for the targeted performing arts professionals, an unavoidable shadow to their work and helped form the character of the East German drama, i.e. constrained, but, nevertheless, communicative of the stresses experienced in a totalitarian state. In conclusion, I come to the view that the creative output of the theatre was indelibly marked by the control imposed, by the struggles of dramatists to conform, and to be free. In this connection, I find fair comment in drama critic Martin Linzer's remarks about the nature of the theatre in the GDR:

> The qualities of the theatre in the GDR were forged by substantially the same conditions according to which the society as a whole functioned. Life and work was based on an accommodation. That to say the theatre naturally adapted to these conditions. It could not give voice to everything freely, but had similarly to use code, to provide translations, to translate into pictures, into symbols. That required a huge effort, and created the means and increased concentration which led to high artistic achievement that the audiences could understand. It was thus a matter of quality that owed something to the surrounding pressure. That is the good and the bad. We see now that without pressure the theatre becomes again more boring. Nevertheless, we will not wish ourselves back under the pressure. One cannot excuse or justify the pressure afterwards as source and a cause of this quality. It was as it was. (Irmer 2003: 239–240)

Bibliography

Akademie der *Gesellschaftswissenschaften* beim ZK der DDR (ed.), (1989) Unsere Kultur: DDR-Zeittafel 1945–1987, Berlin.

Albiro Hartwig, (2001) 'Erlebnis eines Theatermannes: Zensur und Ananas' in Thießen, Friedrich (ed.) *Zwischen Plan und Pleite. Erlebnisberichte aus der Arbeitswelt der DDR*, Cologne, 268–269.

Albrecht, Terrance, (2000) *Rezeption und Zeitlichkeit des Werkes Christoph Heins*, Frankfurt/Main.

Arnold, Karl-Heinz, and Otfrid Arnold, (1994) 'Herrschaft über die Medien' in Modrow, Hans (ed.) *Das Große Haus. Insider berichten aus dem ZK der SED*, Berlin, 97–115.

Bechert, Frank, (1996) *Keine Versöhnung mit dem Nichts: zur Rezeption von Samuel Beckett in der DDR*, Frankfurt/Main.

Beckett, Samuel, (1990) *Warten Auf Godot*, Stuttgart, 1971.

Bögeholz, Hartwig, (1999) *Wendepunkte – die Chronik der Republik. Der Weg der Deutschen in Ost und West*, Hamburg.

Bouvier, Beatrix, (2002) *Die DDR – ein Sozialstaat? Sozialpolitik in der Ära Honecker*, Bonn.

Brandenburgische Neueste Nachrichten, 25 May 1989, Potsdam.

Braun, Volker, (1998) 'Die Kunst – als Streit der Interessen (Gespräch mit Peter von Becker und Michael Merschmeier) ' in Kreuzer, Helmut und Karl–Wilhelm Schmidt (eds) *Dramaturgie in der DDR (1945–1990)* Band 2 (1970–1990), Heidelberg, 563–565.

Bundesministerium für innerdeutsche Beziehungen (ed.), (1985) *DDR Handbuch*, Cologne.

Buning, Marius and Sjef Houppermanns and Danièle de Ruyter (eds), (1992) *Samuel Beckett 1970–1989*, Amsterdam.

Büttner, Gottfried, (1988) 'Beziehungen Becketts zu Kassel' in Brunkhorst, Martin and others (eds) *Beckett und die Literatur der Gegenwart*, Heidelberg, 282-299.

Caute, David, (2003) *The Dancer Defects. The Struggle for Cultural Supremacy During the Cold War*, Oxford.

Childs, David, and Richard Poppelwell, (1996) *The Stasi. The East German Intelligence and Security Service*, Basingstoke.

Cronin, Anthony, (1996) *Samuel Beckett. The Last Modernist*, London.

Czechowski, Heinz, (1995) 'Brief vom 27 November 1994' in Zipser, Richard (ed.) *Fragebogen: Zensur. Zur Literatur vor und nach dem Ende der DDR*, Leipzig, 77–81.

DDR Handbuch 1979, Cologne.

Deinert, Wolf, (1995) 'Brief vom 23 Juli 1993' in Zipser, Richard (ed.) *Fragebogen: Zensur. Zur Literatur vor und nach dem Ende der DDR*, Leipzig, 87–97.

Devenney, Christopher, (2001) 'What Remains' in Sussman, Henry and Christopher Devenney (eds) *Engagement and Indifference. Beckett and the Political*, New York, 139–160.

Die Zeit, 30 June 1989, Hamburg, 41.

Emmerich, Wolfgang, (1996) *Kleine Literaturgeschichte der DDR*, Leipzig.

Engel, Wolfgang, (1991) 'Eine Art von indirektem Spiegel' in Raab, Michael (ed.) *Wolfgang Engel*, Frankfurt/Main.

Etto, Erhard, (1958) 'Keine Versöhnung mit dem Nichts', *Theater der Zeit*, 3. 1958, 31–32.

Fletcher, John, (2003) *About Beckett. The Playwright and the Work*, London.

Fletcher, John, and John Spurling, (1978) *Beckett. A Study of his Plays*, London.

Frotscher, Fredo, (1979) *Theaterkritik – SED Tagespresse – DDR Dramatik*, Diss., Karl-Marx-Universität Leipzig.

Fulbrook, Mary, (1992) *The Two Germanies, 1945–1990. Problems of Interpretation*, London.

—— (1995) *The Anatomy of a Dictatorship. Inside the GDR 1949–1989*, Oxford.

Gauß, Karl-Markus (ed.), (1984) *Ernst Fischer. Kultur Literatur Politik. Frühe Schriften*, Frankfurt/Main.

Gesetzbuch der DDR, Paragraph 219, Absatz 2.

Gill, David, and Ulrich Schröter, (1991) *Das Ministerium für Staatssicherheit. Anatomie des Mielke-Imperiums*, Berlin.

Glees, Anthony, (2003) *The Stasi Files. East Germany's Secret Operations Against Britain*, London.

Glenny, Michael, (1977) 'The Soviet Theatre' in Auty, Robert and Dimitri Obolensky (eds) *An Introduction to Russian Language and Literature. Companion to Russian Studies 2*, Cambridge, 271–283.

Gogol, Nicolai, (1953) *The Government Inspector* (translated and adapted by D. J. Campbell), London.

Groß, Jürgen, (1989) *Revisor oder Katze aus dem Sack*, Berlin.

Guibert-Yêche, Hélène, (1994) *Christoph Hein. L'œuvre romanesque des 80. De la provocation au dialogue*, Bern.

Hager, Kurt, (1982) *Beiträge zur 'Kulturpolitik'. Reden und Aufsätze 1972 bis 1981*, Berlin.

Hammer, Klaus, (ed.), (1992) *Chronist ohne Botschaft Christoph Hein. Ein Arbeitsbuch*, Berlin.

Hammertaler, Ralph, (1994) 'Die Position des Theaters in der DDR' in Hasche, Christa, *Theater in der DDR. Chronik und Positionen*, Berlin.

Hasche, Christa, Schölling Traute, and Fiebach, Joachim, (1994) *Das Theater in der DDR; Chronik und Positionen: mit einem Essay von Ralph Hammerthaler*, Berlin.

Heidicke, Martin, (1957) 'Die Versöhnung mit dem Nichts', *Theater der Zeit*, 11. 1957, 24–26.

Hein, Christoph, (1988) *Die fünfte Grundrechenart. Aufsätze und Reden* 1987–1990, Frankfurt /Main.

Hein, Christoph, (1990) *Die Ritter der Tafelrunde und andere Stücke*, Berlin.

Heinz, Wolfgang,, (1980) 'Theater, das der größten Sache dient' in Lübbe, Peter (ed.) *Dokumente zur Kunst-, Literatur- und Kulturpolitik der SED 1975–1980*, Stuttgart, 950–958.

Henckel von Donnersmarck, Florian (2006) *Das Leben der anderen. Filmbuch,* Frankfurt/Main.

Henckmann, Wolfhart, (1990) 'Zur Diskussion über Gegenstand und Augaben der Ästhetik besonders in den 50er Jahren' in Henckmann, Wolfhart and Gunter Schandera (eds) *Ästhetische Themen in der DDR 1949 bis 1990*, Berlin.

Henning, Friedrich, (1988) *Das industrialisierte Deutschland 1914 bis 1986*, Paderborn.

Hensel, Georg, (1991) *Spiel's noch einmal. Das Theater der achtziger Jahre*, Frankfurt/Main.

Hildemeier, Manfred, (1998) *Geschichte der Sowjetunion 1917–1991. Entstehung und Niedergang des ersten sozialistischen Staates*, Munich.

Hilton, Julian, (1988) 'Back to the Future – Volker Braun and the German Theatrical Tradition' in Sebald, W.G. (ed.) *A Radical Stage. Theatre in Germany in the 1970s and 1980s,* Oxford, 124–144.

Holàn, Gisela, (1978) 'Zur langfristigen Konzeption für die Entwicklung der Theaterkunst in der DDR' in Lübbe, Peter (ed.) *Dokumente zur Kunst-, Literatur- und Kulturpolitik der SED 1975–1980*, Stuttgart, 571–573.

Hörnigk, Frank, (1991) 'Die Literatur ist zuständig: Über das Verhältnis von Literatur und Politik in der DDR' in Goodbody, Axel and Dennis Tate (eds) *German Monitor No. 29 Geist und Macht. Writers and the State in the GDR*, London, 23–24.

Huberth, Franz, (2003) *Aufklärung zwischen den Zeilen. Stasi als Thema in der Literatur*, Cologne.

Hutchinson, Peter, (1991) *Stefan Heym. The Perpetual Dissident*, Cambridge.

Institut für Gesellschaftswissenschaften beim Central Committee der Sozialistische Einheitspartei Deutschlands, (1965) *Kultur in unsrer Zeit*, Berlin.

Irmer, Thomas, and Mathias Schmidt, (2003) *Die Bühnenrepublik. Theater in der DDR*, Berlin.

Jäger, Andrea, (1995) *Schriftsteller aus der DDR. Ausbürgerung und Übersiedlungen von 1961 bis 1989. Studie*, Frankfurt/Main.

Jäger, Manfred, (1993a) *Kultur und Politik in der DDR 1945–90*, Cologne.

—— (1993b) 'Das Wechselspiel von Selbstzensur und Literaturlenkung in der DDR' in Wichner, Ernest and Hubert Wiesner (eds): *'Literaturentwicklungsprozesse' Die Zensur der Literatur in der DDR*, Frankfurt/Main, 18–49.

Jansen, Sue Curry (1988) *Censorship. The Knot That Binds Power and Knowledge,* Oxford.

Kaufmann, Hans, (1974) 'Gespräch mit Christa Wolf' in *Weimarer Beiträge*, 6/1974, Berlin, 90–112.

Kaufmann, Hans, (1981) 'Veränderte Literaturlandschaft' in *Weimarer Beiträge* 27/3/81, 27–53,

Kerndl, Rainer, (1978) 'Die Vielfalt unserer Dramatik' in *Theater der Zeit* 5/78, Berlin, 52–54.

Kerndl, Rainer, (1995) 'Brief vom 25 März 1993.' in Zipser, Richard (ed.) *Fragebogen: Zensur. Zur Literatur vor und nach dem Ende der DDR*, Leipzig, 213–218.

Kirchhoff, Werner, (1994) 'Das Verhältnis der SED zu den anderen Blockparteien' in Modrow, Hans (ed.) *Das Große Haus*, Berlin, 196–207.

Kiwus, Karin (ed.), (1996) *Berlin – Ein Ort zum Schreiben*, Berlin.

Knowlson, James and Elizabeth (eds), (2006) *Beckett Remembering Remembering Beckett. Uncollected Interviews with Samuel Beckett and Memories of Those Who Knew Him*, London.

Koch, Hans, (1983) *Grundlagen sozialistischer 'Kulturpolitik' in der Deutschen Demokratischen Republik*, Berlin.

Koehler, John, (1999) *Stasi. The Untold Story of the East German Secret Police*, Boulder.

Kopstein, Jeffrey, (1997) *The Politics of Economic Decline in East Germany, 1945–1989*, Chapel Hill and London.

Kranz, Dieter, (1990) 'Gespräch mit Volker Braun, Thomas Langhoff and Albert Hetterle über "Die Übergangsgesellschaft"' in Kreuzer, Helmut and Karl-Wilhelm Schmidt (eds) (1998) *Dramaturgie in der DDR (1945–1990)* Band 2 (1970–1990), Heidelberg, 554–560.

Kreuzer, Helmut, und Karl-Wilhelm Schmidt (eds), (1998), *Dramaturgie in der DDR (1945–1990) Band 2 (1970–1990)*, Heidelberg.

Kröhnke, Karl, (1994) *Ernst Fischer oder Die Kunst der Koexistenz*, Frankfurt/Main.

Kröplin, Wolfgang, (1984) 'Die Stellung der Dramatik der sozialistischen Brüderländer im Repertoire der Schauspieltheater seit 1971 und die Bedeutung dieser Dramatik für unsere Theaterkunst und ihre gesellschaftliche Wirksamkeit' in *Material zum Theater* 186/61, Berlin.

Lauter, Hans, (1951) *Der Kampf gegen den Formalismus in der Kunst und Literatur, für eine fortschrittliche deutsche Kultur*, Berlin.

Leder, Lily, (1954) 'Zu einigen Aufführungen in Westberlin', *Theater der Zeit* 3/1954, 41–44.

Leinemann, Jürgen, (1999) *Gratwanderung, Machtkämpfe, Visionen. Deutsche Momente*, Vienna.

Lennartz, Knut, (1988) 'Klaus Höpcke und das Drama vom Drama' in *Deutschland Archiv* 21.1., 12–14.

Linzer, Martin, (1981) 'Offene Worte, Offene Fragen' in *Theater der Zeit*, 8/81, 4–5.

Linzer, Martin, (2001) *Ich war immer ein Opportunist... Zwölf Gespräche über Theater und das Leben in der DDR, über geliebte und ungeliebte Zeitgenossen, aufgezeichnet von Nikolaus Merck*. Theater der Zeit Literaturforum im Brecht-Haus Berlin, Eggersdorf.

Loest, Erich, (1984) *Der vierte Zensor: vom Entstehen und Sterben eines Romans in der DDR*, Köln.

Lübbe, Peter (ed.), (1984) *Dokumente zur Kunst-, Literatur- und Kulturpolitik der SED*, Stuttgart.

Lunn, Eugene, (1984) *Marxism and Modernism*, Berkeley.

Mayer, Hans, (1995) *Brecht und Beckett. Erfahrungen und Erinnerungen.Ein Vortrag*, Berlin.

McMillan, Dougald, and Martha Fehsenfeld, (1988*) Beckett in the Theatre*, London and New York.

Meech, Anthony, (1988) 'A New Definition of "Eingreifendes Theater" – Some Recent Productions in the Theatre of the GDR' in Sebald, W.G. (ed.) *A Radical Stage. Theatre in Germany in the 1970s and 1980s*, Oxford, 110–125.

Meinhold, Gottfried, (1997) 'Die verhinderte Authentizität von Literatur' in Kratschmer, Edwin (ed.) *Literatur und Diktatur*, Jena, 160–166.

Merschmeier, Michael, (1991) 'Pleite und Geier, Geld und Gagen im Theater der ehemaligen DDR' in *Theater Heute* 32, 2/1991, Berlin, 1–4.

Michael, Hans-Friedrich, and Hans Deiber, (1989) *Geschichte des deutschen Theaters*, Stuttgart.

Minetti, Hans-Peter, (1997) *Erinnerungen*, Berlin.

Misterek, Suzanne, (2002) *Polnische Dramatik in Bühnen- und Buchverlagen der Bundesrepublik Deutschland und der DDR*, Wiesbaden.

Mittenzwei, Werner, (2001) *Die Intellektuellen. Literatur und Politik in Ostdeutschland von 1945 bis 2000*, Leipzig.

Modrow, Hans (ed.), (1994) *Das große Haus*, Berlin.

Modrow, Hans, (1999) *Ich wollte ein neues Deutschland*, Munich.

Müller, Beate (ed.) (2004) *Censorship and Cultural Regulation in the Modern Age*, Amsterdam.

Müller, Christoph, (1990) 'Theater in Dickicht der Chemiestadt' in *Theater Heute* 3/1990. 3, 27–30.

Müller, Heiner, (1994) *Krieg ohne Schlacht. Leben in zwei Diktaturen.Eine Autobiographie*, Cologne.

Neubert, Ehrhart, (1998) *Geschichte der Opposition in der DDR 1949–1989*, Bonn.

Niven, Bill, and Alan Clarke, (2000) *Christoph Hein*, Cardiff.

Padover, Saul (ed. and translator), (1979) *The Essential Marx. The Non-Economic Writings*, New York.

Patterson, Michael, (1995) 'The German Theatre' in Lewis, Derek, and John R.P. McKenzie (eds) *The New Germany. Social, Political and Cultural Challenges of Unification*, Exeter, 259–275.

Pattie, David, (2000) *The Complete Critical Guide to Samuel Beckett*, London

Pietsch, Ingeborg, (1988) 'Versuch zu fliegen' in *Theater der Zeit* 5. 1988, 57–58.

Pilling, John (ed.), (1994) *The Cambridge Companion to Beckett*, Cambridge.

Przybylski, Peter, (1991) *Tatort Politbüro: Die Akte Honecker*, Berlin.

Reichel, Peter, (1990) *Kontinuität und Diskontinuität in der DDR. Dramatik der 80er Jahre. Studien zur Entwicklung von Autorenpositionen, Wirkungsstrategien und*

Gestaltsweisen in der DDR-Drama der Jahre 1980 bis 1986, Diss., Humboldt University Berlin.

Riewoldt, Otto, (1978) *Von Zuckmayer bis Kroetz. Die Rezeption westdeutscher Theaterstücke durch Kritik und Wissenschaft in der DDR*, Berlin

—— (1983) 'Theaterarbeit. Über den Wirkungszusammenhang von Bühne, Dramatik, 'Kulturpolitik' und Publikum' in Schmitt, Hans-Jürgen (ed.) *Die Literatur der DDR*, Vol. 11, Munich, 133–186.

Roßmann, Andreas, (1985) 'Warten auf Beckett. Absurdes Theater ums "absurde Theater" in der DDR, *Deutschland Archiv* 18/1985, 803–805.

Roßmann, Andreas, (1987) 'Die späte Zusage für den Clown S.B. Tabu-Bruch auf Raten: zur beginnenden Beckett-Rezeption in der DDR' in *Deutschland Archiv* 26.12. (1987), 1302–1311.

Runge, Monika, (1981) *Zur gesellschaftlichen Funktion des Theaters in der DDR. Möglichkeiten des Theaters bei der Ausprägung von sozialistischem Patriotismus, untersucht an ausgewählten Schauspielaufführungen der siebziger/ achtziger Jahre*, Diss., Institut für Marxist-Leninistische Kultur und Kunstwissenschaft Berlin.

Rüß, Gisela (ed.), (1976) *Dokumente zur Kunst-, Literatur- und 'Kulturpolitik' des SED 1971–1974*, Stuttgart.

Rusta, Irana, (1980) *Zeitgenössische sowjetische Produktionsstücke und ihre Rezeption an den DDR-Theatern der 70er Jahre*, Diss., Zentral Institut für Literaturgeschichte Berlin.

Sandberg, Renate, (1985) *Zur Wirklichkeitserfassung im dramatischen Werk von Samuel Beckett*, Diss. Karl-Marx-Universität, Sektion Germanistik und Literaturwissenschaft, Leipzig.

Satgé, Alain, (1999) *Samuel Beckett: en attendant Godot*, Paris.

Sauerland, Karol, (1990) 'Zensur im realen Sozialismus' in *The Germanic Review* Special Issue Literary Censorship in the German-Speaking Countries. Part Two: Literary Censorship in the Federal Republic of Germany and the German Democratic Republic. Summer 1990. Vol. LXV Number 3, New York, 130–131.

Schabowski, Günter, (1991) *Der Absturz*, Berlin

Schell, Manfred, and Werner Kalinka,, (1991) *Stasi und kein Ende. Die Personen und Fakten*, Frankfurt/Main.

Scherpe, Klaus R., (2002) *Stadt. Krieg. Fremde. Literatur und Kultur nach den Katastrophen*, Tübingen.

Schriel, Adrianus, (1998) *The History of the Hans Otto Theater Potsdam and its Reflection of Cultural Politics in the German Democratic Republic*, Diss. D.Phil., University of Georgia.

Schroeder, Klaus, (1998) *Der SED-Staat: Partei, Staat und Gesellschaft 1949–1990*, Munich.

Schulze-Reimpell, Werner, (1992) *Entwicklung und Struktur des Theaters in Deutschland*, Bonn.

Schumacher, Ernst, (1989) 'Noch einmal: Die Marxisten und die Tragödie' in *Maske und Kothurn* 35 (1989) H 1, Berlin, 21–35.

Schumacher, Ernst, (1990) 'Entschuldigung – und eine Erneuerung?' in *Theater Heute* 3/90, Berlin, 30–32.

Schwan, Heribert, (1997) *Erich Mielke: der Mann, der die Stasi war*, Munich.

Smith, Ken, (1990) *Berlin: Coming in from the Cold*, London.

Streisand, Joachim, (1981) *Kulturgeschichte der DDR*, Cologne.

Stuber, Petra, (1998) *Spielräume und Grenzen. Studien zum DDR-Theater*, Berlin.

Suckut, Siegfried (ed.), (1996) *Das Wörterbuch der Staastsicherheit. Definitionen zur 'politisch-operativen Arbeit'*, Berlin.

Süß, Walter, (1999) *Staatssicherheit am Ende. Warum es den Mächtigen nicht gelang, 1989 eine Revolution zu verhindern*, Berlin.

Theater der Zeit 3/1989, *Revisor oder Katze aus dem Sack*, Berlin, 52–64.

Theaterlandschaft Deutschland. Ein Sonderdruck des Theatermagazins *Die Deutsche Bühne*, 1993, Munich.

Tomson, William, (2003) *The Soviet Union under Brezhnev*, Harlow.

Töteberg, Michael, (1991) 'Der Anarchist und der Parteisekretär. Die DDR-Theaterkritik und ihre Schwierigkeiten mit Christoph Hein', *Text und Kritik* 111, July 1991.

Träger, Claus (ed.), (1986) *Wörterbuch der Literaturwissenschaft*, Leipzig.

Wallace, Ian (1991), 'Die 'Kulturpolitik' der DDR 1971–1990' in Glaesner, Gert-Joachim (ed.) *Eine deutsche Revolution. Der Umbruch in der DDR : seine Ursachen und Folgen*, Frankfurt/Main, 101–125.

Walther, Joachim, (1996) *Sicherungsbereich Literatur. Schriftsteller und Staats-sicherheit in der Deutschen Demokratischen Republik*, Berlin.

Walther, Joachim, and Gesine von Prittwitz, (1993) 'Mielke und die Musen. Die Organisation der Überwachung' in Arnold, Heinz Ludwig (ed.) *Text und Kritik Nr 120. Feinderklärung Literatur und Staatssicherheit*, Munich, 74–88.

Weber, Hermann, (2000) *Geschichte der DDR*, Munich.

Weigel, Alexander, (1999) *Das Deutsche Theater. Eine Geschichte in Bildern*, Berlin.

Weimann, Robert, (1973) 'Diskussion um Plenzdorf' in *Sinn und Form* 1973. 1. 219–252.

Wer Spielt Was (1986–1988) 1985–1987, Bühnenrepertoire der DDR, Berlin.

—— (1993) 1988–1990, Bühnenrepertoire der DDR, Cologne.

Westgate, Geoffrey, (2002) *Strategies under Surveillance. Reading Irmtraud Morgner as a GDR Writer*, Amsterdam.

Wichner, Ernest, und Herbert Wiesner (eds), (1993) '*Literaturentwicklungsprozesse' Die Zensur der Literatur in der DDR*, Frankfurt/Main.

Wolf, Christa, (1993) *The Writer's Dimension. Selected Essays. A conversation with Grace Paley*, translated by Christine Friedlander, New York.

Zipser, Richard, (1990) 'The Many Faces of Censorship in the German Democratic Republic, 1949-1989' in *The Germanic Review Special Issue*. Literary Censor-ship in the German-Speaking Countries. Part Two: Literary Censorship in the

Federal Republic of Germany and the German Democratic Republic. Summer 1990. Vol. LXV Number 3, New York, 111–129.

Zipser, Richard (ed.), (1995) *Fragebogen: Zensur. Zur Literatur vor und nach dem Ende der DDR*, Leipzig.

Theatre documentation

Archiv der Akademie der Künste, Letter and enclosure regarding *Die Übergangsgesellschaft* fom Albert Hetterle to Magistrat Berlin 31 March 1987, D571, Berlin.

Archiv der Akademie der Künste, Stephan, Erika, Discussion about *Die Übergangsgesellschaft* between Albert Hetterle und Lilo Millis 2 July 1991, D 571, Berlin.

Archiv der Akademie der Künste, 1988–1989, *Revisor oder Katze aus dem Sack*, D 678, Berlin.

Archiv der Akademie der Künste 1991, Baum, Dirk, Maschinenschriftliche Tonbandprotokolle zum Vorgang *Revisor*, D 678, Berlin.

Maxim Gorki Theater Privat-Archiv, 1988, Braun, Volker, *Die Übergangsgesellschaft*, Berlin.

Staatsschauspiel Dresden Privat-Archiv, 1989, Hein, Christoph, *Die Ritter der Tafelrunde*, Dresden.

State Archives

Landesarchiv Berlin, *Der Georgsberg*, C Rep 902 Nr, 5295.

Die Bundesbeauftragte für die Unterlagen des Staatssicherheitsdienstes der ehemaligen Deutschen Demokratischen Republik:

BStU AIM 248/80 T.II/1.

BStU AOP 15582/83 1.

BStU BVfS Potsdam, KD, Pdm 458.

BStU 000268–9 Kreisdienststelle Potsdam 30 May1989.

BStU 00057 Kreisdienststelle Potsdam 21 June 1989.

BStU 000275 Kreisdienststelle Potsdam 7 June 1989.

BStU MfS\BV Dresden Abt. XX 9214.

BstU MfS HA XX ZMA 20015.

BStU 14048/92.

Stiftung Archiv der Parteien und Massenorganisationen der DDR im Bundesarchiv:
SAPMO-BArch, DR1 (MfK) 1699, 1–28.
SAPMO-BArch, DY 30/IV B 219 06/67.
SAPMO-BArch, DY30 B2/2 024/86.
SAPMO-BArch, DY30 B2/9 06/68.
SAPMO-BArch, DY30/IV B2/9 06/66.
SAPMO-BArch, DY30/vorl. SED 32803.
SAPMO-BArch, DY30/vorl.SED 32803.
SAPMO-BArch, DZ/30/3058.
SAPMO-BArch, J4 2/2 – 2109.
SAPMO-BArch, SED ZK B2/9 06/08.
SAPMO-BArch, SED ZK B2/9 06/70.
SAPMO-BArch, ZPA vorl. SED 42322/2.

Transcripts of broadcasts

Staatliches Komitee für Rundfunk *Redaktion Monitor* 5 July 1989, Berlin.
Stimme der DDR, *Kulturspiegel*, 'Theaterkritik', 31 March 1988, Berlin.

Index

Prussia 47

Ragwitz, Ursula 30, 32
Reading University 148
Revisor oder Katze aus dem Sack 59, 87,
90, 92, 93, 96, 100, 117, 122, 172,
173, 174, 175, 178, 179, 187, 189,
192
Roßmann, Andreas 148

Sächsisches Staatsschauspiel 35, 37, 90,
148, 155, 192
Sartre, Jean-Paul 149
Schiller, Johann 27, 142
Schiller Theater 147
Schlesinger, Klaus 53
Schneider, Rolf 7
Schriel, Adrianus 93
Schroth, Christoph 36, 125
Schumacher, Ernest 68
Schütz, Stefan 60
SED 17, 18, 19, 20, 24, 30, 34, 42, 47,
54, 55, 57, 62, 69, 78, 81, 95, 103,
106, 119, 121, 170, 172, 173, 175,
178, 182, 183
Seghers, Anna 152
Seidel, Georg 59, 88, 89, 94
Shakespeare, William 119, 149
Shaw, Bernard 114
Simplex Deutsch 153, 154, 155, 158
Sinclair, Peggy 147
Smith, Ken 169
Sodann, Peter 40, 41, 68, 171
Solzhenitsyn, Alexander 143
Soviet Union 18, 108, 114, 116, 117,
144, 149
Stalin, Josef 113
Stasi 31, 70, 74–100, 133, 173, 175,
185, 186, 187
Stein, Wolfgang 138, 139, 141

Strahl, Rudi 56, 59, 174
Strittmatter, Erwin 50

Theater der Bergarbeiter 27
Theater Zeitz 64
The Government Inspector 117
Third Reich 74
Three Sisters 118, 130, 131, 133, 141,
151, 174
Tinka 97
Tisch, Harry 45, 156
Tolstoy, Leo 112
Tophoven, Elmar 146, 158
Trilse, Christoph 160
Trolle, Lothar 60, 66
Turgenev, Ivan 147
Ulbricht, Walter 33, 82, 111
Ullrich, Peter 27

Valentin, 160
Vilar, Jean 149
Volksbühne 27, 34, 38, 59, 102, 103,
112, 125

Waiting for Godot 44, 45, 73, 100, 101,
123, 125, 127, 132, 143, 145–68,
175, 176, 192
Walther, Joachim 99
Was heisst'n hier Liebe? 66
Weiberkomödie 38
Wekwerth, Manfred 68, 84–85, 93, 99,
133
Wendt, Erich 166
Winterlich, Gerhard 38
Wir die Endesunterzeichnenden 62, 117
Wolf, Christa 49, 180
Wolfram, Gerhard 33, 40, 44, 45, 61,
125, 143, 155, 156, 175
Wolokolamsker Chausee 23, 91
Wunderlich, Fritz 37

German Linguistic and Cultural Studies

Edited by Peter Rolf Lutzeier

At a time when German Studies faces a serious challenge to its identity and position in the European and international context, this new series aims to reflect the increasing importance of both culture (in the widest sense) and linguistics to the study of German in Britain and Ireland.
GLCS will publish monographs and collections of essays of a high scholarly standard which deal with German in its socio-cultural context, in multilingual and multicultural settings, in its European and international context and with its use in the media. The series will also explore the impact on German society of particular ideas, movements and economic trends and will discuss curricu-lum provision and development in universities in the United Kingdom and the Republic of Ireland. Contributions in English or German will be welcome.

Frommer's®

Brazil

6th Edition

by Shawn Blore & Alexandra de Vries

WILEY

John Wiley & Sons, Inc.

Published by:
JOHN WILEY & SONS, INC.
111 River St.
Hoboken, NJ 07030-5774

ISBN 978-1-118-08606-3 (paper); ISBN 978-1-118-22334-5 (ebk); ISBN 978-1-118-23156-2 (ebk);
ISBN 978-1-118-26166-8 (ebk)

Editor: Jennifer Polland
Production Editor: Eric T. Schroeder
Cartographer: Guy Ruggiero
Photo Editor: Richard Fox
Production by Wiley Indianapolis Composition Services

Front Cover Photo: The Devil's Throat (Garganta do Diabo) near Canoa Quebrada, Ceara state, Brazil
© Arnaud Chicurel / hemis.fr / Alamy Images

Back Cover Photo: Sao Pedro Church, Recife, Brazil © Peter Adams Photography Ltd. / Alamy Images

For information on our other products and services or to obtain technical support, please contact our
Customer Care Department within the U.S. at 877/762-2974, outside the U.S. at 317/572-3993 or fax
317/572-4002.

Wiley also publishes its books in a variety of electronic formats. Some content that appears in print may
not be available in electronic formats.

Manufactured in the United States of America

5 4 3 2 1

CONTENTS

5 SIDE TRIPS FROM RIO DE JANEIRO 131

6 MINAS GERAIS: BELO HORIZONTE & THE HISTORICAL CITIES 157

7 SÃO PAULO 180

8 SALVADOR & THE BEST OF BAHIA 223

LIST OF MAPS

HOW TO CONTACT US

In researching this book, we discovered many wonderful places—hotels, restaurants, shops, and more. We're sure you'll find others. Please tell us about them, so we can share the information with your fellow travelers in upcoming editions. If you were disappointed with a recommendation, we'd love to know that, too. Please write to:

Frommer's Brazil, 6th Edition
John Wiley & Sons, Inc. • 111 River St. • Hoboken, NJ 07030-5774
frommersfeedback@wiley.com

ADVISORY & DISCLAIMER

Travel information can change quickly and unexpectedly, and we strongly advise you to confirm important details locally before traveling, including information on visas, health and safety, traffic and transport, accommodations, shopping, and eating out. We also encourage you to stay alert while traveling and to remain aware of your surroundings. Avoid civil disturbances, and keep a close eye on cameras, purses, wallets, and other valuables.

While we have endeavored to ensure that the information contained within this guide is accurate and up-to-date at the time of publication, we make no representations or warranties with respect to the accuracy or completeness of the contents of this work and specifically disclaim all warranties, including without limitation warranties of fitness for a particular purpose. We accept no responsibility or liability for any inaccuracy or errors or omissions, or for any inconvenience, loss, damage, costs, or expenses of any nature whatsoever incurred or suffered by anyone as a result of any advice or information contained in this guide.

The inclusion of a company, organization, or website in this guide as a service provider and/or potential source of further information does not mean that we endorse them or the information they provide. Be aware that information provided through some websites may be unreliable and can change without notice. Neither the publisher nor author shall be liable for any damages arising herefrom.

ABOUT THE AUTHORS

A native of California, **Shawn Blore** has lived and worked in a half dozen countries and traveled in at least 60 more (but who's counting). Long a resident of Vancouver, Shawn has in recent years made his home in Rio de Janeiro. He is an award-winning journalist and author of *Vancouver: Secrets of the City.*

Alexandra de Vries is a freelance writer and translator. Born in Amsterdam to a Dutch father and Brazilian mother, Alexandra made her first trip to Brazil at the ripe old age of 1 month. Throughout the years, Alexandra has returned many more times to travel, explore, and live in this amazing country. Alexandra wrote the *Frommer's Rio de Janeiro Day by Day* guide and has translated books and articles on Brazilian icons such as Oscar Niemeyer, Burle Marx, Vinicius de Moraes, and Chico Buarque.

FROMMER'S STAR RATINGS, ICONS & ABBREVIATIONS

Every hotel, restaurant, and attraction listing in this guide has been ranked for quality, value, service, amenities, and special features using a **star-rating system.** In country, state, and regional guides, we also rate towns and regions to help you narrow down your choices and budget your time accordingly. Hotels and restaurants are rated on a scale of zero (recommended) to three stars (exceptional). Attractions, shopping, nightlife, towns, and regions are rated according to the following scale: zero stars (recommended), one star (highly recommended), two stars (very highly recommended), and three stars (must-see).

In addition to the star-rating system, we also use **eight feature icons** that point you to the great deals, in-the-know advice, and unique experiences that separate travelers from tourists. Throughout the book, look for:

special finds—those places only insiders know about

fun facts—details that make travelers more informed and their trips more fun

kids—best bets for kids and advice for the whole family

special moments—those experiences that memories are made of

overrated—places or experiences not worth your time or money

insider tips—great ways to save time and money

great values—where to get the best deals

warning—traveler's advisories are usually in effect

The following **abbreviations** are used for credit cards:

AE American Express	**DISC** Discover	**V** Visa
DC Diners Club	**MC** MasterCard	

THE BEST OF BRAZIL

Whether it's the explosion of Carnaval colors or the roaring power of Iguaçu Falls, Brazil is bound to make an impression. Tear yourself away from the beach and explore Rio de Janeiro's bohemian neighborhood of Santa Teresa with its trendy boutiques, artists' studios, and hip eateries. Dance to the beat of African drums in Salvador and inhale the distinct scent of the red dendê palm oil that flavors Bahian cooking. The heart of the world's largest rainforest, Manaus is the starting point for an adventurous jungle expedition.

Cities　One of the world's most iconic cities, **Rio de Janeiro** greets visitors with dazzling views from the statue of Christ the Redeemer. **São Paulo**'s majestic bank towers lining the Avenida Paulista ooze power and money. Travel back in time with a stroll along the hilly cobblestone streets of **Ouro Preto** and **Olinda,** packed with baroque churches and exquisite Portuguese colonial architecture. Explore the eco-friendly city of **Curitiba** with its ground-breaking urban transportation system and vibrant cultural life.

Countryside　Follow in the steps of the old miners and explore the many caves, mountains, and valleys in Bahia's **Chapada Diamantina.** Stylish and comfortable jungle lodges are the perfect base for venturing into the Amazon's dense tropical rainforest. Ride a water buffalo into the sunset on **Marajó island** where the Amazon river meets the Atlantic Ocean. The wetlands of the **Pantanal** are Brazil's best-kept secret for wildlife viewing; birders will delight in the frequent sightings of storks, spoonbills, toucans, macaws, and hawks.

Eating & Drinking　From Bahia's fragrant *moqueca* (seafood stew with coconut milk) to flavorful Amazonian fish or succulent *picanha* beef, Brazil offers a dazzling array of culinary landscapes. In Rio, feast on hearty *feijoada* (black bean stew), washed down with a refreshing caipirinha cocktail. Enjoy São Paulo's sophisticated contemporary cuisine prepared by the country's top chefs. Feast on juicy grilled steak served by an army of waiters, *rodizio*-style, in Porto Alegre. Try a fresh tropical fruit juice at an inexpensive juice bar.

Coast　With more than 7,000km (4,350 miles) of coastline and a sunny tropical climate to boot, Brazil has a beach for everyone. The tanned and toned pack **Ipanema,** Rio de Janeiro's most famous beach. Beaches come in unspoiled, almost deserted stretches along Bahia's **Marau Peninsula.**

Steep sand dunes stop just shy of the ocean near **Natal.** Snorkel in natural pools teeming with colorful fish in family-friendly **Porto de Galinhas,** explore Brazil's best marine life in the waters around **Fernando de Noronha,** or rub shoulders with Brazil's jet set in posh **Buzios.**

THE best BRAZIL EXPERIENCES

- **Attending Carnaval in Rio:** This is the biggest party in the world. Whether you dance in the streets, watch thousands participate with their elaborate costumes in the samba parade, or attend the fairy-tale Copacabana Palace ball, it's the one event not to miss! See p. 126.
- **Watching a Soccer Game:** Nothing can prepare you for a game in the world's most soccer-crazy nation. Tens of thousands of fans sing, dance, and drum for hours in Rio. See p. 109.
- **Getting to Know Pelourinho:** The historic center of Salvador is a treasure of baroque churches, colorful colonial architecture, steep cobblestone streets, and large squares. See p. 229.
- **Watching the Sunset over the Lençóis Maranhenses:** The magical snow-white dunes interlaced with strings of turquoise, blue, and green lagoons make one of the most spectacular sights in all of Brazil. See chapter 12.
- **Herding Water Buffalo in Marajó:** The buffalo ranches on this island in the mouth of the Amazon offer city slickers a unique cowboy experience. Riding out on horseback, visitors to Fazenda Sanjo help round up the water buffalo herd and bring it back to the ranch. See chapter 13.
- **Kayaking in the Amazon:** To explore the rainforest in depth, nothing beats a slow descent of an Amazon tributary; the kayak provides the freedom to view the rainforest at leisure, guides explain the workings of this ecosystem, and cooks prepare meals of delicious Amazon fish. See chapter 13.
- **Admiring the Modernist Architecture of Brasilia:** Built from scratch in a matter of years on the red soil of the dry *cerrado,* Brasilia is an oasis of modernism in Brazil's interior. Marvel at the clean lines and functional forms and admire some of the best public art in the country. See chapter 14.
- **Getting Drenched at Amazing Iguaçu Falls:** These falls consist of 275 cataracts along a 2.5km (1½-mile) stretch of the Iguaçu River. The water's power mesmerizes as you stare into the roiling cauldrons. See chapter 15.
- **Wildlife Viewing on Horseback in the Pantanal:** Richer in bird life by far than the Amazon, but far too soggy to hike, the wet fields of the Pantanal are best explored on horseback. And if you like it fast, there's nothing like galloping through the fields, as a flurry of colorful birds scatter and caimans scurry off underfoot. See chapter 16.

THE best BEACHES

- **Ipanema, Rio de Janeiro:** Yes, this is one of the most urban beaches in the world, but it's still one of the country's prime tanning spots. The long stretch of white sand is perfect for observing the tan and lovely (male and female alike). Or watch a game of volleyball while having a beer and some fresh seafood; if you feel like it, go for a swim or a stroll. See chapter 4.

- **Ilha Grande:** This former prison colony off the coast of Rio de Janeiro offers dozens of beaches. The nicest may well be **Lopes Mendes,** facing the ocean on the eastern tip of the island. This long stretch of sand is unspoiled by any development, and features fine soft sand, clear clean water, and excellent waves for surfing. See p. 148.
- **Boipeba, Bahia:** The perfect island getaway, Boipeba makes Morro de São Paulo seem busy and hectic. Just south of Morro, Boipeba offers glorious empty beaches framed by rows and rows of palm trees. At Boca da Barra, where the river Inferno meets the ocean, huge sand banks appear at low tide. You can choose whether to swim on the freshwater side or play in the salty ocean. See chapter 8.
- **Fernando de Noronha:** The island archipelago of Fernando do Noronha has so many spectacular beaches, it's hard to single out just one. Praia do Leão offers wild crashing surf and sea turtle hatchings in season. The most gorgeously secluded is Praia da Baía do Sancho, a crescent of red sand on shimmering clear blue water that can only be reached by clambering down a rickety iron ladder through a chasm in the cliff side. See chapter 9.
- **Praia da Pipa:** Just outside of Natal, this small beach town has been kept resolutely small-scale. Low-rise constructions, pedestrian-friendly streets, a laid-back and fun atmosphere, and gorgeous beaches await visitors. See chapter 10.
- **Ponta Negra, Manaus:** Not an ocean beach but a river beach, Ponta Negra, on the shores of Rio Negro, is the most popular tanning spot in the dry season. You'll find vendors plying food, drinks, and souvenirs, and beach kiosks serving up snacks until the wee hours. See chapter 13.
- **Praia Mole, Florianópolis:** Praia Mole is one of the most popular beaches on the beautiful southern island of Santa Catarina (aka Florianópolis). Perfectly white fluffy sand, lush green vegetation, and rocky outcrops give the beach an isolated, paradisiacal feel. Yet, the strand is anything but quiet, packed with a bohemian crowd of locals from Floripa, yuppie tourists, surfers, gay and gay-friendly sunbathers, and families. See chapter 15.

THE best OUTDOOR ADVENTURES

- **Hang Gliding in Rio:** Running off the edge of a platform with nothing between you and the ground 800m (2,624 ft.) below requires a leap of faith, so to speak, but once you do, the views of the rainforest and beaches are so enthralling that you almost forget about the ground until your toes touch the sand at São Conrado beach. See chapter 4.
- **Hiking or Biking the Chapada Diamantina:** These highlands inland from Salvador have rock formations similar to the buttes and mesas of the American Southwest. They also have waterfalls and natural water slides of smooth red marble, plus lots of great hiking and biking trails. See chapter 8.
- **Diving in Fernando de Noronha:** Brazil's best diving is found on this small archipelago off the coast of Pernambuco. See dolphins, turtles, manta rays, and lots of underwater caves. Crowds are limited, because only 420 visitors are allowed on the island at a time. See chapter 9.
- **Riding a Beach Buggy from Natal to Fortaleza:** The long coast from Natal to Fortaleza is one of the last places on earth with hundreds of kilometers of

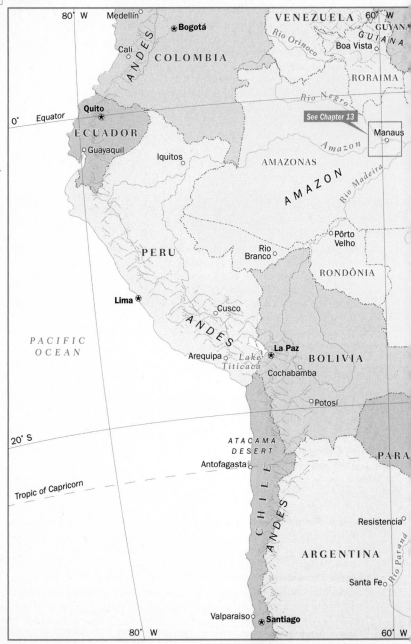

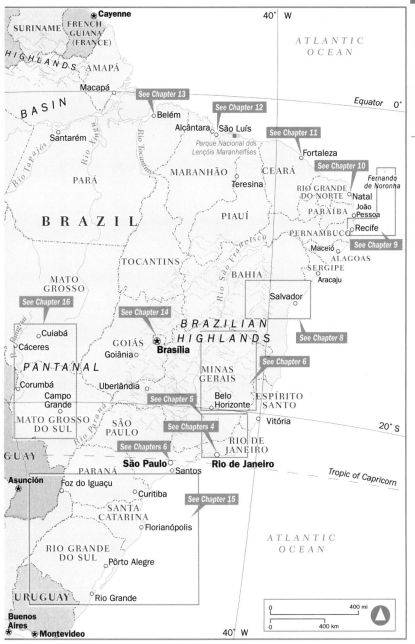

unobstructed sand. Make the 4-day journey by dune buggy and never once leave the beach, exploring vast towering dunes along the way. See chapter 10.

o **Kite Surfing in Jericoacoara:** From July to November, kite-surfing fans from around the world gather in this tiny village to enjoy some of the best and most reliable kite-surfing conditions in Brazil, suitable for both beginners and advanced surfers. Spend the day on the water and catch the stunning sunset at the top of the 60m (200-ft.) sand dune overlooking the town. See chapter 11.

o **Swimming in the Lençóis Maranhenses:** The end of the rainy season signals the best time of year to visit the dunes at Lençóis National Park. June to October, the dunes are full of crystal-clear freshwater lagoons. A swim is the best reward for hiking through the desert of dunes. See chapter 12.

o **Canoeing the Amazon:** Just you and a canoe in the jungle. Your senses heighten as you listen to the sounds of the forest, watch for splashes in the water, and peer into the trees to find birds, sloths, and monkeys. See chapter 13.

o **Tree Climbing in the Amazon Forest:** Get off the river and delve into the forest. Most visitors only see the trees from the bottom up. Actually climbing into the tree will give you a whole new perspective on the forest and its ecosystem. See chapter 13.

o **Swimming in the Waterfalls of Chapada dos Guimarães:** The red-rock formations of this minicanyon hide some spectacular waterfalls nestled in small stands of lush tropical forest. With dozens and dozens of falls and trails, it's not hard to find one all for yourself. See chapter 16.

THE best WILDLIFE ENCOUNTERS

o **Sea Turtle Hatchings** (Bahia): From mid-February to April you have a good chance to watch turtle hatchings at Praia do Forte Tamar's turtle project. See how these tiny sea turtles crawl out of the egg, and cheer them on as they waddle to the ocean for their first swim. See p. 260.

o **Sea Horses (Porto de Galinhas):** The roots of the mangroves in Porto de Galinhas are home to one of the most magical sea creatures, the sea horse. Guides dive in the water to look for these delicate animals and are usually successful in scooping one up (literally, in a glass jar). Once you have had a chance to learn a little bit more about the animal it goes back into its natural habitat. See chapter 9.

o **Caiman Spotting** (the Amazon): Spotting caimans (alligators native to South America) involves setting out in a canoe after the sun has set. Boating through the dark Amazon forest is quite an experience, but nothing quite prepares you for the sight of those caiman eyes that light up in the beam of the spotlight. See chapter 13.

o **Pink River Dolphins** (the Amazon): Although you may catch glimpses of pink river dolphins throughout the Amazon, at Anavilhanas Lodge (p. 383) you have a chance to experience a magical eye-to-eye encounter as these friendly creatures belly up to the dock for a bite of fresh fish. See chapter 13.

o **Butterflies** (Iguaçu): Everyone talks about the falls, but few mention the butterflies. The lush rainforest provides the perfect environment for many colorful species, and everywhere you go lovely butterflies are aflutter. Hard to miss is the metallic-blue Morpho butterfly; it's about the size of your hand. See chapter 15.

o **Bird and Wildlife Spotting in the Pantanal:** Even if you're not a birder, the Pantanal has hundreds of species to spot, some as big as your little brother, others as

colorful as Carnaval. There are also hungry caimans and giant ri

sometimes even a jaguar, all of it best viewed from horseback. See

- **Red Araras** (The Pantanal): The sunset over the red-rock formati

pada dos Guimarães, north of Cuiabá, is a magical experience in i

special is the view of scarlet macaws working the thermals off t

the warm glow of the setting sun. See chapter 16.

THE best MUSEUMS

- **Inhotim** (Belo Horizonte; ✆ **031/3227-0001**): Brazil' most spectacular modern art museum features some 500 works by Brazilian and international artists, displayed in a vast and beautiful tropical landscape. See p. 162.

- **Museu do Oratorio** (Ouro Preto; ✆ **031/3551-5369;** www.oratorio.com.br): Behind Ouro Preto's main square stands the town's loveliest museum, which houses a colorful collection of oratories, which are in fact little minialtars, used by people so they could pray without having to go to church. The Afro-Brazilian oratories are decorated with flowers and shells from the Candomblé religion. See p. 170.

- **Museu de Arte Sacra** (Mariana; ✆ **031/3551-4736**): One of the best collections of sacred art in Brazil can be found in the small town of Mariana, just outside of Ouro Preto. The vast collection of impressive gold and silver works is displayed in a gorgeous old colonial mansion. See p. 175.

- **Monument to Latin America** (São Paulo; ✆ **011/3823-4600;** www.memorial.org. br): Designed by famed Brazilian architect Oscar Niemeyer, the monument is, well, *so* Niemeyer—shy of a visit to Brasilia, it's the best place to see Brazilian modernism in all its concrete austerity. See p. 206.

- **Pinacoteca do Estado** (São Paulo; ✆ **011/3324-1000**): The Pinacoteca in São Paulo is the place to come for anyone who wants to see Brazilian art. The museum has an excellent collection of Brazilian art from the 19th and 20th centuries, including works by Alfredo Ceschiatti, the artist who designed many of the sculptures in Brasilia. See p. 208.

- **Museu de Arte Sacra** (Salvador; ✆ **071/3283-5600**): One of the finest museums in Salvador, the Arte Sacra displays one of Brazil's best collections of Catholic art. The artifacts are shown in the monastery adjoining the Igreja de Santa Teresa, a simple, beautiful building that is itself a work of art. The collection includes oil paintings, oratorios (small cabinets containing a crucifix or saint image), and amazing silver work. See p. 243.

THE best HOTELS

- **Hotel Sofitel** (Rio de Janeiro; ✆ **021/2525-1232;** www.sofitel.com): Considered Rio's best hotel, the Sofitel combines old-world elegance and style with one of the city's best locations, across from the Copacabana Fort and steps from Ipanema. See p. 53.

- **Portinari** (Rio de Janeiro; ✆ **021/3222-8800;** www.hotelportinari.com.br): Designed by eight different Brazilian designers and architects, the hotel offers a wonderful showcase of Brazilian style and inventiveness; everything from the furniture to the lighting and accessories is unique. Best of all, this style doesn't get in the way of comfort. See p. 56.

olito Boutique Hotel (Búzios; ✆ 022/2623-2172; www.insolitohotel.com.br): This luxury boutique hotel clings to the rocks overlooking Ferradura beach. With only 12 rooms set amid lush tropical gardens and spectacular terraces, guests practically have the place to themselves. See p. 135.

○ **Unique** (São Paulo; ✆ 011/3055-4700; www.hotelunique.com.br): Extraordinary high-design rooms and suites feature the cleanest-of-clean white-on-white decor, luscious bedding, sparkling bathrooms with Jacuzzi tubs, a plethora of room gadgets, plus a rooftop view of the Avenida Paulista's power skyscrapers and lush green Ibirapuera park. See p. 193.

○ **Zank** (Salvador; ✆ 071/3083-4000; www.zankhotel.com.br): Salvador's only hip boutique hotel is housed in a lovely heritage building that has been joined with a modern, minimalist Miami-chic annex. The result is an exclusive luxury oasis on a hillside overlooking Rio Vermelho. See p. 232.

○ **Hotel de Lençóis** (Lençóis, Chapada Diamantina; ✆ 075/3334-1102; www.hoteldelencois.com): Set in lush gardens in the upper part of the village, this eco-friendly hotel is the perfect base for exploring the Chapada Diamantina. After a long hike, relax in a comfortable room furnished with a brand-new king-size bed, fine linens and lovely regional artwork. See p. 265.

○ **Bourbon Cataratas** (Foz do Iguaçu; ✆ 045/3521-3900; www.bourbon.com.br): Make sure you don't forget to see the falls! The Bourbon Hotel has plenty to keep you busy. Over 3km (2 miles) of trails through orchards and tree nurseries are the perfect place to watch for toucans, butterflies, and parrots. There are several pools, tennis courts, a climbing wall, and volleyball nets. See p. 423.

THE best POUSADAS

○ **Pousada do Mondego** (Ouro Preto; ✆ 031/3551-2040; www.mondego.com.br): Wake up to the unforgettable view of Ouro Preto's most famous church, São Francisco de Assis, just outside your window. Early in the morning the surrounding hills are often shrouded in mist. See p. 172.

○ **Solar da Ponte** (Tiradentes; ✆ 032/3355-1255; www.solardaponte.com.br): In the heart of Tiradentes, one of the most charming colonial villages, Pousada Solar da Ponte is a real retreat. The spacious antiques-furnished rooms look out over the cobblestone streets. The lovely garden, library, and sitting rooms are perfect for a relaxing day. See p. 178.

○ **Pousada Santa Clara** (Boipeba; ✆ 075/3653-6085; www.santaclaraboipeba.com): For a romantic getaway, there's no place better than this lovely pousada, on the small island of Boipeba south of Morro de São Paulo. Each room is uniquely decorated, and many feature a veranda and large windows looking out over the lush tropical garden. The nearly deserted beach is only 5 minutes away, if you walk slowly. See p. 270.

○ **Lagoa das Cores** (Vale do Capão, Chapada Diamantina; ✆ 075/ 3344-1114; www.lagoadascores.com.br): Tucked away in a narrow valley in the Chapada Diamantina, this pousada is the best place to do absolutely nothing. Soak up the views, relax your body and soul, savor the excellent organic local cuisine, and forget all your worries. See p. 267.

○ **Toca da Coruja** (Praia da Pipa; ✆ 084/3246-2226; www.tocadacoruja.com.br): A contender for one of the best pousada's in Brazil, Toca da Coruja offers outstanding service, spacious rooms with elegant rustic decorations, top-notch amenities, and

a delicious breakfast prepared on a wood-burning stove, only minutes from Pipa's fabulous beaches. See p. 328.

○ **Vila Kalango** (Jericoacoara; ✆ **088/3669-2290;** www.vilakalango.com.br): You couldn't ask for a more idyllic setting on the edge of the village, overlooking the ocean and the large dune, perfect for watching the sunset. The rustic round bungalows on stilts let in the cool sea breeze and are tastefully decorated with local artwork. See p. 344.

○ **Anavilhanas Lodge** (Manaus; ✆ **092/3622-8996;** www.anavilhanaslodge.com): A visit to the Amazon is no excuse to give up life's little luxuries. This small, exclusive lodge offers beautiful luxury accommodations on the bank of the Rio Negro. See p. 383.

○ **Araras Eco Lodge** (Pantanal; ✆ **065/3682-2800;** www.araraslodge.com.br): This lodge is the best in the Pantanal for wildlife viewing and experiencing the lifestyle of the *pantaneiro* cowboy. Accommodations are rustic, but the quality of guides, the amazing food, and the unparalleled wildlife are worth it. The owner has a history of environmental work in the region and runs an excellent program. See p. 462.

THE best FOOD & DRINK EXPERIENCES

○ **Experiencing Feijoada, the National Dish:** It's impossible to single out one restaurant in all of Brazil for its *feijoada.* Just try it and try it right. Start with a caipirinha (that potent, delicious lime and sugar-cane drink) and some *caldo* (soup), followed by steaming hot black beans with all the various meats. Side dishes include *farofa,* cabbage, orange slices, and rice. Dab some *malagueta* peppers on the beans for an extra kick.

○ **Tasting Street Food:** Whether you want prawns, chicken, tapioca pancakes, coconut sweets, or corn on the cob, it can all be purchased on the street for next to nothing. Don't be afraid to try some of the best snacks that Brazil has to offer.

○ **Eating Beef Until You Burst:** *Rodízio* churrascarias are all-you-can-eat meat orgies. The best cuts of beef are served up one after another; try one or two, or try them all. As long as you can take it, they dish it out. Our favorite is surely *picanha,* the lean, tender rump steak—it will melt in your mouth. One of the country's most popular restaurants is **Porcão,** a small Brazilian chain. Their flagship location is in Rio's Flamengo neighborhood (✆ **021/2554-8535;** p. 75), with views of the bay.

○ **Sampling Sophisticated Brazilian Cuisine at Le Pré Catelan:** Don't miss the sophisticated rice and beans tasting menu or the Amazonian 10-course gourmet meal fit for a king (and presidents) at Sofitel's **Le Pré Catelan** (✆ **021/2525-1160**). French top chef Roland Villard has outdone himself by turning Brazilian ingredients into exceptional haute cuisine. See p. 67.

○ **Sipping Colonial Coffee in Rio:** For the most elegant coffee experience, visit **Confeitaria Colombo** (✆ **021/2505-1500;** www.confeitariacolombo.com.br). This 19th-century Belle Epoque establishment is one of the most beautiful salons in all of Brazil. See p. 66.

○ **Dining in Elegant São Paulo:** Brazil's biggest, richest city is where you'll find the best chefs and the most demanding customers. It is the place in Brazil for sophisticated fine dining. Two places you won't go wrong, for service, ambience, or food

are **Figueira Rubaiyat** (© 011/3063-3888; www.rubaiyat.com.br) and **D.O.M.** (© 011/3088-0761; www.domrestaurante.com.br), both in the Jardins. D.O.M. offers ultra-high-end dining, with one of the best wine lists in the hemisphere. Figueira offers excellent food, and one of the nicest dining rooms anywhere, beneath the limbs of a huge fig tree. See p. 197 and 198, respectively.

○ **Slurping *Moquecas* in Salvador:** You can't say you've been to Salvador without trying *moqueca,* the tasty stew of fresh seafood with coconut milk, lime juice, cilantro, and red dendê palm oil. Try Pelourinho's **Axego** (© 071/3242-7481), p. 283.

○ **Experiencing Fine Dining in Porto de Galinhas:** Beijupirá (© 081/3552-2354), in a small resort town in Brazil's Northeast, is perhaps one of the most pleasant little restaurants in the country. The decorations are whimsical and rustic, the food an inspired Brazilian cuisine that makes use of fresh seafood, tropical fruit, and spices. See p. 303.

○ **Trying the Regional Cuisine of Belém:** Located in the Tropics, on the Amazon River but at the mouth of the ocean, Belém has access to a richer assortment of ingredients than almost anywhere else in Brazil. Local chefs make the most of the variety. For regional cuisine, try **Lá em Casa** (© 091/3212-5588). See p. 394

○ **Savoring Italian Fare in Curitiba:** In the heart of Curitiba's Italian Santa Felicidade neighborhood, **Madalosso** (© 041/3372-2121) seats over 4,500 diners and serves up an all-you-can-eat feast of chicken, pasta, polenta, risotto, and more. See p. 434.

THE best MARKETS

○ **Antiques Fair** (São Paulo): Every Sunday from 10am to 5pm there's an antiques fair in the open space beneath the **MASP** building on Avenida Paulista. Dealers are registered, and the quality of the wares is often good. See p. 207.

○ **Japanese Market** (São Paulo): One of the largest Asian street markets takes place every Sunday on the **Praça da Liberdade** (next to the Liberdade Metrô stop) in São Paulo's Liberdade neighborhood. The city's Japanese residents celebrate their heritage with an excellent and inexpensive selection of Japanese cuisine and arts and crafts. See p. 203.

○ **Mercado Municipal** (São Paulo): The elegant market hall with its skylights and stained-glass windows is a fabulous setting for the city's largest food and produce market. Don't leave without trying the mortadella sandwich! See p. 206.

○ **Mercado Modelo** (Salvador): Souvenir junkies will think they've died and gone to heaven. In the former Customs building, this market has around 300 merchants selling a large variety of souvenirs: leather goods, hammocks, instruments, masks, carvings, paintings, lace, terra-cotta figurines, and jewelry. See p. 244.

○ **Crafts Market** (Fortaleza): Hundreds of merchants set up their stalls every night at one of the largest craft fairs in Brazil. Browse the large selection of wares from the Northeast in the cool evening sea breeze. See p. 341.

○ **The Ver-o-Peso Market** (Belém): The Ver-o-Peso market is a vast waterside cornucopia of outrageously strange Amazon fish, hundreds of species of Amazon fruit found nowhere else, traditional medicine love potions, and just about anything else produced in the Amazon, all of it cheap, cheap, cheap. See p. 397.

THE best NIGHTLIFE

o **Arco do Teles** (Rio de Janeiro): Tucked away in an alley just off the Praça XV, the Arco de Teles reveals perfectly preserved colonial buildings set on narrow cobblestone streets, lined with restaurants and cafes. With over 15 bars and botequins it doesn't matter which one you pick; walk around and see what's doing. If you get there after 10pm you'll be lucky to find a seat at all. See p. 121.

o **Centro Cultural Carioca** (Rio de Janeiro; © **021/2252-6468;** www.centrocultural carioca.com.br): This beautifully restored building from the 1920s hosts local musicians and big names who specialize in samba, MPB, *choro,* and *gafieira.* The room is cozy, and guests sit at small tables to watch the shows. See p. 117.

o **Carioca da Gema** (Rio de Janeiro; © **021/2221-0043;** www.barcariocadagema. com.br): One of the hottest nightspots in the samba-rich sector of Lapa, Carioca da Gema offers some of the finest *pagode* and samba. Just steps from the Lapa aqueduct, Carioca da Gema is one of the many small music venues in this funky bohemian neighborhood. See p. 117.

o **Rua das Pedras** (Búzios): The hottest beach resort close to Rio, Búzios is the place to go if you're on a mission to party. Nightlife central is on the Rua das Pedras where the pubs, bars, discos, and restaurants stay open on weekends until 3 or 4am. Enjoy a delicious cocktail at the **Anexo Bar and Lounge,** or dance until the early hours at popular Ibiza nightclub **Pacha.** See p. 138.

o **The Botecos of Belo Horizonte:** The city is justly proud of its tradition of *botecos,* simple bars selling cold draft beer and hearty home-cooked snacks. Ask locals for recommendations to their favorite *boteco* or visit **Petisqueira do Primo** (© **031/ 3335-6654**) to soak up the atmosphere. See p. 165.

o **Skye** (São Paulo; © **011/3055-4702;** www.hotelunique.com.br): One of the city's trendiest bars, Skye also comes with one of the best views in the city. On the Unique Hotel's top floor, the bar's large glass windows and pool deck offer spectacular skyline views of South America's largest city. See p. 202.

o **Grazie a Dio** (São Paulo; © **011/3031-6568;** www.grazieadio.com.br): This fun bar and restaurant with great live music is only one of many excellent nightlife venues in São Paulo's vibrant nightlife district of Vila Madalena. See p. 219.

o **Pelourinho** (Salvador): Every Tuesday night, Pelourinho transforms itself into one big music venue as locals and tourists gather to celebrate *Terça da benção* (blessed Tuesday) to the sounds of Bahia's unique Afro-Brazilian drum beats. See p. 264.

o **The Reviver** (São Luís): Now that it's been brought back to life, the historic downtown of São Luís has a new name—Reviver. It's packed with bars and restaurants that center around the Rua da Estrela. One of the prettiest is **Antigamente** (© **098/3232-3964**). Grab a table outside and enjoy the bustling atmosphere. See p. 351.

BRAZIL IN DEPTH

Brazil is a unique combination, simultaneously old and young. "Old" in the sense that, though charted and colonized by Europeans at roughly the same time as North America, European civilization took root faster and flowered far earlier here. While Virginia Company adventurers starved to death on the James River, and Massachusetts Bay colonists subsisted in rude huts clustered around a single narrow church, Brazilian cities like Salvador and Olinda thrived with paved streets, walls and houses of stone, and high cathedrals gilded with gold. "Young" because Brazil as a country did not achieve independence until 1822, and didn't throw off the monarchy and proclaim itself a republic until 1888. In today's Brazil, elements of old and new coexist in every aspect of society: architecture, technology, culture, festivals, food, business attitudes—all mix the most modern with the most tradition-bound.

BRAZIL TODAY

Brazil is a land of incredible diversity, a place where native hunters, Pantanal cowboys, priests of West African gods, and city slickers with roots in Italy, Syria, Portugal, and Japan all happily call themselves Brazilian.

Despite the global economic crisis, Brazil is faring well economically. Because of the country's steady growth, responsible public finances, and vast potential, Brazil is considered to be one of the breakthrough nations of the 21st century—a fact which can be evidenced by its status as one of the **BRIC** nations, an acronym that combines the first letters of the four countries (Brazil, Russia, India, and China) that are expected to spearhead new economic development in the upcoming years.

Brazil's own growing confidence in its future has led it to reach out to the rest of the world, ramping up a campaign for a UN Security Council seat, while simultaneously bidding to host a variety of international sporting events. The first of these, the Pan American Games, was held in Rio in 2007. That proved to be just an audition. As a follow-up, Brazil bid successfully to host first the Soccer World Cup in 2014. Then in 2009, Rio de Janeiro was selected to host the 2016 Olympic Summer Games. As the host of the **World Cup in 2014** and the **Olympic Games in 2016,** Brazil is investing billions in infrastructure: airports are being overhauled, stadiums are being built or renovated, roads are getting expanded and improved, and new hotels and restaurants are springing up everywhere.

In spite of its economic success, there is still a lot of inequality between classes in Brazil, where 5% of the population holds 85% of the wealth. But despite huge differences in income, the extraordinary ability to enjoy life may be the one and only thing all Brazilians have in common. Making that first million by age 30, scaling a mountaintop because it's there—these aren't the things that animate Brazilians. Friends, and especially family, are what matter, plus beer and a beach, bar, or soccer stadium in which to enjoy it all.

Yet despite this fun-loving attitude, many young Brazilians are politically aware and outspoken. It was not so long ago that Brazilians would have thought twice about protesting, after 2 decades of suppression by the military regime. Now, almost 30 years of democracy have given birth to a more vocal, tech-savvy generation of Brazilians regularly using social media sites, such as Facebook and Twitter, to denounce government corruption. President Dilma Rousseff's government is trying to improve government transparency and diminish government corruption.

Brazil—and Rio, in particular—has been investing heavily in public security. In 2010, the Rio de Janeiro state government began an innovative program to bring community-style policing to favela communities that had previously been completely controlled by drug gangs. Instead of periodically swooping into favelas with heavily armed SWAT teams, the government established permanent community policing posts, known as UPPs, staffed by police officers drawn straight from the presumably untainted pool of the police academy. In November 2010, during the largest police operation in the history of Rio de Janeiro, armored tanks and camouflaged soldiers expelled drug traffickers en masse from favelas in the Zona Norte. Now a dozen or so favelas have been freed from the reign of terror imposed by armed drug gangs and the communities have been brought into the law and order mainstream. The program has been so successful that other communities are now clamoring for UPPs, and the government finds itself unable to staff and build them quickly enough. The plan, over the next several years, is to extend the community policing initiative to many more favelas. While drug-related violence still exists, few argue the net positive effects of the police operations on the city and the favelas.

Challenges in the future include getting a grip on corruption (not the petty kind that bothers tourists, but the lose-a-billion-dollars-in-a-Swiss-bank-account kind that bothers taxpayers); coping with growth, as Brazil's already huge cities continue to expand; finding a way to balance environmental preservation—particularly in the Amazon—with the demand for economic development; and delivering the 2014 Soccer World Cup and the 2016 Olympic Games. If Brazilians have learned the hard way that they can't solve these problems at the drop of a hat, they can at least behave like the rest of the democratic world and somehow muddle through—having great fun even as they muddle.

LOOKING BACK AT BRAZIL

In the Beginning

No one is quite sure when or how Brazil's first inhabitants arrived. But by the year A.D. 1500, between one and eight million aboriginals lived in Brazil, speaking nearly 170 different languages. Unlike in the Inca territory across the Andes, Brazil's indigenous civilization was largely tribal: small groups living in villages making a subsistence living from the local environment.

The Portuguese Arrive (16th c.)

In 1500, the first Europeans arrived: 13 ships under the command of **Pedro Alvares Cabral,** a Portuguese explorer. The Europeans were after **pau-brasil,** a type of wood that could be processed to yield a rich red dye. Coastal Indians were induced to cut and sell timber in return for metal implements such as axes. It was such an efficient system that within a little over a generation the trees—which by then had given their name to the country—were all but nonexistent.

What worried Portuguese **King João III,** however, was the number of French and Spanish ships taking part in the trade. In an attempt to establish Portuguese authority (while saving the cost of a formal colony) the king divided the Brazilian coast into 15 parcels or **"captaincies,"** each of which was given to a Portuguese noble as his hereditary property, on the understanding he'd show the flag, build up a colony at his own expense, and maybe generate some tax revenue for the royal treasury.

A few of the newly arriving captains forged alliances with local Indian tribes. Mostly, however, the Portuguese arrivals generated hostility. Many of the new settlements were burned out and destroyed, the would-be settlers killed. Perhaps the captaincies only lasting effect was on the political map—the borders of many Brazilian states still reflect the boundaries laid down for those first 15 captaincies. Establishing viable colonies in Brazil, however, was going to require the sort of armed force only a king could provide.

In 1549, King João revoked the captaincies and sent out a force of 1,500 men—soldiers, priests, artisans, and administrators—under the command of Brazil's first governor-general, **Tomé de Sousa.** Landing at **Salvador** in what is now the state of **Bahia,** de Sousa's force was large enough to turn the tide. Warfare with Brazil's native inhabitants would continue for another 200 years or so, but for the most part the Portuguese would have the upper hand.

Sugar Cane & Slavery

What made the expense worthwhile—in the eyes of the crown—was **sugar.** The cash crop of the 16th century, it grew well in the tropical climate of northeast Brazil. **Salvador,** the new capital, was soon surrounded by rapidly expanding plantations of sugar cane.

Turning that cane into sugar, however, was backbreaking work, and the Portuguese were critically devoid of labor. Local Indians were uninterested in the repetitive drudgery of cutting cane, so the Portuguese began to import **slaves,** captured or bought in West Africa. Brazil was soon one leg on a lucrative maritime trade triangle: guns and supplies from Portugal to Africa, slaves from Africa to Brazil, sugar from Brazil back to Europe. Within a few decades, colonial cities such as Salvador and **Olinda** were fabulously rich.

A Dutch Threat & the Rise of Rio (17th–18th c.)

Other European powers took note. In 1624, a **Dutch expedition** conquered and briefly occupied the Brazilian capital of Salvador, leaving a year later after a combined Portuguese-Spanish fleet counterattacked. The Dutch soon returned, burning Olinda to the ground, taking control of **Pernambuco,** and establishing their own capital city of **Recife.** Under the leadership of **Maurits van Nassau,** Dutch Brazil was soon a thriving colony, exporting ever-larger quantities of sugar. When internal politicking forced Nassau out of the colony in 1644, however, Dutch fortunes began to wane. A rebellion of the local Portuguese planters, followed by renewed attacks from Portugal,

finally forced the surrender of Dutch forces in 1654. Never again would another European power successfully challenge Portuguese control of the country.

Free of external threat, the settlers turned their attention inland. Small expeditions of Brazilian adventures—called *bandeirantes* because they often carried the royal flag—began exploring westward seeking gold, minerals, or other treasure. **Gold** and diamonds were soon uncovered in what would later be the state of **Minas Gerais,** followed by further gold strikes farther west in Mato Grosso. The resulting flood of miners and other settlers gave effective control of the interior to Portugal—a fact recognized by the **1750 Treaty of Madrid,** which gave the entire Amazon basin and those lands east of the Rio Prata to Brazil.

In addition to the miners, the other main beneficiary of the Minas gold rush was **Rio de Janeiro,** the major transshipment point for gold and supplies. In recognition of this, in 1762 the **colonial capital** was officially transferred to Rio.

Stunning as its physical setting was, Rio was hardly then the *cidade maravilhosa* it would become. Indeed, it would likely have remained little more than a backwater colonial capital had it not been for **Napoleon.** In 1807, having overrun most of western Europe, the little French emperor set his sights on Portugal. Faced with the imminent conquest of Lisbon, Portuguese **Prince Regent João** (later **King João VI**) fled to his ships, opting to relocate himself and his entire court to Brazil. And so it was that in March 1808, the king and 15,000 of his nobles, knights, and courtiers arrived in the raw town of Rio.

Independence Arrives (19th c.)

The changes wrought by the royal presence were enormous: palaces, parks, and gardens were built all over the city. A new administrative class was formed. Indeed, the denizens of Rio got so used to being at the center of things that the king's return to Portugal in 1821 created no small outrage. Used to being at the heart of the empire, Brazilians—among them the king's 23-year-old son Pedro—were outraged at the prospect of being returned to the status of mere colony. In January 1822, Pedro announced he was remaining in Brazil. Initially, he planned on ruling as prince regent, but as the year wore on it became clear that Lisbon was not interested in compromise, so on September 7, 1822, Pedro declared **Brazil independent,** and himself **Emperor Pedro I.**

His reign lasted only 9 years. In acceding to the throne, Dom Pedro had agreed to rule as a constitutional monarch, but in practice sharing power with a parliament of meddling politicians went against his aristocratic nature. A costly war with **Argentina**—which led to the creation of **Uruguay** in 1828—only lessened his popularity. Finally, in April 1832, Dom Pedro was presented with an ultimatum demanding he appoint a reformist cabinet. He chose instead to **abdicate.** His 5-year-old son became Emperor Pedro II.

Brazil in this period was a deeply conservative country, with a few very wealthy plantation owners, a tiny professional class, and a great mass of slaves indentured into cultivating either sugar or Brazil's new cash crop, **coffee.** Though the antislavery movement was growing powerful across the globe, Brazil's conservative landowning class was determined to hold on to slavery at all costs.

Taking power in 1840 at the tender age of 14, **Dom Pedro II** found himself in a political bind. Though he personally favored abolishing slavery, the conservative slave owners were also the chief supporters of the monarchy. The liberal abolitionists in the parliament were republicans to a man. Faced with this intractable situation, Dom

Pedro opted to ally himself with the conservatives. He would move forward on the slavery issue, but at a glacial pace.

In the 1850s, under heavy pressure from Britain, Brazil finally moved to halt the **importation** of slaves from Africa. Slavery was still legal within the country, but its days were clearly numbered. Seeking a new source of labor, in 1857 Brazil opened itself up to **immigration.** Thousands poured in, mostly **Germans** and **Italians,** settling themselves in the hilly, temperate lands in the south of Brazil. Not only did they provide alternate labor on coffee plantations, but these newcomers also established their own small farms and vineyards, or else moved into Brazil's growing cities, giving the southern part of Brazil a very European flavor.

Through the 1860s and 1870s, the government showed little interest in confronting the slavery issue. A law passed in 1871 envisioned the legal end of slavery—but not until 1896. Another passed in 1885 promised to free only those slaves over the age of 65. As immigration continued, the plantation class became an increasingly tiny fraction of the populace, albeit one that maintained a stranglehold on Brazilian politics. Dom Pedro himself seemed to have lost interest in governing, spending much of his time on extended trips abroad. Finally, in 1888, his daughter the **Princess Regent Isabel** passed the **Lei Aurea,** which set Brazil's slaves free. There were celebrations in the streets, but by this time the monarchy was so thoroughly associated with the plantation owners, it had little popular support. When reformist army officers and other liberals staged a coup in 1889, Pedro II's 57-year rule came to an end.

The Age of Vargas & WWII (mid-20th c.)

The new republic had many of the same ills of Pedro II's old regime. In a country with an increasingly large working class, the government remained in the hands of the coffee-growing elite. Corruption was endemic, rebellions a regular occurrence. Finally, in 1930, reformist army officers staged a **bloody coup.** After several days' fighting, a military-backed regime took charge, putting an **end to the Old Republic** and ushering in the 15-year reign of the fascinating, maddening figure of **Getulio Vargas.**

A pol to his fingertips, Getulio Vargas managed to ride each new political wave as it swept in. He began his time in office as a **populist,** legalizing unions and investing in hundreds of projects designed to foster Brazil's industrial development. When the workers nevertheless looked set to reject him in renewed elections (and in the aftermath of a failed Communist revolt), Vargas tore up the constitution and instituted a **quasi-fascist dictatorship,** complete with a **propaganda ministry** that celebrated every action of the glorious leader Getulio. In the early 1940s, when the **United States** made it clear Brazil had better cease its flirtation with Germany, Vargas dumped his fascist posturing, **declared war on the Axis powers,** and sent 20,000 Brazilian troops to take part in the **invasion of Italy.** When the troops came home at war's end, the contradiction between the fight for freedom abroad and the dictatorship at home proved too much even for Vargas's political skills. In 1945, in a very **quiet coup,** the army removed Getulio from power.

In 1950, **Vargas returned,** this time as the democratically elected president. His reign was a disaster. By 1954, there were riots in the streets, the army was on the verge of mutiny, and even his own vice president was calling for his resignation. Vargas, instead, retired to his office in the Catete Palace in Rio, and on the night of August 4, 1954, put a bullet through his heart.

A New Capital Is Born: Brasilia

In 1956, **Juscelino Kubitschek** (known as JK) was elected president of Brazil, largely on the strength of a single bold promise: Within 4 years, he would **transfer the capital** from Rio de Janeiro to an entirely new city located somewhere in Brazil's vast interior. Few thought he could do it.

The site chosen in Brazil's high interior plateau—the *sertão*—was hundreds of miles from the nearest paved road, not to mention the nearest airport. Undaunted, JK assembled a team of Brazil's top **modernist architects**—among the best in the world at the time—and an astounding 4 years later, the new capital of **Brasilia** was complete.

Democracy, unfortunately, did not fare well in the arid soil of the *sertão*. In 1964, the army took power in a coup, ushering in an ever more repressive **military dictatorship** that would last for another 20 years.

The "Economic Miracle" & Its Aftermath (late 20th c.)

For a time, no one much complained about the military dictatorship. Thanks to massive government investment, the economy boomed. São Paulo, which had been little more than a market town in the 1920s, exploded in size and population, surpassing Rio to become the heart of Brazil's new manufacturing economy. These were the days of the Brazilian **"economic miracle."**

In the early 1970s, however, it became clear that much of the "economic miracle" had been financed on easy international loans, much of that invested in dubious development projects (roads that disappeared back into the forest, nuclear power plants that never functioned) or channeled directly into the pockets of various well-connected generals. The international banks now wanted their money back, with interest. As discontent with the regime spread, the military reacted with ever-stronger **repression.**

The 1980s were perhaps Brazil's worst decade. **Inflation** ran rampant, while growth was next to nonexistent. Austerity measures imposed by the International Monetary Fund left governments with little money for basic infrastructure—much less social services—and in big cities such as Rio and São Paulo, favelas (shanty-towns) spread while crime spiraled out of control.

Soccer Champions

The 2014 soccer World Cup is an opportunity for the host to show the rest of the world what it is capable of, both on and off the field. It's what soccer players call *o jogo bonito* (the beautiful game). On the soccer field, Brazil rules, having won five World Cups. True, in the **1950 World Cup**—held in the specially built **Maracanã** stadium in Rio—Brazil lost in a 2-to-1 final to underdog Uruguay. (The shame of that defeat haunts Brazil to this day.) Brazil came back strong, however, taking the World Cup championships in 1958, 1962, 1970, 1994, and a fifth in 2002, making Brazil the only country to ever have won the World Cup five times. The only country able to rival this achievement in 2014 and seriously rain on Brazil's parade is Italy, currently four-time World Champion (1934, 1938, 1982, and 2006).

In the midst of this mess, the army began a **transition to democracy.** In 1988, in the first direct presidential election in over 2 decades, Brazilians elected a good-looking millionaire named **Fernando Collor de Mello.** It proved to be a bad move. Not only did Collor seize the bank savings of private citizens via government fiat, he was also soon found lining his own pockets with government cash. The civilian government did prove capable of legally forcing him from office, however, paving the way in 1994 for the election of **Fernando Henrique Cardoso.**

Though an academic Marxist for much of his career, once in office FHC proved to be a cautious centrist. In his 8 years in office he managed to rein in inflation, bring some stability to the Brazilian currency, and begin a modest extension of social services to Brazil's many poor.

Lula & Modern Brazil

The main opposition throughout this period was the **Workers Party (PT),** lead by **Luiz Inácio Lula da Silva,** a charismatic trade unionist with a personal rags-to-riches story. Born into poverty in the Northeast of Brazil, Lula, as he is usually known, left school to work as a shoeshine boy, got a job in a São Paulo factory, joined the metalworkers' union, and began to get involved in politics. During the waning days of Brazil's dictatorship he and others formed the Workers Party, and only just lost Brazil's first democratic election in 1988, thanks in large part to some blatant scare-mongering by the Globo print and television conglomerate. Lula persevered, however, contesting the following two elections against FHC, while refining and moderating policies to bring them into a form more acceptable to the Brazilian electorate. Finally, in 2002, in his fourth attempt, Lula was elected Brazilian president, the first democratically elected leftist ever to hold power in Brazil.

Hopes for Lula's first term in office were enormous. Confounding expectations of financial markets and right-wing critics, Lula in office proved to be an economic moderate, continuing the tight-money policy of his predecessor. But to the disappointment of his supporters on the left, Lula also proved to be a poor and often absent administrator. Many of the hoped-for reforms—from the distribution of land, to access to education and health care, to environmental policy—were never enacted. Worse, his government, which had pledged to clean up Brazilian politics, was plagued by corruption scandals as bad as or worse than any of his predecessors.

On the positive side, Lula's government broadened Brazil's welfare system, extending a guaranteed basic income to the poorest families for the first time. Lula's government also eased credit terms on housing and durable consumer goods, sparking a consumer boom, particularly in the lower middle class. These measures, combined with gradually diminishing unemployment and steady but not spectacular growth, were enough to win Lula reelection in 2006 to a second 4-year term in office. At the end of his 8 years in office, Lula remained enormously popular with the Brazilian electorate, so much so that he was able to personally select, groom, and ensure the election in 2010 of his successor and protégée, Brazil's first female president, **Dilma Rousseff.**

BRAZIL IN POP CULTURE

Music

Ever since Vinicius de Moraes and Tom Jobim penned the bossa nova hit "The Girl from Ipanema," Brazil has been a player on the international music scene. The

A Presidenta

On October 31, 2010, **Dilma Rousseff**, the daughter of a Bulgarian immigrant, was elected as Brazil's 36th president, thus becoming the country's first-ever female head of state. A member of the left-of-center Worker's Party (PT), Rousseff spent several years in prison for her activism against the regime during the years of Brazil's dictatorship. She later served as minister of Mines and Energy in Lula's cabinet and was then appointed Lula's chief of staff. *Forbes* magazine called her rise to Brazil's top political post "remarkable," and named her the 16th most influential woman in the world.

outside world, however, seems only able to absorb one Brazilian musical style at a time. **Bossa nova** and **samba** were hot in the 1950s and 1960s; **tropicalismo**—spearheaded by Brazil's megastars Caetano Veloso and Gilberto Gil—was popular in the 1970s. This movement paved the way for some of Brazil's most loved **MPB** (*musica popular brasileira*) stars to break through on the international stage: Gal Costa, Milton Nascimento, Djavan, Maria Bethania, and Jorge Ben. Other such as João Bosco, Tim Maia, Chico Buarque, and Elis Regina were huge in Brazil but never quite made the crossover. One style that did make it out of Brazil (and maybe shouldn't have) to briefly dominate the dance floors of the late 1980s was the **lambada.** In the 1990s, a crop of new artists such as Marisa Monte, Daniela Mercury, and Olodum managed to get airtime outside of Brazil, while the "golden oldies" such as Caetano Veloso, Gilberto Gil, and Milton Nascimento continue to tour the global stages. In the past 10 years, samba has also made a strong comeback, with dozens of clubs opening up in Rio and São Paulo, and *pagode* (a type of samba) bands like Revelação, Fundo de Quintal, and Sorriso Marroto, and solo performers such as Zeca Pagodinho, Diogo Nogueira, and Dudu Nobre selling double-platinum albums and touring to packed houses.

There are regional trends that almost never make it to the rest of the world, among them the uniquely Brazilian country sound known as *sertanejo.* In smaller towns and rural communities, this style—which like its American counterpart is big on broken hearts and horses—is incredibly popular. Artists such as Chitãozinho e Xororó have sold over 30 million albums. Solo artist Leonardo has sold more than 12 million albums in the last 15 years. One of the most popular teen sensations is 20-year-old Luan Santana who always seems to perform to the tune of screaming girls.

In Bahia, there's been a huge revival of **reggae** and **Afro-rhythms.** The Bahian group Olodum performs original tunes and old Bob Marley classics using massed percussion (15 to 30 people wielding six to seven kinds of drums). Also from Bahia is *axé,* a lighter mélange of African, Caribbean, and Brazilian infused pop; successful representatives include Bahian superstars Ivete Sangalo and Claudia Leitte.

Likely the most unlooked-for trend is the mania for *forró* that has recently swept the country. A happy, upbeat, accordion-infused brand of country, *forró* began in Brazil's poorer northeastern regions, and came to the big cities as poor Nordestino migrants made their way south (in Portuguese it is often referred to as *musica nordestina*). Originally looked down upon by southern Brazilians, *forró* was confined to Nordestino dance halls where crowds of transplanted peasants would dance the night away doing a simple two-step. There was something about this infectious rhythm that would not be denied, however (for one thing it's incredibly danceable, and Brazilians

MTV in Brazil has lately recorded a number of acoustic sessions with some of Brazil's best artists, and the results have been phenomenal. Many of Brazil's major artists or bands have gone into the studio to record an unplugged version of their biggest hits; check out those by Marcelo D2, Kid Abelha, Capital Inicial, Cassia Eller, O Rappa, Jorge Ben Jor, Zeca Pagodinho, or any other one you can lay your hands on.

love to dance), and *forró* grew and grew to the point where it has now taken over many of Rio and São Paulo's most sophisticated nightclubs. The grandfather of all *forró* is Luiz Gonzaga, a man who was never seen without his accordion.

And then there's **brega,** a kind of glam version of *forró,* with over-the-top costumes and shamelessly sentimental lyrics—the very word *brega* in Portuguese means "tacky," and *brega* is. It's also infectiously fun and danceable. Hailing from Belém and the northern Amazon, where Brazil edges close to the Caribbean, *brega* combines *forró* with a kind of reggaeton beat and the salsa band fixation with the horn section. The biggest Brazilian *brega* bands are Calypso and Calcinha Preta.

In the first decade of the millennium, the new music phenomenon has been **funk,** a mix of funk and rap and hip-hop with a driving (and monotonous!) dance beat. Funk originated in the favelas and the other poor neighborhoods but has slowly made its way down from the hills and begun infiltrating the rest of the city. Performers, mostly male, surround themselves with scantily clad women who bump and grind to misogynist and sexually explicit lyrics. Usually performers play at large dance events called *bailes funk,* held in large warehouses or empty lots. Cities have tried to prohibit some of these events but, not surprisingly, the resulting controversy has only made both the events and the performers more popular, particularly among teenagers.

Brazil has always had a tradition of strong female artists and performers such as Cassia Eller, Sandra de Sá, Ana Carolina, and Adriana Calcanhoto who have paved the way for a whole new crop of talented female singers. Some new names to look for include Vanessa da Mata, Maria Gadu, Roberta Sá, and Paula Fernandes.

Books

Brazilians aren't great book lovers. Their great popular figures are singers, not writers. The most popular narrative form is not the novel but the *novela,* the nightly prime-time television soap opera. Despite this unpromising soil, Brazil has still managed to produce a substantial crop of important writers.

Most popular among them is the Bahian novelist Jorge Amado who, until he passed away in 2001, was considered a serious candidate for the Nobel Prize. His greatest novels came in the 1950s after he set aside leftist polemics and got back to what he knew best, the colorful characters of his beloved Bahia. His best known works include **Dona Flor and Her Two Husbands, Tieta** (the story of a successful whore returning to the conservative town of her birth), and **Gabriela, Clove and Cinnamon** (the title works better in Portuguese: *Gabriela, cravo e canela*).

In a previous generation, Joaquim Maria Machado de Assis wrote closely observed and fiercely ironic novels and short stories, many set in Rio toward the end of the 19th century. In recent years there's been renewed critical interest in Machado de Assis, including a new translation of his work by the renowned American literary

translator Gregory Rabasa. Look for Rabasa's version of **Posthumous Memoirs of Bras Cubas** and **Quincas Borba.** Also available in English is the short-story collection **The Devil's Church and Other Stories.** Brazil's greatest social realist is Graciliano Ramos. His masterpiece **Barren Lives** is considered to be one of Brazil's finest novels.

From the postwar generation, Clarice Lispector is another Brazilian author to be gaining renewed respect in the English-speaking world, including a new 2009 biography, **Why This World: A Biography of Clarice Lispector,** by Benjamin Moser. Lispector's most ambitious novel, **The Apple in the Dark,** has been translated into English by Gregory Rabasa. The success of the film *Cidade de Deus (City of God)* has spawned a whole subgenre of favela literature. Look for the original novel **City of God** by Paulo Lins.

There is no single good general history covering Brazil from 1500 to the present. **Colonial Brazil,** by Leslie Bethel, is a scholarly but readable account of Brazil under the Portuguese, while Peter Flynn's **Brazil: A Political Analysis** covers political history from the birth of the first republic to the close of the second dictatorship.

For a fascinating introduction to a whole range of topics in Brazil, pick up the truly excellent anthology **Travellers' Tales: Brazil.** Less varied but equally interesting is **Tristes Tropiques,** by the great French anthropologist Claude Lévi-Strauss. Lévi-Strauss got his start teaching at the university of São Paulo in the 1930s. His description of that town before the monster boom of the 1940s and 1950s is fascinating. Even better, Lévi-Strauss exhibits a wry sense of humor, the rarest of qualities for a French academic. Those who would like to learn more about Brazil's fascinating and convoluted race relations may want to pick up a copy of **The Masters and the Slaves (Casa Grande e Senzala),** by Gilberto Freyre. Even though it was written almost 80 years ago, it's still one of the more comprehensive efforts to explain Brazilian society.

Film

Brazil has a long and impressive history of filmmaking, including a number of films by directors who have moved back and forth between Brazil and Hollywood. Hector Babenco is best known in Brazil for **Carandiru** (2003), his excellent film about life in a São Paulo maximum security prison. North American audiences are more likely to have seen his work in **At Play in the Fields of the Lord** or **Kiss of the Spider Woman** (1985). Hector Babenco directed the hard-hitting political thriller **Four Days in September** (1997) about the kidnapping of the U.S. ambassador to Brazil in the 1970s, then followed it up with the fun and fluffy **Bossa Nova** (2000), a romantic comedy filmed in English and set in Rio, starring Amy Irving (Bebenco's wife) and many of the stars of Brazil's *novela* soap operas. Babenco's latest film is **Last Stop 174** (2008), a true story about the hijacking of a city bus in downtown Rio de Janeiro. Many of these films don't make it to North American screens. One that did was **Central Station** (1998), which was nominated for best foreign film Oscar in 1998.

Five years later, the extraordinary **City of God** (2003) exploded across screens in North America and around the world, with its powerful story of a young man growing up in one of Rio's ultraviolent favelas. Director Fernando Meirelles followed up that film with **The Constant Gardener** (2005) and **Blindness** (2008). The granddaddy of Brazilian crossover hits has to be **Black Orpheus,** a 1959 retelling of the myth of Orpheus and Eurydice, set in a poor neighborhood in Rio during the glorious nights of Carnaval. (Worth it for the music alone; most songs were composed by Antonio Carlos Jobim.)

Without doubt, Brazil's most commercially successful pair of films in the past 5 years consists of **Tropa da Elite** (Elite Squad, 2007) and the even more successful follow-up, **Tropa da Elite II** (2010). Both center on Rio de Janeiro's elite police strike force BOPE, and its battles with Rio's drug cartels and the protection rackets/death squads that have recently moved up into politics.

In 2011, Rio de Janeiro made its animated 3-D debut in Carlos Saldanha's production **Rio.** The director of the popular Ice Age movies created a colorful, animated story that brings many of the city's landmark attractions to life.

EATING & DRINKING
The Cuisine

Brazilian cuisine comes in many regional varieties but the one truly national dish is *feijoada,* a black-bean stew that originated with African slaves who used leftovers to make a tasty meal. Traditionally served on Saturdays, the beans are spiced with garlic, onions, and bay leaves and left to stew for hours with a hodgepodge of meats that may include sausage, beef, dried meat, and obscure bits of pork. Accompanied with rice, *farofa* (manioc flour), slices of orange, and stir-fried cabbage, it's a meal by itself.

Brazil's most distinguished regional cuisine is found in coastal Bahia, a region with very strong African influences. (Most Brazilian slaves arrived first in Bahia, and after slavery was abolished many of them settled in that area.) **Bahian cuisine** mixes African spices with the fresh and bountiful local ingredients. Bahia's most famous dish is the *moqueca,* a rich stew made with fresh fish or seafood, coconut milk, lime juice, cilantro, and spicy *malagueta* peppers, and flavored with the oil from a dendê palm, which gives this dish its characteristic red color.

In the **Amazon,** whatever food does not come from the forest or the river has to be shipped in and is therefore very expensive. Fortunately, the region is blessed with a large variety of fish. Cast aside any preconceived notions you may have about freshwater fish. The Amazon fish are delicious—firm white meat that tastes best just plainly grilled with salt and herbs. Local names for the best fish vary from one part of the Amazon to the next, but look for *surubim, pacu, dourado,* and *pirarucu.* The forest also yields a large variety of fruit that are often unknown outside of the Amazon. The best way to try them is just to order something off the juice menu; point if you can't wrap your tongue around Indian names such as *cupuaçu, açai,* or *jabuticaba.*

In the **south** and **southwest** of Brazil (the Pantanal, Iguaçu, and the south of Brazil) the cuisine is more European, and as the largest beef-producing region in Brazil, meat is always on the menu. Churrascarias, or Brazilian steakhouses, are everywhere; indeed it's sometimes hard to find anything else to eat. Often churrascarias operate on a *rodízio* system—all-you-can-eat meat barbecue. Endless waiters scurry from grill to tables bearing giant skewers of beautifully roasted beef, chicken, pork, or sausage, from which they then slice off succulent portions onto your plate. The parade of meat continues until you cry enough. If carnivorous overconsumption doesn't appeal, there are other places to get yourself a fine cut of beef. Neighborhood bars *(botequins)* and even street vendors also offer barbecued beef, often served with a side of vinaigrette sauce, rice, and *farofa.*

Also very popular in Brazil is the simple hearty fare from **Minas Gerais,** a state settled largely by European immigrants. Favorite dishes include *tutu mineiro,* Brazil's version of refried beans, served with grilled pork sausage, pork tenderloin, crispy bacon bits, *couve mineiro* (green cabbage), and a boiled egg. Other dishes include a

If you are allergic to nuts you should be extra careful around certain dishes. Especially those with a seafood or shellfish allergy may want to check before ordering stews from the Northeast such as *moqueca, vatapá,* and *bobó.* These dishes often have ground-up shrimp in the sauce. Also, many fish dishes come with shrimp sauce, which may not be listed on the menu. Desserts often have nuts in them so always ask before digging in. Peanuts are *amendoim* (ah-man-doo-*een*), cashews in Portuguese are *castanha de caju* (ka-*stan*-ya de ka-zhoo) or *caju* for short, and Brazil nuts are known as *castanha do Pará* (ka-stan-ya doh pa-*rah*). The general word for nuts is *nozes* (no-*zhes*) and you can let people know that you have an allergy by saying *"Tenho alergia de amendoim"* (*Ten*-yo ah-lehr-*gee*-ah de ah-man-doo-*een*).

variety of stews made with chicken or beef, potatoes, carrots, and sometimes pumpkin.

In **Rio** and **São Paulo,** the restaurant scene is very cosmopolitan: excellent Japanese restaurants, fabulous Italian, traditional Portuguese, and Spanish food as well as popular restaurants that serve Brazilian food—rice, black beans, *farofa,* and steak.

Eating Out

Brazilians love to eat out. There is no shortage of eateries, from beach vendors selling grilled cheese and sweets, to lunch bars serving pastries and cold beers, to fine French cuisine complete with the elegance and pretensions of Paris. Most Brazilians eat a very small breakfast at home—usually café au lait and some bread—then go out for lunch. Traditionally, these lunches are full hot meals, but these days you can also find North American–style sandwiches and salads as a lighter alternative. Dinner is eaten late, especially when dining out. Most restaurants don't get busy until 9 or 10pm and will often serve dinner until 1 or 2am. The trick to lasting that long without fainting is to have a *lanche* or light meal—often a fruit juice and a pastry—around 5 or 6 pm.

In Brazil, portions often serve two people, especially in more casual restaurants. Always ask or you may well end up with an extraordinary amount of food. In Portuguese ask, *"Serve para dois?"* (pronounced *Sir*-vay p'ra doysh—"Does it serve two?").

The standard Brazilian menu comes close to what some restaurants label as international cuisine: pasta, seafood, beef, and chicken. Except in Brazil, these are served with a local or regional twist. The pasta may be stuffed with Catupiry cheese and *abóbora* (a kind of pumpkin); the chicken could have *maracujá* (passion-fruit) sauce. In Brazil the cows are open-range and grass-fed, making for a very lean beef which comes in uniquely Brazilian cuts such as *picanha* (tender rump steak), *fraldinha* (bottom sirloin), or *alcatra* (top sirloin). And of course, no Brazilian meal is complete without *farofa* and rice or black beans.

These days you will find more and more **kilo** (*quilo* in Portuguese) restaurants. The food is laid out in a large buffet, and at the better ones there's a grill at the back serving freshly cooked steaks, chicken, and sausage. Kilos aren't all-you-can-eat. Rather, you pay by weight. If you're not familiar with Brazilian food, it's a great way to see all the dishes laid out in front of you; you can try as little or as much as you like. Even better, they often have a variety of salads and vegetables that can be hard to come by

in Brazil. The system works as follows: When you enter the restaurant, a piece of paper on which all your orders are recorded. Don't lose this slip to pay a ridiculously high penalty. You grab a plate, wander by the buffet ling up on whatever catches your eye (all items have the same per-kilogram cost, which is usually advertised both outside and inside the restaurant), and then take the plate to the scale to be weighed. The weigher records the charges on your bill, after which you find a table. Normally a waiter will then come by and take your drink order, adding these charges to your tally. On your way out, the cashier sums it all up. *Tip:* Small cups of strong dark coffee (called *cafezinhos*) are usually served free by the cashier or exit. Look for a thermos and a stack of little plastic cups.

A **churrascaria** is a steakhouse that operates on the *rodízio* system, essentially all you can eat—though you'll pay extra for drinks and dessert. The set price buys you unlimited access to a massive salad bar buffet, often also including fish and sushi, and the attention of an army of waiters all offering different cuts of meat, sliced directly onto your plate. All the typical and unique Brazilian cuts of beef are on offer, as well as chicken breast, chicken hearts, sausage, and on and on and on.

WHEN TO GO

High season in Brazil lasts from the week before Christmas until Carnaval (which falls sometime in Feb or early Mar, depending on the year). Flights and accommodations are more expensive and more likely to be full during this period. Book well ahead of time for accommodations during New Year's and Carnaval. This is the most fun time to travel—towns and resorts are bustling as many Brazilians take their summer vacations, the weather's warm, and New Year's and Carnaval are fabulously entertaining. If you want to spend New Year's in Brazil, it's best to arrive after Christmas. The 25th is really a family affair, and most establishments will be closed.

Other busy times of the year include Easter week and the months of July, when Brazilian schools and universities take their winter break, and August, when most Europeans and North Americans visit during their summer vacations. This is probably the worst time of year to travel; prices go up significantly, and except for in the north and parts of the northeast, the weather can be iffy and downright chilly from Rio de Janeiro southward. Temperatures as low as 5° to 10°C (40s–50s Fahrenheit) are not unheard of in the south.

Consider visiting Brazil in September or October. The spring weather means warm days in São Paulo, Iguaçu, and Rio, and tropical heat everywhere else; in the Amazon and the Pantanal, you'll be there just before the wet season starts. As an added bonus, in Rio you'll be able to attend some of the samba school rehearsals as they get ready for Carnaval (yes, they start 4 months early). Another good period for a visit is after Carnaval (early to mid-Mar, depending on the dates) through May, when you can take advantage of low-season prices, while still enjoying good weather.

Weather

As Brazil lies in the Southern Hemisphere, its seasons are the exact opposite of the Northern Hemisphere: **summer is December through March** and **winter June through September.** Within the country the climate varies considerably from region to region. In most of Brazil the summers are very hot. Temperatures can rise to 43°C (110°F) with high humidity.

The **Northeast** (from Salvador north) is warm year-round, often with a pleasant breeze coming off the ocean. Temperatures hover between the upper 20s to mid-30s

Celsius (low 80s and mid-90s Fahrenheit). The winter months (June–July) are slightly wetter, but even then the amount of rain is limited—a quick shower that cools things down briefly before giving way to more sunshine.

The **Amazon** is hot and humid year-round, with temperatures hovering around the mid- to high 30s Celsius (mid-90s to low 100s Fahrenheit). The dry season lasts from June to December and is often called "summer" by the locals as it is hot and sunny. As the rivers recede, beaches and islands reappear. The wet season typically runs from December to May and is referred to as "winter." The humidity is higher in the rainy season, building up over the course of the day to produce a heavy downfall almost every afternoon. Even then, however, mornings and early afternoons can be clear and sunny.

The **Pantanal** is very hot in the rainy season, with temperatures climbing over the low 40s Celsius mark (100°F). Most of the rain falls December through March. The driest time of the year is May through October. In these winter months things cool down considerably, though nighttime temperatures will seldom drop below 20°C (68°F).

Rio has very hot and humid summers—38°C (100°F) and 98% humidity are not uncommon. Rio winters are quite mild, with nighttime temperatures dropping as low as 19°C (66°F), and daytime temperatures climbing to a pleasant and sunny 30°C (86°F).

São Paulo has a similar climate to Rio's, hot in the summer and mild in winter. As São Paulo sits atop a plateau at approximately 700m (2,300 ft.) of elevation, it can sometimes get downright chilly, with daytime lows June through September sometimes reaching 12°C (54°F). **South of São Paulo,** things get even colder in the winter. In Porto Alegre and Curitiba, winter daytime temperatures regularly fall below 10°C (50°F). In Florianópolis, many restaurants and even some hotels and pousadas shut down for the winter season. Also, in the mountain resort of Petrópolis and the historic towns of Ouro Preto and Tiradentes, it often gets cold enough to see your breath (5°C/41°F) in the fall and winter, and Brazilians will travel here to experience winter.

Average Monthly Temperature (Celsius/Fahrenheit)

	JAN	FEB	MAR	APR	MAY	JUNE	JULY	AUG	SEPT	OCT	NOV	DEC
Rio de Janeiro	28/	28/	27/	26/	23/	22/	22/	22/	23/	24/	26/	27/
	83	84	82	79	75	73	72	73	74	76	79	81
Manaus	27/	26/	26/	27/	27/	27/	27/	27/	28/	28/	28/	27/
	81	80	80	81	81	81	81	81	82	82	82	81

Average Precipitation (Centimeters/Inches)

	JAN	FEB	MAR	APR	MAY	JUNE	JULY	AUG	SEPT	OCT	NOV	DEC
Rio de Janeiro	13/	12/	13/	10/	7/	5/	4/	4/	6/	8/	9/	13/
	5.3	4.9	5.3	4.3	3.1	2.0	1.8	1.8	2.4	3.2	3.9	5.4
Manaus	25/	27/	30/	29/	26/	10/	8/	5/	7/	10/	15/	20/
	64	69	76	74	66	25	20	13	18	25	38	51

Holidays

The following holidays are observed in Brazil: New Year's Day (Jan 1); Carnaval (Feb 9–12, 2013; Mar 1–4, 2014); Easter (Mar 31, 2013; Apr 20, 2014); Tiradentes Day (Apr 21); Labor Day (May 1); Corpus Christi (June 7, 2012, May 30, 2013); Independence Day (Sept 7); Our Lady of Apparition (Oct 12); All Souls' Day (Nov 2); Proclamation of the Republic (Nov 15); and Christmas Day (Dec 25). On these days banks, schools, and government institutions will be closed, and some stores may be closed as well.

Brazil's biggest holidays are New Year's and Carnaval. Easter is also a big celebration in a number of towns around the country, particularly in the historic towns of Minas Gerais and Novo Jerusalem outside Recife.

Brazil Calendar of Events

For an exhaustive list of events beyond those listed here, check http://events.frommers.com, where you'll find a searchable, up-to-the-minute roster of what's happening in cities all over the world.

JANUARY

New Year's Celebration, Rio de Janeiro. Close to two million people gather for one of the most spectacular New Year's celebrations in the world. Starting on the evening of December 31 (**Reveillon,** New Year's Eve) and continuing well into the morning of January 1, the main event takes place on Copacabana beach with live music and fireworks, as well as Candomblé religious ceremonies. See "Reveillon: New Year's Eve in Rio," p. 130. January 1.

Three Kings Festival, Salvador (✆ 071/3103-3103; www.bahia.com.br). Salvador celebrates the Three Kings Festival with a procession and events around the Praça da Sé in the old town. January 6.

Washing of the Steps of Bonfim Church, Salvador (✆ 071/3103-3103; www.bahia.com.br). This is one of the most important religious ceremonies in Salvador, when hundreds of women in traditional Bahian dress form a procession and carry perfumed water to wash the church steps, accompanied by 800,000 onlookers and revelers. Third Thursday of January.

Saint Sebastian Day, Rio de Janeiro (✆ 021/2271-7000; www.riodejaneiro-turismo.com.br). The patron saint of Rio de Janeiro is honored in this regional holiday. The highlight is a procession to the city's modern cathedral. January 20.

FEBRUARY

Celebration of Yemanjá, the Goddess of the Sea, Salvador (✆ 071/3103-3103; www.bahia.com.br). Devotees throughout Brazil offer flowers, perfumes, and jewelry to the sea. Celebrations take place on the beach with music and food. The largest celebration takes place in Salvador on Praia Vermelha. February 2.

Carnaval. This event can take place anywhere from early February to mid-March. Carnaval begins the weekend before Ash Wednesday and ends on the morning of Ash Wednesday. The largest celebrations take place in Rio, Salvador, and Recife/Olinda. For details, contact **Riotur** (✆ 021/2271-7000; www.riodejaneiro-turismo.com.br); in Salvador contact **Bahiatursa** (✆ 071/3103-3103; www.bahia.com.br); or the **Recife** tourist office (✆ 081/3232-8409). Book ahead if you plan on attending this event. February 9 to 12, 2013; March 1 to 4, 2014.

MARCH

Passion Play, Nova Jerusalem (✆ 081/3232-8409). South America's largest Passion Play (daily) takes place in Nova Jerusalem, just outside of Recife in Brazil's Northeast. Ten days preceding Easter.

APRIL

Easter Weekend (Semana Santa), Ouro Preto (✆ 031/3551-1469; www.ouropreto.org.br). This important Catholic holiday is celebrated with processions and concerts. Ouro Preto, with its 13 baroque churches, is a popular destination during Easter. March 31, 2013; April 20, 2014.

Week of the Inconfidência, Ouro Preto (✆ 031/3551-1469; www.ouropreto.org.br). Tiradentes Day on April 21 is a national holiday, but only Ouro Preto has made it into a large event with celebrations, plays, and cultural events taking place. April 16 to April 21.

Manaus Opera Festival (✆ 092/3182-6250; www.visitamazonas.am.gov.br). Every year the city of Manaus hosts a month-long opera festival. The premier events are held in the city's stunning 19th-century Opera House, but various other events are held at venues across the city. Late March to late April.

JUNE

Bumba-meu-boi, São Luis (📞 **098/3231-2000;** www.turismo.ma.gov.br). In São Luis in Maranhão, the peasant folklore festival bumba-meu-boi begins June 1 with the baptizing of the bull, and continues throughout the month, culminating with a large street party on June 30, the feast day of São Marçal. The largest *boi-bumbá* celebration takes place in the small Amazon town of Parintins during the last weekend of June.

São Paulo Pride Parade (www.gaypridebrazil.org). Brazil's largest gay pride parade has grown from an initial 2,000 participants in 1997 to four million people in 2011. The event takes place on the impressive Avenida Paulista in the heart of São Paulo's business center. Second Sunday in June.

Festas Juninas, Rio de Janeiro (📞 **021/2271-7000;** www.riodejaneiro-turismo.com.br). This folklore event in honor of saints Anthony, John, and Peter is celebrated throughout Brazil. The harvest festival offers country music, bonfires, hot-air balloons, and fun fairs. June 13 and 14.

Bauernfest, Petrópolis (📞 **0800/024-1516;** www.petropolis.rj.gov.br). Petrópolis celebrates the German heritage of its many settlers with a week of German food, folklore, and music. Last weekend of June and first week of July.

JULY

FLIP (Festa Literária Internacional de Paraty), Paraty (📞 **024/3371-7082;** www.flip.org.br). The Paraty International Literary Festival, held near the beginning of July, draws a cultured crowd to one of the most charming colonial towns in Brazil. First week of July.

SEPTEMBER

Independence Day. This is Brazil's national holiday. Most cities hold military parades. In Rio de Janeiro this impressive event takes place around Avenida Rio Branco. September 7.

Film Festival Rio BR, Rio de Janeiro (www.festivaldorio.com.br). Rio's film festival showcases Brazilian and international films. Subtitles are in Portuguese, but there is usually a good selection of international movies. Late September to early October.

OCTOBER

Free Jazz Festival, Rio de Janeiro and São Paulo. A 3-day jazz festival with national and international acts. For Rio details, contact **Riotur** (📞 **021/2271-7000;** www.riodejaneiro-turismo.com.br). In São Paulo contact the **tourist information agency** (📞 **011/3231-4455** or 2226-0400). Mid- to late October.

Cirio of Nazaré, Belém (📞 **091/3212-0575;** www.paraturismo.pa.gov.br). Hundreds of thousands of the faithful parade an icon of the Virgin of Nazaré through the streets and harbor of Belém. Second Sunday of October (Oct 14, 2012; Oct 13, 2013).

International Film Festival, São Paulo (📞 **011/3141-0413;** www.mostra.org). The festival presents the best films of Brazil, Latin America, and the world. Most venues concentrate around the Avenida Paulista. Last 2 weeks of October.

Grand Prix, São Paulo (www.gpbrasil.com.br). Brazilians are car-racing fanatics; watching a big race in the company of Brazilian fans is an event in itself. The Grand Prix at Interlagos (a suburb of São Paulo) is the prime event in the country. Third week of October.

São Paulo Bienal (📞 **011/5576-7600;** www.bienalsaopaulo.org.br). Art, theater, music, and architecture—the biggest arts event in Latin America takes place every even year in Ibirapuera Park. Month-long.

NOVEMBER

Aleijadinho Week, Ouro Preto (📞 **031/3551-1469;** www.ouropreto.org.br). Special exhibits and presentations about the beloved sculptor. November 14 to November 21.

DECEMBER

Santa Barbara, Salvador (📞 **071/3103-3103;** www.bahia.com.br). This festival is celebrated with processions, music, and dance. Santa Barbara is the Candomblé equivalent of Iansã, the goddess of wind. December 4.

Christmas Eve. Brazilians go to midnight Mass to celebrate Christmas. Mass is usually followed by a late-night supper with family. December 24.

LAY OF THE LAND

Though continental in dimensions, Brazil has some six predominant ecosystems, each with representative flora and fauna. On the coast, from the north of Bahia south to Rio de Janeiro and São Paulo, it's Mata Atlantica, or Atlantic rainforest, said by scientists to be nearly as rich in biodiversity as the Amazon, but now sadly degraded by the heavy settlement and farming along Brazil's Atlantic coast. Only about 4% of the original Atlantic rainforest cover remains, with large intact stands in the south of Bahia and on islands such as Ilha Grande and Ilha Bela. The golden lion tamarin—a beautiful squirrel-size primate—is the signature species of Brazil's Atlantic ecosystem, now much endangered. Common tamarins can often be seen in trees and parks in Rio. The coast is also the only place you'll find truly significant mountains.

Inland, Brazil rises to a high plateau of from 1,000m to 1,500m (3,280–4,920 ft.) in altitude that rolls all the way to the western foothills of the Andes. In the southern parts of Brazil (Paraná, Santa Catarina, Rio Grande do Sul), this plateau was covered in subtropical rainforest, most of which has long since been converted to cropland.

In the center and center west where things are drier (Goiania, Brasilia, Mato Grosso do Sul, Mato Grosso, Tocantins), you'll find *cerrado,* dry scrubland forest, dotted with beautiful branching ipe trees, known for their bright yellow or purple flowers. Farther west still, on the Paraguay river basin that forms the border with Bolivia, stands the Pantanal. This world's biggest wetland (about the size of Florida) is actually a seasonal flood plain that fills and then slowly drains in response to seasonal rains. It is home to a rich assortment of wildlifebirdlife: jabiru storks, American wood storks, red and hyacinth macaws, plus capybaras, giant otters, anteaters, and caimans. In the north, the semidesert inland from the coast is known as *sertão.* This is cowboy country, with cattle, bandits (historically), cactus, and not much else.

In the north, covering about a third of the country (Amazonas, Acre, Mato Grosso, Para, Roraima), stands the Amazon rainforest, the richest assortment of plants and animals on earth. Deforestation rates have been reduced in recent years, though a chunk the size of Connecticut still falls to the chainsaw every year.

RESPONSIBLE TRAVEL

Brazilians are generally environmentally aware, and Brazilian cities are far less energy-intensive and resource-hungry than most other cities in the Western Hemisphere. Brazilians—even the middle class—tend to live in high-rise apartments in dense urban neighborhoods, and navigate their cities by public transport or small fuel-efficient cars. Do as they do and stay in a high-rise near the beach, take the Metrô or a bus or even cabs. If you're renting a car, try to rent one that can run on ethanol, the gasoline derived from sugar cane, a green alternative; in Brazil, 90% of the country's new cars can run on either gasoline or ethanol.

Outside of cities though, your options are somewhat limited. Brazilian resorts and tour operators do advertise "eco-tourism," but in Brazil this means anything that takes place in the outdoors, be it leave-only-footprints nature hikes or churn-up-the-wildlife ATV expeditions. There are very few lodges or hotels with solar heating or clever ways of dealing with wastewater, or even outdoor operators that take particular care of their local ecosystems. "Eco-tourism" in Brazil is a term that has been stretched to and beyond the bounds of any useful meaning.

Brazil's two most vulnerable remaining ecosystems are the **Pantanal** (chapter 16) and the **Amazon** (chapter 13). Major threats to the Amazon include illegal logging,

clearing land for soy production (to make bio fuel) and agriculture, and the cons... tion of a mega dam (the third largest in the world) in Belo Monte, Pará. The less known Pantanal is a rich wetland region in the east of Brazil on the border with Bolivia. Teeming with birds and other wildlife, this unique region depends on the seasonal flooding and draining of water for its survival. Increasing pressures for more agricultural land have led to attempts to control the natural flow of waters, with disastrous consequences for the environment.

There are some tourism operators and lodges here that strive to protect their local ecosystems in both the Amazon and the Pantanal. In the Pantanal, the **Araras Eco Lodge** (p. 462) and the **Jaguar Ecological Reserve** (p. 462) have helped to popularize the private ecological reserve, a Brazilian program through which the government provides tax breaks in return for a landowner committing to preserving a portion of his land in perpetuity. The presence of eco-tourism operators in the Pantanal—particularly Araras—has also provided a lobby to counter certain ill-advised development schemes, including the paving of the Transpantaneira highway, and the widening, straightening, and deepening of the Rio Paraguay.

In the Amazon, the **Pousada Uakarí** (p. 387) serves as an integral part of the **Mamiraua Sustainable Development Institute** (www.mamiraua.org.br), a project designed to preserve the habitat of the uakari monkey while improving the living standards of local human populations living in and around the Uakarí reserve. Other Amazon lodges come nowhere near this standard, though they do provide some local employment for guides and other lodge staff. Unfortunately, the minuscule scale of eco-tourism operations in comparison with the employment and revenues generated by the timber and cattle industries has rendered eco-tourism a nonplayer in the debate over preserving the Amazon.

However, one could argue that those who experience the Amazon become more likely to lobby to save it. Certainly, awareness of the importance of the Amazon, both globally and in Brazil, has led to the passage in Brazil of a range of reasonably stringent preservation measures, including parks, reserves, national forestlands, and restrictions on deforestation on private landholdings. The problem in Brazil is that these regulations are often not respected, while enforcement on the ground remains weak. Deforestation in the Brazilian Amazon is once again on the rise. Satellite images from Brazil's National Institute for Space Research showed 590 square kilometers (228 sq. miles) of deforestation in April of 2011—nearly six times more than in the same period the year before. A new forest code with less stringent environmental protection policies also favors industry and agriculture. For more information on making an informed decision when booking your trip to the Amazon, see chapter 13. Also see www.frommers.com/planning for more tips on responsible travel.

TOURS

Academic Trips & Language Classes

Learning Portuguese will greatly enhance your travel experience in Brazil. "Knowing a bit of Spanish" usually won't cut it here, especially outside of the main tourist destinations. The better language programs are found in large cities where there is a constant supply of students. In addition to learning Portuguese, many programs will also include cultural outings (such as music and events) and provide a great opportunity to meet other travelers. **Languages in Action** (www.languagesinaction.com) offers individual and group courses in São Paulo and Salvador. A company with a language school in

io de Janeiro is **Bridge Brazil,** Rua da Quitanda 191, Rio de Janeiro 4-8606 in the U.S. and Canada, or 021/2220-8659 in Rio; www.bridge For educational tours in Bahia, contact **Tatur** (✆ **071/3114-7900;** www.). This Salvador-based travel agency has more than 20 years of experience ng and operating faculty-led study programs focusing on, among other issues, Bahian cultural heritage, performing arts, education, architecture and urban planning, public health, environmental issues, and gender and race studies.

General-Interest Tours

Many travel agencies offer package tours to Brazil, but few have the knowledge to effectively customize your trip or make interesting recommendations. To book a package with Brazil travel experts, contact **Brazil Nuts,** 1854 Trade Center Way, Ste. 101A, Naples, FL 34109 (✆ **800/553-9959** or 914/593-0266; www.brazilnuts. com). The owners and staff are indeed nuts about Brazil and possess a vast amount of knowledge about the country and its attractions. Depending on your needs you can book just a flight and hotels, or you can add one or more group excursions in more inaccessible places such as the Amazon. Their website is a font of information, and staff can answer any questions you may have about Brazil.

Note: Brazilian travel agents still have a firm grip on the hotel market, and Brazilian hotels will usually offer their lowest rates to travel agents instead of posting them on their websites. Once you have narrowed down your hotel options, it can pay to contact an agency like Brazil Nuts to compare rates.

Another excellent resource on Brazil and South America travel in general is **South America Travel** (✆ **800/747-4540;** www.southamerica.travel). South America Travel offers packages customizable to whatever level you're comfortable with. A number of interesting add-ons are available—outdoors lovers will be pleased to see some great hiking and camping options.

Travelers planning a trip beyond Brazil, to Argentina and Chile, may want to consult with **Borello Travel & Tours,** 7 Park Ave., Ste. 21, New York, NY 10016 (✆ **800/405-3072** or 212/686-4911; www.borellotravel.com). This travel agency specializes in the Southern Cone and can help you plan a great itinerary to make the most of the region.

A good travel agency to book your ticket through is **Santini Tours,** 6575 Shattuck Ave., Oakland, CA 94609 (✆ **800/769-9669** or 510/652-8600; www.santours.com). The owner as well as many of the travel agents are Brazilian and can give you many useful suggestions on air pass routings and answer any questions you have about your itinerary. In addition to selling tickets and air passes, Santini can also arrange customized tours, including everything from airport transfers to sightseeing and guided tours.

For more information on escorted general-interest tours, including questions to ask before booking your trip, see www.frommers.com/planning.

Medical Tourism

Brazil is emerging as one of the prime destinations for cosmetic and plastic surgery. Brazilian surgeons are second only to U.S. doctors in the number of procedures performed and therefore have extensive experience. Their training is top-notch (in fact, many foreign surgeons come to Brazil to train) and cities like Rio de Janeiro and São Paulo have outstanding medical facilities. In addition to plastic surgery, travelers can also opt for excellent dental care and other beauty treatments, like laser hair removal, botox, and peelings. Of course it pays to do your research. One company that offers

a lot of information and a free consultation service to get you started is **Cosmetic Vacations,** 120 E. Oakland Park Blvd. 105-1A, Fort Lauderdale, FL 33334 (② **877/627-2556;** www.cosmeticvacations.com).

Volunteer & Working Trips

For a different kind of travel experience, consider donating some of your time as a volunteer to a local organization. One organization that is particularly well set up to accommodate foreign volunteers is **Iko Poran,** Rua do Oriente, 280/201, Rio de Janeiro (② **021/3852-2916;** www.ikoporan.org). They can provide you with detailed information and help you decide if this is something you want to do. Although speaking Portuguese is not a prerequisite, some language knowledge will open up more interesting opportunities. California-based organization **Go Overseas** (② **415/796-6456;** www.gooverseas.com) provides a range of opportunities in Brazil, including volunteer work, internships, teaching positions, and study programs.

Walking Tours

Most visitors limit their walking in Rio de Janeiro to the beachside boulevards and city parks. However, the historic center and the newly pacified hillside favelas offer some outstanding opportunities to see the city from a whole different angle. **Soul Brasileiro ★★** (② **021/2358-9409;** www.soulbrasileiro.com.br) offers a range of walking tours—including favela tours—that give visitors a glimpse of the fascinating architecture and stunning geography of these vibrant communities. History buffs Priscila and Raul Melo of **Rios de História** (② **021/3283-4583** or 021/9177-1072; www.riosdehistoria.com) run daily walking tours through historic downtown Rio and visits to Rio's military fortresses on both sides of the bay.

SUGGESTED BRAZIL ITINERARIES

3

A vast, beautiful, sprawling country, Brazil covers a large portion of South America. Its diverse geography ranges from the dense Amazon rainforest in the north to the savanna-like interior of Bahia to the wetlands of the Pantanal.

Brazil's rich culture encompasses elements from its original native inhabitants, Portuguese explorers, African slaves, and many other immigrants that have followed since. Getting even a taste of such an ocean of experiences requires time and air travel. Most of the itineraries below cover just over 2 weeks. If you have more time, by all means add destinations from other routes, or better yet, slow down and take things easy. It is a vacation, after all.

THE REGIONS IN BRIEF

Brazil's 190 million citizens inhabit the fifth-largest country in the world, a nation about 10% larger than the continental United States. The **Amazon** dominates the northern third of the country—a vast tropical rainforest with the river at its heart. The country's central interior is dominated by the *planalto,* a high dry plateau covered in *cerrado,* a type of dry savanna reminiscent of that of southern Africa. The chief city in this region is the planned federal capital Brasilia. West of the *planalto* but south of the Amazon rainforest you find the **Pantanal,** a wetland the size of France that is one of the best places to see wildlife in the whole of South America. Brazil's **Northeast** is a land apart. Running roughly from São Luis to Salvador, the coast is dominated by midsize cities and sugar cane, the culture strongly Afro-Brazilian, while on the dry interior plateau those Nordestinos who haven't yet fled to the cities eke out a bare living on the land. Brazil's two chief cities, **Rio de Janeiro** and **São Paulo,** stand within a few hundred miles of each other close to the country's south coast. São Paulo is the larger and more important of the two, but Rio, the former capital and *cidade maravilhosa* (marvelous city), is by far the more interesting. The southern tip of the country is inhabited largely by descendants of European immigrants. **Curitiba** is often hailed as an example of a well-organized, modern Brazilian city that works. The area has the astonishing natural wonder of **Iguaçu Falls,** for many visitors a must-see. The island of Santa Catarina in the south, also called **Florianópolis,** has over 40 beaches.

Suggested Brazil Itineraries

BRAZIL IN 1 WEEK
- **1-3** Rio de Janeiro
- **4-5** Salvador
- **6-7** Iguaçu Falls

BRAZIL IN 2 WEEKS
- **1-5** Rio de Janeiro
- **6** Salvador
- **7-11** The Amazon
- **12** Transit
- **13-14** Iguaçu Falls

BRAZIL FOR FAMILIES
- **1-2** Rio de Janeiro
- **3-6** Olinda & Porto de Galinhas
- **7-11** Amazon
- **12-15** Belém & the Island of Marajó
- **16-17** Iguaçu Falls

BRAZIL FOR NATURE LOVERS
- **1-2** Rio de Janeiro
- **3-6** Pantanal
- **7-12** Amazon
- **13-16** Fernando de Noronha
- **17-18** Iguaçu Falls

RIO DE JANEIRO Few cities are as striking as Rio. The city folds itself into the narrow bits of land between tropical beaches and mountains that leap to 750m (2,500-ft.) heights (one of these is crowned by the city's landmark statue of Christ). The city offers much in the way of sightseeing, from nature to sunbathing to museums and historic neighborhoods. The culture, perhaps best expressed in music and nightlife, is just as appealing. Samba is alive and well, augmented by many vibrant newer forms of distinctly Brazilian music. The event of the year is **Carnaval,** the biggest party of the world. And believe me when I say that Cariocas—as Rio residents are known—know how to throw a party.

SÃO PAULO Some 25 million people live in and around São Paulo, the largest city not only in Brazil but in all of South America. São Paulo is a melting pot that attracts the best and brightest to make their fortune. The city overflows with restaurants, including the best fine dining in Brazil. São Paulo has emerged as the cultural capital of Brazil, rich with art galleries and strong in new theater. And it's the best place in Brazil to shop.

THE NORTHEAST Even in a country with such strong regional distinctions, Brazil's Northeast (Nordeste) stands apart. Roughly speaking, the Nordeste encompasses the area from Salvador to São Luis, including cities such as Recife, Natal, and Fortaleza. Everything Nordeste is different: the food richer, the cities more historic, the beaches longer and whiter, the music more vibrant, the politics more Byzantine and traditionally more corrupt. This was the first part of Brazil to be settled, the area where sugar cane and slavery dominated the economy and society for more than 3 centuries. The downturn in the sugar economy left the area a backwater, and only with the recent advent of tourism have Nordeste fortunes really begun to pick up. For visitors, the Northeast offers a year-round tropical climate with long, sandy beaches, historic cities, and a vibrant Afro-Brazilian culture, which is reflected in the cuisine, the festivals, and, especially, the music and dance. Olinda is a quiet colonial gem of a city, while Salvador's 16th-century colonial core has been transformed into a stroller's dream.

THE AMAZON The largest rainforest in the world is so vast it defies easy description: All of western Europe would fit comfortably with room to spare beneath its leafy canopy. Thanks in large part to media coverage of the many threats to this region, interest in eco-tourism and visits to the Amazon have skyrocketed. The main staging ground for trips to the Brazilian Amazon is the city of Manaus, located where the Rio Negro joins the Rio Solimões to form the Amazon. Manaus itself is surprisingly modern. Moderately interesting in itself, its real interest is as the starting point for expeditions into the rainforest. Options include everything from day trips on the Amazon to multiday trips to virgin rainforest where one can catch sight of countless unique plants and animals. In contrast to Manaus, the city of Belém, located at the mouth of the Amazon, is an old and settled city, with numerous churches and a historic downtown, and the incredible Ver-o-Peso market, where the entire produce of the Amazon is bought and sold. Close to Belém in the mouth of the Amazon river is Marajó, an island larger than Switzerland, dotted with buffalo ranches and rich with bird life. Halfway between Manaus and Belém there is Santarem, and the astonishing white-sand beaches of Alter do Chão.

THE CENTER WEST Brazil's center west is a broad flat plain, dotted here and there with craggy highlands, and populated chiefly by ranchers, cowhands, and increasingly by large commercial farms. It was in the midst of this vast and

not especially intriguing region that nearly 50 years ago Brazil erected its striking modernist capital, Brasilia. While the capital may be the region's man-made wonder, the natural wonder is the Pantanal. A wetland the size of France, the Pantanal has traditionally been overlooked in favor of the Amazon, but that's changing as people become increasingly aware of the incredible wildlife-viewing opportunities the area offers. More than 600 bird species, anacondas, jaguars, caimans, giant otters, and anteaters are just some of the animals found in the wetlands. As this area lacks the dense foliage of the Amazon, the animals are much easier to spot.

THE SOUTH The southern part of Brazil, made up of the states of Paraná, Santa Catarina, and Rio Grande do Sul, has a temperate climate and good soil, attributes that long attracted large numbers of European immigrants. It's a settled, well-organized region. The prime beach destination in the south is Florianópolis, a large island with over 40 beaches, clean waters, and excellent restaurants and nightlife. The Iguaçu Falls, a UNESCO World Heritage Site, are located on the border of Brazil, Argentina, and Paraguay. These spectacular falls are made up of 275 falls that cascade from 72m (240 ft.) down a 2.5km-wide (1½-mile) precipice in a fabulous jungle setting.

BRAZIL IN 1 WEEK

You've got a week, and you want to see Brazil? Your first step should be to talk your boss into giving you another week, preferably two. Failing that, the route below gives a quick taste of three of Brazil's highlights: Rio de Janeiro, the historic city of Salvador, and the natural wonder of Iguaçu Falls. It'll be a busy week, though. Those who like a more laid-back pace should skip either Salvador or Iguaçu.

Days 1–3: Rio de Janeiro ★★★

To get into the Brazilian spirit, start off your trip in **Rio de Janeiro** (chapter 4). After getting settled in your hotel, head for the beach. Enjoy the scene, and tan (but don't overdo it). Watch the sunset from **Arpoador.** You'll be tired from the flight, so take it easy with dinner in one of the top restaurants of **Ipanema** or **Leblon.** On day 2 get out and see the mountains. Take a tram up to the **Corcovado,** or take a jeep tour up through **Tijuca Forest.** Stop by **Cinelândia** in Rio's Centro in the afternoon. That night, discover the late-night Carioca lifestyle. Have dinner around 11pm, then catch some samba, played live in **Lapa.** You'll be sleeping late the next day, so spend some more time at the beach, or take a trolley up to explore the hillside neighborhood of **Santa Teresa.** All this should acclimatize you to the Brazilian way before you set off to explore the rest of the country.

Days 4 & 5: Salvador ★★★

Early on day 4, catch a flight for **Salvador** (chapter 8). This is the city where the country's African roots are strongest. Stay in one of the lovely pousadas in **Pelourinho** like the **Casa do Amarelindo** (p. 229), or pamper yourself with a stay in the luxurious **Villa Bahia** (p. 230). Wander through Pelourinho's 17th-century streets. In the evening, try some Bahian cuisine, then go out and enjoy the music in Pelourinho after dark. Next day, take the boat tour of the **Bay of All Saints,** or head out to the church of **Bonfim,** or tour the lovely **Museu de Arte Sacra.** Or if you're the Energizer Bunny, do all three.

Days 6 & 7: Iguaçu Falls ★★★

A final must-see—one of the most awe-inspiring natural wonders of the world—**Iguaçu Falls** (chapter 15). The early flight from Salvador should get you to Iguaçu before 2pm. Store your stuff and go see the falls. Today stick to the Brazilian side. Don't forget to take the **Macuco boat safari** (p. 425). Unforgettable.

Your next step the next day depends on flights. Theoretically, you could get up early (again) and make the trip to the Argentine side and make it back in time for an afternoon flight. Or you could do the sensible thing and stay another night in Iguaçu. Get up a little later, and go explore the Argentine side at a leisurely pace. That night, have dinner somewhere in downtown Foz do Iguaçu.

Next morning, you can catch an early flight to São Paulo and spend the day exploring, or you can dawdle by the hotel pool in Iguaçu (or go see the **Bird Park,** p. 427), before catching a later flight to São Paulo and then home.

BRAZIL IN 2 WEEKS

In 2 weeks, you can get a good taste of Brazil at a pace that won't wear you out. The route below takes you to Rio de Janeiro and the historic city of Salvador. Then head inland to explore the magnificent Amazon rainforest—just keep in mind that visiting the Amazon is fascinating, but it requires both money and travel time. This route includes Iguaçu Falls and a brief taste of the urban sophistication that is São Paulo.

Days 1–5: Same as Above
Day 6: Salvador ★★★

With your extra day in Salvador, dig deeper into this city's treasures at a leisurely pace; head out to the church of **Bonfim,** or tour the lovely **Museu de Arte Sacra.** See the lighthouse and beaches of **Barra.**

Days 7–11: The Amazon ★★★

Catch an early flight to **Manaus** (p. 363). It's time to experience a bit of the largest standing rainforest on earth, the Amazon. On your first day you should have time to see the highlights of Manaus, including the famous **Opera House.** The next morning, set off early for a jungle lodge (or better yet, if you have more time, go kayaking through the forest with **Amazon Mystery Tours,** p. 386). Choose a smaller lodge farther from the city. Although the area around Manaus is hardly unexplored, a few days will allow you to experience the fauna and flora of a tropical rainforest. Enjoy the trees, the monkeys, the caimans, and the bright pink dolphins.

Day 12: Transit

It's going to take a day of taxis, boats, and airplanes to get you to your next destination, Iguaçu. Most flights from Manaus will connect through Brasilia, Rio de Janeiro, or São Paulo.

Days 13 & 14: Iguaçu Falls ★★★

A final must-see—one of the most awe-inspiring natural wonders of the world—is **Iguaçu Falls** (chapter 15). Stick to the Brazilian side today and perhaps take the **Macuco boat safari** (p. 425). The next day, go explore the falls from the

Argentine side. You can catch an early flight to São Paulo and spend the next day exploring, or you can dawdle by the hotel pool in Iguaçu (or go see the **Bird Park,** p. 427), before catching a later flight to São Paulo and connecting to your flight home.

BRAZIL FOR FAMILIES

Brazilians love children nearly as much as they love beaches, beer, and music. Maybe more. This route combines Brazil's top destinations in ways that will allow both you and your kids to have fun.

Days 1 & 2: Rio de Janeiro ★★★

To get into the Brazilian spirit, start off your trip in **Rio de Janeiro** (p. 42). See the must-sees such as the **Corcovado, Sugarloaf,** and **Copacabana beach,** while discovering the typically Brazilian *joie de vivre* and the late-night Carioca lifestyle—spend an afternoon at the beach, watch the sunset at **Arpoador,** drink beers in an old-fashioned bar in the hillside neighborhood of **Santa Teresa,** dance to samba in **Lapa,** start dinner after midnight (assuming you aren't traveling with small children). More than seeing the sights, it will acclimatize you to the Brazilian way before you set off to explore the rest of the country.

Days 3–6: Olinda & Porto de Galinhas ★★★

From Rio, it's only a short flight to **Recife** and **Olinda** (chapter 9). As historic as Salvador, Olinda is more lived in, full of artists, among them the famous puppet makers who show works in the **Puppet Museum** (p. 295). Spend a day here, then head south to the beachside village of Porto de Galinhas. Snorkel the shallow reef pools full of fish. Look for sea horses in the tidal mangroves.

Days 7–11: The Amazon ★★★

Catch an early flight to Manaus. It's time to experience a bit of the largest standing rainforest on earth, the **Amazon** (chapter 13). On your first day you should have time to see the highlights of Manaus, including the famous Manaus Opera House. Set off early the next morning for a jungle lodge. Choose a smaller lodge farther from the city. Don't go to the Ariaú. Although the area around Manaus is hardly unexplored, a few days will allow you to experience the fauna and flora of a tropical rainforest. Enjoy the trees, the monkeys, the caimans, and the bright pink dolphins.

Days 12–15: Belém & the Island of Marajó ★★

From Manaus, fly to **Belém** (p. 387), and hop on a ferry for the big river island of **Marajó** (p. 400). Spend a few days on a buffalo ranch—we recommend the Fazenda Sanjo—with a Marajó family, riding horses, herding buffalo, and seeing caimans and flocks of bright red roseate spoonbills (p. 401).

Days 16 & 17: Iguaçu Falls ★★★

A final must-see on a first-time visit—one of the most awe-inspiring natural wonders of the world—is **Iguaçu Falls** (chapter 15). You can easily spend 2 days exploring the falls from various angles and in various ways: on foot, by boat, by train, and by helicopter.

BRAZIL FOR NATURE LOVERS

Brazil has a lot of natural beauty to offer: the wide floodplains of the Pantanal are a bird lover's paradise, while the Amazon impresses visitors with its lush, dense rainforest and amazing biodiversity. To see marine mammals, the island archipelago of Fernando de Noronha is the place to be. Complete your nature tour in Iguaçu. Although best known for its awe-inspiring waterfalls, the natural park also boasts exotic birds, butterflies, and mammals, including the elusive jaguar.

Days 1 & 2: Rio de Janeiro ★★★

Yes, it's a city of 12 million. But it's one of those rare cities with an intimate relationship with nature. Instead of the busy beach neighborhoods, stay in one of **Rio de Janeiro's** small B&Bs in hilltop **Santa Teresa.** Take a guided hike through the **Tijuca** rainforest with **Rio Hiking** (p. 106). Take a walk below the Sugarloaf by **Praia Vermelha,** and admire the bird life and rainforest and with luck, the troupe of marmosets that make their home on the hillside. Go up to the **Corcovado,** look down at Rio, and see how ocean, beach, city, and forest merge into one.

Days 3–6: The Pantanal ★★★

Catch a flight to **Cuiabá** and head down the **Transpantaneira** into the **Pantanal** (chapter 16). This flooded landscape is a bird-watcher's dream, so bring your binoculars and several pencils to keep track of all the new species you'll be seeing.

Days 7–12: The Amazon ★★★

From the Pantanal, fly north to the **Amazon** (chapter 13). The species diversity is greater here, but the very richness of the foliage makes the animals and birds much harder to see. So enjoy the trees. And the monkeys, and dolphins, and parrots. Go out on a kayak trip on the upper Amazon with **Amazon Mystery Tours** (p. 386). Or head for one of the lodges far from **Manaus,** preferably the **Mamiraua Reserve** (p. 387).

Days 13–16: Fernando de Noronha ★★

From Manaus, catch a flight all the way out to **Fernando de Noronha** (chapter 9). A vastly different ecosystem, this semidesert tropical island is home to large schools of spinner dolphins, not to mention the sea turtles that lay their eggs on the island's long beaches. If you scuba dive, bring your gear. If you don't, there's still plenty to see above the surface of the water.

Days 17 & 18: Iguaçu Falls ★★★

Take the long flight all the way south to **Iguaçu Falls** (chapter 15), one of the natural wonders of the world. Astonishing enough in themselves, the falls create a misty microclimate perfect for toucans, dusky swifts (which actually nest on the cliff behinds the waterfalls), and bright, colorful butterflies. In the rainy season, thousands of the colorful insects float and flutter at the edge of the roaring falls.

BRAZIL FOR THE ACTIVE TRAVELER

This is the itinerary for those who want to be out doing—hiking, climbing, swimming, diving. Brazil is rich in outdoor sports, be they on mountain peaks, on the beach, in the ocean, or underneath it. This route starts in Rio, then has three different options for hiking—in the mountains near the city, on an island covered in Atlantic rainforest,

or north in the dry highlands of Bahia. The route then includes time in Fernando de Noronha and the Lençóis Maranhenses, two magical landscapes found nowhere outside Brazil.

Days 1 & 2: Rio de Janeiro ★★★

Arrive in **Rio de Janeiro** (chapter 4). Spend a half-day rock climbing up the **Sugarloaf,** or hike the **Floresta de Tijuca,** a vast rainforest that wraps itself around the city. Or rent a board and catch the surf bus out to **Barra** for the city's best waves.

Days 3–6: Teresopolis to Petrópolis ★

The 2- to 3-day hike between the royal cities of **Teresopolis** and **Petrópolis** takes in the high mountain terrain (approx. 1,500m/4,900 ft.) in Serra dos Orgãos mountains close to Rio de Janeiro. Hiking specialists **Rio Hiking** (p. 106) can arrange transfer to and from the city, and make your trek more comfortable.

OR Days 3–6: Chapada Diamantina ★★

Fly to **Salvador** and get a bus or plane up to the **Chapada Diamantina** (p. 262). This magic highland area is full of bluffs, buttes, and waterfalls, and is laced with stunning crystal caverns. Do day hikes from the city of **Lençóis,** or contract a guide to take you on a multiday trek past the Falls of Smoke (Cachoeira de Fumaça).

OR Days 3–6: Ilha Grande ★★

Take the bus and ferry to **Ilha Grande** (p. 145). This former prison colony has beaches for **surfing, swimming,** and **body boarding,** forest-covered mountains for **hiking,** wrecks for **diving,** little sheltered inlets for **snorkeling,** and wide-open seas for **kayaking.** Take 3 days and do it all.

Day 7: Transit Day

Whether you start from Rio, Ilha Grande, or the Chapada Diamantina, it's going to take you most of a day to get to the island of Fernando de Noronha.

Days 8–11: Fernando de Noronha ★★

Grab your scuba gear and go diving. This isolated archipelago (chapter 9) has the best underwater sea life in Brazil. **Atlantis Divers** (p. 311) is the company to go with. Don't forget to rent a buggy and explore the island. While you're there, try to see the baby sea turtles hatch.

Days 12–15: Lençóis Maranhenses ★★

From Fernando, fly to **São Luis** and catch a plane or bus for **Barreirinhas,** gateway to the **Lençóis Maranhenses** (chapter 12). An ecosystem unlike anything else on earth, the Lençóis is a vast desert of shifting white-sand dunes, chock-full of rainwater. In the wet season, the rainwater collects to form countless crystal pools and lakes in the depressions between the dunes. Best of all, the sand is so fine-grained that it's cool on your feet, even in the height of summer.

BRAZIL FOR ARCHITECTURE & HISTORY BUFFS

This is for those who like to stroll and observe and learn, understanding a country's culture by researching its history, and by close observation of that most enduring of

the visual arts, architecture. The route takes in both of Brazil's former capitals (Rio de Janeiro and Salvador), the rich baroque cities of Minas Gerais, and the modern new city of Brasilia.

Days 1–3: Rio de Janeiro ★★★

Start in **Rio de Janeiro** (chapter 4). Brazil's former capital is rich in history. Tour the **Museu Histórico Nacional** and the **Quinta da Boa Vista** where the Emperor Pedro II lived in baroque splendor, collecting scientific specimens all the while. Wander the **Paço Imperial** where the emperor once ruled, and the nearby **Praça XV** where rebellious army officers brought his reign to an end. Don't forget to have a look at the **Palácio Gustavo Capenema** in Rio's downtown. Designed by Le Corbusier and Oscar Niemeyer, this building is where the Brazilian love affair with modernism began, where the seeds of what became Brasilia were laid.

Days 4–7: Historic Cities of Minas Gerais ★★★

Rent a car (or hop on a bus) and take a road trip through the historic cities of **Minas Gerais, Ouro Preto, Mariana,** and **Tiradentes** (chapter 6). These cities were awash in gold when the colonial baroque was at its height. Admire the churches and fine buildings, and the phenomenal sculpture works of crippled sculptor **Aleijadinho.**

Days 8–10: Salvador ★★★

Back in Rio, catch a flight to **Salvador** (chapter 8). Stay in one of the lovely pousadas in **Pelourinho** like the **Boqueirão.** Wander through the 17th-century streets of Pelourinho, and marvel at the wealth brought by sugar. Tour the **Museu de Arte Sacra** to see the fine artwork wrought from Brazilian silver.

Days 11–13: Recife & Olinda ★★

From Salvador fly north to **Recife** (chapter 9), a city founded not by the Portuguese but by the Dutch, who conquered northern Brazil for a time. For more on this period, tour the city's fine **history museum,** housed in the **Fort of Five Points.** To compare Dutch and Portuguese styles of city-building, travel but a few miles north to **Olinda** (p. 281), the former capital of the region, and a city built by the Portuguese. Olinda rivals Salvador for the quality of its churches and historic buildings.

Days 14 & 15: Brasilia ★★

Leave the 17th century behind, and make a bold leap into the modern world. Fly to **Brasilia** (chapter 14). Admire the fluid and futuristic architecture of **Oscar Niemeyer.** Judge for yourself whether the world's first fully planned national capital has succeeded or failed in making Brazil the country of the future.

Day 16: São Paulo ★

From Brasilia, fly to **São Paulo** (chapter 7). See Niemeyer's later (and to my mind, inferior) works such as the **Monument to Latin America.** Then see what Brazilian architects are doing now. Walk the Avenida Paulista. If you can afford it, stay at the Hotel Unique. If you can't, have a drink on its rooftop bar. Admire the run of skyscrapers on the Avenida Paulista in the distance.

BRAZIL BEACHES, BEACHES & BEACHES

This is the trip for those who think white grains of silicon assembled together by the seaside is the sole and perfect definition of paradise. Brazil is especially blessed with beaches: urban beaches, party beaches, surfing beaches, and wild, desolate, and lonely beaches. This tour takes a short splash on all of them.

Days 1–3: Rio de Janeiro ★★★

Start in **Rio de Janeiro** (chapter 4), and spend a couple or a few days experiencing the beach culture of the *cidade maravilhosa*. Dozens of kilometers of beach are within the city limits. Key beaches to explore include **Copacabana, Ipanema, Leblon, Barra,** and the **Grumari.**

Days 4 & 5: Salvador ★★★

From Rio, take the plane to **Salvador** (chapter 8). Enjoy the colonial architecture and the music scene for a day, but don't forget to test out the music and dining on Salvador's best urban beach, **Porto da Barra.**

Days 6–10: Morro de São Paulo & Boipeba

From the Bahian capital take the catamaran south 2 hours and party for a day or two in **Morro de São Paulo** (p. 266). In this little beach resort, even the streets are made of sand. Then take a short boat trip one island south to relax for a day or two on **Boipeba** (p. 270), one of the most relaxed and isolated beaches on the Bahian coastline.

Days 11–16: Natal to Fortaleza by Dune Buggy

From Boipeba, take the boat back to Morro and catch a plane back to Salvador airport in time to make a connecting flight to **Natal** (chapter 10), a city surrounded by sand. Rent a dune buggy and explore the sand, sea, and massive sand dunes that stretch from the city's edge hundreds of kilometers north. Better yet, make a 4-day journey by beach buggy with **Buggy & Cia** to **Fortaleza** (p. 325).

OR Days 11–16: São Luis & Lençóis Maranhenses

Fly to **São Luis** (p. 346). It's worth spending a day wandering this historic city, before catching a plane or bus for the town of **Barreirinhas** (p. 357), gateway to the **Lençóis Maranhenses** (p. 357). The Lençóis are not so much beaches as a vast Sahara-like desert of perfect white-sand dunes, laced with countless rainwater lakes. You can hike the dunes, swim in the lagoons, and visit the wild, untouched coast nearby.

Days 17–20: Florianópolis

Returning to São Luis, catch a long flight down to **Santa Catarina,** and spend some days on the southern, surf-crazy island of **Florianópolis** (chapter 15). Rent a car and drive to the southern tip of the island and feast on fresh oysters.

RIO DE JANEIRO

S ay "Rio" and mental images explode: the sparkling costumes of Carnaval; the mountaintop statue of Christ the Redeemer, arms outspread; white-sand beaches crowded with fit women in minuscule bikinis; the granite grandeur of the Sugarloaf; and sultry samba rhythms. Fortunately, there's much beyond the festive glitter and grimy favelas (shanty towns): historic neighborhoods, compelling architecture, exhilarating nature, and, above all, the passionate, welcoming Cariocas who make this a truly *cidade maravilhosa* (marvelous city).

4

Things to Do Rio's scenery of lush green mountains plunging down to the Atlantic is pure drama. Survey Rio's immensity from the monolithic **Sugarloaf Mountain** and the mighty **Christ the Redeemer** statue crowning Mount Corcovado. Try a different beach every day—from white-sand **Arpoador,** famous for surf and sunsets, to people-watching **Ipanema** and **Copacabana.** A futuristic swirl on the landscape, **Niterói Contemporary Art Museum** showcases contemporary Brazilian art. Sneak away to Cascatinha Waterfall in the forested **Tijuca National Park.** Rio's sights are spread out, so plan carefully.

Shopping Cariocas are image-mad. Work your look shopping for dazzling Carnaval costumes in **Saara,** and hot Brazilian styles and itsy-bitsy bikinis in **Ipanema.** For more glitz, accessorize with quartz and topaz from **Copacabana**'s exclusive jewelry shops. The **Fashion Mall** in São Conrado is a one-stop-shop for Brazilian high-end stores and designers. On the weekends, locals descend on **Feira de São Cristóvão** market to dance to Northeastern rhythms and shop for leatherwork, pottery, and specialties like chili peppers and *cachaça* (sugar cane liqueur).

Nightlife & Entertainment There's always a reason to celebrate in Rio. In festive **Lapa** and the **Centro,** you'll find street parties, open-air bars, and clubs wiggling to samba and *choro.* For Northeastern rhythms like *forró,* there's **Casa Rosa** in Laranjeiras. Swing your hips at the free summertime concerts on **Copacabana** beach and at the rehearsal of a **samba school** (such as Vila Isabel or Mangueira) before Carnaval. The opulent Parisian-style **Theatro Municipal** stages first-rate opera and ballet.

Restaurants & Dining Rio's cuisine has as many origins as its people. Dine on world cuisines from Italy to Japan in **Zona Sul.** Bohemian **Santa Catarina** tempts with German food and Brazilian favorites like *feijoada* (meat and bean stew) and *moqueca* (seafood stew). Business people on the run enjoy sandwiches and exotic juices at *casas de suco* in **Centro** and snack on sardines in **Beco das Sardinhas.** Nibble on fingerfood and crepes in bar-lined **Lapa.**

ESSENTIALS

359km (223 miles) NE of São Paolo

Getting There

BY PLANE

GALEÃO AIRPORT Most major airlines fly to Rio de Janeiro, sometimes with a stop or connection in São Paulo. International passengers arrive at **Antônio Carlos Jobim Airport** (✆ 021/3398-5050), more commonly known as **Galeão Airport,** 20km (12 miles) from downtown.

On the third floor of Terminal 1 is a Banco do Brasil office (daily 8am–10pm), as well as ATMs of HSBC and Banco 24 Horas, both of which use the Visa/PLUS system. The American Express office (daily 6:30am–10pm) is in the second floor departure area of Terminal 1.

Taxis at Galeão are a challenge. Drivers will start to hassle you the minute you step through the sliding doors. The safer but more expensive bet is to buy a prepaid fare at the **TransCoopass** desk in the arrivals hall (✆ 021/2209-1555; www.transcoopass.com.br; all major credit cards accepted). Rates are about R$86 to Flamengo, and R$99 to the beach hotels of Copacabana, Ipanema, and Leblon. These prepaid taxis are about 40% more expensive, but give you peace of mind; it doesn't matter if you get stuck in traffic or if the driver takes the long route, and you don't have to get cash right away as you can pay with a credit card. On the other hand, if you speak some Portuguese, you can cut those prices significantly just by hailing a regular taxi out in front of the terminal. A ride to Flamengo should cost about R$40 in average traffic conditions, and to Ipanema around R$55. Note that if you don't know what you're doing, your friendly Rio taxi man may well take you on a detour long enough to double that price, or even claim the meter reads in dollars.

Gray Line (✆ 021/2512-9919; www.grayline.com) offers a minibus transfer service from Galeão to the hotels of the Zona Sul or Barra. The cost is R$40 and must be reserved ahead of time through the website. For two or three people it works out the same or more expensive than a taxi. The slowest, but most affordable, option is bus service operated by **Real** (✆ 021/3035-6700). This company offers a comfortable air-conditioned bus service from the airport to the domestic Santos Dumont Airport and all along the beach neighborhoods. It will stop anywhere along the route upon request. It departs every hour between 5:30am and 10:30pm, and costs R$9 per person.

SANTOS DUMONT AIRPORT Rio's second airport, **Santos Dumont,** Praça Senador Salgado Filho (✆ 021/3814-7070), is downtown, surrounded by the Baia de Guanabara. Most Brazilian airlines now use Santos Dumont for domestic flights. These airlines include **TAM** (✆ 021/4002-5700; www.tam.com.br), **Gol** (✆ 0300/115-2121; www.voegol.com.br), **Azul** (✆ 021/3003-2985; www.voeazul.com.br), **Webjet** (✆ 0300/210-1234; www.webjet.com.br), **TRIP** (✆ 021/3003-8747; www.voetrip.com.br), and **Ocean Air** (✆ 0300/789-8160; www.oceanair.com.br).

Taxis from Santos Dumont are less of a problem. Prepaid taxis are available from the **TransCoopass** (✆ 021/2209-1555; www.transcoopass.com.br) booth in the arrivals hall. The prepaid service costs about double what a metered taxi will cost. Better just to hail a cab from the taxi row in front of the terminal. Airport cabs are about 20% more expensive than a normal taxi (not officially, but almost universally so in practice), but distances from Santos Dumont are short enough that this won't make a huge difference. A metered taxi to Ipanema should cost around R$30. A more

Essentials

Rio de Janeiro

affordable alternative to the beach hotels or the international airport is the **Real** bus service (see above).

A variety of bank machines, including a Banco do Brasil and HSBC, are located at the center entrance of the airport.

BY BUS

All long-distance buses arrive at the **Novo Rio Rodoviaria,** Av. Francisco Bicalho 1, Santo Cristo (✆ **021/3213-1800;** www.novorio.com.br), close to downtown near the old port. It's best to use a taxi traveling to or from the station. It's not the best part of town, particularly with all your bags. Prepaid taxi vouchers are available at the booth next to the taxi stand. A ride from the bus station to Ipanema costs about R$40.

BY CRUISE SHIP

Cruise ships dock in the terminal almost opposite Praça Mauá. Downtown is an easy walk, and public transit is close by. During business hours this part of downtown is quite safe. Any other time of day or night, it's best to take a taxi.

Rio's Neighborhoods in Brief

Mountains and ocean are ever present in Rio. The city has essentially squeezed itself into any available space on the tiny littoral between the two. The city is traditionally divided into four zones: **North (Zona Norte), Center (Centro), West (Zona Oeste),** and **South (Zona Sul).** A much more detailed description of Rio's neighborhoods can be found in "Neighborhoods to Explore" on p. 97.

ZONA NORTE

Largest and least interesting from a visitor's perspective, the Zona Norte stretches from a few blocks north of Avenida Presidente Vargas all the way to the city limits. With only a few bright exceptions—the Maracanã stadium, the Quinta da Boa Vista gardens, the Floresta da Tijuca park, and Galeão Airport—the region is a dull swath of port, residential high-rise, industrial suburb, and favela. It's not the sort of place one should wander unaccompanied.

ZONA OESTE

The Zona Oeste houses some of the poorest and richest neighborhoods of the city. Inland on one side of a wide lagoon there's Cidade de Deus—featured in the movie *City of God*—a huge low-income housing project built in the 1960s to relocate people from downtown slums out to what was then the far edge of the city. On the waterfront are the seaside condominium enclaves **Barra da Tijuca** and **Recreio.** Beyond Recreio is **Grumari,** a pristine beach on the city's outskirts.

CENTRO

Rio's **Centro** neighborhood, the oldest part of the city, is where you'll find most of the city's notable churches, squares, monuments, and museums, as well as the modern office towers where Rio's white-collar elite earn their daily bread. Roughly speaking, Centro stretches from the **São Bento Monastery** in the north to the seaside **Monument to the Dead of World War II** in the south, and from **Praça XV** on the waterfront east to the **Sambodromo** (near Praça XI). Bustling with life during the week, on weekends and particularly Sundays, this area becomes very deserted, and a little too spooky to warrant a visit.

ZONA SUL—THE BAY

Just to the south of Centro lies the fun and slightly bohemian hilltop neighborhood of **Santa Teresa,** and then one after the other the neighborhoods of **Glória, Catete,** and **Flamengo.** These last three were the fashionable sections of the city around the start of the 20th century, located as they were on flat ground by the edge of Guanabara Bay. Other neighborhoods in this section include **Botafogo** and **Urca** (nestled beneath the Sugarloaf), and in the narrow valley behind Flamengo the two residential neighborhoods of **Laranjeiras** and **Cosme Velho.** Today they're all still pleasant and walkable. Botafogo was more commercial, but has

been undergoing a residential boom over the past few years; Catete and Flamengo contain a number of historic buildings, but their bloom faded in the 1920s when engineers cut a tunnel through the mountainside to Copacabana.

ZONA SUL—THE BEACHES

The big attraction here is the ocean. Where Centro and Flamengo sit on Guanabara Bay, **Leme, Copacabana, Ipanema, Leblon,** and **São Conrado** face the open Atlantic. The waves are bigger, the water cleaner, and the beaches more inviting. First to be developed, **Copacabana** officially covers only the lower two-thirds of the beach. The northern third (the bit closest to Urca, farthest from Ipanema) is known as **Leme.** Taking a 90-degree turn around a low headland, one comes to **Ipanema.** Like Copacabana, Ipanema is a modern neighborhood, consisting almost exclusively of high-rise apartments from the 1960s and 1970s. Here, too, the same stretch of beach is considered to be two neighborhoods: Ipanema sits next to Copacabana, while the area at the far end of the beach is known as **Leblon.** Again, the two ends of the beach are nearly indistinguishable, though Leblon has a few more restaurants. Behind Ipanema there's a lagoon, the **Lagoa Rodrigo de Freitas,** which is circled by a pleasant 8.5km (5¼-mile) walking/cycling trail. At its north end, farthest from the beach, stand the two quiet residential neighborhoods of **Lagoa** and **Jardim Botânico,** the latter named for the extensive botanical gardens around which the area grew.

At the far end of Leblon stands a tall sheer double-pointed rock called the **Pedra Dois Irmãos (Two Brothers Rock).** The road carries on, winding around the cliff face to reach the tiny enclave of **São Conrado.** One of the better surfing beaches, this is also where the hang gliders like to land after swooping down from the 830m (2,700-ft.) **Pedra de Gâvea.**

At night, the wide beaches are dark and mostly deserted; if you're in the mood for a moonlit stroll, stick to the brightly lit and police-patrolled pedestrian walkway that parallels the beach.

Getting Around

BY PUBLIC TRANSPORTATION

Rio may seem like a large and sprawling city, but the neighborhoods in which visitors spend most of their time are very easy to get around in. From Centro south to São Conrado, the neighborhoods hang like beads on a string on the narrow strip of land between the ocean and the mountains. You can almost always see one or the other; with landmarks like these it's pretty hard to stray too far from where you want to go. *Note:* Tram service in Santa Teresa has been temporarily halted to carry out some much needed maintenance and restore the historic line. Service should resume in the first half of 2014.

BY METRÔ The easiest way to get around is by subway; in Centro and the Zona Sul it covers almost every major area of interest, particularly now that there are integrated bus/subway lines for the parts of the city where the Metrô has not yet reached. There are only two lines: **Line 1** goes north from downtown—it's useful for going to the Maracanã and the Quinta da Boa Vista—while **Line 2** begins at the Central Station and goes south, covering most of Centro, then swinging through Glória, Catete, Flamengo, and Botafogo before ducking through the mountain to its final destination in Ipanema. The trip takes about 20 minutes to move you from Centro to Copacabana (as compared to a 40- to 60-min. bus ride in rush hour). The system is very safe and efficient. You purchase a magnetic ticket card at the entrance of the station, either from a machine or from a ticket booth. You can buy a single ride card (R$3.10), or opt for a rechargeable magnetic card, to which you then add value, which gets deducted when you swipe the card passing through the turnstile. There is no charge for the magnetic card, but the minimum recharge value is R$10.

Know the Subway Hours

The Metrô operates Monday through Saturday from 5am to midnight. On Sundays and statutory holidays the Metrô runs from 7am to 11pm. Special schedules apply during New Year's and Carnaval when trains will run all night, but some stations may be closed.

The subway system recently expanded its integrated **Metrô/bus service,** and now has new air-conditioned buses feeding into the Metrô system from all parts of the city. The more popular routes include: Metrô/Gavea or Barra (to Leblon and Gavea or Barra; transfer at General Osório) or Metrô/Gavea (via Jardim Botanico, transfer at Botafogo). Other useful timesaving bus/subway routes include Metrô/Rodoviaria (to the main bus terminal; transfer at Largo do Machado); Metrô/Urca (to the Sugarloaf; transfer at Botafogo); and Metrô-Cosme Velho (to the Corcovado; transfer at Largo do Machado). The price is R$4, cheaper than paying separately for the Metrô and bus. After you use the electronic ticket to enter the subway turnstile, the ticket is returned so that you can present it on the bus at the transfer station.

BY BUS Rio's buses follow direct, logical pathways, sticking to the main streets along much the same route you'd take if you were driving. What's more, they're fast. Indeed, it's a good idea to wedge yourself in your seat; Rio drivers like to lean into the turns.

More than 30 different buses run from Centro to Copacabana alone. Figuring out which to take is straightforward. The route number and final destination are displayed in big letters on the front of the bus. Smaller signs displayed inside the front window (usually below and to the left of the driver) and posted on the side of the bus list the intermediate stops. *Tip:* If you're going from Ipanema or Copacabana all the way to Centro (or vice versa), look for a bus that says VIA ATERRO in its smaller window sign. These buses get on the waterfront boulevard in Botafogo and don't stop until they reach downtown.

Buses only stop if someone wants to board. If you see your bus coming, wave your hand at the driver. Most buses are boarded from the front and exited from the rear. Have your bus money ready—R$2.50 to R$3.50—as you will go through a turnstile right away. You pay for each ride; there are no transfers (except on special Metrô routes, see above). Buses are safe during the day; just watch for pickpockets when it gets busy. In the evening, when fewer passengers ride, it is better to take a taxi.

BY TAXI

Taxis are plentiful and relatively inexpensive. They're the perfect way to reach those out-of-the-way places and the best way to get around in the evening. Regular taxis can be hailed anywhere on the street. You will also find taxi stands throughout the city. A ride from Copacabana to Praça XV in Centro costs about R$25 to R$30; a ride from the main bus station to Leblon is about R$35 to R$40 in traffic. Radio taxis are about 20% more expensive, often work with a set fee per destination, and can be contacted by phone; try **Coopertramo** (© 021/2209-9292) or **TransCoopass** (© 021/2209-1555). Most hotels work with radio taxis, so if you don't want to pay extra, just ask them to hail you a regular taxi. Radio taxis are said to be more reliable, but—aside from at the airport—we've never had a problem with any regular taxi.

BY VAN

When you see the chaotic bus-ridden streets of Rio de Janeiro, it's hard to believe that there could be a shortage of buses. However, in the last few years the city has seen an explosion of additional bus services provided by Volkswagen vans and microbuses.

Some of these vans are licensed, many more remain officially illegal. Fares range from R$2 to R$4.50 and quality ranges from downright scary to clean, modern vehicles. Those that circulate along the Zona Sul waterfront and farther out to Barra da Tijuca are generally quick and efficient. Vans can be hailed anywhere and will let you off anywhere on their route.

BY FERRY

Rio has a number of ferries operated by **Barcas SA** (*©* **0800/704-4113;** www.barcas-sa.com.br), departing from Praça XV downtown. The busiest routes link downtown Rio with downtown Niterói or Charitas (also in Niterói) across the bay—also reached by car and bus by crossing the 14km (8½-mile) bridge. The service to Niterói runs daily from 6am to 11:30pm; to Charitas the service is Monday to Friday 6:50am to 9pm. Departures on both routes run at approximately half-hour intervals. On the Niterói route, the cheapest ferry (R$2.80) is the regular one, taking about 25 minutes to cross. The catamaran and *aerobarco,* a hydrofoil, cross the same route in less than 10 minutes and cost R$5. The Charitas ferry costs R$12. A popular ferry for tourists as well as Cariocas on the weekend is the route to Paquetá, a large car-free island in the Baia da Guanabara. The ferries to Paquetá depart Rio at 5:15, 7:10, 10:30am, 1:30, 3:30, 4, 7, 9, and 11pm; the fare is R$4.50.

BY CAR

A car is not required for exploring Rio; a combination of public transit (in the daytime and evening) and taxis (late at night) gets you pretty much anywhere in the city for very little money. But for information about renting a car, see the entry for "Car Rentals" under "Fast Facts: Rio de Janeiro," below.

The truth is, driving in Rio is not for the weak of heart. Traffic is hectic, street patterns confusing, drivers just a few shades shy of courteous, and parking next to nonexistent. Better to get used to the city traffic as a pedestrian first and rent a car only if you're going out to destinations such as Petrópolis and the historic towns of the Minas Gerais region.

SPECIAL DRIVING RULES The rule is, *there are no rules.* Okay, maybe we're exaggerating. Traffic has improved immensely in recent years since police began using photo-radars. People now wear seat belts and stop at red lights during the day. In the few years since strict drinking and driving campaigns have been introduced, the numbers of accidents has been reduced. However, Cariocas still drive aggressively. Lane dividers are either absent or ignored. Any space larger than 10 centimeters (4 in.) between your car and the one in front will be instantly occupied by another driver. Later at night red lights become optional. Be careful when approaching intersections.

Visitor Information

Riotur (*©* **021/2271-7000;** www.riodejaneiro-turismo.com.br) provides excellent information on the city of Rio de Janeiro and operates a number of offices and kiosks around town. At **Rio's international airport,** booths in the international arrivals halls of both Terminal 1 (*©* **021/3398-4077**) and Terminal 2 (*©* **021/3398-2245**) and in the domestic arrivals hall (*©* **021/3398-3034**) are all open daily 6am to 11pm. At Rio's main bus station, **Rodoviaria Novo Rio,** there's a counter in the arrivals area, open daily 8am to 8pm (*©* **021/2263-4857**). The main **Riotur Information Center** (*©* **021/2541-7522**) is on Av. Princesa Isabel 183, Copacabana. Open Monday to Friday 9am to 6pm, this office has the largest selection of brochures and information. There is also a convenient **Riotur** kiosk on Copacabana beach,

open daily from 8am to 8pm, in front of Rua Hilário de Gouveia. Riotur also operates an information line, **Alô Rio** (📞 021/2542-8080 or 0800/285-0555), with English-speaking staff, Monday to Friday from 9am to 6pm.

A must-have is Riotur's *Guia do Rio–Rio Guide* booklet (www.rioofficialguide.com), published every 2 months. Written in both English and Portuguese, it lists all tourist attractions, events, and festivals, and has many other useful phone numbers.

The Rio de Janeiro state tourism agency, **TurisRio** (📞 021/2215-0011; www.turisrio.rj.gov.br), offers information on destinations in both the city and state of Rio de Janeiro. Their office, on the ground floor of Rua Mexico 125, Centro, is open Monday to Friday from 9am to 6pm. They also run an information line, **Disque Turismo** (📞 0800/282-2007), with English-speaking staff, available Monday to Friday 8am to 8pm.

[FastFACTS] RIO DE JANEIRO

Area Code The area code for Rio de Janeiro is **021.**

Banks Banco do Brasil has branches at Rua Joana Angelica, Ipanema (📞 **021/3544-9700**), Av. N.S. de Copacabana 594, Copacabana (📞 **021/3816-5800**), and at the international airport, Terminal 1, third floor (📞 **021/3398-3652**); all have 24-hour ATMs. For currency exchange, try **Casa Aliança Cambio,** Rua Miguel Couto 35, Centro (📞 **021/2224-4617**), **Citibank,** Rua da Assembleia 100, Centro (📞 **021/4009-8229**), and **Casa Universal Cambio,** Av. N.S. Copacabana 371, loja E, Copacabana (📞 **021/2548-6696**).

Car Rentals Antônio Carlos Jobim International Airport has **Hertz** (📞 021/3398-2379), **Localiza** (📞 021/3398-5445), and **Unidas** (📞 021/3398-2286). Santos Dumont Airport has **Hertz** (📞 021/2262-0612), **Localiza** (📞 021/2220-5455), and

Unidas (📞 021/2240-6715). Copacabana has **Hertz,** Av. Princesa Isabel 500 (📞 021/2275-7440), **Localiza,** Av. Princesa Isabel 150 (📞 021/2275-3340), and **Unidas,** Av. Princesa Isabel 166 (📞 021/3873-2521). Rates start at R$100 per day for a compact car with air-conditioning. Insurance adds R$30 per day.

Consulates The **Australia consulate** is at Av. Presidente Wilson 231, 23rd floor, Centro (📞 **021/3824-4624**). The **Canada consulate** is at Av. Atlântica 1130, fifth floor, Copacabana (📞 **21/2543-3004**). The **U.K. consulate** is at Praia do Flamengo 284, second floor, Flamengo (📞 **021/2555-9600**). The **U.S. consulate** is at Av. Presidente Wilson 147, Centro (📞 **021/3823-2000**).

Dentist For a dentist, go to **Sorriclin,** Rua Visconde de Pirajá 207/209, Ipanema (📞 **021/2522-1220**).

Doctor Clinica Galdino Campos, Av. N.S. de Copacabana 492, Copacabana (📞 **021/2548-9966;** www.clinicagaldinocampos.com.br), offers 24-hour service, including house calls. English is spoken. Ask your hotel for further recommendations, as they may have an arrangement with a doctor nearby.

Emergencies For police call 📞 **190;** and for fire and ambulance call 📞 **193.** Tourist police, Av. Afrânio de Melo Franco on the corner of Rua Humberto de Campos 315, Leblon, can be reached at 📞 **021/2332-2924** or 2332-2885 or 2332-2889.

Hospitals Public hospital emergency rooms can be found at **Miguel Couto,** Rua Bartolemeu Mitre 1108, Leblon (📞 **021/3111-3800**), or at **Souza Aguiar,** Praça da Republica 111, Centro (📞 **021/3111-2600**). Private emergency rooms can be found at the **Cardio Trauma Ipanema,** Rua Farme de Amoedo 86,

Ipanema (☏ **021/2525-1900**), and at the city's best hospital, **Copa D'or,** Rua Figueiredo de Magalhães 875, Copacabana (☏ **021/2545-3600**).

Internet Access Internet cafes or Lan Houses can be found everywhere. There is also free public Wi-Fi on the entire beachfront, from Leme to Leblon.

Mail Look for the yellow-and-blue sign saying COR-REIOS. **Downtown:** Av. Rio Branco 156, Centro (☏ **021/2240-8764**); **Copacabana:** Av. N.S. de Copacabana 540, Copacabana (☏ **021/2256-1439**); **Ipanema:** Rua Visconde de Pirajá 452, Ipanema (☏ **021/2567-6197**). The international airport also has a post office (☏ **021/3398-7024**), open Monday to Friday 9am to 9pm, Saturday till 1pm.

Maps **Riotur** (Av. Princesa Isabel 183, Copacabana) has helpful small maps of the main tourist areas.

Newspapers Your best bets for international papers are the newsstands along Visconde de Pirajá in Ipanema, and the bookstore **Letras e Expressões,** Visconde de Pirajá 276, Ipanema (☏ **021/2521-6110**). The English-language Rio paper, the *Gringo Times* (www.thegringotimes.com) is mostly Web-based but has free distribution in some Zona Sul hotels.

Pharmacies In Copacabana, **City Farma,** Rua Toneleiro 153 D

(☏ **021/3208-0000**), delivers Monday to Saturday 7am to 10pm and Sunday 8am to 2pm. All major credit cards are accepted. In Ipanema, **Drogaria Pacheco,** Rua Visconde de Pirajá 265, Ipanema (☏ **021/2287-7686**), is open 24 hours.

Safety Rio retains a somewhat unsavory reputation for street violence, though things have improved significantly since their nadir in the late 1980s and early 1990s. That said, there are still several things to keep in mind. It's a bad idea to wander unaccompanied into any of the favelas (shantytowns) found in and around the city. In the ritzy areas like the Zona Sul, favelas cling to steep hillsides and ridge tops. It's also best to avoid the city center (Centro) on weekends and holidays when this part of town remains mostly empty, and more than a little eerie. Avoid the parks and beaches at night, which are dark and mostly deserted (stick to the brightly lit and police-patrolled pedestrian walkway that borders the beach). At night, traveling by taxi is recommended—don't rely on public transportation. Finally, as in any large metropolitan area, it's wise to observe common-sense precautions: Don't flash jewelry and large amounts of cash, and stick to well-lit and well-traveled thoroughfares.

Taxes The city of Rio charges a

5% accommodations tax, collected by the hotel operators. This amount will be added to your bill. Hotels may also add a 10% service charge to your bill. Hotels that are members of the Rio Convention and Visitor's Bureau may also levy a tourist tax of R$3 to R$9 per day. This can add up to a total of 18% extra on your bill. There are no taxes on retail items.

Time Zones Rio de Janeiro is 3 hours behind GMT. During daylight saving time, Rio's time difference changes to 2 hours behind GMT.

Visa Renewal If you need to extend your visa, go to the **Policia Federal** at Galeão airport (top floor Terminal 1; ☏ **021/3398-3897**), open Monday to Friday 10am to 5pm. The fee is R$75, and you may need to show evidence of sufficient funds for your stay and a return ticket.

Weather Rio's summers, from December to March, are hot and humid. Temperatures rise routinely above 40°C (105°F). In the spring and fall, the temperatures stay between the high 20s to low 30s Celsius (high 70s and low 90s Fahrenheit). In the winter, June to August, it can cool off at night to as low as 15°C (59°F), but during the day temperatures are in the 20s Celsius (70s to the mid-80s Fahrenheit). Rain falls in the summer in short, intense tropical showers, and in the winter in longer drizzly showers.

Occasionally Brazil experiences out-breaks of dengue fever, a malaria-like ill-ness transmitted by mosquitoes. Most of the cases were reported in the state of Rio de Janeiro, with additional out-breaks in São Paulo as well. See the

section on "Health" in chapter 17 for more information. For the latest infor-mation on the situation in Rio, check the **Centers for Disease Control** website (www.cdc.gov) before you leave.

WHERE TO STAY

Though Rio has a good number of hotels, there's surprisingly little variety: There are few pousadas, boutique hotels, or fancy bed-and-breakfasts, at least not in the beach neighborhoods. In Copacabana and Ipanema, the vast majority of hotels are in mod-ern high-rises, many built in the 1960s and 1970s, most with a similar layout and design. The difference between hotels thus lies in the location, the room size, the amenities, and, of course, the view. The best rooms always face the ocean and are priced accordingly. Hotel prices in Rio are some of the highest in Brazil. The city draws tourists almost year-round, which means hotels are often packed. To get good deals, book ahead.

The best-known hotel area is **Copacabana,** with easy access via Metrô back to the city core, and a good selection of hotels close to the beach. One beach over from Copacabana, **Ipanema** and **Leblon** have become increasingly popular over the past decade and have better nightlife and trendier shopping than Copa.

Farther out in **Barra da Tijuca** is where you will find the city's newest and most modern hotels. Hotels out here are closer to the convention center and the big new malls and office complexes, but it's a 30- to 60-minute cab ride from Ipanema and Copacabana and the people and street life that make Rio so fascinating.

Back toward downtown you find the lively and more historic neighborhoods **Glória, Catete,** and **Flamengo.** Located a 15-minute subway ride from both down-town and Copacabana, they offer more affordable options. The hilltop neighborhood of **Santa Teresa** now has a few wonderful pousadas, B&Bs, and boutique hotels, most of them in the gorgeous converted mansions of Rio's 19th-century elite. Santa Teresa offers cobblestone streets and terrific views in all directions, and a bohemian artistic feel. The only drawback is access; getting up to or down from Santa Teresa is a matter of a bus or taxi ride, and later in the evening some taxis are reluctant to go up the hill.

In the lobby, hotels always list the rack rates on a sign behind the desk, but you can expect to pay 60% to 80% of this amount, depending on the season, the staff person, and your bargaining skills. Prices are quite flexible; always negotiate. Some-times just paying with cash can result in a 10% to 15% discount.

The only time of year when it's difficult to get a deal is during **high season,** from the week before Christmas through the end of Carnaval. The city overflows with visi-tors from all over the world, not to mention Argentines and Brazilians taking their summer holidays. New Year's and Carnaval are the tourism industry's cash cows, and during this time most hotels will only accept reservations for set package deals—usu-ally a 2- or 3-night minimum stay for New Year's and a 5-night minimum stay for Carnaval—at highly inflated prices. Shop around in advance if you're going to be in

Rio during these times; packages (*especially* the less expensive ones) sell out by October or November. Most hotels now have websites and will provide quick information upon request.

Make sure to ask about taxes that will be added to your bill. Most hotels charge a 10% service tax, a 5% city tax, and, if they are a member of the Rio Convention and Visitor's Bureau, a tourist tax of R$3 to R$9 per day. This can add up to a total of 18% extra on your bill.

Copacabana & Leme

Copacabana may not be the upscale neighborhood that it was in the days when bossa nova was young, but there are still advantages to staying in this part of the city. Prices are lower than in Ipanema, and with Copacabana's strategic location, it's only a 10- to 15-minute cab ride to Ipanema or to downtown; there's excellent bus service and a Metrô line, which makes it easy to get downtown or to places farther out, such as the Sambodromo or the Maracanã soccer stadium. The best hotels are on the Avenida Atlântica and some of its cross streets. Avoid the hectic Nossa Senhora de Copacabana Avenue and Rua Barata Ribeiro.

The drawback to Copacabana is that you share the hood with seniors, lots and lots of other tourists, vendors, hawkers, hustlers, and, in certain sections, street hookers and (mostly foreign) johns—it's particularly bad around Av. Prado Junior and the Lido. With some common precautions the neighborhood is just as safe as Ipanema, but you do get that extra local flavor. We find it quite colorful and a part of what makes Copa unique. However, it may not be for everybody.

Leme, at the far end of Copa, could be the perfect alternative for those who want to have all the benefits of being close to Copa without sinking in the midst of it.

VERY EXPENSIVE

The Copacabana Palace ★★ The spot where beachfront luxury in Rio began way back in the Jazz age, the Palace is still the place to splurge. Deluxe beach-view rooms here give you that coveted ocean view but to get value for money at the Palace it's really a case of go big or go home: The pool or oceanview suites are spacious, elegant, and tastefully decorated, each with its own private veranda overlooking the pool and Copacabana beach. One step up again and you've reached the penthouse suites, which are tasteful, sophisticated, and vast, each with a sitting room and bedroom and a private terrace looking down on the beach. The penthouse floor also has a private pool and bar. Avoid the city-view rooms and suites; though slightly cheaper, they face a busy city street and offer not a drop of ocean view. Better to simply stay elsewhere.

Av. Atlântica 1702, Copacabana, Rio de Janeiro, 22021-001 RJ. www.copacabanapalace.com. ✆ **0800/211-533** or 021/2548-7070. Fax 021/2235-7330. 225 units. R$850 deluxe city-view double; R$1,170 deluxe oceanview double; R$1,960 pool/oceanview suite double; R$3,580 penthouse suite. Extra person about 25%. Children 12 and under stay free in parent's room. AE, DC, MC, V. Free parking. Metrô: Arcoverde. **Amenities:** 2 restaurants; bar; babysitting; concierge; executive-level rooms; health club; Jacuzzi; large outdoor pool; room service; sauna; rooftop tennis courts. *In room:* A/C, TV, hair dryer, minibar, Wi-Fi.

Hotel Sofitel ★★★ There may be newer, more trendy hotels in town, but when it comes to top-notch service and luxury accommodations, the Sofitel gets it right every time. Rooms include elegant, modern furniture, efficient work spaces, a comfy lounge chair, top-notch lighting, flatscreen TVs, the Sofitel's signature mattresses and the finest linen, a pillow menu, fabulous showers, and luxurious L'Occitane amenities.

But wait, there is more: two gorgeous swimming pools (one for the morning sun and the other for the afternoon rays), a state-of-the-art fitness center, a running kit for those who prefer to jog along the beach, and a killer oceanfront location with exclusive services for hotel guests. Sofitel also deserves kudos for offering the city's best rooms for travelers with disabilities. The hotel's **Le Pré Catelan** restaurant offers one of the best dining experiences in town.

Av. Atlântica 4240, Copacabana, Rio de Janeiro, 22070-002 RJ. www.sofitel.com. © **0800/241-232** or 021/2525-1232. Fax 021/2525-1200. 388 units. Starting at R$550 superior double; R$675 deluxe double. Breakfast not included (R$55 per person). Children 12 and under stay free in parent's room. AE, DC, MC, V. Paid parking. Bus: 474. **Amenities:** 2 restaurants, include Le Pré Catelan (see review, p. 67); bar; babysitting; concierge; health club; 2 outdoor pools; room service; sauna; smoke-free floors. In room: A/C, TV, hair dryer, minibar, Wi-Fi.

JW Marriott ★★ Smack in the heart of Copacabana, the elegant JW Marriott offers some of the best accommodations in town with the high-level service guests expect from this hotel chain. The rooms are beautifully appointed and come with all kinds of little extras, such as a feather bed with deluxe duvet, coffeemaker, iron and ironing board, and iPod docking station. Facilities include an excellent fitness center and gorgeous rooftop swimming pool. However, all of this does come at a price—the prices at the JW Marriott are some of the highest in town. Especially the atrium rooms (hotelspeak for small rooms with only an internal view of the hotel lobby) are quite expensive.

Av. Atlântica 2600, Copacabana, Rio de Janeiro, 22070-002 RJ. www.marriott.com. © **0800/703-1512** or 021/2545-6500. 245 units. R$675–R$900 atrium double; R$825–R$1,040 deluxe double. Children 5 and under stay free in parent's room. AE, DC, MC, V. Paid parking (US$21 per day). Metrô: Siqueira Campos. **Amenities:** 2 restaurants; bar; health club; 2 outdoor pools; sauna; smoke-free floors. In room: A/C, TV, hair dryer, minibar, MP3 docking station, Wi-Fi.

Windsor Atlântica ★ After almost 2 years of renovations, the former Meridien hotel recently reopened as the Windsor Atlântica. Millions of dollars bought a major upgrade of amenities, such as elegant sober furniture, comfortable queen- or king-size beds with a multitude of pillows, high-end electronics, and soundproof windows. Standing 39 stories tall, the hotel boasts outstanding views. However, the original structure of the 1970s building remains unchanged; this means small rooms and low ceilings that give you a bit of a shoe-box feel. What makes the hotel worthwhile is the service and central location on the border of Copacabana and Leme, with quick access to all the tourist attractions of Copa while being only steps away from one of Rio's most pleasant beachside residential neighborhoods.

Av. Atlântica 1020, Leme, Rio de Janeiro, 22010-000 RJ. www.windsorhoteis.com.br. © **021/2195-7800.** Fax 021/2195-7850. 545 units. R$595 standard double; R$650–R$850 deluxe oceanview double. Extra person 25%. Children 10 and under stay free in parent's room. AE, DC, MC, V. Paid parking. Metrô: Arcoverde. **Amenities:** 2 restaurants; bar; health club; Jacuzzi; large outdoor pool; sauna. In room: A/C, TV, hair dryer, minibar, Wi-Fi.

EXPENSIVE

Golden Tulip Continental ★ ✦ Located a block off the beach in green and quiet Leme, a residential neighborhood at the far end of Copacabana beach, the Continental offers outstanding value. Although the rack rates are quite high, Internet rates and specials seldom top R$275. For that you get services that are worthy of a deluxe hotel: room service, a business center, Wi-Fi, a large fitness room, and a rooftop pool. The rooms themselves are comfortable albeit a tad on the plain side, with a double bed or twins, a work counter, and a small table and chairs. Though adjacent

Hotels & Restaurants in Copacabana, Leme, Ipanema & Leblon

RESTAURANTS ◆

Alfaia **33**
Arab **34**
The Bakers **31**
Bar d'Hotel **10**
Cafeina **30**
Casa da Feijoada **20**
Chez L'Ami Martin **1**
Churrascaria
 Carretão **19**
D'Amici **38**
Delirio Tropical **15**
Fratelli **5**
Frontera **18**

Gero **13**
Giuseppe Grill **9**
Gula Gula **2**
KURT **7**
Le Pré Catelan **26**
Le Vin Bistro **14**
Marius Degustare **42**
Mok Sakebar **3**
Sawasdee **4**
Shirley **39**
Siri Mole **24**
Talho Capixaba **6**
Zazá Bistrô
Tropical **16**

HOTELS ■

Arpoador Inn **22**
Atlantis Copacabana Hotel **23**
The Copacabana Palace **36**
Copacabana Sol Hotel **29**
Fasano **21**
Golden Tulip Continental **41**
Hotel Praia Ipanema **12**
Hotel Sofitel **26**
Hotel Vermont **17**

JW Marriott **28**
Leme Othon **40**
Marina All Suites Hotel **10**
Marina Palace **11**
Mercure Rio de Janeiro Arpoador **25**
Olinda Othon Classic **32**
Portinari **27**
Porto Bay Rio Internacional Hotel **35**
Spot **8**
Windsor Atlântica **37**

to busy Copacabana, Leme is a cul-de-sac with much lighter traffic. To make the most of the view, reserve a room on the 16th floor or higher that faces the ocean.

Rua Gustavo Sampaio 320, Leme, Rio de Janeiro, 22010-010 RJ. www.goldentulipcontinental.com. © **021/3545-5300.** Fax 021/35445-5301. 275 units. R$495 standard double; R$550 deluxe double. Extra person 25%. Children 12 and under stay free in parent's room. AE, DC, MC, V. No parking. Bus: 472. **Amenities:** Restaurant; bar; concierge; health club; outdoor pool; room service; sauna; smoke-free rooms. *In room:* A/C, TV, hair dryer, Internet, minibar.

Leme Othon ★ 🏄 This older hotel offers one of the more affordable beachfront locations in quiet Leme, only a 15-minute walk from all the action in Copacabana. The rooms and bathrooms are quite spacious, more so than the average hotel room in this price category. The furnishings are pretty basic though: just a comfortable double or two twin beds, a desk and chair, and a closet with a large mirror. Everything is spotless. Unless you are on a very tight budget, it is worth upgrading from a standard room to an oceanview room. Depending on the time of year, the price difference may be as low as R$70. The hotel doesn't have a swimming pool, but the beach is only 90m (300 ft.) across the street.

Av. Atlantica 656, Leme, Rio de Janeiro, 22010-010 RJ. www.hoteis-othon.com.br. © **021/2106-0200.** Fax 021/35445-5301. 275 units. R$365–R$460 standard double; R$385–R$550 ocean double. Extra person 25%. Children 5 and under stay free in parent's room. AE, DC, MC, V. No parking. Bus: 472. **Amenities:** Restaurant; bar. *In room:* A/C, TV, hair dryer, Internet, minibar, Wi-Fi.

Olinda Othon Classic ★★ 🏄 A lovely heritage building, the Olinda has finally gotten a much-needed makeover. The lobby has been transformed into an elegant salon with a restaurant and piano bar. Elevators have been upgraded to the 21st century, and all the rooms have been renovated, and are decorated with light woods, soothing pale colors, and stylish furniture. You should still avoid the standard rooms, which are smaller and face the back of the building. The deluxe oceanview rooms (luxo) feature a king-size bed, elegant 1950s detailing, and a view of the ocean. The luxo rooms with veranda are actually smaller, but have a lovely little veranda for two with a view out over the ocean. The spacious suites are one of the best deals in town; located on the top floor, they feature a large veranda with a view of the beach, a bedroom, and a sitting room, all with lots of light and a lovely Art Deco feel.

Av. Atlântica 2230, Copacabana, 22041-001 RJ. www.hoteis-othon.com.br. ©/fax **021/2545-9091.** 102 units. R$250–R$350 standard double; R$488 deluxe double; R$550–R$700 suite double. Extra person add 40%. Children 10 and under stay free in parent's room. AE, DC, MC, V. No parking. Metrô: Arcoverde. **Amenities:** Restaurant; bar; room service. *In room:* A/C, TV, minibar, Wi-Fi.

Portinari ★★ 🏄 The only thing that keeps this Rio design hotel from getting three stars is its location just off the busy Avenida N.S. de Copacabana; it lacks the sex appeal of a beach address. Inside, the hotel is fabulous. Each floor has a unique look. Styles range from classic romantic with elegant furniture and pale colors to environmentally friendly rooms furnished with recycled wood and natural fabrics. Our favorites are the rooms designed by Marcia Muller; the design is sensuous with gorgeous indirect lighting and luxurious white linens, and the shower is separated by a translucent wall from the bedroom. All rooms come with queen-size or twin beds with 200-thread linen and goose down pillows. The large suites feature large bathrooms (some with sauna or tub) and DVD players.

Rua Francisco de Sá 17, Copacabana, 22080-010 RJ. www.hotelportinari.com.br. © **021/3222-8800.** Fax 021/3222-8803. 66 units. R$340 double; R$385–R$500 suite. Extra person add 25%. Children 10 and under stay free in parent's room. AE, DC, MC, V. Valet parking R$30 per day. Bus:

415. **Amenities:** Restaurant; coffee shop; bar; concierge; small exercise room; rooftop pool; room service; sauna; smoke-free floors. *In room:* A/C, TV, hair dryer, minibar, Wi-Fi.

Porto Bay Rio Internacional Hotel ★★ The Porto Bay proves that you shouldn't judge a hotel by its cover. Behind the '80s-style black glass facade hides a remarkably pleasant hotel with friendly and attentive staff that welcome guests with a glass of champagne. A recent US$4-million overhaul equipped all guest accommodations with new, attractive furnishings, firm king- or queen-size beds, flatscreen TVs, and DVD and CD players. Thanks to the building's corner location, all rooms have at the bare minimum a partial ocean view. The prime rooms, the deluxe suites, have large panorama windows and a balcony—definitely worth the splurge. The hotel also has a lovely rooftop bar and swimming pool. Located next to the Copacabana Palace and 3 blocks from the subway, the Porto Bay makes an excellent base for exploring the city.

Av. Atlântica 1500, Copacabana, Rio de Janeiro, 22021-000 RJ. www.portobay.com. ✆ **0800/021-1559** or 021/2546-8000. Fax 021/2542-5443. 117 units. R$460 superior double; R$580–R$655 deluxe double. Children 10 and under stay free in parent's room. AE, DC, MC, V. Parking. Metrô: Cardeal Arcoverde. **Amenities:** Restaurant; bar; exercise room; rooftop pool; room service; smoke-free floors. *In room:* A/C, TV/DVD, CD player, hair dryer, minibar, Wi-Fi.

MODERATE

Atlantis Copacabana Hotel ★ Located between Ipanema and Copacabana on a quiet residential street, the Atlantis Copacabana Hotel is perfect for those who like to keep their options open. Either beach is within minutes from your hotel, and shopping and restaurants are easily accessible. The hotel offers basic accommodations. All 87 rooms are standard with only a small variation in size and layout; rooms ending in 07 and 08 (for example, nos. 107 and 108) are slightly larger. Rooms above the eighth floor that look out the back offer a view of Arpoador and Ipanema beach.

Rua Bulhões de Carvalho 61, Copacabana, Rio de Janeiro, 22081-000 RJ. www.atlantishotel.com.br. ✆ **021/2521-1142.** Fax 021/2287-8896. 87 units. R$220–R$270 double. Extra person R$50. Children 5 and under stay free in parent's room. AE, DC, MC, V. Limited street parking. Bus: 128 or 474. **Amenities:** Concierge; rooftop pool; room service; sauna. *In room:* A/C, TV, fridge, minibar, Wi-Fi.

Copacabana Sol Hotel ★ If you don't mind being off the waterfront, the Copacabana Sol offers good value and pleasant accommodations only 4 blocks from Copacabana beach. The lobby, a positively funky space, features colorful furniture and modern art. Rooms don't quite live up to this standard, but are still pleasant and comfortable. Superior rooms overlook the street and have balconies and a small sitting area. The Rua Santa Clara is not too noisy (especially at night), making these rooms preferable to the alley-facing standard rooms. Both superior and standard rooms have very small bathrooms with showers only. The suites are often a great deal. Spacious and cool with granite floors, the suites have comfortable sitting rooms and gorgeous bathrooms with Jacuzzi tubs and separate showers.

Rua Santa Clara 141, Copacabana, Rio de Janeiro, 22041-010 RJ. www.copacabanasolhotel.com. br. ✆ **0800/025-4477** or 021/2549-4577. Fax 021/2255-0744. 70 units. R$195–R$250 standard and superior double; R$325 suite double. Extra person R$40. Children 5 and under stay free in parent's room. AE, DC, MC, V. Free parking. Bus: 128 or 474. **Amenities:** Restaurant; concierge; room service. *In room:* A/C, TV, fridge, minibar, Wi-Fi.

Ipanema & Leblon

One beach over from Copacabana, **Ipanema** and **Leblon** offer some of the city's trendiest shopping and best dining options. Leblon, in particular, has become Rio's

prime neighborhood for fine dining. There are both affordable hotel options and outstanding luxury accommodations.

VERY EXPENSIVE

Fasano ★ ♨ The first-ever hotel designed by superstar designer Philippe Starck, the Fasano features wood-paneled hallways accented with oversize Dr. Seuss–inspired chairs, giving the hotel a type of 1960s shagalicious feel. The rooftop pool is a thing of beauty. Even the least expensive rooms (called superior) come gussied up in high design, with queen-size beds set off at an oblique angle to the room's basic rectangle. All that decorative sense doesn't change the fact that many rooms are small, very expensive, and lack both a balcony and an ocean view. If design is not your thing, you can get much more room for the money staying somewhere else. If you are in the mood to splurge, the deluxe oceanview rooms are a comfortable size, offering a small sitting area and a balcony with a pair of lovely (high-design) deck chairs. The difference in feeling is significant. The quality of everything in all rooms—bedding, bathroom products, bathrobes—is top-notch.

Av. Vieira Souto 88, Ipanema, Rio de Janeiro, 22420-000 RJ. www.fasano.com.br. ☎ **021/3202-4000.** Fax 021/3202-4010. 91 units. R$1,000–R$1,200 superior double; R$1,250–R$1,450 deluxe oceanview double. Extra bed R$150. Children 12 and under stay free in parent's room. Inquire about seasonal discounts. AE, DC, MC, V. Valet parking. Metrô: General Osorio. **Amenities:** Restaurant; bar; babysitting; concierge; well-equipped fitness center; rooftop pool; room service; sauna; smoke-free floors; small spa. *In room:* A/C, TV, hair dryer, minibar, Wi-Fi.

Marina All Suites Hotel ★★★ ♨♨ This place offers design with a capital *D*. The architects and decorators behind this hotel bought, gutted, and redecorated all the rooms, in the process reducing the original layout of six rooms per floor to a very spacious three. All are so precociously modern they positively squeak, with original pieces of art and a style unique to each unit. The two-bedroom Suite Diamante must be the most beautiful suite in Rio and is said to be Gisele Bündchen's favorite room when in town. The "basic" suites (basic being an understatement) are studio apartments. The design suites have a separate bedroom. All feature an American kitchen (microwave, fridge, and wet bar), ample desk space and sitting areas, spacious bathrooms, and luxurious furnishings, making this truly one of Rio's most outstanding hotels. The restaurant **Bar d'Hotel** is one Rio's more chic nightspots.

Av. Delfim Moreira 696, Leblon, Rio de Janeiro, 22441-000 RJ. www.marinaallsuites.com.br. ☎ **021/2172-1100.** Fax 021/2172-1010. 38 units. R$700–R$940 basic suite; R$1,000–R$1,350 design suite. AE, DC, MC, V. Free parking. Bus: 474. **Amenities:** Restaurant, Bar d'Hotel (see

review, p. 70); babysitting; concierge; excellent gym; outdoor pool; room service; sauna. *In room:* A/C, TV, fridge, hair dryer, kitchen, minibar, Wi-Fi.

EXPENSIVE

Hotel Praia Ipanema ★★★ Straddling the border between Ipanema and Leblon, the Praia Ipanema offers beachfront luxury accommodations, all within walking distance of Lagoa, the upscale shopping and restaurants of the Zona Sul, and the restaurants and bars of Leblon. All 101 units offer king-size beds and lovely bedding, plus balconies and ocean views. In the lowest category, superior master rooms offer either a front ocean view on a lower floor, or a side view from an upper floor. (As the side-view rooms are actually a bit larger than the front-views, an upper-floor side view may well be the best deal.) One step up, the deluxe (luxo) rooms offer a front view from a higher floor. Deluxe master (luxo master) rooms offer the same front view from floors 10 and up—where views of sand and sea get ever more spectacular—plus extras like a DVD and flatscreen TV.

Av. Vieira Souto 706, Ipanema, Rio de Janeiro, 22420-000 RJ. www.praiaipanema.com. ✆ **021/2540-4949.** Fax 021/2239-6889. 101 units. R$480 superior master double; R$550 deluxe double; R$590 deluxe master double. AE, DC, MC, V. No parking. Bus: 474 or 404. **Amenities:** Restaurant; 2 bars; small gym; rooftop pool; room service. *In room:* A/C, TV, fridge, hair dryer, minibar, Wi-Fi.

Marina Palace ★ The Marina Palace has the same fabulous beachfront location in Leblon as the Marina All Suites, but costs significantly less. This four-star hotel is slowly giving its facilities a much-needed overhaul. However, thanks to the high occupancy rates, it will probably take another year until all rooms are completed, so it is worth requesting a room on one of the renovated floors. These *executivo* rooms have been decorated with contemporary wooden furniture, subtle grey and beige color accents, and modern electronics such as a TV with DVD player and an iPod docking station. The other floors don't have the same modern feel, but have recently been outfitted with comfortable new mattresses. Located on the side of the hotel, the standard rooms on the higher floors still offer an ocean view and are more affordable than the beachfront superior rooms.

Av. Delfim Moreira 630, Leblon, Rio de Janeiro, 22420-000 RJ. www.hotelmarina.com.br. ✆ **021/2172-1000.** Fax 021/2172-1010. 150 units. R$435–R$485 standard double; R$515–R$585 standard *executivo* double; R$545–R$605 superior double; R$585–R$675 superior executive double. AE, DC, MC, V. Bus: 474 or 404. **Amenities:** Restaurant; bar; exercise equipment; rooftop pool. *In room:* A/C, TV/DVD, hair dryer, minibar, MP3 docking station, Wi-Fi.

Mercure Rio de Janeiro Arpoador ★★ ✦ Here you'll find an excellent value for money, and a location that gives you easy access to both Ipanema and Copacabana. All units in this flat hotel are small suites—bedrooms come with comfortable queen-size beds, the sitting rooms have a fold-out couch and sizable desk, and there's a small but fully equipped adjoining kitchen. Both bedroom and sitting room have a TV/DVD, and there's free Wi-Fi throughout. They're great for a family, or if you have work to do and are spending more time in Rio. Note that though the hotel backs onto the beach (rooms higher up on the back side get a beach view), to reach the beach you have to exit the hotel and walk a full 100m (328 ft.) or so on the street.

Rua Francisco Otaviano 61, Arpoador, Rio de Janeiro, 22080-060 RJ. www.accorhotels.com.br. ✆ **021/2113-8600.** 56 units. R$465 standard double. Up to 25% discount in low season and on weekends. AE, DC, MC, V. Parking R$15. Bus: 474. **Amenities:** Outdoor pool; room service; sauna. *In room:* A/C, TV/DVD, kitchen, Wi-Fi.

4

MODERATE

Arpoador Inn ★ 🍴 The only moderately priced oceanfront hotel in Ipanema, the Arpoador Inn enjoys a privileged location on a quiet stretch of beach popular with the surf crowd, and just around the corner from Copacabana. Even better, the beach in front of the hotel is closed to cars and is therefore pleasantly quiet. The deluxe rooms all face the ocean; the furniture is simple but the rooms are bright and spotless. Obtaining these rooms does require booking ahead; if they're full, the superior rooms, which look out over the street behind the beach, make an acceptable alternative. Avoid the standard rooms, which are small, dark, and look into an interior wall.

Rua Francisco Otaviano 177, Ipanema, Rio de Janeiro, 22080-040 RJ. www.arpoadorinn.com.br. ✆ **021/2523-0060.** Fax 021/2511-5094. 50 units. R$265 standard double; R$380 street-view superior double; R$530 deluxe ocean view. Children 6 and under stay free in parent's room. AE, DC, MC, V. No parking. Metrô: General Osorio. **Amenities:** Restaurant; room service. *In room:* A/C, TV, fridge.

Hotel Vermont ★ The Vermont sits smack in the middle of Ipanema's swankiest shopping district, and thanks to the rates at this small reasonably priced hotel, you'll have plenty of cash left for conspicuous consumption. All rooms have tile floors, new furniture, large mirrors, and clean, modern fixtures. Standard rooms face the back and are simply furnished with two twins or a double bed, a closet, and a desk. Superior rooms are a little more spacious but they also get some street noise, although at night traffic slows down significantly. Most of the rooms have twin beds so if you want a double it's best to reserve in advance. Note that the hotel is a bad choice for those with limited mobility—access to the hotel elevators is up one flight of stairs.

Rua Visconde de Pirajá 254, Ipanema, Rio de Janeiro, 22410-000 RJ. www.hotelvermont.com.br. ✆ **021/3202-5500.** Fax 021/2267-7046. 84 units. R$290–R$355 standard or superior double. Extra person R$90. Children 2 and under stay free in parent's room. AE, DC, MC, V. No parking. Bus: 415. *In room:* A/C, TV, minibar, Wi-Fi.

INEXPENSIVE

Spot ★ Location, location, location! This modern design hostel is way hipper than those boring youth hostels and offers affordable accommodations in the heart of Leblon's upscale restaurant row. In addition to the standard hostel dorms with 4, 6, or 10 beds, there are also several pleasant private double rooms furnished in bright white tones with a few antique touches. Starting at R$250, you will be hard-pressed to find a cheaper room in this part of the city. The hostel also features a fully equipped kitchen for use of the guests, a lounge, and a small deck with a terrace.

Rua Dias Ferreira 636, Leblon, Rio de Janeiro, 22431-050 RJ. www.leblonspot.com. ✆ **021/2137-0090.** Dorms (bunk bed) R$60–R$80 per person; 5 private rooms R$250–R$320. Extra person R$50. Children 5 and under stay free in parent's room. MC, V. No parking. Bus: 415. *In room:* A/C, TV, Wi-Fi.

São Conrado & Barra da Tijuca

The only reason to stay beyond Leblon is if you prefer a hotel with a large leisure area including such things as tennis courts and large swimming pools. Close to the convention center and the new business centers, hotels in Barra usually have huge recreational areas. The drawback is that you're anywhere from 30 minutes to an hour or more from Ipanema and Copacabana (depending on traffic) and thus quite isolated. If you do choose Barra, resign yourself to long cab or bus rides.

VERY EXPENSIVE

Sheraton Barra Hotel & Suites ★★★ ☺ Located on Barra's premier stretch of waterfront, the Sheraton offers the most modern and luxurious accommodations

in Rio. Rooms all have balconies and face the ocean. Classic rooms are located on floors one to five. Preferred rooms take up floors 6 to 15. All rooms come with a large desk, a sitting area, and a wet bar. Beds are indulgent, with a firm king-size mattress, a cozy fleece blanket, a plump duvet, and five cushy pillows. What really sets this hotel apart is its leisure amenities, with two swimming pools and Jacuzzi tubs set in a beautifully landscaped garden, a state-of-the-art fitness center, squash courts, a fully equipped business center, and a trendy lounge. Guests also have access to the 18-hole Itanhangá golf course. There's a free shuttle to the Barra Shopping.

Av. Lúcio Costa 3150 (aka Av. Sernambetiba), Barra da Tijuca, 22630-011 RJ. www.sheraton-barra. com.br. © **021/3139-8000.** Fax 021/3139-8085. 292 units. R$565 classic room double; R$725 preferred room double. Extra person R$155. Children 12 and under stay free in parent's room. AE, DC, MC, V. Bus: Metrô *Integração* Barra. **Amenities:** Restaurant; 2 bars; concierge; health club; 1 outdoor heated adult pool and 1 outdoor heated children's pool; room service; sauna; smoke-free rooms. *In room:* A/C, TV, fridge, hair dryer, Internet, kitchenette, minibar.

Sheraton Rio Hotel & Towers ★★★ ☺ This Sheraton is the only hotel in Rio that is actually on the beach instead of across the street. You are only a 30-minute walk from Leblon or a 10-minute taxi ride from Ipanema. (The hotel offers a free regular shuttle to the Rio Sul mall.) It is also the place where Rio's societal divisions will stare you right in the face, or rather, into your room. Located directly on its own beautiful pocket beach, the Sheraton sits in the shadow of a hillside favela. Guests in the north-facing rooms awake to the calls of roosters roaming round the small brick shacks across the road. The hotel itself features three large swimming pools in a beautiful parklike setting, beachfront access, and sweeping ocean views. The rooms are bright and spacious, with verandas with a partial or full ocean view. The location is suitable for children, and the hotel staff offer lots of activities to keep little ones busy.

Av. Niemeyer 121, São Conrado, Rio de Janeiro, 22450-220 RJ. www.sheraton-rio.com. © **021/ 2274-1122.** Fax 021/2239-5643. 559 units. R$425–R$560 standard double; R$520–R$680 oceanview double. Check the website for specials. Extra person add 25%. Children 12 and under stay free in parent's room. Breakfast not included. AE, DC, MC, V. Free parking. Taxi recommended. **Amenities:** 3 restaurants; 3 bars; babysitting; children's center; concierge; executive-level rooms; health club (extra charge); 3 outdoor heated pools; room service; sauna; smoke-free floors; spa (extra charge); tennis courts (extra charge); Wi-Fi (lobby only). *In room:* A/C, TV, fridge, hair dryer, Internet, minibar.

Windsor Barra ★★ ☺ Less expensive than the Sheraton, the Windsor Barra is all modern design on the outside. Inside, rooms feature classic, elegant furnishings and color schemes that are easy on the eye—lots of beiges and moss greens. The superior apartments are on lower floors and have side views of the ocean. The best rooms are the spacious deluxe corner rooms on the higher floors—these have both side and full ocean views, plus a Jacuzzi tub. The best view in the house is reserved for the leisure area; the swimming pool and bar have a sweeping 360-degree view of Barra Beach and surroundings.

Av. Sernambetiba 2630 (aka Av. Lúcio Costa), Barra da Tijuca, 22620-170 RJ. www.windsorhotels. com.br. © **021/2195-5000.** Fax 021/2195-5050. 338 units. R$475 double superior; R$725 double deluxe. Extra person 25%. Children 6 and under stay free in parent's room. AE, DC, MC, V. **Amenities:** 2 restaurants; 2 bars; concierge; health club; 1 outdoor heated adult pool and 1 outdoor heated children's pool; room service; sauna; smoke-free rooms. *In room:* A/C, TV, hair dryer, Internet, kitchenette, minibar.

Flamengo, Catete, Glória & Santa Teresa

These older neighborhoods just south of downtown offer a range of excellent accommodations. These neighborhoods are also architecturally interesting and offer many

Santa Teresa Bed & Breakfast Network ★★

Quite a change from most of Rio de Janeiro's high-rise accommodations, the **Santa Teresa Cama e Café B&B Network** (📞 **021/2225-4366;** www.camaecafe.com.br) offers beautiful rooms in one of the city's most charming neighborhoods. The participating homes are often quite spectacular and situated in some of Santa Teresa's finest locations. Houses range from century-old mansions to Art Deco villas to spacious apartments with fab views. Prices range from R$150 to R$250. The drawback to Santa Teresa is its isolation. In the evening you need to rely on taxis to get around. However, in the daytime you can grab a bus and be at the Metrô or downtown in 20 minutes. Santa Teresa in itself is worth a day of exploration. It's a perfect retreat, away from the beach.

glimpses into Rio's fascinating history. The chief drawback to the area is its distance from the ocean beaches.

VERY EXPENSIVE

Hotel Santa Teresa ★★★ This is one of the most romantic small hotels in the whole city, standing head and shoulders above other boutique hotels in the Santa Teresa neighborhood (comparable in price to the nearby Mama Ruisa, the Santa Teresa offers infinitely more bang for your splurging buck). Rooms are tastefully decorated with hardwood floors and king-size four poster beds, top-quality linens, and tasteful little touches of artwork and design. Deluxe rooms have a bit more space and better views of the city and surrounding hills. Suites are larger still, with sitting areas and designer bathrooms. The hotel spa features a variety of Amazon-themed treatments. The outdoor pool offers fabulous city views, as does the lounge bar. The hotel restaurant **Térèze** is one of the city's best. The Largo dos Guimarães, Santa Teresa's main square and "restaurant row," is only a 5-minute walk away.

Rua Almirante Alexandrino 660, Santa Teresa, Rio de Janeiro, 20241-260 RJ. www.santateresahotel.com. 📞 **021/2222-2755.** Fax 021/2221-1406. 44 units. R$650–R$725 double; R$800–R$1,600 suite. Children 10 and under stay free in parent's room. AE, DC, MC, V. No parking. Integrated Metrô/bus from Carioca Metrô stop. **Amenities:** Restaurant, Térèze (see review, p. 75); outdoor pool; limited room service; spa; Wi-Fi. *In room:* A/C, TV, fridge, minibar, Wi-Fi.

EXPENSIVE

Windsor Hotel Florida ★★ 🛄 The Florida is popular with business travelers from São Paulo who know a good deal when they see it: On top of a reasonable room rate, the Florida offers free parking, free local calls, and free Internet access. Built in the 1940s, the hotel doesn't suffer from the modern "small room" syndrome; rooms are spacious and pleasant, and though furnishings are a bit dated, there are good queen-size beds, hardwood floors, and ample workspace. The standard rooms overlook the rear or the side of the building, whereas deluxe rooms offer street views; some are equipped with whirlpool tubs. The nicest rooms are those overlooking the lush gardens of the Palácio do Catete, Brazil's former presidential palace. The deluxe rooms are the most spacious, with a large entrance hall, king-size bed, sitting area, and desk. The hotel offers excellent discounts on weekends.

Rua Ferreira Viana 81, Flamengo, Rio de Janeiro, 22210-040 RJ. www.windsorhoteis.com. 📞 **021/2195-6800.** Fax 021/2285-5777. 312 units. R$324 standard double; R$400 deluxe double. Extra person add 25%. Children 10 and under stay free in parent's room. AE, DC, MC, V. Free

Hotels & Restaurants in Flamengo, Catete, Glória & Santa Teresa

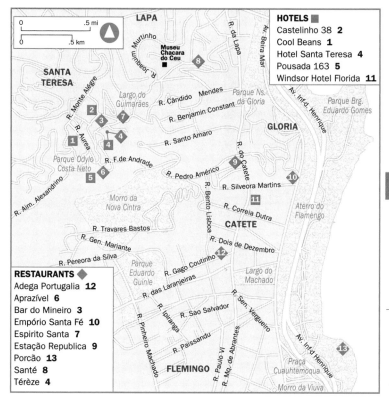

HOTELS ■
Castelinho 38 **2**
Cool Beans **1**
Hotel Santa Teresa **4**
Pousada 163 **5**
Windsor Hotel Florida **11**

RESTAURANTS ◆
Adega Portugalia **12**
Aprazível **6**
Bar do Mineiro **3**
Empório Santa Fé **10**
Espirito Santa **7**
Estação Republica **9**
Porcão **13**
Santé **8**
Térèze **4**

parking. Metrô: Catete. **Amenities:** Restaurant; bar; concierge; weight room; rooftop pool; room service; sauna; smoke-free floors. *In room:* A/C, TV, fridge, hair dryer, minibar, Wi-Fi.

MODERATE

Castelinho 38 ★ A pretty two-story neoclassical mansion in the heart of Santa Teresa, the Castelinho offers airy ceilings, and a pretty garden and terrace overlooking the center of the city. Accommodations are quirky but comfortable. On the ground floor, facing the garden, are three rooms with private ensuite bathrooms. On the same floor are also two triple rooms (a double bed and a single) with private external bathrooms. Somewhat fancier, the two master suites on the first floor feature higher ceilings and a bit of view. The first floor also has a comfortable mini apartment that can house up to five people. Best of all is the master suite—the *mangueira*—with air-conditioning and a lovely view of the city.

Rua Triunfo 38, Santa Teresa, Rio de Janeiro, 20240-320 RJ. www.castelinho38.com. ✆ **021/2252-2549.** Fax 021/2242-7511. 9 units. R$220–R$290 double. 25% discount in low season. Children 1 and under stay free in parent's room; children 2–7 R$60. MC, V. **Amenities:** Bar. *In room:* Fan, Wi-Fi.

Rio's ongoing revitalization has brought major improvements to the downtown area, attracting several new hotels. Geared toward business travelers, these hotels can't quite compete with all the advantages of the beachside or romantic Santa Teresa locations, but they do provide an affordable alternative—especially if you are flying out really early or arriving late at night. Close to the bars and theaters of the Praça Tiradentes, **Formule 1,** Rua Silva Jardim 21, Torre 2, Centro (✆ **021/3511-8500;** www.accor.com.br), offers modern no-frills rooms for as little as R$169 a night. Rooms at the adjacent **Ibis Centro,** Rua Silva Jardim 21, Torre 1, Centro (✆ **021/3511-8200;** www.accor.com.br), range from R$189 to R$239. Another option is the **Ibis Santos Dumont,** Rua Av. Marechal Camara 280, Centro (✆ **021/3506-4500;** www.accor.com.br), right across the street from the Santos Dumont airport; rooms here start at R$209 for a double.

Cool Beans ★★ In the heart of Santa Teresa, Cool Beans is a great bed-and-breakfast run by two Americans who love to share their passion for Rio with their guests. The house features seven rooms; all are tastefully decorated with colorful local artwork, new mattresses, and quality sheets and towels. The largest rooms are located on the ground floor and have lovely high ceilings and a mezzanine with a second double bed. On the main floor are five more rooms. Avoid nos. 5 and 6; although comfortably furnished, these rooms are small and lack the lovely large windows and high ceilings of the other rooms. A delicious breakfast is served at a large common table on the rooftop, where guests mingle and swap travel tips. There is even a small pool and sun deck. No children under the age of 16 are allowed.

Rua Laurinda Santos Lobo 136, Santa Teresa, Rio de Janeiro, 20240-270 RJ. www.casacoolbeans. com. ✆ **021/2262-0552;** in the U.S. call 202/470-3548. 7 units. R$200–R$235 double. Free parking. No children 15 and under. **Amenities:** Bar; small swimming pool. *In room:* A/C, TV, minibar, Wi-Fi.

Pousada 163 Pousada Um Meia Tres ("163" in Portuguese) is located on one of our favorite streets in Santa Teresa, within easy walking distance of the neighborhood's main attractions and just a few steps from Aprazível Restaurant. British hosts Bill and Sue welcome you into their lovely three-story home; each of the five guest rooms is nicely furnished with firm orthopedic mattresses and high-quality linens. All rooms boast fabulous views of Santa Teresa and downtown Rio de Janeiro; the three rooms on the top floor also have private terraces. Guests also have the use of a large sitting room and an outdoor pool with a sun deck.

Rua Aprazivel 163, Santa Teresa, Rio de Janeiro, 20241-270 RJ. www.hotelinrio.net. ✆ **021/2232-0034.** 5 units. R$200–R$240 double. Free parking. **Amenities:** Bar; small swimming pool. *In room:* A/C, TV, Wi-Fi.

WHERE TO EAT

Cariocas love to eat out. Better yet, they love to linger over their meals. Waiters in Rio would never dream of coming by to ask you to "settle up" so they can go off shift. So take your time. Dawdle. Savor. Enjoy.

Rio offers an endless variety of places to eat. There are the *chopperias*, the places for cold beer and casual munchies. Slightly more upscale are the botequins, many of

which are open to the early hours. There are hundreds of food kiosks, each with its own specialty, be it barbecued prawns, Bahian finger food, or vegetarian sandwiches. And on top of all that, there's a wide variety of restaurants in all neighborhoods, ranging from inexpensive to very expensive, from simple sandwiches to delicious steaks, from fresh sushi to the complicated stews and sauces of Brazil's Northeast. There's no excuse for going hungry in Rio.

Most restaurants are open from around 11am until 4pm and then again from 7pm until midnight or later. There are also quite a few establishments that will stay open all day, especially on the weekends when people leave the beach at 4pm to go eat lunch. Sunday is often the busiest day for lunch as extended families get together for a meal. Many restaurants close Sunday evening. The exception to these hours is in Rio's downtown, where restaurants cater to the office crowd; only a few of them remain open evenings and weekends.

Note: For maps of restaurants in Leblon, Ipanema, Copacabana, Botafogo, Flamengo, and Catete, see the "Hotels & Restaurants" maps, earlier in this chapter.

Centro

Note: For a map of the restaurants in Rio Centro, please see p. 87.

EXPENSIVE

Cais do Oriente ★★ ASIAN/MEDITERRANEAN This 19th-century warehouse has been transformed into a stunning restaurant and bar, complete with large gilt mirrors and opulent antique furniture. The menu travels from the Orient to the Mediterranean, including dishes such as sweet-and-sour duck and fried rice tossed with cashews and pistachio nuts, and prawn risotto with basil and grilled salmon served with a Gorgonzola-and-ricotta-stuffed pancake. The upstairs bar is a great venue for live music on Fridays or Saturdays.

Rua Visconde de Itaboraí 8, Centro. ℰ **021/2233-2531.** www.caisdooriente.com.br. Main courses R$32–R$58. AE, DC, MC, V. Tues–Sat noon–midnight; Sun–Mon noon–4pm. In the evenings, taxi recommended. Bus: 119. Get off 1 stop past the Praça XV.

MODERATE

Bistro do Paço ★ BRAZILIAN This is the perfect spot to escape the heat and noise in downtown. Inside the historic Paço Imperial, the thick whitewashed walls keep out the bustle while you recharge your batteries in the cool shade of the inner courtyard. The restaurant serves mostly bistro fare as well as a daily lunch

🄾 DON'T SHY away FROM STREET FOOD

Some of the best meals I've had in Brazil have been purchased from a street vendor. One night in Rio, on the Rua Ouvidor, we came across a man and his charcoal brazier, selling skewers of fresh-grilled prawns, lightly salted and doused with lemon. We bought two skewers, which lasted about 40 seconds . . . so we went back for four more . . . and then another four. The moral? Eating from street vendors is fine, as long as you take precautions. Does the vendor look clean and healthy? Is the food stored in a cooler? Are Brazilians queuing up? If so, odds are the food's good, and whatever supplies he has in his cooler haven't been hanging around long enough to go bad. So eat, enjoy, and don't have a cow. Or rather, *do*, if that's what they're selling.

special that will set you back R$15 to R$26 for a plate of roast beef with a side order of pasta, and spinach crepes with a ricotta-and-mushroom stuffing. For a light snack try a quiche, a freshly made sandwich with grilled vegetables, or a cold-cut plate. Desserts are strictly European: Austrian Linzer tortes, German fruit strudels, and Black Forest chocolate cakes, all of which go so well with a Brazilian *cafezinho*.

Praça XV 48 (inside the Paço Imperial), Centro. ✆ **021/2262-3613.** Main courses R$18–R$35; sandwiches and quiches R$10–R$22. AE, DC, MC, V. Mon–Fri 10am–8pm; Sat noon–7pm. Bus: 415.

Confeitaria Colombo ★★ BRAZILIAN/DESSERT This stunning Victorian tearoom hasn't changed much since it opened in 1894. Two large counters at the entrance serve up sweets and snacks with coffee or other refreshments. The rest of the ground floor features an elegant tearoom, where a variety of teas, sandwiches, and sweets are served on fine china underneath a 1920s stained-glass window. The upstairs is for full lunches—on Saturdays the *feijoada* (black beans and pork stew) is worth a trip downtown. *Tip:* A branch of the Confeitaria Colombo is inside the Forte Copacabana, with a smaller menu but fabulous views.

Rua Gonçalves Dias 32, Centro. ✆ **021/2505-1500.** www.confeitariacolombo.com.br. Tearoom snacks and lunches R$10–R$35; buffet lunch or Sat *feijoada* buffet R$55 including dessert. AE, DC, MC, V. Mon–Fri 8:30am–7pm; Sat 9am–5pm. Metrô: Carioca.

Focaccia BRAZILIAN/SANDWICHES The name already gives it away; this restaurant specializes in perfectly grilled focaccia bread sandwiches. The large menu offers more than 20 different combinations. I particularly enjoyed the roast beef with mustard dressing and sun-dried tomatoes, the Parma ham with brie, and the grilled vegetables with goat cheese. All the sandwiches also come in a half order; perfect for small appetites or gluttons who cannot make up their minds and prefer to order two different halves. For heartier appetites there are four daily specials, usually a pasta, a fish, and a beef dish. You can also complement your meal with a delicious salmon tartare on toast or a fresh salad, and wash it all down with a glass of pinot grigio or chardonnay. There is also a small Focaccia cafe inside the bookstore Livraria da Travessa, Rua 7 de Setembro 54 (✆ **021/2224-5073**).

Rua do Acre Av. Mem de Sà 90, Lapa. ✆ **021/2509-5943.** All items R$10–R$25. DC, MC, V. Mon–Fri 10am–6pm. Metrô: Uruguiana.

INEXPENSIVE

Beco das Sardinhas ★ 🎎 BRAZILIAN Known as "the sardine triangle," this corner in Rio's historic downtown is the perfect place to spend a Friday afternoon as locals gather to unwind from the workweek. It started in the 1960s when the Portuguese owners of three small restaurants began selling fried sardines. These days, the triangle has expanded to include six restaurants in a pedestrian area between Rua do Acre and Rua Mayrink Veiga. Every Friday after 6pm it transforms into a giant TGIF party. The patio tables and counters fill up almost as quickly as the fried sardines, salted and breaded in manioc flour, come piping hot off the grill. Accompanied by a *loira gelada* ("icy blond," the local nickname for draft), it's the perfect way to start a weekend.

Rua Miguel Couto 139, Centro. ✆ **021/2233-6119.** Everything under R$15. No credit cards. Mon–Fri 11am–10pm. Metrô: Uruguaiana.

Paladino ★ BRAZILIAN Is Paladino a deli, with racks of spices and jars of capers and artichoke hearts? Is it a liquor store, as the hundreds of glass bottles lined up in gleaming wooden cases seem to suggest? Or is it a bustling lunch bar with some of

the best draft beer in town? Is an exact definition really important? What matters is that the beer is clear and cold and comes at the wave of a finger, the atmosphere is that of Rio in the Belle Epoque, and the sandwiches and snack plates are delicious. *Pratinhos,* as the latter are known in Portuguese, cost next to nothing—R$4 to R$8—and come loaded with sardines or olives, cheese, or great heaping stacks of smoked sausage. All this delectable nosh is served up by old-fashioned waiters in black pants and white shirts. Since 1907, an eclectic mix of lawyers, shopkeepers, workers, and executives has come here, and though none have ever succeeded in defining exactly what it is, they've never stopped coming.

Rua Uruguaiana 226, Centro. *C* **021/2263-2094.** Reservations not accepted. Sandwiches and side dishes R$4–R$15. No credit cards. Mon–Fri 7am–8:30pm; Sat 8am–noon. Metrô: Uruguaiana.

Copacabana & Leme
VERY EXPENSIVE

D'Amici ★★★ ITALIAN It is easy to miss the unassuming entrance to this Italian restaurant. I lived around the corner for years before I finally went in and regretted not having gone in sooner! The small dining room with nicely set tables has a warm atmosphere and the waiters seem to know many customers by name. The kitchen doesn't specialize in one region, but serves up a selection of dishes from across Italy. Everything is carefully prepared with fresh ingredients, starting with delicious home-baked bread (I dare you to restrain yourself!), various carpaccios, and soups. Next, you may order a homemade ravioli with haddock or a rigatoni with asparagus tips, langoustines, and arugula. The fresh fish is also excellent—order it grilled or baked with herbs and white wine. One of the most popular meat dishes is the veal *osso buco* served with saffron risotto. The wine list has recently been overhauled and includes more than 25 options of bubbly and prosecco, perfect for Rio's warm weather.

Rua Antonio Vieira 18, Leme. *C* **021/2541-4477.** www.damiciristorante.com.br. Main courses R$38–R$67. AE, DC, MC, V. Daily noon–1am. Bus: 415.

Le Pré Catelan ★★★ FRENCH Even after a decade as one of Rio's celebrity chefs, Roland Villard still manages to offer diners a "wow" every time. Villard takes on the challenge of transforming the Brazilian staples of rice and beans into a gourmet experience. Half the fun comes from guessing with each course how these two ingredients have been used. For example, the second course includes a white bean blini with a tomato and mozzarella salad and basmati rice pesto. This is followed by a grilled prawn with olive oil bisque served on a bed of green bean risotto. One of the two meat dishes includes the guinea fowl stuffed with mushrooms and a black bean petit gâteau and wild rice. The eight-course extravaganza will give you renewed appreciation for the lowly rice and bean. Of course, guests may also order from the a la carte menu, but you would be foolish to miss out on the opportunity to get the full dining experience.

Hotel Sofitel, Av. Atlântica 4240, Copacabana. *C* **021/2525-1160.** Reservations recommended. Main courses R$88; 8-course tasting menu R$250. AE, DC, MC, V. Mon–Wed 7:30–11:30pm; Thurs–Sat 7:30pm–midnight. Bus: 415.

Marius Degustare STEAK One of the better all-you-can-eat *rodízio* restaurants, Marius serves up prime cuts of beef. In addition to this carnivore's dream, the buffet also includes excellent seafood such as fresh oysters, shrimp, langoustines, smoked salmon, and paella, in addition to salads and other side dishes. But back to what we

came for. Here at Marius, waiters will come out over and over with your favorite cuts of steak, whether it is juicy tender rib-eye, T-bone, rack of lamb, or any of the other kinds of typical Brazilian beef cuts such as *maminha, alcatra, picanha,* and *fraldinha.*

Av. Atlântica 290A, Leme. © **021/2104-9000.** www.marius.com.br. Reservations accepted. R$92 per person, all-you-can-eat buffet. AE, DC, MC, V. Mon–Fri noon–4pm and 6pm–midnight; Sat–Sun noon–midnight. Bus: 472.

EXPENSIVE

Arab ★ MIDDLE EASTERN Arab has a terrific waterfront patio (on Copa beach) and delicious Middle Eastern cuisine. For lunch, the kitchen puts on an excellent kilo buffet (R$42 per kilo), great for trying a variety of dishes. Offerings include tasty salads with chickpeas, lentils, grilled vegetables, and outstanding main dishes such as the roasted chicken with apricots, couscous with cod, grilled lamb kabobs, and piping hot, fresh pita breads. In the evenings, dishes are a la carte. Our favorites include the tray of *mezzes* (appetizer plates). Perfect for sharing, these plates come with enough munchies for three or four people and include hummus, baba ghanouj, savory pastries with ground beef or lamb, and other finger food. Desserts are dangerously rich and include sweet pastries made with sugar, rosewater, and almonds or pistachios.

Av. Atlântica 1936, Copacabana. © **021/2235-6698.** www.restaurantearab.com.br. Main courses R$29–R$42. AE, DC, MC, V. Mon 5pm–1am; Tues–Sun 8am–1am. Metrô: Cardeal Arcoverde.

Siri Mole ★★ BAHIAN Siri Mole is one of the best Bahian restaurants in town. Although the location on the corner of the busy Rua Francisco Otaviano is less than inspired, the food is worth the trip. The *moquecas* are outstanding, perfectly balancing the mix of coconut milk, red dendê palm oil, and fresh cilantro that give this dish its signature flavor. Try a *moqueca* with prawns, octopus, fish, or langoustine. The grilled seafood or fish are also excellent. Portions are a reasonable size and can often be shared. During Saturday's lunch buffet (noon–5pm) the restaurant serves up a variety of delicacies (R$60 per person, all you can eat). Make sure to save room for dessert. There's *quindim* (a creamy coconut pudding) or *cocada* (pure coconut mixed with pure cane sugar) which can be washed down with a hot and black *cafezinho.*

Rua Francisco Otaviano 50, Copacabana. © **021/2267-0894.** www.sirimole.com.br. Reservations accepted. Main courses R$60–R$95; many are for 2 people. AE, DC, MC, V. Mon 7pm–midnight; Tues–Sun noon–midnight. Bus: 415.

MODERATE

Alfaia ★★ 🍴 PORTUGUESE Portuguese cooking is a staple of Brazilian cuisine, but somewhat more rare in North America. This lovely neighborhood restaurant, tucked away off Avenida N.S. de Copacabana, is one of the best places in Rio to give Portuguese dishes a try. The house specialties always include *bacalhau* (salted cod-fish). Start off with the perfectly deep-fried *bolinhos de bacalhau* (codfish dumplings). The classic main dish here is the *bacalhau à Bras,* oven-baked codfish served with potatoes, scrambled egg, onion, and olives. Portions are huge, but half-portions are available. We found that with appetizers and dessert a half-portion was plenty for two people. (For non–cod lovers, there's sole *á belle meuniére,* or grilled octopus with red peppers.) The wine list includes some excellent Portuguese whites and reds. For dessert there are delicious Portuguese pastries. Try the *pastel de nata,* a flaky pastry stuffed with creamy custard.

Rua Inhangá 30, Copacabana. © **021/2236-1222.** Main courses R$46–R$85 for 2 people. AE, DC, MC, V. Mon–Sat noon–midnight; Sun noon–11pm. Metrô: Cardeal Arcoverde.

Churrascaria Carretão ☺ 🍴 BRAZILIAN/STEAK For a churrascaria meal without breaking the bank, try Carretão. It's an all-you-can-eat *rodízio* system: Meats are delivered to your table by a constant parade of waiters carrying a variety of cuts, and you can help yourself to a large buffet with a selection of 20 salads, sushi, and even grilled salmon or trout. Carretão also serves up a variety of pork, sausage, chicken, and turkey cuts. Children 4 and under eat free, those ages 5 to 9 pay only half price. Just keep them away from the fruit smoothies and desserts so eagerly pushed by the waiters; these aren't included in the price, and jack up the bill pretty quickly.

Rua Visconde de Pirajá 112, Ipanema. ✆ **021/2267-3965.** Reservations accepted. R$45–R$51 all you can eat (drinks and desserts not included). AE, DC, MC, V. Daily 11am–midnight. Bus: 404 or 474 (corner Teixeira de Melo). Also in Copacabana: Rua Ronald de Carvalho 55, ✆ **021/2543-2666,** and Rua Siqueira Campos 23, ✆ **021/2236-3435.**

Shirley ★★ 🍴 SPANISH This hole-in-the-wall Spanish seafood restaurant has been packing them in for more than half a century. The restaurant is small, the tables close together, and the older waiters quaint, though not exactly perky, and the food is definitely worth the trip. When you finally nab a spot, order the *couvert* while perusing the menu; you get a plate of chunky sardines in tomato sauce, olives, and lots of pickled veggies. It's better than many of the appetizers, and goes nicely with the house sangria. The menu offers a range of fish and seafood dishes, including typically Spanish items such as paella and *zarzuela,* a souplike stew. The prawn dishes are made with the fresh, monster-size prawns you see in the display window. Fish lovers have the option of sole, sea bass, and snapper, which can be grilled, sautéed, broiled, or breaded. Plates come with generous side dishes of vegetables, potatoes, or rice and will easily feed two.

Rua Gustavo Sampaio 610, Leme. ✆ **021/2275-1398.** Main courses R$39–R$75; most are for 2 people. No credit cards. Daily 11am–midnight. Bus: 472.

INEXPENSIVE

The Bakers SANDWICHES/DESSERT This place offers the perfect combination of American-style sandwiches and Brazilian sweets and desserts. The sandwich menu includes breads not often seen in Rio, including ciabatta, eight-grain, whole wheat, and challah. The Romeo and Juliet is a delicious combination of chicken breast, herb-flavored Catupiry cheese, greens, and an apricot dressing. The mouthwatering selection of cakes and pies, includes the Ecstasy, a chocolate cake with fresh strawberries, whipped cream, and chocolate sauce. The bakery also serves up a mean cappuccino.

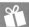

Where to Find the Finest *Feijoada*

For the best *feijoada* (a type of Brazilian stew with beans and different types of meat) in town, try one of the following restaurants (on a Sat, of course—lunch only). **Confeitaria Colombo** serves an outstanding *feijoada* in the loveliest dining room in town, Rua Gonçalves Dias 32, Centro (✆ **021/2221-0107;** www.confeitariacolombo.com.br). **Galani,** on the 23rd floor of the plush Caesar Park Hotel, Av. Vieira Souto 460, Ipanema (✆ **021/2525-2525;** www.caesarpark-rio.com), is famous for its Saturday buffet. Even fancier is the spread at the Sheraton's **Mirador,** Avenida Niemeyer, São Conrado (✆ **021/2274-1122;** www.sheraton-rio.com). After lunch you'll welcome the 30-minute walk back to Leblon.

Rua Santa Clara 86, Copacabana. ℰ **021/3209-1212.** www.thebakers.com.br. Everything under R$15. No credit cards. Daily 9am–8pm. Bus: 415.

Cafeina CAFE/BREAKFAST There's excellent coffee and cappuccino here, homemade specialty breads, and a good selection of sandwiches, but what really draws folks in is the breakfast menu: There are waffles with honey or whipped cream or Nutella, delicious eggs and omelets, or the classic breakfast for two: fresh OJ, a basket of breads with jam and honey and cheese, cold cuts, cakes, papayas, yogurt with granola, and of course coffee (R$47 for two).

Rua Barata Ribeiro 507, Copacabana. ℰ **021/2547-4390.** www.cafeina.biz. Main courses R$8– R$30. MC, V. Daily 8am–11pm. Metrô: Cardeal Arcoverde. Plus 4 other locations in Copacabana, Ipanema, and Leblon.

Ipanema & Leblon
VERY EXPENSIVE

Bar d'Hotel ★★ ⚃ CONTEMPORARY On the first floor of the Marina Hotel in Leblon, the baroque dining room with gilded mirrors and sheer curtains exudes a hip and upscale vibe that attracts a beautiful crowd. Drop in just for a drink and try an exotic *sakerinha* or vodka cocktail, or grab a table and enjoy the kitchen's excellent food (use the clever overhead mirrors to spy on the dishes of your fellow diners). Appetizers include mini lamb burgers with foie gras and a salmon tartare. For mains there's an excellent seafood risotto, a rich stew of prawns with coconut milk, or filet mignon with a crust of caramelized macadamia nuts. The executive lunch menu offers an appetizer, main course, and dessert for R$48.

Av. Delfim Moreira 696, 2nd floor (inside the Marina All Suites Hotel), Leblon. ℰ **021/2540-4990.** Reservations recommended in the evening. Main courses R$46–R$65. MC, V. Daily noon–2am. Bus: 415.

Fratelli ★★ ITALIAN With its large bay windows and cozy tables, Fratelli has the ambience of a friendly neighborhood restaurant, but with excellent food from Tuscan chef Mario. Start with the freshly baked focaccia bread drizzled with truffle-infused olive oil. This goes really well with the seafood *panelote,* a skillet of garlic sautéed octopus, squid, and shrimp. The menu offers a lengthy selection of main courses, including risottos, homemade pasta, veal, lamb, beef, fish, and chicken. An excellent shortcut is the seasonal menu that highlights a handful of the chef's new creations. We were very pleased with the perfectly al dente veal ravioli in a light mushroom cream sauce and the guinea fowl, stewed in a flavorful red wine reduction and served with a cream of Parmesan risotto. For a more casual meal, the kitchen also prepares delicious pizzas in a wood-burning oven. The wine list includes an excellent selection of affordable sparkling wines and Argentinean and Chilean malbecs, cabernet merlots, and shirazes.

Rua General San Martin 983, Leblon. ℰ **021/2259-6699.** www.restaurantefratelli.com.br. Main courses R$49–R$77. AE, DC, MC, V. Mon–Fri 6pm–2am; Sat–Sun noon–2am. Bus: 415.

Gero ★★ ITALIAN The Rio branch of a highly successful São Paulo restaurant brings the same sophisticated styling to the room and the same meticulous preparation to the meals. Signature dishes include rack of lamb with a black truffle and foie gras sauce, or *osso buco* with mushrooms. Pastas include gnocchi with squid, and a ravioli of veal with a mushroom sauce. The room is open but warm, with a hardwood floor

and exposed brick walls. Wines lean to the higher end—avoid the overpriced token Brazilian vintages, and seek out the midpriced Chilean and Argentine vintages.

Rua Anibal de Mendonça 157, Ipanema. © **021/2239-8158.** www.fasano.com.br. Main courses R$56–R$75. AE, DC, MC, V. Mon–Fri noon–4pm and 7pm–1am; Sat noon–2am; Sun noon–midnight. Bus: 415.

Giuseppe Grill ★★ STEAK With outstanding steak, an affordably priced wine list, and excellent and attentive service, what's not to recommend? The house specialty is beef. You can choose from grilled beef or slowly roasted beef on a charcoal grill. Both options include numerous cuts—prime rib, Argentine chorizo, filet mignon, and rump steak as well as beef ribs, pork, and chicken. Each main course comes with a side dish; you can choose from salads, rice, and potatoes served fried, roasted, baked, or sautéed. In addition, the restaurant also serves up outstanding fresh seafood. There's shrimp and *namorado* and catch of the day—ask for the waiter's recommendation. We went with the octopus, grilled to perfection and served tossed with arugula as a warm salad. At lunch, the kitchen serves a full three-course menu with a choice of fish, meat, or chicken for R$60.

Av. Bartolomeu Mitre 370, Leblon. © **021/2249-3055.** www.bestfork.com.br. Main courses R$36–R$65. AE, DC, MC, V. Mon–Thurs noon–4pm and 7pm–midnight; Fri–Sat noon–1am; Sun noon–11pm. Bus: 415.

Mok Sakebar ★★★ JAPANESE To do this restaurant justice would require three reviews. First there is the sushi bar, run by talented chef Takashi Kawamura. His creations alone are worth the trip—try the tuna marinated in green apple wasabi or the dragon roll with eel and shiitake mushrooms. Then there is the sake bar with an amazing selection of sake, including gold-flecked, bubbly, or 30-year-old vintage sakes. No idea what to order? Try the sake sampler (three small shot glasses) or order a banana or ginger-mandarin caipirinha. As *pièce de résistance*, there is the restaurant itself with main courses such as tender grilled duck breast or spicy seared tuna with avocado tempura. The perfect three-part harmony.

Rua Dias Ferreira 78, Leblon. © **021/2512-6526.** www.moksushi.com.br. Main courses R$42–R$70. AE, V. Mon 7pm–1am; Tues–Fri noon–3:30pm and 7pm–1am; Sat noon–1:30am; Sun 1–11pm. Bus: 415.

Sawasdee ★★ THAI Normally it's Rio restaurants that branch out, but in this case Buzios's best Thai restaurant made the trek in to the big city to set up shop in Leblon. The menu includes the tried and tested bestsellers, focusing on fresh, top-quality ingredients. Start off with the spicy chicken satay with peanut sauce or salmon fish cakes with a tangy dipping sauce. For main courses, we highly recommend bringing friends, ordering a variety of dishes, and sharing. Try at least one of the salads, like the mango salad with shrimp, a noodle dish (the pad Thai is outstanding), and perhaps a traditional green or red curry. The kitchen also serves a large variety of vegetarian dishes and prepares several child-friendly versions of Thai classics.

Rua Dias Ferreira 771, Leblon. © **021/2511-0057.** www.sawasdee.com.br. Main courses R$45–R$68. AE, MC, V. Tues–Thurs noon–midnight; Fri–Sat noon–1am; Sun noon–11pm. Bus: 415.

EXPENSIVE
Casa da Feijoada ★ BRAZILIAN There may be restaurants with better *feijoada* in town—there are certainly better-decorated ones—but what they can't offer you is

feijoada any old day of the week. (Brazilian tradition dictates that the full-on *feijoada* meal is only served on Sat.) That's where the Casa da Feijoada comes to the rescue. Get off to a good start with the *caldo de feijão* (bean soup), washed down with a *batida de limão* (lime cocktail) to line your stomach, as the Brazilians would say. Next bring on the actual bean stew, served in a clay pot with whatever meat you've a hankering for, be it sausage, bacon, *carne seca* (dried meat), pork loin, pig's snout, or other more obscure cuts. Side dishes include white rice, stir-fried cabbage, *farofa* (roasted manioc flour), and orange slices. To spice it up, ask for *pimenta*, and they will bring you oil-soaked *malagueta* peppers to drizzle on the beans. Have another lime cocktail standing by in case you underestimate the heat.

Rua Prudente de Moraes 10, Ipanema. ✆ **021/2247-2776.** www.cozinhatipica.com.br. R$37–R$42 main courses; *feijoada* meal R$58 per person, including appetizers, dessert, and a drink. AE, DC, MC, V. Daily noon–11pm. Metrô: General Osorio.

Chez L'Ami Martin ★★ FRENCH This French-style bistro with its bright white and green decor is a great addition to the Rio restaurant scene. The menu ranges from lighter lunchtime fare, such as grilled fig salad, salmon ceviche, croque-monsieur sandwiches, eggs Benedict, and omelets, to more sophisticated creations such as grilled tuna in balsamic glaze, slow-roasted lamb, guinea fowl, and tournedos steak. The small wine list ranges from affordable R$60 to R$85 bottles to the very expensive (just in case you feel like splurging on a R$600 bottle). A more affordable alternative is to order by the glass. Lunchtime guests have the option of the R$48 executive menu, which includes an appetizer, main course, and dessert. For dessert, the *clafoutis* raspberry cake is outstanding! It is served piping hot, with a side order of fresh vanilla cream and raspberry coulis.

Rua General San Martin 1227, Leblon. ✆ **021/2512-8623.** www.chezlamimartin.com.br. Main courses R$32–R$65. AE, DC, MC, V. Mon–Fri noon–4pm and 7pm–midnight; Sat–Sun noon–midnight. Bus: 415.

Gula Gula ★ BRAZILIAN For a lighter, healthier meal, stop in at Gula Gula. The menu includes a selection of pastas, quiches, and fresh salads, such as the quinoa with eggplant, or a chicken Caesar. One of our favorite lunch options is the selection of *grelhados*, grilled steak, fish, or chicken. Each dish comes with a choice of sauce and two side dishes (vegetables, potatoes, rice, or salad). For dessert, you can try one of the low-cal options, but to do justice to the restaurant's name (*gula* means "gluttony"), go for a banana crème brûlée or the rich chocolate brownie.

Av. Gen. San Martin 1196, Leblon. ✆ **021/2294-0650.** www.gulagula.com.br. Main courses R$26–R$39. AE, MC, V. Daily noon–midnight. Bus: 415.

Le Vin Bistro ★★ FRENCH This place offers French bistro cuisine, though perhaps a tad higher end than is normal in Paris. For starters, try the half-dozen oysters, the *mouilles et frites*, or the obligatory escargots, served dripping in garlic and adorned with parsley. For a main course, try the lamb in a red-wine reduction, or steak in béarnaise sauce, with baked potatoes. The wine list has an extensive selection by the glass, a good way to mix and match reds and whites to every dish. For dessert, try the traditional profiterole or petit gâteau. *Et voilà.*

Rua Barão de Torre 490, Ipanema. ✆ **021/3502-1002.** www.levin.com.br. Main courses R$35–R$55. AE, DC, MC, V. Mon–Sat noon–midnight; Sun noon–11pm. Bus: 415.

Zazá Bistrô Tropical ★★ BRAZILIAN/FUSION Zazá is Rio's funkiest eatery, serving up a creative menu of South American cuisine fused with Oriental flavors.

Everything about Zazá is fun, from the playful and eclectic decorations to the unique and excellent dishes. Diners can choose from a table on the terrace or in the dining room. The more adventurous can ask for a spot upstairs where everyone sits on the floor, surrounded by candlelight, leaning back on silk-covered pillows. It feels like a palace from the *Arabian Nights.* The menu offers plenty of choices. Appetizers include a deliciously grilled squid salad served on a bed of greens with an orange vinaigrette, or an order of mini *acarajés* (deep-fried dumplings made of mashed beans and spicy shrimp) served with tomato chutney instead of the usual hot-pepper sauce. Main courses also mix up the flavors. Try the *namorado* fish filet served with a purée of banana and palm heart, or a prawn ravioli served with grilled salmon in a saffron sauce. For vegetarians there is always an intriguing daily special.

Rua Joana Angelica 40, Ipanema. ✆ **021/2247-9101.** www.zazabistro.com.br. Main courses R$28–R$45. AE, DC, MC, V. Sun–Thurs 7:30pm–1am; Fri–Sat 7:30pm–1:30am. Bus: 415.

MODERATE

Delirio Tropical ★ BRAZILIAN Delirio Tropical is perfect for a light and healthy lunch. The menu includes delicious fresh salads such as the *caprese* (a layered tower of sliced tomatoes, basil, and mozzarella), *salpição* (shredded chicken with carrots and corn), pasta salads, and at least six other salads. You can put together a meal with a selection of salads alone, or you can add some grilled meat, or make a choice from the daily hot dish specials, often stuffed cannelloni or roast beef. The sandwich bar serves made-to-order sandwiches, with your choice of bread, filling, and salad. The

RIO'S AVENIDA gourmet

We could probably fill half the Rio section with reviews of restaurants on the **Rua Dias Ferreira.** This windy street on the far edge of Leblon has become a one-stop shop for gourmands. Trendy vegetarians head straight for **O Celeiro** (no. 199; ✆ **021/2274-7843**). You pay by the weight so help yourself to the delicious offerings and grab a spot on the large patio. For pasta there's **Quadrucci** (no. 233; ✆ **021/2512-4551**), which is open for lunch and dinner and has a great patio. In the mood for Asian? Try **Mekong** (on the corner of Rua General Urquizia 188; ✆ **021/22529-2124**) and order from the large selection of Malaysian, Indian, Thai, and Vietnamese dishes.

For fine dining there are a number of options, mostly only open in the evenings. **Zuka** (no. 233; ✆ **021/3205-7154**) offers creative seafood dishes such as crab in phyllo pastry or grilled tuna in a cashew-nut crust. Across the street, you'll find **Carlota** (no. 64; ✆ **021/2540-6821**), chosen by *Condé Nast Traveller* as one of the 50 most exciting restaurants in the world. Chef Carlota opened this Rio restaurant after her original São Paulo digs became the toast of the town. As in the original, her Rio dishes are fresh and creative, but portions are tiny. Farther down on the corner of Rua Rainha Guilhermina is the sushi hot spot of the city, **Sushi Leblon** (✆ **021/2512-7830**). Thursday through Saturday evenings the lines can be long, but most people don't seem to mind the wait. If you're up on who's who in the Brazilian entertainment world, you can pass the time spotting artists and actresses. If a smaller and intimate sushi venue is more your style, check out **Minimok** (no. 116; ✆ **021/2511-1476**). By the same owners as the Mok Sakebar (p. 71), this very stylish hole-in-the-wall serves up a great variety of sushi, sashimi, tempura, and rolls.

service is cafeteria-style; you choose your dishes, load up your tray, and find a seat. This is a perfect brunch spot!

Rua Garcia d'Avila 48, Ipanema. ⓒ **021/3624-8164.** www.delirio.com.br. Main courses R$14–R$32. AE, MC, V. Daily 9am–9pm. Bus: 415.

Frontera ★ INTERNATIONAL For a better than average kilo lunch, step inside Frontera's cozy dining room with exposed brick walls. Dutch chef Mark Kwaks likes to take his guests on a culinary trip around the world and takes great pride in serving up a variety of international dishes. The menu changes regularly, but you can always expect at least a dozen different salads and interesting mains, such as Indonesian fried rice, sushi and sashimi, Thai curry, duck confit, or smoked chicken. You may either pay by the kilo or opt for the all-you-can-eat option for R$39 (not including sushi and sashimi).

Rua Viscone de Pirajá 128, Ipanema. ⓒ **021/3289-2350.** www.frontera.com.br. Main courses R$20–R$39. AE, MC, V. Daily 11:30am–11pm. Metrô: General Osório.

INEXPENSIVE

KURT ★ 🍴 DESSERT So what if Leblon has a higher than average number of dessert shops? This is one we couldn't leave out. German pastry maker Kurt passed away a few years ago but his legacy (and treats) live on in the hands of his grandsons (who obviously inherited the sweet gene; they run the pastry shop the Bakers, p. 69). This tiny shop in Leblon remains one of the best places in town to go for an *apfelstrudel*, pecan pie, or apricot cake. A famous Kurt creation is the "bee sting" (*picada de abelha*), a chocolate cake, the recipe of which is a closely guarded family secret.

Rua General Urquiza 117 (corner of Rua Ataulfo de Paiva), Leblon. ⓒ **021/2294-0599.** www.confeitariakurt.com.br. Everything under R$15. V. Mon–Fri 8am–7pm; Sat 8am–5pm. Bus: 415.

Talho Capixaba ★ BAKERY One of the best bakeries in town, Talho Capixaba draws a crowd from early in the morning until closing with its homemade delicacies. Locals flock here to buy fresh bread, baked goods, cold cuts, cheeses, desserts, and exotic goods like peanut butter. The fabulous deli also serves breakfast, coffee, sandwiches, and snacks in the upstairs lunch room, but for some of the best people-watching in town, nab a spot on the coveted sidewalk tables.

Av. Ataulfo de Paiva 1022, Leblon. ⓒ **021/2512-8760.** www.talhocapixaba.com.br. Everything under R$15. AE, DC, MC V. Daily 7am–10pm. Bus: 415.

Flamengo, Catete, Glória & Santa Teresa
VERY EXPENSIVE

Aprazível ★★ 🏠 BRAZILIAN Much of the charm of this Santa Teresa fixture comes from its setting in a hilltop mansion. Tables spill out over the gardens and patios, offering views of downtown Rio by day, and warm and exotic lighting in the evening. View junkies should ask for a table on the house veranda, or on the patio tables outside by the bar. The food, while good, doesn't quite rise to the same standard. The kitchen serves up an intriguing variation on Brazilian cuisine, using many ingredients from the Nordeste region. Interesting starters include fresh grilled palm hearts, and pumpkin cream soup with prawns. The signature main is the *peixe tropical*, grilled fish in an orange sauce, served with coconut rice and baked banana.

Rua Aprazível 62, Santa Teresa. ⓒ **021/2508-9174.** www.aprazivel.com.br. Reservations recommended. Main courses R$38–R$55. AE, MC, V. Thurs 8pm–midnight; Fri–Sat noon–midnight; Sun 1–6pm. Taxi recommended.

Porcão ★★ BRAZILIAN/STEAK A mass carnivorous orgy, Porcão is where you go not to sample or taste or nibble, but to munch and stuff and gorge yourself on some of the best beef the world has to offer—in this case served up with some of the best views in the world. Porcão is a churrascaria (a chain, in fact; there are several in Rio, but this one has the best view) operating on the *rodízio* system. It's one price for all you can eat (dessert and drinks are extra), and once you sit down, an onslaught of waiters comes bearing all manner of meat (steak cuts, roast cuts, filet mignon, chicken breast, chicken hearts, sausage, and much more) which they slice to perfection on your plate. Oh, and don't forget the nonmeat dishes: Included in your meal is a buffet with dozens of antipasto items, hot and cold seafood dishes, and at least 15 different kinds of salads and cheeses. Alas, no doggy bags allowed.

Av. Infante Dom Henrique s/n, Parque do Flamengo. ℂ **021/2554-8535.** www.porcao.com.br. Reservations accepted. R$85 per person all-you-can-eat meat and buffet. 50% discount for children 6–9, free for children 5 and under. AE, DC, MC, V. Daily 11:30am–1am. Taxi recommended.

Santè ★ 🏠 BRAZILIAN Dining in Santa Teresa is first and foremost about the views and lovely architecture—and Santè has both. As you enter the 160-year-old house, head past the bar to the prime tables on the veranda with fabulous views of Sugarloaf and Guanabara Bay. With an extensive cocktail menu and decent wine list, Santè is a great happy hour destination. Open Thursday through Sunday, the restaurant serves contemporary Brazilian cuisine, but this is no Aprazível. We recommend sticking to the simple dishes they do well, like the eggplant gnocchi, grilled lamb with ravioli, or the rib-eye steak on a bed of black rice with creamy mushroom sauce. For dessert, order the cheese plate or the grilled strawberries. At night the resident DJ spins hip background music.

Rua Hermenegildo Barros 193, Santa Teresa. ℂ **021/3042-2269.** www.espiritosanta.com.br. Main courses R$39–R$55. DC, MC, V. Thurs 6pm–2am; Fri–Sat noon–2am; Sun noon–7pm. Bus: 214 (get off at Curvelo).

Térèze ★★ ASIAN/MEDITERRANEAN Here you'll find sophisticated dining on a hilltop in the heights of Rio's most historic neighborhood, with a view of treetops, colonial houses, and the city and bay below. The menu offers an upscale take on fusion: miso-marinated lamb, grilled and served with wok-fried vegetables, *gyoza* with sweet-and-sour *maracujá* dipping sauce, or grilled *cherne* with cashew tapenade. Desserts can be equally creative, such as the macaroni-shaped chocolates with hazelnut *farofa* and vanilla ice cream. On Thursdays there's a tasting menu, featuring smaller portions and matched wines.

In the Hotel Santa Teresa, Rua Almirante Alexandrino 660, Santa Teresa. ℂ **021/2222-2755.** www.santa-teresa-hotel.com/pt/tereze. Reservations recommended. Main courses R$38–R$65. AE, MC, V. Mon–Fri noon–5pm and 8pm–midnight; Sat noon–midnight; Sun noon–5pm. Taxi recommended.

EXPENSIVE

Emporio Santa Fé ★★ BRAZILIAN/PASTA This lovely two-story restaurant overlooking the Aterro do Flamengo is one of the best restaurants in Flamengo. The ground floor has a small wine bar and a few tables, but you really want to head upstairs and, if possible, grab one of the window tables in the elegant L-shaped dining room. The chef's forte is pasta; all dishes are made fresh and combine some creative flavors. We loved the ravioli with prawns in a leek sauce with mushrooms as well as the *tortele tricolor,* pasta rounds stuffed with smoked ricotta, figs, and Parma ham. Steak lovers have plenty to choose from, including filet mignon medallions with

grilled brie and potatoes, or grilled tournedos in a balsamic jus, served with rice and mushrooms. The wine list has over 400 options covering most of the world's regions, many reasonably priced (under R$70).

Praia do Flamengo 2, Flamengo. ☏ 021/2245-6274. www.emporiosantafe.com. Reservations accepted. R$35–R$65 main courses. AE, DC, MC, V. Sun–Thurs noon–midnight; Fri–Sat noon–2am. Bus: Any bus to Praia do Flamengo.

Espirito Santa ★★ BRAZILIAN Espirito Santa proves there's no great secret to success—a cute restaurant, a great patio looking out over Santa Teresa, and inventive Brazilian cuisine. Chef Natacha Fink hails from the Amazon, and it shows in her menu. The signature starter is the *tambaqui* "ribs"—made of *tambaqui* (a popular Amazonian fish) lightly breaded and served with a pesto of *jambu* herbs. The *mujica de piranha* (piranha soup) is thick and tasty. For salads, there's one with toasted Brazil nuts and a passion-fruit vinaigrette. The classic fish dish is a grilled *namorado* with a cashew crust, served on a bed of grilled fresh palm heart. Meat lovers should try the *bacuri* steak, grilled filet mignon served with a *bacuri* (Amazonian fruit) sauce and mashed sweet potatoes. Or try grilled filet of duck in *açai* sauce. For dessert, there's warm gâteau filled with guava cream and cheese, or ice cream of *cupuaçu*.

Rua Almirante Alexandrino 264, Santa Teresa. ☏ **021/2508-7095.** www.espiritosanta.com.br. Main courses R$28–R$55. AE, DC, MC, V. Mon, Wed, and Sun noon–7pm; Thurs–Sat noon–midnight. Bus: 214, or take the tram, getting off just before the Largo dos Guimarães.

MODERATE

Adega Portugalia PORTUGUESE This simple little bar/restaurant looks out on the Largo do Machado, a graceful Rio urban square. Sample a plate of appetizers—cheese, olives, spiced potatoes, octopus—from the counter deli, order a portion of *frango a pasarinho* (garlic baked chicken wings), or sample a steak or Portuguesa pizza. Make sure to order a chopp beer to go with the munchies.

Largo do Machado 30, Flamengo. ☏ **021/2558-2821.** Reservations not accepted. All items R$15–R$30. MC, V. Mon–Sat 10am–midnight; Sun 10am–6pm. Metrô: Largo do Machado.

Bar do Mineiro ★★ 🍴 BRAZILIAN Minas Gerais is looked on as the source of down-home hearty comfort food. Bar do Mineiro is a little piece of Minas in Santa Teresa. Meals are hearty and portions generous. Appetizers include sausages and *pasteis*—savory pastries with a variety of stuffings, including sausage, cheese, or cabbage. The *frango com quiabo* (stewed chicken with okra) is popular, as is the *feijão tropeiro*, a hearty bean stew with bacon and cassava flour. There's also a very good (and very Carioca) *feijoada*. During peak hours (especially lunch on weekends), crowds spill onto the sidewalk as people enjoy cold beers and flirt with their neighbors while waiting for their tables.

Rua Pascoal Carlos Magno 99, Santa Teresa. ☏ **021/2221-9227.** Main courses R$14–R$28. AE, V. Tues–Thurs 11am–2am; Fri–Sat 11am–3am; Sun 11am–midnight. Bus: 214, or take the tram, getting off at the Largo dos Guimarães.

Estação da República ★ 😊 BRAZILIAN/KILO The Estação is top of the heap in that unique Brazilian category, the kilo restaurant, which serves up a large buffet and charges by weight. It offers a daily selection of at least 20 salads, a range of pastas, pizza, and many Brazilian favorites such as *feijoada* (bean stew), *vatapá* (seafood stew), and *bobó* (shrimp stew). Fancier dishes include carpaccio and sushi. The *pièce de résistance* is the grill in the back of the restaurant where skilled chefs serve you a

Restaurants in Botafogo, Humaitá, Urca, Jardim Botânico & Lagoa

RESTAURANTS

Bar do Adão **14**
Bar Lagoa **18**
Bar Urca **17**
Café Prefacio **15**
Capricciosa **7**
Casa do Filé **12**
Circulo Militar **16**
Couve Flor **2**
Do Horto **1**
Ki **10**
Lorenzo Bistro **3**
Meza Bar **11**
Mil Frutas **6**
Mormaço **5**
Olympe **9**
Oro **8**
Oui Oui **13**
Roberta Sudbrack **4**

choice of beef, chicken, and a wide assortment of fish. You can have your meat nearly raw or very well done; just ask the chef. It's a great place for children; they can see the food and try as much or as little as they like. Make your selection, weigh your plate, and find yourself a seat; drinks are served at your table.

Rua do Catete 104, Catete. ✆ **021/2128-5650.** Reservations not accepted. R$48 per kilo. AE, DC, MC, V. Daily 11am–midnight. Metrô: Catete.

Botafogo, Urca & Humaitá
EXPENSIVE
Casa do Filé ★ STEAK Lots of restaurants in Rio offer beef, but Casa do Filé excels in serving up thick succulent steaks that are seared at a very high temprature. This procedure seals in the flavor and gives the meat a delicious light crust. The *filé* Oswaldo Aranha is served with roasted garlic, the *filé* Boursin is prepared with goat cheese and caramelized figs. You may also put together your own combination with an order of filet mignon and your choice of sauce, such as a creamy Dijon mustard, Gorgonzola, or mushroom sauce. Your order also includes a portion of rice or potatoes, and a side order of grilled vegetables, roasted onions, or salad. The wine list includes an excellent selection of Argentinean and Chilean reds that go quite nicely with the meat. Vegetarians, alas, will find little to their liking on the menu.

Largo dos Leões 111, Humaitá. ✆ **021/2246-4901.** Reservations accepted. Main courses R$37–R$55. AE, DC, MC, V. Tues–Sat 11:30am–midnight; Sun 11:30am–7pm. Bus: 176.

MODERATE
Bar do Adão BOTEQUIM This lovely heritage house in Botafogo houses an excellent bar that serves up the best *pasteis* in town, or the second-best *pasteis,* as the original Bar do Adão in the Zona Norte neighborhood of Grajau first developed their recipe for success. Made out of light fluffy dough, the *pasteis* come in an amazing variety of fillings, are quickly deep-fried, and arrive piping hot at your table. The 60 different flavors include brie and apricot, Gorgonzola and sun-dried tomato, prawns and cream cheese, shiitake mushrooms, and more.

Rua Dona Mariana 81, Botafogo. ✆ **021/2535-4572.** www.bardoadao.com.br. Reservations not accepted. Main courses R$16–R$25. MC, V. Daily noon–midnight. Metrô: Botofogo.

Bar Urca ★ BOTEQUIM This tiny botequim has one of the best views in the city—or does if you make like the locals, and drink your beer and munch from the delicious selection of *pasteis* on the sea wall overlooking Botofogo Bay. (Waiters used to cross the street and serve you *in situ,* but due to a recent crackdown, customers now have to order in the restaurant and carry their wares to the sea wall themselves.) If you do go inside, sit upstairs with a window view and order one of the delicious seafood stews—fish or prawns in a rich broth, with rice and *pirão* on the side. Don't think of drinking anything but beer.

Rua Candido Gaffree 205, Urca. ✆ **021/2295-8744.** www.barurca.com.br. Main courses R$10–R$35. DC, MC, V. Daily 9am–11pm. Metrô: *Integração* from Botofogo.

Café Prefacio CAFE Books. Wine. Food. Food. Books. Wine. No matter how you put the words together, it's a winning combination. This bookstore/cafe (or cafe/bookstore) in the Botofogo cinema zone offers good coffee, wine by the glass, and a simple menu of delicious sandwiches and salads. Seating is at the coffee bar in the front, the mezzanines above the bookshelves, or in the small dining room at the back. Browse the titles while awaiting your order (there's an English-language section, and

a wide selection of art books), or order up a bottle of Argentine malbec (R$40 or so) and stay the night.

Rua Voluntarios de Patria 39, Botafogo. © **021/2527-5699.** www.prefaciolivrarias.com.br. Reservations not accepted. Main courses R$15–R$30. MC, V. Mon–Sat 9am–11pm; Sun 4:30–11pm. Metrô: Botafogo.

Circulo Militar ★★ 🍴 BRAZILIAN Whenever we hanker for dinner and a view we head to the Circulo Militar. This fabulous view of the Sugarloaf and Bay comes courtesy of the Brazilian armed forces. From the tree-shaded patio of a military club in Urca called the Circulo Militar, you look out across a tiny bay full of fishing boats to the sheer solid sides of the Sugarloaf. Civilians are completely welcome. The menu serves up standard Brazilian fare (the two stars are for the view, not for the food) such as the churrasco for two with beef, sausage, chicken, and pork served with fries and rice. In the evenings the kitchen fires up the wood-burning oven and turns out some decent pizzas. There's live music from 8pm onward, Tuesday through Sunday.

Praça General Tiburcio s/n, Praia Vermelha (on the far right, inside the military complex). © **021/2275-7245.** www.cmpv.com.br. Main courses R$24–R$42. No credit cards. Daily noon–midnight. Bus: 107 from downtown, 512 from Ipanema and Copacabana.

Oui Oui ★★ FUSION Better late than never! Tapas has finally made it to Rio at Oui Oui, which has created a wonderful menu of 20 small dishes that can be combined into a very satisfying meal. Start off with a refreshing *moranguito* cocktail (sparkling wine, strawberries, and mint) and a plate of spring rolls stuffed with fresh figs and shredded duck. Other interesting dishes include the vegetable risotto with mascarpone, spicy grilled beef with lemon grass, and the shrimp *moqueca* stew with cashew nuts and mango. The hands-down (and finger-licking) winner was the portion of caramelized spareribs served with a pumpkin and goat cheese purée, topped with toasted almonds. It probably violates the cardinal rule of tapas eating, but next time

JUICE magic

Rio's juice bars are a bit like a magician's hat. You peer into a hole-in-the-wall diner and think there's nothing there, then the guy behind the counter conjures up any kind of fruit juice you care to name, all of it made fresh to order. The menu in these often standing-room-only spots will typically list over 25 different kinds of fruit juice. There are the standards such as passion fruit *(maracujá)*, pineapple *(abacaxi)*, mango *(manga)*, or cashew fruit *(caju)*; there's *carambola* (star fruit), *goiaba* (guava), *jaca* (jack fruit), and *açerola* (red juice from the tiny *açerola* fruit). This is where things get fun. You can mix anything with anything else. Try *laranja com açerola* (orange juice with *açerola*, a very

popular combination); *maracujá com mango;* or *pineapple e guava, cashew e açerola.* Some of these work, some don't. The magicians behind the counter are full of suggestions if you have any doubts. (Brazilians like to mix their fruit juice with milk.) You can also just throw caution to the wind and see what comes out of the hat.

Excellent juice bars include **Big Nectar,** Teixeira de Melo 34A, Ipanema (© **021/2552-3949**; 24 hr.). Five other locations are in Ipanema, Copacabana, and Catete. Or try **Bibi Sucos,** Av. Ataulfo de Paiva 591, Leblon (© **021/ 2259-4298;** www.bibisucos.com.br; daily 8am–2am), with 10 other locations in Rio.

I am not sharing that dish! The wine list is a tad overpriced, but does contain a few good deals such as a South African chenin blanc for R$64.

Rua Conde de Irajá 85, Humaitá. © **021/2527-3539.** Main courses R$19–R$29. DC, MC, V. Tues–Sun 7:30pm–1am. Metrô: *Integração* Botafogo.

INEXPENSIVE

Meza Bar ★★ TAPAS It may be time for a new review category: the gourmet bar. Meza has all the trappings of a hip bar: a beautiful heritage building in trendy Humaitá, modern and funky decorations that spill out over several rooms, a discreet DJ, free Wi-Fi, and awesome drinks. How about a Hot Chip, a *cachaça* or vodka cocktail with watermelon, cardamom, and basil, or the Apple Mojito, with premium rum, lime juice, mint, and caramelized apple? My favorite is the Bordello, sake with peach liqueur, litchi, and basil. There is food and it's light-years ahead of your average pub grub. From the kitchen comes a steady flow of small dishes, like spicy chicken with lime and tequila, tuna tartare with orange and Parmesan crisps, quinoa salad with a grilled squid skewer, or a spicy Thai salad with shrimp and mango.

Rua Capitão Salomão 69, Humaitá. © **021/3239-1951.** www.mezabar.com.br. Main courses R$12–R$17. AE, DC, MC, V. Sun–Wed 6pm–1am; Thurs–Sat 6pm–3am. Bus: 176.

Jardim Botânico & Lagoa

VERY EXPENSIVE

Olympe ★★★ FRENCH Popular host of a culinary TV show, Claude Troisgros still finds time to regularly win awards for the best French cooking in the city and the country. His recipes combine a French approach with ingredients drawn from Brazil. Thus for appetizers there's Burgundy escargots with oven-roasted palm hearts. Mains include roast quail stuffed with *farofa* mixed with raisins, served with a sweet-and-sour *jabuticaba* sauce. Other chefs have tried this approach of course; Troisgros just does it better. There are also more traditional French dishes: oven-roasted rabbit in red wine and chocolate sauce, coquilles St. Jacques with a caviar tapioca. The wine list is high end (nothing much under R$100) and drawn largely from France.

Rua Custódio Serrão 62, Jardim Botânico. © **021/2539-4542.** www.claudetroisgros.com.br. Reservations recommended. Main courses R$55–R$95. MC, V. Mon–Sat 7:30pm–12:30am; Fri noon–4pm. Bus: 572 (from Leblon or Copacabana) or 170 (from downtown).

Oro ★★★ BRAZILIAN Be prepared for quite the show at this new eatery of Rio's talented young chef Felipe Bronze. Start off with a creative appetizer, such as the quail egg tempura with foie gras foam or dehydrated mango cone with raw tuna tartare. Next order a light appetizer, such as the refreshing gazpacho or tuna/watermelon ceviche to save your appetite for things to come. Seafood lovers will enjoy the langoustine with a pistachio cream and fresh palm hearts. The smoked *tambaqui*, an Amazonian fish, is served with a cashew crust and palm heart gnocchi. One of my favorite dishes is the suckling pig; after braising for 30 hours, the tender meat is accompanied by a smoked potato purée and apple compote. The dishes are smaller than a main course, because Bronze likes to encourage his guests to sample a variety of flavors. You can also entrust yourself to his competent hands and order a five- or seven-course tasting menu. Knowledgeable Argentinean sommelier Cecilia Aldaz offers creative pairings for all the dishes. And whatever you do, order ice cream for dessert. It is not only homemade, but table-made, as the fresh ingredients and cream are mixed up with nitrogen right in front of your very eyes.

Rua Frei Leandro 20, Jardim Botânico. ☎ **021/2226-4586.** www.oro.com.br. Reservations recommended. Main courses R$39–R$59. MC, V. Mon–Thurs 7:30pm–midnight; Fri–Sat 7:30pm–12:30am. Bus: 572 (from Leblon or Copacabana) or 170 (from downtown).

Roberta Sudbrack ★★★ BRAZILIAN Maybe it was Sudbrack's 7-year stint as chef at Brazil's presidential palace that inspired her to bring good food to the masses. Although she has no qualms about charging Rio's well-heeled diners R$180 (five courses) to R$240 (eight courses) for a tasting menu, on Tuesday nights dinner will only set you back R$59 and Friday's lunch goes for R$89. Sudbrack prides herself on cooking only with fresh, seasonal ingredients, giving typical Brazilian products a serious makeover. Some examples include the smoked okra with shrimp, *dourado* fish with green corn compote, or beet ravioli. Her small, modern bistro only seats 62 people. Once a month, Roberta Sudbrack also hosts a cooking class. See the website for details.

Rua Lineu de Paula Machado 916, Jardim Botânico. ☎ **021/3874-0139.** www.robertasudbrack. com.br. Reservations recommended. Set menus R$49–R$240. MC. Tues–Thurs 7:30pm–midnight; Fri–Sat 8:30pm–1am; Fri noon–3pm. Bus: 170 or 571.

EXPENSIVE

Capricciosa ★ PIZZA One of Rio's trendiest pizza restaurants, Capricciosa features beautiful people at the tables and a wood-burning oven at the back. This turns out great-tasting pizzas and calzones, including the signature Capricciosa, with tomato, ham, artichoke, mushrooms, bacon, and egg. There's also a delicious cold-cut and antipasto buffet, served with slices of homemade crusty bread, and a selection of pasta dishes. Those who prefer a more low-key and intimate setting can opt for the wine bar, to the left of the busy and bustling main dining room; the menus are the same. Note that a cheap meal this ain't . . . these prices would buy you a juicy steak elsewhere, but that is the price you pay to hobnob with the hip.

Rua Maria Angelica 37, Jardim Botânico. ☎ **021/2527-2656.** www.capricciosa.com.br. Main courses R$28–R$51. AE, DC, MC, V. Daily 6pm–1am (later if it's busy). Bus: 572 (from Leblon or Copacabana) or 170 (from downtown). Also on Rua Vinicius de Moraes 134, Ipanema. ☎ **021/3394-1169.** Metrô: General Osório.

Ki ★★ JAPANESE If you are tired of the same old standard Japanese fare, treat yourself to a night at Ki. The pleasant first-floor dining room, with colorful paper lanterns, has comfortable booths and tables overlooking the street. Settle in with a sampler of sake or a sake cocktail before tackling the vast menu. Start off with an order of sautéed *nira* garlic shoots or breaded oysters with a spicy garlic sauce. Another great choice is the mix of tender grilled mushrooms in a light butter sauce. Then it is time to move on to the sashimi and sushi. You can save yourself time by ordering the Chef Omura special, a selection of the day's freshest fish transformed into a delectable work of art. Delicious a la carte options include the Vitoria Regia sashimi (thin slices of salmon drizzled with herb-infused olive oil) or the *ebi name* (a roll with shrimp tempura and mushrooms). Vegans will be pleased with a special veggie selection of rolls with mushrooms, garlic shoots, and tofu. Desserts are not the kitchen's forte, but if you indulge in as much sushi as we did, you certainly won't mind skipping.

Rua Fonte da Saudade 179, Lagoa. ☎ **021/2535-3848.** www.restauranteki.com.br. Main courses R$39–R$62. DC, MC, V. Mon–Sat 6pm–midnight; Sun 1pm–midnight. Bus: 157.

Lorenzo Bistrô ★ FRENCH/ITALIAN Cute little bistros are hard to find in Rio and this is a real gem, tucked away in a Jardim Botânico side street. Grab a table on the pleasant sidewalk patio or find a spot in the cozy upstairs dining room. The menu offers satisfying French and Italian "comfort food." No fussy, precious haute cuisine, but a decent steak *au poivre* or a traditional steak with *pommes frites* (make sure your fellow diners get a portion or they will steal yours!). Other dishes include boeuf bour- guignon, a hearty coq au vin, or more Italian-inspired options such as risottos, fish, and pasta. Red wine drinkers will be pleased to find a number of good (and afford- able) South American reds and whites.

Rua Visconde de Carandai 2, Jardim Botânico. ✆ **021/2294-7830.** Main courses R$38–R$52. AE, MC, V. Mon–Thurs noon–11:30pm; Fri–Sat noon–12:30am; Sun 1–7:30pm. Bus: 170 or 571.

MODERATE

Bar Lagoa BOTEQUIM In business since 1934 (when it was known as Bar Berlin), this Lagoa institution features a graceful Art Deco interior, cold clear chopp, and a menu drawn from Germany. Favorites include smoked pork with sauerkraut, or bratwurst with a heaping side of potatoes. Since 1987, the bar has been a designated heritage site. Have another chopp, sit back, and toast history.

Av. Epitacio Pessoa 1674, Lagoa. ✆ **021/2523-1135.** www.barlagoa.com.br. Reservations not accepted. Main courses R$18–R$42. MC, V. Daily 6pm–2am. Bus: 119.

Couve Flor ★ BRAZILIAN/KILO The mother of all kilo restaurants, Couve Flor is where it all started in the mid-'80s. Even now that the system has been widely adopted, Couve Flor still goes the extra mile. The menu offers an astonishing range of dishes, including elaborate and interesting options such as rabbit stew, fish *moqueca*, fresh pasta, at least 20 different kinds of salads, and grilled meats. The buffet even offers vegetarian choices such as stroganoff made with soybean "meat." In the evenings Couve Flor also serves a selection of pizzas from a wood-burning oven, and the weekend lunch buffet is legendary with even more dishes and a choice of 15 desserts. The beauty of the kilo system is that you can have a bite of as many dishes as strike your fancy.

Rua Pacheco Leão 724, Jardim Botânico. ✆ **021/2239-2191.** www.couveflor.com.br. Price per kilo: R$42–R$54. DC, MC, V. Mon–Fri noon–4pm and 7–11pm; Sat noon–11pm; Sun noon–9pm. Bus: 572 (from Leblon or Copacabana) or 170 (from downtown).

Do Horto ★ CAFE Half the fun of going to Do Horto is the wonderfully kitsch decor of colorful and creative junk. The menu consists of numerous small dishes that you can mix and match according to your appetite. Share an order of grilled lamb sausage with mint sauce, *bolinhos de aipim* (deep-fried manioc dumplings), or tapioca pizza. The most popular main course is the *bobó de camarão,* a creamy prawn stew, served in a pumpkin. Starting at 9pm on Wednesday through Saturday evenings there is live music, ranging from *forró* to samba and MPB (popular Brazilian music). This is a great place to go for a drink or a snack, rather than a full meal.

Rua Pacheco Leão 780, Jardim Botânico. ✆ **021/3114-8439.** www.dohorto.com.br. Main courses R$23–R$32. DC, MC, V. Tues–Sun noon–2am. Bus: 572 (from Leblon or Copacabana) or 170 (from downtown), get off at corner Rua Jardim Botânico with Pacheco Leão, 10-min. walk or take bus 406 from Flamengo.

Mormaço ★★ BRAZILIAN You will find *galeto* (grilled chicken) restaurants all over town, but Mormaço offers superb quality and selection. Start off with an order of *rolinhos de queijo coalho,* a batch of light crispy cheese rolls served with tangy

branching out **TO BARRA**

Upscale Barra da Tijuca boasts many fine restaurants. However, a number of them are located in less-than-charming shopping centers or far from any other attractions. A noteworthy exception is the small **neighborhood of Jardim Oceânico,** immediately beyond the tunnel that links the Zona Sul to Barra. Unlike the rest of Barra, which features six-lane thoroughfares and sterile high-rises behind large gates, Jardim Oceânico boasts low-rise buildings on tree-lined pedestrian-friendly streets, fine dining, and pleasant sidewalk cafes—especially around Rua Olegário Maciel and Avenida Erico Verissimo.

By far the best restaurant in the neighborhood is modern Italian eatery **Duo** (Rua Érico Veríssimo 690; ✆ **021/ 2484-4547;** www.duorestaurante.com. br; Tues–Sun noon–11pm). The kitchen serves up contemporary dishes, such as sautéed mini squid with truffle essence and white bean purée, black ravioli with cod fish, or sea bass with a potato and olive crust. At night, the cook fires up the wood-burning stoves to prepare his excellent pizzas. Duo's best kept secret is the affordable R$48 lunch special that includes a delicious fresh bread basket, an appetizer, and a main course.

Much less elegant, but very popular, is steak house **O Tourão** (Praça do Ó 116; ✆ **021/2493-4011;** www.tourao. com.br; daily 11:30am–midnight; main courses R$30–R$45). This all-you-can-eat meat restaurant is perfect for refueling after a long lazy day on the beach. If you are in the mood for something lighter, like a fresh fruit juice with a ciabatta sandwich or burger, head to **Balada Mix** (Av. Erico Verissimo 843; ✆ **021/2491-6222;** daily 9am–1am). No day on the beach is complete without a scoop of ice cream, and **Sorvete Italia** (Rua Olegário Maciel 366; ✆ **021/2491-8666;** www. sorveteitalia.com) specializes in fancy gourmet ice cream. Eat outside on the small patio or take a walk down to the beach.

mustard sauce. Then order a grilled chicken with your choice of side dishes. In addition to the standard rice, beans, and french fries, there are various salads, half a dozen potato dishes, and tenderly grilled vegetables such as mushrooms, palm hearts, asparagus, and zucchini. Besides chicken, the menu also includes various steak options and finger-licking-good pork ribs with barbecue sauce. On weekdays, between noon and 4pm, you may also opt for the buffet that includes an order of grilled chicken, beef, or fish with all-you-can-eat side dishes and a small salad bar (R$21–R$28).

Rua Jardim Botânico 595, Jardim Botânico. ✆ **021/3874-4000.** www.galeteriamormaco.com.br. Main courses R$18–R$27. DC, MC, V. Daily noon–1am. Bus: 572 (from Leblon or Copacabana) or 170 (from downtown).

INEXPENSIVE

Mil Frutas ICE CREAM This little store serves some of the best ice cream in town. Everything is made from scratch with all-natural ingredients and no preservatives. The selection is quite overwhelming, but the staff are happy to let you sample a few flavors to help you make up your mind (or confuse you even further). Some of the great options on the fruit side include orange with ginger, passion fruit, raspberry with lime, and mango. The rich and decadent list includes hazelnut, cashew, fig with mascarpone, chocolate with orange, crème brulée, and much, much more.

Rua J.J. Seabra s/n, Jardim Botânico. ☎ **021/2511-2550.** www.milfrutas.com.br. All items R$6–R$12. MC. Daily 10:30am–midnight. Bus: 572 (from Leblon or Copacabana) or 170 (from downtown).

EXPLORING RIO DE JANEIRO

Most visitors to Brazil start or end their visit in Rio de Janeiro. A wise choice. There may be wider beaches in the north, higher mountains in the south, and larger jungles in the Amazon, but nowhere else on earth is there that wonderful combination of white-hot sand and tall green peaks, with a blaze of urban humanity filling all the spaces in between. The beachfront neighborhoods of **Copacabana** and **Ipanema** are great places to soak up the sun and to people-watch. In the historic downtown neighborhoods of **Centro, Lapa,** and **Santa Teresa** you'll find narrow cobblestone streets, grand plazas, gold-covered churches, and buildings of the baroque, Beaux Arts, and Art Deco styles. If you have the energy, Rio's stunning setting offers numerous recreational activities: Hiking, hang gliding, surfing, rock climbing, and kayaking are just a few options. Taking in a game of soccer is an adventure in itself—nowhere are the crowds larger or livelier than at Rio's Maracanã stadium.

SUGGESTED RIO DE JANEIRO ITINERARIES

If You Have 1 Day

If you're like me—a pale-skinned gringo—it's an act of utter insanity on the first day to set foot on the beach during the peak afternoon sunshine. On your first day **hit the beach early.** Enjoy the clear air and an hour or so of tanning in the softer morning rays. Then head up to the **Corcovado** and see Rio laid out below you in all its glory. Stop in for a quick lunch at any of Rio's countless kilo restaurants, then in the afternoon head to **Centro** to explore what you've seen from on high. Wander **old Rio,** making sure to check out the Uruguaiana shopping district, and to poke your head into any one of countless baroque churches. Finish your walk with a nice cold chopp (beer) at a sidewalk cafe in **Cinelândia,** or in the countless patios in the **Arcos do Teles.** Have dinner back in the Zona Sul, at one of the top-notch restaurants in **Leblon.** If it's a Saturday in pre-**Carnaval** season, go see a **samba school rehearsal.** Or find a **botequim** or restaurant that plays music and enjoy Rio until the wee hours.

If You Have 2 Days

On your second day, get some culture. Go see the **Museu de Arte Moderna (MAM),** or if painting's not your thing see the **Museu Histórico Nacional,** the **Forte de Copacabana,** or **Ilha Fiscal.** Have lunch overlooking **Sugarloaf (Pão de Açúcar)** at the **Circulo Militar** in **Urca.** Afterward, work off those calories by climbing up to the Pão de Açúcar's peak. Reward yourself for your efforts by having dinner at the **Porção** on **Flamengo** beach—all-you-can-eat Brazilian barbecue, with a view of the bay and the Sugarloaf thrown in. In the evening, go for a drink, some dancing, and some live Brazilian music at any of a number of spots in **Lapa.**

RIO history 101

Rio was not always the *cidade maravilhosa* (marvelous city) it would become. The town grew up as a shipping center for gold and supplies during Brazil's 18th-century gold rush. In 1762, the colonial capital was transferred from Salvador to Rio, though the city remained a dusty colonial backwater.

In 1808, the Portuguese royal family fled Lisbon ahead of Napoleon's armies and moved the court and the capital to Rio. Accustomed to the style of European capitals, the prince regent and the 12,000 nobles who accompanied him began to transform Rio into a city of ornate palaces and landscaped parks. King João VI's son, Pedro, liked Rio so much that when the king returned to Lisbon, Pedro stayed on and declared Brazil independent.

Rio grew at a phenomenal pace; by the late 1800s it was one of the largest cities in the world. A sizable segment of the population were Brazilians of African descent who brought with them the musical traditions of Africa and the Brazilian Northeast.

A new "low culture" of distinctly Brazilian music began to develop in the city's poorer neighborhoods. The high point of the year for both high and low cultures was the celebration of Carnaval. In palace ballrooms the elite held elaborate costume balls. In the streets, poorer residents staged their own all-night parades. Not until the 1920s did the two celebrations begin to merge. At about the same time, the first road was punched through to Copacabana, and Cariocas (as Rio residents are called) flocked to the new community by the beach.

All of these elements came together in the 1930s with the opening of the Copacabana Palace hotel—a luxury hotel on Copacabana beach with a nightclub that featured exclusively Brazilian music. The 1933 Fred Astaire–Ginger Rogers musical *Flying Down to Rio* portrayed Rio as a city of beach, song, and passionate people.

In the years following World War II, São Paulo took over as Brazil's industrial leader; the federal capital moved inland to Brasilia in the early 1960s. By the 1980s, violence and crime plagued the country, and Rio was perceived as the sort of place where walking down the street was asking for a mugging. Cariocas began to fear for the future of their city.

Fortunately, in the early 1990s, governments began putting money back into basic services and cops were stationed around the city. Public and private owners began renovating the many heritage buildings of the city's colonial core. Rio's youth rediscovered samba, returning to pack renovated clubs in the old bohemian enclave of Lapa. Rio began reaching out to the rest of the world, with successful bids to host the Pan-American games in 2007, followed by soccer's World Cup in 2014 and the 2016 Olympic Summer Games.

If You Have 3 Days

In the morning, take the old streetcar across the **Arcos da Lapa** to the quirky hilltop neighborhood of **Santa Teresa.** See the **Museu Chácara do Céu.** Enjoy the view at the **Ruin Park,** or have lunch in an outdoor cafe. In the afternoon, go **hang gliding.** Soar above the beach, feeling the wind, admiring the mountains and the waves below. Or if that's a bit too much, take a hike in

On the second floor of the Modern Art Museum (MAM), the **Laguiole Restaurant** (© **021/2517-3129**) offers modern decor and inventive cuisine—Brazilian, with a subtle touch of French. And if the prices at the Laguiole give you a turn, head back down the ramp to the museum's ground-floor cafe—operated by the same chef—which offers reasonably priced light snacks, coffee, and desserts.

the rainforest in **Tijuca National Park,** or stroll amid the stately palm trees in the **Jardim Botânico.** In the evening, stroll the walkway round the edge of the **Lagoa,** or people-watch in the nightlife area of Baixo Leblon. Have a snack, a beer, or dinner at one of the many restaurants.

If You Have 4 Days or More

Take Marcelo Armstrong's **Favela Tour** through the huge and hidden neighborhood of **Rocinha.** Or check out the sights in **Niterói** across the bay. Try some extreme sports, like **rappelling** or **rafting.** Or take a gentle tour down the coast to the **Museu Casa do Pontal** and **Grumari beach.** If you've got several days to spare, go inland to the summer capital of **Petrópolis,** or the pretty historical cities of **Paraty** or **Ouro Preto** and **Mariana.** Or else head up the coast to **Búzios** and do some **scuba diving** or just hang out on the long white **ocean beaches.** Lord knows, you could even spend more time on the beach in Rio.

The Top Attractions
CENTRO

Espaço Cultural da Marinha ★ ☺ With a destroyer, a submarine, and some great ship models, the Navy Cultural Center is guaranteed to delight naval and maritime buffs. Inside are countless ship models, including a full-size replica of the royal barge, and smaller-scale models of everything from the *Golden Hind* to primitive Brazilian sailing rafts. Moored outside the museum are the *Riachuelo,* a 1970s-era submarine, and the *Bauru,* a small World War II destroyer. Self-guided tours of these ships run from noon until 5pm.

Av. Alfredo Agache s/n, Centro. © **021/2104-6721.** Free admission. Tues–Sun noon–5pm. Bus: 119 or 415 (Praça XV). From Praça XV turn right and walk 100m (328 ft.) underneath the elevated freeway.

Ilha Fiscal ★ This little ceramic castle afloat on its own island in the bay off Praça XV looks like the dwelling of a fair elfin princess, but in fact was built as the headquarters for the Brazilian Custom Service. Initial plans for a rather prosaic edifice were shelved after Emperor Pedro II intervened, and the result was the tiny jewel box of a building, designed by Adolpho Del-Vecchio. On the inside, alas, this Gothic Revival palace is mostly a small and rather boring museum on the Brazilian navy, which owns the island. The tour lasts about 2½ hours. On weekdays, the trip to the island is by boat, whereas on weekends it's by bus along a causeway.

Av. Alfredo Agache s/n, Centro (behind Praça XV). © **021/2104-6992.** Admission R$10, R$5 children 12 and under. Guided tours only. Departures Thurs–Sun at 1, 2:30, and 4pm. Bus: 415 (Praça XV).

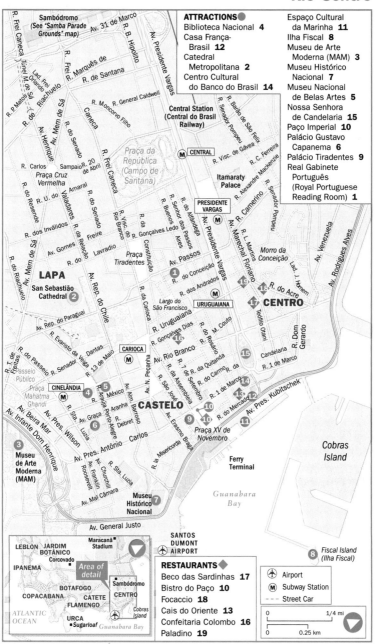

ATTRACTIONS
Biblioteca Nacional **4**
Casa França-
 Brasil **12**
Catedral
 Metropolitana **2**
Centro Cultural
 do Banco do Brasil **14**

Espaço Cultural
 da Marinha **11**
Ilha Fiscal **8**
Museu de Arte
 Moderna (MAM) **3**
Museu Histórico
 Nacional **7**
Museu Nacional
 de Belas Artes **5**
Nossa Senhora
 de Candelaria **15**
Paço Imperial **10**
Palácio Gustavo
 Capanema **6**
Palácio Tiradentes **9**
Real Gabinete
 Português
 (Royal Portuguese
 Reading Room) **1**

RESTAURANTS
Beco das Sardinhas **17**
Bistro do Paço **10**
Focaccio **18**
Cais do Oriente **13**
Confeitaria Colombo **16**
Paladino **19**

⊕ Airport
Ⓜ Subway Station
--- Street Car

0 1/4 mi
0 0.25 km

Museu de Arte Moderna (MAM) ★★ Located in the waterfront Flamengo park, the MAM is a long, rectangular building lofted off the ground by an arcade of concrete struts, giving the museum the appearance of an airplane wing. Inside, the concrete struts do all the load-bearing work, allowing for walls of solid plate glass that welcome views of both city and sea. Displays change constantly, and include Brazilian art and international exhibitions—check the website to see what's on. Signage—a rare bonus—is in both English and Portuguese. The MAM also has a cafe, a bookstore, and a film archive containing over 20,000 Brazilian titles. Allow an hour to 90 minutes. *Tip:* Have a look at the garden from the second-floor patio: The lawn, with its wavy shapes, is the work of Brazil's great landscape architect Roberto Burle Marx.

Av. Infante Dom Henrique 85, Parque do Flamengo (Aterro), Centro. ℃ **021/2240-4944.** www.mamrio.com.br. Admission R$8 adults, R$4 students and seniors, free for children 12 and under. Tues–Fri noon–6pm; Sat–Sun noon–7pm. Metrô: Cinelândia. Bus: 472 or 125 (get off at Av. Beira Mar by the museum's footbridge).

Museu Histórico Nacional ★★ This is the place for anyone looking for a good overview of Brazilian history from Cabral's arrival in 1500 to the present. Housed in the former national armory, the National History Museum features seven permanent exhibits on themes such as early exploration, coffee plantations, and modernism, each illustrated with abundant maps and artifacts. Better still, much of the Portuguese signage comes with often very opinionated English translation. Allow 2 hours.

Praça Marechal Ancora s/n. ℃ **021/2550-9224.** www.museuhistoriconacional.com.br. Admission R$6 adults, free for children 5 and under. Free admission Sun. Wed–Fri 10am–5:30pm; Sat–Sun 2–6pm. Bus: 119 or 415 (10-min. walk from the Praça XV).

Museu Nacional de Belas Artes ★ The National Museum of Fine Art houses an interesting collection of European and Brazilian art, with an emphasis on 19th- and 20th-century work. Allow an hour.

Av. Rio Branco 199, Centro. ℃ **021/2240-0068.** www.mnba.gov.br. Admission R$8. Free admission Sun. Tues–Fri 10am–6pm; Sat–Sun noon–5pm. Metrô: Cinelândia.

Paço Imperial ★ For 2 centuries this was the nerve center of Brazil, serving as vice-regal palace and then as the seat of imperial power from 1808 until the fall of the monarchy in 1888. Nowadays it serves as an exhibition hall for traveling cultural exhibits. A room on the ground floor charts the history of the palace, with maps, paintings, and engravings. Allow about an hour.

Praça XV 48, Centro. ℃ **021/2533-4407.** www.pacoimperial.com.br. Free admission. Tues–Sun noon–6pm. Bus: 119 or 415 (and many others).

COPACABANA & LEME
Forte de Copacabana ★★ This place is simply massive. Built on the eve of World War I, Copacabana Fort boasts walls of reinforced concrete 12m (39 ft.) thick,

and a monstrous 305mm (1 ft.) cannon that could fire a deadly shell 23km (14 miles) out to sea. Inside, rooms contain then-state-of-the-art instruments for targeting and aiming the great guns. Best of all, the bored soldiers guarding the place never leave the gate, so you're free to touch, fiddle, and play as much as you want. Twirl the knobs on the great cannon until its muzzle points toward your hotel, trundle a shell over from the magazine and let fly. Allow an hour.

Skip the **Army History Museum,** also on the fort grounds, an amateurish and laughably biased tribute to the role of the army in Brazilian history. Coup? What coup?

Praça Coronel Eugênio Franco 1, Copacabana. ℂ **021/2521-1032.** www.fortedecopacabana. com. Admission R$4 adults, free for children 9 and under. Tues–Fri 10am–5pm; Sat–Sun 10am–8pm. Bus: 415 to far end of Copacabana Beach.

Forte do Leme ★★ 🏛 This is one of Rio's best-kept secrets. On the top of the 183m (600-ft.) granite rock you get a 360-degree view of Copacabana and Guanabara Bay. The main gate is toward the back of the square at the end of Leme beach. Once inside, you make your way up a cobblestone road that winds around the back of the hill. It's a 20-minute walk through lush forest to the top where you'll be rewarded with a splendid view of Copacabana and beyond. *Tip:* Grab some snacks and drinks from the Zona Sul supermarket in Leme (Av. Atlântica 866) and have a picnic at the top.

Praça Almirante Julio de Noronha s/n, Copacabana. ℂ **021/2275-7696.** Admission R$3. Sat–Sun 8am–4pm. Metrô: Cardeal Arcoverde/*integração* bus to Leme or bus 472.

FLAMENGO, CATETE, GLÓRIA & SANTA TERESA

Museu Carmen Miranda ★ A concrete bunker in a postage stamp–size park surrounded by four lanes of traffic hardly seems a fitting tribute to the flamboyant 1940s film star who created the worldwide mania for bananas and pineapples as headgear. Inside, however, the small collection does a fine job, showing life-size publicity photos and numerous photos illustrating her life and career in music and movies. There's also a large collection of video documentaries, plus all of her movies, and a compilation of her songs. The receptionist is delighted to play these for visitors.

Av. Rui Barbosa s/n (across the street from no. 560), Flamengo. ℂ **021/2334-4293.** Free admission. Wed–Fri 11am–5pm; Sat–Sun 1–5pm. Metrô: Flamengo.

Museu Chácara do Céu ★★ A wealthy man with eclectic tastes, Raymundo Castro Maya had this ultramodern mansion built in the hills of Santa Teresa, then filled it with all manner of paintings, engravings, and drawings. The museum displays

While You're in Santa Teresa . . .

The **Ruin Park** (Parque das Ruinas) in Santa Teresa, next to the Museu Chácara do Céu, was once a sizable mansion belonging to Laurinda Santos Lobo, one of Rio's leading socialites. When the house burned down, the city cleverly reinforced the gutted shell and then installed all manner of ramps and catwalks. Visitors without a fear of heights can now clamber this way and that gaining excellent views of the city in all directions; one lookout at the top provides a 270-degree view of Rio. The park is open Tuesday to Sunday from 8am to 6pm; admission is free.

The perfect spot for a break in Santa Teresa is the **Jasmim Manga Café,** Largo dos Guimarães 143 (ℂ **021/ 2242-2605**). This cute courtyard cafe serves outstanding coffees and desserts.

European painters (Monet, Matisse, Picasso, Dalí) and Brazilian art, particularly 19th-century landscapes. The house itself is a charmer, a stylish melding of hillside and structure that evokes Frank Lloyd Wright's work in the American West. The views from the garden are fabulous.

Rua Murtinho Nobre 93, Santa Teresa. ℰ **021/3970-1126.** www.museuscastromaya.com.br. Admission R$5 adults, free for children 11 and under. Free admission Wed. Wed–Mon noon–5pm. Tram: Curvelo.

Museu da República—Palácio do Catete ★★ This gorgeous baroque palace served as the official residence of Brazilian presidents from 1897 to 1960. The more boring traditional displays preserve the air of the palace in its administrative days. The better exhibits try to engage visitors with the history and politics of the Brazilian republic. The best exhibit is the three-room hagiography of President Getulio Vargas, a curious choice, given that Vargas overthrew the First Republic in a coup in 1930, and killed himself in 1954 while facing impeachment and a likely coup. The exhibit includes the pearl-handled Colt that Getulio used to blast a hole in his heart. The surrounding gardens include a small folklore museum, with free admission.

Rua do Catete 153, Catete. ℰ **021/3235-2650.** www.museudarepublica.org.br. Admission R$6 adults, free for children 10 and under. Free admission Wed and Sun. Tues–Fri 10am–5pm; Sat–Sun 2–6pm. Metrô: Catete.

BOTAFOGO, URCA & HUMAITÁ

Museu do Indio ★★ The Indian Museum's collection is one of the most important in Latin America, with over 30,000 artifacts, papers, and books, and over half a million historical documents on Brazilian Indian tribes. While that sounds a little dry, the museum's exhibits are some of the most innovative and artistic I have seen in a Brazilian museum. In one room the hunt is symbolized by a dark room with just a ray of light illuminating the floor, casting an eerie glow on spears and animal skulls. Signage is in Portuguese, but the exhibits are so vivid they speak for themselves. Allow 1 hour.

Rua das Palmeiras 55, Botafogo. ℰ **021/3214-8702.** www.museudoindio.org.br. Admission R$3 all ages. Free admission Sun. Tues–Fri 9am–5:30pm; Sat–Sun 1–5pm. Metrô: Botafogo.

Sugarloaf (Pão de Açúcar) ★★★ Along with samba, beaches, and beautiful women, the Sugarloaf remains one of the original and enduring Rio attractions. Deservedly so. Standing on its peak, the entire *cidade maravilhosa* lays at your feet: the beaches of Ipanema and Copacabana, the favelas of Babylonia, the Tijuca Forest, Christ the Redeemer on his mountain, the Bay of Guanabara, and the fortresses at the edge of far-off Niterói. It's a truly beautiful sight. The cable car leaves every half-hour from 8am to 10pm daily, more frequently if there are enough people waiting. *Tip:* If you're feeling active, hike up. The trail is challenging, but the rewards! You start just above the crashing waves, and the views just keep getting better as you go. See "Hiking" under "Outdoor Activities" later in this chapter for details.

Av. Pasteur 520, Urca. ℰ **021/2461-2700.** www.bondinho.com.br. Admission R$53 adults, R$26 children 6–12, free for children 5 and under. Daily 8am–9pm. Last ride up at 8pm. Metrô: Botafogo, then catch the *integração* bus marked Urca.

JARDIM BOTÂNICO & LAGOA

Jardim Botânico ★ In the 2 centuries since its founding by Emperor Dom João VI, the botanical garden has grown to 141 hectares (348 acres) and added 6,000 species of tropical plants and trees to its collection. Most visitors come to enjoy the peace and beauty, meandering along the many little paths and garden trails; the bromeliad

and orchid greenhouses are especially nice. Those more scientifically minded may find themselves frustrated. The gardens are run as a research institute under the Federal Environment Ministry, with the result that treatment of visitors is somewhat hit-and-miss. Many trees and shrubs are labeled with common and Latin names, but there's not much more species information. Free English-language guided tours are supposed to be available (call ahead or check in at the visitor center) but the service is sporadic and unreliable.

Rua Jardim Botânico 1008. ℂ **021/3874-1808.** www.jbrj.gov.br. Admission R$5 adults, free for children 7 and under. Daily 8am–5pm. Bus: *Integração* (Jardim Botânico) from Metrô Botafogo.

COSME VELHO

Corcovado ★★★ ☺ The statue of Christ the Redeemer on Corcovado Mountain was recently chosen as one of the new Seven Wonders of the World. The view from the toes of Rio's mountaintop Christ is spectacular: the mountains, the bay, and the city all lay revealed beneath your (his?) feet. It's enough to give you a feeling of omniscience. The statue was intended to mark the 100th anniversary of Brazilian independence in 1922, but in true Carioca fashion it arrived a decade or so late in 1931. Access is via a steep narrow-gauge railway, followed by a pair of escalators that whisk you up to the base of the statue. Allow 2 hours round-trip.

(Train Station) Rua Cosme Velho 513, Cosme Velho. ℂ **021/2558-1329.** www.corcovado.com.br. Admission R$36, free for children 5 and under. Trains depart daily every 30 min. from 8:30am–8pm. Bus: Cosme Velho *intergração* from Metrô Largo do Machado.

FARTHER AFIELD

Feira de São Cristóvão ★★ This entry could just as easily go in the nightlife section, as the Feira Nordestino is essentially one long weekend party, Friday to Sunday, featuring exclusively *forró*, the dance-happy accordion two-step of Brazil's Northeast. Two large stages at either end of this market complex feature alternating bands, while more *forró* bleats out from three or four smaller restaurants in the no man's land between. In addition to the music, there are lots of shops selling Nordestino arts and crafts, and stalls and restaurants offering Northeastern cuisine. **Note:** The inside of the fairgrounds are quite safe, but don't go wandering the surrounding neighborhood after dark. Take a taxi there, and another one home.

Pavilhão de São Cristóvão. ℂ **021/2580-5335.** www.feiradesaocristovao.org.br. Admission R$1 adults, free for children 10 and under. Tues–Thurs 10am–6pm (shops and restaurants only); continuously 10am Fri till 8pm Sun.

Island of Paquetá ★★ ☺ For an old-fashioned day trip visit the island of Paquetá in Guanabara Bay, a favorite destination since the early 1800s, when the Emperor Dom João VI began spending his summers on the island. In some ways not much has changed. No cars are allowed on Paquetá. Visitors toodle about the island on rented bicycles (R$2 an hour) or relax in horse-drawn carriages (R$35 for an hour, including stops). The island's attraction lies not in any one spot, but rather in the conjunction of its quiet pace, cobblestone streets, tree-lined beaches, graceful old summer homes, and wonderful views of the bay. Many visitors stop for a fresh-cooked fish at one of numerous beachside kiosks, but there are a half-dozen restaurants scattered around the island, all acceptable, none outstanding. If you love Paquetá enough to stay overnight, there's the **Hotel Farol** (ℂ **021/3397-0402;** www.hotelfarol depaqueta.com.br) or the **Pousada Paraiso** (ℂ **021/2438-5073**). Though locals swim in most Paquetá beaches, the only ones given a green light by the City of Rio

Exploring What's Beyond the Saucer

From Niemeyer's saucer-shaped museum, it's only a short walk to Niterói's main beach, Icarai, which offers a pleasant stroll and fabulous views of Rio. Niterói's main shopping street, Rua Coronel Moreira Cesar, runs parallel to the beach, 1 block inland. The stretch between Rua Miguel Frias and Rua Otavio Carneiro is lined with boutiques and *galerias* (small shopping centers). Take a break at the bakery and restaurant **Confeitaria Beira Mar,** Rua Coronel Moreira Cesar 149, corner of Rua Pres. Backer (© **021/2711-1070**), or for an excellent kilo lunch try **Buzin,** Rua Pereira da Silva 169 (© **021/2711-5208**), just 2 blocks past Rua Colonel Moreira Cesar. To return to the ferryboats, catch any bus on the waterfront that says BARCAS. You can also catch a van straight to Ipanema via downtown and Copacabana (R$5).

are Praia da Imbuca, Praia de José Bonifacio, and the very pretty Praia da Moreninha. Including the 70-minute ferry ride (each way), allow 4 to 6 hours for the trip.

Island Info: www.ilhadepaqueta.com.br. Ferry (© **021/2533-7524**) departs from Praça XV, R$9 round-trip. Rio-Paquetá departs 5:15, 7:10, 10:30am, 1:30, 4, 5:45, 7, 9, and 11pm. Return ferry Paquetá-Rio departs daily at 5:30, 7, 9am, noon, 3, 5:30, 7:15, 8:30, and 10:15pm. It's a good idea to confirm return times upon arrival in Paquetá.

Jardim Zoológico—Rio City Zoo ★ ☺ If you haven't got time to get to the Amazon, this may be the place to come. Though not huge, the zoo is green, leafy, and pleasant, and has about 2,000 different species on display, most of them Brazilian. It's particularly good for birds. There are toucans (of Fruit Loops cereal fame), macaws, and other colorful tropical species, some in an open aviary so you can walk among them while they fly around. The reptile house and primate displays are also quite good. Some displays are inevitably small and cramped, which may produce cries of pity from your budding environmental activist, but all in all, the zoo does a creditable job reproducing habitats while providing access to the public.

Quinta da Boa Vista s/n, São Cristóvão.© **021/3878-4200.** Admission R$6, free for children less than 1m (39 in.) tall. Tues–Sun 9am–4:30pm. Metrô: São Cristóvão.

Museu Casa do Pontal ★★ The museum's a long way off: an hour's drive from Copacabana along the coastal road past Barra da Tijuca. However, it's a gorgeous location—ocean on one side and mountains on the other—featuring a quirky and intriguing collection of over 5,000 pieces collected by French designer Jacques van de Beuque. The collection's charm lies in the beauty of its naive portrayal of traditional Brazilian life. The thousands of small clay sculptures, woodcarvings, and metal tableaux depict religious and music festivals and farm and family routines. The most astonishing room houses a mechanical diorama representing an *escola de samba* (samba school)—complete with cheering audience—marching in the Carnaval parade.

Estrada do Pontal 3295, Recreio dos Bandeirantes. © **021/2490-3270.** www.popular.art.br/museucasadopontal. Admission R$8 adults, free for children 7 and under. Tues–Sun 9:30am–5pm. No public transit.

Museu de Arte Contemporânea—Niterói ★ Oscar Niemeyer's spaceship design for Niterói's new Contemporary Art Museum has done for this bedroom city what Gehry's Guggenheim did for Bilbao, Spain: put it on the map (at least in Brazil).

Set atop a promontory with a stunning view of Rio, the all-white flying saucer says clearly yet elegantly that here is a landmark structure. As a gallery, however, the museum has serious drawbacks, not least that most of the construction funds were spent on the exterior. Curators bring in a constantly changing selection of Brazilian contemporary art (think abstract sculpture, textiles, and painting) but one can't help thinking the best piece of work on display is the building itself. Allow about an hour.

Mirante de Boa Viagem s/n, Niterói. © **021/2620-2400.** www.macniteroi.com.br. Admission R$5, free for children 7 and under. Tues–Sun 10am–6pm. From Praça XV take the ferry to Niterói, then take Bus 47-B or a short taxi ride along Niterói's waterfront and up the hill to the museum.

Museu Nacional (Quinta da Boa Vista) ★★ This pretty pink palace that was once the home of Brazil's royal family is now home to a vast and varied collection—many items were originally acquired by the Emperor Pedro II and Empress Teresa—including mastodon trunks, a saber-tooth tiger skull, and a monster meteorite cut in cross section so visitors can run their hands across its polished iron-nickel surface. One vast wing devoted to the Brazilian culture contains regional costumes, weapons and masks of aboriginal tribes, whips and saddles from interior cowboys, and much more. The other wing attempts to present all of life, beginning with the smallest protozoa. At press time the museum was undergoing major renovations and some displays may be temporarily closed. The extensive palace grounds are a popular weekend destination for families with children. Allow 2 hours.

Quinta da Boa Vista s/n, São Cristóvão. © **021/2562-6901.** www.museunacional.ufrj.br. Admission R$3 adults, free for children 10 and under. Wed–Sun 10am–4pm. Park daily 5am–6pm. Metrô: São Cristóvão.

Cultural Centers

Casa França-Brasil ★ Right behind the Centro Cultural do Banco do Brasil, the former Customs house now features beautiful exhibit spaces. The lovely neoclassic construction from 1819 has been updated with a movie theater that often screens interesting art films. Their bistro, the Line, makes a great lunch or afternoon tea destination.

Rua Visconde de Itaborai 78, Centro. © **021/2332-5120.** Free admission. Admission for movies or special events. Mon–Fri 9am–6pm. Metrô: Uruguiana.

Centro Cultural do Banco do Brasil ★★ It's worth stepping inside this gorgeous neoclassical building just to gaze up at the soaring domed atrium. Once the headquarters of Brazil's national bank, the building is now one of the city's premier cultural spaces. Inside there's a pleasant cafe, a small bookstore with an excellent selection of art and architecture books (many in English), several small galleries featuring changing art exhibits, and three theaters featuring film, theater, and music. Allow 30 minutes.

Tour du Jour

Rio Hiking (© 021/9721-0594; www. riohiking.com.br) offers an excellent day tour (R$300 per person) that includes a visit to Pedra Bonita for the views (with the option of taking a leap in a hang glider; an additional R$325 per person) followed by a visit to the Museu Casa do Pontal, Sitio Burle Marx, and time for a swim or a walk along Grumari, one of the city's loveliest beaches.

Rua Primeiro de Março 66, Centro. ☏ **021/3808-2020.** Free admission; theaters or events may charge a separate fee. Tues–Sun 10am–9pm. Metrô: Uruguaiana.

Real Gabinete Português (Royal Portuguese Reading Room) ★ This is a temple to books. The interior is four stories tall, capped with a stained-glass cupola and stuffed with over 350,000 volumes, many of them from the 17th and 18th centuries. By showing ID (and maybe filling out a form—it depends on who's working) visitors can request and peruse these books, for as long as the room is open.

Rua Luís de Camões 30, Centro. ☏ **021/2221-3138.** Free admission. Mon–Fri 9am–6pm. Metrô: Carioca or bus 125 to Praça Tiradentes.

Architectural Highlights
HISTORIC BUILDINGS & MONUMENTS

Rio's a great place for architecture buffs, and an even better place to watch what happens when overconfident urban designers set their hands to the task of urban renewal. For a city so blessed with mountains, ocean, and historical roots several centuries deep, Rio's movers and shakers have suffered from a striking sense of inferiority. As a result, various well-meaning Cariocas have since the early 1900s taken turns ripping out, blowing up, filling in, and generally reconfiguring huge swaths of their city in order to make Rio look more like Paris or Los Angeles or, lately, Miami Beach. The results of these various movements are—for better and worse—now and forever on permanent display.

Around Cinelândia

"Rio Civilizes Itself!" Armed with this slogan and a deep envy of what Baron Haussman had done in Paris, engineer-mayor **Pereiro Passos** set to work in 1903, ripping a large swath through Rio's Centro district to create the first of the city's grand boulevards, the **Avenida Central.** So efficient was "Knock-it-down" Passos that the old colonial Rio he set out to demolish can now be found only in the few square blocks around the **Travessa do Comércio** to the north of **Praça XV.** Accessed via the **Arco do Teles**—an arch built in 1790 to allow passage through a commercial building facing the square—it's a charming area of narrow cobblestone streets and gaily painted colonial shops, now much missed by civilized Cariocas.

The boulevard Passos created in its stead, however, was also quite graceful. Now renamed the **Avenida Rio Branco,** it runs from **Praça Mauá** south past the grand neoclassical **Igreja de Nossa Senora da Candelária** to what was then the waterfront at the **Avenida Beira Mar.** The four-story Parisian structures that once lined the street are now found only in photographs, replaced by tall and modern office towers. (Rio Branco remains the heart of Rio's financial district.) The best place to witness the handiwork of these turn-of-the-20th-century Parisizers is on the **Praça Floriano,** referred to by most Cariocas by the name of its subway stop, **Cinelândia.** Anchored at the north end by the extravagant Beaux Arts **Teatro Municipal,** and flanked by the equally ornate **Museu de Belas Artes** and neoclassical **Biblioteca Nacional,** the praça beautifully emulates the proportions, the monumentality, and the glorious detail of a classic Parisian square. The Teatro Municipal was in fact explicitly modeled on the Paris Opera House and inaugurated on Bastille Day (July 14) 1909. In 2009, the theater was beautifully restored to its former glory to celebrate its 100th anniversary. Guided tours are available from Tuesday to Friday at 11am, 1pm, 2pm, and 4pm, and on Saturday at 11am, noon, and 1pm. They cost R$10 per person; there is a Portuguese-speaking guide only.

Around Castelo

The next stage in urban reform came in the early 1920s, when a group encouraged by public health advocate **Oswaldo Cruz,** backed by a development consortium, decreed that the hilltop castle south of Praça XV had to go; the 400-year-old castle was a breeding ground, they said, for pox, plague, and other infectious diseases. In 1922, the castle was blown up, the hill leveled, and—starting in the early 1930s—construction was begun on a series of government office towers inspired by the modernist movement then sweeping Europe. The first of these—then the Ministry of Education and Health but now known as the **Palácio Gustavo Capanema** (Rua da Imprensa 16; no phone)—listed among its architects nearly all the later greats of Brazilian architecture, including **Lucio Costa, Oscar Niemeyer,** and **Roberto Burle Marx,** with painter **Candido Portinari** thrown in for good measure. Supervising as design consultant was Swiss über-modernist Le Corbusier. The result can be underwhelming at first, but that's because 70 years later we've seen a lot of things similar. But when this was built, no one had ever done anything like it. The entire structure is raised on pilings 12m (40 ft.) off the ground, creating an open, airy plaza beneath.

Around Cidade Nova

Knock-it-down Passos had nothing on **Getulio Vargas.** On the national scene, the Brazilian dictator was creating a new quasi-fascist political structure called the Estado Novo; in his capital city, he set about creating a **Cidade Nova** to match. In 1940, on Vargas's personal order, a monster 12-lane boulevard was cut through the city fabric from the beautiful **N.S. de Candelária Church** out through the **Campo de Santana** park to the northern edges of downtown. Anchoring this new megaboulevard was the **Central Station** (known officially as the Estação Dom Pedro II, it's worth popping in to see the Art Deco interior), a graceful modern building with a 135m (443-ft.) clock tower that still stands overlooking the city, providing a much-needed reference point in the northern half of downtown. At the end of the boulevard is the **Sambodromo,** the used-once-a-year permanent Samba Parade Ground created by Oscar Niemeyer. Designed in typically Niemeyer all-concrete style, it stands in the shadow of an elevated freeway, about 1km (½ mile) along Presidente Vargas.

Around Aterro

The next great reconfiguration of Rio came 2 years after the federal capital fled inland to Brasilia. City designers took the huge high hill—**Morro Santo Antônio**—that once dominated the Largo da Carioca, scooped away the earth, and dumped it on the beach from Lapa to Flamengo, creating a vast new waterfront park. On the rather raw spot where the hill once stood there arose the innovative cone-shaped **Catedral Metropolitana,** and at the intersection of the new avenidas **República do Chile** and **República do Paraguai,** a trio of towering skyscrapers, the most interesting of which is the "hanging gardens" headquarters of Brazil's state oil company **Petrobras.** On the waterfront park—officially called Parque do Flamengo but most often referred to as Aterro, the Portuguese word for landfill—designers created new gardens and pathways, a new beach, and a pair of modernist monuments: the **MAM** (Modern Art Museum) and the impressive **Monument to the Dead of World War II.** Not incidentally, the park also bears two wide and fast roadways connecting Centro with the fashionable neighborhoods in the Zona Sul.

PALACES

There aren't a lot of true palaces in Rio, for the simple reason that the aristocracy wasn't around long enough to build many. But as if to make up for this lack of palaces, Brazilians have taken to granting any number of grand structures the appellation "palace." The **Palácio Tiradentes,** Av. Presidente Antônio Carlos s/n (© **021/2588-1411**), for example, was built in 1926, long after the aristocracy had departed. Located at the back edge of Praça XV, this rather overwrought neoclassical structure was built to serve as the Brazilian Federal Legislature, which up until then had been meeting in an old jailhouse. Four years after its inauguration, dictator Getulio Vargas overthrew the government and turned the palace into his ministry of propaganda. Nowadays the building serves as the legislature for the state of Rio de Janeiro.

CHURCHES & TEMPLES

Rio is awash with churches, with some 20 in Centro alone. Likely the most impressive church in Rio is **Nossa Senhora de Candelária ★★**, set on a traffic island of its own at the head of Avenida Presidente Vargas (© **021/2233-2324**). Although a church has stood on the spot since the 1680s, the current clean and simple neoclassical design dates from a renovation begun in 1775. Particularly worth noting are the huge and ornate cast-bronze doors, the ceiling panels telling the story of the church, and the two large Art Nouveau lamps on either side of the pulpit; they look like cast-iron Christmas trees. It's open Monday through Friday from 8am to 4pm, and Saturday and Sunday from 9am to noon. A 10-minute walk from Candelária, on a hill on the far-north corner of downtown, stands the **Mosteiro São Bento,** Rua Dom Gerardo 68. Access is via an elevator on Rua Dom Gerardo 40; it's open daily from 8 to 11am and 2:30 to 6pm. The church itself is a shining example of the Golden Church, the high baroque practice of plastering every inch of a church's richly carved interior in gold leaf. We find it disappointing the way the church forecourt has been transformed into a car park. And the monastery's strategic hilltop has no view whatsoever. Sunday morning Mass features Gregorian chanting by the monks. Service begins at 10am, but arrive early if you want a seat.

Worth a visit and much more centrally located is the **Igreja da Ordem Terceira de São Francisco da Penitencia ★**, Largo da Carioca 5 (© **021/2262-0197**). Set on a hilltop overlooking Largo da Carioca, this and the Church of Santo Antônio next door form part of the large Franciscan complex in the city center. The São Francisco church is simply outstanding: Interior surfaces are filled with golden carvings and hung with censors of ornate silver. It's open Tuesday through Friday 9am to noon and 1 to 4pm.

On a hilltop all its own is the **N.S. de Glória do Outeiro ★**, which can be accessed via the stairway or elevator located next to Rua da Russel 300 (© **021/2557-4600**). It's unique among churches in Rio, thanks to its octagonal ground plan and domed roof. It's open Tuesday through Friday from 9am to noon and 1 to 5pm, and Saturday and Sunday from 9am to noon.

Last and most innovative of Rio's significant churches is the **Catedral Metropolitana ★★**, Av. República de Chile 245 (© **021/2240-2669**). Some dislike this building, finding its shape disconcerting and its interior dark. I love it. At each of the four cardinal compass points, a rectilinear latticework of concrete and stained glass soars upward, tilting inward as it rises. Where they meet at the ceiling there's another stained-glass latticework—a cross—shining softly with light filtered in from the sky.

The form is modern; the feeling is soaring High Gothic. The church is open daily from 7am to 6pm; Mass is held Monday through Friday at 11am and Sunday at 10am.

Note: The neighborhood around the cathedral is best visited on weekdays. The area can be unsafe on weekends when the streets are deserted.

Neighborhoods to Explore

Rio is divided into four zones: **North (Zona Norte)** from a few blocks north of Avenida Presidente Vargas all the way to the city limits; **Center (Centro),** defined narrowly as the old downtown and business section, or known in a broader sense to include older residential neighborhoods like Santa Teresa, Catete, and Glória; **South (Zona Sul),** the beach neighborhoods of Copacabana, Ipanema, Leme, Lagoa, and São Conrado; and **West (Zona Oeste),** which begins in Barra da Tijuca and extends all the way to the far-flung suburbs.

CENTRO ★★

The place where it all began, Rio's **Centro** contains most of the city's notable churches, squares, monuments, and museums, as well as the modern office towers where Rio's white-collar elite earn their daily bread. Roughly speaking, Centro stretches from the **Morro de São Bento** in the north to the seaside **Monument to the Dead of World War II** in the south, and from **Praça XV** on the waterfront east more or less to the **Sambodromo.** It's a compact, pleasantly walkable area; crossing from one side of downtown to the other on foot takes no more than 45 minutes.

Rio (and Centro's) first and most important square is **Praça XV,** located in the center of the city's old waterfront. This is the place where governors and emperors resided, and the site where the Brazilian republic was proclaimed on November 15, 1889. Notable sights around the square include the **Paço Imperial,** and on the north side of the square, the **Arco do Teles.** Walk through this unobtrusive old archway, and you come to a tiny remnant of old colonial Rio, complete with narrow shop fronts and cobblestone streets. The area's main street, the **Travessa do Comércio,** transforms into a lively outdoor patio/pub in the evenings.

Forming the back edge of Praça XV is **Rua Primeiro de Março,** a busy commercial street with a number of churches, including the **Ordem Terceiro do Carmo,** the **Santa Cruz dos Militares,** and near the far end of the street, the massive yet lovely **Nossa Senhora de Candelária.** Continue along Primeiro de Março to the end, and you come to the foot of the hill upon which rests the **São Bento Monastery.** Southward, the Premeiro de Março transforms into **Avenida Presidente Antônio Carlos,** the main street of a not-very-interesting area of government office towers known as **Castelo.**

Continuing west from Praça XV along either the **Rua Ouvidor** or the **Rua Sete de Setembro** takes you to Centro's prime upscale shopping enclave. Its far border is marked (more or less) by the **Avenida Rio Branco.** Created in 1905 as an answer to Paris's Champs-Elysées, Rio Branco is still the city's most desirable commercial address. It runs from the cruise-ship terminal on the **Praça Mauá** southward to the pretty Parisian square known as **Cinelândia.** About halfway along, a block to the east of Rio Branco, lies the large irregular **Largo da Carioca.**

Though not very interesting in itself, the square is useful as a landmark. Above it on a hilltop stands the glorious golden **Igreja de Santo Antônio.** To the north of the

square, from **Rua da Carioca** to the vast, traffic-choked wasteland known on maps as the **Avenida Presidente Vargas,** and from **Avenida Rio Branco** in the east to the **Campo de Santana** park in the west, lies one of Rio's prime walking, shopping, and sightseeing areas. It's an area of narrow, irregular streets, two-story shops, little squares, and charming small churches. Among the chief sights are the **Largo de São Francisco de Paula,** the **Real Gabinete Português (Royal Portuguese Reading Room),** and an old-style tearoom called the **Confeitaria Colombo.** Shopaholics will enjoy the **informal market** centered on the **Uruguaiana** Metrô stop and the bargains to be had elsewhere in the neighborhood.

Looking south, the Largo da Carioca marks the transition from old Rio to new, and from low-rise to high-rise. Toward the east, **Avenida República de Chile** has many of the city's most important commercial skyscrapers, including the landmark **Petrobras** building and the distinctive conical ziggurat that is the **Catedral Metropolitana.** Just south of the modern concrete cathedral, the past makes a token resurgence in the form of the **Arcos da Lapa,** a Roman-style aqueduct that now carries trams south from the city center up to the hilltop neighborhood of **Santa Teresa.**

South and west of Largo da Carioca lies **Cinelândia** (officially called **Praça Floriano**), a Parisian city square faithfully reproduced all the way down to the **Teatro Municipal** and the many sidewalk cafes. Many of the high-rises surrounding the square show the Art Deco and modern touches of buildings from the 1930s and 1940s. Across from the Teatro stands the lovely neoclassical Biblioteca Nacional. It's worth poking your head in just to see the grand entrance hall with staircases extending up through a lofty atrium five floors high.

South again from Cinelândia, making use of a pedestrian overpass to cross a pair of wide and busy roads, you come to the man-made **Parque do Flamengo,** Rio's largest leisure area between downtown and the beaches; the chief sights in the park are the **Museu de Arte Moderna (MAM)** and the soaring concrete **Monument to the Dead of World War II.**

COPACABANA ★★

Beach! The one word comprises everything there is to say about Copacabana, but then it's a word that contains within it an endless variety of human behavior. Four kilometers (2½ miles) long and bright white, Copacabana beach is the stage upon which people swim, surf, jog, preen, make sand castles, sunbathe, and play volleyball. The broad and beautifully landscaped **Avenida Atlântica** runs along the beach's entire length. Running parallel two streets inland, **Nossa Senhora de Copacabana** is the main shopping and commercial street. These two avenues and their many cross streets contain numerous hotels, restaurants, and bars. For more on Rio's beaches, see "Beaches, Parks & Plazas," below.

IPANEMA ★★

The famous stretch of beach immortalized in Tom Jobim's song "The Girl from Ipanema" nestles in between Copacabana, Leblon, and Lagoa. No more than 8 blocks wide in some areas, it is one of the most coveted residential neighborhoods in town. Built mostly after Rio's Art Deco boom, there are very few landmark buildings to speak of; most apartment buildings are nondescript, some downright ugly. What Ipanema does offer is great shopping on **Rua Visconde de Pirajá** and its side streets, an excellent nightlife scene, some terrific restaurants, and of course, the beach—the major recreation area for residents and visitors alike. Joggers and walkers

cruise the black-and-white patterned sidewalk every day of the week, but Sunday is the day to see and be seen when the beachside **Avenida Vieira Souto** is closed for traffic and people cycle, inline skate, and scooter along, at all times showing tans and tight form to advantage.

LEBLON ★★

A smaller and, if anything, trendier version of Ipanema, Leblon sits directly to the east of Ipanema; the dividing line is the drainage canal for the Lagoa, now landscaped into a park called the **Jardim de Ala.** The most significant difference between the two neighborhoods is the street names. The beachside avenue in Leblon is known as **Avenida Delfim Moreira,** while the main shopping street is **Avenida General Martin.** Most of the best restaurants cluster around the end of **Avenida Ataulfo de Paiva** where it meets **Rua Dias Ferreira.**

LAPA

A tiny, funky little neighborhood once known as the "Montmartre of the Tropics," Lapa is easy to find. It's centered at the **Largo da Lapa** at the foot an old picturesque aqueduct known as the **Arcos da Lapa.** In addition to those two sights, Lapa offers some lovely old colonial buildings and—in recent years—an active nightlife scene.

BARRA DA TIJUCA

The Brazilian envy of things American has finally expressed itself in architecture. Though ostensibly part of Rio de Janeiro, Barra (as it's usually called) looks and feels much like an American beach city, like L.A. or Miami Beach. Streets are wide and filled with 4×4s because in Barra—as in L.A.—only somebody who's a nobody walks. Instead, folks here drive—to the beach, to their penthouse apartments, or to the full-size replica of Studio 54 at the **American Center** mall. The only exception is the small neighborhood of Jardim Oceânico, trapped between the beach, mountain, and lagoons, immediately on the other side of São Conrado. Its tree-lined streets, sidewalk cafes, and busy beachfront give it more of a Rio feel than the rest of Barra da Tijuca.

FLAMENGO, CATETE & GLÓRIA ★

Extending south from the Glória Metrô stop to the top end of Botafogo bay, these three neighborhoods once comprised Rio's toniest residential area—that is, until the tunnel to Copacabana opened in 1922. Recently, however, the area's made a comeback as Carioca yuppies and other urban pioneers have discovered the advantages (high ceilings, huge windows, and so on) of the old 19th-century houses, while residents and visitors alike have realized that, thanks to the Metrô, the area is but minutes from both Centro and Copacabana. The main north-south street—known variously as the **Rua da Glória,** the **Rua do Catete,** and the **Rua Marques de Abrantes**—is well worth an afternoon or evening stroll. Particularly pretty is the **Largo do Machado,** at the Metrô stop of the same name. For visitors, the chief attractions in this area include the lovely hilltop **Church of Our Lady of Glória,** the **Catete Park and Palace,** home to the **Museum of the Republic,** lively Flamengo beach, and the extensive **Aterro do Flamengo** park, designed by renowned landscape architect Roberto Burle Marx.

SANTA TERESA ★★

Most hilltop neighborhoods in Rio are favelas—unsanctioned shantytowns. Santa Teresa is anything but—it's a respectable, slightly bohemian neighborhood with a

number of sights to lure visitors. Chief among these is the *bonde,* the old-fashioned streetcar that whisks passengers from downtown over the **Arcos da Lapa** into Santa Teresa. The attractions in the **Museu Chácara do Céu** (p. 89) are worth a visit, and when you're done, wander the neighborhood enjoying the fabulous views, and the mix of modern, colonial, and Art Deco architecture.

Note: The Santa Teresa tram station is not easy to find. It's behind the big "hanging gardens" Petrobras building, on Rua Prof. Lélio Gama, a little street that runs off Rua Senador Dantas. Please note that tram service in Santa Teresa has been temporarily halted to carry out some much needed maintenance and restore the historic line; service is slated to resume in early 2014. A less charming but certainly more efficient connection is the Metrô/bus *integração;* take the Santa Teresa bus from the Cinelândia Metrô station (make sure you purchase the Metrô-*integração* ticket and save the card to present to the bus driver).

BOTAFOGO & HUMAITÁ

The neighborhood of Botafogo reacted to the rise of Copacabana and Ipanema by reinventing itself as a secondary commercial center. Its broad streets contain a number of office high-rises and big retail shopping malls, including the **Shopping Rio Sul,** the first mall to open in the city. The neighborhood is experiencing quite the revival with many new apartments going up and the opening of a several new movie theaters and restaurants. Botafogo has a couple of worthwhile sights of its own, including the **Villa-Lobos** and **Indian museums.** On the border of Botafogo and Humaitá are several fine restaurants and bars, as well as the bustling food fair and nighttime music-jam in the **Cobal Public Market.** Toward the Lagoa, Botafogo becomes Humaitá, home to excellent restaurants and funky bars, and the Cobal, a busy marketplace by day and fun nightlife destination after the shops and market stalls close.

URCA

Urca is the pretty little neighborhood nestled round the foot of the Pão de Açúcar. Partly residential, partly home to a naval training college, the area was built on a landfill during the 1920s, thus accounting for the Art Deco and modern style of many of the neighborhood's buildings. Architecture aside, for nonresidents the only reason to visit Urca is for the views. The first is from the peak of **Sugarloaf (Pão de Açúcar),** reached by cable car from Urca's Avenida Pasteur. The second view can be enjoyed while strolling the sea wall on **Avenida Portugal.** A jutting peninsula, Urca provides an excellent vantage point from which to gaze back at the Rio skyline. And for those who think views go best with something cold, the third and final view spot is from a table at the **Circulo Militar** (p. 79), on the edge of **Praia Vermelha.** The view of the Sugarloaf is without a doubt the best in town.

LAGOA

Lagoa is an odd neighborhood, as the focus is the big lagoon **(Lagoa Rodrigo de Freitas)** that drains into the ocean between Ipanema and Leblon. For the majority of Cariocas, this is primarily a recreation area. They come to walk, cycle, in-line skate, or run the 8.5km (5¼-mile) pathway that circles the lagoon. In the afternoon and evening, the neighborhood's pleasures become more hedonistic as people come to the many waterside kiosks to grab a drink, have some food, or listen to live music.

TIJUCA NATIONAL PARK

Backstopping all of these Zona Sul neighborhoods is the massive **Tijuca National Park.** Mostly mountainous, the 3,300-hectare (8,151-acre) forest was begun in the

1800s as a personal project of the Emperor Dom Pedro II. It's invariably shown on maps as one big swatch of green, but in fact any number of shantytowns (favelas in Portuguese) have taken over parkland, usually in areas adjacent to official city neighborhoods. The park that's left—and there's lots of it—is cut through with excellent walking and hiking trails, many leading to peaks with fabulous views. Climb to the top of the Pico da Tijuca at 1,022m (3,352 ft.) on a sunny day, and beneath your feet you'll have a view of every neighborhood in Rio.

Beaches, Parks & Plazas

BEACHES

Beaches are to Rio what cafes are to Paris. And while each beach has its own particular traits, there are some general rules to help you take the waters like a true Carioca.

BE PREPARED First and foremost: **Get a Brazilian bikini or bathing suit.** No matter how funky or fashionable your swimsuit looked up north, on a Rio beach it's guaranteed to scream *gringo*. And if you're thinking your figure's not quite bikini-ready, relax. In Brazil everybody and their grandma wears a two-piece. (Note, however, that no matter how small they may shrink that top, Brazilian women *never* go topless—that's for the heathen French.)

Second: **Don't be a pack rat.** If you observe your fellow beachgoers you'll note that Brazilians bring neither picnic basket nor backpack full of stuff and gadgets. All you really need is a few beach chairs, a sunshade (both can be rented on the beach), a towel, sunscreen, and enough cash for beer, food, and other incidentals.

Third and most important: **Relax.** Go for a little swim, chat with the one that brung ya or the cutie on the towel next door, have a beer and some snacks, and soak up those rays.

For further discussion of the more subtle social beach-going dynamics, see "Know the Beach Rules," below.

WATER CONDITIONS The beaches facing Guanabara Bay (primarily **Flamengo** and **Botafogo**) are nearly always too polluted for swimming. Thanks to a substantial current, the ocean beaches (**Copacabana, Ipanema,** and **Barra**) are much cleaner, but even so, sometimes after a heavy rain the fecal coli form count rises beyond acceptable levels. The newspaper *Globo* prints a daily beach report listing all beach closings. Consult that or ask at your hotel.

SAFETY ISSUES Another argument for traveling light to the beach is security. You're unlikely to get mugged on a Rio beach in the daytime, but leaving that iPod, wallet, or pocket camera on the sand while you head off for a swim *is* an open invitation to be relieved of your valuables. I would also advise against moonlit strolls by the waterline. At night the sand is dark and deserted; stick to the large sidewalk fronting the beach—it's well lit and patrolled often by the tourist police.

THE BEACHES **Botafogo** and **Flamengo** are fine and picturesque for an afternoon stroll, but too polluted for swimming. Off by itself in Urca, **Praia Vermelha ★** faces the ocean and is often fine. It offers a fabulous view of the Sugarloaf, and next to no tourists. On the other hand, it's completely lacking in waves.

The first of the ocean beaches, **Copacabana ★★** remains a favorite. The wide and beautifully landscaped Avenida Atlântica is a great place for a stroll. (The wavy landscaped sidewalk mosaic is the work of landscape designer Roberto Burle Marx.)

KNOW THE beach RULES

Certain unspoken, gender-specific rules govern the public behavior of men and women on the beach at Ipanema—and by extension, on all Brazilian beaches. What follows is a tongue-in-cheek rundown of beach-going do's and don'ts.

Sunbathing 101: The most important rule is that *nothing* shall come between a man and the raw, hot sand. A man who uses a beach chair, a towel, or a *kanga* is not a man but a gringo, and shall be shunned. A Brazilian man must plant his Lycra-covered butt down in hot white silicon, making sure his lower back and thighs are covered in sticky white grains.

There are certain exceptions. A man may sit on a sheet of folded newspaper. A man may sit on a *tiny* corner of a woman's *kanga*, provided the woman is beautiful and he occupies no more than 3% of the total *kanga* surface. A man may also stand, drinking a *cerveja* (beer), looking around manfully and sharing the company of other men.

A woman must sit on a *kanga*. Beach chairs are also acceptable. Women do not touch the sand, nor do women stand. Women do not join in beach sports such as soccer or foot volley, nor do they plod sweatily down the beach pretending to be joggers. The acceptable positions for women are lounging on their backs, lying dreamily on their bellies, or sitting cross-legged in a circle with at least three other women.

When rising from the sand—or newspaper, or corner of a woman's *kanga*—a man may not brush the sticky white sand from his butt. A woman, when rising from the sand, must brush herself voluptuously, making sure both glutes are thoroughly massaged from waist down to lower thigh. Particular attention must be paid to readjusting the bikini bottom so that it rests comfortably between her butt cheeks.

Water Frolicking 101: Men *must* swim or at least pretend to swim (many

When the feet start to tire, pull up a chair at any of the countless beachside kiosks, grab a chilled coconut or a *cerveja,* and spend some time admiring the picture-perfect view. (The new kiosks also offer modern, clean bathroom facilities, at a cost of R$1.) The far end of the beach near the Forte de Copacabana is where fishermen beach their small craft; it's a good place to find freshly grilled shrimp or other seafood. For those with other fish to fry, the area in front of the Copacabana Palace around the Rainbow kiosk is a well-known gay area.

The *postos* (lifeguard stations) along Copacabana and Ipanema beaches are open daily from 8am to 8pm. They offer first aid (free if needed) and changing and toilet facilities for a charge of R$1. *Postos* are numbered 1 through 11 starting from Leme and ending in Leblon. Cariocas often use them as reference points.

Ipanema Beach ★★★ was famous among Brazilians even before Tom Jobim wrote his song about the tall and tan and young and lovely girl he saw and sighed over. Stretching almost 3km (2 miles) from the foot of the Pedra Dois Irmãos to the Ponta Arpoador, the beach at Ipanema is a strand like nowhere else. Part of the attraction does involve observing the self-confident sensuality with which the Ipanema *garotas* (girls) stroll the sands. (Equal-opportunity purists should note that there's an equivalent amount of male beefcake on hand—it just hasn't inspired any songs or poetry.) But more than anything, Ipanema is a carnival. Watch the games of volleyball or

Cariocas actually don't know how to swim but will fake it). A man who dibbles his toes or contemplates the waves with a far-off look in his eye is not a man but a gringo. Men approach the sea in a series of angry stomps, stopping at the waterline to regard the surf with a steely glare before sprinting forward and diving into a breaking wave. Once immersed, a man may swim farther out, or he may bodysurf. A man may *not* play in the waves.

Women may play in the waves, turning their backs to the surf and giggling as the water breaks over them. This, however, is rare. Generally, a woman dips her toes, advances as deep as mid-calf, and then waits for a breaker, at which time she squats and allows the surf to immerse her bikini bottom. If this is found to be too traumatizing, a woman may also bring a cup to the beach, dip it in the frothy foam and pour the water over various parts of her body,

thoroughly massaging each part for *at least* 30 seconds afterward.

Beach Flirting 101: Men and women do not enter the water together. This is not to say they do not interact. For instance, a man may approach a group of no more than three pretty women sitting cross-legged on their *kangas* and ask them to watch his shorts and sandals while he manfully attacks the ocean. Their agreement obtained, the man will then place his stuff on the sand near their *kangas* and stomp angrily toward the surf, which he will regard with a glare all the more steely for the fact that he knows three pretty women are admiring the manful way he's attacking the elements. The women will ignore him, missing the determined plunge into the roiling surf and the angry stomp back up the beach. But at least they will never call him a gringo!

futvolei (like volleyball, but no hands allowed), beach soccer, surfing, and wake boarding. Vendors stop by selling sarongs (called *kangas* in Brazil), hats, shades, peanuts, beer, cookies, suntan lotion, Styrofoam airplanes, Winnie-the-Pooh books, sticks of grilled shrimp, shelled coconuts, even deep-muscle massages. Claim a piece of sand on Ipanema, and all of life's essentials will come to you.

The section just around the point from Copacabana—called **Praia do Arpoador**—is a prime surf spot and a great location for watching the local dudes take to the waves. One of the surf schools also runs lessons for kids from the local favelas. The area around Posto 8 (opposite Rua Farme Amoedo) is Ipanema's gay section.

Farther down into **Leblon** (still the same beach, just a different name once you cross the canal) you will find the **Baixo Baby.** This play area, equipped by corporate sponsors with lots of playground equipment and beach toys, is a popular gathering place for nannies and parents to watch their kids run around and play with sand.

Off on its own surrounded by mountains, **São Conrado Beach** offers some fine scenery and a (relative) sense of isolation. Its other main claim to fame is as a landing strip for all the hang gliders (*asa delta* in Portuguese) who leap from nearby peaks.

Farther from the city is the beach at **Barra da Tijuca.** The main reason to go out here is if you're a surf-head desperate for a wave. The surfing is said to be the best in Rio, particularly around the Barraca de Pepê (a beach kiosk) where surfers like to

SPECTACULAR—& free—VIEWS

Rio's best two views—from the **Sugarloaf** and the **Corcovado**—are both ticket-charging attractions. But in a city with so much geography it's impossible to fence off everything. What follows are views you get for free.

Smack in the middle of Botafogo is the **Mirante do Pasmado.** It is walkable (enter off Rua General Severino, close to the Shopping Rio Plaza), although it would probably take you at least 30 minutes. A lot easier is to take a taxi up and then walk back down. The views of Sugarloaf, the bay, and the Christ are quite spectacular.

Just a short 3km (2-mile) drive uphill along Estrada da Canoa from the beach at Sao Conrado, the **Canoas Lookout (Mirante de Canoas)** provides a view of São Conrado, Rocinha, and the Pedra Dois Irmaos near Leblon, and looking back uphill, the 630m (2,100-ft.) **Pedra Bonita** from whence the hang gliders

launch. Carry on up the road for 2km (1¼ miles), then turn left on Caminho da Pedra Bonita, and you too can stand by the hang gliders as they launch.

The military fort in Leme (p. 89) offers the most spectacular views of Copacabana, the Bay of Guanabara, and Sugarloaf. At R$3, it's effectively free. The newest spectacular free view can be had from the **Mirante da Paz** (Peace Lookout) at the top of the **Cantagalo Elevator,** Rua Barão da Torre, corner of Rua Texeira de Melo. Built to facilitate access for the residents of the Cantagalo favela, the elevator whisks locals and visitors from the subway station to the viewing platform overlooking Ipanema and Leblon (as you contemplate the view, imagine yourself walking up this hill every day carrying groceries and small kids). The viewing platform is open daily from 8am to 8pm.

gather. The only reason to go even farther beyond Barra is to get to **Grumari,** a lovely small beach set in a nature reserve. Grumari has no high-rises or beachside restaurants, just lush vegetation and a few kiosks by the side of the road. However, don't expect to get away from the crowds even this far out; on weekends the place is packed.

PARKS & GARDENS

In addition to numerous beaches, Rio is also blessed with a variety of parks. On the waterfront near Centro there's **Flamengo Park,** a good place to stroll in the late afternoon if you're looking for a nice view of the Sugarloaf.

Parque da Catacumba (Av. Epitácio Pessoa 3000) sits on the hillside overlooking the Lagoa. A 15-minute uphill trail through the sculpture garden leads to a panoramic lookout.

On the other side of the lagoon, near the Jardim Botânico, lies the **Parque Lage** (Rua Jardim Botânico 414, Jardim Botânico). The park includes various species of Atlantic rainforest flora, but is not as landscaped as the botanical garden. In the center of the property sits a dramatic mansion, built in 1926 by millionaire Henrique Lage, which now houses a lovely cafe and art school. It's open daily from 9am to 5pm.

Just past the northern edge of downtown, the **Quinta da Boa Vista,** the royal family's former country residence, sits on Avenida Bartolomeu de Gusmã, just a short walk from the Sao Cristóvão Metrô stop. It's as delightful now as it was when the royal princesses scampered round the villa gardens. Designed in the Romantic style,

the Quinta da Boa Vista has all the tricks of the gardener's trade: tre̖ small ponds and waterfalls, a grotto, a lookout, even a temple of Apollo. The also home to the city zoo and the national museum (see "The Top Attractions," ea̖ in this chapter). It's open daily from 7am to 6pm.

Last and best, the **Parque Nacional da Tijuca (Tijuca National Park)** ★★ is a wonder. At more than 3,360 hectares (8,300 acres) it's the biggest urban forest in the world and one of the last remnants of Atlantic rainforest on Brazil's southern coast. It's a great place to go for a hike, splash in a waterfall, or admire the view. Among its more special points are the Pico da Tijuca, the Vista Chinesa, and the Pedra da Gávea.

Especially for Kids

There are few things in Rio that *aren't* for kids. Brazilians take their children everywhere—restaurants, bars, even dances—and voice no objection when others do the same. Still, a few places stand out as being especially kid-friendly. First and most obvious is the **beach.** Sun, surf, and sand castles have kind of an enduring kid appeal. For younger children the beach at **Leblon** features the **Baixo Baby,** a free play area equipped with all manner of toys and play stuff geared for toddlers. On Sundays and holidays, the waterfront avenues that line the beaches of Flamengo, Copacabana, Ipanema, and Leblon are closed for cars. With no traffic, the miles and miles of waterfront become the world's best playground. Both adults and children will enjoy the pleasant bustle of Carioca families going for a stroll, and there's plenty of entertainment to boot. You'll find an array of buskers such as jugglers, magicians, musicians, stilt-walkers, and fire-eaters, as well as bike rentals and small electric toy-car rentals. For slightly older kids, the **city zoo** (**Jardim Zoológico,** p. 92) is guaranteed to delight and just possibly to educate. In Catete, the beautiful (if slightly formal) **Parque do Catete** has a *brinquedoteca,* a kind of toy library from which you can loan out toys by the hour for a nominal fee (about R$7 per hour). The much larger **Aterro do Flamengo** has more than enough room for kids to blow off steam; they can play on the beach or have fun in the various playgrounds scattered throughout the park. For more serious adventure, visit Lagoa's **Parque da Catacumba** (p. 104) for some tree climbing, rapelling, or climbing. Few kids can resist the fun of a train—or tram ride. The Santa Teresa tram zooms over a high aqueduct, then snakes through the narrow cobblestone streets. The tram service is suspended for maintenance until early 2014.

Organized Tours

BUS TOURS Gray Line (© 021/2512-9919; www.grayline.com) offers a number of tour itineraries: The 4-hour US$53 walking tour of Rio's historic downtown is a quite reasonable value; the US$65 half-day tours of the Corcovado or Pão de Açúcar are really a bit of a racket, all they're providing is transfer to and from the train station or gondola, at a very hefty markup.

BOAT TOURS Saveiros Tour ★ (© 021/2225-6064; www.saveiros.com.br) offers 2-hour tours of Guanabara Bay aboard an antique wooden fishing schooner. The cost is R$40, children 5 to 10 and seniors R$20, children 4 and under free. Daily departures are at 9:30am from the Glória Marina (taxi recommended).

FAVELA VISITS & VOLUNTEERING Rio's hillside favelas (shantytowns) are huge, complex, and fascinating—a whole other world, in fact—but as an outsider it's

us) to navigate your way through this world. Licensed guide f **Marcelo Armstrong's Favela Tour ★** (© 021/3322-2727 www.favelatour.com.br) knows the territory; he's been doing tours er than any of his competitors. A 3-hour tour to the favelas of Canoas costs R$65 if booked directly, including pickup and drop- f the fee goes to fund a school that tourgoers get to visit.

he police have pacified a number of the favelas in Rio's Zona Sul by forcing ou. he drug gangs and setting up community police programs, you have the option of taking a walking tour through Cantagalo, Chapeu Mangueira, or Dona Marta. **Soul Brasileiro ★★** (© 021/2358-9409; www.soulbrasileiro.com.br) offers a range of walking tours for R$100 to R$160 per person that give visitors a glimpse of the intrinsic architecture and geography of these vibrant communities, but also provide insight into the local culture and traditions. For the community, these tours play an important role in promoting sustainable local tourism. (Part of the proceeds are donated to the projects.)

For a very different tour, experience **Iko Poran**'s community tours (© 021/3852-2916; www.ikoporan.org). This local organization sets up volunteer projects for foreign visitors who would like to help a community organization.

HELICOPTER TOURS Rio is a town where taking the high ground is rewarded. **Helisight** (© 021/2511-2141, on weekends 2542-7895; www.helisight.com.br) offers nine different helicopter sightseeing tours. They start at R$180 per person for a 6-minute circuit around the statue of Christ; for R$420 per person there is a 12-minute flight over the Christ, Botanical Gardens, Rocinha, Lagoa, Leblon, Ipanema, Copacabana, and the Sugarloaf. There is a minimum of three people per flight. Tours depart from Urca Hill (halfway up to the Sugarloaf) and the shore of Lagoa (opposite the rowing stadium in Leblon).

WALKING TOURS Founded by history buffs Priscila and Raul Melo, **Rios de História** (© 021/3283-4583 or 021/9177-1072; www.riosdehistoria.com) runs daily walking tours through historic downtown Rio (R$60 per hour; groups up to 10 people). One of the most interesting walks includes Morro da Conceição, a lovely residential hillside enclave in the heart of downtown. Another great tour takes visitors to several of Rio's historic military fortresses on both sides of the bay and includes a visit to Oscar Niemeyer's flying saucer Modern Art Museum in Niterói (R$90 per person).

Outdoor Activities

Rio Hiking ★★ (© 021/9721-0594; www.riohiking.com.br) is Rio's adventure-sport specialist, offering a range of exciting outdoor sports that take full advantage of Rio's extraordinary geography. Rio Hiking offers **hiking, rock climbing, rafting, ocean kayaking, cycling, hang gliding, horseback riding, scuba diving, surfing** (with lessons), and **rappelling.** Depending on the sport, half-day adventures cost from R$150 to R$190, full-day adventures from R$190 to R$320, guides and transfer to and from your hotel included. The **white water–rafting** trip takes you to a river about 2 hours north of Rio with Class III (and sometimes Class IV) rapids. The descent takes about 3 hours. The cost is R$320. The company also offers 3-day **trekking** trips (see "Trekking," below).

Rio Adventures (© 021/2705-5747 or 8204-7559; www.rioadventures.com) offers a variety of tours and adventure-sport options, including hiking, rappelling, hang gliding, tree canopy tours, and more. On the **rappelling** trip, you drive past

Barra da Tijuca to beautiful Guaratiba, hike for an hour to a cliff undeveloped beach, then rappel down a 377m (115-ft.) rock face. The swim for bit, and head back. The minimum age for this trip is 12. tour involves zipping through the tops of the rainforest trees in love The cost for either tour is R$250 per person for two people, includir and lunch. With a bigger group the price goes down significantly.

BICYCLING Unlike its "mean" city streets, Rio's waterfront is very bike-friendly; bike paths extend from downtown through Flamengo Park, all to way to Urca and along the southern beaches. And best of all, there are no hills! **Bike e Lazer,** Rua Visconde de Pirajá 135, Ipanema (☎ 021/2267-7778), rents bikes by the hour (R$15) or by the day (R$60). **Rio Hiking** offers two half-day guided bike tours of the city. The first involves an easy ride along the beachfront of the Zona Sul. The second, more challenging tour rides through the gorgeous rainforest of the Floresta da Tijuca. The tour costs R$180 per person.

GOLFING Rio's only public golf course is out in Barra da Tijuca. **Golden Green,** Av. Conde de Marapendi 2905 (☎ 021/2434-0696), is a par-3, 6-hole course inside a private condominium but open to the public. The course is open Tuesday to Sunday from 7am to 10pm. The course is floodlighted for evening play. Greens fees are R$60 Tuesday to Friday and R$75 on weekends and holidays. One of the city's best courses (par 5, 18 holes) is the elegant **Gávea Golf Club,** Estrada da Gávea 800, São Conrado (☎ 021/3323-6050; www.gaveagolf.com.br). However, the club—like virtually every golf course in Brazil—is private. The Copacabana Palace Hotel and the Sheraton Rio Hotel are a few of the hotels that have an arrangement allowing their guests to tee off. If you are a golf fiend, check first with your hotel of choice for privileges.

HANG GLIDING For a bird's-eye view of Rio's beaches and mountains, check out **Just Fly Rio ★★** (☎ 021/9985-7540 mobile, or 2268-0565; www.justfly.com.br). Flight instructor Paulo Celani has been flying for more than 25 years and soared in tandem with thousands of people ages 5 to 85. There's no experience or special skills necessary, aside from a willingness to run off a ramp into the open sky. It's one of the most exciting things you can do in Rio, well worth the R$280 per flight, pickup and drop-off included. *Tip:* There's a 10% discount on the price if you call and book with Paulo directly. Also, if you are keen on flying, it's a good idea to contact Paulo on the day you arrive. What may be a great day for the beach may not be the best flying!

HIKING **Rio Hiking ★★** offers guided hiking trips to most of Rio's peaks. The 4-hour Sugarloaf trip, which includes a short stretch of rock climbing, costs R$180. The 6-hour Pedra da Gávea hike offers terrific views, a waterfall in the middle, and an ocean dip at the end. The cost is R$200. Less strenuous is the Tijuca Forest tour, which involves a tour of the forest, stops at a waterfall and a couple of lookouts, and a 2-hour hike to Pico da Tijuca. The cost is R$160, with the option of returning via the fascinating hilltop neighborhood of Santa Teresa. Guides Denise Werneck and Gabriel Barrouin know Rio well, speak excellent English, and are a delight to be with.

JEEP TOURS Open jeep tours give visitors to Rio fabulous unobstructed views of their surroundings. The most popular tour is the 4-hour visit to the Tijuca Forest and includes most of the park's highlights (R$100 per person). There are also tours to the hilltop neighborhood of Santa Teresa, and to the favelas of Rocinha and Corcovado (R$115–R$130 per person). For information and bookings call **Jeep Tour** (☎ 021/2108-5800;** www.jeeptour.com.br).

We've always said that organized trips to the Maracanã are a scam. They charge R$80 to R$100 for a ticket (which costs R$20) and bus transport (to a stadium that's on the Metrô line). Even if you took a cab there and back, you'd still come out ahead. Now that all of Rio's big games are held at Engenhão stadium in the Zona Norte, an organized tour with bus transport has become a much better value.

SEA KAYAKING Get out onto Guanabara Bay. **Rio Hiking** organizes kayaking tours from Praia Vermelha at the foot of the Sugarloaf, traveling out to one of the small islands just off the coast for some snacks and snorkeling. The cost is R$260 for a half-day tour, including transfers, refreshments, and an English-speaking guide.

SURFING Rio has a number of good spots to catch the waves. And if the waves aren't as big as in Hawaii, the water's certainly warmer than Vancouver Island. The surfing beach closest to the main part of Rio is **Arpoador Beach** in Ipanema. Waves are between 1 and 3m (3–10 ft.). São Conrado Beach is off and on. Sometimes there are good 2m (6½-ft.) waves, sometimes it's dead. Out in Barra da Tijuca the main surf beach is **Barra-Meio,** a 1km-long (½-mile) stretch in the middle of the beach (around Av. Sernambetiba 3100). Waves average around 2m (6 ft.). Carry on down that same beach another 6.5 to 8km (4–5 miles), and you come to **Macumba-Pontal,** a 2.5km (1½-mile) beach with waves up to 3m (10 ft.). If you've brought your board and just need transport, there's a **surf bus** that departs the Largo do Machado (on the corner of Rua do Catete, by Drogaria Pacheco) at 7, 10am, 1, and 4pm and goes along Copacabana, Arpoador, São Conrado, and Barra da Tijuca as far as Prainha, past Recreio. Call to confirm departure times (© **021/2539-7555** or 8702-2837; www.surfbus.com.br); tickets cost R$5 each way.

If you're looking for **lessons,** a surf school is conveniently located in Ipanema. The **Escolinha de Surf Paulo Dolabella** (© **021/2259-2320** or 9814-9702 mobile) is in front of the Caesar Park Hotel. The regular lessons are Tuesday and Thursday from 8 to 10am and 3 to 5pm, but you can also arrange for a lesson on the weekends or other days. Drop-in rates are R$60 per hour, including the equipment. However, like true surf dudes, they rarely answer phones; it's best to go find them. **Rio Hiking** (© **021/9721-0594;** www.riohiking.com.br) offers the most hassle-free option, a half-day surf lesson with an English-speaking instructor, plus gear and transportation, for R$240. In Recreio de Bandeirantes, **Surf Cades** (© **021/2490-3271;** www.surfecades.com) offers group and private lessons (R$60 per hour). The **EBC** (**Escola Bodyboarding de Copacabana;** © **021/2236-6676;** www.escolabc.com.br) offers private body-boarding lessons on Copacabana beach; each 90-minute lesson costs R$100.

TREKKING Rio Hiking ★★ offers a number of guided 2- to 3-day treks in the mountains or rugged coast around Rio. Particularly recommended is the 2-day trek in the **Serra dos Orgãos National Park** (R$600), where the Atlantic rainforest is pristine and the views extraordinary. Avid hikers will certainly enjoy the spectacular hikes in Itatiaia National Park. Located about 3 hours from Rio, on the border of the states of Minas Gerais and São Paulo, the park is home to the highest peak in the state, the 2,787m (8,000-ft.) Agulhas Negras. This 3-day trip takes you to some of the region's best scenery and includes a visit to the waterfalls in the lower part of the

national park, a full-day hike to the highest peak in Rio state, and on the third day a 4-hour hike to the stunning rock formations of the Prateleiras (shelves), with an optional rappel. This 3-day package costs R$1,400 per person and includes accommodations, food, specialized guides, and transportation. All you have to bring are sunscreen, hiking boots, warm clothes, and a raincoat.

The Only Spectator Sport in Rio: Futebol ★★★

The best and only true way to experience the world's most popular sport is during a big game. What an experience! At press time, Rio de Janeiro's Maracanã stadium, Rua Profesor Eurico Rabelo s/n (✆ 021/2569-4916), was closed in preparation for the World Cup games; it is slated to reopen in early 2014. In the meantime, all games have been transferred to the modern **João Havelange Stadium,** Rua Arquias Cordeiro s/n, Engenho de Dentro (✆ **021/2597-9775**), locally known as the ***Engenhão.*** Fans arrive a few hours before the game starts—and the world's biggest party begins. Outside, folks drink ice-cold beer. Inside, the *torcedores* (fans) bring out the samba drums and pound away for a good half-hour, psyching themselves up before parading in the banners—huge flags in team colors—to the wild applause of their fellow fans. Then the other team parades in their flags, and your team boos. Then your side sings a song insulting their team. Then their team sings a song insulting your team. Then they unveil a massive *banderão* covering half the stadium. Then your side unveils your *banderão.* Samba drums beat all the while. Eventually after several hours of this silliness a soccer game breaks out. Tickets are quite affordable, ranging from R$10 to R$40.

Rio's top soccer clubs include **Flamengo** (www.flamengo.com.br), **Fluminense** (www.fluminense.com.br), **Botafogo** (www.botafogo.com.br), and **Vasco de Gama** (www.crvascodagama.com). Any game pitting one of these teams against another is worth seeing. To get a feel for what is going on in Carioca soccer, check the sports section of the **www.riotimesonline.com**. Also, any Carioca soccer fan will be able to tell you about any upcoming games that are worth seeing. Even if you don't go to the stadium, it is a lot of fun to join fans at a local bar and watch them watch a heated game over a couple beers.

SHOPPING

If Cariocas had to list their primary joys in life, shopping probably wouldn't come out at the top—there are, after all, beaches, music, and sex to consider—but it'd certainly be in the top five. Even on the beach, vendors peddle an enormous range of products. Elsewhere clothing, shoes, arts and crafts, musical instruments, and other souvenirs can all be had at good prices.

The old downtown neighborhood of Centro offers great deals for clothes and shoes. Fun to explore are the pedestrian streets around **Rua da Alfândega, Rua Uruguaiana,** and **Rua Buenos Aires,** jampacked with hundreds of merchants in small shops side by side. Back in the 1970s, the area was slated to be demolished to make room for a viaduct, but over 1,200 shopkeepers formed a merchant's association and banded together to put a halt to the development. The best days for shopping are Monday through Friday when downtown is full of office workers. More upscale clothing can be found around the **Rua Gonçalves Dias,** with many stores selling Brazilian brand names and local designers.

Botafogo has two interesting shopping centers, the **Botafogo Praia Shopping** and the older **Rio Sul.** Rio Sul was one of the first malls of Rio and is still a very

popular shopping destination. Many Brazilian stores can be found in this mall, and it makes a convenient place to browse and get a sense for brands and prices.

Copacabana, Ipanema, and Leblon don't have any large malls, just boutique malls known as *galerias* in Brazil. The prominent shopping areas are the main streets of the neighborhood. In Copacabana, **Nossa Senhora de Copacabana** is the main shopping street, with the best stores concentrated around the Rua Santa Clara and Rua Figueiredo de Magalhães. The beachfront area also houses a street market on Saturdays and Sundays, selling souvenirs and arts and crafts from various regions of Brazil. For upscale and exclusive shopping in Ipanema, try **Rua Visconde de Piraja,** especially between the **Rua Anibal de Medonça** and **Rua Vinicius de Moraes.** Another popular destination for Rio's well-heeled shoppers is the classy São Conrado Fashion Mall, located in São Conrado, a neighborhood wedged in between Leblon and Barra. Those who prefer megamalls may want to head straight for Barra da Tijuca. This newly developed neighborhood is home to many malls, including the **Barra Shopping**—the largest mall in Latin America.

Hours for small stores and neighborhood shops are typically Monday through Friday from 10am to 7pm, and 9am to 1pm on Saturday. Malls are usually open from 10am to 10pm Monday through Saturday and limited hours on Sunday (2–8pm). In tourist areas shops will often be open on weekends.

While street vendors and markets take only cash, most shops accept one or more type of credit card. Please note that there is a difference between *Credicard* (a brand of credit card) and *cartão* or *cartão de credito* (the generic word for any kind of credit card).

Shopping from A to Z
ANTIQUES
Shopping Cassino Atlantico Attached to the Sofitel Hotel, this 180-store mall specializes in antiques and art galleries. Every Saturday from 11am to 7pm the mall features an antiques fair. Av. Atlântica 4240, Copacabana. ✆ **021/2523-8709.** www.shopping cassinoatlantico.com.br. Metrô: Cantagalo.

ARTS & CRAFTS
Brasil&Cia This Ipanema store specializes in Brazilian arts and crafts, featuring quality artwork made from wood, ceramics, paper, and fibers. Look for the collection of ballerina dolls made from gourds and painted in delicate colors and patterns. Rua Maria Quitéria 27, Ipanema. ✆ **021/2267-4603.** www.brasilecia.com.br. Bus: 472.

O Sol O Sol is run by a nonprofit society dedicated to supporting and promoting the work of regional artists. The collection varies from beautiful but not very portable furniture pieces to portable miniature terra-cotta sculptures, chess sets, and textiles, including carpets and wall hangings. Rua Corcovado 213, Jardim Botânico. ✆ **021/2294-5099.** www.artesanato-sol.com.br. Bus: 572.

Trilhos Urbanos A great little store in Santa Teresa, Trilhos Urbanos sells a variety of Brazilian artwork, including paintings, photographs, and crafts made out of tile, paper, and other materials. Rua Almirante Alexandrino 402, Santa Teresa. ✆ **021/2242-3632.** Tram stop: Largo dos Guimarães.

BEACHWEAR
Blue Man This is my favorite swimwear store. Blue Man is known for its original designs of bathing suits and bikinis, allowing you to mix and match tops and bottoms. Visconde de Pirajá 351, loja 308, Ipanema. ✆ **021/2247-4905.** www.blueman.com.br. Bus: 474. Also in the Rio Sul shopping center and other locations.

Rio has a thriving arts scene, and you can discover the works of new artists at various galleries around the city. **A Gentil Carioca** (Rua Gonçalves Ledo 17; www.agentilcarioca.com.br) represents 18 Brazilian artists and organizes at least eight exhibits a year. **Progetti** (Travessa do Comércio 22; www.progettirio.com) was recently founded by a duo of Italian artists living in Rio. **LGC Arte Contemporanea** (Rua do Rosario 38; © **21/ 2263-7353**) often hosts photography exhibits around a local theme. For details on art galleries, ateliers, and cultural events, see www.mapadasartes. com.br.

Bum Bum This is the place to shop for the infamous Rio bikini. Collections vary constantly, but one thing never changes—the smaller the better. The styles and colors on display will give you a quick feel for the current beach fashions for both men and women. Rua Vinicius de Morais 130, Ipanema. © **021/2521-1229.** www.bumbum.com.br. Bus: 415.

Lenny Niemeyer Lenny Niemeyer, or simply Lenny, is quickly becoming one of Brazil's premier beachwear designers. Nicole Kidman ordered several of her pieces after seeing her elegant and flattering swimwear collection in *Vanity Fair.* Rua Garcia d'Avila 149, Ipanema. © **021/2227-5537.** Also several other locations, including in the São Conrado Fashion Mall. www.lenny.com.br. Bus: 415.

Reserva Often the forgotten sex when it comes to swimwear design, men will find plenty of stylish options to choose from at this Ipanema store. Rua Maria Quitéria 77, Ipanema. © **021/2247-5980.** www.usereserva.com.br. Metrô: General Osório.

BOOKS

Livraria da Travessa With floor-to-ceiling shelves stuffed with books, this store positively invites hours-long browsing sessions. They have a good collection of English-language books, plus children's books and guidebooks. On the mezzanine there's a cafe that serves coffee, sweets, sandwiches, and wines. Rua Visconde de Pirajá 572, Ipanema. © **021/3205-9002.** www.travessa.com.br. Bus: 474 or 128. Also in the Shopping Leblon.

Saraiva Megastore This is practically a department store with DVDs, music, stationery, dictionaries, magazines, and books. Rua do Ouvidor 98, Centro. © **021/2507-9500.** www.saraiva.com.br. Metrô: Carioca. Also in the Shopping Rio Sul and Shopping Botafogo.

CARNAVAL COSTUMES

Casa Turuna For those creative types who want to make their own Carnaval costume, Casa Turuna is the supplier of choice. Established in 1920, this store in Rio's downtown sells everything you can imagine: beads, feathers, sequins, fabric, headdresses, and so much more. Rua Senhor dos Passos 122, Centro. © **021/2509-3908.** www.casaturuna.com.br. Metrô: Uruguaiana.

FASHION
For Men

Hering This is the best known Brazilian brand of basic T-shirts, jeans, shorts, and tank tops in lots of different colors. Most products are 100% Brazilian cotton. Rua Uruguaiana 78, Centro. © **021/2224-3831.** www.hering.com.br. Metrô: Carioca.

Sandpiper Offering trendy and affordable casual wear, this is a great spot for shirts or informal jackets. Like most men's stores in Brazil, they add a few more splashes of color than you may be used to. Rua Santa Clara 75, Copacabana. ✆ **021/2236-7652.** www.sandpiper.com.br. Metrô: Arcoverde.

Siberian For more dressy menswear, check out Siberian. The store sells its own label as well as several other Brazilian labels and focuses on quality clothing at an affordable price. Their fall and winter collection sales offer great bargains for those who live in colder climates and want to pick up some cords or long-sleeved shirts. Rua Lauro Muller 116, Shopping Rio Sul, Botafogo. ✆ **021/2543-2881.** www.siberian.com.br. Bus: 119 or 415.

For Women

Farm This hip store embodies the colorful Carioca fashion spirit with its collection of vibrant, summery clothes in unique designs and eye-catching prints. This is where those girls from Ipanema come to shop. Rua Visconde de Pirajá 365, Ipanema. ✆ **021/2522-0023.** www.farmrio.com.br. Metrô: General Osório.

Folic Folic sells upscale clothing for women over 30; think *Sex and the City* meets Banana Republic. The collection ranges from casual to office wear and evening wear. The store will make any adjustments to your purchases for free to ensure the absolutely perfect fit. The March and August sales at Folic are legendary, as prices drop up to 70%. N.S de Copacabana 690, Copacabana. ✆ **021/2548-4021.** www.folic.com.br. Metrô: Siqueira Campos.

Vertical Shopping This downtown shopping mall features 13 floors of chic boutiques and ready-to-wear fashions, lingerie, swimwear, jewelry, and more, all of it shoehorned in to a tall, thin office high-rise. Elevators take you one floor to the next, and open directly into the shops. Open Monday to Friday 9am to 8pm. Rua Sete Setembro 48, Centro. ✆ **021/2224-0697.** www.verticalshopping.com.br. Metrô: Carioca.

GIFTS & SOUVENIRS

Feirarte If you need to grab some last-minute souvenirs, the two Feirarte markets in Copacabana are ideal. The smaller market operates only on the weekends in front of the Lido park (cross street Rua Rodolfo Dantas). The larger market runs every night from 6pm to 1am on the median, opposite Rua Djalma Ulrich. On offer is the standard array of souvenirs such as T-shirts, jewelry, leatherwork, ceramics, precious stones, bikinis, and paintings. Cobacabana. No phone. Metrô: Cardeal Arcoverde or Cantagalo.

Gilson Martins For fun, colorful, and practical souvenirs, check Gilson Martins's collection of bags. That is, bags in the broad sense, which includes purses, backpacks, wallets, and toiletry bags. His Brasil collection is decorated in yellow and green, often with designs of the Brazilian flag. Visconde de Piraja 462, Ipanema. ✆ **021/2227-6178.** www.gilsonmartins.com.br. Bus: 474. Also Rua Figueiredo de Magalhães 304A, Copacabana. ✆ **021/3816-0552.** Metrô: Siqueira Campos.

Mutações This small eco-design store is packed with lovely—and socially responsible—gifts. You will find embroidered pillowcases, baskets, handmade bookmarks, purses, T-shirts, and much more. Everything is made with natural or recycled products. Largo dos Leões 81, Humaitá. ✆ **021/2537-9324.** www.lojamutacoes.com.br. Bus: 170.

JEWELRY

Amsterdam Sauer This Ipanema location of Brazil's best-known name for gems, jewelry, and semiprecious and precious stones houses both a store and a museum; it's

worth a visit even if you don't plan to buy. The museum shows off many of Mr. Sauer's original finds when he first came to Brazil in 1940 and started working as a miner, gemologist, geologist, and finally as a jeweler. The store offers a wide range of jewelry and loose gemstones including emeralds, aquamarines, imperial topaz (mined only in Brazil), tourmalines, citrines, and Brazilian opals. The staff is friendly and low-pressure. Items can be delivered to your hotel. Rua Visconde de Piraja 484, Ipanema. 🕾 **021/2279-6237.** www.amsterdamsauer.com. Bus: 474.

H. Stern This store in Ipanema is the world headquarters of H. Stern. Specializing in precious and semiprecious stones, the company also owns mines and polishing shops, guaranteeing the quality of their products from start to finish. Rua Visconde de Pirajá 490, Ipanema. 🕾 **021/2274-3447.** www.hstern.com.br. Bus: 474.

O Banquete This small store showcases the collections of at least a dozen Brazilian designers. Many of these contemporary creations are one-of-a-kind pieces and prices are quite reasonable. Visconde de Pirajá 611, store 17, Ipanema. 🕾 **021/2512-1914.** www.obanquete.com.br. Bus: 474.

MALLS & SHOPPING CENTERS
Botafogo Praia Shopping This mall is spread out over seven floors, which makes for a lot of escalator time, but that's the only drawback. There's a good selection of clothing stores. The seventh-floor food court has a pair of excellent restaurants (Kotobuki, Emporium Pax), with gorgeous views of Botafogo beach and the Pão de Açúcar. Praia de Botafogo 400, Botafogo. 🕾 **021/3171-9872.** www.botafogopraiashopping.com.br. Metrô: Botafogo.

Rio Sul One of the largest and most popular malls in the city, Rio Sul is very accessible, located in Botafogo just before the tunnel that goes to Copacabana. With over 450 stores, a movie theater, and an excellent food court, Rio Sul is always busy and a great place to get a feel for Brazilian fashion and prices. Rua Lauro Muller 116, Botafogo. 🕾 **021/2122-8070.** www.riosul.com.br. Bus: 119 or 474.

São Conrado Fashion Mall This is the favorite haunt for Rio's well-heeled and fashion-conscious shoppers. If you are up on Brazilian movie stars and models, this will be the place to spot them! Over 150 stores carry national and international designers. The mall's food court is the best in town, with a number of high-end restaurants. Estrada da Gávea 899, São Conrado. 🕾 **021/2144-4444.** www.scfashionmall.com.br. Bus: 178.

Shopping Leblon Rio's newest mall sits right on the edge of Leblon and Ipanema and offers an elegant shopping experience. The mall offers a great selection of upscale stores and labels. The excellent food court has views of the lagoon and the Corcovado. Rua Afrânio de Melo 290, Leblon. 🕾 **021/3138-8000.** www.shoppingleblon.com.br. Bus: 415.

MARKETS
Feira do Rio Antigo (Lapa Antiques Market) Every first Saturday of the month, the Rua do Lavradio becomes a large bustling outdoor antiques market. Although not quite garage-sale prices, good bargains can still be had. Of course, an event in Lapa wouldn't be complete without samba; there are live music performances in the afternoon. Arrive early if you are serious about bargain hunting. Rua do Lavradio, Lapa. Bus: 464.

Feira Hippie Ipanema In the '60s, this square was the hippie hangout in Rio, and it's still a fun place to browse for arts and crafts. Open every Sunday, rain or shine, 8am to 6pm. Praça General Osorio. No phone. www.feirahippieipanema.com. Metrô: Generaç Osório.

MUSIC

Toca de Vinicius 📖 In the heart of Ipanema, this small temple is dedicated to the god of bossa nova, poet and composer Vinicius de Moraes. The second floor houses a tiny shrine with original manuscripts, photos, even a lock of hair from the great poet himself. Anything related to bossa nova can be found in this tiny store: an impressive collection of CDs and vinyl, songbooks, and (mostly Portuguese) books and magazines on the smooth and mellow sounds of Brazil. Rua Vinicius de Moraes 129, Ipanema. ℂ **021/2247-5227.** Bus: 474.

MUSICAL INSTRUMENTS

The *berimbau*, that wooden string instrument from Bahia, is one of Brazil's most popular souvenirs, but for music lovers there are many more interesting instruments to choose from (most of which are far more portable). The Rua da Carioca (Metrô: Largo da Carioca) has turned into Music Store Central with at least five shops grouped together on its short length. Look for rattles that fit in the palm of your hand, or else pick up a tambourine or small set of drums. The *agôgô* is an interesting-looking double bell used to keep a beat. Guitar players will love the *cavaquinho*, a Brazilian mandolin. It's what gives samba its distinctive twang. For these and more, visit **Musical Carioca,** Rua da Carioca 89 (ℂ **021/3814-3400;** www.musicalcarioca.com.br), **Casa Oliveira Musicais,** Rua da Carioca 70 (ℂ **021/2252-5636**), or **Guitarra Prata,** Rua da Carioca 37 (ℂ **021/2262-9659;** www.aguitarradeprata.com.br).

PERFUME & BEAUTY PRODUCTS

Granado Founded in 1870, Granado has gone from stuffy and old-fashioned to stylish and hip. The deliciously scented soaps in retro packaging are always a popular gift among my friends back home. The store also sells complete lines of bath products, body lotions, and hair care. More recent additions include a line of aromatherapy products, fragrances, pet care, shaving, and skin care products for men. Rua General Artigas 470 (corner of Rua Dias Ferreira), Leblon. ℂ **021/3231-6759.** www.granado.com.br. Bus: 415.

O Boticario This Brazilian success story is known for its fragrances made with flowers and herbs. In recent years, the store has branched out (à la the Body Shop) to include skin-care products and makeup, but the most popular items remain the lightly scented perfumes and soaps for men, women, and children. Various locations including Rua Buenos Aires 220, Centro. ℂ **021/3970-1232.** www.boticario.com.br. Metrô: Uruguaiana.

SHOES

Arezzo If Carioca women had to choose a favorite shoe store, it would undoubtedly be Arezzo. This company always seems to stay just a step ahead of the trends without being too avant-garde, and the prices are reasonable. It also sells a great selection of high-quality leather purses. Various locations, including Rio Sul and Rua Visconde de Pirajá 295, Ipanema. ℂ **021/2513-0783.** www.arezzo.com.br. Bus: 415.

Constança Bastos Consider yourself a real shoe connoisseur if you have already heard of Constança Bastos, the Manolo Blahnik of Brazil. This young designer's shoes

WORDS TO help you THROUGH THE NIGHT

Here's some vocabulary to help you decipher the listings in the newspapers.

Under *Música* or *Show* you will find the listings for live music. Lovers of Brazilian music should look for anything under *Forró, MPB (música popular brasileira), Bossa Nova, Choro, Pagode,* or *Samba.* Listings under *Pista* refer to events at nightclubs or discos. Most listings will include the price of admission: *Couvert* is the cover charge and *consumação* states the drink minimum. It is quite common to have two rates, one for women *(mulher)* and one for men *(homem)*, the latter usually paying more.

Children's programs are listed under *Infantil* or *Para Crianças.* Many dance clubs offer a matinee program on Saturdays or Sundays for teenagers. The days of the week are given in abbreviations: *seg* or *2a* (Mon), *ter* or *3a* (Tues), *qua* or *4a* (Wed), *qui* or *5a* (Thurs), *sex* or *6a* (Fri), *sab* (Sat), and *dom* (Sun).

are perfect for elegant evening wear. Stars like Charlize Theron and Cameron Diaz have recently worn her creations. Constança's latest project has been the creation of a more affordable, casual label called Peach. http://constancabasto.com. Various locations, including the São Conrado Fashion Mall, ℂ **021/2422-0355,** bus: 178; Shopping Leblon, ℂ **021/2511-8801,** bus: 415; the Peach label can be found at the Rio Sul, Av. Lauro Muller 116, ℂ **021/2295-5632,** bus: 119.

Mr. Cat Mr. Cat goes for classic designs, business as well as evening wear, for men and women. All shoes are made of high-quality Brazilian leather. Rua Visconde de Piraja 414, loja D, Ipanema. ℂ **021/2523-4645.** www.mrcat.com.br. Bus: 474. Another branch at Rua Gonçalves Dias 18, lojas D, E, Centro. ℂ **021/2509-1163.** Metrô: Carioca.

SPORTING GOODS

Galeria River Cool central, this is not just one shop but a minimall with at least a dozen sports and outdoor stores that sell skateboards, surf gear, inline skates, and climbing equipment as well as accessories such as clothing, sunglasses, and hiking boots. A great place to pick up tips on where to go, lessons, and local hangouts. Galeria River, Rua Francisco Otaviano, Ipanema. www.galeriariver.com.br. Metrô: General Osório.

RIO AFTER DARK

It's an open question whether Cariocas possess some hidden nightlife gene or whether they've trained themselves for decadence through years and years of practice. Whatever the case, Rio has a lot to keep you busy at night. It starts early and continues very late. Cariocas themselves don't make a big deal about a night on the town: They're happy either heading out for beers or dancing to *forró* music or eating shrimp in some hole-in-the-wall botequim. Head out in the cool early evening for a coconut juice on the beach. Sip it while watching the sunset (in summer around 8pm), then around 9pm stroll over to a patio for a predinner drink, or maybe walk along the pathway by the waterfront in Copa or Ipanema and find a table at one of the new beachfront kiosks. Plan to have dinner around 10pm, to be ready for your evening of dancing around midnight or 1am. (Most places don't even open until

11pm.) If you're in Rio between September and Carnaval, attending one of the **samba school rehearsals** on Saturday night is a must. Otherwise, on a Thursday night see who's playing at some of the hip samba spots in Lapa like the **Rio Scenarium, Carioca da Gema,** or the **Centro Cultural Carioca.** Or just enjoy the scene by the Arcos de Lapa on a Friday night. Of course, there are a number of discos and bars to choose from, and then there are always the botequins, Rio's neighborhood bars. Wherever you wind up, after 3 or 4 hours dancing you may find yourself getting peckish. For a late-night or early-morning snack in Lapa, stop in for some pizza at the lovely upstairs **Pizzaria Carioca da Gema,** Av. Mem de Sá 77 (✆ **021/3970-1281;** www.barcariocadagema.com.br); it's open until at least 4am on weekends. In Leblon, **Pizzeria Guanabara** or **Jobi** are both open until at least 5am on weekends. By the time they throw you out, it'll just be time to wander down to the beach and watch the sunrise, ready for a new morning—and another night—in Rio.

To find out more about listings for arts and entertainment, check the Friday editions of the *O Globo* (www.oglobo.com.br), *O Dia* (www.odia.com.br), or *Jornal do Brasil* (http://jbonline.terra.com.br) newspapers. Available at all newsstands, all three publish a detailed weekly calendar of events, including nightlife, performing arts, concerts, and other events in the city. The Rio tourism agency **Riotur** also publishes a detailed booklet of events in English and Portuguese called *Guia do Rio* or *Rio Guide,* available at its main information center at Av. Princesa Isabel 183 in Copacabana, or call **Alô Rio** at ✆ **021/2542-8080** or 0800/707-1888 for information on events around town; they keep an updated list and their staff speak English.

The Performing Arts

The performing-arts season in Brazil runs from early April until early December. April is a particularly good time—the equivalent of the Northern Hemisphere's September—as theaters and companies unveil their programs and kick off their season premières.

Centro Cultural do Banco do Brasil The two theaters in the center host regular recitals, concerts, dance performances, films, and Portuguese-language theater. There are also regular photography and art exhibits in the center's small exhibition rooms. Check the website for more information. Rua Primeiro de Março 66, Centro. ✆ **021/3808-2007.** www.cultura-e.com.br. Admission varies from free to R$30. Exhibits are always free. Metrô: Uruguaiana.

Teatro Municipal Brazil's prime venue for the performing arts, the elegant Parisian-style Teatro Municipal stages everything from opera to ballet to symphony concerts. The theater's ballet corps and symphony orchestra perform regularly throughout the year, and the theater also hosts many visiting companies. Besides the formal programming, the theater also offers an inexpensive noon-hour opera series (*opera do meio-dia*) and Sunday morning concerts starting at 11am for R$5. Praça Marechal Floriano s/n, Centro. ✆ **021/2332-9195.** www.theatromunicipal.rj.gov.br. Ticket prices R$15–R$70 on most performances. Metrô: Cinelândia.

Teatro Rival This small theater has just received a major overhaul and is a great venue for seeing local and popular national acts, mostly of MPB. Ticket prices are quite reasonable. You may be looking at the next Marisa Monte or another of Brazil's many talented performers who haven't made it big internationally. Rua Alvaro Alvim 33, Centro. ✆ **021/2240-4469.** www.rivalpetrobras.com.br. Ticket prices R$10–R$60. Metrô: Cinelândia.

The New Lapa: Gamboa

Just beyond the Praça Mauá, close to the port, lies one of Rio's older neighborhoods, **Gamboa.** It features lovely 19th-century buildings, pretty squares, and a fascinating history (it served as Rio's slave market and was also the likely birthplace of samba). It's also on the cusp of an urban revival similar to Lapa's 10 to 15 years ago. The pioneer was **Trapiche Gamboa,** Rua Sacadura Cabral 155 (℗ **021/2516-0868;** www.trapichegamboa.com; closed Sun–Mon). Taking up a gorgeous three-story building from 1856, it has been transformed into a fabulous live-music venue playing, what else, samba. Another popular destination is the **Week,** Rua Sacadura Cabral 154 (℗ **021/2253-1020;** www.theweek.com.br), one of Rio's hottest new gay dance clubs. Keep an eye on this area as new places seem to open up every couple of months.

Music & Dance Clubs

In most clubs and discos you can expect to pay a cover charge. Women usually pay less than men; you'll see the two prices listed at the door. Often there is also a drink minimum which can go up as high as R$120 at upscale Ipanema clubs. In most venues you are handed a paper card or electronic swipe card upon entry that is to be used to record all your purchases. The bill is then settled when you leave. A 10% service charge will be included, and a tip on top of that is not required. Hang on to your card for dear life. If you lose it you'll be charged an astronomical fee.

LIVE MUSIC

Many small *chopperias* and botequins (see "Bars & Pubs," below) will often have a singer or small combo playing. Usually there's a small cover charge (*couvert* in Portuguese) for this entertainment. By sitting down and listening you're agreeing to foot the bill. The fee is automatically added to your tab. If you want to know what the *couvert* is before deciding to stay, simply ask the waiter. The key phrase is *"Quanto é o couvert?"* ("How much is the cover?").

Carioca da Gema One of the best little venues in town, Carioca da Gema offers all samba all the time. Even on weeknights when many other places are closed or slow, Carioca da Gema is often hopping. The busy nights are Friday and Saturday when latecomers will be left with standing room only. The show normally kicks off at 9pm, so come early if you want to grab a spot close to the stage, and enjoy a bite to eat while waiting for things to heat up. Open nightly. Rua Mem de Sá 79, Lapa. ℗ **021/2221-0043.** www.barcariocadagema.com.br. Cover R$15–R$25. Bus: 464.

Centro Cultural Carioca ★★ This beautifully restored building from the 1920s (just off the Praça Tiradentes) makes a great live-music venue. Housed on the second floor, the Centro Cultural hosts local musicians and big names who specialize in samba, MPB, *choro,* and *gafieira.* The room is cozy and intimate, and guests sit at small tables to watch the shows. Usually open every night; check the schedule for up to date programming. Rua do Teatro, Centro. ℗ **021/2252-6468.** www.centroculturalcarioca.com.br. Cover varies, usually R$15–R$25. Bus: 125 to Praça Tiradentes.

Circo Voador This large tentlike structure (the name translates as "flying circus") is located right beneath the aqueduct in Lapa. Modeled after the original 1980s *Circo*

Bars and clubs have their moments, and so do neighborhoods. Lapa is definitely on the rise again. In the roaring 1920s, Lapa's vibrant nightlife earned it the nickname "Montmartre of the Tropics." It fell on hard times in the 1950s and 1960s, but in the last few years Lapa has undergone a major revival, as even Cariocas from trendy Ipanema and Leblon come here to party. On weekends things get really hopping. On Friday and Saturday, starting at 10pm, the two main streets that run from the aqueduct toward downtown are closed to traffic for a 6-block stretch giving the throngs of partyers more space to safely move about. Lapa's nightlife consists of two different kinds of experiences. There are the carefully preserved heritage buildings turned music venues such as Carioca da Gema, Mas Será o Benedito, Rio

Scenarium, and Café Sacrilégio that offer some of the best samba in town. Then there is the much grittier street scene, centered around the Rua da Lapa and the parallel-running Rua Joaquim Silva. These two streets are a major *point* where mostly young people come to drink, chat, flirt, and dance. The small music venues on the Rua Joaquim Silva are anything but nicely renovated (some are big-time sleazy), but half the fun is walking around and poking your head in (cover rarely exceeds R$5). In a 2-block range you will hear anything from reggae to samba to *brega*, hip-hop, funk, and salsa. The square in front of the arches is packed with food and drink stalls. As long as you stick to the main streets that have lots of people on them, the area is quite safe at night.

that was the venue for avant-garde, up-and-coming artists, the new Circo Voador is one of the most eclectic venues in town, offering everything from samba and *pagode*, to house and funk. The open structure is perfect for Rio's tropical climate and a large outdoor patio allows you plenty of space to take in the music under the stars, with the rumbling of the streetcar on the arches overhead for company. Rua dos Arcos s/n, Lapa. ✆ **021/2533-0354.** www.circovoador.com.br. Cover depends on event, R$20–R$80. Bus: 464.

Clube dos Democraticos This is an old-style dance hall with a vast wood floor and a long stage where a dozen or so musicians strum and pluck and sing the sounds of samba or *forró*. It gets packed here, but couples on the dance floor still strut their stuff. For those not dancing, there are lots of tables and balcony windows that look out over the street. Wednesday is *forró* night, Thursday is samba, and Friday and Saturday feature a mix of Brazilian music. Rua Riachuelo 91, Lapa. ✆ **021/2292-5504.** www. clubedosdemocraticos.com.br. Cover R$15–R$25. Bus: 464.

Fundição Progresso Lapa's largest converted venue draws big Brazilian and international artists and hosts a variety of interesting music events. Housed inside a former foundry, the venue lacks charm and offers standing room only. However, if you don't mind a hint of post-apocalyptic chic it is worth checking the concert schedule for upcoming acts. Concerts usually start pretty late, often not before midnight. Rua dos Arcos 24, Lapa. ✆ **021/2250-5070.** www.fundicaoprogresso.com.br. Ticket prices vary. Bus: 464.

Mas Será o Benedito This live samba venue takes up three floors of a big red renovated Lapa mansion: The first floor is a *pé sujo* bar, floor two is for pool, and on the third floor there's another bar, a dance floor, a stage, and live samba. It's a great space, good music, and an agreeable crowd. Plus there's cold chopp draft and a good menu of

snacks and munchies. Open Tuesday and Thursday through Saturday; music starts around 10pm. Av. Gomes Freire 599, Lapa. ☎ **021/2232-9000.** Cover usually R$15–R$20. Bus: 464.

Rio Scenarium ★★★ ✋ It may seem like a contradiction to give the Rio Scenarium both three stars and an overrated at the same time but let me explain. The Rio Scenarium is probably the most beautiful bar in Rio and always offers outstanding Brazilian samba and *choro* music. Located in a renovated warehouse on the edge of Lapa, this antiques-store-turned-bar was one of the pioneers in reviving Lapa's nightlife 10 years ago when there were few classy options available. Now, however, I'd say the Rio Scenarium is a victim of its own success. Recommended by every single guidebook and travel article about Rio, the place is often packed with more tourists than locals. Although still worth seeing, don't make this your only stop when exploring Lapa's music scene. Open Tuesday through Saturday. Rua do Lavradio 20, Centro. ☎ **021/2233-3239.** www.rioscenarium.com.br. Cover R$20–R$25. Taxi recommended.

Vivo Rio ★★★ One of Rio's newest concert venues, the Vivo Rio is located right next to the Museu de Arte Moderno on Rio's downtown waterfront. It specializes in big-name concerts, with both Brazilian and foreign artists, including B. B. King, Maria Bethania, and Gilberto Gil. The only drawback here is the high ticket prices—R$180 or more for a decent seat is not unheard of in this venue. Rua Infante Dom Henrique, Centro, next to the Museu de Arte Moderna. ☎ **021/2272-2900.** www.vivorio.com.br. Cover R$60–R$300. Taxi recommended.

DANCE CLUBS

Baronneti One of the most happening dance clubs in Rio, Baronneti attracts a well-to-do and attractive crowd in their 20s to 40s. Part of their secret is the minimum drink requirement; at a stiff R$70 minimum for guys on Saturdays, there's no rubbing elbows with the riffraff here. What you get is a fine-looking classy upscale club, two floors of fabulous dance music to dance the night away, plenty of couches, and a chill-out space. Rua Barão da Torre 354, Ipanema. ☎ **021/2247-9100.** www.baronneti.com.br. Drink minimum women R$20–R$50, men R$50–R$80. Bus: 474.

Casa da Matriz Not everyone swoons to bossa nova or the upbeat sounds of samba and *forró*. At Casa da Matriz, Rio's young and pierced move to the pounding

LADIES OF THE night . . . & DAY

They've been an integral part of the neighborhood since the 1940s—those working girls and their customers who occupy selected slices of the Copacabana waterfront. The good news is that these places are not dangerous or even overly sleazy. Indeed, it can be interesting observing the hustle and bustle and to and fro, though the atmosphere is not exactly family entertainment (unless you come from a very odd family). Regular hangouts for sex tourists and working women include the Balcony Bar and the Lido square, which is also home to a number of strip clubs. This area is between the Copacabana Palace and the Avenida Prado Junior, Copa's main drive-by thoroughfare for street prostitutes. Farther down the waterfront, the Terraço Atlantico is where johns and hookers hook up in the afternoon and early evening. For those who like people-watching it can make for a fascinating scene. The area around the Rio Othon Hotel is another popular meeting place. Daytime contacts are made at the Meia Petaca patio, or else out on the beach while working on that tan line.

Botequins are to Rio what pubs are to London and cafes are to Paris: the spot where locals gather, be it for end-of-day drinks or impassioned late-night philosophizing. Brazilians refer to botequins as *pé sujos*—literally "dirty feet"—meaning they're nothing fancy, often just plastic tables and fluorescent lights (though rich in character and local flavor). Some botequins have developed into popular nightlife attractions, offering live music and excellent food, and drawing crowds from all over the city. But most botequins remain small, not very fancy watering holes where one can kick back with a cold beer, have some snacks, and catch up with the latest gossip.

sounds of techno, indie, pop, hip-hop, trance, and house spun by different DJs. Open Monday and Wednesday through Saturday after 11pm. Rua Henrique de Novaes 107, Botafogo. ✆ **021/2266-1014.** Cover R\$15–R\$25. Taxi recommended.

Fosfobox Gay-friendly Fosfobox is Copacabana's trendy club du jour, or rather *de nuit*. Located in a basement off Rua Siqueira Campos, the club only has room for about 150, who hear discs spun by a variety of DJs. On Thursday it's rock, Friday and Saturday are house and techno. Open Wednesday through Sunday. Rua Siqueira Campos 143, Copacabana. ✆ **021/2548-7498.** www.fosfobox.com.br. Cover R\$20. Metrô: Siqueira Campos.

Melt Melt is a great unpretentious club that has been making quite a name for itself with excellent live music by a variety of interesting artists. Open Tuesday through Sunday, the small club offers a range of music, varying from hip-hop to salsa, dance, or samba-rock, and in the summer months samba on Sunday. Rua Rita Ludolf 47, Leblon. ✆ **021/2249-9309.** www.meltbar.com.br. Cover R\$25–R\$50. Bus: 415.

Nuth A lovely, very upscale club in Lagoa, Nuth has a small restaurant upstairs, an outdoor patio section, and an indoor dance floor featuring lounge music early on and dance beats as the night goes on. Arrive early (before 10pm) if you want to make it past the doormen—VIPs and beautiful women get preference, and if you're not one of these, you may find yourself exiled to a long wait in the outside line. Open Tuesday through Saturday after 7pm to 4am. Av. Epitacio Pessoa 1244, Lagoa. ✆ **021/3575-6850.** www.nuth.com.br. Cover R\$30–R\$50. Bus: 415.

00 Pronounced "zero-zero," this nightclub is located right next to the planetarium in Gávea. The club has a large outdoor deck with wooden benches and comfortable recliners, perfect for those warm summer evenings. The inside space is divided into a restaurant area, bar, and small dance floor. On Sundays, 00 hosts a gay-friendly electro and house music event; things kick off around 7pm with great chill music outside and continue later on the dance floor when famous guest DJs spin power house until the early hours. Rua Padre Leonel France 240, Gávea. ✆ **021/2540-8041.** www.00site.com.br. Cover R\$20–R\$50. Taxi recommended.

Bars & Pubs

If a bar has a musician playing, chances are something between R\$2 and R\$10 per person or per table will be added to your bill (a *couvert*). Always ask when going into a restaurant or bar with live music if there is a cover or *"couvert para a música,"* to avoid any surprises when your bill comes.

BOTEQUINS

Arco do Teles Tucked away in an alley just off Praça XV, the Arco do Teles, which looks like a movie set of old Rio, is an area with dozens of bars. Perfectly preserved colonial two-stories are set on narrow cobblestone streets lined with restaurants and cafes. Though it's a good place for a quick lunch, prime time is after work hours, especially on Thursday and Friday. Office workers flock here to grab a few cold chopps and catch some music before heading home. Often they forget to go home. As the evening wears on, tables and chairs take over the alley, creating a large impromptu patio—it's one of the best people-watching spots in town. With over 15 bars and botequins, it doesn't matter which one you pick. If you get there after 10pm you'll be lucky to find a seat at all. Travessa do Comércio, Arco do Teles (from the Praça XV, facing toward the bay, you will see the arch that marks the entrance to the alley on your left). Bus: 110 or 415.

Belmonte An old-fashioned botequim with bright lights, dark-wood furniture, and tile floors, the Belmonte serves up great beer, sandwiches, and snacks at almost any time of the day, but in the evenings and on weekend afternoons things get really hopping: Patrons spill out on the sidewalk, making do with improvised tables made out of barrels. It's now a local chain with brand-new old-fashioned Belmontes in Lagoa, Ipanema, and Copacabana, but the Flamengo Belmonte remains the best. Praia de Flamengo 300, Flamengo. ✆ **021/2552-3349.** www.botecobelmonte.com.br. Bus: 464.

Bip Bip Another internationally acclaimed botequim—the Parisian daily *Le Monde* featured this tiny bar on its front page—Bip Bip owes its fame to an outstanding musical program. Tuesday and Sunday nights are the best evenings to catch some great samba or *pagode* (a more mellow kind of samba); it's not unusual to see some Brazilian greats such as Beth Carvalho, Nelson Sargento, Walter Alfaiate, and others come out to sing and play. Owner Alfredo Melo—Alfredinho to most everyone—tries

The Kiosks of Lagoa

They began as lowly concession stands, but the kiosks around the Lagoa Rodrigo de Freitas have evolved into a fun, casual nightlife scene. Known in Portuguese as *quiosques da Lagoa*, they're the perfect place to stroll, munch, drink, and people-watch. Set at regular intervals along the pleasant green path that girdles the Lagoa, the kiosks range in size and quality from simple snack stands to full-fledged restaurants and entertainment centers. The cuisine ranges from Brazilian basic to Lebanese, Japanese, or Italian, while the entertainment ranges from a boombox on volume "11" to excellent live bands (some of which charge a small cover). The thickest concentration of kiosks begins opposite the Jockey Club.

Another grouping clusters close to the Parque da Catacumba, near the area where Copacabana and Ipanema meet and back up to the Lagoa. One of the nicest ones is **Palaphita Kitsch** (Av. Epitacio Pessoa s/n, kiosk nr. 20; ✆ **021/2529-6432**) with rustic furniture and an exotic Amazonian menu. The kiosks are open year-round, but they're especially popular in summer; weekday hours are from 6pm onward—they get busy around 10pm—and on weekends from noon onward. A full loop around the Lagoa is 7.5km (4½ miles), making for a pleasant 2-hour walk. For an interactive map of all the kiosks, showing opening hours and types of cuisine and music, see **www.lagoarodrigodefreitas.com.br**.

Waterfront Upgrade

In 2006, Rio began a major overhaul of the sidewalk kiosks along the waterfront, replacing the old ones with modern glass kiosks with spacious decks, a full bar and kitchen, and underground washrooms and showers. Leme and Copacabana have all new kiosks. Ipanema and Leblon are slated for upgrades in the coming years.

to keep his neighbors happy, so on Sunday the live music winds down early at 10pm. The bar stays open daily until 1am. Rua Almirante Gonçalves 50, Copacabana. ✆ **021/2267-9696.** Bus: 432.

Bracarense Once voted the best botequim in town—the *New York Times* even proclaimed it the best in Brazil—Bracarense may be suffering a bit from its own success. On Saturday when the botequim is packed, service often slows to a crawl. Still, Bracarense's beer remains top-shelf. Food quality is another key part of the botequim experience, particularly the little munchy appetizers that go so well with beer. Rua José Linhares 85, Leblon (corner of Ataulfo de Paiva). ✆ **021/2294-3549.** Bus: 464.

Chico & Alaíde Both Chico and Alaíde used to work at Bracarense (see above). In fact, it was Alaíde's talented cooking that made the bar's tasty pub food truly noteworthy. Now the duo is giving their former place of employment a run for its money with their own bar on trendy Rua Dias Ferreira. Order a cold Brahma while you peruse your options of delectable savory snacks. Rua Dias Ferreira 679, Leblon. ✆ **021/2512-0028.** www.chicoealaide.com.br. Bus: 464.

OTHER BARS & PUBS

Academia da Cachaça A field trip to the Academia da Cachaça puts the concept of advanced education in a whole new light. Here you can dispute and discuss the finer points of the fiery white cane liquor that is Brazil's national drink. For though all *cachaça* comes from sugar cane, not all *cachaças* are created equal. The selection at the Academia is overwhelming. Ask the bartenders for advice, and begin that lifelong intellectual quest for the perfect "white one." Just don't down them on an empty stomach. The menu here offers a variety of Brazilian snacks to munch on while trying yet one more shot. Or two more shots. Or three. Or . . . Rua Conde de Bernadotte 26, loja G, Leblon. ✆ **021/2529-2680.** www.academiadacachaca.com.br. Bus: 415.

Bar dos Descasados ★★★ Rio's most romantic patio bar sits tucked away inside the elegant Hotel Santa Teresa. Spend a lazy afternoon or evening (or both, once you get comfortable you may not want to leave) lounging in a big comfy chair on the terrace of a 19th-century mansion. Order a caipirinha and enjoy the fabulous views of Santa Teresa and downtown. ***Tip:*** This is a prime sunset spot. Rua Almirante Alexandrino 660, Santa Teresa. ✆ **021/2222-2755.** Bus: 206.

Devassa What started as a cute neighborhood bar in Leblon is slowly spreading around the city. The original location on the Rua General San Martin still packs them in on most nights, but patrons now have the option of heading out to the Jardim Botânico location and enjoying the large patio. The Devassa microbrews can now be purchased at many other bars around the city. The most popular Devassa brews are the blond *(loura)*, redhead *(ruiva)*, and brunette *(morena)*. Rua General San Martin 1241, Leblon.

021/2540-6087. www.devassa.com.br. Bus: 415. Also at Av. Lineu de Paula Machado 696, Jardim Botânico. *021/2294-2915.* Bus: 572 (get off at Rua Jardim Botânico, corner Rua J.J. Seabra).

Garota de Ipanema 🖐 The bossa nova tune "The Girl from Ipanema" (*"Garota de Ipanema"* in Portuguese) is indeed a thing of sublime beauty, composed in one afternoon by poet Vinicius de Moraes and singer Tom Jobim while the two sat drinking chopp and watching the Brazilian beach beauties go by in a little bar then called the Veloso. After the tune became a world hit, the bar changed its name and plastered the song's lyrics and score on the wall in a blatant attempt to cash in. Jobim and Moraes themselves shunned the place in short order, driven out by the hordes and attendant crass commercialism. Nowadays, the beer is cold and the food okay (both come at a premium), and the people walking by are still tall, tan, young, and lovely, but the Garota itself is neither a musical nor cultural hot spot. Rua Vinicius de Moraes 49 A, Ipanema. *021/2523-3787.* Bus: 434.

Mercado Cobal de Humaitá 🎁 Is it a bar? Is it a restaurant? Or is it a great seething mass of people at plastic patio tables quaffing chopp, munching food, and listening to tunes from one or more live bands? That last is probably the best description of the nighttime scene at the Mercado Cobal. Seven or eight different restaurants and *chopperias* (*chopperias* sell draft beer and very basic snacks) all meld into one large bustling patio, with busy waiters racing up and down the aisles trying to keep their tables straight. **Galeto Mania** serves up a tasty grilled chicken, **Pizzapark** offers a full range of pizzas, and **Manekineko** whips up tray after tray of fresh sushi, while **Espirito Chopp** serves the best cold draft beer. Cobal de Humaitá, Rua Voluntários da Patria 446, Botafogo. Galeto Mania, *021/2527-0616.* Manekineko, *021/2537-1510.* Bus: 178.

Venga Rio's first tapas bar forwent the trendy fusion route and opted for a classic Spanish approach. The bustling bar has a casual atmosphere, popular with Rio's 30-plus crowd. The kitchen serves interesting authentic minidishes, which most people accompany with a glass of sangria or Spanish wine. Smack in the middle of Leblon's nightlife district, the people-watching is superb! It's open Monday to Friday 6pm to 1am, Saturday and Sunday 1pm to 1am. Rua Dias Ferreira 113, Leblon. *021/2512-9826.* Bus: 474. A second Venga just opened up on Rua Garcia D'Avila 147, Ipanema. *021/2247-0234.* Bus: 474.

Gay & Lesbian Nightlife

Rio's gay community is smaller than one would expect from a city of 10 million people. For all Rio's reputation for sexual hedonism, the macho culture still predominates. As lasciviously as heterosexual couples may behave in public, open displays of affection between same-sex couples are still not accepted in Brazil. This is changing, though only slowly.

Currently, the most popular nightspot is in Ipanema around the Galeria Café on the Rua Teixeira de Melo. During the day the stretch of sand close to Posto 8 (opposite the Rua Farme de Amoedo) is also popular. Copacabana has a number of gay clubs and bars as well as a popular meeting place on the beach at Rainbow's, in front of the Copacabana Palace Hotel. A good resource to pick up is the latest edition of the *Gay Guide Brazil,* a small booklet available at some of the clubs and bookstores in Ipanema, or check **www.riogayguide.com**.

Set in a small gallery stunningly decorated with a changing display of work by local artists, the **Galeria Café,** Rua Teixeira de Melo 31E, Ipanema (✆ **021/2523-8250;** www.galeriacafe.com.br), packs a gorgeous collection of men, shoulder to shoulder, bicep to bicep, into its combo art space, dance club, and bar. The Galeria really gets hopping, inside and out, after 1am. The cover charge is R$10 to R$25; it's open from Wednesday through Sunday.

Also popular is **Dama de Ferro** (the **Iron Lady**), Rua Vinicius de Moraes 288, Ipanema (✆ **021/2247-2330;** www.damaadeferro.com.br). Decorated by artist Adriana Lima, who also did the amazing decor at Galeria Café, Dama de Ferro is popular with gays and straights; high tolerance for electronic music is a must. The cover is R$10 to R$25; it's open Wednesday through Sunday.

Le Boy, Rua Raul Pompeia 102, Copacabana (✆ **021/2513-4993;** www.leboy.com.br), is the largest and best-known gay club in Rio. It's glamorous, funky, and extremely spacious with a soaring four-story ceiling hovering somewhere above the dance floor. A range of special events attracts national and international celebrities and assorted (beautiful) hangers-on. Go after midnight, when things really start to hop. The club is open Tuesday through Sunday; the cover ranges from R$5 to R$15 for men. This may be the only club in town where women pay more than men; any night of the week the cover for women is set at a hefty R$60. Le Boy also runs **La Girl** next door, Rua Raul Pompeia 102 (✆ **021/2247-8342;** www.lagirl.com.br), Rio's first truly upscale nightclub for gay women with excellent DJs and go-go girl shows. La Girl is open on Monday and Wednesday to Sunday (men allowed only on Mon and Sun). The cover ranges from R$5 to R$15.

The **Week,** Rua Sacadura Cabral 154, Saude (✆ **021/2253-1020;** www.theweek.com.br), is the new hottest gay dance club in town. This huge mega dance club can hold 2,000 people and is packed every Saturday night. Famous national and international DJs and go-go boys keep the crowd going. Open Saturdays at midnight, and it's often open for events on Fridays and Wednesdays; check the listings.

In Centro, **Cine Ideal,** Rua da Carioca 64 (✆ **021/2221-1984;** www.cineideal.com.br), is a gay-friendly outpost of house music, open every Friday and Saturday 11am to 6am. The cover is R$40.

EVERYTHING YOU NEED TO KNOW ABOUT CARNAVAL

Ah, Carnaval. The name evokes explosive images of colorful costumes, lavish floats, swarming masses, and last-minute debauchery before the sober Lenten season begins. Though it may look like sheer entertainment, Carnaval means hard work and dedication for many Cariocas; to some, it's a full-time job.

What's It All About?

The religious aspect of the celebration faded some time ago, but Carnaval's date is still determined by the ecclesiastical calendar, officially occupying only the 4 days immediately preceding Ash Wednesday. With typical ingenuity and panache, however, Cariocas have managed to stretch the party into an event lasting several months, culminating in a 5-day feast of music, color, and sound that is the **Samba School Parade,** where tens of thousands of costumed dancers, thousands of percussionists,

and hundreds of gorgeous performers atop dozens of floats all move in choreographed harmony to the nonstop rhythm of samba.

If you're not able to attend Carnaval itself, **rehearsals**—which usually start in mid-August or September—are an absolute must, and the closest you'll get to the real thing. Although located in the neighborhoods outside of the Zona Sul, a number of the *quadras* (where the rehearsals are held) are very accessible and just a short taxi ride away. Mangueira, Salgueiro, Vila Isabel, Viradouro, and Rocinha are easy to get to by taxi from the Zona Sul and are used to receiving foreign visitors.

Good seats for the top Carnaval parade on Sunday and Monday night are awfully expensive! A much cheaper alternative is to watch the *Grupo de Acesso* (Runners Up) on Saturday night. These schools are competing for a spot in next year's top group—each year the last-placed school in the top league gets demoted to the *Grupo de Acesso* and the winner of the *Grupo de Acesso* moves up to the top group, so the competition is fierce and the schools put on an excellent show. This is a great opportunity to get a taste of the real thing at a fraction of the cost! Expect to pay somewhere in the R$60 to R$200 range. Contact the **Liga das Escolas de Samba** (✆ 021/3213-5151; www.liesa.com.br), **Blumar** (✆ 021/2142-9300; www.blumar.com.br), or **Rio Services Carnaval** (✆ 877/559-0088 U.S. and Canada; www.rio-carnival.net) for ticket sales.

In the 2 to 3 weeks leading up to the big event, you'll begin to see the **blocos.** These are community groups—usually associated with a particular neighborhood or sometimes with a bar—who go around the neighborhood, playing music, singing, and dancing through the streets. Everyone is welcome and encouraged to follow along. A number of blocos are so well known that they draw throngs of followers in the tens of thousands. The **Banda de Ipanema** in Ipanema with its extravagant drag queens is a hoot. During Carnaval, at least a dozen **blocos** parade every day from Saturday through Tuesday.

Finally, there are the **Carnaval balls** (*bailes*). Originally the *bailes* were reserved for the elite, while the masses partied it up with vulgar splendor in the streets. Today, only a few remain; the classiest—and priciest—affair, the **Copacabana Palace Ball,** remains *the* society event in Rio.

Watching the Samba Parade

Then, there is the *pièce de résistance:* the **Samba School Parade,** the event that the samba schools work, plan, and sweat over for an entire year. Starting Sunday and continuing through Tuesday morning, the 14 top-ranked samba schools compete for the honor of putting on the best show. The competition takes place in the **Sambodromo,** a 1.5km-long (1-mile) concrete parade ground built in the center of Rio for this once-a-year event. Each night over 60,000 spectators watch the contest live, while millions more tune in on TV to catch this feast for the senses.

How & Where to Get Tickets

It is next to impossible to buy tickets directly from Liesa, the **Liga das Escolas de Samba** (✆ 021/3213-5151; www.liesa.com.br). The tickets go on sale a few months before Carnaval and always sell out in 20 minutes. The few tourist tickets that remain Liesa sells at an extraordinary markup. Most tourists are left buying from scalpers or travel agencies. Reputable travel agencies include **Blumar** (✆ 021/2142-9300; www.blumar.com.br), **Rio Services Carnaval** (✆ 877/559-0088 U.S. and Canada; www.rio-carnival.net), and **BIT** (✆ 021/3208-9000; www.bitourism.com), which sell good tickets at reasonable rates, but which often sell out early. If you've got your heart set on seeing the parade, buy your tickets by October or at the latest November preceding the year you want to go. As a next to last resort, try your hotel, but expect to pay a hefty premium for this service.

Depending on the agency, tickets for the bleachers begin at around R$110 for section 4, and rise to R$300 for section 7. Chairs in a front row box (*frisa*) start at R$3,000 in section 4 and R$4,800 in section 7. These are base prices. Many agencies charge much more.

Whether you choose bleacher or *frisa*, the best sections are 5, 7, and 9. These place you near the middle of the parade avenue, allowing you to see up and down as the schools come through. Avoid sitting at the start or the end of the Avenida (sections 1, 3, 4, 6, and 13).

If you have tickets you can head directly to the Sambodromo. The parade grounds are divided into sections (see map on p. 125): Even-numbered sections can be accessed from the Central Station side (Metrô: Central); odd-numbered sections can be accessed from the Praça XI side (Metrô: Praça XI). Don't worry, lots of police and staff are around to point you in the right direction.

The parade starts at 9pm, but unless you want to stake out a particular spot, you may as well take your time arriving, because the event will continue nonstop until about 7 or 8am.

A Few Helpful Hints

Whether you are attending a rehearsal, following a bloco, or watching the parade, here are a few helpful hints to ensure you have a good time.

○ Dress casually and comfortably; a tank top and shorts are fine. Comfortable shoes are a must as you will be on your feet for hours.

○ Pack light. A purse or any extra accessories are not recommended, especially at the rehearsals and the blocos as you will be dancing and moving around. When watching the parade you can bring a small bag or knapsack. Make sure you bring enough cash for the evening, some form of ID (driver's license or some other picture ID that is not your passport), and a small camera you can tuck into your pocket. Leave jewelry and other valuables at home.

○ The events themselves are very safe, but beware of pickpockets in large crowds. At the end of the event, take a taxi or walk with the crowds, avoiding any deserted streets or unfamiliar neighborhoods.

○ Plan to have enough cash for the entire Carnaval period. All financial institutions close for the duration, and it's not unusual for bank machines to run out of money.

Participating in the Parade

If you think watching the parade from up close sounds pretty amazing, imagine being in it. Every year, the samba schools open up positions for outsiders to participate in

 Carnaval Redux

If you miss the parade during Carnaval, attend the Parade of Champions on the Saturday after Carnaval. The five top schools give an encore to close the Sambodromo Carnaval season. Tickets go on sale the Thursday after Carnaval. Starting at R$120 and up for a good spot, they're considerably less expensive than the original event. Contact the **Liga das Escolas de Samba** (✆ 021/3213-5151; www.liesa.com.br), **Blumar** (✆ 021/2142-9300; www.blumar.com.br), or **Rio Services Carnaval** (✆ 877/559-0088 U.S. and Canada; www.rio-carnival.net) for ticket sales.

the parade. Putting on this extravaganza is an expensive proposition, and by selling the costumes and the right to parade, the school is able to recuperate some of its costs. But outside paraders are also needed for artistic and competitive reasons. To score high points the school needs to have enough people to fill the Avenida and make the parade look full and colorful. A low turnout can make the school lose critical points.

To parade (*desfilar* in Portuguese) you need to commit to a school and buy a costume (about R$500–R$1,200), which you can often do online. Some sites are in English as well as Portuguese; if not, look under *fantasia* (costume). Depending on the school, they may courier the costume or arrange for a pickup downtown just before the parade, or you may have to make the trek out to wherever they are.

For an added charge, a number of agencies in Rio will organize it all for you, getting you in with a school and arranging the costume. **Blumar** (© **021/2142-9300;** www.blumar.com.br) or **Rio Services Carnaval** (© **877/559-0088** U.S. and Canada; www.rio-carnival.net) can organize the whole event for you for about R$1,000. For other organizations, contact **Alô Rio** (© **021/2542-8080** or 0800/707-1888).

Note that as a participant in the parade, you do not get a ticket to watch the rest of the event. If you want to see the other schools, you need to purchase a separate ticket.

Watching a Rehearsal

Every Saturday from September (or even as early as Aug) until Carnaval, each samba school holds a general samba rehearsal (*ensaio*) at its home base. The band and key people come out and practice their theme song over and over to perfection. People dance for hours, taking a break now and then for snacks and beer. The income generated goes toward the group's floats and costumes. By the end of the night (and these rehearsals go until the wee hours) everyone knows the words to the song. (General rehearsals usually don't involve costumes or practicing dance routines.) In December and January, the schools also hold dress rehearsals and technical rehearsals at the Sambodromo. Check with Riotur for dates and times.

Most of the samba schools are based in distant suburbs, but famou schools such as **Mangueira, Salgueiro, Vila Isabel, and Rocinha** are very accessible and no more than an R$30 cab ride from Copacabana. Nor should you worry overly much about safety. Rehearsals take place in an open-air space called a *quadra* that looks like a large gymnasium. There is always security, and the rehearsals are very well attended. Plan to arrive anytime after 11pm. When you are ready to leave there'll be lots of taxis around. Just don't go wandering off into the neighborhood, unless you're familiar with the area. *Tip:* A number of the famous schools that are located on the outskirts of the city will hold special rehearsals in the Zona Sul. The ones organized by Beija Flor and Grande Rio are the most popular, often attended by models, actors, and other VIPs. However, it's still better to go to the actual school.

To find out more about specific schools, rehearsals, or participating in the parade, contact the **Liga das Escolas de Samba** (© **021/3213-5151;** www.liesa.com.br). If you can't find anyone there who speaks English, contact **Alô Rio** for assistance (© **021/2542-8080** or 0800/707-1888). Or you can try contacting one of the samba schools directly; below is a partial list:

o **Mangueira,** Rio's most favorite samba school and close to downtown, Rua Visconde de Niterói 1072, Mangueira (© **021/2567-4637;** www.mangueira.com.br).

- **Beija-flor,** far from downtown but a crowd favorite and winner in 2003, 2004, 2005, 2007, 2008, and 2011, Rua Pracinha Walace Paes Leme 1025, Nilópolis (✆ **021/2791-2866;** www.beija-flor.com.br).
- **Portela,** winner of the very first parade in 1935, Rua Clara Nunes 81, Madureira (✆ **021/2489-6440;** www.gresportela.com.br).
- **Rocinha,** a young school, located in the Zona Sul close to Ipanema and Leblon, Rua Bertha Lutz 80, São Conrado (✆ **021/3205-3318;** www.academicosda rocinha.com.br).
- **Salgueiro,** close to downtown, draws Rio's young and beautiful, Rua Silva Teles 104, Andaraí (✆ **021/2238-0389;** www.salgueiro.com.br).
- **Vila Isabel,** close to downtown, mostly locals and very untouristy, winner in 2006, Bd. 28 de Setembro 382, Vila Isabel (✆ **021/2578-0077;** www.gresunidos devilaisabel.com.br).

Hanging with the Blocos

Although the glamorous Carnaval parade in the Sambodromo draws most of the attention, Rio's real Carnaval is celebrated on the streets with hundreds of parading blocos. In the last 10 years, the blocos have undergone a huge revival and are now the biggest draw of Carnaval. In 2011, over 400 blocos drew several million revelers. The key to the popularity of the blocos is the informality; everyone is welcome and costumes are optional. A group of musicians plays music while parading through the streets followed by the singing and dancing crowd. Different blocos have certain styles or attract specific groups, so pick one that suits you and have fun. Riotur publishes an excellent brochure called *Bandas, Blocos and Ensaios,* available through **Alô Rio** (✆ **021/2542-8080** or 0800/707-1888). Also available from **Riotur,** Av. Princesa Isabel 183, Copacabana (✆ **021/2271-7000**), is the *Rio Incomparavel* brochure, which has a full listing of events. In Portuguese, the website **www.samba-choro.com.br** provides a comprehensive list of blocos, including parade routes and starting times. The *Globo* newspaper (www.oglobo.com.br) also provides a bloco listings page.

Some of the best blocos to look for are **Escravos de Mauá, Cordão de Bola Preta, Boitatá,** and **Bloco Cacique de Ramos** in Centro; **Carmelitas** and **Ceú na Terra** in Santa Teresa; **Gigantes de Lira** and **Volta Alice** in Laranjeiras; **Barbas** and **Bloco de Segunda** in Botafogo; **Bloco do Bip Bip** and **Banda Santa Clara** in Copacabana; **Meu Bem Volto Já** in Leme; and **Banda de Ipanema** and **Simpatia é Quase Amor** in Ipanema.

Bailes

Traditionally reserved for Rio's elite, the *bailes* were elegant masked balls where the rich and famous would celebrate Carnaval. Over the years, many have disappeared, while others deteriorated into raunchy and risqué bacchanals. Today only a few *bailes* remain and events do vary from year to year; for up-to-date programming, contact **Alô Rio** (✆ **021/2542-8080** or 0800/707-1888) for details and ticket information. The popular Copacabana nightclub **Le Boy** (p. 124) organizes a differently themed ball every night during Carnaval, Friday through Tuesday included. These balls are gay friendly but not gay only. Call ✆ **021/2240-3338** for information. The prime gay event—and one of Rio's most famous balls—is the Tuesday night **Gala Gay** (venue varies). TV cameras vie for position by the red carpet, à la Oscar night. Google "Gala Gay" for video clips of the silliness.

The grand slam of all Carnaval balls is the Saturday night extravaganza at the Copacabana Palace Hotel, the **Grande Baile de Carnaval,** which plays host to the crème de la crème of Rio's high society. This is the ball of politicians, diplomats, models, business tycoons, and local and international movie stars. Tickets start at R$800 per person and sell out quickly. Call ℂ **021/2548-7070** for details.

 REVEILLON: new year's eve **IN RIO**

Trust Brazilians to throw a party where everyone is welcome and admission is free. At Rio's annual New Year's Eve extravaganza, millions pack the beach for an all-night festival of music, food, and fun, punctuated by spectacular fireworks.

Music kicks off at 8pm, as people make their way down to the beach until every square inch of sand is packed. By midnight, more than two million have joined the countdown. As the clock strikes midnight, the fireworks begin. When the last whistling spark falls into the sea, bands fire up their instruments and welcome in the new year with a concert that goes on until wee hours. Many stay all night and grab a spot on the sand when they tire. The event is safe.

During the party, followers of the Afro-Brazilian religion Candomblé mark Reveillon in their own way. New Year's Eve is an important moment in Candomblé, a time when followers make offerings to the sea goddess Yemanjá. Along the beach circles of women dressed all in white light candles and prepare small boats loaded with flowers, mirrors, trinkets, and perfumes. They launch the boats into the surf in hopes of obtaining Yemanjá's favor for the year to come.

Cariocas traditionally wear white on New Year's Eve; it's the color of peace and the color worn by devotees of Candomblé to honor Yemanjá. Don a pair of white shorts and a T-shirt, but don't forget your swimsuit. The traditional New Year's Eve "polar bear swim" will be even more tempting when the temperature is a balmy 40°C (105°F).

The best way to get to the event is by subway (buy tickets in advance). Most streets in Copacabana are closed to traffic, and parking is impossible. Contact **Alô Rio** at ℂ **021/2542-8080** or 0800/707-1888 for more information.

SIDE TRIPS FROM RIO DE JANEIRO

Two of the greatest joys of Rio are its mountains and its beaches. Side trips from the cidade maravilhosa explore these two features in greater detail. On weekends and holidays, many head north to the beach resorts dotting the warm Atlantic coast. First and most famous of these is the town of Búzios, "discovered" in the 1960s by a bikini-wearing Brigitte Bardot. Now it's a haven for Rio socialites, visiting Argentines, and anyone else who loves their beaches Brazilian-style—civilized, with a beachside table in sight, and a caipirinha in hand.

5

Heading inland, one finds the summer refuge of an earlier, prebeach generation, the mountain resort. The prettiest of these is also the closest: **Petrópolis,** the former summer capital of Emperor Pedro II. Just an hour from Rio, this green, graceful refuge is a place of peaceful strolls, great museums, and mountain hikes in the Atlantic rainforest.

Want your history served up with a splash of ocean? The perfect blend can be found in the former colonial port of **Paraty.** Situated almost halfway between Rio and São Paulo, this beautiful historic town had its heyday in the 18th and 19th centuries as a prime transshipment point for gold and later for coffee. Visitors can sail the bays and visit the surrounding sandy beaches and islands in the daytime, and at night wander the cobblestone streets of this UNESCO World Heritage Site, in search of architectural beauty or just some very fine dining.

Finally, there's **Ilha Grande,** a pristine island (and former political prison) to the south of Rio, where forest-clad tropical mountains splash their toes in a clear blue green tropical sea.

BUZIOS

134km (83 miles) E of Rio de Janeiro, 489km (303 miles) NE of São Paulo

It's anyone's guess how small or sleepy the fishing town of Búzios truly was when French starlet Brigitte Bardot stumbled onto its sandy beaches in 1964, but it's certain that in the years since the little town used the publicity to turn itself into Rio's premier beach resort. In the summer the town is packed; many Carioca celebrities own places here, and Argentines continue to invade with a gusto not seen since the Falklands. Despite

the influx, the town has managed to retain a good deal of the charm of its fishing-village past.

Búzios (the town's full name is Armação de Búzios) sits on the tip of a long, beach-rich peninsula jutting out into the clear blue Atlantic. The sheer number of beaches close to town makes it easy to experience Brazilian beach culture firsthand. **Geribá Beach** is the place for surfing. Quiet and calm and very deep, **Ferradura Beach** is a perfect horseshoe-shaped bay ideal for a lazy afternoon snorkel. Far from town are more isolated spots to steal a quiet moment with a special beach friend, while right in town on **Ossos Beach** you can sip a caipirinha at a beachside cafe and pretend for a moment you're young, rich, and beautiful. In this South American Saint-Tropez, everyone else certainly is.

Finally, on top of serious inquisitions into beach culture, there are more trivial pursuits such as diving, sailing, windsurfing, fine cuisine, and endless opportunities to shop. And at night, everyone comes to the busy, bar- and cafe-lined **Rua das Pedras** to stroll, primp, drink, and party.

Essentials
GETTING THERE
BY CAR Búzios is about a 2-hour drive from Rio de Janeiro. Leaving Rio, follow the signs to Niterói to cross the 16km-long (10-mile) Rio-Niterói bridge. Remember to have R$4.60 handy to pay the toll. Across the bridge, stay in the left lane and take the Rio Bonito exit. Once close to Rio Bonito, take the Via Lagos to Araruama/Cabo Frio and follow the signs to the RJ-106 and Búzios. Note that the Via Lagos is also a toll road (R$10 on weekdays, R$16 on weekends).

BY VAN/TAXI **Malizia Tours** in Búzios (✆ **022/2623-1226** or 2623-2022; www.maliziatour.com.br) offers transfers to/from Rio by van and taxi. The cost in a 15-person air-conditioned minibus is R$50 per person one-way. Pickup can be at your hotel or from the airport.

BY BUS **Auto Viação 1001** (✆ **021/4004-5001;** www.autoviacao1001.com.br) has departures seven times a day from Rio's main bus station (**Novo Rio Rodoviaria;** Av. Francisco Bicalho 1, Santo Cristo; ✆ **021/3849-5001**). The cost of the 3-hour trip is R$36. In Búzios, buses arrive (and depart) at the Búzios Bus Station (✆ **022/2623-2050**) on Estrada da Usina, corner of Rua Manoel de Carvalho, a 10-minute walk from the center of town.

GETTING AROUND
BY WATER TAXI Water taxis are an efficient and fun way to get around, but they run only in the daytime and only on the protected side of the bay, from João Fernandes to Tartaruga. To catch a water taxi you can hail one from the beach or the pier in town, or phone ✆ **022/2620-8016.** When being dropped off by water taxi, you can set a time for pickup. Rides cost between R$5 and R$12 per person; from Centro to Azeda beach costs R$6 per person and from Centro to João Fernandes beach R$8 per person. Taxis carry up to seven people.

BY TAXI Taxis can be hailed at the *ponto* in Praça Santos Dumont (✆ **022/2623-2160**) or by calling **Búzios Rádio Táxi** (✆ **022/2623-2509**).

BY RENTAL CAR **Malizia,** Rua José Bento Ribeiro Dantas 16, Shopping do Canto, Búzios (✆ **022/2623-1226;** www.maliziatour.com.br), has rental cars. The

cost starts at R$75 per day for a Fiat Palio with air-conditioning, including 120km (74 miles) per day and insurance.

VISITOR INFORMATION

The **Búzios Tourism Secretariat** operates an information kiosk on the downtown Praça Santos Dumont 111 (𝄐 **022/2633-6200;** daily 8am–10pm). Two good websites on Búzios are **www.buziosonline.com.br** and **www.buziosturismo.com**.

FAST FACTS **Banco do Brasil,** Rua Manuel de Carvalho 73 (4 blocks from Rua das Pedras), is open Monday through Friday from 11am to 6pm. ATMs are open 24 hours. You will find most major **ATMs** in the Praça Santos Dumont. **Búzios Cybar,** Shopping de Búzios, loja 4, corner of Rua Turibe (𝄐 **022/2623-2969**), has Internet for R$8 per 30 minutes. *Note:* Practically all hotels in Búzios have Wi-Fi.

Exploring Búzios

HITTING THE BEACHES

The charm of Búzios lies largely in its beaches, the 20 stretches of sand large and small within a few kilometers of the old town. Thanks to the irregular topography of

this rugged little peninsula, each beach is set off from the other and has developed its own beach personality. Farthest from the old town is **Manguinhos** beach. Sheltered from the heavy surf, this gentle beach is where many learn to sail and windsurf. A short hop over the neck of the peninsula lies **Geribá** beach, a wonderful long stretch of sand facing out toward the open ocean. This is the beach for surfing, boogie boarding, and windsurfing. Closer to town is **Ferradura** or **Horseshoe** beach. Nestled between rocky headlands in a beautiful horseshoe bay, this beach offers calm, crystal-clear waters, making it the perfect place for a long, lazy afternoon's snorkel. Tiny and beautiful, **Olho de Boi,** or **Bull's Eye,** beach is tucked away on its own at the far end of a small ecological reserve. It can only be reached by a 20-minute walk from surfers' favorite **Brava** beach. Thanks to this isolation, Bull's Eye beach has been adopted by Búzios's clothing-optional crowd. Back on the calm inland side of the peninsula, **João Fernandes** and the pocket-size **João Fernandinho** beaches are busy, happening places lined with beachside cafes and full of people intent on getting and showing off their tans.

OUTDOOR ACTIVITIES & WATERSPORTS

BIKING Hard-core mountain bikers would likely find it a little tame, but Búzios is an excellent place for gentle, recreational off-road cycling. There are lots of trails accessible only to pedestrians and cyclists. **Buzios Dacar,** Manoel José Carvalho 248 (© **022/2633-0419**), rents bikes for R$45 per day. Another company that offers bike rental and 1-day bike tours is **Eco Bike Tour** (© **022/9259-0720** or 022/8189-7906; www.ecobiketour.com).

BOATING **Schooner trips** are a great way to spend a day in Búzios. A small fleet of converted fishing schooners makes a circuit of about eight of Búzios's beaches plus three offshore islands. On board, you trundle along in the sunshine eating complimentary fresh fruit and drinking free caipirinhas (or mineral water). At any of the beaches you're free to get off, hang out and swim for a bit, and then hop back on the next schooner (from your company) that comes along. There are enough boats that you usually don't have to wait long. One company is **Malizia Tour** (© **022/2623-1226**), but there's really no need to seek them out. Just walk along Rua das Pedras anywhere near the pier, and you're guaranteed to be approached by a schooner tout. The exact price depends on the time of year and how hard you negotiate, but competition between various schooner operators keeps things fairly competitive. Expect to pay from R$25 to R$45 for a half-day's cruise.

DIVING The islands just off Búzios are—along with Angra dos Reis and Arraial do Cabo—some of the best diving spots within a 1-day drive of Rio. Diving takes place at a number of islands about 45 minutes off the coast. Water temperature is normally around 22°C (72°F). Visibility ranges from 10 to 15m (30–50 ft.). Coral formations are fairly basic—mostly soft coral—but there are always lots of parrotfish, and there are often sea turtles (green and hawksbill) and stingrays of considerable size.

Casa Mar, Rua das Pedras 242 (© **022/9817-6234;** www.casamar.com.br), offers a full range of services including cylinder refill and courses all the way from basic to nitrox. For a certified diver, a two-dive excursion costs R$150 or R$190 if you need to rent all the equipment such as a regulator, BCD (buoyancy control device), wet suit, and mask/fins/snorkel. For those wanting to get their diving license, a 5-day PADI open-water course costs R$1,350. If you just want to try diving, there are also introduction dives—you practice in the pool first and then the dive instructor takes

you out for a controlled one-on-one dive in the open ocean—for R$180. Nondivers who come on the boat pay R$80.

FOR KIDS If your kids get bored with the beach, you may want to bring them to **Radical Parque,** Estrada da Usina 1 (right next to the bus station; ☎ **022/2623-2904;** www.radicalparque.com.br; daily 9am–11pm). This oversize playground offers rappel, climbing walls, giant trampolines, paintball, and go-karts. Prices are per activity and range from R$10 for climbing or rappel to R$30 for half an hour of paintball or R$35 for 15 minutes of go-karting.

GOLF The **Búzios Golf Club & Resort** (☎ **022/2629-1240;** www.buziosgolf. com.br) is located just in from Manguinhos beach. Greens fees for this 18-hole course are R$165 per day for unlimited golf. Cart rental is R$100 for 18 holes and R$50 for 9 holes.

SURFING Geribá and **Tocuns** beaches are the best for surfing. They're located on the way in to Búzios, about 5km (3 miles) from downtown. Closer to town, **Brava** beach also often has good waves. Surfboard rentals and/or lessons are available at **Escolinha de Surfe do Rato** (☎ **022/9262-4756;** www.escolinhadesurfdorato. com) on Geribá beach.

WATERSPORTS Most everything in the way of watersports equipment can be rented in Búzios, generally right on the beach.

On **Ferradura** beach, **Happy Surf** (☎ **022/2623-3389** or 022/9229-7493) rents **sailboards, lasers, Hobie Cats,** and **kayaks.** Happy Surf also gives courses. A 6-hour beginner's **sailboard** course costs R$150. More advanced students can choose from 1- and 2-hour courses costing from R$35 to R$60. Lasers rent for R$35 per half-hour, R$45 with instructor. Hobie Cats rent for R$25 per half-hour, R$40 with instructor. Kayaks rent for R$5 per half-hour.

The following equipment is available at **João Fernandes Beach: kayaks,** R$5 for 30 minutes; **masks and snorkels,** R$12 per hour; and **sailboards,** R$30 per hour.

On **Manguinhos** beach, **Búzios Vela Club,** Rua Maurício Dutra 303 (☎ **022/2623-0508**), rents windsurf equipment. A full-day rental ranges from R$150 to R$210. Manguinhos is also a popular **kite-surfing** location. Intensive weekend courses are available for R$1,000, including gear and 6 hours of instruction. To book a lesson call **Búzios Kite Surfing School** (☎ **022/2633-0396;** www. kitenews.com.br).

Where to Stay

Búzios is known for its pousadas, similar to North American B&Bs. These small, often owner-operated hotels provide excellent personalized service. By avoiding high season (Dec–Mar and July) and weekends throughout the year, you should be able to get a discount, although you should still expect to pay more at a pousada in Búzios than you would anywhere else in Brazil.

VERY EXPENSIVE

Insólito Boutique Hotel ★★★ This exclusive luxury boutique hotel clings to the rocks overlooking Ferradura beach. With only 12 rooms set amid lush tropical gardens and spectacular terraces, guests practically have the place to themselves. All rooms face the ocean and are exquisitely decorated with tasteful modern Brazilian artwork, books, and furniture. King-size beds, 300-thread count sheets, LCD TVs, DVD players, and iPod docking stations are par for the course in each room. We are

not sure why you would want to leave paradise and mingle with the crowds in downtown Búzios, but the hotel provides a free shuttle service just in case.

Praia da Ferradura, Armação de Búzios, 28950-000 RJ. www.insolitos.com.br. © **022/2623-2172.** Fax 022/2623-2923. 12 units. High season R$1,010 double; low season R$965 double. AE, DC, MC, V. No children 13 and under. **Amenities:** Restaurant; bar; saltwater and freshwater outdoor pools; sauna; spa. *In room:* A/C, TV/DVD, hair dryer, minibar, MP3 docking station, Wi-Fi.

Pousada Casas Brancas ★★ Tucked away on Orla Bardot, Casas Brancas sits on a hill overlooking the ocean, yet is only a 5-minute walk from the nightlife and restaurants of the busy Rua das Pedras. This sprawling Greek villa–like hotel offers spacious, comfortable rooms decorated in a clean, modern style. Only the best rooms face the ocean and feature a private terrace; the other rooms offer a partial ocean view or face the garden. Fortunately, all guests have equal access to the hotel's gorgeous swimming pool and sun deck. Service is attentive and competent, and the well-equipped spa offers a wide range of professional beauty treatments.

Rua Alto do Humaitá 10, Praia da Armação, Armação de Búzios, 28925-000 RJ. www.casasbrancas. com.br. © **022/2623-1458.** Fax 022/2623-2147. 32 units. Dec–Mar R$550 standard room (garden view), R$750 deluxe room (ocean view); low season R$420–R$490 standard room (garden view), R$680 deluxe double. Extra person 30% extra. AE, DC, MC, V. No children 4 and under. **Amenities:** Restaurant; bar; outdoor pool; spa; Wi-Fi. *In room:* A/C, TV (upon request), hair dryer, minibar.

EXPENSIVE

La Boheme ★ ☺ At the beginning of João Fernandes Beach, La Boheme overlooks the beach and the ocean from its hillside vantage point. The apartments all offer beautiful ocean views and are within walking distance of the main village and the beaches. All are very spacious and feature kitchenettes, perfect for groups or families traveling with children. A few are split-level suites and sleep up to seven people; the other apartments are on one level only, accommodating up to four people comfortably. The pool area includes a great children's pool, and the beach, about 90m (300 ft.) below the hotel, is safe enough even for the little ones, with almost no waves and perfect bathtublike temperatures.

Praia de João Fernandes, Armação de Búzios, 28950-000 RJ. www.labohemehotel.com. © **022/2623-1744.** 40 units. R$420 1-bedroom apt that sleeps up to 4 people; R$680 double in an apt that sleeps up to 7 people. Children 4 and under stay free in parent's room, 5 and over R$50 extra. AE, DC, MC, V. Free parking. **Amenities:** Restaurant; 2 outdoor pools; Wi-Fi. *In room:* A/C, TV, kitchen, minibar.

Pousada Abracadabra ★★ Right next door to Casas Brancas, Abracadabra has the same stunning location at a much more affordable price tag. But don't worry; you will hardly be slumming it (that is, as long as you avoid room no. 7, which feels like a glorified walk-in closet). The superior and deluxe rooms look out toward the ocean; the standard rooms have a garden view. The best part about this pousada is its privileged location on the top of a hill. Its swimming pool, sun deck, and bar offer a spectacular view of Búzios and the ocean. And when you have enjoyed all the quiet contemplation you can take, the hustle and bustle of the Rua das Pedras is only a 5-minute walk away.

Rua Alto do Humaitá 13, Praia da Armação, Armação de Búzios, 28925-000 RJ. www.abracadabra pousada.com.br. © **022/2623-1217.** Fax 022/2623-2147. 16 units. Dec–Mar R$270–R$340 standard room (garden view), R$450 deluxe room (ocean view); low season R$230–R$300 standard room (garden view), R$350 deluxe room (ocean view). Extra person 30% extra. Children 2 and under stay free in parent's room. AE, DC, MC, V. **Amenities:** Restaurant; bar; outdoor pool; Wi-Fi. *In room:* A/C, TV (upon request), hair dryer, minibar.

MODERATE

Búzios Internacional Apart Hotel ⚜ ☺ One of the few relatively inexpensive options in town, this modern apart-hotel is just a few blocks from Rua das Pedras. Units are all self-contained flats equipped with a living room with foldout couch, kitchen, and either one or two bedrooms. These are an excellent option for a family traveling together. All units are pleasantly if simply furnished and come with a balcony and hammock looking out over a central garden. The complex also has a swimming pool, sauna, game room, and bar. Rentals are either calculated by the day or by the week. Prices for two are comparable to the less expensive pousadas, but if there are more than three people (up to a maximum of six) savings can be significant. Discounts for 7-day stays available.

Estrada da Usina Velha 99, Armação de Búzios, 28980-000 RJ. www.buziosbeach.com.br. ℂ/fax **022/2537-3876.** 44 units. High season (mid-Dec to Mar) R$300–R$440 for 2; low season (Mar to mid-Dec, except holidays) R$200–R$260 for 2. Extra person R$40. AE, V. Free parking. **Amenities:** Restaurant; outdoor pool. *In room:* A/C, TV, hair dryer, kitchen, minibar.

Where to Eat

Buzin BRAZILIAN/KILO One of the better kilo restaurants, Buzin offers a large buffet of excellent salads, antipasto, and vegetables. The grill serves up a variety of cuts of steak, grilled to your preference. Of course, being right by the sea, the restaurant also includes a daily selection of fresh seafood and fish in its offerings.

Rua Manoel Turibe de Farias 273. ℂ **022/2633-7051.** www.buzinbuzios.com.br. Reservations not accepted. Main courses R$44 per kilo. AE, V. Daily noon–midnight.

Estancia Don Juan ★★ STEAKHOUSE The Don loves meat: The menu features *linguiça* (smoked sausage) and numerous exquisite beef cuts such as *picanha*, entrecôte, and *olho de bife*. Side dishes such as broccoli, baked potatoes, or carrots must be ordered separately. Fish flesh is also acceptable: The Don offers a toothsome catch of the day served with hollandaise sauce, capers, or balsamic vinaigrette. You can eat your meat on a lovely flowered patio, or in a multilevel hacienda dripping with atmosphere. The wine list features a fine selection of South American reds (R$40–R$120 sold by the bottle). On Tuesday evenings at 9pm, there's a live tango show.

Rua das Pedras 178. ℂ **022/2623-2169.** www.estanciadonjuan.com.br. Reservations accepted. Main courses R$34–R$52 for 2. AE, DC, MC, V. Mon–Tues 6pm–midnight; Wed–Sun noon–2am.

Porto da Barra

The Rua das Pedras is no longer the only option for a fun night out in Búzios. A new dining area has developed on Manguinhos beach (Av. José Bento Ribeiro Dantas 2900, Manguinhos; www.portodabarrabuzios.com.br; most restaurants closed for lunch on weekdays; 10–15 min. by taxi from downtown Búzios), overlooking the ocean and mangroves. Especially at night, this makes for a romantic outdoor dining destination when the restaurants and boardwalk through the mangrove are beautifully illuminated. Enjoy an Italian meal with a fabulous view at upscale **Quadrucci** (ℂ **022/2623-6303**) or grab some fresh seafood at the **Bar dos Pescadores** (ℂ **022/2623-6785**). Other options include delicious eclectic fusion dishes at **Zuza** (ℂ **022/2623-0519**) and sushi at the **Captain's Sushi Bar** (ℂ **022/2623-9097**).

Sawasdee ★★★ THAI Over the last 10 years, chef Marcos Soudré and his wife, Sandra, have made Sawasdee into one of Brazil's finest Thai restaurants. The menu can be a bit overwhelming (it is huge), but everything is delicious, so be adventurous. Don't just stick with the fragrant coconut soup, spicy red curry, or tangy pad Thai noodles. How about grilled fish with shiitake risotto and passion-fruit curry or grilled duck breast in tamarind sauce? The drink menu includes tasty tropical concoctions like the *koh thao* (vodka, litchi, and orange juice) or the mai tai (a vodka cocktail with mint, ginger, and lemon grass). Wine drinkers can choose from a variety of affordable options, either by the glass or by the bottle.

Av. José Bento Ribeiro Dantas 500 (Orla Bardot), Praia da Armação. ℂ **022/2623-4644.** www. sawasdee.com.br. Main courses R$32–R$58. AE, DC, MC, V. Sun–Tues and Thurs 6pm–midnight; Fri–Sat 6pm– 2am. Closed Wed.

Búzios After Dark

If you're looking for a night out, **Rua das Pedras** is the place to crawl. This 1,219m-long (4,000-ft.) street has pubs, bars, discos, and restaurants open on weekends until 5am.

To simply sit, sip a drink, and check out the action, the place to be is the **Anexo Bar and Lounge,** overlooking the happening waterfront. If you prefer your entertainment live, there's **Patio Havana,** which features a nightly selection of jazz, blues, and MPB. Thursdays is salsa night. Should you get bored of the band, you can wander out to the ocean-side patio and enjoy the nighttime view. For a late night snack, locals and visitors gather at **Chez Michou'**s large outdoor patio for a crepe (open until 6am in high season). Popular Rio brewpub **Devassa** has set up shop in Porto da Barra (see above). To dance until you drop, Búzios boasts two mega-nightclubs on the Orla Bardot, **Privilege** and **Pacha** (one of Ibiza's hottest clubs). These only operate on Saturdays, with additional nights in high season. But remember, don't bother showing up until 1 or 2am.

PETRÓPOLIS ★

44km (27 miles) N of Rio de Janeiro, 371km (230 miles) NE of São Paulo

Known as Cidade Imperial (the Imperial City), Petrópolis is one of Rio de Janeiro's premier mountain resorts, located 720m (2,400 ft.) above sea level. Though only an hour from Rio, its quiet and calm put it light-years from the hectic pace of the city. The lovely tree-lined streets, the palaces, mansions, and museums can be comfortably explored on foot or by horse and buggy, and the mountain air ensures a pleasant climate year-round. Once just a stopover on the gold route between Minas Gerais (chapter 6) and Rio de Janeiro, its fine location and cool climate drew the attention of Emperor Dom Pedro II, who in 1843 founded the city of Petrópolis and built his summer palace (now the Imperial Museum) on a piece of land acquired by his father. Construction of the first railway in 1854 opened up easy access to the new city. Many of Brazil's merchant nobility—industrialists, coffee moguls, and politicians—built their summer residences here, turning Petrópolis into the de facto summer capital. Even after independence in 1889, Petrópolis maintained its prestige. In 1904, the former residence of the Baron of Rio Negro became the official summer residence of the president of the Republic.

Nowadays Petrópolis is a favorite weekend getaway for Cariocas: in the summer to escape the heat and humidity of the city, in the fall and winter for a chance

to experience "really cold" weather, wear winter clothes, eat fon⌐
fireplace. The historic part of the city, centered around the Impe·
cathedral, contains the majority of the monuments and musei
and large squares give the small city a remarkably pleasan⌐
streets are worth exploring just to have a peek at the many mɑ.
ticularly nice are Avenida Koeler and Avenida Ipiranga as far as the ᴗ.

In addition to the Cariocas's noble pursuit of culture and nature, they ᴗ
here to visit the **Rua Teresa,** to shop for great, affordable clothing. The area arou.
Petrópolis has many textile factories, and the Rua Teresa has become the prime retail
and wholesale outlet for cotton and knitwear at unbelievably low prices.

Petrópolis makes an easy day trip from Rio, but to experience the atmosphere of
the city and take in some mountain air, it's better to spend the night. The region has
a number of beautiful pousadas and excellent restaurants, and is close to a national
park with excellent hiking trails.

Essentials

GETTING THERE

BY BUS Unica/Facil (✆ **021/2263-8792;** www.unica-facil.com.br) offers daily
service between Rio's bus station, the Novo Rio Rodoviaria, and the main bus station
in Petrópolis. The trip takes 90 minutes. Buses traveling either direction leave daily
every 30 to 45 minutes between 5:15am and midnight. Tickets cost R$17. In
Petrópolis, buses arrive at the new bus station, **Terminal Rodoviaria Governador
Leonel Brizola,** on the city outskirts, a short taxi ride from the historic center.

GETTING AROUND

All the sites in the historic center are within walking distance of the bus station and
each other. There is no need to drive or take a taxi.

BY RENTAL CAR A rental car is useful if you're thinking of checking out some of
the nearby national parks. Check out **Localiza,** Rua Coronel Veiga 746, Centro
(✆ **024/2246-0100;** www.localiza.com; Mon–Fri 9am–6pm, Sat 9am–2pm).

BY TAXI For trips outside the city center, to pousadas or restaurants, call **Disk
Taxi Imperial** (✆ **024/2242-9188**) or just hail one of the many circulating taxis.

BY HORSE & BUGGY This is a great way to see the city without doing all the
walking. Buggies depart only from the main entrance of the Museu Imperial. (Buggies in front of other attractions are waiting for their clients to come back from their
visit.) You have two options for sightseeing: the first tour, R$60 per buggy for up to six
people, stops at the cathedral, Palácio de Crystal, Casa de Santos Dumont, Palácio
Rio Negro, and Palácio Barão de Mauá, allowing you to get off and visit each site
while the buggy waits. It takes about an hour and a half. On the second, cheaper
option you cover the same route, but the buggy never stops so you see the sights only
from the outside. The cost is R$40 for up to six people, and it takes about 30 minutes.
Tours run year-round, Tuesday through Sunday. *Note:* The tour price does not
include admission to any of the museums along the way.

VISITOR INFORMATION

The **Petrópolis Foundation of Culture and Tourism** maintains an English-language website (www.petropolis.rj.gov.br) and a toll-free information line, **Disque
Turismo** (✆ **0800/024-1516**). There's also a number of tourist information centers
around town. The main one is in the **Centro Histórico,** Praça Visconde de Mauá

Petrópolis

ne absolute worst day to visit Petrópolis is Monday; most attractions are closed, and shops at the Rua Teresa open only at 2pm. Some attractions are also closed on Tuesday, and many restaurants are closed Monday through Wednesday. The best days to visit are Wednesday through Friday. Weekends can be busy, so book accommodations ahead of time. Avoid holidays, as museum lines and traffic can be very bad.

305 (Mon–Sat 9am–6pm, Sun 9am–5pm); another is in the Governador Leonel Brizola **main bus terminal,** Rua Ministro Lucio Meira (daily 8am–6pm); and another is near the Rua Teresa shopping district, Rua Aureliano Coutinho s/n (Tues–Sun 9am–6pm). Ask for the English version of the excellent *Petrópolis Imperial Sightseeing* brochure. It comes with a map and opening hours of each of the attractions.

The Petrópolis Convention and Visitor's Bureau also has a website with information on Petrópolis attractions, accommodations, and restaurants: **www.pcvb.com.br**.

The **Banco do Brasil** branch is on the Rua do Imperador 940 (corner of Rua Alencar Lima; ✆ **024/2243-6143**).

SPECIAL EVENTS

To honor the German immigrants who played an important role in the early days of Petrópolis, the city holds **Bauernfest,** an annual festival celebrating German music, culture, and food. It is held yearly on the last weekend of June and the first week of July. Contact Petrotur for more information (✆ **0800/024-1516**).

Making the most of Petrópolis's reputation as a winter destination, the **Festival de Inverno (Winter Music Festival)** takes place in the last 2 weeks of July at the Palácio de Crystal, Palácio Rio Negro, Centro Cultural Raul de Leoni, and Praça da Liberdade. For information contact ✆ **0800/024-1516**.

Exploring Petrópolis

The historic heart of Petrópolis can easily be explored on foot: The city is fairly flat and extremely safe; even traffic is less hectic than in Rio. Following the directions below will take you to most points of interest.

Starting on the corners of Avenida Ipiranga and Tiradentes, the first thing you see is the **Cathedral São Pedro de Alcantara** (daily 8am–6pm), a neo-Gothic church named for both the patron saint of the Empire and—not coincidentally—the Emperor Dom Pedro II himself. Construction began in 1876, but the celebratory first Mass wasn't held until 1925. Just inside the main doors to the right is the Imperial Chapel containing the remains of the Emperor Dom Pedro II, the Empress Dona Teresa, their daughter Princess Isabel, and her husband (whose name no one remembers). The princess, who often ruled during her father's many trips abroad, lived in the beautiful mansion immediately across the street, now known as the **Casa da Princesa Isabel** (closed except for special exhibitions). Continuing along the Avenida Koeler as it follows the tree-lined canal, it's a 5-minute walk to the beautiful **Praça da Liberdade.** The bridge in front of this square offers the best view of the cathedral and the canal. Just behind the Praça da Liberdade is the **Museu Casa de Santos Dumont** (see below). From here follow Avenida Roberto Silveira, then turn

right on Rua Alfredo Pachá to the **Palácio de Cristal,** Rua Alfrec (**024/2247-3721;** admission R$5; Tues–Sun 9am–6:00pm). Commiss Princess Isabel and built in France, the structure was inaugurated in 1894 agricultural exhibition hall. Nowadays, the palace is used for cultural events a exhibits (see "Special Events," above). The tourist information center inside the Pal- ace has a great brochure in English featuring a map plus a listing of all the attractions with their opening hours.

Crossing the bridge to Avenida Piabanha, you come to the **Casa Barão de Mauá,** Praça da Confluencia s/n (**024/2246-9215**). Built in 1854 in neoclassical style by the industrial baron who constructed Brazil's first railway, the grounds of the house are open daily, from 9am to 6pm. The columns surrounding the winter garden are solid iron, made by the baron himself. Admission is free.

Continue by taking Rua 13 de Maio—right across the street from the Casa Barão de Mauá—toward the cathedral and then turning left on Avenida Ipiranga at the intersection just before the cathedral. Along this street are a number of interesting buildings as well as some gorgeous mansions and villas. Standing on the right side of the street at no. 346 is the 1816 **Igreja Luterana,** the oldest church in Petrópolis (open for visitation only during Sun morning service at 9am). On the left side of the street at no. 405 is the **Casa Rui Barbosa,** the summer residence of the liberal journalist, politician, and positivist who helped found the First Republic. A bit farther along the Avenida Ipiranga at no. 716 is the lovely **Casa de Ipiranga,** a museum, cultural center, restaurant, and garden (see below). From here it's a simple matter to retrace your steps to the cathedral.

Casa de Ipiranga ★★ Guided tours of this beautifully preserved house will take you through numerous salons lavishly decorated with satin curtains and wallpaper, gold-leaf chandeliers, and ornate and beautiful furniture. The banquet room is a marvel of jacaranda wood—the room's generous palette of colors is the result of judi- cious use of variously colored jacaranda subspecies. The rest of the house is used for concerts and exhibits. Weekly concerts take place on Saturday night at 8pm; tickets cost R$15. The lovely garden is also well worth a look. Allow 1 hour.

Rua Ipiranga 716. (**024/2231-8718.** www.casadaipiranga.blogspot.com. Admission R$5. Thurs– Mon noon–8pm.

Museu Casa de Santos Dumont ★ Who invented and flew the first airplane? Santos Dumont! Brazil's most famous aviator was the first in the world in 1906 to take off and land under his own power (unlike the Wright brothers, who used a catapult for takeoff on their first flight at Kitty Hawk). Dumont's creativity extended well beyond aviation. Among many other things, he also invented the wristwatch. Flying in balloons and blimps, he needed a watch at hand so he tied his pocket watch with a scarf to his wrist. Later he took the idea to his jeweler friend Cartier in Paris, who developed the first wrist strap. The Paris design house still comes out with a new watch design every year named "Santos." On display in this house are a number of bits of personal memorabilia: the medallions he earned for his many flight projects; his photos, books, and letters; and the Brazilian flag he carried with him on every flight. In the bathroom there's another Dumont original: the first hot shower in Brazil, heated by alcohol. Expect to spend 20 minutes. Helpful guides happily provide infor- mation in English.

Rua do Encanto 22. (**024/2247-3158.** Admission R$5. Tues–Sun 9:30am–5pm.

★★ Built by Dom Pedro II in 1845 as his summer palace, this ⌐remier museum. (On Sun and holidays the line can be fierce.) ⌐gh numerous salons decorated with period furniture, household ⌐and drawings depicting the life and landscapes of 19th-century ⌐razil's equivalent of the crown jewels: Dom Pedro II's crown, ⌐ilograms (4 lb.), encrusted with 639 diamonds and 77 pearls. ⌐the bedrooms, including lovely baby cribs made out of jacaranda wood and decorated with bronze and ivory—fit for a pair of princesses. In the garden, the palace's coach house has a beautiful collection of 18th- and 19th-century carriages. The highlight is the royal carriage, painted in gold and pulled by eight horses. Expect to spend 1½ hours.

Rua da Imperatriz 220. ✆ **024/2237-8000.** www.museuimperial.gov.br. Admission R$8 adults, R$4 children 7–14, free for children 6 and under. Tues–Sun 11am–5pm.

Palácio Rio Negro Built by the coffee mogul Barão de Rio Negro in 1890, the palace has served as the summer residence of Brazilian presidents from 1903 onward. The rest of the year it functions as a cultural center. Most of the furniture inside is Portuguese baroque—dark, heavy, and beautifully carved. The hardwood floors are particularly ornate. Each room has a different pattern; the dining room floor is done in a coffee-bean pattern. Upstairs many of the rooms bear the decorative stamp of a particular president.

Av. Koeler 255. ✆ **024/2246-9380.** Free admission. Sat–Sun 10am–5pm.

OUTDOOR ACTIVITIES

HIKING Petrópolis has great hiking in the hills surrounding the town. **Serra Trekking Ecoturismo** (✆ **024/2242-2360;** www.serratrekking.com.br) offers everything from short day hikes to full overnight treks, ranging in price from R$15 to R$120. For do-it-yourselfers, the Petrópolis Convention and Visitor's Bureau **website** (www.pcvb.com.br) has a full page of information on local Petrópolis hikes. Click on "Trekking." To hook up with local hikers, try **Grupo de Ecoturismo Maverick** (✆ **024/2291-3789;** www.grupomaverick.com.br). **Rio Hiking** (✆ **021/2552-9204** or 9721-0594; www.riohiking.com.br) also organizes a variety of hiking trips in the Petrópolis region, with transportation to and from Rio included.

HORSEBACK RIDING Contact **Cavalgada Ecologica** (✆ **024/2222-9666** or 8823-5528; www.cavalgadaecologica.com.br) for tours lasting from 2 to 4 hours.

Where to Stay

Overnight visitors to Petrópolis can choose to stay at hotels or pousadas in the historic part of town, or head farther out and find a nice hotel in the hills and valleys close to town. The advantage of staying downtown is that all the attractions are easily accessible on foot. If you choose to stay farther out it's always a good idea to contact your pousada for instructions on how to get there; some can arrange for pickup or send a taxi. Petrópolis does not have a pronounced low or high season.

Casablanca Hotel Imperial ★ 🍃 Located next door to the Museu Imperial on one of Petrópolis's fine canals, Casablanca is within easy walking distance of all the city's historic sites. The hotel consists of the original mansion and a modern annex. The nicest rooms are the deluxe ones on the second floor of the original building. These have sky-high ceilings, air-conditioning, bathtubs, and antique dark-wood furniture. On the same floor there is also a lovely reading lounge with a fireplace

looking out over the canal. The standard rooms with showers only—in the annex and on the ground floor of the main house—are pleasant but lack character. The only drawback to this hotel's central location is the neighboring school; it gets very noisy during recess.

Rua da Imperatriz 286, Petrópolis, 25610-320 RJ. www.casablancahotel.com.br. ℂ **024/2242-6662.** 50 units, 7 with bathtub. R$200 standard; R$240 deluxe. Extra bed R$90. Children 6 and older R$40. AE, DC, MC, V. Free parking. **Amenities:** Outdoor pool; limited room service; sauna. *In room:* A/C (in *luxo* rooms only—standard rooms w/fans), TV, minibar.

Fazenda das Videiras ★★★ ⚶ This is the perfect romantic getaway spot in the mountains close to Rio. The chalets here feature a king-size four-poster bed and a fireplace, plus in the ample bathrooms a Jacuzzi for two with a skylight or peekaboo view of a creek or the woods. For more relaxation, there's a little private deck with a view of a babbling creek and the mountains. The rooms in the main building are nice, but not really worth the price or effort of getting here. The French restaurant attached to the pousada is one of Petrópolis's best. Note that chalets usually rent for a 2-night minimum.

Estrada Araras 6000, Vale das Videiras, Petrópolis, 25610-320 RJ. www.videiras.com.br. ℂ **024/2225-8090.** 5 chalets, 4 rooms. R$450–R$558 double; R$729–R$1,000 chalet (per night, based on a minimum 2-night stay). AE, DC, MC, V. Free parking. Children 14 and under not permitted. **Amenities:** Excellent restaurant; outdoor pool; sauna. *In room:* A/C, TV/DVD, minibar.

Pousada Monte Imperial Koeller This cute inn is located on one of the prettiest boulevards in Petrópolis, amid many of the historic buildings. Some of the rooms have a balcony and offer pleasant views of the gardens. Other rooms look out over the historic Casa da Princesa Isabel mansion next door. All rooms are nicely decorated and feature comfortable beds and Egyptian cotton sheets. Breakfast is included.

Av. Koeller 99, Petrópolis, 25620-000 RJ. www.pousadamonteimperial.com.br. ℂ **024/2243-4330.** 11 units. R$215–R$370 double. Extra person R$55. Children's rate negotiable. AE, DC, MC, V. Free parking. *In room:* TV, fridge, minibar.

Solar do Imperio ★★★ Fit for a king, or a princess to be more precise, the Solar do Imperio is a lovingly restored neoclassical palace built in 1875 as the home for Brazil's Princess Isabel. Upgraded as much as possible to modern standards, the rooms have air-conditioning and heat, and king-size beds with down comforters and pillows. Guests can choose between the *real* suite or the imperial suite. *Real* suites are much more spacious and have soaring high ceilings. The hotel also boasts a beautifully restored reading room, and an elegant veranda and garden—a royal experience indeed. Note that the hotel has recently added eight standard suites in the more modern spa building; though the quality is excellent they lack some of the historical charm.

Av. Koeler 376, Petrópolis, 25610-220 RJ. www.solardoimperio.com.br. ℂ **024/2103-3000.** 24 units. R$380–R$455 standard; R$398–R$495 imperial suite; R$480–R$585 *real* suite. AE, DC, MC, V. Free parking. **Amenities:** Restaurant, Imperatriz Leopoldina (see review, p. 144); bar; outdoor pool; limited room service; sauna. *In room:* A/C, TV, hair dryer, minibar.

Where to Eat

Petrópolis offers a range of dining opportunities, from schnitzel to sushi to churrasco, from cheap and cheerful to high-end (and expensive) fine dining. Check opening times carefully, though, as a number of restaurants are closed Monday through Wednesday or Monday through Thursday.

VERY EXPENSIVE

Locanda della Mimosa ★★★ ITALIAN The cuisine and wine list at this restaurant in the mountains have won plaudits and regular clients from Rio, Sao Paulo, and farther abroad. The dishes are Italian and contemporary, but the menu changes constantly to reflect seasonal ingredients and chef Dânio Braga's desire to create something new. Among the offerings is a four-course tasting menu, with wine pairings chosen from the Locanda's extensive cellars (awarded "Best Wine List in Brazil" in 2009 by Guia Brasil Turismo). Decor is elegant and refined, and service is excellent. Note that the restaurant is only open on weekends.

Al. das Mimosas 30, Vale Florido (15km/24 miles from Centro). ☏ **024/2233-5405.** www.locanda. com.br. Reservations required. Main courses R$65–R$125. DC, MC. Fri–Sat 12:30–3:30pm and 8–11:30pm; Sun 12:30–3:30pm.

EXPENSIVE

Imperatriz Leopoldina ★★ BRAZILIAN New in town and already winning awards, this elegant restaurant (in the Solar do Imperio hotel) features high ceilings, literally palatial windows, and walls decorated with creatures of the forest with knife and fork in hand, getting ready to tuck into dinner. As an appetizer, don't miss the *casquinha de bacalhau*—cod served with spices on a crab shell. For mains, the menu features succulent duck and lamb dishes, as well as regional favorites such as filet mignon with banana rice. On Fridays and Saturdays, the restaurant serves a scrumptious high tea.

Av. Koeller 376, Petrópolis (Centro). ☏ **024/2103-3000.** www.solardoimperio.com.br. Main courses R$35–R$65. AE, DC, MC, V. Mon–Thurs noon–10pm; Fri–Sat noon–midnight; Sun noon–9pm.

Parrô de Valentim ★★ PORTUGUESE Here you'll find traditional Portuguese cuisine, which means simple ingredients—pork or cod, onions, olives, and potatoes—cooked with olive oil and seasonings, then served together in a large earthenware pan. Try the *bacalhau* (cod) *a Valentim*, or the *leitão a Portuguesa* (Portuguese suckling pig). You won't be sorry. Many dishes serve two. Save room for some of the traditional Portuguese sweets (mmm, *pastel de nata*).

Estrada União-Industria 10289, Itaipava (17km/28 miles from Centro). ☏ **024/2222-1281.** www. parrodovalentim.com.br. Main courses R$35–R$65. DC, MC, V. Wed–Thurs 11:30am–10pm; Fri–Sat 11:30am–midnight; Sun 11:30am–9pm.

MODERATE

Churrascaria Majoricá ★ CHURRASCO A traditional-looking churrascaria with wood panels and booths, Majoricá is a local favorite when it comes to a good steak. Make your choice: T-bone, *picanha*, entrecôte. Most dishes serve two people.

Rua do Imperador 754. ☏ **024/2242-2498.** www.majorica.com.br. Main courses R$18–R$34. AE, MC, V. Sun–Thurs 11am–10pm; Fri–Sat 11am–11pm.

Luigi ITALIAN This is a place for lovers of simple Italian food. Luigi's lists pasta and sauce separately, allowing guests to mix and match. There are also stuffed pastas such as cannelloni, ravioli, and lasagna. The large buffet includes cold cuts, cheeses, quiches, and sliced roast beef. In the evenings the restaurant serves excellent pizzas.

Praça Rui Barbosa 185, Centro. ☏ **024/2244-4444.** www.massasluigi.com.br. Main courses R$16–R$38. AE, DC, MC, V. Sun–Thurs 11am–midnight; Fri–Sat 11am–1am.

Paladar KILO Just a block from the Santos Dumont Museum, the Paladar restaurant is great for a quick and inexpensive lunch. The restaurant puts out a great spread

including salads, pasta, roast beef, chicken, beans, and other dishes. The selection varies daily.

Rua Barão do Amazonas 25. ✆ **024/2243-1143.** Main courses R$20 per kilo. AE, MC, V. Tues–Sun 11am–4pm.

Petit Palais Tea Room ★ 🛍 TEA/CAFE Tucked away in the corner of the gardens surrounding the museum, this lovely tearoom is the perfect place for lunch. Head toward the coach house and follow the path downhill to the left. Full tea service is available, including cakes, pies, croissants, madeleines, toast, jam, cold cuts, and pâté. For something lighter, the restaurant also serves a variety of quiches, omelets, soups, sandwiches, and pastas.

Rua da Imperatriz 220. ✆ **024/2244-7912.** Main lunch courses R$14–R$26; full tea R$39. No credit cards. Tues–Wed noon–7pm; Thurs noon–8pm; Fri–Sat noon–midnight; Sun noon–7pm.

ILHA GRANDE ★★★

Angra dos Reis: 114km (71 miles) SW of Rio de Janeiro, 246km (153 miles) NE of São Paulo

One man's paradise is another man's prison, quite literally in the case of Ilha Grande. During Brazil's long years of military dictatorship, the prison on the far side of the island was where the generals sequestered political prisoners, throwing them in with the general population in the expectation that these effete intellectuals would get eaten alive. As it turned out, the political prisoners had solidarity and revolutionary theory on their side. Not only did they manage to dominate the general population, but they soon began to recruit among the other prisoners for the cause, imparting to these new cadres all their hard-won knowledge of revolutionary theory and urban guerilla warfare. With the return of democracy, the middle-class revolutionaries returned to politics, while the criminal cadres put their new skills to use revolutionizing the theory and practice of crime. The citywide drug syndicates that now control the favelas in Rio de Janeiro and São Paulo can be tracked back to lessons learned in the presidio of Ilha Grande. (A 2004 film version of this story, *Quase Dois Irmãos* [Almost Brothers] featured a screenplay by *City of God* author Paulo Lins.) The remains of the prison can still be seen on the island's windward shore, but that's not what draws people to Ilha Grande.

Instead, the reason most people sentence themselves to a stint on the Big Island has more to do with pristine beaches, turquoise ocean water, and green rainforest hills running from the shoreline up to peaks over a thousand meters high. For the active, there are schooner tours and scuba diving, kayaking, rainforest hikes to hidden waterfalls, surfing and body boarding, and sailing. For the sedentary, there's quiet and calm and some of the prettiest beaches in Southern Brazil.

The main town on Ilha Grande—and the spot where the ferries and boats from the mainland arrive—is **Vila do Abraão** (often just Abraão), a not very big collection of pousadas and restaurants on the island's eastern end. Numerous other pousadas are tucked away on small bays and beaches around the rest of the island. Spend a few days here and you may find you've lost all will to escape.

Essentials
GETTING THERE
To reach Ilha Grande you first travel by road, either to **Mangaratiba, Conceição de Jacareí,** or **Angra dos Reis,** and then by ferry, private schooner, or water taxi

over to the island. Which point you depart from depends on where you're staying. If you're staying in or near the village of Abraão, then Conceição de Jacareí is probably the best bet, as the private schooner Saveiro Andéa offers four departures daily (six on Fri) and the trip is only 50 minutes. A large public ferry also travels from Mangaratiba and Angra dos Reis to Abraão on Ilha Grande. From Mangaratiba the ferry departs at 8am, while Angra dos Reis has an afternoon departure, either 3:30pm (weekdays) or 1:30pm (weekends). Angra is the larger town, the only one of three with banks and other services. Angra also has a number of private water taxis which offer transfers to pousadas spread out on the island. If you're staying in a pousada on the western half of the island, the water taxi likely departs from Angra.

BY BUS From Rio de Janeiro, **Costa Verde** (✆ **024/3371-1326;** www.costa verdetransportes.com.br) has approximately hourly departures to Mangaratiba, Conceição de Jacareí, and Angra dos Reis (it's the same bus) from Rio's main bus station (Novo Rio) starting at 4am and ending at 9pm. The cost is R$38. The trip to Angra takes about 2½ hours, to Mangaratiba and Conceição de Jacareí a little less. *Tip:* If you're planning to get off at Conceição de Jacareí, let the bus driver know when you board the bus. That way he'll stop and call out when you arrive. From São Paulo, **Reunidas Paulista** (✆ **0300/210-3000;** www.reunidaspaulista.com.br) has four departures per day to Angra from the Tietê station, at 8am, 12:15pm, 4pm, and 10pm. The trip takes 7 hours and costs R$61.

BY PRIVATE TRANSFER **Paraty Tours** (✆ **024/3371-2651;** www.paratytours. com.br) offers private transfers from Rio de Janeiro with set times for a minimum of two people at 8:30am, 12:30pm, and 5pm. Airport pickups are anytime between 8:30am and 5pm. Travel time is about 2½ hours. Rates per person are R$115. For three people or more you can set your own pickup time.

BY FERRY From Angra dos Reis, **Barcas S.A.** (✆ **0800/704-4113;** www. barcas-sa.com.br) has one departure a day, at 3:30pm on weekdays, and 1:30pm on weekends. The return trip from Ilha Grande to Angra departs at 10am. From Mangaratiba, the ferry departs at 8am daily (with one extra 10pm sailing on Fri). The return ferry to Mangaratiba departs at 5:30pm daily. For both routes, the cost is R$14 one-way, R$25 round-trip, and the trip takes about 80 minutes.

BY PRIVATE SCHOONER The private schooner **Saveiro Andréa** (✆ **021/9744-0732** or 024/8826-3809) makes four trips daily between **Conceição de Jacareí** on the mainland and **Vila do Abraão** on Ilha Grande. From Conceição de Jacareí, the boat departs at 9am, 11:30am, 3pm, and 6:15pm, with two extra sailings on Fridays at 6:45pm and 9pm. From Vila do Abraão, the ship departs at 7:30am, 10am, 1pm, and 5pm. The cost is R$15 each way, travel time is 50 minutes.

From **Angra dos Reis,** the schooner **Saveiro Resta 1** (✆ **024/3365-6436**) departs for **Abraão** at 8am weekdays, 7:30am, 11am, and 4pm weekends. Going the other way, the boat departs at 5pm weekdays, 9:30am, 1pm, and 5pm weekends. Also from Angra dos Reis, the schooner **Saveiro Samurai** (✆ **024/3361-5920**) departs for Abraão daily at 5pm. Journeys from Abraão to Angra take place in the morning, daily at 10am. The cost is R$10 to R$15 depending on the departure time, and the trip takes 90 minutes.

A new service, the **Catamaran IGT** (✆ **024/3365-6426** or 3361-5500), departs Angra dos Reis for the island daily at 8am, 10:45am, and 4pm, and departs Vila do Abraão for Angra at 9am, 12:30pm, and 5pm. The cost is R$25, and the trip takes 45 minutes.

Note: This being Brazil, schooner departure times, locations, and fares are subject to change at unpredictable intervals. Always call to confirm (or check www.ilhagrande.org/Horarios-Saveiros-Ilha-Grande).

BY WATER TAXI Numerous smaller boats make the trip to Ilha Grande, either to ferry passengers to pousadas on more isolated beaches or to take visitors on day trips. Transfers on these smaller boats is normally R$50 per person, with a minimum of four people. To find a skipper, ask at your pousada, or try the **Associação dos Barqueiros de Angra** (**Boat Captains' Association of Angra;** ✆ **024/3365-3165**) or the **Associação dos Barqueiros da Ilha Grande** (✆ **024/3361-5920**).

GETTING AROUND

The town of Abraão is easily walkable, and there are numerous trails on the island.

VISITOR INFORMATION

Though there is no official Ilha Grande tourism bureau, a number of websites have useful information about Ilha Grande. These include **www.ilhagrande.org**, **www.ilhagrande.com**, and **www.ilhagrande.com.br**. They provide general tourist information as well as suggestions on hotels, tours, and excursions.

FAST FACTS There are no banks on Ilha Grande. Most pousadas and restaurants accept credit cards, but its best to check beforehand, and bring extra cash.

Exploring Ilha Grande
THE BEACHES

Though nearly all the beaches on Ilha Grande are beautiful, a few are simply spectacular. One of these is **Lopes Mendes,** facing the ocean on the eastern tip of the island. Considered the prettiest beach on the island, this long stretch of strand is unspoiled by any development, and features fine soft sand, clear clean water, and excellent surfing waves. You can walk to Lopes Mendes from Abraão (about 2½ hr.) but most people catch a boat (see "Boating," below) to the anchorage at Pouso, from which it's an easy 20-minute walk up and over a low ridge.

Dois Rios beach also lies on the open ocean side of the island. The ruins of Ilha Grande's **Candido Mendes Prison,** deactivated and destroyed in 1994, still stand at the southern end of the beach. Beach and prison are reached via a broad trail (a former road, in fact) from Abraão. The hike takes about 2½ hours, and is of medium level difficulty.

On the island's western end, the beaches of **Aventureiro, Praia Sul,** and **Praia Leste** slope gently out to sea, making for lots of shallows with only gentle surf. The beaches are reached via schooner to Aventureiro, after which you walk along the shoreline to Praia Sul and Praia Lest. Aventureiro has a small restaurant where you can relax and have lunch.

Though not strictly a beach, **Lagoa Azul** is a delightful area of shallows and small islands near the north (landward) tip of the island. Its calm waters and extreme visibility make it a great place to snorkel. The Blue Lagoon is reached via boat, a 40-minute trip from Abraão.

THE HIKING TRAILS

The classic Ilha Grande hike goes from Abraão up to **Pico de Papagaio (Parrot Peak),** so-called because the mountain supposedly looks like a parrot's head. The trail is rough but reasonably well-marked, and covers 11km (7 miles) and gains 1,080m (3,543 ft.) in altitude. If you know how to hike, there's no need for a guide, but services are available. Round-trip takes about 10 hours. There are several excellent lookout spots on the way up. The view from the peak is marvelous. Less intense hikes go from Abraão to **Lopes Mendes beach** (about 2 hr. one-way, easy), from Abraão to **Dois Rios beach** and the old prison (about 2 hr. one-way, medium). From Praia Vermelha on the island's western end you can also hike to **Provetá beach** (2 hr., medium) and from there to **Aventureiro** beach on the seaward coast (1½ hr., medium). Easiest and arguably best of all, the hike from Abraão to the 15m-high (49-ft.) **Cachoeira da Feiticeira** waterfall requires no great effort, and provides a tremendous reward (1½ hr., easy).

OUTDOOR ACTIVITIES

BOATING Numerous boats transport visitors to various beaches and other spots around the island. In Abraão, the boats or their agents have ticket booths on the piers. If you're staying at a pousada out of town, odds are your pousada owner will know where and when to catch a boat, or you can call the **Associação de Barqueiros do Abraão** (© 024/3361-5920). The standard boat trip destinations include **Lopes Mendes** (R$25), **Lagoa Azul** (R$35), and (if staying near the western part of the island) **Aventureiro** (R$25). Trips to **Dois Rios** (R$35) often don't travel when

waves and sea are rougher. Another excellent option is the full-day 8-hour trip by fast launch to the island's aquatic high points, including Cachandaço, Dois Rios, and Lagoa Azul. These small boats take a maximum of 10 people, and you stop along the way to snorkel, swim, and enjoy the sights. The cost is R$150 per person. For details contact **Phoenix Turismo** (*©* **024/3361-5822**).

DIVING Excellent dive spots are all around the island. Located in the mini-shopping mall Buganville in Abraão, **Elite Dive Center** (*©* **024/3361-5501** or 9991-9292; www.elitedivecenter.com.br) offers day trips including two dives and all equipment for R$150. Four-day PADI course for beginners cost R$800.

HIKING For guiding services on Ilha Grande hikes, contact **Phoenix Turismo** (*©* **024/3361-5822**). For more information, see "The Hiking Trails," above.

Where to Stay

Vila do Abraão is the most settled part of the island. Staying here offers the chance to stroll out during the evening and have an ice cream, or sample different restaurants. Day trips are also easy to arrange from here. On the downside, the beach at Abraão is not as nice as elsewhere on the island, and the campers and backpackers can detract from the idyllic calm.

IN VILA DO ABRAÃO

Pousada Manaca ★ On the beach, the Manaca offers the best compromise between being close to things while maintaining tranquillity and quiet. Rooms are airy and comfortable, featuring queen-size beds, verandas, and hammocks. The two best rooms are the upstairs suites with a view of the ocean. A lovely garden—where breakfast is served—adds to the atmosphere, as does the tasteful indigenous art displayed throughout the pousada. For cooler evenings, there's a sauna.

Praia do Abraão 133, Ilha Grande, 23970-000 RJ. www.ilhagrandemanaca.com.br. *©* **024/3361-5742.** 7 units. Dec–Mar R$190–R$230 double; Apr–Nov R$150–R$170 double. Extra person R$50 (R$60 high season, R$40 low season). Children 6 and under stay free in parent's room. MC, V. **Amenities:** Restaurant. *In room:* A/C, minibar, no phone, Wi-Fi.

Sagu Mini Resort ★★ The most luxurious spot within walking distance of Abraão, the Sagu sits on a rocky headland with a small micro-beach just a 2-minute walk to one side. Rooms are airy and elegant, with tile floors, wood accents and furnishings, and comfortable queen-size beds. All but two have a sizable private veranda with a hammock and a view of the sea (price is the same, so make sure to ask when reserving). The common grounds are lovely, with walkways, trees, and ocean views. The hotel restaurant, Toscanelli Brasil, is one of the best on the island, offering innovative seafood dishes in a romantic setting (not included in the room rates). The resort also offers other services such as massage, kayak rental, dive trips, and hiking tours, at an extra cost. Free transfer to Abraão on check-in and checkout.

Praia da Bica, Ilha Grande, 23970-000 RJ. www.saguresort.com. *©*/fax **024/3361-5660.** 9 units. Nov–Apr R$360–R$390 double; May–Oct R$320 double. Extra person R$80. Children 4 and under stay free in parent's room. MC, V. **Amenities:** Restaurant, Toscanelli Brasil (see review below). *In room:* A/C, minibar, Wi-Fi.

ON BEACHES ELSEWHERE

Estrela da Ilha ★★ What a spot. This place is set on a small cliff top overlooking the ocean, a 1-minute walk from a long and mostly deserted stretch of sand. Rooms are set in a long row, each looking out over a small veranda with a hammock to the

blue sea beyond. Beds are comfortable queens. The pleasant common area features a small selection of books and games and some comfy couches for relaxing. On the beach, there are free chairs and umbrellas and sunshine. And when that palls, the pousada offers a wide variety of extra activities (at an extra cost), including kayaking, guided hikes, snorkeling, and massages. Meals are delicious and included (ask beforehand if you want a vegetarian menu), as is transfer from the mainland.

Enseada das Estrelas, Ilha Grande, 23970-000 RJ. www.estreladailha.com. © **021/9925-9756** or 024/9831-0020. 11 units. R$450–R$620 double. Rates include all meals and mainland transfer. Extra person R$80. Children 6 and under stay free in parent's room. DC, MC, V. **Amenities:** Restaurant; bar. *In room:* A/C, fan, no phone.

Pousada Lagamar ★ What makes this pousada special is its location, nestled on a hillside above a pocket beach, amid the trees of the Atlantic rainforest. There's verdant foliage all around, hummingbirds buzz beside you on the restaurant deck, while the view is of turquoise ocean and unspoiled sand. Praia Itaguaçú, a 2-minute walk from the pousada, features boulders, sand and blue-green water, and very little else. Praia Vermelha, the "busier" beach a 10-minute walk away, features a pier, some fishermen's homes, and all of two restaurants. Accommodations are comfortable but not luxurious. The chalet offers a double bed downstairs and a pair of singles in an upstairs loft. The suites feature comfortable doubles. Both suites and chalets offer a veranda and hammock, and the wood construction gives the place a pleasant rustic air. Breakfast and delicious seafood dinners are part of the package, as is the hospitality of Mel, the host and owner.

Praia Vermelha, Ilha Grande, 23970-000 RJ. www.pousadalagamar.com.br. © **024/9221-8180** or 9218-9191. 4 suites, 1 chalet. Low season R$130 standard, R$175 suite; high season R$150 suite, R$210 chalet. Extra person add R$80. Rates include breakfast and dinner. MC, V. **Amenities:** Restaurant. *In room:* Fan, fridge, no phone.

Where to Eat

Downtown Vila do Abraão offers a number of simple eateries, many of them acceptable, though none outstanding. The **Pizzaria Dom Pepe,** Rua Amancio de Souza 4 (© **024/3361-5910**), offers cheap and cheerful pizza and other dishes, daily from noon to 9pm. The **Bossa Nova Restaurant,** Rua Santana 145 (© **024/3361-5668;** daily noon–11pm), has a house specialty—grilled shrimp and fish served on a piping hot griddle—that's served in a pleasant candlelit room. **Mix de Sabores,** Rua Getulio Vargas 161 (© **024/3361-5727;** daily 4pm–midnight), offers a wide range of pastas, including a delicious seafood pasta.

Lua e Mar SEAFOOD The nicest restaurant in all Abraão sits on the beach just on the outskirts of town. Dine inside in the small candlelit dining room or outside on plastic tables by the shoreline. The menu includes meat and pasta dishes, but ordering these is a waste of time. The specialty is seafood—rich stews of fish or shrimp or octopus—or fresh filets of fish served steamed or fried. Drinks include beer and a variety of fruity cocktails.

Rua da Praia 297. © **024/3361-5113.** Main courses R$15–R$35. AE, DC, MC, V. Daily 11am–11pm.

Toscanelli Brasil BRAZILIAN Here you'll find innovative cuisine made with fresh seafood ingredients, along with traditional Brazilian seafood dishes, including an excellent fish *moqueca* and a delicious Bahian *bobó de camarão*. There are also meat and pasta dishes. The wine list is certainly the best on the island. The walk from Abraão takes only about 15 minutes, but bring a flashlight and watch for rocks and tree roots.

Sagu Mini Resort (see above), Praia da Bica. (C) **024/3361-5114.** www.saguresort.com. Main courses R$25–R$45. AE, DC, MC, V. Daily 7–10pm.

Ilha Grande After Dark

If you came looking for nightlife, then you made a wrong turn at Albuquerque. Evening excitement on the Ilha consists of watching newcomers troop off the ferry. That said, you don't have to stay cooped up in your pousada. **Espaco Café Tropical,** Rua Santana s/n (C) **024/3361-5577;** Tues–Sun 9am–midnight), offers coffee and *cachaça,* and a vantage point in the thrumming heart of downtown Abraão. Also in Vila do Abraão, the **Bar Biergarten,** Rua Getulio Vargas 161 (C) **024/3361-5583;** Mon–Fri 6:30pm–midnight), features patio tables, a reasonable wine list, fancy cocktails, and a tapas bar of snacks.

PARATY ★★★

156km (97 miles) SW of Rio de Janeiro, 200km (124 miles) NE of São Paulo

Paraty has a gorgeous colonial center, surrounded by turquoise blue waters and flanked by the soaring rainforest-covered mountains of Rio de Janeiro's Costa Verde. The historic core, a UNESCO World Heritage Site, features beautifully preserved colonial architecture. In contrast to the ornate baroque opulence of Ouro Preto, Paraty was a port, a working-class kind of town. The architecture is simple and colonial. Even the churches and municipal buildings seem to have been built more for daily use than as a statement of wealth.

Paraty (also spelled Parati; if you want to start a long conversation, ask a local why there are two spellings) first grew in importance in the 1800s when it became the main shipping port for the gold from the mines of Minas Gerais (chapter 6). The gold was transported down windy trails and cobblestone roads from Ouro Preto to the coast, where it was loaded on ships sailing for Portugal. Once gold became scarce, Paraty switched to coffee, but with the abolishment of slavery in 1888, that too dried up and Paraty faded to near oblivion; the population fell from 16,000 in its glory days to 600 in the early 1900s. From a heritage perspective it was the city's saving grace.

In 1966, the historic colonial center of Paraty was declared a UNESCO World Heritage Site. To preserve its premodern character, cars were banished from the old colonial core. Radical as that may sound, it actually works rather well. Boat tours of the surrounding islands leave from the dock in the city center. Day trips into the surrounding hills include transportation.

The region surrounding the city adds much to Paraty's quiet beauty. The hills are still mostly covered in lush green coastal rainforest, and the waters around Paraty, dotted with 65 islands, are tropical turquoise, warm, and crystal clear, perfect for snorkeling, swimming, or scuba diving. If you only have time to visit one of the historic towns, Paraty makes a fine (long) 1-day or easy overnight destination from either Rio or São Paulo.

Essentials

GETTING THERE

BY BUS From Rio de Janeiro, **Costa Verde** (C) **024/3371-1326;** www.costa verdetransportes.com.br) has eight departures per day from Rio's main bus station (Novo Rio), the first at 6am, the last at 9pm. The cost is R$55. The trip takes

approximately 4 hours. From São Paulo, **Reunidas Paulista** (© **0300/210-3000;** www.reunidaspaulista.com.br) has six departures per day from the Tietê station, beginning at 8am and finishing at 10pm. The trip takes about 6 hours and costs R$47.

BY PRIVATE TRANSFER **Paraty Tours** (© **024/3371-2651;** www.paratytours. com.br) offers private transfers from Rio de Janeiro with set times for a minimum of two people at 8:30am, 12:30pm, and 5pm; airport pickups are available anytime between 8:30am and 5pm. Rates per person are R$135. For three people or more you can set your own pickup time.

GETTING AROUND

ON FOOT The historic center of Paraty is perfect for exploring on foot. The city center is closed to cars (parking is on the outskirts), making walking a traffic-free dream. Wear comfortable shoes as the big cobblestones make for a bumpy stroll.

BY TAXI Taxis in Paraty can be hailed outside of the car-free historic city center, or call © **024/9999-9075** or 3371-2411.

BY RENTAL CAR Car rentals are available from **Alugue Brasil Paraty,** Av. Roberto Silveira 99 (© **024/3371-0019;** www.paratyturismo.tur.br).

VISITOR INFORMATION

The official **Paraty Tourist Information,** Av. Roberto Silveira 1, on the corner of Rua Domingos Gonçalves de Abreu (© **024/3371-1897;** www.paraty.com.br), is open daily 9am to 9pm. **Paraty Tours** operates an information kiosk downtown, just a block down from the historic center at Av. Roberto da Silveira 11 (© **024/3371-2651;** www.paratytours.com.br). They provide general tourist information as well as suggestions on hotels, tours, and excursions.

FAST FACTS **Banco do Brasil,** Av. Roberto Silveira s/n (© **024/3371-1379**), is open Monday through Friday 10am to 3pm. ATMs are open 24 hours. **Paraty Web Internet Access** is located inside the Quero Mais Restaurant, Rua Marechal Deodoro 243 (© **024/3371-7375**). The connection cost is R$4 per hour. There's also Wi-Fi in much of the old historic center, R$20 for 2 hours, with **www.paraty. com**.

Exploring Paraty
THE HISTORIC CENTER

Start your exploration of Paraty at the main pier at the bottom of **Rua da Lapa.** Fishing boats come and go, as well as frequent schooner excursions. Turn and face the city and you will see the postcard-perfect vista of Paraty: the **Santa Rita** church framed by a background of lush green hills. The church was built by freed slaves in 1722 and despite its plain exterior, displays some fine rococo artwork. The church also houses the small **Museum of Sacred Art** (Wed–Sun 10am–noon and 2–5pm; admission R$4). It's worth a quick peek, though it can't compare to some of the fine art on display in Ouro Preto or Mariana. The building just to the left of the church was once the town jail; now it's home to the city library and historical institute. Paraty's biggest and most ornate church, the **Igreja da Matriz,** stands on the Praça da Matriz, close to the River Perequê-Açu. What started with a small chapel in 1646 became a bigger church in 1712 and was finally replaced with the current large neo-classical building, completed in 1873. The **Casa da Cultura** (Rua Dona Geralda) was originally built in 1754 as a private residence and warehouse. Later it housed the

town's public school. In the 1990s, the city restored it to serve as a cultural center and exhibit space.

OUTDOOR ACTIVITIES

BIKING A mountain bike is the perfect way to reach some of the waterfalls in the surrounding hills or some of the beaches just a 10km (6½-mile) ride out of town. **Paraty Tours,** Av. Roberto da Silveira 11 (© **024/3371-1327**), rents bikes by the hour for R$10 or by the day for R$40. Maps are provided.

BOATING Just beyond the muddy Paraty waterfront, the coast is dotted with more than 60 islands, many lush and green, surrounded by turquoise water. It shouldn't be surprising then that schooner trips are extremely popular. The pier in the city center is the main departure point. Boats leave daily, weather permitting, and take you on a 5- to 6-hour tour, stopping several times for a swim or snorkel and a lunch break. **Paraty Tours,** Roberto da Silveira 11 (© **024/3371-2651;** www.paratytours.com. br), and **Saveiro Porto Seguro** (© **024/3371-1254**) are just two of several companies that have daily departures at 11am (as well as 10am and noon in high season); the cost is R$35 for adults, free for children under 5, R$15 for 5- to 10-year-olds. To explore the bay at a more leisurely pace, Paraty tours offers a kayak tour. The 6-hour paddle provides plenty of opportunity for checking out some of the islands and beaches. The cost is R$75 per person, including a guide and all the equipment (minimum of two people).

DIVING The islands around Paraty have some decent diving and cater to a variety of levels. Most operators take you to the many islands around Angra dos Reis (up the coast from Paraty). Dive companies in town include **Adrenalina,** Marina Farol de Paraty (© **024/3371-2991;** www.adrenalinamergulho.com.br), **Una Tour e Dive,** Rua da Lapa 213 (© **024/3371-6188;** www.unatouredive.com.br), and **Paraty Tours,** Roberto da Silveira 11 (© **024/3371-2651;** www.paratytours.com.br). All offer a full range of services, including cylinder refill and courses, and an introductory dive if you do not have a license. For a certified diver, a two-dive excursion costs approximately R$235. This rate includes all the equipment such as a regulator, BC (buoyancy control), wet suit, and mask/fins/snorkel.

HIKING In the surrounding hills one can still find stretches of the old wagon trail that was used to bring the gold from Ouro Preto down to the coast. Parts of the old cobblestone trail have been restored and are accessible to hikers. **Paraty Tours,** Roberto da Silveira 11 (© **024/3371-2651;** www.paratytours.com.br), offers an easy trek along this historic route. The 3-hour tour leaves Thursday through Sunday at 11:30am and includes a guide (R$25 per person, children 4–10 half price). Paraty Tours also offers a number of guided day hikes to the isolated beaches at Trinidade and Praia do Sono (R$35–R$45 per person). Transportation is by jeep and includes several stops. If you want a more serious hike, consider a 2- or 3-day trip. **Rio Hiking** (© **021/9874-3698;** www.riohiking.com.br) offers excellent hiking trips along the beaches and through the coastal rainforest on the peninsula just south of Paraty, called Paraty-Mirim. Transportation from Rio de Janeiro and rustic accommodations are included (2-day trip R$450 per person, and 3-day trip R$650).

Where to Stay

Paraty's historic center is jampacked with pousadas. Of course, retrofitting modern accommodations into 18th-century buildings requires some adaptations. Don't expect fancy plumbing. Stairways are narrow and steep and there is no parking, as all

cars have to remain outside the historic core. What you do get are charming bed-and-breakfasts in beautiful heritage buildings.

Casa Turquesa ★★ For a romantic getaway, check into the luxurious Casa Turquesa. Each of the nine spacious rooms is uniquely furnished with lovely rustic furniture, colorful upholstery and high-end linen. The larger suites have a Jacuzzi tub or sitting room. Although the historic building has a beautiful antique style, it is equipped with every modern convenience, including Wi-Fi, LCD TVs, and fabulous showers. Guests also have the use of a swimming pool, sun deck, and reading lounge with a fireplace for those cooler evenings.

Rua Doutor Pereira 50, Paraty 23970-000 RJ. www.casaturquesa.com.br. ©/fax **024/3371-1037.** 9 units. High season R$920–R$1,400 double; low season R$790–R$1,120 double. DC, MC, V. No children 14 and under. **Amenities:** Bar; small outdoor pool. *In room:* A/C, TV, minibar, Wi-Fi.

Pousada Arte Urquijo ★ Paraty's most unusual pousada, Arte Urquijo is a true labor of love by the owner, artist Luz Urquijo. Her bold and colorful artwork is prominently displayed throughout the pousada. Guests are greeted with classical music and asked to take their shoes off and help themselves to comfortable slippers. Luz has paid a lot of attention to detail and each of her six rooms is unique. Our favorite is the Sofia, which looks out over the rooftops toward the ocean and has a small deck. All rooms come with a very tiny private bathroom. The pousada is not for people who have difficulty with stairs; the higher floors can only be reached via a narrow winding staircase.

Rua Dona Geralda 79, Paraty, 23970-000 RJ. www.urquijo.com.br. ©/fax **024/3371-1362.** 6 units. High season R$410–R$510; low season R$350–R$470. Rooms are doubles only. DC, MC, V. No children 11 and under. **Amenities:** Bar; small outdoor pool. *In room:* A/C, TV, minibar, no phone, Wi-Fi.

Pousada da Marquesa ★ A lovely sprawling colonial mansion, Pousada da Marquesa offers affordable accommodations with some great amenities. The pousada actually consists of two buildings, the original main building and an annex along the side overlooking the garden and swimming pool. These rooms are on ground level and perfect for those who don't want to climb the steep and narrow stairs. All rooms are simply and nicely furnished and the common rooms have beautiful antiques. A swimming pool and garden offer a perfect refuge on hot summer days.

Rua Dona Geralda 99, Paraty, 23970-000 RJ. www.pousadamarquesa.com.br. © **024/3371-1263.** Fax 024/3371-1299. 21 units. Dec–Mar R$418–R$539 double; Apr–Nov R$330–R$517 double. Extra person 30%–50% extra. Children 6 and under stay free in parent's room. AE, DC, MC, V. **Amenities:** Bar; free Internet; outdoor pool. *In room:* A/C, TV, minibar.

Pousada Porto Imperial One of the largest pousadas in the city center, Porto Imperial still feels like a small inn. The decorations throughout are quite impressive, blending antique furniture with modern folk art and tropical colors. In contrast, the rooms are very simply decorated with plain wooden furniture and bedding. The inner courtyard hides a lovely garden and swimming pool as well as a sauna.

Rua Tenente Francisco Antonio s/n (across from the Matriz church), Paraty, 23970-000 RJ. www.pousadaportoimperial.com.br. © **024/3371-2323.** Fax 024/3371-2111. 50 units. R$440 standard; R$570 superior. Extra bed R$160. Off season and Mon–Thurs 30% discount. Children 2–12 R$60. AE, DC, MC, V. **Amenities:** Outdoor pool; limited room service; sauna. *In room:* A/C, TV, minibar.

Where to Eat

Banana da Terra ★★ BRAZILIAN This beautiful little restaurant on one of Paraty's side streets offers exotic combinations of seafood and tropical ingredients.

Cachaça Festival

The region around Paraty is very well known for its *cachaça* (also known as *pinga*), the Brazilian booze made from sugar cane. Several distilleries are nearby, and each year, on the third weekend of August, the city celebrates the **Festival da Pinga.** Events include live music and lots of tastings. *Tip:* If you miss the festival, make sure to stop at the **Emporio da Cachaça,** Rua Dr. Samuel Costa 22 (© **024/3371-6329**), a specialty store with over 300 types of *cachaça* from all over Brazil.

Ponta Negra is a fabulous fish dish served in a coconut sauce with shrimp. Another dish stars the lowly squid dolled up with a banana-and-cheese stuffing and served in coconut milk. Another seafood favorite is the risotto with squid, crab, and prawns spiced with ginger and chutney. Desserts include banana sweets or baked banana.

Rua Dr. Samuel Costa 198. © **024/3371-1725.** Main courses R$28–R$65 for 2. AE, DC, MC. Mon and Wed–Thurs 7pm–midnight; Fri–Sun noon–4pm and 7pm–midnight.

Café Pingado COFFEE SHOP For your morning shot of caffeine or a sweet snack, try this pleasant coffee shop. They have great espressos and cappuccinos, and a good selection of sweet and savory snacks.

Rua Dr. Samuel Costa 208. © **024/3371-8333.** Everything under R$15. No credit cards. Daily 10am–8pm.

Casa do Fogo BRAZILIAN This cozy bistro combines great food with local *cachaças* to create excellent flambé dishes. The main courses combine sweet and savory, like the prawns with star fruit, fish with grilled bananas and vegetables, or tender octopus with a passion fruit sauce. The restaurant also has a great selection of straight up *cachaças* and the staff will let you sample a great variety, perfect for a digestive.

Rua Comendador José Luiz 390. © **024/9819-5111.** www.casadofogo.com.br. Main courses R$32–R$49. AE, M, V. Daily 6pm–1am.

Restaurante Refúgio BRAZILIAN A refuge indeed, Restaurante Refúgio is tucked away from the busy streets and offers a large patio overlooking Paraty's harbor. The specialty here is seafood. As an appetizer, try the *camarão casadinho* (a large deep-fried prawn stuffed with a spicy *farofa* and dried shrimp filling), a regional specialty found only in Paraty. For a main course, try the fish or seafood *moquecas* (stews with coconut milk and palm oil).

Praça do Porto 1, on the waterfront. © **022/3371-2447.** www.restauranterefugio.com.br. Main courses R$25–R$45. DC, MC, V. Daily noon–11pm.

Paraty After Dark

Paraty is not a wild party town (that's Búzios). The crowd's a bit older, the nightlife more laid-back. Enjoy some live music, have some drinks, and chat with the other folks who are quite likely visiting as well.

One of the more popular live-music venues is the **Café Paraty,** Rua do Comércio 253 (© **024/3371-2600**). It bills itself as a restaurant—and the food is pretty decent—but the place really gets hopping later in the evening, after 10pm or so. The

restaurant has a small stage and the excellent bands usually play covers of popular Brazilian music. It's open daily 9am to midnight.

Another popular spot in the evenings is **Porto da Pinga,** Rua da Matriz 12 (© **024/9907-4370**). This bistro specializes in local *cachaças*. There's live music nightly; it's a great spot to go and try some of the regionally produced firewater. Should you find one you particularly like, you can pick up some extra to take home from their on-site *cachaçaria*. Another restaurant doing double duty as a bar is the **Margarida Café,** Praça do Chafariz (© **024/3371-2441**; www.margaridacafe. com.br). On weekends, there is always live Brazilian music, a perfect spot to enjoy a nightcap after dinner.

MINAS GERAIS: BELO HORIZONTE & THE HISTORICAL CITIES

M inas Gerais is the original gold rush state. Sometime in the early 1700s, explorers from São Paulo pushed beyond a forbidding range of mountains and discovered gold in the high plains beyond. Tens and then hundreds of thousands of miners poured into the new territory, setting up camp in and around the new town of Vila Rica de Ouro Preto.

The Portuguese crown tried to stem the tide, even banning emigration from Portugal for a time, to no avail. In 1720, Portuguese authorities bowed to the inevitable and switched their focus to taxing the new wealth. A new captaincy of Minas Gerais (General Mines) was declared, with Vila Rica as its capital, and a small army of Customs agents and tax collectors was sent out from the mother country to collect the royal fifth, the 20% tax owed the crown.

The gold that poured out of Minas Gerais made king and mother country rich, while changing the dynamics of colonial Brazil. In 1763, the capital was shifted south from Salvador to Rio de Janeiro, the port that served as the embarkation point for Minas gold.

The boom lasted for over half a century, but by the 1780s production was slumping, even as Portuguese taxation demands increased. The situation came to a head in 1789 in the Inconfidência Mineira, a short-lived conspiracy in Ouro Preto led by a dentist known as Tiradentes ("the Teeth-Puller"). Though it accomplished next to nothing, the Inconfidência is now seen as a forerunner of the Brazilian independence movement.

With the gold petering out, miners shifted to ranching cattle, and later to growing coffee. A distinctive Mineiro culture developed, the archetypical Mineiro simple but proud, practical and self-reliant, and hospitable to strangers. The history of mining and ranching lead to a unique Mineiro cuisine, with rich stews and sauces.

In the early 1900s, geology again came to the fore with the discovery of iron ore deposits. Minas soon developed into Brazil's leading steel producer, and one of its leading manufacturing states.

The capital was shifted to a new planned city dubbed **Belo Horizonte**—the Beautiful Horizon—or more often just BH. Belo Horizonte today is a pleasant and efficient business city with some good Mineiro restaurants and pleasant neighborhoods for strolling.

The real reason for a visit to Minas Gerais, however, lies back in those old gold towns. Built during the gold boom of the 18th century, the cities of **Ouro Preto, Mariana,** and **Tiradentes** are gems of high baroque architecture; thanks to the later gold-mining bust, most have been preserved in their original condition. Together, the historical cities of Minas Gerais are an architectural wonderland.

Several of these cities have excellent hiking nearby, but the main joys here are quiet and largely visual. It's enough to simply contemplate the beauty of the surrounding mountains and the architectural creativity of man.

BELO HORIZONTE

343km (213 miles) N of Rio de Janeiro, 487km (303 miles) NE of São Paulo

A large and bustling city, Belo Horizonte serves as the capital of Minas Gerais and is home to nearly 2.5 million Mineiros, as the proud inhabitants of this inland state are known. Minas Gerais is Brazil's second most important industrial state after São Paulo, and Belo Horizonte is an important city for business. It makes an excellent jumping-off point for a visit to the historical cities of Ouro Preto, Mariana, and Tiradentes. Belo Horizonte (or just BH) features some pleasant strollable neighborhoods, hearty restaurants, lively clubs and cafes, and a few intriguing sights. If you have some time to spare either before or after visiting the historical cities, BH is worth an afternoon and evening. That said (and though Mineiros will almost certainly beat me for saying it), if your schedule doesn't permit a stopover, you shouldn't spend a lot of time regretting what you've missed.

Essentials
GETTING THERE
BY PLANE Most flights arrive at **Aeroporto Internacional Tancredo Neves–Confins,** Rodovia MG-10 (✆ 031/3689-2700), an airport inconveniently located some 40km (25 miles) from the city center. A taxi from here to the city center costs about R$80. A cheaper alternative is to take the **Unir** airport bus (✆ 031/3663-8020; www.conexaoaeroporto.com.br), which costs R$8.15 to the downtown bus station. If you can, book a flight that lands at **Pampulha Airport,** Praça Bagatella 204 (✆ 031/3490-2001), the older, smaller airport next to the artificial lake near the center of the city.

Azul (✆ 031/3003-2985; www.voeazul.com.br), **Gol** (✆ 0300/115-2121; www.voegol.com.br), **Ocean Air** (✆ 031/4004-4040; www.oceanair.com.br), **TAM** (✆ 031/4002-5700; www.tam.com.br), **TRIP** (✆ 031/3003-8747; www.voetrip.com.br), and **Webjet** (✆ 0300/210-1234; www.webjet.com.br) have daily flights to most major cities in Brazil.

BY BUS Long-distance buses arrive at the **Terminal Rodoviaria Gov. Israel Pinheiro da Silva,** Praça Rio Branco 100, Centro (✆ 031/3271-3000; www.transportal.com.br). To/from Rio de Janeiro, **Util** (✆ 021/3907-3900; www.util.com.br)

has seven daily departures, the first at 8am and the last at 12:30am. The trip takes 7 hours, and costs R$72 to R$95. To/from São Paulo, **Cometa** (© **031/4004-9600;** www.viacometa.com.br) has 11 daily departures, the first at 9am and the last at 11:45pm. The cost is R$75 to R$135, and the trip takes 7 hours.

GETTING AROUND

ON FOOT Downtown BH is pleasant and walkable by day and into the evening. Later in the evening it may be advisable to take a taxi.

BY BUS The three types of buses in BH are coded by color. **Yellow** buses, called *circulares,* stick to the Contorno, the ring road around BH's center, and cost R$2.45. Short-distance city buses are **blue,** and cost R$2.45. Longer-distance city buses, for travel from the city to far-off suburbs, are **red** and cost R$3.

BY TAXI Taxis can be hailed in the street almost anywhere. To order a taxi, call **Coomotaxi** (© **031/3419-2020** or 0800-39-20-20) or **Coopertaxi** (© **031/3421-2424** or 0800/979-2424).

BY CAR Navigating Belo Horizonte's inner city is extraordinarily difficult, due to the complicated street pattern and the shortage of parking. However, to explore the countryside and reach the historical cities, a car is ideal.

CITY LAYOUT

Created as the new state capital in the 1890s, Belo Horizonte was Brazil's first planned city, and thus a direct precursor of Brasilia (Juscelino Kubitschek, founder of Brasilia, was mayor of BH in the 1940s). One legacy of this urban planning is BH's urban core, which features an intriguing street pattern: a wider grid of broad ceremonial avenues has been set atop the regular street grid, offset at a 45-degree angle. At every intersection where two broad avenues and two regular streets come together, it forms a city square. It's an intriguing and beautiful design, but for those used to a simple grid it does make for confusing navigation. (When you turn right, you are not turning 90 degrees, but 135 degrees.) The pattern was discontinued outside the city center, but as it happens that is precisely the area of most interest for visitors. The most important neighborhoods are **Savassi** (more or less btw. Av. Cristovão Colombo and Av. Alfonso Pena), and **Lourdes** (centered on Av. Alvares Cabral). **Av. Alfonso Pena** is home to BH's main office and business district.

VISITOR INFORMATION

The city's official tourism agency, **Belotur** (*©* **031/3277-9777;** www.belohorizonte. mg.gov.br), has tourism information centers at **Confins airport** (*©* **031/3689-2557**); at the **bus station** (*©* **031/3277-6907**); and in Centro at the **Mercado das Flores,** Av. Afonso Pena 1055 (*©* **031/3277-7666**). All are open daily 8am to 6pm. There's also a tourist hot line, **Alô Turismo** at *©* **156.**

[FastFACTS] BELO HORIZONTE

Car Rental **Localiza** (*©* **0800/979-2000**), **Avis** (*©* **0800/725-2847**), **Unidas** (*©* **0800/121-121**), and **Hertz** (*©* **0800/701-7300**) are all located in Belo Horizonte. Rates start at R$100 per day for a compact car with air-conditioning and unlimited mileage. Insurance adds R$30 per day.

Hospital In an emergency, visit **Hospital da Clinicas,** Av. Prof. Alfreda Balena 110, Santa Efigênia (*©* **031/3248-9300**).

Internet Access **Internet Club Café,** Rua Fernandes Tourinho 385, Savassi (*©* **031/ 3282-3132;** www.internetclubcafe.com.br; daily 9am–10pm), charges R$4 per hour.

Money **Banco do Brasil,** Av. Amazonas 303, Centro (near Praça 7 de Setembro; *©* **031/3218-2300;** Mon–Fri 10am–4pm) has an ATM. You can also exchange money at **Action S/A,** Confins Airport (*©* **031/3689-2861;** daily 5am–10pm), and **Minas Cambio Turismo,** Av. Amazonas 507, Centro (*©* **031/3201-4515;** Mon–Fri 9am–6pm).

Weather Located on an interior plateau, Belo Horizonte is similar in climate to São Paulo. December through March is hot and humid. Temperatures rise to the mid-30s Celsius (high 90s Fahrenheit). June through August, it can cool off to a minimum of 15°C (59°F), but during the day temperatures can sometimes rise to the 20s Celsius (70s or mid-80s Fahrenheit). Between May and September it can be quite cool in the evenings; bring some cool-weather clothes. Most rain tends to fall in the summer (Dec–Feb); January is especially wet.

Exploring Belo Horizonte

Downtown Belo Horizonte is a sight in itself, as planned cities often are. It's worth strolling through the center to admire the broad avenues and smaller streets branching off at odd angles. The city center is safe and pleasant, and there are often shops to browse and cafes at which to snack.

ATTRACTIONS ●
Mercado Central **3**
Mineiro Museum **5**
Museu de Artes e Oficios **4**
Museum of Mineralogy **7**
Praça da Liberdade **8**

HOTELS ■
Ibis **6**
Promenade Lourdes **2**
Royal Savassi Boutique Hotel **9**

RESTAURANTS ◆
A Favorita **1**
Dona Lucinha **11**
Splendido **10**

Start with a visit to the **Praça da Liberdade,** located where the two broad avenues—Avenida Brasil and Avenida Cristovão Colombo—intersect. This was BH's central square, deliberately modeled on Paris, with fountains and a green central garden surrounded by official government buildings. Initially, the buildings were neoclassical, but as time wore on a modern Niemeyer building was put up, and then a postmodern pastiche was added to the mix. The square still works, though. Recently, the state government relocated to a large government compound near Confins airport, and the government buildings on the square were repurposed as museums. These include the **Museum of Mineralogy,** Av. Bias Fortes 50 (✆ 031/ 3271-3415; Wed–Sun 9am–5pm; admission R$3), and the **Mineiro Museum,** Av. João Pinheiro 342 (✆ 031/3269-1168; Wed–Sat 10am–6pm, Sun till 4pm; admission R$5), a neoclassical building featuring art and antiques of Mineiro origin.

Also worth a visit is the **Mercado Central,** Av. Augusto de Lima 744 (✆ 031/ 3274-9434; Mon–Sat 7am–6pm, Sun till 1pm), BH's huge covered produce and fresh meat market. There's local *cachaças,* cheeses, fresh fruit, and numerous little *botecos.* Stop by **Casa Cheia,** Mercado Central (✆ 031/3274-9585), for a sandwich of smoked turkey and *quiabo,* or smoked pork, or some homemade sausage.

The **Praça de Estação** (officially called Praça Rui Barbosa, but no one does) is the site of the old railway station. A suburban Metrô still operates from here, but the attraction is the neoclassical grace of the square and train station, now repurposed as the **Museu de Artes e Oficios (Museum of Arts and Crafts),** Praça Rui Barbosa s/n (✆ 031/3248-8600; www.mao.org.br; Wed–Fri noon–7pm, Sat–Sun 11am– 5pm; admission R$4, on Sat admission is free). The museum uses displays, actual tools, and photographs to demonstrate the ways in which craftsmen and artisans make things. It's an intriguing concept, and a lovely display space.

Farther out from the city center one finds **Lake Pampulha,** and the **Pampulha Architectural Complex.** The area took shape in the 1940s, when a progressive young mayor named Juscelino Kubitschek hired an ambitious young architect named Oscar Niemeyer to design a complex of ceremonial buildings to give some form to what was then a new neighborhood on the edge of the city. Niemeyer's curvy forms and raw concrete didn't please everyone. The wavy-topped **Church of St. Francis of Assisi** (✆ 031/3427-1644; Tues–Sat 9am–5pm and Sun noon–5pm) is now a city icon, but it took the Catholic diocese 16 years to resign itself to the design, and actually consecrate the building as a church. The vivid blue exterior tiles are by noted Brazilian artist Portinari. The other buildings in the complex are less interesting. The ex-casino is now the **Museu de Artes da Pampulha** (✆ 031/3443-4533; Wed– Sun 9am–5pm), which features visiting exhibits and sculptures in its garden. The small **Casa de Baile,** or dance hall, is now mostly closed, and anyway best appreciated from the outside.

The Pampulha Architectural Complex was completed in 1943. The mayor was so pleased with the results that when he became president 13 years later, he hired the same architect to design an entirely new city: Brasilia.

One of the best sights in Belo Horizonte is **Inhotim,** Hwy. BR-381, Km 490, Brumadinho (✆ 031/3227-0001; www.inhotim.org.br; Wed and Fri 9:30am– 4:30pm, Sat–Sun 9:30am–5:30pm; admission R$20, children 12 and under R$10), an hour's drive from the city center, but well worth the trip. Opened in 2008 by a wealthy Mineiro industrialist, Inhotim is at its heart a modern art museum, with some 500 works by Brazilian and international artists, dating from the 1960s onward. What makes Inhotim special is the setting: a vast and beautiful tropical landscape,

much of it laid out by noted Brazilian landscape designer Roberto Burle Marx. The paintings, sculptures, drawings, photographs, video, and sound installations are integrated into this vast tropical arcadia in innovative and intriguing ways. It is best to travel by car to the museum. On Saturdays and Sundays you can also reach the museum by bus, departing at 9am from platform F2 of the Belo Horizonte bus station, returning at 4:30pm (R$10; 90 min.). Contact **Saritur** (✆ **031/3419-1800**) for details. You can purchase tickets including transportation for R$30 at www. htticket.com.br/inhotim.

Shopping

Minas Gerais is known for its crystals and semiprecious gemstones, as well as its arts and crafts (many of them kitchen or culinary focused). For a one-stop shop, try the **Central de Artesanato do SESC,** Rua Tupinambás 956, Centro (✆ **031/3279-1476;** Mon–Fri 9am–6:30pm, Sat 9am–1pm). Though a bit heavy, the soapstone cooking bowls make fine gifts and souvenirs.

On Sundays, a large crafts fair takes place on the **Avenida Alfonso Pena** (www. feiradeartesanato.net), corner of Avenida Alvares Cabral, which is closed to traffic for the day (9am–4pm). Hundreds of small kiosks offer bags, belts, sandals, and other leather work; jewelry, semiprecious gems, and crystals; soapstone cookware; woodcarvings and larger pieces of wood furniture; and antiques.

The **Patio Savassi,** Av. Contorno 6061, Savassi (✆ **031/4003-4171;** www.patio savassi.com; Mon–Sat 10am–10pm, Sun 2–8pm), where Avenida Crisovão Colombo intersects with the Avenida Contorno ring road, is an upscale shopping mall with a movie theater, bookstore, fine dining and food court, and dozens of upscale women's boutiques.

Where to Stay

As a business city, BH empties out on the weekends and prices drop 30% to 50%. It pays to time your visit for the weekend.

EXPENSIVE

Clarion Hotel Lourdes ★★ The Promenade offers the extra space and kitchenette of a flat hotel, with the price and location of a regular hotel. Rooms are spacious, with a king-size bed, glass-top writing desk (with a good reclining desk chair), plus a kitchenette with fridge, sink, dishes, microwave, coffeemaker, and a small breakfast table. The rooms even come with an iron and ironing board—a rarity in Brazil. Master rooms are on higher floors with better views.

Rua Bernardo Guimarães 2032, Lourdes, Belo Horizonte, 32224-050. www.atlanticahotels.com.br. ✆ **031/3290-0933.** 102 units. R$385 double. On weekends prices drop to R$199. Extra person 30% extra. Children 5 and under stay free in parent's room. AE, DC, MC, V. Parking R$15 daily. **Amenities:** Restaurant; bar; fitness center; outdoor small pool; room service; smoke-free rooms. *In room:* A/C, TV, minibar, Wi-Fi.

Royal Savassi Boutique Hotel ★★ The Royal Savassi offers good-quality accommodations plus a full-service business center in the city's best neighborhood. Rooms feature either carpet or tile flooring, king-size beds with nice linens, a work desk, free Wi-Fi, and large bathrooms with high-end toiletries. Service is good, and the little extras like fluffy robes and turndown service are nice, though perhaps not enough to justify the (new) claim to boutique hotel-dom. Still, they're trying.

Rua Alagoas 699, Savassi, Belo Horizonte, 32228-050. www.royalhoteis.com.br. ✆ **031/3247-6999.** 81 units. Mon–Fri R$350 double; Sat–Sun R$200 double. Extra person 30% extra. Children 5

MINEIRO food

The food in Minas Gerais is renowned in Brazil for its heartiness and simplicity. The favorite dishes are rich stews and bean dishes with pork. Two typical Minas dishes are *tutu á Mineira* and *feijão tropeiro*. In *tutu* the beans are cooked, mashed, cooked again (similar to Mexican refried beans), and served with roasted pork, sausages, bacon, collard greens, egg, and rice with side dishes. The *feijão tropeiro* is fairly similar except the beans are kept whole and mixed with cassava flour. Two other traditional dishes are made with chicken: *frango a molho pardo* and *frango com quiabo*. *Frango a molho pardo*, originally a Portuguese dish, is a stew made with fresh chicken blood—a little gruesome sounding but surprisingly tasty. The other chicken dish is a rich tomato stew with okra. There's also *vaca atolada*, a kind of beef rib stew, and *torresmo*, crunchy deep-fried pork rind. You'll find these in almost every Minas restaurant. The servings are always enough for two.

and under stay free in parent's room. AE, DC, MC, V. Parking R$15 daily. **Amenities:** Restaurant; bar; fitness center; outdoor pool; room service; sauna; smoke-free rooms. *In room:* A/C, TV, hair dryer, minibar, Wi-Fi (free).

MODERATE

Ibis 🗲 Located just a block from the central Praça da Liberdade, this is the best value in BH's business district. Like all Ibis hotels, the concept is basic: All rooms are identical and accommodations are comfortable but plain. Each room has a nice firm double bed, a desk, and closet space. Bathrooms are equally frills-free but are modern and spotless and come with showers only. The hotel amenities are kept to a minimum to reduce the operating costs. Breakfast is optional, for R$15.

Av. João Pinheiro 602, Lourdes, Belo Horizonte, 32433-050. www.accorhotels.com.br. ✆ **0800/703-7000** or 031/2111-1500. Fax 031/2111-0000. 121 units. R$179 double. Extra person R$55. Children 12 and under stay free in parent's room. AE, DC, MC, V. Parking R$15. **Amenities:** Restaurant. *In room:* A/C, TV, fridge.

Where to Eat

A Favorita ★ INTERNATIONAL/SEAFOOD Come to A Favorita, see the world. While the emphasis is always on seafood, the menu offers a range of culinary styles, among them French, Italian, Thai, and Chinese. Start with the *couvert,* a basket of fresh-baked breads and five types of pâtés. Other starters include a mix of mushrooms (portobello, Shimeji, Paris) grilled in truffle butter. Main dishes include grilled Atlantic lobsters, or lemon-scented *cherne* filet in a cashew crust with grainy mustards sauce.

Rua Santa Catarina 1235, Lourdes. ✆ **031/3275-2352.** Main courses R$30–R$75. AE, DC, MC, V. Mon–Sat noon–1am; Sun noon–midnight.

Dona Lucinha ★ MINEIRO A BH fixture for going on 20 years, Dona Lucinha puts out a vast spread of traditional Mineiro dishes. It's self-serve, allowing you to pick and choose what you like from the extensive buffet—great for those who have never experienced Mineiro cooking. Save room for dessert. Dona Lucinha also puts out a huge buffet of typical desserts—dried fruit compotes, fig, guava, pumpkin, papaya, often mixed with cheese or sweet condensed cream.

Rua Padre Odorico 38, São Pedro. ✆ **031/3227-0562.** www.donalucinha.com.br. Main courses R$20–R$45. AE, DC, MC, V. Mon–Sat noon–3pm and 7–11pm; Sun noon–5pm.

Splendido ★ ITALIAN This restaurant serves northern Italian cuisine and a range of inventive pastas with a touch of Brazilian flair. Signature dishes include breast of duck in a merlot truffle sauce, accompanied with a passion-fruit purée and potato *galette*. For dessert, the tiramisu is famous citywide.

In the Flat Volpi Residence Hotel, Rua Levindo Lopes 251, Savassi. ℭ **031/3227-6446.** Main courses R$75–R$125. AE, DC, MC, V. Mon–Fri noon–3pm and 7pm–1am; Sat 7pm–2am; Sun noon–5pm.

Xapuri ★ MINEIRO This is the place for a Mineiro dining experience. Located out near Pampulha, Xapuri features a palm-frond roof covering and long wooden tables upon which waiters plunk down heaping platters of traditional Minas fare—pan-fried chicken with collard greens, leathery steak, stews of all description, griddles of sizzling sausage, dried beef in gravy—all accompanied by *feijão tropeiro* (beans mixed with manioc, eggs, bacon, and shredded kale). In the evenings, men with leather hats, accordions, and a lasting ache in their hearts wander the room serenading diners with traditional Mineiro music. There's also a small gift shop offering Mineiro arts and crafts. And while yes, this does all scream "tourist trap," it's actually a restaurant sought out and enjoyed by locals.

Rua Mandacaru 260, Pampulha. ℭ **031/3496-6198.** www.restaurantexapuri.com.br. Main courses R$30–R$72. MC, V. Wed–Thurs 11am–11pm; Fri–Sat 11am–2am; Sun 11am–6pm.

BOTECOS

In addition to hearty home-cooking, BH is known for its *botecos,* simple bars selling cold draft beer and hearty home-cooked snacks. *Botecos* are a great place to relax after a long day, or if you feel like a snack but aren't hungry enough for dinner. BH's *botecos* typically open Monday to Saturday noon to 3pm and then again from 7pm to midnight (or later). Sundays they're often closed. **Clube da Esquina,** Rua Sergipe 146, Funcionarios (ℭ **031/3222-5712**), offers cold beer and snacks in a 1902 heritage house. **Petisqueira do Primo,** Rua Santa Catarina 656, Lourdes (ℭ **031/3335-6654**), features Galician-style snacks (cod and potatoes, paella, and so on) and, of course, beer. In business since 1929, **Tip Top,** Rua Rio de Janeiro 1770, Lourdes (ℭ **031/3275-1880**), features German bratwurst, pig knuckles, sauerkraut, and beer.

Belo Horizonte After Dark

Belo Horizonte's nightlife centers on the **Savassi** and **Lourdes** neighborhoods. **Praça Savassi**—the square where Avenida Getulio Vargas meets Avenida Cristovão Colombo is a *point*—has dozens of bars and cafes, but young people and students also congregate on the wide sidewalks, drinking, flirting, and playing guitar.

House of (Cheese) Bread

Among its culinary claims to fame, Minas is home to the *pão de queijo*, the little round cheese bread ball now ubiquitous throughout Brazil. Mineiros claim there are no cheese breads like Mineiro cheese breads (they claim much the same about *cachaça* and women). The place to test their claim (about the cheese breads anyway)? Any corner lunch counter should do, or you can try the **Armazem Dona Lucinha,** Rua Padre Odorico 38 (corner of Av. do Contorno; ℭ **031/3281-9526**).

Nearby, for jazz, DJs, books, and a cool atmosphere of students and bohemians, try **Café com Letras,** Rua Antonio de Albuquerque 781 (℃ **031/3225-9973;** www. cafecomletras.com.br; Mon–Thurs noon–midnight, Fri–Sat noon–1am, Sun 5–11pm).

In Lourdes, **Marilia Pizzeria,** Rua Marilia de Dirceu 189, Lourdes (℃ **031/3275-2027;** www.mariliapizzeria.com.br), serves up good pizzas and at night becomes a *point,* a spot for hanging out, flirting, and conversing.

Also in Lourdes, the **Art from Mars** restaurant, Rua Rio de Janeiro 1930, Lourdes (℃ **031/3337-9116;** Wed–Sat 7pm–2am; no cover), offers an Asian-flavored menu, sushi bar, and an upscale lounge with a small chic dance floor.

Farther from the center of town, the **Boate na Sala** (℃ **031/3286-4705;** www. nasala.com.br; Thurs–Sat 10pm–3am; R$25 cover) is an upscale disco frequented by BH's young and pampered. It's located inside the Ponteio Lar Shopping Mall in Santa Lucia.

Tip: If you can get by with a little Portuguese, check the website www.soubh.com. br for great nightlife and music listings.

OURO PRETO ★★★

279km (173 miles) N of Rio de Janeiro, 475km (295 miles) NE of São Paulo, 78km (48 miles) S of Belo Horizonte

The inland state of Minas Gerais struck it rich on gold just about the time the baroque style reached its elaborate architectural height. Newly wealthy citizens needed something to blow their money on, and they turned to architecture. The result? Several small cities with cobblestone streets, soaring palaces, and elaborate churches that rival St. Petersburg or Prague.

The largest of these is the hilltop town of **Ouro Preto;** its cobblestone streets wander up and down hills crowned with more than a dozen ornately carved and elaborately decorated baroque churches. Each corner turns on new surprises: mansions, fountains, ruins, beautiful terraced gardens, and towers glowing with colored tiles. Once known as Vila Rica (Rich Town), Ouro Preto begs to be explored on foot. Yes, the cobblestone streets can get quite steep, but only on foot can you appreciate

THE inconfidência MINEIRA

Ouro Preto has a special place in Brazilian history for its role in the Inconfidência Mineira (1788–92), a failed rebellion against the Portuguese Crown. The movement started as a protest against the 20% royal tax on gold production. A group of intellectuals (doctors, writers, and poets) began meeting with the idea of taking some sort of action. The ringleader was a dentist named Joaquim José da Silva Xavier, also known as Tiradentes (literally, "the Teeth-Puller"). Unfortunately, before the group formulated a plan, someone betrayed their existence, and in 1789, Tiradentes and 11 of his confederates were arrested. All were condemned to death. The vice-regal governor commuted the sentences of the other 11 and sent them into exile. Tiradentes was hanged as an example, his body cut in four pieces, and each piece put on display. Nowadays, the Inconfidência is interpreted as Brazil's first uprising against Portuguese rule, and Tiradentes as Brazil's first martyr in the struggle for independence.

■ Bus Station (Long Distance)

HOTELS ■

Luxor Ouro Preto Pousada **4**
Pousada Classica **13**
Pousada do Mondego **7**

RESTAURANTS ◆

Bar do Beco **10**
Bené da Flauta **5**
Booze Café Concerto **12**
Cafe Geraes **14**
Casa do Ouvidor **11**
Restaurante Chafariz **16**

ATTRACTIONS ●

Matriz da N.S. do Pelar/
 Museu de Arte Sacra **18**
Mina do Chico Rei **1**
Museu da Inconfidência **8**
Museu de Aleijadinho **3**
Museu de Minas **15**
Museu do Oratorio **9**
N.S. do Rosario **17**
São Francisco de Assis **6**

the rich details of the perfectly preserved houses, gaze at the intricately carved fountains, and steal glimpses of courtyards and living rooms. The monuments and museums can be visited in 2 days, allowing plenty of time to stroll and explore.

Essentials

GETTING THERE

BY CAR From Belo Horizonte take the BR-040 for some 30km (19 miles), then turn onto the BR-356 to Ouro Preto. From Rio de Janeiro take the BR-040 highway as far as Conselheiro Lafaiete, then follow the Estrada Real to Ouro Preto. From São Paulo follow the BR-381 to Lavras and then take the BR-265 to Barbacena. In Barbacena take the BR-040 in the direction of Belo Horizonte.

The best way to get to Ouro Preto is through Belo Horizonte (see "Getting There" under Belo Horizonte, p. 158). From Belo Horizonte's Pampulha or Confins airport (Pampulha is about 40km/25 miles closer to Ouro Preto than Confins airport), it's possible to negotiate with a taxi to take you straight to Ouro Preto for a set fee (expect to pay around R$150–R$200, depending on your bargaining skills) or you can take the bus.

Avoid visiting Ouro Preto and Mariana on Monday, as the majority of churches, museums, and attractions are closed. To take advantage of lower room rates in either town, visit Tuesday through Friday. Everything is open but not as busy as on the weekends.

BY BUS Regular buses connect from Rio (7 hr.), São Paulo (11 hr.), and Belo Horizonte (2 hr.) to Ouro Preto. **Util** runs a nightly 11:30pm bus from Rio to Ouro Preto, arriving first thing in the morning (© **021/2518-1133** in Rio, or 031/3551-3166 in Ouro Preto); tickets cost R$76 for a regular seat and R$115 for a comfortable almost bedlike seat (*leito*). **Cristo Rei** has three daily departures between São Paulo Bresser Station (© **011/3692-4073**) and Ouro Preto (© **031/3551-1777**). **Passaro Verde** runs at least 20 buses a day between Belo Horizonte and Ouro Preto (© **031/3073-7575**). Tickets cost R$22. The Ouro Preto bus station is a R$15 taxi ride from the historic core.

CITY LAYOUT

Ouro Preto is a city of twisting, turning streets that seem to change names at every corner, but despite this it's remarkably hard to get lost. Thanks to the ever-present incline you can usually pick out your destination—be it church, museum, or square—either above or below you. The main square in the center of the city is the **Praça Tiradentes.** The **Museu da Inconfidência** stands on one side of the square and the **University of Ouro Preto** on the other. Running downhill out of the square are two parallel streets—**Rua Sen. Rocha Lagoa** and **Rua Conde de Bobadela** (aka Rua Direita)—packed with restaurants, pubs, and shops. Following those streets will lead, via a number of twists and turns, first to the **Praça Reinaldo Alves de Brito** with its lovely sculpted fountain, and below that to the **Igreja Matriz N.S. do Pilar.** Below that again—possibly on the Rua Antonio Albuquerque, though there are several other routes—stands the lovely **Igreja N.S. do Rosario.**

Head downhill on the other side of Praça Tiradentes, and you'll come to the Largo de Coimbra, site of the **Igreja São Francisco de Assis.** Continue following the street down the hillside to the next important church, the **Matriz N.S. da Conceição** and the next-door **Aleijadinho Museum.** Past this church, strolling along **Rua Bernardo Vasconcelos,** the street crosses a lovely stone bridge before it starts to climb very steeply. At the top—the view is worth the effort, but if you're feeling lazy you can always take a cab from the main square for R$6—stands the **Matriz Santa Efigenia dos Pretos,** built by communities of slaves who were not permitted to worship in other churches. Note the Afro-Brazilian motifs, such as shells and goat horns. Retracing your steps down the steep street, you will be rewarded with a beautiful view of the city.

Bring good walking shoes. All the streets are cobblestone, and the sidewalks and steps are often carved out of uneven stones.

VISITOR INFORMATION

Ouro Preto Tourist Information is at Rua Claudio Manuel 61 (© **031/3559-3544;** www.ouropreto.org.br; daily 8am–6pm). For tour guides, contact the **Ouro Preto Tour Guide Association** at © **031/3551-2655.** A 4-hour English-language tour of Ouro Preto (with up to 10 people) costs R$100.

Banco do Brasil, Rua São José 189 (© **031/3551-2663**), has a 24-hour ATM. This branch will also exchange U.S. dollars. Almost next door, the **HSBC,** Rua São José 201 (© **031/3551-2048**), also has ATMs. For Internet access, **Cyber House,** Rua Conde Bobadela 109 (© **031/3552-2048**), is open daily from 10am to 8pm.

Exploring the Town

If you can only take museums in small dosages, save your energies for the Museu de Arte Sacra in Mariana, which is well worth a visit.

Matriz da N.S. do Pilar/Museu de Arte Sacra ★ You may want to shield
your eyes from the glitter of the over 400 kilograms (882 lb.) of gold that were used to decorate this church. Completed in 1786, it was built at the height of Brazilian baroque, when the phrase "less is more" would have evoked only laughter. More is more! And more there is: angels and cherubim everywhere, all of them dripping in gold. Recently opened in the basement, the Museu de Arte Sacra is disappointingly small.

Praça Mons, Castilho Barbosa. © **031/3551-4736.** Admission R$4. Tues–Sun 9–11am and noon–5pm.

Mina do Chico Rei ☺ Touring this former mine in the heart of Ouro Preto gives
you a visceral feel for what life as a miner was like. Not for the claustrophobic, this self-guided tour lets you wander some of the narrow underground tunnels, poking your nose into some of the wall cavities where miners would store their finds during the day. Deeper in the mine, a mineral room shows various types of stone from this area, including the reddish-brown mineral that held Ouro Preto's gold. Allow 45 minutes.

Rua D. Silverio 108. © **031/3551-1749.** Admission R$10 adults, free for children 7 and under. Daily 8am–5pm.

Museu da Inconfidência 🖐 As interesting as the building is—it was the jail
where the conspirators were imprisoned—the museum itself is seriously lacking in content: nothing but a mumbo jumbo of locks, keys, lamps, and other artifacts from the time of the Inconfidência. Given that there is little explanation, none of it in English, you may want to give this one a miss. Allow 30 minutes.

Praça Tiradentes 139. © **031/3551-2811.** Admission R$6 adults, R$3 youth 10–18, free for children 9 and under. Tues–Sun noon–5:30pm.

Museu de Aleijadinho Those hoping to find out more about the artist himself
will be disappointed. Many of Aleijadinho's best works are in the churches around the city, leaving this museum with odds and ends and smaller pieces, often oratories and statues of saints. Not much is known beyond his work, and the museum hasn't really bothered to delve into the artist as a person. However, the displays do provide the opportunity to take a close-up look at the master sculptor's work. The faces of the statues seem almost alive, and the creases and folds of their clothes resemble soft flowing fabric instead of wood. On your way out, have a peek inside the church; Aleijadinho's father carved many of the angels, and both father and son are buried in the church. Aleijadinho's tomb is located

A Taxi Tour

Many of the city's taxi drivers will agree to a full- or half-day sightseeing rate. This is an ideal option for visiting Mariana or getting out into the countryside.

THE incredible ALEIJADINHO

It's impossible to go anywhere in Ouro Preto (or any of the other historic cities, for that matter) and not hear the name or see the work of **Aleijadinho.** Brazil's finest baroque artist, he carved much of the soapstone decorating many of the finest churches both in Ouro Preto and in the other historical cities. (The church of São Francisco de Assis has some particularly fine examples of his work.) His signal achievements are all the more remarkable given that Aleijadinho worked without the use of his hands. The son of a Portuguese architect and a black slave woman, Antonio Francisco Lisboa was born in 1738, inheriting the name Aleijadinho in his 20s when a debilitating disease—probably leprosy— left his hands and legs crippled. Undaunted, Aleijadinho carried on working, even as his body degenerated to the point where his apprentices had to strap hammer and chisel to his wrists. He died in 1814, having completed his last sculpture just 2 years previously.

on the right-hand side underneath the first altar. Allow 45 minutes. Your ticket is also good for the São Francisco de Assis church (see below).

Praça Antonio Dias s/n (entered through the Matriz N.S. da Conceição). © **031/3551-4661.** www. museualeijadinho.com.br. Admission R$5. Tues–Sat 8:30am–noon and 1:30–5pm; Sun noon–5pm.

Museu de Minas ★ ☺ This place is part modern showroom, part old-fashioned museum, but well worth a visit. Unless you are into natural history, most people skip the ground-floor collection of stuffed animals and critters preserved in formaldehyde: The highlight of the museum is its mineral collection. The most valuable and interesting pieces are displayed on the ground floor in a flashy showroom, with perfect lighting and dramatic black backdrops. Opals, emeralds, topaz, quartz, and close to 2,000 lesser-known varieties can be seen. The remainder of the mineral collection is housed upstairs in an old-fashioned lab room with hundreds of small wooden cabinets containing 18,000 samples. To show how these samples were extracted, there's a collection of modern equipment and original tools from the past. Allow 1½ hours.

Praça Tiradentes 20. © **031/3559-1597.** Admission R$5 adults, free for children 5 and under. Tues–Sun noon–5pm.

Museu do Oratorio ★★★ What is an oratory? Visit and ye shall see. One of the loveliest museums in Ouro Preto, the Museu do Oratorio displays a comprehensive collection of oratories, which are in fact little minialtars, used by people so they could pray without having to go to church. The museum showcases home, travel, and work oratories. All are works of art; some are small enough to tuck into your pocket or bag for traveling. The Afro-Brazilian oratories are decorated with flowers and shells from the Candomblé religion and usually portray black saints such as Santa Efigenia. Allow 45 minutes.

Rua Brog. Musqueira s/n (next to the Igreja do Carmo). © **031/3551-5369.** www.oratorio.com.br. Admission R$2. Daily 9:30am–5:30pm.

Nossa Senhora do Rosario ★★ The N.S. do Rosario was built by slaves who were forbidden to worship elsewhere. Rumor has it that they smuggled tiny bits of gold from the diggings to put toward the building of their church. Constructed over a period of 30 years, the church was finally completed in 1792. Strikingly elegant and

very unusual in Brazilian baroque, the church was built in the shape of an ellipse, with beautiful soft curves. In lieu of gold, the altars are beautifully painted and dedicated to black saints such as Santo Elesbão and São Benedito. The Sunday Mass is held at 4pm. Visitors welcome.

Largo do Rosario s/n. ℂ **031/3551-4736.** Free admission. Tues–Sat 12:30–5pm; Sun 1:30–5pm.

São Francisco de Assis ★★★ Completed in 1794, the São Francisco de Assis church is one of the top contenders for most beautiful church in Ouro Preto, if not the whole of Brazil. Most of the artwork was done by Aleijadinho, who designed and decorated the church. His elaborate soapstone carvings, including the pulpits and altars, are simply unbelievable. The baptismal font in the sacristy alone took him 3 years to make! The paintings are by Ataíde, who was also responsible for the ceiling mural of the Virgin Mary in heaven, surrounded by cherubs and musicians.

Largo de Coimbra s/n. ℂ **031/3551-4661.** Admission R$6. Tues–Sun 8:30am–noon and 1:30–5pm. Your ticket is also good for the Aleijadinho Museum.

Where to Stay

One of the busiest times of the year in Ouro Preto is Easter week (Semana Santa). The processions and concerts make it a worthwhile visit, but reserve accommodations at least a few weeks in advance. Carnaval is also a busy time of the year as many flock to take part in the lively street celebrations. Prices go up significantly.

Luxor Ouro Preto Pousada ★★ This lovely 200-year-old colonial mansion has been transformed into a fabulous cozy inn, decorated in authentic period antiques. The standard rooms come either with a double bed or two twin beds. Both the superior rooms and the suites look out over the Santa Efigenia and N.S. das Mercês churches. Many of the rooms feature bathtubs. The suites are much bigger and have a separate sitting room. The restaurant serves very decent Mineiro food.

Rua Dr. Alfredo Beata 16 (Praça Antônio Dias), Ouro Preto, 35400-000 MG. www.luxorhoteis.com. br. ℂ **031/3551-2244.** 19 units. R$200 standard; R$300 suite. Extra person add R$50. Children 6 and under stay free in parent's room. AE, DC, MC, V. **Amenities:** Restaurant; bar. *In room:* A/C, TV, Internet, minibar.

Pousada Classica ★★ A fascinating blend of old and new, the Classica is in an old baroque mansion that's been gutted and completely renovated. The lobby is modern

 Choose Your Guide Wisely

The square in front of the São Francisco de Assis church is particularly notorious for the guides that try to sell their services to visitors entering the church. Some are incredibly knowledgeable and will greatly add to your experience; others are trained only in spewing completely useless facts and can't answer any questions. If interested in a guide, check with the tourist information office on the Praça Tiradentes, or when negotiating with a freelancer be clear on the amount and the length of time (will he/she just give information on one church or visit a number of monuments with you?).

This quote was taken from one of the English-language guides for sale in Ouro Preto: "The constructive process of the temple began in 1733, reaching the decade of 80, when the frontispiece was concluded with base in Manoel Francisco's risk." In short, buyer beware!

and spacious with large glass doors (in place of the original dark shutters). The rooms are very pleasant with high ceilings, hardwood floors, and elegant furnishings, mixing modern amenities with the classic features of the building. The difference in price for a deluxe double and a super deluxe room or a suite is so small that you may as well go for the spacious suite with the whirlpool tub and the prime view. The standard and deluxe rooms don't have tubs, but the brand-new showers are spotlessly clean.

Rua Conde de Bobadela 96, Ouro Preto, 35400-010 MG. www.pousadaclassica.com.br. ℂ **031/3551-3663.** Fax 031/3551-6593. 27 units. R$290–R$340 standard and deluxe double. 40% discount on weekdays and low season. Extra person add 25%. Children 5 and under stay free in parent's room. V. Free parking. **Amenities:** Restaurant; room service. *In room:* A/C, TV, Internet, minibar.

Pousada do Mondego ★★ Located in the heart of Ouro Preto, the Pousada do Mondego looks out over the Largo de Coimbra and the São Francisco de Assis church. The 24 units in this 250-year-old pousada are spread out over three floors. The prime rooms are the suites or deluxe units on the second floor overlooking the square and the city below. These rooms are spacious and elegant, with hardwood floors, a four-poster bed, a sofa, and large dressers. The superior rooms are also quite nice—the beamed ceilings give the rooms a cozy feel—but the view is of the internal courtyard. Avoid the standard rooms, as these have low ceilings and no view at all. Service is outstanding (the pousada belongs to the high-quality Roteiros de Charme association), so it's not surprising that rooms are often booked; call in advance.

Largo de Coimbra 38, Ouro Preto, 35400-000 MG. www.mondego.com.br. ℂ **031/3551-2040.** Fax 031/3551-3094. 24 units. R$200 standard; R$270 superior; R$340–R$490 suite. Extra person R$40. Children 5 and under stay free in parent's room. AE, DC, MC, V. Free parking. **Amenities:** Room service. *In room:* TV, minibar.

Where to Eat

The food in Minas Gerais is known throughout Brazil for its simple ingredients, country-style preparation, and large portions (see "Where to Eat" in "Belo Horizonte," earlier in this chapter). Ouro Preto abounds in Mineiro-style restaurants. Remember, in Minas Gerais, the servings are always enough for two.

Bené da Flauta ★★ BRAZILIAN Although the chefs consider their menu Mineiro food with a contemporary twist, you will find plenty of other options. A great appetizer is the antipasto dish with roasted tomatoes and eggplant in olive oil, served with a basket of bread. Main courses are still far from being light cuisine but include options such as a veal *osso buco* with risotto or a grilled tournedos steak with creamy Piemontese rice. The 18th-century building itself has a lovely history; right next to Ouro Preto's monumental São Francisco de Assis church, it is here that painter Ataíde had his atelier when he was working on the artwork for the church. The gorgeous dining room is decorated in beautiful antiques.

Rua São Francisco 32. ℂ **031/3551-1036.** www.benedaflauta.com.br. Reservations recommended on Fri–Sat. Main courses R$22–R$38. DC, MC, V. Daily noon–11pm.

Cafe Geraes ★ CAFE Cafe Geraes is the perfect little cafe, and with only a dozen tables it is always busy. The best spot is on the mezzanine level overlooking the bar where you can still see part of the original clay and straw wall. This cafe serves delicious *caldos* (thick soups) together with a thick slice of home-baked potato bread. To nibble, you can order appetizers of salami, olives, and crackers. Or you can skip

ahead and go straight for dessert. The strudels and pies are excellent and served with a generous dollop of fresh cream.

Rua Direita 122, Centro. ✆ **031/3551-5097.** www.cafegeraes.com. Main courses R$12–R$24. No credit cards. Sun–Thurs 11am–11pm; Fri–Sat 11am–1am.

Casa do Ouvidor ★★ MINEIRO The Casa do Ouvidor is one of the best restaurants for trying out local cuisine. Located on the second floor above the Rua Direita, this elegant dining room basks in the warm glow cast from candles and numerous antique lamps. The menu includes the four typical Mineiro dishes. Some lighter items such as a grilled chicken breast and a beef brochette are offered, but I was on a mission and ordered the *tutu á Mineira*. The dish was everything I expected and more; the beans were mashed to almost a paste, accompanied by a juicy grilled sausage, tender pork loin, and crispy roasted bacon bits. A side order of rice, a boiled egg, and thinly shredded, stir-fried greens completed my feast. Dessert, not a chance!

Rua Direita 42, Centro. ✆ **031/3551-2141.** www.casadoouvidor.com.br. Main courses R$22–R$36 for 2. AE, DC, MC, V. Daily 11am–3pm and 7–10pm.

Restaurante Chafariz ★ 🍴BRAZILIAN The dining room of the Chafariz does a great job blending old with new. Housed in the former residence of Ouro Preto's beloved poet Alphonsus de Guimaraens, the restaurant looks like an antiques shop with large armoires, wrought-iron chandeliers, and large wooden tables. In contrast, the heavy ceiling beams are painted in cheerful colors, and the glass art is positively funky. Open for lunch only, the restaurant serves an excellent buffet of the best of Minas food as well as a good selection of salads. Dessert is always included, and at the end of your meal, the waiter will bring a complimentary glass of liquor made from the tiny red *jabuticaba* fruit.

Rua São José 167. ✆ **031/3551-2828.** Buffet R$28. DC, MC, V. Daily 11:30am–4pm.

Ouro Preto After Dark

Bar do Beco 📷 If I lived in Ouro Preto, I think I'd come to Bar do Beco every day and slowly work my way through the *cachaça* menu. With at least 65 varieties in stock at any given time, this bar is the perfect spot to embark on a taste trip. The bar special, the ice-cold Milagre de Minas, is made in-house with a secret 15-spice formula. The bartender also makes some wicked *cachaça* cocktails such as *da paixão* with Milagre de Minas, blue Curaçao, passion-fruit juice, and rose petals. With its smooth stone floors and low overhead beams, the bar has the feel of an old tavern. It opens at 6pm. They don't take credit cards. Travessa do Arieira 15. ✆ **031/3551-1429.**

Booze Café Concerto 🍸 This is a great spot to duck into after 9pm on a Friday or Saturday to catch some live music. Bands hail mostly from Minas Gerais and play MPB, blues, or jazz. The cafe itself is a large basement room with exposed brick walls, round windows that look out into the alley, and amazing glass art behind the bar. It's open daily 11am to midnight. They don't take credit cards. Rua Direita 42, subsolo (basement). ✆ **031/3551-1482.** R$5 cover Fri–Sat.

MARIANA ★

18km (11 miles) E of Ouro Preto

Unlike Ouro Preto, Mariana is not a perfectly preserved historic town but rather a town with a perfectly preserved historic section. Unlike its larger neighbor, Mariana also still has active mining on the outskirts of the city. The historic part of Mariana

When to Go

Time your visit to Mariana for the Friday (11am) or Sunday (12:15pm) concert, performed on the exquisite 18th-century organ at the Catedral da Sé.

makes a pleasant half-day trip from Ouro Preto. The monuments, museums, and churches can be seen in a few hours, and the trip by bus is only 30 minutes.

Essentials

GETTING THERE

Buses depart from Ouro Preto for Mariana daily every 30 minutes between 5:30am and 11:30pm from behind the Museu de Minas (Rua Barão Camargos). The trip costs R$2.20, takes approximately 30 minutes, and drops you in the center of Mariana. A much more scenic way to get to Mariana is by **steam train.** Originally built in 1883, the 18km (11 miles) of track that connect the two towns have recently been restored. The trip takes an hour; make sure you sit on the right-hand side as you leave Ouro Preto to get the best views of the landscape. Also, if you sit in the rear of the train you can take some great photos of the front carriages as the track curves. The train departs Ouro Preto for Mariana Friday to Sunday at 11am and 4pm; it returns from Mariana to Ouro Preto only at 2pm. Visitors can return by bus or arrange a taxi. The one-way fare is R$22 adults and R$11 children 6 to 10; for information, call ✆ **031/3551-7705.**

VISITOR INFORMATION

Bring some information on Mariana from Ouro Preto's tourist information as the office here, at Praça Tancredo Neves s/n (✆ **031/3557-1158**), is notoriously unreliable. It's supposed to be open daily 8am to 5pm, but don't count on it.

Exploring the Town

From the bus stop, it is an easy stroll to all of Mariana's sights. Built according to a city plan in 1743, the old part of town has an easy-to-follow grid pattern. Following **Rua Josafia Macedo** out and then the parallel **Rua Dom Viçoso** back to the **Praça Cláudio Manuel** makes for a perfect loop. Starting off on **Rua Josafia Macedo,** the first stop of interest is Mariana's **Pelourinho** at the Praça Minas Gerais. This square is one of the few in Brazil that has kept the *pelourinho* (pillory) to attest to this bloody era of Brazilian history; the locals claim the square is haunted. Surrounding the *pelourinho* are the **Igreja São Francisco de Assis,** viewable upon request, the **Igreja N.S. do Carmo,** with limited opening hours, and the former jail and city council. Both churches were built in the late 18th century and are lovely examples of the local baroque architecture. Continuing up the street, now known as **Rua D. Silverio,** it is a pleasant 20-minute stroll to the top of the hill where the **Basilica de São Pedro dos Clerigos** overlooks the city from its vantage point. Coming back down, zigzagging through the side streets with beautifully preserved colonial houses, make your way to the **Praça Gomes Freire,** the main gathering place for locals. On the corner of the square you can see one of the original drinking troughs used for watering horses. After visiting the **Museu de Arte Sacra** and the **Catedral Basilica da Sé,** loop back to the bus station via the short **Rua Direita,** observing the colorful two-story houses.

Catedral Basilica da Sé ★★ Well worth a visit, this lovely cathedral is the oldest church in Mariana, completed in 1750. Some famous Brazilian baroque artists worked on the decorations: Aleijadinho's father carved many of the altars, Ataíde

painted a number of pieces, and the baptismal font in the sacristy was made by Aleijadinho himself. The stunning chandeliers in the center of the church are pure Bohemian crystal, imported from Germany. The organ, a gift from Dom. João V, has been fully restored after a 70-year silence. Every Friday and Sunday the organist holds a 40-minute concert, followed by a detailed explanation of the organ itself.

Praça Claudio Manuel s/n. ✆ **031/3557-1216.** Church visit R$2; concert R$12. Tues–Sun 8am–6pm. Concerts take place Fri 11am and Sun 12:15pm.

Museu de Arte Sacra ★★★ Although unassuming from the outside, the colonial mansion behind the cathedral houses one of the best collections of sacred art in Brazil. The vast collection is beautifully displayed and illuminated, and the stone floors and thick walls of the building create the appropriate stately ambience. On the ground floor you will find a large collection of silver and gold artifacts: crowns, diadems, crucifixes, and chalices. Also on display are intricately decorated *custodias*—a type of chalice used only for the host—as well as lanterns and processional crosses. Upstairs there's a collection of statues made by Aleijadinho, as well as a portrait of the artist done by Ataíde. What makes the work of this baroque artist so vibrant is the painstaking effort he put in to preparing his canvases and paint. Often working on wood, he started with a white layer to bring out the luminosity in the paint, followed by an ocher layer, and then a white, almost transparent layer to increase the dark and light contrast. In his paints, Ataíde blended in gold dust, red dirt, coal dust, and metal shavings.

Rua Frei Durão 49. ✆ **031/3557-2516.** Admission R$5 ages 5 and over, free for children 4 and under. Tues–Sat 8:30am–noon and 1:30–5pm; Sun 8:30am–2pm.

Where to Eat

Most of Mariana's restaurants do not open for lunch except on weekends and holidays. A great lunch spot, open daily 11am to 3pm and popular with local families on Sunday, is **Lua Cheia,** Rua Dom Viçoso 26 (✆ **031/3557-3232**). Two more-upscale choices are **Tambaú,** Travessa São Francisco 26 (✆ **031/3557-1780**), serving tapas and great Brazilian finger foods, and **Bistrô,** Rua Salamão Ibrahim 61A (✆ **031/3557-4138**), for sushi, pasta, and pizzas. Both are only open for lunch on the weekends.

TIRADENTES ★★★

217km (135 miles) N of Rio de Janeiro, 369km (229 miles) NE of São Paulo, 142km (88 miles) S of Belo Horizonte

Surely one of the loveliest little towns in all of Brazil, Tiradentes doesn't "wow" like Ouro Preto, doesn't seduce like Salvador or charm like Olinda, but it quietly wins you over and before you know it you, too, will be head over heels in love. Nestled at the foot of the Serra de São José, it's a place where time has stood still. When the last mine closed in 1830, people moved away and the town was left as if frozen in amber. A heritage designation early on in 1938 kept any further development at bay.

The town has only a few dozen streets and can easily be seen in a day, but why rush? See the sights, browse the fabulous antiques and jewelry stores, enjoy the fine dining, or just stroll the streets. Despite its size and isolation, Tiradentes has a well-developed tourism infrastructure. In high season and on weekends the town gets hopping; if you prefer peace and quiet, stick to weekdays for your visit.

Mengoooooooooo!

It was the day after Sunday's big game in Rio's Maracanã stadium: Flamengo won, making it a shoe-in (well, a cleat-in) for the Carioca cup. As I strolled through Tiradentes's sleepy streets I heard a car coming, the first one in 2 hours, and as it drove by I heard a loud "Mengoooooooooo"—the drawn-out call of Flamengo fans—and turned to see three guys in Flamengo shirts, with the black-and-red flag proudly draped over the hood. Back in the main square, I was just in time to see residents put up a few tables, pull some *cervejas* from the trunk, and dance and sing to the boombox, belting out Flamengo tunes. Even 1 day later—and no matter where you are—a victory by Brazil's most beloved team is always a good excuse for a party.

Essentials

GETTING THERE As there are no direct long-distance **buses** to Tiradentes, visitors must travel to São João del Rei first and from the *rodoviaria* connect with one of the 11 buses a day that cover the 14km (8½ miles) to Tiradentes in 20 minutes and cost R$4. Regular buses connect São João del Rei to Belo Horizonte, São Paulo, and Rio de Janeiro. The Viação Sandra line runs seven buses a day to Belo Horizonte. The Paraibuna line runs at least three buses a day to Rio. The Vale do Ouro line has five buses a day to São Paulo, and one bus leaves for Ouro Preto every day at 5:30pm.

In a pinch one can always take a **taxi** from São João del Rei, for about R$50. For taxi service contact ℭ **032/3355-1466** or 3355-1100. The Tiradentes Rodoviaria is within walking distance of most pousadas.

To arrive in style, take the 115-year-old narrow-gauge **steam train,** called **Maria Fumaça (Smoking Mary) ★★**, from São João del Rei (ℭ **032/3371-8485**). Following the Rio das Mortes, the train takes 35 minutes to reach Tiradentes's rail station. Trains depart São João del Rei Friday through Sunday and holidays at 10am and 3pm, and from Tiradentes at 1pm and 5pm. One-way tickets cost R$25 adults, R$13 children 6 to 10. The train station is a short taxi ride or a 10-minute walk from the historic center of town.

VISITOR INFORMATION The **tourist office** is at Largo das Forras 71 (ℭ **032/3355-1212**), open daily from 9am to 5:30pm.

Exploring the Town

The list of attractions may seem small, but that's because the town itself is the main attraction. The only way to experience Tiradentes is on foot, so you can get lost in the little streets and absorb the breathtaking architecture.

A STROLL AROUND TOWN

Start at the **Largo das Forras,** the large tree-lined square in the center of town. This is where the tourist office is located (daily 9am–5:30pm) and where, if you really don't want to hoof it, you can hire a buggy and horse to do the hoofing for you (R$15 for a 45-min. tour). Walk to the corner next to the tourism office, and you'll see the beautifully restored post office. Continuing up that street (Rua Resende Costas) you start to climb a bit, and soon to the right you will be able to catch breathtaking views of the Serra de São José. Stay on the street (now renamed Rua Direita) until you come to the **N.S. do Rosário dos Pretos** on your right. The oldest church in town,

it was built entirely by Tiradentes's slave community. It's definitely worth a peek inside. The stars and moon painted on the ceiling refer to the fact that most of the construction had to be done at night, after the enslaved had completed their forced labor. The individually painted wooden panels on the ceiling represent the mysteries of the rosary. From here, instead of continuing up along Rua Direita, duck into the alley behind the church, and it will lead to the **Largo do Sol** and **Museu de Padre Toledo.** One of the *inconfidentes*, Padre Toledo lived in this house until he was arrested and exiled to Lisbon. The museum, unfortunately, doesn't tell much of the padre's story; instead, it's mostly a mishmash of furniture, paintings, oratories, and household objects. Stay on the Rua Padre Toledo as it leads up the hill to the **Matriz de Santo Antônio** church (see below). Take the street to the right of the Matriz and continue farther up the hill to the church of **Santissima Trinidade.** This church stands out for its simplicity: no fancy ornaments, no gold, not even a clock tower. But for an over-the-top display of faith, look no further than the room of miracles around the back of the church. The place where the faithful give thanks for cures and inter-ventions is packed from top to bottom with letters, photos, wax and plastic body parts, and every piece of orthopedic equipment imaginable. Right next door is the holy shop of saints where you can purchase a statue of just about any saint in the calendar. Retrace your steps down the hill and continue past the Matriz to the charming little **Largo do O.** Beyond that, just across the bridge is the large **Chafariz de São José** where residents used to obtain their water. Walking back toward the main Largo das Forras along the **Rua Direita** will take you through Tiradentes's gallery row. Many artists live and work here; painters, furniture makers, silversmiths, and craftspeople make high-quality pieces at reasonable prices. Typical souvenirs include locally made *cachaça*, sweets and preserves, silver jewelry, paintings, and quilts and rugs.

Matriz de Santo Antônio ★ One of the richest churches in Minas Gerais, the Matriz has recently been renovated and looks as good as new. Aleijadinho sculpted the front entrance, portraying a shield with the Lamb of God. The interior is com-pletely plastered with gold; the main altar seems positively ablaze. The sacristy is worth a look for the paintings by Manuel Victor de Jesus representing scenes from the Old Testament. The steps of the church offer one of the best views in the city. On Friday, Saturday, and Sunday there is a sound-and-light show that tells the history of the church (R$10). The show begins at 8pm. On Fridays the sound-and-light show is followed by a baroque concert on the church's recently restored 18th-century Por-tuguese organ. The concert starts at 8:30pm (R$15).

Rua da Camara s/n. ✆ **032/3355-1238** for inquiries about concert. Admission R$3. Daily 9am–5pm.

HIKING

The hills around Tiradentes and São João del Rei offer some spectacular hiking and walking trails. Local company **Lazer e Aventura** (✆ **032/3371-7956** or 032/9981-3474; www.lazereaventura.com) specializes in trips in the region. One of the more popular hikes goes up to the top of the Serra de São José and offers fabulous views of the surrounding valleys. The company also runs a jeep tour, which follows a trail along the base of the hills through some stands of Atlantic forest and takes you through some small villages. More adventurous types can try out rappelling or caving as well. Most tours last about 4 hours and require just an average level of fitness. All transportation is included and prices range from R$60 to R$80 per person.

Where to Stay

Pousada Pé da Serra Run by a friendly family, this pousada sits only 150m (500 ft.) from the bus station directly behind the São Francisco de Paulo church. Thanks to the boost provided by a small ridge, five of the nine rooms offer sweeping views of the mountains and the town itself. The rooms are very basic and simple, no phones and no fancy furnishings, but the location makes up for a lot: Guests have use of a cozy sitting room with a fireplace and bar, and on sunny days can enjoy the large garden with a swimming pool and a complimentary afternoon tea.

Rua Nicolau Panzera 51, Tiradentes, 36325-000 MG. www.pedaserra.com.br. © **032/3355-1107.** 9 units, shower only. R$130–R$180 double. Extra person add R$30. Children 6 and under stay free in parent's room. V. Free parking. **Amenities:** Bar; outdoor pool. *In room:* TV, fridge, minibar, no phone.

Pousada Tres Portas Named after the three double doors forming the entryway, this lovely pousada is located within the historic town. Just off the main square, the views of the Serra São Jose are quite beautiful. The best room has a full view of the Serra and is furnished with a beautiful four-poster bed. The other rooms have partial views and are also very pleasant, featuring lovely antiques, hardwood floors, and colorful bedspreads on comfortable beds. All guests have the use of the lounge, a great spot to relax by the crackling fire.

Rua Direita 280A, Tiradentes, 36325-000 MG. www.pousadatresportas.com.br. © **032/3355-1444.** Fax 032/3355-1184. 9 units, shower only. Mon–Fri R$195–R$230 double; Sat–Sun R$260–R$310 double. Extra person 13 and over, add 50%. Children 2 and under stay free in parent's room, ages 3–12 add 10%. MC, V. Free parking. **Amenities:** Restaurant; bar; small indoor heated pool; sauna. *In room:* TV, fridge, minibar, no phone.

Solar da Ponte ★★★ Though for very different reasons, the Solar da Ponte is much like the Eagles' Hotel California—you may never leave. Located in the heart of Tiradentes, this member of the Roteiro de Charme group of pousadas is the perfect home base for exploring this historic town. The rooms are all uniquely furnished with antiques, harmonious color schemes, fresh flowers, and comfortable couches and chairs. The standard rooms overlook the street and the stone bridge that the pousada is named after, while the superior rooms face out over the garden. The pousada also has a comfortable reading room with ample literature in English and a large fireplace for chilly evenings. The restaurant in the garden room serves a scrumptious breakfast with fresh warm rolls, eggs, cold cuts, cake, and fresh fruit, all on beautiful dishes made by a local artist. In the afternoon, the restaurant offers complimentary tea.

Praça das Mercês s/n, Tiradentes, 36325-000 MG. www.solardaponte.com.br. © **032/3355-1255.** 18 units, shower only. High season R$500 standard; R$610 superior. Extra person R$70. In low season 20%–30% discount. AE, DC, MC, V. Free parking. No children 7 years old and under. **Amenities:** Outdoor pool; sauna. *In room:* TV, hair dryer, Internet, minibar.

Where to Eat

Tiradentes is quite sophisticated when it comes to restaurants. Most specialize in traditional Mineiro cuisine (p. 164). Every year, at the end of August, the city hosts a culinary festival and provides a wonderful opportunity for local chefs to show off their skills. During the off season check ahead for opening hours, particularly Sunday through Tuesday.

Many interesting restaurants can be found just by strolling along Tiradentes's streets. The top restaurants in town all specialize in local cuisine. **Estalagem do**

Sabor, Rua Min. Gabriel Passos 280 (© **032/3355-1144**), is well known for its hearty regional fare. In addition to basic chicken and meat stews, try the *mané sem jaleco,* a dish that combines rice with beans, sliced kale, bacon, eggs, and pork tenderloin; lean cuisine it ain't. **Viradas do Largo,** Rua do Moinho 11 (© **032/3355-1111;** www.viradasdolargo.com.br), is another local favorite that has made a name for itself with outstanding Mineiro dishes. Many of the dishes are made with herbs and vegetables from the restaurant's own garden. Portions here are very generous— often a dish will feed two or three people. Appetizers include handmade pork or chicken sausages. For Mineiro cuisine with a modern twist, check out the restaurant **Tragaluz,** Rua Direita 52 (© **032/3355-1424;** www.tragaluztiradentes.com). Here you will also find some of the typical Mineiro meat stews, but served with shiitake mushrooms instead of cabbage and with a side of mashed *inhame* (a Brazilian root vegetable) instead of rice. Desserts are creative; for example, the staple *goiabada* (guava paste) is served fried with a sprinkling of cashew nuts and cream cheese. It's not open for lunch. For that special night out there is no restaurant more romantic than **Santissima Gula,** Rua Padre Gaspar 343 (© **032/3355-1162;** www. santissimagula.com.br). The cozy candlelit dining room only has a few tables, and guests choose from a number of tasting menus with at least four or five courses. The cuisine is refreshingly modern and usually includes several seafood and meat options.

Minas is almost as famous for its food as it is for the outstanding *cachaça* (hard liquor made from sugar-cane juice) it produces. **Confidências Mineira ★★,** Rua Ministro Gabriel Passos 26 (© **032/3355-2770**), offers an extensive *cachaça* menu; many of the brands have florid and poetic names. For example, try Minha Deusa (My Goddess), a fruit-flavored variety of *cachaça.* One of the best *cachaças* around is Havana. Aged in balsamic barrels and made in small quantities, it is considered the champagne of *cachaças.*

It is also possible to enjoy cuisines other than Mineiro cooking in Tiradentes. Overlooking the Ponte do Solar, **Sapore d'Italia ★,** Rua Francisco de Paula 13 (© **032/3355-1846**), cooks up some excellent Italian dishes. The menu offers a good selection of pasta dishes such as cannelloni with ham. The wine list includes mostly Portuguese, French, and Italian reds, all reasonably priced.

SÃO PAULO

This city of 11 million people is the largest metropolis in South America. Yet don't be daunted by its size: It's a sophisticated, diverse, and cosmopolitan city. São Paulo offers stunning architecture, the finest restaurants in Brazil, incredible ethnic food, boutiques that even New York doesn't have, high-end art galleries and museums, and one of Brazil's most dynamic nightlife scenes. And visitors can experience all this without ever experiencing the big drawback to this city, which is traffic.

Things to Do Take a stroll and admire the city's dazzling skyline, composed of 19th-century churches, steel-and-glass towers, and modernist structures by Oscar Niemeyer. São Paulo boasts Brazil's finest museums: The **Pinacoteca** displays outstanding Brazilian art, while the **Museu do Futebol** showcases soccer. Mingle with the locals in **Ibirapuera Park,** and then head to **Liberdade,** home to the world's largest Japanese community outside of Japan, for some authentic Japanese food.

Shopping São Paulo is a shopper's paradise. Well-heeled fashionistas browse elegant **Rua Oscar Freire** for designer shoes and clothes. For more affordable mainstream brands, head to **Shopping Iguatemi,** one of the city's many fine malls. For the best bargains, brave the crowds on Centro's **Rua 25 de Março,** where local merchants sell everything from lingerie to purses to inexpensive jewelry. The **Mercado Municipal** houses hundreds of stalls piled high with delectable food products, such as tropical fruit, cheeses, and spices.

Restaurants & Dining São Paulo is known as the gourmet capital of Brazil. Dine in upscale **Jardins** on succulent Brazilian beef, elegant Spanish cuisine, or top Italian fare. The city's best Japanese cuisine is found in **Liberdade,** whereas **Higienopolis** and **Vila Madelena** are home to several cozy bistros and fine-dining establishments that serve up contemporary Brazilian food or more classic French fare.

Nightlife & Entertainment This is one happening place! Twenty-somethings flock to the many lively bars and dance clubs in **Vila Olimpia,** while a slightly older crowd frequents the upscale bars and intimate live music venues of **Vila Madelena.** Trendsetting Paulistas flock to the alternative dance clubs and late-night watering holes in São Paulo's former red-light district around **Rua Augusta.** For classical music, check the programming at **Estação Julio Prestes,** a former railway station turned concert hall.

ESSENTIALS

359km (223 miles) SW of Rio de Janeiro

Getting There

BY PLANE Most international airlines fly through São Paulo. Even those heading for Rio often change planes or stop in São Paulo first. There are two main airports. International flights arrive at **Guarulhos Airport** (✆ **011/2445-2945**) 30km (19 miles) northeast of the city. Paulistas will also refer to this airport as Cumbica. São Paulo has a duty-free shop upon arrival **before clearing Customs,** where you can purchase up to US$500 of goods. Once you have cleared Customs you can change money or traveler's checks or use an ATM to obtain cash in Reais. The **American Express** office is open daily from 7am to 10pm and is located in Terminal 1 arrivals. The **Banco do Brasil** charges a US$20 flat rate for traveler's check transactions and US$5 flat rate for cash transactions. ATMs compatible with Visa/PLUS are in Terminal 1 arrivals.

From **Guarulhos Airport** to the city, travelers can either take a taxi or a bus. Prepaid taxi fares are available with **Taxi Guarucoop** (✆ **011/2440-7070;** www. guarucoop.com.br). Sample fares: Congonhas Airport R$92, São Paulo Centro and Tietê R$75, and Jardins and Avenida Paulista R$85. There are regular metered taxis, which are cheaper when traffic is good. When traffic backs up the prepaid ride turns out to be a much better deal. The **Airport Bus Service** (✆ **011/3775-3850;** www. airportbusservice.com.br) operates six different shuttle bus routes to Congonhas Airport, to Praça da República, to Avenida Paulista (stopping at major hotels along the street), to Itaim Bibi, to the Rodoviario Tietê (bus station), and the Rodoviario Barra Funda. The cost is R$31, and each route takes about 50 minutes (if traffic is good). Shuttles depart daily every 30 minutes from 6am to 11pm, and then hourly overnight.

Congonhas Airport (✆ **011/5090-9000**), São Paulo's domestic airport, is within the city limits south of Centro. It is used by seven national airlines for their domestic flights. From Congonhas it is a 15- to 25-minute taxi ride to Jardins or Avenida Paulista. There are two prepaid taxi services with booths near the exit doors at arrivals. Unlike in Rio de Janeiro, prepaid here is a reasonable deal. The cheaper, white **Taxi Commun** (ordinary taxi) charges from R$33 to R$44 for the trip to Avenida Paulista or Jardins. The **Rádio Táxi Vermelho e Branco** (the **Red and White Taxi Company;** ✆ **011/3146-4000;** www.radiotaxivermelhoebranco.com.br) charges about 15% more—R$38 to R$55—but has slightly larger, slightly nicer cars. Regular metered taxis are also available, and will cost as little as R$24 or as much as R$45, depending on traffic.

BY BUS São Paulo has three bus terminals (*rodoviaria*). All are connected to the Metrô system. **Barra Funda** (✆ **011/3392-2110**), near the Barra Funda Metrô, serves buses to the interior of São Paulo, northern Paraná, Mato Grosso, and Minas Gerais. **Jabaquara** (✆ **011/3235-0322**), next to the Jabaquara Metrô, provides transportation to Santos and the south coast. The **Rodoviaria Tietê** (✆ **011/3235-0322**), for buses to Rio and connections to Paraguay, Uruguay, and Argentina, is by far the largest and most important bus station, located on the Tietê Metrô stop.

São Paolo's Neighborhoods in Brief

Some 11 million people make their home in and around São Paulo. It's a daunting number. But for all its ridiculous sprawl there's a charm to South America's biggest city, and getting around the areas of interest is neither difficult nor especially stressful. Though Paulistas do love their cars, most São Paulo neighborhoods can still easily be explored on foot. Just be very careful when crossing the street. São Paulo has the highest number of motorcycle couriers in the country, and motorcycles are responsible for the highest number of pedestrian deaths. Be particularly careful when crossing in between stopped cars; motorcycles often ride at high speed between lanes.

CENTRO

The old heart of the city stands around **Praça da Sé,** atop what was once a small hill circled by a pair of small rivers, the **Tamanduatei** and the **Anhangabaú.** This is where in 1554 the city of São Paulo was founded. Little remains of that original city; Paulistas take a manic joy in knocking buildings down almost as soon as they go up. The neo-Gothic **Catedral da Sé** dates to only 1912. Evidence of the city's age can be seen only in downtown's narrow and irregular streets. **Rua Direita,** São Paulo's original main street, leads through this maze to a viaduct crossing over a busy freeway that now occupies the Anhangabaú valley and goes into the "newer" section of the old town. The Anhangabaú River, which once separated the two halves of downtown, was long ago filled and covered with a freeway, which in turn has been covered over by a broad and open city plaza—the **Parque Anhangabaú**—which effectively rejoins the two halves of downtown. Together, these two halves of the old inner city are known as **Centro.**

Back at the edge of the Anhangabaú valley stands the ornate **Teatro Municipal,** a Parisian-style opera house. This bank of the Anhangabaú is often called **Nova Centro** or New Centro, to distinguish it from the old center, Centro Velho, across the way. The buildings are newer, and apartments and hotels are mixed in with the office towers. From the Teatro Municipal a number of crowded pedestrian streets—avenidas 7 de Abril, Baron de Itapetininga, and 24 de Maio—lead west through downtown to the large and green Praça República.

Going northward from here leads through the run-down Luz neighborhood to the high Victorian Luz Station and adjacent Luz Park. Nearby one also finds the **Pinacoteca do Estado** and the **Sacred Art Museum.**

HIGIENÓPOLIS

Immediately west of Centro is one of São Paulo's original upscale suburbs, **Higienópolis.** At the beginning of the 20th century, wealthier Paulistas were starting to move out of Centro to get away from the mosquito-infested swamps around the banks of the Anhangabaú River. Green and leafy Higienópolis was one of the most sought-after destinations. Even today, some of the elegant mansions from 80 years ago still remain. Higienópolis lies on a slight rise west of Centro, centered around **Rua Higienópolis** and **Avenida Angélica.** It's here you'll find the small but restaurant-packed **Praça Vila Boim** and the **Museu Arte Brasileira** (**FAAP;** p. 207), as well as one of the city's nicest malls, the **Shopping Pátio Higienópolis.**

LIBERDADE & BIXIGA

To the south of Centro are two turn-of-the-20th-century working-class neighborhoods long adopted by immigrants. Due south of Centro is **Liberdade,** said to have the largest Japanese population of any city outside Japan. In addition to great food and interesting shopping, Liberdade is also home to the **Museum of Japanese Immigration.** Southwest of Centro lies **Bela Vista,** more often referred to as **Bixiga.** This is São Paulo's **Little Italy.** Bela Vista in turn butts up against São Paulo's proudest street, the **Avenida Paulista.**

AVENIDA PAULISTA

What was once a track along a ridgeline through virgin Atlantic rainforest has come quite a way in just over 100 years. Today, over one million people and 100,000 cars

make their way along the **Avenida Paulista** on any given business day. Laid out back in 1891, the street was designed as a grand ceremonial boulevard, a place for São Paulo coffee barons and factory owners to build their magnificent villas. One of these grand mansions still remains, the **Casa das Rosas** near the Brigadeiro Metrô stop. Beginning in the 1930s, however, the old mansions gave way to office buildings and then ever-higher commercial skyscrapers occupied by major banks and financial institutions. Collectively, they make for an impressive statement of wealth and prestige, though individually the architecture is pretty mediocre. There are two worthwhile attractions near the north end of the Avenida: the **Museu Arte São Paulo** (**MASP;** p. 207) and, just opposite, **Siqueira Campos Park,** also called by its old name, **Trianon Park.** For shoppers, the south end of the avenue is anchored by a large upscale mall, the **Shopping Pátio Paulista.**

JARDINS

What is currently called Jardins (gardens) is a combination of a number of neighborhoods—including **Jardim Europa, Jardim Paulista,** and **Jardim America—**that extend southwest in a regular grid pattern (mostly) from the towers and offices of the Avenida Paulista. Built after the Avenida Paulista developed at the end of the 19th century, these neighborhoods were carefully planned according to the principles of the British Garden City movement, including rules on lot sizes and restrictions on apartment buildings. Some of these regulations have fallen by the wayside, though Jardim Europa is still home to mostly villas and mansions. The **Rua Augusta,** which runs through the heart of the Jardins, now has many hotels and some of the best restaurants in the city. The few square blocks

where **Rua Augusta** is intersected by **Alameda Lorena** and **Rua Oscar Freire** is the apex of the city's upscale shopping scene—São Paulo's Rodeo Drive.

IBIRAPUERA PARK

The last key element to São Paulo is a green space—**Ibirapuera Park.** Located immediately south of Jardim Paulista, Ibirapuera is to São Paulo what Central Park is to New York. It's a place for strolling, lazy sun-tanning, outdoor concerts, and the view to a couple of the city's top cultural facilities, including the **Modern Art Museum** and the **São Paulo Bienal.**

VILA MADALENA

Tucked away behind Pinheiros, Vila Madalena became popular in the 1960s and 1970s among University of São Paulo staff and students looking for affordable housing. The neighborhood still has a slightly bohemian feel, and many artists and designers have both homes and galleries here. The Vila is also one of the city's most popular dining spots, and pulses with bars and nightlife most evenings until the wee hours. The neighborhood centers around the **Rua Aspicuelta,** from Rua Harmonia to Rua Murato Coelho.

PINHEIROS & ITAIM BIBI

Linked by a single large road, Avenida **Brigadeiro Faria Lima, Pinheiros** and **Itaim Bibi** flank the Jardins to the north and south respectively. Pinheiros lies sandwiched between Jardim Paulista and the nightlife-rich Vila Madalena. Itaim Bibi flanks the southeast side of Ibirapuera Park. Both are prime residential neighborhoods, with good hotels and dining options. Itaim Bibi is particularly blessed with restaurants. **Avenida Brig. Faria Lima** also has the **Museu Casa Brasileira** and the upscale **Shopping Iguatemi** mall.

Getting Around

São Paulo has a convenient public transportation system, and many of its tourist-oriented neighborhoods are compact enough for a stroll. However, at night it's safest to take a taxi to and from your destination.

ON FOOT Though São Paulo itself is huge, many of the neighborhoods that make up the city are compact enough to be easily explored on foot. This is especially true of the more pleasant neighborhoods such as Centro, Higienópolis, Liberdade, Jardins, Vila Madalena, and Ibirapuera. During the day the city is quite safe; in the evening the safest neighborhoods are Jardins, Higienópolis, and the residential areas of the city. Best avoided are the quiet side streets of Centro, particularly the empty shopping streets around Praça Sé, Bexiga, and around Luz station.

BY METRÔ The Metrô is the easiest way to get around São Paulo. There are four lines: the North-South line, East-West line, and the line that travels underneath the Avenida Paulista. The fourth line sits isolated in the southwest of the city, and does not connect to the other three. The two main lines converge at Sé station, the busiest station of all. These two lines run daily from 5am until midnight. The line under Avenida Paulista meets the North-South line at Paraiso and Ana Rosa stations and runs daily from 6am to 10pm. It is usually a lot quicker to take the Metrô as close as possible to your destination—even if it means a bit more of a walk or a short taxi ride—than taking the bus all the way. Metrô tickets cost R$2.90. For more information, contact © **011/3371-7274** or see the very useful website: **www.metro. sp.gov.br**. Note that the Single Fare (Tarifa Unica) program which allows riders to pay one fare and make use of Metrô, bus, and commuter rail is available only to São Paulo residents.

BY BUS Good as Sao Paulo's Metrô is, there are some places you can only get to by bus. São Paulo buses are plentiful and frequent, but the city's sprawling layout and lack of landmarks can make the system hard to navigate. The routing information on the front and sides of the buses works the same as in Rio (see "By Bus" under "Getting Around" in chapter 4 for details). A few useful routes are listed below (more are given with particular attractions and restaurants), but there will be many others running along similar routes. Buses cost R$3, and you pay as you board through the front of the bus. Bus drivers generally won't stop unless you wave your hand to flag them down. Some useful routes are:

- **No. 702P, Belém-Pinheiros:** From Praça da República along Rua Augusta, then north on Avenida Brigadeiro Faria Lima into Pinheiros.
- **No. 701U, Jaçanã-Butantã-USP:** From Praça República along Avenida Ipiranga, Rua da Consolação, and Avenida Rebouças to Buntantã and the University of São Paulo.
- **No. 5100, 5131:** From Brigadeiro Metrô station, along Avenida Brig. Luis Antonio to Ibirapuera Park.
- **No. 5175, 5178:** From Ibirapuera Park (opposite main gate) along Avenida Pedro Alvares Cabral to Brigadeiro Metrô station.

 Watch Out for Rogue Motorcyclists

São Paulo has the highest number of motorcycles in the country, most of them used by couriers. Be careful; even when traffic is backed up motorcycles will ride at high speeds weaving in between stopped cars.

The bottom line? If possible, we recommend going by Metrô, combined where necessary with taxis.

BY TAXI Taxis are a great way to get around São Paulo, and an absolute must late at night. You can hail one anywhere on the street, and taxi stands are usually found on main intersections, or next to malls, squares, and parks. To order a taxi at a specific time,

call a radio taxi. **Rádio Táxi Vermelho e Branco** (Red and White) can be reached at ℭ **011/3146-4000** (www.radiotaxivermelhoebranco.com.br). The cost depends on traffic, so the following prices are only guidelines: From Centro to Avenida Paulista, R$30; from Avenida Paulista to Vila Olímpia, R$35 to R$45; from Avenida Paulista to Higienópolis, R$22.

BY CAR Driving in São Paulo is for the daring, the foolish, or the infinitely patient; traffic is always chaotic and frequently snarled and slow, particularly during rainstorms when the streets flood. Oh, and parking is expensive and difficult to find. São Paulo's appalling traffic has given rise to the world's largest fleet of civilian helicopters that ferry commuting executives in from their suburban homes.

Visitor Information

The single worthwhile service for visitors is produced not by Sao Paulo's state or city government, but by an association of the city's art galleries, which produces the excellent *Mapa das Artes São Paulo,* a clear and detailed city map showing the city's main attractions, its subway lines, and, of course, its art galleries (**www.mapadasartes. com.br**). The map is available, free of charge, at many city hotels, and at the government tourist information booths, if you can find one open.

The state of São Paulo provides a tourist information service, **SELT** (ℭ **011/6445-2380**), at Guarulhos airport in both terminals 1 and 2, supposedly open daily from 7am to 9pm (but don't be surprised if there's no one there).

The city government tourism information center at Rua XV de Novembro 347, Centro (ℭ **011/3231-4455;** daily 9am–6pm), offers maps and pamphlets and not much else; the English that is supposedly spoken sounds much like Portuguese.

[Fast FACTS] SÃO PAULO

Area Code The area code for São Paulo is **011.**

Banks Most banks are located on the Avenida Paulista. You'll find **Banco do Brasil** at Av. Paulista 2163 (ℭ **011/3066-9322**); Rua São Bento 483, Centro (ℭ **011/3491-4008**); and Guarulhos International Airport, daily 6am to 10pm (ℭ **011/6445-2223**). There's also **Bank Boston,** Av. Paulista 800 (ℭ **011/3171-0423;** Mon–Fri 11am–3pm), and **Citibank,** Av. Paulista 1111 (ℭ **011/4009-2563;** Mon–Fri 11am–3pm).

Car Rentals At Guarulhos airport are **Hertz** (ℭ **011/2445-2801**),

Localiza (ℭ **021/3398-5445**), and **Unidas** (ℭ **011/2445-2113**). At Congonhas airport are **Avis** (ℭ **011/5090-9300**), **Hertz** (ℭ **011/5542-7244**), and **Unidas** (ℭ **011/3155-5710**). In the city are **Hertz,** Rua da Consolação 431 (ℭ **011/3258-9384**), **Avis,** Rua da Consolação 382 (ℭ **011/3259-6868**), and **Unidas,** Rua da Consolação 345 (ℭ **011/3155-5710**). Rates start at R$90 per day for a small (Fiat Palio, Ford Ka) car with air-conditioning and unlimited mileage. Insurance adds R$30 per day.

Consulates **Australia,** Al. Santos 700, ninth floor

(ℭ **011/3171-2889**); **Canada,** Av. das Nações Unidas 12901, 19th floor (ℭ **011/5509-4321**); **United States,** Rua Henri Dunant 500, Chácara Santo Antonio (ℭ **011/5186-7000**); **Great Britain,** Rua Ferreira de Araujo 741 (ℭ **011/3094-2700**); **New Zealand,** Al. Campinas 579, 15th floor (ℭ **011/3148-0870**).

Dentists **Portal do Sorriso** (www.portaldosorriso. com; Mon–Sat 7am–9pm) has offices in Pinheiros (ℭ **011/2626-0889**) and Morumbi (ℭ **011/3772-5941**). **Dr. Marcelo Erlich** has an office at Rua Sergipe 401, suite 403, Higienópolis

185

(☎ 011/3214-1332 or 9935-8666). Both offer English-speaking service.

Electricity Generally 110V; some hotels have both 110 and 220 volts.

Emergencies Police ☎ **190;** fire brigade and ambulance ☎ **193.**

Hospitals Albert Einstein Hospital, Av. Albert Einstein 627, Morumbi (☎ **011/2151-1233**), and **Hospital das Clinicas,** Av. Doutor Eneias de Carvalho Aguiar 255 (☎ **011/3069-6000**).

Internet Access Internet access in São Paulo is easy to find in bookstores and Internet cafes. The **FNAC** chain has stores in Pinheiros, Praça dos Omaguás 34 (☎ **011/3579-2000**), and on Av. Paulista 901 (☎ **011/2123-2000**). Both are open daily 10am to 9pm, with Internet for R$12 per hour.

Mail Downtown, there are post offices at: Rua Florencio de Abreu 591, Centro (☎ **011/3229-0084**), and Rua Haddock Lobo 566, Cerqueira Cesar (☎ **011/3088-1610**). The branch at the international airport of Guarulhos is open 24 hours.

Pharmacies Pharmacies are called *farmacia* or *drogaria* in Portuguese. The following are open 24 hours: **Drogaria São Paulo,** Rua Augusta 2699, Cerqueira Cesar (☎ **011/3083-0319**), and Av. São Luis 34, Centro (☎ **011/3258-8872**); **Drogasil,** Rua Pamplona 1792, Jardim Europa

(☎ **011/3887-9508**). Most pharmacies will deliver 24 hours a day, usually for a small surcharge (R$4–R$10); contact your hotel's front desk to place an order at the nearest one.

Police Emergency number ☎ **190. Tourist Police,** Av. São Luis 92 (1 block from Praça da República), Centro (☎ **011/3214-0209**), and Rua São Bento 380, fifth floor, Centro (☎ **011/3107-5642**).

Safety During the day, the tourist areas are generally safe for walking; in the evening the safest neighborhoods are Jardins, Higienópolis, and the residential areas of the city. At night, it's best to avoid the quiet side streets of Centro, particularly the empty shopping streets around Praça da Sé and Bixiga. The area around the Praça da Luz is definitely to be avoided after dark. At night, traveling by taxi is strongly recommended— don't rely on public transportation. The U.S. State Department has reported incidences of armed robbery and widespread pickpocketing in São Paulo, though this has not been our experience. As in any large metropolitan area with great disparities between rich and poor, it's wise to observe common-sense precautions: Don't flash jewelry or cash, and stick to well-lit and well-traveled thoroughfares.

Taxes The city of São Paulo charges a 5% accommodations tax, collected by the hotel operators. This amount will be added to your bill. There are no other taxes on retail items or goods.

Time Zone São Paulo is 3 hours behind GMT (as is Rio de Janeiro).

Visa Renewal For visa renewal, go to **Policia Federal,** Superintendência Regional de São Paulo, Rua Hugo D'Antola 95, Lapa de Baixo (☎ **011/3538-5000;** Mon–Fri 10am–4pm). The fee is R$69, and you may need to show evidence of sufficient funds to cover your stay as well as a return ticket.

Weather São Paulo's summers, December through March, are hot and humid. Temperatures rise to the mid-30s Celsius (high 90s Fahrenheit). In the spring and fall, the temperatures stay between the mid-20s to mid-30s Celsius (high 70s and 90s Fahrenheit). In the winter, June through August, it can cool off to a minimum of 15°C (59°F), but during the day temperatures can sometimes rise to the 20s Celsius (70s or mid-80s Fahrenheit). Those traveling to São Paulo between May and September should bring some cold-weather clothes, the equivalent of what someone would wear in New York or London in the fall. Most rain tends to fall in the summer (Dec–Feb); January is especially wet. When it rains heavily the city is prone to flooding, particularly the area around the Tietê River.

WHERE TO STAY

As the financial and business hub of Brazil, São Paulo has many excellent hotels. Hotels tend to cluster around the financial district of the Avenida Paulista, and in the upscale shopping and restaurant district Jardins. Jardins is one of the safest areas of the city, and even at night one can comfortably go for a stroll. Women traveling alone will feel completely comfortable in this part of town.

São Paulo attracts business travelers Monday through Friday and then sits empty from Friday afternoon to Monday morning. Hotels try to lure weekend travelers with museum or shopping packages, but capacity still far exceeds demand and prices drop up to 50% or even more. Hotels will often throw in free breakfasts and dinners, and checkout can be as late as 6pm on a Sunday evening.

Many visitors to São Paulo prefer to stay in an apart-hotel. These hotels usually offer suites: one- or two-bedroom apartments with fully furnished kitchens. The benefit is much lower prices; even the most expensive apart-hotels are still significantly cheaper than a luxury hotel, and the units are much larger than a standard hotel room. You do give up a few of the amenities that you would get in a top-notch hotel, but the majority of apart-hotels still offer breakfast, parking, a small gym, sauna, and swimming pool as well as limited room service.

Centro

Staying in Centro you're close to the fun and movement of downtown; many of the attractions are within walking distance, and public transit to other regions is very accessible. The drawback is that at night, Centro empties out. Dining and nightlife options are limited, and parts of downtown transform into red-light districts, particularly around the Rua Augusta and Praça da República. However, the savings can be significant, especially on weekends when hotels often slash their prices in half.

EXPENSIVE

Bourbon São Paulo Business Hotel ★ 𝄞 An elegant, slightly Parisian-style building on the outside, on the inside the Bourbon has been kept thoroughly up-to-date and comfortable. Superior rooms come in two types. Those with a queen-size bed are of a good size, with a small breakfast table and full-length mirror. Bathrooms are large and bright. Superior rooms with two single beds are similar but a little smaller. Both room types unfortunately lack any kind of desk. Junior suites are quite spacious, with a queen-size bed and an anteroom set up as a small office, plus a sizable bathroom with bathtubs and showers. The Bourbon often reduces listed rates by up to 50%.

Av. Vieira de Carvalho 99, Centro, 01210-010 SP. www.bourbon.com.br. 𝄐 **0800/118-181** or 011/3337-2000. Fax 011/3337-1414. 129 units. R$232 double; R$302 junior suite. 50% discount weekends and slow periods. Extra person add about 25%. Children 6 and under stay free in parent's room. AE, DC, MC, V. Parking 1 block away, R$15 per day. Metrô: República. **Amenities:** Restaurant; bar; weight room; room service; sauna; smoke-free floors. *In room:* A/C, TV, fridge, hair dryer, Internet, minibar.

Higienópolis

Often overlooked by visitors, Higienópolis is a quiet, green, and pretty residential neighborhood with some excellent restaurants and shops located just a hop and a skip from Centro; a 20-minute walk from the Tryp Higienópolis takes you to the Praça da República. Better yet, prices are much lower than in Jardins.

MODERATE

Tryp Higienópolis ★★★ 🔥 Elegant and luxurious, the Tryp Higienópolis looks more like a high-end condominium than a hotel. The rooms are amazing. Much bigger than your average hotel rooms, these are bright and beautifully furnished with modern decor and colors. Rooms come in standard and superior. The only difference is that superior rooms have a balcony. Otherwise, both are the same spacious size, and come with a king-size bed and a large desk and comfy chair. Unusual for São Paulo, the hotel offers a partially covered pool as well as a large sun deck. As if all of that weren't enough, prices are a steal; Internet rates often go as low as R$160!

Rua Maranhão 371, Higienópolis, São Paulo, 01404-002 SP. www.solmelia.com. ℂ **011/3665-8200.** 252 units. R$340 standard; R$510 superior. Extra person add R$40. Children 6 and under stay free in parent's room. AE, DC, MC, V. Free parking. Metrô: Marechal Deodoro. **Amenities:** Restaurant; bar; concierge; exercise room; outdoor pool; limited room service; sauna; smoke-free floors. *In room:* A/C, TV, hair dryer, Internet, minibar.

Avenida Paulista

The hotels around Avenida Paulista cater to business travelers and executives who spend most of their time in the city's financial district. They're high-end and expense account–friendly. However, on weekends the rates drop almost in half; visitors can treat themselves to a great hotel at a bargain price. Metrô connections make it easy to travel back and forth from this area. From Paulista it is only a short walk or quick cab ride to the upscale neighborhood of Jardins.

EXPENSIVE

Blue Tree Towers Premium Paulista ★★ This place offers a great location, friendly English-speaking staff, and comfortable rooms at a reasonable price. Rooms are clean and modern looking, with queen-size beds, high-quality linen, bright bathrooms with marble touches, and a good-size writing desk. Some floors feature carpeting, others tile flooring. The hotel is located just a few steps from the Avenida Paulista, the MASP, and the Metrô stop. On weekends, prices drop by 50% or more.

Rua Peixoto Gomide 707, Cerqueira César, 01409-001 SP. www.bluetree.com.br. ℂ **011/3147-7000.** Fax 011/3147-7001. 232 units. R$446 standard; R$532 superior; R$617 luxo. Children 12 and under stay free in parent's room. Extra person 25%. AE, DC, MC, V. Valet parking. Metrô: Trianon-MASP. **Amenities:** Restaurant; bar; fitness center; indoor pool; sauna; smoke-free floors. *In room:* A/C, TV, minibar, Wi-Fi.

L'Hotel Porto Bay São Paulo ★★★ Just off the Avenida Paulista, L'Hotel is one of São Paulo's most elegant boutique hotels, offering luxury and friendly, attentive service. Rooms are luxuriously furnished with antique furniture, a queen- or king-size bed with top-quality linen, goose down pillows, and a pleasant well-lit work space. Bathrooms feature bathtubs and L'Occitane amenities. There's a small but well-designed fitness center, spa, small indoor pool, and business center. The prices listed are the high-season rack rates. Call or e-mail for discounts. Weekend packages can often be booked for as low as R$600 for 2 nights.

Al. Campinas 266, Jardim Paulista, 01404-000 SP. www.lhotel.com.br. ℂ **0800/130-080** or 011/2183-0500. Fax 011/2183-0505. 75 units. R$513 double. Children 12 and under stay free in parent's room. Extra person 25%. AE, DC, MC, V. Valet parking. Metrô: Brigadeiro. **Amenities:** Restaurant; bar; fitness center; small indoor pool; room service; smoke-free floors; spa. *In room:* A/C, TV, hair dryer, minibar, MP3 docking station, Wi-Fi.

Hotels & Restaurants in São Paulo Centro

HOTELS ■

Blue Tree Towers
Premium Paulista **4**

Bourbon São Paulo Business
Hotel **17**

Ibis São Paulo Paulista **11**

L'Hotel Porto Bay São Paulo **3**

Quality Jardins **2**

Tryp Higienópolis **15**

RESTAURANTS ◆

Alaska **1**

Amadeus **10**

Antiquarius **9**

Arabia **7**

Baby Beef Rubaiyat **1**

Bakery Itiriki **22**

Capim Santo **6**

Carlota **13**

Famiglia Mancini **16**

Kaburá **24**

Korea House **21**

La Brasserie Erick
Jacquin **12**

Offellê **8**

Ponto Chic **19**

Rei do Mate **18**

Shanghai **20**

Spot **5**

Sushi Yassu **23**

The Higienópolis
DIning Triangle **14**

MODERATE

Ibis São Paulo Paulista ✔ The Accor group's budget Ibis brand offers predictable but quality accommodations in the heart of the business district. All rooms are identically furnished with good, firm double or twin beds, a desk, and a shower. Breakfast can be ordered for an extra R$9. This hotel is nonsmoking.

Av. Paulista 2355, Cerqueira Cesar, 01420-002 SP. www.accorhotels.com.br. ⓒ **011/3523-3000.** Fax 011/3523-3030. 236 units. R$206–R$430 double. Children 12 and under stay free in parent's room. AE, DC, MC, V. Free parking. Metrô: Consolação. **Amenities:** Restaurant; limited room service; smoke-free hotel. *In room:* A/C, TV, minibar, Wi-Fi.

Quality Jardins ★ The Quality Jardins offers some of the best affordable accommodations just off the Avenida Paulista. Rooms are a cross between a studio and a regular hotel room, featuring a desk and TV on a swivel in order to separate the sitting area from the sleeping area. The furnishings are modern and pleasant with light colors, blond wood, and comfortable lighting. The hotel offers three categories of rooms: superior, deluxe, and premium. The difference is mainly in the improved bathroom amenities and the turndown service and bathrobe that come with the premium rooms. Unless you get a free upgrade, it's not worth the money. The hotel has a good-size fitness room with saunas and an outdoor pool.

Al. Campinas 540, São Paulo, 01404-000 SP. www.atlanticahotels.com.br. ⓒ **0800/555-855** or 011/2182-0400. Fax 011/2182-0401. 222 units. R$200–R$240 superior; R$210–R$270 deluxe; R$250–R$340 premium. Extra person add R$50. Children 5 and under stay free in parent's room. AE, DC, MC, V. Free parking. Metrô: Trianon-MASP. **Amenities:** Restaurant; concierge; health club; outdoor pool; room service; sauna; smoke-free floors; Wi-Fi. *In room:* A/C, TV, hair dryer, Internet, minibar.

Jardins

One of the most pleasant hotel neighborhoods in São Paulo, Jardins offers less traffic and streets lined with some of the city's best restaurants, shops, and cafes. The only disadvantage is that you're not on a Metrô line. A bus to Avenida Paulista (and the Metrô) along Rua Augusta will take 15 to 25 minutes; a bus into Centro will take 20 to 45 minutes. A cab to either will take 10 to 15 minutes. The area is safe and pleasant at night.

VERY EXPENSIVE

Emiliano ★★★ The Emiliano offers the kind of five-star service that would cost far more in a place like New York or Paris. It's pampering all the way, from the welcome massage to the minibar stocked according to your preference, to the personalized selection of pillows, carefully fluffed and placed on your Egyptian cotton sheets. The hotel offers deluxe studios and suites. The fabulous, spacious suites come with designer furniture and feature original artwork and the latest home entertainment electronics. The bed is king-size and the bathroom is a minispa in itself; toiletries are customized to your skin type and you can sit back and relax in the claw-foot tub, maybe watch a little TV, or contemplate life on your heated toilet seat. The studios (really just a large room) are equally high design, half the size, and 40% cheaper—but really, is this any time to skimp?

Rua Oscar Freire 384, Cerqueira César, 01426-000 SP. www.emiliano.com.br. ⓒ **011/3069-4399.** Fax 011/3728-2000. 57 units. R$1,200 double; R$2,600 suite. Check the website for special packages. Extra person add 30%. Children 10 and under stay free in parent's room. AE, DC, MC, V. Free parking. **Amenities:** Restaurant; upscale lobby bar; babysitting; concierge; small exercise room; room service; smoke-free floors; outstanding spa. *In room:* A/C, TV/DVD, hair dryer, Internet, minibar.

Hotels & Restaurants in Jardins

HOTELS ■
Emiliano **13**
Fasano **6**
Mercure São Paulo Jardins **18**
Quality Suites Imperial Hall **7**
Regent Park Hotel **14**
Transamerica Flat Opera Five Stars **9**
Unique **3**

RESTAURANT ◆
Alaska **20**
Antiquarius **10**
Arabia **12**
Baby Beef Rubaiyat **20**
Brasil a Gosto **17**
Capim Santo **19**
Casa do Padeiro **1**
D.O.M. **16**
Fasano **6**
Figueira Rubaiyat **5**
Gero **15**
Le Chef Rouge **11**
Offellé **8**
Skye **3**
Toro **4**
Varanda Grill **2**

Ⓜ Metro Stop

Greater São Paulo

Fasano ★★★ Successful São Paulo restaurateurs, the Fasano family decided several years ago to apply their hospitality experience to the hotel industry. The hotel is decorated with elegant 1930s period furniture, combined with clean modern design elements. Rooms and suites are beautifully appointed with sober, modern furniture, hardwood floors, Persian rugs, and king-size beds with 500-thread Egyptian cotton sheets and goose down pillows. The hotel's signature restaurant, Fasano, is one of the top Italian restaurants in South America.

Rua Vitório Fasano 88, Cerqueira César, 01426-000 SP. www.fasano.com.br. ℓ**011/3896-4000.** Fax 011/3896-4155. 57 units. R$1,100 superior; R$1,400 deluxe. Extra person add 30%. Children 6 and under stay free in parent's room. AE, DC, MC, V. Free parking. **Amenities:** 2 restaurants; upscale jazz bar; babysitting; concierge; small exercise room; smoke-free floors; small spa. *In room:* A/C, TV, hair dryer, minibar, Wi-Fi.

MODERATE

Mercure São Paulo Jardins ★ At this pleasant, modern hotel, everything is crisp and clean, the decoration Scandinavian modern with blond wood, simple design, and lots of light. Rooms are spacious with king-size beds, a couple of small sitting chairs, and a good-size maple-wood desk with desk lamp and phone and power jacks for laptops. Bathrooms have nice fixtures but are functionally compact. The leisure area is small, offering only an indoor pool and sauna, but the Mercure's location is excellent, only a hop and a skip to the Avenida Paulista and a 15-minute walk downhill to the best shopping and dining in Jardins. Breakfast costs an additional R$25.

Al. Itu 1151, Cerqueira César, 01421-001 SP. www.accorhotels.com.br. ℓ **0800/703-7000** or 011/3089-7555. Fax 011/3089-7550. 126 units. R$260 double. Children 10 and under stay free in parent's room. AE, DC, MC, V. Free parking. Metrô: Consolação. **Amenities:** Restaurant; laptop-friendly bar; small indoor pool; room service; smoke-free floors. *In room:* A/C, TV, hair dryer, Internet, minibar.

Quality Suites Imperial Hall ★★ The Imperial Hall sits in the heart of São Paulo's toniest neighborhood, surrounded by restaurants, designer boutiques, and trendy shops. The building is new, and the rooms are modern and pleasantly furnished. Built with the business traveler in mind, the hotel offers firm beds, large closets, a small kitchen, in-room Wi-Fi, and a large desk with easy access to lots of plugs. The master rooms on the 13th to 19th floors feature balconies and perks like fluffy bathrobes. There's also a floor exclusively for women travelers.

Rua da Consolação 3555, Jardins, São Paulo, 01416-001 SP. www.atlanticahotels.com.br. ℓ**011/2137-4555.** Fax 011/2137-4560. 150 units. R$290 standard; R$365 master. Extra person add 25%. Children 6 and under stay free in parent's room. AE, DC, MC, V. Free parking. **Amenities:** Restaurant; small weight room; rooftop pool; room service; sauna; smoke-free rooms; spa. *In room:* A/C, TV, kitchen, Wi-Fi.

Regent Park Hotel ★ This small apart-hotel is on one of the best-known streets in Jardins. The neighborhood is safe and packed with shops, cafes, and restaurants. The majority of units are one-bedroom suites, but two-bedroom suites are available as well. The furnishings are a little dated, with 1980s rustic wood, but everything is very well maintained and clean, and all the suites have a full kitchen. The staff is exceptionally friendly and helpful, and business travelers will appreciate the efficient business center.

Rua Oscar Freire 533, Jardins, 01426-001 SP. www.regent.com.br. (ℓ) **011/3065-5555.** 70 units. R$380 1-bedroom; R$425 2-bedroom. Weekend discounts available. Extra person R$40. Children 4 and under stay free in parent's room. AE, MC, V. Free parking. Bus: 702P. **Amenities:** Restaurant; concierge; small weight room; outdoor rooftop pool; limited room service; sauna; smoke-free rooms. *In room:* A/C, TV, fridge, Internet, kitchen, minibar.

Transamerica Flat Opera Five Stars ★ ✦ The bargain of the century happens to be in the heart of the city's best neighborhood. The Opera offers spacious flats, featuring a separate sitting room with a comfy couch, TV, small dinette table, and a good-size work desk, plus a bedroom with a firm queen-size bed, vast closets, and a full-length mirror; there's also a kitchenette with a stove and fridge, all for less than many hotels charge for just a bed. True, the furnishings are a tad dated (though nice, the rooms get nowhere near the five stars claimed in the name), but on the plus side, step out the door and you're in the heart of the Jardins shopping district.

Al. Lorena 1748, Cerqueira César, 04003-010 SP. www.transamericaflats.com.br. (ℓ) **011/3062-2666.** Fax 011/3062-2662. 96 units. R$330 double. Discounts available on weekends. Children 10 and under stay free in parent's room. AE, DC, MC, V. Free parking. Metrô: Consolação. **Amenities:** Restaurant; bar; small gym; small indoor pool; room service; sauna; smoke-free floors. *In room:* A/C, TV, Internet, kitchenette, minibar.

Ibirapuera Park
VERY EXPENSIVE

Unique ★★★ Unique truly is. In form, this latest São Paulo design hotel is a teetering verdigris-colored disk, chopped off at the top to make a roof deck, and propped up at either end by pillars hanging down like unfurled banners. Paulistas call it the *melancia,* or watermelon. Inside it's all high design, from the lobby bar the Wall to the rooms and suites that feature white-on-white decor, queen-size beds with luscious bedding, sparkling bathrooms with Jacuzzi tubs, clever desk space, and a plethora of room gadgets including electric blinds, 48-inch TVs, lots of light options, and a console to control it all. Suites are all located on the rim of the disk so their outer walls rise in one seamless curve from floor to ceiling. From the rooftop pool and lounge you see both Ibirapuera Park and the ridgeline run of skyscrapers on Avenida Paulista.

Av. Brigadeiro Luis Antônio 4700, Jardim Paulista, 01402-002 SP. www.hotelunique.com.br. (ℓ) **011/3055-4700.** Fax 011/3889-8100. 95 units. R$810 double; R$1,700–R$2,100 suite. AE, DC, MC, V. Parking R$20 daily. Metrô: Brigadeiro. **Amenities:** Rooftop restaurant, Skye (see review, p. 202); bar; concierge; fitness center; rooftop pool and indoor pool; room service. *In room:* A/C, TV/DVD, CD player, fridge, Internet, minibar.

WHERE TO EAT

São Paulo is the gourmet capital of Brazil. It's the city with the money to attract the country's best chefs, and the clientele to pay the tab at the most outstanding restaurants. Plus, with no beaches or mountains to play on, Paulistas amuse themselves by eating out. People dress up for dinner here (or more than they would elsewhere in the country) and usually go out around 9 or 10pm *at the earliest.* Though it's becoming more common for restaurants to accept reservations, many will do so only up to 9pm. After that, you have to take your chances. If waiting for a table drives you to distraction, better to arrive unfashionably early at 8pm.

The variety of cuisine is larger than anywhere else in the country. Like New York or Toronto, São Paulo is a city of immigrants. Many of the city's best restaurants are Italian. However, the city has a number of top Middle Eastern restaurants, as well as the best Japanese food in the country, plus Spanish, Portuguese, Bahian, and even Thai cuisine. Churrascarias are always a favorite, as are lunchtime kilo spots, which mad-for-work Paulistas see as the perfect way to fuel up for long hours at the office.

The *Guia São Paulo,* the entertainment listing published in the Friday *Folha de São Paulo* newspaper, contains a detailed restaurant section, handy for confirming hours and phone numbers. Also note that the long street names are often abbreviated by Paulistas; for example, the Rua José Maria Lisboa may also be known as Rua Lisboa.

Centro

For a map of restaurants in this area, see the map "Hotels & Restaurants in São Paulo Centro," p. 189.

MODERATE

Famiglia Mancini ★★ ITALIAN A São Paulo institution, you'll find a line outside this traditional Italian trattoria almost any night of the week. Fortunately they pack in a lot of tables, all covered in little red-and-white checkered tablecloths, so the wait is never too long. Once inside, you're first stop should be the antipasto buffet, an impressive spread of olives, cold cuts, marinated vegetables, cheeses, quail's eggs, and salads. With that on your plate you'll have the energy to tackle the enormous pasta menu. There's every type and kind imaginable, and more than 30 different sauces to match. Portions are huge, enough for two, or often three. Desserts are uninspiring, but by meal's end you should be too stuffed to even contemplate eating more.

Rua Avanhandava 81, Centro. ✆ **011/3256-4320.** www.famigliamancini.com.br. Reservations not accepted. Main courses R$34–R$90 for 2. AE, DC, MC, V. Sun–Wed 11:30am–1am; Thurs 11:30am–2am; Fri–Sat 11:30am–3am. Metrô: Anhagabau.

INEXPENSIVE

Ponto Chic ★ 🍴 CAFE Join the downtown office crowd for a taste of São Paulo's favorite sandwich, the *bauru*—roast beef, tomato, pickles, and melted cheese on French bread. This popular diner also serves up great burgers, fruit juices, and snacks.

Largo do Paiçandu 27, Centro. ✆ **011/3222-6528.** Main courses R$10–R$18. AE, MC, V. Mon–Sat 10am–10pm. Metrô: São Bento.

Rei do Mate 🍴 CAFE Now a popular national chain of iced tea drinks, Rei do Mate had its humble beginnings over 30 years ago in this store. Order the original *mate* (iced tea) or the popular *mate limão* (with lime). Tropical combinations include *mate* with passion fruit or mango. Add a *pão de queijo* (cheese bun) or savory *empanada* for a quick snack.

Avenida São João 530, Centro. ✆ **011/3222-7504.** Menu items R$6–R$10. MC, V. Mon–Sat 7:30am–10pm. Metrô: Republica.

Higienópolis
VERY EXPENSIVE

Carlota ★★ BRAZILIAN Owner and chef Carla Pernambuco blends the flavors of cosmopolitan New York (where she got her training) and her own Italian heritage

IF THIS IS HIGIENÓPOLIS, IT MUST BE
french

Deprived of their sought-after Brazilian colony in the 1500s, the French appear to have decided to take over Higienópolis, or at least a good portion of its restaurants. In addition to **La Brasserie Erick Jacquin,** there's a pair of side-by-side Parisian bistros just around the corner on the Rua Pará. The **Ici Bistro,** Rua Pará 36 (*(C)* **011/3257-4064;** www. icibistro.com.br; Mon–Fri noon–3pm and 7pm–midnight, Sat noon–4pm and 7:30pm–12:30am, Sun noon–5pm), offers top-quality cuisine by a Cordon Bleu–trained chef, plus a rooftop terrace with lighter quicker fare. The **Mercearia do**

Francês, Rua Itacolomi 636 (*(C)* **011/ 3214-1295;** www.merceariadofrances. com.br; Mon–Fri noon–3:30pm and 7pm–midnight, Sat noon–5pm and 7pm–1am, Sun noon–5pm), offers more casual French fare, plus a replica of the Eiffel Tower on its patio. And if that wasn't enough, over at the Praça Vila Boim (in the Higienópolis Dining Triangle), where the rest of the world also has a foothold, there's **Le Vin Bistro,** Rua Armando Penteado 25 (*(C)* **011/3668-7400;** www. levin.com.br; Mon–Sat noon–midnight, Sun noon–11pm).

together with fresh Brazilian ingredients to create dishes such as the *camarão pacifico:* shrimp grilled with sesame seeds and Thai chili sauce on a bed of vegetable-fried rice. She pulls off a great grilled duck with Dijon mustard on mashed mandioc, and the beef with balsamic port sauce and a fig risotto is also outstanding. For a lighter meal, try one of the several pasta options, such as the ravioli stuffed with brie or codfish.

Rua Sergipe 753, Higienópolis. *(C)* **011/3661-8670.** www.carlota.com.br. Main courses R$65–R$95. AE, DC, MC, V. Mon 7pm–midnight; Tues–Thurs noon–4pm and 7pm–midnight; Fri–Sat noon–1am; Sun noon–6pm. Bus: 8107.

La Brasserie Erick Jacquin ★★ FRENCH Celebrity chefs have begun putting their names on their eateries in São Paulo, as this new high-end spot in Higienópolis bears witness. The decor is warm, clean, and modern, with lots of leather and wood grain put to tasteful effect in both the airy front bar and the restaurant area. The cuisine offers both traditional French—duck confit in peppercorn sauce—and French with a Brazilian touch—prawns Provençal, sliced duck in a passion-fruit sauce. The wine list intelligently avoids overpriced French bottles for better value (and equivalent quality) from Chile and Argentina. Desserts feature lots of Belgian chocolate. Enjoy!

Rua Bahia 683, Higienópolis. *(C)* **011/3826-5409.** www.brasserie.com.br. Main courses R$65– R$150. AE, DC, MC, V. Mon–Thurs noon–midnight; Fri–Sat noon–1am; Sun noon–5pm. Bus: 8107.

MODERATE

The Higienópolis Dining Triangle Smack in the middle of Higienópolis just behind the FAAP sits the delightful **Praça Vila Boim.** A lovely three-sided square with beautiful trees, the *praça* offers great casual dining options covering most of the world's cuisines. Sushi lovers will be pleased to find **Sushi Papaia** ★ (*(C)* **011/3666-2086;** www.sushipapaia.com.br). For pizza lovers there's **Piola** ★ (*(C)* **011/3663-6539;** www.piola.it), famous almost as much for its edgy, industrial-chic decor as it is for its 30 pizza combinations. Favorites include the Rimini (smoked salmon and

ricotta) and the Mantova (mozzarella, brie, fresh tomatoes, and arugula). For a great burger and a heavy helping of nostalgia try the **Fifties** (© **011/5094-5454;** www. thefifties.com.br), an old-style diner offering burgers, chili dogs, shakes, and fries. If steak is on your mind, look no further than the **Empório Natan** (© **011/3828-1402**), which specializes in Argentine and Angus cuts. For Mexican lovers, there's **Si Señor** (© **011/3476-2538;** www.sisenor.com.br), with an excellent selection of tacos, enchiladas, and burritos.

Liberdade

EXPENSIVE

Sushi Yassu ★★ JAPANESE The second-generation owners of this traditional Liberdade standard-bearer have begun introducing some new dishes to the Paulista palate. Try the grilled white tuna or anchovy, in salt or with a sweetened soy sauce, or a steaming bowl of udon noodle soup with seafood or tempura vegetables. For traditionalists, there's a large variety of sushi and sashimi, plus stir-fried teppanyaki and yakisoba noodles with meat and vegetables. On Sundays there can be a line.

Rua Tomas Gonzaga 98, Liberdade. © **011/3209-6622.** www.sushiyassu.com.br. Main courses R$20–R$66. AE, DC, MC, V. Tues–Fri 11:30am–3pm and 6–11pm; Sat noon–4pm and 6pm–midnight; Sun noon–10pm. Metrô: Liberdade.

MODERATE

Kaburá JAPANESE Kaburá offers late-night dining in the heart of São Paulo's little Japan. The restaurant serves up the usual Japanese faves—sushi, sashimi, *donburi,* and tempura—in generous portions at a reasonable price. For interesting appetizers try the sashimi made from Brazilian *picanha* beef, or the breaded and crunchy deep-fried oysters.

Rua Galvão Bueno 346, Liberdade. © **011/3277-2918.** Reservations accepted. Main courses R$18–R$45. No credit cards. Mon–Sat 7pm–2am. Metrô: Liberdade.

Korea House KOREAN It's some of the best Korean food in the city, but finding it involves a journey—head down a long hallway, up the stairs, and into a windowless room lit by fluorescent lights, with only the small barbecues built into every table to entice you into eating. The cuisine is a mix of Chinese and Korean, with both spicy dishes from the kitchen or Korean barbecue done in front of you at your table.

Rua Galvão Bueno 43, Liberdade. © **011/3208-3052.** Reservations not accepted. Main courses R$25–R$45. MC, V. Mon–Sat 11am–10pm; Sun 11am–3pm and 6–10pm. Metrô: Liberdade.

Shanghai CHINESE Shanghai offers cheap and cheerful Chinese, in a busy room in the heart of São Paulo's Japantown. Order beef, chicken, vegetables, or splurge on one of the fish fresh from the entryway aquarium.

Rua Galvão Bueno 16, Liberdade. © **011/3208-7914.** Reservations accepted. Main courses R$18–R$42. MC, V. Mon–Sat 11am–9pm; Sun 11am–3pm and 6–9pm. Metrô: Liberdade.

INEXPENSIVE

Bakery Itiriki BAKERY This is the place for a delicious inexpensive break in Liberdade. There are quiches, sandwiches, rolls, coffee, and an extensive collection of desserts, including cakes of chocolate, *aipim,* and banana, plus a rich assortment of truffles.

Rua dos Estudantes 24, Liberdade. © **011/3277-4939.** www.bakeryitiriki.com. Reservations not accepted. Main courses R$10–R$25. MC, V. Daily 8am–7pm. Metrô: Liberdade.

Avenida Paulista

VERY EXPENSIVE

Amadeus ★★ SEAFOOD For 25 years and counting, this elegant spot off the Avenida Paulista has served up traditional top-quality seafood dishes—the shrimp couscous is locally renowned—as well as innovative plates that vary with the seasons, such as Norwegian haddock in a cashew nut crust with a side of garlic-kissed palm heart purée. The wine list leans heavily to expensive whites.

Rua Haddock Lobo 807, Cerqueira César. ℂ **011/3061-2859.** www.restauranteamadeus.com.br. Main courses R$55–R$150. AE, V. Mon–Fri noon–3pm and 6pm–midnight; Sat noon–4:30pm and 7pm–1am; Sun noon–4:30pm and 7–11pm. Metrô: Consolação.

Antiquarius ★★★ PORTUGUESE The Portuguese cuisine here is served up with flair and tradition, in the perfect elegant setting. The menu offers dishes hard to find outside Portugal, such as the *cataplana de peixes e frutos do mar*, a rich seafood and fish stew, with bacon and sausage thrown in for seasoning. Another traditional seafood favorite is *açorda*—crab, shrimp, and mussels baked together in a clay dish, served with a decorative egg on top. Then there's cod *(bacalhau)*, a staple of Portuguese cooking since before Columbus set sail. The wine list leans to higher-end reds, drawn mostly from Portugal and France.

Al. Lorena 1884, Cerqueira César. ℂ **011/3064-8686.** www.antiquarius.com.br. Main courses R$65–R$150. DC, MC, V. Mon 7pm–1am; Tues–Fri noon–3pm and 7pm–2am; Sat noon–2am; Sun noon–6pm. Metrô: Trianon-MASP.

Baby Beef Rubaiyat ★★ STEAK One of the city's signature steakhouses, the Rubaiyat serves prime cuts of beef, many drawn from the owner's own cattle ranch in the state of Mato Grosso. Prime Brazilian cuts include *picanha*, master beef, and baby beef (a type of tender, very young calf). For those who prefer a thicker steak, there are cuts imported from Argentina. Wednesdays and Saturdays there's a full *feijoada*, served buffet style so you can pick and choose which bits of pork to add to your heaping plate of black beans. For the less carnivorous, the salad bar is well provisioned.

Al. Santos 86, Cerqueira César. ℂ **011/3141-1188.** www.rubaiyat.com.br. Main courses R$45–R$95. AE, DC, MC, V. Mon–Fri noon–3pm and 7pm–midnight; Sat noon–midnight; Sun noon–6pm. Metrô: Brigadeiro.

EXPENSIVE

Capim Santo ★★ BRAZILIAN Modeled after a famous Bahian restaurant, the Capim Santo in São Paulo is set in a lovely garden with lush mango trees and plenty of outside tables. The specialty is seafood. Try the *robalo* fish with a crust of cashew nuts and a side of *vatapá* shrimp stew, or the tender grilled tuna, or the stew of prawns in coconut milk, served in a hollowed-out pumpkin. For a vegetarian option try the minicannelloni stuffed with asparagus, ricotta, and tomato confit. Desserts often feature a tropical twist, such as the guava crème brûlée or the tarte tatin with banana. The lunchtime buffet offers 15 salads and more than 10 hot dishes, including seafood, chicken, and pasta, for only R$45 (R$63–R$69 weekends) with dessert included.

Rua Ministro Rocha Azevedo 471, Cerqueira César. ℂ **011/3068-8486.** www.capimsanto.com.br. Main courses R$26–R$49. AE. Tues–Sat noon–3pm and 7pm–midnight; Sun 12:30–4:30pm. Metrô: MASP.

Spot ★ BRAZILIAN More than 15 years old and still trendy, Spot seems to be the exception to the rule that all that is hip soon melts into air. The daytime crowd consists of well-dressed businesspeople. In the evenings, Spot buzzes with musicians, designers, models, and other trendy types who crowd in to this glass-enclosed cocoon to flirt, schmooze, and preen. The food is decent, with offerings like pasta dishes, such as a penne with melon; salads (try the Spot Salad—lettuce, Gorgonzola, dried pears, and nuts); grilled salmon; and tuna with vegetables. Spot's owners have seemingly created a perpetual motion machine: The young and beautiful flock to see the young and beautiful, who flock to see the young and beautiful, and so on . . .

Rua Min. Rocha Azevedo 72, Cerqueira Cesar. ✆ **011/3283-0946.** www.restaurantespot.com.br. Reservations accepted. Main courses R$35–R$65. AE, DC, MC, V. Mon–Fri noon–3pm and 8pm– 1am; Sat–Sun 1–4:30pm and 8pm–1am. Metrô: Trianon-MASP.

INEXPENSIVE

Alaska 🍧 DESSERT One of the city's favorite ice-cream parlors, Alaska has been serving over 30 homemade flavors for over 95 years. Flavor-wise it's fairly traditional: lots of chocolates, vanilla, and fruit, as well as excellent ice-cream desserts such as a banana split, peach melba, or the signature Alaska, served with a choice of two toppings, *farofa,* peach slices, and cookies.

Rua Doutor Rafael de Barros 70, Paraiso. ✆ **011/3889-8676.** Everything under R$15. No credit cards. Sun–Thurs 9am–midnight; Fri–Sat 9am–2am. Metrô: Brigadeiro.

Jardins

For a map of restaurants in this area, see the map "Hotels & Restaurants in Jardins," p. 191.

VERY EXPENSIVE

Brasil a Gosto ★★ BRAZILIAN Chef Ana Luiza Trajano made an extended culinary research tour through Brazil's vast hinterlands to come up with homegrown ingredients and recipes many Brazilians had never heard of. The result was a successful book and even more successful restaurant, which makes use of native ingredients—cane, cashew, *guarana, açaí,* sugar cane, manioc—to create innovative and delightful dishes: appetizers like *pirarucu* (Amazon fish) pastry, an entree of pork cutlets with *jabuticaba*-berry sauce with a side of grilled plantains, and desserts of banana sweets with crushed Brazil nut and coconut covering, served with ice cream. For drinks, there's an extensive menu of homemade *cachaças.*

Rua Prof. Azevedo de Amaral 70, Jardim Paulista. ✆ **011/3086-3565.** www.brasilagosto.com.br. Main courses R$60–R$150. AE, DC, MC. Wed–Sat noon–4pm and 7pm–12:30am; Sun noon–6pm. Bus: 206E.

D.O.M. ★★★ CONTEMPORARY Since chef Alex Atala first opened this restaurant in 1999 to showcase the best Brazilian ingredients, D.O.M. has racked up every significant restaurant award in Brazil, culminating with its inscription in *Restaurant Magazine*'s list of the top 50 restaurants in the world. The menu changes constantly—ask about the specials—but may include favorites such as *robalo* with *tucupi* and manioc, or duck in red-wine and golden-banana sauce. Diners can also opt for a four- or eight-course tasting menu including fish, meat, and cheese courses. The wine list is extensive and expensive, but if you're dining here you expected that. Reserve at least a couple days in advance, or come prepared to wait. D.O.M. is popular.

Rua Barão de Capanema 549, Jardin Paulista. ☎**011/3088-0761.** www.domrestaurante.com.br. Reservations recommended. Tasting menus R$160–R$230. AE, MC, V. Mon–Fri noon–3pm and 7pm–midnight; Sat 7pm–1am. Metrô: Liberdade.

Fasano ★★★ ITALIAN Long considered the best Italian restaurant in the country, the Fasano continues to live up to expectations. The dining room combines black marble and dark furniture with exquisite lighting to create a warm and intimate ambience. The mainstay of the menu remains dishes from the Lombardy region from whence the Fasano family originally hailed. Start off with the traditional tomato soup with prawns and Italian bread. Pasta favorites include the delicate pumpkin tortelli or a hearty duck ravioli in orange sauce. Risottos feature Tuscan sausage and white beans or tender marinated tuna. Meat and seafood options include classic veal cutlets, roasted lamb, *filetto alla Rossini* with foie gras and truffles, or for a lighter choice, grilled tuna steak with Sicilian lemon. If you're feeling decision shy, opt for the five-course tasting menu and let the chef take you on a gastronomic journey around Italy.

Rua Vittorio Fasano 88, Cerqueira Cesar. ☎**011/3062-4000.** www.fasano.com.br. Main courses R$98–R$160; 5-course tasting menu R$275. AE, DC, MC, V. Mon–Sat 7:30pm–1am. Bus: 206E.

Figueira Rubaiyat ★★★ BRAZILIAN/STEAK The most beautiful restaurant in the city, Figueira (fig tree) Rubaiyat is built around the spreading limbs of a magnificent old fig tree. Seating can either be "outside" in the gazebo around the tree boughs or inside in the lovely restaurant. Rubaiyat's specialty is beef. Indeed, it serves the best prime beef in São Paulo, all of it raised with care at the owner's private cattle ranch. For the noncarnivorous, the Figueira also offers a wide variety of top-notch Mediterranean seafood dishes, such as paella, codfish, and grilled prawns.

Rua Haddock Lobo 1738, Cerqueira Cesar. ☎ **011/3063-3888.** www.rubaiyat.com.br. Main courses R$45–R$95. V. Daily noon–12:30am. Bus: 206E.

EXPENSIVE

Arabia ★★ MIDDLE EASTERN This spacious and modern restaurant serves up a range of favorites from Lebanon, including a regularly changing tasting menu. At R$38, it's a great way to sample some of the chef's best. The main menu includes Moroccan rice with roasted almonds and chicken, or the signature stuffed artichoke with ground beef. For a lighter meal, try the *mezze*, the Lebanese equivalent of tapas. Each tray comes with at least half a dozen tasters of the most popular dishes, including hummus, falafel, tabbouleh, and a generous serving of pita.

Rua Haddock Lobo 1397, Cerqueira Cesar. ☎**011/3061-2203.** www.arabia.com.br. Main courses R$25–R$65. AE, DC, MC. Mon–Thurs noon–3:30pm and 7pm–midnight; Fri noon–3:30pm and 7pm–1am; Sat–Sun noon–midnight. Bus: 206E.

Gero ★★ ITALIAN This modern, masculine room in the heart of Jardins is distinguished from the surrounding boutiques by discreet doormen, valet parking, and a lineup of clients waiting patiently for entry to this upscale Italian restaurant. Appetizers can be inventive, like the sliced and spiced fried pumpkin slivers, but the house forte is pasta, made fresh and served in intriguing combinations like the signature duck-filled ravioli in orange sauce. Nonpasta options include some excellent risottos—including one made with red wine, white beans, and hearty Tuscan sausage. Steaks and poultry are on the menu, but if that's what you're hankering for you should really go elsewhere.

Rua Haddock Lobo 1629, Cerqueira Cesar. ☏ **011/3064-0005.** www.fasano.com.br. Main courses R$40–R$75. AE, DC, MC. Mon–Thurs noon–3pm and 7pm–1am; Fri–Sat noon–4pm and 7pm–1am; Sun noon–4:30pm and 7–11:30pm. Bus: 206E.

Le Chef Rouge ★★ FRENCH Listening to the *chansons* in Chef Rouge's cozy dining room, you could easily believe that you were somewhere on the Left Bank (although waiters here are friendly, attentive, and speak English). The menu includes hearty French fare such as the *trois filets aux trois sauces,* a trio of juicy grilled steaks each served with a different sauce, and the *canard à l'orange,* thin slices of duck served in a sweet-savory orange sauce on a bed of wafer-thin potato chips. The wine list includes far too many expensive French bottles, but a small selection of Chilean cabernet sauvignon and Shiraz makes an affordable evening possible. For dessert, the cheese plate makes a wonderful change from Brazilian sweets.

Rua Bela Cintra 2238, Cerqueira César. ☏ **011/3081-7539.** www.chefrouge.com.br. Main courses R$32–R$90. AE, DC, MC, V. Tues–Sat noon–3:30pm and 7pm–midnight; Sun noon–5pm and 7pm–midnight.

MODERATE

Toro ★★ TAPAS This warm terra-cotta restaurant, rich with the look and scents of the owners' native Andalusia, offers a wide variety of tapas, Spanish-style small plates—perfect for snacking and sharing over a glass of red from the substantial wine list. For those less inclined to sharing, there's excellent paella and lamb. All dishes, big and small, are served on hand-painted plates brought directly from Spain.

Rua Joaquim Antunes 224, Jardim Paulista. ☏ **011/3085-8485.** Reservations recommended. Small plates R$15–R$70. AE, MC, V. Daily 8am–7pm.

INEXPENSIVE

Casa do Padeiro CAFE Open 24 hours a day, the Casa do Padeiro (Baker's House) dishes up way more than just bread. It's the perfect spot to grab a light meal any time of the day. There are salads; sandwiches; pasta; desserts; excellent coffee including fresh espresso, café au lait, and cappuccinos; and other hot beverages.

Av. Brigadeiro Faria Lima 2776, Jardim Paulistano. ☏ **011/3812-1233.** Everything under R$25. AE, MC, V. Daily 24 hr. Bus: 5100 or 5119.

Offellê ICE CREAM Offellê's display case shows a dazzling rainbow of Italian gelato-style ice cream. Try the chocolate and mint or the chocolate with hazelnut. Exceptionally yummy. The fruit flavors are made with fresh fruit and range from the tropical passion fruit to more "foreign and exotic" raspberry and blackberry.

Al. Lorena 1784, Cerqueira Cesar. ☏ **011/3088-8127.** Everything under R$12. V. Daily 1–11pm. Bus: 206E.

Vila Madalena
EXPENSIVE

Kabuki ★★ JAPANESE Romantic, chic, Japanese. Not adjectives that usually go together (at least not in Brazil), but Kabuki's candlelit dining room, exposed brick, and wood accents make it an exception. For those who want to nibble, there's a large menu of appetizers including sautéed shiitake or *shimeji* mushrooms, deep-fried prawn, and grilled skewers with meat, seafood, or vegetables. Main courses include a large variety of sushi and sashimi combos, tempuras, yakisoba noodles, and grilled

meats. Interesting dessert options include the flambéed mango and ba
pura ice cream, a wonderful sensation of a hot, crunchy crust and a so, ce
center.

Rua Girassol 384, Vila Madalena. ⓒ011/3814-5131. www.kabuki.com.br. Reservations acc
Main courses R$22–R$70. AE, DC, MC, V. Mon 7–11pm; Tues–Sat noon–3pm and 7pm–1am,
noon–11pm. Metrô: Vila Madalena.

Oficina das Pizzas ★ 🍴PIZZA With over 40 varieties of pie to choose from at
the Oficina das Pizzas, it may take you an eternity to make up your mind. There are
traditional combinations such as tomato, ham, basil, cheese, and onion. Brazilians,
however, have a real thing for sweet and savory pizzas—witness the Gorgonzola
cheese with pineapple pizza, or the smoked bacon, tomato, and mango chutney
combo. For something truly unique, try the banana with mozzarella, sugar, and
cinnamon.

Rua Harmonia 117, Vila Madalena. ⓒ**011/3816-7848.** www.oficinadepizzas.com.br. Main courses
R$26–R$37. AE, DC, MC, V. Mon–Wed 7pm–midnight; Thurs–Sun 7pm–1am. Metrô: Vila
Madalena.

Santa Gula ★★ 🍴ITALIAN/BRAZILIAN One of the quaintest restaurants in
São Paulo, Santa Gula is reached via a fairy-tale lane lush with tropical plants, banana
trees, and flickering candlelight. The lane leads to a dining room with the handmade
furniture and rustic decor of a simple Tuscan villa. The kitchen serves up a mix of
Italian and Brazilian flavors—think risotto with palm hearts or pasta stuffed with
carne seca (a flavorful dried meat) and pumpkin purée. For meat lovers, the steaks
arrive grilled to perfection. For dessert, don't pass up on the Brazil nut pie or the
sweet coconut with tapioca mousse and tangerine sorbet.

Rua Fidalga 340, Vila Madalena. ⓒ**011/3812-7815.** www.stagula.com.br. Reservations recom-
mended. Main courses R$26–R$40. AE, DC, MC, V. Mon 8pm–midnight; Tues–Thurs noon–3pm
and 8pm–1am; Fri–Sat noon–4pm and 8pm–2am; Sun noon–5pm. Metrô: Vila Madalena.

INEXPENSIVE

Deliparis CAFE A combination of cafe and bakery, Deliparis has an excellent
selection of freshly baked breads, including loaves made with olives, nuts, or multi-
grain. Clients linger in the cafe with a tea or cappuccino and some of the delicious
fruit tarts, quiches, or brioches. Deliparis also bakes excellent pies and divine cakes:
Think banana cake with almonds or creamy chocolate ganache.

Rua Harmonia 484, Vila Madalena. ⓒ**011/3816-5911.** www.deliparis.com.br. Everything under
R$12. No credit cards. Daily 7am–10pm. Bus: 473T.

Ibirapuera Park
VERY EXPENSIVE

Varanda Grill ★★ STEAK In a country that values prime beef above everything
but perhaps soccer and sex, the Varanda Grill stands out. Every type and kind of beef
is available: porterhouse, rib-eye, and prime rib from the United States, *bife de chorizo*
from Argentina, *picanha* and baby beef from Brazil, and the house signature dish,
Kobe-style beef from Japan, known for its marbled texture and melt-in-your-mouth
flavor (the latter available with a 24-hr. advance reservation). Decor is spare, perhaps
even a tad too minimalist, though given the quality of the beef you may not even

...ntains over 400 bottles in a range of prices and nationalities ...uth Americans predominate), each with a helpful short

...Jardim Paulista. ℭ **011/3887-8870.** www.varandagrill.com.br. Main ...MC, V. Mon–Thurs noon–3pm and 7pm–midnight; Fri–Sat noon– ...noon–5:30pm.

▀▀ BRAZILIAN Even if you aren't staying at the Unique, it's worth coming to Skye, both to experience the architecture and to enjoy the rooftop restaurant. The views of the São Paulo skyline are spectacular. This modern lounge/restaurant serves up creative and innovative Brazilian cuisine. The menu constantly changes but a few of the recent dishes have included duck confit with a Malbec and *rucula* risotto, or grilled salmon with yakisoba. Plus there's a full sushi bar that serves up excellent sushi and sashimi. In the evenings, the lounge is a city hot spot and popular celebrity hangout. Reservations accepted only for hotel guests.

In the Unique (p. 193), Av. Brigadeiro Luis Antonio 4700, Jardim Paulista. ℭ **011/3055-4702.** www. hotelunique.com.br. Main courses R$42–R$69. AE, DC, MC, V. Daily noon–4pm and 7pm–1am.

EXPLORING SÃO PAULO

Rio is a beauty. But São Paulo—São Paulo is a city.
 —Marlene Dietrich

What was once a little market town in the cool high plateau has jumped its bounds and sprawled for the hills in all directions. São Paulo is now not only the largest city in Brazil, but it's also the largest in South America and the third or fourth largest in the world. What assembles and drives this vast collection of people is commerce. The city and surrounding municipalities account for an incredible 65% of Brazil's GDP. When Paulistas do take a break from work, they devote much the same energy to leisure. The city has some of the best galleries and museums in the country. It has by far the best cuisine and some of the best nightlife. And despite the seeming chaos, remain for a few days and you'll discover, as Paulistas have, that the city could not be otherwise; somehow São Paulo makes sense.

SUGGESTED SÃO PAULO ITINERARIES

If You Have 1 Day

Get to know South America's largest city. Wander the busy pedestrian streets of the old downtown neighborhood of **Centro.** In the constant commercial chatter you'll feel, see, and hear Paulistas at their best: buying, selling, and trading. Drop down the busy **Rua 25 de Março** to the **Mercado Municipal,** to sample the exotic fruit or bite into a monster mortadella and Swiss. Ascend to the top of the **Banespa building** for a 360-degree view of the city. Have a coffee at the **Pátio do Colégio.** In the afternoon, take the Metrô out to the **Avenida Paulista.** Bask in the wealth and power a bit, then go see some fine art at the **MASP.** In the evening, take advantage of your presence in Brazil's culinary capital and go out for dinner at a truly fine restaurant like the **D.O.M.** or **Figueira Rubaiyat.**

If You Have 2 Days

Get some culture. Anyone interested in modern Brazilian architecture should see the **Monument to Latin America.** Those interested in seeing Brazilian art should check out the **Pinacoteca do Estado,** or for older work the **Museu de Arte Sacra.** Reward yourself with an afternoon shopping in the green and leafy **Jardins** neighborhood. The intersection of **Rua Augusta** and **Oscar Freire** is perhaps the most exclusive shopping enclave in all Brazil. The neighborhood is also one of São Paulo's culinary hot spots. For a taste of the diversity in this most cosmopolitan of cities, seek out a Bahian dinner at **Capim Santo,** a French meal at **Le Brasserie Erick Jacquine,** or something Middle Eastern at **Arabia.** In the evening, head out to **Vila Madalena,** have a cold chopp and enjoy the people-watching, or a fine whiskey and light jazz at the **Piratininga Bar.**

If You Have 3 Days

Set off to explore the Japanese neighborhood of **Liberdade,** topped off with a fine Japanese lunch. Walk off those calories with an afternoon in **Ibirapuera Park.** Stroll the pathways, rent a bicycle, and enjoy the people-watching. Don't pass up the **Afro-Brazilian Museum.** Soccer fans shouldn't miss the opportunity to see the impressive **Museu do Futebol.** That night, check out some of the clubs or bars in **Vila Olímpia.** And if your engine is still revving come midnight, head downtown to the **Rua Augusta** to hear some music or dance the night away. Try to make it home by dawn.

The Top Attractions

Ibirapuera Park ★★ Blessed with over 2 million sq. m (22 million sq. ft.) of green space, São Paulo's version of New York's Central Park offers quite a bit to see and do. You can wander the paths beside pleasant lagoons or rent a bicycle (R$5 per hour, near Gate 3; call **Flávio** (*C*) **011/8753-1617**) and cycle the pathways. Every Sunday morning there's a **free outdoor concert** in the park's Praça da Paz. Sunday from 10am to 4pm you can take advantage of the **Bosque de Leitura,** a kind of free outdoor lending library that lets you borrow magazines or books (including many in English) to read in the park for the duration of day. In the corner near Gate 3 there's the **Museum of Modern Art** (see below). Just nearby there's the excellent **Afro-Brazil Museum** (see below) and the **OCA Auditorium,** a flying saucer–shaped building that often hosts traveling art exhibits. Allow half a day.

Av. Pedro Álvares Cabral s/n, Moema. Administration (*C*) **011/5574-5177.** www.parque doibirapuera.com. Free admission. Daily 5am–midnight. Bus: 5185-10 (or taxi from Metrô Brigadeiro).

Liberdade ★★ São Paulo's Japantown got its name (which means "Liberty") after the 1888 abolition of slavery when the neighborhood's main square, which once held the official city whipping post, was renamed **Praça da Liberdade.** Adopted shortly thereafter by Japanese immigrants, Liberdade is now the center of the largest Japanese community outside of Japan. The best way to experience the area is to get off at the **Liberdade** Metrô stop and take a stroll down **Rua Galvão Bueno.** In addition to pretty Japanese lamp standards, the street has some great sushi restaurants (plus Chinese and Korean cuisine as an added bonus), mineral and knickknack shops, Asian grocery stores, and Japanese faces everywhere. On Sundays, the square surrounding the Metrô stop becomes the giant outdoor **Sunday market.** The enthusiastic staff at the **Museu Historico da Imigração Japonesa** ★, Rua São Joaquim

Exploring São Paulo

SANTANA

Av. Bras Leme

Campo de
■ Marte

Carandiru
Ⓜ

Av. Olavo Fontoura

R. C. Pontes

R. J. B. Pinto

R. J. Ramalho

Av. Zaki Narchi

Av. Cruzeiro do Sul

Av. S. Dumont

Av. Guilherme

Portuguesa-
tiete
Ⓜ

Av. Morvan Figueiredo

R. S. Tomal

Prado

Av. Rio Branco

Al. Barrão de Limeira

Av. do Caxias

Parque
da Luz

⑭
Ⓜ Tiradentes
Av. Tiradentes

⑬

Estacao Armenia
Ⓜ

Armenia
Ⓜ

⑮

R. Sta. Clara

R. Bresser

ATLANTIC
OCEAN

Manaus Belém

Amazon

B R A Z I L Natal ○
Recife ○

Brasília ✸

Rio de
Janeiro

São Paulo Salvador

500 mi
500 km

Av. E. Robiano

TATUAPÉ

Av. Celso Garcia

Av. Salim Farah Maluf

São João
Ⓜ

Santa
Cecília Ⓜ

Ipiranga

Luz Ⓜ
R. Mauá

CENTRO

Parque
Anhangabaú

⑯ ⑰

São
Bento
Ⓜ

R. do
Gasómetro

BELÉM

Belém
Ⓜ

R. Siqueira Bueno

R. T. Barreto

Praça da
República

⑫ Ⓜ

Republica
Ⓜ

⑱

Anhangabaú
Ⓜ

Av. Rangel Pestana
Ⓜ

Bresser-
mooca

Viaduto Bresser

Praça
Sé

⑲
Ⓜ Sé

Brás
Ⓜ

⑳

Av. A. Macrado

Pedro Ii
Ⓜ

R. dos Trilhos

R. da Moóca

MOÓCA

Av. 9 de Julho

Pça Dr
Joao Mendes
Ⓜ

Av. Radial Leste-Oeste

Liberdade
Ⓜ

Av. do Estado

Praça
Lugoslávia

R. do Acre

Av. Brig. Luis António

Av. 23 de Maio

Liberdade

R. C. Furtado

LIBERDADE ㉑

R. C.

Largo
São Rafael

Praça
Alexandre
Fleming

VILA
ORATORIO

R. do Oratório

Sao
Joaquim
Ⓜ

R. Tamandaré

R. Muniz de Souza

R. Lins de vaasconcellos

Av. Presidente Wilson

R. Barão de Monte Santo

Av. Pacs de Barros

⑯ Ⓜ

Brigadeiro
Ⓜ

⑪

Vergueiro
Ⓜ

CAMBUCI

Av. DomPedro I

Av. do Estado

Av. Henry Ford

VILA LEME

R Abilio
Soars
Ⓜ

R. do Paraíso

Parque
Aclimação

R. Cel. Diogo

Av. Eng. L. G.Cardim

R. Ricardo Jafet

R.Tabor

R. Cap. P. Chaves

R. do Orfanato

23 de Maio

R. Cubatão

R. D. de Morais

Paraíso
Ⓜ

Ana Rosa
Ⓜ

R. dos Patriotas

R. Bom Pastor

R.Manifesto
R. Silva Bueno

Av. Nazaré

㉒

Av. Prof. Luis Inácio Anahaia Melo

Vila Prudente
Ⓜ

R. Ibitirama

VILA
MARIANA

Vila Mariana
Ⓜ

R. Sena Madureira

R.Borges Lagoa

R. Pedro de Toledo

R. D. de Morais

Chácara
Klabin
Ⓜ

R. Santa Cruz

Santa
Cruz
Ⓜ

Av. Prof. Abraão de Morais

R. Vergueiro

Santos-
imigrantes
Ⓜ

IPIRANGA

Av. Dr. Gentil de Moura

Sacoma
Ⓜ

Tamanduatei

Av. Guido Aliberti

Av. J. M. Whitaker

Av.A. M Fagundes

Av. Jabaquara

Av.Bosque de Saúde

Praça De
áRvore

SAÚDE

Av. do Cursino

Alto Do
Ipiranga

Av. Pres. Tancredo Neves

Estrada das Lágrimas

Av. Almirante Delamare

MUNICÍPIO DE
SÃO CAETANO
DO SUL

Take a Break near the FAAP

Across the street and up the small rise from the FAAP you'll find the Praça Vila Boim, a small square dotted with dozens of casual restaurants, from pizza and sushi to Mexican and a '50s diner. It's a great spot to take a break.

381 (℡ **011/3209-5465;** www. bunkyo.bunkyonet.org.br; R$5 adults, R$1 children 6–11 years; Tues–Sun 8:30am–noon and 1:30–6pm; Metrô: Liberdade), is eager to show off three floors of photographs, artifacts, and film loops telling the 100-year history of the Japanese experience in Brazil.

Daily 9am–6pm. Metrô: Liberdade.

Mercado Municipal ★★ Built in the 1930s, this gorgeous market hall with its skylights and stained-glass windows is a fabulous setting for the city's largest food and produce market. Stand and gawk at fruit stands piled high with exotic tropical offerings, many available only in Brazil. Better yet, buy a few and sample. Or hang out by a deli stand sniffing the salamis and fondling the full round cheeses. Or bite into a monster mortadella sandwich at **Bar do Mané** (℡ **011/3228-2141**). Allow an hour, plus time for lunch. *Tip:* If you don't mind crowds, it's a fun walk downhill to the market along the very busy Rua 25 de Março, starting from just behind the Pateo do Colegio. Hundreds of shops sell inexpensive goods in bulk, with lingerie a specialty. The street is safe during business hours, though keep an eye for pickpockets and don't flaunt your camera gear.

Rua da Cantareira 306, Centro. ℡ **011/3326-3401.** Free admission. Mon–Sat 6am–6pm; Sun 6am–4pm. Metrô: São Bento.

Monument to Latin America ★ Shy of a visit to Brasilia, this is the best place to see Brazilian modernism in all its concrete austerity. Designed by famed Brazilian architect Oscar Niemeyer, the monument consists of a vast field of concrete dotted about the edges with perfectly geometrical concrete pavilions originally painted blinding white, but long since streaked by the rain. If architecture doesn't turn your crank, you probably shouldn't come here. That said, the two pavilions of most interest to non–architecture buffs are the Art Gallery—home to ever-changing fine art exhibits—and the Hall of Creativity, home to a fun and fascinating display of folk art from across the length and breadth of Latin America. Allow 2 hours.

Av. Auro Soares de Moura Andrade 664, Barra Funda (next to the Barra Funda Metrô stop). ℡ **011/3823-4600.** www.memorial.sp.gov.br. Free admission. Tues–Sun 9am–6pm. Metrô: Barra Funda.

Museu Afro Brasil ★★ Dedicated to showing the cultural achievements of Africans in Brazil, both those brought as slaves and their descendants, this museum is thankfully neither boring nor earnest nor prone to guilt-inducing lectures. Instead, what's on offer is a celebration of the art and accomplishments of the African diaspora. Displays show short biographies of writers or painters or politicians who were black, including lots of their artwork and artifacts. Displays are gorgeous—particularly the art and photography—and the museum has wonderful natural light. Even the website is good. Allow an hour.

Parque do Ibirapuera. ℡ **011/5579-0593.** www.museuafrobrasil.org.br. Free admission. Tues–Sun 10am–5pm. Bus: 5185-10 from Metrô Brigadeiro.

Museu Arte Brasileira/FAAP ★ This majestic and slightly pompous building (think Mussolini monumental) in quiet Higienópolis plays host to an ever-changing parade of international exhibits. Check the website before you go. If the exhibit interests you, the FAAP is a lovely space. Supposedly, the museum is also home to a number of works by Brazil's great painters—Portinari, Di Cavalcanti, and others—but in repeated visits over the years I've never seen these actually make it to the display floor. (You're more likely to see the museum referred to as FAAP, which is the acronym for the cultural institute where it's located.) Allow 2 hours.

Rua Alagoas 903, Higienópolis. ✆**011/3662-7200.** www.faap.br/museu. Admission varies from free to R$20 depending on exhibit. Tues–Fri 10am–8pm; Sat–Sun 1–5pm. Bus: 137T or taxi from Metrô Consolação.

Museu Arte São Paulo (MASP) ★★ São Pãulo's flagship art museum is not actually the best place in town to see Brazilian art—that honor belongs to the lovely Pinocoteca do Estado. But this big, long box on the Avenida Paulista did recently reorganize its galleries to give much more space to homegrown talent. The top floor contains the permanent collection, an excellent selection of Western art—Dutch Rembrandts, English Turners, Spanish El Grecos, French everythings (Rodin, Renoir, Degas, and Monet). However, several rooms on this floor are now dedicated to the Brazilian greats, among them Di Cavalcanti and Portinari. Even better, the entire second floor is now a temporary gallery, dedicated to changing exhibitions of mostly Brazilian artists. The display space still has a bit of that big box warehouse feel, but the art is now worth the trip. Allow 2 hours.

Av. Paulista 1578, Cerqueira César. ✆**011/3251-5644.** www.masp.art.br. Admission R$15 adults, free for seniors and children 10 and under. Free admission on Tues. Tues and Thurs–Sun 11am–6pm; Wed 11am–8pm. Metrô: Trianon-MASP.

Museu da Imagem e do Som ★ 🏛 Recently reopened under new direction, the Museum of Image and Sound showcases the best Brazilian contemporary image-makers. Photographs in the changing exhibits are always compelling, beautifully displayed, and intelligently curated. The video lab offers installations of and about video art. Information on current, future, and past exhibits is available on the website. Allow 1 hour.

Av. Europa 158, Jardim Europa. ✆ **011/2117-4777.** www.mis-sp.org.br. Admission R$4, free 5 years and under. Tues–Sat noon–10pm; Sun 11am–9pm. Bus: 373T.

Check Out the Antiques Market

Every Sunday from 10am to 5pm, an antiques fair springs up in the courtyard beneath the MASP building. Dealers are registered, and the quality is often good. Plus, it's the only time you'll ever find anybody voluntarily occupying that open space.

Museu de Arte Moderna (MAM) ★★ Small but intriguing, the MAM in Ibirapuera Park has two galleries devoted to ever-changing exhibits of modern work, be it painting, sculpture, video, textile, or some other medium. At any one time, each of the main building's two spacious and well-lit galleries is given over to a particular artist. Check the website for upcoming exhibits. Surrounding the museum is a **sculpture garden**

featuring 28 works by different Brazilian artists. When not on display, much of the gallery's permanent collection is online. Allow an hour.

Parque do Ibirapuera, Gate 3. ✆ **011/5085-1300.** www.mam.org.br. Admission R$5.50 adults, free for seniors 60 and over and children 10 and under. Free admission on Sun. Tues–Sun 10am–6pm. Bus: 5185-10 from Metrô Brigadeiro.

Museu de Arte Sacra ★★ Sacred art refers to objects—chalices, crosses, statues, sculptures—created to adorn churches or for use in Catholic services. Built in 1774, the Mosteiro da Luz (which still functions as a monastery on the upper levels) provides the perfect setting to view these works: piped-in choral music echoes through the stone corridors as light pours in from the cloister, casting a warm glow on the beautiful collection. Many of the silver objects sparkle in ostentatious testimony to the wealth of the church. Older pieces include woodcarvings and clay statues of angels and saints. Portuguese and English texts explain the origins and name of each piece.

Outside in the garden of the Luz convent is the **Presepio Napolitano,** a lovely miniature village composed of over 1,600 hand-painted figurines depicting life in an 18th-century Neapolitan village. Admission is included with the museum ticket.

Av. Tiradentes 676, Luz. ✆ **011/3326-1373.** www.museuartesacra.org.br. Admission R$6 adults, free for seniors and children 5 and under. Free admission on Sat. Tues–Sun 10am–6pm. Metrô: Luz, Tiradentes

Museu do Futebol ★★ What better way to learn more about Brazilian culture than through its most popular sport (although many Brazilians would claim that soccer is so much more than that!). Located inside the Pacaembu stadium, this museum does an excellent job of visually representing Brazil's passion for the game. Creative exhibits with lots of video installations and images showcase the history of the sport, the most unforgettable goals, and Brazil's World Cup achievements—the only country to win five times. The Baroque Angel room with suspended video installations pays tribute to the 25 greatest Brazilian players of all time . . . although a special exhibit is set aside for the "King of Soccer," Pelé. Allow at least an hour.

Praça Charles Miller s/n, Pacaembu. ✆ **011/3664-3848.** www.museudofutebol.org.br. Admission R$6. Tues–Sun 10am–5pm. Metrô: Clinicas, then a 1km (½ mile) walk or taxi ride.

Museum of the Portuguese Language ★ This fun little museum tells the story of the Portuguese language in a way that's creative, interesting, interactive, and fun. The big drawback? There's no English signage. However, with a basic understanding of Portuguese, or an interest in the language, you should enjoy the experience. In addition to the displays, interactive terminals encourage you to punch up a word, see its origin and history, and hear it pronounced. All-time favorite? The X-burger (X in Portuguese is pronounced *sheeze*—think about it). On one wall, a giant 100m-long (328-ft.) screen shows images and clips relating to unique Portuguese words. Allow 1 hour.

The museum is inside the **Estação de Luz,** a beautifully renovated high Victorian railway station: Wander around and have a look at the Romanesque red-brick arches and cast-iron pillars that vault across the tracks and platforms.

Praça Luz s/n. Administration ✆ **011/3326-0775.** www.museudalinguaportuguesa.org.br. Admission R$6. Tues–Sun 10am–6pm. Metrô: Estação Luz.

Pinacoteca do Estado ★★★ The Pinacoteca is a sunlit joy to be in, and one of the best-curated art collections in the country. It's the perfect place for anyone

ART & cultural exhibit HALLS

São Paulo is blessed with a number of beautiful old buildings that have been converted to cultural centers. They play host to a cavalcade of interesting and ever-changing art exhibits. Even better, they're (almost) all free.

On the Avenida Paulista, the pretty mansion **Casa das Rosas,** Av. Paulista 37 (© **011/3285-6986;** www.casadasrosas. sp.gov.br; Tues–Fri 10am–10pm, Sat–Sun 10am–6pm), plays host to art exhibits and author readings, while the rose garden—complete with small cafe—makes for the perfect escape from the Avenida Paulista. The Casa was built in 1928 by Ramos de Azevedo, the same architect who designed the Teatro Municipal and the Pinacoteca. One block over is **Itaú Cultural,** Av. Paulista 149 (© **011/2168-1776;** www.itaucultural.org.br). Funded by one of the largest banks, the center features art exhibits, movies, concerts, and theater; it's open Tuesday to Friday from 9am to 8pm, Saturday and Sunday from 11am to 8pm. The modern pyramid in the heart of Brazil's "Wall Street" houses the **Fiesp** Cultural Center, Av. Paulista 1313 (© **011/3146-7405;** www.sesisp.org.br/cultura). The program includes art exhibits, dance, music, film, and theater. Opening hours vary according to programming.

In the old downtown or Centro, the former headquarters of the **Banco do Brasil,** Rua Alvares Penteado 112 (© **011/3113-3651**), is now a three-floor cultural center, featuring art exhibits, plays, and screenings of experimental films.

On the far southern edge of the Jardins, the **Museu Casa Brasileira,** Av. Brig. Faria Lima 2705 (© **011/3032-3727;** www.mcb.sp.gov.br; admission R$4, Sun and holidays free admission; Tues–Sun 10am–6pm), was built in 1945 for one of São Paulo's leading families. Inside the yellow Palladian villa, the museum displays an assortment of haute-bourgeois artifacts from the 17th to 19th centuries: jacaranda-wood furniture, porcelain, silver plates, the token oil painting by Portinari. Even better, a new curator has begun hosting changing exhibits and workshops focused primarily on modern Brazilian design.

wanting to see and understand Brazilian art. There is lots of latticework of glass and open spaces, many of which are connected by a series of catwalks. Though none of the signs are in English, the Pinacoteca does an excellent job of displaying some of the best Brazilian artists from the 19th and 20th centuries. The 20th-century work starts to break free of European influence and includes interesting examples of colorful Brazilian pieces bursting with energy. The Pinacoteca's sculpture collection includes a lovely statue by Raphael Galvez entitled *O Brasileiro*, as well as works by Alfredo Ceschiatti, the artist who designed many of the sculptures in Brasilia. Allow 2 hours.

Praça da Luz 2, Luz. © **011/3324-1000.** www.pinacoteca.org.br. Admission R$6, free for children 10 and under. Free admission Sat. Tues–Sun 10am–6pm. Metrô: Luz.

Architectural Highlights

One of the few remaining relics of old São Paulo, the **Pátio do Colégio** complex sits a hop and a skip north from Praça da Sé on Rua Boa Vista, on the exact site where the original Jesuit mission was founded in 1554. Though built in 1896, the simple

Anchieta Chapel (daily 9am–5pm) is an accurate reproduction of the original. Next door to the chapel, the **Museu Padre Anchieta** (Tues–Sat 9am–5pm; admission R$5) features a number of maps of São Paulo through the years, plus a large diorama of the original settlement.

Located at the birthplace of Brazilian independence—it was here that D. Pedro I in 1822 declared Brazil's independence from Portugal—the **Museu do Paulista do Ipiranga,** Praça da Independencia s/n, Ipiranga (✆ 011/2065-8000; www.mp.usp.br; admission R$6; Tues–Sun 9am–5pm), is a classic European palace with a Versailles-like garden out front and a wilder botanical garden out back. Inside are some gems of Brazilian art, photo exhibits showing 19th-century São Paulo as it developed, period furniture, and household objects.

São Paulo's Ellis Island, otherwise known as **Memorial do Imigrante,** Rua Visconde de Parnaiba 1316 (✆ 011/6692-1866; www.memorialdoimigrante.org.br; admission R$4; Tues–Sun 10am–5pm; Metrô: Estação Bresser), saw about three million immigrants pass through during the 19th and 20th centuries on their way to a new life in Brazil. For today's visitors, the admission hall, office, hospital, and dormitories are shown in their original condition. On Sundays and holidays, a historic train takes visitors on a short ride around the museum area.

The 30-story **Edifício Martinelli,** at Av. São João 33, was the city's first skyscraper, inaugurated in 1929. Stylistically it's an interesting mixture—Italian palazzo with a mansard roof—and it remains an important landmark.

More daring and more interesting from an architectural perspective is Oscar Niemeyer's **Copan Building,** erected in 1951 at the corner of Avenida Ipiranga and Avenida Araújo. Its scale, its celebration of raw concrete, and its curvilinear shape were all quite advanced for the time. Photos of its curvy brise-soleil sides show up frequently in São Paulo postcards.

CHURCHES & TEMPLES

A Benedictine monastery has been on this site by the edge of the Anhangabaú Valley since 1600, just a few decades after São Paulo was founded. The current **Basilica de São Bento** dates to 1910 and is worth a look if you're passing by, though to tell the truth, despite all the marble, wood, and stained glass that went into the construction, the net effect is far from beautiful. Visitors may be most impressed by the German organ with 6,000 pipes. Come for High Mass on Sunday at 10am, and the service is accompanied by Gregorian chants. Open Saturday to Thursday 6am to noon and 2 to 6pm, and Friday from 2 to 6pm. Gregorian chanting is Monday and Friday at 7am, Saturday at 6am, and Sunday at 10am.

São Paulo's **Metropolitan Cathedral** is a curious structure, a blend of Byzantine and High German Gothic. Construction began in 1911, but wasn't completed until 1954. Its best feature may be the Praça da Sé out front, which is lined with stately imperial palms and occupied during the daylight hours by street preachers, some of them quite good. It's open Monday to Friday 8am to 7pm, Saturday 8am to 5pm, and Sunday 8am to 1pm and 3 to 6pm.

Plazas & Parks

MARKETS

Saturday and Sunday on the **Praça Dom Orione** in the Italian **Bixiga** neighborhood is a small antiques/flea market. On Sunday on the **Praça da Liberdade** (next to the

 SOME spectacular **VIEWS**

The pedestrian-only **Santa Ifigênia Viaduct** runs from one side of Centro to the other, high above the Parque do Anhangabaú. At the midpoint you get a wonderful view of São Paulo's old downtown.

The best view of São Paulo is from atop the **Banespa Tower ★★**, Rua João Brícola 24 (*℃* **011/3249-7428**). Ascending to its 35th-floor observation deck, you get an incredible view—high-rise towers, 360 degrees of them, filling every inch of land for as far as the eye can see. It's open Monday through Friday from 10am to 5pm, and better yet,

it's free. Bring ID to show the door guards.

Built in 1965, the 42-story **Edifício Itália**, at Av. Ipiranga 344 near Praça da República, features a 41st-floor restaurant and piano bar, the **Terraço Itália** (*℃* **011/2189-2929;** www.terracoitalia. com.br), which offers a great vantage point from which to view the city. (The food's not great—stick to drinks or a snack.) Cover is R$17, and there's a R$15 drink minimum. It's open Monday through Saturday from 3pm to midnight, Sunday from noon to 11pm.

Liberdade Metrô stop) São Paulo's Japanese residents celebrate their heritage with an outdoor market featuring excellent and inexpensive Japanese cuisine, plus Japanese crafts and knickknacks.

PARKS & GARDENS

Adjacent to the Pinacoteca, the **Parque da Luz** is well worth a look. Inaugurated in 1825 as the city's botanical garden, the garden was then outside of the city limits, and locals at the time wondered whether it was wise to set aside such a large piece of land. Nowadays the park's lovely old trees contrast with the modern sculptures from the archives of the Pinacoteca that dot the park's walkways. Note that the large numbers of solitary ladies admiring the statuary are actually working girls; they're so discreetly dressed and nonaggressive they're easy to overlook. The park is heavily policed and safe during the day. It's open Tuesday through Sunday from 9am to 6pm.

Opposite the MASP is the green refuge of the **Parque Tenente Siqueira Campos,** often known by its old name of **Trianon Park.** The park is thickly planted with Atlantic rainforest vegetation, laced with walking trails, and dotted here and there with children's play areas. It's a wonderful green refuge from the bustle on Avenida Paulista and is open daily 6am to 6pm.

There is so much to see and do in the vast green space known as **Ibirapuera Park** that we've covered it under "The Top Attractions," earlier in this chapter.

OUTDOOR PLAZAS

In the **Praça da Sé,** in front of the Metropolitan Cathedral, two files of imperial palms enclose a flagstone-covered courtyard with a sundial at the center. People stroll through this area, slowing or stopping to give an ear to the ever-present street preachers. Keep an eye out for pickpockets.

Between the Praça da República and the Praça da Sé lies the city's newest and most interesting square, the **Parque Anhangabaú.** Running an eight-lane freeway over the top of the Anhangabaú River that once flowed through Centro was probably

> ### Take a Break at Siqueira Campos
>
> Just opposite the MASP on Avenida Paulista, the lush Siqueira Campos Park has several small play areas featuring swings, see-saws, and slides. It's a fun and quiet refuge from the bustle of the city.

not one of São Paulo's better planning moves, but the city recently made amends by covering a 1km (½-mile) stretch of the freeway with this beautifully landscaped urban plaza. In the daytime it's occupied by pedestrians, sun-tanners, lunch-break idlers, and clusters of folks listening to street musicians.

In Centro, **Praça da República** is suffering from a renovation that has turned the top third of the park into a construction site. The remainder appears to have been occupied by camps of squatting homeless. The whole scene is best avoided.

Especially for Kids

Playcenter ★ ☺ Brazil's biggest roller coaster plus a huge variety of other rides and games are all at this large amusement park, about a 20-minute walk from the Barra Funda Metrô stop.

Rua José Gomes Falcão 20, Barra Funda. ⓒ **011/3350-0199.** www.playcenter.com.br. Admission (with unlimited rides on most attractions) R$60 adults, R$32 children 3–10, free for children 2 and under. Sat–Sun noon–9pm. Metrô: Barra Funda. Playcenter runs a free shuttle from Barra Funda every 30 min. during open hours. To catch the shuttle follow signs to Terminal Rodoviaria.

Zoológico ★ ☺ This large and impressive zoo has more than 3,000 species, most in large enclosures that resemble the animals' native habitats. There are also lunch and picnic areas, and a petting zoo for smaller children. It's about 45 minutes southeast of the city. Allow 3 hours.

Av. Migual Estéfano 4241, Agua Funda. ⓒ **011/5073-0811.** www.zoologico.sp.gov.br. Admission R$16 adults and children 13 and over, R$6 children 5–12, free for seniors and children 4 and under. Tues–Sun 9am–5pm. Metrô: Jabaquara; catch microbus to Jardim Zoológico from Jabaquara station (R$3.80).

Outdoor Activities & Spectator Sports

GOLF In the western suburb of Osasco, **São Francisco Golf Club,** Av. Martin Luther King 1527, Osasco (ⓒ **011/3681-8752;** www.golfsaofrancisco.com.br), offers a 9-hole par-71 course open to the public Tuesday through Sunday from 7am to 6pm. Greens fees are R$125 weekdays, R$265 weekends and holidays. The club also rents clubs and shoes.

HORSE RACING Races run Monday, Saturday, and Sunday at the **Jockey Clube de São Paulo,** Av. Lineu Paula Machado 1263, Cidade Jardim (ⓒ **011/2161-8300;** www.jockeysp.com.br). On Monday races start at 6pm; on Saturday and Sunday the races start at 1:30pm. Minimum bet is R$2. The club has a restaurant open for dinner Monday through Friday and for lunch on weekends; the bar Cantér is popular even with those who don't watch the races.

MOTOR RACING Important races such as the **Brazil Formula 1 Grand-Prix** take place at the Autódromo de Interlagos, Av. Senador Toetônia Vilela 259

(✆ 011/5521-9911). Tickets start at R$495, run as high as R$2, out up to 6 months in advance; try www.gpbrasil.com.br for tickets on upcoming dates.

SOCCER The big clubs in town are **São Paulo** (www.saopaulofc.net), **ans** (www.corinthians.com.br), **Palmeiras** (www.palmeiras.com.br), and **guesa** (www.portuguesa.com.br). Any match between these teams is likely seeing. So are all the state championships. Though the team websites provide deta on upcoming games, deciphering soccer schedules is the stuff of serious scholarship; better to just ask your hotel clerk or bellboy if there are any big games coming up. The city's main stadiums are **Morumbi,** located in the Morumbi neighborhood at Praça Roberto Gomes Pedrosa 1 (✆ **011/3749-8071**), and **Pacaembu,** Praça Charles Miller (✆**011/3664-4650**), in Pacaembu.

SHOPPING

Paulistas brag—correctly—that if you can't buy it in São Paulo, you can't buy it in Brazil. São Paulo has it all, from international boutiques to local crafts markets.

In terms of shopping areas, **Jardins** is known for its high-end fashion boutiques. The main shopping street is the **Rua Oscar Freire** and the parallel **Alameda Lorena,** and their cross streets the **Rua Augusta** and parallel **Rua Haddock Lobo,** packed with national and international brands, expensive clothing and jewelry, gourmet foods, and luxurious gift shops.

In **Centro** (downtown São Paulo), **Rua 25 de Março** is the place where Paulistas rich and poor browse the market stalls and small shops for inexpensive items such as belts, buttons, small toys, gadgets, towels, textiles, and socks. Inexpensive lingerie is a specialty. Keep an eye on your purse, though, as the streets are chaotic with vendors and stalls vying for space, and throngs of people making their way through.

Then there are the malls, which in São Paulo have been elevated to a whole other shopping experience: elegant, upscale, and refined. Sophisticated brands, boutiques, and fine dining can be found in a number of malls; the best-known ones are **Shopping Morumbi** (www.morumbishopping.com.br), **Shopping Iguatemi** (www.iguatemisaopaulo.com.br), and **Shopping Pátio Higienópolis** (www.patio higienopolis.com.br), located in upscale neighborhoods close to the city center, and

TAKING AN organized TOUR

Easygoing Brazil (✆ **011/3801-9540;** www.easygoing.com.br) specializes in private tours for foreign visitors. They work with excellent English-speaking guides. The company offers a 1-day tour of São Paulo for R$150 that includes the city's "must-sees" and leaves room for your interests, whether it's art, museums, fashion, parks—anything. Easygoing also runs several tours that will take you out of São Paulo—to a coffee plantation, or to the mountain resort of Campos do Jordão, or on a hike along the Cantareira hills that look over the city (R$250– R$350). Prices are for a private tour for two people; with three or more the price goes down significantly. The company also offers packages for special events, such as Carnaval in São Paulo or the yearly Formula 1 races at Interlagos.

The Jardins neighborhood is the place to find excellent Brazilian labels, including **Guaraná Brasil**, Al. Lorena 1601 (© 011/3061-0182; www.grupoguaranabrasil.com.br), **Maria Bonita**, Rua Oscar Freire 705 (© 011/3063-3609; www. mariabonitaextra.com.br), and **Forum**, Rua Oscar Freire 916 (© 011/3085-6269; www.forum.com.br). For the latest beach styles check out **Rosa Chá**, Rua Oscar Freire 977 (© 011/3081-2793; www.rosacha.com.br).

the **Shopping Pátio Paulista** (www.shoppingpaulista.com.br) on the Avenida Paulista. And then there's **Daslu,** the one-stop ultimate luxury shopping spot. See "Malls & Department Stores" below.

HOURS Most stores are open from 9am to 6pm Monday through Friday and 9am to 1pm on Saturday. Malls are open from 10am to 10pm, Monday through Saturday.

MONEY Most stores will accept credit cards, though you can often get a discount if you pay cash. Traveler's checks are not normally accepted.

Shopping from A to Z
BOOKS
Haddock Lobo Books and Magazines Open every day until midnight, this bookstore has an excellent selection of international magazines and books, including some guidebooks. If you can't find something, ask. Chances are the owner can dig it out for you. Rua Haddock 1503. © **011/3082-9449.** http://haddocklobo.com.br. Bus: 7392.

Livraria Cultura The flagship of one of Brazil's major booksellers has three floors of quality books plus a pleasant little cafe with free Wi-Fi. There's even a large selection of English-language novels and guidebooks. A number of smaller bookstores are in the same Conjunto Nacional mall. Open Monday through Friday 10am to 10 pm, Saturday and Sunday 2 to 8pm. Av. Paulista 2073, Cerqueira Cesar. © **011/3170-4033.** www. livrariacultura.com.br. Metrô: Consolação.

Mille Foglie Everything you ever wanted to read on cuisine is here. This bookstore/cooking school stocks over 3,000 titles on culinary topics, many in English. There's also a section on Brazilian cooking. Open Monday through Friday 11am to 8pm, and Saturday 10am to 2pm. Rua da Consolação 3542 (corner Oscar Freire), Cerqueira Cesar. © **011/3083-6777.** www.millefoglie.com.br. Bus: 7392.

FASHIONS
Huis Clos Huis Clos offers high-end women's fashions, in the heart of the city's most fashionable shopping district. Just don't look at the price tags. Rua Oscar Freire 1105, Jardins. © **011/3088-7370.** www.huisclos.com.br. Bus: 7110.

Mr. Kitsch Name aside, there's nothing tacky in Mr. Kitsch's excellent collection of fashionable menswear. The collection ranges from suits to trendy casual wear. Shopping Morumbi, Av. Roque Petroni Junior 1089, Morumbi. © **011/5181-9304.** www.mrkitsch.com.br. Bus: 5121 or 5154.

Rock Lily Just 2 years out of the gate, Rock Lilly mixes a classic vintage look with casual material (denim's a favorite) to create classy, kicky casual wear for women. Shopping Iguatemi, 3rd floor, Av. Brigadeiro Faria Lima 2232, Jardins. © **011/3814-0920**. www. rocklily.com.br. Bus: 7492.

Sinhá Those looking for elegant and fashionable clothing in plus sizes will have a hard time in Brazil. Most stores only stock up to size 42 (the equivalent of a North American size 12 or 14). Sinhá offers a beautifully designed collection, including evening wear, for sizes up to 52 (North American size 20). Shopping Pátio Higienópolis, Av. Higienópolis 618. © **011/3823-2519**. Bus: 508.

FOOD

Casa Santa Luzia The size of a grocery store, Santa Luzia is stuffed with luxury food products that can be impossible to find anywhere else in Brazil, including cold cuts, pastas, sauces, and cheeses, as well as sweets and desserts; the mango-and-passion-fruit-flavored mini gâteaux are to die for! Al. Lorena 1471 (corner with Rua Augusta), Jardins. © **011/3897-5000**. www.santaluzia.com.br. Bus: 7392.

GALLERIES

Galeria Estação This large and innovative gallery in the bohemian neighborhood of Pinheiros shows sculpture, woodcarvings, oils, and aquarelles, in a lovely warm display space. Rua Ferreira Arauko 625, Pinheiros. © **011/3813-72653**. www.galeriaestacao. com.br. Bus: 2496.

Galeria Fortes Vilaça This gallery represents over 20 Brazilian and international Brazil-based artists, including big names like Vik Muniz and Os Gemeos. Exhibits range from paintings to installation art, sculpture, and mixed media. Rua Fradique Coutinho 1500, Vila Madalena. © **011/3032-7066**. www.fortesvilaca.com.br. Metrô: Vila Madalena.

Galeria Luisa Strina One of the city's most venerable contemporary art galleries, Luisa Strina showcases work from young national and international artists, working in a variety of mediums: oils, bronze, glass, or photo art. The location is in the heart of the upscale Jardins shopping district. Rua Oscar Freire 502, Jardins. © **011/3088-2471**. www.galerialuisastrina.com.br.

GIFTS & SOUVENIRS

Arte Tribal Now just a block off the trendy Rua Oscar Freire, this little store is a great place for a different kind of souvenir: Brazilian native art, including necklaces, pottery, baskets, bags, and woodcarvings. The rear of the store showcases crafts from native peoples all over the world. Brazilian shirts, baseball caps, and other knick-knacks are also for sale. Rua Augusta 2795. © **011/3081-8170**. Bus: 7392.

Your Gallery Guide

For information on the city's galleries, pick up a copy of the *Mapa das Artes São Paulo* at the tourist office or check **www.mapadasartes.com.br**.

Casa do Amazonas Opened 30 years ago in Moema, this gallery/store offers art and craftwork from dozens of Amazonian tribes, among them the Karajá, Kaiapó, Tapirapé, Xavante, and Bororo. Offerings include furniture,

hammocks, baskets, musical instruments, masks, and other products in wood, cloth, and terra cotta. Al. dos Jurupis 460, Moema. ℂ **011/5051-3098. Bus 875 C or taxi from Luz metro station.**

JEWELRY

Antonio Bernardo The clean, modern, and inventive designs here are done mostly in gold, silver, and diamonds. Rua Bela Cintra 2063. ℂ **011/3083-5622.** www.antonio bernardo.com.br. Bus: 7392.

Sara Joias The high-end design at this store often uses Brazilian gemstones to create a unique collection of rings, bracelets, pendants, earrings, and more. Rua Haddock Lobo 1576. ℂ **011/3081-8125.** www.sarajoias.com. Bus: 7392.

MALLS & DEPARTMENT STORES

Shopping Iguatemi One of the more elegant malls in town, Iguatemi features high-end international and Brazilian brand names. On the top floor are a movie theater, a food court, and several full-service restaurants. Av. Brigadeiro Faria Lima 2232, Jardim Paulistano. ℂ **011/3816-6116.** www.iguatemisaopaulo.com.br. Bus: 775 or 637G.

Shopping Pátio Higienópolis This is a favorite mall even among shopping-mad Paulistas. Built in 1999, the entrance resembles a Victorian crystal palace, with large glass and wrought-iron doors and awnings. No department stores or large chains are in this mall; the shops are mostly high-end boutiques. There's also a children's play area. Av. Higienópolis 618. ℂ **011/3823-2300.** www.patiohigienopolis.com.br. Bus: 508 (from Paulista or Liberdade).

Shopping Pátio Paulista An elegant mall on Avenida Paulista, this place features clothing, books, a cinema, cafes, and several restaurants. Av. Paulista 52. ℂ **011/3145-8200.** www.shoppingpaulista.com.br. Metrô: Brigadeiro.

Villa Daslu This place offers shopping with a capital S. Daslu offers 17,000 sq. m (182,986 sq. ft.) of luxurious upscale shopping. Uniformed staff guide you through the maze, while strategically placed espresso bars keep you energized with complimentary hits of caffeine. A large part of the women's department is off-limits to men. Daslu offers some of the best-known international designers such as Prada, Dolce & Gabbana, Dior, Armani, and Gucci as well as an array of Brazilian names. Daslu also sells home decorating items, jewelry, sporting goods, video equipment, and even cars. Av. Chedid Jafet 131, Vila Olimpia. ℂ **011/3841-4000.** www.daslu.com.br. Taxi recommended, though Daslu also offers a helicopter pad.

MUSIC

The city's mega-bookstores, ironically enough, are the best place to find a wide variety of Brazilian music. **Livraria Cultura** (www.livrariacultura.com.br) has an extensive collection of CDs in its two São Paulo megastores: one in the Conjunto Nacional (ℂ **011/3170-4033**), the other in the Villa Daslu mall (ℂ **011/3170-4058**). The **FNAC** flagship store (Av. Paulista 901; ℂ **011/2123-2000;** www.fnac.com.br) offers a whole floor of Brazilian and international CDs. Finally, in the Pátio Paulista mall on the Avenida Paulista is the **Saraiva Megastore** (Av. 13 de Maio 1947; ℂ **011/3171-3050;** www.livrariasaraiva.com.br).

Casa Amadeus This place has a great selection of Brazilian sheet music and very helpful staff. There's also a good variety of musical instruments: *cavaquinhos* (a

Brazilian mandolin), percussion instruments, and hand-held rattles and shakers. Rua Quintino Bocaiuva 22, Centro. ℭ **011/3101-6790.** Metrô: Republica.

PERFUMES

O Boticario Long before aromatherapy became a household term, O Boticario was already using fresh flowers and herbs to create its light fragrances. It now has a line of body products and makeup, but the bestsellers are still the perfumes. Look for several locations throughout the city. Rua Augusta 2887, Cerqueira Cesar. ℭ **011/3898-2973.** Bus: 7392.

SHOES

Banana Price Banana Price offers a huge collection of national and international designers at low prices, including heavily discounted collections from Nine West, Red's, Massimo, and Dilly. Other leather products available include bags, purses, and belts. Al. Lorena 1604. ℭ **011/3081-3460.** Bus: 7392.

Melissa Here you'll find high-end shoe designs, sold from a funky '60s *Barbarella*-style showroom where actual shoes don't appear. Instead, you scroll through the designs on offer on a video terminal, the pretty young clerks then bring you whatever catches your fancy. Rua Oscar Freire 867, Jardins. ℭ **011/3083-3613.** Bus: 7392.

SÃO PAULO AFTER DARK

If Sinatra had known about São Paulo, he would never have given the "city that never sleeps" title to New York. Most Paulistas won't even *set foot* in a club until midnight. Take a cab into Vila Olímpia around the witching hour, and you'll find yourself in a traffic jam formed by everyone just heading out for the evening.

Less casual than Cariocas, Paulistas love to dress up when going out. Women are partial to black or other dark colors. Men are less formal. Good casual is fine, but jeans and running shoes likely won't make it past the door at many clubs.

To catch the big names in Brazilian music, São Paulo is the place. The city gets more of the stars, playing more often, than any other city in Brazil. São Paulo also offers a variety of theater, dance, opera, and classical music.

An excellent source of arts and entertainment information is the **Guia da Folha,** an entertainment guide published in the Friday *Folha de São Paulo* newspaper. In addition to theater and concert listings, it includes bars and restaurants (with updated hours and phone numbers) as well as exhibits and special events. On the first page is a useful overview of all the free events that week, titled in Portuguese *é gratis.* The guide also includes details on upcoming concerts (*shows* in Portuguese) and events at nightclubs (*casas noturnas*). **Veja** magazine (Brazil's equivalent of *Newsweek*) comes out every week on Sunday and includes a separate entertainment guide called *Veja São Paulo;* many hotels provide this insert for free. For vultures of high culture, the cultural department of the state government puts out a listing magazine every

In São Paulo, Know Your Club Lingo!

The word *boate* or *boite* used in Rio for a nightclub or dance club refers in São Paulo almost exclusively to a strip or sex club.

return OF THE RUA AUGUSTA

A streetwalker's stroll for much of the 1990s, the stretch of Rua Augusta close to Centro has made a comeback as the locale for the city's hottest dance and music venues. **Club Outs,** Rua Augusta 486 (② **011/3237-4940;** www.clube-outs.com; cover R$10), offers live alternative rock, starting at midnight and continuing until 5am. For the GLS crowd there's **Studio SP,** Rua Augusta 591 (② **011/3129-7040;** www.studiosp.org; Wed–Sat doors at 11pm, shows at midnight; cover R$20–R$30), all about live music and shows, with just about everything on offer. Located in a former butcher shop, **Z Carniceria,** Rua Augusta 934 (② **011/2936-0934;** www.zcarniceria.com.br; Tues–Sun 7pm–1am; cover R$20), has become a whole new meat market for the local hip crowd. Down below at **Inferno,** Rua Augusta 501 (② **011/3120-4140;** www.inferno club.com.br; Wed–Sun midnight–6am; cover R$10–R$50), it's live music—rock, funk, rap—in a venue with diabolically good acoustics. And then there's **Vegas,** Rua Augusta 765 (② **0911/3231-3705;** www.vegasclub.com.br; Wed–Sat 11:30pm–7am; cover R$15–R$40), where some of the city's best DJs are invited to spin, often for over-the-top theme nights.

month, *Revista Cultural,* with details on classical music, dance, theater, and exhibits.

The Performing Arts

São Paulo is considered—both by Paulistas and grudgingly by Cariocas—to be the cultural capital of Brazil. The classical music scene is excellent, and the theater scene positively thriving.

Estação Julio Prestes/Sala São Paulo The setting is glorious, in the soaring main hall of a grand railway station that's found a second life as a cultural center. Acoustical engineers did a brilliant job on the adaptation; the acoustics are said to be near perfect. The São Paulo Symphony Orchestra (www.osesp.art.br) now makes its home here. The inexpensive Saturday afternoon concerts often sell out. For concert information, check the website under *"programmação e ingressos."* Praça Julio Prestes s/n. ② 011/3367-9500. www.salasaopaulo.art.br. Tickets R$25–R$100. Metrô: Luz.

Teatro Municipal This elegant 19th-century building provides the perfect backdrop for any performance. São Paulo's city opera company, ballet company, and city symphonic orchestra all make their homes here. The theater is also home to a pair of choral companies, an experimental orchestra, and a music school. Check the website listings (look under *"programação"*) for lunchtime concerts, the perfect way to break up a day of sightseeing or shopping. Praça Ramos de Azevedo s/n. ② 011/3397-0327. www. teatromunicipal.sp.gov.br. Metrô: Anhangabaú.

Music & Dance Clubs

Large and varied, São Paulo's nightlife scene is also quite spread out, with little entertainment clusters in neighborhoods all over town; barhopping is really more like car hopping. Best to pick a neighborhood, enjoy dinner, and then grab a drink or catch a

show at a club nearby so you don't waste time and cab dollars stuck in one of São Paulo's late-night traffic jams. **Vila Olímpia** is where the 18- to 30-year-olds go for nightlife, with a number of large dance clubs and some of the city's best bars. **Vila Madalena** is more in vogue with the 25- to 45-year-olds who enjoy bars and restaurants more than dance clubs.

Many bars and clubs charge a drink minimum instead of or in addition to a cover charge. Patrons receive a slip of paper on arrival. All your expenses are recorded on the card and tallied up when you leave. Lose the card and you get charged a steep maximum fee (the assumption being that you've been on a bender all night).

LIVE MUSIC

Bar Camará This bar-and-restaurant establishment offers three spaces in one—a large indoor atrium graced with tall tropical trees, one of the most graceful spots in the city to quaff a draft, plus an upstairs terrace with a fine view of the city, and a second floor bar with live music 7 nights a week. Clientele are upscale and in their late 20s to mid-30s. Open Tuesday to Friday 6pm till 4am, Saturday 1pm till the last client leaves, and Sunday 3:30pm to 10pm. Rua Luís Murat 308, Vila Madalena. ✆ **011/ 3816-6765.** www.barcamara.com.br. Cover R$7–R$18.

Black Bom Bom This venerable São Paulo venue specializes in rap, hip-hop, and Rio de Janeiro–style funk, sometimes with a DJ, but more often live. Open Thursday and Saturday midnight to 6am. Rua Luis Murat 370, Vila Madalena. ✆ **011/3813-3365.** www. blackbombom.com.br. Cover R$20–R$30.

Bourbon Street Music Club In the land of samba and *forró* it can be hard to find a club with blues and jazz on the menu. Such is Bourbon Street. This midsize venue with the signature piano-shaped bar is the place for a well-mixed drink and the sounds of jazz or blues, with a smattering of bossa nova or salsa. Doors open at 9pm; the show starts at 10:30pm (11:30pm on Fri–Sat). Rua dos Chanes 127, Moema. ✆ **011/ 5095-6100.** www.bourbonstreet.com.br. Cover R$15–R$35. Bus: 5154.

Grazie a Dio! For 10 years and counting, this combo bar and restaurant has been one of the best places in the city for live music almost any day of the week. Expect anything from pop to samba-rock to salsa or merengue. Shows start at 10pm and cover rarely exceeds R$20. Open Sunday through Thursday 8pm to 1am, Friday through Saturday 8pm to 3am. Rua Girassol 67, Vila Madalena. ✆ **011/3031-6568.** www. grazieadio.com.br. Metrô: Vila Madalena.

HSBC Brasil This is one of the city's best midsize venues, dedicated to Brazilian MPB. The new custom-built complex hosts big names such as Lulu Santos and Jorge Ben. Ticket prices range from R$50 to R$150. Rua Bragançao Paulista 1281, Chácara Santo Antonio. ✆ **011/4003-1212.** www.hsbcbrasil.com.br. Bus: 675N.

Morrison Rock Bar Downstairs at Morrison it's all rock all the time, be it covers of Brazilian and international bands or original local acts. Upstairs it's the Morrison Hotel, a cozy bar with sofas where you can listen to the music from below, albeit at a lower volume. Open Thursday to Saturday 9pm to 4am. Rua Inácio Pereira da Rocha 362, Vila Madalena. ✆ **011/3814-1022.** www.morrison.com.br. Cover R$15–R$25.

Piu Piu Now in its second decade, this downtown venue still hops with a range of Brazilian contemporary artists, from rock to samba to jazz. Tickets run from R$10 to

ON THE radar: VILA OLIMPIA

In addition to Vila Madalena, São Paulo's other happening nighttime neighborhood is currently Vila Olimpia. Packed with clubs and bars, it's always busy, even on weeknights. Many of the more popular bars are concentrated on the **Rua Prof. Atilio Innocenti.** At Atilio Innocenti 780 is the **Buena Vista Club** (✆ **011/3045-5245;** www.buenavista-club.com.br). Despite the name, the music is only a little Cuban and a lot Brazilian, live from Wednesday to Saturday. For real Cuban and Latin music, head to **Rey Castro,** Rua Min. Jesuino Cardoso 181 (✆ **011/3842-5279;** www.reycastro.

com.br), where mojitos, salsa, and meringue fuel the night. **All of Jazz,** Rua João Cachoeira 1366 ((✆ **011/3849-1345;** www.allofjazz.com.br), offers great live jazz from Monday to Saturday. The cover ranges from R$10 to R$25. To take some music home, check out the CD store upstairs. Packed with large-screen TVs, **Vila Rica,** Rua Min. Jesuino Cardoso 299 (✆ **011/3845-3859;** www.botecovilarica.com.br), draws lots of soccer fans during game times. Pick a side and join the locals in cheering for their team.

R$20. Rua Treze de Maio 134, Bela Vista. ✆ **011/3258-8066.** www.cafepiupiu.com.br. Metrô: Brigadeiro.

Samba The interior of this Vila Madalena hot spot features a 16m-long (52-ft.) collage of photos of famous sambistas of yore. Wednesdays onward the house moves to the sound of live samba. Open Wednesday to Sunday 7pm to 2am. Rua Fidalga 308, Vila Madalena. ✆ **011/3819-4619.** Cover R$10–R$20. Bus: 109P.

DANCE CLUBS

Azucar Azucar offers salsa and merengue most nights of the week, with free lessons Tuesday to Thursday. Doors open at 7pm daily, but things don't really get moving until after midnight. The relatively steep cover attracts a more mature (30- to 45-year-old) and upscale crowd. Rua Mario Feraz 423, Itaim Bibi. ✆ **011/3074-3737.** www.azucar.com.br. Cover R$15; entrance between R$23–R$42. Bus: 107P.

D-Edge São Paulo's hottest dance club features wall-long monster woofers, a *Saturday Night Fever* flashing disco floor, and some of the hottest heaviest funk beats this side of Birmingham. The crowd possesses youth, money, and energy in abundance. Open Wednesday through Friday midnight to 6am and Saturday midnight to 10am. Al. Olga 170, Barra Funda. ✆ **011/3667-8334.** www.d-edge.com.br. Drink minimum R$50–R$60. Bus: 115P.

Lounges, Bars & Pubs
LOUNGES
Bar des Arts This is the place to go when you're trying to convince that would-be partner that, appearances to the contrary, you really do have a sweet and sensitive side. Set in a large garden beneath mature trees, the tables surround an Italian marble fountain whose soft gurgling combines with the flickering candlelight to create a feeling of magic. Open Tuesday through Sunday noon to 1am. Rua Pedro Humberto 9, Chacara Itaim (behind the gas station). ✆ **011/3074-6363.** www.bardesarts.com.br. Bus: 106A.

Piratininga Bar Open since 1982, this small bar features a wonderful warm atmosphere, composed equally of cozy decor, piano on the mezzanine tinkling out jazz and MPB, and a selection of whiskeys and liquors from the bar. Come for a drink after dinner, or come earlier, sip whiskey, and graze from the extensive menu of snacks. Open Monday through Saturday 6pm to 3am, Sunday 3pm to 1am. Rua Wisard 149, Vila Madalena. 🕿 **011/3032-9775.** www.piratiningabar.com.br. Cover R$10. Metrô: Vila Madalena.

BARS & PUBS

Bar Brahma Since 1948, Bar Brahma has been the meeting place for intellectuals, musicians, politicians, and businessmen. Renovations have restored the original wooden and bronze furnishings, and the chandeliers once again illuminate the crowds that gather to chat and drink beer. Open daily 11am to 2am, Friday till 4am, Saturday and Sunday until the last guest leaves. Av. São João 677, Centro. 🕿 **011/3333-0855.** www.barbrahmasp.com. Cover R$10–R$68. Metrô: República.

Filial A great place for a drink and a talk, Filial features a vast collection of bottles lining the walls, intermingled with sports photos from the 1950s. Tables are occupied by youngish clientele quaffing draft beer and nibbling from the snacks menu. Open daily noon to 1am. Rua Fidalga 254, Vila Madalena. 🕿 **011/3813-9336.** www.barfilial.com.br. Metrô: Vila Madalena.

Jacaré Grill There's an extensive menu of grilled meats on offer here, but the real reason locals flock here is to see and be seen, flirt, talk, and meet friends. The two large patios on opposite street corners offer maximum exposure to your fellow patio mates. Open Tuesday through Saturday noon to midnight, Sunday noon to 8pm. Rua Harmonia 321–337, Vila Madalena. 🕿 **011/3816-0400.** www.jacaregrill.com.br. Cover R$15–R$35. Metrô: Vila Madalena.

Madeleine This cozy, small bar/restaurant features exposed red-brick walls, warm candlelight, and the syncopated bop-bebop of bossa nova and jazz, the perfect accompaniment to a meal or snack of wood-fired pizza washed down with a chopp or red wine by the glass. Open Monday to Saturday from 7pm. Rua Aspicuelta 201, Vila Madalena. 🕿 **011/2936-0616.** www.madeleine.com.br. Cover R$10. Metrô: Vila Madalena.

MYNY Bar São Paulo's bar du jour (or *nuit*, rather) is a classy New York–style bar with towering bar shelves and cozy exposed brick walls. The drink list features 24 elegant cocktails made with infusions, fresh fruit juices, and even flavored ice cubes. Check out the specials prepared with seasonal ingredients. Open Monday to Wednesday from 6pm to 1:30am, Thursday and Friday from 6pm to 2:30am, Saturday from noon to 3:30am, and Sunday from noon to 5pm. Rua Pedroso Alvarenga 1285, Itaim Bibi. 🕿 **011/3071-1166.** www.mynybar.com.br. Taxi recommended.

 Late-Night Bite

If you find yourself with an appetite at 4am, try the **Paris 6 Bistro,** Rua Haddock Lobo 1240 (🕿 **011/3085-1595;** www.paris6.com.br), a French brasserie in the Jardins neighborhood open 24 hours a day, 7 days a week.

Pirajá It's all so very Rio de Janeiro. Lots of tables on the sidewalk, lots of people out for a beer and a chat with friends, while eternally surly waiters serve up a never-ending stream of chopp. Undeniably Paulista, however, are the fashion sense of the crowd and the high quality of the food. Nibbles include an outstanding cold-cut buffet with a huge variety of cheeses, olives, sun-dried tomatoes, and marinated mushrooms. Open Monday through Wednesday noon to 1am, Thursday to Saturday noon to 2am, and Sunday noon to 7pm. Av. Brigadeiro Faria Lima 64, Pinheiros. © **011/3815-6881.** www.piraja.com.br. No cover. Bus: 7214.

Gay & Lesbian Bars

A Lôca To dance yourself silly until the sun comes up, head to A Lôca. DJs spin a highly eclectic mix of disco, pop, and house. A Lôca also hosts occasional drag shows and special events. Check the website for upcoming events. Open Tuesday to Saturday starting at midnight; Sunday the door opens at 7pm. Rua Frei Caneca 916, Bela Vista. © **011/3159-8889.** www.aloca.com.br. Cover R$10–R$25. Metrô: Consolação.

Cantho If you think that the music used to be better way back when, then this is the place to be. Mega dance club Cantho spins lots of tunes from the '70s, '80s, and '90s, as well as some contemporary big hits. There is no time like the present to channel your inner Cher and Donna Summer. Open Friday through Sunday, starting at 11pm. Largo do Arouche 32, Centro. © **011/3723-6624.** www.cantho.com.br. Cover R$10–R$25. Metrô: Republica.

Farol Madalena Although GLS, the emphasis in this busy little club is definitely on the *L* for lesbian. The bar has live Brazilian music most evenings. It's open Wednesday to Saturday from 7pm to 1am, and Sunday from 4pm to midnight. Rua Jericó 179, Vila Madalena. © **011/3032-6470.** www.farolmadalena.com.br. Cover R$8 plus R$12 consumption minimum. Metrô: Vila Madalena.

Vermont Itaim On the ground floor of a commercial building, the Vermont offers live music and a young crowd most nights—MPB on Wednesday, danceable pop Thursday through Saturday. The boys predominate through the week and on Saturday, but Sunday the girls take over with a nine-woman samba band. Open Monday to Thursday 6:30pm to 2am, Friday to Saturday 8pm to 4am, Sunday 4:30pm to midnight. Rua Pedroso Alvarenga 1192, Itaim Bibi. © **011/3071-1320.** www.vermontitaim.com.br. Cover R$15. Taxi recommended.

SALVADOR & THE BEST OF BAHIA

A visit to Salvador is a chance to step back in time, to stroll through a perfectly preserved city from the 16th and 17th centuries. It's a chance to experience Brazil's close connection to Africa—to taste this connection in the food, hear it in the music, see it in the faces of the people. All of these elements—architecture, food, and music—mix together in Pelourinho, the restored colonial heart of the city of Salvador.

Beyond Salvador, a trip to Bahia is a chance to stock up on two of Brazil's greatest nonexportable products—sand and sunshine. The beaches of Bahia are some of Brazil's most varied and beautiful. They come blessed by sunshine, lapped by a warm southern ocean, and infused with a laid-back spirit that is uniquely Bahian.

The Italian navigator Amerigo Vespucci—the one who later gave his name to a pair of continents—was the first European to set eyes on the Baía de Todos os Santos, the beautiful bay around which Salvador now stands. He arrived in the service of the king of Portugal on November 1, 1501. By 1549, the new colony of Salvador was important enough that the Portuguese king had a royal governor and a small army to protect it from the French and Dutch.

The wealth of the new colony was not in silver or gold, but something almost as lucrative: sugar. Sugar cane thrived in the Northeast. As plantations grew, the Portuguese planters found themselves starved for labor, and so plunged headfirst into the slave trade. By the mid–19th century, close to five million slaves had been taken from Africa to Brazil.

The wealth earned by that trade is evident in the grand mansions and golden churches in Pelourinho. The legacy of the slave trade is also reflected in the population. Modern Salvador is a city of two million, and approximately 80% of its people are of Afro-Brazilian descent.

This heritage has had an enormous influence on Salvador's culture, food, religion, and especially its music. Even in a country as musical as Brazil, Bahia stands out. A new term has been coined to describe Bahia's Afro-Brazilian blend of upbeat dance music: *axé*, from the Yorubá word for energy. Over the past 2 decades, groups such as Olodum and Timbalada have blended complex African drumming rhythms with reggae melodies, while adding some social activism to the mix.

Capoeira, the balletic mix of martial arts and dance, is now seen on almost every Salvador street corner. The African religious practice of Candomblé is also emerging from generations in the shadows.

The past few decades have seen the resurrection of Salvador's Pelourinho neighborhood. Derelict until as recently as the 1980s, Pelourinho—the 16th-century heart of what was once the richest city on the Atlantic coast—has been painstakingly brought back to its former glory.

And then there's Carnaval. Over a million people now come out to dance and revel their way through the city's streets. Salvador may soon claim to hold the biggest street party in the world.

ESSENTIALS

1,206km (749 miles) NE of Rio de Janeiro, 1,437km (893 miles) NE of São Paulo

Getting There

BY PLANE Azul ((✆ 071/4003-1118; www.voeazul.com.br), **Gol** ((✆ 0300/115-2121; www.voegol.com.br), **TAM** ((✆ 071/4002-5700; www.tam.com.br), **TRIP** ((✆ 071/3003-8747; www.voetrip.com.br), and **Webjet** ((✆ 0800/723-1234; www.webjet.com.br) all fly from Rio, São Paulo, Recife, Brasilia, and other places with connections.

The modern **Aeroporto Deputado Luis Eduardo Magalhães** ((✆ 071/3204-1010), Salvador's international airport, is 32km (20 miles) from downtown. The bank machines are all in the arrivals hall area, to the right at the end of the corridor (past the office for Costa do Sauípe). Cambio Gradual offers 24-hour money-changing services.

To reach your hotel, **Coometas** taxi ((✆ 071/3244-4500) offers prepaid fares. The trip to **Pelourinho** costs R$107 and to **Rio Vermelho** R$97. Regular taxis are a little bit cheaper; on the meter a taxi from the airport to Pelourinho costs around R$90 and to Rio Vermelho R$70.

If you have very little luggage, an inexpensive airport-to-Pelourinho bus runs along the coast, stopping close to (though not at) most of the hotels located along the beach road. Its final stop is Praça da Sé on the edge of Pelourinho. The bus runs daily from 7am to 8pm; the cost is R$3.

BY BUS Bus travelers go through the **Terminal Rodoviaria de Salvador Armando Viana de Castro,** usually simply known as **Rodoviaria.** It's located at Av. ACM (Antônio Carlos Magalhães) 4362, Iguatemi ((✆ 071/3460-8300). For ticket information and schedules, travelers need to contact the specific bus company directly. However, the general bus station number will tell you which company to phone. **Itapemirim** ((✆ 071/3392-3944) travels to Recife and Rio de Janeiro; **Real Expresso** ((✆ 071/3246-8355) has scheduled service to Lençóis for people traveling to the Chapada Diamantina (see "Side Trips from Salvador," later in this chapter); **São Geraldo** travels to destinations like Natal and São Paulo ((✆ 071/3244-0366).

City Layout

The coastal part of Salvador is quite easy to navigate. Picture a wedge thrusting out into the ocean. One side of the wedge borders the Atlantic Ocean, the other side borders the bay (the **Baía de Todos os Santos**). The two sides meet at **Farol da Barra,** the skinny point of the wedge.

Greater Salvador

HOTELS ■
Catharina Paraguaçu **13**
Estrela do Mar **9**
Ibis Rio Vermelho **17**
Monte Pascoal Praia
 Hotel **10**
Pestana Bahia/Pestana
 Bahia Lodge **16**
Pousada Noa Noa **8**
Zank Boutique Hotel **12**

RESTAURANTS ◆
Amado **3**
Barravento **11**
Companhia da Pizza **16**
Dona Mariquita **15**
Fogo do Chão **14**
Pereira **7**
SOHO **5**

ATTRACTIONS ●
Forte São Marcelo **2**
Museu de Arte Sacra **4**
Museu Nautico da Bahia/
 Farol da Barra/Forte de
 Santo Antônio **7**
Nosso Senhor do
 Bonfim **1**
Solar do Unhão **6**

See "Salvador's
Centro Histórico" map

0 1/2 mi
0 0.5 km

RIBEIRA

ATLANTIC
OCEAN

Manaus Belém
Amazon Natal
B R A Z I L Recife
 Brasília
São Paulo Rio de
 Janeiro
500 mi
500 km

BONFIM

MASSARANDUBA

SÃO CAETANO

R. S. Francisco
Av. Imperatriz
Av. D. de Bonfim
Av. L. Tarquinio
C. de Areia
Jardim Castro
Rezende Costa
R. Unguay
R. Regis Pacheco
Av. Suburbana
ROMA
R. F. de Cunha
Av. N. Duare
R. Melo
Av. S. Martin
R. do Corzu
FAZENDA
GRANDE
R. Moraes Filho
R. Barros Reis
Av. S. Martin

*Bahia de
Todos os Santos*

CAIX
D'ÁGUA
*Parque da
Embasa*
R. S. Marinho
R. Lima e Silva
R. Oscar Pontes
Av. Jequitaia
Est. da Rainha
R. P. Miudo
Lad. do Ipiranga
R. Barros Reis
CIDADE
NOVA
Av. Barros Reis
R. do Rodoviarios
Acesso Norte
324

SÃO CAETANO

Av. da França
D. de S. Antônio
Av. Castelo Branco
NAZARÉ
Av. Barros Falcão
Prof. Luiz Anselmo
MATATU
Av. Bonoco
C. de Brotas
Av. S. de Compostela

CENTRO
HISTÓRICO

TORORO
Av. J. Angelica
Av. C. Gomes

Av. Ogunja
Av. Dom João VI
Av. Vasco da Gama
FEDERAÇÃO
CANDEAL
*Parque da
Cidade
J.Silva*
Est. de Santa Cruz
R.Waledemar Falcão
Av. Juracy
Av. Vale depedrinhas
R.Vale do Canela
R. C. Moura
GRAÇA
R. P. Isabel
Av. 7 de Setembro
Av. Centenario
Av. S. Silva
ALTO DAS
POMBAS
A. de Barros
R. Anita Garibaldi
R. A. Santana
*Parque
Zoobotánico*
ONDINA
Av. Oceanica
BARRA
C. A. Celso
Av. Oceanica
RIO
VERMELHO
Av. O. Cruz
Av. Amaralina

ATLANTIC OCEAN

225

Perched on a high cliff on the bay side of the wedge one finds **Pelourinho,** the historic old downtown. This area is also sometimes referred to as the **centro histórico,** or as the **Cidade Alta,** the upper town. This is Salvador's chief area of interest. At the foot of the cliff lies **Comércio,** a modern area of commercial office towers. This area is also sometimes known as the **Cidade Baixa,** or lower town. Upper town and lower town are connected via a cliff-side elevator, the **Elevator Lacerda.** Except for the fun of riding the elevator, and visiting a large crafts market called the **Mercado Modelo,** there's little reason to visit Comércio (the downtown business neighborhood).

About 8km (5 miles) north of Pelourinho, the **Bonfim** peninsula juts out into the bay. Located on a headland on this peninsula is one of Salvador's most famous landmarks, the **Church of Our Lord of Bonfim,** source of many reputed miracles. The area between the church and Pelourinho is occupied by the port, rail yards, and working-class housing.

The photogenic point where All Saints Bay meets the Atlantic is marked by a tall white lighthouse, called the **Farol de Barra.** The point is also home to the sizable **Forte Santo Antônio de Barra,** which also contains the **Naval Museum.** The strip of beach (**Praia da Barra**) that stretches beyond the lighthouse toward Ondina has seen better days but is still one of the most popular gathering places during Carnaval.

The road running from the lighthouse out along the oceanside is called **Avenida Oceanica.** The road continues past a number of good hotels to the oceanside neighborhood of **Ondina.** From here, road names change frequently, and neighborhoods come thick and fast; **Rio Vermelho, Amaralina, Pituba, Costa Azul, Jardim de Alah, Armação, Piatã, Itapuã,** all the way to **Stella Maris** adjacent to the airport all hug the coastline. Except for a few spots where locals like to gather on weekends, such as **Porto da Barra, Jardim de Alah,** and **Itapuã,** the beaches are mostly deserted.

Getting Around

ON FOOT The old historic center, Pelourinho, can only really be experienced on foot and the main streets are mostly car-free. The narrow streets and cobblestone alleys open onto large squares with baroque churches; the stately mansions and homes now house shops, galleries, and wonderful little restaurants.

> **Be Kind to Your Feet in Salvador**
>
> Wear comfortable shoes in Salvador; high heels are both imprudent and uncomfortable on the large, uneven cobblestones and steep streets.

The Cidade Baixa, around the Mercado Modelo, and the commercial heart of Salvador in Comércio are also pedestrian-friendly neighborhoods, but less safe at night and on weekends, when they get quite deserted. The dining and nightlife attractions in Rio Vermelho are almost all within walking distance from the two main squares in the neighborhood.

BY BUS Salvador's neighborhoods of interest all hug the ocean and are connected by one main avenue that winds along the coast and then leads into downtown, ending just steps from the historic center. Once downtown all the attractions are within walking distance of each other. As long as you have a general idea of the order of the beaches, you should be able to find your destination, as a bus from downtown

traveling to the far-off beach of Itapuã via Ondina will automatically stop at all the beaches in between. Buses are marked by name; the main buses for travelers going from any of the beach neighborhoods to downtown are marked PRAÇA DA SE for Pelourinho or COMERCIO for the lower town. To travel to the city's main bus station (or the large mall across from the bus station) take buses marked IGUATEMI or RODOVIARIA. When leaving downtown for the beaches, take a bus that says VIA ORLA, which means along the coast, and make sure that the bus's final destination lies beyond the beach neighborhood you want to reach. Along the coast, you have the option of taking a regular bus, for R$2.50, or an air-conditioned bus, called a *frescão,* for R$4

Know the Hours for Exchanging Money

Note that most banks will change money only during certain hours, often 11am to 2pm. The safest place to withdraw money from ATMs in the evenings or on weekends is in shopping malls.

to R$6. These are more comfortable, but then again if there are three or four of you, a *frescão* is almost the same price as a taxi.

BY TAXI Local taxis can be hailed on the street or from any taxi stand. To book a radio taxi contact **Radiotaxi** (✆ 071/3243-4333) or **LigueTaxi** (✆ 071/3357-7777). You usually pay a surcharge of R$3 to R$5, but these taxis have air-conditioning and are usually new vehicles. Also, these two companies accept credit cards and can be reserved ahead of time.

BY CAR There is no need to drive in Salvador; the historic center of Pelourinho has no parking, and many of the streets are closed for traffic. To get between the city and the beaches, buses are quick and convenient, and taxis are readily available. Outside of Salvador, a car can be useful; see "Car Rentals" under "Fast Facts: Salvador," below, for information.

Visitor Information

Bahiatursa, the state's tourist information service, has booths and kiosks throughout the city. The friendly staff only have a limited number of brochures in stock, but they are usually quite happy to help you with general information. There are Bahiatursa booths at the following locations: **Salvador International Airport** in the arrivals hall (✆ 071/3204-1244), open daily from 7:30am to 10pm; **Rodoviaria** (✆ 071/3450-3871), open daily from 8am to 8pm; **Mercado Modelo,** Praça Cayru 250, Cidade Baixa (✆ 071/3241-0242), open Monday through Saturday 9am to 6pm and Sunday from 9am to 1pm; and **Pelourinho,** Rua das Laranjeiras 12 (✆ 071/3321-2463), open daily from 9am to 8pm. The Bahiatursa website (www.bahia.com.br) offers loads of useful information in English. For quick questions and information, visitors can also call the 24-hour telephone service (in Portuguese, Spanish, and English), **Disque Bahia Turismo** (✆ 071/3103-3103).

[FastFACTS] SALVADOR

Area Code The area code for Salvador is **071.**

Banks In Salvador, you'll find **Banco do Brasil**

branches at Praça Padre Anchieta 11, Pelourinho (✆ 071/3321-9334), or Rua Miguel Bournier 4, Barra

Avenida, parallel to the Avenida Oceanica (✆ 071/3264-5099), and **Citibank** branches at Rua Miguel

Calmon 555, Comércio, close to the Mercado Modelo (☎ 071/3241-4745), or Av. Almirante Marques Leão 71, Barra (☎ 071/4009-6310). All have ATMs.

Business Hours Stores are open 9am to 6pm Monday through Saturday, and closed on Sundays. Pelourinho's stores open Sunday afternoon. Shopping centers open Monday through Saturday from 10am to 8pm; on Sunday malls are closed except for the movie theater. Banks are open Monday through Friday from 9am to 3pm, but exchanging money may be restricted to 11am to 2pm.

Car Rentals **Avis,** Av. Oceânica 2294, 3097, Ondina (☎ 071/3251-8500); **Hertz,** Salvador International Airport (☎ 071/3377-3633); **Localiza,** Av. Presidente Vargas 3057, Ondina (☎ 071/3173-9292); and **Unidas,** Salvador International Airport (☎ 071/3251-8500), all have offices in Salvador.

Dentist **Salvadent**, Rua Conde Filho 87, Graça (☎ 071/3332-9393; emergency number ☎ 071/8818-9603), is a 24-hour dental clinic.

Emergencies For police dial ☎ 190; for fire and ambulance dial ☎ 193.

Hospitals In an emergency, go to **Hospital Portugues,** Av. Princesa Isabel 2, Barra (☎ 071/3203-5700), or **Hospital Aliança,** Av. Juracy Magalhães 2096, Rio Vermelho (☎ 071/3350-5600).

Internet Access For Internet access, go to **Bahia Café.com,** Praça da Sé 20, Centro (☎ 071/3322-1266); **Internet Café.com,** Rua João de Deus 2, Pelourinho (☎ 071/3331-2147), and Av. Sete de Setembro 3713, Barra (☎ 071/3264-3941); or **Pelourinho Virtual,** Largo do Pelourinho 2 (☎ 071/3323-0427). Most are open daily, and rates range from R$6 to R$10 per hour.

Mail There is a post office in Pelourinho at Largo do Cruzeiro de São Francisco (☎ 071/3321-8787). There is also a post office at the airport.

Maps The tourist office has free booklets with small maps of the main tourist areas.

Pharmacies Try **Farmacia do Farol,** Av. Sete de Setembro 4347, Barra (☎ 071/3264-7355), or **Farmacia Santana,** Av. Antônio Carlos Magalhães 4362, at the bus station (☎ 071/3450-3599), open 24 hours. Most pharmacies will also deliver 24 hours a day. Ask at the hotel reception or call ☎ 136 to find the nearest pharmacy.

Safety Salvador's main sightseeing areas are heavily policed and safe. However, as tourism numbers have dropped in Pelourinho as a result of the economic crisis, the area has once again become more of a target for petty crime. Follow some common-sense precautions: Don't carry valuables or excessive

amounts of cash, or display expensive camera equipment unnecessarily. At night, stick to the main streets where there is more foot traffic and surveillance. In Pelourinho, stick to the main squares, the Terreiro de Jesus and the Largo Pelourinho, and the three main streets that connect the two squares. The Cidade Baixa around the Mercado Modelo and the commercial heart of Salvador in Comércio are less safe at night, and mostly deserted on the weekends.

Taxes The city of Salvador charges a 5% accommodations tax, collected by hotel operators. This amount will be added to your bill. There are no other taxes on retail items or goods.

Time Zone Salvador is on the same time zone as Rio de Janeiro and São Paulo, 3 hours behind GMT. However, unlike the south of Brazil, Bahia and a few other states in the north and northeast have no daylight saving time.

Toilets Public washrooms are scarce, except during big events like Carnaval when the city provides chemical toilets. Your best bet is to try a hotel or ask nicely at a restaurant.

Visa Renewal For visa extensions, go to the **Policia Federal,** Av. Oscar Pontes 339, lower city (☎ 071/3319-6082). The fee is R$75. You may need to show a return ticket and proof of sufficient funds to cover your stay.

Weather Salvador has a tropical climate, with an average temperature of 26°C (78°F) year-round. With over 2,220 hours of sunshine a year, there is little precipitation; most of it falls between April and August when brief heavy showers are common. Summer clothes can be worn year-round, and fashions are very casual. But even in summer there is often a cool breeze coming in off the ocean. If you plan to go to the interior (Chapada Diamantina) or do a lot of boating, bring a few pieces of warm clothing.

WHERE TO STAY

For visitors, it's really a choice of staying either in the heart of historic Pelourinho or in modern Rio Vermelho, the heart of Salvador's restaurant and nightlife scene. Pelourinho offers a number of comfortable pousadas, most of them located in restored historic buildings. Rio Vermelho, on the other hand, offers modern, comfortable hotels, nearby beaches, and plenty of great restaurants and bars. Once Salvador's prime beach area, Barra (near the Farol da Barra lighthouse) has lost much of its former glory. We recommend staying here only for Carnaval as it still is party central during Salvador's biggest street party.

Salvador's peak season ranges from mid-December to early March and maxes out during Carnaval. Hotels make big bucks during this time of year by jacking up their prices to insane heights, usually demanding payment in full upon reservation and requiring a minimum stay of 4 or 5 nights. Most Carnaval packages start at R$1,500. Even at these prices, rooms often sell out by October or November. The most popular Carnaval hotels are in Barra, as they are right on the beach and the parade route. In the off season (Apr–June and Aug–Nov) some hotels give as much as a 50% discount, especially if you are staying a couple of nights.

Pelourinho

As the main reason for visiting Salvador is to explore its historic colonial center, we recommend spending at least 1 or 2 nights in Pelourinho. The safest part is the area between the Terreiro de Jesus/Largo Cruzeiro de São Francisco and the Largo do Pelourinho. This area is best for travelers who enjoy small, charming hotels, housed in restored 18th-century buildings. The drawbacks are that accommodations are expensive and lack modern conveniences such as spas, fitness rooms, parking, or pools.

VERY EXPENSIVE

Casa do Amarelindo ★★★ Casa do Amarelindo offers luxurious accommodations in a small, cozy bed-and-breakfast. The hotel's privileged location on the ridge along the Upper City means that guests can choose between a standard or superior room that looks out over the street, and a deluxe room with a private terrace facing the bay. No matter which one you pick, each of the 10 rooms features a comfy king-size bed, double-paned windows, and a huge walk-in shower. Casa do Amarelindo also boasts an excellent restaurant, a lovely rooftop bar, and even a swimming pool with a sun deck.

Rua das Portas do Carmo 6, Pelourinho, Salvador, 40026-290 BA. www.casadoamarelindo.com. ✆ **071/3266-8550.** 10 units. R$325–R$390 standard double; R$399–R$480 superior double; R$498–R$600 luxury double. Children 5 and under stay free in parent's room. MC, V. No parking. Bus: Praça da Sé. **Amenities:** Restaurant, Pelô Bistrô (see review, p. 234); bar; fitness center; pool; smoke-free rooms. *In room:* A/C, fan, TV, DVD, hair dryer, minibar, Wi-Fi.

Note that none of the prices listed below, even those for high season, remotely reflect the room cost during Carnaval. Most of the hotels have websites with information on special Carnaval packages that you can check out as early as September. Consult with the hotels directly or contact a tour company like **Brazil Nuts** (www.brazil nuts.com).

Solar dos Deuses ★★ Almost next door to the Villa Bahia, the Solar dos Deuses offers the same fabulous location at a slightly lower rate. Each of the seven lovely rooms is decorated in honor of an Orixá, the African deities of Candomblé. All rooms are elegantly furnished with period furniture and feature high ceilings, hardwood floors, and large windows looking out over the square or side street just off the square. Most rooms have king-size beds. Breakfast is served in the privacy of your own room at the time of your choice. The biggest room, Oxalá, can accommodate three or four people comfortably.

Largo Cruzeiro de São Francisco 12, Centro Histórico, Salvador, 40020-280 BA. www.solardos deuses.com.br. ⓒ **071/3320-3251.** 7 units. R$320 standard double; R$380 luxury double. Children 6 and under stay free in parent's room. MC, V. No parking. Bus: Praça de Sé. *In room:* A/C, TV, minibar.

Villa Bahia ★★★ Pelourinho's most elegant boutique hotel is located in the heart of Salvador's monumental square, almost right next door to the São Francisco church. Each of the hotel's 17 rooms has a unique size and layout. Some rooms overlook the square, while others face the intimate courtyard and swimming pool; some rooms even have a private deck or rooftop patio. The hotel's common theme is Portugal's overseas explorers, but the rustic furniture and tasteful antiques from Brazil and around the world are combined with every modern convenience, including Wi-Fi, luxury bedding, LCD TVs, and spacious bathrooms. The attentive staff go out of their way to make their guests comfortable. Most of Pelourinho's attractions are within a safe 5 to 10 minute stroll.

Largo do Cruzeiro de São Francisco 16/18, Pelourinho, Salvador, 40020-280 BA. ⓒ/fax **071/3322-4271.** 17 units. R$480 double (low season); R$670 double (high season). Children 11 and under stay free in parent's room. AE, DC, MC, V. No parking. Bus: Praça de Sé. **Amenities:** Restaurant; bar; concierge; small outdoor pool; room service. *In room:* A/C, TV/DVD, hair dryer, minibar, Wi-Fi.

EXPENSIVE

Studio do Carmo Located on the Ladeira do Carmo just steps past the Largo Pelourinho, this pousada offers four bright rooms with double beds and hardwood floors, plus a breakfast table and small kitchen. The decor includes original artwork, much of it on loan from the gallery downstairs. Showers are small, but clean and functional. Thanks to a recent renovation, rooms now have air-conditioning. Room nos. 1 and 3 have a view out over the steps in front of the N.S. do Passo church. Room nos. 2 and 4 look back over the rooftops of Pelourinho; the view's not as nice, but these rooms get a better breeze. Breakfast is brought to your room on a tray each morning.

Ladeira do Carmo 17, Centro Histórico, Salvador, 40301-410 BA. www.studiodocarmo.com.br. ⓒ **071/3326-2426.** 4 units. R$180–R$250 double. Children 5 and under stay free in parent's room. AE, V. No parking. Bus: Praça de Sé. **Amenities:** Smoke-free rooms. *In room:* A/C, fan, TV, kitchen, Wi-Fi (free).

Barra

Barra offers sea and sun, but the area seems to have lost much of its previous charm. This area is best for travelers looking for more affordable accommodations not too far from Pelourinho and near the beach. The area is also a popular Carnaval venue. Be warned that the neighborhood has seen better days; empty buildings line the waterfront and Salvador's better restaurants and bars are found in Rio Vermelho.

EXPENSIVE

Monte Pascoal Praia Hotel ★ 🍴 Fabulously located across from Barra beach, the Monte Pascoal Praia offers great value. All rooms come with a king-size bed or two double beds—great for families traveling with young children. Every room has a balcony and at least a partial view of the ocean. However, it's worth spending the extra money for a full ocean view. The one room that has been fully adapted for travelers with disabilities has wide doorways, handrails, an adapted toilet, and a chair for use in the shower. This hotel is incredibly popular during Carnaval, as its pool deck overlooks the main parade route and the beach is just 45m (150 ft.) across the street.

Av. Oceanica 591, Barra, Salvador, 40170-010 BA. www.montepascoal.com.br. ✆ **071/2103-4000.** Fax 071/3245-4436. 83 units. R$196 double standard; R$250 double ocean view. Extra person R$60. Children 5 and under stay free in parent's room. AE, DC, MC, V. Parking R$12 per day. **Amenities:** Restaurant; bar; fitness room; outdoor pool; sauna. *In room:* A/C, TV, hair dryer, Internet, minibar.

MODERATE

Estrela do Mar ★ 🍴 Irish owner Sean O'Flynn runs a pleasant and spotless B&B located on a residential side street across from the lighthouse in Barra. Spread out over two floors, all nine rooms feature comfortable beds and clean ensuite bathrooms with electric showers. The small hotel has a pleasant common room where travelers mingle over a free coffee or tea and swap travel tips. Lazy holidayers may appreciate that breakfast is served until noon. Estrela do Mar's Carnaval packages sell out fast, so book early.

Av. Afonso Celso 119, Farol da Barra, Salvador, 40140-080 BA. www.estreladomarsalvador.com. ✆ **071/3022-4882.** 9 units. R$140–R$185 double. Extra person R$40. Children 5 and under stay free in parent's room. AE, MC, V. Street parking. *In room:* A/C, TV, minibar, Wi-Fi.

Pousada Noa Noa ★ 🍴 The bright red colonial house sits just around the corner from the lighthouse in Barra. Noa Noa will appeal to those who enjoy the bustle of a hostel and like to mingle with other travelers in the common lounge or kitchen, but still want a comfortable, nicely decorated private room. We recommend booking the Matisse, Margritte, or Degas room with ocean view (only R$30 more than the other rooms). Note that two of the 12 rooms (Gauguin and Cezanne) have a shared bathroom. The Pousada Noa Noa is located right on the Carnaval route, so book early.

Av. Sete de Setembro 4295, Farol da Barra, Salvador, 40140-110 BA. www.pousadanoanoa.com. ✆ **071/3264-1148.** 12 units, 2 units with shared bathroom. R$160–R$190 double. Extra person R$40. Children 5 and under stay free in parent's room. AE, MC, V. Street parking. *In room:* A/C, TV.

Rio Vermelho

Rio Vermelho is quickly emerging as Salvador's most happening neighborhood. It has a lively restaurant and nightlife scene, centered around its main square, with hotels set far enough away from the nightlife to guarantee a good night's sleep. This area is best for travelers who enjoy nightlife and mingling with the locals. Larger hotels offer modern amenities such as swimming pools, a gym, or a spa. The drawbacks

are that Salvador's main attractions are centered around Pelourinho, a R$40 to R$50 cab ride away.

VERY EXPENSIVE

Pestana Bahia Lodge ★★★ Just behind the large Pestana high-rise there was enough land to wedge in an exclusive low-rise lodge with 83 huge suites overlooking the ocean. Access is through the main Pestana hotel, but once you pass through the "restricted access" doorway, you will find yourself in a quiet enclave of luxury without the large groups that often crowd the Pestana Bahia. The suites are modern and contemporary with white leather couches, a large veranda, a kitchen, high-end bedding, and tasteful lighting. The lodge also features its own swimming pool complex, fitness center, and L'Occitane spa.

Rua Fonte do Boi, Rio Vermelho, Salvador, 41940-360 BA. www.pestanahotels.com.br. ✆ **071/ 3453-8005.** Fax 071/3453-8066. 83 units. R$360 superior double; R$520 deluxe double. Extra person add 30%. Children 12 and under stay free in parent's room. AE, DC, MC, V. Free parking. Bus: Rio Vermelho. **Amenities:** 3 restaurants; bar; concierge; small health club; large outdoor pool; smoke-free floors; spa. *In room:* A/C, TV, minibar, Wi-Fi.

Zank Boutique Hotel ★★★ 🎒 This is just what the (travel) doctor ordered: a stunningly beautiful, hip boutique hotel in the heart of Rio Vermelho. Zank is the pet project of three enterprising sisters who started by renovating a lovely heritage building and then added a modern, minimalist Miami-chic annex. With only 20 rooms, Zank is an exclusive oasis on a hillside overlooking Rio Vermelho. To get the full experience, reserve one of the modern design rooms and let yourself be spoiled. Be warned that it will take a concerted effort to tear yourself away from your room, the rooftop lounge, or the tropical garden patio. Fortunately, Rio Vermelho's restaurant scene is just a short walk away. No children 13 and under.

Rua Almirante Barroso 161, Rio Vermelho, Salvador, 41950-350 BA. www.zankhotel.com.br. ✆/fax **071/3083-4000.** 20 units. R$530–R$700 double; R$630–R$850 deluxe double. AE, DC, MC, V. No parking. Bus: Rio Vermelho (short walk up steep hill). No children 13 and under. **Amenities:** Restaurant; bar; concierge; outdoor pool; room service; smoke-free room; spa. *In room:* A/C, TV, hair dryer, minibar, Wi-Fi.

EXPENSIVE

Catharina Paraguaçu ★★ Smack in the heart of Rio Vermelho, Catharina Paraguaçu is a charming hotel with lovely gardens and reasonably priced rooms. It may lack the amenities and infrastructure of the larger hotels in the area, but its architecture, friendly staff, and central location more than make up for that. The hotel offers a variety of rooms; the standard ones accommodate one or two people. The deluxe rooms are more spacious and have room for an extra bed. Families may want to reserve a duplex suite with a kitchen and sitting room on the ground floor. A large garden helps to buffer most of the traffic noise.

Rua João Gomes 128, Rio Vermelho, Salvador, 41950-640 BA. www.hotelcatharinaparaguacu.com. br. ✆/fax **071/3334-0089.** 31 units. R$215 superior double; R$240 deluxe double; R$255 duplex double. Extra person add R$50. Children 5 and under stay free in parent's room. AE, MC, V. Free parking. Bus: Rio Vermelho. **Amenities:** Room service. *In room:* A/C, TV, minibar, Wi-Fi.

Pestana Bahia ★★★ Set on an outcrop overlooking Rio Vermelho, the hotel's privileged location guarantees all 430 units an ocean view. Rooms on the 2nd through the 17th floors are superior; the ones on the 18th to the 22nd floors are deluxe. The difference is really in the small details; the deluxe rooms have bathtubs, 29-inch TVs,

and a couch. Other than that the rooms are identical, very spacious with modern and funky decorations. The outdoor pool and sun deck overlook the beach; the Pestana's beach service includes towels, chairs, umbrellas, and drinks. The hotel is just a 5-minute walk from Rio Vermelho's happening nightlife scene.

Rua Fonte do Boi, Rio Vermelho, Salvador, 41940-360 BA. www.pestanahotels.com.br. ☎ **071/ 3453-8005.** Fax 071/3453-8066. 430 units. R$320 superior double; R$470 deluxe double. Extra person add 30%. Children 12 and under stay free in parent's room. AE, DC, MC, V. Free parking. Bus: Rio Vermelho. **Amenities:** 3 restaurants; bar; concierge; small health club; large outdoor pool; smoke-free floors; spa. *In room:* A/C, TV, minibar, Wi-Fi.

INEXPENSIVE

Ibis Rio Vermelho ★ The Ibis provides inexpensive accommodations without giving up too much comfort. This no-frills brand specializes in clean and plain rooms with quality basics such as firm beds with good linens, a desk or work table, and a hot shower. The hotel doesn't offer many services—no gift shop, business center, buffet breakfast, or valet parking—but, you do have the possibility of an ocean view at bargain rates. There is no price increase for rooms facing the ocean so request one when you reserve or check in. Breakfast, not included, costs R$11. The Mercure hotel next door (owned by the same Accor group) offers pricier rooms with somewhat better amenities, but doesn't quite compare to the nearby Pestana.

Rua Fonte do Boi 215, Rio Vermelho, Salvador, 41940-360 BA. www.accorhotels.com.br. ☎ **071/ 3330-8300.** Fax 071/3330-8301. 252 units. R$149 double. Extra person add 30%. Children 12 and under stay free in parent's room. AE, DC, MC, V. Bus: Rio Vermelho. **Amenities:** Restaurant; bar; room service; smoke-free floors. *In room:* A/C, TV, minibar, Wi-Fi.

WHERE TO EAT

Bahian cuisine is truly regional, with ingredients and flavors not seen elsewhere in Brazil. The coastal version of Bahian cooking is rich in seafood and the distinct African flavors of dendê oil, dried shrimp, and coconut milk. These ingredients are combined into fragrant stews loaded with prawns, oysters, crab, or fish and finished with a handful of fresh cilantro and tangy lime juice. You can't say you have been to Bahia without trying a *moqueca de siri-mole* (stew with soft-shell crab), a *vatapá*, the famous *bobó de camarão*, and the popular *acarajé*.

Pelourinho

Pelô, as the locals call Pelourinho, is not the place for fine dining, but does offer decent Bahian food and plenty of atmosphere. Located in historic colonial houses, restaurants in Pelô provide the perfect backdrop for Salvador's exotic flavors. For a map of restaurants in this area, see the map "Salvador's Centro Histórico," below.

 A Meal Built for Two

Remember that, except in fine-dining establishments, the portions are very generous; one main course is usually enough for two people. When in doubt, ask the waiter, *"Dá para dois?"* ("Does it serve two?")

EXPENSIVE

Axego BAHIAN This restaurant is known for its traditional Bahian fish and seafood dishes. The bestseller is the *moqueca*, prepared with crab, oyster, shrimp, or fish in a rich stew with coconut milk, dendê palm oil, and spices. However, the chef takes great pride in his fresh seafood and also

A glossary OF BAHIAN DISHES

Rich with African influences, Bahian cuisine comes with its own ingredients and terminology. Here is a list of the most common dishes and ingredients:

Abará (ah-bah-*rah*): Usually made by Baianas on the street, this is a tamale-like wrap made with bean paste, onions, and dendê oil, cooked in a banana leaf, and served with ginger and dried shrimp sauce.

Acarajé (ah-kah-rah-*zhey*): Similar to the *abará* in that the dough is made with mashed beans, but the *acarajé* is deep-fried in dendê oil and stuffed with a shrimp sauce, hot peppers, and onion-tomato vinaigrette.

Bobó de camarão (boh-*boh* dje cah-mah-*roun*): A stew made with shrimp, cassava paste, onion, tomato, cilantro, coconut milk, and dendê oil.

Dendê oil (den-*de*): The key ingredient for Bahian food, this oil comes from the dendê palm tree and has a characteristic red color.

Ensopado (en-so-*pah*-do): A lighter version of a *moqueca* made without the dendê oil.

Moqueca (moo-*keck*-ah): Bahia's most popular dish, the ingredients include any kind of seafood stewed with coconut milk, lime juice, cilantro, onion, and tomato. Though the taste is similar, this stew is much thinner than a *bobó*.

Pirão (pee-*roun*): As popular as *farofa* in the rest of Brazil, this dish looks more like porridge (or papier-mâché paste). Cassava flour is added to a seafood broth and cooked until it thickens.

Vatapá (vah-tah-*pah*): One of the richest dishes, the *vatapá* is a stew made with fish, onion, tomato, cilantro, lime juice, dried shrimp, ground-up cashew nuts, peanuts, ginger, and coconut milk. The sauce is thickened with bread.

offers some lighter dishes, such as grilled fish or garlic sautéed prawns. On Sundays, the menu includes a typical Brazilian *feijoada* bean stew with all the trimmings for only R$32. It is worth snagging a table by the large windows in the lovely elegant dining room.

Rua João de Deus 1, 1st floor, Pelourinho. ℘ **071/3242-7481.** Main courses R$42–R$68 for 2. AE, DC, MC, V. Daily noon–10pm. Bus: Praça da Sé.

Pelô Bistrô ★★ BAHIAN This cute bistro in the Casa do Amarelindo goes far beyond the standard Bahian fare. The kitchen combines delicious local ingredients with a French flair, bringing a touch of sophistication to Pelourinho dining. Start with the grilled chicken satay with cashew sauce. Meat lovers may want to try the filet mignon with bacon and grainy mustard in an *açai* reduction. Lighter fare includes a prawn stir-fry with pineapple rice or a grilled fish with banana and Bahian *vatapá* stew. One of the best deals is the three-course tasting menu for R$59. The wine list offers an affordable selection of South American and French wines.

Rua das Portas do Carmo 6, Pelourinho. ℘ **071/3266-8550.** Main courses R$39–R$52. AE, DC, MC, V. Daily noon–10:30pm. Bus: Praça da Sé.

MODERATE

Jardim das Delicias ★ 🍴 BRAZILIAN/CAFE The Jardim das Delicias (Garden of Delights) is appropriately named. Tucked away inside an antiques store on the ground floor of a colonial house in Pelourinho, this lovely courtyard restaurant is the perfect getaway from the bustle and crowds of Pelourinho. The restaurant serves

a full Bahian menu, including *moquecas, bobô de camarão,* and even foods from the interior such as beans with smoked meat and sausage. In the evenings there is live music. However, the Jardim is also very nice for just a drink (the caipirinha made with cashew fruit is delicious) or a coffee and some sweets while you rest your feet.

Rua João de Deus 12, Pelourinho. (🕐 **071/3321-1449.** Main courses R$40–R$70; the more expensive dishes serve 2. Sweets and desserts are all under R$15. AE, DC, MC, V. Daily noon–midnight. Bus: Praça da Sé.

INEXPENSIVE

A Cubana ★ 🍽 DESSERT It's only right that a city with an abundance of tropical fruit and a year-round warm climate would have great ice cream. One of the oldest *sorveterias* (ice-cream parlors) in town, A Cubana can be found in the heart of Pelourinho. The menu is not huge, only 28 homemade flavors at any given time; the owners say they prefer quality to quantity. Try the unusual fruit flavors such as *jáca* (jack fruit) or *cupuaçu,* a fruit only found in the Northeast and the Amazon.

Rua das Portas do Carmo 12 (formerly known as Rua Alfredo de Brito), Pelourinho. A second A Cubana store is right next to the upper exit of the Lacerda elevator. (🕐 **071/3321-6162.** Everything under R$12. No credit cards. Daily 8am–10pm. Bus: Praça da Sé.

Ramma ★ 🍽 BRAZILIAN If you are in the mood for a healthy hot lunch, climb the stairs to this pleasant restaurant that overlooks the Largo do Cruzeiro de São Francisco. The kitchen serves up a large buffet of vegetarian dishes, tofu stir-fries, and veggies with whole grain rice. The menu usually also includes a few fish selections and one or two typical Bahian dishes.

Praça do Cruzeiro de São Francisco 7, Pelourinho. (🕐 **071/3321-0495.** R$15–R$25 per person. MC, V. Mon–Fri 11:30am–3pm. Bus: Praça da Sé.

Comércio

Located at the foot of a cliff directly below Pelourinho, the business and marina district of Comércio is fine for wandering in the daytime during office hours, but come evening the workers head home and the streets become quiet and empty. We recommend taking a taxi instead of walking.

ACARAJÉS & abarás

Everywhere you go in Salvador you'll see Baianas—women dressed in the traditional white hoop skirt, lace blouse, and turban—sitting behind big cooking pots serving up *acarajés* and *abarás,* falafel-like snacks made with beans, onions, and dendê oil, either deep-fried *(acarajés)* or cooked in a banana leaf and served with ginger and dried shrimp sauce *(abarás).*

Although the costume is always the same, there are Baianas, and there are Baianas. Each has her regular spot, sometimes inherited from a mother or aunt. **Abará de Dona Olga** in Pelourinho

on Travessa Agostinho Gomes—in front of the Moderna Funeral Home—has been serving up *abará* for over 50 years, daily from 5pm to 3am. Outside of Pelourinho, by the lighthouse Farol da Barra, look for **Acarajé do Farol Celia.** This lady also sells excellent coconut sweets, daily from 1 to 11pm. The queen of all *acarajés* is **Cira,** who runs the **Acarajé da Cira** ★★, Largo da Mariquita, Rio Vermelho. Open Monday to Friday 3 to 10pm and Saturday and Sunday 11am to 11pm.

To say that Brazilians have a sweet tooth is like saying Italians are fond of pasta. Most Brazilian desserts are just a few ingredients shy of pure sugar—not surprising, given that Brazil was once the world's largest sugar producer. Nowhere is this truer than in the sugar capital of Bahia. From the Portuguese, Bahians inherited the habit of making sweets with egg yolks; they combined this with coconuts imported from Africa and the perfect dessert was born.

Most traditional sweets are just variations on those three ingredients: *cocada*, the ubiquitous little clusters of coconut, which are grated coconut with white or burned sugar; *quindim*, something between a pudding and a pie, which is made with coconut, an incredible number of egg yolks (at least 10 per tiny serving!), and sugar; *manjar*, a soft pudding often served with plum sauce, which combines sugar, coconut milk, and milk. My personal favorite is *baba de moça*—coconut milk, egg yolks, and sugar syrup. The name translates as "girl drool."

VERY EXPENSIVE

Amado ★★ CONTEMPORARY BAHIAN This place embodies the ultimate in cool waterfront dining—the room is vast and gorgeous, mixing wood and stone and glass with open views over the harbor and the bay beyond. The cuisine takes traditional Bahian ingredients—manioc and seafood, principally—and puts them to use in innovative ways, always with lovely presentations. We threw ourselves completely into the ocean, trying the giant squid stuffed with shrimp and leek in a Provençal sauce, the shrimp in a Gorgonzola and pistachio sauce, and a broiled *badejo* filet in a crust of cashews with an okra tapenade. For those not into fish, the menu has an equally intriguing array of chicken and beef creations. The wine list is on the pricey side—nothing good for under R$100, though they do eminently acceptable sparkling wine in the R$50 range. Service is young, pretty, and efficient.

Av. do Contorno 660, Comércio. ✆ **071/3322-3520.** www.amadobahia.com.br. Reservations recommended on weekends and in high season. Main courses R$36–R$54. AE, DC, MC, V. Mon–Sat noon–3pm and 7pm–midnight; Sun noon–4pm. Take a taxi. Even though it's not too far from the Mercado Modelo, the street is dark and very quiet at night.

EXPENSIVE

SOHO ★★★ JAPANESE Judging from the crowds, trendy Soteropolitanos (as residents of Salvador are called) have taken to sushi like fish to water. Located inside the Bahia Marina, SOHO sits at the waterline, offering great outdoor seating and excellent dining. The large menu offers most of the usual Japanese suspects—sushi, sashimi, tempura, yakisoba, and grilled meat teriyaki. But what earns this restaurant an above-average rating are intriguing local dishes such as the *shake lounge* (salmon sashimi with orange sauce, lime, and balsamic vinegar) and the *uramaki shake* (salmon with green onion and sesame seeds). Also worth trying are the *marina maki* (a salmon and prawn roll flambéed in *cachaça*) and the *kyo* (a lightly grilled tuna and *nira* in a thick soy sauce). Many of the hot dishes, such as the yakisoba noodles, are large enough to share, especially after a couple of the sashimi and sushi appetizers.

Av. do Contorno s/n, inside the Bahia Marina, Comércio. ✆ **071/3322-4554.** Reservations recommended. Main courses R$36–R$58. AE, DC, MC, V. Mon 7pm–midnight; Tues–Sun noon–3pm and

7pm–midnight. Take a taxi. Even though it is not too far from the Mercado Modelo, the street is dark and very quiet at night.

MODERATE

Camafeu de Oxossi ★ BAHIAN Most self-respecting travelers would probably steer clear of a restaurant inside a huge crafts market, staffed by women in traditional costume. But this restaurant on the top floor of the Mercado Modelo offers surprisingly decent food, including nine types of seafood *moquecas*, and the views over the bay and the São Marcelo Fort are worth the price of admission.

Praça Visc. De Cayru 250, Mercado Modelo, Comércio. ✆ **071/3242-9751.** Main courses R$24–R$48 for 2. AE, DC, MC, V. Mon and Wed 9:30am–7:30pm; Tues and Thurs–Sat 11am–7pm; Sun 11am–4pm. Bus: Praça da Sé, then take the Elevator Lacerda to the lower city.

Barra

This beach neighborhood is a popular evening destination as people gather around the lighthouse to watch the sunset. For the best views, you can't beat the patio of **Barravento** (see below).

EXPENSIVE

Pereira ★★ BRAZILIAN This beautiful faux-rustic restaurant with exposed brick and expansive glass walls opens up to a lovely patio overlooking the ocean and sea wall in Barra. It's an excellent destination, be it for lunch, dinner, or just a drink and some tapas. In addition to the typical Brazilian snacks such as deep-fried cod or prawn dumplings (*bolinho de bacalhau* and *pastel de camarão*), you'll find bruschetta with ham and goat cheese or grilled squid in teriyaki sauce. Main courses range from pastas, pizzas, and risottos to grilled seafood and steak. Pereira is especially busy on weekends when Salvador's young and beautiful gather to preen and be seen. *Tip:* Don't bother with the Japanese eatery Sato next door. If you want Japanese go to SOHO (see above).

Av. Sete de Setembro 3959, Porto da Barra. ✆ **071/3264-6464.** Main courses R$32–R$48. AE, DC, MC, V. Mon–Wed 6pm–midnight; Thurs–Sun noon–3pm and 6pm–midnight. Bus: Barra or via Orla.

MODERATE

Barravento ★ BAHIAN Underneath a large sail-shaped roof, Barravento offers alfresco dining on a beach patio overlooking all of the beach as far as the Farol da Barra. The menu includes a large selection of Bahian dishes such as *moquecas, mariscadas* (seafood stews), and grilled fish. One dish that every Baiano will recommend is the *moqueca de siri-mole* (soft-shell crab). If you're not in the mood for a full meal, Barravento serves a variety of appetizers such as *casquinha de siri* (spiced crabmeat) and fish pastries. After 8pm from Thursday to Saturday, the restaurant features live Brazilian music. The view is complimentary.

Av. Getulio Vargas 814 (aka Av. Oceanica), Barra. ✆ **071/3247-2577.** Main courses R$29–R$59; all dishes for 2. DC, MC, V. Daily noon–midnight (if busy, open later on weekends and in high season). Bus: Barra or via Orla.

Rio Vermelho

Over the last few years, Rio Vermelho has grown into a bustling, lively restaurant destination. There are several excellent options, most centered around the main square, Praça Brigadeiro Farias Rocha. Stroll around and see what strikes your fancy. We have included reviews of a few worthwhile restaurants that might otherwise get overlooked.

EXPENSIVE

Fogo de Chão ★★ STEAK Even seafood lovers may crave a delicious piece of beef. This elegant all-you-can-eat steak restaurant serves up the finest beef in town. Cuts include all the Brazilian classics, such as *picanha, alcatra,* and *maminha,* as well as prime Argentine and Uruguayan beef. Unlike many other steak restaurants, the buffet is meant to enhance the meat and doesn't include sushi or seafood, but specializes in a delicious array of salads and vegetables. Make sure you try the dessert of grilled mango and pineapple with a hint of brown sugar and a serving of fresh coconut ice cream.

Praça Colombo 4, Rio Vermelho. ✆ **071/3555-9292.** www.fogodechao.com.br. Main course R$73 (doesn't include drinks or dessert; children 2 and under free, ages 3–7 R$24, and ages 8–11 R$48). AE, DC, MC, V. Mon–Fri noon–4pm and 6pm–midnight; Sat noon–midnight; Sun noon–10pm. Bus: Rio Vermelho.

MODERATE

Companhia da Pizza PIZZA This is one of the best pizzerias in town, and also one of the most happening restaurants in Rio Vermelho. In the evenings you may have to wait for a table, but it is worth snagging one on the patio so you have a prime people-watching spot. The menu includes more than 50 pizzas, from sweet to savory. Note that unless you ask for a filled crust you get a thin-crusted "São Paulo–style" pizza. Flavors to try include chicken with palm heart, *rucula* with sun-dried tomato and mozzarella, or the spicy Baiana, with pepperoni, *calabresa* pepper, and ground beef.

Praça Brigadeiro Farias Rocha s/n, Rio Vermelho. ✆ **071/3334-6276.** Main courses R$20–R$42. AE, V. Sun–Thurs 5:30pm–1am; Fri–Sat 5:30pm–2am. Bus: Rio Vermelho.

Dona Mariquita BRAZILIAN Tucked away in a little laneway opposite the main square, this small restaurant is full of surprises. First up, all of Dona Mariquita, pleasant patio included, is beautifully decorated with high-quality Northeastern crafts and artwork. Then there are the delicious *caipiroscas.* We highly recommend the *umbucaja,* combining two typical Northeastern fruits into one outstanding cocktail. And last but not least there is the food. Start off with the pastel, puffy fried savory meat dumpling served with a hot pepper jam. Main courses include specialties from the coast (seafood and fish *moquecas* and *bobó*) as well as interior dishes such as a bean stew and *carne seca* (sun-dried beef).

Rua do Meio 178, Rio Vermelho. ✆ **071/3334-6947.** Main courses R$28–R$36 for 2. AE, V. Tues–Sun noon–5pm. Bus: Rio Vermelho.

EXPLORING SALVADOR

Brazil's first capital city, Salvador serves simultaneously as the repository of the country's historical heritage and the source of much that is new and vibrant in its culture. Nothing symbolizes this dual role better than Pelourinho. The historic core of Salvador, Pelourinho is a perfectly preserved urban gem from the 16th and 17th centuries, the capital of one of the grandest and richest colonial dominions in the Americas. Pelourinho today has a wealth of richly decorated baroque churches, tiny squares, and fine old colonial mansions. By day, one could wander its cobblestone streets for hours.

At night, Pelourinho assumes its cultural role. Bahia has long been the cultural wellspring of Brazil, the source of what's new in music. Since its revitalization in the 1980s, Pelourinho has established itself as one of Salvador's main stages. Unfortunately, the new state government has cut much of the funding for cultural events, and the

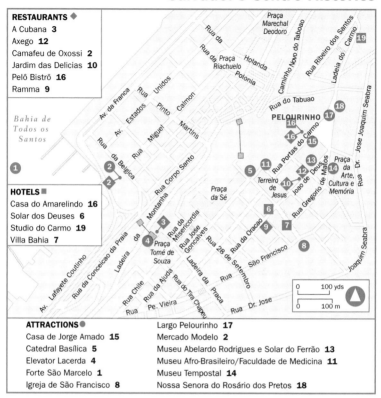

RESTAURANTS ◆
A Cubana **3**
Axego **12**
Camafeu de Oxossi **2**
Jardim das Delicias **10**
Pelô Bistrô **16**
Ramma **9**

HOTELS ■
Casa do Amarelindo **16**
Solar dos Deuses **6**
Studio do Carmo **19**
Villa Bahia **7**

ATTRACTIONS ●	
Casa de Jorge Amado **15**	Largo Pelourinho **17**
Catedral Basílica **5**	Mercado Modelo **2**
Elevator Lacerda **4**	Museu Abelardo Rodrigues e Solar do Ferrão **13**
Forte São Marcelo **1**	Museu Afro-Brasileiro/Faculdade de Medicina **11**
Igreja de São Francisco **8**	Museu Tempostal **14**
	Nossa Senora do Rosário dos Pretos **18**

Map labels: Praça Marechal Deodoro; Rua da; Rua da Praça Holanda; Riachuelo; Polonia; Rua do Tabuao; PELOURINHO; Terreiro de Jesus; Praça da Sé; Praça da Arte, Cultura e Memória; Praça Tomé de Souza; Bahia de Todos os Santos; São Francisco; Pe. Vieira; Rua Dr. Jose; 0 100 yds; 0 100 m

Side tab: **8** SALVADOR & THE BEST OF BAHIA / Suggested Sightseeing Itineraries

wonderful programming that kept Pelourinho hopping almost any night of the week has disappeared. Individual bars and restaurants have stepped in to fill the gap, however, and now schedule their own entertainment and events. Check with the Bahiatursa office in Pelourinho for upcoming concerts or shows.

Outside the old city are several good museums, great arts and crafts, and the glittering Baía de Todos os Santos, the bay that attracted the Portuguese to Salvador in the first place. Beyond the bay, warm Atlantic Ocean beaches stretch unbroken from the Farol de Barra lighthouse some 80km (50 miles) up the coast to Praia do Forte.

SUGGESTED SIGHTSEEING ITINERARIES

If You Have 1 Day

If 1 day is all you've got, you better get moving! Exploring the historic center of Pelourinho is a must. You could spend hours here admiring the colorful colonial mansions and impressive baroque churches. Wander down and marvel at the gilded splendor of the Igreja São Francisco. Visit the Largo do Pelouringo and then make your way to the Lacerda elevator for a ride down to the Cidade Baixa. Bargain hard at the Mercado Modelo. Be at the Farol de Barra around 5pm in

Take It Easy on Sundays

Sundays are pretty slow in Salvador. Everyone's been up partying until 5 in the morning, so next to nobody is on the street. The Cidade Baixa and the Mercado Modelo are deserted, and even Pelourinho isn't much fun. In short, it's a good day to do as the locals do and head to the beach.

time to grab a drink and admire what will almost surely be a spectacular sunset. In the evening, go munch on a *moqueca* or some other Bahian delicacy in one of Pelourinho's cozy restaurants.

If You Have 2 Days

Begin day 2 by viewing some of Brazil's best Catholic art at the Museu de Arte Sacra. Then for a taste of the faith that produced such splendor, visit the most famous church in Salvador, Nosso Senhor do Bonfim. Afterward go for a stroll along Boa Viagem Beach and Forte Monte Serrat for the best views of the city and—if it's a weekend—some great people-watching as well. For a taste of the old and new, visit the Solar do Unhão, an 18th-century sugar mill that hosts a sculpture and modern art collection. Splurge on a waterfront dinner at SOHO or Amado and mingle among Salvador's well-heeled residents.

If You Have 3 Days

Get some R & R by admiring Salvador from the water; book a schooner tour and explore the islands and beaches in the Bay of All Saints. In the evening, head to the newly trendy Rio Vermelho neighborhood for a fine seafood dinner or casual pizza, then join the people-watching on Praca Brigadeiro arias Rocha, or if it's Tuesday night, head to Pelourinho for the weekly Terça da Benção (Blessed Tuesday) party.

If You Have 4 Days or More

Catch a catamaran to the small beach community of Morro de São Paulo, where life is simple and the beaches are fabulous. Or to really get away, go one island farther down to the tiny, quiet, gorgeous beach at Boi Peba. For a more mountainous experience, head inland to the hills and trails of the Chapada Diamantina, which has the best hiking in Brazil.

The Top Attractions

A VISIT TO PELOURINHO ★★★

Make your first stop the Bahiatursa office, located at Rua das Laranjeiras (© 071/ 3321-2133), to pick up maps.

In 1985, the historic core of colonial Salvador was designated a UNESCO World Heritage Site by the United Nations. It's well merited. One could spend years getting to know the history of the churches, squares, and colorful colonial mansions in this old part of the city. What follows is but a brief introduction.

Start a tour of Pelourinho in the main square, called the **Terreiro de Jesus.** Dominating the west end of the square is the 17th-century **Catedral Basílica** (see listing below). Flanking the cathedral is the neoclassical **Antiga Faculdade de Medicina** (see listing for Museu Afro-Brasileiro/Faculdade de Medicina, below), now home to

the excellent Afro-Brazilian Museum. Also on the north side of the square is the smaller baroque **Igreja São Pedro dos Clerigos** (Mon–Fri 1–5pm). Facing the cathedral at the far end of the *terreiro* is the **Igreja de Ordem Terceiro de São Domingos de Gusmão.** Built between 1713 and 1734, this baroque church suffered through an 1870s renovation that destroyed most of its fine interior painting and tile work. On the south side of this church there's a wide cobblestone street with a tall cross in the middle. This is the **Largo Cruzeiro de São Francisco.** The saint on the cross is São Francisco de Xavier, patron saint of Salvador. At the far end of this little praça stand two of the most impressive churches in the city. The large two-towered one on the right is the **Igreja de São Francisco** (see listing below); the central element is the surrounding **Convento de São Francisco.** Next to it is the **Igreja de Ordem Terceira de São Francisco,** immediately recognizable by its ornately carved sandstone facade. Inside (open Mon–Fri 8am–noon and 1–5pm) is a small green cloister, around the outside of which is some fine blue Portuguese tile.

Back at the Terreiro de Jesus, the two streets on either side of the Church of São Pedro (Rua João de Deus and Rua Alfredo de Brito) both run downhill to the **Largo Pelourinho.** This small, steeply sloping triangular square gets its name from the whipping post that used to stand at the top end. This was where slaves and criminals were flogged. The smaller building at the top of the square, now the **Casa de Jorge Amado** (see listing below), used to serve as the city's slave market. Looking downhill, on the right-hand side of the largo you'll find the blue and creamy yellow **Nossa Senora do Rosário dos Pretos** (currently closed for renovations). Literally translated as Our Lady of the Rosary of the Blacks, the high baroque structure was erected over the course of the 18th century by and for the African slaves who represented the backbone of Salvador's sugar economy. At the far end of the square is the tiny **Praça de Reggae.** At the lowest point of the Largo Pelourinho a narrow street leads steeply uphill to a trio of old baroque churches, the **Igreja de Carmo,** the **Igreja de Ordem Terceiro de Carmo,** and the **Igreja do Santissimo Santo do Passo.** Only the Ordem Terceiro is open, and the views back over the city are only okay, so it's likely better to retrace your steps and explore one of the other delights of Pelourinho, its hidden interior courtyards. There are four of them: the **Praça de Arte, Cultura e Memoria;** the **Praça Tereza Batista;** the **Praça Pedro Arcanjo;** and the **Praça Quincas Berro d'Agua.** Their entrances branch off the little streets between the Largo Pelourinho and the Terreiro de Jesus. During the day, they contain cafes and artisan booths and museums. At night, nearly every one features a band.

IN PELOURINHO

Casa de Jorge Amado Though Jorge Amado was long one of Bahia's and Brazil's most beloved writers (he died in 2001 at the age of 93), there's not really much to see in his former house, now a museum dedicated to his memory. The ground-floor cafe has a collage of his book covers, showing the wide range of languages into which his dozens of works have been translated. On the upper floors, the text-heavy exhibits that tell the story of Amado's life are written exclusively in Portuguese. Better to just read one of his books. His most popular works are all set in Bahia. *Dona Flor and Her Two Husbands* is set in Pelourinho. *Gabriela, Clove and Cinnamon* (my personal favorite), and *Tieta do Agreste* take place in provincial towns farther south. *Gabriela, Tieta,* and *Dona Flor* have all been made into movies starring the luscious Sonia Braga.

Largo do Pelourinho 51. ✆ **071/3321-0122.** Free admission. Mon–Fri 9am–6pm; Sat 10am–4pm. Bus: Praça da Sé.

Catedral Basílica ★ Thoroughly restored in 1996, the 17th-century basilica that dominates Terreiro de Jesus square now looks as good as it did when it was first erected by the Jesuits in 1672. The craftsmanship inside is impressive. Beautifully ornate, the many altars are made from cedar and covered with a thin layer of gold; the high altar alone consists of 18 gold-covered pillars. The image of Christ the Savior above the transept is the largest wood sculpture in Brazil. Like much of the carving work in the church, it was likely the work of trained slaves; look closely at some of the altars and you'll notice symbols of the Candomblé religion such as small fishtails, a tribute to Yemanjá, the goddess of the sea. The Basilica hosts Barroco na Bahia, baroque chamber concerts, on Sunday at 11am.

Terreiro de Jesus s/n. ⓒ **071/3321-4573.** Admission R$2. Mon–Sat 8–11:30am and 1:30–5:30pm; Sun Mass at 9am and 6pm. Bus: Praça da Sé.

Igreja de São Francisco ★★★ At a time when Salvador was the biggest port in South America and Portugal still vied with Spain and Holland for the title of world's richest empire, the sugar barons of Salvador decided to splurge a little and let folks know that their colony had *arrived*. Beginning in 1708 and continuing until 1723, they took more than 100 kilograms of gold and slathered it over every available knob and curlicue in the richly carved interior of this high-baroque church. The result could hardly be called beautiful—works of the nouveaux riches seldom are—but by God, it's impressive. The inside fairly gleams; on nights when the doors are open it casts a yellow sheen all the way up to Terreiro de Jesus. If you can, time your visit on a Tuesday toward dusk (5:30pm-ish). The church will be packed with parishioners coming for a blessing, while outside wealthy matrons seeking the special favor of Saint Francis will be passing out little loaves of bread to a veritable mosh pit of Salvador's poor. Next door, the **Ordem Terceira de São Francisco church** (daily 8am–5pm, admission R$3) has a gorgeous sandstone facade on the outside, and on the inside some fine blue tile and a rather silly hall of saints. Allow an hour for both churches.

Largo Cruzeiro de S. Francisco s/n (off Terreiro de Jesus). ⓒ **071/3322-6430.** Admission R$3. Tues 8am–2pm; Wed–Sat 8am–5:30pm; Sun 1–4pm. Bus: Praça de Sé.

Museu Abelardo Rodrigues e Solar do Ferrão ★★ This recently restored 17th-century mansion hosts three floors of permanent collections, including more than 1,000 pieces of African sculptures, masks, utensils, and artifacts. The Lina Bo Bardi collection features hundreds of sculptures and religious artifacts from the Northeast of Brazil. Temporary exhibits may highlight contemporary Afro-Brazilian culture or Bahian artists. Allow 1 hour.

Rua Gregório dos Mattos 45. ⓒ **071/3117-6440.** Free admission. Tues–Sun 10am–6pm. Closed Mon. Bus: Praça de Sé.

Museu Afro-Brasileiro/Faculdade de Medicina ★ This fine old building (built in 1808) is now home to the Museu Afro-Brasileiro, which attempts to show the development of the Afro-Brazilian culture that arose as African slaves settled in Brazil. Particularly good is the large portion of the exhibit space dedicated to the Candomblé religion, explaining the meaning and characteristics of each god (Orixá) and the role the god plays in the community. Make sure to ask for one of the English-language binders at the entrance—they contain translations of all of the displays. In the back room, 27 huge carved wood panels—the work of noted Bahian artist Carybé—portray the Orixás and the animal and symbol that goes with each. Allow 30 to 45 minutes.

The quickest way to move between Pelourinho and the Cidade Baixa (lower city) is via the **Lacerda elevator,** which takes you from the Praça Tomé de Sousa to the Praça Visconde de Cairu, across from the Mercado Modelo. You can also use the **Plano Inclinado do Pilar,** a funicular railway farther down the Rua Direita de Santo Antônio, past the Carmo convent. Restored in 2006, the *plano inclinado* drops you at the Mercado do Ouro. And at R$0.15 a ride you don't have to worry about blowing your transportation budget.

Antiga Faculdade de Medicina, Terreiro de Jesus s/n (just to the right of the basilica). ✆ **071/ 3321-2013.** Admission R$5. Mon–Fri 9am–6pm; Sat–Sun 10am–5pm. Bus: Praça da Sé.

Museu Tempostal ★ Did you know the postcard was invented by Emmanuel Hermann? The Austrian professor first put a paper backing on a photograph and tossed it in the mail in 1869. By 1880, they were legal post in Brazil. This fun little museum has a large collection of postcards dating from the 1880s to the 1990s. Most are of Salvador itself; viewing the collection is a wonderful way to see how the city grew and changed. Allow 45 minutes.

Rua Gregório dos Matos 33. ✆ **071/3117-6382.** Free admission. Tues–Fri 10am–6pm; Sat–Sun 1–5pm. Closed Mon. Bus: Praça de Sé.

IN CENTRO

Museu de Arte Sacra ★★★ This small but splendid museum displays one of Brazil's best collections of Catholic art. The artifacts are shown in the former Convent of Saint Teresa of Avila, a simple, beautiful building that is a work of art in itself. The collection includes oil paintings, oratorios (a cabinet containing a crucifix), metalwork, and lots of wooden statues of saints. In general, the cabinetry is better than the carving: The jacaranda-wood oratorios are things of beauty, while the wooden saints seemed to have kept the same look of stunned piety through more than 2 centuries. If you're pressed for time, head for the two rooms of silver at the back. Walk through these rooms and you can see how Brazilian silversmiths refined their technique, as the rather crude—but massive—works of the 18th century changed and developed until by the early 19th century, Brazilian artists were producing reliquaries, processional crosses, and crucifixes of astonishing refinement. Allow 1½ hours.

Rua do Sodré 276. ✆ **071/3283-5600.** www.museudeartesacradabahia.com.br. Admission R$5 adults, R$3 students with valid ID, free for children 6 and under. Mon–Fri 11:30am–5pm. Located just south of Pelourinho. From Praça de Sé walk 10 min. south on Av. Carlos Gomes, turn right and walk downhill on Ladeira Santa Teresa for 45m (150 ft.). Bus: Praça de Sé.

IN CIDADE BAIXA

Forte São Marcelo ★ The best part about this perfectly round fort (Jorge Amado referred to it as "the belly button of Bahia") is its location at the entrance to the lower city. Originally built in 1650 and modified to its current configuration in 1812, the views of the city are better than the few exhibits on the history of the forts of Salvador (there used to be over 30; 17 now remain). For those who want to stretch their visit, a good restaurant called Buccaneros is inside the ramparts. Boats ferry visitors from shore regularly, leaving from inside the Centro Nautico (across from the

Mercado Modelo, where the catamarans to Morro de São Paulo also leave from). If you are eating at the restaurant you are not required to pay the museum fee. Please inform the ticket office.

Access from the Centro Nautico, next to the Terminal Maritimo da Bahia (across from the Mercado Modelo). ℂ **071/3525-7142.** R$12, R$6 children 7 and older, free for children 6 and under. Daily 9am–6pm. Bus: Comércio.

Mercado Modelo ★ There's no sense pretending you're not a tourist in the Mercado Modelo. If you're here, you are. Still, it's a fun place to wander. This former Customs building and slave warehouse burned to the ground in 1984 and was then rebuilt in its original 19th-century style. It houses just about everything Bahia has to offer in terms of arts, crafts, and souvenirs. Merchants in the little stalls certainly want your business, but they're not annoying about it. Instead, in the best Brazilian tradition, they invite you in to look around, press you if you seem interested, drop their prices if you hesitate (bargain hard in here!), and concede gracefully if you decline.

Praça Cayru (just across from the elevator). ℂ **071/3241-2893.** Mon–Sat 9am–7pm; Sun 9am–2pm. Bus: Comércio.

Solar do Unhão ★★ An old sugar mill, the Solar consists of a number of beautifully preserved heritage buildings centered around a lovely stone courtyard that dates back to the 18th century. It's fun just to wander around and explore the various buildings set on the waterfront (the views are fabulous). The main building houses a small modern art museum; you'll find some works of Portinari and Di Cavalcanti on display. The path to the right of the main building leads above the rocks to the sculpture garden with works by Carybé and Mario Cravo. Allow an hour.

Tip: On Saturdays at 6pm there is a live jazz performance, a great way to spend happy hour (R$4).

Av. do Contorno 8. ℂ **071/3117-6132.** www.mam.ba.gov.br. Free admission. Tues–Sun 1–7pm; Sat until 10pm. It is best to take a taxi from the Mercado Modelo or Pelourinho.

IN BARRA

Museu Nautico da Bahia/Farol da Barra/Forte de Santo Antônio ★
The lighthouse, fort, and museum are mostly worth a visit for the views over the Bay of All Saints. Erected in 1534, the Forte de Santo Antônio da Barra was the first and most important Portuguese fortress protecting Salvador. It thus had the honor of being taken by the invading Dutch in 1624, and retaken the following year by a combined Portuguese and Spanish fleet. You can wander the halls and admire the military architecture, but there's no signage on the history of the fort. The museum inside the lighthouse contains a small collection of maps and charts, navigational instruments, and a number of archaeological finds from wrecks that the lighthouse obviously didn't help. Signage here is in English and Portuguese.

Farol da Barra, Praia da Barra s/n. (© **071/3264-3296.** Admission R$6. Mon 8–10am; Tues–Sun 9am–7pm. Cafe Tues–Sun 9am–10pm. Bus: Barra or Via Orla.

IN BONFIM

Nosso Senhor do Bonfim ★★ Salvador's most famous church has a reputation for granting miracles. Tourists and faithful alike thus flock to this relatively plain 18th-century church on a small peninsula just north of downtown. (You'll be swamped on arrival by kids selling *fitas,* the colorful ribbons that people tie around their wrists for good luck; you may as well buy a dozen and get it over with.) Don't miss the Room of Miracles at the back where people give thanks for miracles by donating valuable or important objects. Definitely eye-catching are the numerous hanging body parts—models made of wood, plastic, even gold. This church also plays a very important role in the Candomblé religion and is dedicated to Oxalá, one of the highest deities. In January one of Salvador's most significant syncretist religious events takes place here, the famous washing of the steps.

Largo do Bonfim. (© **071/3316-2196.** Free admission. Tues–Sun 6:30–11am and 2–6pm. Located about 8km (5 miles)—or a R$25 taxi ride—north of Pelourinho on the Bonfim Peninsula. Bus: Catch a Bonfim bus at Praça de Sé or at the bottom of the Elevator Lacerda in Comércio.

Architectural Highlights

HISTORIC BUILDINGS & MONUMENTS

The old town of **Pelourinho** was recognized in 1985 as a UNESCO World Heritage Site. See "A Visit to Pelourinho," earlier in this chapter, for descriptions of some of the hundreds of interesting structures in this neighborhood.

At the top of the cliff at the edge of Pelourinho one finds the **Praça Tomé de Souza,** flanked on one side by a glass-cube-on-stilts that houses the city hall, on the other side by the neoclassical **Palácio Rio Branco** ★, and on the cliff face by the Art Deco **Elevator Lacerda** ★. The original 80m-tall (236-ft.) elevator was built in 1872 to whisk people between the upper and lower city. The present Art Deco look

THE spectacle OF LAVAGEM DO BONFIM

One of the most impressive demonstrations of faith (Catholic and Candomblé) takes place every year on the third Thursday of January on the steps of N.S. do Bonfim. Beloved because he offers protection even to non-Catholics, N.S. do Bonfim is associated by Candomblé followers with Oxalá, the supreme ruler and one of the most important Orixás (deities). On the day of the Lavagem, hundreds of women in their best Bahian outfits (hoop skirts, white turbans, lovely white lace blouses, and colorful jewelry) parade 8km (5 miles) from the N.S. Conceção de Praia church in the lower city

out to the N.S. do Bonfim. They carry jugs of perfumed water, and are serenaded on the way by the music of the Sons of Gandhi bloco. Vendors sell food and drinks, and thousands of spectators follow along. At the church, the barefoot Baianas go about scrubbing the steps with brooms. The Catholic Church does not approve of this event and keeps its doors shut on this day. Once the actual washing is completed, the party in front of the church lasts well into the night with music, *capoeira,* and plenty of food and drink.

understanding CANDOMBLÉ & THE TERREIROS

The religion of Candomblé is practiced throughout Brazil, but its roots are deepest in Salvador, where it forms an important part of community life. The practice originated with slaves brought to Brazil from West Africa; they believed in a pantheon of gods and goddesses (Orixás) who embodied natural forces such as wind, storm, ocean, and fire. Each Orixá had its own rituals, colors, habits, and even a day of the week associated with his or her worship. A believer who is prepared and trained can become possessed by a certain Orixá and form a link between humankind and the gods.

In Catholic Brazil, the practice of Candomblé was prohibited. Willing or no, Brazilian slaves were converted to Catholicism. Though they weren't allowed inside white churches, the slaves watching from without soon recognized aspects of their Orixás in various Catholic saints. By translating each of their gods into an equivalent saint, Candomblé followers found they could continue their native worship under the very noses of their Catholic priests and masters.

Oxalá, the creator and supreme ruler, thus became the Senhor do Bonfim; Iansã, the Orixá of wind and storms, resembled Santa Barbara; Yemanjá, the queen of the ocean and fresh water, seemed to have the same privileged position as Our Lady of Conception. Unlike the saints, Orixás are far from perfect; Yemanjá, for example, is notoriously vain and jealous. However, in the process of syncretizing Roman and West African practice, much that was Catholic was adopted, and the result is that Candomblé is now something uniquely Brazilian.

There are many *terreiros* (areas of worship) in Salvador, though most are located in poorer neighborhoods far from downtown and are usually not open to the public, except on special dates. To attend an authentic Candomblé session, check with the Afro Brazilian Federation: **Federação Baiana de Culto Afro Brasileiro,** Rua Alfredo de Brito 39, second floor, Pelourinho (© **071/3321-1444**). Another good (English-speaking) resource is **Tatur Turismo** (© **071/3450-7216;** www.tatur.com.br) to find out on which dates ceremonies take place.

was added in 1930, when the old mechanism was replaced with hydraulics. The elevator was also then rechristened Lacerda in honor of the original engineer. Open daily from 5am to midnight. Admission is R$0.15, the cheapest ride in town.

FORTS

After taking Salvador back from the Dutch in 1625, the Portuguese went on a bit of a fort-building binge. Fortresses small and large were built or strengthened all along the Bay of All Saints. Perhaps the city's most famous fort is the perfectly round **Forte São Marcelo** (see above), built in 1625 in the Bay of All Saints directly opposite the lower town. The current low, thick walls were built in 1738. Jorge Amado called the fort "the belly button of Bahia." It was recently restored and is now open for visits (Tues–Sun 9am–6pm). South of Pelourinho stand two forts fairly close to each other. The **Forte de São Diogo** saw a great deal of action during the second Dutch invasion of 1638. Inside, there's a small model of the system of forts protecting the city. It's open Tuesday through Sunday from 9:30am to noon and 1:30 to 5:30pm. The **Forte de Santa Maria** is located on Avenida Sete de Setembro just a bit north of the Farol de Barra point. Its complement of large guns is still in position. It's open Tuesday through

Friday from 8am to 6pm, and Saturday from 8am to noon. The city's most important fortress, the **Forte de Santo Antônio** ★ (see above), was built in 1583, taken by the Dutch in 1624, retaken by the Portuguese in 1625, and rebuilt into its current form in 1702. It's open Tuesday through Sunday from 9am to 7pm (to 9pm in summer).

CHURCHES & TEMPLES

Salvador has a wealth of beautiful old churches, so many in fact that a couple in the centro histórico stand abandoned, sizable trees growing from their ornate baroque bell towers. Some of the best churches are discussed above in the sections Pelourinho or Bonfim. One not covered but that's still worth mentioning is **Nossa Senhora da Conceição da Praia,** Largo de Conceição de Praia (✆ **071/3242-0545**). It's open Tuesday through Friday from 7am to 5pm, and Saturday and Sunday from 7 to 11:30am. Located in the lower city a couple hundred feet south (left) of the Elevator Lacerda, the building was prefabricated in Portugal, shipped in parts to Salvador, and erected in 1736. On the third Thursday in January, a huge procession of white-clad Baianas sets off from this church—water jars on their heads—on their 8km (5-mile) trek to the Church of N.S. do Bonfim, where with great ceremony they wash the church steps (p. 245).

Neighborhoods to Explore

PELOURINHO ★★★

The historic heart of the city, Pelourinho, is a delight to explore. Indeed, it's so worthwhile, it's covered under "The Top Attractions," earlier in this chapter.

COMÉRCIO

The Cidade Baixa (lower city) was always the commercial center of Salvador. In the 16th century, people preferred to live in the cooler heights of Pelourinho and keep their offices and warehouses on the waterfront below. The concept is the same today, but Comércio, as the area is known, is now planted thick with stubby commercial high-rises. The Elevator Lacerda is the easiest way to access this area—though there's really little of interest down here except the ferry docks, the crafts fair in the **Mercado Modelo,** and the historic **Solar do Unhão** that houses the Museum of Modern Art. A number of steep, shabby alleys also connect the lower city to the upper city, but it's safer to take the elevator or a taxi.

VITÓRIA

This quiet and green neighborhood lies immediately south of Pelourinho. It has some lesser city landmarks such as the **Castro Alves Theatre** and **Campo Grande Square,** as well as a few lovely mansions/museums.

BARRA ★★

One of the nicest beaches close to downtown, Barra is a residential neighborhood with some restaurants and shops located south of the city center just where the coastline makes a sharp turn to the east. Many hotels are located here but the area has lost a bit of its former bustle and seems a bit run-down. Sights in the area include the **Farol da Barra (Barra Lighthouse)** and the smaller **Forte Santa Maria.** The prime attraction, however, is the sunset; small crowds gather to watch the show.

BONFIM/MONTE SERRAT ★

Located on a small peninsula that juts out into the bay, Bonfim is home to the **Church of Nosso Senhor do Bonfim,** one of the most important religious sites in

the city. Beloved by both Catholics and Candomblé worshipers (who revere their equivalent deity of Oxalá), the hilltop church draws huge crowds who come to pray or ask for miracles. The **washing of the steps** (p. 245), which takes place on the third Thursday in January, is one of the year's most colorful religious events. The neighborhoods of Bonfim, Ribeira, and Monte Serrat are now mostly home to the lower middle class and working poor, but they started out originally as summer destinations with cottages and summer homes. The other worthwhile sight is the **Forte de Monte Serrat,** which offers fabulous views of Salvador. On Sunday the sea wall is packed with families and teenagers out for a stroll.

ONDINA, RIO VERMELHO & BEACHES ★

Once past Ondina, the coast is an almost uninterrupted string of beaches. Most neighborhoods have few attractions beyond the beach itself. Popular beaches include Rio Vermelho, Praia dos Artistas, Praia de Piatã, Praia de Itapuã, Praia de Stella Maris, and Praia do Flamengo. **Rio Vermelho** is home to some of the city's best waterfront hotels, and has recently evolved into one of Salvador's prime nightlife enclaves. The area around the Praça Brigadeiro Farias Rocha is great for evening people-watching.

Beaches

With over 48km (30 miles) of beaches within the city limits, finding a beach is much less trouble than deciding which one to go to. Here follows a short description of the main beaches: The beaches on the bay side of town (**Boa Viagem** and **Monte Serrat**) are not recommended for sunbathing but can be fun places to walk, watch a pickup soccer game, or have a beer. On weekends the **Forte de Monte Serrat** is crowded with working-class families having a day out.

Barra is the closest clean beach area to downtown. **Porto da Barra** is the beach on the bay side of the lighthouse, whereas **Farol da Barra** is on the ocean side. Both beaches have calm and protected waters and are great for swimming. Just around the bend you will come to **Praia de Ondina,** the first of the true ocean beaches. It's popular with the many visitors who stay in the Ondina hotels, but only because of its proximity; the beach itself is narrow and cut off from Avenida Atlântica by shade-throwing hotel towers. Beyond Rio Vermelho, the beaches are mostly deserted. In a

Spend an Easy Sunday at Boa Viagem Beach

Salvador, we discovered, is deserted on Sunday. No one in Pelourinho. No one at N.S. do Bonfim church. It wasn't until we wandered down the hill through the equally deserted Boa Viagem neighborhood that we discovered where everyone was. At the beach. The place was packed with flirting teens and moms with lawn chairs and little kids with beach balls and inflatable orca whales. We snagged a couple of beers from a passing vendor and watched a pickup soccer game for a while, waving now and again at the folks a little surprised to see a couple of pale-skinned gringos on an unfashionable working-class beach. Then we continued along the shoreline to an old fort where a cafe with tables sat on a tiny bit of sand below a tall stone sea wall. While the tide rolled slowly in we watched a dad and young son make sand breasts (it started out as a sand castle but evolved into a Lara Croft–size bosom), flinching now and again when neighborhood kids would take a run along the top of the sea wall, plant both feet, and do double forward somersaults into the sea.

recent effort to clean up the city, the municipal council removed all kiosks from the beaches. As a result, there are no longer any places to sit and have a beer or a coconut and the beaches are often deserted. **Praia de Amaralina** has excellent surf and windsurfing conditions; the strong seas make it less ideal for swimming. **Praia dos Artistas** is highly recommended for swimmers and has waves gentle enough for children. At low tide the reefs of **Praia do Corsario** form natural swimming pools. **Praia de Piatã** has that tropical paradise look with lots of palm trees. One of the prettier beaches, **Itapuã,** has inspired many a song, including one by Vinicius de Moraes. Fishermen still bring their rafts in at the end of the day. The most recently trendy beaches are the ones the farthest from downtown; **Praia de Stella Maris** and **Flamengo** are where the young and beautiful gather on the weekends. **Stella Maris** combines calm stretches that are perfect for swimming with some rougher spots where the surfers can do their thing. The buses from downtown that are marked VIA ORLA will follow the coastal road connecting all the beaches until their final destination. Sit on the right-hand side, check it out, and get off when you see the beach you like. Keep in mind that on weekdays, especially in the low season, the beaches can be quite deserted. On those days it's better to stick to beaches close to town, such as Barra or Porto da Barra.

Spectacular Views

The classic viewpoint in Salvador is from the **Farol de Barra,** the lighthouse at the point where the Atlantic Ocean meets the Bay of All Saints. The view here, of course, is not of the city but of the sunset. People start gathering in the park around the lighthouse about a half-hour beforehand.

The best place to see the city itself is from the **Forte de Monte Serrat (Forte São Felipe),** located at the foot of the tall headland upon which the Bonfim church stands. From here you can look back across a small stretch of bay at the lower town, the old city on the cliffs above, and behind that the high-rises of modern Salvador.

There are also a couple of good places on the cliff tops to look out over the bay. One is in **Praça Tomé de Souza,** next to the modern city hall and the **Elevator Lacerda.** To have a view with a fine lunch to go with it, go to either of the two restaurants on the top-floor balcony of the **Mercado Modelo.** Both have decent Bahian food and killer views of the bay.

Especially for Kids

A number of the city parks provide plenty of recreational opportunities for kids and adults alike. In **Dique do Tororó Park,** Av. Marechal Costa e Silva s/n (℗ **071/3382-0847**), kayaks and paddleboats are available for rent. This pleasant park is also known for the set of 6m-tall (20-ft.) sculptures of eight Orixás in the middle of the lake. In the evening these are beautifully illuminated.

Pituaçu Park, Av. Otávio Mangabeira s/n, Pituaçu, across from Pituaçu beach (℗ **071/3231-2829**), contains a 2,500-hectare (1,000-acre-plus) reserve of Atlantic rainforest. In addition to the native species, there are lots of palms, cashews, mangoes, and *dendezeiros* (the small dendê palm tree). This popular recreational park has 18km (11 miles) of cycle trails (plus bikes for rent) and a children's playground.

Organized Tours

Tour operators around town operate a fairly standard package of tours. An excellent and reliable company is **Tatur** (℗ **071/3114-7900;** www.tatur.com.br), offering

THE ever-present CAPOEIRA

In Salvador, it is physically impossible not to witness the Brazilian martial art known as *capoeira*. Particularly around Pelourinho, you're bound to hear the sounds of the drums and the metallic drone of the *berimbau* (a banjolike instrument) as you walk around and catch a glimpse of two opponents spinning and kicking in a graceful half-fight, half-dance.

Though its origins are somewhat murky, most agree that *capoeira* evolved from rituals brought to Brazil by slaves from what is now Angola. The story goes that the slave owners were intimidated by the martial-arts rituals practiced by these tribes, and so tried to ban *capoeira* outright. The Africans then came up with a less-threatening form of the martial art, with a lot of moves that are more dance and acrobatics than martial arts. *Capoeira* was eventually outlawed anyway and its practitioners forced underground.

The practice never really went away, however, and with the changing times the public became more tolerant of *capoeira*. Finally in the 1950s, *capoeira* received the establishment seal of approval when President Getulio Vargas referred to it as the only "true Brazilian sport."

customized itineraries for independent travelers, as well as specially tailored educational faculty-led travel programs, involving the local community where and whenever possible. This company also offers a number of interesting multiday customized excursions such as African-heritage tours, folklore, history, or even archaeological tours to Bahia's interior.

The half-day city tours include either a visit to Pelourinho or a more panoramic tour to the lighthouse and the beaches. They range from R$80 to R$100. Full-day schooner tours in the Bay of All Saints usually stop at Ilha dos Frades and Itaparica. The cost is about R$60 to R$80. A number of evening tours include dinner and a folklore show, or a visit to a Candomblé ceremony (depending on the time of year). Prices range from R$80 to R$140. Farther afield, full-day tours to Praia do Forte or Morro de São Paulo depart Salvador almost every day. Praia do Forte costs R$60 to R$120, whereas a day trip to Morro de São Paulo starts at R$140 for the catamaran option or up to R$380 for the plane option.

BOAT TOURS ★ Definitely worth the money, the schooner trips in the Bay of All Saints depart daily from the dock in Comércio. The city views from the water are fabulous, and the beaches at Ilha do Frade and Itaparica are quite refreshing. Plus, if you've been wandering around the city for a day or two, it's a great feeling to be out on the water. To book a schooner trip contact **Tatur** (✆ **071/3114-7900**) or **Prive Tur** (✆ **071/3338-1320**). Prices range from R$75 to R$90 including pickup and drop-off at your hotel.

Outdoor Activities

DIVING The coast and bay around Salvador have some interesting dive spots, including reefs and shipwrecks. Trips and times vary according to the tides and weather conditions. Expect to pay R$240 for a dive trip including full equipment rental for two dives. Contact **Dive Bahia,** Av. Sete de Setembro 3809, Barra (✆ **071/3264-3820;** www.divebahia.com.br), for more information.

8

Exploring Salvador

SALVADOR & THE BEST OF BAHIA

Spectator Sports

CAPOEIRA There are a few good schools in Pelourinho where you can either watch or learn *capoeira* (see "The Ever-Present *Capoeira*," above). **Mestre Bimba**'s school, located on the Rua das Laranjeiras 1, Pelourinho (℃ **071/3322-0639;** www. capoeiramestrebimba.com.br), is the best known and is well set up to receive foreign students of all levels of experience, even those who want to try it for the first time. Visitors are welcome to have a look during lessons, but to see some good *capoeira* it is best to visit during the demonstrations Tuesday through Saturday, from 7 to 8pm. For those interested in taking a lesson, the school offers 1-hour lessons for R$15 per person, no experience required (wear long comfortable pants and a T-shirt or tank top). A 10-lesson package costs R$90. The groups are very small, never more than three or four students per teacher. Contact the school to schedule a lesson.

Many of the "spontaneous" *capoeira* demonstrations that take place around Pelourinho and the Mercado de Modelo are held for the benefit of tourists. They're fun to watch, but keep in mind that if you look on for a while and especially if you take pictures, you're expected to contribute some money to the group. Depending on how good the show is and how long I watch, I usually give between R$5 and R$10.

To watch a more authentic presentation, visit the **Forte de Santo Antonio Alem do Carmo,** aka the Capoeira Fort. Located at the very end of the Rua Direita de Santo Antonio, the fort is home to the *capoeira* school of **Mestre João Pequeno de Pastinha** (℃ **071/3117-1492**). Call ahead for presentation times.

SOCCER The most popular spectator sport in town is soccer. The **Otavio Manga-beira Stadium,** built in the 1950s, holds 80,000 people and hosts many important games. The big local teams are **Esporte Clube Bahia** and **Esporte Clube Vitória.** Contact the tourist information for details on upcoming games at ℃ **071/3013-3103.**

SHOPPING

Salvador offers wonderful shopping and some of the best crafts in all of Brazil. The best buys include crafts made out of wood, ceramics, or leather; musical instruments; and CDs of *axé* music. Remember to always bargain.

Art

Pricey but unique pieces can be bought at the many galleries in Pelourinho. **Galeria 13,** Rua Santa Isabel 13 (℃ **071/3242-7783**), has a large exhibit space with regular showings of work by local artists. **Galeria de Arte Bel Borba,** Rua Luis Viana 14 (℃ **071/3243-9370**), specializes in the sculptures and paintings by Bel Borba; his work is colorful and fresh. For top-of-the-line names check out **Oxum Casa de Arte,** Rua Gregorio de Matos 18 (℃ **071/3321-0617**). The large collection of art includes work by Mario Cravo and Carybé, who did the large wood panels of the Orixás in the Afro-Brazilian museum. The **Fundação Pierre Verger,** Rua da Misericordia 9, centro histórico (℃ **071/3321-2341**), in honor of the French photographer and ethnologist who specialized in Afro-Brazilian culture, displays a fabulous collection of his works and sells Verger's amazing photo books.

Arts & Crafts

Instituto de Artesanato Visconde de Mauá Founded by the government to promote and support regional artists, the institute is an excellent place to get a feel

for Bahian arts and crafts. There are weavings, hammocks, furniture, woodcarvings, and ceramics. Prices are fixed. To see future artists at work take a peek at the third floor, where students learn the traditional arts through workshops and apprenticeships. Just as any American can grow up to be president, every Baiano has the potential to be an artist. As the saying goes, *"O Baiano não nasce, estreia"* ("A Baiano isn't born, he premières"). The institute and shop are open Monday and Wednesday through Friday 8am to 7pm, and Tuesday 8am to 6pm. The shop is also open Saturday and Sunday 10am to 4pm. Rua Gregorio de Matos 27, Pelourinho. ✆ **071/3324-5912.** Bus: Praça da Sé.

Music

Aurisom To pick up the latest *axé* or Afro-reggae tunes, stop in at Aurisom. The compilation CDs of *axé* music that come out every summer give you the best of a whole crop of Bahian artists. This store also has a fabulous selection of LPs of old Brazilian music. Praça da Sé 22, Pelourinho. ✆ **071/3322-6893.** Bus: Praça da Sé.

Midialouca This small music store in the heart of Rio Vermelho, near the Ibis hotel, has a huge collection of Bahian and Brazilian music. In addition to DVDs and CDs, you will also find books on music and art, and songbooks. Best of all, the store is open daily from 8am to midnight—perfect for a browse before heading out for dinner. Rua da Fonte do Boi 81, Rio Vermelho. ✆ **071/3334-2077.** Bus: Rio Vermelho (or beaches beyond).

Oficina de Investigação Musical The *berimbau* must be the most purchased souvenir of all judging from the number of tourists I see leaving with these odd-shaped instruments under their arms. More portable and just as interesting are some of the drums, rattles, and tambourines used in Afro-Bahian rhythms. The shop is closed Sunday. Rua Alfredo Brito 24, Pelourinho. ✆ **071/3322-2386.** Bus: Praça da Sé.

Shopping Malls

Salvador has a number of shopping malls outside of the downtown core. **Shopping Barra,** Av. Centenario 2992, Barra (✆ **071/3339-8222**), is just a few blocks from the Farol da Barra; it's open Monday through Friday from 10am to 10pm and Saturday from 9am to 8pm. A bit farther out, next to the bus station, is one of the larger malls, **Shopping Iguatemi,** Av. Tancredo Neves 148, Pituba (✆ **071/3350-5060**). Open Monday through Friday from 10am to 10pm and Saturday from 9am to 9pm. Take buses marked RODOVIARIA. Here you'll find everything you need: clothing, souvenirs, books, and CDs, as well as movie theaters and an excellent food court.

Souvenirs

For above-average souvenir T-shirts, check out these stores: **Litoral Norte,** Rua Gregorio de Matos 30 (✆ **071/3322-3781**), sells a beautiful collection of T-shirts and also has some lovely hand-painted hammocks; **Boutique Ilê Aiyê,** Rua Francisco Muniz Barreto 16 (✆ **071/3321-4193**), sells CDs and T-shirts and other merchandise with the Ilê Aiyê band's logo, and part of the funds support the group's educational program; **Projeto Axé,** Rua das Laranjeiras 9 (✆ **071/3321-7869**), is a nonprofit organization that sells great skirts, shorts, *kangas,* blouses, and other clothing to raise funds to support projects for street children.

Entre Dedos This little shop sells every kind of Havaiana, as the Brazilians call the colorful flip-flops that are now popular around the world. Havaiana actually refers

to the brand name that made this footwear popular many years ago. You'll find an amazing selection here, including special editions with images of endangered species and artwork. Rua Inácio Acioly 7, Pelourinho. © **071/3321-1383.** Bus: Praça da Sé.

Lembranças da Fé For a different kind of souvenir try this store, which specializes in religious articles. Only in Bahia would you see saints sitting happily side by side with Orixás. Take time to browse the interesting herb mixes, shells, and cards used in Candomblé celebrations. Rua João de Deus 24, Pelourinho. © **071/3321-0006.** Bus: Praça da Sé.

Sweets

Cafelier Santissimo This lovely store fits into so many categories: cafe, bookstore, antiques shop, and souvenir store, but the great thing is that you can look at all the lovely objects, admire the view, and enjoy a delicious sweet or baked good. Rua do Carmo 50, Pelourinho. © **071/3242-5151.** Bus: Praça da Sé.

Delícias Bahia Souvenirs bought here may not last until you get home. The shop has a large selection of coconut sweets, chocolates, jams, and candied fruit as well as over 100 different kinds of liquors flavored with fruit (try the banana or *cupuaçu* flavor), creamy condensed milk, or spices. Rua Inacio Accioli 9, Pelourinho. © **071/3241-0775.** Bus: Praça da Sé.

SALVADOR AFTER DARK

Night owls won't lack for options in Salvador. The old city center of Pelourinho hums with music, people, and a lively mix of activities that Brazilians call *movimento*. Farther out along the beaches, music venues are bigger and more geared toward the club crowd, but it is still easy to find places with live music, particularly in the new nightlife enclave of Rio Vermelho. True, the "high arts" of theater, dance, and classical music do suffer a bit in Bahia, but with everything else going on, odds are you won't notice. The scene in Bahia is very laid-back and casual; you won't find any upscale yuppie pretensions here, unless you look really hard.

The Performing Arts

Balé Folclorico Brazil's only folkloric dance company, the Balé Folclorico travels the world with its beautiful performances of Afro-Brazilian dances and rituals. A small core of dancers also provides a daily presentation in Pelourinho. The 1-hour show tells the story of the most important African deities—Orixás—and introduces viewers to several musical styles that have greatly influenced Brazilian music, such as *maculele, maracatu,* and *samba de roda.* The group performs Monday through Saturday at 8pm. Teatro Miguel Santana, Rua Gregorio Matos 49, Pelourinho. © **071/3322-1962.** www.balefolcloricodabahia.com.br. R$35. Bus: Praça da Sé.

Teatro Castro Alves Home to the Bahian Symphony Orchestra and the Balé (ballet) de Castro Alves, this is your best bet for catching fine-arts performances. Occasionally this venue also serves as a concert hall for popular Brazilian musicians or local music acts. Check the schedule for upcoming events. Praça Dois de Julho s/n, Campo Grande. © **071/3339-8000.** www.tca.ba.gov.br. Admission varies from R$10–R$60. Bus: Praça da Sé or Campo Grande.

Teatro Sesi Rio Vermelho One of the best places to see contemporary bands is the beach neighborhood of Rio Vermelho. The Teatro Sesi Rio Vemelho is housed

in a renovated heritage building and specializes in bringing in local and Brazilian acts. Music varies from jazz to blues to MPB (Musica Popular Brasileira) and even pop. Rua Borges dos Reis 9, Rio Vermelho. *C* **071/3616-7064.** www.fieb.org.br/teatro_sesi. Tickets vary from act to act, but you can expect usually to pay R$10–R$25. Bus: Praia Flamengo or Pituba.

Teatro Vila Velha Much loved by locals, the Teatro Vila Velha has played an important role in the cultural life of Salvador. Caetano Veloso, Gal Costa, Maria Bethania, and Gilberto Gil all performed here in the early days of their careers. These days, it's home to two theater companies and one modern dance company—Viladança. For performances or other events such as MPB, *choro*, or *pagode* concerts, check the schedule. Tickets are inexpensive. Passeio Publico s/n, Campo Grande. *C* **071/3083-4600.** www.teatrovilavelha.com.br. Admission R$10–R$25. Bus: Campo Grande or Praça da Sé.

Music & Dance Clubs

PELOURINHO

Once the musical highlight of Salvador, Pelourinho now hosts significantly fewer events since the government cut cultural funding. Your best bets are Tuesday night and weekends; check with the Bahiatursa office in Pelourinho or look in the newspaper for information on events.

LIVE MUSIC

Bahia Café Aflitos The Bahia Café is a popular bar/dance club close to Centro. The view is spectacular, overlooking the bay. Open Thursday to Sunday, the bar hosts popular local and regional bands, with DJs to keep the crowd going between sets. Die-hards who stay until the wee hours enjoy a plate of spaghetti or a bowl of hearty bean soup, courtesy of the house. Quartel dos Aflitos s/n (the entrance is at the very end of the square; walk toward the viewpoint). *C* **071/3328-1332.** R$10–R$30. Bus: Praça da Sé.

Groove Bar Eighties Rock Rules! This live music venue is the best place in town for rock and blues. Thursdays and Fridays are reserved for excellent cover bands (think U2, Pink Floyd), as well as original acts. Saturday's lineup is more pop and dance music, including classics from Michael Jackson and a range of Brazilian artists. Rua Almirante Marques de Leão 351, Barra. *C* **071/3267-5124.** www.groovebar.com.br. R$10–R$25. Bus: Barra.

 If It's Tuesday, It Must Be Terça da Bençáo

Tuesday is known in Pelourinho as Terça da Bençáo (Blessed Tuesday). It's the day parishioners of the São Francisco de Assis Church give out bread and donations to the poor. Somehow, this simple act of charity has grown into a happening street party that kicks off every Tuesday after the 6pm Mass. The most interesting service takes place at N.S. do Rosário dos Pretos, an eclectic event held to the sound of African drums, attended by the church's black parishioners. At 7pm locals and tourists gather at the steps on the Ladeiro do Carmo to watch popular singer Geronimo perform. Afterward, take a walk through Pelourinho. Up and down the streets, music seems to pour from every corner as bands play in little largos or cafes crank their stereos. Inside Praça Teresa Batista, Olodum holds its traditional Tuesday show. By midnight everyone heads home.

The Mission of Olodum

Olodum is one of the best-known blocos in Salvador, maybe in all of Brazil. Founded in 1979, Olodum started as a recreational group for residents of Pelourinho who had few options during Carnaval. More than 20 years later, Olodum has grown into a cultural phenomenon with international fame, not to mention its own nifty logo, a peace sign filled with reggae colors. The group's mandate is to preserve and value black culture and heritage, and fight all forms of racism and violence. One of the ways they pursue this is through work with young children and teens in some of the poorer neighborhoods of Salvador. Over 150 kids are involved in Olodum-sponsored cultural activities. The money raised by international performances and recordings made with people like Paul Simon help fund the group's educational activities. Every Tuesday night the group performs at the Praça Teresa Batista starting at 8pm. Contact the Olodum office at ✆ **071/3321-5010** or www.olodum.com.br for information on concerts and Carnaval rehearsals, or stop in at the gift shop located at Rua Gregorio de Matos 22, Pelourinho.

DANCE CLUBS

Borracharia A garage by day, this venue attracts Salvador's hip and alternative crowd by night. The tires, tools, and grubby walls make a unique background for the DJs that spin dance, electronic, and other energizing tunes. It's only open Friday and Saturday, midnight to 5am. Rua Conselheiro Pedro Luiz 101, Rio Vermelho. ✆ **071/3334-0091.** Bus: Rio Vermelho.

Madrre Madrre is Salvador's hottest dance club for lovers of house and electro. The beautifully designed space combines classic and modern elements and hosts a range of well-known national and international DJs. Av. Otávio Mangabeira 2471, Pituba. ✆ **071/3346-0012.** R$15–R$35. Bus: Pituba.

Bars & Pubs

Café do Farol ★★ 👶 In all Salvador you can't find a better view. The Café do Farol is inside the lighthouse at Barra, and the patio has one of the most amazing views of the ocean and the city of Salvador. Come here for a drink, or snack on sweet or savory crepes. To access the cafe you must pay admission to the museum (R$6). Open Tuesday through Sunday 9am to 10pm. Praia da Barra s/n, Barra (inside the lighthouse). ✆ **071/3267-8881.**

Cantina da Lua ★ So what if you and every other tourist in town are on this patio? It happens to be one of the loveliest and largest patios on the Praça Terreiro de Jesus, offering the best view of all the activity on the square: the *capoeiristas* sweating in the sun, the hawkers selling souvenirs, and the dressed-up Baianas posing for pictures. In the evening it seems like all of Salvador strolls through this square. Open daily 11am until the last customer leaves. Praça Quinze de Novembro 2, Pelourinho. ✆ **071/3241-5245.** Bus: Praça da Sé.

GAY & LESBIAN BARS

A great resource for gay travelers, the **Grupo Gay da Bahia,** Rua Frei Vicente 24, Pelourinho (✆ **071/3321-1848;** www.ggb.org.br), has information on tourism and recreational opportunities in Salvador as well as on local social issues and community

8

SALVADOR & THE BEST OF BAHIA

Salvador After Dark

activism. Salvador has a small but growing Pride Parade that is usually held in October. Of course the parade includes lots of music and the *trio eletrico* sound trucks. Famous Bahian artists such as Daniela Mercury and Ivete Sangalo have taken part in previous years. Check the Grupo Gay da Bahia for details on the date. During Carnaval, don't miss the contest for Best Gay Costume, which takes place in front of Salvador city hall and includes drag queen performances and lots of music. One of the more popular Carnaval blocos that counts on a huge gay following is the **Bloco dos Mascarados** ((C) **071/3237-0066**), led by Bahian singer Margaret Menezes. Rehearsals take place from November until Carnaval. Check with the tourist office for the dates and locations of these *ensaios*.

Salvador's gay scene is not as open as in Rio de Janeiro, but two popular hangouts are late Saturday afternoons at Porto da Barra beach and Sunday at the Barraca Aruba, a beach kiosk at Praia dos Artistas. In town, Avenida Sete de Setembro, from Praça da Sé to Campo Grande (particularly around the Praça da Piedade), as well as Pelourinho's Praça Pedro Arcanjo, are known cruising areas.

The dance club at **Queens Clube,** Rua Teodoro Sampaio 160, just behind the Biblioteca Nacional ((C) **071/328-6220**), is open Friday and Saturday midnight to 6am. The sex shop, DVD rentals, and movie screening rooms are open Monday through Saturday 3 to 10pm. Also popular, **Off Club,** Rua Dias d'Avilla 33, Barra ((C) **071/3267-6215;** www.offclub.com.br), attracts a mixed crowd of both male and female clubbers. It's open Thursday through Sunday. On Friday the DJs play eclectic flashback hits, while Saturday is house and techno night; the other nights are a mishmash with go-go boys, drag queens, and other performers. Doors don't open until 11:30pm.

CARNAVAL IN SALVADOR

Carnaval is Salvador's biggest party. Over a million and a half people (locals and tourists) join in to celebrate. In contrast to Rio's more spectator-oriented celebration, the focus in Salvador is on participation. There are no samba schools with outlandish costumes and big floats—in fact, there is hardly any samba at all. The beat of choice is *axé* or Afro *axé*, the unique Bahian rhythm that combines African percussion with Caribbean reggae and Brazilian energy. The action is out on the streets with the blocos.

In Rio, blocos are groups of locals who gather up a few instruments for an impromptu parade. In Salvador, blocos started out years ago as flatbed trucks with bands and sound systems, leading people on an extended dance through the streets. The concept's still the same, but as the number of participants has grown, Salvador

 Some Carnaval Do's and Don'ts

Do not bring any valuables with you; bring a photocopy of your passport or driver's license instead of the real thing. Buy a disposable camera that tucks into your pocket. Only bring as much money as you think you'll need and spread it out; put some in your pocket and a few bills in your shoe. Do not underestimate the heat, and drink sufficient water or coconut milk. Don't dress up: For blocos just wear your *abadá*, shorts, and running shoes; otherwise shorts and a tank top will do just fine.

blocos have evolved into more highly organized affairs. All now follow set routes. Many have corporate sponsorship. Some even belong to production companies. Unavoidably, it also comes with a price tag.

The revelers that follow a bloco must buy a T-shirt *(abadá)* to identify themselves. In return they get to sing and dance behind the music truck in a large cordoned-off area, staffed by security guards who keep troublemakers out. Following the revelers is the support car with a first-aid attendant, bar, and washrooms (to which only *abadá* wearers have access). If you follow the entire route you can expect to be on your feet for at least 6 hours. Most blocos parade 3 days in a row, and your *abadá* gives you the right to come all 3 days, if you've got the stamina. It is also possible to purchase an *abadá* for just 1 day. Carnaval officially begins at 8pm on the Thursday evening before Ash Wednesday, when the mayor of Salvador hands the keys of the city over to King Momo, who will rule for the next 5 days.

Carnaval Central

The most convenient **Central do Carnaval** location is in the heart of Pelourinho, Rua Gregorio de Matos 13 (corner of the Rua Laranjeiras; © **071/3321-9365**). Other locations can be found at the Shopping Iguatemi and Shopping Barra. Book early as some of the popular blocos sell out by August!

Blocos

Blocos all follow one of three set parade routes and start at designated times. Most blocos will take 4 to 6 hours to complete the course. The routes are **Osmar, Dodô,** and **Batatinha.** (Osmar and Dodô are named after the two musicians who first came up with the *trio eletrico* idea of mounting the band on a flatbed truck in the 1950s.) The 7km-long (4¼-mile) **Osmar route** starts at Rua Araujo Pinha in Campo Grande, goes up Avenida Sete de Setembro as far as Praça Castro Alves, and returns to Campo Grande via Avenida Carlos Gomes. The **Dodô route** was designed in the 1980s to accommodate the increased number of blocos. It follows the coastal road from Ponto da Barra to Ondina Beach. **Batatinha** is the preferred route for the percussion-heavy Afro *axé* blocos as well as the colorful drag queen blocos. Sticking close to the historic center, Batatinha runs from Praça da Sé to the Praça Municipal, then to Praça Castro Alves, and finishes up in Campo Grande. The blocos parade from Friday to Tuesday, some on 3 days, others on 4. Order and start times vary, so pick up an updated calendar just before Carnaval at one of the tourist offices.

See the list below to help you decide which blocos to follow. To purchase an *abadá*, contact the bloco directly or else call the **Central do Carnaval** (© **071/3372-6000;** www.centraldocarnaval.com.br); they represent at least a dozen of the most popular blocos. The prices for the *abadás* range from R$300 to R$900 for 2 or 3 days. The Central can also sell you an *abadá* for a day if you don't want to commit to the entire 3 days or want to try different blocos.

Ara Ketu Though it's getting more and more known across Brazil, Ara Ketu's roots remain in Salvador where the group works with community organizations and runs music and theater workshops for disadvantaged children and teens.

Blocos Axé Many of the blocos *axé* originated in the poorer and overwhelmingly black neighborhoods on the outskirts of Salvador. With the recent revival of black culture and pride, these blocos have become more and more popular and are now

part of the mainstream events. The most popular ones are Ilê Aiyê, Olodum, Filhos de Ghandi, Ara Ketu, and Filhas de Oxum.

Camaleão Founded in 1978 by a group of university students, Camaleão parades Sunday through Tuesday along the Osmar route. Chiclete com Banana is the lead attraction, one of the most popular Bahian bands. This bloco was a recent winner of the best bloco and best band award. It also takes first prize for most expensive bloco; to partake in all 3 days will set you back a whopping R$2,500!

Cerveja e Cia The star attraction of this bloco is Bahia's musical sensation Ivete Sangalo and other famous musicians. The bloco parades Thursday through Saturday along the Dodô beach route.

Filhos de Ghandi Popular during Carnaval for its symbolic message of peace, this bloco is instantly recognizable for the white Ghandi costumes worn by its 10,000 all-male followers. The bloco parades Sunday through Tuesday (along the Osmar route Sun and Mon and along the Dodô on Tues). To purchase an *abadá* (the Ghandi uniform) contact ✆ **071/3321-7073.**

Ilê Aiyê One of the most traditional Afro blocos, Ilê lets only black participants parade, but everyone is welcome to watch and cheer. Its music is a wonderful blend of reggae and percussion; the drums are phenomenal. The group parades on Saturday, Sunday, and Tuesday along the Osmar route. For *abadás* contact ✆ **071/3388-4969.**

Olodum Internationally known, Olodum's popularity draws huge crowds. The music is fun, some reggae, a little bit of samba, and lots of drums. Olodum always provides a great show. The group parades on 4 days, Friday and Sunday through Tuesday. *Abadás* can be purchased at the store in Pelourinho, Rua das Laranjeiras 30, or contact ✆ **071/3321-5010.**

Rehearsals

Though less organized and structured than the samba school rehearsals in Rio, a small number of blocos do meet regularly in the months leading up to Carnaval. For some this is also an important money generator, and admission can cost R$60 or more. If you won't be in Salvador during Carnaval, these rehearsals are highly recommended.

The most popular rehearsals are run by **Olodum.** On Tuesday nights, the group meets at the Praça Teresa Batista s/n, Pelourinho (✆ **071/3321-3208**). Tickets are

commitment SHY?

Instead of committing to one specific bloco and following along for hours, you can also get a seat in the stands that line the parade route and watch all the blocos go by. Tickets for box seats (*camarote*) or tables are expensive. The Central de Carnaval sells tickets to box seats at three different venues; prices range from R$150 to R$690 per person per day. See www.centraldocarnaval.

com.br for more details. The ticket usually includes drinks, food, and entertainment. To reserve a seat in one of the much less pricey bleachers that line the parade route, contact Salvador city hall at ✆ **071/3450-2711** or the Central do Carnaval at ✆ **071/3372-6000.** These seats go for about R$80 to R$130 per day but don't include any of the fancy trappings of the *camarotes*.

The End of Carnaval: It Ain't Over Till It's Over

In most cities, Carnaval comes to a quiet end as partygoers run out of steam in the early hours of Ash Wednesday and finally flop into bed. In Salvador, the party goes out with a bang. Although this event is an informal one, it takes place every year at the Praça Castro Alves. At the meeting of the trios (*encontro dos trio eletricos*), a few of the blocos that have finished their parades meet to compete for the last bit of energy the crowd has to offer. Usually the party keeps going until the sun comes up. In recent years, Caetano Veloso and Carlinhos Brown were among the prominent musicians who came out for the grand finale and packed the square with tens of thousands of people.

R$20. Unfortunately the ticket does not allow in-and-out privileges, and Olodum's rehearsal coincides with Terça da Benção, one of the most lively nights in Pelourinho. On Sundays, Olodum holds a free rehearsal starting at 6pm at the Largo do Pelô. Several of Salvador's big names such as **Ara Ketu, Ivete Sangalo,** and **Chiclete com Banana** hold regular rehearsals in the months leading up to Carnaval. If you are in Salvador between October and Carnaval, check with the tourist office for details. To purchase *abadás* or *camarote* tickets, or review scheduling and program information, contact the **Central do Carnaval** at ✆ **071/3372-6000** or www.centraldocarnaval.com.br.

SIDE TRIPS FROM SALVADOR
Praia do Forte

70km (43 miles) NE of Salvador

As recently as 10 years ago, Praia do Forte was a sleepy little fishing town with a handful of streets (none of them paved), a couple of small pousadas, and a tiny seaside church. Then a firestorm of real estate speculation swept the coast, bringing massive new resorts, upscale hotels, chain restaurants, and expensive clothing boutiques. The main street was covered with interlocking paving stones, festooned with signs brought to you by Visa, and flanked by shop windows of brightly lit plate glass offering R$300 bikinis and the chance to act now and secure your place in the latest real estate opportunity on the coast.

Why anyone would come all this way to stroll a mall-ified street looking at the same chain stores found in any big shopping mall is beyond me. Indeed, what the people pushing all this development seem to have overlooked is that the attraction of Praia do Forte was never its beach—which is nice but not exceptional for Brazil—but rather the low-key laid-back charm of the place. Now that that's gone, there's hardly any reason to visit Praia do Forte at all. There are much prettier and still practically unspoiled beaches and small towns south of Salvador.

The Projeto Tamar sea turtle project is still there. If it's the right season and the turtles are hatching it may be worth making a short day trip to see the hatchlings make their mad dash for the sea. But if you're looking for a beach experience near Salvador, head south to Morro São Paulo or Boipeba or farther down to Barra Grande.

SALVADOR & THE BEST OF BAHIA

Side Trips from Salvador

GETTING TO KNOW THE TURTLES

Projeto Tamar The sea turtle organization Tamar is Brazil's one big environmental success story. Starting out as a poor and unloved environment agency in the early 1980s, Tamar has since come into the mainstream, forming alliances with the Brazilian environment agency IBAMA and with Petrobras, Brazil's national oil company, and making its SOS (Save Our Sea turtles) symbol a mainstay of posters, billboards, and bumper stickers across the country. Tamar now has numerous conservation outposts along the Brazilian coast, with one of the most important on the nursery beach at Praia de Forte. Most evenings, beginning in December and continuing until mid-March, three different species of sea turtles swim ashore, clamber up the beach, and dig a small pit into which they deposit anywhere from 50 to 200 eggs. Each night, teams of Tamar biologists sweep the beach looking for laying turtles. If the mother has chosen a suitable nest site, the biologists simply cover the eggs with a chicken-wire screen for added protection and mark the spot with a tall white stake. If the eggs are too close to the high-tide line or too near human habitation, Tamar collects the eggs and transfers them to its incubation site nearby. Fifty days later, more or less, the little turtlings hatch, dig their way up through the sand, and make a mad scramble to the sea. Nationwide, Tamar has to date released over three million hatchlings. Unfortunately, it's tough being a sea turtle. Only 1 out of 100 hatchlings will return 35 years later to the same beach to begin the cycle again. Visitors to the Tamar site in Praia do Forte see turtles from days-old hatchlings to 20-year-old adolescents. (There's also a kid-friendly video, a cafe, and a gift shop.) Better still, on certain nights during laying season, visitors are allowed to watch mother turtles lay. Best of all, from late January to the end of April, Tamar lets visitors witness the little turtles hatch out and make for the ocean. Exactly when depends on the turtles, of course, but during February there's a hatch-and-scramble nearly every evening, usually just before sunset.

Av. do Farol s/n, Praia de Forte, BA 48280-000. ℭ **071/3676-1045.** www.projetotamar.org.br. Admission R$15 adults, free for children 4 and under. Daily 9am–5:30pm.

GETTING THERE

BY CAR Praia do Forte is 50km (31 miles) north of Salvador airport on the Estrada do Coco highway, which starts just past Itapoã beach. **Tatur** (ℭ **071/3114-7900;** www.tatur.com.br) offers full-day tours to Praia do Forte for R$60 to R$120 per person.

BY BUS The **Nossa Senhora das Graças** bus company provides regular service between Praia do Forte and Salvador, leaving from the Salvador Rodoviaria. Buses run almost every hour between 6am and 6pm. For exact times phone ℭ **071/3676-1607.** Fares are R$8. The trip takes 2½ hours.

BY TAXI **Centro Turistico** (ℭ **071/3676-1091** or 9989-9864; www.prdoforte. com.br) offers transfers to Praia do Forte from anywhere in the city of Salvador for R$180 per car (up to four people) or R$150 from Salvador airport.

WHERE TO STAY

If for whatever reason you find yourself staying in Praia do Forte, **Pousada Ogum Marinho,** Alameida do Sol s/n (near Projeto Tamar) (ℭ **071/3676-1165;** www.ogummarinho.com.br), has comfortable doubles with verandas and air-conditioning for R$220, parking and breakfast included. Fancier and quieter but more expensive is **Refugio da Vila,** Aldeia dos Pescadores Qd. 39 (ℭ **071/3676-0114;**

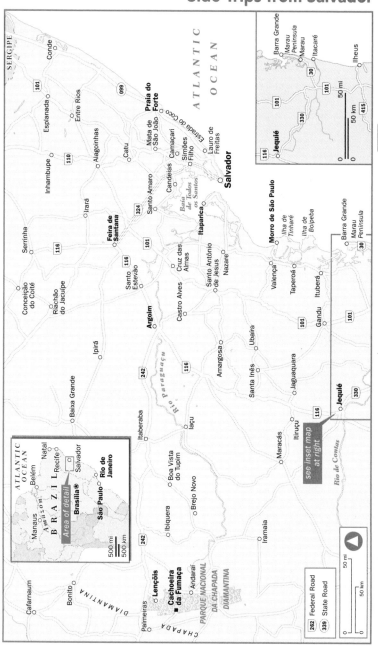

www.refugiodavila.com.br). The Refugio offers a pool and pleasant garden area, plus king-size beds, parking, and breakfast for R$330 to R$400 double.

Lençóis & Chapada Diamantina

394km (245 miles) NW of Salvador

In the dry interior of Salvador lies the Chapada Diamantina, or Diamond Highlands. Valleys of lush green dotted with bright tropical flowers surround a mountain range of twisted red-rock formations reminiscent of the American Southwest. Numerous small rivers carve their way through the highlands, splashing over waterfalls and natural slides. There are also numerous caves, some many kilometers long. Many are quite popular, some just being discovered, some restricted yet to geologists who are trying to figure out just how they and the rock formations they contain were formed.

The gateway community of Lençóis is an old colonial town of stone streets and little churches, with cellphone towers the only real sign of the modern world. The attractions here are entirely natural. People walk the highlands, explore caves, mountain bike old miners' tracks, and swim in natural pools and waterfalls.

ESSENTIALS

GETTING THERE BY CAR The town of Lençóis is 394km (245 miles) from Salvador. Take BR-324 to Feira to Santana, turn onto BR-116 to Argoim and then BR-242 to Lençóis. The road is paved the entire way, but heavy truck traffic makes for an unpleasant drive.

GETTING THERE BY BUS Real Expresso (© 0800/617-325; www.real expresso.com.br) makes the approximately 6- to 7-hour journey between Salvador and Lençóis at a cost of R$56. Buses depart the Salvador Rodoviaria for Lençóis daily at 7am, 4:30pm, and 11:30pm. From Lençóis, buses depart the bus station at Av. Senhor dos Passos s/n (© 075/3334-1112) for Salvador daily at 7:30am, 1:15pm, and 11:30pm.

GETTING THERE BY PLANE TRIP (© 0300/789-8747; www.voetrip.com. br) operates a weekly flight between Salvador and Lençóis. Flights depart Salvador on Saturday at 10:50am and arrive in Lençóis at 11:45am. From Lençóis, flights depart every Saturday at 12:05pm, arriving in Salvador at 1pm. Flights range from R$120 one-way, if you book early, to R$300 in high season.

GETTING AROUND All parts of Lençóis can be reached by foot in less than 15 minutes. Excursions to the many caves and waterfalls in the area include transport.

VISITOR INFORMATION In Lençóis, the local tourism agency **Sectur Lençóis,** Av. Sr. dos Passos s/n, opposite the Portal Lençóis Hotel on the far side of the river from the main square (© 075/3334-1327), has pamphlets on tours and attractions in the area. Staff speaks Portuguese only.

The official city tourism website is www.guialencois.com. Another good website with geology, trail maps, and more can be found at www.gd.com.br/candomba/english.

FAST FACTS The **Banco do Brasil,** Praça Horario de Matos 56 (main square), is open Monday through Friday from 9am to 1pm. The ATM is open 24 hours—PLUS/Visa only. For first-aid and medical supplies there's **Pharmacia Maciel,** Av. 7 de Setembro 50 (© 075/3334-1224), open daily from 8am to 8:30pm. The post office is at Av. Sete de Setembro 18. It's open Monday through Friday from 9am to 5pm.

EXPLORING THE TOWN & BEYOND

The town of Lençóis is a tiny colonial gem, but it won't take more than an hour to see it all. After that, it's out into the highlands to see what the natural world has to offer. A number of excellent hikes in the area lead either to waterfalls or mountaintop viewpoints. Some of these sights are far enough to require transportation, but quite a few you can find with your own two feet.

From the bridge in Lençóis a trail leads up beside the Lençóis River to the **Serrano swimming hole** and **Primavera Falls.** An hour's walk south of town will lead you to the **Ribeirão de Meio** rock slide, a huge natural water slide flanked by many natural swimming holes. A long (8-hr.) hike up this same river leads to the **Sossego** canyon and **waterfall.**

The most famous waterfall in the park is **Cachoeira de Fumaça (Waterfall of Smoke),** so called because the thin stream of water slipping over the 335m (1,100-ft.) precipice fades into a fine mist before it reaches the ground.

The park is also known for its mesalike mountain formations. The most famous are **Morro do Pai Inácio** (located right next to BR-242 west of Lençóis), the 1,067m (3,500-ft.) **Morro do Camelo,** and the 1,403m (4,600-ft.) **Monte Tabor** (also called **Marrão**). All have trails to the top, and from the flat top of any one, you have the entire Chapada spread at your feet.

Caves are a fascinating aspect of the Chapada Diamantina Park. Some of the best-known ones in the area include **Gruta de Lapão,** a rare sandstone-and-quartzite cave over 1km (½ mile) long from end to end. It's located about 5km (3 miles) from Lençóis. Farther afield one finds a number of the more traditional limestone caves, such as **Gruta da Fumaça** (note: this is nowhere near the Cachoeira da Fumaça) with rock flowers, stalagmites, and stalactites. The prettiest cavern may be **Gruta da Lapa Doce,** which extends 850m (2,788 ft.) underground. In the same area is **Gruta da Pritinha,** where an underground river emerges into the sun. Inside there's a large pool where you can dive and swim. Nearby is the small **Gruta Azul.** Late in the afternoon when the sun reaches into this cave, the water glows cobalt blue.

OUTDOOR ACTIVITIES

When the weather gets hot (and it does), take to the natural swimming pools. Close to Lençóis, and so popular that there are now beer and refreshment stands lining its banks, is the **Mucugezinho River.** Below these stands on the same river is a deep cold pool called the **Poço de Diabo.** South of Lençóis, near the town of Andaraí, is an underground pool with crystal-clear water and excellent limestone formations called the **Poço Azul,** where swimming is allowed.

Swimming is not allowed at the **Poço Encantado,** and it's a long way from anywhere down some pretty bad roads, but it's worth seeing anyway. It's a large underground cavern with crystal-clear water. Between April and August light reaches down through a hole in the cavern wall, and the water glows electric blue.

For wildlife watchers there's the **Marimbus** wetland. In addition to lots of caimans, it is also home to capybaras and a wide variety of colorful bird life.

BIKING Rony Bike (© 075/3334-1700) offers guided mountain-bike trips and also rents bikes. Owner **Rony Oliveira** has lived in the area for over 10 years and biked every possible trail. The cost for one person including a bike and guide is R$75 per day. Itineraries can be customized to suit all interests and abilities. **Adilson Trilhas, Passeios e Bikes,** Praça Samuel Sales 32 (© 075/3334-1319), is another option for mountain-bike tours and rentals.

HIKING Trails in the Chapada Diamantina are quite good—many are old miners' supply routes—but signage is nonexistent. Carry a map, compass, and some spare food and water (locals insist the water from the highlands is drinkable, but there are enough cattle still pastured up there that I have my doubts). If in doubt of your trail-finding skills, bring a guide along. To locate a guide, try the tour agencies below or contact the guide association directly: **ACVL** (Associação dos Conductores de Visitores no Lençóis), Av. General Viveiros 61, across the river by the Cantos dos Aguas Hotel (*℗* **075/3334-1425**). **Roy Funch Specialized and Personalized Guide Services** (*℗* **075/3334-1305**; funchroy@yahoo.com) is another source of guide information. Roy is American, but has lived in the area for years.

There are dozens of hikes in the Chapada Diamantina. The following are just suggestions. A short hike up the Lençóis River from the bridge will take you to the **Serrano** swimming holes, composed of little pools of pink conglomerate rock. About .5km (¼ mile) farther up the river, there's the larger **Hartley natural pool.** A short, pretty walk beyond that a small tributary comes in from the right, the **Grizante Creek.** Follow that up and you'll come to **Primavera Falls.**

An hour's walk south of town will lead you to the **Ribeirão de Meio** natural water slide. The water slide is also the trail head for a long (8-hr.) hike along the banks of the Ribeirão River to **Sossego Canyon** and **Sossego Falls.**

A good day hike that will take you through the heart of the Chapada is the 25km (16-mile) trek from the **Capão Valley to Lençóis** (or vice versa).

HORSEBACK RIDING For horseback riding, find one-armed **Taurino Sousa Alcantera** in his souvenir shop at Rua das Pedras s/n, about halfway up the street (*℗* **075/3334-1403**). Itineraries include a 5-hour ride to the **Rio Capivara** (R$60), a short 40-minute ride to **Ribeirão de Meio** (R$30 per person) where you can then play on the natural water slide, and an 18km (11-mile) daylong ride through several rivers to the **Rio Roncador** (R$90 per person).

RAPPELLING A popular sport in Brazil, rappelling is the act of lowering yourself down a length of rope with a harness and a locking carabiner. You can rappel down a cliff face, a waterfall, into a cave, whatever. In Lençóis, the rappelling specialist is **Nativos da Chapada,** Rua Miguel Calmon 29 (*℗* **075/3334-1314** shop, or 9960-0131 cellphone). The company offers a number of different rappel outings, including a 30m (98-ft.) drop down the **Alto da Primavera Cliff,** a 48m (157-ft.) descent into the **Gruta do Lapão Cave,** a 150m (492-ft.) descent from the **Pai Inácio Mesa,** or a soaking 50m (164-ft.) drop through the waters of **Mosquito Falls.** On most outings you get to make six descents. Cash only; prices range from R$80 to R$140 (for two–four people).

TOUR OPERATORS **Lentur,** Avenida Sete de Setembro (*℗* **075/3334-1271;** www.lentur.com.br), offers seven different **guided minivan tours** to just about all of the local caves, springs, waterfalls, and mesas (Lapa Doce, Gruta Azul, Poço do Diable, Poço Encantado, and so on). Tours are in eight-passenger minivans. They begin at 8:30am and end at 6pm, and include a light lunch. Minimum group size is four. The cost for each tour is R$65, including the services of a Portuguese-speaking guide. An English-speaking guide costs R$90, with that cost divided by however many require his services.

Nas Alturas, Praça Horácio de Matos 130 (*℗* **075/3334-1054;** www.nasalturas. net), organizes excellent **guided 7-day trail hikes** for groups of up to eight people.

One of the Chapada's most beautiful hikes traverses the Vale do Pati. Another great itinerary, Rota do Sincorá, includes several day hikes in different parts of the park with overnight stays in Igatu and Mucgê. Prices per person range from R$1,400 to R$1,900, including a guide, transportation, accommodations, breakfast, and lunch. With three or four people the price drops quite significantly.

Chapada Adventure, Praça Horácio Mattos 114 (**℗ 075/3334-2037;** www. chapadaadventure.com.br), specializes in a wide variety of local hikes and tours out of Lençóis. Day tours start at R$90 per person.

SHOPPING

Dois Irmãos, Praça Horario de Matos 3, on the main square (**℗ 075/3334-1405;** daily 8am–10pm), sells high-quality trekking and hiking gear: boots, backpacks, sandals, sleeping bags, and so on. If you're looking for souvenirs, the Diamantina region is famous for semiprecious stones, which local craftsmen make into interesting jewelry. One good shop is **Casa das Pedras,** Rua das Pedras 129 (**℗ 075/ 3334-1434**).

WHERE TO STAY

Lençóis has everything from the cheap and simple to wonderful pousadas to top-service resorts. Note that in the off season (Mar–June and Sept–Nov), all of the establishments below will cut prices from 10% to 40%.

Expensive

Canto das Aguas Hotel ★ Located just below the stone bridge leading to the town square, the Canto occupies a series of terraces cascading downward to a pool and patio that rest by the edge of the riverbank. The standard rooms (the old wing) are vaguely dark and dank, but the special rooms in the new wing are lovely, bright, and spacious; they each come with a queen-size bed and foldout sofa, a nook with a small sitting table, a good-size bathroom, and, overlooking the river, a veranda upon which to sling your hammock. The only special rooms to avoid are nos. 210 and 211, which lack a river view. The hotel is part of the Roteiros de Charme, an association of top-quality inns and pousadas.

Av. Senhor dos Passos s/n, Lençóis, 46960-000 BA. www.lencois.com.br. ℗/fax **075/3334-1154.** 44 units. R$290 standard; R$340 special double; R$500 suite. Extra person add 20%. Children 6 and under stay free in parent's room. AE, DC, MC, V. Free parking. **Amenities:** Restaurant; bar; outdoor pool; room service. *In room:* A/C, TV, fridge, hair dryer, minibar, Wi-Fi.

Hotel de Lençóis ★★ ☺ Set in lush gardens in the upper part of the village, Hotel de Lençóis is run by American-born Rebecca and her family. All rooms are comfortably furnished with brand-new king-size beds, fine linens, and lovely regional artwork. The best rooms are the eight terrace hill apartments with private patios offering great views. The absolute top room is the romantic terrace room, a very spacious and cozy hideaway with breathtaking views, a lovely walk-in bathroom, and a large veranda. Families traveling with kids can enjoy the swimming pool, the playground, and walks on the beautiful grounds where the hundreds of trees attract many colorful birds.

Rua Altina Alves 747, Lençóis, 46960-000 BA. www.hoteldelencois.com. ℗/fax **075/3334-1102** (hotel); for reservations call ℗ **071/3369-5000.** 50 units. R$150–R$190 standard double (high season); R$230–R$295 terrace room double (high season). Low-season rates 20%–30% less. Extra person add R$45. Children 6 and under stay free in parent's room. AE, DC, MC, V. Free parking.

Amenities: Restaurant; bar; outdoor pool; room service; free Wi-Fi in lobby and restaurant. *In room:* A/C, TV, hair dryer, minibar.

Moderate

Alcino Estalagem ★★ 👜 Every town should have such a pousada. Housed in a replica of a 19th-century colonial house, there's antique furniture inside and comfortable nooks upstairs and down to hide out and peruse the sizable book collection. Out back, on the far side of a well-manicured pocket garden, is where the owner keeps his pottery workshop and kiln. The garden is where breakfast is served, and it is a tour de force; the cook brings out delicious local specialties until the table is covered with plates and platters. Next morning she does it all again, but no dish ever seems to appear twice. The only drawback is that three of the eight rooms have a shared bathroom. However, considering all the other advantages, it's a minor complaint.

Rua Tombe Surrão 139, Lençóis, 46960-000 BA. www.alcinoestalagem.com. ℂ/fax **075/3334-1171.** 7 units, 3 with shared bathroom (showers only). R$170–R$345 double high season; R$115–R$170 double low season. Children 6 and under stay free in parent's room. DC, MC. Street parking. **Amenities:** Internet. *In room:* A/C (in 4 rooms), fridge, no phone.

Pousada Casa da Geleia ★★ 🔌 Almost right next door to the Alcino Estalagem, this pousada provides affordable accommodations at a central location. There are only six rooms, and all are spotless and simply furnished with comfortable beds. Two of the rooms accommodate up to four people and one room sleeps five—perfect for families traveling with children. None of the rooms have TV, but you will find plenty of books and a lovely garden with lots of birds and views of the city and river. An added bonus is that owner Lia is a talented cook; breakfast is a delicious meal with sweet and savory dishes, complemented by her amazing selection of homemade jams and chutneys made with local fruit and vegetables.

Rua General Viveiros 187, Lençóis, 46960-000 BA. www.casadageleia.com.br. ℂ/fax **075/3334-1151.** 6 units. R$150–R$170 double. Children 6 and under stay free in parent's room. DC, MC. Street parking. **Amenities:** Internet. *In room:* A/C, minibar, no phone.

WHERE TO EAT

A Fazendinha, Rua das Pedras 125, Lençóis (ℂ **075/9223-8594**), serves up excellent Brazilian steaks, freshly baked pizzas, and *furdunço,* a large batch of stir-fried veggies, noodles, and meat. Don't let the low prices fool you; all dishes serve at least two people. Even if you skip dessert, sample something from the owner's homemade collection of *cachaças* and local liquors. It's open daily from 6pm to midnight (no credit cards). The owner/chef of **Cozinha Aberta Restaurant,** Av. Rui Barbosa 42, Lençóis (ℂ **075/3334-1321**), has traveled the world collecting recipes so you can choose from Italian pasta, pad Thai, goulash, or Indian curry. Dishes are made with fresh regional ingredients and served in a cozy, colorful dining room or in the small garden; it's open daily from 12:30 until 11pm. For a lighter meal tuck into **Natora's,** Praça Horacio de Matos s/n, Lençóis (ℂ **075/9997-7917**), and order a delicious Armenian pizza. The dough is crisp and pitalike, topped with fresh vegetables, herbs, and cheese.

Morro de São Paulo/Ilha de Boipeba ★★

63km (39 miles) SW of Salvador

To really get away from it all (as if the rest of Bahia wasn't relaxed enough) consider the ultimate beach holiday in Morro de São Paulo or the even more remote little

idyllic VALE DO CAPÃO

After a few days of hiking and exploring the Chapada Diamantina, there is no better place to recover your energy (and rest your tired limbs) than at **Pousada Lagoa das Cores** (© 075/3344-1114; www.lagoadascores.com.br; R$285–R$375 double), in Vale do Capão. The owners of this idyllic 12-room mountain retreat love spoiling their guests with little extras such as herbal pillows, fresh tea and cookies, homemade soaps, and an incredible breakfast spread with local organic dishes, prepared on a wood-burning stove. Step outside your room to an array of relaxing leisure options at your disposal; breathe in the clean air as you walk the trails around the large property, explore the organic gardens, spend time in the meditation garden or maze, and contemplate the fabulous views of the steep narrow valley from the look-out. Treat your body to an outdoor foot spa as jets of cold water on the pebbles soothe your feet, enjoy an invigorating outdoor shower, take a dip in the chlorine-free pool, book a steam session in the panoramic glass tree-house sauna,

or watch the night sky as you soak in the Jacuzzi tub. A small spa offers a range of massages and skin treatments. And then there is the food. The Aroma D'Lagoa restaurant offers excellent organic regional cuisine with many ingredients grown on the property; even the coffee is grown and roasted in-house. A cozy fire takes the chill out of the cool evening air as you watch the sun set over the incredible rock formations of the Vale do Capão.

How to get there: Real Expresso runs two daily buses (5 am and 1pm) from Lençóis to Palmeiras (approx. 1 hr.). At the bus station in Palmeiras, you transfer to a van to Pousada Lagoa das Cores, which takes approximately 45 minutes on a dirt road. Ask pousada owners Marcos or Vanie to reserve a spot in the van.

Tip: The trail heads for the challenging Cachoeira da Fumaça hike or the multiday trek through the Vale do Paty start in Vale do Capão and can easily be combined with a stay at Pousada Lagoa das Cores.

village of Boipeba. Built on an island only accessible by boat or plane, these small beachside villages are blissfully isolated—no cars, no roads, no malls, though luxuries abound. The main mode of transport is your feet; wheelbarrows double as taxis transporting everything from luggage to food and drinks for the evening beach party.

Tip: April through June and September to November are low season and travelers can take advantage of lower rates and enjoy peace and quiet in destinations such as Morro de São Paulo, Boipeba, and Barra Grande. However, call ahead to check if your chosen hotel is open as many owners schedule their own vacations or renovations during these quiet months. Just keep in mind that April through June is also the rainy season; temperatures remain pleasant but short daily showers are not uncommon.

By sea, the best approach is by catamaran, leaving from behind the Mercado Modelo in downtown Salvador. A 2½-hour boat ride brings you to Morro (as the locals refer to it), located on the island of Tinharé. As you approach, you'll notice the outline of a large hill (*morro* is "hill" in Portuguese) and the remnants of an old fort. Upon arrival locals with wheelbarrows vie for your business, offering to take your bags to your pousada for R$5 to R$10 per bag—bargain hard and you should be able to get it for R$10 per wheelbarrow. A steep uphill trail takes you from the docks to the main village, which consists of only a handful of sand-covered streets. The main

(sand-covered) street, called Broadway, leads from the main square down to the beaches. The beach at the bottom of the main street is called First Beach (Primeira Praia), followed by Second Beach (Segunda Praia), Third Beach (Terceira Praia), and so on. Most of the pousadas are on Second and Third beaches. The island itself is still lush and green, and the beaches vary from busy and fun close to town to almost deserted once you get beyond third beach.

ESSENTIALS

None of the addresses in Morro de São Paulo have street numbers, but there are only a handful of streets and locals are very helpful with directions. For visitor information stop by the **CIT** (Central de Informações Turisticas), Praça Aureliano Lima s/n (© 075/3652-1083). This office can assist you with accommodations and transportation as well as book excursions. It also has a number of Internet terminals and doubles as the post office. An excellent website on the area is www.morrodesaopaulo. com.br.

Getting There

BY CAR As no cars are allowed on the island, drivers will have to leave their vehicles in Valença, the nearest city to the island, or at the *atracadouro* (pier) at Ponta do Curral, close to Valença.

BY BUS, VAN & BOAT From Salvador, **Viação Camurujipe** (© 075/3642-3280) runs a daily service to Valença (approx. 4 hr.). From Valença there are at least two boat options: The regular service, **Bio Tur** (© 075/3652-1062), takes about 2 hours and costs R$6. The fast boat, **Atobás** (© 075/3641-3011), costs R$14 and takes 45 minutes. In high season you will find a number of other boats on the dock in Valença offering transportation to Boipeba and Morro de São Paulo. **RBH** (© 075/3652-1208; www.rbhviagens.com.br) offers a fast and convenient transfer from Salvador to Morro de São Paulo (or vice versa). Their van picks you up at the airport or hotel in Salvador and transfers you to the ferry or private boat for the crossing to Itaparica. On the other side, another van awaits to take you to Ponta do Curral (20 min. outside Valença), where you board a small speedboat for the 10-minute crossing to Morro de São Paulo. From Salvador, there are 5:30am and 11am departures (starting at the airport). From Morro de São Paulo, the transfers depart at 8:30am and 3pm. Each way costs R$80 and takes about 3 hours. Pickup or drop-off at your hotel or airport are included.

BY CATAMARAN The most direct route to Morro de São Paulo is via the catamaran departing from downtown Salvador; the Terminal Maritimo do Mercado Modelo is just across the street from the Mercado Modelo. There are several daily departures: 8:30am and 10:30am, Lancha Ilhabela (© 071/3326-7158 or 9195-6744); 1:30pm, Catamarã Farol do Morro (© 075/3652-1083); and at 9am and 2pm, Catamarã Biotur (© 071/3326-7674). Each way costs R$75 and takes about 2 hours. The boats return from Morro de São Paulo at 9am (Farol do Morro), 11:30am and 3pm (Biotur), and 2pm (Ilhabela). Note that the sea can get rough, and voyagers on this boat often get seasick. Always confirm departure times.

BY PLANE The quickest way to get to Morro de São Paulo is to fly. **Addey** (© 071/3377-2451; www.addey.com.br) offers at least three flights a day, more on weekends and in high season; one-way fare is R$275, and flying time is 30 minutes. Flights depart and arrive at Salvador's international airport, making for convenient connections with onward flights.

Special Events

For New Year's and Carnaval, book a few months ahead. Most pousadas work with 5-night packages, and prices rise significantly. It's also when the island fills to capacity and even beyond.

Fast Facts

There are no banks in Morro de São Paulo, but there is a Banco do Brasil and Bradesco ATM. It is a good idea to bring some extra cash just in case the ATM doesn't work. Most pousadas and restaurants accept credit cards. In a pinch, they will also exchange small-denomination U.S. dollars ($10s and $20s).

HITTING THE BEACH & EXPLORING THE TOWN

The main attraction of Morro de São Paulo is the beach, or better, the beaches. Each has a unique flavor. **First Beach** is mostly residential; **Second Beach** has lots of pousadas and people. This is where you'll find vendors, watersports, and restaurants and nightlife after sundown. **Third Beach** is quite narrow; at high tide it almost disappears. It is much quieter, perfect for a stroll. **Fourth Beach** is the (almost) deserted island tropical beach—wide, white sand, palm trees, and a few small restaurants. The town itself consists of just a few streets and the main square. During the day it's pretty quiet, as most people hang out at the beach or go off on boat tours. In the evening, a crafts market starts up, attracting both locals and tourists to the main square. The restaurants surrounding the main square fill up with diners feasting on local seafood dishes. More active pursuits include boating, horseback riding, and hiking.

OUTDOOR ACTIVITIES

Marlins, Rua da Prainha s/n (*ℂ* **075/3652-1242**), the island's main tour operator, offers a number of trips. The most popular is the **8-hour boat trip** around the island with plenty of stops for swimming or snorkeling. Another great boat tour goes out to **Ilha de Boibepa** (a small island off the main island). Tours cost R$50 per person, lunch not included. More active trips include **hikes** to waterfalls or a **walk** along the cliffs and beach to Gamboa for R$20 to R$30 per person.

Another operator that offers a number of interesting activities is **Rota Tropical,** Rua da Prainha 75 (along the trail that connects Second and First beaches; *ℂ* **075/3652-1151;** www.morrodesaopaulobrasil.com.br). The company covers practically every possible destination in the region. Full-day boat tours range from R$60 to R$80 per person (minimum of two people). Other tours include horseback riding, various hikes, and boat tours.

Along Third and Fourth beaches you will find a number of local **horseback** tour operators; the common rate is R$15 per person per hour. The best time to go is early in the morning, around 9am or 10am when the horses are fresh.

For scuba diving, contact **Companhia do Mergulho,** Pousada Farol do Morro, Primeira Praia (*ℂ* **075/3652-1200**). Conditions are best in the summer months (Dec–Jan). In the winter (June–Sept), when the rains are heavy, visibility can be poor. A double dive with all equipment included costs R$150. The dive store also rents out masks and snorkels for R$10 to R$15.

Tip: Don't be late for the sunset: One of the best spots in Morro de São Paulo to watch the sunset is from the old fort beyond the catamaran quay. From the docks, take the path along the cliffs; it's an easy 15-minute walk. The fort, originally built in 1630 and expanded in 1728, is extremely photogenic; the red rocks glow in the rich

VISITING boipeba island ★★★

Although most people visit Boipeba on a day trip from Morro de São Paulo, the island is worth a longer stay. A half-hour boat trip south of Morro de São Paulo, Boipeba is often described as "Morro 20 years ago." And indeed, after spending some time in Boipeba, Morro will come to seem "big" and "busy" in comparison. The advantage of spending the night is that, as soon as the day-trippers head back for Morro, you have the beach pretty much to yourself. The island offers enough to see that you can easily spend 2 or 3 days exploring. A variety of coastal hikes (or boat rides) will bring you to other, more remote beaches such as Cueira, Morerê, and Ponta de Castelhano. For a full day of hiking, you can traverse the length of the island to reach a fishing village on the southern tip. Instead of walking back you can arrange for a boat to bring you back to Boca da Barra. The Rio Inferno estuary is also worth exploring; take a gentle canoe trip and experience the mangrove's bird life and the beauty of its vegetation set against sweeping vistas of ocean and river. For photos and information check www.boipeba.tur.br.

If you want to stay overnight it's a good idea to reserve ahead, particularly in high season. The few pousadas here are all quite small. We recommend staying at the lovely **Pousada Santa Clara ★★★**, Boca da Barra (☎ **075/3653-6085;** www.santaclaraboipeba.com). Rates range from R$120 to R$150, depending on the size of your room and time of year. Built and managed by two American brothers—Mark and Charles—the pousada combines Brazilian warmth and luxury with American customer service and amenities, and is only steps from the beach. The pousada has an outstanding restaurant, which serves a three-course gourmet breakfast (complimentary for guests). At night the restaurant is open to the public and serves creative and fresh regional dishes. A little farther up the hill, **Pousada Mangabeiras ★★**, Boca da Barra (☎ 075/3653-6214), offers a spectacular view of the bay. This

light of the setting sun and keen spotters will often see dolphins or whales from their vantage point above the rocks.

SHOPPING

Bring enough toiletries, sunscreen, and personal items to last for your entire stay, as these tend to be pricey in Morro de São Paulo. Every evening in the main square there's a crafts market with some beautiful items for sale, well worth browsing.

WHERE TO STAY

Morro de São Paulo offers many lovely pousadas and small hotels.

Pousada o Casarão ★★ In the heart of the village overlooking the main square, this pousada can be deceptive. From the sandy street, it appears to be (just) a beautiful heritage building (though one with quite a pedigree—it was here that the Emperor D. Pedro II stayed when he visited in 1859). What you can't see from the street is the lush back garden with nine bungalows set against the sloping hillside. Each is decorated in a different style—Indonesian, Japanese, Indian, African—with rich furnishings and artwork. The best bungalows are nos. 15 and 16. Located at the top of the property, these look out over the gardens, the square, and the ocean.

exclusive retreat is nestled in a tropical oasis of fruit trees and lush green and makes for the perfect romantic getaway. Access to the pousada is via a steep long stairway at the end of Boca da Barra beach. Rates range from R$250 to R$375, in high season. To stay a mere foot-length from the beach, reserve one of the four cute chalets at **Vila da Sereia,** Boca da Barra (© **075/3653-6045;** www.vila sereia.com.br). The two-story chalets all look out toward the ocean and offer plenty of privacy. A delicious breakfast spread is served on your front porch. Rates range from R$278 to R$380; discounts are available in low season.

GETTING THERE The quickest way to reach Boipeba is by plane. **Addey** (© **071/3377-2451;** www.addey.com.br) offers three flights a day from Salvador to Boipeba with a minimum of two passengers (R$410 per person). The landing strip is on Fazenda Pontal, just across the river from Boca da Barra. Transfer from the airstrip to the village (a 5-min.

crossing) is included. Boipeba can easily be reached by boat from Morro de São Paulo (2 hr.). The cheapest transfer option is to go with a day tour that leaves Morro around 9:30am and reaches Boipeba in time for lunch. This is perfect in combination with a stay in Morro for a few days. Those who don't want to go through Morro and want to come or return directly to Salvador, can take the ferry from downtown Salvador to Itaparica (there are at least five ferries a day). Upon arrival, the buses to Valença meet the ferry passengers and it takes about 2 hours to reach Valença where you catch a fast boat to Boibepa (R$36, takes approx. 45 min.). Two bus companies cover this route: **Cidade do Sol** and **Aguia Branca.** Charles, of Pousada Santa Clara, can also arrange to have a private boat bring you over, or arrange a car and driver to meet you at the Itaparica ferry at quite reasonable rates, especially if three or four people divide the bill.

Praça Aureliano Lima s/n, Morro de São Paulo, 45428-000 BA. www.ocasarao.net. ©/fax **075/ 3652-1022.** 16 units, 6 rooms and 10 bungalows. Unit in the main building R$125–R$190 double; bungalow R$160–R$230 double; master bungalow R$200–R$300 double (with Jacuzzi). Extra person add 25%. Children 5 and under stay free in parent's room. AE, DC, MC, V. **Amenities:** Restaurant; bar; 2 outdoor pools; sauna. *In room:* A/C, TV, minibar, no phone.

Vila dos Orixás ★★★ As Morro de São Paulo has grown over the last few years, you must now travel to the end of Fifth Beach to find the nearly deserted idyllic Praia do Encanto (Enchanted Beach). The Vila dos Orixás's Spanish owners have built 10 luxurious chalets that are equipped with every convenience, such as satellite TV, a Jacuzzi tub, a king-size bed with Egyptian cotton sheets, and hammocks for two on your private veranda overlooking the ocean or garden. The hotel makes for a perfect romantic getaway; to visit the village there are regular Land Rover transfers (25 min. by dirt road), but we frankly don't see any reason to leave this little paradise.

Praia do Encanto, Morro de São Paulo, 45400-000 BA. www.hotelviladosorixas.com. © **075/3652-2055.** 10 units. High season R$420–R$540 double; low season R$290–R$375 double. Extra person add 30%. Children 5 and under stay free in parent's room. AE, V. **Amenities:** Restaurant; bar; swimming pool. *In room:* A/C, TV, minibar.

Vila Guaiamú ★★ Vila Guaiamú may just have the perfect location in Morro: far enough from the village for total peace and quiet, yet close enough that within 10 minutes you can be dancing the night away. This lovely pousada consists of 24 cabins set among the lush green gardens (through which skulk the cute little species of burrowing freshwater crab that gives the Vila its name). All have verandas with hammocks and are simply furnished. Cabins come in standard or deluxe, the only difference being the air-conditioning and television in the deluxe rooms.

Terceira Praia, Morro de São Paulo, 45400-000 BA. www.vilaguaiamu.com.br. ✆ **075/3652-1035.** Fax 075/3483-1073. 24 units, showers only. High season R$240–R$340 double; low season R$160–R$195 double. Extra person add R$40. Children 5 and under stay free in parent's room. V. Closed May–June. **Amenities:** Restaurant; bar. *In room:* A/C, TV (in 12 rooms only), minibar, no phone.

Villa dos Corais ★★★ Two beaches for the price of one! This miniresort straddles Third and Fourth beaches, located immediately across from the natural pools that form at low tide. Although the two-story apartment buildings scattered across the property lack the charm of other smaller pousadas, the huge rooms with excellent amenities and the hotel's leisure space more than compensate for this. Guests can enjoy a gorgeous swimming pool, kid's pool, sauna, tennis court, lounge, fitness center, and restaurant. The pousada is about a 15-minute walk from the restaurants and nightlife at Second Beach.

Terceira Praia, Morro de São Paulo, 45400-000 BA. www.villadoscorais.com.br. ✆ **075/3652-1560.** 40 units. High season R$490–R$560 double; low season R$350–R$390 double. Extra person add 30%. Children 5 and under stay free in parent's room. AE, V. **Amenities:** Restaurant; bar; fitness center; swimming pools; room service; sauna; tennis court. *In room:* A/C, TV/DVD, minibar, Wi-Fi.

WHERE TO EAT

For a small village in the middle of nowhere, Morro de São Paulo has a surprising number of excellent restaurants. The main street of the village, Broadway, is lined with eateries. Although most are open for lunch, it's in the evening that things really get hopping. **Sabor da Terra** (✆ **075/3652-1156**) is famous for its generous portions of outstanding *moquecas* and *bobó de camarão* (prawn stew). Meat eaters can order the *picanha na chapa,* tender steak served at your own table grill. The tables on the veranda (if you can snag one) offer great views of the main street. One of the prettiest viewpoints in town is that of **O Casarão** (✆ **075/3652-1022**; closed Sun), overlooking the main square. The menu offers a number of excellent fish and seafood dishes (portions serve two people) including *moquecas* and grilled fish. Second Beach offers almost back to back restaurants along the boardwalk with pleasant outside seating on the sand and live music. Staff vie for diners with offers of free drinks or special dishes.

Note: Most restaurants accept Visa or MasterCard. However, bring extra cash when dining out because the online authorization can be fickle and sometimes service is unavailable.

NIGHTLIFE

Surprise, surprise, Morro's nightlife is centered around the beach. If you do want to make a night of it, it's wise to take a nap before starting out—things get hopping only around 1am. While most people are having dinner in the main village, browsing the crafts market in the square, or sampling a dessert from the stalls on Broadway, locals are busy setting up their drinks stands on Second Beach. These are pretty casual affairs—sand-covered dance floors and lots of open-air space right by the beach. The

atmosphere is great, with locals and tourists mingling (there is, of course, nowhere else to go). The fruit-laden bar *barracas* specialize in caipirinhas or *batidas* made with the fresh fruit on display. Just point to your favorite fruit, pick your booze of choice (vodka, *cachaça,* or rum), and it all goes in the blender, coming out as a delicious cocktail.

Barra Frande

113km (70 miles) SW of Salvador

Once you get a taste for this part of Bahia you may want to explore farther south. The Marau Peninsula is a magical place where deserted beaches and unspoiled scenery are still easily found. The main village of Barra Grande sits at the very top of the peninsula that juts out into the Bay of Camamu, the third-largest bay in all Brazil. Part of what has helped preserve the beaches in this region is the limited access. Wedged in between the Atlantic on the east and the enormous bay and its many islands on the west there are no real roads to speak of (although Itacaré is only 50km/31 miles from Barra Grande, it is a 3-hr. drive in a 4×4) so most visitors arrive by boat from Camamu. What they come for are the miles and miles and miles (and miles!) of unspoiled beaches, the beautiful bay and islands, mangroves and lagoons, the Atlantic rainforest and bromeliads, and the excellent food and accommodations. Most visitors stay in or near Barra Grande. It offers a number of excellent bed-and-breakfasts and several great restaurants set amid lots of green in a sleepy village with streets made of sand. A must-see day trip, or even better as an overnight visit, is Taipu de Fora, listed as one of the most beautiful beaches in Brazil (p. 276).

ESSENTIALS

One of the best resources for planning your trip to Barra Grande and Taipu de Fora is **Turismo Taipu** (© **073/3258-9051** or 071/9962-6222). The owner, Tatiana Pugliese, speaks excellent English, has lived here for years, and knows the area like the back of her hand. She and her staff can set up transfers, accommodations, and sightseeing. For a great map of the region, see http://pousadapontadomuta.com.br/barra-grande/como-chegar.

GETTING THERE BY CAR There is effectively no car access. Cars aren't allowed on the ferry (see below). From the south, the only road access is hard-core 4×4 territory.

GETTING THERE BY BUS & FERRY From Salvador, the best route is to take the ferry from Salvador to Bom Despacho on Itaparica island (approx. 1 hr.). From there you can connect with a bus that will take you to Camamu 180km (112 miles) away. Both **Viação Camurujipe** (© **073/3255-2508**) and **Aguia Branca** (© **073/3255-1823**) run a daily service to Camamu from Bom Despacho via Valença (approx. 4 hr.; tickets cost R$20). Then from Camamu you catch another ferry to Barra Grande. You can either take the regular ferry (every hour, btw. 7am and 5:30pm, R$6 per person), which takes an hour and a half or a fast boat that will get you there in 35 minutes; departures are at 7am, 9am, 1pm, and 4:30pm. Tickets are R$25 per person.

GETTING THERE BY PLANE Unfortunately, only guests of the Kairoa resort can make use of their private air transfer from São Paulo. The other option is to fly to Ilheus. There are daily flights by **TAM** (© **071/4002-5700**) and **Gol** (© **0300/115-2121**). From Ilheus you need to travel to Camamu and take the ferry (see above).

SPECIAL EVENTS Only during New Year's and Carnaval does this region get really full. To visit during this period book a few months ahead. Better to go in the off season, when you have the beaches practically to yourself.

FAST FACTS There are no banks or bank machines in Barra Grande. Most pousadas and a number of restaurants accept credit cards (mostly MasterCard and Visa) but it is a good idea to bring plenty of cash.

HITTING THE BEACH & EXPLORING THE TOWN

The main attractions of Barra Grande are the beach and the glorious bay that bathes the peninsula. The beaches in Barra Grande proper are pretty enough and make for a great sunset spot. The pousadas listed below are right on the beach so you can just set out and explore. The town itself consists of three main streets and can be explored in an hour or so. However, this is best done at night when the cozy restaurants and charming patios add a warm glow to the sultry evening. In high season the town is livelier, with live music and a few more bars. The calm and quiet off-season atmosphere is also very attractive. In the daytime you are best off exploring some of the farther beaches such as Taipu de Fora, or setting off on a boat tour of the bay and the many islands.

OUTDOOR ACTIVITIES

Taipu Turismo (✆ 073/3258-9051), the island's main tour operator, offers a number of trips. The most popular is the 8-hour boat trip around the Bay of Camamu, the third-largest bay in Brazil, with several stops at some of the islands for swimming or snorkeling, and a visit to Cajaíba, the wooden boat center of the region. Other boat tours can be combined with a visit to Camamu, the region's main town, a hike to a waterfall, or a visit to a *quilombo* community, a settlement founded by runaway slaves. Another great tour goes out to **Taipu de Fora ★★★** (one of the region's most beautiful beaches), where you can snorkel in the natural pools that form at low tide. The tour by 4×4 takes you across the peninsula's back roads to the Cassange lagoon and the Bromeliad trail. These are not just your boring run-of-the-mill bromeliads. These are humongous alien-looking bromeliad creatures perched high in the treetops that grow to the size of a family sedan. Tours range from R$45 per person, lunch not included, for a boat tour, to R$120 for a full-day tour, including a hike.

SHOPPING

Bring enough toiletries, sunscreen, and personal items to last for your entire stay, as there is very little available here. In the evening there is a small crafts market where local artisans make lovely lampshades and other decorative items of natural materials.

WHERE TO STAY

Barra Grande has a surprising number of excellent pousadas and even a high-end resort.

Very Expensive

Kiaroa ★ The Kiaroa offers the most luxurious accommodations in the region. This seaside resort is set on a gorgeous stretch of beach amid a lovely lush garden. All the bungalows are tastefully furnished in a tropical style, using lots of rustic natural materials and colorful artwork; they are perfect for a romantic getaway. The deluxe bungalows come with a private swimming pool and a separate sitting room, two

bathrooms with Jacuzzi tubs, and a large-screen plasma TV. The apartments are significantly smaller, somewhat noisy, and frankly not worth the money. Splurge or stay elsewhere. Breakfast and dinner are included. If you contact a travel operator like Brazil Nuts or Tatur in Salvador they may well find you a more affordable package. If you book 4 nights, the resort will include the round-trip air transfer from Salvador.

Praia da Bombaça, Barra Grande, 45445-000 BA. www.kiaroa.com.br. © **073/3258-6215.** For reservations contact © **071/3272-1320.** 10 bungalows and 14 apts. R$1,150 apt; R$1,950 bungalow; R$2,350–R$2,950 deluxe bungalow. AE, DC, MC, V. No children 13 and under. **Amenities:** Restaurant; bar; large outdoor pool; room service; spa; tennis court. *In room:* A/C, TV/DVD, CD, hair dryer, minibar, Wi-Fi.

Pousada Barra Bella ★★ ☺ Barra Bella offers affordable and child-friendly accommodations, right on the beach and within walking distance of the village. The pousada features a large garden with plenty of play room and a swimming pool. All rooms are nicely furnished with colorful touches and local artwork. Many look out toward the ocean, and the duplex mezzanine room and the master room are each big enough to comfortably accommodate a family of four or five.

Rua Vasco Neto s/n, Barra Grande, 45428-000 BA. www.pousadabarrabella.com.br. © **073/3258-6298.** 13 units, showers only. Low season R$218 standard, R$260 mezzanine or master; high season R$495 standard, R$517 mezzanine or master. Extra person add 25%. Children 5 and under stay free in parent's room. AE, V. Closed May–June. **Amenities:** Restaurant; bar; outdoor pool. *In room:* A/C, TV, hair dryer, minibar.

Pousada Ponta do Mutá ★★ An affordable and pleasant pousada, Ponta do Mutá is centrally located between the village and the beach. All rooms have a veranda with a hammock and look out either over the garden (the lower ones) or the ocean and garden (the top ones). The pousada is set in a lovely garden with several pleasant sitting (or snoozing) areas in the shade or overlooking the beach. Kayaks are available free of charge.

Rua do Anjo s/n, Barra Grande, 45428-000 BA. www.pousadapontadomuta.com.br. © **073/3258-6028.** 10 units, showers only. Low season R$170–R$220; high season R$300–R$340 double. Extra person add 25%. Children 5 and under stay free in parent's room. AE, DC, MC, V. **Amenities:** Restaurant. *In room:* A/C, TV, hair dryer, minibar, Wi-Fi.

WHERE TO EAT

Barra Grande has a number of excellent restaurants. In fact, if you are only staying for 1 or 2 nights, one of the challenges will be choosing which place to try!

Whatever you do, don't miss **Donanna's** restaurant, Rua do Anjo s/n (© **073/3258-6109**), just past the pousada Ponta do Mutá. This simple restaurant serves up delicious local seafood. Make sure to order the *salada de polvo* (octopus salad), the best we ever had. Other dishes worth trying include the grilled lobster, fried fish, and *bobó*. A great place for dinner, **Café Latino,** Rua Dr. Chiquinho 19 (© **073/3258-6188;** closed May–June), is a cozy bistro/eatery run by a Brazilian-Argentine couple. They serve up excellent homemade pastas, have a decent wine list, and also make delicious specialty coffees and desserts. Even if you don't have dinner here it is worth going for a dessert coffee. For a local home-cooked meal visit **A Tapera,** Rua Dra. Lili s/n (© **073/3258-6119**). The only dish to order here is the *moqueca*, the house specialty. Portions are generous, so you can easily share a main course, especially if you have an appetizer such as the *casquinha de siri* made with shredded crabmeat baked in a clay dish.

visiting TAIPU DE FORA ★★★

Often sold as part of a day tour from Barra Grande, Taipu de Fora is well worth an overnight stay, particularly if you like your beaches endless, gorgeous, and empty. This vast wide strand is framed by thick groves of palm trees, dotted in just a few spots with pousadas. When the day-trippers leave you have the place to yourself. Time your visit during the full moon and you may very well believe you have found paradise. Go for a stroll, enjoy a swim (at low tide there are some impressive natural pools; a mask and snorkel can be rented on the beach for R$10), enjoy a delicious grilled seafood platter at the **Bar das Meninas** (© **073/3258-9051;** www. bardasmeninas.com.br), and try one of the many delicious fruit *roscas* (vodka and fruit juice cocktails).

To spend the night, book a room at **Pousada Taipu de Fora** (© **073/3258-6278;** www.taipudefora.com.br). This 28-room pousada looks out over the ocean and offers comfortable accommodations with some amenities such as room service, rooms for travelers with disabilities, and recreation for children. Rooms range from R$280 to R$350.

Note: All restaurants mentioned above accept Visa or MasterCard. However, bring extra cash when dining out because the online authorization can be fickle and sometimes service is unavailable. During the off season, restaurants will close for a few weeks in May, so check for opening hours.

Itacaré

159km (99 miles) SW of Salvador

The small town of Itacaré is nestled at the mouth of the Rio das Contas, the river that separates the mainland from the southern tip of Marau peninsula. Once a thriving export center of cacao, the town's economic activities now focus mostly on tourism, taking advantage of the exceptional natural beauty of this region. Unlike the coast north of here, where long beaches lined with groves of palm trees form the landscape, Itacaré is set in lush Atlantic rainforest and its small beaches are tucked away in bays protected by rocks and hills. Best of all, most beaches can only be reached on foot, on scenic trails through the forest, keeping most development (still) at bay. The ocean here is often quite rough with big waves, making it a surfer's paradise. For the non-surfer, Itacaré offers lovely unspoiled beaches, great short hikes, and excellent accommodations and dining.

ESSENTIALS

GETTING THERE BY CAR Itacaré is a great place to have your wheels. The roads are in great shape and most of the beaches are a short drive outside of the city. You can either rent a car in Itacaré or at the airport in Ilheus and drive the 64km (40 miles) north on your own. The BR-001 has recently been repaired and the drive takes you along a windy road through the beautiful Atlantic rainforest.

GETTING THERE BY BUS Rota (© **073/3251-2181**) offers regular bus service between Ilheus and Itacaré. Buses go every hour, between 7am and 7pm. Tickets are R$7.

GETTING THERE BY PLANE The nearest airport to Itacaré is in Ilheus. There are daily flights by **TAM** (✆ **073/4002-5700**) and **Gol** (✆ **0300/115-2121**). From Ilheus it is 64km (40 miles) to Itacaré. Many pousadas can arrange transportation. **Eco Trip** (✆ **073/3251-2191**; www.ecotrip.tur.br) also offers a private transfer service from the airport in Ilheus to Itacaré for R$120 for two people.

FAST FACTS There is only a Bradesco bank machine in Itacaré in the Praça do Forum so it's wise to bring some extra cash in case it's down or doesn't accept your card. Most restaurants, hotels, and tour companies accept credit cards (MasterCard and Visa are most common). Internet cafes are everywhere, especially along the Rua Pedro Longo where you will find at least six cybercafes.

HITTING THE BEACH & EXPLORING THE TOWN

The main attraction of Itacaré is the beach, or rather the beaches. In town, the most popular beach is **Praia da Concha,** which is also where a number of pousadas are concentrated. Especially in the summer this is a lively evening destination, as people meet at the beach bars to listen to music and dance. From there it is only a 5-minute drive or a 15- to 20-minute walk to the "city beaches" of **Resende, Tiririca, Costa,** and finally **Ribeira** where the road ends and the trail to the more isolated beaches starts. Starting here, just south of the main village there begins a string of lovely small beaches, each tucked away in its cove, separated from the next by steep hills and rocks. The only way to reach any one of these beaches is to hike from the trail head down to the ocean. Most trails are short (20–45 min.) and your reward is a practically unspoiled beach framed by stands of Atlantic rainforest. From the trail head past Ribeira beach, a 45-minute walk through the forest takes you to the first of the more rugged ocean beaches, **Prainha.** At the end of Prainha, you can pick up the trail again and continue to the next beach over, **São Jose.** Trail guides who hang out at the parking lot will try to frighten you into contracting their services with tales of multiple trails and confusing pathways, but it's really quite straightforward. To reach the more popular beaches farther south, such as **Engenhoca** (a surfers' and hippies' favorite), **Havaizinho** (with more gentle surf, better for swimming), and **Itacarézinho** (a 5km-long/3-mile sandy beach), you need to drive out on the main highway to the appropriate trail head (usually well marked), and then walk from there. From the Havaizinho trail head the walk to Havaizinho takes about 15 minutes, while the walk to Engenhoca takes about 25 minutes. The trail head for Itacarézinho is a little farther south on the highway. It too is well marked, but there's a R$10 parking fee. The walk to the beach takes about 20 minutes. Bring water, plenty of sunscreen, and anything else that you are likely to need, because you will find almost no services at these beaches.

Renting a Car

Car rental costs approximately R$100 per day for unlimited mileage. For insurance add another R$30. If you are arriving in Ilheus, your best plan is to rent a car at the airport. All the major companies (plus some really obscure local ones) are represented here. Some are in the arrivals hall (**Hertz** ✆ **073/3231-5042** and **Localiza** ✆ **073/3231-8007**) and a dozen more are out across the street from the airport. Prices are very similar so we recommend going with a well-known company that offers decent service.

OUTDOOR ACTIVITIES

Besides surfing, Itacaré offers a number of other outdoor activities. The town is at the mouth of the Contas river and there are several excursions, either by kayak or by fast boat upriver to explore the estuary, the mangrove forests, the side channels, and the waterfalls upstream. Even farther upriver there is rafting, but don't expect serious wild water. The Atlantic rainforest also offers some interesting tours. Tree climbing has become very popular. Well, tree climbing with the help of walkways, as you make your way through the forest, overcoming obstacles, and challenging yourself in a fun climbing game. If you are not traveling to the Marau peninsula you can take a day tour by jeep to explore across the river (not recommended for people with back problems; the dirt road is in very poor shape and the trip is uncomfortable). Local eco-tourism operator **Eco Trip** (© **073/3251-2191;** www.ecotrip.tur.br) offers all these activities. Trips range from R$60 for a kayak trip to R$140 for the jeep tour or R$120 for the tree climbing (these prices are for two people).

WHERE TO STAY

Despite all the surfers and younger travelers, Itacaré is not a cheap destination. The best accommodations within walking distance of the amenities and nightlife in the village are in Praia da Concha.

Very Expensive

Txai ★★★ For the ultimate in luxury accommodations check in at the Txai, a resort carefully built to make the most of a stunning location. Set on Jacarezinho beach (approx. 18km/11 miles from Itacaré), the bungalows and facilities are spread out to offer fabulous views and privacy. The most luxurious bungalow comes with a private pool, but even the standard ones are spacious and elegantly furnished. All rooms feature a king-size bed, sofa, CD player, outside shower, and veranda. The hotel's leisure area is beautiful with several swimming pools and decks, an exclusive spa, and of course, the beach. Guests have the entire long strand all to themselves.

Rodovia Ilhéus-Itacaré BR 101, Km 48, BA. www.txai.com.br. © **073/2101-5000.** For reservations © **011/6858-777.** 40 units. R$800–R$1,100 apt; R$1,150–R$1,400 bungalow. Children 3 and under stay free in parent's room. AE, DC, MC, V. **Amenities:** 2 restaurants; 4 bars; concierge; health club; Jacuzzi; 2 large pools; children's pool; room service; sauna; spa; tennis. *In room:* A/C, TV/DVD, CD, fridge, minibar, no phone.

Expensive

Aldeia do Mar ★★ The Aldeia do Mar is fabulously located at the very end of Praia da Concha, the prime sunset spot. The hotel offers 16 brand-new apartments or chalets; these master chalets feature a veranda and new, firm mattresses, and are pleasantly furnished in bright colors. The rest of the apartments are located in a slightly older building. Although a little bit smaller, these Aldeia units also provide clean and comfortable accommodations. The hotel has a spacious lawn, a beach volleyball court, and a large swimming pool. Kayaks can be rented to explore the gentle waters of the inlet.

Praia da Concha, Itacaré, 45530-000 BA. www.aldeiadomar.tur.br. ©/fax **073/3251-2230;** for reservations © **0800/600-8088.** 29 units. R$330–R$500 apartment or Aldeia chalet; R$430–R$680 master chalet. Extra person 20%. Children 5 and under stay free in parent's room. AE, DC, MC, V. **Amenities:** Restaurant; bar; outdoor pool. *In room:* A/C, TV, minibar.

THE PERFECT resort ★★★

On a beach not so far away, in fact only a 50km (31-mile) drive south of Ilheus, there stands the perfect resort, **Fazenda da Lagoa**, Rodovia Una-Ilheus Km 18 (**℃ 073/3236-6046;** www.fazendada lagoa.com.br). Set on what is, for all intents and purposes, an island, the resort has been carefully hidden away at the end of an unmarked dirt road, beyond which you come to a river that you have to cross by boat. A labor of love of a Rio designer and her husband, the Fazenda offers luxurious accommodations without being over-the-top. Staying at the Fazenda, you feel like you're visiting a friend—albeit a friend with oodles of money and exquisite taste. What makes this place so special? First of all, it's the only pousada, and one of only a handful of buildings, on a beautiful 10km-long (6-mile) stretch of beach. Then there are the fabulous 140-sq.-m (460-sq.-ft.) bungalows with king-size beds, large decks, outside (and inside) showers, a beautiful swimming pool, and a lovely main lounge with an outstanding library. There is a small spa, an excellent restaurant, and only 14 bungalows, which means you never have to worry about the crowds. If you can tear yourself away from the lap of luxury (and nobody says that you have to) you can borrow bikes at low tide and ride out along the beach. Or you can take a short hike to the private lagoon with crystal-clear water and enjoy a swim, a paddle, or simply sunbathe or snooze on the wooden deck, then dig into a delicious picnic lunch that the staff will prepare for you in advance. And did I mention that you have the beach practically to yourself? At the Fazenda da Lagoa, the isolation is truly splendid. Low-season rates are R$880 to R$1,100, high season R$1,100 to R$1,450.

Pousada Solar da Baronesa ★ 🍴 Even in high season, rooms in this lovely heritage building don't cost more than R$250, and for an expensive town such as this, that is a pretty good deal. The seven units are all uniquely furnished. The two loveliest ones are the Tropical Suite, with a small winter garden, and the Baronesa, with a four-poster bed and a view of the ocean. Afternoon tea is included. Set in the village, the pousada is a short walk from the beaches and close to the shops and restaurants.

Rua Plinio Soares 101, Centro, Itacaré, 45530-000 BA. www.solardabaronesa.com.br. ℃ **073/3251-2532.** 7 units. High season R$180–R$250 double; low season R$120 double. Children 5 and under stay free in parent's room. No credit cards. *In room:* A/C (2 rooms only), fan, minibar.

WHERE TO EAT

Itacaré has a number of excellent restaurants that specialize in Bahian food. The village is small enough that you can go for a stroll and see what takes your fancy. **A Brasileira,** Rua Pedro Longo 175 (℃ **073/8825-3560**), proves that organic health food can also be delicious and hip. This lovely restaurant serves a range of contemporary seafood dishes in a beautiful and romantic setting. For excellent pizzas, try **Pizzaria Boca de Forno,** Rua Lodonio Almeida 108 (℃ **073/3251-2174**). The oven-baked pizzas are delicious, and the courtyard restaurant has a great atmosphere with regular live music presentations.

Along Rua Pedro Longo, you will find probably a dozen restaurants that serve up Bahian food, sandwiches, crepes, and burgers. One that stands out for the quality of the food (and drinks too; the *caipiroscas* are delicious!) is **O Restaurante,** Rua Pedro Longo 170 (© **073/3251-2012**). This plain and unpretentious restaurant serves up some of the best *moquecas* and *bobós* in town. Portions are huge, so order wisely. In addition to seafood, the restaurant serves pasta and outstanding Argentine steaks.

Note: All restaurants mentioned above accept Visa or MasterCard. However, bring extra cash when dining out because the online authorization can be fickle and sometimes service is unavailable.

RECIFE, OLINDA & FERNANDO DE NORONHA

The state of Pernambuco offers visitors an attractive combination of lively urban culture, colonial history, a family-friendly beach resort, and Brazil's best diving. Start your visit in Pernambuco's state capital, Recife, a modern, vibrant city of 1.5 million on the coast. The city's historic center was laid out by the Dutch during their brief occupation in 17th-century Brazil and features some architectural gems from that period. However, the real colonial star is Olinda. Founded in 1530 by the Portuguese on a hillside overlooking the ocean and Recife, the city is now a UNESCO World Heritage site. Explore Olinda's cobblestone streets lined with fine colonial architecture and exquisite baroque churches and shop for colorful local artwork.

Just an hour drive south of Recife lies one of the Northeast's most popular beach destinations, Porto de Galinhas. This friendly family-style resort offers affordable accommodations, a pleasant small village, and miles and miles of beaches to explore. At low tide, the reefs form natural pools that teem with colorful fish.

For more serious marine life, head straight to Fernando de Noronha, the best diving destination in Brazil. This Atlantic Ocean archipelago is comprised of verdant mountains that descend to sheer cliffs, which in turn fall onto wide, sandy beaches that have known neither condo nor cabana. Beneath the waves live colorful corals and fish, manta rays, and lemon sharks. Sea turtles lay eggs by the thousands on the beaches facing the Atlantic. And then there are the spinner dolphins. Early in the morning, in the Baía dos Golfinhos (Bay of Dolphins), spinner dolphins gather in pods of more than 1,000 to frolic and spin in the morning sunshine.

RECIFE & OLINDA

1,874km (1,164 miles) NE of Rio de Janeiro, 2,121km (1,318 miles) NE of São Paulo, 682km (424 miles) NE of Salvador

Recife and Olinda stand within sight of each other on Brazil's Northeast coast, one city on a hilltop, the other on a river mouth, one founded by the Portuguese, the other by the Dutch. Recife, in keeping with the commercial character of its Dutch founders, is busy, flat, and efficient. Then there's Olinda. Founded by the Portuguese in 1530 on a steep hill overlooking the harbor, Olinda grew rich and proud on sugar exports. The

Dutch at the time were keen to move in on the sugar business, so after trying (and failing) to take Salvador in 1624, they arrived in Pernambuco in 1630, took its capital, Olinda, and with the exception of a few churches, utterly destroyed it. In need of a capital of their own, the Dutch abandoned the ruins of Olinda, and set to work draining and diking the islands at the mouth of the harbor.

Their new city of Mauritstad quickly turned into a bustling commercial center. When the Dutch were expelled in 1654, the Portuguese rebuilt Olinda as a matter of pride, but the center of the region had shifted. The former Dutch city was renamed Recife, after the long coral reefs that menace the harbor. By the 19th century, Recife had far outgrown Olinda; the older town was left blissfully free of development pressures, still in its largely pristine 17th-century condition.

Restoration work began on Olinda in the 1970s. In 1982 its lovingly preserved historic core was declared a UNESCO World Heritage Site. Unlike Salvador's Pelourinho, however, Olinda feels very much lived in. Walk its streets and you'll come across kids playing soccer on a patch of hard-packed dirt, women carrying groceries, perhaps artists in courtyards carving interesting-looking woodwork. The city is hilly but distances are short, and with so much to capture your attention, it's a joy to explore.

Recife has tried to follow Salvador's example by restoring its colonial downtown and promoting the area as a music and nightlife center, but its efforts haven't been as successful. Old Recife is worth a visit if you're here; it's not worth a trip in itself.

The same can be said for the beaches south of Recife. Most are beautiful—Porto de Galinhas is gorgeous, a laid-back town with long, wide beaches, and hotels that cost but a fraction of larger resorts.

Essentials

GETTING THERE

BY PLANE Azul (© 085/3003-2985; www.voeazul.com.br), Gol (© 0300/115-2121; www.voegol.com.br), **Ocean Air** (© 0300/789-8160; www.oceanair.com.br), **TAM** (© 081/4002-5700; www.tam.com.br), **TRIP** (© 030/0789-8747; www.voetrip.com.br), and **Webjet** (© 0300/210-1234; www.webjet.com.br) all have flights to Recife. Visitors fly into Recife's **Aeroporto Internacional dos Guararapes,** Praça Ministro Salgado Filho s/n, Boa Viagem (© **081/3464-4188**), about 12km (7½ miles) south of the city center and just a few kilometers from the beachside hotels in Boa Viagem. A taxi to Boa Viagem costs R$18 to R$26 and to Olinda, R$45 to R$60. You'll find a queue for **Taxi Coopseta Aeroporto** (© **081/3464-4153**) on the arrivals level. For visitors staying in Boa Viagem, the regular **airport bus,** no. 33 or 42, leaves every 15 minutes and passes within 1 block of most hotels along the beach; the fare is R$2.

BY BUS Buses arrive at Recife's **Terminal Integrado de Passageiros (TIP),** Rodovia BR-232, Km 15, Curado (© **081/3452-1999**), 14km (8½ miles) west of downtown. A Metrô connects the bus station to downtown Recife's station, Estação Central. *Note:* Buses from Recife to Olinda or to Porto de Galinhas leave from downtown and Boa Viagem, not from this station.

CITY LAYOUT

Recife's downtown layout can be a little confusing as it is made up of various islands that are connected by several bridges. Downtown Recife consists of three main areas: **Bairro do Recife** (often called Recife Antigo, or Old Recife), **Santo Antônio,** and

Recife & Olinda

See "Olinda" map

See "Recife" map

See "Recife" map

OLINDA

Praia de Olinda

ATLANTIC OCEAN
Manaus
Belém
Natal
Amazon
Recife
BRAZIL
Brasília
Salvador
São Paulo
Rio de Janeiro
500 mi
500 km

VILA POPULAR
PEIXINHOS
Av. Pres. Kennedy
BONFIM
CARMO
VARADOURO
SANTA TEREZA
SÍTIO NOVO
Av. Olinda

TORREÃO
Av. A. Magalhães
Av. Cruz Cabugá
TORRE
Av. João de Barros
STO. AMARO
R. 13 de Maio
Av. Norte
MADALENA
Av. Conde de Boa Vista
Av. A. Magalhães
R. da Aurora
RECIFE VELHO
BOA VISTA
SANTO ANTÓNIO
ESTAÇÃO CENTRAL
SÃO JOSÉ
JOANA BEZERRA
JOANA BEZERRA
AFOGADOS
R. Imperial
Av. Sul
Av. Eng. J. Estelita
R. São Miguel
LARGO DA PAZ

PINHEIROS
Av. Pinheiros
PINHEIROS
PINA
Praia da Pina
Av. Mascarenhas de Morais
ARITANA
Av. Eng. Domingos Ferreira
Av. Boa Viagem
IMBIRIBEIRA
R. António Falcão
TRAQUEDO NEVES
R. R. de Brito
Praia de Boa Viagem
BOA VIAGEM
BOA VIAGEM
SETUBAL

O C E A N

A T L A N T I C

Legend
- (M) Metro Stop
- ---- Metro Line
- (✈) Airport
- Beach

0 ——— 1 mi
0 ——— 1 km

Boa Vista/Santo Amaro. Recife Antigo is the oldest part of the city, founded by the Dutch in the 1630s. Ongoing renovations are reviving and revitalizing this area: an area of at least 15 city blocks centered on the **Rua da Bom Jesus** has been restored to its former glory. The best time to experience this area is during the weekends when it is at its liveliest.

Three bridges connect Old Recife with **Santo Antônio.** It's one of Recife's main commercial areas, and the home of many of its most interesting sights. Narrow streets packed with shops and vendors surround beautiful baroque churches and plazas. On weekdays this part of downtown just hops, particularly the narrow and twisting streets around the **Patio de São Pedro.** The principal street in Santo Antônio is **Avenida Dantas Barreto,** a wide boulevard that runs down the spine of the island. Buses to and from downtown leave from this street, either from **Praça da Independencia,** where Dantas Barreto meets Rua Primeiro de Março, or from farther up opposite **N.S. de Carmo Basilica.**

West of Santo Antônio on the mainland lie the modern and not very interesting office districts of **Boa Vista** and **Santo Amaro.**

The main beach and residential area of Recife starts just south of downtown and carries on uninterrupted for many miles. The first stretch, where **Avenida Boa Viagem** begins, is called **Pina.** The area around **Polo Pina** is a popular nightlife spot with some bars and restaurants. Farther along the beach the neighborhood name changes to **Boa Viagem.** This is the city's main hotel area. The beach itself is pleasant and clean but unfortunately the area has the highest number of shark attacks in all of Brazil. At low tide, the reefs that lie just off the coast are easily visible in the perfectly clear blue water.

Olinda lies atop a hill, 7km (4¼ miles) north of downtown. Regular buses make the trip in about 30 minutes. You'll arrive at the **Praça do Carmo** bus station at the foot of Olinda. From there it's all uphill. The town is small enough that directions aren't really necessary. Keep strolling and you'll see everything.

GETTING AROUND

BY BUS From Boa Viagem, regular buses run along Avenida Domingos Ferreira into downtown, about a 20-minute trip. Those marked CONDE DA BOA VISTA will loop through Boa Vista and into Santo Antônio via the Duarte Coelho Bridge, stopping at Praça da Independencia. Some of these buses continue across the Mauricio de Nassau bridge into Old Recife (ask the ticket seller). If not, it's only a 10-minute walk. Once downtown, all sights are easily reachable on foot.

Stay Alert for Sharks

BATHERS IN THIS AREA ARE AT A GREATER RISK OF SHARK ATTACK reads a sign on Boa Viagem beach. But greater than what, exactly? Those who don't go in the water? The first recorded shark attack occurred on Boa Viagem beach 14 years ago. Since then there have been numerous others, some of them fatal. Locals say the new port built just south of Recife forced the sharks out of their usual habitat and moved them up the coast. Attacks have decreased lately due to more public awareness, but caution is still required on Pina, Boa Viagem, and Piedade beaches. Follow the directions of lifeguards and don't go beyond the reefs.

From Boa Viagem, two regular buses travel directly to and from Olinda's Praça do Carmo bus station: SETUBAL-PRINCIPE and SETUBAL-CONDE DA BOA VISTA. The trip takes about 50 minutes.

From Olinda, all buses depart from the bus station on Praça do Carmo. Buses marked RIO DOCE go to Santo Antônio, stopping on Avenida Nossa Senhora do Carmo. Buses marked JARDIM ATLANTICO also go to Santo Antônio but stop in front of the post office on Rua Siqueira Campos. The trip takes 30 minutes. All buses cost R$2.30.

BY TAXI Taxis are quick and reliable and can be hailed anywhere or booked by phone. Your hotel will usually hail a more expensive radio taxi; to catch a regular one just grab one on the street. **Coopseta Aeroporto** (✆ 081/3464-4153) specializes in airport service. Both **Ligue-taxi** (✆ 081/3428-6830) and **Tele-Taxi** (✆ 081/2121-4242 or 3493-8383) can be booked ahead of time.

BY METRÔ There's a Metrô in Recife, but it's not useful to tourists. The stations are too far from Boa Viagem to walk, and given the time required to take a bus to the Metrô station, you might as well take the bus straight into downtown.

VISITOR INFORMATION

Recife's airport has a **tourist information booth** at the arrivals level that's open daily from 8am to 6pm (✆ 081/3462-4960). The best information booth is at Praça Boa Viagem, open daily from 8am to 8pm (✆ 081/3325-2204). The staff is helpful and will provide an excellent free map of Recife.

In Olinda, the tourist information office is located near the Largo do Amparo on Rua do Bonsucesso 183 (✆ 081/3439-9434), open daily from 9am to 6pm. There is also a kiosk at the Praça do Carmo, where the buses from Recife arrive. The tourist office website is not overly helpful, but is being improved with English information (www2.ipernambuco.com.br).

[FastFACTS] RECIFE & OLINDA

Area Codes The area code for Recife and Olinda is **081.**

Banks Banco do Brasil: in Recife, Rua Barão De Souza Leão 440, Boa Viagem (✆ **081/3462-3777**); in Olinda, Av. Getulio Vargas 1470, Bairro Novo (✆ **081/3439-1344**).

Car Rentals In the area, you'll find **Avis** (✆ **081/3462-5069**), **Localiza** (✆ **081/3341-2082**), and **Unidas** (✆ **081/3461-4661**).

Consulates There is a **Canada** consulate in Recife at Av. Engenheiro Antônio

de Góes 60, 7th floor (✆ **081/2122-3140**). There is a **United States** consulate in Recife at Rua Gonçalves Maia 163, Boa Vista (✆ **081/3416-3050**).

Currency Exchange Change money at **Monaco Cambio,** Praça Joaquim Nabuco 19, Santo Antônio (✆ **081/3424-3727**), and **Colmeia Cambio,** Rua dos Navegantes 783, Boa Viagem (✆ **081/3465-3822**).

Dentist Go to **Clinica Odontologica,** Rua Ademar da Costa Almeida 130, Piedade (✆ **081/3341-3341**).

Emergencies Dial ✆ **190** for police, ✆ **193** for fire and ambulance. **Tourist Police,** Praça Min. Salgado Filho s/n (at the airport; ✆ **081/3303-7217**).

Hospital Centro Hospitalar Albert Sabin, Rua Senador José Henrique 141, Ilha do Leite (✆ **081/3421-5411**).

Internet Access Olind@.com Cyber Café, Praça João Pessoa 15, Carmo, Olinda (✆ **081/3429-4365**), charges R$6 per hour. **Recife Internet,** Shopping Guararapes, Av. Barreto de Menezes 800,

Piedade (📞 **081/3464-2107**), charges R$8 per hour.

Pharmacies **Farmacia dos Pobres,** Av. Conselheiro Aguiar 3595, Boa Viagem (📞 **081/3301-3117**), is open 24 hours.

Visa Renewal Go to the **Policia Federal,** Cais do Apolo 321, Bairro do Recife (📞 **081/3425-4026**). You may need to show both a return ticket and evidence of sufficient funds to cover the remainder of your stay.

Weather Recife, just below the equator, has a pleasant, warm climate year-round, with average temperatures of 28°C (82°F). Most rain falls in winter (July–Sept). The most pleasant months are March through June; it's warm but not as hot as in December through February.

Where to Stay

Just a 20-minute bus ride from downtown Recife, the beach neighborhood of Boa Viagem offers a variety of hotels, some good restaurants, and a bit of nightlife, all with easy access to the beach. Unfortunately, none of the hotels in Recife really stand out. However, whatever Recife lacks in interesting hotels, Olinda more than makes up for with gorgeous pousadas—most in buildings 200 years old or more. Olinda also has some of the best restaurants in the area, and there's great daytime sightseeing. We recommend staying in Olinda for at least 1 or 2 nights and exploring the city from there. A bus between Olinda and Recife takes about 30 minutes and taxis are affordable as well.

BOA VIAGEM/PIEDADE

Recife's main hotel neighborhood for tourists is Boa Viagem, as close as you can get to downtown and Olinda while still being in a safe neighborhood on a lovely, clean beach. This area is best for travelers who like to stay near the beach and prefer modern facilities; there's also lots of dining and nightlife options. The drawbacks are that the neighborhood lacks charm and has no attractions, except for the beach.

Very Expensive

Atlante Plaza Hotel ★★ The Atlante Plaza is in a prime location across the street from Boa Viagem beach. Despite the rather plain exterior, the rooms are pleasantly decorated with modern and bright furnishings. All rooms are pretty much the same. The only advantage as you go higher (floorwise and pricewise) is the view. A nice touch is the extensive pillow menu, perfect for accessorizing your king-size bed. The hotel offers rooms for travelers with disabilities. Unfortunately the rooftop leisure area can only be accessed by a set of stairs.

Av. Boa Viagem 5426, Recife, 51030-000 PE. www.atlanteplaza.com.br. 📞 **081/3302-3333**. Fax 081/3302-3344. 241 units. R$495 superior double; R$660 executive double. Check Internet for off-season discounts. Children 7 and under stay free in parent's room, 8 and over are charged 25% of room rate. AE, MC, V. Bus: Boa Viagem. **Amenities:** 2 restaurants; bar; babysitting; concierge; gym; outdoor pool; room service; sauna; smoke-free rooms; Wi-Fi. *In room:* A/C, TV, hair dryer, Internet, minibar.

Expensive

Beach Class Suites ★★★ The best option in Boa Viagem, the Beach Class Suites offers bright and spacious rooms at a lower rate than most five-star properties. All rooms are decorated with modern furniture, predominantly white with some splashes of colorful art. All rooms have balconies; some also have a small kitchen with a microwave and coffeemaker. A nice feature is the women-only floor, ideal for women traveling alone. Internet rates offer as much as 50% savings over the rack rate.

Recife

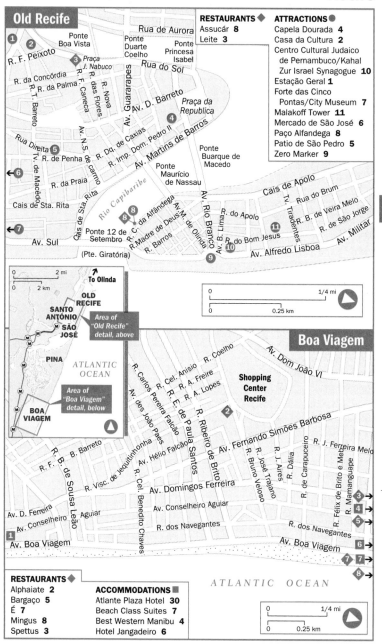

Old Recife

RESTAURANTS ◆
Assucár **8**
Leite **3**

ATTRACTIONS ●
Capela Dourada **4**
Casa da Cultura **2**
Centro Cultural Judaico de Pernambuco/Kahal Zur Israel Synagogue **10**
Estação Geral **1**
Forte das Cinco Pontas/City Museum **7**
Malakoff Tower **11**
Mercado de São José **6**
Paço Alfandega **8**
Patio de São Pedro **5**
Zero Marker **9**

Rua de Aurora
Ponte Boa Vista
Ponte Duarte Coelho
Ponte Princesa Isabel
R. F. Peixoto
Praça J. Nabuco
R. da Concórdia
R. da Palma
R. F. Caneca
R. Nova
R. das Flores
Av. Guararapes
Rua do Sol
Av. D. Barreto
Praça da Republica
Av. N.S. de carmo
R. Dq. de Caxias
R. Imp. Dom. Pedro II
Av. Martins de Barros
Rua Direita
R. de Penha
R. da Praia
Tv. de Macedo
Ponte Buarque de Macedo
Ponte Maurício de Nassau
Rio Capibaribe
Cais de Sta. Rita
Cais de Sta. Rita
R. C. da Alfândega
Av. M. de Deus
Av. Rio Branco
R. Madre de Deus
R. Barros
Av. M. de Olinda
R. B. Lima
R. do Apolo
Cais de Apolo
Rua do Brum
Tv. Tiradentes
R. B. de Veira Melo
R. de São Jorge
Av. B. do Bom Jesus
Av. Alfredo Lisboa
Av. Militar
Ponte 12 de Setembro
(Pte. Giratória)
Av. Sul

0 2 mi
0 2 km
To Olinda

OLD RECIFE
SANTO ANTÔNIO
SÃO JOSÉ
PINA
ATLANTIC OCEAN
Area of "Old Recife" detail, above
Area of "Boa Viagem" detail, below
BOA VIAGEM

0 1/4 mi
0 0.25 km

Boa Viagem

Av. Dom João VI
R. Coelho
R. Cel. Anisio
R. A. Freire
R. E. de R. A. Lopes
R. Carlos Pereira Falcão
Av. des João Paes
R. B. Barreto
R. F. B. de Sousa Leão
R. Visc. de Jequitinhonha
Av. Hélio Falcão
R. Ribeiro de Brito
R. de Paula Santos
R. Cel. Benedito Chaves
Shopping Center Recife
Av. Fernando Simões Barbosa
R. Bruno Veloso
R. José Trajano
R. J. Aires
R. Dália
R. de Carapuceiro
R. J. Ferreira Melo
R. Félix de Brito e Melo
R. Mamanguape
Av. Domingos Ferreira
Av. D. Ferreira
Av. Conselheiro Aguiar
Av. Conselheiro Aguiar
R. dos Navegantes
R. dos Navegantes
Av. Boa Viagem
Av. Boa Viagem

ATLANTIC OCEAN

0 1/4 mi
0 0.25 km

RESTAURANTS ◆
Alphaiate **2**
Bargaço **5**
É **7**
Mingus **8**
Spettus **3**

ACCOMMODATIONS ■
Atlante Plaza Hotel **30**
Beach Class Suites **7**
Best Western Manibu **4**
Hotel Jangadeiro **6**

Av. Boa Viagem 1906, Boa Viagem, Recife, 51011-000 PE. www.beachclasssuites.com.br. ⓒ**0800/ 55-5855** or 081/2121-2626. 162 units. R$310–R$390 double. Extra person in room add 25%. Children 7 and under stay free in parent's room. AE, DC, MC, V. Free parking. Bus: Boa Viagem. **Amenities:** Restaurant; bar; exercise room; outdoor pool; room service; sauna; smoke-free rooms. *In room:* A/C, TV, hair dryer, Internet, minibar.

Moderate

Best Western Manibu ★ ☺ ⚑ The Best Western Manibu is one of the few hotels that easily accommodates three to four people in a room at a decent price, making it ideal for families or friends traveling together. The hotel offers affordable and comfortable rooms, pretty much what you would expect from a Best Western. Several floors, including all rooms in the green wing, have recently been renovated and are in tiptop shape. Being 2 blocks off the waterfront translates into significant savings. Senior travelers (56 and over) are entitled to an additional 10% off.

Av. Conselheiro Aguiar 919, Boa Viagem, Recife, 51011-031 PE. www.hotelmanibu.com.br. ⓒ**081/3084-2811.** Fax 081/3084-2810. 156 units. R$175–R$220 double. Extra person in room add 20%. Children 12 and under stay free in parent's room. AE, DC, MC, V. Free parking. Bus: Boa Viagem. **Amenities:** Restaurant; bar; exercise room; small outdoor pool; room service; sauna; smoke-free rooms. *In room:* A/C, TV, fridge, hair dryer, Internet.

Hotel Jangadeiro ★★ ⚑ Overlooking Boa Viagem beach, Hotel Jangadeiro offers the best value for money in this upscale neighborhood. It's a small, pleasant hotel with spacious and bright rooms. It's worth paying a little bit extra for the ocean-view rooms; all come with balconies and offer stunning views of Boa Viagem beach. The standard rooms look out onto the neighboring buildings, or have a partial ocean view but lack the balcony. Bathrooms come with showers only but are spotless and modern.

Av. Boa Viagem 3114, Boa Viagem, Recife, 51020-001 PE. www.jangadeirohotel.com.br. ⓒ**081/ 3465-3544.** Fax 081/3466-5786. 90 units. R$235 double; R$255–R$295 oceanview double. Children 7 and under stay free in parent's room, 8 and over extra bed 25%. AE, MC, V. Free parking. **Amenities:** Restaurant; small rooftop pool; room service. *In room:* A/C, TV, minibar, Wi-Fi.

OLINDA

Olinda's pousadas, located in the city's historic center, provide charming and comfortable accommodations. They are best for travelers who enjoy small hotels or bed-and-breakfasts with personalized, attentive service and beautifully furnished digs in a unique setting. The drawbacks are that the historic buildings lack some modern conveniences and the streets of Olinda are hilly and paved with uneven cobblestones.

 Note: No buses run within Olinda, as it is a small hillside neighborhood. However, all restaurants, accommodations, and attractions are within walking distance of the main bus station.

Expensive

Hotel 7 Colinas ★★★ ☺ Set on the grounds of a former sugar plantation, the hotel has beautiful lush gardens and the best leisure area of any hotel in the region. Rooms are spread out over a few low-rise buildings, and all come with verandas that overlook the garden. Rustic room interiors feature tile floors and dark-wood furniture. Even the smaller standard rooms are still very pleasant. The hotel's large outdoor pool is set in the lovely garden, with lots of space for kids to run and play, and there's a pleasant bar and restaurant. It may be hard to tear yourself away to see the sights of Olinda just steps away.

Olinda

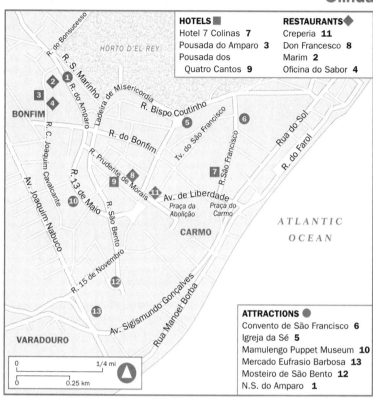

HOTELS ■
Hotel 7 Colinas **7**
Pousada do Amparo **3**
Pousada dos
 Quatro Cantos **9**

RESTAURANTS ◆
Creperia **11**
Don Francesco **8**
Marim **2**
Oficina do Sabor **4**

HORTO D'EL REY

BONFIM

R. do Bonsucesso
R. S. Marinho
R. do Amparo
Ladeira de Misericordia
R. Bispo Coutinho
R. do Bonfim
R.C. Joaquim Cavalcante
R. Prudente de Morais
Tv. do São Francisco
R. São Francisco
Rua do Sol
R. do Farol
Av. Joaquim Nabuco
R.13 de Maio
R. São Bento
Av. de Liberdade
Praça da Abolição
Praça do Carmo
CARMO

ATLANTIC OCEAN

R. 15 de Novembro
Av. Sigismundo Gonçalves
Rua Manoel Borba

VARADOURO

| 0 | 1/4 mi |
| 0 | 0.25 km |

ATTRACTIONS ●
Convento de São Francisco **6**
Igreja da Sé **5**
Mamulengo Puppet Museum **10**
Mercado Eufrasio Barbosa **13**
Mosteiro de São Bento **12**
N.S. do Amparo **1**

Ladeira de São Francisco 307, Olinda, 53020-170 PE. www.hotel7colinas.com.br. ✆/fax **081/3493-7766.** 48 units. R$250 double; R$420 deluxe double. Extra person add about 25%. Children 5 and under stay free in parent's room, children 6–12 pay 15%. AE, MC, V. Free parking. Bus: Rio Doce. **Amenities:** Restaurant; large outdoor pool; children's pool. *In room:* A/C, TV, minibar, Wi-Fi.

Pousada do Amparo ★★★ The most charming place to stay in all of greater Olinda is this concatenation of two 200-year-old colonial buildings in the heart of historic Olinda. Views down the hillside from the sumptuous back garden and pool deck are fabulous. Inside, tile floors, heavy ceiling beams, and lots of dark colonial furniture create a period feel. The addition of light wells and an internal courtyard space have given the building a wonderfully sunlit feel. Rooms come in several configurations; most are quite spacious, and several have verandas. All are furnished with a combination of antiques and modern artwork. The three rooms that face directly onto the street are a bit noisy and better avoided. *Tip:* The downstairs **Restaurante Flor de Coco** (Tues–Sun 6pm–1am) is one of the better ones in Olinda.

Rua do Amparo 199, Olinda, 53020-170 PE. www.pousadadoamparo.com.br. ✆ **081/3439-1749.** Fax 081/3419-6889. 18 units. R$260 double; R$360–R$520 deluxe double. Extra person add about 25%. Children 10 and under stay free in parent's room. V. Street parking. Bus: Rio Doce. **Amenities:** Restaurant; small pool; children's pool; sauna. *In room:* A/C, TV, minibar.

Moderate

Pousada dos Quatro Cantos ★ A lovely large colonial building, this pousada takes up the entire block, hence the name (*quatro cantos* means "four corners"). The best rooms are the three deluxe ones that offer a view of the pool or the city. Also very nice are the deluxe superior rooms that have jetted tubs. The best room is the veranda suite, a spacious chamber overlooking the garden. The two rooms on the ground floor have no in-room bathroom and are next to the lobby. An annex across the garden contains five more rooms, which are comfortable but lack character.

Rua Prudente de Morais 441, Carmo, Olinda, PE. www.pousada4cantos.com.br. ⓒ **081/3429-0220.** 18 units, showers only. R$95 annex room double (shared bathroom); R$177 double; R$219–R$272 deluxe and deluxe superior double; R$353 suite. Seasonal discounts up to 20%. Extra bed add 25%. Children 5 and under stay free in parent's room. MC, V. Street parking. Bus: Boa Viagem. **Amenities:** Small outdoor pool. *In room:* A/C, TV, fridge.

Where to Eat

CENTRO

Recife's historic downtown is a bustling and fascinating part of the city during business hours. Most of the restaurants in Centro cater to a business and office-lunch crowd and are closed at night and on weekends. The best spot in the evening is in Old Recife around the Rua do Bom Jesus, where most bars serve full meals or excellent appetizers. See "Recife & Olinda After Dark," later in this chapter, for more information.

Expensive

Leite ★★ BRAZILIAN Leite was founded in 1882 and is one of Brazil's oldest, still-functioning restaurants. It is also consistently one of Recife's top downtown restaurants, an oasis of old-world elegance with mirrors, dark-wood paneling, and tables set with fine linen and china. It has a large menu with numerous steak dishes including *filet a Dijon,* a grilled steak with mustard sauce and rice with broccoli. Fish dishes include sole in almond sauce and prawns in coconut milk with onions and tomatoes. The kitchen also serves Portuguese dishes such as *bacalhau á moda,* a grilled cod filet with onions, potatoes, olives, and garlic. The most popular dessert is the *cartola,* a fried banana with cheese, sprinkled with sugar and cinnamon.

Praça Joaquim Nabuco 147, Santo Antônio. ⓒ **081/3224-7977.** www.restauranteleite.com.br. Main courses R$26–R$45. DC, MC, V. Sun–Fri lunch only, 11:30am–4pm.

Moderate

Assucár REGIONAL A popular lunch and dinner destination, Assucar serves up modern, regional cuisine with plenty of seafood, grilled fish, and steak dishes. The delicious *couvert* (appetizer plate) features an inventive bean broth cooked with just a dash of *cachaça.* Main dishes include classic regional fare such as *carne de sol,* grilled fish with banana purée, as well as risottos and chicken.

Rua da Moeda 162, Recife Antigo (near the Paço da Alfandega mall). ⓒ **081/8748-7989.** Main courses R$24–R$39. AE, DC, MC, V. Mon–Tues noon–10pm; Wed–Sat noon–midnight; Sun noon–6:30pm.

BOA VIAGEM

The beach neighborhood of Boa Viagem is home to some good restaurants, many of which specialize in seafood and offer great beach and ocean views.

Expensive

Bargaço ★★ SEAFOOD/FISH A Recife institution, the Bargaço restaurant is *the* place in town for seafood. The menu includes such offerings as grilled fish and

garlic-fried shrimp, but we recommend ordering those as an appetizer in order to save room for a *moqueca*. The menu features eight varieties, including lobster, octopus, shrimp, fish, or crab, but it's the Bahian *moqueca* dish that made this restaurant famous. If you can't decide, try the seafood combination *moqueca mixta*. These main courses are big enough for two. Your best bet for dessert is the *cocada*, a typical Bahian sweet made with sugar, more sugar, and coconut.

Av. Eng. Antonio de Gois 62, Pina. (©) **081/3465-1847.** www.bargacorecife.com.br. Reservations recommended on weekends. Main courses R$66–R$90, most dishes serve 2 people. DC, MC, V. Sun–Thurs noon–midnight; Fri–Sat noon–1am.

E ★★ CONTEMPORARY/INTERNATIONAL One of Recife's best restaurants takes you on a culinary tour of some interesting cuisines. Chef Douglas van der Ley loves to play with techniques and flavors from all across the world, and his dishes reveal touches of Vietnamese, Thai, Japanese, Italian, and French cuisine. Some interesting dishes you will find on the menu include *fillet ban chá* (grilled beef medal-lions served on pasta with a Dijon, miso, and green tea sauce) and the Thai prawns (deep-fried and served with a sweet-and-sour honey sauce). The kitchen is open late, until 1:30am.

Rua do Atlântico 147, Boa Viagem. (©) **081/3325-9323.** www.egastronomia.com.br. Reservations recommended on weekends. Main courses R$55–R$82. AE, DC, MC. Tues–Sat 8pm–1:30am. Bus: Boa Viagem.

Mingus ★★ CONTEMPORARY Almost across the street from E is this popular Recife restaurant, named in honor of jazz bassist and composer Charles Mingus. The kitchen serves up excellent contemporary cuisine, using Brazilian ingredients in cre-ative combinations. Try the grilled lamb with shiitake mushrooms and baby potatoes, or the grilled partridge with linguine au poivre. Seafood lovers will also be pleased with dishes such as the grilled fish in cashew crust with leek risotto or the salmon with a ham and melon risotto. Desserts are deliciously decadent and worth lingering over—especially the warm apple compote with a cashew crust and vanilla ice cream or the warm chocolate biscuit with nuts and chocolate mousse topped with rich crème anglaise and red fruit.

Rua do Atlântico 102, Boa Viagem. (©) **081/3465-4000.** www.mingus.com.br. Reservations recom-mended in the evening. Main courses R$66–R$90. DC, MC, V. Sun–Mon noon–3:30pm; Tues–Sat noon–3:30pm and 7pm–midnight. Bus: Boa Viagem.

Spettus ★★ STEAK It may look more like a hip lounge, but this is one of Recife's most popular all-you-can-eat steak restaurants. The meat menu alone covers more than 20 different kinds of beef, chicken, lamb, and pork. However, seafood lovers and even vegetarians (if they can get over the constant parade of succulent meat) can feast on a variety of seafood, sushi, salads, vegetables, and antipasti. Dessert isn't included in the price, but chances are you will be too stuffed to want any.

Av. Eng. Domingos Ferreira 1500, Boa Viagem. (©) **081/3326-3070.** www.spettusboaviagem.com. br. R$62 per person. AE, DC, MC, V. Daily 11:30am–midnight.

Moderate

Alphaiate ★★ STEAK The Alphaiate is the perfect spot to take a break from eating fish and seafood. Located in Boa Viagem, the restaurant faces the ocean and offers indoor as well as covered alfresco dining. Even if you don't feel like a full meal, the Alphaiate is great for just a beer and snack. The beer list includes over 20 options, and a variety of the steaks come in appetizer format. Also good for nibbling are the pork spareribs, served with *farofa* and vinaigrette sauce. Main courses will often feed

two people. The most popular dish is the *picanha* steak for two, served with a side of *farofa*, rice, and beans.

Rua Artur Muniz 82, Boa Viagem. ✆ **081/3465-7588.** Main courses R$41–R$65, many serve 2 people. DC, MC, V. Sun–Wed 11:30am–1am; Thurs–Sat 11:30am–2am. Bus: Boa Viagem.

OLINDA

Who'd-a-thought artists could cook? Long known as an artistic center, Olinda has recently begun to establish itself as the best place for fine dining in Recife.

Expensive

Oficina do Sabor ★★★ BRAZILIAN If you only have time for one meal in Olinda, make sure you reserve a table on the patio of Oficina do Sabor. The most popular dishes are the *jerimums*, a local variety of pumpkin. Bestsellers include the *jerimum recheado com camarão ao maracuja* (pumpkin filled with prawn and passion-fruit sauce) and the *jerimum recheado com lagosta ao coco* (pumpkin filled with lobster in coconut milk). Inside, the Oficina is a beautifully decorated space in a lovely restored building—but that's just icing on the pumpkin. The patio offers gorgeous views of Olinda.

Rua do Amparo 335, Olinda. ✆ **081/3429-3331.** www.oficinadosabor.com. Reservations recommended on weekends. Main courses R$49–R$90, most dishes serve 2. AE, DC, MC, V. Tues–Fri noon–4pm and 6pm–midnight; Sat noon–1am; Sun noon–5pm.

Moderate

Don Francesco ★★★ 🍴ITALIAN This little restaurant serves up some of the best Italian food in town. Owner and chef Francesco Carretta takes care of the kitchen, and his wife, Norma, looks after the dining room and welcomes guests into the cozy restaurant. Many of the herbs and vegetables come from their organic garden. The pastas are made from scratch by Francesco and served with simple sauces. You choose whether you prefer the tagliatelle, ravioli, or rondelle and pick one of the sauces such as the organic pesto, fungi mushrooms, Gorgonzola, or tomato with basil and ricotta. The menu always includes a traditional and a vegetarian lasagna. All desserts, except for the ice cream, are also made in Don Francesco's kitchen.

Rua Prudente de Moraes 358, Olinda. ✆ **081/3429-3852.** Main courses R$31–R$65. MC, V. Mon–Fri noon–3pm and 7–11pm; Sat 7pm–midnight.

Marim ★★ BRAZILIAN/SEAFOOD Not too far from the Oficina do Sabor is another great cozy restaurant where the lovely decorations aren't the only works of art. The kitchen serves some beautiful dishes, specializing in regional seafood such as prawns with mango sauce, grilled fish in banana leaf, or fish stuffed with spicy

crabmeat. The atmosphere is bustling and pleasant, and the service is knowledgeable and friendly.

Rua do Amparo 157, Olinda. ℭ **081/3429-8762.** Reservations accepted. Main courses R$22–R$49. AE, DC, MC, V. Daily 11am–11pm. Bus: Rio Doce.

Inexpensive

Creperia 🍴 CREPES Set in a lovely house just across from the church on the Praça João Alfredo, the Creperia serves up—surprise, surprise—crepes. The menu offers a variety of savory and sweet crepes. Perfect for a quick lunch or snack, try the Ilha de Marajó, made with melted mozzarella cheese, arugula, and sun-dried tomatoes. The prawns with curry sauce are also tasty. In addition to crepes, the kitchen serves up salads and fruit juices. The restaurant has a great patio.

Praça João Alfredo 168, Carmo, Olinda. ℭ **081/3429-2935.** Crepes R$15–R$25. DC, MC, V. Tues–Sun 11am–11pm.

Exploring Recife & Olinda

The allure of both Olinda and Recife lies not so much in particular sights as in the urban fabric. In Olinda, while no particular church merits a special trip, the ensemble of 300- and 400-year-old architecture makes for a memorable stroll. If your time is limited, head first for Olinda, making sure to go up to the Igreja da Sé for the best views.

Downtown Recife has a number of interesting monuments and buildings to see; the Zero Marker makes a fine starting point. From there it's a nice stroll through restored Old Recife (make sure to walk down Rua do Bom Jesus and take a peek from the Malakoff Tower). Then cross the bridge to Santo Antônio; the commercial heart of Recife is as packed with vendors and food stands as any Asian market. Staying in Boa Viagem makes it easy to fit in a morning swim and stroll on the beach. If you need more sand time than that, remember that small, laid-back Porto de Galinhas

 THE PASSION PLAY AT nova jerusalem

If you're in the Recife area in the 10 days leading up to Easter, don't miss the **passion play in Nova Jerusalem, Fazenda Nova ★★**. More than 500 actors and extras assemble on nine different stages to act out the last days in the life of Christ. The specially built theater is massive—the size of 12 football fields, with tall towers and thick walls resembling old Jerusalem. The play's been going since 1968, but in recent years it's become much more popular; well-known actors and actresses now take the coveted roles of Jesus, Mary, Pontius Pilate, and Judas. What makes it worth the trip to Fazenda Nova, 190km (118 miles) from Recife, is the street fair and festival that accompanies the play. Performances start on the Saturday of the week before Easter. Good Friday and Hallelujah Saturday (the day before Easter) are the most popular nights. Up to 8,000 people make the trip out to Nova Jerusalem each night. Tickets cost R$50 to R$80. Performances start at 6pm and finish at 9pm. For up-to-date info on actors and starts, see the play website, **www.novajerusalem.com.br.** For day tours, contact **Luck Viagens** (ℭ **081/3302-6222;** www.luckviagens.com.br; R$70 for tour and ticket) or **Caravana Turismo** (ℭ **081/3221-1623;** R$65 for day trip plus ticket).

boasts one of the finest beaches in the Northeast (see "A Side Trip to Porto de Galinhas," later in this chapter).

HIGHLIGHTS OF OLINDA

The only way to truly explore Olinda is by hitting the cobblestones and setting off on foot. It's hard to get lost in the historic part of the city. The hilltop **Igreja da Sé** dominates the city to the west, while the ocean is always visible to the east; Recife's skyline stands out to the south. Most attractions are open daily; churches usually open from 8am to 5pm, with a 2-hour closure for lunch from noon to 2pm. Sunday and Monday are pretty quiet. If you like it more lively and bustling, visit on Friday and Saturday.

Buses from Recife will drop you off at the Praça do Carmo, dominated by the lovely **N.S. do Carmo church ★**. This more-than-400-year-old church has finally undergone a much-needed renovation. It's worth peeking in to see the huge ornate jacaranda-wood altar. The large leafy square on the front side of the church is known as **Praça da Abolição (abolition square)** because of the statues of Princess Isabel, who was responsible for abolishing slavery in 1888. Follow Avenida da Liberdade, and you'll pass by the 1590 Church of **São Pedro Apostolo** before turning right and walking up the steep **Ladeira da Sé** to the **Igreja da Sé ★**.

Alternatively, from N.S. do Carmo you can swing to your right on the Rua Sã Francisco, which leads to the **Convento de São Francisco ★★** (R$2; closed Sat afternoon and all day Sun). Built in 1577, this was the first Franciscan monastery in Brazil. It's worth coming to see the life history of Jesus in the N.S. das Neves, done in Portuguese blue tile.

From the Convento São Francisco, the Travessia São Francisco leads up to the Ladeira de Sé and the **Igreja da Sé.** Originally built in 1537, this now rather austere church is more interesting for what it's suffered over the years than anything else. A series of photographs and drawings just inside the main door shows the church's various incarnations.

The square in front of the Igreja da Sé provides the best view in town. You see the red-tiled roofs and church towers of Olinda, and tropical trees set against the sparkling blue ocean below. Farther south you get great views of Recife's skyline all the way to Boa Viagem. It's a good place to ponder Recife, Olinda, and the nations that made them. The Portuguese, coming from cities like Lisbon, founded Olinda on a hilltop. The Dutch, with models like Amsterdam in mind, founded Recife on a bit of mudflat by the river mouth. The Dutch choice proved the more practical. But the Portuguese city is far more beautiful.

The square in front of the Igreja da Sé has a great crafts market and excellent food stalls selling fresh tapioca pancakes and shots of flavored *cachaça*. Nearby, at Rua Bispo Coutinho 726, you'll find the **Museu de Arte Sacra de Pernambuco** (Tues– Fri 9am–12:45pm). It's not one of the great ones; if you saw the sacred art museums in Salvador or São Paulo, skip this one.

The very steep **Ladeira da Misericordia** leads down toward the **Rua do Amparo ★★**. This is one of Olinda's prettiest streets, featuring small, brightly colored colonial houses packed with galleries, restaurants, and shops. **Largo do Amparo ★** has the feel of a little Mexican square. On the square itself, **N.S. do Amparo** (built 1613) features two bell towers (a sign they could afford to pay the bell-tower tax back in the old days) on the outside, and some nice tiles and gold work

inside. Farther up the hillside, **N.S. do Rosario dos Pretos** and **São João Batista** have nothing inside worth hoofing it up the hill.

Leaving the square and following Rua Amparo until it becomes **Rua Treze de Maio,** you come to the **Mamulengo Puppet Museum ★** (© 081/3429-6214; Tues–Fri 9am–5pm, Sat–Sun 10am–6pm; free admission). The small three-floor museum assembles puppets used in Northeastern folk drama. Puppet characters come in a wide variety of shapes and sizes. Some have hidden levers that cause them to stick out their tongues (or other, ruder appendages). Almost next door, the **Museu de Arte Contemporânea de Pernambuco** (**Museum of Contemporary Art;** © 081/3429-2587) has next to nothing inside.

Farther down, following **Rua São Bento** leads to the **Mosteiro de São Bento.** Built in 1582, this monastery is still home to 27 Benedictine monks, and only the church is open to the public.

From the monastery, **Rua XV de Novembro** leads down to the **Largo do Varadouro;** the large crafts market **Mercado Eufrasio Barbosa** is worth a visit. Those returning to Recife can take a bus from this square instead of returning to the Praça do Carmo.

HIGHLIGHTS OF RECIFE

The place to start a tour of Recife is at the **Zero Marker** in the heart of Old Recife. Gaze out toward the ocean from here, and about 90m (300 ft.) offshore you'll see the long, low reef from which the city draws its name. On the reef sits a strange tall green pillar capped with something that could charitably be said to resemble a tulip. This more than slightly phallic monument is the work of an eccentric ceramics artist named **Francisco Brennand.** If you're interested in seeing more, he has a large estate on the far edge of town (**Oficina Cerâmica Francisco Brennand,** Av. Cachangá, Varzea; © 081/3271-2466; www.brennand.com.br; Mon–Thurs 8am–5pm, Fri 8am–4pm) brimming with weird and wonderful ceramic creations, many of them long, hard, and potent-looking (see attractions below).

A block back from the Zero Marker is the **Rua do Bom Jesus.** The street and this whole island are the oldest part of Recife, founded not by the Portuguese but by the Dutch. The reconstructed **Kahal Zur Synagogue,** rebuilt on the foundations of the first synagogue in the Americas, is worth a visit. On weekends this part of the city is a fun area to visit for free outdoor concerts. The center of the nocturnal activity is the **Praça Artur Oscar.** At the north end of the square the tall thing like a Norman castle is the **Malakoff Tower,** a former astrological observatory now open as a public viewing platform.

From here north all the way to Forte Brum, Old Recife reverts from antique to just plain old—run-down and a little slummy. The fort at the end of the 5-block walk isn't special enough to warrant the trip, so head back to **Avenida Rio Branco,** and cross the Buarge de Macedo bridge to **Santo Antônio.**

This area, too, was the work of the Dutch. In the heyday of the Dutch colony, Santo Antônio was called Mauritsopolis, after the founder and ruler, Enlightenment prince Maurits van Nassau. The large green neoclassical square almost at the foot of the bridge was once Nassau's private estate, but is now the **Praça da República ★**. It's one of Recife's most graceful public areas.

Just behind the Beaux Arts **Palácio da Justiça** on Rua do Imperador Dom Pedro II, you pass by the **Capela Dourada** (see below). Then, turning right on Rua Primeiro

do Março, you come to a big blue-and-white Beaux Arts confection of a building that has, since the 1880s, been home to the city's premier paper, the *Diário de Pernambuco.* Across the street is the **Praça da Independencia,** a good place to catch a bus, but of no interest otherwise.

Crossing Primeiro do Marco and sneaking south through the fun maze of narrow streets (parallel to but not on Av. Dantas Barreto) you will come—provided you find **Rua do Fogo** on the far side of **Avenida N.S. do Carmo**—to the **Pátio de São Pedro,** a popular outdoor music venue.

The **Concatedral de São Pedro de Clérigos** is a classic example of Portuguese colonial baroque architecture. Nice as it is, however, it's the patio that makes the spot special. This broad cobblestone square is enclosed by dozens of small, restored shops, all gaily painted in bright pinks, blues, and greens.

Crossing Avenida Dantas Barreto from here you would come to the **N.S. do Carmo Basilica,** which would be worth a quick look before continuing for a few more blocks to the **Casa da Cultura** (see below) and the **Estação Geral.**

As it turns out, however, the little shops surrounding the patio are a great place to grab a chopp (cold Brazilian draft) and have a seat at—what else?—a patio table. Toward the end of the day, the place fills up with the one-for-the-road crowd; there's often a band. This is a good place to cease exploring for a while.

ATTRACTIONS

Capela Dourada ★ The Golden Chapel is aptly named. The altar is a two-story arch of jacaranda and cedar, gilt with gold. Christ hangs on a golden cross with gold and silver rays shining out behind his head. The chapel is part of a Franciscan complex that includes a small sacred art museum with a few nice pieces of silver work. Also worth a look is the **Church of the Ordem Terceiro de São Francisco.** One wall of this church is decorated with a rather disturbing oil painting showing Franciscan monks getting crucified. Someone else obviously took a dislike to it; the face of every soldier has been scraped away. Don't miss the **church archives** behind the altar. The cabinets are 3m (12 ft.) high and made of solid jacaranda—gorgeous craftsmanship.

Rua do Imperador Dom Pedro II 206, Santo Antônio, Recife. ✆ **081/3224-0530.** Admission R$2 adults, free for children 7 and under. Mon–Fri 8–11:30am and 2–5pm; Sat 8–11am. Bus: Conde da Boa Vista.

Casa da Cultura ★ This former penitentiary has only barely changed since its prison days; the cells, still with their original numbers, are now occupied by souvenir shops. You'll find a good selection of local crafts: ceramics, woodcarvings, leather sandals, lace, and clothing. Prices are reasonable, but a bit of bargaining is expected. There's still more than a *frisson* of dread as you climb the heavy iron catwalks and duck through a thick doorway into one of the old cells. Good thing there's nothing more frightening than handicrafts inside.

Rua Floriano Peixoto, Santo Antônio, Recife. ✆ **081/3224-2850.** Mon–Fri 9am–7pm; Sat 9am–6pm; Sun 9am–2pm. Bus: Conde de Boa Vista.

Centro Cultural Judaico de Pernambuco/Kahal Zur Israel Synagogue ★★ This reconstructed synagogue is built on the foundations of the original Kahal Zur Israel synagogue, founded in the 1640s when Recife was ruled by religiously tolerant Holland. With the end of Dutch rule in 1654 many of Recife's

Jews fled to New Amsterdam (later New York), and the synagogue was confiscated and sold. Over the centuries, evidence of the temple all but disappeared. In the late 1990s, traces of the old synagogue were discovered in the form of a *mikve,* or ritual bath. The reconstructed building is not a replica of the original but more a monument that honors the Jewish community in Recife. The museum tells the history of Jews in Recife. On the ground floor you can see the remains of the 17th-century temple. The second floor houses the actual synagogue; and if you aren't familiar with Jewish traditions, a guide will show you around. The third floor has a TV lounge where staff will play an excellent documentary (with English subtitles) on the history of the Jews in Recife and the rebuilding of the synagogue. Expect to spend an hour.

Rua do Bom Jesus 197, Bairro do Recife. © **081/3224-2128.** Admission R$4. Tues–Fri 9am–5pm; Sun 2–6pm. Bus: Conde de Boa Vista.

Forte das Cinco Pontas/City Museum ★★ Perhaps the most curious thing about the "Fort of Five Points" is that it only has four. The original Dutch fort built in 1630 had five, but the Portuguese leveled that fort and rebuilt it in their traditional four-pointed style. The fort today has been wonderfully restored; you can wander the ramparts at will. Unfortunately, the city has crept out far past this once seaside installation, leaving the fort outflanked by a freeway. The excellent city museum, which takes up two wings of the fort, has two rooms devoted to the Dutch period, including a wealth of maps and drawings of the early colony.

Largo dos Cinco Pontas, Bairro de São José, Recife. © **081/3224-2812.** Admission R$3. Tues–Fri 9am–6pm; Sat–Sun 1–5pm. Bus: São Jose.

Oficina Cerâmica Francisco Brennand ★★★ Although somewhat off the beaten track, this ceramics workshop/museum is more than worth the price of admission. The lifelong work of ceramic artist Francisco Brennand is on display at this sprawling estate/workshop. Although famous for some notorious giant phallic sculptures, his collection is so much more and includes thousands of sculptures, tiles, and pieces of ceramic art, as well as drawings. His work is beautifully displayed in several buildings as well as various outdoor settings. The Roberto Burle Marx garden was designed by the landscape artist himself and decorated with Brennand statues. *Tip:* The restaurant inside the gift shop serves excellent regional dishes and juices.

Propriedade Santos Cosme e Damião s/n, Várzea. © **081/3271-2466.** www.brennand. com.br. Admission R$4. Mon–Thurs 8am–5pm; Fri 8am–4pm. Taxi recommended.

> **All in the Family**
>
> Don't confuse the Oficina Cerâmica Francisco Brennand with the nearby **Instituto Ricardo Brennand,** Alameda Antônio Brennand, Várzea (© **084/2121-0352;** Tues–Sun 1–5pm; R$5)! The Instituto Ricardo Brennand is a large museum that contains mostly European art, a collection of weapons, and an exhibit on the 17th-century Dutch occupation of Recife. Out of the two, the ceramics museum is by far the most fascinating.

ESPECIALLY FOR KIDS

Veneza Water Park ☺ Just 10km (6¼ miles) north of Olinda, the Veneza Water Park is a great place to frolic. There are slides, pools, a wave pool, water volleyball, Jacuzzis, and many other types of aquatic entertainment. Special family and group rates apply.

Where to Find the Most Spectacular Views

Don't miss the view from the front steps of the **Igreja da Sé** in Olinda. Look out over the red-tile roofs of the old Portuguese city, the white sand, and the bright blue sea. In Old Recife, it's worth taking the elevator to the top of the restored **Malakoff Tower,** an old astronomical observatory on Praça Artur Oscar. It's only four stories high, but the view of the low-rise old city is still good. It's open Tuesday to Friday 10am to 8pm and Saturday and Sunday 2 to 7pm; admission is free.

Praia Maria Farinha. (✆ **081/3436-6363** or 3436-8845. www.venezawaterpark.com.br. Individual ticket R$74 adult, child 1–1.4m (3–4½ ft.) tall R$37, free for children under 1m (3 ft.), family pass (2 adults and 2 children) R$172. Daily 10am–5pm. Bus: to Maria Farinha beach. Catch bus from Terminal Av. Dantas Barreto across from N.S. do Carmo church. A taxi from Olinda would cost approximately R$25–R$30.

ORGANIZED TOURS

BOAT TOURS Recife's location on a series of islands makes a boat tour a good way to see the town. **Catamaran Tours** (✆ **081/3424-2845;** www.catamarantours. com.br) offers sightseeing tours on broad, comfortable catamarans. Historical tours of 1½ hours show the old city. Full-day tours head up the coast to visit Fort Orange and the beaches of Itamaracá. The city tour costs R$30; the 6-hour Itamaracá tour costs R$40. Children ages 6 to 10 pay half price. Tours depart from Avenida Sul, 50m (164 ft.) past the Forte Cinco Pontas. Exact departure times depend on the tide. Call ahead to confirm.

BUS TOURS **Luck Viagens** (✆ **081/3366-6262;** www.luckreceptivo.com.br) offers a range of bus tours. There's a 4-hour city tour that shows the highlights of Recife and Olinda (R$45). There's also a full-day tour to Itamaracá island (R$65), where the Dutch built Fort Orange in 1631, and day trips to Porto de Galinhas for the best beaches and snorkeling in the area (R$39).

OUTDOOR ACTIVITIES

Wreck divers will be in heaven; at least 15 wrecks are diveable and within easy reach. For excursions contact **Projeto Mar,** Rua Tomé Gibson 368, Pina (✆ **081/3326-0162;** www.projetomar.com.br). Two dives including all the gear cost R$250; a nondiving companion pays R$50. Snacks are included.

Shopping

In Recife's downtown neighborhood of Santo Antônio, the streets around the **Pátio São Pedro** and in between **Avenida N.S. do Carmo** and **Rua Primeiro de Março** are all jampacked with little shops. Some of the alleys are so narrow that they resemble Asian street markets. The best time to explore is weekdays during office hours; in the evening this part of town is deserted. Larger, more fashionable stores are located just on the other side of the Duarte Coelho Bridge on **Avenida Conde da Boa Vista.** There are large modern malls located out in Boa Viagem as well as the new Paço Alfandega, the restored 18th-century Customs hall in Old Recife.

Olinda's historic downtown also offers prime shopping: Two markets sell excellent souvenirs (see below), and you will find many more galleries and interesting shops once you start to explore the winding streets.

GIFTS & SOUVENIRS In Olinda there are two excellent markets for local handicrafts. **Mercado Eufrasio Barbosa** (also called Mercado Varadouro) is located in the former Customs house at Sigismundo Gonçalves s/n (© 081/3439-2911). Open Monday through Saturday from 9am to 5:30pm, this market has great souvenirs at reasonable prices. Up the hill close to the Praça João Alfredo is the **Mercado Ribeira,** Bernardo Vieira de Melo s/n (© 081/3439-9708), which is open daily from 9am to 6:30pm; some stores stay open till 9pm. The merchants there specialize in religious arts, paintings, woodcarvings, and regional crafts.

Olinda is jampacked with studios and ateliers that are open to the public. If you like colorful artwork, visit **Imaginário,** on the Rua Bispo Coutinho 814 (© 081/3439-4514; www.imaginariobrasileiro.com.br). This large store displays a comprehensive collection of high-quality local artwork. More expensive but worth checking out is the **Estação Quatro Cantos,** Rua Bernardo Vieira de Melo 134 (© 081/3429-7575; www.estacao4cantos.com.br).

In Recife, a great shop with above-average souvenirs is **Paranambuco,** Rua do Bom Jesus 215 (© 081/3424-1689). The best spot for picking up local crafts is in the **Casa da Cultura** (p. 296), Rua Floriano Peixoto s/n, next to the train station (© 081/3224-2850). Those who are staying in Boa Viagem can visit the large crafts market on the Praça Boa Viagem; it's open Monday through Friday 3 to 11pm and 8am to 11pm on weekends.

MALLS & SHOPPING CENTERS **Shopping Center Recife,** Rua Padre Carapuceiro 777, Boa Viagem (© 081/3464-6123; www.shoppingrecife.com.br), is a modern mall; all buses heading downtown stop here. Farther along the beach where Boa Viagem becomes Piedade there's another pleasant mall, **Shopping Center Guararapes,** Av. Barreto Menezes 800, Piedade (© 081/3464-2211; www.shopping-guararapes.com.br). The most beautiful mall is the **Shopping Paço Alfandega,** Cais da Alfandega 35, Recife Antigo (© 081/3419-7500; www. pacoalfandega.com.br). Housed in the restored 18th-century Customs building, this is one of the city's prime shopping destinations. The bookstore **Livraria da Cultura** has an above-average selection of English-language books. Malls are open Monday through Friday from 10am to 10pm and Saturday from 10am to 8pm.

MARKETS A bustling fruit-and-vegetable market in a lovely old iron-and-glass building, the **Mercado de São José,** Praça Dom Vital s/n, Santo Antônio (no phone), is a great place to browse. Vendors sell locally made hammocks, baskets, ceramics, and lace. Hours are Monday through Saturday from 6am to 5:30pm and Sunday from 6am to noon.

Recife & Olinda After Dark

THE PERFORMING ARTS

Recife's prime theater venue is the elegant **Teatro Princesa Isabel,** Praça da República s/n (© 081/3224-1020; www.teatrosantaisabel.com.br). Built in 1850, the theater underwent major renovations and reopened a few years ago. It's worth checking local listings for events held at this lovely venue.

CLUBS & BARS

Recife's historic downtown has undergone a complete face-lift, becoming a cultural and entertainment district. Activities center around the **Rua do Bom Jesus;** lined with at least 15 bars and restaurants, this is one of the best places in town Thursday through Saturday and Sunday afternoons. Free concerts add to the entertainment, and on Sunday there's a street market.

One of Old Recife's nicest bars is the **Arsenal do Chopp,** Praça Artur Oscar 59, at the corner of Rua do Bom Jesus (© **081/3224-6259**). Most tables are spread out over the sidewalk; for a quiet spot grab a table inside. Another great venue downtown is the **Patio de São Pedro.** Beautifully restored, this square now hosts a variety of free outdoor music events. On Tuesday, locals gather for the Terça Negra, an event with Afoxé music, a style with heavy African influences. On Saturday, a younger crowd gathers to dance to *maracatu, mangue beat,* and other regional tunes. Events start at 7 or 8pm.

In Boa Viagem, the favorite nightspot is **Polo Pina,** a few square blocks around Pina beach and Avenida Herculano Bandeira de Melo. Recently named the best bar in Recife, **Biruta Bar,** Rua Bem-te-Vi, Pina (© **081/3326-5151;** www.birutabar. com.br), features a large veranda looking out over the ocean, making it the perfect setting for a special date. On Thursday, Biruta presents blues bands and on Friday there's *forró.* **Tip:** This bar is not easy to find and the small detour cuts through a bit of a dark corner at the end of Pina. We recommend taking a taxi.

For more live music, head out to the **Uk Pub,** Rua Francisco da Cunha 165, Boa Viagem (© **081/3466-9192**). Open Tuesday through Sunday, there is live music (samba, rock, pop) every night except Wednesday. It also has a great beer menu with more than 50 specialties. Cover ranges from R$5 to R$15. The best night for dancing at **Boratcho,** Av. Herculano Bandeira 513 (inside Galeria Joana d'Arc; © **081/3327-1168;** www.boratcho.com.br), is Thursday when DJs play a variety of music, including samba-rock and regional rhythms. **Boteco,** Av. Boa Viagem 1660, Boa Viagem (© **081/3327-4285**), is a popular destination almost any night of the week. Serving the best beer in town, the bar is often packed with locals stopping by for an ice-cold chopp. It's open daily.

Olinda is not known for its nightlife; most folks settle for wine and conversation over a late-night supper. One of the best spots for a drink or a stroll is the **Alto da Sé.** On weekends (Sun evening especially), locals flock to this prime view spot to grab a drink or some food from the many stalls and just hang out for an impromptu outdoor party. Olinda's cutest hole-in-the-wall spot is **Bodega de Veio,** Rua do Amparo 212 (© **081/3429-0185**). It's just a small bar/old-fashioned convenience store where people put their drinks on the counter or sit on the sidewalk. Saturday features live *forró.* Note that this is not a late-night place; last round is at 11pm. Another laid-back fun spot is the **Casa Maloca,** Rua Amparo 183 (© **081/3429-7811**), an art gallery and restaurant with, at the very back, the lovely **Bar Olindita.** Guests can sit at a long bar or funky tables scattered about the room. The best spots are on the patio, looking out toward Recife.

GAY & LESBIAN BARS **Metropole,** Rua das Ninfas 125, Boa Vista (© **081/3423-0123;** www.metropoledance.com.br), is a huge gay club for men with a bar, dance floor, and video room. Regular shows include go-go boys, strippers, and drag queen performances; it's open Friday and Saturday from 10pm until at least 5am. Another

popular gay venue is the **SPTZ,** Rua Joaquim Nabuco 534, Graças (© **081/3223-9100**). Open Tuesday through Sunday, from 6pm until at least 4am.

A Side Trip to Porto de Galinhas ★★★

70km (43 miles) S of Recife

Porto de Galinhas is one of the nicest beach destinations in all of northeast Brazil. Known for its crystal-clear water, its lovely beaches, and the tidal pools that form in the nearby reefs, the region is a perfect water playground for adults and children. Development has been kept resolutely small-scale. With no high-rises, the town is mostly small pousadas and low-rise hotels. There are perhaps six streets: enough for a dozen restaurants, a bank, some surf shops, and some beachside bars. Colorful *jangadas* (one-sail fishing rafts) come and go all day, and the beachside restaurants and cafes are packed with people soaking up rays.

ESSENTIALS
Getting There

BY CAR Porto de Galinhas is just 70km (43 miles) south of Recife, an hour by car. From Recife take BR-101 south until it connects with the PE-60, then look for the turnoff for the PE-38 that leads to Porto de Galinhas. Exits are well marked but the road has heavy traffic and is in very poor shape. If you are just driving to Porto de Galinhas it's not worth renting a car.

BY BUS Buses to Porto de Galinhas leave daily from 6:30am to 6:30pm every hour on the half-hour from the Avenida Dantas Barreto bus terminal in downtown Recife (across from N.S. do Carmo). Tickets are R$8 and the drive takes 2 hours. A number of these buses go through Boa Viagem and all stop at the airport on the way. From Porto de Galinhas to Recife, buses depart daily once an hour from 5:40am to 5:40pm.

BY TAXI A taxi from Recife airport or downtown will cost from R$80 to R$120 for up to four people and luggage. The price will depend on your bargaining skills. Don't go on the meter, though. Agree on a price beforehand. Many hotels and pousadas can book a taxi service for you at a reasonable rate.

Getting Around

A minivan shuttle runs from the village to Pontal do Cupe and back, stopping by request at hotels and pousadas along the way. Departures are more or less half-hourly from the Petrobras station on Rua da Esperança (R$2).

There are taxi stands (*ponto de taxi*) for dune buggy taxis in the village and halfway down the beach in front of the Armação do Porto hotel. One-way fare is R$15 from the village to either Cupe or Maracaípi beach. If you're planning to spend time at Maracaípi beach, it's a good idea to set a pickup time with your driver as it can be difficult to find a buggy to return. A full-day rental, including driver and up to four passengers, costs R$120 to R$150. In the unlikely event you can't find a buggy, contact **APCI Buggy** (© **081/3552-1930**).

Visitor Information

The **tourist office** is at Rua da Esperança 188 (© **081/3552-1480;** www.portode galinhas.com.br). Hours are Monday through Friday from 9am to 5pm, Saturday and Sunday from 9am to 3pm.

Fast Facts

Banco do Brasil, Via Porto de Galinhas s/n (© **081/3552-1855**), has a 24-hour ATM. The bank is open Monday through Friday from 10am to 4pm. There is also a **Banco 24 Horas** ATM inside the Petrobras Gas Station, open from 7am to 10pm. Internet access is available at **Pé No Mangue,** Rua da Esperança 101, second floor; cost is R$9 per hour.

WHERE TO STAY

Porto de Galinhas is gloriously free of sun-blocking high-rises. Accommodations are mostly in small family-run pousadas and a few larger cabana-style hotels. In recent years, a number of bigger resorts have sprung up, but even these have been kept to a reasonable scale and are located farther from the town. Prices are very reasonable, especially considering the high quality of the accommodations. In town, you'll be close to the action—too close perhaps in high season when the streets are packed until the wee hours. Staying a bit farther out will ensure a peaceful night's sleep and access to a quiet stretch of beach. The disadvantage is that it's a R$10 to R$15 taxi or buggy ride every time you come to town. However, most tours will provide pickup and drop-off at your hotel. In high season, particularly on the weekend, reservations for accommodations are required.

Very Expensive

Nannai Beach Resort ★★★ The only hotel worth splurging on in Porto de Galinhas is the Polynesian-style luxury Nannai. This exclusive resort consists of 49 bungalows and 42 apartments set among lush tropical gardens. The apartments are not worth the money (small and somewhat noisy), but the bungalows are fantastic and perfect for a relaxing vacation. Each has a private swimming pool and beautiful rustic furnishings and decorations. The resort also offers a large, sprawling pool complex and a host of activities such as tennis, pitch and putt golf, beach soccer and beach volleyball, snorkeling, sailing, kayaking, and children's activities.

Muro Alto, Km 3, Ipojuca, Porto de Galinhas, PE. www.nannai.com.br. © **081/3552-0100.** Fax 081/3552-1474. 91 units. High season R$1,040 apt, R$1,665 bungalow; low season R$755 apt, R$1,160 bungalow. Rates include breakfast and dinner. Extra person add 25%. Children 2 and under stay free in parent's room; children 3–12 10%. AE, MC, V. Free parking. **Amenities:** Restaurant; bar; health club; large outdoor pool; room service. *In room:* A/C, TV/DVD, minibar.

Expensive

Tabapitanga ★★★ ☺ A member of the high-end Roteiros de Charme Association, the Tabapitanga offers gorgeous accommodations on the beach just 5km (3 miles) from the village. Rooms are in one- or two-story chalets. All rooms are spacious and decorated with colorful artwork. Furnishings are luxurious; the rooms have king-size beds, large flatscreen TVs, and big bathrooms. Each room also comes with a veranda or deck with patio furniture and a hammock. The least expensive rooms are set in the lovely garden. The newer two-story units offer a view of the ocean but the best units are the *frente mar* rooms with unobstructed views. The hotel has beach service as well as a great pool. A fabulous breakfast is included. Lunch and dinner are optional. The attentive staff is happy to book a variety of reasonably priced tours.

Praia Pontal do Cupe, Porto de Galinhas, PE. www.tabapitanga.com.br. © **081/3552-1037.** Fax 081/3552-1037. 43 units. High season R$375–R$430 double ocean view, R$300–R$345 double garden or partial ocean view; low season R$390 double ocean view, R$260–R$325 double garden or partial ocean view. Children 10 and under stay free in parent's room. AE, DC, MC, V. Free parking. **Amenities:** Restaurant; bar; outdoor pool; smoke-free rooms. *In room:* A/C, TV, fridge, minibar.

Village Porto de Galinhas ★★ ☺ The Village Porto de Galinhas is right on the beach and offers good value for families traveling with kids. All rooms are very spacious and, although not luxurious, pleasantly furnished with comfortable, firm beds and splashes of color. Every room has a balcony with a hammock, overlooking the garden and large swimming pool, with a partial ocean view. Even though the hotel has almost 200 rooms, it has an intimate feel. The pool area can be a bit noisy in the daytime—not for couples seeking a romantic retreat.

Praia do Cupe 4.5 km, Porto de Galinhas, PE. www.villageportodegalinhas.com.br. 𝄢 **081/3552-4200.** Fax 081/3552-1673. 194 units. High season R$425 double garden or partial ocean view; low season R$320 double garden or partial ocean view. Extra person add R$80–R$100. Children 5 and under stay free in parent's room. AE, DC, MC, V. Free parking. **Amenities:** Restaurant; bar; outdoor pool. *In room:* A/C, TV, fridge, minibar.

Moderate

Pousada Canto do Porto ★★ Pousada Canto do Porto is a great option for those who want to stay close to the village without being smack in the middle of things. Only a 5-minute walk from the main square, the pousada is set right on the beach. The nicest room is the deluxe oceanview panorama suite, which offers primo views from its large wraparound veranda. The king-size bed and Jacuzzi are just icing on the cake. The more affordable master suites have a partial ocean view and a veranda. The only rooms to avoid are the small standard ones. These are set back behind the pousada in an annex and have no verandas or views.

Av. Beira Mar s/n, Porto de Galinhas, PE. www.pousadacantodoporto.com.br. 𝄢 **081/3552-2165.** 20 units. High season R$320–R$350 deluxe or master double, R$230 double; low season R$240–R$275 deluxe or master double, R$170 double. Children 6 and under stay free in parent's room, 7 and over R$30. AE, DC, MC, V. Free street parking. **Amenities:** Restaurant; bar. *In room:* A/C, TV, fridge, minibar, no phone.

WHERE TO EAT

Beijupirá ★★★ 👬SEAFOOD One of the best restaurants in the region, Beijupirá is also one of the loveliest, set in a garden aglow with hundreds of candles and lanterns. Everything about this restaurant is creative and fun, from the funky decorations to the phenomenally inventive kitchen. The dishes combine either seafood or chicken with a range of interesting spices that blend together sweet and savory. The *beijupitanga* combines grilled *beijupirá* fish with a sweet-tart *pitanga* sauce (a sour cherrylike fruit) and a side of rice with cashew nuts. The *camarulu* is a generous portion of grilled prawns with a glazing of cane molasses and rice with passion fruit. For non–seafood eaters there's the *galinhatrololo,* grilled chicken breast with bacon and banana, served with cashews, raisins, and rice. Desserts are sweet and luscious; the all-time favorite (and we tried several) is the *cajuendy,* made with dried cashew fruit topped with cheese and honey, flambéed with cinnamon liquor.

Rua Beijupirá s/n, Porto de Galinhas. 𝄢 **081/3552-2354.** www.beijupira.com.br. Reservations required on weekends and holidays. Main courses R$40–R$85. AE, DC, MC, V. Daily noon–midnight.

Peixe na Telha ★★ SEAFOOD Peixe na Telha offers one of the best patios in town, with a terrific view of the beach and a fleet of *jangadas.* The menu offers regional fish and seafood dishes such as *moqueca* stews with coconut milk and red palm oil and *bobó de camarão,* a thick stew made with prawns and manioc. The house special is the *peixe na telha* (fish served on a red roof tile) accompanied with rice and *pirão,* a purée made of seafood broth, manioc flour, and spices. Bring your friends because this dish serves at least three people.

Av. Beira Mar s/n, Porto de Galinhas. ℂ **081/3552-18323.** www.peixenatelha.com.br. Main courses R$38–R$52, most dishes serve 2–3 people. AE, DC, MC, V. Daily 11am–10pm.

Picanha Tio Dadá CHURRASCO Turf on the surf. Tio Dadá serves up fine Brazilian *picanha* on a great patio, just steps from the beach. The meat comes to your table sizzling on its own grill. Vegetables include potatoes, french fries, and *farofa*. There are other cuts besides *picanha,* plus lamb, chicken, fish, and seafood. Forget the wine list—there isn't one—just order a cold Brazilian chopp.

Rua da Esperança 167, Porto de Galinhas. ℂ **081/3552-1319.** Main courses R$27–R$38. MC, V. Daily 11:30am–midnight.

EXPLORING THE TOWN

The main attraction at Porto de Galinhas is the beach, whether you swim, surf, snorkel, or snooze. **Cupe** beach stretches 4km (2½ miles) north from town; it's wide and warm, punctuated at either end by small coral reefs full of fish. Around the point in the other direction, **Maracaípi** beach regularly hosts national and international surfing competitions. Even better, thanks to a nature reserve backing most of the beach, about the only development on Maracaípi is a few *barracas* selling fruit juice and fresh-steamed crab. And if the beach gets dull, you can take nature hikes, trips to nearby islands, or dive trips to offshore reefs.

BUGGY TOURS The best way to see the local beaches is to head out in a buggy. The most popular tour is the Ponta-a-Ponta, which takes you to four different beaches from the northern end of Porto de Galinhas to the southern end. A full-day trip costs R$120 to R$150, leaving from your hotel or from Avenida Beira Mar at the main square. Contact the buggy drivers at ℂ **081/9192-0280.** You can fit four in a buggy, but you'll likely have more fun with just two or three so that one person doesn't have to sit in the boring passenger seat. Included in the tour is a stop at the mangroves of Pontal do Maracaípe. This protected nature reserve is home to several species of sea horses that live among the roots of the mangroves. Small rafts (R$8 per person) take up to 10 people on a gentle float through the mangroves. The guide will don a mask and dive into the water looking for sea horses, which he captures in a glass jar. You get a good look at the little critters before they are returned to their natural habitat.

Outdoor Activities

Porto de Galinhas is all about the sea and the best way to explore the region is by boat. *Tip:* Inquire about the tides upon arrival as many tours are timed according to the tide tables.

BOAT TOURS One of the best ways to see the region is by boat, and **Cavalo Marinho** (ℂ **081/3552-2180** or 8811-7393; www.catamaracavalomarinho.com.br) offers daily **catamaran tours** to offshore islands and isolated beaches such as Ilha de Santo Aleixo and Praia dos Carneiros. Both are to the south of Porto de Galinhas and offer nice scenery, swimming, and snorkeling (R$120 per person, children 11 and under, R$80).

DIVING Though most people opt for tide-pool snorkeling, a number of dive sites are in the surrounding area. Contact **Porto Point,** Praça Av. Beira Mar s/n (ℂ **081/ 3552-1111**), for charters. Expect to pay R$90 to R$180, including gear and two dives. Beginners can do an introductory lesson and dive for R$110. No credit cards.

SNORKELING The coast just off Porto de Galinhas is lined with coral reefs. At low tide they form natural pools that trap hundreds of tropical fish. With a mask and snorkel you just hop in and check out what's doing. The water is warm year-round (24°–28°C/75°–82°F) and the pools are never more than a few meters deep. Most pools are close enough that you could swim out, but another fun way of getting close is by taking a *jangada*. These one-sail fishing rafts are the boat of choice for local fishermen. For R$8 per person, local sailors will take you out to the best pools, and provide you with a mask, snorkel, and some bread to lure in the fish. Check the tide tables at your hotel for low tide; early morning is best if you want to avoid crowds.

If you want to play in the water by yourself, you can rent a **mask/snorkel** combo for R$15 per day at **Porto Point,** Av. Beira Mar s/n (© **081/3552-1111**). They also offer tours to the natural pools in the daytime (R$30) or at night (R$40), including equipment and guide.

FERNANDO DE NORONHA ★★★

360km (223 miles) NE of Natal, 545km (337 miles) NE of Recife

Fernando de Noronha, with its verdant mountains, wide beaches, and spectacular marine life, may be the desert island upon which people dream of being marooned. However, for most of its history people have tried to escape from Noronha. From the 17th until the 20th century, Fernando de Noronha served as an inescapable political prison. This 21-island archipelago sits way out in the Atlantic, 360km (223 miles) from Natal, 545km (337 miles) from Recife, and 2,600km (1,612 miles) from the African coast. Not until 1988, when much of the island was incorporated in the new marine park, did Fernando de Noronha meet its destiny as a sought-after tropical paradise.

Unfortunately, now that everyone wants to get to Noronha—particularly after Brazil's movie-star glitterati discovered the island—prices for accommodations on the island have zoomed to ridiculous heights. Modest little pousadas offering little more than a room in the family home now charge upwards of R$350 a night—as much as some luxury hotels in other parts of Brazil. The islands do remain a special, even magical place. If you can accept being gouged with equanimity, by all means come and experience the magic. If coughing up such large amounts seems likely to stick in your craw, it may be best to plan your escape to somewhere else.

Essentials

High season in Fernando de Noronha is in July and December through March, especially the time between Reveillon (New Year's Eve) and Carnaval. Pousadas fill up, and prices for everything rise. In **low season** (all other times) prices are slightly more reasonable and bargaining is possible—though Fernando de Noronha is still pricier than the rest of Brazil.

GETTING THERE

Gol (© **0300/115-2121;** www.voegol.com.br), **TAM** (© **081/4002-5700**), and **TRIP** (© **0300/789-8747;** www.voetrip.com.br) have direct flights to Noronha from Recife or Natal (approx. 1 hr. of flying time). The **Aeroporto Fernando de Noronha** (© **081/3619-1633**) is in the island's center, a R$25 taxi ride from anywhere.

Fernando de Noronha

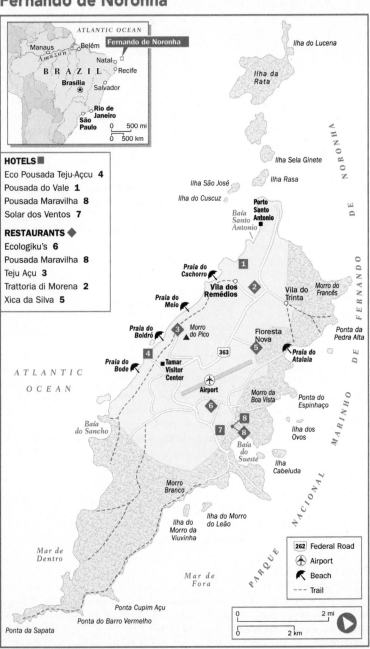

HOTELS ■
Eco Pousada Teju-Açcu **4**
Pousada do Vale **1**
Pousada Maravilha **8**
Solar dos Ventos **7**

RESTAURANTS ◆
Ecologiku's **6**
Pousada Maravilha **8**
Teju Açu **3**
Trattoria di Morena **2**
Xica da Silva **5**

ATLANTIC OCEAN
Fernando de Noronha
Manaus
Belém
Natal
B R A Z I L
Recife
Brasília
Salvador
Rio de Janeiro
São Paulo
0 500 mi
0 500 km

Ilha do Lucena
Ilha da Rata
Ilha Sela Ginete
Ilha São José
Ilha Rasa
Ilha do Cuscuz
Porto Santo Antonio
Baía Santo Antonio

N O R O N H A
D E
F E R N A N D O
D E

Praia do Cachorro
Vila dos Remédios
Vila do Trinta
Morro do Francês
Praia do Melo
Praia do Boldró
Morro do Pico
Floresta Nova
Ponta da Pedra Alta
Praia do Bode
Tamar Visitor Center
363
Praia do Atalaia
ATLANTIC OCEAN
Airport
Morro da Boa Vista
Ponta do Espinhaço
Baía do Sancho
Ilha dos Ovos
Baía do Sueste
Ilha Cabeluda
Morro Branco
Ilha do Morro do Leão
Ilha do Morro da Viuvinha
Mar de Dentro
Mar de Fora
Ponta Cupim Açu
Ponta do Barro Vermelho
Ponta da Sapata

M A R I N H O
N A C I O N A L
P A R Q U E

262 Federal Road
✈ Airport
Beach
- - - Trail

0 2 mi
0 2 km

Renting a Dune Buggy ★★

Tooling around back roads to various beaches is one of the most fun things to do on the island. Buggies can be rented just about anywhere—ask at your pousada. **LocBuggy** (✆ **081/3619-1490;** www.locbuggy.com.br) provides 24-hour service, and also rents motorcycles, 4×4s, and powerboats. Another agency is **Locadora Morro do Farol** (✆ **081/3619-0127**) on Alameda Boldro. The price is R$170 to R$200 per day, though if you rent for several days you can often get a 10% to 20% discount. The cost is the same with or without a driver. Gas costs about R$5 per liter (about US$10 per gallon). A day of exploring around the island will eat up about half a tank, currently about R$75.

ISLAND LAYOUT

The main island, Ilha de Fernando de Noronha, has two distinct sides, a gentle one facing the Brazilian coast and a rockier, rougher one facing the Atlantic. The inshore coast is the place for surfing and lazing on the beach. The offshore beach is for watching the waves crash in.

One paved road, **BR-363,** runs from Baía do Sueste at one end of the island to the port in Baía Santo Antonio at the other. The most settled area on Noronha is **Vila dos Remédios.** This is where you'll find the city hall, the church, the old fort, the only bar/disco, the post office, and the offices of **Atlantis Divers.** Up a small hill about 1km (½ mile) away is **Vila do Trinta.** This area has a couple of restaurants, the police, pharmacy, and main grocery store all together inside the walls of the old armory. **Porto Santo Antonio** has several watersports operators and a few restaurants and pubs. The hospital, school, and other services for locals are located on BR-363 in the middle of the island. The old American army base at **Alameda do Boldró** has boring necessary stuff like the power station and the water plant, but it also has the **Tamar Visitor Center,** which features a small museum where they hold nightly nature talks.

GETTING AROUND

BY BUS Public minibuses depart at 30-minute intervals from opposite ends of the island, running along the main highway (BR-363) from Baía Sueste to Porto Santo Antonio with stops along the way. The bus runs from 5am to 10pm. The cost is R$3.25.

BY TAXI Chances are, wherever you go on the island there'll be a taxi *ponto* with a buggy driver waiting for your business. Should you find yourself unaccountably taxiless, **NorTax** (✆ **081/3619-1314**) will dispatch a buggy from its fleet. Prices for all drivers are fixed according to a table, which the driver will be happy to flash in your face should you utter so much as a peep about the cost. The fare from Vila dos Remédios to Baía do Sueste on the far end of the island costs about R$35; from Vila Remédios to the Tamar Visitor Center is R$20; from Vila Remédios to the port, R$15.

VISITOR INFORMATION

The official government website, **www.noronha.pe.gov.br**, has an English-language version with much useful information. Free maps of the island (with English text) are available in pamphlet racks at the airport. There's good information on the island's natural history at the **Projeto Tamar** office at Av. do Boldró s/n (✆ **081/3619-1171;** www.tamar.org.br).

[FastFACTS] FERNANDO DE NORONHA

Note: For all its charm, Fernando de Noronha is essentially a small town, as lacking in services as the next village on a desert island in the middle of the ocean. If a service or resource isn't listed below, it means Fernando de Noronha doesn't have it.

Currency Exchange & Banks Bring *lots* of cash to the island. The only bank on the island provides absolutely no services to visitors. There is one ATM at the airport. Dive operators and most pousadas take credit cards; so, increasingly, do many tour operators and restaurants. However, taxis and buggy rentals most often do not.

Hospital **Hospital São Lucas,** BR-363 s/n, in Vila da Floresta (✆ 081/3619-0923).

Internet Access For Internet access, go to

Companhia da Lua (✆ 081/3619-1631) in Vila dos Remédios. Rates are R$12 per hour.

Pharmacy **Lojinha de Mãezinha,** Vila Remédios (✆ 081/3619-1104), is open Monday through Saturday from 8am to 6pm, and offers a fairly limited selection.

Police In an emergency, contact the **Policia Civil** (✆ 081/3619-1179).

Post Office The main post office in Vila Remédios (✆ 081/3619-1135) is open Monday to Friday from 8am to 12:30pm.

Taxes There is a special environmental tax—currently R$39 per day—payable (cash only) at the airport when you arrive, or in advance using the Internet. Go to www.noronha.pe.gov.br, look for the link reading "Preservation Fee," then fill

in and print out the form. Pay the fee at any Banco do Brasil or Casa Lotérica (lottery-selling booth). Make sure they stamp your form. If you decide to stay longer than anticipated, go to the airport and pay the extra days *before* your time expires. If you overstay and try to pay up at the airport upon leaving, you'll be charged twice the regular rate for your extension. Divers and boaters who enter the marine park are charged a day tax of R$18. As in the rest of Brazil, hotels normally add 10% to the bill.

Weather The weather is hot year-round, with an average daily temperature of 30°C (86°F). Ocean temperature is 28°C (82°F) year-round. The rainy season is February to July, the dry season from August to January. Surfing season is December to March.

Where to Stay

Pousadas in Noronha used to be simple, even makeshift affairs, but at some point in the last few years Brazil's movie-star glitterati and their attendant national media discovered the island. Supply and demand have gone seriously out of whack, and prices everywhere have zoomed up into the red-line zone that economists label "just plain stupid." There is no longer anywhere inexpensive to stay on Noronha, but on a desert island in the middle of the Atlantic, there's not much you can do about it.

The pousadas listed below, while not inexpensive, at least offer something different or special. Given demand on the island, they may well be booked. If so, try **Pousada Sueste** (✆ 085/3619-1164; www.pousadasueste.com.br), which has a small pool and a view down to Sueste Bay, plus small, clean rooms with smaller bathrooms for R$330 to R$380 per night.

The prices listed are for the high season—January through February and July through September, excluding holidays. In low season—March through June and October through December—most pousadas lower their prices by about 20% to 25%.

Eco Pousada Teju-Açu ★★ Luxury is at least somewhat reconciled with environmental responsibility at these gorgeous self-contained bungalows in a forest setting. Showers in this "eco-pousada" are solar heated, while rain and sink runoff are recycled to water the gardens. Bungalows are light and airy, featuring king-size beds inside and a balcony with hammock outside. The bungalows are built around a small pool with a wooden deck offering little shaded nooks for relaxing, and impressive views of Morro do Pico. The hotel restaurant is one of the better ones on the island.

Estrada da Alamoa s/n, Boldró, Fernando de Noronha, 53990-000 PE. www.pousadateju.com.br. ✆ **081/3619-1277.** 12 bungalows. R$814–R$1,087 double. Children 5 and under stay free in parent's room. AE, DC, MC, V. Free parking. **Amenities:** Restaurant; bar; outdoor pool; sauna. *In room:* A/C, TV/DVD, fridge, Wi-Fi (free).

Pousada do Vale ★ Located in a lovely garden area just a short walk from Vila Remédios, the Pousada do Vale offers both quiet isolation and proximity to town. Rooms are bright and reasonably sized, featuring comfortable queen-size beds with good linens and clean and functional bathrooms. The best two rooms are the Marlim, which is somewhat larger and has a sizable balcony with a hammock, and the Golfinho room. The Golfinho is a tail fin smaller, but it also features a balcony and hammock. The beach is but a 250m (820-ft.) stroll away, and the pousada has beach chairs, umbrellas, and towels for its guests. Room rates include breakfast and a light afternoon tea.

Rua Pescador Sérgio Lino 18, Jardim Elizabeth (down the cobblestone street from Vila Remédios), Fernando de Noronha, 53990-000 PE. www.pousadadovale.com. ✆/fax **081/3619-1293.** 7 rooms. R$792–R$918 double. Children 3 and under stay free in parent's room. AE, MC, V. **Amenities:** Restaurant; free airport transfers. *In room:* A/C, TV, fridge, minibar, free Wi-Fi.

Pousada Maravilha ★★★ This hotel is built with exquisite taste in a Japanese-inspired style. Guests can stay either in self-contained bungalows (recommended) or in the main pousada building (not). The bungalows feature a spacious veranda with hammock and deck chairs, while inside are tile floors, a vaulted ceiling, and a king-size four-poster bed with firm mattress and crisp white linens. Bathrooms are large and lovely, with his-and-her sinks and mirrors, acres of counter space, and large hot showers. Rooms in the main building still feature tasteful decor, king-size futon-style beds, and lovely bathrooms, but are less spacious and luxurious, while almost just as expensive. The small "infinite-horizon" pool has a deck with gorgeous views down to Baía Sueste. Airport transfer is included.

BR-363 s/n, Sueste, Fernando de Noronha, 53990-000 PE. www.pousadamaravilha.com.br. ✆/fax **081/3619-0028.** 8 units. R$2,128 bungalow; R$1,815 deluxe room. DC, MC, V. Free parking. No children 9 and under. **Amenities:** Restaurant; bar; gym; pool; sauna; spa. *In room:* A/C, flatscreen TV/DVD, minibar.

Solar dos Ventos ★★ These comfortable self-contained bungalows are on a green piece of land with a view down to Baía do Sueste. Each unit features a double and two single beds, a couch, a breakfast table, and a balcony with a hammock. The grounds are nicely landscaped, and each cottage is given a nice bit of space. The only drawback is the location at the far end of the island, a R$25 taxi ride from the restaurants and services in Vila Remédios and the port.

Estrada do Sueste s/n, Fernando de Noronha, 53990-000 PE. www.pousadasolardosventos.com.br. ✆ **081/3619-1347.** Fax 081/3619-1253. 8 bungalows. R$770 double. Children 2 and under stay free in parent's room. Extra bed R$215. MC, V. Free parking. **Amenities:** Free airport transfers. *In room:* A/C, TV, minibar, Wi-Fi.

Where to Eat

For prawns and other seafood, try **Xica da Silva** in Floresta Nova (© **081/3619-0437;** Tues–Sun noon–11:30pm). On the road to the beach at Praia do Boldró there's the upscale pousada and restaurant **Teju-Açu** (© **081/3619-1277;** www.pousadateju.com.br; daily noon–10:30pm), which serves seafood plus the standard Brazilian steak and chicken dishes. **Trattoria di Morena,** Rua Nice Cordeiro 2600, above BR-363 near the school (© **081/3619-1142;** Mon–Sat 7–10:30pm), serves good seafood pastas in generous portions. For expensive fine dining, there's the restaurant at the **Pousada Maravilha** (© **081/3619-1290;** www.pousadamaravilha.com.br; daily noon–3pm and 8–11pm). The menu leans toward Italian-inflected seafood dishes. The best restaurant on the island is **Ecologiku's,** Estrada do Sueste, Sueste (© **081/3619-0031;** daily 7–10:30pm; closed every other Sun), which features six plastic tables in the garden of the chef's house. The kitchen specializes in seafood caught and cooked that day—simple but delicious. The house special is the Sinfonia Ecologiku, a spiced and tasty hot pot of fish, octopus, shrimp, and sweet lobster, all in a rich seafood broth.

Exploring Fernando de Noronha

Check with the **Projeto Tamar** office as soon as you arrive. If a turtle hatching is in the offing, rearrange your plans to see it—you won't be disappointed.

If your time is limited, find your pousada and then head out on a boat tour to see the island from the water. Go for an afternoon cruise to see the spinner dolphins or just to snorkel. If you have a bit more time, go diving or snorkeling around Baía do Sancho, saving time for a leisurely walk on the beach. Another great way to see the island is to rent a buggy and explore at will (see "Getting Around," above).

HITTING THE BEACHES

Baía do Sueste ★ is a pretty crescent beach with some good snorkeling. It's perfect for children, thanks to its large shallow areas and complete absence of waves. The beach has a snack stand and bathrooms.

Baía do Sancho ★★ is one of the prettiest beaches in all of Brazil. Access is via a series of precarious-looking iron ladders bolted into crevasses that somehow make it down through 30m (100 ft.) of sheer red cliffs. The beach features lovely red-tinged sand, cliffs with nesting seabirds, and crystal-clear blue water perfect for snorkeling.

Praia do Atalaia ★★ is a unique beach on the outer shore of Noronha. A thick shelf of volcanic rock extends halfway through the surf line, providing a bulwark for some quiet natural pools where tropical fish get trapped at low tide. Only 30 people are allowed in per day, and no suntan lotion can be worn when you swim in the pools. Access is through checkpoints monitored by IBAMA (Brazil's environmental agency), either on the trail from Vila do Trinta or the road from Baía do Sueste.

The **surf beaches** are all on the inshore side of the island, facing back toward the Brazilian mainland. From west to east they are **Cacimba do Padre, Praia do Bode, Praia do Boldró, Praia da Conceição, Praia do Meio,** and **Praia do Cachorro.** Most have one or two small *barracas* (beach kiosks). They're good places to hang out for a morning or afternoon. Be careful swimming, and keep an eye on the shore. These beaches have currents that sweep parallel to the shoreline; it's easy to get carried along.

OUTDOOR ACTIVITIES & WATERSPORTS

DIVING ★★★ Walk into any dive shop throughout Brazil and they'll have a poster of Fernando de Noronha. It's hands-down the best place for diving in Brazil. Water temperature is a constant 28°C (82°F), and especially in the dry season, underwater visibility approaches almost 30m (100 ft.). Underwater there's a wide variety of stunning sea life: rays of all types (mantas are not uncommon); sea turtles; lemon sharks and reef sharks; clownfish; and large schools of anthias, surgeonfish, parrotfish, and sweetlips. The coral formations are only average, but thanks to the island's volcanic heritage you'll come across numerous caves, including a number of terrific swim-throughs.

The only drawback to diving on Noronha is the tight control. You are not allowed to dive except with one of the island's three dive companies. Far and away the best diving outfit on the island is **Atlantis Divers,** Caixa Postal 20, in Vila Remédios (*C* **081/3619-1371,** or in Natal 084/3206-8840; www.atlantisdivers.com.br). For day use, **Atlantis** has a fleet of custom-built catamarans, all new and specially built for diving. Atlantis also recently inaugurated a live-aboard catamaran—the *Atlantis Voyager,* which cruises the best reefs, islands, and wrecks off the Brazilian coast.

Atlantis charges R$220 for two dives, plus R$76 to rent a wet suit, BCD (buoyancy control device), and regulator. With the mandatory R$15 IBAMA tax, the total for two dives comes to R$311. Morning, afternoon, and night dives are offered. If you've never dived, try the one-on-one escorted baptism dives for about R$270 plus IBAMA tax. You can also take a 5-day course to get your PADI diving certificate, for about R$1,000. Atlantis also offers nitrox courses and scooter courses, and for experienced divers, the Atlantis launch is available for custom excursions.

DOLPHIN-WATCHING ★★ Spinner dolphins congregate on Noronha in numbers virtually unmatched anywhere else. The best (and least obtrusive) way to see them is from the **cliff-top lookout** above Baía dos Golfinhos (Dolphin Bay). Monday to Saturday from 5:30am until sunset a researcher from the nonprofit **Projeto Golfinho Rotador** (*C* **081/3619-1846;** www.golfinhorotador.org.br) is on hand to answer questions and pass out binoculars between regular 15-minute counts of dolphin activity. The dolphins usually arrive around 6am and depart between 3 and 5pm on their nightly feeding trip around the island. They're most active around sunrise, when they're just coming off an evening's feeding. In dry season the bay will have between 500 and 1,200 dolphins jumping and spinning about. In the wet season the bay will have between 5 and 300 dolphins. The bay itself is off-limits to all but accredited scientists.

Boat tours cruise past the edge of Dolphin Bay, hoping to be surrounded by a spinner school coming out for the day. The afternoon tours offer the best odds of spotting dolphins.

HIKING Note that on trails within the national park you may be required to register with IBAMA and bring along a local guide. This has long been park policy; it's just never been enforced. Recently, however, the park has tentative plans to outsource the guiding and enforcing to tourism operators (mostly as a way of generating more revenue). To book a guide, contact **ACITUR,** the Ecotourism Guides Association of Fernando de Noronha, located at the TAMAR offices on Avenida Boldró (*C* **081/3619-1399**), or book one of the tours through **LocBuggy** (*C* **081/3619-1490;** www.locbuggy.com.br) or **Atalaia Noronha** (*C* **081/3366-6250;** www.atalaia-noronha.com.br). The

9

RECIFE, OLINDA & FERNANDO DE NORONHA

Fernando De Noronha

Trilha do Capim-açu, which starts near the Dolphin Bay lookout and runs 7km (4¼ miles) as far as the lighthouse on Ponta da Sapata, is really not worth taking. The trail runs through dense forest from beginning to end, with only one small viewpoint on the very first ridge. A much better plan is to hike along or above **Praia do Leão.** The territory is open so you can always see where you're going. More importantly, the beach is wild and beautiful, and the views amazing. One other good but tricky trail runs from **Enseada da Caieira** near the port along the outer coast over a couple of tall rocky headlands to **Praia de Atalaia.** For an easier hike with worthwhile views, try the 2.5km (1½-mile) walk from the **Dolphin Bay Lookout** along the cliff top to **Baía do Sancho.**

MOUNTAIN BIKING In Vila Remédios, **Pousada Solymar** (© 081/3619-1965;** www.pousadasolymar.com.br) rents mountain bikes for R$20 per day.

Watching for Sea Turtles

The Brazilian sea turtle conservation organization, **Tamar ★★★** (Av. do Boldró s/n; © 081/3619-1171), has a site on Noronha with a shop, small lecture theater, and cafe. It's worth checking in every day or so to see if any turtle nests are about to hatch. Watching hundreds of newly hatched turtles scramble into the surf is an experience not to be missed. Nightly nature talks in Portuguese start at 8:30pm.

SNORKELING ★ A number of operators offer organized snorkeling tours. For do-it-yourselfers, **Santuário** (© 081/3619-1247), in the port of Santo Antonio, rents masks and snorkels for R$18 per day for a mask, snorkel, and fins. Baía do Sancho and Baía do Sueste both offer good snorkeling. Tours are also offered by **Alquimista Tour** (© 081/3619-1283; www.alquimistanoronha.com.br).

SURFING ★ The surf season in Noronha runs from **December to March,** the opposite of that in the rest of Brazil. (Outside of this time there are *no surfable waves.*) Surfing takes place not on the outer shore beaches, which are steep and rocky, but on the sandier beaches facing Brazil's Atlantic coast. The best surf beaches are **Cachorro, Cacimba do Padre, Bode, Boldró, Conceição,** and **Meio.** Waves average 2m (6½ ft.), but sometimes reach as high as 5m (17 ft.). Bring your board and the gear you need.

ISLAND TOURS

Formerly just a buggy rental company, **LocBuggy** (© 081/3619-1490; www.locbuggy.com.br) is evolving into a full-service tour agency, currently offering a variety of tours including a dawn trip to see the spinner dolphins, a historic walk, an island tour, several hikes, trips to Atalaia beach, and boat tours. Reservations can be made in advance via the company website. A similar range of tours is offered by **Alquimista Tour** (© 081/3619-1283; www.alquimistanoronha.com.br). You have several options for getting out on the water. You can go on a 3- to 4-hour **dolphin/snorkeling cruise.** Tours depart Porto Santo Antonio and run along the shore of Noronha, looking at the steep cliffs and seabird rookeries on Ilha do Meio and Ilha do Rata, before heading down to cruise the edge of Dolphin Bay, hoping to be surrounded by a spinner school coming out for the day. The 3-hour tours go as far as Ponta da Sapata and include a stop for snorkeling in Baía do Sancho. Afternoon tours have better luck with dolphins. Morning tours focus on snorkeling.

OTHER THINGS TO SEE & DO

In Vila Remédios, the most impressive structure is the **Forte dos Remédios,** built by the Portuguese in 1737. It's a wonderful crumbling ruin, with old cannons half-buried in the dirt and ramparts on the edge of collapse. Extending from the fort are a number of old stone roads, many built by convict labor. One leads back to the Vila Remédios plaza, a steep cobblestone square topped by the pretty yellow-and-white **Igreja Nossa Senhora dos Remédios,** built in 1772. Farther uphill is a bright red colonial building known as the **Palácio São Miguel.** It now serves as the island's administrative headquarters. At the bottom of the hill, a small history museum, the **Memorial Noronhense** (daily 8am–4pm), shows the history of the island, from its discovery in 1503 by Amerigo Vespucci, through the years when the Dutch, Portuguese, and French all fought for possession, to its years as a political prison and then American army base from the 1940s to the 1960s.

Fernando De Noronha

NATAL

Natal is a city built on sand. It blows across the city streets and creates drifts like snow. It lines the city's beaches, landscapes the city's parks, and piles up in towering dunes that form the city's picture-postcard views. Outside Natal, the sand spreads in mountainous dune ranges that stretch for miles.

Perhaps because sand is not the most fertile of foundations, Natal has been an oft-overlooked sandlot of a city for much of its history, noticed by the powers that be only when some other power tried to take it away.

The Portuguese founded a town on the banks of the Potengi River to drive out the French. To hold the territory, the Portuguese built the Fort of the Three Kings in 1599. The fort's foundation was celebrated with a Mass on December 25, 1599, and so the city was named Natal (the Portuguese word for Christmas). After that, the Portuguese pretty much ignored the place. By 1757 there were a whopping 120 buildings in the area, among them a church and a prison.

Natal first came to American notice in the early 1940s. The U.S. had just entered the war against the Axis powers and sleepy little Natal—the closest land base to North Africa—was suddenly a place of world significance. Franklin Roosevelt paid a visit, meeting with Brazilian President Getulio Vargas to work out the details of Brazil's war effort. There's a famous picture of the two presidents, riding through the streets of Natal in an open limousine, sand barely visible beneath the wheels.

Natal became the "Trampoline of Victory," an air and communications base providing cover for the Allied invasion of North Africa. According to local folklore, one lasting legacy of that period was a new Brazilian dance step. Wanting to make the American airmen welcome, the Brazilians invited them to local dances, and developed a simplified two-step rhythm the rather club-footed Yanks could handle. They titled the dances "For All." The dance spread all over the Northeast, while the name got shortened to *forró*.

More recently, Europeans and Americans have discovered the true value of sand and endless sunshine; Natal is one of the sunniest capitals of Brazil and boasts pleasant temperatures year-round.

Why visit? Natal offers glorious dunes, hundreds of feet high and spilling down to within inches of the seashore. To the north of the city the dunes pile up so high that locals have begun to make use of them in a wide variety of peculiar and original sports. You can ski or toboggan down them, rope-slide from the top of them, camel ride across them, and buggy ride over, up, down, and all around them.

North and south of Natal the beaches stretch for hundreds of miles, dotted now and again with fishing villages and only lightly touched by

tourism. The preferred method of transport in these regions is by dune buggy. Off-shore—at places up the coast such as Maracajaú—wide coral reefs lie in shallow water, great places to spend a day snorkeling. And everywhere you go, north and south and in the city, there's sand.

ESSENTIALS

2,068km (1,285 miles) NE of Rio de Janeiro, 2,312km (1,436 miles) NE of São Paulo, 873km (543 miles) NE of Salvador

Getting There

BY PLANE Azul (✆ 084/3003-2985; www.voeazul.com.br), **Gol** (✆ 0300/115-2121), **TAM** (✆ 084/4002-5700), and **Webjet** (✆ 0300/210-1234; www.webjet.com.br) offer flights from major cities in Brazil. Flights arrive at **Aeroporto Augusto Severo,** Rua Eduardo Gomes s/n (✆ 084/3087-1200), 15km (9¼ miles) from downtown and just a few miles from Ponta Negra beach. Taxis to Ponta Negra cost R$40 to R$45.

BY BUS Long-distance buses arrive at the **Rodoviaria,** Av. Cap. Mor Gouveia 1237, Cidade Esperança (✆ 084/3232-7312), about 5km (3 miles) from downtown and Ponta Negra beach.

City Layout

A small downtown aside, Natal is a postwar creation; in many ways it resembles the modern, sprawling cities of the southwestern United States. The original city was founded on a peninsula between the Potengi River and the Atlantic Ocean. Just off the tip of the peninsula, where ocean and river meet, the original **Forte de Reis Magos** still stands, a forgotten bit of the 17th century. Where the fort's causeway touches the mainland the 21st century begins—a modern ocean-side boulevard that under various names runs from here south through the length of the city and out into the dunes beyond. About 3km (1¾ miles) south of the fort the street is called **Avenida Presidente Café Filho,** and the surrounding neighborhood is **Praia dos Artistas,** once a popular beach that has fallen on hard times. Here the road starts to climb a bit, becoming **Avenida Governo Silvio Pedroso,** then **Via Costeira,** which runs for some 9km (5½ miles) between the ocean and a vast nature preserve called **Parque das Dunas.** There are a number of large resort hotels nestled in between the parkway and the ocean. Where the park ends, the road swings away from the beach a bit and becomes **Avenida Engenheiro Roberto Freire,** the backbone of the city's best beach neighborhood, **Ponta Negra.** Avenida Roberto Freire itself is a busy and rather ugly artery, but the streets leading off it down to the ocean are quiet and pleasant, lined with hotels and pousadas. The beach itself has no traffic at all along this stretch, just a pedestrian walkway and sea wall, punctuated by beachside kiosks or *barracas.* About two-thirds of the way along the 3km (1¾-mile) beach, Avenida Roberto Freire drops downhill to the waterfront and becomes **Avenida Erivan França,** a busy beachside boulevard lined with pubs, restaurants, and nightclubs that runs all the way to **Morro do Careca,** the 117m (390-ft.) sand dune that overlooks the beach.

Going the other direction from the Forte dos Reis Magos, along the banks of the **Rio Potengi,** you pass the abutments of a bridge that leads across the river to **Genipabu.** The road then climbs and enters **Centro,** also called the **Cidade Alta,** the commercial heart of Natal. Centro has a few old squares—the **Praça André de**

Natal

Albuquerque and **Praça Sete de Setembro.** The main street is **Avenida Rio Branco.**

North of Natal, the dunes and beaches begin as soon as you cross the river. This area is called the **Litoral Norte** (north coast). The first settlement is the former fishing village of **Genipabu,** about 25km (16 miles) north of downtown. Genipabu caters to tourists who swim at the beach and buggy and climb through the surrounding dunes.

South of Ponta Negra there's a long stretch of beaches known as the **Litoral Sul** (south coast), with something for everyone. **Búzios** beach is excellent for snorkelers, while **Barra de Tabatinga** is a surfer's hot spot. Capping off the string of south coast beaches is **Praia da Pipa,** a gorgeous stretch of sand and a destination in its own right (p. 326).

Getting Around

BY BUS The bus is a quick way to travel from Ponta Negra to Centro and vice versa. In Ponta Negra, buses run along Estrada Ponta Negra. For downtown, look for buses marked CENTRO or CIDADE ALTA. There are two routes. Buses with signs saying VIA COSTEIRA follow the coast as far as Praia dos Artistas and then cut across to Centro. Other CENTRO buses use the inland route along Avenida Prudente de Morais or Avenida Hermes da Fonseca. To return to Ponta Negra, any bus that says PONTA NEGRA or VIA COSTEIRA will do. You enter buses through the front. Fare is R$2.20.

BY TAXI You can hail a taxi anywhere. To reserve one, phone **Cidade Taxi–24 H** (☎ **084/3223-6488**) or **CoopTax** (☎ **0800/842-255** or 084/3205-4455). A taxi from Ponta Negra to downtown will cost about R$35

BY CAR Natal is an easy city for driving; streets are wide, traffic is light, and parking is not much of a problem. You can rent a car to explore up or down the coast, but you'll have more fun if you rent a buggy with a driver who can take you off-road.

Visitor Information

Setur, the state tourism agency, has an English-language website at **www.brasil-natal.com.br**. Natal's **airport** has a tourist information center (☎ **084/3643-1811**) in the arrivals hall, open daily from 9am to 5pm. The **main tourist information center** is in Natal's Centro de Turismo (p. 324), Rua Aderbal de Figueiredo 980, Petrópolis (☎ **084/3211-6149**).

[FastFACTS] NATAL

Car Rental **Localiza** (☎ **0800/979-2000**), **Avis** (☎ **0800/725-2847**), **Unidas** (☎ **084/3643-1222**), and **Hertz** (☎ **084/3087-1428**) all have offices in Natal.

Currency Exchange Near Centro, **Banco do Brasil,** Av. Rio Branco 510, Cidade Alta (☎ **084/3216-4500**), has a 24-hour ATM. There is also **Sunset Cambio,** Av. Hermes da Fonseca 628, Tirol (☎ **084/3212-2552**). In Ponta Negra, you'll find **Banco do Brasil,** Rua Dr. Ernani Hugo Gomes 2700 (☎ **084/3219-4443**), next to the Praia Shopping.

Hospital The local hospital is **Monsenhor Walfredo Gurgel,** Av. Salgado Filho s/n, Tirol (☎ **084/3232-7500**).

Weather Natal lies just 3 degrees from the equator, so temperatures hover around 28°C to 34°C (82°F–93°F) year-round. In winter (June–Aug) it tends to rain a bit more. In summer you get 12 regular hours of sunshine a day.

WHERE TO STAY

High season in Natal is December through February, and then again in July during Brazil's winter holidays. Outside of this period there are substantial discounts.

Ponta Negra

Within Natal's city limits Ponta Negra beach is your best option. It's wide and busy, with good waves for surfing. On the waterfront, a pleasant walkway runs past a number of beachside restaurants and *barracas*. Many of the city's better restaurants are located in the area, and the cafes, bars, and nightclubs of Natal's Alto de Ponta Negra nightlife area are a 5-minute cab ride away.

VERY EXPENSIVE

Manary Praia Hotel ★★★ The best and most romantic place to stay in Natal, the Manary is done up like a Spanish hacienda, with old dark beams, red-tile roofs, and large cool flagstones on the floor. The location is premium, with a large deck and two pools (one regular, one for children) facing out over the sea. In the rooms are king-size beds with top-notch linens, plus unique and tasteful furnishings. All rooms come with a balcony and ocean view. For the 15 standard rooms, the view is a bit oblique, but still lovely. The nine deluxe rooms have a straight-on view. The luxury suite has a broad veranda facing out over the water plus a Jacuzzi whirlpool. Breakfast here is memorable—fresh regional fruit, eggs, pancakes, and lots of regional delicacies. The restaurant here is one of the city's best.

Rua Francisco Gurgel 9067, Praia de Ponta Negra, Natal, 59090-050 RN. www.manary.com.br. ℰ /fax **084/3204-2900.** 24 units. High season Nov–Feb and July R$505–R$665 double; low season R$360–R$485 double. Extra person add 25%. Children 6 and under stay free in parent's room. AE, DC, MC, V. Free parking. Bus: Ponta Negra. **Amenities:** Restaurant; bar; 2 outdoor pools; room service. *In room:* A/C, TV, hair dryer, minibar, Wi-Fi.

EXPENSIVE

Visual Praia Hotel ★ Located right on the sea wall in Ponta Negra, the Visual Praia is kind of a mini–resort hotel, complete with a large pool deck, and waterside bar and children's play area. If it's really a full-service resort you want you'll be better off at the Serhs Natal Grand (see below), but the advantage of the Visual Praia is its location on Ponta Negra beach and its cheaper price tag. Rooms are comfortable and beautifully furnished with blond wood and marble desktops. All but two have a view that ranges from a partial to a full ocean view. Breakfast is served on the beachfront patio.

Rua Francisco Gurgel 9184, Praia Ponta Negra, Natal, 59090-050 RN. www.visualpraiahotel.com.br. ℰ **084/3646-4646.** 136 units. High season R$360–R$430 double. Extra person add R$75. 30% discount in low season. Children 5 and under stay free in parent's room. AE, DC, MC, V. Free parking. Bus: Ponta Negra. **Amenities:** Restaurant; bar; outdoor pool; children's pool and playground; sauna. *In room:* A/C, TV, fridge, minibar.

MODERATE

Quality Suites Natal ★ Although this modern high-rise hotel lacks a bit of personality, its brand new furniture, comfortable beds, and convenient location more than make up for that. The hotel is only 2 blocks from the best nightlife and restaurants in Ponta Negra and a 3-block walk from the beach. All rooms look out over the ocean and Natal's iconic Careca sand dune. Book a room on a higher floor to get the most spectacular views.

Av. Eng. Roberto Freire 3090, Praia Ponta Negra, Natal, 59094-000 RN. www.atlanticahotels.com.br. ℰ **084/4008-4888;** reservations ℰ **0800/555-855.** 131 units. R$230–R$320 double. Children 6 and under stay free in parent's room. AE, DC, MC, V. Free parking. Bus: Ponta Negra. **Amenities:** Restaurant; bar; outdoor pool; children's pool and playground; sauna. *In room:* A/C, TV, hair dryer, minibar, Wi-Fi.

Soleil Suite Hotel The Soleil offers excellent value for the money, with generously sized rooms and a location that's just a 3-block walk from the beach. The least expensive room, the suite luxo, comes with tile floors, a firm queen-size bed, couch, and small kitchen table (no desk space, however); a kitchenette unit comes with a fridge, hot plate, and utensils, plus a balcony, but with no view of the sea. The next step, the suite master, costs about 30% more and is identical except the balcony offers an ocean view. One step up again, the suite master plus offers a couch that folds out

to a double bed, plus French doors separating the bedroom from the sitting room. It's not a bad option if you have kids, but otherwise not worth the price. The hotel has a small pool and a children's wading pool, neither of which is nice enough to tempt anyone away from the beach.

Rua Elia Barros 70, Praia Ponta Negra, Natal, 59090-140 RN. www.soleilhotel.com.br. ⓒ **084/4005-5959.** 31 units. High season Nov–Feb and July R$175–R$295 double. Low season 30% discount. Extra person add 25%. Children 5 and under stay free in parent's room. AE, DC, MC, V. Free parking. Bus: Ponta Negra. **Amenities:** Restaurant; outdoor pool and children's pool. In room: A/C, TV, fridge, minibar.

Via Costeira

The Via Costeira parkway that runs between Ponta Negra and downtown makes a lovely setting for a hotel but there are a couple of drawbacks. Though you get outstanding views and unmatched isolation, the ocean is rougher, the beach rockier, and there is nothing within walking distance, so you're looking at a cab ride any time you want to leave the hotel.

VERY EXPENSIVE

Serhs Natal Grand ★★★ ☺ The Natal Grand is the most luxurious of the top-end resorts strung along the ocean-side Via Costeira. Rooms are bright and modern, with tile floors, clean bright bathrooms, and balconies facing out over the sea. Superior rooms feature firm double beds and a small writing desk. Family rooms feature two double beds but no extra space, making them a little squished. Junior suites are more spacious, with a separate sitting room and fold-out couch, making them a good option for those traveling with kids. A couple looking to splurge, however, should opt for a senior or an executive suite, which feature an outdoor terrace with a Jacuzzi built for two. Recreational facilities are top-notch. The entire front deck is one sprawling wavy pool, dotted here and there with little Jacuzzi islands. The sports center offers volleyball, soccer, and basketball, while the Japanese spa offers a full range of massage and beauty treatments. The Kid's Club features a kids' pool and indoor children's recreation area. On the beach, there's volleyball and soccer, plus beach chairs and a lifeguard service. The hotel's **Tapiro Grill** is excellent.

Av. Via Costeira 6045, Praia de Ponta Negra, Natal, 59090-001 RN. www.serhsnatalgrandhotel.com. ⓒ **0800/702-2411** or 084/4005-2000. Fax 084/4005-2001. 396 units. R$315–R$650 double; R$600–R$1,200 suite. Extra person add 25%. Children 6 and under stay free in parent's room. Off-season discounts (20%) Sept–Oct and Mar–May. AE, DC, MC, V. Free parking. Bus: Via Costeira. **Amenities:** 4 restaurants; 3 bars; exercise room; 3 Jacuzzis; 4 large outdoor pools and children's pool; room service; sauna; Japanese spa. In room: A/C, TV, hair dryer, Internet, minibar.

WHERE TO EAT

Natal's better restaurants have been steadily gravitating toward Ponta Negra. Better yet, quite a few have been moving off the busy and ugly Avenida Engenheiro Roberto Freire and into locations with more charm and better views. That said, there are still a couple of worthwhile places in other parts of the city.

Ponta Negra

Camarões BRAZILIAN/SEAFOOD With a name that means "shrimp," it's not hard to guess the house specialty. *Papa jerimum* shrimp are served in a pumpkin, while champagne prawns are sautéed with butter in a champagne-and-apple sauce.

The *espaguete de camarão* features spaghetti with sautéed shrimp in a creamy cognac sauce. Portions are generous enough for two.

Av. Engenheiro Roberto Freire 2610, Ponta Negra. 𝒞 **084/3209-2425.** www.camaroes.com.br. R$55–R$79 for 2. AE, DC, MC, V. Daily 11:30am–3:30pm and 6:30pm–midnight. Free parking. Bus: Ponta Negra.

Cipó Brasil ★★ PIZZA Leave your high heels at home when dining in this charming restaurant with sand-covered floors, rustic furniture, and a thatched roof. Locals flock here to enjoy the best pizza in town, baked in a wood-burning oven and prepared with homemade tomato sauce, fresh mozzarella cheese, and a delicious sesame seed crust. The large menu of toppings may seem intimidating so order the popular *caipicipó*, a vodka drink with grapes, strawberries, and pineapple served in a traditional coconut shell, and take your time perusing the list. If you have room for desert there is always more pizza or try a delicious crepe with banana and chocolate.

Rua Aristides Porpino Filho 3111, Alto de Ponta Negra. 𝒞 **084/3219-5227.** www.cipobrasil.com. br. Main courses R$22–R$36. MC, V. Daily 6pm–midnight. Bus: Via Costeira.

Farofa d'Agua ★★ BRAZILIAN/NORDESTINO Meat lovers don't want to miss the *carne de sol*, a tender cut of sun-cured beef, sautéed in butter or grilled on the barbecue. The dish is accompanied by green beans, rice, and roasted cassava flour *(farofa)*. Other popular dishes include grilled prawns and fish. All dishes serve two to three people; a handful of dishes (including the *carne de sol*) are also available in half portions. The restaurant offers a free shuttle service to/from most hotels in Ponta Negra and along the Via Costeira.

Av. Praia de Ponta Negra 8952, Praia de Ponta Negra. 𝒞 **084/3219-0857.** Main courses R$54–R$79 for 2. MC, V. Mon–Sat 10am–10pm; Sun 11am–10pm. Bus: Via Costeira.

Manary ★★ SEAFOOD/NORDESTINO The best place in Natal for seafood, the Manary offers top-notch ingredients, good service, and a lovely setting—an outdoor patio overlooking the sea wall and beach of Ponta Negra. Among the most tempting menu items are the *misto fritti di mare* (a platter of grilled lobster, shrimp, octopus, mussels, fish, and grilled vegetables) and the *bobó de camarão*, a rich shrimp-and-pumpkin stew, flavored with dendê oil and coconut milk and served hot in a hollowed-out pumpkin shell—a memorable dish. The wine list is short but serviceable.

Rua Francisco Gurgel 9067, Praia de Ponta Negra. 𝒞/fax **084/3204-2900.** www.manary.com.br. Main courses R$32–R$58. AE, DC, MC, V. Daily 11am–4pm and 7–11pm. Bus: Via Costeira.

Via Costeira

Tábua de Carne ★ 🍴 BRAZILIAN Located on a cliff top overlooking the beach on the Via Costeira, Tábua offers carnivorous dining at its lip-smacking best. The menu includes treats such as lamb and pork chops and even fish (though for seafood you really should go elsewhere) as well as the traditional favorites of *carne de sol* (salted sun-dried beef, a specialty of Northeastern Brazil), chicken, and good old Brazilian *picanha* (sirloin steak). For the decision-shy, there's the Tábua, a wood platter containing *picanha,* sausage, chicken, and *carne de sol.* Dishes here are made for two and would easily feed three. The *picanha* melts delicately on the tongue. The wine list is of minimal length and questionable quality. Stick to beer or fruit juice by the half-liter earthenware jug.

Av. Senador Dinarte Mariz 229. ℭ **084/3202-7353.** www.tabuadecarne.com.br. Main courses R$24–R$43 for 2. AE, DC, MC, V. Daily 11:30am–11pm. Bus: Via Costeira.

Elsewhere

Mangai ★★ 🍴 BRAZILIAN This is the ideal place to get a taste of Nordestino food, the cuisine of Brazil's dry, cattle-raising Northeast. Mangai offers a self-serve smorgasbord featuring over 70 different Nordestino dishes, some of them traditional favorites, others wonderful inventions made using traditional local ingredients such as *carne de sol* (sun-dried beef), *macaxeira* (sweet manioc root), *farofa* (ground, roasted manioc root), beans, and rice. The *carne de sol na nata* (butter-sautéed sun-dried beef) is a house specialty. Mangai is truly best for a long, leisurely lunch. After you indulge, take advantage of the hammocks slung on the patio and settle in for a snooze. Alcoholic beverages are not available, but there is an excellent array of fruit juices.

Av. Amintas Barros 3300 (on the inland road, about halfway btw. Ponta Negra and downtown). ℭ **084/3206-3344.** www.mangai.com.br. Reservations not accepted. R$18–R$32. MC, V. Daily 11am–10pm. Taxi recommended.

EXPLORING

Natal isn't really the place to stroll around looking at pretty old buildings, but then odds are you're here for sun and surf and some time on those famous dunes. So rent a buggy and *bugreiro* (buggy driver) and buggy up the beach and explore. Check out the monster dunes at **Genipabu.** Head farther north and snorkel the reefs off **Maracajaú.** Try *aerobunda* where you slap your behind into a rope-sling and slide *com emoção* into a freshwater lagoon. Or try sand boarding, tobogganing, dune hiking, or camel riding (see "Outdoor Activities," below). Finish the day watching a glorious sunset over the dune tops.

And don't forget the side trips. If buggying gets in your blood, do a second day trip south to the lovely, small beachside town of **Praia da Pipa.** For the ultimate in buggy adventure, do a 4- or 7-day expedition from Natal 800km (500 miles) north to Fortaleza. Travel back in time to the sleepy village of Galos and Galinhos where horse and buggy still have the right of way on the sand-covered streets and you have the dunes and beaches practically all to yourself. Or strike inland and see the otherworldly rock formations at **Cariri,** and 120-million-year-old footprints in the **Vale dos Dinossauros (Valley of the Dinosaurs).**

Top Attractions in the City

Forte de Reis Magos ★★ Every old fort should look like this, standing proud and alone on the reefs off the tip of the city, separated from the mainland by a sand spit that at high tide sinks below less than a meter (3 ft.) of water. Inside, the function of each room is carefully spelled out in Portuguese and English. The small museum in the officers' quarters has disappointingly little on the fort itself, which saw action when the Dutch occupied it between 1633 and 1654. From the ramparts, the view of the city's skyscrapers and the dunes to the north can't be beat. Ask your taxi to wait while you visit the fort; otherwise you may be looking at a very long wait.

Av. Pres. Café Filho s/n. ℭ **084/3202-9006.** Admission R$3. Daily 8am–4:30pm. No public transit.

Museu Câmara Cascudo ★ ☺ The only noteworthy museum in Natal covers the natural history and anthropology of the state of Rio Grande do Norte. See the

original *jangada* rafts made by local fishermen and walk through a fisherman's hut. Visit reproductions of Rio Grande do Norte's archaeological sites, and descend in a cave to see how these digs are carried out. Delve into a life-size salt mine. There are no English signs, but the displays are self-explanatory and great for kids. Allow 1 hour.

Av. Hermes da Fonseca 1398, Tirol. (🕐 **084/3215-4192.** www.mcc.ufrn.br. Admission R$3. Tues–Fri 8–11am and 2–5pm; Sat 1–5pm. Bus 33, 37, 39, 45, 46, 47, 51, or 68.

Centro Natal

On the highlands above the port is the **Cidade Alta.** This commercial part of the city has a number of pretty squares that make for a fine stroll. There are actually four separate squares here, all melded together: **Praça João Maria, Praça Andrè de Albuquerque, Praça João Tibuco,** and **Praça Sete de Setembro.** The largest is the Praça André de Albuquerque, dominated by the **N.S. da Apresentação.** Just across from the church is the **Memorial Câmara Cascudo** ★, Praça Andre de Albuquerque 30 (🕐 **084/3211-8404;** free admission; Tues–Sun 8am–5pm). One of Natal's most beloved sons, **Câmara Cascudo** (1898–1986), was a journalist, professor, founder of the federal university of Rio Grande do Norte, and author of the dictionary of Brazilian folklore; most Brazilian kids have read his stories of *jangadas,* fishing nets, and bumba-meu-boi (a peasant harvest festival involving the death and miraculous resurrection of a sainted bull). The memorial shows the life of Cascudo and artifacts portraying the folklore he wrote about. It also houses all of his works and his personal library. The museum is very small, but admission is free and the proud staff (one of them is Cascudo's grandson) love receiving visitors.

Parks

The 1,376-hectare (3,400-acre) **Parque das Dunas** ★ occupies a huge swath of Natal, from the edge of downtown all the way to Ponta Negra. There's a visitor center in the park headquarters, Av. Alexandrino de Alencar s/n (🕐 **084/3201-3985;** www.parquedasdunas.rn.gov.br), from which you can set off on guided walks through the dunes. Entrance is R$2, which includes the trail fee. Walks depart at 8am, 9am, and 2pm. Call ahead to reserve.

Top Excursions from Natal

The best way to access the terrain north and south of Natal is by buggy, but if you'd prefer a more comfortable 4×4, contact **Cariri Ecotours** (🕐 **084/9928-0198;** www.caririecotours.com.br). The company offers single- and multiday 4×4 trips south to Praia da Pipa and north to Maracajaú. The 1-day trip to Praia de Pipa includes a trek through the Atlantic rainforest and dolphin-spotting at Enseada do Madeiro.

BUGGY EXPEDITIONS ★★★ Untouched dunes, beaches, and lagoons stretch away north and south of Natal for hundreds of kilometers. The best way to see them in all their glory is to rent a dune buggy with a driver, and head out to explore. Prices in high season average around R$300 to R$400 for a full day for up to four people. If you're in a group of fewer than four, the tour operator can make up a full group, but it's better to pay for the full rental; if you have the buggy to yourself, it stops and goes at your command.

The classic north-coast day trip crosses the Potengi River and proceeds up to **Genipabu,** where you have the chance to ride camels or slide down the dunes on a sand board (see "Outdoor Activities," below). While here, make sure you don't miss

the **Extreme Dune Park,** an enclosed area with monstrous dunes of shifting sands, some of them hundreds of feet high. Only licensed drivers are allowed in, and once inside they make use of buggy and terrain to provide a natural roller coaster ride. Among the stunts they'll treat you to are the Wall-of-Death and the Sheer Vertical Descent. Make sure your sun hat has a string. *Tip:* Make sure that your tour includes a stop in the Extreme Dune Park, and that your driver is licensed to enter.

From there you float your buggy across a small stream on a tiny raft and carry on up the beach to **Jucumã,** where you can try your bum at *aerobunda* (see "Outdoor Activities," below). From there, it's another 35km (22 miles) of wide, flat sand until you get to **Maracajaú,** a magic spot where at low tide you can snorkel in the natural pools in the offshore coral reef. (Buggy tours normally time their arrival to coincide with low tide.) At day's end, the driver returns to Genipabu to see the sun set over the dunes.

The classic south-coast trip heads south along 55km (34 miles) of coast and sand to **Praia da Pipa** (p. 326). Along the way, buggies pass along numerous gorgeous beaches, among them **Búzios, Barra de Tabatinga, Barreta,** and **Tibau do Sul.** It's possible with a full-day tour (about R$300–R$400 per buggy) to stop in at several and still enjoy time at Pipa itself. Better still, head south and spend a few days in the Pipa, a pretty former fishing village of small pousadas and cobblestone streets.

There are lots of buggy drivers in Natal and your hotel can usually hook you up with someone. An excellent longtime *bugreiro* who speaks English is **Kadmo Donato** of **Buggy & Cia** (© 084/9982-3162 or 9416-2222; www.buggyecia.com.br). You can also check **Buggy Tour** (© 084/3086-2258) and the **APBCA,** the buggy owners' association (© 084/3225-2077).

SNORKELING THE POOLS AT MARACAJAÚ ★★ The coast north and south of Natal is hemmed with shallow coral reefs that make for perfect snorkeling. Nowhere are they more impressive than in Maracajaú, about 1 hour north of Natal. A stop here is often included in a full-day buggy tour; if not, ask your buggy driver. You need to time your arrival with low tide. From the beach, a boat takes you about 7km (4¼ miles) offshore to a moored diving platform. At low tide, the honeycomb of reefs forms natural pools rich in tropical fish and other marine life. As the maximum depth is about 4.8m (16 ft.), these pools can be easily explored with just a mask and snorkel. The water is crystal clear and warm. Expect to spend at least 2 hours. Contact **Maracajaú Diver,** Praia de Maracajaú (© 084/3261-6200 or 9983-4264 mobile; www.maracajaudiver.com.br; snorkeling R$75 adults, R$35 children 6–12, free for children 5 and under; check the website for departure times, which are tide related). *Note:* If you've never been scuba diving, Maracajaú Diver offers a "baptism" dive. The water is never deeper than 4.8m (16 ft.), so there is no danger of sinking or decompression; it costs R$170 for 15 to 20 minutes.

Outdoor Activities

AEROBUNDA JACUMÃ The perfect antidote to the high-tech world of the American amusement park. At Lagoa Jacumã, Litoral Norte, Km 35, there's a dune about 60m (200 ft.) high. At its foot is a big lake. At the top of the dune someone has hammered in three telephone poles to make a scaffold, then attached a thick rope from there to another peg on the far side of the lake. To execute the *aerobunda,* you slide your butt into a sling hanging from a pulley attached to the line. The attendant then lets go. You scream down toward the lake, gathering speed and momentum. Splash! Huge fun. Back on shore you hop into a rickety iron cart, wave your arm at

the guy on the donkey engine (a small portable engine), and he hauls you up the dune so you can go again. The price is R$5 per ride; it's open daily from 8am to 5:30pm (② 084/3228-2402).

SAND BOARDING　Sand boarding is worth doing as long as you believe that no sport is too stupid to be tried at least once. As snowboarders, we felt obligated. Turns out that sand doesn't glide nearly as well as snow. But then, I guess you can't snowboard in a bikini. If you're interested, look for the entrepreneurs at the south end of Genipabu beach; the cost is R$5 per trip (less, if you bargain).

SURFING　The beach at Ponta Negra is a great place to learn to surf. Waves vary from small and manageable to large and exciting. For instructors try the **Escola de Surf Ponta Negra** (② 084/8806-1087), in a tent about halfway along Ponta Negra beach. Lessons cost R$25 per hour.

SHOPPING

GIFTS & SOUVENIRS　Natal has transformed its former prison complex into a crafts market, **Centro de Turismo de Natal,** Rua Aderbal de Figueiredo 980, Petrópolis (② 084/3211-6218). About 40 crafts shops are now housed in the cells and provide easy one-stop shopping for local crafts. Look for the handmade white-linen tablecloths and the small painted clay figurines depicting characters from folk dances. There are also hammocks, woodwork, and sweets made with sugar cane and coconut. The market is a steep 15-minute walk from Praia dos Artistas. Open daily from 9am to 7pm. The **tourist information booth** at the entrance is open daily from 9am to 5pm.

In Ponta Negra, the **Shopping do Artesanato Potiguar,** Av. Engenheiro Roberto Freire 8000 (② 084/3219-3207; www.shoppingartesanatopotiguar.com.br), features more than 180 shops packed with souvenirs and local handicrafts.

SHOPPING MALLS　The midsize **Praia Shopping,** Av. Engenheiro Roberto 8790 (② 084/3219-4323; www.praiashopping.com.br), is at the edge of Ponta Negra, a short cab ride back in the direction of downtown. Shops are open Monday through Saturday 10am to 10pm, Sunday 3 to 9pm.

NATAL AFTER DARK
The Performing Arts

Teatro Alberto Maranhão　This is Natal's main theater and concert stage. Check the calendar for upcoming events. During box-office hours you can have a peek inside this renovated colonial building. Open Tuesday to Sunday from 8am to 6pm. Praça Augusto Severo 251, Ribeira (near Cidade Alta). ② **084/3222-3669.** www.teatroalberto maranhao.rn.gov.br.

Clubs & Bars

Natal's nightlife centers on the Ponta Negra neighborhood. The waterfront **Avenida Erivan França,** at the far end of **Ponta Negra beach,** is a busy and bustling area of restaurants and bars. Some years back much of the activity consisted of Brazilian women looking to sell their services to male charter tourists from Europe, but the area has since been cleaned up substantially.

ALTO DE PONTA NEGRA

The prime nightlife scene, the **Alto de Ponta Negra,** is located on the heights on the far side of the busy Avenida Roberto Freire (near the corner of the Rua Dr. Manoel A.B. de Araújo, just 2 blocks past the Quality Suites Hotel). It's a pleasant and strollable enclave of cafes and creperies, knickknack shops, bars, and discos.

If you're in the mood for a snack, **Casa de Taipa,** Rua Dr. Manoel A.B. de Araújo 130A (**ⓒ 084/3219-5798**), offers tapioca pancakes with over 40 different types of filling, not to mention delicious caipirinhas, coffee, and homemade ice cream. It's open daily 5pm to midnight, and is a popular gathering place for a drink and a bite to eat before hitting the dance clubs.

Rastapé This place attracts a young and pretty crowd. The small stage pumps out live *forró,* and lots and lots of dancing. Open Wednesday to Saturday, 7pm to 2am. Rua Aristides Porpino Filho 2198. (ⓒ **084/3219-3164.** www.rastapenatal.com.br.

Sgt. Pepper's Rock Bar Local rockers gather at this comfortable bar offering casual dining and live rock 'n' roll. The menu offers burgers and pizza. Open Tuesday through Saturday 7pm to 2am. Rua Manoel A.B. Araujo 130. ⓒ **084/9113-6377.**

Taverna Pub Natal's favorite bar is in the basement of an ersatz castle–cum– youth hostel. It's low and dark and cramped, with bad acoustics and terrible sight-lines, and it's packed Thursday to Sunday with 20- to 30-year-olds who come for the DJs or local bands playing live on the tiny stage. Open daily 11pm to 4am. Rua Chile 25, Ribeira. (ⓒ **084/3236-3696.** www.tavernapub.com.br. Cover R$15.

SIDE TRIPS FROM NATAL

The Natal-to-Fortaleza Buggy Adventure ★★★

If you can't get enough of the coast, consider the 800km (500-mile) adventure trip from Natal north along the beach to Fortaleza. On the way you'll visit 85 beaches and countless dunes, some of them massive monsters seemingly transplanted from the Sahara. You'll pass through petrified forests and pocket deserts, float your buggy across dozens of little estuaries on rafts, and visit little fishing towns that rarely, if ever, see tourists.

Buggy & Cia, Rua Guilherme Tinoco 1274 (**ⓒ 084/9982-3162;** www.buggye cia.com.br), specializes in this trip. The expedition takes 4 days, usually starting from Natal. The cost is R$2,500 total for two people, including accommodations and breakfast plus buggy and driver. The owner, Kadmo Donato, speaks English. The website has a map of the route and some excellent photos showing what's in store on the trip. Note that with Buggy & Cia, a driver does the driving. Some find this a disappointment, but it actually allows you to spend your time drinking in the views from the prime buggy spot—above the roll-bars on the back of the buggy's chassis.

Heading Inland

The hot, dry interior of the Northeast hides some outstanding natural beauty: indigenous petroglyphs, rock formations as odd and impressive as many in Utah, and fossilized dinosaur footprints 120 million years old. Based in Natal, **Cariri Ecotours** (ⓒ **084/9928-0198;** www.caririecotours.com.br) specializes in trips into this Brazilian outback. The 4-day, 3-night Valley of the Dinosaurs package strikes inland for the far west of Paraiba state. Here, 120 million years ago, dozens of species of dinosaurs lived at the edge of a great shallow lake. The tracks they left in the mud of this lake

filled with sediment and became fossilized; hundreds of tracks in this area remain clearly visible to this day. The tour then swings back toward the Cariri region, to the vast and magic rock formations at **Lajedo do Pai Mateus** and **Saca de Lã.** The expedition finishes up with a visit to one of Brazil's most significant archaeological sites, a stone wall inscribed with the symbols and artwork of a now-vanished prehistoric people. Trips can be made by either air-conditioned Land Rover or comfortable air-conditioned Fiat Duplo. The cost per person for groups of two to four people is R$2,600 by Fiat, and R$2,955 by Land Rover. Meals are included, and accommodations are at some of the finer pousadas of the interior.

Mandacaru Expedições (℅ **084/9988-5892;** www.mandacaruexpedicoes. com.br) offers a shorter 2-day tour to the Cariri region, including a hike around the rock formations of Lajedo do Pai Mateus and Saca de Lã. Departuring from Natal or Pipa, the package includes all transfers, guides, meals, and 1 night of accommodations for R$1,700 per person (two people) and R$1,050 per person (four people).

Praia da Pipa
85km (52 miles) from Natal

Located 85km (52 miles) south of Natal by road (or a mere 55km/34 miles if you go by beach buggy), **Praia da Pipa** is one of the most picturesque beaches in all of Brazil's northeast. This former fishing village was discovered by surfers back in the 1970s, and developed in the decades since, without yet overdeveloping. Though the town does fill up on weekends and holidays, Pipa's pousadas and hotels remain manageable and small-scale. The village of Pipa is well known for its nighttime activity, and for the excellent cafes and restaurants lining its cobblestone streets. Down on the long crescent beach are natural pools and reefs for snorkeling.

ESSENTIALS
GETTING THERE BY CAR Praia da Pipa is an easy drive from Natal down highway BR-101. After approximately 45 minutes, at Goianinha, you turn onto a winding secondary road for the last 20km (12 miles) to Pipa. This last stretch of road is in pretty bad shape and we don't recommend driving this at night. A more comfortable and very affordable alternative is to take a **taxi** from Natal; the fare is R$100 to R$120 for up to four people.

GETTING THERE BY BUS Oceano (℅ **084/3205-6833**) offers regular bus service between Natal and Pipa. Buses depart regularly between 7am and 6pm; some buses will also stop at the airport, check for specific times. Tickets are R$11.

FAST FACTS There is only one **Banco do Brasil** ATM in Praia da Pipa so it's wise to bring some extra cash in case it's down. Most restaurants, hotels, and tour companies accept **credit cards** (MasterCard and Visa are most common).

HITTING THE BEACH
Pipa is all about beaches and there are at least a dozen or so to pick from. The town's main beach, **Praia do Centro,** is lively and busy with lots of bars and restaurants. Heading north from the village you will find a number of beautiful beaches just a short stroll away. Most of them have very few services, especially in the low season, so grab a bottle of water before setting out on a walk. The first beach beyond Praia do Centro is **Praia do Curral,** with gorgeous sandstone cliffs. Dolphins can often be spotted close to shore, especially later in the afternoon. It is worth continuing to the next beach, **Praia do Madeiro;** framed by lush vegetation, this wide bay is one

of the region's most beautiful beaches. You will find a few beach kiosks here, but compared to Praia do Centro and Praia do Amor, this beach is still blissfully empty. This beach can also be accessed by road followed by a short walk down some steep long steps. Praia do Madeiro makes for a fine destination, but if you seek even more solitude you may continue to **Praia de Cacimbinhas.** There are no beachside restaurants or kiosks here, just a long stretch of sand framed by steep sandstone cliffs. Just around the bend, at Praia do Giz, lies the small oasis of **Ponta do Pirambu,** Rua Sem Pescoço 252 (✆ **084/3246-4333;** www.pontadopirambu.com.br). This beachside retreat features a restaurant, spa, pool, showers, sun deck, and hammocks. You pay a minimum fee of R$50 (low season) to R$80 (high season), which may be applied to any of the services, including food or drinks. From here it is only a short walk to **Timbau do Sul.** The entire walk from Praia do Centro to Timbau do Sul takes approximately 3 to 4 hours. Make sure you check the tide tables before setting out on any beach walks to time your walk around low tide.

Another string of popular beaches lies just to the south of Praia do Centro. From the village, follow the **Rua Praia do Amor** and continue to just beyond the Sombra e Agua Fresca hotel (approx. a 15-min. walk). At the top of the cliff, you can observe the heart-shaped bay that has given the beach its name (*amor* means "love" in Portuguese). Steep steps lead down to the beach. This is hardly an idyllic destination; cheek by jowl bars and restaurants vie for customers and in summer it gets quite busy. If you want to get away from the action, continue farther south to **Praia das Minas.** This rugged beach is not recommended for swimming, but makes for a great walk. It is also a popular kite-surfing destination. **Bar das Minas,** Av. Dos Golfinhos 3500 (✆ **084/3246-2086**), toward the end of the beach, is the perfect stop for a delicious seafood lunch or afternoon drink.

OUTDOOR ACTIVITIES

Beyond Pipa's beaches there are plenty of other outdoor activities to pursue. Just north of Tibau do Sul, where the Tibau River and Guarairas lagoon meet the ocean, lies a beautiful mangrove, perfect for a **kayak** tour. **Bicho do Mangue,** Tibau do Sul s/n (✆ **084/9928-1087**), offers daily tours. Times vary according to the tides so that you paddle into the mangrove at slack tide and return on the outgoing tide. It costs R$60 per person (cash only). Another great way to explore Pipa's beaches is by **dune buggy.** Local guide **Rodrigo** (✆ **084/9911-0440;** rodrigobuggy@hotmail.com) puts together a wonderful full-day tour that visits several beaches and some of the internal countryside; it costs R$400 per buggy (up to four people). More active pursuits can be booked via **Trieb Club,** Rua Praia do Amor 48 (✆ **084/3246-2377;** www.triebclub.com.br). Their mountain-bike tours are a fun way to explore the beaches and inland region around Pipa. Choose from a moderate 2- to 3-hour ride (R$95 per person) to a full-day tour along the Rio Catu, including a kayak tour (R$195 per person). Trieb also offers kite surfing and surfing packages. An introductory basic kite-surfing lesson costs R$300 (lesson and equipment included). A complete 3-day package with 9 hours of instruction costs R$800. To try your hand at surfing, book a 2-hour intro course (R$80); experienced surfers can also rent their boards at Trieb.

WHERE TO STAY

Pipa offers some of the finest pousadas in the northeast with top-quality accommodations and excellent service. By avoiding peak season (Dec–Mar and July) you save some money and avoid the big crowds of Brazilian vacationers.

Very Expensive

Sombra e Agua Fresca ★★★ This small luxurious hotel has the best location in Pipa, perched on a tall cliff overlooking Praia do Amor and the village, yet it's only a 5-minute stroll from the main strip. All the rooms cling to the steep hillside, but a golf cart is available to drop guests off in front of their room. Skip the standard rooms; although nicely furnished with king-size beds, fancy linen, a flatscreen TV, and CD player, they are much smaller than the executive rooms and lack the deck or balcony and a Jacuzzi tub or private pool. Service isn't as attentive as in Toca da Coruja, but the hotel's swimming pool and restaurant with Asian-style reading lounge offer the best views in town.

Rua Praia do Amor 1000, Praia da Pipa, 59178-000 RN. www.sombraeaguafresca.com.br. © **084/ 3246-2258.** 40 units. High season R$430 standard, R$550 executive, R$660 executive ocean view; low season R$297 standard, R$420 executive, R$485 executive ocean view. Children 6 and under stay free in parent's room. AE, DC, MC, V. **Amenities:** Restaurant; bar; large pool; sauna; spa. *In room:* A/C, TV/DVD, CD player, minibar, Wi-Fi.

Toca da Coruja ★★★ Tucked away at the end of a green driveway, Toca da Coruja is one of the perfect little hotels that has it all: gorgeous landscaped grounds with lush tropical gardens, an outstanding restaurant, a stunning swimming pool, impeccable service, and luxurious rooms. Evoking the atmosphere of a 19th-century plantation manor, each spacious room features sky-high ceilings, elegant rustic furniture, wooden shutters, and beautiful artwork, as well as every modern convenience imaginable, including a super king-size bed, deluxe bathroom fixtures, and luxury appliances and amenities. If you can tear yourself away from the lap of luxury, you will find that the hub of the village is only a 5-minute walk away.

Praia da Pipa s/n, Praia da Pipa, 59173-000 BA. www.tocadacoruja.com.br. ©/fax **084/3246-2226.** 25 units. R$580 bungalow; R$935 deluxe bungalow. Extra person 20%. Children 5 and under stay free in parent's room. AE, DC, MC, V. **Amenities:** Restaurant; bar; outdoor pool. *In room:* A/C, TV/ DVD, hair dryer, minibar, Wi-Fi.

Moderate

Pousada Spa da Alma ★★ To truly get away from it all, retreat to this hilltop paradise. Located 2km (1¼ miles) outside of the village, Spa da Alma is set in a private nature reserve with beautiful gardens and sweeping views. Facing the ocean, each chalet is divided into two spacious apartments with comfortable bedrooms, modern bathrooms, and a lovely balcony or porch. The panoramic suites also feature a sitting room. Lounge by the beautiful pool or follow the trails down to Praia do Amor or Praia das Minas, which even in high season remains blissfully devoid of crowds. Spa lovers will be in heaven; set in a narrow green valley, the spa offers massages and other treatments in a peaceful outdoor setting. Should you miss the action of the village, the hotel offers regular transfers into Pipa, a 10-minute ride away.

Rua do Spa 9, Praia da Pipa, RN 59179-000. www.spadaalma.net. © **084/3246-2356.** 18 units. High season R$270 suite, R$330 panoramic suite; low season R$216 suite, R$264 panoramic suite. Extra person 20%. Children 5 and under stay free in parent's room. AE, DC, MC, V. **Amenities:** Restaurant; bar; outdoor pool; spa; Wi-Fi. *In room:* A/C, TV, hair dryer, Internet, minibar.

Pousada Tamanduá ★ One block off the main strip, Tamanduá is just a hop and a skip from all the hustle and bustle in Pipa, yet far enough away to guarantee a relaxing, quiet sleep. The rooms in this small pousada are furnished with comfortable beds, wooden furniture, stone floors, and local artwork. Some feature balconies with comfortable hammocks and most look out over the lovely lush garden. The friendly staff will gladly help with sightseeing tips or book tours.

Rua Tamanduá 3, Pipa, 59178-000 RN. www.pipapousadatamandua.com.br. ✆ **084/3246-2340** or for reservations ✆ **084/3206-8841.** 12 units. High season R$250 double; low season R$190 double. Extra person 20%. Children 5 and under stay free in parent's room. MC, V. Free parking. **Amenities:** Restaurant; bar; outdoor pool; Wi-Fi. *In room:* A/C, TV, minibar.

WHERE TO EAT

Praia da Pipa has a number of excellent restaurants that offer a wide range of cuisines. The village is small enough that you can go for a stroll and see what takes your fancy. It is hard to go wrong with any of the freshly prepared Italian dishes at **Dell Italiano,** Rua do Ceu 17 (✆ **084/9152-8651**). All the thin crust pizzas and pasta are made from scratch. The wine list includes affordable Argentinean, Chilean, and Italian options, including some half bottles. Just one door down, you find the small Mexican eatery **Guacamole,** Rua do Ceu 23 (✆ **084/9187-0062**). The kitchen serves up generous portions of enchiladas, burritos, fajitas, and other Mexican favorites. The music can be a tad on the loud side, but the staff will happily turn it down. **Tapas,** Rua dos Bem-te-vis 8 (✆ **084/9414-4675**), is one of Pipa's best restaurants. The Spanish owners serve up original Spanish tapas. The menu changes daily, but you can't really go wrong with any of their tasty morsels, especially the seafood options. It's closed in May and June. A few doors down is **Oba Yakisoba,** Rua dos Bem te Vis 32 (✆ **084/9188-5992**), a great little Japanese restaurant that doesn't serve any sushi, but serves excellent stir-fries with ginger chicken or noodles. The signature dish is the deep-fried *tonkatsu* beef, pork, or fish, deliciously dry and crisp, served with rice and *sunomuno* salad. For dessert, stroll down to **Preciosa,** Av. Baia dos Golfinhos 1074 (✆ **084/9600-2276**), and get a scoop of their delicious homemade Italian ice cream.

Galos & Galinhos ★★

167km (104 miles) north of Natal

If your idea of a fabulous beach destination includes glorious sand dunes dotted with clear freshwater lagoons, miles of deserted beaches, and a sleepy village where horses and buggies still have the right of way, then Galos and Galinhos is the place for you. This rustic jewel is tucked away on a sandy peninsula wedged between the Galos River and the Atlantic Ocean. On the cusp of becoming the next hot beach destination, Galos and Galinhos is the perfect low-key Brazilian beach destination, with no nightclubs, no bars, no souvenir shops, and no fast-food restaurants. The streets are made of sand, and at night locals gather in the main square to watch TV.

ESSENTIALS
Getting There

Part of the charm of Galos and Galinhos is its isolation and lack of road access; the best way to reach Galos and Galinhos is by **private transfer or tour. Mandacaru Expedições** (✆ **084/9988-5892;** www.mandacaruexpedicoes.com.br) is one of the experts in this region and offers a 3-day package from Natal, including excursions and accommodations. In high season, the cost is R$1,125 per person with two people or R$860 per person with four people. Just the transfer from Natal along the beaches by 4×4 costs R$950 for up to four people.

A cheaper alternative is to take public transportation. **Bus** company **Cabral** (✆ **084/3223-4041**) has daily departures from the main bus station in Natal to Macau at 6am, 9am, noon, 3pm, and 6pm. Tickets cost R$15 per person, and the ride takes 3 hours. Ask the driver to let you off at the *trevo para Galinhos* (the turnoff

to Galinhos). From here there is no regular bus service to the port, so it is best to ask the pousada to arrange a taxi (approx. R$30) to meet you at the intersection for the final 25km (16-mile) stretch to the port, where you board a boat to the peninsula (R$2 per person, crossing time approx. 15–20 min.).

EXPLORING

A long stretch of unspoiled beach runs along the entire peninsula that is home to two small villages. Not to be confused with Porto de Galinhas near Recife, **Galinhos** is the larger community with a population of approximately 2,000 people, whereas **Galos,** 7km (4 miles) away, is home to approximately 400 people. You can easily spend 2 to 3 days exploring the area.

A main draw are the beautiful white sand dunes and freshwater lagoons, reminiscent of the Pequenos Lençois in Maranhão. Visitors either explore these dunes on foot, by horseback, or by dune buggy. Contact Galos and Galinhos experts **Mandacaru Expedições** at ✆ **084/9988-5892** or www.mandacaruexpedicoes.com.br to set up tours.

WHERE TO STAY & EAT

There are only a handful of accommodations available. We highly recommend staying at the lovely **Pousada Peixe Galo ★★★**, Rua da Candelaria 30, Praia de Galos (www.pousadapeixegalo.com.br; ✆ **084/3552-2001** or 084/3206-8841; R$250 high season, R$190 low season). The comfortable rooms with air-conditioning, TV, and hot showers look out toward the river and garden. Although you can enjoy the pousada's swimming pool, the beach is only a 10-minute walk away. Right next door to the pousada is the village's best (and only) restaurant, **Dona Irene ★★**, Beira-Mar s/n, Praia de Galos. Named after the restaurant's owner and cook Dona Irene, the simple eatery serves up outstanding seafood. Make sure you try her prawn risotto and seafood broth.

FORTALEZA

T he capital of the state of Ceará is best known for its
beaches: glorious long stretches of sand interrupted by
impressive red cliffs, palm trees, dunes, and lagoons that
offer a true tropical playground.

The most beautiful and isolated beach is the small settlement of Jeri-
coacoara, a tiny coastal community with streets of sand, set by itself on
the edge of its own tiny desert of Sahara-like dunes.

The first Portuguese settlers arrived in the area in 1603. The colony
grew slowly, beset by attacks by Tabajara Indians, and later by the Dutch,
who in 1637 drove out the Portuguese, only to be slaughtered in turn by
the Tabajara. When the Portuguese regained control of the area in 1654,
they gave the substantial five-pointed Dutch fort a new name: Fortaleza
Nossa Senhora de Assunção.

Fortaleza remained a backwater until the 1820s, when Brazilian ports
opened to foreign ships and the city began to grow into an important
seaport, shipping cotton, cattle, and leather from the interior to England.
In response to the resulting growth, city governors in 1875 commissioned
a plan to transform Fortaleza into a tropical Paris, a city of broad boule-
vards overlaying a functional grid. Some of this early city planning can still
be seen, but much was overwhelmed in the 1950s and 1960s as migrants
from the state's dry and drought-stricken interior flocked into the city,
practically doubling Fortaleza's population.

Now about two million strong, the city's major industries are cashews
and tourism. The Dutch, Portuguese, and other foreigners land en masse
on the beaches armed with cameras and bathing suits and a fierce will to
enjoy the sun and ocean. What sets Fortaleza's beaches apart from Brazil's
other 8,000km (4,960 miles) of coastline is the combination of colorful
cliffs and huge sand dunes, best seen in nearby communities such as
Morro Branco, Canoa Quebrada, and Jericoacoara.

For first-time visitors with limited amounts of time, the best plan of
attack is to spend no more than a day in the city itself, then head out to
explore the nearby beach communities, particularly the isolated Sahara-
like dunes of Jericoacoara.

ESSENTIALS

2,169km (1,348 miles) NE of Rio de Janeiro, 2,358km (1,465 miles) NE of São Paulo,
1,019km (633 miles) N of Salvador

Getting There

BY PLANE **Azul** (𝒞 **085/3003-2985;** www.voeazul.com.br), **Gol**
(𝒞 **0300/115-2121** or 0800/704-0465; www.voegol.com.br), **TAM**

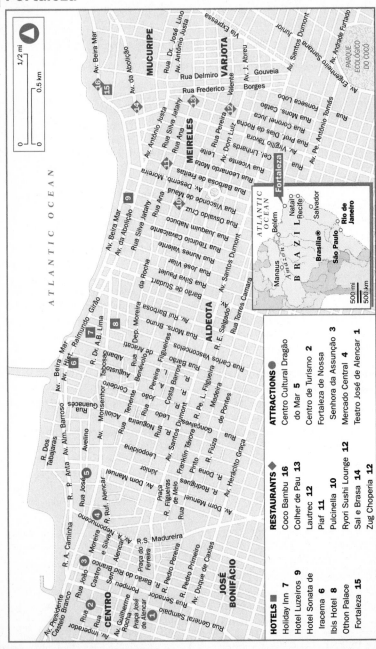

ATLANTIC OCEAN

MUCURIPE

VARJOTA

MEIRELES

ALDEOTA

CENTRO

JOSÉ BONIFÁCIO

PARQUE ECOLÓGICO DO COCO

ATLANTIC OCEAN

Manaus
Belém
Fortaleza
Natal
Recife
Salvador
Rio de Janeiro
São Paulo
Brasília
B R A Z I L

500 mi
500 km

1/2 mi
0.5 km

HOTELS ■
Holiday Inn **7**
Hotel Luzeiros **9**
Hotel Sonata de
Iracema **6**
Ibis Hotel **8**
Othon Palace
Fortaleza **15**

RESTAURANTS ◆
Coco Bambu **16**
Colher de Pau **13**
Lautrec **12**
Piaf **11**
Pulcinella **10**
Ryori Sushi Lounge **12**
Sal e Brasa **14**
Zug Choperia **12**

ATTRACTIONS ●
Centro Cultural Dragão
do Mar **5**
Centro de Turismo **2**
Fortaleza de Nossa
Senhora da Assunção **3**
Mercado Central **4**
Teatro José de Alencar **1**

(℡ **0800/570-5700** or 085/4002-5700; www.tam.com.br), and **Webjet** (℡ **0300/ 210-1234;** www.webjet.com.br) have daily flights from most major cities in Brazil. Flights arrive at **Aeroporto Internacional Pinto Martins,** Av. Senador Carlos Jereissati 3000 (℡ **085/3392-1030**). Taxis cost about R$30 to R$40 to the beaches or downtown.

BY BUS Long-distance buses arrive at the **Rodoviaria São Tomé,** Av. Borges de Melo 1630, Fatima (℡ **085/3256-2100**).

City Layout

Located just east of the Ceará River, the commercial heart of Fortaleza—called **Centro**—is small and quite walkable, though the traffic and sidewalk vendors can make the area seem a little hectic. Starting from the waterfront **Fortaleza N.S. de Assunção,** Centro stretches inland in a grid pattern. Following the **Avenida General Sampaio** or **Rua Barão do Rio Branco** will lead you straight into Fortaleza's main shopping area, centered on a large city square, the **Praça José de Alencar.** Smaller but lovelier is the **Praça dos Leões,** just 1 block east of the Rua Barão do Rio Branco at the corner of **Rua São Paulo.**

An easy stroll to the east of Centro leads to the ocean-side neighborhood **Praia de Iracema,** the first of a long string of beaches that line the waterfront, linked together by the **Avenida Beira Mar.** (Unfortunately, none of the urban beaches is recommended for bathing.) Iracema isn't so much a beach as an ocean-side party place. You'll find lots of restaurants and bars along the sea wall, and the **Rua Tabajaras** that runs parallel to the beach is packed with nightlife and restaurants. A kilometer (½ mile) or so east of Iracema you come to the next beach neighborhood, **Meireles.** From here onward, the beachside boulevard becomes a pleasure to walk. It's wide and shaded with plenty of kiosks for a drink or snack. The nightly **crafts market** (p. 341) always attracts large crowds. **Mucuripe** is the next neighborhood to the east of Meireles. At the end of Mucuripe beach there's a small colony of fishermen and a seafood market where the catch of the day is sold fresh off the boat. Farther east, the coastline curves south. The bend contains an industrial area of little interest to visitors, but once around the bend you come to **Praia do Futuro,** the only urban beach where the water is clean enough to swim. Some stretches of this beach become quite lively on Thursday evenings and on weekends but can be deserted during the week.

Getting Around

BY BUS Most visitors use the bus to go between the beach neighborhoods and Centro. In Meireles or Mucuripe you catch the bus on the street parallel to the beach (Av. Abolição). Look for buses marked MEIRELES, CAÇA E PESCA, or GRANDE CIRCULAR. Fare is R$2.

BY TAXI Taxis can be hailed almost anywhere. To order a taxi, call **Disk Rádio Táxi Ceará** (℡ **085/3243-8111**), **Taxi Fortaleza 24 Horas** (℡ **085/3254-5744**), or **Rádio Táxi Cooperativa** (℡ **085/3261-4181**). Fare from Meireles to Centro is about R$20, and from Mucuripe to Praia de Iracema it's about R$24.

BY CAR Within Fortaleza, a car is more a nuisance than a pleasure: Traffic is chaotic and parking a challenge. However, to explore outlying beaches on your own, a car is ideal.

Visitor Information

The state tourism agency, **Setur,** has a Portuguese-only website at **www.setur. ce.gov.br**. Fortaleza's **airport** has a tourist information center (☎ **085/3477-1667**) in the arrivals hall, open daily 6am to 11pm, where you can pick up a good free map of the city. The **state tourist information center (Centro de Turismo do Ceará)** is downtown at Rua Senador Pompeu 350 (☎ **085/3101-5508**), open Monday through Saturday from 9am to 6pm, Sunday 8am to noon.

[FastFACTS] FORTALEZA

Banks Banco do Brasil, Rua Barão do Rio Branco 1515, Centro (☎ **085/3254-2122**), has an ATM. There is also an **HSBC,** Av. Monsignor Tabosa 1200, Praia de Iracema (☎ **085/3219-2436**). Both are open Monday to Friday 10am to 4pm.

Car Rental Localiza (☎ **085/3308-8350**), **Avis** (☎ **0800/725-2847**), **Unidas** (☎ **085/3242-4055**),

and **Hertz** (☎ **085/3477-5055**) all have offices here.

Hospital The local hospital is **Hospital Batista Memorial,** Av. Padre Antônio Tomás 256, Aldeota (☎ **085/3224-5417**).

Internet Access Cyber Café, Av. Abolição 2655, Meireles (☎ **085/3242-5422**), charges R$4 per hour; it's open daily 9am to 10pm. **Cyberoom Rent a**

Computer, Av. Mons Tabosa 937, Centro (☎ **085/3219-6731**), also charges R$4 per hour; it's open Monday to Saturday 10am to 8pm.

Weather Fortaleza has a pleasant sunny climate year-round, dry and tropical with an average temperature of 28°C (82°F); a cooling ocean breeze often takes the edge off the heat.

WHERE TO STAY

Most people stay within walking distance of the city beaches. The boulevards are pleasant and there are plenty of restaurants and activity along the oceanfront. The best of the beach neighborhoods is **Meireles,** which has a wide, well-trod boulevard by the sand, dotted with pleasant little kiosks where you can have a beer or fresh cool coconut. Meireles also has plenty of restaurants, vendors, and an excellent nightly crafts market. The beach neighborhood closest to downtown is **Praia de Iracema.** After a major overhaul, this stretch of beach has been completely revitalized and draws both tourists and locals. The neighborhood is also close to Fortaleza's downtown attractions and the city's prime nightlife enclave. This is not the place for early sleepers. Farther east and more upscale, **Mucuripe** is just a continuation of Meireles; lined with apartment buildings, it runs all the way to a fishing colony at the eastern end of the beach.

Iracema
MODERATE

Holiday Inn ★★ The Holiday Inn offers deluxe accommodations on the waterfront, just a few minutes' walk from the nightlife attractions in Praia de Iracema. The rooms are divided into deluxe, superior deluxe, and suites. All are spacious and have ocean views; even the most basic room is large with a queen-size bed, a big desk, a pullout couch, and a separate vanity area next to the bedroom. The superior deluxe rooms are larger and come with a veranda and a king-size bed. The furnishings are in great shape and the amenities are top-notch—the pool is especially nice.

Av. Historiador Raimundo Girão 800, Praia de Iracema, Fortaleza, 60165-050 CE. www.holidayinn. com. ✆ **085/3455-5000.** Fax 085/3455-5055. 273 units. R$200–R$260 double. Extra person 30% extra. Children 5 and under stay free in parent's room. AE, DC, MC, V. Free parking. **Amenities:** Restaurant; bar; outdoor pool; room service; sauna; smoke-free rooms. *In room:* A/C, TV, hair dryer, minibar, Wi-Fi.

Hotel Sonata de Iracema ★ 🏨 Now that Praia de Iracema has been revitalized, this beachside hotel has become a very attractive and affordable option. Especially at the end of the day, this stretch of the beach becomes a bustling gathering place for locals playing beach volleyball or soccer, families out for a stroll, joggers, and rollerbladers. Although not as luxurious as the Holiday Inn, all rooms have an ocean view and the accommodations have a modern, fresh look with comfortable king-size beds and flatscreen TVs. The hotel also features a pleasant pool and small fitness room.

Av. Beira Mar 848, Praia de Iracema, Fortaleza, 60165-120 CE. www.sonatadeiracema.com.br. ✆ **085/4006-1600.** Fax 085/4006-1606. 123 units. R$185–R$240 double. Extra person 30% extra. Children 10 and under stay free in parent's room. AE, DC, MC, V. Limited parking. **Amenities:** Restaurant; bar; fitness room; outdoor pool; room service. *In room:* A/C, TV, Internet, minibar.

Ibis Hotel 🛏️ Located a block off the water, the Ibis is the best value in Praia de Iracema. Like all Ibis hotels, the concept is basic: All rooms are identical and accommodations are comfortable but plain. Each room has a nice firm double bed, a desk, and closet space. Bathrooms are equally frills-free but are modern and spotless with hot showers. The hotel amenities are kept to a minimum to reduce the operating costs. The optional breakfast is R$11.

Rua Dr. Atualpa Barbosa Lima 660, Praia de Iracema, Fortaleza, 60060-370 CE. www.accorhotels. com.br. ✆ **0800/703-7000** or 085/3219-2121. Fax 085/3219-0000. 171 units. R$149 double. Extra person R$20. Children 5 and under stay free in parent's room. AE, DC, MC, V. Limited free parking. **Amenities:** Restaurant. *In room:* A/C, TV, fridge.

Meireles

EXPENSIVE

Hotel Luzeiros ★★★ The nicest hotel in the city, this is as hip (and expensive) as Fortaleza gets. Nearly all rooms have balconies, all have king-size beds and are elegantly furnished. White tile floors, quality linens, and high-end finishes add an air of luxury to even the most basic rooms. The prime rooms have a full ocean view (*frente mar*); the standard rooms have partial views (*vista mar*). (**Tip:** Rooms ending in 5 do NOT have balconies; avoid these.) The swimming pool, business center, and fitness room are excellent.

Av. Beira Mar 2600, Meireles, Fortaleza, 60165-121 CE. www.hotelluzeiros.com.br. ✆ **085/4006-8585.** Fax 085/3486-8587. 202 units. R$290–R$375 double, partial ocean view; R$475 double, full ocean view. Extra person add about 25%. Children 6 and under stay free in parent's room. AE, DC, MC, V. Free parking. **Amenities:** Restaurant; bar; outside pool; limited room service; smoke-free rooms. *In room:* A/C, TV, Internet, minibar.

MODERATE

Othon Palace Fortaleza ★★ 🛏️ This place has a great location and even better value. The hotel's rooms are all beautifully furnished in blue and yellow tones and come with king-size beds; the bathrooms are done in beautiful marble. The smaller, standard rooms do not have balconies but do look out over the ocean. The deluxe rooms all have balconies and are spacious—definitely worth the price difference. The executive suites are twice the size of a deluxe apartment, with two bathrooms, a separate sitting room, and a balcony—perfect for families.

Av. Beira Mar 3470, Meireles, 60165-121 CE. www.othonhotels.com. ✆ **0800/725-0505** or 085/ 3466-5500. Fax 085/3466-5501. 110 units. R$160–R$190 standard double; R$260 deluxe double; R$430 executive suite double. Extra person add about 25%. Children 4 and under stay free in parent's room. AE, DC, MC, V. Free parking. **Amenities:** Restaurant; bar; fitness center; large outdoor pool; room service; sauna; smoke-free rooms. *In room:* A/C, TV, fridge, hair dryer, Internet, minibar.

WHERE TO EAT

Fortaleza's restaurants are surprisingly excellent. There's fine dining, including outstanding seafood at surprisingly low prices. In the main tourist zone, **Praia de Iracema,** the **Rua das Tabajaras** and its cross streets are lined with restaurants and patios. Take care, however, as many of these touristy establishments sacrifice quality for high turnover. There are some real gems, however, so with a bit of discernment it's possible to dine well. Farther out, **Meireles** and **Mucuripe** beaches offer excellent options as well. For a fun dining scene frequented mostly by Fortalezans, head to the ever-more-vibrant restaurant enclave of **Aldeota.**

If you find yourself in desperate need of a high-end coffee, try **Santa Clara Café Organico,** Rua Dragão do Mar 81 (✆ **085/3219-6900**), located inside the Dragão do Mar cultural center. It features a range of excellent organically grown coffees and a range of chocolates and pastries. Open Tuesday through Sunday 3 to 10pm.

Coco Bambu ★★ SEAFOOD On a warm night, there is nothing better than a delicious seafood meal on the large deck overlooking Meireles beach. One of the most popular dishes is the *camarão* Jangadeiro, a large plate of crispy breaded prawns stuffed with creamy Catupiry cheese, served on a bed of rice with vegetables. Other options include fresh grilled fish and a mixed seafood platter with saffron rice. The restaurant has a large wine list with some interesting South American options, but to start off, try one of the refreshing *caipifruta* cocktails with kiwi or strawberry.

Avenida Beira Mar 3698, Meireles. ✆ **085/3198-6000.** www.restaurantecocobambu.com.br. Main courses R$64–R$95 (for 2–3 people). AE, DC, MC, V. 11:30am–3pm and 5pm–midnight (Sat until 2am).

Colher de Pau ★★★ BRAZILIAN Get a taste for the regional cuisine at this pleasant outdoor restaurant, voted "Best Brazilian in Fortaleza" 7 years in a row. The large bustling patio makes a perfect happy hour destination where you can enjoy a delicious caipirinha accompanied by a large selection of appetizers. On Thursdays, the kitchen serves up several crab specialties. The large lunch or dinner menu includes fish and seafood options, like grilled fish, sautéed prawns, and various *moqueca* stews with fish or shrimp. The meat dishes are a heartier affair with various steak dishes, accompanied by typical Brazilian side dishes such as rice, fried banana, *pirão* (a polenta-like dish), or beans. Don't get carried away when ordering; the portions are quite generous and most dishes will serve two people.

 You Buy, We Fry

The fresh fish market in the fishing colony at the end of Mucuripe beach offers what may be the shortest distance anywhere between catch and cook. Buy fresh prawns or fish at one of the market stalls (about R$8 for a half-kilo of prawns) and the stall at the corner of the market will clean, cook, and serve your meal to you on plates with rice—all for R$6. Cold beer is extra. Open daily 2 to 10pm. No phone.

Rua Ana Bilhar 1178 (corner of Rua Frederico Borget), Varjota. (*) **085/3267-6176.** www.restaurant ecolherdepau.com.br. Main courses R$45–R$75 for 2 people. AE, DC, MC, V. 11am-midnight.

Piaf ★★ FRENCH This small cozy bistro just a couple blocks off Meireles serves creative French cuisine at reasonable prices. Start off with some fresh oysters flown in from the Brazilian island of Florianópolis. Main courses include more traditional dishes such as duck in orange sauce and exotic meats like ostrich served with risotto. For lunch, the kitchen prepares excellent specials at R$19 a plate. Check the blackboard for the daily offerings. The wine list offers a decent selection from France, Italy, Portugal, Australia, and South America.

Rua Silva Jatahy 942, Aldeota. (*) **085/3242-5079.** Main courses R$18–R$42. AE, DC, MC, V. Sun–Fri noon–4pm; Mon–Sat 6pm–midnight.

Pulcinella ★ ITALIAN One of Fortaleza's favorite Italian restaurants, this eatery features a traditional pasta menu just ever so slightly tilted toward the sea. Antipastos include sautéed shrimp and squid or salmon carpaccio. Mains include risottos and pastas with mussels, shrimp, and octopus. Stuffed ravioli dishes are more land based, including regional specialties such as sun-dried beef and locally made *mussarella,* or chicken and Catupiry cheese. The menu includes beef and chicken dishes for those not in the mood for pasta. The wine list includes a range of midpriced vintages from Brazil, South America, and Italy, with an added select few from Australia and France.

Rua Oswaldo Cruz 640, Aldeota. (*) **085/3261-3411.** Main courses R$24–R$48. AE, DC, MC, V. Mon–Thurs noon–3pm and 6:30pm–1:30am; Fri–Sun noon–1am.

Sal e Brasa ★ STEAK For an affordable all-you-can-eat Brazilian steak extravaganza, head just a few blocks inland from the beach. Sal e Brasa is part of the outstanding São Paulo restaurant chain that knows how to serve a perfect steak and more. Waiters come around with an endless stream of beef, chicken, and pork in a variety of cuts. A large buffet of salads, appetizers, and hot dishes, including seafood, is included in the price. Just watch your drinks and desserts; that's where they make their real money!

Av. Abolição 3500, Meireles. (*) **085/3261-8888.** www.salebrasa.com.br. Main courses R$55. AE, DC, MC, V. 11:30am–midnight.

 ## Good Eating at Aldeota

The restaurant neighborhood of Aldeota is becoming ever more popular with Fortalezan locals. Just a short taxi ride from the beach hotels, the area around the Shopping Buganvília mall off Rua Prof. Dias da Rocha has recently seen the opening of a number of outstanding restaurants. One of the most beautiful restaurants is **Lautrec,** Shopping Buganvília, Av. Dom Luis 1113 ((*) **085/3032-4020),** a small bistro offering outdoor dining and a menu of French and Italian seafood—think flambéed prawns with tarragon or grilled prawns with pesto and mozzarella. For sushi, there's **Ryori Sushi Lounge** ((*) **085/3224-9997;** www.socialclube.com.br/ryori), inside the mall itself. For a more casual night out try **Zug Choperia,** Rua Prof. Dias da Rocha 579 ((*) **085/3224-4193;** www.zugchoperia.com.br), a lovely bar/restaurant with a large patio, live music, and fabulous appetizers, including a variety of *pasteis* or cold-cut-and-cheese platters.

EXPLORING FORTALEZA

Fortaleza's main attractions are the beaches outside of the city, including **Morro Branco** with its multicolored cliffs, the sand dunes of **Canoa Quebrada,** and the idyllic and stunningly beautiful **Jericoacoara.** Fortaleza itself has a small **historic center** that's worth a visit if you have a day to spare, but it's certainly not worth the trip by itself. The **beaches** of Cumbuco, Canoa Quebrada, and Morro Branco make for a pleasant day tour. Only a short distance from Fortaleza, these beaches offer buggy tours, sand boarding, sand tobogganing, parasailing, boat rides—you name it and you can experience it, all under a hot tropical sun. But unless you are a kite surfer, these beaches also don't justify the trek to Fortaleza. What is worth the trip is Jericoacoara (p. 342), one of the jewels on the Brazilian coast. This isolated beach community features Sahara-like sand dunes, stunning white beaches, plus a steady wind that makes it Brazil's windsurf and kite-surf capital.

The Top Attractions

CANOA QUEBRADA ★★ ☺ Canoa Quebrada offers miles of soft white sand and green-blue waters framed by low red cliffs. The symbol of the town is a half-moon and star, representing fertility. Hippie heritage aside, locals have expanded their businesses to include **horseback riding** for R$30 per hour, **sand boarding** for R$3 per trip, and especially **buggy rides** either along the beach or into the vast sand dunes piled up behind the city. The full 2½-hour buggy tour, which includes a passage along the beach and up into the dunes, costs R$180 per buggy (buggies seat two or three comfortably, four if you squish). Shorter tours ride along the cliff top overlooking the beach, usually with a stop at a rainwater lagoon that looks like an oasis in the desert, the perfect stop for a swim or a cold beer. On the beach, *barracas* (stalls) rent out chairs and umbrellas, and food and drink is always close at hand, while local women offer scalp and shoulder massages for R$10.

Canoa Quebrada is located 156km (97 miles) east of Fortaleza. For tourism information, see **www.canoa-quebrada.com**. To reach the community, take CE-040 east to Aracati. Just past Aracati there will be a turnoff for Canoa Quebrada. The easiest way to visit is to book a day trip from Fortaleza. See "Organized Tours & Outdoor Activities," below. By bus, the bus company **Viação São Benedito** (© **085/3444-9999** or 088/3421-2020) has departures from Fortaleza's central bus terminal at 8:30am, 11am, 1:30pm, and 4:30pm. Alternatively, there are six daily departures to the city of Aracati, located 9km (5½ miles) from Canoa. Either trip costs R$18. From Aracati it is possible to get a cab or local bus.

CUMBUCO ★★ Located just a 45-minute drive from the city (37km/23 miles east), Cumbuco is where many Fortalezans come to spend a day at the beach. The big attraction? Beach and dunes. The main activity? The dune buggy ride. Drivers are able to take you on a roller-coaster ride over the shifting sands, dropping down steep inclines, swerving over piles of sand as if they were minor speed bumps, and skidding and sliding at almost vertical angles off the face of the taller dunes. **Buggy rides** cost R$100 per hour for a buggy that fits two or three people comfortably. Gentler beach activities include **horseback riding** at R$20 for 30 minutes and **boat rides** on the *jangada* fishing rafts for R$10 per 30 minutes. Cumbuco is also one of the best places near Fortaleza for **kite surfing.** Optimal kite-surfing conditions occur from late June throughout November (check conditions on www.windfinder.com/

forecast/cumbuco). The Dutch owners of **Windtown,** Rua das Cavalas 6 (℃ **085/8819-7887;** www.windtown.nl), have created a facility that offers top-notch windsurfing and kite-surfing lessons, plus a spa and resort that pampers and accommodates surfers and nonsurfers alike. Rooms cost R$160 to R$230. A 3-day basic kite-surfing course (9 hr. of instruction) costs R$720. More experienced kite surfers can also rent all their gear from Windtown. If you want to come out early and make a day of it at the beach, the **Aldeia Brasil** restaurant (℃ **085/3318-7541**) makes a good base. The restaurant has a pool, sun deck, beach chairs, and bar, all of which are available to customers on the understanding that you'll order drinks and snacks and likely lunch at the restaurant. Open daily 9am to 6pm.

To reach Cumbuco, follow the signs for CE-085. The turnoff for Cumbuco is 11km (7 miles) past Coité. For transfers to Cumbuco see "Organized Tours & Outdoor Activities," below.

MORRO BRANCO ★ Most visitors come to see the maze of colored sand cliffs that line the beach. Local guides (who work for a donation, anything from R$5–R$10) will take you through the maze of cliffs, showing off the spots with the best colors. A close-up look at the sand reveals incredible variations in color, ranging from almost pure white to yellow, gold, pink, orange, red, and purple. At the top of the cliffs there are usually artisans working on the region's best-known souvenir, sand-filled glass bottles with intricate designs of colored sands. The beach in itself is not significantly different from other beaches in the region. Allow an hour for a tour of the sand cliffs.

Morro Branco is 85km (53 miles) east of Fortaleza. Take CE-040 to Beberibe, then take the turnoff for Morro Branco (it's approx. 4km/2½ miles from the main junction to the beach). For tours to Morro Branco see "Organized Tours & Outdoor Activities," below.

Downtown Fortaleza

Downtown Fortaleza has some worthwhile sights if you want to take a day off from the beach. Just a short stroll from the Praia de Iracema is the area that the locals call **Casario,** a lovely collection of restored 19th-century colonial buildings, located primarily on the **Rua Dragão do Mar** and **Rua Almirante Tamandaré.** The area really comes to life at night, as most of the historic buildings house nightclubs or cafes. The new centerpiece of this area—built in a contrasting but somehow complementary contemporary style—is the **Centro Cultural Dragão do Mar,** Rua Dragão

 Splish Splash

Beach Park (℃ **088/4012-3000;** www. beachpark.com.br) is located 29km (18 miles) outside the city on Praia do Porto das Dunas, and is the largest water park on the northeast coast. The park features four pools—including the earthquake wave pool with 2.5m (8-ft.) waves—and a number of water slides.

The largest, the *Insano,* boasts a 41m (135-ft.) vertical drop. There are also restaurants and tennis courts for adults. It's open 11am to 5pm. Admission is R$130 adults, R$120 children 12 and under, and children shorter than 1m (3¼ ft.) are free.

do Mar 81 (📞 **085/3488-8600;** Tues–Fri 8:30am–9:30pm, Sat–Sun 2:30–9:30pm). This modern cultural center is built in the shape of a mosque with a white spiraling walkway that rests on an arcade over the historic buildings on the street below. At night, the structure glows with a faint blue light. For the full range of programming at the cultural center, see www.dragaodomar.org.br.

On the waterfront, there's the **Fortaleza de Nossa Senhora da Assunção,** Avenida Alberto Craveiro (📞 **085/3255-1600;** daily 8–11am and 2–5pm). Built by the Dutch in 1649 (as Fort Schoonenborch) in a five-point-star shape, the fort was rechristened after the Dutch were driven from Brazil in 1654.

The highlight of the square is the **Teatro José de Alencar,** Praça José de Alencar s/n (📞 **085/3101-2583**), open for visits Tuesday to Friday 8 to 11am and 1 to 4pm, and Saturday and Sunday 1 to 4pm. At R$4, it's worth a peek. Built in 1908, the theater is a marvel of colorful high-Victorian cast-iron construction, shipped in from Scotland. The gardens, added in 1974, were designed by Roberto Burle Marx.

Organized Tours & Outdoor Activities

Good tour operators in Fortaleza include **Ernanitur,** Av. Barão de Studart 1165 (📞 **085/3533-7700;** www.ernanitur.com.br), and **Girafatur,** Rua Tenente Benévolo 13 (📞 **085/3219-3255;** www.girafatur.com.br). Both offer similar services, such as transfers to Jericoacoara (prices range R$50–R$100 each way) and tours to Cumbuco, Canoa Quebrada, Morro Branco, and Beach Park. Prices at both are around R$40 for a city tour, R$40 to R$50 for Cumbuco, Morro Branco, and Canoa Quebrada, and R$25 for Beach Park (not including admission).

BOAT TOURS **Ceará Saveiros,** across the street from Av. Beira Mar 4293 (📞 **085/3263-1085**), runs two daily boat trips along Fortaleza's waterfront. The morning tour departs at 10am and takes in the city's main beaches. The 2-hour sunset tour leaves around 4pm. Either tour costs R$35 per person; children 5 to 12 are R$15.

WATERSPORTS The urban beaches of Fortaleza have relatively calm waters and are perfect for practicing watersports. **Brothers Wind School** offers a range of equipment rentals as well as lessons. Sailors can take out a laser or Hobie Cat for R$30 per hour. Windsurfers can rent a board for R$30. You can also purchase a

It's July, So It Must Be Carnaval?

Fortaleza's biggest event is **Fortal,** or Carnaval Out-of-Season. The event takes place beginning on the Thursday of the last weekend of July, and attracts up to a million revelers. If you plan to be in town, book your accommodations well in advance. Most of the events take place in Meireles on the Avenida Beira Mar, which gets closed to traffic and covered with bleachers for spectators. The event is similar to Salvador's Carnaval. Each night there are blocos, often with the same well-known artists who perform in Salvador—Olodum, Chiclete com Banana, Timbalada, and Ivete Sangalo. You can either purchase a T-shirt and follow a bloco or buy a seat in the bleachers to watch all the blocos file past. For exact dates and a list of who's playing, see www.fortal.com.br or call 📞 **085/3261-4050.**

shopping IN FORTALEZA

Ceará is known for its quality handicrafts. The most famous souvenirs are the sand-filled glass bottles. Though admittedly touristy, they are as wickedly complex as a boat-in-a-bottle. Other excellent souvenirs include handmade cotton hammocks and local craft *cachaças*. The **Mercado Central,** Rua Alberto Nepomuceno 199 (℃ **085/3454-8586;** Mon–Sat 9am–7pm, Sun 9am–noon), is one of the best crafts markets in the city. The large circular building houses over 500 stalls and small shops selling a variety of handicrafts, including hammocks, lace, T-shirts, leather products, and sweets. Another good place to browse for crafts is the **outdoor market** with hundreds of vendors that takes place nightly from 5 to 10pm in **Meireles.** The other craft you will see everywhere is lace, a tradition brought to Ceará by the Portuguese. The lace-makers (*rendeiras)* create delicate and complicated patterns, requiring enormous amounts of work, which in Fortaleza can still be bought

for relatively little. Look for tablecloths, bedspreads, blouses, place mats, and numerous other items with lace trims. Good-quality lace is available at the crafts markets mentioned above, as well as at the **Centro de Turismo,** Rua Pompeu 350 (℃ **085/3101-5508;** Mon–Sat 8am–6pm, Sun 8am–noon). Housed in the former city jail, it has over 100 crafts stalls (in addition to a tourist information booth that gives out a good free map).

If you are shopping for **clothes,** Fortaleza is one of the cheaper cities in Brazil. One main shopping area lies in Downtown Fortaleza on **Avenida Monsenhor Tabosa.** From Avenida Dom Manuel, 6 blocks down to Rua João Cordeiro, this street is devoted almost exclusively to locally made purses, shoes, and clothing. The other shopping area is on **Rua General Sampaio, Sen. Pompeu,** and **Barão do Rio Branco,** and particularly the side streets around the **Praça José de Alencar.**

package of 8 hours of instruction with 10 hours of free rentals for R$160. Kayaks rent for R$10 an hour. Brothers is located just across the street from the Golden Fortaleza Flat, Av. Beira Mar 4260, in Mucuripe (℃ **085/9984-1967;** daily 8am–5pm).

FORTALEZA AFTER DARK
The Performing Arts

Teatro José de Alencar This high Victorian theater is one of the loveliest venues in Fortaleza, with regular classical music performances by the Eleazar de Carvalho Chamber Orquestra. Call the box office or check out www.secult.ce.gov.br under *"programe-se"* for schedules. Praça José de Alencar s/n, Centro. ℃ **085/3101-2583.**

Clubs & Bars

Fortaleza is well known for its nightlife, with something happening almost every night of the week. The two most happening areas downtown are **Praia de Iracema** and the **Casario,** the historic buildings around the **Centro Cultural do Dragão,** located at **Rua Dragão do Mar** and **Rua Alm. Tamandaré.**

Note: The four bars at the intersection of Rua dos Tabajaras and Tr. Iracema (**Cafe del Mar, Europa, Bikini,** and **Kapital**) are patronized exclusively by working girls and their customers. Bars in the rest of Iracema beach, and elsewhere in Fortaleza, try to prevent prostitutes from entering.

On Monday night, everybody heads down to **Pirata,** Rua dos Tabajaras 325, Praia de Iracema (*©* **085/4011-6161;** www.pirata.com.br). Doors open at 8pm, and after a few warm-up bands, the Pirata band takes the stage around midnight and the party continues until the wee hours. Tuesdays, the crowds leave the beach and head out to Varjota, to **Arre Egua,** Rua Delmiro Gouveia 420 (*©* **085/3267-5610;** www.arreegua.com.br), where things catch fire with the Nordeste musical style known as *forró.*

On Thursday night, locals head out to **Praia do Futuro,** southwest of Mucuripe, for a traditional evening of crab eating (*caranguejada*). The place to be is **Chico do Caranguejo,** Av. Zéze Diogo 4930 (*©* **085/3262-0108;** www.chicodocaranguejo.com.br). Things warm up after 7pm. The band starts around 8:30pm. A taxi is recommended.

Friday through Sunday, the options abound. The historic downtown area around the **Centro Cultural do Dragão do Mar,** Rua Dragão do Mar 81 (*©* **085/3488-8600;** www.dragaodomar.org.br), features at least a dozen bars and nightclubs side by side. Many have live music and almost all have wonderful patios. **O Brasileirinho,** Rua Dragão do Mar, 441 (*©* **085/3219-3701**), has live music Thursday through Sunday. The house band plays samba from Thursday through Saturday, and on Sunday nights it's *forró.* The bar opens at 4pm, and the music usually starts around 10pm.

JERICOACOARA ★★★

233km (145 miles) NW of Fortaleza

The pearl on the Ceará coast, Jericoacoara's attraction is partially its isolation. Visitors can only arrive by 4WD, preferably driven by someone who knows what they're doing; the 18km (11-mile) drive from Jijoca through the constantly shifting sands is not for the uninitiated. The payoff for those who persevere? Miles and miles of gorgeous white-sand beaches, most completely unspoiled, many completely untouched, plus rock formations, lagoons, mangroves, palm trees, and a Sahara desert landscape of towering, beautiful sand dunes, some over 30m (100 ft.) tall.

In recent years this formerly sleepy fishing village has gotten, if not exactly crowded, certainly much more visited. The region is now an environmental protection zone, with laws forbidding the construction of new hotels and pousadas within the protected area and guidelines for garbage and recycling. These rules have preserved the laid-back charm of the area. Streets are still made of sand; local transportation is by foot or buggy. Still, in high season it can be busier than you'd expect in paradise, so plan your travel for the shoulder season (Aug–Nov and late Mar to June).

For visitors, Jeri (as locals call it) offers buggy tours, hikes, sand boarding, and visits to freshwater lagoons. Beyond that, there's the wind; Jeri is one of those places—like the Gorge in Oregon—with the kind of consistent near-gale beloved by top-notch windsurfers and kite surfers, especially from June until November. A useful tourism website is **www.jericoacoara.com.br.**

Essentials
GETTING THERE

Jericoacoara is 300km (186 miles) west of Fortaleza. There are essentially two ways to get there—the cheaper and quicker way is by bus or minibus along the state highways, with the last short stretch across the sand. The trip takes 6 to 7 hours. The agencies listed in "Organized Tours & Outdoor Activities," above, all offer this kind of transfer. The other way is to travel by Land Rover, traversing the many beautiful beaches that lie between Fortaleza and Jeri. For this kind of tour, contact **Jeri Off Road** (C **088/3669-2268,** or 088/9971-3330; www.jeri.tur.br), which offers both 1-day and 2-day transfers that include a lot of off-road driving and scenic beaches such as Cumbuco, Lagoinha, Mundaú, and Baleia (R$750 for three to four people). *Tip:* We don't recommend renting a car if you are going to Jeri. The road from Fortaleza is bad, and stops before reaching Jeri in any case. For those who do opt for this route, from Fortaleza take the CE-085 west to Barrento and then connect to the BR-402 to Jijoca. In Jijoca you will have to park and leave your car. The last 23km (14 miles) from Jijoca are completed by 4×4 as regular cars are not able to handle the sand dunes and poor road conditions.

Tip: Jericoacoara has no banks. Most hotels, restaurants, and shops take credit cards, but bring enough cash to pay local tour guides and cover small purchases. In high season, Jeri gets absolutely packed, which may well affect your experience. If you do come in high season make sure you reserve accommodations and transfers well ahead of time. Finally, allow plenty of time for your return transfer, especially if catching a flight from Fortaleza on the same day. The moving dunes, tides, and changing water levels may affect transfer times.

GETTING AROUND

The village of Jeri only boasts a handful of sand-covered streets, and all hotels, restaurants, and shops are within easy walking distance. Make sure you bring flat shoes.

Exploring Jericoacoara

Jeri's attractions all involve the outdoors, be it on land, lagoon, or sea. Two of the top attractions, the Sunset Dune and Pedra Furada Rock, are within a short walk of the village. Every day, about half an hour before sunset, visitors and residents walk up the 30m-high (100-ft.) dune on the edge of town for a spectacular view of the setting sun. To reach the town's other landmark, Pedra Furada (a large rock with a hole in the center), requires a 30- to 45-minute walk (depending on the tide). Alternative modes of transportation include horseback or dune buggy (see below).

The two most popular day trips around Jericoacoara are Tatajuba and Lagoa Azul. Both destinations can be reached only by dune buggy as there are no roads. Make sure you bring plenty of sunscreen. The visit to Tatajuba takes you over some impressive large sand dunes, across river estuaries and long stretches of mangrove and beach, and it includes a stop at a small lagoon to observe sea horses in their natural habitat. The day trip to Lagoa Azul covers less terrain (or sand) but in compensation takes you to several beautiful lagoons where you can enjoy a swim and lunch. In some of the smaller dunes your driver will be able to show off his car-handling skills in the deep sand. You will also drive along Praia do Préa, one of Brazil's top beaches for kite surfing (high season for kite surfing is July–Nov). A day trip costs R$220 to R$250

for a buggy and driver. Each buggy can take up to four people, but you will have more fun with three people so that everybody can sit in the back. Contact **Jeri Off Road** (see below) or the **Buggy Association** (℡ 088/3669-2284) to reserve.

OUTDOOR ACTIVITIES

Jeri Off Road (℡ 088/3669-2268 or 088/9958-5457; www.jeri.tur.br) is one of the outdoor specialists offering a variety of sightseeing buggy tours and expeditions from Jeri to other destinations.

HORSEBACK RIDING Jericoacoara's unpaved streets and dune trails are perfect for horseback riding. However, tours are best suited for more experienced riders. There are no organized tours, only local guides (who don't speak English) with a couple of horses. A perfect late afternoon tour takes you along a narrow trail above the steep cliffs to Pedra Furada and then across the village to the Sunset Dune. There is nothing more amazing than galloping at full speed through the deep sand to the top of this huge dune to be rewarded with a fabulous sunset. Guides and horses gather outside the Vila Kalango. A 2-hour ride costs R$40 per person.

KITE SURFING **Clube dos Ventos** (℡ 088/3669-2288; www.clubedosventos. com) is kite-surfing central in the heart of Jericoacoara. The facility has new, top-grade gear for rent. Price (with prebooking) is R$140 per day, R$725 per week. Their website has loads of details on gear and wind conditions (including a daily wind report). Private lessons start at R$125 for 1½ hours, including equipment. Staff are avid surfers themselves and can put together a customized package according to your level, interest, and time availability.

Where to Stay

In many ways Jeri remains a rustic spot—no paved streets, no bank machines, but that doesn't mean you need to suffer. A number of excellent small hotels have set up shop recently. One of our favorite hotels in town is **Vila Kalango,** Rua das Dunas 30 (℡ 088/3669-2290; www.vilakalango.com.br; R$260–R$310 double, R$345–R$425 bungalow). This idyllic hotel is located on the beach, right on the edge of the village overlooking the sunset dune. The best accommodations are the rustic (but very comfortable) round bungalows on stilts that make the most of the breeze and the view. Those who prefer a more traditional hotel will enjoy the **Mosquito Blue,** Rua da Farmacia s/n (℡ 088/3669-2203; www.mosquitoblue.com.br; R$270–R$360 double). In addition to luxurious accommodations, the hotel also features an outstanding spa and restaurant. Less expensive but still comfortable is **Pousada do Capitão Thomáz,** Av. Beira Mar 202 (℡ 088/3669-2221; www.capitaothomaz. com.br; R$220 double). For the ultimate romantic getaway, stay at the **Chili Beach Hotel,** Rua da Igreja s/n (℡ 088/9909-9135; www.chilibeach.com; R$950 double high season, R$500–R$650 double low season). With only six rooms, this hip boutique hotel combines Miami chic with Brazilian hospitality. Rooms feature the latest gadgets and deluxe amenities, such as an iPod docking station, flatscreen TV, Wi-Fi, light dimmers, and 1,000-thread Egyptian cotton sheets. The restaurant is fabulous and the deck (which you will have practically all to yourself) overlooks an almost deserted stretch of beach.

Where to Eat

Jeri is small enough that you can set out on foot (no heels please, the streets are made of sand) and explore the various restaurants. The variety and quality is surprisingly

high. **Mosquito Blue's Oceano Restaurant,** Rua da Farmacia s/n (© 088/3669-2203), has one of the best locations right on the beach. The kitchen serves international cuisine with an emphasis on fresh fish and seafood. At night the candlelit tables by the beach make for pleasant outside dining. On Jeri's main street you will find **Leonardo Da Vinci,** Rua Principal 40 (© 088/3669-2222). The kitchen prepares excellent steak and fish dishes and the stuffed pastas are made from scratch. The scrumptious desserts come from the outstanding bakery next door. Also on the main street is the cozy eatery of **Pimenta Verde,** Rua São Francisco s/n (© 088/3669-2202). The cook serves excellent steak, fish, and pasta dishes, accompanied by steamed vegetables, rice, or potatoes. For a snack or a light meal try **Naturalmente Creperia,** Rua da Praia s/n (no phone). This small eatery on the beach, next to the Kite Center, prepares delicious sweet and savory crepes, as well as juices and salads.

SÃO LUIS &
THE LENÇÓIS
MARANHENSES

12

t was the French, not the Portuguese, who founded the city of
São Luis. In 1612, a French colony 500 strong under the com-
mand of Daniel de la Touche, Sieur de la Ravardiere, established
a fortress and city that they named in honor of King Louis XIII.

Ironically enough, almost 400 years later, French and other visitors flock
to São Luis because its historic center, better than almost any city in
Brazil, preserves the look and feel of a traditional Portuguese city.

The northeast coast of Brazil was a void on explorers' maps when the
French colonists arrived. Though Portuguese cities farther south such as
Salvador and Olinda were already thriving, winds and currents conspired
to isolate this part of the coastline. It was quicker to sail from Olinda to
Lisbon than it was from Olinda up the coast to Belém. The French hoped
to take advantage of this gap to establish a successful commercial and
missionary settlement before the Portuguese even noticed.

It was not to be. The Portuguese rallied, and by 1615 succeeded in
driving out the would-be French colonists. Portugal took over the colony,
but kept the name bestowed by the French.

São Luis's heyday came in the 18th and 19th centuries, when the city
grew rich on the export of sugar, cattle, and especially cotton. Sometime
in the 1820s, the fashion spread among São Luis's rich middle classes of
covering their houses with Portuguese ceramic tiles. Not only were the
blue, yellow, and green tiles ornate and beautiful, but they also reflected
the sun and kept houses cooler. São Luis became one of the richest, most
beautiful cities in the Northeast.

But in the late 1800s, the Maranhão economy went into a steep
decline. The end of slavery spelled the end of cheap cotton and sugar,
while the city's tidal port grew too shallow for the new large ships of the
steam age.

Marooned in an economic backwater, the center of São Luis—tiles and
all—survived the 20th century intact. Restoration work on the city's old
center began in 1989, culminating with the recognition in 1997 of the
historic center of São Luis as a World Heritage Site.

Though still one of Brazil's poorer states, Maranhão has lately seen an upswing. With a new deepwater port, São Luis now serves as the export point for iron ore mined in the interior. Brazil's satellite-launching facility is located across the bay from São Luis near the city of Alcântara. Tourism is also a growing force in the economy, but remains very much in its infancy.

Visitors to São Luis can wander the streets of a beautiful colonial city without the crowds now found in Salvador. They can also savor the strong musical culture of São Luis, expressed in its love of reggae and in the yearly celebration of bumba-meu-boi.

Farther afield, there is the chance to visit the Lençóis Maranhenses, a desert of snow-white sand dunes whose low points are full of water—truly one of the most intriguing natural landscapes in Brazil.

ESSENTIALS

2,262km (1,405 miles) N of Rio de Janeiro, 2,340km (1,454 miles) N of São Paulo.

Getting There

BY PLANE Gol (© 0300/115-2121; www.voegol.com.br) and **TAM** (© 0800/570-5700 or 098/4002-5700; www.tam.com.br) have flights to São Luis. The airport, **Marechal Cunha Machado,** Av. Dos Libaneses s/n, Tirirical (© 098/3217-6101), is 13km (8 miles) from the city center. A taxi to the centro histórico costs R$40.

BY BUS Buses arrive at the **Terminal Rodoviário de São Luis,** Av. Dos Franceses s/n, Santo Antonio (© 098/3249-2488), 10km (6 miles) from the centro histórico.

BY FERRY Ferries to Alcântara depart from the **Terminal Hidrovário** (© 098/3232-0692), located opposite the Reviver area in the centro histórico. Ferries depart daily at 7am and 9:30am, and return at 8:30am and 4pm. Note that if the tide is out, ferries depart from the beach at Ponta d'Areia. Also, ferry departure times are only approximate. It's best to check at the ferry terminal the day before departure.

City Layout

The city of **São Luís** sits on the **Ilha São Luis,** a vast low-lying alluvial island that floats between two large river estuaries, the **Baía São Marcos** (to the northwest) and the **Baía São José** (to the southeast). Small tidal inlets—called *igarapés*—divide the island into numerous smaller islands and peninsulas. The oldest part of the city—called the **centro histórico**—sits on one of these peninsulas, almost completely surrounded north and south by wide *igarapés*.

The old city's oldest section lies at the very tip of the peninsula. It is here (tide willing) that the ferries to Alcântara dock, and where in times past ships used to unload their cargos. On maps this area is often labeled **"Praia Grande."** In recent years, as the city has poured money into renovating old buildings and bringing the old city back to life, the area has been renamed the **Reviver.**

Roughly speaking, the Reviver runs from the ferry dock east past the old Customs house and along the cobblestone streets up the steps to the **Praça João Lisboa,** and from the small rise in the north that holds the fort and governor's palace (**Palacio dos Leões)** and south as far as the **Convento das Mercês.**

São Luis

HOTELS ■
Hotel Pousada Colonial **15**
Pestana São Luis **1**
Pousada Portas
da Amazônia **13**
Rio Poty **1**

RESTAURANTS ◆
Antigamente **11**
Cabana do Sol **2**
Kitaro Lagoa **2**
Maracangalha **2**
O Armazén da Estrela **12**
Por Acaso **2**
Restaurante Senac **9**

ATTRACTIONS ●
Casa das Tulhas **10**
Casa do Maranhão **8**
Centro de Cultura Popular **14**
Convento das Mercês **17**
Igreja da Sé **5**
Museu do Negro/Cafua das
Mercês **16**
Museu Historico e Artistico
do Maranhão **3**
Palacio dos Leões **7**
Palácio la Ravardiere **6**
Teatro Arthur Azevedo **4**

The city has long since spread beyond the original small peninsula. Two bridges lead from the north side of the original peninsula into the newer parts of São Luis. Closest to the mouth of the estuary, the **José Sarney bridge** (named for a former Brazilian president and Maranhão governor) turns into the **Avenida Castelo Branco** (named for a former president and dictator) which leads to the **São Francisco** neighborhood. This is São Luís's small central business district. It has a few banks and office towers, but is otherwise completely lacking in sights or restaurants or anything else of interest to tourists.

Beyond a roundabout at the top end of São Francisco, the road turns into **Avenida Ana Jansen,** which leads past the **Lagoa de Jansen** and then out to the first of the city's beach neighborhoods, **Ponta d'Areia.** The city recently installed a boardwalk

and small park on the north side of Lagoa de Jansen, then encouraged bars and restaurants to move in, transforming the lake into one of São Luis's most popular dining and nightlife areas.

In Ponta d'Areia, the Avenida Jansen becomes **Avenida dos Holandeses,** a wide, busy highway that runs parallel to the coast forming the commercial backbone for the beach neighborhoods of **Praia de São Marcos, Praia do Calhau, Praia do Caolho,** and **Praia Olho d'Agua.** Most of the hotels in these neighborhoods are located on the seaside Avenida Litorânea, which splits from Avenida dos Holandeses in Praia de São Marcos and travels out along the shoreline.

Getting Around

BY BUS São Luis is a big spread-out city, not really ideal for bus travel. Buses to the old city are marked PRAIA GRANDE. Buses to the beach neighborhoods are marked PONTA D'AREIA or PRAIA CALHAU. Buses cost R$2.10. You board through the front.

BY TAXI Taxis are widely available. To reserve, phone **Cocoma** (© 098/3231-1010) or **Coopertaxi** (© 098/3245-4404). A taxi from Ponta d'Areia to the centro histórico costs about R$15 to R$25.

Visitor Information

São Luis's airport has a tourist information booth in the arrivals hall that's open daily from 8am to 6pm (© 098/3244-4500). In the city, there is a state tourist information office in the centro histórico on Praça Benedito Leite, Rua da Palma 53 (© 098/3212-6211), open Monday to Friday 8am to 7pm, Saturday, Sunday, and holidays 9am to 2pm. Both give out an excellent free map of the old city.

[FastFACTS] SÃO LUÍS

Area Codes The area code for São Luís is **098.**

Banks In the centro histórico, you'll find **Banco do Brasil** (© 098/3215-4992) on Av. Dom. Pedro II 78, in front of the Palácio dos Leões; **Banco do Brasil** is also in the Reviver at Travessa Boa Ventura 26-B (© 098/3232-8507).

Car Rentals In São Luis airport is **Avis** (© 098/3245-5957); **Localiza,** also at Av. Dos Holandeses lotes 7 e 8 (© 098/3245-1566); and **Unidas** (© 098/3244-1597).

Dentist **Clínica Odontológica Maranhão,** Rua

Grande 1164, Centro (© 098/3232-7144).

Emergencies Dial © **190** for police, © **193** for fire department, © **192** for ambulance. The **Tourist Police** station is on Rua da Estrela 427 in the centro histórico (© 098/3214-8682).

Hospital **Santa Casa de Misericórdia,** Rua do Norte 233, centro histórico (© 098/3221-0144 or 3232-0248).

Mail The main post office is on Praça João Lisboa 290 in the centro histórico. There is another post office in the airport terminal. Both are open Monday through Friday from 9am to 4pm.

Pharmacies Reliable pharmacies are **Farmácia Gonçalves,** Rua das Hortas 379A, centro histórico (© 098/3232-1072), and **Extrafone,** which delivers 24 hours daily (© 0800/983-000).

Weather São Luís, just below the equator, has a pleasant, warm climate year-round, with average temperatures of 28°C (82°F). Most rain falls in winter (July–Sept). The most pleasant months are March through June; it's warm but not as hot as in December through February.

WHERE TO STAY

There are essentially two options in São Luís, the centro histórico or the beach neighborhoods such as Praia d'Areia and Praia de Calhau. The centro histórico offers beautiful surroundings, some nice restaurants, and a busy nightlife scene in the Reviver area. However, there are no full-service hotels, and the few pousadas have only a limited number of rooms. The beaches have lovely resort-style hotels, but they are a 20-minute cab ride from the attractions of the old city.

Centro Histórico
MODERATE

Hotel Pousada Colonial The Colonial looks gorgeous from the outside—an old colonial mansion covered with intricate Portuguese tile—but inside the rooms can be a tad cramped, the walls and floors a bit scuffed up. All rooms feature either a firm queen-size bed or two single beds, plus small functional bathrooms with showers. The two best rooms—nos. 201 and 202—have large bright windows looking out on the street. The worst room—no. 105—is small and dark, and should be avoided at all costs. Between these extremes, the Colonial offers clean, functional accommodations in the heart of the centro histórico. If you can, stay at the Pousada Portas de Amazônia, but if that's unavailable the Colonial is a serviceable backup.

Rua Alfonso Pena (Rua Formosa) 112, Centro Histórico, São Luis, 65080-680 MA. www.hotel pousadacolonial.com.br. ⓒ/fax **098/3232-2834.** 27 units. R$125 double. Extra person add R$30. AE, DC, MC, V. Bus: Praia Grande. **Amenities:** Room service; Wi-Fi. *In room:* A/C, TV, fridge, minibar.

Pousada Portas da Amazônia ★★ The nicest place to stay in São Luis is this renovated colonial mansion in the heart of the old city. The best rooms, called master suites (nos. 1, 2, 15, 16, 17, 24, 25, and 26—the best of the best is no. 16) are vast and high ceilinged, with tall colonial windows looking out on the small cobblestone square. Master suites also feature firm queen-size beds, often raised up on a small dais. Standard rooms are not as bright or spacious, with windows facing the courtyard. Bathrooms in the standard rooms are also a tad cramped. Breakfast is excellent.

Rua do Giz 129, Praia Grande, São Luis, 65080-680 MA. www.portasdaamazonia.com.br. ⓒ **098/ 3222-9937.** Fax 098/3221-4193. 35 units. High season R$130 standard; R$190–R$210 master. 20%–30% discount in low season. Extra person add about 20%. Children 7 and under stay free in parent's room. AE, DC, MC, V. No parking. Bus: Praia Grande. **Amenities:** Wi-Fi. *In room:* A/C, TV, fridge, minibar.

Beaches
EXPENSIVE

Pestana São Luis ★★ Though a little far from the centro histórico, the full-service Pestana has the advantage of a lovely location on Praia do Calhau, the city's nicest beach. Formerly the Park, the hotel was recently bought and renovated by the Pestana group. Rooms feature tile floors, firm queen-size (or two twin) beds, and a private balcony. What really sets the hotel apart, however, are its amenities—a large outdoor pool and children's pool, tennis courts, a grass soccer field—and its location on the beach. The drawback, of course, is that the sights in the centro histórico are a R$25 cab ride away.

Av. Avicênia 10km, Praia do Calhau, São Luis, 65071-370 MA. www.pestana.com. ⓒ **098/2106-0505.** Fax 098/2106-0500. 111 units. R$392–R$529 double. Children 7 and under stay free in parent's

room. AE, DC, MC, V. Free parking. Bus: Praia Calhau. **Amenities:** Restaurant; bar; weight room; outdoor pool and children's pool; room service; sauna; tennis courts. *In room:* A/C, TV, fridge, minibar, Wi-Fi.

Rio Poty ★ Located on the beach on Ponta d'Areia, the new Rio Poty is the best beach hotel closest to the centro histórico. The hotel's striking inverse ziggurat form means every room gets a view of the sea. Rooms include queen-size beds (king-size in luxury rooms and suites), tile floors, small granite desks and workspaces with Internet, and clean, basic bathrooms with tubs and showers. The large leaf-shaped pool—with little Jacuzzi islands—fans out over a vast sun deck looking out over the beach. There is little or nothing within walking distance, but the hotel itself offers a number of restaurants and bars (including a disco). The nightlife scene by the Lagoa Jansen is but a R$5 cab ride away; getting to the centro histórico will cost about R$20 by cab.

Av. dos Holandeses 4km, Praia da Ponta d'Areia, São Luis, 65077-310 MA. www.riopotysaoluis. com.br. ✆ **098/3311-1500.** 142 units. R$368–R$415 double. Children 7 and under stay free in parent's room. AE, DC, MC, V. Free parking. Bus: Lagoa Jansen. **Amenities:** Restaurant; bar; weight room; outdoor pool; room service; sauna. *In room:* A/C, TV, fridge, Internet, minibar.

WHERE TO EAT
Centro Histórico

Restaurants in the centro histórico cater mostly to tourists, and they usually look better than they taste. Expect mostly Brazilian food such as *carne seca* (lightly salted dried beef), seafood stews, or grilled steak with fries and *farofa*. Farther out, there are a number of good restaurants by the edge of the Lagoa de Jansen.

Antigamente 🍴 BRAZILIAN Surely one of the prettiest restaurants, Antigamente is also lively and fun. The restaurant is located inside a renovated heritage building in the old city and has gorgeous mosaic floors and rustic furnishings. In the evenings, it's one of the more happening restaurants with a great patio. The food, alas, is disappointing. Better to have a snack and just enjoy the atmosphere.

Rua da Estrela 220, Centro Histórico. ✆ **098/3232-3964.** Main courses R$12–R$39; the more expensive dishes are for 2. MC, V. Mon–Sat 10am–midnight.

O Armazém da Estrela ★ BRAZILIAN This place is a mix of bar, restaurant, sandwich deli, and cybercafe, housed in a lovely two-floor mansion in the heart of the old city. Most nights, there's live music.

Rua da Estrela 401, Centro Histórico. ✆ **098/3254-1274.** Main courses R$12–R$44. AE, MC, V. Mon–Fri noon–midnight; Sat 6pm–1am.

Restaurante Senac ★ BRAZILIAN This lovely two-story historic building houses the restaurant of the regional hospitality industry training institute where students learn on the job. The lunch buffet is an excellent deal. For R$29 to R$35 (including dessert) you can feast on a variety of freshly prepared dishes. The most popular days of the week are Friday (seafood and fish), and Saturday (traditional *feijoada*). The restaurant also opens for dinner (Thurs–Sat only) with an a la carte menu of regional dishes.

Praça Benedito Leite s/n, Centro Histórico. ✆ **098/3198-1100.** www.ma.senac.br. Main courses R$24–R$43. AE, DC, MC, V. Mon–Sat noon–3pm; Thurs–Sat 7–11pm.

Ponta d'Areia/Calhau

Cabana do Sol ★ BRAZILIAN Cabana do Sol is one of São Luis's best known regional restaurants. People come in droves to try out the food; the spacious open veranda-like structure can seat several hundred people, but thanks to a small army of waiters things go smoothly here. The dishes are huge, often enough for three people. Meat dishes, like *carne de sol,* suckling pig, and roasted goat are the kitchen's forte. These are served on a large platter, hot off the grill, and come with a variety of the usual side dishes including rice and *farofa.* The menu also includes some fish and seafood options, but for more interesting dishes we recommend going to Maracangalha.

Rua João Damasceno 24, Ponta do Farol. ✆ **098/3235-2586.** www.cabanadosol.com.br. Main courses R$44–R$70 for 2 or 3. AE, DC, MC, V. Daily 11am–midnight. Bus: Ponta d'Areia or Culhau.

Maracangalha ★★ BRAZILIAN One of the best restaurants in town for fresh seafood dishes is this tongue-twister, Maracangalha, run by celebrity chef Dantas, an avid promoter of regional cuisine. One of our favorites is the grilled anchovy (nothing like those tiny salty slivers); this large fish is seasoned and grilled on a charcoal fire. The tender white meat is served with a number of side dishes, including the famous *cuxá* rice. Another popular dish is the *caldeirada,* the Northeast's version of a bouillabaisse, a delicious seafood stew. The restaurant doesn't close between lunch and dinner, making it a popular après-beach destination.

Rua Parnaiba 12 (off Av. dos Holandeses), Renascença. ✆ **098/3235-9305.** Main courses R$52–R$70 for 2 or 3. DC, MC, V. Mon–Sat 11:30am–midnight; Sun till 5pm. Bus: Ponta d'Areia or Culhau.

Lagoa Jansen

Kitaro Lagoa ★ JAPANESE/BRAZILIAN Pretty much every self-respecting Brazilian town must have a trendy Japanese restaurant, and São Luis is no different. Overlooking the lagoon, Kitaro is a Zen oasis with soft lighting and modern furniture. The best tables are those that look out over the water, either inside or out on the patio. The menu covers the basics from sushi to tempura, teriyaki, and yakisoba noodles. Lately, the kitchen has been branching into regional Brazilian cuisines, including a delicious *moqueca* made with *jabiraca* (a local freshwater fish considered by some as tasty as cod). The restaurant has live music every night, usually starting around 9pm, and the kitchen is open late, until 3am on Friday and Saturday.

Av. Mario Meireles s/n, Lagoa de Jansen–Ponta d'Areia. ✆ **098/3227-2416.** Main courses R$22–R$45. MC, V. Tues–Thurs and Sun 5pm–1am; Fri–Sat 5pm–3am. Bus: Ponta d'Areia.

Por Acaso ★ BRAZILIAN Just down from Kitaro, also on the lagoon, is a great casual *chopperia.* This bar/restaurant is one of the more happening places at night. Even on a Wednesday evening it is packed with locals enjoying a beer and helping themselves to the outstanding antipasto buffet. The restaurant actually has a pretty decent menu with excellent steak and seafood dishes but the buffet is a meal in itself; a selection of cheeses, cold cuts, various salads, olives, marinated eggplant, sun-dried tomato, homemade dips, fresh bread, and more. There's nothing better than snagging a table by the window, ordering a few cold chopps, and making several trips to the buffet to try out the tasty nibbles. Live music daily at 8pm.

Av. Mario Meireles s/n, Lagoa de Jansen–Ponta d'Areia. ✆ **098/3235-9881.** Main courses R$16–R$35. MC, V. Tues–Sat 5:30pm–1am. Bus: Ponta d'Areia.

EXPLORING SÃO LUIS

Perhaps for lack of other options, São Luis takes tourism seriously. The city does an excellent job in several small museums presenting the culture and history of the region. Many of the museums in the old city offer visually attractive and informative displays, professionally presented by engaging and informative museum guides. Even better, most of them are free.

The Centro Histórico ★★★

"The Historic Center of São Luis do Maranhão is an outstanding example of a Portuguese colonial town that adapted successfully to the climatic conditions in equatorial South America and which has preserved its urban fabric, harmoniously integrated with its natural setting, to an exceptional degree." So read the UNESCO declaration, giving the center of São Luis a World Heritage designation in 1997.

The centro histórico formed the heart of São Luis through the 19th-century boom years, but went into decline in the 1920s. Restoration started only in 1989, under pressure from state governor Jose Sarney, and continues to today. The neighborhood still lacks modern water and sewer systems. There is also controversy over whether the historic center should be a tourist enclave or a real residential neighborhood. After fixing up buildings, the state government wants to turn them over to owners with the financial wherewithal to maintain them. That rules out the poor and working classes who for nearly a century have made the neighborhood their home. It's a problem that has not yet been resolved.

The centro histórico sits on a peninsula, almost completely surrounded north and south by wide *igarapés*. Twice every 24 hours the tide sucks the water from the estuary, leaving the city completely cut off from the ocean. If this seems an odd place to put a seaport, recall that the French expeditions that founded the city were interested mostly in defense. The old city is effectively an island, protected by the tides from large warships and their guns.

The **Reviver** area, the oldest part of the old city, lies at the very tip of the peninsula, to the east of the Jose Sarney bridge. This area contains most of the centro histórico's museums, and interesting streets and monuments.

The best plan is just to go for a stroll. Numerous antique buildings have been renovated into museums or tourist attractions of one kind or another. The best are given separate listings below. But just as rewarding is the fine-grained texture of the old city, and the serendipitous discovery of a lovely colonial building covered in brilliant blue or yellow tile.

The best place to start a walk is by the **Casa do Maranhão ★★**, just opposite the ferry terminal to Alcântara. The **Rua Portugal** is just around the corner. This narrow, cobblestone street features numerous restored colonial buildings from the 18th and 19th centuries, many covered in bright patterned tile. Close to the end of the street, one comes to a small indoor market, the **Casa das Tulhas ★**, Rua da Estrela 184 (Mon–Fri 6am–8pm, Sat 6am–6pm, Sun 6am–1pm).

Rua Portugal dead-ends at **Rua da Estrela.** This is the heart of the Reviver area. At night this wide, tree-shaded street is full of cafes and musicians. Parallel to Rua da Estrela 1 block farther in is **Rua da Giz.** This lovely colonial street serves as a kind of crossroads leading to many more of the old city's attractions.

Turn right on Rua da Giz and proceed uphill and you come to a small formal square, **Praça Benedito Leite.** The far side of the square is formed by the **Igreja**

da Sé (© 098/3222-7380; Tues–Fri 8am–6:30pm, Sat 8am–noon and 3–6:30pm, Sun 8am–noon and 4–7pm) and the **Bishop's Palace.** Just around the corner lies Avenida Pedro II, a broad ceremonial boulevard on which you find the **Palacio La Ravardiere,** which houses city hall, and the Palacio dos Leões, which was built on the foundations of the city's original fort, Fort Saint Louis. Guided visits through the upstairs salons of the **Palacio dos Leões** (© 098/3232-9789; Mon, Wed, and Fri 2–5:30pm, Sat–Sun 3–5:30pm) show furniture and oil paintings from the 18th and 19th centuries, none especially distinguished.

Turn left on the Rua da Giz and you come first to the **Centro de Cultura Popular ★★** (see below), and then at the far end of the street to the pretty **Convento das Mercês,** and the **Cafua das Mercês,** which is now home to the small **Museu do Negro** (no phone; Mon–Fri 9am–6pm). During the slave era, the courtyard inside the Cafua was used as an enclosure to keep slaves newly arrived from Africa penned up before they could be auctioned. A whipping post is still in evidence.

Go straight uphill from the Rua da Giz and you come to **Praça Joao Lisboa,** a rather ugly central square, with the **Teatro Arthur Azevedo** on one side. Built in 1817, the neoclassical Teatro reopened in 2006 after lengthy renovations (guided visits Tues–Fri 2–5pm; R$2; © 098/3218-9900, ext. 33).

East of the Praça João Lisboa, the centro histórico becomes less touristed and more residential. Many of the buildings in this part of the centro histórico are just as historic and picturesque as down in the Reviver area, while the atmosphere is that of a working-class Brazilian neighborhood. In daylight hours it's a fine place to stroll and discover; however, at night it is best to be avoided. Highlights of this part of the old town include the **Museu Historico e Artistico do Maranhão ★★** (see below) and the **Mercado Central** (daily 6am–5pm), the city's large public market, located at the far end of Avenida Magalhães de Almeida.

Centro de Cultura Popular ★★ The arid Northeast is one of the richest sources of folklore and folk festivals in Brazil. Located in a four-story mansion in the old city, this museum has dioramas and mannequins presenting many of these rich folk traditions. Included is bumba-meu-boi in all its various accents, as well as the rhythms such as the *tambor de crioula,* and more religious spiritual festivals such as the *Festa do Divino.* A highlight is the superb collection of photographs of folk festivals around the state, many showing the often aged matriarchs who rule these festivals decked out in all their sumptuous regalia. Guides should, but may not, speak English.

Rua do Giz 221, Centro Histórico. © **098/3218-9924.** Free admission. Tues–Fri 9am–7pm; Sat–Sun 9am–6pm.

Museu Historico e Artistico do Maranhão ★★ If you want to get a sense of how the elite of 19th-century São Luis lived, visit the Historical Museum of Maranhão. The museum is located in a mansion built in 1836, which has been restored and decorated with the heavy wood furniture, porcelain, crystal, and artwork favored by the commercial aristocracy of the time. Tours are guided, though in Portuguese only, and there is little explanatory signage. Allow 30 minutes (or more if you're an *Antiques Roadshow* person).

Rua do Sol 302, Centro Histórico. © **098/3218-9922.** Admission R$5. Tues–Sun 9am–5pm.

Alcântara ★★

A visit to Alcântara makes a great day trip. An hour's ferry ride north across Baía São Marcos, the village of Alcântara is a curious thing, a struggling small town living

BUMBA-MEU-BOI

It's a festival celebrated throughout Brazil under a host of names—*boi-bumbá, boi calemba, boi surubim, boi zumbi*—but locals insist that Maranhão is Brazil's leading stronghold of bumba-meu-boi. Through music, costume, and drumming, the festival tells the story of the life and death and rebirth of a magical Brazilian bull.

The bull belongs to a wealthy rancher. Pai Chico, a peasant working for the rancher, steals the bull, kills it, and feeds its tongue to his pregnant girlfriend, Catirina, to satisfy her cravings. Discovering the deed, the rancher condemns Pai Chico and Catirina to death. It looks dark for the pair, but St. John warns the rancher in a dream not to kill the couple. Pai Chico and Catirina go to the *curandeiros*, the community's traditional healers, and with the help of everyone in the village, they magically drum the bull to life again.

In Maranhão, bumba-meu-boi has evolved into a kind of competition. Dozens of different groups—normally organized by neighborhood—hold their own bumba-meu-boi celebrations, competing with each other to see who can put together the best costumes and put on the best party. The music played by each group belongs to one of about five rhythms, or *sotaques* (accents), each of which has its own set of instruments. The *matraca sotaque* uses wooden blocks that musicians rap together to create complicated percussion rhythms. The *zabumba sotaque* uses only long wooden drums covered in snakeskin. Each *sotaque* also has its own elaborate costumes, and each group has its own magic bull.

Though made of a wire frame and papier-mâché (a dancer goes inside to act out the part of the bull), the bull is an important creature. A new bull is created each year, and the parties held by each bumba-meu-boi group mark the milestones in the magic bull's existence.

Rehearsals begin on the Saturday before Easter (these are open to the public). In early June, the bull is taken to the church to be baptized (after which there is a party). Different groups choose different dates for the christening. The most popular date is June 23, the day of São João (there is usually a party on this day). On June 29, all the bumba-meu-boi groups bring their bulls to the church of São Pedro in the Madre Deus neighborhood. And on June 30, all of São Luis comes to a halt as 200 or more bumba-meu-boi groups bring their bulls out to celebrate the feast of São Marçal, mostly in the João Paulo neighborhood.

The last step in the bull's life is the *morte do boi*, the death of the bull, which each group holds on a different day, anytime between June 30 and the end of December. For those who want to take part in the festivities, local papers publish the dates and locations where the different groups are celebrating the birth, blessing, life, and death of their bull.

inside the ruins of a once-thriving colonial city. In the boom years of the 18th and 19th centuries, Alcântara was a regional capital, the place where the merchant and plantation elite kept their families and traded their sugar and cotton. With the end of slavery in 1888, the plantation economy crashed and the merchants and planters fled, leaving the half-empty city in the hands of newly freed slaves and their descendants.

In 1948, the city was declared a historic site, primarily for its lovely collection of colonial houses with ornately decorated doors and coverings of bright Portuguese tile.

Called Windows and Doors (in Portuguese, Portas e Janelas), the style is both functional (the tile reflects the heat) and extraordinarily pretty.

A visit to Alcântara involves strolling down the main cobblestone street that leads from the port up the hillside through a series of small squares to a beautiful ruined church on a hilltop. Along the way are hundreds of beautiful houses to admire, and at least six ruined churches to poke about.

There are also three fine, small museums. The best, the **Casa Historica do IPHAN Seculo XVIII** (IPHAN 18th-Century Historical House; Praça Gomes de Castro s/n; no phone; daily 9am–2pm), is a huge colonial mansion filled with paintings, porcelain, furniture, and all of the belongings of a rich merchant family, including the still-intact slave quarters in the interior courtyard. Guides do an excellent job telling the history of the house and the families that built it. Admission is R$1.

Everything in Alcântara is very laid-back. Local residents pretty much leave you to wander their city. There are a few gift shops and numerous small restaurants, which make good places to do as the locals seem to be doing—trying to keep cool in the blazing heat.

Brazil's satellite-launching center is just 5km (3 miles) away, but has been off-limits to visitors since a rocket blew up on the launchpad in 2003, killing 21 technicians. There's a visitor center in the town, but it's not worth visiting.

Lotus Turismo (© 098/3221-0942; www.lotusturismo.com.br) has guided tours to Alcântara that cost R$60 per person.

The ferry to Alcântara departs daily at 7am and 9am. The trip takes about 1 hour. Tickets each way cost R$12. Call © 098/3232-0692 for information. Tickets can be purchased on the ferry, or beforehand at the Terminal Hidrovário on the waterfront in the São Luis centro histórico. Ferries depart either from the terminal, or if the tide is out, from the sandbar by the yacht club in Ponto d'Areia. Check beforehand at the terminal. Departures are subject to change and delay without notice. Returning from Alcântara, ferries depart from the Alcântara Terminal at 4pm.

SHOPPING

The best shopping in São Luis is in the **centro histórico.** The **Reviver** area features a number of good crafts and art shops, as well as the small but intriguing indoor market called the **Casa das Tulhas,** Rua da Estrela s/n (Mon–Fri 6am–8pm, Sat 6am–6pm, Sun 6am–1pm). Higher up in the old city, the principal shopping street **Rua Grande** features an intriguing mix of national chain stores and cheaper local stores selling clothing, hardware, refrigerators, and everything else. Rua Grande is pedestrian-only for much of its length, making it pleasant for strolling and people-watching.

The city's biggest shopping mall, the **São Luis Shopping,** Av. Euclides Figueiredo 1000, Jaracaty (© 098/3251-3621; www.saoluisshopping.com; Mon–Sat 10am–10pm, Sun 2–8pm), has a six-screen cinema, a large food court, and hundreds of shops. It's located a little past the Bandeira Tribuzzi bridge leading out of the centro histórico.

GIFTS & SOUVENIRS In the Reviver area of the centro histórico are a number of shops selling products unique to the state of Maranhão. One of the best places to browse for lace, tiles, baskets, ceramics, and sweets is the **Ceprama** craft center, Rua S. Pantaleão 1332 (© 098/3232-2187; Mon–Sat 9am–6pm and Sun 9am–1pm).

Local artisans gather here daily to display and sell their wares. If you like the tile work you've seen all over the old city, check out **Ateliê Mão na Massa,** Rua do Giz 117 (© **098/3232-5957;** Mon–Sat 9am–6pm). In addition to tiles, the workshop also features beautiful pieces of glazed pottery, as well as cheaper souvenirs.

MARKETS In the Reviver area, there's the **Casa das Tulhas,** Rua da Estrela s/n (Mon–Fri 6am–8pm, Sat 6am–6pm, Sun 6am–1pm), also known as the Feira da Praia Grande, a small but bustling indoor market with staples such as *farinha* and dried shrimp and fish, as well as a selection of herbs, roots, and tree bark used for a variety of medicinal purposes. At night, the **Rua da Alfândega** in the Reviver fills up with stalls selling local sweets and pastries and handmade leatherwork and basketry.

SÃO LUIS AFTER DARK

The best place to go for some music and fun after dark in São Luis is the **Reviver** area in the centro histórico. Close to a dozen bars, cafes, and restaurants offer music in the evening, most of it live. Most nights of the week, something's happening—with music usually starting around 8pm and ending around 1am. Thursday through Saturday it really hops, and the music continues past 3am. The **Roots Bar,** Rua da Palma 85 (© **098/3221-7580**), and **Bar do Porto** on Rua Trapiche 49 (© **098/3221-3749**), both offer reggae. Both charge a nominal cover of about R$5.

Outside of downtown, the Lagoa da Jansen has a number of more mellow music venues, often doubling as restaurants. **Kitaro Lagoa,** Av. Mario Meireles s/n (© **098/3268-6528**), has live music—usually MPB—every night starting around 9pm. Farther along the lakeshore, **Por Acaso,** Av. Mario Meireles s/n (© **098/3233-5837**), is a great casual *chopperia* offering live music daily at 8pm.

LENÇOIS MARANHENSES

The 155,000-hectare (383,000-acre) Parque Nacional Lençóis Maranhenses offers an intriguing and spectacular landscape seen nowhere else on earth—a vast desert formed of tall, snow-white sand dunes, interwoven with beautiful pools of turquoise rainwater. The dunes are formed by the region's strong coastal winds. During the December-to-May rainy season, over 1,500mm (60 in.) of rain falls and collects in the basins between dunes forming countless blue freshwater lagoons. In June, when the water levels are at their highest, the dunes look like a giant mosaic of white interspersed with sparkling dots of blue, turquoise, and green.

Visitors can enter the park only on foot. The town of Barreirinhas, just outside the park, is the jumping-off spot for exploring the park and the surrounding region. The best season is June through September, when the rainwater lagoons are deepest, most swimmable, and most spectacular, and the weather warm and dry. By December and January, the water has all but evaporated, leaving only desert.

Essentials
GETTING THERE
BY CAR Barreirinhas is 250km (155 miles) from São Luis, along the BR-135 and MA-402 highways. Both highways were recently paved and are in good shape.

BY BUS **Santur** (© **098/3248-3072**) offers daily service to and from Barreirinhas by comfortable air-conditioned minivan. The trip costs R$50 per person and takes 3 to 4 hours. Pickup is at your hotel. Vans depart São Luis anywhere from 5 to

9am (depending on demand). Vans depart Barreirinhas daily at 5pm. **Cisne Branco** (© **098/3243-2847**) has regular non-air-conditioned buses four times daily in both directions, departing from either the São Luis *rodoviaria,* or the *rodoviaria* in Barreirinhas. The trip takes from 4 to 6 hours. The cost is R$29.

GETTING AROUND

Taxi stands are in the city center. A taxi from the center to an outlying hotel costs R$12. A motorcycle taxi costs R$4 from center to the hotels. Call © **098/3349-0687** or cellphone 9111-5609.

VISITOR INFORMATION

There is no official tourist office in Barreirinhas, but tour operator **Ecodunas,** Rua Inácio Lins 164, in the center of town (© **098/3349-0545;** www.ecodunas.com.br; daily 9am–6pm), has a helpful staff. The state tourism website is **www.turismo. ma.gov.br/en/index.html**. A useful website for Lençóis Park is **www.parque lencois.com.br**.

FAST FACTS Banco do Brasil, Av. Joaquim Soeiro De Carvalho s/n (© **098/ 3349-1172;** Mon–Fri 9am–2pm), has a 24-hour ATM. Internet access at **Sol e Lua Cybercafe,** Av. Beira Mar s/n (Mon–Sat 8am–noon and 1:30–11pm), costs R$4 an hour, but the connection is unreliable.

Exploring

Barreirinhas doesn't take long to see. The Rio Preguiças loops its way through town. There is a pleasant boulevard with numerous restaurants and cafes facing the river, and next to that a big dune where locals swim. Most pousadas are located on the banks of the river a little out of town.

Several companies specialize in multiday packages. These can be as simple as transportation to and excursions in Lençóis, or as complicated as multiday jeep excursions to the Lençóis and then through the Parnaiba delta all the way to Jericoacoara. For details contact **Ecodunas** (© **098/3349-0545;** www.ecodunas.com.br) or **Rota das Trilhas** (© **098/3349-0372;** www.rotadastrilhas.com.br).

EXPLORING THE DUNES

Exploring the great shifting mass of glorious white dunes is the whole point of coming here. Contact **Ecodunas** (see above) or **Rota das Trilhas** (see above), both in Barreirinhas and offering similar tours at comparable prices.

There are several ways to explore the area:

o **Hikes:** The most popular is a **half-day trip** by 4×4 to **Lagoa Bonita.** The dirt road travels by increasingly rough sand trails to the park entrance, after which you climb into the dunes and hike for about 2 hours, allowing for plenty of time to swim in a couple of small rainwater lagoons. The cost is R$50. The half-day trip can be done in the morning, but in the afternoon it's cooler and you get to see the sunset. Variations on this trip go to other nearby lakes such as Lagoa Azul and Lagoa Paraiso. **Longer hikes** with customized itineraries can be arranged by consultation with Ecodunas. Guides are quite cheap at R$80 per day for up to three people. A 4×4 and driver—to drop you off or pick you up at a trail head—costs R$300 per day.

o **Four-Wheel ATV:** These full-day trips zoom up and down the dunes at the very fringes of the national park (ATVs aren't allowed inside the park boundaries), covering the roughly 30km (19 miles) between Barreirinhas and Atins on the coast. A full-day trip costs R$350 per ATV, which fits two people.

- **Scenic Flights:** The best way to admire the spectacular patchwork of crystal-clear lagoons amid the dazzling white sand dunes is from above. The cost of a 30-minute scenic flight is R$180 per person, with a minimum of three people. Flights are best in the morning.

TRIPS TO ATINS, CABURÉ & MANDACARU

At the mouth of the Rio Preguiças are two tiny villages sandwiched between the Lençóis dunes and the ocean. **Mandacaru** is a fishing village close to the mouth of the river; **Caburé** is a narrow neck of pure sand perhaps 200m (650 ft.) wide, with crashing surf on one side and the lazy Rio Preguiças on the other. What started as simple camps on this windswept piece of geography have since grown into a small collection of pousadas and restaurants.

One popular option for visiting these areas is to take a day trip by boat from Barreirinhas. The trip descends the river, stopping at the Smaller (Pequenos) Lençóis on the way. This sand dune area is still growing, and you can see where the advancing sand is eating away at the riverside forest. The trip stops in at Caburé for lunch, with time in **Mandacaru** to wander this tiny picturesque village and climb the 45m (150-ft.) lighthouse for a view of the national park, before returning to Barreirinhas. The tour can be arranged with **Ecodunas** or **Rota das Trilhas** (see above). Both charge R$60, lunch not included.

Many people opt to spend the night in Caburé or Atins. This allows time the next day to make a walking expedition into the Lençóis dunes along the coast beyond Atins. The route takes you through several beautiful and completely isolated small lakes before stopping at the **Restaurante de Luzia** (no phone), a tiny palm-frond-covered shack at the ocean side that serves an orgiastic feast of giant prawns for R$15 per person. The cost of this coastal dune expedition is around R$100 for up to four people, prawn lunch not included, with departure from Caburé. You can arrange the entire trip (boat from Barreirinhas, coastal day trip, and boat back to Barreirinhas) with **Ecodunas** or **Rota das Trilhas** (see above).

If you decide to stay in Caburé, there are several rustic pousadas. The sandspit has no electricity, so it's generators only and at 10pm it's lights out, candles on. **Pousada Porto Buriti** (𝄐 **098/3349-1802** or cellphone 9984-0088; www.pousadadoburiti. com.br) has the best infrastructure. It offers 10 small chalets at R$120 to R$200 a night. Make arrangements before staying overnight as accommodations are limited. An option in Atins is **Pousada Rancho do Buna** (𝄐 **098/3349-5005;** www.rancho dobuna.com.br), with basic but very clean and pleasant accommodations for R$110 double. The owners can also arrange horseback rides, bird-watching tours, or a variety of hikes and boat tours in the area.

WATERSPORTS

In other parts of the world, **Boia Cross** is called "floating down the river in an inner tube." **Ecodunas** (see above) offers a half-day float. The trip there and back is 90 minutes each way, and you spend 2 hours floating downstream. The cost is R$50 per person.

Where to Stay

Barreirinhas's two best pousadas are a little outside the town, a short ride by cab or moto-taxi. Though not nearly as nice, there are two options in town. The **Pousada Buriti** (𝄐 **098/3349-1802**) is a sort of motor-court motel. Rooms are quite large, but they're motel blocks surrounding a hot, treeless, courtyard parking lot. However,

there is a pool and children's play area. The **Pousada Beira Rio** (📞 **098/3349-0579;** www.hotelbeirario-lencois.net) is a three-story hotel by the riverside. Rooms are simple and clean, with tile floors and small balconies overlooking the river.

Porto Preguiças Resort ★★ ☺ The only luxury accommodations available in Barreirinhas, the Porto Preguiças Resort has 30 chalets set on a nicely landscaped piece of land by the river Preguiças. The leisure areas of the resort are nicely done. There's a gorgeous lagoon-shaped swimming pool with a sand-covered bottom, a hammock "central" for relaxing by the river, an authentic bocce game area, and a big beautiful restaurant and bar area. Unfortunately, the chalets are clumped together cheek by jowl. Inside, the chalets are spacious (many come with king-size beds) with large bathrooms with hot showers. Furnishings are rustic and simple. In short, the resort is very nice, though perhaps not worth what they're charging.

Carnaubal Velho 2km (1 mile) from town, Barreirinhas, 65590-000 MA. www.portopreguicas.com.br. 📞 **098/3349-1220.** Fax 098/3349-0620. 34 units, shower only. High season R$350–R$450 double; low season R$295 double. Extra person add 25%. Children 5 and under stay free in parent's room. AE, DC, MC, V. Free parking. **Amenities:** Restaurant (see below); bar; outdoor pool; sauna. *In room:* A/C, TV, fridge, minibar.

Pousada Encantes do Nordeste ★★ 🖉 Located just on the outskirts of town, the Pousada Encantes do Nordeste has a natural charm that makes it one of the nicest pousadas in the region. The chalets are set on a gently sloping hillside. The garden is beautiful and lush with a hammock for two to enjoy a lazy nap in the hot afternoon. A short trail leads to the river Preguiças. The rooms are very pleasant with nice, comfortable beds, air-conditioning, and television. There's even a closed-circuit DVD system that allows you to pick out a movie and watch it in your room. The staff at the pousada is very friendly and helpful in hooking you up with all the excursions. All tours include pickup and drop-off at the pousada.

Rua Principal s/n Barreirinhas, 65590-000 MA. www.encantesdonordeste.com.br. 📞 **098/3349-0288** or (São Paulo) 011/3331-3434. 15 units, shower only. R$210–R$362 eco-chalet. Extra person R$50. Children 6 and under stay free in parent's room. AE, V. Free parking. **Amenities:** Restaurant, Bambaê (see below); bar. *In room:* A/C, TV, minibar, no phone.

Where to Eat

For a town as small as Barreirinhas there are a surprising number of restaurants. Most of them have a fairly similar menu, involving grilled steak and seafood. The nicest restaurants are on the Avenida Beira Mar, the street that runs along the riverside. Next to and above the water—a number of tables are on the floating pier—is the **Tropical Marina Restaurant,** Av. Beira Mar s/n (📞 **098/3349-1143**). The best dish here is prawn *moqueca* with coconut milk and palm oil. For R$25 you get a clay pot full of fragrant stew packed with shrimp that serves two people. The menu also includes steak dishes, pasta, and grilled fish. The Marina serves up an inexpensive and tasty kilo buffet, one of the few places where you can grab a quick hot lunch. Another nice waterfront restaurant is the **Barlavento,** Av. Beira Mar s/n (📞 **098/3349-0627**), close to the Terraço Preguiças on the Avenida Beira Mar. The kitchen serves up grilled chicken and some steak dishes, as well as fish. Finally, for a more elegant night out try the restaurant at the **Porto Preguiças Resort,** Estrada do Carnaubal s/n (see above; 📞 **098/3349-1220**). Start off with a drink or a cocktail from the best-stocked bar in Maranhão. If you are hungry, order the *peixada* seafood stew with sea bass; the generous portion will easily feed three people.

TAKE THE long way HOME

Just beyond the Lençóis Maranhenses lies one of Brazil's most beautiful and still unexplored regions, the **Parnaíba River Delta.** This magical landscape is composed of sand dunes, beaches, river estuaries, mangroves, islands, and remote villages. If you have a few extra days you can travel from Barreirinhas, by boat and/or 4×4, to Paulinho Neves, on the edge of the Pequenos Lençóis, another protected dune area, and then to Tutóia, the jumping-off point to a number of remote islands in the delta. One of the largest islands, **Ilha do Caju** (www.ilhadocaju.com.br), is a nature sanctuary with only one small rustic pousada, where guests can truly get away from it all. Instead of backtracking all the way to São Luis, you can continue overland to Jericoacoara and then to Fortaleza (chapter 11). Of course you can also start in Fortaleza/Jeri and make the trip in the other direction. There are several companies that organize this trip. In Barreirinhas contact **Ecodunas** (ⓒ 098/3349-0545; www.ecodunas.com.br) or **Rota das Trilhas** (ⓒ 098/3349-0372; www.rotadastrilhas.com.br). You may also contact adventure specialists **Jeri Off Road** (ⓒ 088/3669-2268; www.jeri.tur.br) in Jericoacoara.

On the outskirts of town is **Bambaê,** Estrada de São Domingos Km 4.5 (at Pousada Encantes do Nordeste, see above; ⓒ **098/3349-0691**). This beautiful bar/restaurant on the shore of the Preguiças River is a perfect destination for a drink or a meal. The restaurant serves up snacks, sandwiches, and salads, as well as more sophisticated dishes such as the *robalo* fish with black olives. On Fridays and Saturdays there is live music. (Call ahead for opening hours in the low season.)

12

SÃO LUIS & THE LENÇÓIS MARANHENSES

Lençóis Maranhenses

THE AMAZON: MANAUS & BELÉM

13

I t was a lost Spanish conquistador who gave a name to the largest river and rainforest on earth. In 1541, Francisco de Orellana returned after a year's absence with a tale of a vast new river, and of attacks by hostile Indians, some led by bands of female warriors.

In Europe, these women warriors were taken to be the last remaining members of the tribe whose queen Achilles slew at Troy. Land and river both were named for this likely mythical tribe—the Amazons.

Three centuries later, it was a British explorer, Alfred Russel Wallace, who first noted what is today very likely the Amazon's greatest claim to fame—its diversity. The Amazon rainforest has more biodiversity—more species of plants and animals per given patch of forest—than any ecosystem on earth. Being a naturalist, Wallace also proposed an explanation. It was due, he believed, to the Amazon's extraordinary number of rivers, streams, and channels, which effectively cut the forest up into millions of small islands. Marooned and isolated, a separated single species would evolve into many new species.

So logical did this seem that only in the past 10 years did scientists try to test it out. At which point they discovered it, too, was a myth. The reason for the Amazon's diversity has once again retreated into mystery.

The Brazilian Amazon today remains one of the most isolated, most sparsely populated regions on earth. Yet it is also home to more than four million people. Tarzan myths aside, most of them live not in the jungle, but in cities. Indeed, the state of Amazonas is one of the most urbanized in Brazil.

The Amazon's two principal cities are Manaus and Belém, capitals of the states of Amazonas and Pará, respectively. Belém sits at the mouth of the river, Manaus at the spot where the two principal tributaries—the Rio Negro and the Solimões—join to form the Amazon. Belém is the older, more civilized of the two, with colonial architecture, forts, stately churches, and a sense of itself as the natural senior partner, somehow left behind by a brash new upstart. The upstart, Manaus, has in the past 50 years grown from a city of a few hundred thousand to a metropolis of almost two million. There's an exciting, frontier feel to Manaus. Belém offers history, excellent food, and much better nightlife. Manaus offers a sense of its own future and an opportunity to step into the vastness of the tropical rainforest.

A visit to the Amazon is a chance to penetrate the mystery, to experience the tangle of myth and reality firsthand.

MANAUS

2,836km (1,762 miles) NW of Rio de Janeiro, 2,682km (1,666 miles) NW of São Paulo

On the surface, Manaus looks a lot like other Brazilian cities. The old downtown is shabby and bustling. Along the shoreline in the upscale Ponta Negra area you'll find the familiar beachside high-rises, wide streets, and waterfront kiosks. But stop for a moment and contemplate: You're in the middle of nowhere with 1,610km (1,000 miles) of forest in every direction.

Inhabitants of the largest city in the Amazon, Manaus's 1.6 million people live on the shores of the Rio Negro, just upstream from where it joins the Rio Solimões to become the Amazon. Though first settled in the 1600s, there's a frontier feel to the place.

Near the end of the 19th century, when the Amazon was the world's only rubber supplier, there was a 30-year boom in rubber and Manaus got rich indeed. Some of the city's finest buildings date back to this time, among them the Customs house and the famous Teatro Amazonas. The boom ended around 1910, some years after an enterprising Brit stole some Amazon rubber seeds and planted them in new plantations in Malaya (modern-day Malaysia).

The city's next boom came in 1966, when Manaus was declared a free-trade zone. Electronics assembly plants sprouted across the city, and workers poured in to staff the factories. In the space of just a few years the city's population doubled to half a million. The retail traffic dried up in the early 1990s when the government reduced import tariffs, but with the free-trade zone still in place, manufacturing carries on.

These days, the city's biggest employer is the Brazilian army, which has jungle-training schools, listening stations, and a substantial standing force stationed in the city—all to preserve Brazilian sovereignty over the Amazon. Tourism has also expanded, most of it focused on the rainforest. Manaus is the main departure point for trips into the Amazon.

Essentials

GETTING THERE

BY PLANE Azul (© 092/3003-2985; www.voeazul.com.br), **Gol** (© 0300/115-2121; www.voegol.com.br), **TAM** (© 0800/570-5700; www.tam.com.br), and **TRIP** (© 092/3003-8747; www.voetrip.com.br) have flights from major cities in Brazil. Flights from Rio or São Paulo (often with a change of planes in Brasilia) take about 5 hours. TAM also has regular direct flights to Manaus from Miami.

Manaus's international airport, **Eduardo Gomes,** Avenida Santos Dumont (© 092/3652-1212), is 17km (10 miles) from downtown. There's a **Tourist Information** desk in the arrivals hall (© 092/3652-1120; daily 7am–11pm) with free maps of the city and some information on hotels and tours. A taxi to Manaus Centro will cost about R$45. Guests of the Tropical can take the **Fontur shuttle,** for R$24 per person. There is a small currency exchange at the airport as well as Banco do Brasil and HSBC ATMs connected to the Visa/PLUS systems.

BY BOAT Boats dock at the new **Hidroviaria do Amazonas (Riverboat Terminal)** (© 092/3621-4310) in the middle of downtown at Rua Marquês de Santa Cruz 25. There is an information desk inside the front door where you can find out

Manaus

RESTAURANTS ◆
Banzeiro **2**
Fiorentina **9**
Glacial Sorveteria **11**

ATTRACTIONS ●
Alfândega **14**
Largo de São Sebastião **5**
The Meeting of the Waters
(Encontro das Aguas) **16**
Mercado Adolpho Lisboa **15**
Museu do Indio **13**
Palacete Provincial **10**
Palacio Rio Negro **12**
Public Library **8**
Teatro Amazonas **6**

HOTELS ■
Blue Tree Premium **3**
Go Inn **7**
Hotel do Largo **4**
Mango Guest House **1**

about arrival and departure times, and a ticket kiosk where you buy tickets. Boats for
Belém normally depart Wednesday and Friday at noon. The trip downstream takes 4
days, upstream travel takes 5 days. Delays are not uncommon. For information on the
5-day journey from Belém to Manaus, see "By Riverboat," under "Getting There," in
the section on Belém (p. 389). The cost of a first-class hammock spot (on the upper
deck with A/C) is R$270. Hammocks are not supplied. Buy one in Manaus (see
"Shopping," later in this chapter). Cabins cost R$750 to R$1,200. Good, simple
meals and filtered water are supplied on the boat at no extra cost. From the terminal
it's a short walk or taxi ride, R$10 to R$15, to the downtown hotels. To the Tropical
Manaus, it's a 20-minute taxi ride that will cost about R$50, or a 40-minute bus ride,
no. 120 from Centro.

Tip: If you have some competence in Portuguese, you can negotiate a 10% to 20%
cheaper fare by heading straight to the dock and talking directly with the crew of the
riverboats, most of which dock downstream by the quay opposite the Mercado
Municipal.

CITY LAYOUT

The city is the river. Downtown, all activity gravitates toward the waterfront on the
Rio Negro, and it's there that you really feel the heart of the city. The entire city is

Steer Clear of Aggressive Airport Touts

The airport touts have (finally!) been banished from the baggage claim area of the Manaus airport, so now they accost newcomers in the arrivals hall, offering every type of city and jungle tour. *Do not book with these people!* Their standard MO is to ask what you're interested in doing. Surprise, surprise, whatever you want to do, they have that tour. Once you pay, they resell you to another operator doing the standard 50-people-on-the-boat Meeting of the Waters day tour. Complain all you like—you'll never get your money back.

plotted in an easy-to-follow grid pattern; in the oldest part of town—which occupies a peninsula at the river's edge—the grid runs at a slight angle to that of the rest of the city. The **port** and the **municipal market (*mercado municipal*)** both face the river. The main attractions for visitors concentrate in a 20-block radius around the port and are easily accessible on foot. The downtown **bus terminal** is directly in front of the port; on the other side there's the busy and newly renovated **Praça da Matriz.** To the east of the square are a number of narrow parallel streets, centered on **Rua Guilherme Moreira,** that form Manaus's main downtown **shopping district.** The busy east-west **Avenida Sete de Setembro** marks the end of the oldest section of downtown. From here north, the grid angles slightly, and things get less interesting. The only real sight of interest is the **Teatro Amazonas,** 4 blocks farther north on **Rua Barroso.** The entire downtown area is safe during the day; just watch your purse and wallet in the crowds. In the evening stay on the main squares and avenues; avoid the port area and any of the side streets at night. From the downtown core the city sprawls inland and along the river. **Ponta Negra Beach,** about 18km (11 miles) from downtown, is one of the more upscale neighborhoods where the beachfront has become a popular nightlife-and-entertainment area. This is also where you'll find the **Tropical Manaus.** A good part of the beach disappears in the wet season (Jan–Apr), but the food stands and entertainment stay. In the dry season the beach is a great place to swim and suntan on the shores of the Rio Negro.

GETTING AROUND

BY BUS From the Tropical Manaus to downtown, take bus no. 120 (R$2); the trip takes 35 to 40 minutes. The bus stops at the **Praça da Matriz,** which is within easy walking distance of all downtown attractions. To get to the Ceasa Port from downtown, take the CEASA bus from Praça da Matriz.

BY TAXI Taxis can be hailed on the street or reserved for a specific time by phoning ahead. For the airport, contact **Coopertaxi** (✆ **092/3652-1544** or 3652-1568). In town, phone **Tele-Rádio Táxi** at ✆ **092/3633-3211.** You're most likely to use taxis if you are staying at the Tropical and going back and forth to downtown. For this trip taxis all quote the same price—currently R$60—and don't run the meter. You can knock R$10 off the price if you bargain before you get in the cab.

BY CAR Renting a car in Manaus makes little sense. In the city all the sights are within walking distance. Outside of the city it's, you know, a jungle.

VISITOR INFORMATION

The **Manaustur** tourism information desk at the airport is open daily from 7am to 11pm and located in the arrivals hall (✆ **092/3652-1120**). They can provide city maps, brochures, hotel information, and telephone numbers of tour operators. The

State of Amazonas tourism agency, **AmazonasTur** (www.visitamazonas.am.gov.br/site), has an info center at the airport (☎ 092/3182-9850), open 24 hours. There is also a downtown location close to the Opera House, at Av. Eduardo Ribeiro 666 (☎ 092/3182-6250), open Monday to Friday 8am to 5pm and Saturday till noon.

[FastFACTS] MANAUS

Car Rentals **Avis** (☎ 092/3652-1579) and **Localiza** (☎ 092/3652-1176) have locations in Manaus.

Consulates The **United States** consulate is at Rua Franco de Sá 310, sala 306 (☎ 092/3611-3333); the **Great Britain** consulate (Honorary) is at Rua Poraquê 240, Distrito Industrial (☎ 092/4009-1819).

Currency Exchange Change money at **Banco do Brasil,** Rua Guilherme Moreira 315, Centro (☎ 092/3621-5500), **Cortês Câmbio,** Av. Sete de Setembro 1199, Centro (☎ 092/3622-4222; www.cortez.com.br), or **Amazonas Shopping** (☎ 092/3642-2525).

Dentist For dental issues, go to **Clínica Odontológica Ortomax,** Av. Joaquim Nabuco 2285 (☎ 092/3633-3121, or cellphone 9964-5211).

Hospital The hospital is **Pronto Socorro e Hospital dos Acidentados,** Av. Joaquim Nabuco 1755, Centro (☎ 092/3663-2200).

Internet Access The **Tropical Manaus** has an Internet cafe open daily from 9am to 10pm; the charge is R$18 per hour. In Centro, try **Amazon Cyber Café,** Av. Getulio Vargas 626 (☎ 092/3232-9068). It's open Monday through Friday 9am to 11pm, Saturday from 10am to 8pm, and

Sunday from 1 to 8pm; the cost is R$4 per hour.

Time Zone Manaus is 1 hour behind São Paulo and Rio de Janeiro.

Weather It's hot year-round—hot and muggy and rainy from December through March (30°–36°C/86°–96°F) and just plain hot the rest of the year. The wet season (Dec–Mar) is the best time to experience the flooded forest; the river rises and brings boats and canoes up to eye level with the tree-tops. The dry season (Aug–Nov) is wonderful for exploring the forest and beaches that appear when the water recedes.

Where to Stay

Downtown Manaus has recently undergone a major face-lift and offers several affordable hotels within walking distance of the Opera House, the city parks, the port and the museums. Most excursions and jungle lodges will provide pickup services from any of these hotels. This area is best for affordable hotels within walking distance of the city's top attractions. The drawbacks are that many hotels don't have leisure facilities, like a swimming pool, which is a nice feature in a hot city like Manaus.

CENTRO
Moderate

Go Inn ★ ☺ Opened in 2010, this hotel offers comfortable accommodations within walking distance of Manaus's downtown attractions. The rooms are a bit on the small side and have either one double or two twin beds. But thanks to large windows and bright, modern furnishings, they shouldn't really cramp your style. Children will love the interior courtyard with a toy room.

Rua Monsenhor Coutinho 560, Centro, Manaus, 69010-110 AM. www.atlanticahotels.com.br. ☎ **092/3306-2600.** Fax 092/3306-2601. 215 units. R$165 double. Children 5 and under stay free in parent's room. AE, DC, MC, V. Parking R$15. **Amenities:** Restaurant; bar; room service. *In room:* A/C, TV/DVD, hair dryer, minibar, Wi-Fi.

Hotel do Largo Behind the unassuming facade hides a pleasant hotel with affordable rates in downtown Manaus, only 1 block from the Opera House. The rooms are simply furnished with comfortable beds, a small desk, and a spotless bathroom. If you want something a little fancier, reserve a superior room on the top floor; recently renovated, these rooms are quite spacious and feature a balcony and stylish new modern furniture and amenities. The in-house travel agency on the ground floor makes a convenient stop for booking excursions, boat travel, or jungle lodges.

Rua Monsenhor Coutinho 790, Centro, Manaus, 69010-110 AM. www.hoteldolargomanaus.com.br. ℂ **092/3304-4751.** 39 units. R$140–R$190 double. Children 6 and under stay free in parent's room. AE, DC, MC, V. Limited free parking. **Amenities:** Restaurant; room service. In room: A/C, TV, minibar, Wi-Fi.

PONTA NEGRA

Located 20km (12 miles) from downtown, Ponta Negra Beach offers luxury accommodations on the banks of the Rio Negro. This is the perfect place to recover after spending a few days in the jungle. Come here for a pampered stay in a luxury hotel with ample leisure facilities, surrounded by rainforest and near the Rio Negro. The drawback is that the city's downtown attractions are a long and expensive cab ride away.

Very Expensive

Park Suites Manaus ★★★ Located right on the shore of the Rio Negro, the Park Suites is one of the best hotels in town and offers modern and spacious rooms with king-size beds, Wi-Fi Internet, efficient air-conditioning, 21st-century plumbing, and fabulous views of the Rio Negro. The suite experience is nearly identical to the regular rooms; the only added feature is the veranda overlooking the river which, considering the hot humid climate, is not really worth the extra money. The hotel has a large outdoor pool and sun deck overlooking the Rio Negro and a state-of-the-art fitness center. **Bistro Mon Plaisir** on the top floor is one of the prime sunset spots in town.

Av. Coronel Texeira 1320, Ponta Negra, Manaus, 69037-000 AM. www.atlanticahotels.com.br. ℂ **0800/701-2670** or 092/4009-8200. Fax 092/4009-8234. 350 units. R$330 standard; R$460 suite. Extra person add 25%. Children 10 and under stay free in parent's room. AE, DC, MC, V. Bus: 120. **Amenities:** Restaurant, Bistro Mon Plaisir (see review, p. 369); 2 bars; concierge; health club; large outdoor pool; room service; sauna; smoke-free floors. In room: A/C, TV, hair dryer, minibar, Wi-Fi.

Tropical Manaus ★ ☺ ✋ After the Copacabana Palace, this is the most famous hotel in Brazil. Built on the shores of the Rio Negro, within its own little patch of rainforest, the Tropical features a vast pool, zoo, children's play area, archery range (lessons complimentary), a jogging trail, beach volleyball, soccer fields, and the list goes on. Inside, the original wing of the hotel is referred to as *ala colonial,* in contrast to the more modern *ala moderna.* Where you stay is more a matter of preference than quality. The colonial rooms have more character, with beautiful dark-wood furniture and hardwood floors, but they can also be a bit musty. The modern wing is furnished with a more contemporary decor in light colors. All rooms are a good size with high ceilings and large windows, and the bathrooms are spacious with showers and bathtubs. Unfortunately, the hotel seems to be coasting mainly on its reputation and has been providing less than top-notch service and sloppy room maintenance and cleanliness. It is a good idea to inspect your room before settling in and unpacking.

Av. Coronel Texeira 1320, Ponta Negra, Manaus, 69029-120 AM. www.tropicalhotel.com.br. ℂ **0800/701-2670** or 092/3659-5000. Fax 092/3658-5026. 601 units. R$250–R$320 standard or superior double; R$360 deluxe double. Extra person add 25%. Children 10 and under stay free in parent's

room. AE, DC, MC, V. Bus: 120. **Amenities:** 3 restaurants; 2 bars; disco; children's program; health club; large outdoor pool complex; room service; sauna; smoke-free floors; spa; tennis courts; watersports. *In room:* A/C, TV, hair dryer, Internet, minibar.

ADRIANÓPOLIS

Blue Tree Premium ★ This is where the business travelers stay in Manaus. Located in Adrianópolis—fast becoming the city's restaurant hot spot—this modern high-rise hotel offers comfortable clean rooms with parquet floors and queen-size (or two twin) beds, plus a small functional work desk with plug-ins for laptops and high-speed Internet. There's a small, pretty rooftop pool with views of the city, a good-quality fitness center, and a sauna for relaxing in afterward.

Av Umberto Calderaro Filho 817 (formerly: Rua Paraíba), Adrianópolis, 69057-021 AM. www.blue tree.com.br. ⓒ **092/3303-2000.** 163 units. R$310–R$346 deluxe double; R$435–R$490 master suite. Extra person add 25%. AE, DC, MC, V. Taxi recommended. **Amenities:** Restaurant; bar; fitness center; rooftop pool; room service; sauna. *In room:* A/C, TV, fridge, minibar, Wi-Fi.

ELSEWHERE

Mango Guest House ★ 🗦 The Mango is a nice small guesthouse, unfortunately located in a boring walled-off suburb about halfway between downtown and Ponta Negra. Rooms are simple, small, and pleasant, with tile floors, firm single or double beds, and clean, functional bathrooms with super-hot showers. All rooms have a small veranda that looks out on a grassy courtyard and small pool, and the guesthouse has several nice lounges and sitting rooms and free Internet access. The Mango is perfect for those who just need to spend a night in Manaus before or after a jungle stay. All tours pick up and drop off here, and the guesthouse will happily store your excess luggage while you are off in the rainforest. Tell taxi drivers the guesthouse is in Kissia Dois, off Rua Jacira Reis, which runs off Rua Darcy Vargas.

Rua Flavio Espirito Santo 1, Kissia II, 69040-250 AM. www.naturesafaris.com.br. ⓒ **092/3656-6033.** Fax 092/3656-6101. 14 units. R$105–R$150 standard. Extra person add 25%. Credit cards only when booking online or via travel agency: AE, DC, MC, V. Bus: 121. **Amenities:** Restaurant; outdoor pool; Wi-Fi (free). *In room:* A/C, fridge.

Where to Eat

CENTRO

Fiorentina ITALIAN After some sightseeing, tuck into this little Italian cantina for a hearty lunch or dinner. The lunchtime buffet is a charge-per-kilo affair and offers a generous spread of salads, antipasto, pasta, and local fish dishes. The a la

JUNGLE green

Golf enthusiasts looking for an exotic location may now tee off on a lovely 18-hole, 72-par course set amid lakes, *igarapés*, sand banks, and lush rainforest. Only an hour outside of Manaus, the **Amazonia Golf Resort,** Rodovia AM 010 km 64 (ⓒ **0800/603-5323** or 092/3637-7000; www.nobilehoteis.com.br), offers a 115-room luxury hotel with beautiful grounds, large fitness facilities, and an outdoor swimming pool. However, with so many other jungle lodges in the area, it only makes sense to come here if you want to play golf. Rooms start at R$490 per night, not including greens fees (R$80 per hour).

THE lowdown ON AMAZONIAN CUISINE

Amazonian dishes mix a dollop of Portuguese and a dash of African flavors with native traditions and lots of local ingredients. The star attraction in most dishes is fish, fresh from the Amazon's many tributaries. It's worth visiting the market in Manaus just to see what these creatures look like. Make sure you try at least the *tucunaré;* the meat is so tasty it's best served plainly grilled. *Pirarucú* is known as the codfish of the Amazon. It can be salted and used just like *bacalhau*. *Tambaqui* and *paçu* also have delicious firm flesh that works well in stews and broths. One popular stew is **caldeirada.** Often made with *tucanaré*, the rich broth is spiced with onion, tomato, peppers, and herbs. Very different is the **pato no tucupí,** a duck dish stewed with *tucupí,* the juice of fermented and spiced cassava. **Tacacá** is a delicious native soup, made with the yellow *tucupí* cassava, *murupí* peppers, and garlic, onion, and dried shrimp. You'll often see this for sale on the streets, traditionally served in a gourd cup. To add kick to your food, try some **murupí** pepper sauce.

The region is also rich in fruit, many of which can only be found in the Amazon, most of which do not even have English names. The citruslike **bacuri,** with its soft spongelike skin and white flesh, is addictive. The most commonly eaten fruit is **cupuaçu.** This large round fruit, like a small pale coconut, has an odd sweet-and-sour taste at first bite, like it's almost too ripe. But you'll learn to savor it in desserts and juices. **Tucumã** is a small, hard fruit similar to an unripe peach. Locals eat slices of it on bread. At lodges it's also a favorite of half-tame monkeys and parrots who will snag one whenever they get a chance. **Açai** is a popular fruit, but it can't be eaten raw; the berries are first soaked and then squashed to obtain the juice. You will find it in juices and ice cream. In the jungle, you'll come across fruit that you don't even see in Manaus markets. My favorite is the **mari-mari,** a snakelike vine about as long as your arm; when opened with a quick twist it reveals a row of Lifesaver-looking fruit. Green, juicy, and full of vitamins.

carte lunch or dinner menu includes lasagna, pasta, pizza, fish, and steak dishes. Most portions are quite generous and will serve two people.

Praça Heliodoro Balbi s/n, Centro. ✆ **092/3215-2233.** Main courses R$35–R$52. MC, V. Daily 11am–10pm.

Glacial Sorveteria DESSERT One of the best ways to try many of the exotic fruits of the Amazon is in the form of ice cream. Some suggested flavors are *cupuaçu, açai, jaca, bacaba,* and *graviola.* Grab a couple of flavors here and taste away. Another shop is in Ponta Negra (✆ **092/3658-3980**).

Av. Getulio Vargas 161, Centro. ✆ **092/3233-7940.** www.glacial.com.br. R$4.50–R$9. No credit cards. Mon–Sat 10am–11:30pm; Sun 3–11:30pm.

PONTA NEGRA

Ponta Negra offers a number of nighttime dining options, none outstanding in terms of food, but most in very pleasant surroundings. *Note:* At press time, the entire Ponta Negra waterfront was being redeveloped; it's slated to reopen to the public by 2012.

Bistro Mon Plaisir For the best view in town head up to this restaurant, located on the roof of the Park Suites Manaus Hotel. Enjoy a drink on the patio as the sun

sets over the Rio Negro, and then indulge in the chef's contemporary Amazonian dishes, like the *pirarucú* carpaccio or *tambaqui* fish "ribs."

Av. dos Expedicionários 1320. ☏ **092/3342-8936.** Main courses R$46–R$55. MC, V. Tues–Sat 11:30am–3pm and 5–11pm; Sun 11:30am–7pm.

ADRIANÓPOLIS

In the past few years, the upscale neighborhood of Adrianópolis has emerged as Manaus's culinary hot spot, with a number of fine restaurants in a relatively concentrated area. In addition to the **Banzeiro** (one of the city's best, reviewed below), there's top-quality (and top-dollar) Portuguese cuisine at **Casa do Bacalhau,** Rua Humberto Caldeirado Filho 1587-A (formerly called Rua Paraíba; ☏ **092/3642-1723;** Mon–Sat noon–4pm and 7:30pm–midnight, Sun 11:30am–4pm). For local—and more affordable—Amazonian dishes there's **Choupana,** Rua Mario Ypiranga Monteiro 790 (formerly called Rua Recife; ☏ **092/3635-3878;** Tues–Sat 11am–3pm and 6:30–11pm, Sun noon–4pm). Even cheaper, and arguably more fun, is **Açaí e Companhia,** Rua Acre 98 (☏ **092/3584-0188;** daily noon–midnight), a kind of outdoor kiosk which specializes in local fish dishes such as *jambu* and *tambaqui.* On Friday and Saturday evening there's live music. Korean food is hard to find anywhere in Brazil, much less in the middle of the rainforest, and yet in Adrianópolis there's **Ara,** Rua Mario Ypiranga Monteiro 1005 (formerly called Rua Recife, casa 1; ☏ **092/3234-2650;** daily 11am–2pm and 6–10pm).

Banzeiro REGIONAL BRAZILIAN Voted "Best Amazonian Cuisine" in 2010 by Brazilian magazine *Veja,* Banzeiro specializes in Amazonian fish and meat dishes. Highlights of this simple bistro include the firm and savory *pirarucú, tambaqui,* and *tucanaré* fish dishes, served grilled or in stews. The most popular fish dish is the fried *costela de tambaqui,* juicy pieces of grilled *tambaqui* fish that resemble spareribs, served with banana, rice, and *farofa.* Meat lovers will also enjoy the succulent steaks or the duck leg and breast with *tucupi* sauce. The wine list includes a number of affordable selections in the R$40 to R$60 range. For dessert, try the rich Amazonian *cupuaçu* fruit mousse or a scoop of fresh ice cream.

Rua Libertador 102, Adrianopolis. ☏ **092/3234-1621.** www.restaurantebanzeiro.com.br. Main courses R$68–R$93 for 2. AE, MC, V. Mon–Sat 11:30am–3pm and 7–11:30pm; Sun 11:30am–4pm.

Exploring Manaus

You won't need more than 1 day to see Manaus. Start your exploration at the port to see the river's bustling waterfront. Farther down, the **Feira do Produtor** has every Amazon product imaginable, and the waterfront out front where boats load up is a fascinating glimpse of Amazon frontier. The **Opera House** is an extravagant, impressive testament to the legacy of the rubber boom. A half-day trip out to the **Meeting of the Waters** is a worthwhile afternoon excursion. In the evening, head to the beach at **Ponta Negra,** and stop for a cold beer or an exotic ice cream as you watch the river. And then get thee out into the Amazon. There's wild stuff to see.

THE TOP ATTRACTIONS

CIGS Zoo ☺ It's a strange place, this zoo. It's part of the army's jungle warfare–training center, and many of the animals were captured by soldiers on patrol. The animal enclosures range from the worst you've ever seen to quite sophisticated and humane habitats. One poor black jaguar is kept in a concrete-floored cage no more than two jaguar-lengths square, while the cougars are kept in sizable enclosures with grass and a small pond. The collection is tremendous: black and spotted jaguars,

cougars and smaller cats, toucans, macaws, and more. You'll also see harpy eagles stuck in heartbreakingly small enclosures. Yet the monkey habitat is wide and well done—go figure. Allow an hour to 90 minutes.

Estrada do Ponta Negra, Km 13. ⓒ **092/3625-1966.** Admission R$2 adults, free for children 12 and under. Tues–Sun 9am–4:30pm. Bus: 120.

The Meeting of the Waters (Encontro das Aguas) ★★ For more than 200 years, tourists have been venturing out to see this remarkable sight: The dark slow waters of the Rio Negro meet the faster muddy brown waters from the Rio Solimões, and because of differences in velocity, temperature, and salinity, the two rivers carry on side-by-side for miles, with progressively less distinct whorls and eddies marking the interface between these two rivers. It's a classic Manaus trip, and a great excuse to get out on the Amazon. If you're booked at a lodge downstream of Manaus, you'll pass through the Meeting of the Waters on the way there and back. If not, consider booking a day trip. This tour will usually include the main sights of Manaus, such as the public market, the port, the Opera House, and a long stop at **Lago Janauary Ecological Park.** Located about an hour from Manaus, the Lago Janauary features some elevated boardwalks weaving through the trees and giant floating Vitoria Regia lily pads. *Note:* In the dry season (Aug–Dec), the trip through the Lago becomes impossible and tour operators take you to the Ilha da Terra Nova to see the rubber trees.

All Manaus agencies offer day tours for about R$110 per person. Try **Viverde** (ⓒ **092/3248-9988**).

Mercado Adolpho Lisboa ★ The Adolpho Lisboa is a beautiful iron-and-glass copy of the now-demolished market hall in Les Halles, Paris. At press time, the market was closed for renovations. Unfortunately, a disagreement between various government agencies has interrupted the work in progress, without any resolution in the immediate future. In the meantime, the market has been relocated to a nearby facility. Although it lacks the classic charm of the original market, it's still a great place to see some of the local fish, fruit, and vegetables—the variety of fish is overwhelming.

Rua dos Barés 46, Centro. ⓒ **092/3233-0469.** Daily 8am–6pm.

Museu do Indio Spread out over six rooms, this museum presents the culture and social structure of the indigenous peoples of the Upper Rio Negro. Artifacts and clothing give an overview of their hunting and fishing traditions, as well as showing the spiritual rituals of a funeral and healing ceremony. The displays contain photos, drawings, a large number of artifacts, and occasionally models and replicas. All descriptions are in Portuguese, English, and German. Allow 1 hour.

Rua Duque de Caxias 356, Centro. ⓒ **092/3635-1922.** Admission R$5. Mon–Fri 8:30–11:30am and 2–4:30pm; Sat 8:30–11:30am.

Palacete Provincial Built in 1874, the former Manaus police headquarters has recently been restored and now houses several excellent exhibits. The most interesting one is the Pinacoteca, which exhibits art by contemporary Amazonas artists. Make sure to have a look at the exuberant, colorful paintings by Rita Loureiro. Other exhibits include a comprehensive coin display and the history of the Military Police in Manaus, worth a peek for its lovely old photographs. Allow 1 hour.

Praça da Policia s/n, Centro. ⓒ **092/3622-8387.** Free admission. Tues–Thurs 9am–5pm; Fri–Sat 9am–7pm; Sun 4–8pm.

Teatro Amazonas (The Opera House) ★★★ This is one "must-see" that is actually worth seeing. This remarkable landmark was erected in the midst of the Amazon jungle in 1896 at the peak of the rubber boom. The half-hour guided tour shows off the lobby of marble and inlaid tropical hardwoods, the fine concert hall, and the romantic mural in the upstairs ballroom. Even better is to see a concert (see "Manaus After Dark," below).

Praça São Sebastião. ℂ **092/3232-1768.** www.culturamazonas.am.gov.br. Guided 30-min. tours in English and Portuguese depart every 30 min. R$10. Mon–Sat 9am–5pm.

ARCHITECTURAL HIGHLIGHTS

The square and the buildings around the Opera House—the **Largo de São Sebastião**—have been restored almost to their original condition. In the evenings, the city often programs free concerts here.

The pretty neoclassical **Public Library,** Rua Barroso 57 (Mon–Fri 8am–5pm), on the corner of Avenida Sete de Setembro, dates from 1870. It's worth climbing the grand central staircase to the top floor to see a large oil painting marking the end of slavery in the Amazon. Done in the best overwrought allegorical style, it positively overflows with bare-breasted Amazon princesses, each a symbolic representation of some aspect or another of the province. Farther east along Avenida Sete de Setembro (toward the Museu do Indo) stands the grand **Palacio Rio Negro,** Av. Sete de Setembro 1546 (ℂ **092/3232-4450;** Mon–Fri 9am–3pm). Built by a Manaus rubber baron in the early years of the 20th century, the main palace is wonderfully ornate, with rich tropical hardwoods used for floors, doors, banisters, and moldings. The building has been transformed into an excellent cultural center with temporary art exhibits and daily guided tours. The old Customs house, or **Alfândega,** on Rua Marquesa da Santa Cruz, was prefabricated in England, shipped to Manaus in 1912, and re-erected block by block. The tower on the water side of the building was once a lighthouse.

> **Take a Break**
>
> For a unique Amazonian snack, stop in at **Casa da Pamonha,** Rua Barroso 375 (ℂ **092/3222-1028**), and order the X-Caboclo: firm slices of *tucumã* fruit and grilled cheese (the *X* is pronounced as *sheeze*) on a bun. More traditional snacks, such as *açai* or tapioca pancakes, are also available. Open Monday through Saturday only.

NEIGHBORHOODS TO EXPLORE

Downtown Manaus is a fun place to explore. Check out the waterfront behind the **Feira da Produtor** on **Avenida Lourenço da Silva Braga** to see riverboats discharging passengers or loading up with everything under the sun for the next trip up or down the river. Two blocks inland, **Rua dos Bares** is full of chandleries and hardware shops; it's also a good place to buy a hammock. Small and picturesque, **Praça Tenreiro Aranha** contains an informal outdoor crafts fair. The covered pedestrian mall **Rua Marechal Deodoro** is the center of Manaus's thriving downtown shopping bazaar. The triangular plaza at the corner of **Avenida Presidente Vargas** and **Avenida Sete de Setembro** is a pleasant place to relax in the shade for a spell. Like so many Brazilian squares, it goes by two names: either **Praça da Poliçia** or **Praça Heliodoro Balbi.** The city's most famous sight, the **Opera House** or **Teatro Amazonas,** is but a short walk from here.

PLAZAS, PARKS & GARDENS

Mindu Park, Avenida Perimitral ((Ⓒ) 092/3236-7702; Tues–Sun 8am–5pm; bus: 511), is a 33-sq.-km (20-sq.-mile) forest reserve that is also one of the last remaining habitats of the sauim-de-coleira monkey, a species found only in the Manaus area. The park has walking trails with interpretive signage, a suspended treetop walkway, and an interpretation center with a library.

The **Bosque de Ciência** or Ecological Park, Rua Otávio Cabral ((Ⓒ) 092/3643-3293; Tues–Sun 9am–3pm; bus: 511), was created by INPA, the National Institute for Amazon Research, to promote ecological awareness. There's a small aquarium on-site with river otters and manatees.

Organized Tours

AIR TOURS To get an aerial view of the rainforest and the city, **Viverde,** Rua dos Cardeiros 26 ((Ⓒ)/fax **092/3248-9988;** www.viverde.com.br), offers sightseeing flights on a floatplane that takes off from the river in front of the Tropical Manaus. The best deal is the **30-minute flight** that gives you aerial views of the city, the flooded forest, and the Meeting of the Waters, an amazing sight from the air. It costs R$450 per person with a minimum of two people. For R$900 per person you get a **1-hour flight** that allows you to go as far as the Anavilhanas Archipelago (more than 300 islands in the Rio Negro) and buzz some of the beaches and forest on your way back.

BUS/BOAT TOURS The best Manaus tour operator is **Viverde,** Rua dos Cardeiros 26 ((Ⓒ)/fax **092/3248-9988;** www.viverde.com.br). **Fontur,** located at the Tropical Manaus, Estrada da Ponta Negra ((Ⓒ) **092/3658-3052;** www.fontur.com. br), also offers a variety of tours. Because of its location in the Tropical, Fontur tends to be a bit more expensive.

Both companies offer half-day **city tours,** with English-speaking guides and an air-conditioned vehicle, that cover the highlights: the Opera House, the port and the market, and one museum, either the Palácio Rio Negro or the Museu do Indio. Viverde offers a scientific city tour that includes a visit to the **Bosque de Ciência.** The cost is around R$235 per person (with two people). They also offer full-day tours that include a visit to the **Meeting of the Waters** and boat trips to the **Anavilhanas Archipelago.**

CITY TOURS Long the experts in deep Amazon exploration, **Amazon Mystery Tours** ((Ⓒ) **092/3308-9073** or 092/9174-3047; www.amazondaytrips.com) has recently branched out into the city, offering innovative city tours like a **Manaus by Night** series (R$120–R$180; depending on how late you go), which will take you out to a popular neighborhood to hang with locals, sample street food, and move to the sound of Manaus-based samba and *pagode.* The company offers a day trip up to the waterfalls and caverns of **Presidente Figueiredo,** a beautiful highland area about 100km (62 miles) north of Manaus (R$330; including transportation, guide, entrance fees, lunch, and snacks). Check the website for details on new tours being developed.

Shopping

Downtown Manaus is one big shopping area: Vendors hawk their wares, stalls clog up the sidewalks and squares, and the streets are jam-packed with little stores. The main shopping streets run behind the **Praça Tenreiro Aranha, Rua Marcilio Dias,**

Stock Up to Put Your Feet Up

Manaus is a great place to buy a hammock. They make great souvenirs, and if you're taking a riverboat, they're indispensable. The best stores are located on the Rua dos Barés, near the Mercado Municipal. Expect to pay R$45 to R$75.

Rua Guilherme Moreira, and **Rua Marechal Deodoro.** The streets around the market at **Rua dos Barés** sell more household goods and hammocks. The church square, **Praça da Matriz,** has a large market during weekdays selling everything from clothing to hair accessories and bags. The city's best mall is **Shopping Manauara,** Adrianopolis (© **092/3643-4700;** www.manauarashopping.com. br). It's open Monday through Saturday from 10am to 10pm. The mall's unique architecture with indigenous elements and expansive windows overlooking a preserved grove of buriti palm trees makes for a pleasant stroll.

ARTS & CRAFTS

AMAZONAS ECO SHOP More high-end design than knickknack stand, this gift shop specializes in good-quality crafts, artwork, and furniture made with local woods and seeds. The designs are often inspired by traditional native artifacts. Open Monday through Saturday 10am to 6pm. Largo de São Sebastião, just across the street from the Teatro Amazonas. © **092/3234-8870.** www.ecoshop.com.br.

ARTINDIA The crafts market located on the Praça Tenreiro Aranha sells a wide variety of Indian crafts, including necklaces, bracelets, woodcarvings, baskets, and handbags. Open Monday through Saturday 8am to 6pm. Praça Tenreiro Aranha, Centro. © **092/3232-4890.**

CENTRAL DE ARTESANATO BRANCO & SILVA Located about a 15-minute cab ride north of downtown, Central de Artesanato is worth the trek. In one location you'll find 23 handicrafts shops specializing in regional crafts. A lot of the artisans work with wood, weavings, ceramics, bark, seeds, and other organic materials. The selection is amazing, and some of the crafts are of gallery quality. Open Tuesday through Friday 9am to 6pm, Saturday 9am to 4pm. Rua Mario Ypiranga Monteiro 1999 (formerly called Rua Recife), Parque 10. © **092/3236-1241.** By taxi only, no convenient bus route.

Manaus After Dark

THE PERFORMING ARTS

Teatro Amazonas (The Opera House) The theater has a resident philharmonic orchestra, choir, and dance group (classic and popular dance) that perform regularly. Tickets are eminently affordable, usually around R$20 to R$40. The annual Opera Festival takes place in April and May. Praça São Sebastião s/n, Centro. © **092/3232-1768.**

CLUBS & BARS

Many bars and pubs are located in **Centro,** downtown Manaus. Near the **Praça da Matriz,** Manaus's downtown nightlife scene degenerates into the sleazy mix of sailors and prostitutes traditional in a large port. Praça da Matriz itself remains reasonably safe, but it's best to stay off side streets like Rua Visconde de Mauá.

The city's other popular nightlife spot is out near the Tropical Manaus at **Ponta Negra Beach.** People stroll up and down the wide boulevard, there are regular concerts and events at the amphitheater, and a number of bars have live entertainment in the evening. Lower down close to the river, there's a bunch of *barracas* (beach

kiosks) during the day when the beach is crowded and open at night for a casual beer or snack. Most places open at 5 or 6pm on weekdays and stay open until at least 1 or 2am. On weekends many venues open at 11am and stay open until 3 or 4am.

On the waterfront, **Laranjinha** (☎ 092/3658-6666; Mon–Sat 5pm–3am, Sun 5pm–5am) has a great patio and makes for fine people-watching. Most nights there's a slightly Vegas folklore show featuring beautiful young things (male and female) in skimpy "traditional" costumes.

A Viuva Champanheria This elegant champagne bar is a sure sign that Manaus is becoming hip and trendy. To accompany the bubbly, order a selection of cheeses, cold cuts, or bruschetta. Rua Ferreira Pena 91, Centro. ☎ **092/8439-2565.**

Bar do Armando This is the best spot for an evening drink in downtown Manaus. Located on the square in front of the Opera House, this venerable drinking spot is the nighttime home of Manaus's artists, intellectuals, journalists, and other ne'er-do-wells. The conversation is always interesting and the beer is served icy cold (closed on Sun). Rua 10 de Julho 593, Centro. ☎ **092/3232-1195.**

Laranjinha This popular bar has a great patio and stays open until the wee hours of the morning. It's open Monday to Saturday from 5pm to 3am, and Sunday from 5pm to 5am. Ponta Negra. ☎ **092/3658-6666.**

O Chefão Just across the street from A Viuva Champanheria, you will find this large, sprawling pub, which features live music 6 days a week. The program ranges from Brazilian music to rock, jazz, and blues. There's a R$10 cover. Rua Ferreira Pena 50, Centro. ☎ **092/9225-9606.** www.ochefao.com.

INTRODUCING THE AMAZON
What Is a Rainforest?

Rainforests are found throughout the world, wherever the annual rainfall is more than 2,000 millimeters (80 in.) and evenly spread throughout the year. Rainforests grow in temperate zones (such as the Pacific Northwest) as well as in tropical regions. Tropical rainforests are found in a thick belt extending around the earth on either side of the equator. The constant heat and humidity in a tropical rainforest allow trees and plants to grow year-round. Vast columns of hot, humid air rise and then condense as rain, resulting in annual rainfall of between 2,000 and 10,160 millimeters (80–400 in.); annual temperatures average over 27°C (80°F).

What distinguishes the Amazon from other tropical rainforests is the sheer variety. Biologically, it is the richest and most diverse region in the world, containing about 20% of all higher plant species, roughly the same proportion of bird species, and around 10% of the world's mammals. Each type of tree may support more than 400 insect species. The Amazon is estimated to contain 2,000 species of fish—10 times the number found in European rivers—and countless varieties of reptiles. Why the Amazon should be so diverse is a question that mystifies scientists still.

Not only is it the most diverse, but the Amazon is also the largest tropical rainforest in the world, covering 3.7 million sq. km (2.3 million sq. miles) over nine countries, including Peru, Colombia, Venezuela, and Bolivia. The largest chunk, about 60%, falls within Brazil's borders.

The lifeline of the forest is the Amazon River, the second longest in the world and the largest in terms of water flow and drainage area. The river has over 1,000 tributaries, some of them sizable rivers in their own right. In March and April, the water

Amazon Lodges Near Manaus

Amazon Eco Lodge **7**
Amazon Ecopark Lodge **4**
Amazon Jungie Palace **3**
Amazon Village Lodge **6**
Anavilhanas Lodge **1**
Ariaú Amazon Towers **2**
Juma Lodge **8**
Tiwa Amazonas Ecoresort **5**

262 Federal Road
339 State Road
✈ Airport

levels in these rivers rise and flood the banks and the surrounding forest for months. A seasonally flooded forest is called *varzea* (on the Rio Solimões) or *igapó* (on the Rio Negro), while the upland forest that stays above water is called *terra firme*.

The annual flooding of the forest is one of the key factors in maintaining this ecosystem. As the river covers the forest floor, sometimes leaving just the treetops above water, the fish also expand their terrain. These fish play a vital role in the fertilization of the forest. Many Amazonian fish are fruit eaters that feast on the nuts and seeds of the trees in the wet season. The fish feces deposit the seeds in the fertile ground of the forest, and when the waters recede, new growth occurs.

The difference in water levels between the wet and dry seasons can be as much as 12m (40 ft.). Many of the smaller side channels—called *igarapé*—and creeks that are perfectly navigable in March and April are completely dry by November.

The rainforest itself has a very defined structure. The **understory** is what you see when you hike through the forest. Shielded by the tall trees and overhead layers, the understory can be surprisingly dark. Plants, fungi, and animals found here thrive in the dark, humid conditions. The **canopy** is where a lot of the action is; birds, butterflies, and monkeys are usually up here, 18 to 27m (60–90 ft.) above the understory. With more sunlight and less humidity, the rainforest at this height is green and lush. The **emergent** layer refers to those trees, often upwards of 36m (120 ft.), that send their crowns above the canopy to find the sunlight. Being higher also means these

trees are more exposed to storms and rain. Wide buttress roots support these trees. This layering of the forest contributes to the biodiversity; each layer has its own flora and fauna that thrive in those particular conditions. Cutting through the forest opens up the understory to bright, unexpected light. The dark, humid environment vanishes, other plants and trees take over the space, and the ecological balance is thrown out of whack.

Exploring the Amazon

There are many ways to explore the Amazon. What suits you depends on how much time you have and how comfortable you want to be. Most people choose to stay at a lodge. Most are land-based, located within a few hours by boat from Manaus, and make excursions to the surrounding area. Lodges vary in luxury but the programs offered are similar (see "Amazon Lodges," below).

Another comfortable way of seeing the Amazon is by riverboat. These range from basic to air-conditioned and luxurious. The vessel serves as your home base; you take excursions in canoes up the smaller channels. (See "Boat Trips," later in this chapter.)

Regular boats that locals use to travel the river are another option. Although extremely inexpensive, these are *not* sightseeing tours; it's rare that you get close to shore, and no excursions are possible. You do meet locals traveling the river, and you'll have a front-row seat as you pull in to harbors along the way.

Specialized operators offer expedition-style trips where the emphasis is on truly experiencing the rainforest. You don't need to be in top shape for these; you just have to be able to hike or paddle a boat, and be willing to forego amenities like hot showers for a more hands-on jungle experience. One excellent outfitter is **Amazon Mystery Tours** (see "Deeper into the Amazon: Expedition Tours," later in this chapter).

The Amazon & Eco-Tourism: Questions to Ask

Some visitors come away from a visit to the Amazon energized and excited by what they've seen. Others come away pissed off: The forest was degraded, the animals impossible to see, the guide had no idea what he was talking about. Some of these complaints stem from expectations set too high, from mental pictures of animal encounters developed over too many years of nature documentaries. Other times the complaints are entirely legitimate.

 Viewing Wildlife

Wildlife viewing in the Amazon is a subtle event. It's the occasional flutter of a giant blue butterfly, the glimpse of a startled bird, or the splash as a caiman swims away from your canoe. With a keen eye you may spy snoozing bats tucked away underneath the tree branches, or a large, perfectly camouflaged iguana draped over the branch of a tree. At night, a flashlight reveals the many small frogs that dot the flooded forest; a searchlight shows the hiding places of the caimans as they lie in wait, only their eyes and snout above water. What isn't subtle is the noise. It's everywhere: the tortured squawks of macaws, the high-pitched screams of monkeys high in the trees. And in the "still" of the night, the decibel levels generated by chirping cicadas and "ribbiting" frogs rivals that of a construction site.

Eco-tourism in the Amazon is far from perfect. The section that follows will give you a better idea of what to expect, and of what to do to make your experience the best it can be. I'd also like to encourage you to use your power as a consumer to raise the level of eco-tourism as practiced in the Brazilian Amazon—for the benefit of the Amazon itself.

I love the Amazon. It's a dense, intricate, fascinating ecosystem. I also believe that eco-tourism, done right, can help endangered ecosystems throughout the world. At its best, eco-tourism teaches visitors about the ecosystem, while teaching locals that a functioning natural ecosystem is a thing of real economic value, to be guarded and preserved. Unfortunately, even after 20 years as a tourist destination, "eco-tourism" so defined has yet to develop around Manaus. Indeed, at its worst, Manaus-based eco-tourism seems to be teaching locals that you may as well chop it all down because you can show gringos any damn thing and they'll still ooh and aah, and pay the big bucks.

It's not all bad. Some of it is very good. But things seem to have fallen into a rut, and there's no local impetus for change. Only you, the consumer, can change things, and you can do it simply by demanding more. Below I give a checklist of things to ask, and things to verify before going.

WHAT YOU WON'T GET

First, though, let's dispel the unreasonable expectations. Most lodges, for logistical reasons (food, supplies, attracting staff, ferrying people back and forth to the airport) are located no more than a half-day journey from Manaus. This rules out the "never-before-seen primeval jungle" experience. You will see houses on the riverbank and lots of other boats. In recent years, as cattle prices have soared, pastureland has begun replacing forest on accessible riversides close to Manaus.

Most lodges cater to foreign tourists. For Brazilians, the Amazon is quite expensive. The majority of your fellow travelers will be European, Japanese, or North American. Like it or not, you'll be lumped in with the gringos.

Animals are hard to spot in the dense rainforest. You will see caimans (you may yawn at caimans by trip's end) and more than likely little pink dolphins and some species of monkeys. You will see lots of birds—kingfishers and egrets (snowy, great, and cattle), herons (gray, green, tiger), cormorants, hummingbirds, parakeets, and vultures. Macaws and toucans are also common, though not guaranteed. You *may* see sloths (I've seen one in over 10 trips to the Amazon) and capybaras and agoutis as well as other small nocturnal rodents. The odds of seeing a predatory feline of any species are astonishingly small. Amphibians are also tough—those famous photos of poison arrow frogs took a lot of work and a lot of time.

On the bright side, those worried about creepy-crawlies can rest easy. Insects in the Amazon are really not that bad. There are ants (some about the size of a bumblebee), butterflies, and flying beetles and mosquitoes. In all my visits to over a dozen different parts of the forest (including a 1-week kayak trip in the far-off depths of the Amazon), I've only ever seen one snake, and it was tiny and harmless.

WHAT YOU SHOULD GET

What you can expect is an opportunity to see and experience the rainforest around Manaus. Much of it is in pristine condition, and the vegetation, the range of species, and the sheer oddness of the trees and plants are truly impressive and remarkable. You can expect to learn about life on the Amazon. As the river is the main means of transportation and a major source of food, most people live on or close to it. It can be

fascinating watching children going to school by canoe, seeing 4-year-olds paddle themselves around, seeing women washing their dishes or catching dinner off the decks of houses built on stilts. You can expect to learn about the ecosystem. Many of the guides are quite knowledgeable and they speak foreign languages very well, making it easy to ask questions and learn about the Amazon environment. You should expect to eat well. The lodges put on a wonderful spread of Amazonian specialties, much better than in most restaurants in town. The river fish are delicious.

HOW TO GET IT (& DO GOOD THINGS AT THE SAME TIME)

The following is a checklist of questions to ask the travel agent (or better yet the lodge manager) when researching your stay in the Amazon. The list is by no means comprehensive, but it should help you find the best available option. As importantly, by putting these questions to the operators in the Amazon, you will be educating them on what matters to foreign, ecologically minded tourists. In the listings for the lodges, I've created a lodge checklist with the answers to most of these questions.

1. **How far is the lodge from Manaus?** Farther is better. Although distance does increase travel time, it also lessens the "city effect" on the animals, trees, and people.

2. **How big is the lodge?** Smaller is better. The more people there, the bigger the local environmental impact, the more the trails have been treaded and the animals spooked. Ten rooms is excellent, 20 acceptable, 35 pushing the limit, and 260 obscene.

3. **What is the group size?** Again, smaller is better. The larger the group, the less likely you will see animals or enjoy the forest peacefully. We have been to lodges where huge motorized canoes take 25 people out at a time. Lodges lie about group size, so I've found it more instructive to ask, "What is the maximum capacity of the boats used to take guests on outings?" Generally, that's the group size.

4. **Are the guides trained naturalists?** Is there a biologist at the lodge? Is there a library or resource center at the lodge? Are there any nature talks? The answer to all these questions will be "no" (with a few notable exceptions). But perhaps if enough people ask, maybe someday it will happen. And it's a good lead-in to the next question.

5. **When do trips go out?** Trips scheduled around breakfast and supper are almost guaranteed to show nothing but forest. If you want to see animals, you have to be on the water or in the forest at sunrise or sunset; ask about early morning or dusk excursions if you want to maximize your animal spotting odds.

6. **Are jungle-tour boats motorized or nonmotorized?** If motorized, what kind of engine? Nonmotorized canoes are the best, but only two lodges (the Mamiraua and the Ecopark) use these regularly. The noise of an outboard will scare off most wild creatures. However, they're justifiable if you're on the way somewhere farther off in the forest. But they should still be quiet outboards. Some lodges (the Ariaú is especially bad) use so-called *rabete* engines, unmuffled high-revving two-strokes, with the engine mounted on the drive shaft. The smell and noise of these motors are enough to make you sick; never mind the animals that you'll never get to see.

7. **Are there canoes for guest use at the lodge?** There is inevitably a fair bit of downtime at a lodge. Tours go out early and late, leaving a big chunk of time in the middle of the day. Lodges could offer nature talks or presentations to fill this

time, but they don't. Some people swim. Some snooze in their hammocks. I like to grab a small dugout canoe and go for a paddle. The water is flat and calm, and the scenery can be fascinating. Only the floating Amazon Eco Lodge keeps a fleet of canoes on hand. Other lodges can usually rustle one up if you make a fuss.

8. Finally, one question you should ask yourself. **How much do you want to rough it?** Can you live without air-conditioning, hot water, fridge, and TV? There is an Amazon trip for everyone. Picking the right one will greatly enhance your experience.

AMAZON LODGES

Lodges are a popular way to experience something of the Amazon while keeping comfort levels high. Most are within a 3-hour boat ride from Manaus. Some are more luxurious than others, but in all, your meals are taken care of—usually hearty and healthy fare made with local fish and fruit. You will have access to a shower and toilet, and guides are there to show you around. Nearly all the lodges include the same basic package of excursions: the introductory jungle tour, the sunset and/or sunrise tour, the forest hike, the visit to a native village, the evening of caiman hunting, and the afternoon of piranha fishing (yipes!). What distinguishes one lodge from another is the size of the lodge itself (smaller is better), the quality of the surrounding forest, and the quality of the guides.

Most lodges start off with a reconnaissance tour, taking you out in a motorized canoe to give you an idea of what the area around the lodge looks like; this is a good opportunity to check out some of the smaller channels. The **sunrise** or **sunset tour** is a great way to experience the forest at its most interesting times of the day, when animals are active and there are few disturbances around. All lodges will take guests on a **jungle hike.** This is where you really get a feel for the biodiversity of the forest; it's not the animals that make this jungle so overwhelming, it's the number of plants and trees and how these coexist. Another standard excursion is the **visit to a *caboclo* village.** *Caboclos* are river people. The visits provide a close-up look at how they build their homes, the foods they grow, and the tools they use. Even their pets are neat; sloths and monkeys are the animals of choice. Finally, there's the obligatory caiman spotting and piranha fishing. **Caiman spotting** is fun; you head out in a canoe on the river in the pitch-black night. Once you get to a good shallow area, the guide turns on the spotlight and starts looking for a caiman. The caiman should be big enough to impress the lodge-dwellers, but not *so* big that the guide can't leap into the water and wrestle it back into the boat. (That's exactly what he does.) Once it's in the boat the creature becomes the centerpiece of a short nature talk. Many enjoy **fishing for piranhas.** You put some beef on your hook and hold your rod in the water, pretty much like fishing anywhere. When you catch one, your guide will pull it off the hook—very carefully, those teeth really are razor sharp—and you'll see the little fish back at dinnertime when the kitchen serves it up grilled.

What to Bring: A Checklist

Most hotels will let you store your luggage while you are away at a lodge so you don't have to carry it all with you. The smaller lodges often have a luggage limit. Whatever you leave behind, don't forget to bring the following:

o A small daypack.
o Binoculars.

- A light rain jacket.
- A few zip-lock bags to protect camera gear, notebook, and so on . . . in a sudden downpour, everything gets soaked.
- Good walking shoes.
- Sunglasses.
- Sunscreen. (The glare from the river can be quite strong.)
- Enough dry clothes; nothing dries once it's damp, so have a couple of changes of shirts and socks.
- Toiletries such as toothpaste, contact lens fluid, tampons. The lodges usually don't carry any such items.
- Medicinal items for personal use (aspirin, antacid, and so on; lodges and tour operators will have proper first-aid kits). Malaria is not an issue on the Rio Negro; the high acidity of the water prevents mosquitoes from laying their eggs.
- Anything you can't live without: chewing gum, dental floss, tissues, cookies, and the like.

Booking a Lodge

You can contact lodges directly or contact a tour operator who can assist you in choosing the right package. In the U.S. or Canada, your best option is to contact the experts at **Brazil Nuts** (℡ **800/553-9959;** www.brazilnuts.com). In Manaus, contact **Viverde,** Rua dos Cardeiros 26 (℡ **092/3248-9988**). They have an excellent English-language website (www.viverde.com.br) with detailed information on both tours and the Amazon in general.

Note: All prices are per person and include transportation, all meals, and basic excursions. Airport transfer or hotel pickup is usually included in the price, but always check. The policies for children vary per lodge and per season; depending on occupancy you may have bargaining power. Most lodges offer up to a 50% discount for children 12 and under; ask when making reservations. Some lodges list their rates in U.S. dollars only; please confirm current prices before booking.

Lodges Close to Manaus

Amazon Ecopark Lodge ★★ The Amazon Ecopark is one of the better lodges close to Manaus, as long as you arrive with the right expectations. The lodge itself is about a 2-hour boat trip from Manaus and sits on a private reserve. The *igarapé* is used exclusively by the lodge, which gives it a secluded feel. In the dry season there are several beaches right across from the lodge, and the vegetation is lush and beautiful. The lodge also has some natural pools for swimming, particularly nice for people who are never quite comfortable swimming in the dark waters of the Rio Negro. Most of the excursions take place in proximity to the lodge and are done in nonmotorized canoes. Paddling into the flooded forest, you'll be able to get a good sense of the sights and sounds of the jungle. The lodge also houses a rehab for monkeys that are apprehended by Brazil's environmental agency, Ibama. Guests can see the daily feedings and observe and even interact with these monkeys. Most packages include a visit to an Indian village. Although undoubtedly a touristy experience, it is well done and you will be able to see their traditional houses and the little plots of land where they grow and process manioc and other fruit and vegetables. All packages include airport transfers, all meals (the food is fabulous), deluxe accommodations, and well-trained guides who speak excellent English.

Lodge Checklist: Distance: 20km (12 miles); Biome: Igapó; Size: 60; Boat Capacity: 12; Boat Motors: Outboard; Canoes: Yes (canoes used for many excursions); Library: No; Biologist: No; Nature Talks: No; Other Excursions: "Jungle survival training."

www.amazonecopark.com.br. Reservations office in Rio ☎ **021/2547-7742** or ☎/fax 021/2256-8083. 64 units. A 3-day package costs US$565 per person; a 4-day package is US$690 per person (both these packages include a tour to the Meeting of the Waters). Children 6–12 pay 25% of rate, 13–16 pay 50% of rate. AE, DC, MC, V. **Amenities:** Restaurant; bar; outdoor pool. *In room:* A/C, fan, no phone.

Amazon Jungle Palace ★★

If you are short on time and prefer your jungle experience with a touch of luxury, this may be a good fit. The three-story hotel sits atop a floating structure that is anchored in a lake, just off the Rio Negro. The structure consists of two buildings that house the upscale accommodations equipped with hot showers, cable TV, Wi-Fi, and air-conditioning. The restaurant, swimming pool, and deck are practically at the river level. Completely surrounded by water, it feels as if you are on a boat; in fact, when the water level is high you occasionally feel the entire structure sway. The lodge offers all the standard excursions, such as piranha fishing, caiman spotting, boating, and jungle walks. Despite its closeness to Manaus there are enough *igarapés* and trails in the area to give you a taste of the jungle, before retreating to your island of luxury.

Lodge Checklist: Distance: 20km (12 miles); Biome: Igapó; Size: 60; Boat Capacity: 12; Boat Motors: Outboard; Canoes: Yes (canoes used for many excursions); Library: No; Biologist: No; Nature Talks: No; Other Excursions: No.

www.amazonjunglepalace.com.br. Reservations office in Rio ☎ **092/3658-8120.** 65 units. A 2-day package costs R$1,250 for 2 people; a 3-day package is R$2,160 for 2 people. Ask about discounts for children. AE, DC, MC, V. **Amenities:** Restaurant; bar; fitness center; outdoor pool. *In room:* A/C, TV, minibar, Wi-Fi.

Amazon Village Lodge ★

The Amazon Village is a well-run operation with its own small rainforest reserve, now alas being seriously encroached upon by ever-growing cattle operations and the beginnings of urban sprawl from the city. It's too bad, because the Amazon Village is a class act—owners treat guides well and do a good job presenting the rainforest. Although not as remote as some other jungle lodges, like Juma Lodge, this lodge offers a good introduction to the rainforest. The lodge buildings are attractively designed with local wood in the native *maloca* style, while rooms are small and clean with private toilets and showers. There is no hot water, and electricity is limited to the evening hours. There's the usual package of excursions. The lodge doesn't have a swimming pool, but you can swim in the river.

Lodge Checklist: Distance: 40km (25 miles); Biome: Igapó; Size: 36; Boat Capacity: 12; Boat Motors: Outboard; Canoes: Yes (1); Library: No; Biologist: No; Nature Talks: No; Other Excursions: No.

Rua Ramos Ferreira 1189, sala 403, Manaus, 69010-120 AM. www.amazon-village.com.br. ☎ **092/3633-1444.** Fax 092/3633-3217. 45 units. 3-day packages start at US$440 per person. AE, DC, MC, V. **Amenities:** Restaurant; bar.

Tiwa Amazonas Ecoresort

The Tiwa fills an odd ecological niche, neither jungle lodge nor city hotel. It sits directly opposite the Tropical, on the far bank of the Rio Negro. Access is via fast motor launch; the trip takes about 20 minutes, and there are boats going back and forth every other hour. Each of the sizable rooms takes up half a log cabin, which are set in circles around a small pond. The hotel pool is lovely. Theoretically, the Tiwa could serve as an alternative to the Tropical—a luxury resort, just a little farther from the city. But what the Tiwa is selling itself as is a jungle lodge,

with 2- and 3-day packages and the usual outings, including caiman spotting and treetop walking. The Tiwa is just simply too close to the city for that. The "forest" surrounding the lodge is a small patch of barely regrown second-growth; walk too far and you stumble onto roads and clear cuts. If you don't have time to go to a jungle lodge, and just want a teensy-tiny taste of the Amazon, the Tiwa may be an option. Otherwise, go elsewhere.

Lodge Checklist: Distance: 8km (5 miles); Biome: Terra Firme; Size: 52; Boat Capacity: 50; Boat Motor: Outboard; Canoes: No; Library: No; Biologist: No; Nature Talks: No; Other Excursions: Trips to Meeting of the Waters, Lago Janauary.

Caixa Postal 2575, Manaus, 69005-970 AM. www.tiwa.com.br. (C) **092/9995-7892.** 52 units. 3-day packages with excursions and including transfers in and out cost R$1,200 per person. Policy for children negotiable. AE, DC, MC, V. **Amenities:** Restaurant; bar; Internet; outdoor pool. *In room:* A/C, fridge, minibar, no phone.

Lodges Farther from Manaus

Amazon Eco Lodge ★★ Located just a few kilometers from the Juma Lodge (see below), the Amazon Eco Lodge has the same excellent forest surroundings, and the same long trip from Manaus. The package of outings at both lodges is also essentially the same. The one thing the Eco Lodge has over the Juma is its fleet of small canoes, always at the ready should a guest feel like going off for a paddle. The Eco Lodge floats on the lake, on top of huge log rafts, which is really quite charming. It's also a great place for river swimming. The disadvantage is that accommodations are in fairly small rooms, built in wings with wooden walls; it can get noisy. Also, toilets and showers are shared, in a shower block near the center of the raft complex. Prices at the Juma and Eco Lodge are comparable, but for the money the Juma provides better value.

Lodge Checklist: Distance: 85km (53 miles); Biome: Igapó; Size: 18; Boat Capacity: 12; Boat Motor: Outboard; Canoes: Yes; Library: No; Biologist: No; Nature Talks: No; Other Excursions: No.

Rua Flavio Espirito Santo 1, Kissia II, Manaus 69040-250 AM. www.naturesafaris.com.br. (C) **092/ 3656-6033.** Fax 092/3656-6101. 18 units, common bathrooms and showers. 4-day packages US$599–US$745 per person. Policy for children negotiable. AE, DC, MC, V. **Amenities:** Restaurant; bar; outdoor pool. *In room:* A/C, fridge, minibar, no phone.

Anavilhanas Lodge ★★★ This lodge lies 180km (112 miles) upstream from Manaus, near Anavilhanas, the largest freshwater archipelago in the world. Hundreds of islands and islets dot this 27km-wide (16-miles) stretch of the Rio Negro, forming a lush green maze of pristine rainforest best explored by small boat. Especially in the wet season (Dec–June) you paddle right among the treetops. The other big draw is the resident population of pink river dolphins (*boto cor de rosa*). At a nearby viewing platform, visitors enjoy close encounters as the dolphins belly right up to get fed fresh fish. Although the feeding sounds environmentally incorrect, it has helped to preserve these animals as local fishermen no longer shoot them now that there is money to be made from tourism. The luxurious lodge sits on *terra firme* on the shore of the Rio Negro; the spacious rooms are tastefully appointed with elegant rustic furniture, king-size beds, high-end linens, and top of the line amenities. In between excursions you can relax in the beautiful reading lounge or in the swimming pool overlooking the archipelago. Transfer to the lodge is entirely by car. This may sound dull, but the 3-hour drive provides a unique peek into the other Amazon rainforest where we find settlements, farms, and plantations.

Lodge Checklist: Distance: 180km (112 miles); Biome: Freshwater archipelago; Size: 20; Boat Capacity: 12; Boat Motor: Outboard; Canoes: Yes; Library: Yes; Biologist: No; Nature Talks: No; Other Excursions: No.

Rod. AM 352, Km 1, Novo Airão 69040-250 AM. www.anavilhanaslodge.com. ☎ **092/3622-8996.** 20 units. 3-day packages R$1,420 per person; 4-day packages R$1,850 per person. Children 4 and under free, children 5–11 50%. AE, DC, MC, V. **Amenities:** Restaurant; bar; outdoor pool; Wi-Fi. *In room:* A/C, TV, minibar.

Ariaú Amazon Towers 🖐

Avoid this place. Just don't go. The Ariaú is all that is wrong with Amazon "eco-tourism"; it is the Disneyland Ford Factory of jungle lodges. Marketing photos of treehouses and boardwalks may suggest a Swiss Family Robinson adventure, but what the Ariaú delivers is mass-market tourism, with hundreds of guests getting trundled each day along a set tourist route that has already been treaded literally tens of thousands of times. Repetition is a factor at any lodge, but the Ariaú has a serious problem of scale—there are over 250 units in place—combined with a management fixation on minimum expense and maximum profit. Although the Ariaú charges top price and has economies of scale on its side, it has never seen fit to hire a lodge biologist or open an on-site interpretation center (though there is a gym and spa, a helipad, and a jewelry boutique). Excursions are the usual, but at the Ariaú, group size runs up to 25. Trips are always in motorized canoes, equipped with noisy, fume-spewing two-stroke *rabete* motors.

Lodge Checklist: Distance: 35km (22 miles); Biome: Igapó; Size: 300; Boat Capacity: 25; Boat Motors: Large rabete; Canoes: Yes (1); Library: No; Biologist: No; Nature Talks: No; Other Excursions: Yes, but at steep add-on prices.

Rua Leonardo Malcher 699, Manaus, 69010-040 AM. www.ariautowers.com. ☎ **092/2121-5000,** or in Rio de Janeiro **021/2254-4507.** Fax 092/3233-5615. 269 units. 3-day packages start at R$1,500; 4-day packages R$1,900 per person. Children 6 and younger are free, ages 7–11 pay 50%. AE, DC, MC, V. **Amenities:** Restaurant; bar; gym; Internet; outdoor pool; spa. *In room:* A/C, fridge, no phone.

Juma Lodge ★★★

One of the best of the lodges in the area, the Juma gets jungle points for its small size and its distance from Manaus; it really feels like you are out in the forest. Rooms are all in comfortable cabins built on stilts. The best rooms are the charming self-contained doubles (room nos. 9, 10, and 11) with a view out over the lake. Cabins are connected to the dining hall by elevated boardwalks. The Juma is located in the middle of a sizable private nature reserve, so the forest surroundings are well preserved. The lodge offers the standard excursions. By prior arrangement, the more adventurous can also spend a night sleeping in a hammock in the jungle. The lodge also has one dugout canoe that guests can borrow. The transfer to the lodge from Manaus takes approximately 4 hours. However, it's not simply dead time. As you cross the Rio Negro there is time to observe the Meeting of the Waters. Then, after a short van ride, you transfer to a small boat that takes you all the way to the lodge; keep an eye out for birds, monkeys, and sloths.

Lodge Checklist: Distance: 90km (56 miles); Biome: Igapó; Size: 23; Boat Capacity: 8; Boat Motors: Rabete; Canoes: Yes (1); Library: No; Biologist: No; Nature Talks: No; Other Excursions: Will program night walks in forest and sleepovers in forest on request.

Lago do Juma (no mailing address). www.jumalodge.com.br. ☎ **092/3245-1177** (lodge) or 3232-2707 (reservations office). 23 units. 3-day, 2-night packages start at R$1,300 per person; 4-day packages R$1,600 per person. Children 6–12 pay 50% of rate. AE, MC, V. **Amenities:** Restaurant; bar. *In room:* Fan, no phone.

BOAT TRIPS

On a boat-tour package, the experience is similar to that of a lodge; there are excursions on the small side channels, a sunset and sunrise tour, caiman spotting, piranha fishing, and a visit to a *caboclo* (river peasant) settlement. The difference is that in the time you're not on an excursion, you're moving on the river. There is always something to see, even if it's just the vastness of the river itself.

Viverde, Rua dos Cardeiros 26, Manaus (✆/fax **092/3248-9988;** www.viverde. com.br), can arrange boat voyages or charters. Their website has photos and descriptions of the better Manaus-based touring boats.

Amazon Clipper Cruises (✆ **092/3656-1246;** www.amazonastravel.com.br/ amazon_clipper_i.html) has three old-style Amazon riverboats—the *Amazon Angler, Selly Clipper,* and *Selly Clipper II*—that make regular 3- and 4-day trips departing from the Tropical Manaus. The boats have cabins with bunk beds and private bathrooms, and in the evening the cabins have air-conditioning. The 3-day tour stays on the Amazonas River; the 4-day tour goes up the Rio Negro. Both tours include a visit to Janauary Park and the Meeting of the Waters. The price for the 3-day Amazonas tour is US$655, and the 4-day Rio Negro tour costs US$890. Children 12 and under receive a 20% discount. A newer and more luxurious boat has recently been launched, the *Amazon Clipper Premium.* The main differences are that the boat has a number of pleasant common rooms and the cabins come with real beds, not bunk beds. Rates, however, are at a premium; the 3-day Amazonas package costs US$913, and the 4-day Rio Negro tour US$1,215.

Iberostar Grand Amazon ★★ (✆ **092/2126-9900;** www.iberostar.com) provides the ultimate luxury Amazon river experience. This 75-cabin pocket cruiser offers a 3-night Solimões cruise or a 4-night Rio Negro cruise. Both are worth taking; for most people it's just a matter of which one fits better into their travel plans. Cabins are beautifully appointed and feature king-size beds, large-screen TVs, a private veranda, and a luxurious bathroom. All the luxury aside, however, the cruise is actually well set up (better than many of the lodges we have visited) for making the most out of your Amazon experience. There is a well-stocked library with books on the region, and the knowledgeable guides give daily presentations on the region's fauna and flora. Excursions are made in aluminum launches with twin 240-horsepower motors, allowing you to quickly get to any place of interest. As the ship is constantly moving, you move into far more diverse territory than at a lodge. We have seen some of our best wildlife on this cruise. *Tip:* Operators like Viverde or Brazil Nuts can often book a much better rate than listed on the Iberostar website. Packages start at US$848 per person for a 4-day package and US$1,160 per person for a 5-day package, including all meals, beverages (alcoholic and nonalcoholic), guided excursions, and entertainment.

Swallows and Amazons ★, Rua Ramos Ferreira 922, Manaus (✆ **092/3622-1246;** www.swallowsandamazonstours.com), is run by New Englander Mark Aitchison and his Brazilian wife, Tania. The company's core trip is a 7-night adventure program that includes 2 nights in Manaus and then sets off up the Amazon and Rio Negro to explore the territory around the Anavilhanas Archipelago. Transportation is on family-owned traditional wooden riverboats, while exploration is done either on foot or by canoe. Accommodations are either on the riverboat (hammocks) or on a houseboat (with air-conditioning and cabins). Prices range from US$1,350 (riverboat) to US$1,650 per person (houseboat) and include all meals, airport transfers,

transportation, and activities. These trips run year-round; check the website for more information and other tour options. We highly recommend booking ahead of time to make sure that the 8-day program fits into your travel schedule.

RIDING THE RIVERBOATS

The old-style wood or steel-hull riverboats that ply the Amazon basin are about transport, not seeing wildlife. They stick to deeper channels, taking passengers and goods up and down the Amazon. The most popular routes are Manaus-Belém and Manaus-Santarém. Most boats have small cabins, though it's more fun just to sling your hammock on deck. Good, simple meals and filtered water are supplied on the boat at no extra cost.

Boats depart from the new **Hidroviaria do Amazonas** (**Riverboat Terminal;** ☎ 092/3621-4310) in the middle of downtown at Rua Marquês de Santa Cruz 25. An information desk inside the front door provides information about arrival and departure times, and numerous kiosks sell tickets. By purchasing here, you can be sure you will not be cheated. Boats for **Belém** normally depart Wednesday and Saturday at noon. The trip downstream takes 4 days. Delays are not uncommon. The cost of a first-class hammock spot (on the upper deck) is R$275. Hammocks are not supplied. Buy one in Manaus (see "Shopping," earlier in this chapter). Cabins cost R$750 to R$850. Boats for **Santarém** normally depart Tuesday and Thursday. The cost is R$125 for a first-class hammock, R$98 for a second-class hammock, and R$325 for a cabin. The trip takes about 40 hours.

DEEPER INTO THE AMAZON: EXPEDITION TOURS

Amazon Mystery Tours ★★★ 🔥 If you want to really explore the jungle, this is the company to go with. Amazon Mystery has the skills and experience to bring you deep into the rainforest; make your time there safe, fun, and informative; and then get you back to town again. The company has core adventures in either a kayak or speedboat of the Amazon tributary rivers upstream of Manaus. For the kayak adventures, a typical day includes a few hours of paddling, followed by a delicious lunch of fresh fish, followed by a hike to a waterfall or hidden cavern that few have ever seen. At night, you head out with a spotlight to search for caimans or other jungle creatures. The speedboat adventures cover much the same territory, but with less time on the river, and more time to explore the forest. The company's regular guide is Rinaldo; fluent in English, he has extensive knowledge of the Manacapuru, Urubu, Jatapu, Uatama, Solimões, Negro, and Amazon rivers, and is an expert at identifying and describing the flora and fauna of the jungle. Participants need a basic level of physical ability—for example, you should be able to hike and paddle a small boat—but no special skills. The camping is very comfortable, the food is excellent, and the company knows to bring along the little extras like folding chairs (not to mention caipirinha cocktails) that make camping civilized. You sleep in hammocks. At present, Amazon Mystery has 4- to 6-day descents on the Manacaparu river, 7-day descents of the Rio Urubu, and 8-day descents of the Jatapu river. However, the owner is always exploring new territory, so it's a good idea to check the website. The company also offers a 3-day adventure sports trip involving rappelling and white-water kayaking.

Rua 2, casa 23, Parque Tropical, Manaus. www.amazon-outdoor.com. © **092/3308-9073** or 092/9174-3047. Prices start at R$400–R$500 per person per day, which includes all airport transfers, accommodations, equipment, drinks (alcoholic and nonalcoholic), meals, guides, and excursions.

Pousada Uakarí in the Mamiraua ★★★ The only place in the Brazilian Amazon practicing real eco-tourism, the Uakarí pousada is the eco-tourism branch of the Mamiraua Sustainable Development Institute. The Mamiraua reserve was created on the upper Amazon in 1999 in order to preserve the prime habitat of the uakari monkey (a primate with a bright red face and pale white fur, often called the English monkey). The institute fosters research while working to preserve the area by helping local inhabitants develop alternate ways of exploiting the forest. The eco-tourism operation is part of that effort. Accommodations are in small but comfortable chalets, each with its own hot shower and veranda. Excursions completely break the pattern set in other lodges. In the wet season visitors get paddled through the forest in small canoes. In the dry season tours go on walking trails. Nighttime excursions aim not to capture a caiman, but to show off the nocturnal animals. A local guide is always present; normally there is a trained naturalist as well. Nature talks are a nightly occurrence. The researchers working in the area have dinner with guests, sharing their experiences. For longer stays at certain times of year, guests can accompany researchers in the field. Good as all this sounds, there are disadvantages: guides are local people being trained in tourism, so they may not be as polished as you'd expect; it's a lot farther than other lodges; the ecosystem is *varzea*, which means more mosquitoes; and it's very nature-focused, which isn't for everyone.

Getting to Tefe: Tefe lies some 200km (125 miles) upriver of Manaus. **TRIP** (© **0300/789-4747;** www.voetrip.com.br) has daily flights. The cost of a one-way ticket starts at R$170. There is also a fast ferry departing Manaus for Tefe at 7am every Wednesday and Saturday. The journey takes about 12 hours. The cost is R$190.

Lodge Checklist: Distance: 200km (125 miles); Biome: Varzea; Size: 10; Boat Capacity: 12; Boat Motors: Outboard; Canoes: Yes, canoes used for most excursions, but no individual canoeing allowed; Library: Yes; Biologist: Yes; Nature Talks: Yes; Other Excursions: Yes.

Av. Santos Dumont 1350, loja 16 (Manaus Airport), Manaus, 69049-000 AM. www.mamiraua.org.br. © **092/3652-1213** or (main eco-tourism line) 097/3343-4160. Fax 097/3343-2967. 10 units. 4-day packages cost R$1,140 per person; 5-day packages are R$1,378 per person. Price does not include plane or boat fare to city of Tefe. AE, DC, MC, V. **Amenities:** Restaurant; bar.

BELÉM

Belém's an old city, founded in 1616 on the spot where the Amazon River reaches the sea. The first and most important building was the fort. Belém was not a commercial enterprise but a strategic investment. By controlling the mouth of the Amazon, Portugal could prevent other nations from penetrating into the vast interior, and not incidentally expand the borders of its own South American empire. Peasants and soldiers were required to feed and man the fort, along with a church and governor to keep peasants and soldiers in line. And that, give or take a tiny merchant class, was pretty much Belém for some 200 years, until in the latter half of the 1800s a Scottish engineer named Dunlop discovered vulcanized rubber, and realized it would be the perfect thing to cushion the ride on that nifty new invention, the bicycle.

Demand for rubber latex, then grown exclusively in Amazonia, soared to unimagined heights. Awash in money from rubber, Belém's unimaginative elite began importing civilization wholesale from abroad: a cast-iron market hall from Scotland;

FOLKLORE extravaganza IN THE AMAZON

Every year, during the last weekend of June, the small town of Parintins hosts a folkloric event that rivals Rio de Janeiro's Carnaval in scale, color, and pageantry. The annual *Boi Bumbá* festival is truly one of Brazil's most spectacular events, as two competing teams, the Blue *Caprichoso* and the Red *Garantido*, vie for top marks in representing the legend of the *boi* (bull). In a nutshell, the legend tells the story of Pai Francisco (or Pai Chico) who kills a bull so he can satisfy his pregnant girlfriend's craving for ox tongue. Several characters, including a medicine man and a priest, attempt to revive the bull so that Pai Francisco doesn't get punished for killing it.

The battle of the bulls takes place in a custom-built stadium, known as the *bumbodromo*, which accommodates 30,000 spectators. Just like in the Carnaval parades, the groups get marks for float design, story, costumes, and music. Three nights in a row, each team puts on a 2½-hour extravaganza that combines enormous carnival floats with theatrical choreography, opera-like sets, creative costumes, and an energizing beat. Hundreds of performers tell the legend of the *boi* and several other indigenous legends. Unlike the Carnaval parades in Rio de Janeiro, outsiders cannot buy a costume and participate. However, the audience plays a very active role in the show, interacting with the singer and performing all kinds of choreographed moves and gestures.

This entire extravaganza takes place in a town of 120,000 people, set on an island in the middle of the Amazon, 400km (249 miles) downstream from Manaus. The whole town participates, and is divided into blue and red fans. Even the ads are made up in two colors and locals proudly boast that this is the only place in the world where Coca-Cola is blue. The few hotels in town cannot accommodate the thousands of visitors who come to witness the festival; instead, hundreds of riverboats anchor around the city to house the revelers.

Parintins operator **Tunucaré Turismo** (✆ **092/3234-5071;** www.tucunare turismo.com.br) and Manaus-based **Paradisetur** (✆ **092/3648-5888**) offer various packages including flights, accommodations, and tickets. Two days is enough to experience the event and see the town. During the days leading up to the festival and during the event, there are at least a dozen flights a day from Manaus.

streetlights and electric trams from England; dresses and lingerie from Paris. In the copied-from-England parade ground park (now Praça da República) they built a copied-from-Italy opera house, a nice counterpoint to the copied-from-Rome basilica in the suburb of Nazaré. Everything built and bought was of the finest materials: marble, jacaranda, ebony, iron, silk, lace. Then the price of rubber crashed, and Belém never quite figured out how to bounce back. Today the city of 1.5 million survives as an export point for Amazon products.

For visitors, the chief attraction remains that 19th-century legacy. The vast Ver-o-Peso Market on the banks of the Amazon has every rainforest product imaginable available for sale. The old downtown, with its fort and cathedral and decaying stock of 19th-century buildings, provides a decent day's strolling.

Belém's cuisine is remarkable, with a mix of Amazon and seafood ingredients found nowhere else in Brazil. No visit is complete without an evening at a good Belém restaurant, and a stop at a tropical fruit-juice stand or ice-cream shop.

In a long-ago world before deforestation, the other attraction to Belém might have been the rainforest, but Pará state has chopped its forest down with such enthusiasm there's very little original forest left that is reachable in an easy journey from Belém.

Instead, Belém's chief wildlife attraction is the island of Marajó, the world's largest freshwater island, which sits at the mouth of the world's largest river. Occupied by buffalo ranches and prone to periodic flooding, Marajó's landscape has vast flocks of colorful wading birds, caimans, and piranhas.

For visitors with limited time to spend, I'd recommend no more than a day or two in Belém, and then a 3- or 4-day journey to Marajó.

Essentials
GETTING THERE
BY PLANE Gol (© 0300/115-2121; www.voegol.com.br) and **TAM** (© 0800/570-5700 or 091/4002-5700; www.tam.com.br) fly to Belém's international airport, the **Aeroporto Internacional de Val-de-Cães** (© 091/3210-6039), 22km (13 miles) from downtown. **Coopertaxi** (© 091/3257-1720) operates all the taxis at the airport. The company can be reached 24/7 and accepts Visa and MasterCard. Fares to downtown (Praça da República area) average R$40.

BY BUS The bus station, or **Terminal Rodoviario,** is located at Av. Almirante Barroso s/n on the corner of Avenida Gov. José Malcher (© 091/3266-2625; Bus: 900, CIDADE NOVA IV—VER-O-PESO from in front of the Ver-o-Peso Market or on Av. Nazaré on the bottom tip of Praça da República). Companies that run popular routes include **Boa Esperança** (© 091/3266-0033) to Natal, Recife, São Luis, and Fortaleza; **Itapemirim** (© 091/3226-3458) to Salvador, São Paulo, and Rio de Janeiro; and **Transbrasiliana** (© 091/3226-1942) to Brasilia and São Luis. Brazilian long-distance buses are safe, air-conditioned, and comfortable, especially the overnight ones, which have fully reclining (*leito*) or mostly reclining (*semi-leito*) seats. Tickets can be purchased only at the station.

BY RIVERBOAT Most people choose to make the 4-day riverboat journey downstream from Manaus to Belém, but you can make the 5-day journey upstream the other way. Tickets and information are available from the riverboat company kiosks located inside the **Rodoviaria Fluvial,** Av. Marechal Hermes s/n (© 091/3224-6885), located on the waterfront a kilometer (½ mile) downstream of the Estação das Docas near the corner of Avenida Visconde de Sousa Franco. The terminal looks run-down and seedy, but it's safe enough during the day. Several boats make the journey, departing on different days of the week. **Macamazon,** Av. Boulevard Castilho França 744 (© 091/3222-5604), has departures for Manaus Monday, Tuesday, Wednesday, and Friday at 6pm. The cost is R$350 for a hammock spot, R$600 for a cabin. You can often negotiate a 30% discount if you buy the day before sailing.

English-speaking agents at **Amazon Star** (© 091/3241-8624; www.amazonstar.com.br) will gladly book you passage on board the NM *Santarem,* which departs every other Tuesday at 6pm, arriving in Manaus on Sunday. The boat stops for a day in Santarem en route, and passengers have the option of making a day trip to Altar do Chão, the beach resort on the Tapajos river.

CITY LAYOUT
Belém was founded on a small headland where the Rio Guamá flows into Guajará Bay on the Amazon estuary. It was here in 1616 that the Portuguese erected the

Belém

ATTRACTIONS

Basílica de Nazaré **21**
Casa das 11 Janelas **7**
Catédral da Sé **8**
Estação das Docas **2**
Forte do Presépio **5**
Gem Museum of Pará **14**
Icoaraci **1**
Mangal das Garças **12**
Museu do Círio **6**
Palácio Antônio Lemos **11**
Palácio Lauro Sodré /
Museu do Estado **10**
Parque-Museu Emílio
Goeldi **22**
Sacred Art Museum **7**
Theatro da Paz **17**
Ver-o-Peso Market **4**

RESTAURANTS

Estação das Docas **2**
Lá em Casa **2**
Manjar das Garças **13**
Sorveteria Cairu **3**
Sushi Ruy Barbosa **20**

HOTELS

Crowne Plaza Belém **19**
Hilton **16**
Hotel Grão Pará **15**
Hotel Massília **18**
Portas da Amazonia **9**

Forte do Belém. Defense taken care of, the Portuguese turned to religion, erecting both the **Catédral da Sé** and the **Igreja de Santo Alexandre** on the small square opposite the fort, **Praça Frei Caetano Brandão.** On a much larger adjacent square—**Praça Dom Pedro II**—the early city builders gave unto Caesar, erecting two palaces—the white **Palácio Lauro Sodré** and the blue **Palácio Antônio Lemos**—that would house the civil administration of the state and city, respectively. On the riverbank slightly downstream (north) is where they put the **Ver-o-Peso Market,** and next to that, the city's docklands, which have recently been renovated into a restaurant and shopping complex called the **Estação das Docas.** Running parallel to the river is the broad, busy **Avenida Castilhos França.** Inland from this street is the old commercial section of the city, an area of small shops and old colonial buildings called the **Cidade Velha** or **Old City.** It's a fun area to wander during business hours, but it should be avoided in the evening and on Sundays. The northern boundary of the old city is **Avenida Presidente Vargas,** which runs inland from the waterfront uphill out of the old city to a large green square—the **Praça da República**—upon which sits the **Theatro da Paz.** At the tip of the praça, **Avenida Nazaré** veers off at an oblique angle, leading into a more upscale residential district of **Nazaré,** home to the **Basilica of Nazaré,** as well as other attractions such as the **Museum of Emilio Goeldi.** This street leads to the bus station.

GETTING AROUND

Most of Belém's main attractions are within easy walking distance of Praça da República. For destinations farther afield, Belém's buses are fast and efficient and the city's taxis are plentiful and affordable.

BY BUS Bus fare is R$2 with no transfers. The buses' origin and destination are given on the front, while smaller signs on the front and sides give route information. Because of the many one-way streets in Belém, buses normally follow different routes going and coming, so the smaller signs list route information for the trip out—IDA— and for the return route—VOLTA. For visitors, the two most useful routes are the ones that take you from either the Ver-o-Peso Market or Praça da República out past the Nazaré Basilica, the bus station (*rodoviario*), and the Bosque Rodrigues Alves. The following will accomplish that, but as always there are others.

 From in front of the Ver-o-Peso, the buses are BENGUI—VER-O-PESO; CIDADE NOVA IV—VER-O-PESO AF900; JIBÓIA BRANCA—VER-O-PESO AF 986.

 From Avenida Presidente Vargas (Praça República), the buses are AGUAS BRANCAS—PRES. VARGAS AU 988; CASTANHEIRA—PRES. VARGAS AG 440; ICOARACI—A. BARROSO. (This last bus will also take you out to Icoaraci.)

BY TAXI Taxis are plentiful and inexpensive. They can be hailed on the street or at numerous taxi stands. Rides are always metered. Sample fares: from the airport to Praça da República, R$40; from the main bus station to Praça da República, R$20; from Praça da República to the Ver-o-Peso Market, R$10. **Coopertaxi (© 091/3257-1720** or 3257-1041) can be reached 24/7 and accepts Visa and MasterCard.

BY CAR Belém drivers buckle up religiously and carefully observe posted speed limits; Belém's police enforce the rules ruthlessly. Roads and destinations are well-marked, making travel straightforward if you decide to rent a car.

VISITOR INFORMATION

The city and state tourism agencies, **Belémtur** and **Paratur,** have side-by-side kiosks at the airport. Both have excellent free maps of Belém. The Belémtur kiosk is open Monday through Friday 8am to 11pm, Saturday and Sunday 9am to 9pm. The

Paratur kiosk is open Monday through Friday 9am to 9pm, Saturday 9am to 1pm. Paratur also has a very good English-language website: www.paraturismo.pa.gov.br. In the city, **Paratur** (☎ **091/3212-0575**) has an office near the shipping port at Praça Maestro Waldemar Henrique s/n. **Belémtur** (☎ **091/3283-4850;** www.belem. pa.gov.br, Portuguese only) has an office at Av. Gov. José Malcher 257. The staff is friendly, though they only speak Portuguese and have little useful information. Both are open Monday through Friday 8am to noon and 1 to 6pm.

[FastFACTS] BELÉM

Area Code The area code for Belém is **091.**

Banks & Currency Exchange Banco do Brasil, Av. Presidente Vargas 248, Comércio (☎ **021/ 2223-2537**), is open Monday to Friday 10am to 4pm, with a 24-hour ATM on-site. **Turvicam** on Praça da República, Av. Presidente Vargas 640, loja 3 (☎ **091/9609-5539**), changes cash and traveler's checks; it's open Monday to Friday 8am to 6pm, Saturday 8am to 1pm.

Car Rentals Avis is at the airport (☎ **091/3257-2257**) and Hotel Hilton (☎ **091/3225-1699**). Also at the airport is **Localiza** (☎ **091/3257-1541**).

Consulates Great Britain has an honorary consulate at Av. Governador Magalhães Barata 651, Room 610 (☎ **091/4009-0050**). There is a **U.S. consulate** at Edificio Sintese, 21, Avenida Conselheiro Furtado, 2865 (☎ **091/ 3259-4566**).

Dentist Visit **Cliniodonto,** Travessa Padre

Eutiquiuio 1971 (☎ **091/ 3225-0413**).

Emergencies Police ☎ **190;** fire and ambulance ☎ **192.**

Hospital The hospital in Belém is **Hospital Ofir Loyola,** Av. Governador Magalhães Barata 992, Nazaré (☎ **091/3249-9429**).

Internet Access For Internet access, go to **TVTron Business Center,** in the basement of the Hotel Hilton on Praça da República (☎ **091/3225-0028**). It's open Monday to Friday 7:30am to 10:30pm, Saturday and Sunday 7:30am to 6:30pm; the cost is R$10 per hour.

Pharmacies Farmacia Big Ben, Av. Serzedelo Correa 15, near Praça da República (☎ **091/3283-4145**), is open Monday to Friday 8am to 10pm and Saturday 8am to 4pm. Big Ben also has an order-by-phone service (☎ **091/3241-3000**) that is open 24/7.

Safety Pickpockets and purse-snatchers are common in the Ver-o-Peso

Market. They're especially fond of the two-man distract-and-snatch technique, so keep your wits about you and your bag or purse in front of you. Avoid the Old City completely on Sundays, and on weekdays after dark stick to main streets and squares (the Praça da República, Av. Pres. Vargas, and the Estação das Docas are well lit and policed in the evening).

Taxes Hotels add a 10% accommodations tax directly to your bill. There are no other taxes on retail items or goods.

Time Zones Belém is 3 hours behind GMT, the same as Rio.

Weather Belém has two seasons: hot, humid, and rainy from December to May, and hot, humid, and less rainy from June to November. The daytime maximum temperature usually reaches 33°C (92°F) or slightly higher, and relative humidity is always above 90%. Rain comes in the form of short violent thundershowers, usually in the afternoon.

Where to Stay

Accommodations aren't Belém's strong suit. Most of the hotels in the central part of the city are too old, run-down, or seedy to be worth considering—odd for a city that sees tourism as a serious part of its future.

VERY EXPENSIVE

Crowne Plaza Belém ★★ The Crowne Plaza is the only truly top-notch hotel in Belém. Better yet, it's located in Nazaré, a leafy neighborhood with shops and cafes and a nice safe feel, still just a pleasant 20-minute stroll from the sights in Centro. Rooms are spacious and modern, with tile floors and king-size or two twin beds, dressed up in top-quality Egyptian cotton, with bathrobes and slippers for an added touch of elegance.

Av. Nazaré 375, Belém, 66010-010 BR. www.crownebelem.com.br. (© **0800/118-778** or 091/3202-2000. Fax 091/3202-2222. 174 units. R$450 superior double; R$550 deluxe double. Check the website for discounts and upgrades. AE, DC, MC, V. Parking R$20. **Amenities:** Restaurant; bar; exercise room; outdoor pool; room service; smoke-free rooms. *In room:* A/C, TV, fridge, hair dryer, minibar.

Hilton ★ The Hilton offers a great location on the Praça República, plus a great pool and all the services that come with the Hilton brand. The standard rooms are pleasant if not outstanding, featuring a firm queen-size bed, a work table, lounge chairs, a small balcony, and a bathroom with standard-size tub/shower combo. Superior rooms are identical, except the superior rooms are located on higher floors. The deluxe rooms include access to the 14th-floor executive business lounge. Junior suites aren't worth the cost premium, but the corner suites are—they feature a furnished separate sitting room and balcony with a great view of the Theatro da Paz.

Av. Presidente Vargas 882, Belém, 66017-000 BR. www.hilton.com. (© **091/4006-7000.** Fax 091/3241-0844. 361 units. R$350 standard; R$490 superior; R$575 deluxe; R$615 corner suite. 30%–50% discount on weekends and low season. Children 8 and under stay free in parent's room. AE, DC, MC, V. Free parking. **Amenities:** Restaurant; bar; babysitting; large gym; large outdoor pool; room service; smoke-free rooms. *In room:* A/C, TV, hair dryer, minibar.

MODERATE

Portas da Amazonia ★ 🖌 Just a stone's throw from the fort, this lovely bed-and-breakfast offers comfortable accommodations in a beautifully restored heritage building. Every room is a little different, but they all feature an interesting mix of modern industrial chic with rustic wooden furniture, lovely hardwood floors, sky-high ceilings, king-size beds, and modern bathrooms. The location is perfect for exploring downtown Belém or for people traveling to or from Marajó as the ferry terminal is only a 5-minute cab ride away. Note that there is no elevator in the building.

Rua Dr. Malcher 15, Cidade Velha, Belém, 66020-250 PA. (© **091/3222-9952.** 9 units. R$150–R$250 standard. Children 4 and under stay free in parent's room. Extra person R$40. AE. MC, V. No parking. **Amenities:** Restaurant. *In room:* A/C, TV, minibar, Wi-Fi.

INEXPENSIVE

Hotel Grão Pará This hotel has a fabulous location on the Praça República, two doors down from the Hilton. Guests come here for clean, fairly comfortable accommodations at a reasonable price. Rooms, with a firm queen-size mattress and good linens, aren't large—there is just space enough for a bed and a small breakfast table. Bathrooms are clean and functional. The staff here is friendly and professional. Given the small price difference and vast increase in quality, the Massilia is a better bet, but if it's full, the Grão Pará is an acceptable backup.

Av. Presidente Vargas 718, Belém, 66017-000 PA. www.hotelgraopara.com.br. (© **091/3321-2121.** 150 units. R$100 standard. Extra person R$30. Children 8 and under stay free in parent's room. AE, V. *In room:* A/C, TV, fridge, minibar.

Hotel Massilia ★★ 🖌 Considering price, quality, and location, this small hotel is the best place to stay in Belém. Unless you really need the four-star services of the

Crowne Plaza or Hilton, this should be your first choice. The 10 standard rooms come with nice firm beds (either a queen-size or two singles), and are tastefully decorated with tile floors, exposed brick walls, and a writing desk made of tropical "cathedral" wood. Bathrooms are small but spotless, with showers that give lots of hot water. Upstairs, the six suites, or *apartamentos*, are spread out over two floors, with a small bed/couch and sitting area on the main floor, and a queen-size bed and desk in a small upstairs loft. A delicious breakfast, served outside on the patio, comes with an ever-changing variety of specialty breads.

Rua Henrique Gurjão 236, Belém, 66053-360 PA. www.massilia.com.br. ✆ **091/3222-2834.** Fax 091/3224-7147. 17 units. R$115 standard; R$130 apt. Extra person R$15. Children 6 and under stay free in parent's room. 10% discount with cash. MC, V. Free parking. **Amenities:** Restaurant; small outdoor pool. *In room:* A/C, TV, fridge, hair dryer, Internet, minibar.

Where to Eat

Blessed by geography, Belém has one of the richest cuisines in Brazil. In addition to the whole range of Amazon freshwater fish, there are saltwater species and shellfish, including shrimp and crab. Beef is plentiful, as is buffalo from the island of Marajó.

Tip: On the waterfront, the **Estação das Docas** (✆ 091/3212-5525) has a half-dozen restaurants, waterfront incarnations of some of Belém's best restaurants with locations elsewhere. The specialist in regional cuisine is **Lá em Casa** (see below). The **Cappone** (✆ **091/3212-5666**) Italian restaurant is a great spot for some pasta or risotto, and Asian food lovers can have a good meal on the patio at **Sanuk Asian Cuisine** (✆ 091/8870-7707). For a quicker regional snack, try the **As Mulatas** (✆ 091/3212-5300) kiosk for a bowl of *tacacá* soup, or the **Sorveteria Cairu** (✆ 091/3212-5595) for ice cream made with local Amazon fruit. You can dine on the waterfront overlooking the river, or inside in air-conditioned comfort. All six are open Monday to Friday noon to midnight, Saturday and Sunday 10am to 2am.

Lá em Casa ★ SEAFOOD/REGIONAL BRAZILIAN The longtime master of local Pará cuisine serves up creative dishes prepared with regional fruit and fish. For a sampling of local fish, try the *corridinho de peixe*, which includes a variety of fresh fish, including grilled *pirarucú*, skewers of *tambaqui*, local haddock, *filhote* in *tucupi* sauce, *pescada amarela*, and *farofa* flavored with *pirarucú*. Pará's signature dish of duck in *tucupi* sauce is particularly well done here. The lunchtime buffet is a perfect opportunity to try a variety of dishes. For dessert, try the tapioca balls with *cupuaçu* filling, served with *cupuaçu* ice cream.

Bd. Castilhos França (Estação das Docas). ✆ **091/3212-5588.** Main courses R$24–R$42. AE, DC, MC, V. Daily noon–midnight.

Manjar das Garças ★★ SEAFOOD/REGIONAL BRAZILIAN The excellent food at the restaurant in the Mangal das Garças park (p. 396) comes with complimentary views of the Guamá river. The lunch buffet is top-notch and includes a large salad bar and a variety of steak, fish, and seafood dishes such as the *filhote* in *tucupí* sauce or grilled calamari with onions. In the evenings, the restaurant serves an a la carte menu, specializing in fish and seafood. Dishes include local ingredients such as the grilled *tucanaré* with roasted palm heart in an orange sauce or the baked *pescada amarela* fish with a cashew-nut purée. Desserts include several wonderful pies with tropical ice cream; try the chocolate cake with *cupuaçu* coulis and tapioca ice cream. The restaurant has some outside tables and makes a wonderful sunset destination.

Praça Carneiro da Rocha (inside Mangal das Garças Park). ☏ **091/3242-1056.** R$48 lunch buffet; dinner main courses R$28–R$52. AE, MC, V. Tues–Wed noon–midnight; Thurs–Sat noon–2am; Sun 11am–4pm. Taxi recommended.

Sorveteria Cairu ★ ICE CREAM The specialized ice creams of the Amazon are one of Belém's treats. Made from a variety of Amazon fruit, they are delicious and exotic and not to be missed. There are numerous flavors, mostly made from fruit without English names. The best strategy is to go and sample.

Travessa 14 de Março 1570. ☏ **091/3267-2749.** Also at Estação das Docas. ☏ **091/3212-5595.** All items R$3–R$9. No credit cards. Daily 9am–11:30pm. Bus: Ver-o-Peso.

Sushi Ruy Barbosa ★★ JAPANESE Sleek and modern, this new restaurant looks more upscale lounge than traditional Japanese restaurant. Fortunately, the chef is focused on serving outstanding cuisine; start off with a steaming bowl of miso with quail eggs while perusing the extensive raw and smoked fish menu. There are interesting sushi combos, like the *tako* special (octopus with smoked anchovies). Hot dishes include sautéed shiitake mushrooms in butter or risotto with clams. As the night wears on, the DJ cranks up the music. So skip dessert, order a basil caipirinha, and mingle with the well-heeled locals.

Travessa Rui Barbosa 1918, Nazaré. ☏ **091/3223-4497.** Main courses R$36–R$48. AE, MC, V. Tues–Thurs and Sun noon–midnight; Fri–Sat noon–2am. Bus: Nazaré.

OTHER OPTIONS

The **Umarizal** neighborhood has a number of excellent dining options. Enjoy alfresco Italian at **Trattoria San Gennaro,** Av. Wandelkolk 666 (☏ **091/3241-0019**), which takes great pride in making all the pasta, bread, and sauces in-house. There's top-quality steak at **Picanha e Cia,** Rua Bernal do Couto 260, on the corner

THE CÍRIO OF nazaré

Every year in Belém on the second weekend of October, more than two million of the faithful gather in the streets to watch and participate in the annual *Círio of Nazaré,* a procession of an image of the Virgin of Nazaré. The procession has been taking place for more than 200 years, ever since a Belém peasant discovered an image of the Holy Virgin in the forest on the spot where the Basilica of Nazaré now stands. According to legend, the holy nature of the image was revealed when the peasant brought the image back to his hut, only to have it disappear overnight and reappear back on that same spot in the jungle. That original image has now been permanently installed in the nave of the specially built Basilica of Nazaré. Each year a replica image leads a procession of thousands of faithful followers, who travel from the Basilica to the Catédral da Sé and back again.

The procession begins on Saturday with a nautical journey, when the image departs from the beach in the village of Icoaraci and, along with a convoy of colorful floats, arrives around noon at the Estação das Docas. The image then travels to the Catédral da Sé. Sunday morning there's a Mass, and then around 7am the image departs the cathedral and begins its return journey to the Basilica of Nazaré. The 5km (3-mile) procession normally takes all day, with hundreds of thousands of the faithful following. At the end, the Virgin returns to her resting place in the square opposite the basilica, and thus commences a 3-week harvest festival party.

of Avenida Almirante Wandenkolk (© **091/3224-3343**). The city's best pizza restaurant is **Xícara da Silva,** Av. Visconde de Souza Franco 978-A (© **091/3241-0167**), a vast high-ceilinged room with a big pizza oven at the far end.

Exploring Belém

One day is likely enough to see all that Belém has to offer. *Tip:* On Tuesdays, entrance is free to all Belém's museums at the fort.

THE TOP ATTRACTIONS

Forte do Presépio ★ A wood-and-earth fort—constructed on the site of today's more substantial installation—was the very first thing built in Belém when the Portuguese arrived in 1616. The fort was variously abandoned, rebuilt, and renamed over the years (it's also known as the Forte do Castelo and the Forte do Belém). From the ramparts you get a wonderful view of Ver-o-Peso Market, the Catédral da Sé, and the Praça Dom Pedro II. A small museum inside the fort tells the history of the area's indigenous tribes and the settlement of Belém. Allow 30 minutes.

Praça Frei Caetano Brandão 117. © **091/4009-8828.** Admission R$2. Tues–Sun 10am–4pm. Bus: Ver-o-Peso.

Icoaraci ★ The central street of this seaside town close to Belém has evolved into a pottery and artisan's enclave. Belém pottery is fashioned in the style of either the **Marajóara** or **Tapajônica** tribes, Belém's indigenous inhabitants. The more ancient Marajóara tribe used angular geometric designs. **Tapajônica** pottery features countless rotund gods and animals, somewhat like Hindu sculpture. The better shops include **Anísio Artesanato,** Travessa Soledade 740 (© **091/3227-0127;** www. anisioartesanato.com.br), and **Cultura Indigena,** Travessia Soledade 790 (© **091/3233-4583**). Both are open business hours (Mon–Sat 8am–noon and 1–6pm). At the waterfront there are more pottery options at the **Paracuri Fair, Praça de São Sebastião. Amazon Star Turismo** (© **091/3241-8624;** www. amazonstar.com.br) offers daily 3-hour tours to Icoaraci for R$90 per person, including transport and a guide to explain the pottery styles and introduce you to the potters. The public bus from Belém takes about 45 minutes.

Travessa Soledade (entire street). www.icoaraci.com.br. Daily 9am–6pm. Bus: Icoaraci, from Praça República.

Mangal das Garças ★★ ☺ A birthday present from the navy (who donated the land) to the city of Belém, this park was inaugurated in 2005. Located on the river Guamá, the Mangal does an excellent job representing Belém's regional culture, flora, and fauna. A series of lagoons portrays the Amazonian ecosystem, starting off with a narrow *igarapé* creek that opens up into a larger lagoon with white herons and scarlet ibises and finally empties into mangroves. There is a large viewing platform overlooking the river and the marsh along the shore. The park also has an excellent restaurant (p. 394), a gift shop, and a number of attractions. For R$9 you can see everything. This includes a 45m-tall (150-ft.) modern lighthouse that offers 360-degree views; a walk-through aviary that houses over 20 species of local birds; a glass-enclosed space with hundreds of butterflies flying loose; and a small but interesting navigation museum. Allow 2 hours. *Tip:* If you want to see the birds and butterflies at their best, avoid the heat of the day. Late afternoon is great as you can combine it with a sunset stroll on the deck or a drink at the restaurant.

Praça Carneiro da Rocha (behind the Navy Arsenal), Cidade Velha. ℭ **091/3242-5052.** www.mangalpa.com.br. Park is free, admission only for exhibits R$9. Paid exhibits Tues–Sun 9am–6pm. Park and restaurant open later. Closed on Mon. Taxi recommended.

Museu do Círio ★ Two air-conditioned rooms tell the story of the Círio of Nazaré—an incredible religious spectacle held each year beginning on the second Saturday of October, during which more than two million participants either witness or participate in a 2-day procession behind an image of the Virgin Mary. The museum explains the origins and development of the procession, from the discovery of the Virgin's image by an 18th-century peasant to the huge festival today. Included are models of the parade, images of Círio's past, and examples of floats and costumes and models of the imitation body parts offered up by the faithful. Some of the tour guides speak limited English. Allow 30 minutes.

Praça Dom Pedro II (on the side closest to the river). ℭ **091/4009-8846.** Admission R$2. Tues–Sun 10am–6pm. Bus: Ver-o-Peso.

Parque-Museu Emilio Goeldi ★ ☺ Brazil's oldest zoo-botanical research institute sits in a gorgeous swath of rainforest in the middle of the city. The lovely park is home to more than 3,000 species of Amazonian plants and also features a small zoo with regional fauna, including jaguars, birds, alligators, tapirs, monkeys, fish, and turtles. Kids will have a blast spotting the chameleons, sloths, coatis, toucans, and ibises that roam the park freely. Several of the buildings have been converted into museum space and offer temporary natural history exhibits. Allow 1 to 2 hours.

Rua Magalhães Barata 376, Nazaré. ℭ **091/3219-3369.** Admission R$2. Tues–Sun 10am–5pm. Bus: Nazaré.

The Ver-o-Peso Market ★★★ The Ver-o-Peso Market is Belém's star postcard attraction. It's a vast waterside cornucopia, with just about every Amazon product available for purchase. Stroll into the original market hall—the one with the cute blue Gothic arches, imported prefab from England in 1899—and you're in an Amazon Fish World, with outrageously strange Amazon fish like the 100-kilogram (220-lb.) catfishlike *pirapema*, all laid out on ice or on the chopping table. Outside under the canopies there are hundreds of species of Amazon fruit; most of them for sale for R$5 per kilo or less. The love-starved can seek out the traditional medicine kiosks, where every potion and bark-derived infusion seems to heighten allure, potency, and fertility. There's also an arts-and-crafts fair. When you tire of browsing, dozens of food counters sell cheap, quick eats and fresh-blended tropical fruit juices. Allow 2 hours.

Av. Castilhos França s/n. No phone. Daily 5am–2pm. Bus: Ver-o-Peso.

OTHER ATTRACTIONS

Belém's **Theatro da Paz** (ℭ **091/4009-8750;** tours every hour Tues–Fri 9am–1pm; admission R$4) is an ornate opera house modeled on Milan's La Scala theater. Inside is a rich assortment of Italian marble, tropical hardwoods, wrought iron, and gold gilt.

Located side by side on the Praça Dom Pedro II are two lovely colonial palaces. Both are worth a glance if you have time on your hands, but don't feel guilty if you miss them. The white neoclassical **Palácio Lauro Sodré** used to house the Pará state government, but is now home to the **Museu do Estado,** Praça Dom Pedro II (ℭ **091/3219-1138;** Tues–Sat 10am–6pm, Sun 10am–2pm; admission R$2), which displays the former staterooms complete with lovely tropical furnishings. Each

room is done in a different ornate style: Art Nouveau, rococo, neoclassical, and so on. Next to the Forte do Belém, the former Church of Santo Alexandre has been converted into a small and eminently missable **Sacred Art Museum** (**Arte Sacra;** ✆ **091/4009-8802;** Tues–Sun 10am–4pm). There's so little on display, in fact, that it's not really worth paying the R$4 admission.

Also located beside the Forte do Belém, the yellow 11-windowed **Casa das 11 Janelas,** Praça Frei Caetano Brandão s/n (✆ **091/4009-8823;** Tues–Sun 10am–6pm; admission R$2), has two floors of contemporary art by Belém painters and sculptors.

Housed in a former hellhole of a prison, the **Gem Museum of Pará (Museu de Gemas),** Praça Amazonas s/n (✆ **091/3230-4452;** admission R$4; Tues–Sat 10am–7pm, Sun 10am–7pm; bus: Igautemi [but take a cab back if you buy jewelry]), is definitely quirky enough to merit a visit. The museum showcases an extraordinary variety of Pará's crystals and gems. Geologists will be in heaven. Those less than rock-happy may find it a tad much. Other cells have been leased to private jewelry companies that show off their original designs.

ARCHITECTURAL HIGHLIGHTS

The **Cidade Velha,** or **Old City,** opposite the Ver-o-Peso Market is a wonderful mixture of Portuguese colonial, Art Nouveau, Art Deco, and concrete-and-glass 1960s modernism. This promiscuous mixing of architectural styles is the reason Belém's downtown was denied UNESCO World Heritage Site status, though Belenenses protest that the mix of styles makes their historic core all the more intriguing. The most fascinating building is the **Paris n' America** shop at Rua Gaspar Viana 136. At the height of the rubber boom this was the boutique for haute couture in Belém, the place where wealthy rubber barons would dress their wives and daughters. Fashions were imported from Paris, along with models to show the rather provincial Belém baronesses how the clothes ought to be worn. It's worth traipsing up the sweeping iron staircase to have a look at the still-abandoned second floor.

CHURCHES

The two most important churches in town are the **Catédral da Sé,** Praça Frei Caetano Brandão (✆ **091/3223-2362;** Mon 2–6pm, Tues–Fri 8am–noon and 2–6pm, Sat 5–8:30pm, Sun 7–11am and 5–8:30pm), and the **Basilica de Nazaré,** Praça Justo Chermont (✆ **091/4009-8400;** Mon–Fri 6am–7:30pm, Sat–Sun 6am–noon and 3–9pm). Located on the square opposite the fort, the Catédral da Sé is neglected and rather dilapidated but still gorgeous inside, a mix of baroque and neoclassical with a soaring vaulted ceiling and lovely Art Nouveau candelabras. However, the church that Belenenses are most proud of is the Basilica in Nazaré, located on the spot where in the late 17th century a simple *caboclo* hunter supposedly tripped over an image of the Virgin. It's from here that a replica of that original image sets off on a pilgrimage during the yearly Círio of Nazaré. The original image is now permanently ensconced in the wall above the altar. Modeled on St. Peter's Basilica in Rome, the church itself, like much of Belém, is a nouveau riche rehash of things done first and better elsewhere.

PLAZAS & PARKS

The green anchor of Belém's downtown, **Praça República,** is a lovely three-sided traditional square with plentiful benches and many small patches of grass on which small children play with balls. The current classical configuration of this former

military parade ground is the work of Belém's 19th-century rubber barons, who also erected the **Theatro da Paz** at the Praça's narrow end. Being snobby aristocrats, of course, they also put up a fence to keep the unwashed public out. The fence came down only after rubber prices crashed.

The gardens of the **Parque da Residencia,** Av. Magalhães Barata 830, corner of Travessa 3 de Maio, used to be part of the official residence of Pará's state governors. The park features fountains, a small orchid arbor, a display space with the governor's old Rolls-Royce, and a good if slightly pricey kilo restaurant, the **Restô do Parque** (© 091/3229-8000; Tues–Sun noon–3:30pm).

ORGANIZED TOURS

The tour agency in Belém with the best and largest variety of tours is **Amazon Star Turismo,** Rua Henrique Gurjão 236 (© 091/3241-8624; www.amazonstar.com. br). **Valeverde Turismo,** Estação das Docas, building 1 (© 091/3212-3388; www. valeverdeturismo.com.br), is another reputable agency, located at the upstream end of the Estação das Docas.

BOAT TOURS The most unique tour in Belém is the early-morning **excursion to Parrot Island ★★**, a small semiflooded island a few kilometers offshore that is the bedroom of choice for hundreds of Amazonian parrots. Boats depart at 5am (4:30am hotel pickup) to arrive at the island in the gray predawn. As the sky lightens, the parrots awake. They squawk, circle around to find their mates, then fly away into the dawn. Afterward the tour explores the small side channels of islands in the estuary. **Amazon Star** does this tour particularly well. The price is R$110, hotel pickup and drop-off included (only Tues, Thurs, and Sat). For later risers, Amazon Star also has a half-day **River Trip** through the channels and creeks of Guamá River (a tributary of the Amazon), with a stop for a guided walk in the forest. Departures are 8:30am and 2:30pm; the R$100 fee includes pickup and drop-off.

A gorgeous early evening option is **Valeverde's** 1½-hour **Sunset** tour that departs at 5:30pm or the 8pm **Lights of the City** cruise, which departs nightly from the Estação das Docas and circles offshore of Belém, allowing passengers to observe as the lights come on in the city's historic churches and monuments. The price is R$45; cruises depart Tuesday through Sunday.

BUS TOURS The trip to Icoaraci (p. 396) is highly recommended. Both Amazon Star and Valeverde offer morning and afternoon tours; they cost about R$75 per person for a 3-hour tour.

HIKING TOURS Highly recommended for those in reasonable physical condition are **Amazon Star's trekking tours.** The **1-day tour** departs before sunrise, crossing the Guamá River to a jungle-covered section of the Amazon estuary around Boa Vista. There follows a full-day trek in the jungle, observing wildlife and visiting *caboclo* communities who make a living growing cassava and fishing. At the far end of the Acará River there's time for a rest and some swimming, followed by a sunset cruise back to Belém. The cost is R$300 per person, guide and lunch included (July–Dec only; only Tues, Thurs, and Sat).

Shopping

The specialty of Belém is **pottery,** mostly fashioned in the style of either the **Marajóara** or **Tapajônica** tribes, the indigenous inhabitants of Belém. The Marajóara tribe used angular designs, somewhat like the Aztec or the tribes of the American

Southwest. Marajóara pottery features countless rotund gods and animals, somewhat like Hindu sculpture. The best place to shop for pottery is in the village of **Icoaraci** (p. 396). The **Ver-o-Peso Market** (p. 397) is one vast shoppers' paradise. In Belém's historic downtown, the **Rua Gaspar Viana** is a pretty pedestrian street with cobblestones and countless small shops selling everything from hammocks to lingerie, clothing, appliances, and bootleg CDs. For more upscale boutiques and high-end fashion, head to **Rua Braz de Aguiar** in Nazaré (around Travessa Benjamim Constant). **Largo das Mercês** is a good place to look for leather sandals, belts, and handbags. For jewelry and raw gemstones, go to the **Gem Museum of Pará** (p. 398). For anything else, there's the new **Shopping Boulevard** mall, Av. Visconde de Souza Franco 776, Reduto (© **091/3299-0500;** www.boulevardbelem.com.br; open Mon–Sat 10am–10pm and Sun 3–9pm).

Belém After Dark

THE PERFORMING ARTS

Theatro da Paz This Escala-in-miniature offers symphonies, chamber concerts, and light operas most weekends throughout the fall and winter (May–Sept). Tickets are reasonable, and the acoustics are very good. Check the website under *"Agenda de espetaculos"* for programming. Av. de Paz s/n. © **091/4009-8750.** www.theatrodapaz.com.br. Box office © 091/4009-8758. The box office is in the main lobby area.

BARS & DANCE CLUBS

The **Estação das Docas** features live music on Thursday through Sunday nights starting at 8pm. Belém's other nightlife area centers on the **Avenida Visconde de Sousa Franco** and the surrounding side streets (notably the **Av. Almirante Wandenkolk**) located north of downtown. There are many clubs, bars, and discos in this area, close enough together that it's easy to stroll from one to the next. The better ones include the **Roxy Bar,** Av. Senador Lemos 231 (© **091/3224-4514**), and the popular **Ventura,** Rua Boaventura da Silva 727 (corner of Av. Wandenkolk; © **091/3224-1053**).

One of the best places for live music is **Boêmio Cervejaria,** Av. Visconde de Souza Franco 555 (© **092/3224-0075;** www.boemiocervejaria.com.br), on the corner of Avenida Senador Lemos in the Reduto neighborhood. Bands play MPB on Thursdays, rock on Fridays, and samba on weekends for a R$10 cover.

If you're looking to hear local live music, try **A Pororoca,** Av. Senador Lemos 3316 (© **091/3233-7631;** www.apororoca.com.br). This traditional showplace has room for 6,000 guests and leans heavily toward *brega,* but also plays *forró,* MPB, and very occasionally samba. Cover is around R$10 and hours are Thursday to Saturday 10pm to 4am and Sunday 7pm to midnight.

Note that the outdoor **Bar do Parque,** located in the shadow of the Theatro da Paz, is exclusively patronized by prostitutes and their customers.

A SIDE TRIP TO MARAJÓ

Marajó holds the title for the world's largest river island, a vast land expanse in the mouth of the Amazon that is larger than many countries. The island has been settled for centuries so most of the original rainforest is gone. Instead, Marajó has low-lying, periodically flooded ranchland like that of the Pantanal. The ranches are lightly stocked with water buffalo and chock-full of incredible populations of large and colorful birds—egrets, herons, parrots, toucans, and startling scarlet ibis—not to mention

caimans and the occasional troupe of monkeys. A number of these ranches (fazendas) have opened themselves up to tourism, allowing visitors to experience the island's nature and unique way of life.

Essentials
GETTING THERE

The only reason to go to Marajó is to stay at one of the hotel fazendas. Though there are two small towns—Selvaterra and Soure—close together on the eastern shore of the island, they are not in themselves worth a long ferry ride. (It's worth spending 1 night in Soure to get a feel for the local culture and community and enjoy a day at the beach, Marajó-style.) Most of the fazendas will include transportation in your package, which you should arrange ahead of time either with the hotel fazenda or through a tour agency such as **Amazon Star Turismo,** Rua Henrique Gurjão 236 (© **091/3241-8624;** www.amazonstar.com.br).

FERRIES There's a **Belém-Selvaterra passenger ferry,** run by **Araparí Navega-ção,** Rua Siquiera Mendes 120 (© **091/3242-1570**), departing from Portão 10 (downstream of the Estação das Docas). Departures are Monday through Saturday at 6:30am and 2:30pm, Sunday at 10am. The trip takes 3 to 4 hours and costs R$16. To reach Soure from the ferry dock in Camará is about a 30-minute bus ride (R$7) and then a 5-minute ferry ride (free for passengers). Competition for the public bus is fierce; better to have your transport arranged beforehand with a lodge or pousada.

Lodges

Most lodges offer similar activities. The most popular ones are horseback riding, the perfect way to explore the flooded fields; buffalo riding, which is much more comfort-able than it sounds; fishing; and bird-watching.

Fazenda N.S. do Carmo ★ Located on the banks of the Rio Camará, this lodge has a wonderful authentic feel. Accommodations are comfortable, clean, and basic. In the main ranch house there are six bedrooms with simple twin beds, and three shared bathrooms with not especially hot showers, plus a pair of sitting rooms and a shared phone and TV. Tours cover the ranch and the nearby forest. They include horse and buffalo riding, canoe and kayak tours on the river and smaller chan-nels, fishing, bird-watching, and photo safaris, plus time to kayak in the river or swim in the ranch's small freshwater lake.

Marajó. © **091/9161-1521** (lodge) or 3241-2202 (reservations). 8 units, showers only, shared bathrooms. Rate per day (including pickup from ferry, meals, and activities) R$350 per person. Children 5 and under stay free in their parent's room, children 6–10 R$100 per day. AE, DC, MC, V. *In room:* No phone.

Fazenda Sanjo ★★★ ☺ This ranch offers a wonderful rustic family experience. Ana, whose family has owned the ranch for generations, and her husband, Carlos, look after their guests from the minute they pick them up in Belém or at the ferry. The ranch is not luxurious but is quite comfortable. The six rooms are located on the ground floor of the ranch and have comfortable beds and screened windows. The common rooms and large decks offer fabulous views of the surrounding landscape. Fazenda Sanjo still has a herd of 300 buffaloes that guests can help round up in the afternoon. It's quite the experience to chase after a bunch of large water buffaloes while on a horse. One of our most memorable excursions includes a buffalo-drawn canoe ride (yes, these animals can swim!) through the flooded fields teeming with

DO EAT THE buffalo

One of the best things about Marajó is the food. Buffalo is the local specialty, and we were expecting to try a bite, but after a few days we lost track of all the dishes that were in some way or other derived from water buffalo. We tried buffalo roast beef for our first meal. The meat is delicious, very lean and tender, with a stronger taste than cow, though not as pronounced as lamb. For dessert we had caramel pudding made with buffalo milk. In the evening, with the cold beer and view of the sunset, our cook brought us slices of fresh *mozzarella di buffalo*. Only 24 hours old, the cheese had a light, creamy taste. Another dinner started off with a rich cheese and onion soup made with, you guessed it, buffalo cheese, followed by a buffalo meatloaf. Our breakfast buffet included buffalo butter, buffalo milk, buffalo cheese, and buffalo cream, in addition to waffles, omelets (no buffalo eggs), and other goodies. Had we stayed more than a few days it would have taken a buffalo to carry us out of there.

birdlife. The cheese, milk, and buffalo meat are used in a lot of the excellent dishes served here. The ranch also has a small spa specializing in treatments with local clay and mud.

Tip: For an additional R$180 per person, Ana and Carlos can take care of all transfers, door-to-door from your hotel to the ranch and back, including ferry tickets.

Marajó. www.sanjo.tur.br. ℗ **091/9145-4475** (lodge) or 3242-1385 (reservations). 6 units, showers only. 3-day packages R$720; 4-day packages R$1,080. Children 6 and under stay free in parent's room, children 7–12 50% discount. Daily departures. MC, V. *In room:* No phone.

Soure

If you have an extra day, it's worth spending a night in Soure, a particularly charming small Brazilian town, wedged between the river and the bay. Streets are made of grass instead of dirt, and it is there that the buffalo roam. Indeed, buffalo play an important role in the life of the island and the town. Not only are they an economic resource for the farmers, but in Soure the buffalo are also put to work pulling the garbage carts, and used as transportation. There is even a squad of buffalo-mounted police. The best time to stay in Soure is on a Saturday night when locals gather in the main square, promenade along the river, eat ice cream, and as often as not enjoy cultural presentations put on in the city square. One evening we lucked out and saw a presentation of *carimbó*, the local dance, which is a mixture of Portuguese folk dancing with Caribbean rhythms and steps.

The beaches just outside of Soure are a unique experience. The water is mostly fresh, and the tides are thoroughly impressive. At low tide, so much of the beach lies exposed that locals ride bicycles to reach the far-off water's edge. At high tide, bathers retreat to the kiosks, nestled amid the vast spreading root systems of the coastal mangrove trees.

Casarão da Amazonia ★ This Italian-owned pousada consists of five rooms in a gorgeous 19th-century mansion and another five rooms in a newly built annex. Amenities and furnishings in both are basic but very clean and comfortable with a double or two or three single beds. We prefer the rooms in the new building with more spacious bathrooms and a small deck with a hammock and patio furniture.

Prices here are almost double that of Pousada o Canto do Françês, just around the corner; for the extra money you get a beautiful swimming pool and sun deck.

Quarta Rua 626, Soure. www.hotelcasarao.com. ⓒ **091/3741-2222.** 9 units. R$185–$R240 double. Children 4 and under stay free in parent's room, extra mattress R$40. V. **Amenities:** Restaurant; outdoor swimming pool. *In room:* A/C, minibar, no phone, Wi-Fi.

Pousada o Canto do Francês ★ 🏊 This pleasant pousada offers inexpensive and tasteful accommodations within walking distance of "downtown" Soure. The rooms are clean and comfortable with mosquito screens, new mattresses, and renovated bathrooms. Breakfast is served in the lovely garden. The pousada rents bicycles for R$10. They're the perfect way to explore the area: it's only a 20-minute ride to the beach of Barra Velha, and within an hour you can ride all the way out to Pesqueiro beach. French owner Thierry can book you on a variety of local excursions.

Sexta Rua, esquina com travessa 8 (the 6th street, corner with the 8th cross street), Soure. www.ocantodofrances.blogspot.com, or reserve through www.amazonstar.com.br. ⓒ **091/3741-1298** or 8822-8746. 9 units. R$100 double. Children 5 and under stay free in parent's room. Extra mattress or hammock R$20. V. **Amenities:** Restaurant; bicycle rental. *In room:* A/C, minibar, no phone, Wi-Fi.

BRASILIA

There are other planned cities in the world—Washington, D.C.; Chandigarh; Canberra—but none has the daring and sheer vision of Brasilia. In the 1950s, a country that had shucked off a failed monarchy, a corrupt republic, and a police-state dictatorship decided to make a clean break from the past by creating a brand-new space for politics.

In place of the pretentious Greek columns and stone facades that other political capitals used to engender awe, designers opted for modernism, a style of clean lines and honestly exposed structure, a style in love with technology and progress and the glorious possibilities inherent in the new materials of glass and steel and concrete.

The city plan was done by Lucio Costa. The buildings were designed by Oscar Niemeyer.

Costa's Master Plan was pure architectural modernism: Transit would be by road and car; activities would be strictly segregated; residential buildings were to be identical in size and shape and appearance. Worker and manager would live in the same neighborhoods, send their children to the same schools. In place of a grid, there were but two great intersecting streets, one straight, one curved. Viewed from on high, the city looked like an airplane in flight, or an arrow shooting forward into the future.

That the entire city was completed in just 4 years is thanks to the will of then-president Juscelino Kubitschek, elected in 1956 on a promise to move the capital inland from Rio de Janeiro. Few expected him to succeed.

The site, on Brazil's high interior plateau, was nothing but *cerrado*—short scrubby forest, stretching thousands of miles in every direction. It was nearly 644km (400 miles) from the nearest paved road, over 120km (75 miles) from the nearest railroad, 193km (120 miles) from the nearest airport.

Groundbreaking began in 1957. Thousands of workers poured in from around the country. By April 21, 1960, there was enough of a city for a grand inauguration. Politicians and civil servants began the long shift inland.

In the years since, Brasilia has been a source of controversy. Even as ground was being broken, urbanists were beginning to doubt the rationality of rationalist planning. Cities, it was being discovered, were vital, growing entities, whose true complexity could never be encompassed in a single master plan. Costa's carefully designated zones for this and that now feel stifling and ill-equipped to address the vital, messy complexity of a living, growing city.

The social aspirations of the architecture also proved illusory—politicians were no less corrupt; rich and poor did not live in harmony. Instead, the rich banished the poor to a periphery beyond the greenbelt.

But if nothing else, Brasilia did succeed in shifting Brazil's focus from the coast to its vast interior.

For visitors, the attractions here are purely architectural. Brazil's best designers, architects, and artists were commissioned to create the monuments and buildings and make them beautiful. A visit to Brasilia is a chance to see and judge their success.

ESSENTIALS

924km (574 miles) NW of Rio de Janeiro, 870km (540 miles) N of São Paulo

Getting There

BY PLANE Gol (✆ 0300/115-2121; www.voegol.com.br), **TAM** (✆ 061/4002-5700; www.tam.com.br), and **Webjet** (✆ 0300/210-1234; www.webjet.com.br) have several flights a day to Brasilia from major Brazilian cities. Brasilia's airport, **Aeroporto Internacional de Brasilia—Presidente Juscelino Kubitschek** (✆ 061/3364-9000), is about 10km (6¼ miles) west of the Eixo Monumental. Taxis from the airport to the hotel zones cost about R$35. Regular city buses aren't worth the trouble. They take you only to the main bus station, leaving you a painfully long walk (or taxi ride) from the hotels. *Note:* Brasilia's layout is so striking from the air that's it's worth getting a window seat on the flight in.

BY BUS Long-distance buses arrive at the **Rodoferroviario** (✆ 061/3363-2281), located at the far western point of the Eixo Monumental. Keep in mind that Brasilia really *is* in the middle of nowhere: 1,000km (620 miles) from Salvador, 930km (577 miles) from Rio, and 870km (539 miles) from São Paulo.

City Layout ★★★

What makes Brasilia unique—besides its amazing architecture—is its layout. Two main traffic arteries divide the city. **Eixo Monumental** runs dead straight east/west; **Eixo Rodoviario** runs north/south, curving as it goes. Seen from above, the city resembles an airplane or an arrow notched into a partially bent bow. Where these two axes intersect is the city's central bus station, the **Rodoviaria** (not the same as the long-distance bus station; see "Getting Around," below).

The other main distinguishing feature of the city plan is the strict separation of uses by zoning. All of the city's important government buildings are located at the "point" of the arrow—that is, on the eastern end of the Eixo Monumental. All of the city's hotels can be found in two hotel districts near the Rodoviaria. Similarly, the city's offices, shopping malls, theaters, and hospitals are in their individually designated clumps, usually close to where the "bow" meets the "arrow."

Because the plan is so simple, people mistakenly believe it's easy to find their way around. Figuring out how to navigate Brasilia requires delving back into the city structure in a bit more detail.

The Eixo Monumental (the east-west avenue with all the monuments and government buildings) divides the city into two perfectly symmetric wings, the **Asa Norte,** or N (north wing), and **Asa Sul,** or S (south wing). (Always check whether an address is in the south or north wing; otherwise, you could find yourself in the complete

Brasilia

ATTRACTIONS
Catedral Metropolitana
N.S. Aparecida **13**
Congresso Nacional **15**
Espaço Lucio Costa **18**
Memorial do Povos
Indígenas **5**
Memorial JK **4**
Museu Nacional **12**
Palácio do Itamaraty **14**
Palácio do Planalto **19**
Supremo Tribunal
Federal **16**
TV Tower **6**

HOTELS
Allia Gran Hotel Brasilia
Suites **11**
Hotel Monumental
Bittar **10**
Hotel Phenicia Bittar **8**
Royal Tulip Brasilia
Alvorada **20**
Tryp Convention **9**

RESTAURANTS
Alice Brasserie **17**
Belini **1**
C'Est Si Bon **22**
Corrientes 348 **2**
Fogo de Chão **7**
Lagash **21**
Original Shundi **3**

SETOR DE
HABITAÇÕES
INDIVIDUAIS SUL

ASA NORTE

SUPERQUADRA NORTE

Via W3 Norte
Via W1 Norte
Via L2 Norte
Via L3 Norte
Via L1 Norte

Universidade
de Brasilia

SETOR DE
EMBAIXADAS
NORTE

Via L4 Norte

SETOR DE CLUBS
ESPORTIVOS
NORTE

Camping

Autódromo
Internacional

Estádio Mané
Garrincha

Instituto Nacional
de Meteorologia

Parque de
Cidade

SUPERQUADRA SUL

Via W3 Sul
Via W1 Sul
Via L1 Sul
Via L2 Sul

ASA SUL

SETOR DE
EMBAIXADAS
SUL

SETOR DE CLUBS
ESPORTIVOS SUL

Avenida das Nações

Esplanade dos Ministérios

Cemitério Campo
da Esperança

ATLANTIC
OCEAN

B R A Z I L

Manaus
Belém
Natal
Recife
Salvador
Brasilia
Rio de
Janeiro
São Paulo

500 mi
500 km

0 1 km
0 1 mi

opposite part of town.) The various single-use zones (one in each wing) are designated on maps by letter codes. SHS for Setor Hoteleiro Sul (hotels), SBN for Setor Bancario Norte (banks), or SCS for Setor Comercial Sul (commercial business).

Addresses in Brasilia read like a futuristic code: "SQN 303, Bl. C, 101" or "SCS, Q. 7, Bl. A, loja 43" or "SHN, Q. 5, Bl. C." Here's how to do the decoding. The first three letters are the sector code (for example, SHS for Setor Hoteleiro Sul—hotels). Within each sector, a group of about 10 or so buildings is called a **Quadra**. Sometimes you can tell the buildings of a Quadra belong together either by appearance or spacing. Within each Quadra individual buildings are identified as **Conjunto** (conj.) or **Bloco** (B or Bl.). An individual store or office can be identified by **loja** or **lote**. So an address that reads "SCS Q. 7, Bl. A, loja 43" means that the office is located in the Setor Commercial Sul (the commercial zone in the south wing), Quadra 7 and building A, and the shop number is 43. "SHN, Q. 5, Bl. C" would be Setor Hoteleiro Norte (the hotel zone in the north wing), Quadra 5, building C.

Residential addresses are given a three-letter prefix—SQN (Super Quadra Norte) or SQS (Super Quadra Sul). Within each wing, each Super Quadra is given a three-digit number (for example, 203, 404, or 508). Each Super Quadra then consists of 16 buildings or Blocos (Bl. or B) that are identified by a letter. Within each Bloco there are apartment numbers. So SQN 303, Bl. C, 101 refers to Super Quadra 303 in the north wing. Within that Super Quadra you look for building C and apartment 101.

One final note: When looking for restaurants or bars, it's important to note the following distinction. SCLN (or CLN) means Setor Commercial Local Norte and refers to the *local* block of retail and commerce that is found within each Super Quadra; CLN404 is the 1 block of small shops and restaurants found within the Super Quadra 404 in the north wing. Do not confuse this with SCN, Setor Commercial Norte, which is the large mall sector adjacent to the Eixo Monumental.

Getting Around

The bus hub in the center of town, where the Eixo Monumental and Eixo Rodoviario intersect, is called the **Rodoviaria.** All city buses go through the Rodoviaria. It's where you transfer from an east-west to a north-south bus. Most of the city's malls and hotels are within walking distance of the Rodoviaria.

As long as you're on the Eixo Monumental looking at monuments or shopping, Brasilia is easy to understand. Stray into the residential sections, and confusion ensues. Costa's mass-production mentality means that every single Super Quadra looks identical. There are no landmarks whatsoever, so pay *close* attention to the street addresses. Get even one digit wrong, and you'll never find your destination. For visitors, it's often wiser to save yourself the hassle and just take taxis.

BY BUS Buses run from the tip of the south wing to the tip of the north wing, along W1 and W3 on the west side of the Eixo Rodoviario (the bow) and on L1 and L3 on the east side of the Eixo Rodoviario. To travel across town you catch a bus traveling to the opposite part of the city: From Asa Sul catch a bus that says ASA NORTE, or vice versa. On the Eixo Monumental you can catch buses labeled PLANO PILOTO CIRCULAR that just circle up and down this main boulevard. Many buses will go via the Rodoviaria, located in the center of town. These will get you pretty close to the main monuments, hotels, and malls along the Eixo Monumental. Bus tickets are R$2.

BY TOURIST BUS **Brasilia City Tour** (© **061/3356-1707** or 9298-9416; www. brasiliacitytour.com.br) offers a double-decker bus that covers the main tourist

destinations along the Eixo Monumental. The bus operates Monday to Wednesday at 10:30am, 2pm, 4pm, and 6pm and Friday to Sunday departing at 10:30am, 12pm, 1:30pm, 3:30pm, 5pm, and 7pm from Brasilia Shopping. It stops at 16 different attractions, including the City Park, the Memorial JK, the Cathedral, and main government buildings. For R$20 (children 6–12 pay half price), you can get on and off wherever you like. As the bus only comes by every 90 minutes, you may want to plan your stops strategically around the more interesting museums and monuments.

BY METRÔ Brasilia has a Metrô, but it is unfortunately of little use to most visitors as it currently only runs from the bus station along the Asa Sul to the satellite cities and doesn't cover the hotel section or the Eixo Monumental.

BY TAXI Taxis are plentiful and my preferred transportation method, especially if I can't easily figure out where I'm going. Just hand the address to the driver and he'll figure it out. From the hotel sector to the tip of the Asa Sul costs approximately R$25. For taxis call **Brasilia** (✆ **061/3321-0204**) or **Rádio Táxi** (✆ **061/3201-9739**).

BY CAR Brasilia was designed specifically for cars. One of the big selling points of the original plan was that it made traffic lights unnecessary. All intersections were originally designed to be roundabouts (there are now traffic lights, but not that many). The rule for roundabouts: The car that's already in the roundabout (for example, going around on a curve) has the right of way. Traffic is relatively calm in Brasilia; residents even stop for pedestrians, but they're fierce if you break the roundabout rule.

Visitor Information

The official government tourist agency, **Setur,** has an information desk in the arrivals hall of Brasilia Airport, open daily 8am to 8pm (✆ **61/3364-9102**). The other information desk, open Tuesday to Sunday 9am to 6pm, is located on the ground floor of the Museu Nacional, the building with the large white dome next to the cathedral. The site **www.infobrasilia.com.br** has short biographies of the city's founders, and some great photos.

[FastFACTS] BRASILIA

Banks & Currency Exchange To change money, go to **Air Brazil Turismo** (✆ **061/3321-2304**), in the National Hotel. The **Banco de Brasil** (✆ **061/3424-3000**) on the second floor of the Conjunto Nacional and the one in Brasilia Airport (✆ **061/3365-1183**) have 24-hour ATMs. ATMs are in all of the malls.

Car Rental For car rentals, contact **Avis** (✆ **061/3365-2344**), **Localiza**

(✆ **061/3365-1288**), or **Unidas** (✆ **061/3364-2955**).

Dentist For dental emergencies, contact **Instituto Brasiliense de Odontologia,** SCLS406, Bl. A, loja 35, Asa Sul (✆ **061/3244-5095**).

Embassies Since Brasilia is the country's capital, most embassies are located here. The **Australia** embassy is at SES, Q. 801, conj. K, lote 7 (✆ **061/3226-3111;** www.brazil.embassy.gov.au). The **Canada** embassy is at SES Av. das Nações, Q. 803,

lote 16 (✆ **061/3424-5400;** www.canada.org.br). The embassy of **Great Britain** is at SES Av. das Nações, Q. 801, lote 8 (✆ **061/3229-2300;** www.uk.org.br). The **Irish** embassy is at SHIS QL 12, conj. 05, casa 09, Lago Sul (✆ **061/3248-8800;** www.embassyofireland.org.br). The **New Zealand** embassy is at SHIS Qi 09, conj. 16, casa 01, Lago Sul (✆ **061/3248-9900;** www.nzembassy.com/brazil). The **United States** embassy is at SES Av. das Nações, Q.

801, lote 3 (📞 **061/3312-7000;** www.embaixada-americana.org.br).

Emergencies For police dial 📞 **190;** for fire and ambulance dial 📞 **193.**

Hospitals All hospitals are in the hospital section (SHLS and SHLN). **Hospital Santa Lucia** is at SHLS, Q. 76, conj. C

(📞 **061/3445-0000;** www.santalucia.com.br).

Internet Access Cyber Point, on the bottom floor of the Conjunto Nacional mall (📞 **061/3036-14955;** R$6 per hour), is open Monday through Saturday from 8am to 10pm, Sunday noon to 6pm.

Pharmacies Try **Drogaria Distrital,** on the ground

floor of the Shopping Conjunto Nacional (📞 **061/3328-0405**).

Weather Brasilia is hot, hotter in the winter than in the summer. In the summer (Dec–Mar), cooling rains fall almost daily. In the winter, temperatures climb to 35°C (95°F), and rain holds off for weeks.

WHERE TO STAY

With few exceptions (see below) the vast majority of hotels in Brasilia are located in one of the two hotel sectors: SHN (Setor Hoteleiro Norte, north hotel sector) or the SHS (Setor Hoteleiro Sul, south hotel sector). The areas are within a 10-minute walk of each other, and of the city's two shopping sectors. The only variety is the level of luxury and size of the building.

The majority of hotel guests in Brasilia are politicians and businesspeople. Demand for hotel rooms is thus huge on weekdays and almost nonexistent on weekends. It pays to schedule your visit to Brasilia on the weekend as most hotels offer a decent discount. (Most monuments are open Sat and Sun and closed Mon). For the same reason, low season in Brasilia is during statutory holidays, January and February, and Carnaval. If you must visit Brasilia midweek, book well ahead of time (at least a month).

Hotels are concentrated in their own area with few services around, so amenities tend to be plentiful; many hotels offer fine dining, shopping, salons, car rental, and business centers. Even when not staying at a top luxury hotel, you can utilize the facilities in adjacent hotels.

Lakeside

The exception to the hotel-sector rule are the hotels situated on the shores of the lovely man-made lake surrounding the city. Staying here means a minimum R$20 cab ride whenever you want to visit any sites, shops, or restaurants. But then staying at the regular hotel sectors will still involve a cab for restaurants and nightlife. And the lake is lovely. It's a trade-off.

EXPENSIVE

Royal Tulip Brasilia Alvorada ★★★ Designed by Brazil's other hotshot contemporary architect, Ruy Ohtake, the Royal Tulip has quickly become one of Brasilia's top hotels. Set on the edge of the artificial lake that surrounds the city, the hotel encompasses a beautiful leisure area with a large outdoor pool complex, a spa, a fitness center, and a pier. The spacious rooms feature king-size beds and classy modern fixtures with desks big enough for two people. The hotel offers free shuttles into the city throughout the day.

Setor de Hoteis e Turismo Norte, Trecho 1, lt. 1-B, bl. C (Lago Norte), Brasilia, 70800-200 DF. www.royaltulipbrasiliaalvorada.com. 📞 **061/3424-7000.** Fax 061/3424-7001. 395 units. R$430 standard; R$500 superior. Off season and weekends 40%–50% discount. AE, DC, MC, V. Free parking.

Amenities: Restaurant; 2 bars; gym; 3 pools; room service; sauna; smoke-free rooms; spa; tennis courts. *In room:* A/C, TV, hair dryer, Internet, minibar.

Setor Hoteleiro Sul

EXPENSIVE

Allia Gran Hotel Brasilia Suites ★★ This 6-year-old hotel offers comfortable and pleasant accommodations in the heart of the hotel sector. The decorations are modern and bright and the rooms feature queen-size beds, a comfortable work desk, and free Internet. The deluxe rooms include a small sitting area with a sofa, while premium rooms come with a small kitchen. There's also an outdoor swimming pool, sauna, and small fitness center. Check the website for discounts and early booking specials.

SHN, Q. 5, Bl. B, Brasilia, 70705-000 DF. www.alliahotels.com.br. ✆ **061/3424-2500.** 159 units. R$340 standard double; R$380 premium double. AE, DC, MC, V. Free parking. **Amenities:** 2 restaurants; bar; gym; outdoor pool; room service; sauna; smoke-free rooms. *In room:* A/C, TV, hair dryer, Internet, minibar.

Tryp Convention ★★ Inaugurated in 2009, the Tryp offers top-quality accommodations and the little extras business travelers need. Rooms are spacious, with queen-size beds, nice lighting, comfortable chairs, and a sofa. Desk space is more than adequate; amenities are excellent and include the use of a heated outdoor pool and full business center.

SHS, Q. 6, Bl. B Brasilia, 70316-000 DF. www.solmelia.com. ✆ **0800/703-3399** or 061/3218-4700. Fax 061/3218-4703. 150 units. R$320 standard, R$350 superior; weekends and off season R$220 standard, R$250 superior. AE, DC, MC, V. Free parking. **Amenities:** Restaurant; bar; gym; outdoor pool; room service; sauna; smoke-free rooms. *In room:* A/C, TV, hair dryer, Internet, minibar.

MODERATE

Hotel Phenicia Bittar ★ This small Setor Sul hotel recently renovated its floors and rooms as part of a transformation into a boutique hotel. Renovated rooms have lovely hardwood floors or new carpets, double or twin beds, wood furniture, a sitting area, and brand-new beds. Even better are the stylish renovated suites, which feature a living room with a dining table, a large desk, and a spacious bedroom with a second desk. A third bed can easily be added for those with children.

SHS, Q. 5, Bl. J, Brasilia, 70322-911 DF. www.hoteisbittar.com.br. ✆ **061/3704-4000.** Fax 061/3225-1406. 130 units, shower only. R$240 double weekdays; R$150 double weekends and low season. AE, DC, MC, V. Free parking. **Amenities:** Restaurant; room service. *In room:* A/C, TV, Internet, minibar.

Setor Hoteleiro Sul

Hotel Monumental Bittar ★ The low-rise Monumental looks unassuming but it's actually a pleasant, moderately priced hotel. A recent spruce-up has meant new bedding and drapery. Rooms have either wall-to-wall carpeting or (a better choice) wood floors. Rooms with double beds are better than those with two twins—they have larger desks and closets and are larger overall. Avoid the east-facing rooms, which face the main street. A few rooms are adapted for travelers with disabilities.

SHN, Q. 3, Bl. B, Brasilia, 70710-300 DF. www.hoteisbittar.com.br. ✆ **061/3328-4144.** 111 units, shower only. R$175 double weekdays; R$120 double weekends and low season. AE, DC, MC, V. Free parking. **Amenities:** Restaurant; bar; room service; smoke-free rooms. *In room:* A/C, TV, Internet, minibar.

WHERE TO EAT

Brasilia has some outstanding restaurants; politicians and businesspeople prefer to eat well and having an expense account helps. Unfortunately the city's fine-dining establishments are scattered throughout the residential wings, the Asa Sul (south wing) and Asa Norte (north wing), or off in the Club Sectors. At night they can be particularly hard to find; taking a taxi is recommended. Some of the commercial strips in the Super Quadras have grown into small enclaves with a number of excellent dining options. The majority of top restaurants are concentrated in the Asa Sul.

Asa Sul

Belini ★ 🍴 ITALIAN This gourmet complex encompasses a deli, food store, restaurant, cafe, and cooking school. It's a great place to grab an espresso and some sweets, or buy some fresh bread and cold cuts for an impromptu picnic. The casual outdoor patio serves sandwiches (the pastrami, mortadella, and brie is good) for R$6 to R$14. For a more formal occasion, the restaurant upstairs serves fine Italian dishes such as lamb filet with mint sauce and risotto, or large prawns in an apple-and-ginger sauce. The restaurant also serves breakfast and afternoon tea.

SCLS 113, Bl. D, loja 36. ⓒ **061/3345-0777.** www.belini-gastronomia.com.br. Main courses R$14–R$40. MC, V. Restaurant Tues–Sat noon–3pm and 7:30pm–midnight; Sun noon–4pm. Bakery daily 6:30am–midnight. Bus: W3 Asa Sul.

Corrientes 348 ★★ 🍴 ARGENTINE/STEAK Corrientes 348 offers a large covered patio and some of the finest steaks in town. The menu offers classic Argentine appetizers, including grilled red peppers, stuffed empanadas, and grilled spicy sausage. Meat lovers will go gaga over the fine selection of prime Argentine steak, such as the *ojo de bife* (rib-eye) and *tapa de cuadril* (rump steak). Side dishes include salads, grilled vegetables, and rice. Note that all portions are extremely generous. Most plates come in half or whole portions, and for most people a half portion will be more than enough.

SCLS 411, Bl. D, loja 36. ⓒ **061/3345-1348.** www.restaurante348.com.br. Main courses R$49–R$89 for 2. AE, DC, MC, V. Mon–Thurs noon–3pm and 7pm–midnight; Fri–Sat 12:30pm–midnight; Sun noon–6pm. Bus: W3 Asa Sul.

Fogo de Chão ★★ STEAK One of the best all-you-can-eat steak restaurants in Brazil, the Fogo de Chão chain doesn't bother with a buffet and instead puts the focus on its high-quality cuts of meat. All dishes serve to enhance your steak-eating experience. Start off with some delicious antipasto, grilled vegetables, or a salad and then wait for the competent waiters to bring you cut after cut of fine beef, lamb, chicken, or pork. Feel free to request your favorite cut. The service is very attentive and friendly. As at most churrascarias, the drinks and desserts are not included in the price of the meal and tend to be on the pricey side, but the quality remains top-notch.

SHS, Quadra 5, Bl. E, Asa Sul. ⓒ **061/3322-4666.** www.fogodechao.com.br. Main courses R$79. AE, DC, MC, V. Mon–Fri noon–4pm and 6pm–midnight; Sat noon–midnight; Sun noon–10pm.

Original Shundi ★★ JAPANESE This Japanese restaurant makes a bold statement with its stunning red-and-black dining room, designed by Ruy Ohtake. Decoration aside, however, the food is the real star here. The best deal may be the all-you-can-eat lunch buffet (R$39), which includes creative sushi rolls, fresh

sashimi, and several hot dishes. The a la carte menu goes way beyond the average list of sushi staples. Order one of the tasting menus and let the chef surprise you with dishes such as baby eel, mini octopus, or spring rolls with asparagus, mushrooms, and scallops.

SCLS 408, Bl. D, loja 35. ℂ **061/3244-5101.** www.originalshundi.com.br. Main courses R$36–R$64. AE, DC, MC, V. Mon–Fri noon–3pm and 8pm–1am; Sat noon–5pm and 8pm–1am; Sun noon–5pm and 8–11pm.

Asa Norte

C'Est Si Bon CREPES This is the place for an inexpensive snack or light meal. Owner and chef Sergio Quintiliano has created more than 50 different savory and sweet crepes. One example is the crepe Almodovar, stuffed with tender beef, mushrooms, and creamy Catupiry cheese. There are now two locations; the Asa Sul location also features a lovely patio and Thursday evening jazz music.

Asa Norte: SCLN 213, Bl. A, loja 13. ℂ **061/3272-1005.** Asa Sul: SCLS 408, Bl. A, loja 5. ℂ **061/ 3244-6353.** www.cestsibon.com.br. Main courses R$12–R$26. MC, V. Both open daily noon–midnight.

Lagash ★★ MIDDLE EASTERN This is the best Middle Eastern food in Brasilia. (Okay, there's not a lot of competition, but the quality here is excellent.) Appetizers include baba ghanouj, made with eggplant and tahini; hummus; and roasted *merguez* (lamb sausage). The most popular entree is the Moroccan lamb—tender pieces of boneless lamb cooked with nuts, scallions, onions, and rice. The wine list is heavy on the Italian and French reds to accompany the hearty and spicy dishes.

SCLN 308, Bl. B, loja 11. ℂ **061/3273-0098.** Main courses R$20–R$60. AE, DC, MC, V. Mon–Sat noon–4pm and 7pm–midnight; Sun noon–6pm. Bus: W3 Asa Norte.

Elsewhere

Alice Brasserie ★★★ FRENCH/BRAZILIAN The best French restaurant in town began in Alice Mesquita's home and in 2007 moved into this lovely brasserie, where both food and service continue to garner rave reviews. The menu encompasses both classic French dishes—*cassoulet maison, confit de canard,* and beef bourguignon—and innovative Brazilian creations such as the grilled fish with spicy banana purée. The wine list features fine French vintages, as well as the usual suspects from Argentina and Chile. Tuesday to Saturday an excellent lunch special is featured: R$50 for a three-course meal.

SHIS QI 17, lojas 201-204, Edificio Fashion Park, Lago Sul. ℂ **061/3248-7743.** www.restaurante alice.com.br. Main courses R$58–R$100. AE, DC, MC, V. Tues–Sat noon–3pm and 7:30pm–midnight; Sun noon–4pm. No public transit.

EXPLORING BRASILIA

A day is enough to see all that Brasilia has to offer. The heat of Brasilia's sun makes it a good idea to get an early start. The eastern half of the Eixo Monumental is where you'll find some of the best modern architecture in the world. Time your visit to be at the TV Tower around sunset. The elevator ride to the lookout is free, and from the 72m-high (240-ft.) platform you have a 360-degree view of the city. On April 21, 2010, the city celebrated its 50th anniversary and several buildings (including the Presidential Palace and the Cathedral) underwent renovations to celebrate the occasion in style.

If it's sunny, bring a hat. There is little shade, and it gets *hot;* also bring a water bottle, because you won't find as many street vendors as elsewhere in Brazil. If you plan on visiting the cathedral, any monuments, or government buildings, do not wear shorts or a tank top. And perhaps most importantly, *be careful crossing the Eixo Monumental.* Cars go fast here and you must cross a lot of lanes.

The Top Attractions

Catedral Metropolitana Nossa Senhora Aparecida ★★★ The cathedral is surprisingly small from the outside, but once you descend through the walkway, you emerge in the brightest and most spacious church you have ever seen. The floors and walls are made of white marble, with an expanse of glass overhead. The altar is surprisingly sparse, white marble decorated with a plain image of Christ on the cross. Sculptor Alfredo Ceschiatti designed the statues of the four apostles in front of the cathedral, as well as the angels suspended from the ceiling. You'll note his name on other sculptures, such as the figure of Justice in front of the Federal Supreme Court.

Esplanada dos Ministerios. ⓒ **061/3224-4073.** Free admission. Daily 8am–5pm. Mass Mon–Fri 6:15pm; Tues–Fri 12:15pm; Sat 5pm; Sun 8:30am, 10:30am, and 6pm. No touring of the cathedral during Mass. No shorts. Bus: Rodoviaria (short walk to the cathedral) or the Plano Piloto Circular.

Congresso Nacional One of Brasilia's best-known images is the shot of the congress building's two towers on the Planalto Central, flanked by the two "bowls," one faceup and one facedown. It is quite beautiful in an abstract way. The inside is open for English-language tours (including a visit to the Chamber of Deputies), though it's really only of moderate interest to non-Brazilians. No shorts or tank tops allowed. If you don't take the tour, you're only allowed in the museum and the lobby.

Esplanada dos Ministerios. ⓒ **061/3216-1771.** Free admission. Daily 9:30am–5pm. Bus: Plano Piloto Circular.

Espaço Lucio Costa ★ Brasilia owes its shape and design to urban planner and architect Lucio Costa. This space, sunken beneath the surface of the square, contains a full-scale model of the city. Shy of a visit to the TV Tower it's the best way to get a bird's-eye view of his plan. Disappointingly, the Espaço has little information on Costa's life and career. On the back wall there are some photos of the city under construction and, best of all, reproduced and enlarged copies of Costa's original submission, the one that won him the competition.

Praça des Tres Poderes. ⓒ **061/3325-6163.** Free admission. Tues–Sun 9am–6pm. Bus: Plano Piloto Circular.

Memorial dos Povos Indigenas Architect Oscar Niemeyer modeled the Monument to the Indigenous Peoples on the houses of the Bororó Indians. It was briefly redesignated as an arts museum, until the uproar caused it to be re-redesignated. However, it still seems underutilized. Exhibits highlight the art and daily life of Brazilian Indians. Pottery, baskets, hammocks, nets, spears, paddles, and headdresses of colorful feathers are on display. Unfortunately, there isn't any signage to indicate the origin or usage of the items. Museum staff come in varying degrees of helpfulness.

Praça do Buriti, Eixo Monumental Oeste. ⓒ**061/3344-1155.** Free admission. Mon–Fri 9am–noon and 1–6pm; Sat–Sun 10am–6pm. Bus: Plano Piloto Circular.

Memorial JK ★ This remarkable monument was built in 1980 by Oscar Niemeyer to honor the founder of Brasilia, Juscelino Kubitschek. Inside, the former

president's remains rest beneath a skylight in a granite tomb, his only epitaph an inscription on the coffin reading O FUNDADOR (the founder). Aside from this slightly spooky scene, the memorial contains a lot of JK's junk that no one could care about (JK's ribbons and medals, JK's suits and tie clips). Upstairs, there's some interesting stuff on Brasilia, including photographs of the city being built, and copies of the designs that didn't get chosen.

Eixo Monumental Oeste. ⓒ **061/3225-9451.** Admission R$4. Tues–Sun 9am–6pm. Bus: Plano Piloto Circular.

Museu Nacional ★ You can't miss the large white dome of the Museu Nacional, rising like a giant igloo from the barren concrete tundra. Built in 2006, the museum's pleasant interior space houses free changing art exhibits. Right next to the museum is the new national library, a large rectangular structure raised on short stumpy columns. Both are late Oscar Niemeyer designs, little more than austere geometric purity. Although open to the public, there are few books and not much to see. *Tip:* Tucked underneath the ramp of the Museu Nacional is a tourist information desk that gives out excellent maps and photo brochures of all the monuments in Brasilia.

Eixo Monumental Oeste. ⓒ **061/3325-5220.** Free admission. Tues–Sun 9am–6:30pm. Bus: Plano Piloto Circular.

Palácio do Itamaraty ★★★ One of the most beautiful modernist structures ever created (designed by Oscar Niemeyer with landscaping by Roberto Burle Marx and detailing by Milton Ramos), the Palácio do Itamaraty now serves as a ceremonial reception hall for the Department of Foreign Affairs. The interior is a match for the outside, so it's worth taking the tour. The ultramodern structure—mostly open space inside—is decorated with rich antique furnishings of Persian carpets, hand-carved jacaranda-wood furniture, and 18th- and 19th-century paintings. Somehow it really works. Guided tours only. Call ahead to request an English-speaking guide.

Esplanada dos Ministerios. ⓒ **061/3411-8051.** Free admission. Mon–Fri 2 and 4:30pm; Sat–Sun 10am and 3:30pm. Guided tours only, call to confirm. No shorts or tank tops allowed. Bus: Plano Piloto Circular.

TV Tower ★★★ ⬥ The best view in town is free! Take the elevator up to the 72m-high (240-ft.) lookout, and Brasilia is laid out at your feet. You'll get the best perspective of the Eixo Monumental with the ministry buildings lining the boulevard like dominoes waiting to be knocked over. Time your visit toward day end to take in the city with a fiery red Brasilia sunset. You can skip the gem museum without qualms.

Eixo Monumental (close to the bus station and malls). ⓒ **061/3321-7944.** Free admission. Mon–Fri 9am–noon and 2–5:30pm; Sat–Sun 11am–5:30pm. Bus: Rodoviaria.

Architectural Highlights

The signature buildings in Brasilia were all designed by architect **Oscar Niemeyer.** The strength of this Brazilian über-modernist has always been with form; his structures are often brilliant. His weakness has always been detailing, materials, and landscaping. These bore Niemeyer, who prefers to work purely with bare concrete. Left to his own devices, Niemeyer creates austere, even boring, collections of pure geometry, like the new Museu Nacional or the Monument to Latin America in São Paulo. Fortunately, in Brasilia Niemeyer was teamed up with Brazil's best landscape

designer, **Roberto Burle Marx,** and detailing- and materials-focused architects like **Milton Ramos,** and talented sculptors and artists like **Alfredo Ceschiatti.** Every building also had to conform to the overall plan of **Lucio Costa.** The result is a collection of buildings that has rightly been called the highest expression of architectural modernism on earth. Niemeyer's work is scattered far and wide throughout the city, but the best of the best is on the eastern portion of the Eixo Monumental, from the Rodoviario to the Praça dos Tres Poderes on the far side of the Congresso Nacional.

Several of these buildings are covered under "The Top Attractions" above: the **Congresso Nacional,** the **Catedral Metropolitana,** and the **Palácio do Itamaraty.** Also worth mentioning are the structures that no one would ever put in a top attraction, the standard ministry buildings, 17 of which flank the **Esplanada dos Ministerios** like big glass-and-concrete dominoes. The idea with these boring, repetitive buildings is that they be boring and repetitive. Costa and Niemeyer had notions that this rigidly enforced equality would cut back on bureaucratic infighting (as if) and, more importantly, provide an urban fabric against which the monumental buildings would stand out. That, at least, succeeded brilliantly.

Behind the Congresso Nacional stands the wide, austere Praça dos Tres Poderes (see below). On the north side of the square, the **Palácio do Planalto** is well worth a look. Visitors aren't allowed into this building, but can watch the not-very-exciting changing of the guard every 2 hours. Similar in form is the **Supremo Tribunal Federal,** the office of the Brazilian Supreme Court located on the other side of Three Power Plaza. The tribunal is open for guided visits, but only on weekends and holidays between 10am and 2pm.

Plazas & Parks

Behind the Congress building, the **Praça dos Tres Poderes (Plaza of the Three Powers)** is immediately identifiable by the huge Brazilian flag flapping 99m (330 ft.) above the hot, wide-open space below. The plaza is named for the three branches of government that surround it: the legislative branch in the **Congresso Nacional** (see above), the judiciary in the **Supremo Tribunal Federal,** and the executive in the presidential **Palácio do Planalto** (see above). The praça itself is unrelieved Niemeyer, a vast expanse of pure white stone, with nowhere to hide from the blazing Brasilia sun. Don't visit on a hot afternoon, or you'll fry. Near the front of the square there's a long white marble box about the size and shape of a truck semitrailer, but cantilevered one floor off the ground. This is the **Museu de Cidade** (Tues–Sun 9am–6pm; free admission). Inside it's a bare marble room with eight inscriptions on each long wall telling the story of Brasilia. No maps, no photos, just words. Next to it, below the square, is the **Espaço Lucio Costa** (see above). Toward the southern side of the square is the awkward-looking **Panteão da Patria Tancredo Neves** (Tues–Sun 9am–6pm; free admission). The building's two interlocking rhomboids are supposed to suggest a dove, but it's hard to see. Inside the Homeland Pantheon it's dark as the tomb, with lighting only on a mural depicting the life and gruesome death of 18th-century rebel Tiradentes, and a book with brass pages, each inscribed with the name of a congressionally approved Brazilian hero. It's short reading so far—just four pages.

Brasilia's prime leisure space, the **Parque da Cidade,** was landscaped by Roberto Burle Marx. The park is mostly grass fields intersected by jogging and cycle paths. You'll also find playgrounds and a small fair.

Organized Tours

SPECIALTY TOURS To make the most of your visit to Brasilia it pays to hire a tour guide. Not only will it save you all the time and hassle of getting around, but you will also gain a greater appreciation of the city's architecture and structure. **Roberto Torres** (© 061/9963-4732; carneirotorres@msn.com) is an experienced licensed tour guide with architectural knowledge who speaks excellent English. Book in advance. You can also contact **Prestheza Turismo,** Patio Brasil Shopping, Sala 917 (© 061/3226-6224; www.prestheza.com.br). In addition to city tours, the company also offers a variety of other tours, such as a visit to the Vale do Amanhecer (Valley of the Dawn) spiritual community or to one of the national or regional parks in the area. Half-day tours start at R$80 per person.

SHOPPING

Shopping in Brasilia means malls. The granddaddy of Brasilia malls is the **Conjunto Nacional** (see below). Other shopping malls close to the hotel districts include the **Patio Brasil,** SCS Q.7 Bl. A (© 061/2107-7400; www.patiobrasil.com.br), located in the south wing not far from the Meliá hotel. Near the hotel sector in the north wing, the **Brasilia Shopping,** SCN, Q.5, lote 2 (© 061/3328-5259; www. brasiliashopping.com.br), has a number of movie theaters and an excellent food court. Malls are open Monday through Saturday 10am to 10pm, Sunday 2 to 8pm.

For nonmall shopping, there is the **Feira de Artesanato da Torre de Televisão,** a large crafts fair that takes place every weekend underneath the TV Tower on Eixo Monumental, with crafts from the Northeast. It's open from 8am to 6pm.

Conjunto Nacional Built in 1971, the Conjunto Nacional was the first mall in Brasilia. Stores include two large drugstores, the Pão de Açucar supermarket, and a post office (Mon–Sat 9am–10pm). The large Siciliano bookstore has a CD department, English books, and a good variety of English magazines. Asa Norte, SCN. © **061/3316-9733.** www.cnbshopping.com.br. Bus: Rodoviaria.

BRASILIA AFTER DARK

There's a fair bit of stuff to do in Brasilia after dark, but there is no "scene" as such. Bars and cafes have sprung up in discrete, widely separate spots throughout the small commercial zones in the two residential wings. Best to decide what you're in the mood for, then choose your spot and stick with it.

Most classical concerts and dance and theater performances in Brasilia take place in one of the three concert halls at the **Teatro Nacional,** Setor Cultural Norte (© 061/3325-6240). For program information, phone the events calendar hot line at © 061/3325-6239. The box office (in the main lobby area) is open daily noon to 8pm.

Tip: During the season, the Teatro Nacional hosts free Tuesday night concerts by the Symphony Orchestra. Concerts start at 8pm and tickets can be picked up from the box office starting at noon on the day of the concert.

Bars & Live Music

Armazém do Ferreira The Armazém resembles a bustling Rio de Janeiro botequim, decorated with lovely 1950s photos of Brazil's former capital. The bar is a very popular happy hour destination for Brasilienses, especially on Fridays. On Saturdays,

the bar serves a delicous *feijoada* stew (R$29) for lunch, accompanied by live samba music. Open Monday to Thursday 5pm to 2am, Friday and Saturday noon to 2am. Closed on Sundays. CLN 202, Bl. A, loja 47, Asa Norte. ✆ **061/3327-8342.** www.armazemdo ferreira.com.br. Cover R$8–R$20.

Clube do Choro 🎁 This basement club on the Eixo Monumental specializes in *choro* and bossa nova. The crowd takes the music seriously so this is not the place to catch up with old friends. Shows from Wednesday to Sunday; starting times vary. Check the website for programming. No credit cards accepted. SDC (Setor de Difusão Cultural), Eixo Monumental. ✆ **061/3224-0599.** www.clubedochoro.com.br. Cover R$20.

Feitiço Mineiro This restaurant in the Asa Norte has become one of the best places in town to catch well-known Brazilian acts, including samba, MPB, blues, and bossa nova. Shows usually take place Tuesdays through Saturdays and start around 10pm. The restaurant operates Monday to Saturday noon to 1am and Sunday noon to 5pm. 306 Norte, Bl. B, loja 45. ✆ **061/3272-3032.** www.feiticomineiro.com.br. Main courses R$15–R$25. Cover price for shows R$10–R$20.

Gate's Pub It looks like a British pub on the outside, but that's where the authenticity stops: The beer is cold, the crowd is beautiful, and the music is hip. On Friday and Saturday jazz, blues, rock, and MPB bands take the stage. Programming often includes new, upcoming bands. The rest of the week, DJs take care of the sound and keep the crowd moving. Open Tuesday to Sunday 10pm to 3am. SCLS 403, Bl. B, loja 34. ✆ **061/3225-4576.** www.gatespub.com.br. Cover R$5–R$20.

THE SOUTH OF BRAZIL

When people think of Brazil, they rarely conjure up images of European-style villages, vineyards, cold winters, and pine trees. But the south is all that and a lot more, proof of this vast country's impressive diversity. Bordering Paraguay, Argentina, and Uruguay, the south of Brazil is formed by the states of Paraná, Santa Catarina, and Rio Grande do Sul. With a total population of approximately 25 million, these states boast some of Brazil's highest per capita income and highest rankings in the Human Development Index, which includes high rates of literacy and life expectancy. The entire region lies in the subtropics, below the Tropic of Capricorn, with regular rainfall year-round. While summers are still pleasantly warm and occasionally hot, in winter (June–Sept) temperatures drop close to freezing levels, and at higher elevations sleet, hail, and even snow are not uncommon.

15

The most popular destination in the south is Foz do Iguaçu and its magnificent waterfalls. In fact, after Rio de Janeiro and São Paulo, this is the most visited destination in Brazil.

Another sought-after holiday destination is Florianópolis, an island with beautiful beaches and sand dunes. The northern part of Floripa—as the locals call it—is very developed with sophisticated hotels, restaurants, bars, and shopping, while the south remains an unspoiled outpost of small Portuguese fishing villages and rugged, almost deserted strands. The only drawback is its relatively short beach season; from May to November it is often too cold to tan and swim.

A year-round destination, Curitiba is Brazil's urban environmental showcase, a green city with progressive public transit and social programs, a vibrant cultural scene, and great restaurants. Porto Alegre, the capital of Brazil's most southern state, is a modern city in the heart of Brazil's ranching, farming, and wine-growing region.

Most visitors to Brazil skip the south altogether (except for perhaps a quick 2-day jaunt to Iguaçu) in favor of more tropical, exuberant destinations. However, those who have the time to explore this region will be rewarded with a whole new perspective and understanding of this country where the descendents of German, Italian, and Polish immigrants are every bit as proud to call themselves Brazilian.

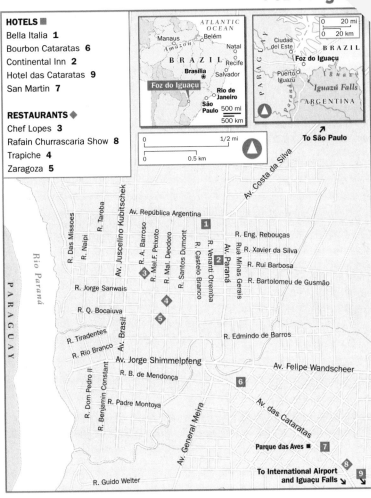

HOTELS ■
Bella Italia **1**
Bourbon Cataratas **6**
Continental Inn **2**
Hotel das Cataratas **9**
San Martin **7**

RESTAURANTS ◆
Chef Lopes **3**
Rafain Churrascaria Show **8**
Trapiche **4**
Zaragoza **5**

FOZ DO IGUAÇU & THE FALLS

1,093km (679 miles) SW of Rio de Janeiro, 847km (527 miles) SW of São Paulo

There are but three great waterfalls in the world, and curiously they seem to all fall on borders: Niagara Falls, on the border between the United States and Canada; Victoria Falls, between Zimbabwe and Zambia; and Iguaçu Falls, between Brazil and Argentina.

ll. Iguaçu is without doubt the most beautiful of the three. Niagara
marred by 2 centuries of industry and kitsch. Victoria Falls in Africa
narrower, and the mist thrown up by all that water funneling into
greatly obscures the view.

water pours down over not one but some 275 different falls, spread
some 5km (3 miles) wide and 81m (266 ft.) high.

The fine mist tossed up by all that falling water precipitates down and creates a
microclimate of lush rainforest, with tropical birds and an abundant population of
glorious butterflies.

Iguaçu has been attracting visitors since the first European explorer stumbled
across the area in the 1540s. In the 1930s more than 404,685 hectares (1 million
acres) on the Brazilian side was made into a national park, and in 1985 the falls were
designated a UNESCO World Heritage Site.

Iguaçu Falls never quite achieved the same iconic status as Niagara. The Iguaçu
Falls did get one good breakout role, though, when they were cast almost as a sup-
porting actor in the Robert De Niro film *The Mission* (worth renting for its story of
the expulsion of the Jesuits, in addition to the great film footage of the falls).

Debate is endless as to whether the view from the Brazilian or Argentine side is
better. You should really visit both sides to get the full experience. Beyond the imme-
diate zone of the falls, the national park is closed to visitors. For a close encounter of
the wet kind, the zodiac trips upstream toward the falls are highly recommended.
There are also rubber raft trips through the rapids downstream, as well as an extraor-
dinary 50m (164-ft.) rappel from the top of the gorge all the way down to the edge of
the Iguaçu River.

The falls are remote enough that a 1-day trip is, well, insane. Iguaçu makes a per-
fect 2 to 3 day stopover. Those with limited time or money should consider whether
the falls—glorious though they are—are worth the 1,000km (620-mile) trip from Rio
or São Paulo.

Essentials

GETTING THERE

BY PLANE Gol (© 0300/115-2121; www.voegol.com.br), **TAM** (© 045/4002-
5700; www.tam.com.br), and **Webjet** (© 0800/723-1234; www.webjet.com.br)
have daily flights. Book ahead in peak season; flights fill up quickly.

The **Aeroporto Internacional Foz do Iguaçu** (© 045/3521-4200) is on
BR-469 halfway between downtown and the national park. The 13km (8-mile) taxi
ride to downtown Iguaçu or to the hotels along the parkway costs about R$50. The
airport's tourist information desk is open daily from 9am to midnight.

BY BUS Long-distance buses arrive at the **Terminal Rodoviario,** Av. Costa e
Silva s/n (© 045/3522-3633). The station is 4km (2½ miles) northeast of down-
town. The bus station has a tourist information office, open daily from 9am to 6pm.
For buses to Rio de Janeiro, São Paulo, Curitiba, or Florianópolis, as well as long-
distance buses to Argentina (Buenos Aires) and Paraguay (Asunción), contact the
Pluma bus company (© 045/3522-2515; www.pluma.com.br). For buses across to
Puerto Iguazú in Argentina, see the review for Parque Nacional Iguazú (Argentine
Falls), later in this chapter.

BY CAR Foz do Iguaçu is 1,028km (639 miles) from São Paulo and 620km (384
miles) from Curitiba on BR-277.

CITY LAYOUT

A small, modern city of 325,000 people, **Foz do Iguaçu** (normally just called Iguaçu) is effectively located on a peninsula. West of the city is the **Rio Paraná** and, beyond that, Paraguay. North of the city lies **Lago de Itaipu,** a great man-made lake created by putting up what was the world's largest hydroelectric dam across the Rio Paraná; the dam is well worth a visit. To the south of the city lies **Rio Iguaçu** and, beyond it, Argentina. The **falls** are upstream on this river, a 28km (18-mile) drive southeast from downtown. The city's downtown is small and easy to navigate, but offers few attractions. Just north of downtown, **BR-277** comes in from Curitiba and São Paulo and crosses the **Ponte da Amizade (Friendship Bridge)** into Paraguay. At the southern end of downtown, **Avenida das Cataratas** (BR-469) tracks southeast toward **Iguaçu National Park** and the falls. There are quite a few good hotels, some other attractions, and restaurants along this road. About 7km (4¼ miles) from downtown, there's a turnoff for the **Ponte Tancredo Neves,** which crosses into Argentina. Public buses take this route, and border formalities are minimal. The road to the falls, now called **Rodovia das Cataratas,** continues past the airport turnoff until, at 17km (11 miles) from the city, it reaches the gates of **Iguaçu National Park.**

GETTING AROUND

BY BUS City buses begin and end their routes at the **Terminal Urbana** on Avenida Juscelino Kubitschek (also called Av. JK—pronounced Zho-ta Ka) at the corner of Avenida República Argentina. Buses for the airport and the falls run along Avenida JK and Avenida Jorge Schimmelpfeng to the Avenida das Cataratas. Falls buses are marked CATARATAS or PARQUE NACIONAL (fare is R$2.20). They run every 20 minutes until 6:40pm. The trip to the park gate and visitor center takes 45 minutes. From the park gate, a free shuttle (departing every 20 min.) will take you the rest of the way to the falls. Getting to the Argentine Falls by bus is cheap but time-consuming. The one-way trip takes about 90 minutes. See review for Parque Nacional Iguazú (Argentine Falls), later in this chapter.

BY TAXI Taxi *pontos* (stands) are available throughout the city or you can flag a taxi on the street. A trip across town costs around R$20. A trip from the city center to a hotel on the Avenida das Cataratas costs between R$25 and R$35. A taxi from the center of town to the park gates costs R$45. Hiring a taxi to take you to the Argentine Falls, wait while you see them, and then bring you back costs about R$200, depending on your negotiation skills. **Coopertaxi** (✆ **0800/524-6464** or 045/3529-8821) has cabs available 24/7.

BY CAR Renting a small car to travel to the Argentine Falls is a reasonable option. The cost is about the same as a tour, and rental and border hassles are minimal. You'll need a credit card, a valid state or provincial driver's license, and some other piece of ID (for example, a passport).

VISITOR INFORMATION

Iguaçu's tourist bureau employs excellent English-speaking attendants who have up-to-date and accurate information at their fingertips. They also give out free maps of the city. The main **tourist information center** is at Praça Getulio Vargas, Av. JK and Rua Rio Branco (✆ **045/3521-1455;** www.fozdoiguacu.pr.gov.br; Mon–Fri 9am–5pm). Tourist information booths are at the airport and bus station, or you can call the Iguaçu tourist information service **Teletur** (✆ **0800/451-516** toll-free within Brazil). The service operates daily from 7am to 11pm.

[FastFACTS] FOZ DO IGUAÇU

Banks & Currency Exchange **Banco do Brasil,** Av. Brasil 1377 ((✆ **045/3521-2525**), has a 24-hour ATM. The **HSBC** branch is nearby at Av. Brasil 1151 ((✆ **045/3523-1166**).

Car Rental Prices at **Localiza** ((✆ **0800/979-2000**), **Avis** ((✆ **0800/725-2847**), **Unidas** ((✆ **0800/121-121**), **Hertz** ((✆ **0800/701-7300**), and **Yes** ((✆ **045/3522-2956**) are similar: about R$110 for a subcompact with air-conditioning for a 24-hour day with unlimited mileage, plus R$15 to R$30 for optional insurance. Gasoline is extra; expect to spend about R$25 for a trip to the Argentine Falls. Avis and Yes provide free hotel pickup and drop-off. With Avis, airport drop-off is free; Yes charges R$10.

Dentist **Clinica Odontologica** ((✆ **045/3523-5965**) is on call 24 hours.

Hospital For emergencies, go to **Hospital Internacional,** Av. Brasil 1637 ((✆ **045/3523-1404**).

Pharmacy **Farmarede,** Av. Brasil 46, Centro ((✆ **045/3572-1363**), is open 24 hours and will deliver to local hotels.

Weather In the summer Iguaçu is warm and muggy, but in the winter there's a very un-Brazilian chill. From April to September daytime temperatures drop to 10°C to 20°C (50°F–68°F). The falls are best seen in the summer from January to March when there is plenty of water.

Where to Stay in Iguaçu

Iguaçu has a wide variety of accommodations, with the more affordable options in town and the luxury hotels found on the Avenida das Cataratas. High season is from December to February and in July. Outside of these months you can usually negotiate a discount. However, Iguaçu is a popular convention destination, so book early.

CENTRO
Moderate

Bella Italia 🍴 This midpriced hotel offers pleasant rooms in downtown Iguaçu, each of which is furnished with a queen-size bed, writing desk, tub/shower combo in the bathroom, and a small balcony with a downtown view. The only real drawback to the hotel is the traffic noise. The best rooms and suites face downtown, and though the glass provides good sound insulation, there is still some traffic murmur, especially during rush hour. However, if you're up early and out sightseeing all day, this shouldn't be an issue.

Av. República Argentina 1700 (corner of Rua Venanti Otremba), Foz do Iguaçu, 85852-090 PR. www.bellaitalia.tur.br. (✆ **0800/45-4555** or 045/3521-5000. Fax 045/3521-5005. 135 units. R$180–R$230 double. 20% discount for business travelers or in off season. Extra person add 30%. Children 7 and under stay free in parent's room, 8–12 pay R$30 extra. AE, DC, MC, V. Parking R$10 daily. **Amenities:** Restaurant; bar; small weight room; small outdoor pool and children's pool; room service; smoke-free floors; Wi-Fi. *In room:* A/C, TV, hair dryer, Internet, minibar.

Continental Inn ★★ 🍴 Located in town, the Continental Inn is a real gem. The comfortable regular rooms feature firm twin or double beds, modern Art Deco–ish decor, good desk space, and showers with lots of high-pressure hot water. The suites are outstanding; regular suites feature a separate sitting area, a firm queen-size bed, and a large round bathtub. The top-quality master suites have hardwood floors, a king-size bed, fancy linens, a large desk, a separate sitting area, a walk-in closet, and a bathroom with Jacuzzi tub and a view over the city. Rooms for travelers with

disabilities are available. ***Note:*** Make sure when reserving your room that you insist on staying at the Continental Inn. The hotel has another property, Recanto Park, which is quite pleasant but outside town.

Av. Paranà 1089, Foz do Iguaçu, 85852-000 PR. www.continentalinn.com.br. Ⓒ **0800/707-2400** or 045/2102-5000. 124 units. R$200–R$250 double; R$350 suite; R$485 master suite. In low season 20% discount. Children 4 and under stay free in parent's room, 5 and over R$30 extra. AE, DC, MC, V. Free parking. **Amenities:** Restaurant; exercise room; outdoor pool; room service; sauna. *In room:* A/C, TV, fridge, hair dryer, Internet, minibar.

ON THE PARK ROAD
Very Expensive
Hotel das Cataratas ★★★ Part of the elegant Orient Express chain, this hotel boasts the most luxurious (and most expensive) accommodations in Iguaçu. The hotel is also the only property located inside the national park, which allows you to explore the trails and lookouts over the falls before anyone else arrives. Rooms are spread out over a number of wings in the colonial-style building, connected by spacious corridors. The superior rooms are on the small side; if you have the extra money splurge on a more spacious deluxe room with beautiful hardwood floors and large bathrooms with bathtubs; a few have balconies. Despite some deluxe units being advertised as "Cataratas rooms," lush vegetation blocks most of the views of the falls. Guests also have use of a large pool complex and a forested area behind the hotel with nature walks and trails to explore. Perhaps the only drawback to staying here is that it's 25km (16 miles) from town. For many, this rather limited sacrifice is more than made up for by the magic of staying so close to the falls.

Parque Nacional do Iguaçu, Foz do Iguaçu, 85863-000 PR. www.hoteldascataratas.com. Ⓒ **0800/726-4545** or 045/2102-7000. 193 units. R$540 superior; R$640 deluxe. Check the website for Internet packages including tours and transfers. Children 12 and under stay free in parent's room. AE, DC, MC, V. Free parking. Take the road to Iguaçu Falls, go straight toward the gate, do not turn left into the visitor's area. **Amenities:** 2 restaurants; bar; children's programs; large outdoor pool; room service; spa; tennis court. *In room:* A/C, TV, hair dryer, minibar, Wi-Fi.

Expensive
Bourbon Cataratas ★★ ☺ The real draw of the Bourbon is its leisure space. True, all the rooms are beautifully appointed. In the original wing, the standard rooms look out over the front of the hotel, whereas the superior rooms have a veranda and look over the pool. The new wing houses the master suites—really just a room, but with newer furnishings and huge windows providing lovely views. Out back, there's a 2km (1¼-mile) trail through orchards and lovely gardens; keep an eye out for toucans, parakeets, and colorful butterflies in the aviary. The vast pool complex includes three large pools, one especially for children. In high season, activity leaders organize all-day children's activities. But wait, there's more: a top-notch gym and indoor pool, a climbing wall and tennis courts, a soccer field, and a beach volleyball court. The Brazil Nuts tour company often has specials at a low R$250 a night.

Rodovia das Cataratas, Km 2.5, Foz do Iguaçu, 85853-000 PR. www.bourbon.com.br. Ⓒ **0800/451-010** or 045/3521-3900. 311 units. R$400–R$600 superior or master. Extra person R$140. AE, DC, MC, V. Free parking. Bus: Parque Nacional or Cataratas. **Amenities:** 3 restaurants; children's programs; huge pool complex (2 outdoor pools, 1 small indoor pool); room service; sauna (dry and steam); smoke-free rooms; outdoor lighted tennis courts. *In room:* A/C, TV, fridge, hair dryer, Internet, minibar.

Moderate
San Martin ★★★ ☺ Also located on the park road, the San Martin is near the park entrance, close to the bird park. This sprawling hacienda-style hotel is one of the

best deals in town, especially now that most of the rooms have been renovated and feature hardwood floors and elegant, modern furnishings. Families will appreciate the two-bedroom suites that come with two double and two single beds. For kids, the hotel's vast grounds offer several play areas, a soccer field, a swimming pool, and gardens with walking trails.

Rodovia das Cataratas, Km 17, Foz do Iguaçu, 85853-000 PR. www.hotelsanmartin.com.br. ℂ **0800/645-0045** or 045/3521-8088. 135 units. R$180 standard; R$220 superior; R$320 family superior, sleeps 4–6 people. AE, DC, MC, V. Free parking. Bus: Parque Nacional or Cataratas. **Amenities:** Restaurant; outdoor pool; room service; sauna; smoke-free rooms; tennis court; Wi-Fi. *In room:* A/C, TV, minibar.

Where to Eat in Iguaçu

Don't come to Iguaçu for the culinary experience. Menus are rarely adventurous, but expect excellent Brazilian beef and fresh-caught fish from the Iguaçu or Paraná rivers. In addition to the restaurants below, most hotels outside of downtown also offer good dining options.

Chef Lopes STEAK Being just a hop and a skip from Argentina, it is not surprising that you would find excellent Argentine steak dishes in town. Chef Lopes serves up a nice range of dishes, including salads, risotto, pasta, and fish, but most people come to feast on the fabulous juicy *bife de chorizo*. The well-chosen wine list includes some excellent Argentine and Chilean selections.

Rua Almirante Barrosos 1713, Centro. ℂ **045/3025-3334.** www.cheflopes.com.br. Main courses R$38–R$52. AE, DC, MC, V. Mon–Sat 11:30am–3:30pm and 6–11:30pm; Sun 11:30am–3:30pm.

Rafain Churrascaria Show CHURRASCO One of the most popular nighttime restaurants in town, the Rafain serves up a traditional all-you-can-eat Brazilian steak feast, including salads, pasta, fish, seafood, and dessert, followed by an impressive show of South American music and dance. The dazzling event gives a great overview of the folklore of neighboring countries, such as Argentina, Chile, Paraguay, and Uruguay, as well as of the different regions within Brazil.

Av. das Cataratas 1749. ℂ **045/3523-1177.** www.rafainchurrascaria.com.br. Show and dinner (drinks not included) R$79 per person, R$40 children 6–10, children 5 and under are free. AE, DC, MC, V. Mon–Sat 7–11pm (show begins at 8:45pm).

Trapiche ★ SEAFOOD For some excellent seafood, try the Trapiche. The large menu includes everything from grilled fish such as tilapia, salmon, and trout to Bahian seafood stews such as *moqueca, bobó,* and *caldeirada* (with crab, shrimp, and octopus). The kitchen also takes pride in serving up high-end seafood such as lobster and oysters and local fish from the Paraná and Iguaçu rivers.

Rua Marechal Deodoro 1087, Centro. ℂ **045/3527-3951.** Main courses R$30–R$60. The more expensive dishes serve 2 people. AE, DC, MC, V. Mon–Fri 5pm–midnight; Sat–Sun 11am–midnight.

Zaragoza SPANISH For those who are tired of eating steak, Zaragoza offers a wonderful alternative: international cuisine with a strong Spanish flavor. The menu is particularly strong on seafood such as prawns, lobster, and local fish served grilled or broiled. On Saturday, there's a traditional Brazilian *feijoada,* and on Sunday people come from far and wide to savor the paella for lunch. The wine list puts the emphasis on Spanish, Argentine, and Portuguese vintages.

Rua Quintino Bocaiúva 882. ℂ **045/3028-8084.** www.restaurantezaragoza.com.br. Main courses R$28–R$58. AE, DC, MC, V. Daily 11:30am–3pm and 7pm–midnight.

Exploring Iguaçu Falls

Your first priority should be to visit the Brazilian Falls. The walk along the gorge starting from just below the soft-pink **Hotel das Cataratas ★★★** (see above) is spectacular. Keep an eye out for the hundreds of colorful butterflies. Make the time to get up close and personal with the falls on a zodiac ride. (**Note:** In the zodiac, a motorized inflatable rubber boat, you *will* get drenched.) Time permitting, pay a visit to the Parque das Aves for a close-up of the many bird species that inhabit the park. Also worth a look is Itaipu Dam, the world's largest hydroelectric project.

THE FALLS

Parque Nacional do Iguaçu (Brazilian Falls) ★★★
The Brazilian Falls now have a newly renovated visitor center and a new restaurant—Canoas—above the falls. A new observation deck is also complete. The elevator is a work in progress. The **visitor center** is where you park your car or get off the bus and buy your entry tickets. The building has a gift shop and a small display area with some park history. From here, you board a shuttle bus and set off down the parkway for the falls. The bus will stop at the **Macuco Safari center** (from where rafting and zodiac trips depart, but do that after you've seen the falls), the pink **Hotel das Cataratas,** and then at **Canoas** restaurant before heading back to the visitor center. The hotel is the place to get off the bus. A small viewpoint at the foot of the hotel lawn is where you get your first magical view of the falls. From here, the pathway zigzags down the side of the gorge and trundles along the cliff face, providing views across the narrow gorge at water cascading down in a hundred different places. There are 275 separate waterfalls, with an average drop of 60m (197 ft.). While you walk, you'll see colorful butterflies fluttering about the trail and grumbling coati (a larger relative of the raccoon) begging for food. At the end of the trail an elevator will lift you up to the restaurant by the edge of the falls. Before going up, take the elevated walkway leading out *in front* of one of the falls. The wind and spray coming off the falls are exhilarating and guaranteed to have you soaked in seconds. (You can buy a plastic coat from the souvenir stand for R$5.) Allow at least a half-day.

Rodovia dos Cataratas, Km 18. ☏ **045/3521-4400.** www.cataratasdoiguacu.com.br. Admission R$41, R$7 children 2–11, includes transportation inside the park. Parking R$12. Daily 9am–5pm. Bus: Cataratas or Parque Nacional.

Macuco Boat Safari ★★★
Niagara Falls has the *Maid of the Mist.* Iguaçu has Macuco. I know which one I'd choose. Macuco participants pile aboard 8m (25-ft.) zodiacs, the guide fires up twin 225-horsepower outboards, and you're off up the river, bouncing over wave trains, breaking eddy lines, powering your way up the surging current until the boat's in the gorge, advancing slowly toward one of the (smaller) falls. As the boat nears, the mist gets thicker, the roar louder, the passengers wetter and more and more thrilled (or terrified), until the zodiac peels away, slides downstream, and hides in an eddy until everyone's caught his or her breath. Then you do it all again. Bring a change of clothes as you will get soaking wet. Macuco provides lockers and changing rooms. Allow 1 hour for the entire trip.

Parque Nacional do Iguaçu. ☏ **045/3574-4244.** www.macucosafari.com.br. R$140 per person, children 7–12 half price. Mon 1–5:30pm; Tues–Sun and holidays 9am–5:30pm. Bus: Parque Nacional or Cataratas.

Parque Nacional Iguazú (Argentine Falls) ★★★
Visitors to the Argentine Falls arrive at a new complex, which consists mostly of restaurants and gift shops. A

small visitor center does have displays on the history and ecology of the falls, but text is exclusively in Spanish. (*No!* They do not, will not, cannot provide an English-language pamphlet.) Leave them then to their lonely pride, because the chief attraction of the Argentine park is the **Devil's Throat walkway ★★★**. To reach it, you take a free small-gauge railway, which departs every 30 minutes from 8am to 4pm, either from the visitor center station or from a second station located 600m (1,968 ft.) down a paved walking trail. The train takes about 20 minutes to trundle the 3km (2 miles) up to the Devil's Throat station. From here it's about a 1km (½-mile) walk along the steel catwalk to the viewpoint overlooking Devil's Throat. The amount of water falling down is both magical and mesmerizing; nothing people do seems to mar it. The return train leaves on the half-hour, with the last departure at 5:30pm.

There are several other trails in the park. The **Circuito Superior (Upper Trail)** loops around the top of the falls for excellent views of the falls. The **Circuito Inferior (Lower Trail) ★★** is very easy to walk—to the point that much of it is wheelchair accessible. It leads down to the edge of the Iguazú River, offering some excellent views up toward the falls. It's the only way to reach **Isla San Martin ★**, an island that's surrounded on all sides by falling water—well worth the short boat ride (currently free of charge). The last boat back leaves at 5pm. Expect to spend at least 4 hours in the park, more if you take a boat excursion (see below).

Iguazu Jungle Explorer (📞 03757/421696) operates a number of fast zodiac excursions. The **Adventura Nautica** (approx. R$43) leaves from the bottom of the Circuito Inferior and blasts up as close as driver and passengers dare to one of the big falls on the Argentine side. The **Gran Aventura** (approx. R$85) does much the same but starts 5km (3 miles) farther down the river, giving you a 4×4 drive through the forest and a bit more time on the river; the Aventura Nautica is a better value. The **Ecological Tour** (R$20) begins at the Devil's Throat boardwalk above the falls. Passengers hop into rubber rafts and drift 2km (1¼ miles) downstream through the forest, then disembark and get trucked back to the visitor center. Please note that all rates are approximate as they are calculated from the Argentine peso.

Getting There: From Foz do Iguaçu take the PORTO IGUAZU bus from downtown. Customs formalities at the border are minimal Stay on the bus and tell the Customs officer who boards that you're going to the Parque Nacional; sometimes you are waved through without even a stamp in your passport, but most likely you will need to present your passport and fill out a landing card. Please note that citizens of the U.S., Canada, and Australia must pay a reciprocity fee of approximately US$140 to enter Argentina (valid for the life of your passport). To travel from Argentina to Brazil, citizens of the U.S., Canada, and Australia must also have a valid visa for Brazil (see chapter 17). After clearing immigration, the bus then goes to the main bus station in Puerto Iguazú. Go to stall no. 5, where a bus departs every hour between 7:40am and 7:40pm for the 20-minute trip to the park. Including connections, total trip time from Brazil will be at least an hour. The bus from Brazil to Argentina costs R$3, and the one from Puerto Iguazú to the falls costs R$5. A taxi to or from the Argentine side costs about R$70 each way.

Getting Back: The bus from Parque Nacional to the Puerto Iguazú bus station departs hourly from 8am to 8pm. Once back at the bus station, go to stall no. 1 and catch the bus marked FOZ DO IGUAÇU back to Brazil. Another option is to book a guided tour or transfer. See below.

Av. Victoria Aguirre 66, Puerto Iguazú, 3370 Misiones, Argentina. 📞 **03757/420-722.** www.iguazuargentina.com. Admission 100 pesos (approximately R$42) adults, 70 pesos (R$29) children ages 6–12, free for 5 and under. Daily 8am–6pm.

OTHER TOP ATTRACTIONS

Canion Iguaçu (Rappel and Climbing Park) ★★ This company has converted a part of the park into a delightful adult playground. A highlight is the *arvorismo* (tree-climbing) trail, an obstacle course made out of ropes, wires, and platforms attached to the trees. The lower portion of the course starts out at just 1m (3 ft.) above the forest floor; this lower section is appropriate for younger children 5 to 10 years of age. The more challenging higher obstacles will take you at least 7m (25 ft.) up into the trees. If that doesn't make your stomach flip, you can rappel down 37m (120 ft.) off a platform overlooking the falls. Maybe your thing is going up instead of down? The park offers a variety of climbing options. Beginners can try the artificial wall while more experienced climbers can explore over 33 different routes on the basalt rock face. And, last but not least, the company runs daily rafting trips over a 4km (2½-mile) stretch of the river. The run covers about 2km (1¼ miles) of rapids with a three-plus rating; the rest is calmer water that gives you a chance to observe the forest and the river. If you're traveling with children, be sure to check on minimum age and height requirements for certain activities.

Parque Nacional do Iguaçu. (🕾 **045/3529-6040.** www.campodedesafios.com.br. Rappel R$70. Rafting R$80. Tree climbing R$80 for the higher part, R$70 for lower part only. Climbing R$50. Daily 9am–5:30pm. Bus: Parque Nacional or Cataratas.

Itaipu Dam ★★ One of the world's largest hydroelectric projects stands 10km (6¼ miles) upriver from Foz do Iguaçu on the Rio Paraná. The project produces over 90 billion kilowatt hours per year, nearly 25% of Brazil's supply. Visitors are shown a 30-minute video on the dam's construction, featuring endless shots of frolicking children and nothing on the dam's environmental impact. Then you board a bus that crosses to an observation platform in the midpoint of the dam. For a much more in-depth look at the dam, which includes a visit to the Production Building and the Central Command Post, book the Special Tour. The Technical Tour (where you go inside the dam to see the turbines) is available only by prior arrangement. Contact the visitor center at least a week in advance. It is mostly of interest to engineers and people with a technical background who want to see the ins and outs of the dam. *Note:* No sandals, high heels, shorts, or miniskirts allowed.

Av. Tancredo Neves 6702. (🕾 **0800/645-4645.** www.turismoitaipu.com.br Regular guided tour R$19. Daily hourly 8:30am–4:30pm. Special in-depth 2-hr. tour R$50. Daily at 8am, 8:30am, 10am, 10:30am, 1:30pm, 2pm, and 3:30pm. Call ahead to check times with English-speaking guide. Bus: 110 or 120.

Parque das Aves ★★ Set in 4.8 hectares (12 acres) of lush subtropical rainforest, the Bird Park offers the best bird-watching in Iguaçu. A large number of birds are in huge walk-through aviaries, some 24m (80 ft.) tall and at least 60m (200 ft.) long, allowing visitors to watch the birds interact as they go about their daily routines. Highlights include the toucans and multicolored tanagers as well as a Pantanal aviary with roseate spoonbills, herons, and egrets. Signage is in English. The best time to visit is early in the day when the birds are most active. Allow 2 hours.

Rodovia das Cataratas, Km 17, 300m (984 ft.) before the national park entrance. (🕾 **045/3529-8282.** www.parquedasaves.com.br. Admission R$25, free for children 8 and under. Daily 8:30am–5:30pm. Bus: Parque Nacional or Cataratas.

SPECTACULAR VIEWS

The confluence of the Rio Iguaçu and the Rio Paraná, about 7.5km (4½ miles) south of the town of Foz do Iguaçu on Avenida General Meira, is also the spot where Brazil,

Paraguay, and Argentina all meet. Called the **Marco das Três Fronteiras,** it features a public viewing platform with good views up and down the Iguaçu and Paraná rivers.

ORGANIZED TOURS

BOAT TOURS The **Iguaçu Explorer,** operated by Macuco Safari, offers a boat tour along the Iguaçu and Paraná rivers. Although there are no views of the falls, this leisurely tour is a great way to see the region from the water. Highlights include a view of the Tancredo Neves bridge that connects Brazil and Argentina, the tri-border marker, and a visit to a small regional museum on the Paraguay side. The vegetation along the way is quite nice but if you're going to the Pantanal or the Amazon, I would skip this excursion. If not, it's a good way to get a small taste of the country's natural wonders. Tours cost R$90, lunch included. Departure times vary. Details are available at ⓒ **045/3523-6475** or www.macucosafari.com.br.

HELICOPTER TOUR Taking the helicopter tour in the park involves a small moral dilemma. The noise from the helicopters does scare the wildlife. Park naturalists say that toucans appear only when it's rainy, windy, or fogged in—days that the copters are grounded. The helicopters are one of two issues over which UNESCO threatened to pull Iguaçu's World Heritage designation (the other was a plan to reopen highway BR-373, cutting the park in half). On the other hand the company has invested in the newest, quietest helicopters. And the view of the falls and canyon from the air truly is spectacular. Contact **Helisul–Helicopter Tours,** Avenida das Cataratas, Km 16.5, Foz do Iguaçu (ⓒ **045/3529-7327;** www.helisul.com; 10-min. flight over the falls and park R$180 per person, three-person minimum; children are free if they don't occupy a seat; daily 9am–5pm; Parque Nacional or Cataratas).

GUIDED TOURS & TRANSFERS A number of tour operators organize transportation and guides for visits to the falls. Trips can be customized to include visits to other attractions such as the bird park, Macuco Safari, or the Itaipu Dam. The most popular service is the 1-day visit to the Argentine Falls, which at most agencies costs around R$80 per person. Reputable companies include **Conveniotur,** Rua Rui Barbosa 820 (ⓒ **045/3523-3500;** www.conveniotur.com.br), **Central Tours** (ⓒ **045/3526-4434;** www.centraltours.com.br), and **Loumar Tourismo** (ⓒ **045/3572-5005;** www.loumarturismo.com.br). Loumar also offers a 1-day excursion to the shopper's paradise of Paraguay.

OUTDOOR ACTIVITIES

Just outside of Iguaçu Park is **Iguaçu Golf Club,** Av. das Cataratas 6845 (ⓒ **045/3521-3400**), an 18-hole, par-72 golf course. In addition to the course, the club also has a 300-yard driving range and putting green, golf-club rental, a gift shop, and a large leisure area with a restaurant, lounge, sauna, and pool. It's open daily year-round from 7am to sunset. Fees for visitors are R$70 for 18 holes, R$50 for 9 holes. Cart rental is R$70 for 18 holes and R$45 for 9 holes. To get there, take the PARQUE NACIONAL or CATARATAS bus.

Shopping in Iguaçu

Foz do Iguaçu's *centro* is a popular shopping district. Most shops are concentrated around **Avenida Brasil, Rua Barbosa, Rua Almirante Barroso,** and **Quintino Bocaiuva.** You'll find many clothing and shoe stores, as well as excellent leather goods such as jackets and purses.

Tres Fronteiras 🛍 You can find anything here, from all regions of Brazil: T-shirts, carvings, carpets, hats, hides, semiprecious stones, precious stones, you name it; anything you ever considered picking up and didn't, it's here at reasonable prices. BR 469 Rodovia das Cataratas, Km 11 (just before the turnoff for Argentina). ℂ **045/3529-6565.** www. tresfronteiras.com.br.

Iguaçu After Dark

The corner of Avenida JK and Avenida Jorge Schimmelpfeng is Iguaçu's prime night-life area, home to a number of restaurant/pubs, most with large patios. A favorite with locals and visitors is **Bar do Capitão,** Av. Jorge Schimmelpfeng 288 (ℂ **045/3572-1512;** daily 6pm–1am, Fri–Sat until the last customer leaves). In addition to *cachaças* and great cocktails, the **Cachaçaria Agua Doce,** Rua Benjamin Constant 63 (ℂ **045/3523-7715**), features live music on Friday and Saturday. Another popular downtown live music venue is the **Ono Teatro Bar,** Rua Rosa Cirilo de Castro 85 (Av. Paraná and Av. Venezuela; ℂ **045/3027-5700;** www.onoteatrobar.com.br; Fri–Sat).

CURITIBA

297km (185 miles) NW of Florianópolis, 411km (255 miles) SW of São Paulo, 862km (535 miles) SW of Rio de Janeiro

Curitiba is "the little city that could": a modern, developed city with low poverty rates, green streets, efficient public transportation, a dynamic cultural life, and strong environmental awareness.

Like so many other regions in the south of Brazil, the area around what is now known as Curitiba was first inhabited by Tupi-Guarani Indian tribes. Most traces of these early inhabitants, along with the pine forests that once blanketed the region, have now all but vanished, except for the city's name: derived from the Tupi-Guarani word *curii-tiba,* which means "pine forest." European settlers started to arrive in the 17th century looking for gold and precious stones. Farmers and cattle ranchers followed soon after. The miners soon moved on to Minas Gerais, chasing after the next gold rush, but the farmers and ranchers stayed behind to form the backbone of the region's economy.

To promote the region's economic development in the second half of the 19th century, the government began an active campaign to attract European immigrants. A large number of German, Italian, Polish, and Ukrainian immigrants settled in this area.

In the post–World War II boom, Brazil underwent rapid industrialization and urbanization, with Curitiba one of the fastest growing cities. In an effort to control and regulate this growth, forward thinkers began to develop urban master plans for zoning, roads, and mass transportation. As a result, Curitiba was able to stave off the uncontrolled, chaotic growth that has plagued so many other Brazilian cities. However, it wasn't until urban planner Jaimie Lerner became mayor in 1972 that Curitiba began to make an international name for itself. During his three terms as mayor, he created many social programs, invested in education, and invented the world's first Bus Rapid Transit system, an efficient network of preferential bus corridors that can move people as quickly and efficiently as a subway, but costs only a fraction to build. (Lerner went on to become Parana state governor, but in 2011 was convicted of illegally awarding untendered road construction contracts. Fortunately, Curitiba fared better.)

Today, the city enjoys one of the highest standards of living in Brazil. Held up as a marvel of green development, Curitiba boasts pleasant neighborhoods, lovely parks, and a vibrant cultural life. Although foreigners may find the city perhaps lacking in tropical sex appeal, for Brazilians this city is an exotic destination.

Essentials

GETTING THERE

BY PLANE **Gol** (✆ **0300/115-2121;** www.voegol.com.br), **TAM** (✆ **041/4002-5700;** www.tam.com.br), and **Webjet** (✆ **0300/210-1234;** www.webjet.com.br) have daily flights, often connecting through São Paulo. The **Aeroporto Afonso Pena** (✆ **041/3381-1515**) lies 18km (8 miles) southeast of the city center. *Note:* Curitiba's airport is notorious for heavy morning fog in the colder months. If you can, avoid early morning flights between May and September.

A taxi ride to downtown costs approximately R$50 to R$60. A more affordable option is the **Aeroporto Executivo bus** (✆ **041/3381-1515;** www.aeroporto executivo.com.br), which costs R$8 per person. This shuttle leaves every 20 to 30 minutes and drops passengers at various downtown locations (check with your hotel for the nearest stop).

BY BUS/TRAIN Long-distance buses arrive at the **Rodoferroviária,** Av. Presidente Affonso Camargo 330 (✆ **041/3320-3000**), about 10 blocks from downtown. The bus station has a tourist information office, open daily from 9am to 6pm. For online information, ticket prices, and routes, check **www.rodoviariaonline.com.br** or call ✆ **041/8737-7464.** Popular routes include Foz do Iguaçu (approx. 10 hr.), Florianópolis (approx. 4 hr.), and Porto Alegre (approx. 11 hr.).

Curitiba's last remaining **train** line to Paranaguá leaves from this location.

BY CAR Curitiba is 411km (255 miles) from São Paulo along highway BR-116, and 648km (402 miles) from Foz do Iguaçu via BR-277.

CITY LAYOUT

A modern city of 1.7 million people, Curitiba lies approximately 100km (60 miles) inland from the coast on a 1,000m-high (3,200-ft.) plateau. The city has a circular layout. Its core is composed of the commercial downtown, the historic center (*centro),* and the Centro Civico, which houses the state government buildings. The newer neighborhoods form a semicircle to the west of downtown. Of most interest to visitors are the residential neighborhoods of **Agua Verde** and **Batel;** immediately southwest of downtown, these areas boast excellent shopping and dining. The city's nicest parks, including Barigui, Tingui, Bosque do Alemao, and Tangua, lie north and northwest of downtown. One outlying neighborhood that is worth visiting is **Santa Felicidade,** Curitiba's Little Italy. Locals come here to dine in the popular all-you-can-eat pasta and chicken restaurants or to visit one of the local wineries.

GETTING AROUND

BY BUS Heralded as an example of public transportation, Curitiba has excellent bus service throughout the city. Most buses will cover one of the two downtown terminals, passing either through Praça Tiradentes or Praça Rui Barbosa. The famous **Rapid Transit** buses (www.onibusdecuritiba.com.br) have their own transit corridor; you enter through the "space capsules." The best option for tourists is the **Linha**

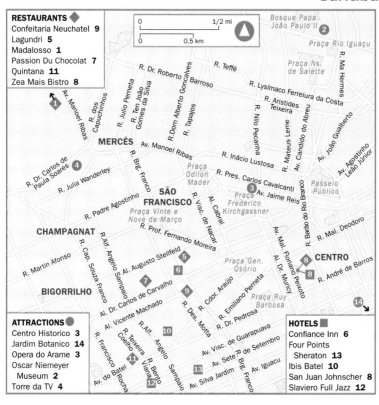

RESTAURANTS ◆
Confeitaria Neuchatel **9**
Lagundri **5**
Madalosso **1**
Passion Du Chocolat **7**
Quintana **11**
Zea Mais Bistro **8**

ATTRACTIONS ●
Centro Historico **3**
Jardim Botanico **14**
Opera do Arame **3**
Oscar Niemeyer
 Museum **2**
Torre da TV **4**

HOTELS ■
Confiance Inn **6**
Four Points
 Sheraton **13**
Ibis Batel **10**
San Juan Johnscher **8**
Slaviero Full Jazz **12**

Turismo (𝄐 **041/3352-8000;** www.viaje.curitiba.pr.gov.br) sightseeing bus, which does a regular loop, covering 25 attractions across the city.

BY TAXI Taxi *pontos* (stands) are found throughout the city or you can flag a taxi on the street. Curitiba is small enough that most taxi rides cost less than R$25; especially in the evening, this is a convenient way to get around. **Radio Taxi Cidade** (𝄐 **0800/41-1411** or 041/3333-3333) has cabs available 24/7.

BY CAR In the city a car is not required; downtown attractions are accessible on foot and the tourist bus covers all outlying sights efficiently. The main side trip from Curitiba is the train ride through the Serra do Mar; to cover the same route by car would take all the fun out of it.

VISITOR INFORMATION

The **Curitiba Municipal Tourism Office** (𝄐 **041/3552-8000;** www.turismo. curitiba.pr.gov.br) offers excellent visitor information services. You will find their booth at the airport (arrivals hall; open daily 7am–7pm), at the Rodoferroviária bus/ train station (daily 9am–6pm), and in the historic downtown at Praça do Garibaldi 7.

[FastFACTS] CURITIBA

Banks & Currency Exchange **Banco do Brasil,** Praça Tiradentes 410 ((C) **041/ 3321-2000**), has a 24-hour ATM. You will also find a variety of ATMs in every mall. **Action Cambio,** Avenida Marechal Deodoro 500, Centro ((C) **041/4002-1010**), exchanges foreign currency.

Car Rental Prices at **Localiza** ((C) **0800/979-2000**), **Avis** ((C) **0800/725-2847**), **Unidas** ((C) **0800/121-121**), and **Hertz** ((C) **0800/701-7300**) are similar: about R$110 for a sub-compact with air-conditioning for a 24-hour day with unlimited mileage, plus R$15 to R$30 for optional insurance. Gasoline is extra.

Hospital In an emergency, go to **Hospital De Clinicas,** Rua General Carneiro 181, Centro ((C) **041/3360-1800**).

Pharmacy **Drogaria Nissei,** Av. Batel 1514, Centro ((C) **041/3215-9139**), will deliver to your hotel and has a large network across the city.

Weather Curitiba has a subtropical climate with regular rainfall year-round. Summertime temperatures rarely exceed 30°C (86°F); however, winter months are quite cool. The average daytime temperature lies around 13°C (55°F), but temperatures just above the freezing point are relatively common. Snow is rare; count yourself lucky if you happen to experience this! The heaviest rain falls between November and March.

Where to Stay in Curitiba

Curitiba has modern accommodations, mostly high-rise buildings, with amenities geared toward business travelers. Prices tend to be more affordable than in other large Brazilian cities; save even more money by planning your stay for weekends or during Brazilian holidays.

CENTRO

Downtown Curitiba offers quality hotels within walking distance of many attractions, including the historic downtown. Unlike many other Brazilian cities, the center of Curitiba is quite safe and pleasant at night and on weekends.

Expensive

San Juan Johnscher ★★ 🏠 This is the closest you will come to a hip boutique-style hotel in Curitiba. Built in 1917, the city's oldest still functioning hotel received a complete overhaul in 2008. Each of the 24 rooms is nicely appointed with a king-size bed, embroidered duvets, and modern amenities, including high-speed Internet, a flatscreen TV, and modern bathroom fixtures. The lobby features a beautiful lounge with a fireplace and the adjacent Zea Mais restaurant is one of the best in town.

Rua Barão do Rio Branco 354, Centro, Curitiba, 80010-180 PR. www.sanjuanhoteis.com.br. (C) **0800/41-5505** or 041/3302-9600. 24 units. R$245–R$320 double. In low season 20% discount. Children 5 and under stay free in parent's room. AE, DC, MC, V. No parking. **Amenities:** Restaurant, Zea Maïs (see review, p. 434); exercise room. *In room:* A/C, TV, hair dryer, minibar; Wi-Fi.

Moderate

Confiance Inn 🔑 This modern hotel, which is only a few years old, offers the best value for money in downtown Curitiba. Rooms feature comfortable box spring mattresses with pillow tops, LCD TVs, and trendy black-and-white color schemes. The rooms with two twin beds are a tad on the small size, so you may want to reserve a double or queen-size bed. The suites are even more spacious and feature a Jacuzzi tub for only an additional R$80 to R$100. The hotel is within walking distance of the downtown attractions.

Al. Dr. Carlos de Carvalho 795, Centro, Curitiba, 80430-180 PR. www.hotelconfiance.com.br. ℰ **041/3233-6666.** 42 units. R$170–R$210 double; R$260 suite. Children 6 and under stay free in parent's room. DC, MC, V. Paid parking. **Amenities:** Restaurant; bar. *In room:* A/C, TV, minibar, Wi-Fi.

BATEL

Just outside of downtown, Batel is the city's prime entertainment district with outstanding shopping and dining.

Very Expensive

Four Points Sheraton ★★ If only the best hotel in town will do, the Sheraton is the place to be. Curitiba's top hotel is geared toward high-end business travelers, but all visitors will like the modern rooms with new furniture, comfortable king-size beds, fine linens, large desks with ergonomic chairs, fast Internet, and little extras like a welcome drink. An added bonus is the large heated indoor swimming pool and fitness room. The hotel is also one of the best options for travelers with limited mobility. Check the website for special discounts on weekends and Brazilian holidays.

Av. Sete de Setembro 4211, Agua Verde, Curitiba, 80250-210 PR. www.starwoodhotels.com. ℰ **0800/55-5855** or 041/3340-4000. 165 units. R$350–R$475 double. Check the website for weekend specials. Children 10 and under stay free in parent's room. AE, DC, MC, V. Paid parking. **Amenities:** Restaurant; bar; fitness room; heated indoor pool. *In room:* A/C, TV, hair dryer, high-speed Internet (free), minibar, Wi-Fi.

Expensive

Slaviero Full Jazz ★★ Jazz up your stay at this comfortable and surprisingly affordable hotel in the heart of Curitiba's entertainment district. Piped-in jazz music, pictures of Jazz legends, a jazz bar, and a DVD library with more than 200 jazz-related movie titles lend a nice touch, but more important is that the rooms are excellent. Even the most basic rooms are quite spacious and feature firm king-size beds, spotless bathrooms, and stylish chic furniture. The corner rooms are more expensive, but get you almost twice the size. Although the windows are double-paned, light sleepers may prefer to request a room away from the street.

Rua Silveira Peixoto 1297, Batel, 80240-120 PR. http://www.slavierohoteis.com.br. ℰ **0800/704-3311** or 041/3312-7000. 84 units. R$250–R$260 deluxe double; R$280–R$450 deluxe corner double. Check the website for weekend specials. Children 10 and under stay free in parent's room. AE, DC, MC, V. Paid parking. **Amenities:** Restaurant; bar; small fitness room. *In room:* A/C, TV/DVD, hair dryer, minibar, Wi-Fi.

Moderate

Ibis Batel ♨ Spend your money going out, instead of sleeping in. The 5-year-old Ibis Batel offers affordable basic accommodations in the heart of Curitiba's entertainment district, right across from the Crystal Shopping Center. The hotel offers no laundry facilities or room service, and you pay extra for amenities such as Internet (R$12 per day) and breakfast (R$13), but every room is spotless and furnished with a comfortable bed, a desk, and a functional modern bathroom. The modern hotel also offers rooms for travelers with disabilities, including for the hearing impaired.

Rua Com. Araujo 730, Batel, Curitiba, 80420-000 PR. www.accorhotels.com. ℰ **041/2102-2000.** 150 units. R$159 double. AE, DC, MC, V. Paid parking. **Amenities:** Restaurant; smoke-free rooms. *In room:* A/C, TV, fridge, hair dryer, minibar, Wi-Fi (R$12 per day).

Where to Eat in Curitiba

Curitiba is known for its excellent restaurants and prices are surprisingly affordable. For a fun dining experience, visit a traditional Italian family–style restaurant in Santa Felicidade, Curitiba's Little Italy, such as Madalosso (see below), or visit a local

winery, such as **Vinicola Durigan,** Av. Manoel Ribas, 6169 (© **041/3272-6242;** open daily 8am–6pm).

EXPENSIVE

Lagundri ASIAN The warm and intimate decor of this Asian restaurant is the perfect setting for a culinary tour of Southeast Asia. Start off with an order of grilled chicken satay or a bowl of spicy Thai soup. For your main course, head over to Indonesia and order the popular *nasi goreng* (fried rice), or the delicious *gado gado* (salad with peanut sauce). You will also find staples such as pad Thai noodles or red or green curries with chicken or prawns. Cool your lips with a refreshing Lagundri lemonade, made with fresh fruit juice, soda, and a splash of ginger.

Rua Saldanha marinho 1061, Centro. © **041/3232-7758.** www.lagundri.com.br. Main courses R$42–R$58. AE, DC, MC, V. Mon–Fri noon–2:30pm and 7–11:30pm; Sat 7–11:30pm.

Zea Maïs ★★ BISTRO Enjoy Curitiba's best contemporary cuisine in this elegant bistro, adjacent to the Johnscher hotel. The chef loves to combine different textures and flavors, such as a baked pear appetizer served with creamy Camembert and crunchy pecans, or the fresh tuna tartare with a zingy ginger sorbet. One of the signature mains is the grilled tenderloin with a balsamic vinegar glaze, served on a bed of Parmesan polenta. Also delicious is the grilled tuna with foie gras, green beans, and marinated tomatoes. For the full experience, order the tasting menu composed of three appetizers, two mains, and a dessert for R$120. The wine list includes various South American reds under R$70.

Rua Barão do Rio Branco 354, Centro. © **041/3232-3988.** www.zeamais.com.br. Main courses R$42–R$56. AE, DC, MC, V. Mon–Sat 8pm–midnight.

MODERATE

Confeitaria Neuchatel DESSERT The European tradition of afternoon tea has evolved into a local tradition of pure gluttony at Confeitaria Neuchatel's Colonial Tea. Several tables are stacked high with sweets, desserts, pastries, cakes, sandwiches, quiches, and other savory finger foods.

Av. Vicente Machado 643, Batel. © **041/3223-2995.** www.neuchatel.com.br. R$25 all you can eat or R$4.75 per 100 grams. MC, V. Daily 8:30am–9:30pm; afternoon tea served from 3:30–9:30pm.

Madalosso ☺ ITALIAN Fine dining it ain't, but lunch or dinner at Brazil's largest restaurant is a popular Curitiba tradition and a fun experience. The enormous dining room seats over 4,500 people and up to 160 waiters are on hand to dish out an endless stream of salads, pasta dishes, risotto, fried chicken, and polenta. The all-you-can-eat feast attracts both locals and tourists.

Av. Manoel Ribas 5875, Santa Felicidade. © **041/3372-2121.** www.madalosso.com.br. R$29 per person, drinks and dessert not included. MC, V. Mon–Sat 11:30am–3pm and 7–11pm; Sun 11:30am–3:30pm.

Quintana INTERNATIONAL Only open for lunch, Quintana serves a fast and delicious buffet of salads and hot dishes. Serve yourself and weigh your plate before sitting down. Each day highlights a different region, such as Asia, Brazil, the Mediterranean, or Northern Europe. On warm days, grab a table on the pleasant patio of this beautiful heritage house.

Av. do Batel 1440, Batel. © **041/3078-6044.** http://quintanacafe.com.br. R$44 per kilo. AE, DC, MC, V. Mon–Fri 11:30am–2:30pm; Sat–Sun 11:30am–3:30pm.

Start celebrating Oktoberfest early with a pint of German beer and an order of sausages or grab a coffee with *apfelstrudel* (warm apple in a puff pastry) at **Schwarz-** **wald Bar do Alemão,** Rua Claudino dos Santos 63 (℗ **041/3223-2585;** daily 11am–2am), a local fixture just up the street from the Praça Garibaldi.

INEXPENSIVE

Passion du Chocolat ★ DESSERT Curitiba's cool fall and winter climate is perfect for sampling a hot chocolate or coffee with a rich dessert. Try a macaroon, madeleine, cupcake, or éclair. The chocolate bars make great gifts for friends and family back home—or at least that is what I tell myself whenever I stock up.

Alameda Presidente Taurnay 543, Batel. ℗ **041/3022-7603.** www.passionduchocolat.com.br. Everything under R$15. Mon–Sat 10am–7pm.

Exploring Curitiba

Curitiba is a compact city with a circular layout. Its downtown attractions are easily visited on foot. The downtown commercial heart of the city lies around **Rua XV de Novembro** and the pedestrian-only **Rua das Flores.** There are few landmarks, but the car-free shopping zone with its many cafes and bars has a great lively atmosphere. Just beyond the **Praça Tiradentes** lies the well-preserved historic center of Curitiba, a lovely collection of 19th-century buildings (see below). The other neighborhoods of Curitiba fan out from the center core and are a short taxi or bus ride away. The **Linha Turismo** tourist bus (p. 436) provides convenient and affordable access to all attractions.

TOP ATTRACTIONS

Centro Historico ★★★ Start your tour of historic Curitiba at the **Largo da Ordem,** a pleasant square dominated by the 18th-century church **Igreja da Ordem Terceira de São Francisco das Chagas.** Founded in 1737, this lovely Portuguese church is one of the oldest buildings in the city; observe the beautiful blue and white tiles inside. Sunday morning Mass is still held in Latin. Just a block up the street, the Largo meets up with the **Praça Garibaldi** and the city's landmark **Flower Clock (Relogio das Flores),** a sundial made of plants and flowers. Many of the 19th-century mansions flanking the square have been converted into cultural centers, like the **Palacete Wolf,** Praça Garibaldi 7 (℗ **041/3321-3205**), and the **Solar do Rosario,** Rua Duque de Caixas 4 (℗ **041/3225-6232**); the latter also features art exhibits and gardens that are open to the public. The next square over is **Praça João Candido,** home to the **Museu Paranense,** Rua Kellers 289 (℗ **041/3304-3300;** open Tues–Fri 9am–5pm and Sat–Sun 11am–3pm). Housed in an elegant 1928 mansion, this museum gives an overview of the history of Paraná.

Every Sunday between 10am and 2pm, these three squares are packed with the excellent **Feira de Artesanato** (crafts fair), where you can shop for local handicrafts and taste typical local cuisine.

Curitiba-Moretes Train Ride ★★★ The railway between Curitiba and the coast was inaugurated in 1885 to transport agricultural products to the coast. It was

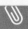

Linha Turismo: The Best Way to Sightsee

The most convenient way to visit the city's main attractions is by bus. The Linha Turismo (📞 **041/3352-8000;** www.viaje.curitiba.pr.gov.br) sightseeing bus departs every 30 minutes between 9:30am and 5:30pm and makes 25 stops, including at the Botanical Garden, the Niemeyer Museum, Bosque Alemão, Tingui Park, and the TV Tower. The full loop takes a little over 2 hours. Tickets cost R$20 and allow you to get on and off at four different stops. The first bus departs from the Praça Tiradentes at 9:30am.

quite a feat of engineering; the train line clings to the Serra do Mar mountain range, traversing 13 tunnels and 30 bridges. The views are truly spectacular. On a clear and sunny day it is worth upgrading to the executive class with larger windows. The tour starts with a train ride from Curitiba to Morretes, a small historic town in the Serra do Mar. Here you have time for a traditional *barreado* beef stew lunch and a short sightseeing walk. In the afternoon you return to Curitiba by van, snaking up the narrow, windy Estrada da Graciosa road.

Other options include a visit to the port of Paranaguá, a boat ride to the island of Ilha do Mel, or a rafting or canoe excursion; contact Serra Verde Express (see below) for information.

Serra Verde Express. www.serraverdeexpress.com.br. 📞 **041/3888-3488.** Daily departures at 8:15am. Train ticket: R$39 (second class), R$66 (tourist class), R$96 (executive class). Return via train (R$39–R$64) or van (R$35). A full-day tour, including transportation and guide, costs R$195–R$299 for adults, R$99–R$210 for children ages 6–12, and R$53–R$90 for children ages 4–5 (exact price depends on train class chosen).

Jardim Botanico ★★★
The Botanical Garden is one of Curitiba's loveliest parks (for more parks, see p. 437). Admire the impressive candelabra-shaped Araucária pine trees, the official state tree. The Art Nouveau greenhouse, inspired by London's 19th-century Crystal Palace, houses a large display of Atlantic rainforest flora. Allow 1 hour.

Rua Ostoja Roguski s/n. 📞 **041/3264-6994.** www.curitiba-parana.net/parques/jardim-botanico. htm. Free admission. Daily 6am–8pm.

Opera do Arame ★★★
The "Wire Opera" is an impressive structure of tubular steel with a transparent roof. The result is surprisingly elegant, especially at night, when the venue is all lit up. Set in a former stone quarry amidst a beautiful garden, the theater hosts plays, concerts, and dance performances. Check the newspapers for up-to-date programming.

Rua João Gava s/n. 📞 **041/3355-6071.** www.curitiba-parana.net/parques/jardim-botanico.htm. Free admission. Tues–Sun 8am–10pm.

Oscar Niemeyer Museum ★★★
Designed by Brazil's most famous architect, the Oscar Niemeyer Museum is better known as the "Eye" due to the eye-shaped construction on top of a freestanding pillar. The space is actually one of Niemeyer's better buildings, both impressive and pleasant on the inside and the outside. The museum houses regular contemporary art and photography exhibits, as well as a small permanent exhibit on Niemeyer's work.

Rua Mal. Hermes 999, Centro Civico. 📞 **041/3350-4400.** www.museuoscarniemeyer.org.br. Admission R$4. Tues–Sun 10am–5:30pm.

Torre da TV ★★★ The best view in town is from the top of the 110m-high (360-ft.) TV tower. On clear days you can see all the way to the Serra do Mar mountain range.
Rua Prof. Lycio Grein de Castro Vellozo 191, Mercês. ℭ **041/3339-7613.** Admission R$3. Tues–Sun 10am–7pm.

Shopping in Curitiba

In addition to the pedestrian-only shopping area around **Rua XV Novembro** and **Rua das Flores** in downtown Curitiba, there are a few very pleasant malls. One of my favorite ones close to downtown is the **Shopping Estação,** Av. 7 de Setembro 2775, housed in an old railway station. Batel's upscale entertainment district boasts several malls, including the new **Shopping Crystal,** Rua Comendador Araujo 731, and **Shopping Curitiba,** Rua Brigadeiro Franco 2300, housed in a lovely 19th-century building. Both are perfect for a rainy day power-shopping session. For a more old-fashioned (and infinitely more affordable) spree, visit the local fruit and vegetable market at the **Mercado Municipal,** Av. 7 de Setembro 1865; it's open Sunday and Monday from 7am to 1pm, and Tuesday to Saturday from 7am to 6pm. Browse the local produce and taste the region's traditional *pinhão* (pine nuts).

Curitiba After Dark

You will find the greatest variety of nightlife in Curitiba's popular entertainment district of Batel. Bars and clubs cluster near the Praça da Espanha, around Rua Col.

CURITIBA'S parks

Curitiba is justly famous for its many lovely parks. In addition to the **Botanical Garden** (see above), there are several other pleasant green areas. **Bosque do Papa João Paulo II,** Rua Wellington Oliveira Vianna, Centro Civico (ℭ **041/3313-7194;** open Mon 1–6pm, Tues–Sun 9am–6pm), is located right next to the Oscar Niemeyer Museum and was inaugurated in honor of Pope John Paul's visit to the city in 1980. In addition to walking trails and cycle paths, it also houses the Memorial to Polish Immigration, with a small collection of Polish artifacts. **Tingue Park,** Av. Fredolin Wolf, Pilarzinho (ℭ **041/3240-1103;** open Tues–Sun 10am–6pm), boasts the Ukrainian Memorial, a small outdoor museum with a replica of an Orthodox church, and a craft store. **Bosque Alemão** (German Forest), Rua Niccolo Paganini or Rua Franscico Schaffer (ℭ **041/3338-6022**), is another tribute to the city's immigrant population. It features a

concert hall, a lookout, and a Brothers Grimm walking trail. The **Universidade Livre do Meio Ambiente** (Free University of the Environment), Rua Victor Benato 210, Pilarzinho (ℭ **041/3254-5548;** www.unilivre.org.br; open daily), features a lovely park with walking trails and an award-winning eco-friendly building that hosts exhibits and special events to promote environmental awareness. **Barigui** park is popular among locals for a jog, walk, or picnic. Lovers of antique cars will enjoy the **Museu do Automovel,** Av. Candido Hartmann 2300, Santo Inacio (ℭ **041/3335-1440;** www.museuautomovel.com.br; open Tues–Fri 2–5:30pm and Sat–Sun 10am–noon and 2–6pm; admission R$5), a small automobile museum with over 50 well-preserved vehicles, including a 1919 Ford T and a classic 1970s Cadillac.

Tip: All of these parks are on the Linha Turismo bus route.

Dulcidio, and along nearby Rua Bispo Dom José. Close to the Praça da Espanha, **Bar Curityba,** Alameda Presidente Taunay 444, Batel (✆ **041/3018-0444**), features live samba music from Tuesday to Saturday night and on Sunday afternoons. For great beer and live pop and rock, head to Irish bar **Sheridan's Pub,** Rua Bispo Dom José 2315, Batel (✆ **041/3343-7770;** www.sheridansirishpub.com.br); it's open Tuesday to Sunday. There are also numerous casual *boteco* bars downtown and in the Centro Historico, around the Praça Osório. Upscale **Vox Bar,** Rua Barão do Rio Branco 418, Centro (✆ **041/3233-8908;** www.voxbar.com.br), has a cool lounge-like vibe with smooth jazz on Wednesdays and Thursdays; on Fridays and Saturdays it transforms into a hopping dance bar.

FLORIANÓPOLIS

742km (461 miles) SW of Rio de Janeiro, 488km (303 miles) SW of São Paulo

Florianópolis, aka the Island of Santa Catarina, is known throughout Brazil for its miles and miles of gorgeous beaches, excellent seafood (oysters especially), and traditional Azorean fishing villages. Figuring out the names may be the only tricky part of a visit to this most serene of Brazilian beach resorts. Florianópolis, the city, is the capital of the *state* of Santa Catarina. Florianópolis is also located on the *island* of Santa Catarina. Island and city together are usually just referred to as Florianópolis, which people often then shorten to Floripa. Confused? Don't worry, it's the beaches that matter.

The *city* of Florianópolis is small and pleasant but of no real interest except as a jumping-off point to the island's countless beaches.

Brazilians are infatuated with Floripa and flock here en masse in summer. Perhaps Brazilians see in Floripa a model of what their country could be—well organized, well run, calm, efficient, and law abiding. Perhaps in a land with so much tropical exuberance, the opposite becomes exotic. In any case, when Brazilians rave about Florianópolis, they mention the fair-skinned, green-eyed residents, the affluent communities, the quaint Portuguese fishing villages, the pristine and unpolluted beaches.

There is more than enough variety on the island to customize a visit according to your interests. The northeastern part of the island is an urbanized, heavily visited beach scene, particularly in the high summer months of December, January, and February. Farther south in the center of the island there's the Lagoa da Conceição, a large partly salty lagoon partially surrounded by tall sand dunes. Nearby, the small quiet community of Lagoa da Conceição has some of the best restaurants in the region. Just to the east are the beaches of Galheta, Mole, and Joaquina—beautiful, wide, sandy beaches surrounded by lush green hills and blessed with large, surfable waves. Farther south toward Campeche, the beaches become more rugged and almost deserted. Even in the summer you won't find large crowds here. Finally, over to the west side of the island facing the mainland, you will find the quaint Azorean fishing village of Riberão da Ilha, accessible only via a gorgeous, narrow, winding, seaside road offering views of the Baia Sul and the lush hills of the mainland across the bay.

Essentials

GETTING THERE
BY PLANE TAM (✆ **048/4002-5700;** www.tam.com.br) and **Gol** (✆ **0300/115-2121;** www.voegol.com.br) both have daily flights to Florianópolis from all major

Florianópolis

HOTELS ■
Ingleses Praia Hotel **2**
Pousada das
 Palmeiras **6**
Pousada da Vigia **1**
Pousada Penareia **14**
Pousada Vila Tamarindo
 Eco Lodge **12**
Praia Mole Eco Village **4**
Quinta das Videiras **10**

RESTAURANTS ◆
Bar do Arante **15**
Bistrô D'Acampora **3**
Bistro Isadora Duncan **9**
Mar Massas **8**
Ostradamus **13**
Patagonia **11**
Pizzaria Basilico **5**
Villa Magionne **7**

Praia
Lagoinha
Praia Ponta
das Canas
Praia Cachoeira
do Bom Jesus
Praia Canasvieiras
Praia do
Forte
Praia Jurerê
Praia
Daniela
Praia
Brava
Praia
Ingleses
Praia
Sambaqui
Praia
Sto. António
de Lisboa
Praia
Cacupé
Praia
Moçambique

*Baía
Norte*

FLORIANÓPOLIS

**SÃO
JOSÉ**

CATARINA

SANTA

Lagoa da Conceição

Praia
Barra da
Lagoa
**BARRA
DA LAGOA**

Praia
Mole

**CANTO
DA LAGOA**

Praia
Joaquina

*ATLANTIC
OCEAN*

*Baía
Sul*

**Aeroporto
Hercílio Luz**

Praia
Campeche

*Ilha do
Campeche*

ILHA

DE

Lagoa do Peri

Praia
Ribeirão
da Ilha

Praia Morro
das Pedras

Praia
Armação

Praia
Matadeiro

Praia
Tapera

Praia
Caieira da
Barra do Sul

Praia Pântano do Sul
Praia Solidão

Praia
Saquinho

Praia
Lagoinha
do Leste

Praia
Naufragados

K Beach
262 Federal Road
339 State Road

0 — 3 mi
0 — 3 km

*ATLANTIC
OCEAN*
Manaus
Belém
Amazon
Natal
B R A Z I L
Recife
Brasília ⊛
Salvador
São Paulo
**Rio de
Janeiro**
Florianópolis
500 mi
500 km

15

THE SOUTH OF BRAZIL | Florianópolis

To make the most of your visit you really need a car, allowing you to explore the more remote beaches and towns at your own pace. Floripa's roads are in great shape, speed limits and regulations are strictly obeyed, the island is easy to navigate, and you can safely park almost anywhere. Just remove all valuables from the vehicle when parking. See car-rental information in "Fast Facts: Florianópolis," below.

cities in Brazil. All flights arrive at **Aeroporto Hercílio Luz** (📞 048/3331-4000). Taxis from the airport to the northern beaches (Praia dos Ingleses) cost R$60 to R$70; to the southern part of the island (Campeche or Lagoa de Conceição, R$50; and to downtown, R$25.

BY BUS Long-distance buses arrive at the **Rodoviaria Rita Maria,** Av. Paulo Fontes s/n (📞 048/3212-3100). **Auto Viação 1001** (📞 021/4004-5001; www.autoviacao1001.com.br) offers daily departures to São Paulo for R$75 to R$115; the trip takes about 10 hours.

CITY/ISLAND LAYOUT

The city of Florianópolis straddles the narrow part of the straight about halfway down the island and is connected to the mainland by two bridges. The oft-photographed, scenic **Hercílio Luz suspension bridge** is currently closed for renovations. The historic downtown sits just a hop and a skip from the small but efficient Rita Maria bus station, the departure and arrival point for all long-distance buses. If you want to do a bit of shopping, just follow the elevated walkway across the main road for a short walk to the Praça XV, one of the city's main squares. The **Rua Felipe Schmit** and the **Rua Cons. Mafra** and its cross streets around the Praça XV are closed to traffic and packed with stores. A bustling indoor market is located at **Av. Paulo Fontees s/n,** almost on the corner of the **Praça Fernando Machado.**

The island itself is long and thin (approx. 70km/43 miles from north to south) and features a number of distinct regions. The most urbanized beaches are those near the northern tip of the island; **Praia dos Ingleses, Canasvieiras,** and **Jurerê** are popular and busy beach destinations in the summer. Farther south, facing the open Atlantic on the east side of the island, are the much less developed beaches of **Praia Mole** and **Joaquina,** and the clothing-optional **Galheta beach.** All are popular with locals on the weekends. The **Lagoa da Conceição** forms the center of the island. This large lagoon is the year-round nightlife and dining hub, attracting both locals and visitors. The southern part of the island is divided into two regions, the beaches (on the east side, facing the ocean) and **Riberão da Ilha** (on the west side, opposite the mainland). The ocean-facing beaches such as **Campeche** and **Armação** are mostly undeveloped, and even in the peak of the tourist season (Dec–Feb) it's easy to find a near-deserted stretch of sand. Farther south toward the tip of the island, the beaches of **Lagoinha do Leste** and **Naufragados** are only accessible by a short hike. Facing the mainland, **Riberão da Ilha** features Portuguese (actually Açorean [fishermen from the Azores]) settlements that have been beautifully preserved.

Access to the various parts is by well-paved state highways. From downtown Florianópolis there are three main roads: The **SC-401** goes north to the beaches of **Ingleses** and **Canasvieiras.** The **SC-404** cuts across the center of the island to the

restaurant and nightlife area of Lagoa. The **SC-405** dips south toward **Ribeirão da Ilha.** A fourth highway, the **SC-406,** runs along the eastern side of the island, connecting to the SC-405 in the south and the SC-401 near the northern beaches.

GETTING AROUND

BY BUS Local bus service on the island is slow and infrequent. In Florianópolis a vehicle is strongly recommended.

BY TAXI Taxis are easily found in the city or at the airport, and hard to find elsewhere. To call a cab from anywhere on the island dial © **197,** or call © **048/3240-6009.** Taxi fares add up; a one-way ride from Campeche to the bus station costs R$50. After two or three rides it's better to rent a car.

VISITOR INFORMATION

The state tourism board has an English-language website at www.santacatarina turismo.com.br. The **main tourist information center** is in downtown Florianópolis, Praça XV de Novembro s/n, Centro (© **048/3244-5822**), open Monday to Friday, 8am to 6pm.

[FastFACTS] FLORIANÓPOLIS

Banks **Banco do Brasil,** Praça XV de Novembro 321 (© **048/3216-6500**), is open Monday through Friday, 10am to 4pm, and has a 24-hour ATM. The **HSBC** is located on Rua Felipe Schmidt 376, Centro (© **048/3221-9000**).

Car Rental Daily rental charges with unlimited mileage start at R$90 for a Fiat Palio (the smallest two-door Fiat) without air-conditioning. Insurance costs R$30 per day. Off-season discounts can cut the costs by 40% to 50%. Agencies at the airport include **Hertz** (© **048/3236-1654**), **Unidas** (© **0800/121-121**), and **Localiza** (© **0800/979-2000**); **Le Mans** (© **048/3222-9999**) will deliver and pick up from anywhere, including the airport and bus station.

Hospital **Hospital Governador Celso Ramos,** Rua Irmã Benvarda s/n, Centro (© **048/3251-7000**), is the main hospital in Floripa.

Weather Florianópolis has a temperate climate; summers (Nov–Mar) are hot and sunny but fall and winter (May–Sept) can be downright chilly, with temperatures falling below 10°C (50°F).

Where to Stay in Florianópolis

The island offers great variety, everything from small pousadas to five-star resorts and high-rise hotels. The northern part of the island is very busy and urban in the high summer season. Out of season, restaurants and shops close and the area feels a touch dreary. Halfway down the east coast of the island, Praia Mole offers excellent accommodations in one of the nicest beach areas, only a short drive from Lagoa's restaurants and nightlife options. In the south, Campeche offers quiet accommodations on a beach that is often deserted and great for long walks. Note that the rates listed do not cover holidays such as New Year's, Carnaval, and Easter, when hotels and pousadas sell packages at a hefty markup, usually with a minimum stay of 3 nights.

NORTH ISLAND

Ingleses Praia Hotel ★ ☺ Right on the beach, the Ingleses Praia Hotel offers a large outdoor pool and playground, making it perfect for kids. Deluxe rooms feature

at least a partial ocean view, while the super-deluxe rooms and suites offer a full ocean view. The super-deluxe units are the best value: for a little extra (R$25 or so) you get a flat with a full kitchen and small den that can accommodate four people comfortably. The hotel is within walking distance of restaurants and shops in Praia dos Ingleses. Check the website for packages in the low season: a 3-night stay can cost as little as R$125 per night.

Rua Dom João Becker 447, Praia dos Ingleses, Florianópolis, 88058-600 SC. www.inglesespraia. com.br. ✆/fax **048/3261-3300.** 110 units. Apr–Nov R$250 double deluxe or super deluxe, R$665 suite; Dec–Mar R$485 deluxe or super deluxe, R$1,250 suite. Extra person R$90. Children 5 and under stay free in parent's room. AE, DC, MC, V. Free parking. **Amenities:** Restaurant; bar; exercise room; Jacuzzi; 2 pools (indoor and outdoor); room service. *In room:* A/C, TV, Internet, minibar.

Pousada da Vigia ★★ Literally on the northern tip of the island, this lovely pousada has one of the finest beach views around. The rooms are beautifully appointed (though a tad on the small side) and the pousada offers top-notch amenities such as a heated indoor pool, beach service, sitting room with home theater, and spa treatments. The two best rooms are suite nos. 9 and 10. These feature a master bedroom with king-size bed, a deluxe bathroom with jetted tub for two, a living room with home theater and DVD, and a spacious deck with sauna, barbecue, and outdoor Jacuzzi. To reach the pousada from the airport, take the SC-401 to Canasvieiras, then follow the signs to Lagoinha. The pousada also offers a transfer service if contacted ahead of time.

Rua Con. Walmor Castro 291, Lagoinha, Florianópolis, 88056-770 SC. www.pousadavigia.com.br ✆ **048/3284-1789.** Fax 048/3284-1108. 10 units. Mar–Oct R$280–R$460 double, R$680 luxo suite; Nov–Feb R$300–R$560 double, R$830 luxo suite. Children 2 and under stay free in parent's room. AE, DC, MC, V. Free parking. **Amenities:** Restaurant; bar; exercise room; Jacuzzi; small indoor heated pool; room service. *In room:* A/C, TV, Internet, minibar.

MID-ISLAND

Pousada das Palmeiras ★ More Bali than Florianópolis, the Palmeiras offers high-end accommodations in a lush tropical setting. Just a few minutes from the main village, the location is ideal for those who like to go out at night. The six units are all beautiful split-level cabanas with verandas set in a lovely garden. All come with fully equipped kitchens, high ceilings, king-size beds, DVD players, and views of the lagoon and gardens. All are charmingly furnished with lots of wood and bamboo, bright colors, and interesting artwork.

Rua Laurindo da Silveira 2720, Canto da Lagoa, Florianópolis, 88056-770 SC. www.pousadadas palmeiras.com.br. ✆ **048/3232-6267** or 9962-2900. 6 units. Mar–Nov R$380–R$420 double; Dec–Feb R$545–R$580 double. Extra person add R$90–R$125. Children 2 and under stay free in parent's room. AE, DC, MC, V. Free parking. *In room:* A/C, fan, TV/DVD, Internet, kitchen, no phone.

Praia Mole Eco Village ★★ ☺ Set astride a piece of land between Praia Mole and the lagoon, this large hotel features beautiful trees and lush gardens with tennis courts, a soccer field, and an orchid park. Rooms are spread out over several buildings. The smallest building, overlooking the beach, has the feel of a small European seaside hotel. When reserving a room, make sure to request a *frente mar* to get the best ocean view. The central building sits in the middle of the property, close to the swimming pool and leisure area. The third large building, the Solar, sits closer to the lagoon. Finally, for those who want a bit more privacy and space, there are 18 bungalows, with one or two bedrooms and views of the garden and lagoon.

Estrada Geral da Barra da Lagoa 2001, Florianópolis, 88062-970 SC. www.praiamole.com.br. ✆ **048/3239-7500.** Fax 048/3232-5482. 98 units. May–Nov R$150–R$216 standard or lagoon-view

double, R$250 oceanview or bungalow double; Dec–Apr R$290–R$400 standard or lagoon-view double, R$480 oceanview or bungalow double. Extra person add R$75. Children 5 and under stay free in parent's room. AE, DC, MC, V. Free parking. **Amenities:** Restaurant; bar; exercise room; Jacuzzi; large indoor heated pool; room service; tennis courts; watersports. *In room:* A/C, TV, hair dryer, Internet, minibar.

Quinta das Videiras ★★ The perfect spot for a romantic getaway, the newest boutique hotel in Florianópolis offers high-end comforts and colonial charm, in a quiet spot in the restaurant hub of Lagoa. All rooms offer high ceilings, parquet floors, top-quality bed linen, and a decor of colonial-era antiques, all carefully selected, catalogued, and arranged by the hotel owner. Luxo rooms have double beds, while plus and premium rooms offer queen-size beds and a bit more space. The master suite has a king-size four-poster bed plus an *ofuro* (a wooden Japanese tub). A full breakfast is served in the room, or in an outdoor solarium by the pool.

Rua Alfonso Luis Borba 113, Lagoa da Conceição, Florianópolis, 88062-040 SC. www.quinta dasvideiras.com.br. ⓒ **048/3232-3005.** 10 units. R$550–R$730 luxo double; R$980 master suite (on holidays 4-night minimum). AE, DC, MC, V. Free parking. **Amenities:** Small outdoor pool; small spa. *In room:* A/C, TV/DVD, free Wi-Fi.

SOUTH ISLAND

Pousada Penareia ★★ In a beautiful spot overlooking Armação Beach, this pousada is perfect for active, adult travelers. The owners are happy to lend you an inflatable kayak, soccer ball, or bike, or provide you with hiking tips. Inside, all rooms are bright and spacious; the beds are very comfortable, and even the standard rooms feature a private veranda with a hammock (but no air-conditioning). The special rooms are bigger and come with air-conditioning. The top-level deluxe rooms come with a Jacuzzi, a DVD and CD player, and a large veranda with a barbecue. A few steps down from the pousada is a wonderful deck overlooking the beach—the perfect sunset spot.

Rua Hermes Guedes da Fonseca 207, Praia da Armação, Florianópolis, 88063-000 SC. www. pousadapenareia.com.br. ⓒ **048/3338-1616.** 12 units. Mar–Oct R$160–R$200 standard or special double, R$240 deluxe double; Nov–Feb R$210–R$250 standard or special double, R$290 deluxe double. Extra person add R$40. AE, DC, MC, V. Free parking. No children 11 and under. *In room:* A/C or fan, TV, fridge.

Pousada Vila Tamarindo Eco Lodge ★★ This lovely small pousada is just off Praia do Campeche, one of the nicest beaches on the southern part of the island. Even in high season it's relatively empty. The 13 apartments are pleasantly furnished in bright colors and decorated with local artwork. All have ocean-facing verandas; if you leave your door open you can fall asleep to the sounds of the surf. The first floor "ocean" rooms feature air-conditioning and better ocean views. For families or couples traveling together there are two master suites, which are spacious two-bedroom apartments. **Note:** The region around Campeche is very quiet and a car is required to get around to restaurants and attractions.

Av. Campeche 1836, Praia do Campeche, Florianópolis, 88063-000 SC. www.tamarindo.com.br. ⓒ **048/3237-3464.** Fax 048/3338-2185. 15 units. Mar–Oct R$190 double, R$330 master suite; Nov–Feb R$320 double, R$450 master suite. Extra person add R$50–R$95, depending on the season. Children 8 and under stay free in parent's room. AE, DC, MC, V. Free parking. **Amenities:** Outdoor pool. *In room:* A/C or fan, TV, minibar, no phone.

Where to Eat in Florianópolis

There are two seafood specialties for which Florianópolis is especially well known. The first is *sequencia de camarão* (shrimp in sequence), which consists of a number

of shrimp dishes served one after another. Normally, there's *casquinha de siri* (baked crabmeat), followed by steamed shrimp, breaded shrimp, garlic shrimp, and then a fish filet with shrimp sauce. The other Floripa specialty is the oyster. Most oysters served in Brazil come from the area around Riberão da Ilha. Here at the source they're fresher and cheaper (R$12 a dozen). Always call ahead for opening hours during the low season, as many restaurants adjust their times during the quiet period.

NORTH ISLAND

Bistrô d'Acampora ★★★ FRENCH/ITALIAN This cozy dining room–cum–art gallery makes for an intimate dining experience. The menu varies constantly, but normally includes three salads, five main courses, and three desserts, all made with fresh local ingredients and a mix of French and Italian preparation. Among salads, the mango stuffed with crabmeat on a bed of greens is a longtime favorite. Main courses can be *trés* French, such as the *confit de canard* (duck confit) or a seafood in a bisque sauce served over Moroccan couscous. Desserts include the signature chocolate torte with pecans and *crème anglaise*. The restaurant also has a fantastic wine list with over 400 labels, including everything from outrageous R$1,000 bottles to many affordable options in the R$60-to-R$100 range.

SC 401 to Canasvieiras, Km 10 (Santo Antônio de Lisboa), on the northwest side of the island. ✆ **048/3235-1073.** www.dacampora.com.br. Reservations required. 3-course meal (without wine) approx. R$125. DC, MC, V. Tues–Sat 8pm–midnight.

LAGOA

Bistro Isadora Duncan ★★ BRAZILIAN/SEAFOOD The perfect place for a romantic dinner, this lovely antiques-furnished house offers a tiny handful of tables in a dining room by a fireplace or on a veranda overlooking the lake. The menu is kept fairly small, offering a limited selection of seafood and meat dishes. In the land of the prawn you can't go wrong with the *camarões abençoados* (blessed prawns), served in a creamy Gorgonzola sauce with sautéed potatoes, or the *camarões encantados* (enchanted prawns), prawns flambéed in orange juice, served with wild rice. And if it is a romantic dinner, why not start off with a plate of local oysters au gratin? The wine list offers a few reasonably priced selections from Argentina and Chile.

Rod. Jornalista Manuel de Menezes 2658, Fortaleza da Barra. ✆ **048/3232-7210.** www.bistro isadoraduncan.com.br. Reservations recommended on weekends and in high season. Main courses R$75–R$125. MC, V. Mon–Sat 7pm–midnight.

Mar Massas ★★ ITALIAN/SEAFOOD This cozy Italian cantina sits on a hillside overlooking the southern end of the lagoon. The atmosphere is casual with paper place mats, checkered tablecloths, and chianti bottles for decorations. The menu offers a wonderful range of top-quality seafood pastas such as the *tagliatelle a Don Edson* with prawns, mushrooms, and a mustard-cream sauce, or the *tortelli Alleluia*, stuffed with sweet pumpkin and served with a generous helping of grilled prawns in pesto. Even the *piccolo*-size (small) plates are generous enough to serve two small appetites, especially if you are having an appetizer and dessert.

Rua Laurindo Januário da Silveira 3843, Morro do Badejo, Lagoa. ✆ **048/3232-6109.** Main courses R$75–R$100. DC, MC. Tues–Fri 6pm–midnight; Sat–Sun noon–11:30pm; Jan–Apr also Mon 6pm–midnight.

Patagonia ★★ STEAK Large and succulent cuts of Argentine beef, lovingly prepared, are served in a large sunny room with a view of the lake. The highlight of the menu is the *bife de chorizo,* a thick contra-filet, served with red potatoes sliced

and fried in extra-virgin olive oil. The wine list (surprise) hardly ventures forth from Argentina, leans heavily to reds, and offers both affordable and insanely expensive options. Don't come here if you're in a hurry. Patagonia's steaks take a minimum of 45 minutes to prepare.

Rua Laurindo Januário da Silveira 1233, Lagoa. ℂ **048/3232-5679.** Main courses R$50–R$75. AE, DC, MC, V. Mon–Sat 7pm–midnight; Sun 1–10:30pm.

Pizzaria Basilico ★★ PIZZA The best place on the island for pizza, Basilico serves them in 30 different varieties, all thin-crusted and delicious. Order a large and you can choose three different flavors. The options include the Portuguesa, with ham, slices of boiled egg, and olives; the ricotta, with mozzarella, tomato sauce, fresh ricotta, and slices of tomato; or the spicy Maçarico, with tomato sauce, sausage, hot peppers, and onions. The patio sprawls out in several directions, and a roaring fireplace adds much-needed warmth on chilly evenings.

Rua Laurindo Januário da Silveira 647, Lagoa. ℂ **048/3232-1129.** www.pizzariabasilico.com.br. Main courses R$30–R$60. MC. Daily 7pm–midnight.

Villa Magionne ★★★ MEDITERRANEAN Villa Magionne is in a lovely small house overlooking a garden by the lagoon; you literally dine in the owner's living room. The menu includes salads, pastas, steak, and risottos. Make sure you start with one of the salads; the Moroccan salad is a delicious heap of crunchy lettuce hearts topped with toasted almonds, orange slices, and an orange vinaigrette. For a main course, stick with pasta. All are made from scratch with the freshest ingredients. Our favorite is the *ravioli de anatra,* a freshly made ravioli stuffed with tender duck served in a broth seasoned with mushrooms and cream. Also good is the *tonnarielli al filetto,* pasta served with a generous portion of filet mignon strips flambéed in bourbon. The scrumptious desserts are made in-house. The *torta romeo ande giuliett* is a guava compote twist on the traditional cheesecake.

Rua Canto da Amizade 273, Canto da Lagoa. ℂ **048/3232-6859.** www.restaurantevillamaggioni. com.br. Reservations required. Main courses R$65–R$95. DC, MC. Mon–Fri 7pm–midnight; Sat noon–5pm and 7pm–midnight; Sun noon–5pm. In low season closed Mon–Tues.

SOUTH ISLAND

The southern part of the island, especially around Riberão da Ilha, is thick with oyster farms. Looking out over the water you'll see the white floats that mark the locations of the baskets that contain the various-size oysters. Numerous restaurants in this part of the island serve up fresh oysters.

Bar do Arante ★ SEAFOOD Located smack on the beach in Pantano do Sul, this most authentic of local eateries is known for its seafood buffet, its delicious seafood *pasteis* (try the *pastel de berbigão*—steaming small mollusks wrapped in a pastry shell), and the thousands of messages, notes, and poems festooning the walls and rafters. The note-leaving tradition dates from the '70s, when visiting campers would leave messages for friends on the walls. Inspired by shots of Arante's free homemade *cachaça* (another tradition that continues), the utilitarian "behind dune number 3" note soon morphed into art and poetry. Try a shot yourself, and release the poet inside.

Rua Abelardo Otacilio Gomes 254, Pantano do Sul. ℂ **048/3237-7022.** Reservations not accepted. Main courses R$25–R$90. MC, V. Daily 11:30am–midnight.

Ostradamus ★ SEAFOOD This large waterfront restaurant serves up bivalves in a variety of delicious ways: plain, steamed, grilled and topped with a béchamel

sauce, smoked, or served with garlic and olive oil. All are freshly harvested from the farms just outside the restaurant's door. The menu also offers prawns, squid, clams, and grilled fish. On Thursday night, the kitchen serves up oysters prepared in over 30 different ways—a feast for oyster lovers.

Rodoviaria Baldicero Filomeno 7640, Riberão da Ilha. ℭ **048/3337-5711.** www.ostradamus.com. br. Reservations recommended. Main courses R$55–R$130. DC, MC, V. Tues–Sat noon–11pm; Sun noon–6pm.

Exploring Florianópolis
BEACHES

Florianópolis's main attraction is the more than 100 beaches scattered across the island. Each has its own character. Starting clockwise from the northern part of the island, the most visited beaches are **Daniela ★, Canasvieiras, Jurerê,** and **Praia dos Ingleses.** Daniela, Canasvieiras, and Jurerê lie on the bay side of the island and have pleasant, calm waters with almost no waves. Praia dos Ingleses faces the open ocean and often has rougher surf. Daniela is the quietest of the four. The other three are very urbanized and packed in the summer months when tourists flock here from all over Brazil. Jurerê is popular with Brazilian celebrities, many of whom own houses or condos in the exclusive subdivisions.

The northern part of the island has some places to escape the crowds (relatively speaking). At the very northern tip of the peninsula in between Praia dos Ingleses and Canasvieiras sits **Lagoinha ★★,** a lovely small beach backed by a small fishing village. This is one of the best sunset spots on the island. A short drive south of Ingleses one finds **Praia do Santinho ★,** a small and pretty beach with a large beach resort at one end.

Moving clockwise along the eastern coast of the island you come to **Praia do Moçambique ★,** a vast 19km-long (12-mile) stretch of strand, protected along its entire length by an ecological reserve that forms a construction-free buffer zone of thick vegetation between beach and road. Moçambique is one of the best beaches for those seeking solitude. As it faces the open ocean, the waves are often substantial. It's not a beach for weak swimmers.

Heading south from Praia do Moçambique, you'll come to **Praia Mole ★★★,** the hotshot surf beach at the moment. Largely unspoiled, the beach is framed by green hills and rocky outcrops, and the sand is white and very soft. One of the island's prettiest beaches, **Praia da Galheta ★★★** is only accessible on foot from Praia Mole. Look for the trails through the dunes at the north end of Praia Mole. Note that Praia da Galheta is also the island's clothing-optional beach and a popular gay cruising area. However, the beach is family-friendly and also popular with surfers.

Just south of Praia Mole is **Praia da Joaquina.** To reach this beach you drive past the shifting sand dunes east of the Lagoa. It was once the island's most popular surf beach, but these days Praia Mole seems to get most of the action.

Campeche ★★ is far enough south that even in high season it's not hard to find a quiet spot here. The beach is very wide, but large waves can make it dangerous for swimming. Another favorite surf destination (and a spot where one can often see dolphins) is **Praia da Armação ★,** just south of Campeche.

Following the SC-406 all the way to the end will lead you to **Pântano do Sul,** located on the eastern side of the skinny southern tip of the island. It's one of the main fishing communities on the island and has a busy, bustling atmosphere. However, the boat traffic (and dirty gray sand) make it less than ideal for swimming. However, it is the place to leave your car and set out on a hike.

Another of the island's prettiest beaches, **Lagoinha de Leste ★★★** sits on the outer shore of an environmentally protected headland, accessible only via a 4km (2½-mile) trail from Pântano do Sul. The trail takes about 90 minutes, one-way. The lovely wild beach sits nestled at the bottom of a large hill, with a small river at one end that flows into the ocean.

The **Lagoa da Conceição** sits almost at the center of the island, to the east of the city of Florianópolis and west of Praia Mole. The lagoon is about 30% fresh water. The water temperature is balmy—in the summer it can reach 26°C (80°F). Watersports are allowed on the lagoon, but jet skis have been banned.

SIGHTSEEING

The main square in Florianópolis's city center, **Praça XV,** is a verdant, green space with intriguing mythological figures set into the cobblestones beneath the trees. Look especially for the Bernúncia, a unique bull-alligator hybrid endemic to Santa Catarina mythology. The centerpiece of Praça XV is an enormous fig tree, said to have magical powers. Circling it thrice clockwise is said to bring on matrimony, seven times counterclockwise divorce, and while hanging upside down from its branches is said to be a shortcut to widowhood. Try it and see. Close by, the **Rua Felipe Schmit** and the **Rua Cons. Mafra** and its cross streets are closed to traffic and packed with stores; specialty items include shoes and leather goods such as belts and wallets. Thanks to the cooler climate, the stores stock excellent boots and sweaters that will hold up to Northern Hemisphere falls and winters. Also nearby, the **Public Market,** Av. Paulo Fontes s/n (Mon–Fri 7am–7pm, Sat 7am–1pm), is packed with small stalls offering local arts and crafts and a vast variety of fresh seafood. For a good quick snack, stop by **Box 32 (✆ 048/3224-5588;** www.box32.com.br).

On the northwest coast of the island, the small settlement of **Santo Antônio de Lisboa** is a lovely collection of traditional Azores-style homes, plus some of the best and cheapest oysters on the island. Stop by the **Cantinho das Ostras (✆ 048/3235-2296;** Mon–Fri 8am–6pm) at the south end of the beach to watch as oysters are brought in, cleaned, and shucked. Sample a few fresh and raw (R$5 per dozen) or for just a bit more have them steamed and served with lemon (R$12 per dozen). Delicious.

In the southern part of the island, the western shore facing the mainland lacks beaches entirely, but in compensation offers some fabulous driving and sightseeing. South of the airport, heading down the SC-405 toward **Riberão da Ilha** leads to a small, winding road that hugs the coastline virtually all the way to the southern tip of the island. Don't miss a visit to this part of the island! It's a region of small villages with colorful Portuguese-style houses, settled by fishermen from the Azores. Their descendants still live in this region and make a living fishing or raising oysters. Note that although Riberão da Ilha looks like it's just a short drive away, the road is winding

THE SOUTH OF BRAZIL

Florianópolis

and there are viewpoints and picturesque villages to distract you along the way. Plan to spend at least half a day, with lunch or dinner at a seafood restaurant in Riberão da Ilha.

BOAT TOURS

The traditional schooner trips travel around the western side of the island. **Scunasul Tours** (© 048/3225-1806; www.scunasul.com.br) leaves from downtown Florianópolis, heading underneath the Hercílio Luz suspension bridge to the north bay. The tour visits two beautifully preserved fortresses on small islands. A lunch stop and time for a swim are included in this leisurely day on the water. Another great boat trip is a visit to the **Ilha do Campeche,** located off Praia do Campeche, on the eastern side of the island. The boat leaves from Barra da Lagoa on the east side of the island and cruises south. Once at the island you will have time to hike, swim, or snorkel. Tours cost R$35 to R$40 per person, half price for 6- to 12-year-olds, and free for children 5 and under.

OUTDOOR ACTIVITIES

A vast range of outdoor activities available on the island are coordinated by the tour agency **ViaFloripa** (© 048/3224-4668; www.viafloripa.com). They include: a day in a fisherman's life (R$230, 5 hr.), a boat tour of the east coast beaches (R$350, 6 hr.), snorkeling (R$70, 4 hr.), a 2-day waterfall trekking tour (R$375, incl. hotel), horseback rides on Moçambique beach (R$55 for 2 hr.), bird-watching tours (R$270, 5 hr.), canoe trips on the ocean or Lagoa de Peri (R$140, 3 hr.), sand boarding (R$85, 2 hr.), snorkeling on Ingleses beach (R$60, 1 hr.), surf lessons (R$75, 1½ hr.), rappelling (R$90, 3 hr.), mountain biking (R$85–R$225, 3–5 hr.), and ATV touring (R$180, 1 hr.). All tours include a licensed guide or instructor.

KITE SURFING/WINDSURFING The prime kite-surf and windsurf spot in Florianópolis is the Lagoa da Conceição. Experienced surfers can rent gear from **Open Winds** (© 048/3232-5004; www.openwinds.com.br) starting at R$45 per hour. For beginner kite surfers, a course of six 90-minute lessons costs R$1,200. The lessons can be spread over several days.

SCUBA DIVING Florianópolis is not a diver's paradise, but if you want to check out the waters, **Parcel** (© 048/3284-5564; www.parcel.com.br) offers a number of dive tours depending on the weather and group size. One regular trip heads out to the biological reserve of Arvoredo. A 4-hour tour, including two dives and equipment, costs R$165. In low season, call ahead to book as they may not go out every day.

Florianópolis After Dark

Every summer, bars and clubs come and go in the northern part of the island around **Praia dos Ingleses.** Most of the year-round nightlife options can be found around the **Lagoa da Conceição,** where locals and tourists mingle. To start the evening off with a fabulous view, head up to the Morro da Lagoa da Conceição, just west of the village. Follow the Rodovia Admar Gonzaga up the hill; the road will switch back until you get to the lookout. Just across from the lookout is where you find **Mandalla,** Rod Admar Gonzaga 4720 (© 048/3234-8714). This bar sits high above the road and offers spectacular views of the lagoon and the village below. On most nights, Mandalla has live bands starting at 10pm (closed Mon).

Back down in the village a couple of nightlife options are within an easy stroll of one another. **Drakkar,** Av. Afonso Delambert Neto 607, Lagoa (✆ **048/3232-9516;** www.klounge.com.br), is a happening live-music venue with a varied program. Open as early as 6pm, it's perfect for an early-evening cocktail. The live music usually doesn't get started until 10pm. Downtown is where you'll find popular **Bianco Lounge** (✆ **048/3209-3777;** www.biancolounge.com.br), a trendy restaurant and ultraminimalist lounge, with fancy cocktails and a low-key DJ. Also downtown you'll find the **Scuna,** Avenida Beira Mar (underneath the bridge; ✆ **048/3225-3138;** www.scunabar.com.br), which features a menu of live music, snacks, and booze 3 nights a week (Tues, Fri, Sat) starting at 10pm. The best features of the Scuna are the two large patios overlooking the city's waterfront.

PORTO ALEGRE

714km (441 miles) SW of Curitiba, 1,122km (697 miles) SW of São Paulo, 941km (584 miles) SE of Foz do Iguaçu, 1,300km (807 miles) N of Buenos Aires, Argentina

The capital of Rio Grande do Sul, Brazil's most southern state, Porto Alegre is home to 1.4 million people and is the fourth largest metropolitan area in the country. The city was founded in 1772 as an army garrison to discourage Spanish claims on the region, and populated largely by Portuguese immigrants from the Azores. In the following centuries, especially in the 19th century, a large influx of other European immigrants from Italy, Germany, and Poland left a distinct European mark on the city. Porto Alegre lies on the eastern bank of the Guaíba River, at the confluence of five rivers that form the enormous lagoon Lagoa dos Patos, which separates Porto Alegre from the ocean.

The city is an important industrial and commercial center, and most visitors are business travelers. The city holds little attraction for tourists, especially compared to Brazil's many other more exotic destinations. The weather also doesn't compare favorably to other Brazilian cities, especially in the colder months between May and October. During a 5-day stay in September, we experienced driving rain and temperatures that never got above 10°C (50°F). If you do find yourself here on a stopover, 1 day is more than enough to see the city and enjoy an excellent traditional gaúcho steak dinner. If you have more than a day, venture out to the nearby mountain resorts of Gramado and Canela or visit the vineyards around Bento Gonçalves.

Essentials

GETTING THERE

BY PLANE **Gol** (✆ **0300/115-2121;** www.voegol.com.br), **TAM** (✆ **051/4002-5700;** www.tam.com.br), and **Webjet** (✆ **0300/210-1234;** www.webjet.com.br) have daily flights, often connecting through São Paulo. Tam and Gol also offer direct flights to Buenos Aires, Argentina; Montevideo, Uruguay; and Santiago, Chile.

The **Aeroporto Afonso Pena** (✆ **041/3358-2048**) lies 10km (6 miles) from the city center. A taxi ride to downtown costs approximately R$30. If you don't have a lot of luggage, you can also take the subway (Metrô) from the airport to the Mercado Publico downtown and then grab a cab from there.

BY BUS Long-distance buses arrive at the **Estação Rodoviária,** Largo Vespasiano Veppo 70, Centro (✆ **051/3210-0101;** www.rodoviaria-poa.com.br). The south of Brazil has an excellent road system, but don't underestimate the distances. From Porto Alegre to Curitiba takes 11 hours by bus, to Florianópolis 6 hours, and to Buenos Aires, Argentina, a whopping 18 hours. It pays to compare plane fares; a Gol ticket for the 1-hour flight to Curitiba can cost as little as R$165, compared to the R$110 to R$145 bus ticket.

GETTING AROUND

ON FOOT Downtown Porto Alegre is pleasant and easily walkable by day and into the evening. Later at night it may be advisable to take a taxi.

BY BUS Municipal buses cost R$2.70. The most useful bus line is the T9, which goes from downtown to Moinhos de Vento (stopping close to the park and the Moinhos Shopping).

BY TAXI Taxis can be hailed in the street almost anywhere. To order a taxi, call **Teletaxi Cidade** (✆ **051/3223-3030**) or **Transtaxi Cooperativa** (✆ **051/ 3381-2002**).

BY CAR A car is not necessary inside the city of Porto Alegre. However, to explore the countryside and mountain resorts, a car is ideal, unless you are going on a wine tasting tour.

VISITOR INFORMATION

The city's municipal tourism office (✆ **0800/517-686;** www2.portoalegre.rs.gov.br) has tourism information centers at **Salgado Filho airport** (open daily 8am–10pm), in the Centro Historico at the **Mercado Publico** (daily 9am–6pm), at the **Usina do Gasometro** (Tues–Sun 9am–6pm), and at the tourism bus terminal, Travessa do Carmo 84, Cidade Baixa (✆ **051/3289-0176;** daily 8am–6pm).

[FastFACTS] PORTO ALEGRE

Banks & Currency Exchange **Banco do Brasil,** Rua Uruguai 185, Centro Historico (✆ **051/3214-7777;** Mon–Fri 10am–4pm), has an ATM. **Casa Branca Cambio,** Av. Senador Salgado Filho 200, Centro Historico (✆ **051/3228-2066;** Mon–Fri 9am–5pm), exchanges foreign currency.

Car Rental **Localiza** (✆ **0800/979-2000**), **Avis** (✆ **0800/725-2847**), **Unidas** (✆ **0800/121-121**), and **Hertz** (✆ **0800/701-7300**) all have locations in Porto Alegre. Rates start at R$100 per day for a compact car with air-conditioning and unlimited mileage. Insurance adds R$30 per day.

Consulates The **U.S. consulate** is located in the Instituto Cultural Brasileiro Norte Americano, Rua Riachuelo 1257, Centro (✆ **051/225-2255**).

Hospital **Hospital Clinicas de Porto Alegre,** Rua Ramiro Barcelos 2350, Bom Fim (✆ **051/2101-8000**).

Weather Porto Alegre has a subtropical climate with regular year-round rainfall. In summer, temperatures can soar above 32°C (90°F) and humidity is high. Winters can be quite cold with temperatures ranging from 4° to 16°C (40°–60°F). Like in Curitiba, fog is very common in the colder months, often causing early morning flight delays.

Porto Alegre

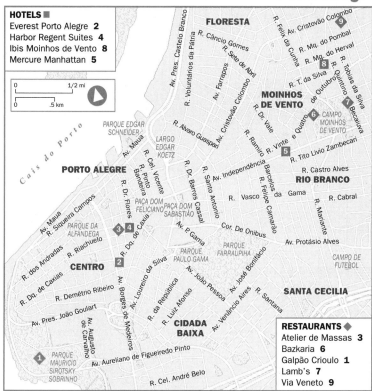

HOTELS ■
Everest Porto Alegre **2**
Harbor Regent Suites **4**
Ibis Moinhos de Vento **8**
Mercure Manhattan **5**

RESTAURANTS ◆
Atelier de Massas **3**
Bazkaria **6**
Galpão Crioulo **1**
Lamb's **7**
Via Veneto **9**

Where to Stay in Porto Alegre

As a business city, Porto Alegre offers mostly uninspired modern high-rise hotels. The best neighborhoods are Moinhos de Vento, packed with excellent shopping, dining, and a pleasant park, and the downtown Centro, near the city's historic attractions. On weekends and holidays, hotel prices often drop 20% to 40%.

MOINHOS DE VENTO

Ibis Moinhos de Vento ★ On the opposite side of the park from the Mercure Manhattan, the Ibis offers cheaper rooms, but without all the nice touches of the Mercure. The rooms here are modern and equipped with the basic amenities of a good hotel room: a comfortable firm bed with new linen, a desk, and a clean bathroom. At R$159 a night you will be hard pressed to find a better deal in this part of town.

Rua marques de Herval 540, Moinhos de Vento, Porto Alegre, 90570-140. www.ibis.com.br. ℭ **051/2112-2772.** 154 units. R$159 double. Extra person 30% extra. Children 5 and under stay free in parent's room. AE, DC, MC, V. Paid parking. **Amenities:** Restaurant; smoke-free hotel. *In room:* A/C, TV, hair dryer, minibar, Wi-Fi.

gaúcho CULTURE

Even in Porto Alegre, the modern capital of Rio Grande do Sul, you will still come across gaúchos wearing traditional *bombachas* (a type of baggy pants) and drinking *chimarrão* (bitter tea). The term gaúcho originally applied to the cowboys on the pampa grasslands, but is now used to refer to the residents of Rio Grande do Sul. Fiercely proud of their regional identity, men can still be seen wearing the typical cowboy uniform of boots, *bombachas*, and leather hats. The other symbol of this region is the *chimarrão*, or *erva-mate*, a bitter green tealike beverage brewed from the leaves of the mate plant. It is prepared by pouring the leaves and hot water into a gourd and sipping it through a metal straw. Even in the city, locals are frequently seen porting a Thermos of hot water and their personal gourd.

Mercure Manhattan ★★ ☺ This is one of the city's best hotels, located in the heart of the entertainment district and only 3 blocks from the Parcão and local shopping and dining options. The rooms are very spacious and feature a separate bedroom and living room with a sofa-bed and an open kitchen, equipped with a stove, fridge, and microwave—these are perfect for families traveling with small children. The hotel also features a heated indoor pool and small fitness area.

Rua Miguel Tostes 30, Moinhos de Vento, Porto Alegre, 90430-060. www.mercure.com.br. © **0800/703-7000** or 051/3024-3030. 148 units. R$180–R$230. Extra person 30% extra. Children 5 and under stay free in parent's room. AE, DC, MC, V. Paid parking. **Amenities:** Restaurant; bar; fitness center; small pool; smoke-free rooms. *In room:* A/C, TV, kitchen, minibar, Wi-Fi.

CENTRO

Everest Porto Alegre ★ One of the city's older hotels, the Everest offers excellent service and pleasant accommodations in a convenient downtown location, near the theater and the cathedral. The best rooms are the recently renovated standard executive rooms and the deluxe executive rooms; these feature new wooden floors, large work desks, comfortable office chairs, and new box springs and bedding. The main difference between the two categories is size. Check the hotel website for discounted Internet rates. Breakfast is served in the panoramic restaurant on the 16th floor.

Rua Duque de Caxias 1357, Centro, Porto Alegre, 90570-140. www.everest.com.br. © **051/3215-9500.** 111 units. R$320 double standard executive; R$360 double luxo executive. Extra person 30% extra. Children 6 and under stay free in parent's room. AE, DC, MC, V. Parking R$18. **Amenities:** Restaurant; fitness area. *In room:* A/C, TV, hair dryer, minibar, Wi-Fi.

Harbor Regent Suites ★ This small 10-year-old hotel offers affordable downtown accommodations, particularly suitable for business travelers. The rooms have spacious work desks, comfortable king-size beds, and a small kitchen space with a coffeemaker, microwave, and fridge. This part of the city is pretty quiet outside of business hours, so if you are spending the weekend, you are better off booking a hotel in Moinhos de Vento to take advantage of the shopping and dining options.

Rua Vigário José Inácio 700, Centro, Porto Alegre, 90020-110. www.harborhoteis.com.br. © **0800/600-3200** or 051/3025-3200. 54 units. R$220 double. Inquire about weekend discounts.

Children 5 and under stay free in parent's room. AE, DC, MC, V. No parking. **Amenities:** Restaurant; bar; small fitness center. *In room:* A/C, TV, kitchenette, minibar, Wi-Fi.

Where to Eat in Porto Alegre

Porto Alegre is home to excellent and very affordable restaurants. As you might expect in one of Brazil's prime cattle-farming regions, beef is very popular. There are churrasco restaurants everywhere, but unlike in the rest of Brazil, it is all about the meat; don't expect a smorgasbord with sushi, salads, or fish dishes.

Atelier de Massas ★ ITALIAN Decorated with colorful artwork by the chef and several other local artists, this downtown eatery serves up excellent Italian fare. Start off with a helping from the antipasto buffet, a great spread of olives, artichokes, cheeses, marinated seafood, and more (R$7.30 per 100 grams). For your main course, order one of the freshly made pastas with your sauce of choice. The wine list includes some excellent local wines that are hard to find elsewhere.

Rua Riachuelo 1482, Centro. ⓒ **051/3061-31252.** Main courses R$21–R$43. DC, MC, V. Mon–Sat 11am–2:30pm and 7–11:30pm.

Bazkaria ★ ITALIAN A Basque pizzeria may sound odd, but it actually makes perfect sense. Here, you get delicious contemporary pizzas prepared with quality ingredients like goat cheese, Parma ham, and seafood, in addition to authentic Spanish tapas, cheeses, and cold cuts. A refreshing jug of sangria goes perfectly with all dishes. In the cold winter months, guests cozy up indoors by the wood-burning stove, and in summer there is a fabulous sidewalk patio.

Rua Com. Caminha 324, Moinhos de Vento. ⓒ **051/3311-4514.** www.bazkaria.com.br. Main courses R$38–R$52 (for 2). AE, DC, MC, V. Daily 6pm–midnight.

Galpão Crioulo ★ STEAK You certainly won't need our help in finding a steak restaurant in Porto Alegre, but this one is tucked away in the park near the Usina do Gasometro. The rustic farmlike establishment serves up a traditional gaúcho feast. Waiters come by with more than 24 different cuts of meat. Side dishes include salads and various regional rice and bean dishes. On weekdays there is also an executive lunch special with a selection of 16 different meats for only R$20.

Parque Mauricio Sirotsky Sobrinho s/n, Centro. ⓒ **051/3226-8194.** www.churrascariagalpao crioulo.com.br. R$26–R$39 all you can eat. MC, V. Daily 11:30am–3pm and 7:30–11pm.

Lamb's ★ TEAHOUSE If you think afternoon tea is a delicate, dainty affair, you haven't been to Lamb's. The huge spread includes more than a dozen cakes and pies, sandwiches, quiches, fruit tarts, *apfelstrudel* (apple strudel), breads and jams, as well as fruit juices and tea.

Rua Coronel Bordini 905, Moinhos de Vento. ⓒ **051/3332-7007.** www.lambs.com.br. Tea buffet (dessert not included) Mon–Fri R$20, Sat–Sun R$30. DC, MC, V. Daily 8am–8pm.

> ## Keep an eye on the clock
>
> Unlike other big cities in Brazil where restaurants often stay open all day, Porto Alegre restaurants keep strict lunch and dinner hours. Especially on weekdays, lunch is served early, usually between 11am and 2pm. Restaurants don't reopen until 7pm.

Via Veneto ★ GRILL This restaurant has been voted the best *galeteria* (chicken restaurant) in town!

Come hungry; for R$35 you are served a copious feast that starts with *capelleti* soup and a tray of antipasto, followed by unlimited quantities of grilled chicken (*galeto*), pork ribs, lamb, steak, and various pasta dishes. To lighten the load, you can also help yourself to the salad bar.

Rua Dom Pedro II 1148, Higienópolis. ✆ **051/3337-2173.** www.galeteriaveneto.com.br. R$35 all you can eat (drinks and dessert not included). DC, MC, V. Mon–Fri 11am–2:30pm and 7pm–midnight; Sat 11am–3pm; Sun 11am–4pm.

Exploring Porto Alegre

Downtown Porto Alegre's attractions are easily explored on foot. Half a day is enough to visit the main landmarks.

Start with a visit to the **Praça da Matriz or Praça Marechal Deodoro;** the city's main square is framed by several attractive 19th-century and early-20th-century buildings. The original **Metropolitan Cathedral** was built in 1772, but the current structure dates from 1921. One of the most impressive buildings on the square is the late-19th-century elegant neoclassical **Palacio Piratini,** Praça Marechal Deodoro s/n, the seat of the state government. On the opposite side of the square stands the **Teatro São Pedro,** Praça Marechal Deodoro s/n (✆ 051/3227-5100), Porto Alegre's premier concert venue. The theater is open for visitation (Tues–Fri noon–6:30pm, Sat–Sun 4–6pm). Heading a few blocks north along the Rua General Camâra takes you to the **Praça da Alfandega** with three noteworthy early-20th-century neoclassical buildings. One of them is the **Santander Cultural** (✆ 051/3287-5500; open Tues–Fri 10am–7pm, Sat–Sun 11am–7pm), a former bank building that now houses temporary art exhibits, a movie theater, and a cafe. Next door, the former post office has been transformed into the **Memorial do Rio Grande do Sul** (✆ 051/3224-7210; open Tues–Sat 10am–6pm), a small exhibit with tributes to famous gaúchos, including former president Getulio Vargas and singer Elis Regina. The third building is home to the **Museu de Arte do Rio Grande do Sul** (✆ 051/3227-2311; open Tues–Sun 10am–7pm), which hosts exhibits on Brazilian artists, including some works by Portinari and Di Cavalcanti. Admission to all three buildings is free.

For a change of pace, take Rua 7 de Setembro to the Praça XV de Novembro and visit the **Mercado Público,** the city's bustling public market. More than 100 stalls and small shops sell food and local products, including erva-mate and *cuia* (a type of gourd) with metal drinking straws (*bomba*). It is also a great place for a quick sandwich or ice cream.

One of Porto Alegre's most interesting cultural venues is the **Usina do Gasometro,** Av. Presidente João Goulart 551 (✆ 051/3289-8140; Tues–Sun 9am–9pm), located on the waterfront, at the end of Rua dos Andrades. Built in 1828, this former thermoelectric plant with its 117m-high (380-ft.) chimney was the city's first reinforced concrete construction. It now houses a theater, exhibition spaces, and a cinema. The terrace is a prime sunset spot. Daily boat tours of the Guaíba river depart from the pier (see below).

ESPECIALLY FOR KIDS

Museu de Ciências e Tecnologia Kids of all ages will have a blast with the many hands-on science exhibits and experiments at the Science and Technology

Museum. Test the hair-raising Van de Graaff generator, play CSI investigator, enjoy a 15-minute movie on our solar system, or take a 3D tour of the human body.

Av. Ipiranga 6681 (at PUC University), Partenon. (*C*) **051/3320-3697.** www.pucrs.br/mct. Admission R$17 (including admission to movies), R$11 children ages 3–12. Tues–Fri 9am–5pm; Sat–Sun 10am–6pm.

Parque Moinhos de Vento (Parcão) Porto Alegre's favorite city park features lovely gardens and a lake with turtles, geese, ducks, and fish. There are also tennis courts, soccer fields, and various playgrounds where little ones can burn off energy.

Rua 24 de Outubro, Rua Mostardeiro, and Travessa Comendador Caminha.

ORGANIZED TOURS

BOAT TOURS Enjoy great views of the city's skyline and Porto Alegre's islands by boat. **Porto Alegre 10** ((*C*) **051/3211-7665;** www.barcoportoalegre10.com.br) offers regular afternoon boat tours (Tues–Fri at 4:30pm and Sat–Sun at 2pm and 4pm). Tours depart from the Usina do Gasometro, Av. Presidente Jõao Goulart 551, Centro. Tickets are R$15 for adults and R$7.50 for children ages 3 to 10.

GUIDED TOURS The **Linha Turismo** ((*C* 051/3289-6744) offers a panoramic tour of Porto Alegre's attractions onboard an open double-decker bus. The 80-minute tour with multilingual tour guides covers the city's downtown, parks, and riverfront. Buses depart from Travessa do Carmo 84, Cidade Baixa, Tuesday to Sunday at 9am, 10:30am, 1:30pm, and 3pm. Tickets are R$15 per person.

Shopping in Porto Alegre

Porto Alegre is famous for its leather products, such as shoes, purses, and jackets. You will find a variety of clothing and shoe stores in the downtown pedestrian-only shopping area around **Avenida Borges de Medeiros** and **Rua dos Andradas,** near the **Praça da Alfândega.** Rio Grande do Sul also produces the best wines in Brazil. While the mass-produced inexpensive wine sold in most supermarkets in the rest of Brazil is no great ambassador for the local production, there are some fine local vintages. The good stuff, however, either gets bought up by high-end restaurants, or gets sold locally. Visit a local wine store to pick up some outstanding vintages. **Via Vino,** Rua Dinarte Ribeiro 131, Moinhos de Vento ((*C* **051/3312-1001;** www.viavino. com.br), has a store/wine bar where you can sample wines. **Casa dos Vinhos,** Rua Alcides Cruz 351, Santa Cecilia ((*C* **051/3332-3921;** www.casadosvinhosrs.com. br), is one of the better wine stores for regional vintages and worth the trek; call ahead to inquire about any upcoming wine tastings.

For more regional products, including wine and crafts, visit the bustling Mercado Público (see above). On Sundays, browse the excellent selection of handicrafts and antiques at the outdoor market in **Parque Farroupilha,** also known as Redenção (entrance off Av. José Bonifacio; 9am–5pm). Take your shopping indoors to the **Moinhos Shopping,** Rua Olavo Barreto Viana 36, Moinhos de Vento ((*C* **051/2123-2000;** www.moinhosshopping.com.br), one of the city's more pleasant malls with over 120 stores, movie theaters, and cafes.

Porto Alegre After Dark

Porto Alegre's nightlife centers on the downtown and Moinhos de Vento neighborhoods. Centro—particularly around **Rua General Lima e Silva, Rua Republica,**

and **Rua José de Patrocinio**—has dozens of bars and cafes. Voted best *boteco* (local bar), **Apolinario,** Rua José do Patrocínio 527, Centro (© **051/3013-0158;** www. apolinariobar.com.br), draws a hip crowd with its lengthy beer menu, excellent snacks, and casual atmosphere (closed Sun). Nearby **Bodega,** Rua João Alfredo 507 (© **051/3212-6258;** www.bodegapoa.com.br), is known for its lively samba bands; admission is R$10 to R$15. Wine bar **Champanharia Ovelha Negra,** Rua Duque de Caxias 690, Centro (© **051/3061-7021;** www.champanhariaovelhanegra.com. br), is popular among the ladies who enjoy a crisp glass of bubbly, including some excellent regional vintages from the Serra Gaucha; it's closed Saturday and Sunday. Moinho de Vento's nightlife clusters around **Avenida Goethe, Rua Padre Chagas,** and **Rua Fernando Gomes. Caminito,** Rua Padre Chagas 318, Moinhos de Vento (© **051/3346-2556;** www.caminitobar.com.br), offers colorful, rustic decor and a range of music, from samba to Brazilian and international pop.

THE PANTANAL

I t's a secret that, until recently, was known only to film crews: The best place in South America to see wildlife is not the Amazon but the Pantanal, a Florida-size wetland on the far western edge of Brazil that bursts with animals—capybaras, caimans, jaguars, anacondas, giant otters, colorful hyacinth macaws, kites, hawks, and flocks of storks and herons hundreds strong. In fact, many species that live in the Amazon and are next to impossible to see there can be viewed here in abundance. The Pantanal is home to over 700 species of birds, 100 mammal species, more than 250 fish species, and 80 reptile species.

The largest flood plain in the world, the Pantanal has a rhythm governed by its rivers. In the wet season (Nov–Apr), rivers swell and spill over to cover a vast alluvial plain for months. Millions of birds are attracted by this aquatic paradise, as mammals take refuge on the remaining few mounds of dry land. As the water drains (from May onward), the land dries up and the situation slowly reverses: Animals congregate around the few remaining water pools. Fish get trapped in these pools, and birds and mammals alike gather for water and food as they wait for the rains to start.

Most farmers use the land for cattle grazing in the dry season only, moving the cattle when the fields flood. Few roads of any kind exist in the Pantanal; the best way to explore the area is to make like the locals and head out on horseback. Many of the area's fazendas (cattle ranches) have slowly converted to tourism. Staying at one of these lodges is the best way to get a feel for the region.

A stay in a Pantanal lodge normally involves a number of activities—a boat trip to spot birds and caimans, a horseback trip through the fields, bird spotting by foot or in an open vehicle, and often a nighttime excursion to see nocturnal animals. Some lodges offer additional activities such as canoe trips, fishing expeditions, or specialized bird-watching outings. If you have a specific interest, make contact ahead of time.

TOUR OPERATORS IN THE PANTANAL

Whether you decide to go to the North Pantanal or the South, whichever lodge you decide to visit, you may find it easier and often cheaper to arrange your visit through a tour operator, who can arrange not only your stay but your transfers to and from the lodge, and even help out with flights to the gateway cities. Sometimes there is a premium on top of the lodge costs for this service. Sometimes the operator can make up his costs through the discount he gets from the lodge, in effect passing this savings

The best way to experience the Pantanal and observe its amazing birds and wildlife is by staying at a small lodge; depending on the time of year you'll either head out in a four-wheel-drive, canoe, boat, on foot, on horseback, or a combination of these. The Pantanal has three gateway cities: **Cuiabá**, which connects to the Transpantaneira Highway and gives access to the South Pantanal; **Campo Grande**, which leads in to the South Pantanal; and most isolated of all, **Corumbá**, which provides access to lodges in the southwest of the ecosystem. None of these cities is really worth visiting in itself. Most lodges will pick you up at the airport and whisk you out into the swamp with nary a second glance at the city. The quickest access to the Pantanal is via the city of Cuiabá, just an hour and a half by car from the Transpantaneira Highway.

on to you. In any case, it's worth checking out what they have to offer. You can always book directly with a lodge afterward if you decide the service being offered isn't worth the money or effort.

Two particularly good operators offer expeditions to lodges in either the North or the South Pantanal. Located in the U.S., **Brazil Nuts** (✆ 800/553-9959; www.brazilnuts.com) offers packages to a number of lodges, including the two pioneers of Pantanal eco-tourism, **Araras Eco Lodge ★★★** in the North, and **Caiman Ecological Reserve ★★** in the South.

Located in Campo Grande, **Pantanal Tours** (✆ 067/3042-4659; www.pantanaltours.com) has some excellent packages for the Pantanal, Bonito, and combinations of the two. They work with a wide variety of lodges in both the North and South Pantanal, including difficult-to-reach reserves such as **Fazenda Barranco Alto ★★★**.

In the individual sections on the North and South Pantanal below, we list a number of very good, but more regionally focused, tour agencies.

CUIABÁ & THE NORTH PANTANAL

1,576km (979 miles) NW of Rio de Janeiro, 1,321km (815 miles) NW of São Paulo

The capital of Mato Grosso state, Cuiabá is a modern, pleasant town of 430,000 that sits in the middle of Brazilian cattle country. The city serves as the main gateway to the northern part of the Pantanal—the Transpantaneira Highway starts just 98km (61 miles) away—and as the jumping-off point to the Chapada dos Guimarães.

Essentials

GETTING THERE BY PLANE Flights to Cuiabá are available on **TAM** (✆ 0800/570-5700 or 065/4002-5700; www.tam.com.br), **Gol** (✆ 0300/115-2121; www.voegol.com.br), and **TRIP** (✆ 0300/789-8747; www.voetrip.com.br). Most flights connect to Cuiabá's **Aeroporto Marechal Rondon** (✆ 065/3614-2510) through Brasilia. Tours to a Pantanal lodge normally include pickup and drop-off at the airport, so there is no real reason to stay in Cuiabá.

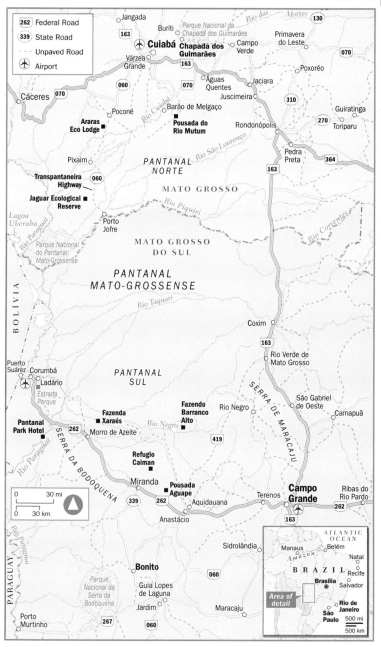

262	Federal Road
339	State Road
- - -	Unpaved Road
✈	Airport

Jangada

Buriti

Parque Nacional da
Chapada dos Guimarães

130

Rio das Mortes

Primavera
do Leste

163

Cuiabá
Chapada dos
Guimarães

Campo
Verde

070

Várzea
Grande

163

Poxoréo

060

070

Águas
Quentes

Jaciara

Cáceres 070

Poconé

Barão de Melgaço

Juscimeira

310

Guiratinga

Araras
Eco Lodge ■

Pousada do
Rio Mutum

Rondonópolis

270

Toriparu

Rio Cuiabá

Rio São Lourenço

Pixaim

PANTANAL
NORTE

Pedra
Preta

364

Transpantaneira
Highway 060

MATO GROSSO

163

Jaguar Ecological ■
Reserve

Rio Piquiri

Lagoa
Uberaba

Rio Paraguai

Porto
Jofre

MATO GROSSO
DO SUL

Rio Correntes

Parque Nacional
do Pantanal
Mato-Grossense

B O L Í V I A

PANTANAL
MATO-GROSSENSE

Rio Taquari

Coxim

163

Puerto
Suárez Corumbá

✈ Ladário

PANTANAL
SUL

Rio Verde de
Mato Grosso

Estrada
Parque

Fazendo
Barranco
Alto ■

Rio Negro

São Gabriel
de Oeste

Camapuã

SERRA DE MARACAJU

Pantanal
Park Hotel ■

Fazenda
■ Xaraés

Rio Negro

262

Morro de Azeite

419

Rio Paraguai

SERRA DA BODOQUENA

Refugio
Caiman

Miranda

Pousada
■ Aguape

Campo
Grande

Ribas do
Rio Pardo

339 262

Aquidauana

Terenos

✈

262

Anastácio

163

| 0 | 30 mi |
| 0 | 30 km |

PARAGUAY

Rio Paraguai

Sidrolândia

Bonito

Parque
Nacional da
Serra da
Bodoquena

Guia Lopes
de Laguna

060

Jardim

Maracaju

Porto
Murtinho

267

060

ATLANTIC
OCEAN

Manaus

Belém

Amazon

Natal

B R A Z I L

Brasília ✷

Recife

Salvador

Area of
detail

São
Paulo

Rio de
Janeiro

500 mi

500 km

A Health Warning: Yellow Fever

In this region of Brazil, yellow fever is endemic, and you should get a shot at least 10 days before you travel to the Pantanal. Health authorities may ask for proof of vaccination, so carry your vaccine certificate.

GETTING THERE BY BUS Cuiabá's efficient bus terminal, **Engenheiro de Sá** (✆ **065/3621-1040**), is on Av. Marechal Deodoro s/n in Alvorada, just north of the city center. Buses to Campo Grande, gateway to the South Pantanal, depart daily at 7am, 8pm, and 9:30pm and take 10 hours. The overnight buses have comfortable reclining chairs. Contact **Motta** (✆ **065/3621-2514;** www. motta.com.br). The fare is R$90.

VISITOR INFORMATION The state tourist office, **Secretaria de Turismo** (✆ **065/3613-9300;** www.sedtur.mt.gov.br), is located far from downtown.

[FastFACTS] CUIABÁ

Banks & Currency Exchange **Banco do Brasil,** Av. Pres Getúlio Vargas 553 (✆ **065/3624-1944**), has a 24-hour ATM. *Tip:* Just outside the airport are 24-hour ATMs for all major banks that accept foreign cards. Although most lodges will let you run a tab for your personal expenses during your stay, make sure you have some cash for tips and souvenirs.

Car Rental **Unidas** is at Av. Gov. João Ponce Arruda 920 (✆ **065/3682-4052**), and **Localiza** is at Rua Mal Rondon s/n (airport; ✆ **065/3682-7900**).

Hospital The main hospital is **Hospital Santa Casa de Misericórdia,** Praça do Seminário 141 (✆ **065/3321-0166**).

Internet Access **Digitus Informática,** Av. Ten Cel Duarte 595 (✆ **065/3321-0166**), charges R$4 an hour.

Weather The state of Mato Grosso is hot and muggy in the summer; temperatures can rise to 35° to 40°C (95°–104°F). Most rain falls from December to March. In the winter (June–Sept) it can cool off significantly, with temperatures as low as 15°C (59°F).

Where to Stay

All the Pantanal lodges will pick you up at the airport, sparing you the need to stay in Cuiabá. If you do find yourself stuck for a night (probably because your flight was delayed), you can find a clean and decent room literally across the street from the airport at the **Hotel Diplomata,** Av. João Ponce de Arruda 678 or Avenida do Aeroporto (✆/fax **065/3688-8500;** www.diplomatahotel.com.br). A double room costs around R$190. More pleasantly located, but a 20- to 30-minute cab ride into town, is the **Hotel Amazon,** Av. Presidente Getúlio Vargas 600 (✆ **065/2121-2000;** www.hotelamazon.com.br). The hotel is near the city's shopping and restaurant area. Rates range from R$140 to R$220.

Where to Eat

Most of Cuiabá's better restaurants are located in the Goiabeiras neighborhood. **Peixaria Popular** ★, Av. S. Sebastião 2324 (✆ **065/3322-5471**), offers fish from the great inland fishery of the Pantanal. *Pintado, dourado, paçu,* and *piraputanga* are served up grilled, fried, or in filets. **Getulio Grill** ★, Av. Getúlio Vargas 1147, across

from Praça Santos Dumont (℃ **067/3624-9992**; www.getuliogrill.com.br), offers steak and excellent local fish dishes. At night, it's also a popular local tavern.

Exploring the North Pantanal

Three days is the minimum reasonable itinerary for the Pantanal. With wildlife viewing, the longer you spend in an area, the better your chances of seeing animals. Spend the minimum possible time in Cuiabá, then a take a slow wildlife-spotting drive out along the Transpantaneira to a lodge. Take a guided hike, and after sunset, go for a spotlight drive on the Transpantaneira to see the night creatures: capybaras, tarantulas, and (with the most incredible of luck) jaguars. I also strongly recommend that you take the time to explore the Pantanal as it was meant to be seen, on the back of a horse. Canoeing one of the North Pantanal's small rivers is a great way to spot monkeys and giant river otters.

After exploring the Pantanal, consider a 1-day or overnight trip to the **Chapada dos Guimarães** (p. 463), the highlands to the north of Cuiabá. The beautiful redrock formations, plateaus, and canyons offer excellent hiking and fabulous views, great waterfalls and swimming holes, and some excellent bird life, including red macaws.

TOUR OPERATORS IN THE NORTH PANTANAL

All tour operators work with one or more Pantanal lodges. These operators provide a package itinerary—usually quite flexible—that includes transportation to a lodge plus nature tours and guide services.

One of the best tour operators is **Pantanal Explorer,** Av. Governador Ponce de Arruda 670, Varzea Grande (℃ **065/3682-2800;** fax 065/3682-1260; www.pantanalexplorer.com.br). Stays in the Pantanal are at the excellent Araras Eco Lodge. In addition, the company offers trips to the Chapada dos Guimarães and boat trips in the Pantanal, as well as eco-tours to the Mato Grosso part of the Amazon rainforest, excellent if you do not have an opportunity to head up to the Amazon. All of these trips can be combined with a Pantanal stay.

Another good tour operator is **Anaconda Turismo,** Av. Isaac Povoas 606, Centro, Cuiabá (℃ **065/3028-5990;** www.anacondapantanal.com.br). This operator works with a large number of fazendas and pousadas and can customize a package according to your interests. It also operates in the Chapada dos Guimarães and can organize fishing expeditions.

DRIVING THE TRANSPANTANEIRA

There are a couple of ironies about the Transpantaneira. Though the name implies that the road traverses the entire Pantanal, the highway stops in Porto Jofre, 144km (89

Three Ecosystems

The state of Mato Grosso features three different ecosystems within striking distance of Cuiabá. Visitors can explore the southern border of the Amazon rainforest, hike through the savanna landscape of the Chapada dos Guimarães with lush waterfalls and beautiful rock formations, and observe the astonishing birds and abundant wildlife of the flood plains of the Pantanal. Contact **Pantanal Explorer** (℃ **065/3682-2800;** www.pantanalexplorer.com.br) for more details on this 7-day program.

miles) from where it began, and at least that far from the opposite edge of the Pantanal. The other irony is that the project, which if completed would likely have destroyed the Pantanal (by skewing the ecosystem's drainage pattern), has instead, in its unfinished state, become an incredible wildlife-viewing area. Ditches on either side of the roadbed have become favorite feeding grounds for kingfishers, capybaras, egrets, jabiru storks, giant river otters, and caimans by the dozen. Spend but a day on the Transpantaneira, and you'll see more wildlife than you'd see in a week in the Amazon.

Lodges in the North Pantanal

Araras Eco Lodge ★★★ Araras Lodge is the best spot for exploring the North Pantanal. The location by the Transpantaneira is excellent, and lodge owner Andre Thuronyi has done extensive work to improve the local wildlife habitat. With only 19 rooms, the lodge is pleasantly small and rustic. Guest rooms are simple, and come with a private bathroom and a hammock on the veranda. The guides are usually knowledgeable. Activities include hikes along a rustic boardwalk through the flooded fields to the lodge's lookout tower. One afternoon as we watched the sun set over the Pantanal, a group of five hyacinth macaws flew right over us, attracted by our guide who sounded a credible macaw call. Other excursions include boat or canoe trips on a small local river known for large hawks and giant river otters (we saw both). On drives along the Transpantaneira, even in a 3-hour time span, you'll lose track of the number of birds you'll see. Fortunately, the guide always seems to remember their names. Horse lovers will be in heaven riding through the flooded fields. The food is delicious and plentiful, often including excellent local fish. Packages and programs can be fully customized according to your preferences.

Transpantaneira Hwy. Reservation office: Av. Governador Ponce de Arruda 670, Varzea Grande, MT. www.araraslodge.com.br. (⟟) **065/3682-2800.** Fax 065/3682-1260. 19 units, showers only. R$1,400–R$1,800 per person for a 3-day, 2-night package; R$3,000 6-day package (including the Chapada Guimarães), including airport pickup and drop-off plus all meals and guided activities. Extra person add about 25%. Children 10 and under stay free in parent's room. AE, DC, MC, V. Free parking. **Amenities:** Restaurant; bar; outdoor pool. *In room:* A/C, no phone.

Jaguar Ecological Reserve ★★ Wildlife viewing is always a matter of luck and patience, particularly when it comes to large predators like jaguars. But one of the best ways of improving your odds is to visit this lodge—the centerpiece of a private ecological reserve—where an astonishing one in four guests sees one of these huge South American cats. It's a long way (110km/68 miles) down the bumpy Transpantaneira, and the accommodations are expensive and only basic, but for a view of that big cat it may be worth it. For the 75% of guests who do not see jaguars, there is the usual vast array of caimans and colorful birds, so rare in the rest of the world, so common in the Pantanal. It's best to book your stay here through **Pantanal Tours** (⟟ **067/3042-4659;** www.pantanaltours.com). The JER has been in operation for a number of years, and while operations in the field run smoothly, their booking operations have been a little on the amateur side. Better to deal with professionals.

Transpantaneira Km 110, Poconé, MT. www.jaguarreserve.com. (⟟) **065/3646-8557** (office) or 067/9919-5518 (lodge). 9 units. US$825 per person 4-day, 3-night package, accommodations, transfers, meals, and excursions included. AE, MC, V. *In room:* No phone.

Pousada do Rio Mutum This pousada is highly recommended for those who enjoy fishing. The *pintado* catfish is a particularly prized catch, but anglers can also

I have to admit, I always thought birding was boring: Get up at dawn, sit in a blind, wear camouflage, and just be really quiet. But my first visit to the Pantanal opened my eyes. Just driving along the Transpantaneira for an hour I spotted parakeets, tanagers, hawks, egrets, and the amazing 1.5m-tall (5-ft.) jabiru stork. In less than 2 hours I counted at least 20 different species. That evening as I stood on a viewing platform to see the sun set over the flooded fields, I heard the unmistakable shrieks of a macaw. As my eyes adjusted to the low light I was able to spot three hyacinth macaws flying within a few feet of the platform. On a horseback ride the next day, splashing loudly through the wet fields, I still managed to log at least 15 species, including roseate spoonbills, toucans, egrets, herons, and cormorants. Not just one or two of each—great big flocks. Now there's a sport I can get in to!

expect to hook *dourado, paçu,* or *piraputanga.* (The best months for fishing are Feb–Oct; there is no fishing Nov–Jan during spawning season.) For nonfishers there are tours of the Pantanal ecosystem by boat, foot, and canoe. The lodge also offers special bird-watcher packages, which do many of the same activities but are accompanied by a bird expert. Accommodations are in simply furnished rooms that come with private bathrooms and a veranda. All meals and activities are included. This region is a bit east of Poconé, and access is through the town of Barão de Melgaço.

Av. Isaac Póvoas 1177, Cuiabá, 78045-640 MT. www.pousadamutum.com.br. ⓒ **065/3052-7022.** 22 units, showers only. From US$720 per person 3-day, 2-night packages, including meals and pickup/drop-off at airport. MC, V. **Amenities:** Restaurant; bar; pool. *In room:* A/C, no phone.

A SIDE TRIP FROM CUIABÁ: CHAPADA DOS GUIMARÃES

74km (46 miles) E of Cuiabá

In appearance, the Chapada dos Guimarães has much in common with the desert buttes of Arizona or Utah in the States—weird, wonderful formations of bright red rock, and long beautiful canyons. Vegetation is dry and scrubby, except where the many river channels flow; then you get waterfalls streaming down into basins lush with tropical vegetation. Officially, more than 32,000 hectares (80,000 acres) of this vast highland were set aside in 1989 as a national park—the Parque Nacional da Chapada dos Guimarães. Only about half of the total area has been expropriated; much of the rest still lies in private hands, including the small town—also called Chapada dos Guimarães—within the park boundaries. It's a quiet, laid-back place with a slight counterculture feel, and the most convenient base from which to set off exploring. Hiking nearby is excellent; trails are clear even if—as ever in Brazil—they're completely without markers or signage. Most trails end at a viewpoint, a waterfall, or a natural pool (sometimes all three!). Wildlife is not up to the standard set by the Pantanal, but in the Chapada you do have the opportunity of seeing the gorgeous red macaw, often playing in the thermals by a cliff side.

Essentials

GETTING THERE

BY CAR The Chapada is 74km (46 miles) north of Cuiabá. The best way to get there is by rental car (see "Fast Facts: Cuiabá," earlier in this chapter). Roads are excellent. Follow the MT-251 to the park and the town of Chapada dos Guimarães.

BY BUS Direct buses operated by **Viação Rubi** (© **065/3624-9044**) leave from Cuiabá's *rodoviaria* and take about 1 hour. The cost is R$10 and departures are daily at 9am, 10:30am, 2pm, and 6:30pm.

VISITOR INFORMATION

The **tourist office** is at Rua Quinco Caldas s/n (© **065/3301-2045**). The park visitor center (© **065/3301-1133**) is located on highway MT-251 about 8km (5 miles) past the park entrance, and about 15km (9 miles) before the town of Chapada dos Guimarães. An excellent local tour operator, **Ecoturismo Cultural,** Praça Dom Wunibaldo 464 (© **065/3301-1693;** www.chapadadosguimaraes.com.br), arranges day trips with guides and transportation and can assist with accommodations.

All tour operators listed under "Tour Operators in the North Pantanal," above, can provide day trips or overnight packages to the Chapada, in combination with a visit to the Pantanal or as a separate trip.

Exploring the Park

Two days are plenty to explore the Chapada. Even if you only have a day, you can still see the best of the Chapada—take in the magnificent views, frolic in a few waterfalls, and get some hiking in, all before sunset.

Note: Due to park maintenance, some areas of the park are closed on Tuesdays and Wednesdays. Also, at the time this book went to press, the trail to Cidade de Pedras was closed, but was expected to reopen soon. Check with the park administration office (© **065/3301-1133**) or ask at your pousada.

RECOMMENDED HIKES

All times are one-way for the hikes listed below. Trail heads have sizable parking lots, but on weekends the sights closest to town can get crowded. There is no public transportation in the park or surrounding area.

CACHOEIRA VEU DE NOIVA The tallest waterfall in the park is the gorgeous **Véu de Noiva.** The trail head is at the park visitor center, about 15km (9 miles) from the town of Chapada dos Guimarães. From the visitor center it is a short and obvious walk to the lookout (closed on Tues).

MIRANTE DA GEODESIA This lookout marks the geodesic center of Brazil. The spot also happens to mark a fabulous lookout over the lowlands below the Chapada, with Cuiabá in the distance. Short trails below the lookout take you down some of the cliffs with more views. The parking lot lies 8km (5 miles) east of the town of Chapada dos Guimarães.

 Hiking Tips

Wear high-top shoes or boots—not sandals—as the rocks and sand are perfect spots for snakes (some may be poisonous). Be careful when sitting down and putting your hands on the rocks.

CIDADE DE PEDRAS The City of Stone is named after the beautiful eroded rock formations that look like the ruins of buildings. A short hike takes you through these rocks to the edge of a canyon, where the sheer

cliffs drop 350m (1,148 ft.) straight down. To reach the trail head, go west from town on MT-251 for about 2km (1¼ miles), turn right (there's a small sign), and follow the smaller, rougher blacktop road straight on for 13km (8 miles). See the note above about this trail.

PAREDÃO DO ECO A 20-minute hike takes you to the edge of a mini Grand Canyon. Steep cliff walls and eroded rocks in various shapes form an amazing pattern, and on the far side where the walls are the steepest and sheerest you can often spot scarlet red *araras* (macaws). At sunrise and sunset the light bathes the rocks in a warm red glow. To reach the trail head, follow the same directions for Cidade de Pedra, above. About 12km (7½ miles) along the blacktop road, take the left turn on a dirt road and follow it for 3km (2 miles).

Where to Find Local Art

For local art and crafts, visit **Artes da Chapada Artesanatos,** Rua Cipriano Curvo 464, Centro (© **065/3301-2739**). Open Monday through Saturday from 10am to 7pm. Around the Chapada's central square you will find a number of other arts and crafts stores.

MORRO SÃO JERÔNIMO The highest point in the Chapada, this tabletop mountain can be reached by a 4-hour hike. Bring water and sunscreen. The trail for the Morro begins at the visitor center parking lot. The peak is almost due south, but trails are poorly marked. Follow the signs to Cachoeira Véu de Noiva, then to Casa de Pedra, and then to Morro São Jerônimo.

Where to Stay

Pousada do Parque ★★★ ☺ This pousada has a fabulous location, on the edge of a cliff looking out toward Morro São Jerônimo. The rooms are a bit small but very comfortable and several have heaters, great for the chilly fall and winter days. Guests can also warm up in the fireplace lounge or enjoy a glass of wine and an outstanding meal by the wood-burning stove. The owners are avid hikers and birders with lots of tips to offer. Ask the front desk for a copy of their detailed bird list. *Note:* Access is via a dirt road at Km 52 of the Cuiabá–Chapada dos Guimarães Highway. The gate is normally locked, so notify the staff of your expected time of arrival.

MT-251 Hwy., Km 52 (15km/8 miles from the center of town), Chapada dos Guimarães, 78065-010 MT. www.pousadadoparque.com.br. © **065/3391-1346** or 3682-2800. 8 units. R$265 double. Seasonal discounts available. Children 5 and under stay free in parent's room. AE, DC, MC, V. Free parking. **Amenities:** Restaurant; bar; small outdoor pool; sauna. *In room:* A/C, no phone.

Solar do Inglês ★ This small but charming pousada with a lovely English garden (plus a very un-English pool) is the perfect couple's getaway. Rooms are lovingly decorated in antiques and bric-a-brac. In addition to a hearty breakfast, the pousada serves a proper afternoon tea, at 5pm on the dot.

Rua Cipriano Curvo 142, Centro, Chapada dos Guimarães, 78195-000 MT. www.solardoingles.com. br. © **065/3301-1389.** 8 units. R$285 double. Extra person add 25%. AE, V. Free parking. Children 13 and under not accepted. **Amenities:** Bar; pool; sauna. *In room:* A/C (in 7 rooms), fan only (1 room), TV/DVD, hair dryer, minibar.

Where to Eat

The town of the Chapada dos Guimarães doesn't really stand out as a culinary destination. Perhaps most visitors are so tired after a day of hiking that they can't be bothered to go out, and prefer to eat at their pousadas.

Chacara Morro dos Ventos REGIONAL BRAZILIAN This is an excellent lunch spot. Perched on the edge of a cliff, the restaurant offers fabulous views. With luck, you'll spot red macaws flying along the rock faces. The menu offers regional home cooking. Try the chicken stew with okra, served in a heavy cast-iron pot with generous side dishes of beans, salad, *farofa,* and rice. Other options include the *pintado* or *paçu* fish.

Via Estrada do Mirante Km 1, Chapada dos Guimarães. (✆) **065/3301-1030.** Main courses R$23–R$45. MC, V. Daily 9am–6pm.

CAMPO GRANDE & THE SOUTH PANTANAL

1,221km (758 miles) NW of Rio de Janeiro, 902km (560 miles) NW of São Paulo

Campo Grande is a fairly new town and an important transportation hub for the region. When Mato Grosso state was split in two in the 1970s, Campo Grande became the capital of Mato Grosso do Sul. As with Cuiabá, there's nothing about Campo Grande that merits a visit, and most lodge packages will whisk you out of town right away. The Pantanal in Mato Grosso do Sul is less wild, more given over to cattle ranching, and significantly harder to access than in the north. That said, the avian life is still remarkable, and the lodges are larger, more established, and more luxurious by far.

As in the north, a stay in a Pantanal lodge normally involves a number of activities—a boat trip to spot birds and caimans, a horseback trip through the fields, bird spotting by foot or in an open vehicle, and often an evening excursion to see nocturnal animals. Some lodges also offer canoe trips, fishing expeditions, or specialized bird-watching outings. If you have a specialized interest, it's a good idea to make contact ahead of time.

The main road from Campo Grande to Corumbá, the BR-262, follows the southern border of the Pantanal, affording small inroads here and there, particularly around Miranda, Aquidauana, and toward Corumbá.

Essentials

GETTING THERE BY PLANE TAM (✆ **0800/570-5700** or 067/4002-5700; www.tam.com.br), **Gol** (✆ **0300/115-2121;** www.voegol.com.br), **TRIP** (✆ **0300/ 789-8747;** www.voetrip.com.br), and **Azul** (✆ **067/3003-2985;** www.voeazul. com.br) all have flights to Campo Grande. The city's airport (✆ **067/3368-6093**) is 7km (4¼ miles) west of downtown. A taxi to downtown (the best option) costs about R$25.

GETTING THERE BY BUS The bus station in Campo Grande is at Rua Dom Aquino and Rua Joaquim Nabuco (✆ **067/3321-8797**). Buses connect Campo Grande to Cuiabá (approx. 10 hr.), Bonito (5 hr.), and Corumbá (7 hr.).

VISITOR INFORMATION A **tourist information booth** is at the **airport** (✆ **0800/647-6050** or 067/3363-3116) and the **main bus terminal** (✆ **067/3382-2350**). Both are open 9am to 6pm Monday through Saturday, but neither offers English-speaking staff. However, they can offer a few maps of the city, and some information on the Pantanal, Bonito, and other sights of interest.

Banks Banco do Brasil, Av. Afonso Pena 2202 (✆ **067/3326-1064**), is open 11am to 4pm Monday to Saturday, with a 24-hour ATM.

Car Rental Try either **Localiza** (✆ **067/3363-4598**) or **Avis** (✆ **067/3325-0036**), both at Campo Grande airport.

Hospital In an emergency, go to **Hospital Santa Casa,** Rua Eduardo Santos Pereira 88 (✆ **067/3322-4000**).

Internet Access Virtual Cafe, Rua 14 Julho 1647 (✆ **067/3384-0092**), is open daily 8am to 8pm; the cost is R$6 per hour.

Tour Operators in the South Pantanal (Campo Grande)

It's worth contacting both the lodge and a tour operator and comparing prices. Often (though not always) the tour operator can offer a lodge package with airport pickup and transfers for the same cost or less than you might get booking directly with the lodge.

Located in Campo Grande, **Brazil Nature Tours** (✆ **067/3042-4659** or 9258-6581; www.brazilnaturetours.com) has some excellent packages for the Pantanal, for Bonito, and for combinations of the two. The agency is quick in responding to e-mail.

If you're just interested in the Pantanal, a 4-day, 3-night package tour at a Pantanal lodge including all meals and activities, with transfer from and to Campo Grande airport, starts at US$800 per person. Trips to Bonito include admission to a few of the most popular activities, such as a visit to the blue lake cave and snorkeling on the Rio Sucuri. A 4-day, 3-night Bonito trip starts at US$748 per person, including accommodations and transfers from and to Campo Grande. A 6-day, 5-night combo tour, with a 3-night stay in the Pantanal and a 2-night stay in Bonito, including all transfers, starts at US$1,330 per person.

Mostly geared toward backpackers, **Pantanal Trekking Tour,** Rua Jaoquim Nabuco 185, Campo Grande (✆ **067/3042-0508;** www.pantanaltrekking.com), offers more rustic 3- to 5-day overland trips through the Pantanal—mostly along the Estrada Parque, a dirt road through the South Pantanal—between Campo Grande and Corumbá. Trips include guides and activities such as horseback riding. The price depends on your itinerary and the number in your group, but starts at about R$250 per day per person.

Exploring Campo Grande & the South Pantanal

There's not much to keep you dawdling in Campo Grande. Those who are booked on package tours to Bonito or the Pantanal can time their arrivals to connect with their transfers onward, eliminating the need to stay in Campo Grande for a night.

Because of the distance and the difficulty of access, there is no 1-day option for the South Pantanal. Either commit to 3 days, or don't bother to come. The **Refugio Caiman** is one of the best ranches in the South Pantanal and a wonderful, cushy way to explore the ranch land and see some amazing wildlife. If you have a few extra days in this region, consider a 2-day side trip to Bonito to swim in the crystal-clear waters of the Rio Prata or Sucuri, and maybe try some rappelling or caving.

Where to Stay in Campo Grande

If you need to spend the night in town, try to book a room at the **Bristol Exceler Plaza Hotel,** Av. Afonso Pena 444, Campo Grande (*©* **067/3312-2800;** www. bristolhoteis.com.br). This hotel offers top-notch amenities including tennis courts, a swimming pool, and a sauna. The rooms are spacious and comfortably furnished, with tile floors, firm queen-size beds, and a small desk area. A double room goes for R$180 to R$210 (children 7 and under stay free in parent's room).

Where to Eat in Campo Grande

At **Casa Colonial,** Av. Afonso Pena 3997 (*©* **067/3383-3207;** www.casacolonial. com.br), the house special is grilled chicken (delicious!), *picanha* beef, or roasted pork. At the popular Portuguese restaurant **Acepipe,** Rua Eduardo Santos Pereira 645 (*©* **067/3383-4287**), the house specialty is *bacalhau* (cod), served grilled or with egg and onion. Surprisingly enough, Campo Grande is also a good city for Japanese food, a legacy of the Japanese laborers who worked building the railroad through the state in the 19th century. For a full-menu Japanese restaurant, try **Kendô,** Av. Alfonso Pena 4150 (*©* **067/3382-9000**); it's open Tuesday to Sunday 7pm to midnight.

Lodges in the South Pantanal (Campo Grande)

Fazenda Barranco Alto ★★ This South Pantanal farm lies on the Rio Negro, in a region known for its landscape of small salt lakes (called *salinas*) and freshwater ponds, as well as its large populations of animals and birds. Hyacinth macaws are common, as are trogons, jacamars, toucans, raptors, and several hundred other bird species. There are also capybaras and giant river otters. Jaguars are spotted now and then by the river (but no guarantees). The best time to visit is from March to October. For migrant birds, the best months are July to October. Bird-watching is popular. Other tours include horseback riding to spot animals or trips by jeep in search of tapirs, anteaters, marsh deer, giant otters, and others. There is also swimming, fishing, and canoeing. Guesthouse rooms are simply but comfortably furnished with firm double or single beds. All rooms have a private veranda. The best way to reach the fazenda is by plane from Campo Grande. The pilot charges R$3,500, which covers the flight in *and* out, for up to three people. In the dry season (Mar–Oct) you can also come in by 4×4. The 6-hour drive costs R$1,500 (in and out) with room for four to five people. Brazil Nature Tours offers packages (4 days/3 nights), including the flight from Campo Grande airport for US$1,919 per person.

Caixa postal 109, Aquidauana, 79200-000 MS. www.fazendabarrancoalto.com.br. *©* **067/9986-0373.** 4 units. R$440 per person per night, including meals, drinks (including beer), guides, and activities. Owner recommends staying 4 days, but there is no minimum. Children 5 and under stay free in parent's room, 6–13 50% adult rate. AE, MC, V. **Amenities:** Internet. *In room:* A/C, no phone.

Pousada Aguapé ★ Though still a working ranch, the Aguapé has largely transformed into a tourism and fishing lodge. It's located on 60km (37 miles) of dirt road from Aquidauana, itself 130km (81 miles) of paved highway from Campo Grande. Accommodations are in comfortable but simple rooms. Activities include horseback riding, trail walking, fishing for piranhas, a boat tour on the Aquidauana River, a nighttime search for caimans, and some time helping out with the cattle. The grounds are well equipped for downtime, with a pool, volleyball court, and soccer pitch. Avid fishermen can skip the eco-tourism activities and make use of the boats and drivers to fish the Aquidauana.

Rua Marechal Mallet 588, Aquidauana. ☎ **067/3258-1146** or 9986-0351 (cellphone). www.aguape.com.br. 15 units, showers only. Packages start at US$880 per person (double room), including excursions, meals, and transfers from Campo Grande. Children 3 and under stay free in parent's room. AE, DC, MC, V. Free parking. **Amenities:** Restaurant; bar; pool. *In room:* A/C, no phone.

Refugio Caiman ★★ ☺ ✋ The most luxurious lodge in the Pantanal, the Refugio Caiman is set on a huge cattle ranch outside the town of Miranda, about 250km (155 miles) from Campo Grande. We have given this place an overrated icon because it is by far the most expensive lodge in the Pantanal, and the staff really does its best to "hold your hand," making you feel, unfortunately, like just another tourist. However, the facilities are very comfortable and the wildlife population is still quite stunning. Huge jabiru storks, flocks of roseate spoonbills, egrets of all shapes and sizes, caimans, and capybaras can all be seen within steps of the lodge. Hyacinth macaws are frequently spotted. Soft-adventure activities here are very safe—perfect for families with young children. Excursions are geared to those who lack the fitness level for longer hikes or expeditions. Listed below are the rack rates; transportation from Cuiabá is not included. The lodge can arrange this for R$147 per person, one-way. Individual reservations can only be made for the period from mid-June to December. Contact tour operators for less expensive packages that include transfers. *Note:* Children 7 and under are only accepted in December, January, and July.

Reservations: Av. Brigadeiro Faria Lima 3015, cj. 161, Itaim Bibi São Paulo. www.caiman.com.br. ☎ **011/3706-1800;** lodge ☎ **067/3242-1450.** 25 units. R$550–R$750 per person per night, including all meals, guides, activities, and insurance. Children 11 and under stay free in parent's room. AE, DC, MC, V. Free parking. **Amenities:** Restaurant; bar; outdoor pool. *In room:* A/C, no phone.

A SIDE TRIP TO BONITO

300km (186 miles) SW of Campo Grande

You have to admire Bonito. Though located in the middle of nowhere—it's 300km (186 miles) from Campo Grande, and Campo Grande is *already* the end of the earth for most Brazilians—this small town has turned itself into a prime eco-tourism destination for Brazilians and foreigners who come to snorkel, raft, and rappel. To accommodate these eco-tourists, Bonito's tourism industry has created the kind of collusion that would make oil companies envious. All excursions cost the same, no matter where and how you book them. All trips are guided, numbers are capped each day, and transportation is not provided. Only taxis offer transportation and—you guessed it—they all charge the exact same fare. Brazilians first arrived after the town was featured in a nightly soap opera (if the moon had been featured in one of those *novelas,* the Brazilians would have been the first ones to land there), and more and more international travelers are drawn to Bonito as well.

The attraction is not the town. What people come for are the rivers; the numerous streams that bubble up from the substrate of limestone rock are so free of impurities that you get the kind of crystal-clear visibility normally found only in tropical oceans. You can see 21 to 30m (70–100 ft.) in these fast-flowing rivers, and they're full of freshwater *dourado* and *pintado,* not to mention the occasional anaconda. The area also has numerous caves and waterfalls. However, all of the prime terrain is on private land and you're only allowed on as part of an excursion.

Is the trip worth it? It's a long way to go, but the rivers are fun and fascinating. It's also instructive to see this little town in action, gouging tourists who fork over the bucks as a matter of course. A package tour with transportation and admission is recommended; you will get no better prices once you get there, and at least it'll save the frustration of opening your wallet every time you want to do something.

Essentials

GETTING THERE BY PLANE The fastest way to get to Bonito is to fly. **TRIP** (☎ **3003-8747** or 0300/789-8747; www.voetrip.com.br) offers flights between Campo Grande and Bonito twice a week, on Sunday and Thursday, departing at noon. Return flights from Bonito to Campo Grande depart on the same days, at 12:55pm. Flying time is 30 minutes and one-way airfare starts at R$159.

GETTING THERE BY CAR To reach Bonito take the BR-060 from Campo Grande to Guia Lopes da Laguna and then the MS-382 to Bonito. Count on a 4-hour drive.

GETTING THERE BY BUS From Campo Grande, take **Viação Cruzeiro do Sul** (☎ **067/3312-9700;** www.cruzeirodosulms.com.br). Tickets cost R$55, and the bus ride takes about 5 hours. Daily departures are at 7am, 9am, 11am, 4pm, and 6pm (call to confirm).

VISITOR INFORMATION The official **tourist office** is at Rua Cel. Pilad Rebuá 1780 (☎ **067/3255-1850**); it's open daily from 9am to 5pm. The Bonito tourist information site is **www.portalbonito.com.br**.

GETTING AROUND Getting around Bonito without a car means getting gouged by taxis. Tour operators don't provide transportation; taxi companies all charge the same high rates. If you haven't come with a package tour, think seriously about renting a car. Contact **Agência Ar Bonito** to reserve a vehicle (☎ **067/3255-1008** or 3255-1897).

FAST FACTS **Banco do Brasil** is at Rua Luiz Costa Leite 132 (☎ **067/3255-1121**). For Internet access, try **Rhema Cópias Lanhouse,** Rua Pilad Rebuá 1626 (☎ **067/3255-4271**); it's open daily from 8:30am to 10pm, and charges R$8 per hour.

Exploring the Area

All of the activities listed below (plus quite a few others) are sold through tour operators in Bonito. One operator with a good English website is **Ygarapé Tour,** Rua Pilad Rebuá 1823 (☎ **067/3255-1733;** www.ygarape.com.br). Every tour operator offers the same packages at the same price, so don't waste time shopping around. Numbers are limited, so it's key to book your excursions as early as possible. Avoid long weekends and high season in January, February, and July if you can; the popular trips fill up quickly.

All activities are guided. If you are a real outdoors do-it-yourselfer, Bonito will drive you insane. On the other hand, if you are a novice adventurer or are traveling with young children or older people, this is the perfect environment to try some rafting, snorkeling, or hiking. If you are driving, ask for detailed directions; some of these attractions can be tricky to find. The prices listed below are for the peak season. Some of the tours offer a small discount (up to 20%) in the low season.

Aquario Natural ★ The best known of the springs and rivers that people swim in is the Aquario Natural. Starting at the wellspring of the Rio Baia Bonita, you snorkel a .5km (½-mile) stretch of crystal-clear river with amazing underwater views of fish. The downside is that this is also the busiest excursion, and your time on the river (an hour or so) is shorter than some of the others.

Road to Jardim, Km 7. www.aquarionatural.com.br. R$109–R$150.

Cachoeira do Rio do Peixe For a more mellow activity, take a visit to the waterfall of Rio do Peixe. Over 10m (30 ft.) tall with crystal-clear pools and caves to swim in, it's a great spot to spend a hot afternoon.

Road to Bodoquena, Km 35. R$95–R$115.

Floating the Sucuri ★★ First you walk through the forest to see where the Sucuri River gurgles up through limestone fissures. A bit farther down, once the river has gained some depth and momentum, you get in the water for your 2km (1¼-mile) snorkel trip. It's like floating in an aquarium with an amazing number of fish to look at. Drift and enjoy the view.

Road to São Geraldo, Km 20. R$131–R$151, includes lunch.

Gruta do Lago Azul Tour operators promote this tour as a must-see, which is likely why it's always packed. Every 15 minutes, a group sets off on the 351m (1,170-ft.) trail into the 69m-deep (230-ft.) cave. The calcium formations are certainly cool—amazing stalactites, stalagmites, stone flowers, and dish-shaped travertine. The lake at the bottom is an eerie clear blue; it's also fenced off to prevent people from sticking in their little fingers or toes. While you make your way back up, the next two groups will already be on their way down. From mid-December to mid-January, from 8:30 to 9:30am, the sun hits the lake directly—an impressive sight.

Road to Campo dos Indios (Fazenda Jaraguá). R$36.

Rafting on the Rio Formosa The rapids are nothing to write home about, but it is a peaceful float. This 7km (4¼-mile) trip takes you over some small rapids, and you'll stop along the way for a swim in some of the waterfalls. Keep your eyes peeled for birds, monkeys, and butterflies.

Road to Ilha do Padre, Km 12. R$75.

Rappelling and Snorkeling in Anhumas Abyss ★★★ Book ahead for this most popular adventure, especially during weekends or holidays. If you have never rappelled before, you will learn how and be provided with all the gear for the grand descent of 72m (236 ft.) into an abyss packed with stalactites and stalagmites. At the bottom you can snorkel in the crystal-clear water.

Road to Campo dos Indios (Fazenda Jaraguá). R$465.

Where to Stay

Aguas de Bonito ★ The Aguas is more like a small resort, with an outdoor pool and whirlpool, and lighted tennis courts. In addition to breakfast, an afternoon snack is included as well. The rooms are tile-floored and spotless, featuring a double or two single beds, plus a clean, functional bathroom. Each room comes with a small veranda and hammock. The best ones are on the second floor of the two-story chalets.

Rua 29 de Maio 1679, Bonito, 79290-000 MS. www.aguasdebonito.com.br. © **067/3255-2330.** 30 units. High season (Dec–Feb and July) R$256–R$296 double; low season R$197–R$228 double. Extra person add 25%. Children 6 and under stay free in parent's room. MC, V. Free parking. **Amenities:** Restaurant; bar; Jacuzzi; outdoor pool; lighted tennis courts. *In room:* A/C, TV, fridge, minibar.

Santa Esmeralda ★★ Perhaps the nicest place in all Bonito, Santa Esmeralda is located in a green piece of parkland on the banks of the Rio Formosa. Accommodations are in pretty, self-contained bungalows, each with a hammock and a broad front veranda. Guests can swim in the river, or lounge in the natural pools and small waterfalls, or go for a paddle in the complimentary kayaks. There's a pleasant outdoor restaurant, where both breakfast and dinner (included) are served. The only potential drawback is the location, a 17km (11-mile) drive out of town.

Rodovia Guia Lopes Km 17, Bonito, 79290-000 MS. www.hotelsantaesmeralda.com.br. © **067/ 3255-2683** or 9986-4580. 16 units. R$346–R$428 double. Extra person add R$80. Children 5 and under stay free in parent's room. Rates include breakfast and dinner. AE, DC, MC, V. Free parking. **Amenities:** Restaurant; outdoor pool. *In room:* A/C, TV, fridge, no phone.

Wetiga ★★ This beautiful, modern hotel with an innovative design features extensive use of *aroeira* tree trunks in its structure. The hotel is built in a U around a central reflecting pool, so most units have pleasant balconies overlooking the pool. Rooms are new and modern, with tile floors and queen-size beds with nice linen. The restaurant (in the low season, dinner is also included) serves innovative cuisine using local ingredients, with the option of outdoor dining by the pool. Check the website for packages and special offers.

Rua Coronel Pilad Rebuá 679, Bonito, 79290-000 MS. www.wetigahotel.com.br. © **067/3255-1699.** 67 units, showers only. R$285–R$360 double. Rates include dinner in low season. Extra person add 25%. Children 4 and under stay free in parent's room. MC, V. Free parking. **Amenities:** Restaurant; bar; Jacuzzi; outdoor pool. *In room:* A/C, TV, fridge, minibar.

Where to Eat

Aquária Restaurante SEAFOOD Dine on the main-street patio—you'll see all of Bonito file by. The food is simple home cooking, with lots of local fish such as grilled *pintado* or *dourado* served with a mushroom caper sauce. All dishes are served with rice, fries, and salads and are plenty for two. There are also individual churrasco plates such as the *picanha* with fries and salad for R$12.

Rua Pilad Rebuá 1883. © **067/3255-1893.** Main courses R$22–R$35. No credit cards. Daily 10am–4pm and 6–11pm.

Cantinho do Peixe BRAZILIAN The best fish place in town serves up locally caught *pintado* and *dourado,* simply grilled and served with lots of *farofa* and fries on the side. The menu also includes chicken and various grilled beef dishes.

Rua 31 de Março 1918. © **067/3255-3381.** Main courses R$18–R$28. No credit cards. Daily 11am–3:30pm and 6:30pm–midnight.

Taboa Bar BRAZILIAN Taboa is the nighttime gathering place. Sidewalk tables pack the street, and inside, locals and visitors quickly fill up the tables. The drink of choice is *cachaça;* the house special is served with honey, cinnamon, and *guarana* powder. For food there are starters such as the *caldinho de feijão,* a tasty bean soup, as well as small plates with grilled fish, chicken, or beef.

Rua Pilaud 1837. © **067/3255-1862.** www.taboa.com.br. Everything under R$25. No credit cards. Daily 5pm–2am.

CORUMBÁ & THE SOUTH PANTANAL

351km (218 miles) NW of Campo Grande

If you have a taste for real adventure consider exploring the region in the far southwest corner of the Pantanal, around Corumbá. For hundreds of years, the only route to Corumbá was by water, either across the Pantanal by canoe or up the Paraguay River by boat through Argentina and Paraguay. A railway linking Corumbá to Campo Grande wasn't built until the early 20th century and a road wasn't built until the 1970s. The isolation has left the Pantanal around Corumbá more pristine than in more settled places farther east. But the difficulty of access has been a challenge to the city's eco-tourism operators. Corumbá's one true forte is sport fishing. The Paraguay River offers larger, more varied sport fish than anywhere else in Brazil, as well as a better fishing infrastructure. There are lodges, camps, and even floating lodges that cruise up the river, allowing guests to fish away the day and relax with a cold beer in the evening. Eco-tourism also exists. Many of the lodges have fishing and eco-tourism options, allowing visitors to combine the two.

Essentials

GETTING THERE

BY PLANE TAM (© 0800/570-5700 or 067/4002-5700; www.tam.com.br) and **TRIP** (© 3003-8747 or 0300/789-8747; ww.voetrip.com.br) offer daily flights to Corumbá via Campo Grande. Corumbá's airport is 5km (3 miles) north of downtown on Rua Santos Dumont (© 067/231-3322).

BY BUS The bus station is on Rua Porto Carrero (© 067/3231-2033), about 3km (2 miles) west of downtown. **Andorinha** (© 067/3231-2033 or 0300/210-3900; www.andorinha.com) has 10 buses per day to Campo Grande (approx. 6 hr.); the cost is R$76 to R$92.

Tour Operators in the Corumbá Pantanal

Local tour operators can set up all the logistics of your journey, sometimes at a cheaper rate than if you can contact the lodge directly. It's worth making contact, if only to compare prices. Operators in Corumbá have, in recent years, been eager enough for business to offer serious discounts. **Pantur** (© 067/3231-2000; www.pantur.com.br) offers day tours along the Estrada Parque into the Pantanal, and fishing expeditions along the Paraguay. **Perola do Pantanal** (© 067/3231-1470/1460; www.peroladopantanal.com.br) specializes in multiday fishing expeditions along the Paraguay, but also offers photo safaris along the Estrada Parque. **Canaã Viagens e Turismo** (© 067/3231-3667; www.pantanalcanaa.com.br) also specializes in fishing expeditions, but offers a few eco-tourism options as well. Generally speaking, a 5-day, 4-night eco-tourism adventure includes accommodations at a Pantanal fazenda, horseback-riding trips, and wildlife-watching, and starts at about R$1,400 per person.

Lodges in the South Pantanal (Corumbá)

Note: The lodges listed below also regularly arrange transfers from Campo Grande. They also offer both eco-tourism trips and sport-fishing packages. Both lodges are

located off the **Estrada Parque (Park Rd.),** a little-traveled dirt and gravel road crisscrossed by innumerable small watercourses that—much like the Transpantaneira in the North—offer tremendous wildlife-viewing opportunities.

Fazenda Xaraés ★ Located by the banks of the Rio Abobral, the Xaraés is very much a fazenda (ranch) experience, with visits to the corrals, rides in bullock carts, and outings to herd the cattle. In addition to horseback riding, guests can take advantage of the river to set out for self-guided paddles, as well as motorized bird-watching, night hunts for caimans, and 4×4 photo safari expeditions. Accommodations are in rustic but comfortable quarters by the riverbank. There's also a pleasant ranch-style main house, with a bar, snooker table, and small library. Access to the fazenda is over a rough 13km (8-mile) track, in a 4×4 provided by the hotel. Meals are included.

Estrada Parque Km 17, Abobral, Corumbá. www.xaraes.com.br. ✆ **067/9906-9272.** Fax 018/9906-9282. 17 units, showers only. R$330 per person, includes all meals and guided activities. Children 5 and under stay free in parent's room, children 6–12 50% of adult rate. V. Free parking. Access by 4×4 from Miranda. **Amenities:** Restaurant; bar; outdoor pool. *In room:* A/C, TV, fridge.

Pantanal Park Hotel ★ Set on the shores of the Paraguay River, this lodge specializes in fishing trips. For eco-tourists, there's horseback riding, bird spotting, piranha fishing, and nighttime caiman-spotting trips. Accommodations are in small chalet buildings, with four apartments per building. These vary in quality. The most basic ones—on the ground floor of the buildings—are clean and comfortable, with firm single beds and functional bathrooms. The more luxurious upstairs rooms have a screened-in sitting area with TV, couches, and chairs. Common lodge areas include a large outdoor pool and restaurant/bar with nightly karaoke. All meals are included.

www.pantanalpark.com.br. Reservations: ✆ **018/3908-5332.** Fax 018/3908-1333. Lodge: ✆ **067/3275-1500** or 9987-3267. 41 units, showers only. R$640 per person 3-day package. Children 4 and under stay free in parent's room, children 5–10 years old R$480. AE, DC, MC, V. Free parking. Access by boat from the Paraguay River bridge in Porto Morrinho. **Amenities:** Restaurant; bar; large outdoor pool. *In room:* A/C, TV, fridge, no phone.

PLANNING
YOUR TRIP
TO BRAZIL

B
razil is a vast, sprawling country, with much to see and do—
from the Amazon rainforests to the civilized beaches of Rio
to the restored colonial buildings of Salvador and the
hundreds of frolicking dolphins of Fernando de Noronha. This
chapter helps you figure out where to begin: how to get there; what pre-
cautions to take; and best of all, how to save money on your trip.

GETTING THERE
By Plane

The major international gateway to Brazil is São Paulo's **Guarulhos
international airport** (**GRU;** www.aeroportoguarulhos.net). Most inter-
national airways have flights to Guarulhos, and it is possible to connect to
all other cities in Brazil from there. The other major gateway is Rio de
Janeiro's **Galeão international airport** (**GIG;** www.aeroportogaleao.
net). Though a modern international airport, Galeão has fewer direct
flights to other Brazilian cities; you may have to connect through São
Paulo or Brasilia.

The two big Brazilian airlines—**Gol** and **TAM**—also operate a number
of international flights. **TAM** (**℃ 888/2FLY-TAM** [235-9826] in the
U.S. and Canada, 020/8897-0005 in the U.K., or 0800/570-5700 in Bra-
zil; www.tam.com.br) has the most international connections to North
America, Europe, Asia, and the rest of South America. Low-budget carrier
Gol (**℃ 0300/115-2121** in Brazil; www.voegol.com.br) offers service to
a number of South American destinations (Argentina, Chile, Peru, and
Bolivia), a good alternative for those traveling within South America.

GETTING AROUND
By Plane

The sheer vastness of Brazil (and the absence of rail travel) makes air
travel the only viable option for those who want to visit a variety of cities
and regions. A number of domestic carriers cover most of the country and
tickets are quite affordable, especially if you purchase ahead of time and
fly outside of peak hours. During peak travel times (holidays, high season)
long delays are not an unlikely occurrence. Brazil's biggest domestic

Domestic Travel Do's and Don'ts

There are a few tricks to avoiding delays and cancellations when flying domestically in Brazil. **First,** if possible, avoid flying through São Paulo. That may be hard to do; the city serves as Brazil's major hub, and its airports as a result have a tendency to get clogged and backed up. **Second,** travel early in the day: Delays tend to accumulate throughout the day and lead to bigger and bigger backlogs. **Third,** don't book tight connections, especially if you have to transfer from the domestic airport in Rio or São Paulo to the international airport. For a connection within the same airport, give yourself an hour. For a transfer from domestic to international airports, allow for at least 2 hours in Rio and 3 hours in São Paulo.

airlines are **TAM** (© 0800/123-100 in Brazil; www.tam.com.br) and **Gol** (© 0300/789-2121 in Brazil; www.voegol.com.br). This airline has modeled itself after American discount carriers like Southwest Airlines—quick bookings online and no-frills flights between nearly every significant city in Brazil. The company flies brand-new Boeing 737s and provides friendly and efficient service.

In the past couple of years a number of lower-cost airlines have sprung up, offering competitive and often cheaper fares between Brazilian cities. These newcomers include **Azul** (© 011/3003-2985; http://viajemais.voeazul.com.br), **Ocean Air** (© 0300/789-8160; www.oceanair.com.br), **TRIP** (© 011/3003-8747; www.voetrip.com.br), and **Webjet** (© 0300/210-1234; www.webjet.com.br).

For those traveling larger distances in Brazil there is also the option of purchasing an **air pass** with TAM or Gol (much to the envy of Brazilians, air passes are only available to foreigners). These passes offer travelers four flights within a 21-day period. Air passes need to be purchased and booked outside of Brazil. Only limited changes are allowed once you arrive in the country. Also, it's a good idea to read the small print before choosing your pass. Often flights between Rio's and São Paulo's downtown airports are excluded (meaning you have to use the international airports) and the pass does not allow round-trips on the same stretch.

TAM (© 0800/123-100 in Brazil; www.tam.com.br) offers four segments for US$553 if you arrive on an international TAM flight (or one of its partners). The pass is valid for 21 days. Check TAM's special English-language site for more details on the air pass (www.tamairlines.com). **Gol** (© 0300/789-2121 in Brazil; www.voegol.com.br) also offers an air pass for the northeast of Brazil with four flights for US$390, including major destinations such as São Luiz, Fortaleza, Natal, and Salvador. If you're traveling to only one or two destinations within Brazil, it can be cheaper to skip the air pass and buy a separate ticket. U.S.-based Brazil travel specialist **Brol** (www.brol.com) has a great air pass booking tool on its website for convenient step-by-step reservations. Make sure you read the terms and conditions before traveling to Brazil as the air pass must be purchased outside of the country.

By Car

Car rentals are expensive, and the distances are huge. From Recife to Brasília is 2,121km (1,315 miles); Salvador to Rio is a 1,800km (1,116-mile) drive. Within Brazilian cities, renting a car is only for the confident driver. Brazilian drivers are

aggressive, rules are sporadically applied, and parking is a competitive sport. That said, there are occasions—a side trip to the mountain resorts of Rio, a visit to the historic towns of Minas Gerais, or a drive to the Chapada dos Guimarães outside of Cuiabá—where a car makes sense.

A two-door compact car rental (Fiat Palio, Ford Ka) with air-conditioning and unlimited mileage costs about R$100 to R$125 per day, plus some R$20 to R$30 for insurance. Most rental cars in Brazil work on either unleaded gasoline or ethanol. Gasoline costs about R$3 per liter, and ethanol costs about R$2.35 per liter.

Officially you need an international driver's license, but we have never encountered any problems having a U.S., Canadian, or European license. To obtain an international license, contact your local automobile association. While expensive, comprehensive insurance is probably a good idea. Brazilian drivers believe that bumpers are meant to be used, and if a bit of nudging is required to get into that parking spot, so be it.

Speed limits within the cities range from 40kmph to 70kmph (25mph–43mph). Many cities have radar and automated monitoring. Fines are expensive—R$100 to R$500, depending on how fast you're going. Highway speed limits range from 90kmph to 120kmph (56mph–75mph), but are much less rigorously enforced.

Brazilians mark accident sites by leaving cut branches or small piles of leaves on the road. If you see such a pile of foliage on the tarmac, it means there's an accident ahead. Slow down. It's a good idea to seek local information about the state of the roads on the route you plan to travel. Brazilian roads have been improving, but some can still be potholed and difficult. Ask locals or your local rental agency for alternative routes.

The following agencies have offices in most airports and major cities in Brazil: **Avis** (www.avis.com.br), **Hertz** (www.hertz.com.br), **Localiza** (www.localiza.com), and **Unidas** (www.unidas.com.br). To rent a car you need a passport and valid driver's license.

By Bus

Bus travel in Brazil is comfortable, efficient, and affordable. The only problem is, it's a long way from anywhere to anywhere else. A trip from Rio to São Paulo takes 6 to 8 hours, from Rio to Brasilia closer to 20 hours.

There are a vast number of bus companies, serving various regional routes. There is no nationwide bus company. To find out which bus company travels to your desired destination, contact the bus station in your city of origin, and they will pass on the number of the appropriate company. This can be tricky if you don't speak Portuguese. Fortunately, however, the bus stations in major cities now have websites, which allow you to select your destination from a drop-down menu, and then provide the departure times, price, and the name of the bus company. You can often also purchase tickets online. Tickets can be purchased ahead of time with reserved seats. All buses are nonsmoking. On many popular routes, travelers can opt for a deluxe coach with air-conditioning and *leito* (seats that recline almost flat).

TIPS ON ACCOMMODATIONS

Brazil offers a wide range of accommodations. In the large cities there are modern high-rise hotels as well as apartment hotels (or rental flats, for you Brits) known in Brazil as apart-hotels. The apart-hotels are often a better deal than regular hotel

, offering both cheaper rates and more space: a separate living room, bedroom, and kitchen. The drawback is that you sometimes don't get the pool, restaurants, and other amenities of a hotel.

Some of the better hotels that you will find in Brazil are among the **Accor Group** (www.accorhotels.com.br). This French company operates a number of brands such as the Sofitel luxury hotels and the more affordable Mercure, Ibis, and Formule 1. The Ibis and Formule 1 chains generally offer clean and reliable but no-frills accommodations.

A more high-end chain with numerous new properties is the **Meliá** (www.sol melia.com). The **Blue Tree** (www.bluetree.com.br) is also represented in many Brazilian cities. A relative newcomer is the **Atlantica Hotels** (www.atlanticahotels.com.br) chain. Some of its best-known brands are the **Comfort Suites** and **Quality.** Both are good, affordable hotels with modern amenities.

Outside of the large cities you will often find **pousadas,** essentially equivalent to a bed-and-breakfast or small inn. A great resource for finding some of Brazil's best pousadas is **www.hiddenpousadas.com**, with well-written reliable information in English. Accommodations prices fluctuate widely. The rates posted at the front desk—the rack rate or *tarifa balcão*—are just a guideline. Outside of high season and peak travel days you can almost always negotiate significant (20%–30%) discounts. High season is from mid-December to Carnaval (mid- to late Feb), Easter week, long weekends, and July (winter vacation). Notable exceptions are Brasilia and São Paulo, where rooms are heavily discounted during the typical high season and weekends.

Tip: Always check the quotes you have obtained from a hotel with a travel agency such as **Brazil Nuts** (www.brazilnuts.com), as many hotels will give their best rates to travel agents and stick it to individual travelers or those who book via the Internet. For example, the Sofitel quoted us a price of R$960 for a room, whereas Brazil Nuts can sell you that same room for R$640.

Brazilian hotel rooms generally do not feature coffeemakers, irons, or ironing boards, although the latter can sometimes be delivered to your room upon request. Even in luxury hotels, the complimentary toiletries are usually very basic, so pack your own. On the other hand, **breakfast** (*café de manha*) at Brazilian hotels is almost always included in the room price and at most places includes a nice buffet-style spread including bread, meats, cheeses, fruit, eggs (sometimes), and *café com leite,* strong coffee served with hot milk. In recent years, a few of the more expensive hotels have taken to charging for *café de manha;* if this is the case it's noted in the review.

Accommodations **taxes** range from nothing to 15%, varying from city to city and hotel to hotel. Always check in advance.

FAST FACTS: BRAZIL

Area Codes Brazil's country code is **55.** For city codes, see Fast Facts in each chapter.

Business Hours Stores are usually open from 9am to 7pm weekdays, 9am to 2pm on Saturdays. Most places close on Sundays. Small stores may close for lunch. Shopping centers are open Monday through Saturday from 10am to 10pm. On Sundays many malls open the food court and movie theaters all day, but mall shops will only open from 2 to 8pm. Banks are open Monday through Friday either from 10am to 4pm or from 9am to 3pm.

Car Rental See "By Car" under "Getting Around," above.

Cellphones See "Mobile Phones," later in this section.

Crime See "Safety," later in this section.

Customs As a visitor you are unlikely to be scrutinized very closely by Brazilian Customs; however, there are random checks, and your luggage may be thoroughly inspected. Visitors are allowed to bring in whatever they need for personal use on their trip, including electronics such as a camera and laptop. Gifts purchased abroad worth more than US$500 must be declared and are subject to duties for the value over US$500. Merchandise for sale or samples should also be declared upon arrival.

For information on what you're allowed to bring home, contact one of the following agencies:

Australian Citizens: Australian Customs Service (✆ **1300/363-263;** www.customs.gov.au).

Canadian Citizens: Canada Border Services Agency (✆ **800/461-9999** in Canada, or 204/983-3500; www.cbsa-asfc.gc.ca).

New Zealand Citizens: New Zealand Customs (✆ **04/473-6099** or 0800/428-786; www.customs.govt.nz).

U.K. Citizens: HM Customs & Excise (✆ **0845/010-9000;** from outside the U.K.: 020/8929-0152; www.hmce.gov.uk).

U.S. Citizens: U.S. Customs & Border Protection (CBP) (✆ **877/287-8667;** www.cbp.gov).

Disabled Travelers Travelers with disabilities will find Brazil challenging. Those who use a wheelchair to get around will find that very few places are accessible. In the large cities, increasing numbers of hotels, restaurants, and attractions are making themselves accessible. The trick lies in getting to them. Sidewalks are often uneven, ramps are usually absent, and buses and taxis are not adapted to handle a wheelchair. City Metrô systems in Rio and São Paulo are beginning to provide ramps and elevators, but not all stations are equipped. To inquire about wheelchair accessibility, ask *"Tem acesso para cadeira de rodas?"* (is there wheelchair access?).

Drinking Laws Officially, the legal drinking age in Brazil is 18, but it's not often enforced. Beer, wine, and liquor can be bought on any day of the week from grocery stores and snack stands. Drinking is allowed in public places. For drivers, the legal alcohol limit is 0.00 (*tolerância zero* or zero tolerance). This is now strictly enforced with roadside checks.

Driving Rules See "Getting Around," earlier in this chapter.

Electricity Brazil's electric current varies from 100 to 240 volts, and from 50 to 60Hz. Most laptop or battery chargers can handle the full range of voltage, but always check your appliance before plugging it in. Most hotels do a good job of labeling their outlets, but when in doubt always ask; some may even have both voltages in the same room. Traditional Brazilian plugs have three prongs: two round and one flat. All new plugs have three round plugs, but not all outlets have been adapted. Adapters for converting plugs are cheap and can be found in most markets or hardware stores (ask for an *adaptador*).

Embassies & Consulates All embassies are located in Brasilia, the capital. Australia, Canada, the United States, and Great Britain have consulates in both Rio and São Paulo. New Zealand has a consulate in São Paulo.

In Brasilia: The **Australia Embassy** is at SES, Quadra 801, Conjunto K, lote 7 (✆ **061/3226-3111;** www.brazil.embassy.gov.au). The **Canada Embassy** is at SES Av. das Nações Quadra 803, lote 16 (✆ **061/3424-5400;** www.canada.org.br). The Embassy of **Great Britain** is at SES Av. das Nações Quadra 801, lote 8 (✆ **061/3329-2300;** www.uk.org.br). The **New Zealand Embassy** is at SHIS QI 09, conj. 16, casa 01 (✆ **061/3248-9900;** www.nzembassy.com/home.cfm?c=44). The **United States Embassy** is at SES Av. das Nações Quadra 801, lote 03 (✆ **061/3312-7000;** www.embaixada-americana.org.br).

See Fast Facts in the individual chapters for information on local consulates.

Emergencies For police dial ✆ **190;** for ambulance or fire dial ✆ **193.**

Family Travel Brazilians love kids. They will go out of their way to please children—you will see children out and about here, even at restaurants, bars, or late-night events. Traveling with children is a wonderful way to meet Brazilians, as people will be receptive, friendly, and inquisitive. Hotels are very accommodating but do usually charge 10% to 25% extra for children over the age of 6 or 12 who stay in the same room as a parent or guardian. In most hotels, the age limit and the amount of extra percentage charged can be flexible and is certainly worth bargaining over.

If a child is traveling with people other than his or her parents, or even if the child is only traveling with one of his or her parents, it is a good idea to have a notarized letter from the parents confirming permission for the child to travel. Buses and airlines sometimes demand such a letter before allowing a child to board. For even greater safety, have the notarized letter stamped by the Brazilian consulate or embassy. (Please contact the Brazilian consulate or embassy for further information.) To locate accommodations, restaurants, and attractions that are particularly kid-friendly, refer to the "Kids" icon throughout this guide.

Gasoline Please see "By Car" under "Getting Around," earlier in this chapter.

Health Standards for hygiene and public health in Brazil are generally high. Before leaving, however, check with your doctor or with the **Centers for Disease Control** (www.cdc. gov) for specific advisories. Use common sense when eating on the street or in restaurants.

If you do wind up with traveler's tummy or some other ailment (upset stomach, diarrhea, sunburn, or rash), Brazilian pharmacies are a wonder. Each has a licensed pharmacist who is trained to deal with small medical emergencies and can make recommendations for treatment. The service is free and medication is fairly inexpensive. If you take medication that may need replacement while in Brazil, ask your doctor to write out the active ingredients of the prescription, as many drugs are sold under different trade names in Brazil. Many drugs available by prescription only in the U.S. and Canada are available over-the-counter in Brazil. While this is incredibly convenient, the downside is that Brazilians are the world's biggest pill-poppers who will happily "prescribe" drugs for themselves or their relatives or friends at the slightest whiff of sickness.

Here are some common ailments to watch for in Brazil:

DENGUE FEVER Dengue fever is a viral infection transmitted by mosquitoes. It's unfortunately common in Rio de Janeiro. It's characterized by sudden-onset high fever, severe headaches, joint and muscle pain, nausea/vomiting, and rash. (The rash may not appear until 3–4 days after the fever.) Proper diagnosis requires a blood test. The illness may last up to 10 days, but complete recovery can take 2 to 4 weeks. Dengue is rarely fatal.

The risk for dengue fever is highest during periods of heat and rain, where stagnant pools of water allow mosquitoes to breed. Though it strikes most often in poorer communities, the disease has infiltrated Rio's more affluent neighborhoods. There is no vaccine for dengue fever. Symptoms can be treated with bed rest, fluids, and medications to reduce fever, such as acetaminophen (Tylenol); aspirin should be avoided. The most important precaution a traveler can take is to avoid mosquito bites in dengue-prone areas. Try to remain in well-screened or air-conditioned areas, use mosquito repellents (preferably those containing DEET) on skin and clothing, and sleep with bed nets. For up-to-date information on the status of dengue fever in Brazil, consult the Centers for Disease Control website (www.cdc.gov) before departing.

INSECT/ANIMAL BITES Tourists rarely encounter snakes and are even more rarely bitten. You'll find ticks most everywhere in Brazil, but the only place I considered them a

nuisance was hiking in highland areas like the Chapada Diamantina inland from Salvador or the Chapada Guimarães near Cuiabá.

MALARIA There is malaria endemic to the Amazon or the Pantanal, though it's not very common. Still, a malaria prophylaxis (usually pills that you take daily) may be recommended.

SUN EXPOSURE The Brazilian sun is very strong, particularly in summer (winter in the northern hemisphere). Frequently apply sunscreen (of at least SPF 15).

SEXUALLY TRANSMITTED DISEASES According to recent UN statistics, Brazil has the dubious honor of ranking third in the world for total number of people with HIV infections. Though condom usage is becoming more accepted, the reality is that some people still won't use them, and AIDS and other STDs are still being spread. So be careful and be safe—always insist on using a condom. Condoms are readily available in Brazilian pharmacies; to purchase condoms in Brazil ask for a *preservativo* or a *camisinha* (kah-mee-zeen-ya), literally a small shirt; the latter word is the commonly used term for condom.

Insurance For information on traveler's insurance, trip cancellation insurance, and medical insurance while traveling, please visit www.frommers.com/planning.

Internet & Wi-Fi Web access is widespread in Brazil; practically every hotel offers Internet service, often free of charge. Internet cafes are inexpensive and ubiquitous. Even in the smallest of towns we found at least one Internet cafe. Prices generally range from US$1 to US$4 per hour.

Language The language of Brazil is Portuguese. If you speak Spanish you will certainly have an easier time picking up words and phrases, but Spanish speakers often underestimate how different Portuguese is. In the large cities you will find people in the tourism industry who speak English well, but in smaller towns and resorts English is very limited. If you are picking up language books or tapes, make sure they are Brazilian Portuguese and not Portuguese from Portugal: big difference! A good pocket-size phrase book is *Say It in Portuguese* (Brazilian usage) by Prista, Mickle, and Costa, or try *Conversational Brazilian Portuguese* by Cortina.

Legal Aid In larger Brazilian cities, there are special police detachments for dealing with tourists, called DEAT (Delegacia Especial Atendimento ao Turista). See the Fast Facts sections in each chapter for contact details. If you find yourself involved with the police, demand to be taken to the nearest DEAT station. DEAT officers speak English, and are normally better trained. For any other legal issues, even minor ones, contact your embassy or consulate. See the list of embassies above.

LGBT Travelers Gay and lesbian travelers will find small but vibrant gay communities in São Paulo, Rio de Janeiro, Salvador, and some of the other big cities, more often geared toward men than women. There are now gay pride parades in many of Brazil's big cities—Rio, São Paulo, Belo Horizonte, even Manaus in the Amazon. There are gay beach areas in Rio, and gay bars and clubs in most larger Brazilian cities. Outside of the big cities, openly gay men or women will certainly draw attention and perhaps be subjected to comments or jokes. Brazil is still a macho culture and any open sign of affection between people of the same sex will meet with disapproval. Public displays of affection are not common among gays and lesbians even in the cities, and in small towns and communities the level of acceptance is significantly lower—rude remarks and jokes are almost guaranteed, though physical violence is thankfully rare. One Brazilian travel agency in Rio that specializes in tours for gay and lesbian travelers is **Rio G Travel,** Rua Teixeira de Melo 16, Ipanema (✆ **021/3813-2879;** www.riog.com.br).

Mail Mail from Brazil is quick and efficient. Post offices (*correios*) are found everywhere, readily identifiable by the blue-and-yellow sign. A postcard or letter to Europe or North

America costs R$1.80. Parcels can be sent through FedEx or regular mail (express or common); a small parcel—up to 2.5kg (5½ lb.)—costs about R$55 by common mail and takes about a week or two.

Medical Requirements Before going, check your vaccinations and get booster shots for tetanus and polio if required. Children ages 3 months to 6 years may be required to show proof of polio vaccination. One vaccination that is definitely recommended—and mandatory for international travel between endemic regions—for Brazil is yellow fever. Outbreaks are sometimes reported in the Amazon, the Pantanal, Brasilia, or even Minas Gerais. Make sure you get an international certificate of vaccination as Brazilian authorities sometimes require proof of vaccination for people going to or coming from an affected area. Travelers who have been to Colombia, Bolivia, Ecuador, French Guyana, Peru, Surinam, or Venezuela within 90 days prior to their arrival in Brazil must show proof of yellow fever vaccination. Keep in mind that the vaccine takes 10 days to take effect. Also see "Health" above.

Mobile Phones International GSM cellphones work in most parts of Brazil. Charges can be high—usually US$1 to US$1.50 per minute. A better option is to buy a local SIM card, which gives you a local Brazilian number and allows you to pay local Brazilian rates (about R$1 per minute for local calls, R$1.40 for long distance). There is no charge to receive calls if you are in your home area. Outside your area code, roaming charges of about R$1 per minute apply. There are a number of cellphone providers that sell SIM chips in Brazil, but the only one that provides service throughout the country is **TIM** (www.tim. com.br). There are TIM kiosks in all major malls, and airports and department stores. Note that after you buy a TIM SIM chip, you will have to call and register your account (as part of its anti-crime laws Brazil does not allow anonymous cellphone accounts). You will need to give your name and passport number. Cards that allow you to add credit to your account are available at newsstands throughout Brazil.

Now that Internet services are available practically anywhere (even in the Amazon!), **Skype** (www.skype.com) is a great affordable way to make cheap international calls from a computer.

Money & Costs Frommer's lists exact prices in the local currency. The currency conversions quoted below were correct at press time. However, rates fluctuate, so before departing consult a currency exchange website such as **www.oanda.com/currency/converter** to check up-to-the-minute rates.

The official unit of currency in Brazil is the **real** (pronounced ray-all; the plural is reais, pronounced ray-eyes). Brazil's strong economy and the steady decline of the U.S. dollar has resulted in a strong currency worth approximately R$1.70 to the dollar. For travelers this means that Brazil has become significantly more expensive, especially in the major cities.

Tip: When exchanging money, always keep the receipt. You will need it in case you want to change back any unused reais at the end of your trip. Also note that some tour operators that work with the international market list their prices in US$ only.

The best way to get cash at a reasonable exchange rate is by withdrawing money from an **ATM.** You will find ATMs everywhere in Brazil, even in the smallest towns. The only trick is finding one that works with your card. ATMs are linked to a network that most likely includes your bank at home. **Cirrus** (*©* **800/424-7787;** www.mastercard.com) and **PLUS**

THE VALUE OF THE BRAZILIAN REAL VS. OTHER POPULAR CURRENCIES

R$	Aus$	Can$	Euro (€)	NZ$	UK£	US$
1	A$0.57	C$0.57	€0.42	NZ$0.71	£0.38	$0.58

What Things Cost in Rio de Janeiro	Real (R$)
Taxi from the airport to downtown Rio de Janeiro	35
Double room, moderate	250–350
Double room, inexpensive	180
Three-course dinner for one without wine, moderate	40–50
Bottle of beer	3.50
Cup of coffee	2.50
Admission to most museums	4.00–8.00

(℃ **800/843-7587;** www.visa.com) are popular networks; call or check online for ATM locations at your destination. You need to have a four-digit PIN to be able to access ATMs in Brazil. For most ATMs the limit is R$1,000, but depending on the machine these amounts may be lower. The vast majority of travelers find they are able to use the **HSBC** and **Banco do Brasil** ATMs bearing a PLUS/Visa and Cirrus/MasterCard logo. Almost all Brazilian airports have HSBC and Banco do Brasil ATMs. **Bradesco, Banco 24 Horas,** and **Citibank** ATMs are often compatible with PLUS/Visa. If in doubt, check with your bank to find out which Brazilian bank networks are compatible with your card. Also, plan ahead to ensure that you have enough cash; for safety reasons many ATMs do not operate 24 hours. Your best bets for late-night withdrawals are at airports, malls, or gas stations. Finally, make sure that during New Year's and Carnaval you get enough cash ahead of time, as machines often run out of money by the end of the holidays.

Tip: Before you leave home, write down all your card numbers, expiration dates, and contact phone numbers. Leave a copy with someone you can easily reach, and e-mail a copy to yourself and save it in an account that can be accessed anywhere, so you have the information at your fingertips in case of loss or theft.

The best exchange rates can be obtained through **credit cards,** which are accepted at most Brazilian shops and hotels and restaurants. Just keep in mind that you are sometimes able to negotiate a better discount on a room or in a store if you pay cash. The most commonly accepted cards are Visa and MasterCard. American Express and Diners Club are also often accepted. Beware of hidden credit-card fees while traveling. Check with your credit or debit card issuer and your bank to see what fees, if any, will be charged for overseas transactions. Fees can amount to 3% or more of the purchase price.

For help with currency conversions, tip calculations, and more, download Frommer's convenient Travel Tools app for your mobile device. Go to www.frommers.com/go/mobile and click on the Travel Tools icon.

Multicultural Travelers Black travelers shouldn't encounter much in the way of open discrimination, but Brazil is still a very unequal society and especially in high-end restaurants, hotels, and other establishments there will be almost no black Brazilians. Mixed couples (particularly where the woman is black and the man is not) may encounter discrimination in hotels or bars because people may assume that the woman is a Brazilian prostitute who has hooked up with a gringo guy. Particularly in Rio and the Northeast such "temporary couples" are a common sight, and people unfortunately make assumptions based on appearances.

Newspapers & Magazines The most popular Brazilian newspapers are *O Globo* and *Jornal do Brasil,* published out of Rio, and *Folha de São Paulo,* the leading business

Don't Leave Home Without a Picture ID

Bring an alternative picture ID, like a driver's license or student ID. You are required to carry ID in Brazil, and it's sometimes requested when entering office buildings or even tourist sites. Your passport is safer in the hotel safe and not required except for official transactions.

17

Packing

PLANNING YOUR TRIP TO BRAZIL

paper published in São Paulo. The most popular current affairs magazine (the equivalent of *Newsweek*) is *Veja,* published weekly. In Rio and São Paulo, *Veja* magazine always includes an entertainment insert that provides a detailed listing of nightlife, restaurants, and events. Foreign papers and magazines are only easily found in Rio and São Paulo. A great English-language source is the weekly digital *Rio Times* (www.riotimesonline.com). It contains excellent articles on news, politics, and sports, as well cultural listings and entertainment updates.

Packing You can pretty much find everything you need in Brazil. However, imported goods tend to be more expensive, so bring your favorite brands of cosmetics, contact lens fluid, toothpaste, and other personal care products. The most important thing to keep in mind when packing for Brazil is that the seasons are the exact opposite of those in the Northern Hemisphere; summer is from December through March and winter from June through September (see "When to Go" on p. 24). And although Brazil conjures up images of warm tropical sunshine, from May through October it can be downright chilly in the Southern half, including Rio de Janeiro and São Paulo. Bring warm clothing and a rain jacket. For more helpful information on packing for your trip, download our convenient Travel Tools app for your mobile device. Go to www.frommers.com/go/mobile and click on the Travel Tools icon.

Passports Every foreigner needs a passport valid for at least 6 months to enter Brazil. Depending on your nationality you may also need a **visa.** (See "Visas," below, for more information.) To obtain a passport, contact your official **passport office:**

○ **Australia Australian Passport Information Service** (© **131-232;** www.passports. gov.au).

○ **Canada Passport Office,** Department of Foreign Affairs and International Trade, Ottawa, ON K1A 0G3 (© **800/567-6868;** www.ppt.gc.ca).

○ **Ireland Passport Office,** Setanta Centre, Molesworth Street, Dublin 2 (© **01/671-1633;** www.foreignaffairs.gov.ie).

○ **New Zealand Passports Office,** Department of Internal Affairs, 47 Boulcott Street, Wellington, 6011 (© **0800/225-050** in New Zealand or 04/474-8100; www.passports. govt.nz).

○ **United Kingdom** Visit your nearest passport office, major post office, or travel agency or contact the **Identity and Passport Service (IPS),** 89 Eccleston Square, London, SW1V 1PN (© **0300/222-0000;** www.ips.gov.uk).

○ **United States** To find your regional passport office, check the U.S. State Department website (travel.state.gov/passport) or call the **National Passport Information Center** (© **877/487-2778**) for automated information.

Petrol Please see "By Car" under "Getting Around," earlier in this chapter.

Police For police dial © **190.** The Military Police (Policia Militar or PM) are the most visible police force responsible for general law enforcement on the street. The Civil Police

(Policia Civil) have an investigative role. The Federal Police (Policia Federal) are responsible for border control, including passport control and/or visa renewal. In general the police are helpful to foreigners, but there have been reports of police officers looking for a bribe. This usually involves the Military Police, and as a tourist you may encounter this if you commit a traffic violation or some other minor infraction. Instead of writing a ticket, they may request a "financial contribution" to solve the matter on the spot. If that happens, you will have to use your best judgment on how to handle the situation. However, in recent years there has been a growing movement against police corruption and the penalties for bribing an officer are often much steeper than those for minor infractions, so never offer an unsolicited bribe. Brazilians are very easily offended by foreigners who try to take advantage of their system—even if the system is seriously flawed. If you have any concerns about a police matter, please contact your embassy or consulate for assistance.

Safety Although Brazil once had a reputation for violence and crime, nowadays, though still not perfect by any means, Rio, São Paulo, and Brazil's other big cities are as safe as other large international cities. Statistically, Rio and other big Brazilian cities still have very high crime rates. Most of that crime, however, takes place in the favelas and suburbs and rarely affects tourism. Brazil is a highly unequal society and the burden of crime falls disproportionately (and unfairly) on the country's poor.

When in large centers such as São Paulo, Rio, Salvador, and Recife, use common sense. Don't flash your valuables. Diamond rings and Rolex wristwatches are a no-no. Always have a few small bills ready in your pocket or bag to avoid pulling out your wallet in public places. Plan your sightseeing trips to the city's central core during office hours when there are lots of people about. By all means bring your camera or video camera, but keep it inside a backpack or purse, and only take it out when you want to use it. Don't stroll Copacabana beach at 3am with R$1,000 in your pocket and a video camera pressed to your eyeball (a true story, alas). And though public transit is safe during the day and evening, watch for pickpockets when it gets really packed, and come nightfall, use taxis instead. Be careful at night; stick to the main streets where there is traffic and other pedestrians, and avoid dark alleys or deserted streets. If you do become the victim of a robbery, don't be a hero. Most robbers will be armed so try to stay calm and simply hand over your belongings.

Perhaps even more importantly, keep your wits about you in traffic! Brazilian drivers (with a few exceptions) show no respect for pedestrians and there's no such thing as pedestrian right of way. So be very careful when crossing the street, particularly at night when drivers will often run red lights.

Senior Travelers Senior travelers may be entitled to discounts (usually up to 50%) at museums and cultural events. Although officially reserved for those over 60 or 65 years of age who can show Brazilian ID, foreigners are often granted a discount as well. The phrase to use is *"Tem desconto para idosos?"*

Smoking Smoking is prohibited on planes and long-distance buses and many states have outlawed smoking in enclosed public spaces, including restaurants.

Taxes There are no taxes added to goods purchased in Brazil. Restaurants and hotels normally add a 10% service tax. In Rio, the city also levies a 5% tax on hotels.

Telephones As in most parts of the world, using the phone from your hotel room is an invitation to a gouging at the checkout desk. Premiums almost always apply, and can sometimes reach extraordinary levels. The cheapest way to make international phone calls is to use Internet services such as Skype (www.skype.com).

To call Brazil from abroad:

1. Dial the international access code (011 in the U.S. and Canada, 00 in the U.K., Ireland, and New Zealand, or 0011 from Australia).
2. Dial the country code: 55.
3. Then the area code without the 0 (for example, 21 for Rio, 11 for São Paulo).

To call within Brazil:

Dialing a local number is straightforward: dial the number without the area code. However, for long-distance dialing, telephone numbers are normally listed with a three-digit prefix, followed by the area code, followed by the seven- or eight-digit number (for example, 0XX-21-5555-5555). Since phones were deregulated, a number of very competitive companies have sprung up. The two digits that fill in the XX are the number of the appropriate service provider (in Portuguese this is called the *prestadora*). Any phone can be used to access any service provider. In some cities there may be a choice of two or three providers. The only code that works in all of Brazil (and the only *prestadora* code you need to remember) is the one for Embratel—21 (which also happens to be the area code of Rio). So, if you were dialing long distance to a number in Rio, you would dial 0-21 (selecting Embratel as your provider), 21 (Rio's area code), and 5555-5555 (the number). Dialing long distance to a number in São Paulo, you'd dial 0-21-11-5555-5555.

To make international calls:

Dial 00 + 21 + the country code (U.S. or Canada 1, U.K. 44, Australia 61, New Zealand 64) + area code + phone number.

International collect calls can be requested by dialing 000-111, or automatically by dialing 90 + 21 + country code (U.S. or Canada 1, U.K. 44, Australia 61, New Zealand 64) + area code + phone number. Major long distance company access codes are as follows: AT&T ℂ 0800/890-0288; Sprint ℂ 0800/888-8000; and Canada Direct ℂ 0800/890-0014.

Time Brazil has four time zones. The coast, including Rio de Janeiro, Salvador, and as far inland as São Paulo and Brasilia, is in one time zone (-3 GMT). Mato Grosso and Mato Grosso do Sul, the Pantanal, and the Amazon around Manaus are in the second time zone, 1 hour behind Rio (-4 GMT). The third time zone includes the state of Acre and the western part of the Amazon, 2 hours behind Rio (-5 GMT). The island archipelago of Fernando de Noronha is an hour ahead of Rio and São Paulo (-2 GMT). The time difference between cities in Brazil and North America varies by up to 2 hours over the course of the year as clocks spring forward and fall back for daylight saving time. From approximately March to September Rio de Janeiro is in the same time zone as New York City. From October to February, Rio is at least 1 and often 2 hours ahead of New York (for example, noon in New York City is 2pm in Rio). For help with time translations and more, download our convenient Travel Tools app for your mobile device. Go to www.frommers.com/go/mobile and click on the Travel Tools icon.

Tipping A 10% service charge is automatically included on most restaurant and hotel bills and you are not expected to tip on top of this amount. If service has been particularly bad you can request to have the 10% removed from your bill. Taxi drivers do not get tipped; just round up the amount to facilitate change. Hairdressers and beauticians usually receive a 10% tip. Bellboys get tipped R$1 to R$2 per bag. Room service usually includes the 10% service charge on the bill. For help with tip calculations, currency conversions, and more, download our Travel Tools app for your mobile device. Go to www.frommers.com/go/mobile and click on the Travel Tools icon.

Toilets Public toilets are rare in Brazil, except in shopping malls. You're better off seeking out hotels and restaurants. Toilets in Brazil can be marked in a few different ways.

Usually you will see *mulher* or an *M* for women and *homem* or an *H* for men. Sometimes it will read *damas* or *D* for ladies and *cavalheiros* or *C* for gentlemen. It's not a bad idea to carry some toilet paper or tissue with you as in many public restrooms, the toilet attendant doles out sheets only grudgingly.

Visas Nationals of the United States, Canada, and Australia require a visa to visit Brazil. British nationals and New Zealand passport holders do not require a visa. Most holders of E.U. passports do not need a visa, but check with your consulate or embassy for up to date visa requirements. A number of visa types are available; the cost, processing time, and documentation requirements vary. Visas for Australians cost A$90, plus local handling fees, and take about 2 weeks to process. For Canadians a similar visa costs C$72 and takes about the same processing time. U.S. citizens pay US$100 for a standard single-entry tourist visa valid for 90 days (add another US$10 for handling fees, passport photos, and courier costs if you don't live near a consulate). Count on at least 2 weeks of processing time.

Upon arrival in Brazil, visitors will receive a 90-day entry stamp in their passport and a stamped entry card. Hang on to the card for dear life, as losing it will result in a possible fine and a certain major hassle when you leave. If necessary, the visa can be renewed once for another 90 days. Visa renewals are obtained through the local Policia Federal. This is best done in large cities which have experience with tourists.

Children 17 and under must have their own passports and visas. If a child is traveling with people other than his parents, or even if the child is only traveling with one of his parents, the child must have a notarized letter from both parents confirming permission for the child to travel. The Brazilian consulate or embassy in your region or country can provide a model of this letter *(autorização de viagem para menor de idade)*. Immigration authorities may well demand such a letter on entry or exit. Buses and airlines often demand such a letter before allowing a child to board.

For more information regarding visas and to obtain application details, contact one of the following agencies:

Australia Australians can call ℂ **02/6273-2372** (in Australia) or log on to www.brazil. org.au.

Canada Canadians can apply through Toronto's Brazilian consulate (ℂ **416/922-2503;** www.consbrastoronto.org).

New Zealand Citizens of New Zealand do not require a visa. For information on traveling to Brazil, contact the consular section of the Brazilian embassy in Wellington (ℂ **4/ 473-3516;** www.brazil.org.nz).

United Kingdom Citizens of the United Kingdom (and other European Union countries) do not require a visa. For information on Brazil, check the useful website of the Brazilian embassy in London at **www.brazil.org.uk**.

United States U.S. citizens can contact the Brazilian consulates in New York (ℂ **917/ 777-7791;** www.brazilny.org), Los Angeles (ℂ **323/651-2664;** www.brazilian-consulate. org), or Miami (ℂ **305/285-6200;** www.brazilmiami.org). Links will connect you to the consulate closest to you.

Visitor Information The Brazilian national tourism agency, **Embratur,** has a good site at www.embratur.gov.br. The Brazilian Embassy in the U.K. has an outstanding website including links to local tourism websites: www.brazil.org.uk.

Water The tap water in Brazil is increasingly safe to drink. However, as a result of the treatment process it still doesn't taste great. To be on the safe side, drink bottled or filtered water (most Brazilians do). All brands are reliable; ask for *agua sem gas* for still water and *agua com gas* for carbonated water. However, you can certainly shower, brush your teeth, or rinse an apple with tap water.

Wi-Fi See "Internet & Wi-Fi," earlier in this section.

Women Travelers Machismo is alive and well in Brazil, but it's a kinder, gentler machismo than in other parts of Latin America. Single women and a few women traveling together will undoubtedly attract masculine attention. There are upsides to this. It's usually fairly harmless and can sometimes lead to some fun conversations. The downside is that it's difficult for a woman to go out for a drink by herself and not receive attention. If you're not comfortable with this, you may want to form up a mixed group with other travelers or else stick to higher-end restaurants or hotel bars. Brazilian women in groups of two or three often link arms or hold hands as a sign that they are not interested in male attention. Use common sense to avoid situations where you may find yourself alone with someone giving you unwanted attention. At night, taking taxis is safer than walking by yourself.

Index

See also Accommodations index, below.

General Index

A

Academia da Cachaça (Rio de Janeiro), 122
Academic trips, 29–30
Accommodations, 477–478. *See also* Accommodations Index
best, 7–8
Active travelers, suggested itinerary for, 38–39
ACVL (Associação dos Conductores de Visitores no Lençóis), 264
A Gentil Carioca (Rio de Janeiro), 111
Air tours, Manaus, 373
Air travel, 475–476
Alcântara, 354–356
Aleijadinho, 170
Aleijadinho Week (Ouro Preto), 27
Alfândega (Manaus), 372
All of Jazz (São Paulo), 220
A Lôca (São Paulo), 222
Alô Rio (Rio de Janeiro), 116
Alquimista Tour (Noronha), 312
Alto da Primavera Cliff, 264
Alto da Sé (Olinda), 169
Alto de Ponta Negra (Natal), 325
The Amazon, 28–29, 362–403
brief description of, 34
climate, 25
eco-tourism, 377–380
expedition tours, 386–387
lodges, 380–384
Amazonas Eco Shop (Manaus), 374
Amazon Clipper Cruises, 385
Amazon Mystery Tours (Manaus), 386–387
Amsterdam Sauer (Rio de Janeiro), 112–113
Anaconda Turismo (Cuiabá), 461
Anchieta Chapel (São Paulo), 210
Anhumas Abyss, rappelling and snorkeling in, 471
Antigamente (São Luis), 11
Antiques Fair (São Paulo), 10
Antonio Bernardo (São Paulo), 216
Antônio Carlos Jobim Airport (Galeão Airport), 43
A Pororoca (Belém), 400
Aquario Natural (Bonito), 471
Ara Ketu (Salvador), 257
Araras Eco Lodge, 29, 458, 461, 462

Architecture
Brasilia highlights, 414–415
suggested itinerary, 39–40
Arco do Teles (Rio de Janeiro), 11, 94, 97, 121
Area codes, 478
Arezzo (Rio de Janeiro), 114
Armazém do Ferreira (Brasilia), 416–417
Army History Museum (Rio de Janeiro), 89
Arpoador Beach (Rio de Janeiro), 108
Arsenal do Chopp (Recife), 300
Artes da Chapada Artesanatos (Chapada dos Guimarães), 465
Arte Tribal (São Paulo), 215
Art from Mars (Belo Horizonte), 166
Artindia (Manaus), 374
Aterro do Flamengo (Rio de Janeiro), 105
Atlantis Divers (Noronha), 311
ATMs (automated-teller machines), 482–483
Aurisom (Salvador), 252
Avenida Alfonso Pena (Belo Horizonte), 163
Avenida Central (Rio de Janeiro), 94
Avenida Paulista (São Paulo), 183
accommodations, 188, 190
restaurants, 197–198
Aventureiro Beach (Ilha Grande), 148
Azucar (São Paulo), 220

B

Bahia Café Aflitos (Salvador), 254
Baía do Sancho (Noronha), 310
Baía do Sueste (Noronha), 310
Bailes (balls), Rio de Janeiro, 129–130
Baixo Baby (Rio de Janeiro), 103, 105
Balé Folclorico (Salvador), 253
Balls, Carnaval (bailes), Rio de Janeiro, 126, 129–130
Banana Price (São Paulo), 217
Banco do Brasil (São Paulo), 209
Banda de Ipanema (Rio de Janeiro), 126
Banespa Tower (São Paulo), 211
Bar Biergarten (Ilha Grande), 151
Bar Brahma (São Paulo), 221
Bar Camará (São Paulo), 219
Bar des Arts (São Paulo), 220
Bar do Beco (Ouro Preto), 173
Bar dos Descasados (Rio de Janeiro), 122
Bar Olindita (Olinda), 300
Baronnetti (Rio de Janeiro), 119
Barra (Salvador), 244–245, 247
accommodations, 231
restaurants, 237



Barra da Tijuca (Rio de Janeiro), 99
beach, 103–104
restaurants, 83
Barra Frande, 273–276
Barra-Meio (Rio de Janeiro), 108
Barra Point (Salvador), 244
Barra Shopping (Rio de Janeiro), 110
Basilica de Nazaré (Belém), 398
Basilica de São Bento (São Paulo), 210
Basilica de São Pedro dos Mariana, 174
Batatinha route (Salvador), 257
Bauernfest (Petrópolis), 27, 140
Beach buggies, 3, 6
Beaches
Barra Frande, 274
best, 2
Búzios, 132–134
Florianópolis, 446–447
Itacaré, 277
Morro de São Paulo, 269
Noronha, 310
Praia da Pipa, 326–327
Rio de Janeiro, 47, 101–104, 148
Salvador, 248–249
São Luis, 350–351
suggested itinerary, 41
sunbathing rules, 102–103
Beach Park (near Fortaleza), 339
Beachwear, Rio de Janeiro, 110–111
Beija Flor (Rio de Janeiro), 129
Belém, 387–400
accommodations, 392–394
exploring, 396–399
getting around, 391
getting there, 389
layout of, 389, 391
nightlife, 400
restaurants, 10, 394–396
shopping, 399–400
tours, 399
visitor information, 391–392
Belmonte (Rio de Janeiro), 121
Belo Horizonte, 11, 158–166
Bike e Lazer (Rio de Janeiro), 107
Biking and mountain biking
Búzios, 134
Chapada Diamantina, 3
Lençóis and Chapada Diamantina, 263
Noronha, 312
Paraty, 153
Rio de Janeiro, 107
Bip Bip (Rio de Janeiro), 121–122
Bird-watching
Iguaçu and Iguaçu Falls, 427
the Pantanal, 6–7, 458, 463
Biruta Bar (Recife), 300
Bishop's Palace (São Luis), 354
Black Bom Bom (São Paulo), 219
Bloco dos Mascarados (Salvador), 256

493